Gary Kelley
Artist
Page 200

Holly Solomon
Gallery Owner
Page 472

Keith Coleman
President, Afrocentrex
Page 519

Richard Grefé
Executive Director, AIGA
Page 679

1997
ARTIST'S &
GRAPHIC
DESIGNER'S
MARKET

Managing Editor, Market Books Department: Constance J. Achabal;
Supervising Editor: Michael Willins;
Production Editor: Tara A. Horton.

This 1997 hardcover edition of *Artist's & Graphic Designer's Market* features a "self-jacket" that eliminates the need for a separate dust jacket. It provides sturdy protection for your book while it saves paper, trees and energy.

International Standard Serial Number 1075-0894
International Standard Book Number 0-89879-744-6

Portrait Artist: Ervin Henderson.
Cover Illustration: Celia Johnson.

Attention Booksellers: This is an annual directory of F&W Publications. Return deadline for this edition is December 31, 1997.

1 9 9 7
ARTIST'S & GRAPHIC DESIGNER'S MARKET

WHERE & HOW TO SELL YOUR ILLUSTRATION, FINE ART, GRAPHIC DESIGN & CARTOONS

EDITED BY

MARY COX

WRITER'S DIGEST BOOKS
CINCINNATI, OHIO

Contents

THE VACATIONS...

© Kevin Ahern

Page 7

The Markets

Page 348

© Richard A. Williams/Scholastic Inc. Reprinted with permission

Page 531

© Richard Comely 1996

Resources

© Mary Ross

Page 663

From the Editor

Chance is always powerful. Let your hook be always cast; in the pool where you least expect it, there will be a fish. —Ovid

Recently, an artist told me she was ready to give up until another artist revealed his "secret formula" for success. Can you guess what it might be?

While you're pondering that question, let me welcome you to this year's *Artist's & Graphic Designer's Market.* Whether you are a painter, illustrator, sculptor, airbrush artist, designer, conceptual artist, or cartoonist you'll find companies and galleries anxious to see your samples. In addition to listings, we offer practical business advice and articles to expand your horizons. You'll find information on copyright, billing, shipping and sales. Maria Piscopo's Super Sales Strategies for Illustrators and Designers is filled with so many ideas, it's like attending one of her seminars. Taking your Show on the Road by Pat Seslar offers the scoop on art festivals from an artist who's been there. We shed light on the Mac vs. PC controversy in Computers: The State of the Art, offer a glimpse into Cyberspace in Working the Web, report Internet Resources, and offer a new index to lead you to multimedia markets.

We interviewed 14 experts for Insider Reports. You'll hear award winning artist, **Gary Kelley** express his views on fine art vs. illustration; and listen as **Holly Solomon**, owner of Holly Solomon Gallery in New York City shares insights into collectors and galleries. Art directors and art buyers tell how to win assignments. As we do every year, we pried a few secrets from artists who conquered their markets.

And speaking of secrets, have you guessed that secret strategy yet? Maybe this story will give you a clue.

The artist found herself seated next to a successful artist on a flight to Baltimore. They started chatting and pretty soon she confided that she was about to give up. "How many submissions do you send each month?" he asked. "It seems like every month I send at least one or two," she replied. The successful artist smiled. "Let me tell you a secret that worked for me. Always mail at least 12 submissions at a time. There's something magical about that number." When she got to Baltimore, the artist sent out 12 submissions. Two weeks later, she sent out 12 more. "I no longer focused on rejection because I was too busy getting my samples ready to mail. Lo and behold, the system worked. I started getting assignments and repeat business."

Now I'm not claiming this strategy will work for you. After all, I haven't seen your artwork. There's probably nothing magical about the number 12. The "secret formula" worked because it involved consistency and action. Without a plan, the artist submitted in dribs and drabs. Then she'd wait by the mailbox. The new strategy shifted her into the active mode. There's something to be said for having a plan and boldly setting out to follow it. In the words of Goethe, "Whatever you think you can do or believe you can do, begin it. Action has magic, grace, and power in it." *That's* the secret.

Mary Cox
wdigest@aol.com

How to Use Your *Artist's & Graphic Designer's Market*

This book consists mainly of listings of companies that buy artwork and design services, and galleries that exhibit and sell fine art. Before you jump in and start searching for listings, take a few minutes to read this article. Knowing where to look and what to look for will improve your odds for success.

HOW TO READ LISTINGS

Information within listings is grouped under bold-faced headings, allowing you to quickly scan listings for key elements. Symbols and abbreviations—such as the double-dagger preceding new listings and SASE for self-addressed, stamped envelope—are used to conserve space. (Refer to the Key to Symbols and Abbreviations on page 40 or the Glossary on page 685 if you come across puzzling words or phrases.)

Each listing contains a description of the artwork and/or services it prefers. In the Greeting Card, Games & Products section this information always follows the **Needs** heading. The information often reveals how much freelance material is used by each market, whether computer skills are needed, and which software programs are preferred. For example, the **Needs** section of Enesco Corporation's listing states:

> **Needs:** Works with 300 freelance artists/year. Assigns 1,000 freelance jobs/year. Prefers artists with experience in gift product and packaging development. Uses freelancers for rendering, illustration and sculpture. 50% of freelance work demands knowledge of Adobe Photoshop, QuarkXPress or Adobe Illustrator.

In some sections, needs for artwork are broken down into separate subheads to make it easy for you to identify potential markets for your work. Magazine listings specify needs for cartoons and illustrations. Galleries specify media and style.

After you've found potential buyers it's important to submit the right material. In the next article, What Should I Submit?, we list the standard submission requirements for each market, but if you want more specific information, look within each listing for detailed information. In some sections, this information is listed under the **First Contact & Terms** subhead. In sections such as Magazine and Book Publishers, where listings are broken down according to type of work sought, submission information is contained within the appropriate subhead. Here's how Future Features Syndicate describes its preferred method of submission:

> **First Contact & Terms:** Sample package should include cover letter, photocopies and a short paragraph stating why you want to be a syndicated cartoonist. 12-36 samples should be included.

For the past several years we also have included editorial comments within listings. Denoted by bullets (●), these comments give you extra information about markets, such as company awards, mergers and insight into a listing's staff or procedures. The editorial comment for Koucky Gallery in Naples, Florida states:

> ● Koucky Gallery also has a location in Charlevoix, Michigan.

WHICH LISTINGS ARE BEST FOR YOU?

Listings are divided into sections representing professional categories, such as book publishing or magazines. Your talents could be marketable in several sections. Scan the following list for opportunities in your area of interest:

Fine art. Galleries, posters and prints and greeting cards will be your main markets, but book and magazine publishers, advertising agencies, design firms and record companies seek illustration with a fine art feel.

Sculpture and crafts. Galleries is an obvious choice, but design firms and advertising agencies hire sculptors to create models and displays. Games and products manufacturers hire sculptors to create ornaments and figurines. You can market your work as 3-D illustrations to magazine and book publishers.

Cartoons and comic strips. Consult the Humor Index to quickly target greeting cards, magazines, book publishers, syndicates, design firms and advertising agencies seeking humorous illustrations and cartoons. Comic strip creators should look under syndicates.

Illustration. Check greeting cards, games & products, magazines, book publishers, record companies, clip art firms, design firms and advertising, audiovisual & public relations firms.

Science fiction and fantasy art. Check games, poster & prints, and book publishers.

Architectural rendering, medical and fashion illustration. Check magazines, book publishers, design firms and advertising.

Calligraphy. Look under book publishers, greeting cards, design firms, advertising, audiovisual and public relations firms.

Airbrush art. Look under greeting cards, games & products, poster & prints, magazines, book publishers, design firms, and advertising, audiovisual & public relations firms.

Storyboards. Look under design firms and advertising, audiovisual and public relations firms.

Design and production. Check greeting cards, games & products, magazines, posters & prints, book publishers, record companies, design firms and advertising, audiovisual and public relations firms.

Multimedia design and animation. The Multimedia Index will steer you to advertising and design firms, publishers and record companies in need of your skills.

T-shirts, mugs and toys. Check greeting cards, games & products and design firms.

WHAT TO LOOK FOR WHEN EVALUATING LISTINGS

As you scan listings, look for specific information and ask key questions to evaluate a listing's potential. Certain elements provide valuable clues that can lead you to the most promising market for your artwork or skills. For example, if you are looking for galleries, check first to make sure a gallery exhibits the style and media you work in. When looking for advertising agencies, be sure to check their clients and specialties to determine if your talents will fit in. If you want to submit to magazines, choose those magazines whose subject matter and readers are appropriate to the work you do. Before sending out any mailings, always ask "Is my work appropriate?"

Another helpful tip is to compare the number of artists who approach a listing with the number it actually works with. Quite naturally, you'll have the best chance with business that work with many artists. As you become more familiar with the listings, you will discover which key elements within each listing help you make the best choices.

What Should I Submit?

Your success as an artist depends largely on the quality of the samples you submit to galleries and potential clients. Whether you are beginning your career or are an old hand at submissions, review the following guidelines before sending samples. Like anything else, submission policies change and evolve. This year, we've noticed a definite trend toward streamlined submissions. Dozens of art directors and gallery owners asked us to revise their submission preferences because they don't have time to review bulky submissions. Many art directors who requested query letter, brochure and samples last year now say they'd rather see a simple postcard. Similarly, many galleries reduced the number of slides they need to see. Increasingly, art buyers ask for samples that do not have to be returned so they can just keep them on file.

Richard Ross, a freelance designer/illustrator based in New York City has noticed the shift away from elaborate submissions. "Keep your samples simple, elegant and functional," says Ross, who sends several promotional mailings each year. Ross sends two types of targeted mailings. To market his illustration, Ross has five of his images printed by a commercial printer on $8\frac{3}{4} \times 11\frac{1}{2}$ postcards along with his name, address and phone number. A short paragraph on the reverse lists past clients and experience. Though it's fine to mail postcards without envelopes, Ross likes to insert his cards in 9×12 envelopes. He sends a separate mailing targeting design clients. To show capabilities, he mails a slightly more extensive submission consisting of three or four cards. Since he mails it to a smaller list, Ross orders C-prints of several images from a local color lab at $1.10 per print.

"It makes a big difference what time of year you send your mailings," says Ross, "Right around New Year's is the best time to mail your samples." Art directors are gearing up for the new year and new projects. Summers are generally slow, says Ross. From his experience, the next best time to mail is right around Labor Day. Ross also reports a shift away from portfolio reviews. "Most of the time I'll get called for jobs just based on my postcard." Again, more evidence that art directors are increasingly pressed for time.

We divided this article into three sections, so whether you are a fine artist, illustrator or designer, check under the appropriate heading for guidelines. Read individual listings for more specific instructions.

As you read the listings, you'll see the term SASE, short for self-addressed, stamped envelope. Enclose a SASE with your submissions if you want your material returned. If you send postcards or tearsheets for art directors to keep on file, no return envelope is necessary.

GUIDELINES FOR FINE ARTISTS

When submitting introductory material to galleries, send a 9×12 envelope containing material they request in their listings. Usually that means a query letter, slides and résumé, but check each listing. Some galleries like to see more. Here's an overview of the various components you can include:

- **Slides.** Send eight to twelve slides of your work in a plastic slide sleeve (available at art supply stores). To protect slides from being damaged in the mail, insert slide sheets between two pieces of cardboard. Ideally, slides should be taken

by a professional photographer, but if you must take your own slides, refer to *Photographing Your Artwork*, by Russell Hart (North Light Books). Label each slide with your name, the title of the work, media, and dimensions of the work and an arrow indicating the top of the slide. Some galleries like to see photographs rather than slides. Refer to the listings to find out which they prefer. When choosing artwork to photograph, choose only your very best work.

Gallery directors look for a sense of vision or direction and a body of work to demonstrate this. It's not enough to show a collection of unrelated work. You'll need to show you are capable of cultivating an idea into an entire exhibition's worth of work.

Provide gallery directors with a list of titles and suggested prices they can refer to as they review slides. Make sure the list is in the same order as the slides. Type your name, address and phone number at the top of the list.

- **Query letter or cover letter.** Type one or two paragraphs expressing your interest in showing at the gallery, and include a date and time when you will follow up.
- **Résumé or bio.** Your résumé needn't list every job you've ever had—concentrate on your art-related experience. List any shows your work has been included in and the dates. A bio is a paragraph describing where you were born, your education, the work you do and where you have shown in the past.
- **Artist's statement.** Some galleries require a short statement about your work and the themes you are exploring. A few paragraphs are all that is necessary.
- **Brochures and business cards.** Some artists design brochures showing color samples of their artwork and biographical information. Business cards are another professional touch. These extras make a good impression in your submission package, but are optional.
- **SASE.** If you need material back, don't forget to include your SASE.

GUIDELINES FOR ILLUSTRATORS AND CARTOONISTS

Illustrators have several choices when submitting to markets. Many freelancers send a cover letter and one or two samples in initial mailings. Others prefer a simple postcard showing their illustrations. Here are a few of your options:

- **Postcard.** Choose one (or more) of your illustrations that is representative of your style, then have the image printed on postcards. Have your name, address and phone number printed on the front of the postcard, or in the return address corner. Somewhere on the card should be printed the word "Illustrator." If you use one or two colors you can keep the cost below $200. Art directors like postcards because they are easy to file or tack on a bulletin board. If the art director likes what she sees, she can always call you for more samples. (See examples on page 6.)
- **Promotional sheet.** If you want to show more of your work, you can opt for an 8 × 12 color or black & white photocopy of your work. (See Kevin Ahern's promotional sheet on page 7.)
- **Tearsheets.** After you complete assignments, acquire copies of any printed pages on which your illustration appears. Tearsheets impress art directors because they are proof that you are experienced and have met deadlines on previous projects.
- **Photographs and slides.** Some illustrators have been successful sending photographs or slides, but printed or photocopied samples are preferred by most art directors.
- **Query or cover letter.** A query letter is a nice way to introduce yourself to an art director for the first time. One or two paragraphs stating you are available for freelance work is all you need. Include your phone number, samples or tearsheets.

MARIS BISHOFS
251-16 NORTHERN BLVD
LITTLE NECK, NY 11363
PHONE 718 229 7570
FAX 718 229 6089

This ink and watercolor illustration by Maris Bishofs, illustrating the idea of governments helping with loans, is the first of a number by the artist published in *Inc. Magazine*. Bishofs put the published image on a postcard-size mailer to be used for self-promotion. He feels having published work seen by art directors at other magazines is a great way to land more assignments.

Ron Coddington
CARICATURIST 408/920-5654

Ron Coddington lets his work speak for itself on this simple promo piece including only an image, his name and his phone number. The piece appeared in an ad in *RSVP*, with this ad he was given several hundred postcards to use for promotion. This humorous take on the Father of Our Country generated a number of freelance connections for the caricaturist.

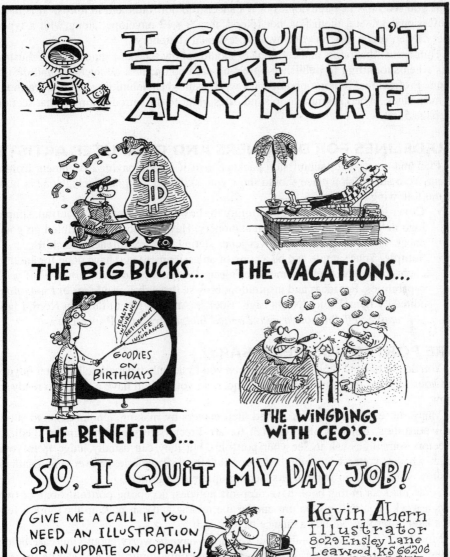

Kevin Ahern shows off his humorous illustration style in this 8½ × 11 pen & ink piece, part of a promotion package Ahern created and sent to prospective clients found through *Artist's & Graphic Designer's Market*. The mailing resulted in favorable replies and several assignments (which may have caused him to miss a few episodes of "Oprah.")

If you send 8×12 photocopies or tearsheets, do not fold them in thirds. It is more professional to send them flat, not folded, in a 9×12 envelope, along with a typed query letter, preferably on your own professional stationery.

Humorous illustrators and cartoonists should follow the same guidelines as illustrators when submitting to publishers, greeting card companies, ad agencies and design firms. Professional looking photocopies work well when submitting multiple cartoons to magazines. When submitting to syndicates, refer to the introduction for that section on page 516.

GUIDELINES FOR DESIGNERS AND COMPUTER ARTISTS

Plan and create your submission package as if it were a paying assignment from a client. Your submission piece should show your skill as a designer. Include one or both of the following:

- **Cover letter.** This is your opportunity to show you can design a beautiful, simple logo or letterhead for your own stationery. Have the stationery printed on good paper. Then write a simple cover letter stating your experience and skills.
- **Sample.** Your sample can be a copy of an assignment you have done for another client, or a clever self-promotional piece. Design a great piece to show off your capabilities. For ideas and inspiration, browse through *Fresh Ideas in Promotion*, edited by Lynn Haller (North Light Books). Another great title from North Light is *Creative Self-Promotion on a Limited Budget*, by Sally Prince Davis.

ARE PORTFOLIOS NECESSARY?

You do not need to send a portfolio when you first contact a market. But after buyers see your samples they may want to see more, so you should have a portfolio ready to show.

Many successful illustrators started their careers by making appointments to show their portfolios. But it is often enough for art directors to see your samples. Gallery directors sometimes ask to see your portfolio, but they can usually judge from your slides whether your work would be appropriate for their galleries. Never visit a gallery to show your portfolio without first setting up an appointment.

Some markets in this book have drop-off policies, accepting portfolios one or two days a week. You will not be present for the review and can pick up the work a few days later, after they've had a chance to look at it.

Most businesses are honorable and you don't have to worry about your case being stolen. However, since things do get lost, include only duplicates that can be insured at a reasonable cost. Only show originals when you can be present for the review. Label your portfolio with your name, address and phone number.

WHAT SHOULD I INCLUDE IN MY PORTFOLIO?

The overall appearance of your portfolio affects your professional presentation. Your portfolio need not be made of high-grade leather to leave a good impression. Neatness and careful organization are essential whether you are using a three-ring binder or a leather case. The most popular portfolios are simulated leather with puncture-proof sides that allow the inclusion of loose samples. Choose a size that can be handled easily. Avoid the large, "student" size books which are too big and bulky to fit easily on an art director's desk. Most artists choose 11×14 or 18×24. If you are a fine artist and your work is too large for a portfolio, bring your slides and a few small samples.

Don't include everything you've done in your portfolio. Select only your best work and choose pieces germane to the company or gallery you are approaching. If you're

showing your book to an ad agency, for example, don't include greeting card illustrations.

In reviewing portfolios, art directors look for consistency of style and skill. They sometimes like to see work in different stages (roughs, comps and finished pieces) to see the progression of ideas and how you handle certain problems.

When presenting your portfolio, allow your work to speak for itself. It's best to keep explanations to a minimum and be available for questions if asked. Prepare for the review by taking along notes on each piece. If the buyer asks a question, take the opportunity to talk a little bit about the piece in question. Mention the budget, time frame and any problems you faced and solved. If you are a fine artist, talk about how the piece fits into the evolution of a concept, and how it relates to other pieces you've shown.

Don't ever walk out of a portfolio review without leaving the buyer a business card or sample to remember you by. A few weeks after your review, follow up by sending a small promo postcard or other sample as a reminder.

For more information, see *The Ultimate Portfolio*, by Martha Metzdorf and *The Fine Artist's Guide to Showing and Selling Your Work*, by Sally Prince Davis, both published by North Light Books.

WHAT IS SELF-PROMOTION?

Self-promotion is an ongoing process of building name recognition and reputation through introducing yourself to new clients and reminding past clients you are still available.

Experts suggest artists spend about one-third of each week and up to 10 percent of their gross income on self-promotion. Whether you decide to invest this much time is up to you, but it is important to build time into your schedule for promotional activities. For more insight into sales and promotion, read Maria Piscopo's article, Super Sales Strategies for Illustrators and Designers on page 33.

It's a good idea to supplement your mailings with other forms of self-promotion. There are many additional strategies to make prospective clients aware of you and your work. Consider some of these options:

- **Talent Directories.** Many graphic designers and illustrators buy pages in illustration and design annuals such as *Black Book*, *The American Showcase* and *RSVP*. These go to thousands of art directors across the country and many keep their directories for up to five years.

 A page in one of these directories can run from $2,000 to $3,500 and you have no control over who receives them. Yet, some artists who buy pages claim they make several times the amount they spend. One bonus to these directories is they provide you with up to 2,000 loose pages, depending on the book, to use as samples.

- **Media relations.** The media is always looking for good public interest stories. If you've done something unique with your work, send a press release to magazines, newspapers and radio. This kind of exposure is free and will help increase public awareness of you and your work.

- **Pro bono work.** Donating your design or illustration services to a favorite charity or cause not only makes you feel good—it can be good public relations. These jobs can offer you added exposure and an opportunity to acquaint potential clients with your work. For example, a poster designed for your local ballet company may put your work in front of area business communicators, gallery directors and shop owners in need of artistic services. If you design a brochure for a charity event, you'll reach everyone on the charity's mailing list. Only donate

free services to nonprofit organizations in need of help—don't give away work to a client who has the means to pay.

- **Networking.** Attending seminars, organization meetings, trade shows, gallery openings and fundraisers is a good way to get your name out. It doesn't hurt to keep a business card on hand. Volunteering to work on committees gives you an even better opportunity to make contacts.
- **Contests and juried shows.** Even if you don't win, contests provide good exposure. Judges of design and illustration contests are usually art directors and editors who may need work in the future. Winners of competitions sponsored by design magazines like *HOW* and *Print* are published in awards annuals and result in national exposure. Since there are many categories and levels of awards there are many chances to win. Judges of fine art shows are often gallery directors. Entering a juried show will also allow you to show your work to the community.
- **Home shows.** If you are a fine artist and have a body of work nearly complete, go over your mailing list and invite a select number of people to your home to preview the work. (Before pursuing this option, however, make sure you are not violating any contracts you already have with galleries.)

Negotiating the Best Deal

When clients and galleries show interest in your work, the moment can be so exhilarating you'll agree to just about anything. Before you sign on the dotted line, or give your verbal consent, familiarize yourself with basic copyright and fee-setting information. Take time to discuss the terms of agreement with your client or gallery. Doing so will improve your image as a professional in the client's eyes and will protect both you and the client in the long run. The sections that follow cover some important points to keep in mind during business negotiations.

REPRODUCTION RIGHTS

As creator of your artwork, you have certain inherent rights over your work and can control how it is used. When a client buys "rights" to your work, he or she buys the right to reproduce it for a certain duration of time. Unless all rights are purchased, you temporarily "lease" your work to the client for reproduction or publication. The artwork must be returned to you unless otherwise specified. Once the buyer has used the rights purchased, he has no further claim to your work. If he wants to use it a second or third time, he must pay additional fees.

The more rights you sell to one client, the more money you should receive. Negotiate this upfront with your client before agreeing on a price. Find out how long he intends to use it and where so that you will not relinquish too many rights. If the work is going to be used internationally, for example, you can charge a higher fee. Because copyright is frequently misunderstood, it is paramount to know your rights and to make sure your clients do, too. Here is a list of rights typically sold in the art marketplace:

- **One-time rights**. The artwork is "leased" for one use. The buyer has no guarantee he is the first to use the piece. Rights revert back to you after use.
- **First rights**. This is generally the same as purchase of one-time rights though the art buyer is paying a bit more for the privilege of being the first to use the image. He may use it only once unless other rights are negotiated.
- **Exclusive rights**. These guarantee the buyer's exclusive right to use the artwork in his particular market or for a particular product. A greeting card company, for example, may purchase exclusive rights to an image with the stipulation that it not be sold to a competing card company for a certain time period. You retain rights to sell the image to other, noncompeting markets.
- **Second serial (reprint) rights**. These give a newspaper or magazine the opportunity to print your work after it has already appeared in another publication.
- **Subsidiary rights**. This category covers additional rights purchased. Each right must be specified in the contract. For example, a publisher might want to include the right to use your illustration for the second printing or paperback edition of a book. Most U.S. magazines ask for "first North American serial rights" which gives them the right to publish your work in North America.
- **Promotion rights**. Such rights allow a publisher to use your work for promotion of a publication in which the artwork appeared. You can charge more if the agreement asks for promotional use in addition to the rights first sold to reproduce the image.
- **Works for hire**. Under the Copyright Act of 1976, section 101, a "work for

hire" (as applied to artwork) is defined as: "a work prepared by an employee within the scope of his or her employment; or a work specifically ordered or commissioned for use as a contribution to a collective work, as part of a motion picture or audiovisual work, or as a supplementary work if the parties expressly agree in a written instrument signed by them that the work shall be considered a work made for hire." Proceed with caution if a client requests this arrangement. You could be losing possible royalties and the work you create could make your employer very, very rich. Consult *Graphic Artist's Guild's Handbook of Pricing & Ethical Guidelines* before signing anything.

- **All rights**. This involves selling or assigning all rights to a piece of artwork for a specified period of time. It differs from work for hire, which means the artist surrenders all rights to an image and any claims to royalties or other future compensation. Terms for all rights—including time period of usage and compensation—should always be negotiated and confirmed in a written agreement with the client.

COPYRIGHT SPECIFICS

The following questions touch upon the basics of copyright. For further information on copyright, refer to *The Legal Guide for the Visual Artist*, by Tad Crawford (Allworth Press) and *The Artist's Friendly Legal Guide* (North Light Books).

What can you copyright? You can copyright any work that has sprung from your creative efforts and is fixed on paper or any other tangible medium such as canvas or even in computer memory. Reproductions are copyrightable under the category of compilations and derivative works.

What can't be copyrighted? Ideas are not copyrightable. To protect an idea, you must use nondisclosure agreements or apply for a patent. Copyright protects the form but not the mechanical aspects of utilitarian objects. While you can copyright the form of your "Wally the Whale" lamp, you can't stop other people from making lamps. You can also copyright the illustration of Wally painted on the lamp.

What is copyright notice? A copyright notice consists of the word "Copyright" or its symbol ©, the year of first publication and the full name of the copyright owner. It must be placed where it can easily be seen, preferably on the front of your work. You can place it on the back of a painting as long as it won't be covered by a backing or a frame. Always place your copyright notice on slides or photographs sent to potential clients or galleries. Affix it on the mounts of slides and on the backs of photographs (preferably on a label).

If you omit the notice, you can still copyright the work if you have registered it before publication and you make a reasonable effort to add the notice to all copies. If you've omitted the notice from a work that will be published, you can ask in your contract that the notice be placed on all copies.

When is a work "published"? Publication occurs when a work is displayed publicly or made available to public view. Your work is "published" when it is exhibited in a gallery; reproduced in a magazine, on a poster or on your promotional pieces.

How do you get copyright protection? Although you will own the copyright from the time your work is expressed in tangible form, you must register your copyright with the U.S. Copyright Office in order to be able to enforce your rights against infringers. While there is no deadline for filing a copyright registration application, you may lose important recourse to infringement if the copyright for an artwork is not registered within 90 days of publication or before infringement begins.

How do I register a work? Write to the Copyright Office, Library of Congress, Washington DC 20559 and ask for form VA (works of visual arts). After you receive

the form, you can call the Copyright Office information number, (202)479-0700, if you need any help. You can also write to the Copyright Office for information, forms and circulars (address your letter to Information and Publications, Section LM-455). After you fill out the form, return it to the Copyright Office with a check or money order for the required amount, a deposit copy or copies of the work and a cover letter explaining your request. For almost all artistic work, deposits consist of transparencies (35mm or $2\frac{1}{4} \times 2\frac{1}{4}$) or photographic prints (preferably 8×10). For unpublished works, send one copy; send two copies for published works.

How does registration protect the artist? If you have registered a copyright you can legally sue for an injunction to prevent infringers from continuing to use infringed work and prevent distribution of the infringing material. You can sue for actual damages—what would have been earned (you must prove how much money you've lost). You can also sue for a percentage of the infringer's profits resulting from unauthorized use of your work. Or, you can sue for statutory damages of between $200-20,000 from innocent infringers to between $500-100,000 from willful infringers. If you win your case, the infringers can be forced to pay legal costs and sometimes, attorney's fees.

What constitutes an infringement? Anyone who copies a protected work owned by someone else or who exercises an exclusive right without authorization is liable for infringement.

How long does copyright protection last? Once registered, copyright protection lasts for the life of the artist plus 50 years. For works created by two or more people, protection lasts for the life of the last survivor plus 50 years. For works created anonymously or under a pseudonym, protection lasts for 100 years after the work is completed or 75 years after publication, whichever is shorter.

What is a transfer of copyright? Ownership of all or some of your exclusive rights can be transferred by selling, donating or trading them and signing a document as evidence that the transfer has taken place. When you sign an agreement with a magazine for one-time use of an illustration, you are transferring part of your copyright to the magazine. Transfers are usually limited by time, place or form of reproduction, such as first North American serial rights.

What is a licensing agreement? A license is an agreement by you to permit another party to reproduce your work for specific purposes for a limited amount of time in return for a fee or royalty. For example, you can grant a nonexclusive license for your polar bear design, originally reproduced on a greeting card, to a manufacturer of plush toys, to an art publisher for posters of the polar bear, or a a manufacturer of novelty items for a polar bear mug.

FEE-SETTING IN COMMERCIAL MARKETS

It's difficult to make blanket statements about what to charge for illustration and design. Every slice of the market is somewhat different. Nevertheless, there is one recurring pattern: hourly rates are generally only paid to designers working inhouse on a client's equipment. (Clients are more likely to pay hourly if they can easily keep track of the hours freelancers work.) Freelancers working out of their own studios (this is nearly always the arrangement for illustrators) are almost always paid a flat fee or an advance against royalties.

If you are unsure about what to charge for a job, begin by devising an hourly rate, taking into consideration the cost of your materials and overhead and whatever you think your time is worth. (If you are a designer, determine what the average salary would be for a fulltime employee doing the same job.) Then estimate how many hours the job will take and quote a flat fee based on these calculations. *Setting the Right Price for Your Design & Illustration*, by Barbara Ganim (North Light Books) includes easy-

to-use worksheets to help you set prices for 33 kinds of projects.

There is a distinct difference between giving the client a job estimate vs. a job quotation. An estimate is a "ballpark" figure of what the job will cost, but is subject to change. A quotation is a set fee which, once agreed upon, is pretty much set in stone. Make sure the client understands which you are negotiating. Estimates are often used as a preliminary step in itemizing costs for a combination of design services such as concepting, typesetting and printing. Flat quotations are usually used by illustrators, as there are fewer factors involved in arriving at fees.

For recommended charges for different services, refer to the *Graphic Artist's Guild's Handbook of Pricing & Ethical Guidelines*. Many artists' organizations have hotlines you can call to find out standard payment for the job you're doing.

As you set fees, certain stipulations call for higher rates. Consider these bargaining points:

- **Usage (rights)**. The more rights bought, the more you can charge. For example, if the client asks for a "buyout" (to buy all rights), you can charge more because by relinquishing all rights to future use of your work you will be losing out on resale potential.
- **Turnaround time**. If you are asked to turn the job around in a short amount of time, charge more.
- **Budget**. Don't be afraid to ask a project's budget before offering a quote. You won't want to charge $500 for a print ad illustration if the ad agency has a budget of $40,000 for that ad. If the budget is that big, ask for higher payment.
- **Reputation**. The more well-known you are, the more you can charge. As you become established, periodically raise your rates (in small steps) and see what happens.

PRICING YOUR FINE ART

There are no hard and fast rules for pricing your work. Most artists and galleries base prices on market value—what the buying public is currently paying for similar work. Learn the market value by visiting galleries and checking prices of works similar to yours. When you are starting out don't compare your prices to established artists, but to emerging talent in your region. Consider these when determining price:

- **Medium**. Oils and acrylics cost more than watercolors by the same artist. Price paintings higher than drawings.
- **Expense of materials**. Charge more for work done on expensive paper than for work of a similar size on a lesser grade paper.
- **Size**. Though a large work isn't necessarily better than a small one, as a rule of thumb you can charge more for the larger work.
- **Scarcity**. Charge more for one-of-a-kind works like paintings and drawings, than for limited editions, such as lithographs and woodcuts.
- **Status of artist**. Established artists can charge more than lesser-known artists.
- **Status of gallery**. It may not be fair but prestigious galleries can charge higher prices.
- **Region**. Although this is changing, works sell for more in larger cities like New York and Chicago.
- **Gallery commission**. The gallery will charge from 30 to 50 percent commission. Your cut must cover the cost of materials, studio space, taxes and perhaps shipping and insurance, and enough extra to make a profit. If materials for a painting cost $25; matting, framing cost $37; and you spent five hours working on it, make sure you get at least the cost of material and labor back before the gallery takes their share. Once you set your price, stick to the same price structure wherever

you show your work. A $500 painting by you should cost $500 whether it is bought in a gallery or directly from you. To do otherwise is not fair to your gallery and devalues your work.

As you establish a reputation, begin to raise your prices—but do so cautiously. Each time you "graduate" to a new price level, you will not be able to come back down.

CONTRACTS

Contracts are simply business tools to make sure everyone is in agreement. Ask for one any time you enter into a business agreement. Even if you take an assignment by phone, arrange for the specifics in writing, or provide your own. A letter stating the terms of agreement signed by both parties can serve as an informal contract. Several excellent books such as *The Artist's Friendly Legal Guide* (North Light Books) provide sample contracts you can copy and use. *Business and Legal Forms for Illustrators*, by Tad Crawford (Allworth Press) contains negotiation checklists and tear-out forms. The sample contracts in these books cover practically any situation you might run into from renting your fine art to spelling out royalties in a contract with a book publisher.

The items specified in your contract will vary according to the market you are dealing with and the complexity of the project. Nevertheless, here are some basic points you'll want to cover:

Commercial Contracts

- *A description of the service you are providing.*
- *Deadlines for finished work.*
- *Rights sold.*
- *Your fee.* Hourly rate, flat fee or royalty.
- *Kill fee.* Compensatory payment received by you if the project is cancelled.
- *Changes fees.* Penalty fees to be paid by the client for last-minute changes (these are most often imposed by designers).
- *Advances.* Any funds paid to you before you begin working on the project.
- *Payment schedule.* When and how often you will be paid for the assignment.
- *Statement regarding return of original art.* Unless you are doing work for hire, your artwork should always be returned to you.

Gallery Contracts

- *Terms of acquisition or representation.* Will the work be handled on consignment? What is the gallery's commission?
- *Nature of the show(s).* Will the work be exhibited in group or solo shows or both?
- *Time frames.* At what point will the gallery return unsold works to you? When will the contract cease to be in effect? If a work is sold, when will you be paid?
- *Promotion.* Who will coordinate and pay for promotion? What does promotion entail? Who pays for printing and mailing of invitations? If costs are shared, what is the breakdown?
- *Insurance.* Will the gallery insure the work while it is being exhibited?
- *Shipping.* Who will pay for shipping costs to and from the gallery?
- *Geographic restrictions.* If you sign with this gallery, will you relinquish the rights to show your work elsewhere in a specified area? If so, what are the boundaries of this area?

Computers: The State of the Art

Ever since Microsoft Windows came along, the Mac vs. PC debate has accelerated. Mac aficionados find themselves defending their choice to a growing population of Windows-lovers. Friends, co-workers, children and significant others hold strong opinions on which is best. Increasingly, buyers searching computer retail shelves for new software and CD-ROM titles find less choices for Macs, while shelves are packed with packages bearing shiny "Runs on Windows" stickers. What gives?

Before beginning this article, we took an informal survey of graphic arts professionals. Out of 63 designers and art directors surveyed, 52 are sticking with Mac, two are switching to Windows, two are switching *from* Windows *to* Mac, and seven plan to use both platforms.

The majority of respondents were vehement in their preferences. "Mac forever!," "Viva Mac" and "*Definitely* sticking with Mac!" were common replies. All praised Mac for reliability, compatibility and ease of use. "We're sticking with Mac—its operating system is top notch," said one. Another said, "Windows is still light years behind the Mac . . . [Windows] documents are nothing but trouble for printers to image out."

Yet there were signs of change. One designer said, "I'm sticking with Mac unless I'm forced to change." Another who reluctantly left Mac because his corporate clients use IBM-based PCs said, "Our firm is currently 100 percent Windows. The future is in multi-platforms. We can't wait for a proven version to be confirmed."

If Mac is so superior, why are 90 percent of computers in the corporate world IBM-compatible PCs? How did this whole Mac vs. Windows thing get started anyway?

A MATTER OF ARCHITECTURE

The change didn't happen over night. It started in the mid-1970s when some dedicated computer hobbyists experimented with the new technology. Two of them, Steve Jobs and Steve Wozniak, barely out of their teens, created the Apple II in Jobs' garage. If at first IBM failed to recognize the potential of personal computers, in 1980 they became hell-bent to enter the frey. In their rush to bring a personal computer to market, IBM used an "open architecture"—using chips created by one company, an operating system developed by another and a hard drive created by still another. "Open architecture" paved the way for other companies to create similar computers. Around 40 companies developed affordable IBM-compatible "clones."

Mac, however, maintained a "closed architecture," developing its entire system in-house until 1995. Buyers had two choices—buy Mac or IBM-based computers. Installing and running "user friendly" Mac was easier, and the system allowed for greater compatibility between designer and service bureaus. While Mac customers consistently rated Macs high for reliability and buyer satisfaction, PC users (at first) experienced system crashes and compatibility problems.

Depending on who you talk to, Mac's decision to keep a "closed architecture" was a boon or a bust. It allowed Mac to maintain control of its product's integrity. Mac also insisted all Mac software developers abide by stringent standards. PC hardware and software developers, meanwhile, enjoyed free rein to develop products for the many brands of PCs on the market.

HOW PCs GOT PERSONALITY

Prior to the introduction of Windows, IBM-compatibles were not user-friendly. When you turned on a PC you got a blank screen with a boring computer prompt and you had to type odd-sounding commands to tell your computer what to do. Apple's Macintosh, introduced in 1984, was fun. It came with a mouse! And cute icons helped you navigate the system. These icons, or GUI (pronounced "gooey") for graphical user interface, made Mac the most "user-friendly" computer on the market. Then, in 1985, Microsoft created a GUI for IBM-compatibles and named it "Windows." When redesigning Windows 3.0 they even hired the same artist who worked on the Mac GUI, and to some extent Windows took on the feel and flow of the Mac. Because there were so many affordable PC clones on the market, Microsoft, the software company that created Windows, made a killing. Meanwhile, Mac continued to rule in its niche, owning 70-80 percent of the prepress and graphic arts markets. Mac remains the preeminent platform for publishing and artistic use throughout the world.

SEND IN THE CLONES!

A turning point came in the winter of 1995 with the introduction of the first Mac clones. For the first time Mac licensed its operating sytem to other companies. Power Computing has introduced their Power Tower Mac OS system (more powerful than Mac's own Power Mac) and PowerWave (http://www.powercc.com). Umax's Super-Mac (http://www.info@supermac.com) will soon be available. The question of the moment seems to be "Did Mac wait too long?" Though Macs are ahead in the educational and graphics markets, PCs have an unassailable stronghold in the corporate market. Mac watchers hope affordable clones will help Mac gain inroads into a corporate market, that bases its decisions largely on price.

Software and CD-ROM developers complain their Mac platform products sit in warehouses unsold. When developers try to please both Mac and Windows customers by creating hybrids or multi-platform titles, retailers don't know where to shelve the products. Producing two packages is not cost-effective. Software developers say this will change only if buyers request more Mac and hybrid products, and bug retailers to display them prominently.

Should Mac-lovers hold on to their Macs? As Michael Sullivan, computer expert and author of *Make Your Scanner A Great Design & Production Tool* (North Light Books) points out, there's no reason to panic. Even though most computers sold are PCs, Mac offers a far superior system—especially for graphic artists. Working between systems is already possible and easy, he says. And since so many people already have a capitol investment in Macs, and are happy with them, why would they switch? "There's just no comparison. PCs are just not very elegant. Comparing Macs to PCs is like comparing BMW to General Motors."

LIVING IN A "DUAL PLATFORM" WORLD

Many freelance illustrators already work easily on either platform by saving Mac-generated or scanned illustrations in TIFF or EPS files. It's relatively easy to then transport them via modem to an IBM-compatible PC. Text can be moved from one system to another by saving it in the ASCII format, or can also be saved in like programs of applications that are used in both environments, such as Wordperfect or Microsoft Word.

There are other options available to help you work on both platforms if that becomes necessary:

- SoftWindows 2.0 from Insignia Solutions (415)694-7600, lets you run Windows from your Mac.

- You can run Windows applications on your Mac using PC System boards from Orange Micro (costs between $740-2,500) (714)779-2772 or http://www.or angemicro.com.
- There are Windows utilities to make PCs more friendly to Mac files. MacOpener ($75) from DataViz (800) 733-0030, lets Windows users preview Mac text and graphic files. MacDrive 95 ($70), a Windows 95 utility by Media4Productions (515)225-7409, enables PC users to read and write Mac files.

WHAT'S IN STORE?

Mac's highly anticipated System 8 (formerly known as Copland) will allow users to work freely between both environments and has multimedia and Internet access capabilities. Though it won't be be available for purchase until mid-1997, you can now get a free CD-ROM preview of System 8 by calling (800)825-2145 or (303)297-8070. Ask for the Mac OS-8 tour. For more information about Mac's products visit http://www.info.apple.com or http://www.apple.com or look for keyword "applecomputer" on America Online.

There's a rule of thumb that every 18 months or so new technology appears on the market that is twice as powerful as its predecessor. In this period of adjustment, computer buyers have had to scramble just to keep up. Professionals learned to anticipate changes and build the cost of new equipment and upgrades into business plans. Within the next few years, even more changes are in store. And all the competition out there is great for buyers. Companies are offering more products, at lower prices, to help you work in both environments. In the future, it won't matter whether you own a Mac or a PC. Your computer's power will depend on the software you choose. Amazing multimedia capabilities will become affordable, everyday options. Soon you'll be cutting and pasting text and videos from the World Wide Web and incorporating them seamlessly into your documents.

According to conventional wisdom, it takes 30 years for a society to fully assimilate a new technology. Up until now, say the experts, we've been experiencing horse and buggy days. Today's technology is the equivalent of a Model T. To follow the analogy further, within just a few years, we'll be cruising the Autobahn in a Lamborghini!

NEED SOME HELP?

Whether you're trying to decide whether to buy a used computer or have a question about the latest bells and whistles, you'll find sympathetic advice from online user groups. America Online's User Group Forum (keyword UGF) gives listings for user groups all over the world, with links to many of them. Listings for user groups are also available at http://www.ugconnection.org/. At http://www/macworld.com/software/ sponsored by *Macworld*, editors describe shareware you can point and click to download. Look for more information at http://www.macworld.com. You can intereact with *MacUser* editors at ZD Net/Mac, hosted on CompuServe. Type GO ZMC:MACUSER if you have CompuServe or visit http://www/zdnet.com/macuser. Virtual Software Library (http://www.shareware.com) provides a good index of Mac and PC shareware. Adobe offers free software from http://www.adobe.com/.

Working the Web: Online Opportunities for Artists

BY CYNTHIA GOODMAN

1995 was hailed as "The Year of the Internet" in the cover story of the year end issue of *Newsweek*. The pervasiveness of this relatively new technology is inescapable. Nevertheless, for many, the conduits for global interconnectivity on this worldwide computer network were intitially difficult to grasp. The sudden, ubiquitous rise of the network was overwhelming, and traveling into the unknown terrain of Cyberspace seemed mysterious. However, demystification is occurring with similar velocity. Although some adults have been tentative in their embrace of the World Wide Web, children race home from school to communicate online with new friends from all over the world.

GOLD RUSH OF THE NINETIES?

Over the past decade, initially trepidatious artists have embraced computer technology with increasing eagerness and varying degrees of experimentation. The mood has changed from caution to outright jubilation. Perhaps the most dramatic component in this evolution has been the acceptance of the Internet as a forum for the display, creation, exchange and selling of art. The World Wide Web frenzy we are witnessing may be attributed as much to its potential as a tool for creativity and communications as to its economic possibilities. Although it is undeniable that sales can be facilitated by online services, it is not yet certain how much art-purchasing activity has actually transpired in this manner. Despite the euphoric expectations and the commonly held assumption that the Internet is synonymous with the Gold Rush of the Nineties, so far there are no statistics to support this belief. The quip of Steven Rutt, president of Rutt Video Inc. (http://www.rvi.com), a leading New York video and computer graphics facility, that "the Internet is a zero billion dollar industry" aptly sums up both the promise and the economic reality of the situation so far.

Each of the individuals I interviewed for this article has used the Internet either for the display of his or her own artwork or that of others. Their experiences typify those of countless artists who either have their own websites, or whose work is available on other sites. *For more information on websites and online services for artists, see Internet Resources, page 685.*

A RENOWNED ARTIST GOES ONLINE

Internationally renowned glass artist Dale Chihuly's blown glass received national attention for its presence on the Internet when it was among the works in an exhibition

CYNTHIA GOODMAN *is the former Director of the IBM Gallery of Science and Art in New York, where she organized the landmark "Computers and Art" exhibition. A world authority on digital art, Goodman is the author of* Digital Visions: Computers and Art, *which serves as a textbook in the field. She is currently organizing an exhibition of interactive art for The Museum of Fine Arts, Houston. She has edited and produced a CD-ROM,* InfoART, *published by ARTway and distributed by D.A.P. Publishers, New York. (800)673-4626.*

of American crafts displayed in the White House and exhibited simultaneously in an online version. A cerulean blue bowl by Chihuly was one of the works featured in a *New York Times* (May 7, 1995) review of the online exhibition, which included video clips as well as tours of five of the artist's studios.

Now, Chihuly has his own website (http://www.chihuly.com), which was launched in May of 1995, and his own webmaster. Visitors to this site can learn about the artist and his current exhibitions, see a gallery of his selected work and architectural installations, place orders for books on the artist, as well as e-mail comments about the site. Although digital technology does not play a role in Chihuly's creative process, he launched a site cognizant of the enormous impact that technology exerts on the art world as well as the art-viewing public.

What do you see as your website's primary function, i.e., sales, promotion, information?
Dale Chihuly: At this time the primary function is to provide information about the work and its exhibition schedule. It is also used for the sale of books and other paper products.

Have you sold work over the Web?
DC: Two works have been sold as a result of the website.

Are there particular online capabilities that you feel are most helpful to you as an artist?
DC: Responses from visitors to the site, especially school-age children.

Despite the avalanche of websurfers, we are still in a time of considerable skepticism about the Web. Are you at all fearful that having your work accessible on the Web will diminish interest in or become a substitute for viewing the actual work?
DC: No. I think exposure through the Web increases interest in seeing the real thing.

Your work was among those featured in the *New York Times* review last year of the White House exhibition of American arts and crafts and its simultaneous display on the Web. What was the reaction to this display?
DC: The reaction was favorable, but I have no documentation of numbers and types of responses.

Your current Venice project is on the Web. Can you explain why you selected this project for Web display?
DC: "Chihuly Over Venice" is on the Web because it is the most important project we are working on at this time. Besides being an exciting artistic venture, it tells the story of collaboration, teamwork and the breaking down of cultural barriers.

You have your own webmaster. Do you plan similar viewings/exhibitions in the future?
DC: We plan to have the website reflect the activities of the studio. No more, no less.

PIONEERING THE VIRTUAL GALLERY
Artist Darcy Gerbarg, a pioneer in the field of digital imaging, is president of ART-way, (http://www.artway.com) an online arts service organization of computer and mu-

seum professionals. Gerbarg sees the Internet as a means of disseminating information about art in a broad and efficient manner. She is also appreciative of the ways in which the digital transmission of art makes it accessible in ways previously impossible.

What do you see as the potential of an online service for museums?

Darcy Gerbarg: No serious art professional can ignore the staggering potential of this tool for our field. Internet services are crucial to every arts organization.

What are some of the services that ARTway offers to the museum community?

DG: ARTway can expand the reach of institutions not only in their communities, but also far beyond. Our services offer opportunities for most museum departments. Information about current and future programming as well as special events can be posted and updated on an ongoing basis, so that all last minute changes and additions can be accommodated. Information about museum activities will no longer be limited to museum members, but also be available to users of the Net.

What are some of the special features of your online service?

DG: A special feature of our service is our ability to document exhibitions via Quicktime VR [virtual reality]. Through ARTway's creation of a virtual reality gallery or panoramic display, viewers can navigate the work on display in museums at their leisure on a computer screen at home. This feature is of interest not only to prospective museum visitors eager to preview an exhibition, but also to other institutions as a means of reviewing a show for potential travel. No longer will museum professionals or interested members of the public be reliant on printed publications that often appear months after an exhibition closes for information about current activities.

In what other ways will viewers learn about art through your service?

DG: ARTway will also feature exhibitions curated by authorities in their respective fields. The topic of these exhibitions will be broad and ranging for example, from European and American paintings to American arts and crafts, Asian art, digital art, performance and video. Regularly scheduled chat rooms will make dealers, artists, museums and other arts professionals available to those participating in these online sessions.

VISIONS OF LASCAUX

Through his "Visions of Lascaux" project, Benjamin Britton, assistant professor of electronic art at the University of Cincinnati, made the Paleolithic rock art in the caves of Lascaux art available to the public via state-of-the-art virtual reality techniques. Participants who don VR goggles and navigate the grottoes on a computer screen wielding a Spaceball tracking mechanism, witness unprecedented vistas and modes of exploration.

What do you see as the future of virtual reality on the Internet?

Benjamin Britton: To be in what I call "mutual reality," which is multi-user virtual reality, is clearly the future of virtual reality on the Net. I would like to build intelligent algorithms that would create selected groups able to interact in mutual reality. I believe that the electronic frontier will really be most broadly opened when high band width capabilities are brought into the residential market, and when the phone companies are

able to solve this socio-economic dilemma. Then we can have extremely high quality multi-user VR, in which we can all participate in a very rich graphic environment with absolute uncompromised image quality and full immersive capabilities.

How long do you think this will take to happen?

BB: The ultimate VR has not yet been made, but I definitely believe it can be. The foundation is in place for it to happen. When computers have 3-dimensional graphics capabilities with millions of polygons per frame and a minimum of 256 megabytes of texture memory, then we can approach the kind of photo realistic image quality that people really expect when they think of good VR. It remains for creative people to implement these new ideas in this physical form.

Can you envision your exhibition, "Visions of Lascaux," now seen in galleries and on CD-ROM, as being available on the Web? If so, what would your dream implementation be based on the digital capabilities available today?

BB: I would like to have absolutely great graphic capabilities so that we wouldn't have to compromise on the image quality, the sound, or the interactive capabilities of the experience. This might mean newer technologies than we have today, but built on the good work that is presently being done. I would like to have "Lascaux" exist on a server, so that people could dial in and experience it in the best way possible—that is, in groups of five at a time. So that even if 25,000 people dialed in, they would experience it and wander through the cave in groups of five. All the others would be invisible to each other. In that way the cave and its natural scale would not be obviously overpopulated.

A RARE BIRD AT THE OLYMPICS

University of Kentucky Professor Eduardo Kac uses electronic media in his innovative work in holography, telecommunications events and conceptual art. Kac is one of eight artists whose work will be shown in the exhibition "Out of Bounds: New Work by Eight Southeast Artists" organized by Nexus Contemporary Art Center in Atlanta in collaboration with the Atlanta Committee for the Olympic Games. Kac has a long history of interest in telecommunications-based artwork and dates his first such work to 1985 when he was still living in Rio de Janeiro. Kac's work can be viewed at http://www.uky.edu/FineArts.Art/Kac/Kachome.html.

You had an early interest in telecommunications and art. What was your first piece in this medium?

Eduardo Kac: In 1985, working with the phone company in Rio, I created what we today call a virtual gallery, enabling myself and a few other artists to place works in a remote site to be accessed from different parts of the country. In fact, there were public terminals placed by the phone company in airports, shopping centers, universities.

When did you create your first public presentation involving the Internet?

EK: I created the first public presentation of my telerobotic artwork in Chicago in 1992. There, people interacted with the piece in one location and by doing so, manipulated the robot in a remote place. In 1994, I created the first networked telepresence installation in which the robot was located in Chicago and people would control it from sites around the U.S. One of the unique things about this was that the body of the telerobot was inhabited by more than one person at the same time. As a consequence, they had to

share the controls democratically, seeing through the eyes of the robot at the same time. So they developed a sense of being together in that remote body. The vision was shared through live digital video on the Internet, with anybody in the world who had access to the Internet. We had people coming online from Ireland, Canada, several American cities, Germany, Finland and other countries.

Do you approach your work on the Net in a different way than you do in other mediums?

EK: No, I don't come to telecommunications and networking differently from the other work I do. All my work, I guess, is concept driven, not so much media driven. It's not like I have a medium and see what I can do with it, but the works follow a general interest I have in language and how communication lies at the core of our very experience of the world.

Can you tell me about the work you created for the Olympics?

EK: When you enter the exhibition and see my work "Rare Avis," you walk into a triangular room and immediately see a cage in the space and notice there is something not quite normal about it. Eventually you will notice that there are two things in the cage: a group of small monochromatic birds, and towards the back of the cage, a colorful, tropical, large beautiful telerobotic macaw.

What happens next?

EK: When you put on the VR headset, you project yourself into the body of the telemacaw. Several things happen at once. As you move your head to the left, headtracking moves the telerobotic head to the left. As you move your head to the right, the telerobotic head is moved to the right. The macaw is both in color and in stereo. What you see with your left eye is displayed on a large monitor so that other people in the exhibit can see what's going on. What you see with your right eye is being fed live, in real time, to the Internet and digitized and transmitted as digital video. In principle, anybody, anywhere in the world who has Internet access can see it. There are no restrictions. The vision system is being controlled by you in the gallery, so what people on the Net see pretty much responds to your physical motion.

Why do you now choose to create works on the Net, involving the public, rather than with groups of networked artists, as you did in your earlier work?

EK: When the Internet finally became available, it became a natural extension for me. The Internet is not comparable to the smaller parallel artists' networks that I had either initiated or participated in, because it is worldwide and involves a lot of other people that are not necessarily artists. When you can use the Net you can create pieces you couldn't create otherwise instead of porting works to the Net. You can create situations that are truly democratic.

Business Nuts & Bolts

Whether you sell paintings, illustration or design services you'll need business savvy in order to survive and prosper. This chapter will give you an overview of the business aspects of your career.

BILLING

If you are a designer or illustrator, you will be responsible for sending out invoices for your services. Clients generally will not issue checks without them. Most graphic artists arrange to be paid in thirds, billing the first third before starting the project, the second after the client approves the initial roughs, and the third upon completion of the project.

Standard invoice forms allow you to itemize your services. The more you spell out the charges, the easier it will be for your clients to understand what they are paying for. Most designers charge extra for changes made after approval of the initial layout. Keep a separate form for change orders and attach it to your invoice.

A NOTE ABOUT GALLERIES

If you are working with a gallery, you will not need to send invoices. The gallery should send you a check each time one of your pieces is sold (generally within 30 days). To ensure that you are paid promptly, call the gallery periodically to touch base. Let the director or business manager know that you are keeping an eye on your work.

If you are an illustrator, your invoice can be much simpler, as you'll generally be charging a flat fee. It's helpful, in determining your quoted fee, to itemize charges according to time, materials and expenses (the client need not see this itemization—it is for your own purposes).

Most businesses require your social security number or tax ID number before they can cut a check so include this information in your bill. Be sure to put a due date on each invoice. Most artists ask for payment within 10-30 days.

Sample invoices are featured in *The Designer's Commonsense Business Book*, by Barbara Ganim (North Light Books) and *Business and Legal Forms for Illustrators*, by Tad Crawford (Allworth Press).

RECORD KEEPING

The best bookkeeping systems are simple ones. Visit an office supply store and pick out a journal, ledger or computer software suited to your needs. If you are an illustrator or designer, assign a job number to each assignment. Record the date of the project, the client's name, any expenses incurred, sales tax and payments due.

A simple system for fine artists consists of two folders—one for expenses and one for sales. Every time you purchase art supplies, place the receipt in your "expenses" folder. When you make a sale, photocopy the check or place a receipt in your "sales" folder.

You must save all receipts, invoices and canceled checks related to your business in order to report your income to the IRS. A handy method is to label your records with the same categories listed on Schedule C of the 1040 tax form. This allows you to easily transfer figures to tax forms. Make an effort to keep your files in chronological order.

As your business grows, consult with or hire an accountant who specializes in working with creative people or small business operators. Find someone who understands your needs and keeps track of legislation affecting freelancers.

TAXES

You have the right to take advantage of deducting legitimate business expenses from your taxable income. Art supplies, studio rent, advertising and printing costs, and other business expenses are deductible against your gross art-related income. It is imperative to seek the help of an accountant in preparing your return. In the event your deductions exceed profits, the loss will lower your taxable income from other sources.

To guard against taxpayers fraudulently claiming hobby expenses as business losses in order to offset other income, the IRS requires taxpayers to demonstrate a "profit motive." As a general rule, you must show a profit three out of five years to retain a business status. This is a guideline, not a rule. The IRS looks at nine factors when evaluating your status and examines losses closely. If you are audited, the burden of proof will be on you to demonstrate your work is a business and not a hobby.

The nine criteria the IRS uses to distinguish a business from a hobby are: the manner in which you conduct your business, expertise, amount of time and effort put into your work, expectation of future profits, success in similar ventures, history of profit and losses, amount of occasional profits, financial status, and element of personal pleasure or recreation. If the IRS rules that you paint for pure enjoyment rather than profit, they will consider you a hobbyist.

Even if you are a "hobbyist," you can deduct expenses such as paint, canvas and supplies on a Schedule A, but you can only take art-related deductions equal to art-related income. That is, if you sold two $500 paintings, you can deduct expenses such as art supplies, art books, magazines and seminars only up to $1,000. Itemize deductions only if your total itemized deductions exceed your standard deduction. You will not be allowed to deduct a loss from your other source of income.

Document Each Transaction

Keep all receipts, canceled checks, contracts and records of sale in a journal or diary. Record your expenses daily, showing what was purchased, from whom, for how much and the date. Log automobile expenses separately showing date, mileage, gas purchased and reason for trip. Complete and accurate records will demonstrate to the IRS that you take your career seriously.

To deduct business expenses, your accountant will fill out a regular 1040 tax form (not 1040EZ) and prepare a Schedule C. Schedule C is a separate form used to calculate the profit or loss from your business. The income (or loss) from Schedule C is then reported on the 1040 form. In regard to business expenses, the standard deduction does not come into play as it would for a hobbyist. The total of your business expenses need not exceed the standard deduction.

There is a shorter form called Schedule C-EZ for self-employed people in service industries. It can be applicable to illustrators and designers who have receipts of $25,000

HOME OFFICE DEDUCTION

If you freelance fulltime from your home, and devote a separate area to your business, you may qualify for a home office deduction. If eligible you can deduct a percentage of your rent and utiiities, expenses such as office supplies and business-related telephone calls.

The IRS does not allow deductions if the space is used for reasons other than business. A studio or office in your home must meet three criteria:

- The space must be used exclusively for your business.
- The space must be used regularly as a place of business.
- The space must be your principle place of business.

The IRS might question a home office deduction if you are employed fulltime elsewhere and freelance from home. If you do claim a home office, the area must be clearly divided from your living area. A desk in your bedroom will not qualify. To figure out the percentage of your home used for business, divide the total square footage of your home by the total square footage of your office. (To determine square footage, multiply length by width.) This will give you a percentage to work with when figuring deductions. If the home office is 10 percent of the square footage of your home, deduct 10 percent of expenses such as rent, heat and air conditioning.

The total home office deduction cannot exceed the gross income you derive from its business use. You cannot take a net business loss resulting from a home office deduction. Your business must be profitable three out of five years. Otherwise, you will be classified as a hobbyist and will not be entitled to this deduction.

Consult a tax advisor before attempting to take this deduction, since its interpretations frequently change.

Refer to IRS Publication 587, Business Use of Your Home, for additional information. *Homemade Money*, by Barbara Brabec (Betterway Books), provides formulas for determining deductions and provides checklists of direct and indirect expenses.

or less and deductible expenses of $2,000 or less. Check with your accountant to see if you qualify.

Deductible expenses include advertising costs, brochures, business cards, professional group dues, subscriptions to trade journals and arts magazines, legal and professional services, leased office equipment, office supplies, business travel expenses and many other expenses. Your accountant can give you a list of all 100 percent and 50 percent deductible expenses (such as entertainment).

As a self-employed "sole proprieter" there is no employer regularly taking tax out of your paycheck. Your accountant will help you put money away to meet your tax obligations, and may advise you to estimate your tax and file quarterly returns.

Your accountant also will be knowledgeable about another annual tax called the Social Security Self-Employment tax. You must pay this tax if your net freelance income is $400 or more, even if you have other employment.

The fees of tax professionals are relatively low, and they are deductible. To find a good accountant, ask colleagues for recommendations, look for advertisements in trade publications or ask your local Small Business Association. And don't forget to deduct the cost of this book.

Independent Contractor or Employee?

Some clients automatically classify freelancers as employees and require them to file Form W-4. If you are placed on employee status, you may be entitled to certain benefits, but a portion of your earnings will be withheld by the client until the end of the tax year and you could forfeit certain deductions. In short, you may end up taking home less than you would if you were classified as an independent contractor.

The IRS uses a list of 20 factors to determine whether a person should be classified as an independent contractor or an employee. This list can be found in Publication 937. Note, however, that your client will be the first to decide whether or not you will be so classified.

The $600 Question

If you bill any client in excess of $600, the IRS requires the client to provide you with a form 1099 at the end of the year. Your client must send one copy to the IRS and a copy to you to attach to your income tax return. Likewise, if you pay a freelancer over $600, you must issue a 1099 form. This procedure is one way the IRS cuts down on unreported income.

Good News About Sales Tax

The good news is, you could be tax exempt when buying art supplies. The bad news is you have to collect and report sales tax.

Most states require a 2 to 7 percent sales tax on artwork you sell directly from your studio, or at art fairs, or on work created for a client, such as art for a logo. You must register with the state sales tax department, which will issue you a sales permit, or a resale number, and send you appropriate forms and instructions for collecting the tax. Getting a sales permit usually involves filling out a form and paying a small fee. Reporting sales tax is a relatively simple procedure. Record all sales taxes on invoices and in your sales journal. Every three months total the taxes collected and send it to the state sales tax department.

As long as you have the above sales permit number, you can buy art supplies for paintings and assignments without paying sales tax. You will probably have to fill out a tax-exempt form with your permit number at the sales desk where you buy materials. The reason you do not have to pay sales tax on your art supplies is that sales tax is only charged on the final product. However, you must then add the cost of materials into the cost of your finished painting or the final artwork for your client. Keep all of your purchase receipts for these items in case of a tax audit. If the state discovers that you have not collected sales tax, you will be liable for tax and penalties.

If you sell all your work through galleries they will charge sales tax, but you will still need a tax exempt number so you can get a tax exemption on supplies.

Some states claim "creativity" is a non-taxable service, while others view it as a product and therefore taxable. Be certain you understand the sales tax laws to avoid being held liable for uncollected money at tax time. Write to your state auditor for sales tax information.

In most states, if you are selling to a customer outside of your sales tax area, you do not have to collect sales tax. However, this may not hold true for your state. You may also need a business license or permit. Call your state tax office to find out what is required.

STILL CONFUSED ABOUT TAXES?

Most IRS offices have walk-in centers open year-round and offer over 90 free IRS publications to help taxpayers. Some helpful booklets available include Publication 334—Tax Guide for Small Business; Publication 505—Tax Withholding and Estimated Tax; and Publication 533—Self Employment Tax. Order by phone at (800)829-3676.

The booklet that comes with your tax return forms contains addresses of regional Forms Distribution Centers you can write to for further information. The U.S. Small Business Administration offers seminars on taxes, and arts organizations hold many workshops covering business management, often including detailed tax information. Inquire at your local arts council, arts organization or university to see if a workshop is scheduled.

PACKAGING AND SHIPPING YOUR WORK

Send your submissions via first class mail for quicker service and better handling. Package flat work between heavy cardboard or foam core, or roll it in a cardboard tube. Include your business card or a label with your name and address on the outside of the packaging material in case the outer wrapper becomes separated from the inner packing in transit.

Protect larger works—particularly those that are matted or framed—with a strong outer surface, such as laminated cardboard, masonite or light plywood. Wrap the work in polyfoam, heavy cloth or bubble wrap and cushioned against the outer container with spacers to keep from moving. Whenever possible, ship work before it is glassed. If the glass breaks en route, it may destroy your original image. If you are shipping large framed work, contact a museum in your area for more suggestions on packaging.

The U.S. Postal Service will not automatically insure your work, but you can purchase up to $600 worth of coverage. Artworks exceeding this value should be sent by registered mail. Certified packages are logged in at each destination en route. They travel a little slower, but are easier to track.

Consider special services offered by the post office, such as Priority Mail, Express Mail Next Day Service and Special Delivery. For overnight delivery, check to see which air freight services are available in your area. Federal Express automatically insures packages for $100 and will ship art valued up to $500. Their 24-hour computer tracking system enables you to locate your package at any time.

UPS automatically insures work for $100, but you can purchase additional insurance for work valued as high as $25,000 for items shipped by air (there is no limit for items sent on the ground). UPS cannot guarantee arrival dates but will track lost packages. It also offers Two-Day Blue Label Air Service within the U.S. and Next Day Service in specific zip code zones.

Before sending any original work, make sure you have a copy (photostat, photocopy, slide or transparency) in your files. Always make a quick address check by phone before putting your package in the mail.

Taking Your Show on the Road

BY PATRICK SESLAR

Art festivals are one of the most attractive and accessible marketing avenues open to artists. Where else can you rent "gallery" space for a weekend, see thousands of eager patrons, get instant feedback from customers and get your paycheck before you pack up for the night? Art festivals give you hands-on control of your career—you decide when and where to exhibit, what to paint, how to frame your artwork and how to price it.

Even if you aren't greatly concerned about making sales, art festivals are a great way to gain exposure for your work. Many gallery owners, print publishers and art collectors regularly visit top art festivals. In many juried festivals, guest judges such as museum curators, gallery owners and other art professionals visit each booth during the show and award cash prizes for the best works in each category. In better festivals, the Best of Show award is usually worth from $750-1,500—at top shows such as the Winter Park Sidewalk Art Festival near Orlando, Florida, this award can be as much as $10,000.

Beyond these obvious advantages, art festivals provide a great opportunity to network with fellow artists. Visiting with other artists fosters a sense of community and can provide inspiration, as well as a source of experienced critiques and advice from your peers.

As an artist who has sold his work at art shows in almost every state from Florida to California, I can tell you shows are profitable. Experienced artists estimate that they earn $1,500 (before expenses) for a typical 2-day festival. But sales will vary from show to show.

BEGIN WITH A PLAN

There is a lot of planning and work involved. You'll need to buy or build an attractive portable booth; become an expert at matting and framing; establish rapport with customers; learn how to keep track of sales, money and mailing lists. And if you want to significantly increase your income, you'll have to spend a lot of time on the road. The effort is definitely worth it if you value the personal freedom that comes with life as an artist.

Don't just enter the first show you learn about, have a plan. Start an "art fair notebook" to keep track of data as you learn. Work out costs on paper to find out just how much you'll need to invest in your display and travel expenses before you take on the circuit. In the majority of festivals, once you've been accepted and have paid your booth fee, there are no commissions or additional charges.

This article offers many tips on how to break into this profitable market, what you might expect to earn and, once in, how to maximize your sales and minimize your costs. But it is a good idea to pick up additional information by visiting shows and talking to fellow artists before you make a commitment to enter your first show.

PATRICK SESLAR *is a fine artist who has sold his work in hundreds of art shows. He is also a contributing editor of* The Artist's Magazine.

LOCATE THE BEST SHOWS

Not all art festivals are equal. Research to find out what shows are available nationally and locally. Do a little reading on the subject in your public library. *Sunshine Artist Magazine* (2600 Temple Dr., Winter Park FL 32789. (800)597-2573) publishes a comprehensive listing of upcoming festivals and offers a helpful rating system so you can evaluate opportunities. More than 10,000 shows a year are announced through this periodical. Shows are also announced under "Showplace" in the classified section of *The Artist's Magazine* (see Publications of Interest, page 681), your local newspapers and local arts publications. Most opportunities fall into one of the following categories:

Art Association Exhibits

Some art clubs sponsor exhibitions for their members at local malls or in the lobbies of businesses. Most shows are small, informal, easy to get into and have limited sales potential. However, there are some, such as the Summer Arts Festival in Ann Arbor, Michigan, sponsored by the Michigan Guild of Artists and Artisans, that are large, well-attended and profitable.

Privately Organized, For-profit Festivals

"Promoter shows" are organized by professional promoters. They vary widely as to overall quality and sales potentials. Entrance requirements are less strict than for other shows and booth fees range from about $75-400, averaging about $175. Be sure to look up the rating of a show in *Sunshine Artist Magazine* and talk to fellow artists for recommendations before you sign on. Find out how long the show has been in existence. As a general rule, the longer the show has been offered the better the chance that sales are good and exhibitors are happy.

Civic-sponsored Festivals

A third category of festival is typically sponsored by local chambers of commerce, or by civic groups. These art festivals vary widely in quality and entrance requirements. The best and most profitable ones are carefully juried by slides and competition can be stiff. In a juried show, a screening of all artists takes place. Even though you might pay an entry fee, there is no guarantee you will be selected. It's not uncommon for top juried art festivals, such as the Winter Park Sidewalk Art Festival to receive 1,700 or more applications for 250 booth spaces. By contrast some smaller art festivals scarcely get enough applications to fill the available spaces.

Since many shows are annual events, it is possible to attend shows the year before you enter to make sure the quality of the work displayed equals yours. You can also observe how art is selling. See if there is enough space between booths for shoppers to browse and see the artwork. How is the layout? Do some booths seem to be in low traffic areas, while others seem to be in prime areas for sales? Talk with artists to see if they have entered the show year after year (a good sign). If you talk to several artists who are disappointed with the way the show is run, you could save yourself from entering the show and having a bad experience.

TEN TIPS FOR SUCCESS ON THE ART FESTIVAL CIRCUIT

1. Send for an application/prospectus before entering a show. A prospectus lists rules the exhibitors must abide by. It should contain deadlines, jury/processing fees, restrictions, booth fees, judges name(s) (if it is a juried show), prizes awarded, whether a commission is taken by the organizers and other pertinent information.

Jury/processing fees range from $10-25 and are nonrefundable. Booth fees for juried

shows range from $75-400 and usually must be submitted with your application. If accepted into a festival, your booth fee check will be cashed and is nonrefundable even if you do not ultimately exhibit in the festival for some unexpected reason such as car trouble or a sell-out at a previous festival.

For most applications, you'll also need at least three 35mm slides of your work and one of your display. Have a professional take the slides of your work if possible since jurors will have about 15 seconds to decide whether or not you'll be among those invited to exhibit at the festival. If you don't have the exact display you'll be using, take a tip from Hollywood—set up a mock set of inexpensive painted plywood panels and hang your work long enough to get the necessary display slide.

2. Build up an inventory of work in popular sizes and prices. Works priced at $100 and less sell best. The next price bracket, $200-1,000 is more difficult to sell. Oddly enough, works priced over $1,000 seem to sell better than those in the $200-1,000 range. So offer one or two works in the over $1,000 category. Even if you don't sell them, they'll make your smaller works look like great values. You'll need enough work to create an attractive display of framed work and perhaps fill a bin of unframed, shrink-wrapped works. Have plenty of work available at the most saleable prices. This doesn't mean you should spend a lot of time painting large works and selling them for $39. Savvy artists mat smaller works, such as sketches and color studies, that they might normally file or throw away. Sketches and studies have a wonderful spontaneity customers love. Multiple originals (etchings, monotypes, etc.) or offset reproductions also are attractive alternatives that can usually be offered in this same popular price range.

3. Consider your first show a learning experience. Don't expect to make a profit. Use the experience to learn the ropes, try out your display and get customer feedback on your work.

4. Budget for booth fees, meals and travel expenses. Pack a lunch. Art festival food is notoriously bad as well as overpriced. Take a small cooler and thermos and you'll save $15-20 per day. Pick shows within reasonable driving distance. Motel costs can add $40-100 per day to your overhead. Some artists drive as much as three hours to and from a show each day to save on motels; but generally it's neither cost- nor time-effective to drive more than an hour and a half to and from a festival. When you must stay in motels, ask about commercial rates, bargain plans or automobile club discounts.

5. Build your own booth. You might be surprised to discover that you can't just show up at an outdoor festival with work; you must furnish a display. Most festivals provide space for a $10' \times 10'$ booth. The cost of ready-made display components such as canopies and display panels can easily run $1,200-1,500. Once you start selling your work, that investment can easily be absorbed over a number of festivals. However, when you first start out, the cost of a suitable display can become a major obstacle to what otherwise is one of the most accessible markets for your work.

One solution is to build your own display. For as little as $200-400 you can build a display from lightweight screen door-like panels constructed of chicken wire stretched over a frame of 4″ hardwood. Hinge the panels together and cover the chicken wire with attractive fabric to create a gallery-like backdrop for your work. Another simple design can be assembled from nine 36″ wide "hollow-core" interior doors joined with butt hinges. Use three doors for each side and three for the back. Add a coat of waterseal to the outside and wall paint on the inside. Voila! An instant outdoor art gallery. To protect yourself and your artwork from sun and rain, try stretching a white tarp over the top of your display. Keep in mind that appearance is important—show sponsors don't want tacky displays and potential collectors will get their first impressions of you and your work from your display long before they get close enough to appreciate your technique.

For more specifics, visit art fairs to see how other artists build their booths and displays. If you see one you like, ask the artist for more details. When planning your display, consider whether you'll carry the panels inside a vehicle or on top of it, and make sure the display is manageable enough to assemble yourself. Bring wooden blocks to level your display when you have to set up on uneven terrain. You'll also want ropes and weights for setting up on concrete or asphalt or dog stakes for grass to keep your display from becoming a kite in gusty winds.

6. Do your own framing and matting. Buying ready-made frames or having a framer cut mats for you quickly eats into your profits. By purchasing prefinished molding in 10-foot lengths, you may be able to cut your framing costs by half or more. Glass and molding are the most expensive components of framed artworks. To minimize your costs, consider framing only a few of your best pieces. Mat the rest and protect them with clear, heat-shrink plastic film.

7. Offer special services. Of course you should be aware of the basics, like bringing enough cash to make change for customers, but consider offering extra services. For example, let customers know through signs or conversation, that you accept commissions, that you will crate and ship their purchases for an additional fee, or that you'll change a mat or frame for them. You can offer MasterCard and VISA if you first contact your local banker to make the necessary arrangements. The transaction fees are nominal; you will make sales you might otherwise miss. Consider offering a "layaway" plan for purchases—get a 25% down payment and allow the customer to make the balance payable in installments over a 90-day period. In nearly 20 years of selling artwork, I've only received two bad checks and never had a default on an installment sale.

8. Keep accurate financial records. Keep records of every sale you make for tax purposes. (See federal and sales tax information in the Business Nuts & Bolts article on pages 24-28.)

9. Keep a guest book at your display. Invite customers to sign your guest book and provide addresses so you can add them to your mailing list. If you have a computer and printer, consider sending an annual or more frequent newsletter with dates and locations of your festivals along with news of any awards or other accomplishments in your life. Collectors buy the artist as well as the art, so keep them posted and keep them enthused. Many artists credit mailing lists with turning mediocre festivals into consistent producers.

10. After you gain experience, plan a season of shows. Try a few different types of shows first to see which you like best. Then get out your calendar and set some goals for shows you'd like to enter, perhaps tying some in with your vacation plans. Keep in mind that application deadlines are often 2-4 months prior to show date. Try to get into the quality art festivals with the best reputations, that have high attendance. For example, the annual Pacific Northwest Arts & Crafts Fair, held since 1947 in Bellevue, Washington, featuring over 300 artist booths, draws 300,000 people and generates over $1.3 million in art sales and was ranked number seven in the nation's top fine art festivals by *Sunshine Artist Magazine*. The more people that see your work, the more work you will sell. Make sure your work fits the festival. For example, some shows are geared more toward crafts, some are slanted toward fine art.

Establish a sales goal. When figuring out your budget, allow enough money to stay in a hotel if necessary, and to pay for your meals, gas and materials. Deduct these expenses from the amount you expect to sell. That will give you the gross profit you are likely to make for the show. Next, figure out how many shows you must participate in to make your sales goal. Most fulltime festival artists exhibit in 25 or more art festivals each year.

Super Sales Strategies for Illustrators and Designers

BY MARIA PISCOPO

Today's competitive marketplace requires a more creative approach to finding and keeping clients. Whether you are just getting started, or have been in business for a while and hope to make the transition to additional markets, the following tips, techniques and steps will help you secure the best assignments.

Our objective with this feature is to increase your success and decrease the rejection you will experience out there in the real world. First, we will talk about finding direction. Once you have direction, you can identify potential clients. We'll list the directories and other sources you'll need to find them, and offer pricing techniques to make it easier for you to help your clients hire you.

OPEN DOORS WITH A SPECIALTY

The question "Are you a specialist or a generalist?" is best answered by stating "Both." It is normal and smart to want to work in more than one style with more than one kind of client. Diversification leads to more assignments and more money. However, *initially*, it is very important when approaching markets to position yourself as someone with a specialty.

Clients will always hire the specialist in order to get exactly what they need. Once clients who hire you for one particular style or subject become comfortable and happy with you, they will ask you back. After you have established a working relationship with them, then you can let them know you are available for a greater variety of projects. Not before. If you want your initial contact with them to make the strongest impact, start out with a single marketing message.

CHOOSE YOUR MARKETING MESSAGE

The following targeting techniques will help you position yourself, narrow potential markets, and decide on your single marketing message. You have four choices. You can market yourself by **style**, **industry**, **usage** or **subject**. Read each description and consider how each category applies to the work you do. There is no need to use just one category all the time. At different times in your career you may develop marketing strategies in all four categories.

Style

If your style is one of your biggest sales assets consider this approach. High-end clients in cutting edge industries such as editorial or entertainment often go after illustra-

MARIA PISCOPO *has been an art/photo rep since 1978 and added consulting to her services in 1985. Her articles advising artists and designers on marketing and management issues have appeared in* HOW, Computer Artist, Step-By-Step Graphics *and* Communication Arts *magazines. Maria gives seminars for Dynamic Graphics Educational Foundation and her third book,* Marketing & Promoting Your Work, *was published in 1995 by North Light Books. Maria can be reached at MPiscopo@aol.com for more information and questions.*

tors and designers on the basis of style. If you decide to make style your marketing message, create introductory samples showing one very unique style only. It doesn't matter what subjects you choose, portray them in your signature style.

Industry

This is probably the most common type of target marketing because it is so easy to identify clients. Almost all resource books are organized by industry or standard industrial classification codes. Industrial clients need design and illustration for brochures, newsletters, mailers, ads and booth graphics. For example, you might target the financial industry because you enjoy creating graphs. Once you have done some work for a financial firm, you can sell your experience and expertise in the industry to other financial companies. There are many industries you can target, such as the health care industry, the real estate industry or the travel/tourism industry.

Usage

First, ask yourself which type of assignments you prefer working on. Do you like to design labels for packaging? Perhaps you prefer editorial design or illustration. Deciding how you want your work to be used will help you identify how you want to position your talents. For example, industries that use packaging design include food, pharmaceutical and beauty products. (Visit your favorite grocery store to see how large a specific usage category—like packaging—can be.) If you want your illustration to be used as editorial illustration, target magazines and newspapers. If you want to illustrate book covers, target book publishers.

Subject

Many artists starting out like to focus on a particular subject, such as food illustration or portraits. This specialty works very well when you are selling your work to ad agencies and design firms. Once they see your work, it is much easier for them to remember to hire you than if you show a very general portfolio of all different subjects.

FIND CLIENTS WHO NEED YOUR MESSAGE

Once you decide on a specific marketing message your next step is locating potential clients who will welcome what you have to offer. It won't be as difficult as you might think. There are a number of resources that can help you build a database of potential clients. Your most important resource will be directories that contain listings of names and addresses of various businesses. The directory you hold in your hands, *Artist's & Graphic Designer's Market*, is a great beginning. Narrow the markets in this book to fit your marketing message and you're bound to find several hundred for your mailing list. But don't stop here! There are plenty of other sources out there to help you in your search.

One of the best things you can do for your career is to spend several hours in the business reference section of your public library. Librarians will steer you toward helpful business directories for your target markets. If you have decided to specialize in portraying food products, ask a librarian "Where can I find a list of companies specializing in food products?" She will point you toward a thick book full of new leads for your mailing list.

Before you spend hours at a copier with a pocketful of change, however, ask the librarian if the library carries the directory on disk or CD-ROM. If you bring in a disk some libraries will allow you to download the information.

Below is a list of directories and types of directories that will help you locate your client base. Consider your focus when choosing which to consult:

• **Ad agency directories.** *The Standard Directory of Advertising Agencies* and the

Adweek Agency Directory list names and addresses of advertising agencies. Each listing also reveals the type of clients the ad agency specializes in. Choose agencies that work within your area of specialization.

- **Corporate directories.** Called "client direct" directories, these directories help identify corporate clients and are also available in the public library. Some of the most popular are *Standard Directory of Advertisers*, *Chamber of Commerce Directory*, *Adweek Client (Brand) Directory*, *Services Directory/Manufacturers Register*, *Business Journal Book of Lists* (available on disk), and *Encyclopedia of Associations* (by industry).

- **Pre-qualified directories.** Particularly helpful are directories that contain pre-qualified information, such as industry association directories. To be listed in them, companies must be members of one of their industry's trade organizations. So, if you have chosen to target a certain industry, ask your librarian to direct you to a good pre-qualified directory for your chosen industry. You'll find excellent leads in pre-qualified directories because you'll automatically weed out the less aggressive companies. You'll find names of firms that are actively promoting their products and services. What can you guess from this pre-qualifier? They are probably doing more promotion and need more design or illustration!

- **Direct marketing directories.** Look in the *Directory of Major Mailers* and the *Directory of Marketing Marketplace*. Direct marketing agencies are firms that are responsible for the design and production of promotions—primarily direct mail. Since so many companies have found direct mail more cost effective than some forms of print or electronic advertising, millions of dollars in marketing budgets have been shifted to direct marketing agencies. This market is particularly good for catalog design or illustration projects.

- **Editorial/magazines/publications directories.** Look for the *Standard Rate & Data Service*, the *Gebbi Press All-In-One Directory*, *Gale's Directory of Publications* and *Editor & Publisher* (newspaper directory). Though the rates for editorial assignments are usually less than those paid for advertising or corporate jobs, many artists pursue editorial work because it provides creative freedom and visibility. Before you submit samples to editorial clients you should thoroughly read and review copies of their publications so you are familiar with the direction of their design. Some are cutting edge, some are conservative—know who you are selling to!

- **Graphic design directories.** The *Design Directory* and *The Workbook* and other sources list hundreds of design firms interested in your creative services. Design firms are wonderful clients for illustrators and designers just starting out. Like ad agencies, they work with the "better" projects a company feels can't always be done internally. Like editorial clients, they work very collaboratively with their freelancers and often choose artists on the basis of style. The projects are often extensive, such as annual reports and corporate capabilities brochures. Sometimes their needs are regular and seasonal, such as catalogs.

- **Paper products/book publishers/music industry directories.** These directories contain names and addresses of potential clients. Paper products is a very subject-specific market and great for design or illustration. It includes publishers of calendars, greeting cards, posters and other novelty products. In this market category, assignments are often done on a small advance plus royalty payment. Be sure to have your personal attorney or a reliable artists' representative look over any contract before you agree to the use of your work. Don't overlook book publishers and the music industry in your search.

THREE WAYS TO GET MORE REFERRAL WORK

1. Join your professional peer association. It is essential you don't try to go it alone. No one can better support you, and send more referrals than your professional peers.

2. Always ask where a job lead came from. Many times you'll get a call and not know who referred the job to you. Find out!

3. Always say "thanks" to the person who gave you a referral. Whether you get the job or not, do it. When rewarded for sending you a potential client, people will do it again.

TAP TRADE SOURCES FOR INSIDE INFORMATION

Next to directories, publications such as newspapers and magazines can provide inside information to give you an edge on your competition. Once you start reading the Promotions and Transfer items in the business section of your newspaper and trade publications with an eye toward finding new clients, you'll see potential markets daily. The following are a few resources to push you in the right direction!

• **Daily newspapers.** Every day the business section of your daily newspaper publishes news released by companies that include new products, expanded services and changes in personnel. Often changes in art directors or announcements of product launches are great indicators of when the time is right to approach a certain company with your design or illustration services. Look for items related to companies you'd like to freelance for. For example, if an item tells of the recent promotion of Lisa Brown to art director of an ad agency or company you're interested in, here's a chance to write a short note congratulating her on her promotion. Be sure to include your samples!

• **Trade magazines.** Ask the librarian in the periodicals section of your library for trade magazines of your target industries. These publications publish news items specific to the area of design or illustration you're interested in. (Some industries with trade publications include the gift industry, the magazine and book publishing industries, collectibles, health care, advertising and design. See Publications of Interest on page 681.) You may even want to subscribe to a trade magazine to be among the first to know when art directors change jobs, a new ad campaign is announced, or a new product line is about to be launched. Learn to read between the lines. Say you read in *Adweek* that a small advertising agency has just been awarded an account with a large hospital. That's a valuable clue that the agency is going to need freelance help very soon. Why? It stands to reason that this small agency will be feeling growing pains. Their small staff will be stretched thin with a larger workload, yet the owner may not be ready to take on a larger staff. Send a short note congratulating the owner on landing the account and tell her you can help. Say something like "If you are looking for an illustrator who always makes deadline, please give me a call." Enclose your best samples. Similarly, if you are a greeting card illustrator and you read in *Greetings* that a certain card company's profits have gone up and they plan to expand their line of everyday cards, send some samples—and make it snappy—before your competition beats you to the punch!

• **Trade show exhibitors' guides.** Every industry has some kind of annual trade show. The value of names found in such a guide is that the names are "pre-qualified" for buying design or illustration. It's a good guess they need more design or illustration for booths, brochures and displays than their competitors who don't exhibit.

• **Editorial calendars**. When researching any kind of publication for design or illustra-

tion services, the editorial calendar gives you the issue-by-issue themes for the year. Then, when you approach the publication, you will be able to reference your work to a specific need they will have for design or illustration in an upcoming issue. You can get the editorial calendar by calling the advertising sales department and asking for a media kit or by talking to the editorial department secretary.

• **Awards annuals**. Finally, when you have a very strong visual style, look in these directories to find clients who win creative awards in their industry. If a client used a strong design or illustration style once, they are more likely to do it again. Find out the type of clients who wins awards by reviewing advertising and design industry award directories and annual award issues of design publications such as *HOW*, *Communication Art*, *Studio Magazine* or *Applied Arts* (Canada).

SEND TO A PERSON, NOT A JOB TITLE

Unfortunately, most directories (unlike this one), do not list the contact person to whom you should send samples. Your mailing will lose its impact if you address it to "Art Director." People buy design and illustration, not companies or job titles! So do a little investigative research to find your contact person.

You will need to call companies to find out the best name to send your mailing to. What you are trying to get is the name of the *true* client, the person in charge of buying design or illustration. Often the switchboard operator can give you the name. When you call, be sure to specify the area of design or illustration work you are looking for. There might be several art directors or art buyers at any given ad agency or company, so keep asking questions until you are sure who's who.

Since getting a name is research and not selling, it is very easy to do. Write your own role-playing scripts before you pick up the phone to get the most information with the least amount of effort. It is very important to prepare ahead for even the simplest verbal interaction.

Your approach phone call script could go something like this: *"Hello, my name is _____ and I'm updating my files. Who is in charge of hiring freelance illustrators? (or designers)"* or *"Hello, my name is _____ and I need information on your company. Who is responsible for hiring design (or illustration) services?"* Add the contact person's name and company to your mailing list database and your promotional mailing will have the greatest chance of reaching the right target. Information is power!

HELP THE CLIENT HIRE YOU

The best step to getting hired is to quote a price both you and the client can live with—and profit by! This process begins when a prospective client asks the big question, "What do you charge?" There are two typical situations when clients will ask for your design or illustration costs. To answer this ask yourself "What does it cost to do my job?"; "How many hours will the assignment take?"; "How much are my talents worth?" and "What cost is the market willing to pay?" In this case you receive from the client a complete job description and it is fairly simple to give them a cost.

It gets a little more complicated when the client doesn't have a job for you at the moment, but would like to know what it would cost to work with you when they have one. In today's new economy of buying design and illustration, this is a more frequently-asked question. It is also very difficult to answer. How do you quote a job when you don't know what they need? Here's a clue to understand pricing from your client's position. All the client is really asking for is some way to measure you against other artists. Your best bet is to be prepared in advance with some simple measuring devices to give out when the client wants a price, but doesn't have a job at hand. Try a price range. Ask them to describe a typical job, pricing something they like out of your portfolio.

SIX QUESTIONS TO ASK BEFORE PRICING A JOB

When the client has a specific job request, it is very important to get a complete description of what is needed before you present your cost proposal. Ask your personal version of these six questions:

1. **What do they specifically need?** Describe the number of comps, variations, any background information as well as the number of meetings or consultations the client will need.
2. **When do they need it delivered?** Don't forget to include any possible rush charges for a faster than normal delivery.
3. **Who will see it and what will they do with it?** Great question when your client isn't familiar with copyright and usage pricing. This question will determine whether your design or illustration will be a simple booth graphic or used for a national advertising campaign.
4. **What is the budget?** What were they planning to spend on the design or illustration? Clients won't always tell you, but at least they know that you are concerned. You'll get the information in a later contact with them, so don't worry if they won't answer.
5. **Who else is giving them a cost proposal?** This question often answers the "budget" question! Again, your client may not want to give you the information, but at least you'll know whether the job is being put out for bids.
6. **When is the best time to meet?** If you want to meet with a client to show your portfolio or discuss an assignment, never ask "Can we meet?" or "Do you want to make an appointment?" These closed questions too often lead to "No!"

NEVER QUOTE PRICES OFF THE TOP OF YOUR HEAD!

Plan on calling the client back when you don't know them well or don't know if you have the job. Don't quote prices off the top of your head! Without inconveniencing your client, a short delay will give you the time to do an accurate cost estimate and show your client the respect his request for design or illustration deserves. Don't worry about seeming unprofessional when asking for time to get back to your client with an estimate. This procedure is very standard in businesses, so more than likely your client will expect you to need a little time. In a relaxed manner, just say something like, "Now that we've got all the elements of the project, I'll need just a few hours to work up some figures. I can get back to you tomorrow afternoon if that's convenient."

When you return for a second meeting, or call them back, their feedback will help determine exactly how much work you still have to put into the cost proposal. Prepare our verbal presentation in advance so that you can handle any response. For example, "From what you described, it will cost $5,000. How does that fit your budget?" They will respond positively or negatively and you can negotiate until you and your client agree the price is "in the ballpark."

THE PAY-OFF? A MORE ENJOYABLE CAREER!

When you choose a focus, analyze markets, prospect for clients, plan strategical mailings and adapt professional pricing methods, you are using the same methods top professionals use. As this new mindset kicks in, you'll find yourself becoming more pro-active in looking for new markets. And you'll start seeing possibilities everywhere. Instead of being grateful for any assignment, you'll seek out the most enjoyable and profitable ones. Not only will you enjoy your work more, but you'll be paid better, too. Isn't that worth the effort?

TEN SALES TIPS THAT REALLY WORK!

1. Think of yourself as a consultant. Consultive selling seems to work better for artists than other sales methods. Forget high pressure sales techniques. Act friendly, professional and poised when talking to prospects. Find out what they need, then strategically offer your services. Look at rejection as valuable information.

2. Listen. The client should do 70 percent of the talking, you should stick to 30 percent. Without probing, find out as much as you can about your prospect. Aim for information.

3. Identify needs. Keep an eye out for problems you can solve. Example: a restaurant in your neighborhood serves fantastic food, but never seems to have customers. You specialize in logos and hope to get into menu design. Bingo. You just found a potential client.

4. Educate your client. In the case of the above restaurant, the owner may not realize scruffy menus and home-made signs hurt business. Tell him you'd like to help him attract more customers. Then show him how other restaurants use signage and menus to develop identity in the community.

5. Phrase your offer in terms of benefits. Don't tell your client your logo designs win awards. Tell her how a strong logo and professional stationery will help her business grow. Instead of pointing out your great brochure design, explain how a well-designed brochure will increase her visibility.

6. Watch for body language. If your prospect leans forward or his eyes light up when you mention an offer, that's your cue to take it further. If he glances at his watch or folds his arms (both signals he wants to conclude your talk), schedule a time to continue your discussion.

7. Consider objections as buying signals. If an art director tells you she didn't hire you because it wasn't clear from your samples if you could draw figures—that's valuable information! Send another sample to alleviate her doubts.

8. Employ "trial" closes. According to sales legend, 80 percent of all sales are lost because people don't ask for (close) the sale—or they close at the wrong time. Consultive salespeople use "trial" closes, testing the water to make sure they are on the right track. Here's how it works: If you make a follow-up call to an art director who says he will keep your samples on file, don't hang up the phone yet. Say "I am really anxious to work for your magazine. Do you have anything I can work on now?" That simple question could prompt him to respond "Well, there is a spot illustration, but I'm not sure your work is appropriate." Hmmm. Sounds a bit negative, but remember—objections are often buying signals. Try another approach. Ask what the article is about. As he discusses the article, and your mind races with ideas, head in for another trial close. Say "Sounds interesting! Would it be OK if I work up a couple of rough sketches for you? I could fax them to you by tomorrow afternoon." You've offered a benefit. If you show enthusiasm and willingness to work, chances are he'll at least be willing to see what you can do.

9. Prepare a script. Practice simple phrases before you talk to a client. Rehearse your script with a relative or friend, or even on a tape recorder until you sound relaxed and natural. Eliminate the "er, um, ah" syndrome. Your script could be as simple as "Hi, this is Mark James, I sent you samples of my illustrations and I'm calling to see if you might have some work for me." Then keep quiet and listen!

10. Don't burn your bridges. When prospects decline your artwork or services, thank them and try again with future mailings. People's situations change. They might need your artwork in the future.

—Mary Cox

IMPORTANT NOTE ON THE MARKETS

- The majority of markets listed in this book are those which are actively seeking new talent. Some well-known companies which have declined complete listings are included within their appropriate section with a brief statement of their policies. In addition, firms which have not renewed their listings from the 1996 edition are listed in the General Index with a code to explain the reason for their absence.
- Listings are based on editorial questionnaires and interviews. They are not advertisements (markets do not pay for their listings), nor are listings endorsed by the *Artist's & Graphic Designer's Market* editor.
- Listings are verified prior to the publication of this book. If a listing has not changed from last year, then the art buyer has told us that his needs have not changed—and the previous information still accurately reflects what he buys.
- Remember, information in the listings is as current as possible, but art directors come and go; companies and publications move; and art needs fluctuate between the publication of this directory and when you use it.
- *Artist's & Graphic Designer's Market* reserves the right to exclude any listing that does not meet its requirements.

KEY TO SYMBOLS AND ABBREVIATIONS

‡ New listing in all sections and all indexes
● Comment from *Artist's & Graphic Designer's Market* editor
♣ Canadian listing
* Listing outside U.S. and Canada
ASAP As soon as possible
b&w Black and white
IRC International Reply Coupon
P-O-P Point-of-purchase display
SASE Self-addressed, stamped envelope
SAE Self-addressed envelope

The Markets

Greeting Cards, Games & Products

According to our latest reader survey, this section is the most widely used in the book, resulting in more sales than any other section. Because it is so important to you, we moved it to the front of the book, gave it a more accurate title and beefed up the number of listings. You'll find 97 new listings—companies that were not included last year. The new listings are easily identifiable by the double dagger symbol before each new company's name.

THE PERFECT "CROSSOVER" MARKETS

Whether you're an illustrator, designer, painter, sculptor, calligrapher or cartoonist, you'll find opportunities on the following pages. Many of the markets are perfect "crossover" markets. That is, they need fine art images to sell to commercial markets. The largest industry represented is the greeting card industry, but browse through the listings. I guarantee you're in for a few surprises.

Businesses need images to adorn all kinds of products: balloons, banners, party favors, paper plates, napkins, tablecloths, shopping bags, stationery, T-shirts, school supplies—you name it. Want your artwork to be admired by collectors, to possibly be seen all over the world? Check out IGPC (page 76), a company that produces postage stamps! In this section you'll find publishers of calendars, diaries, personal checks, playing cards, educational software, role-playing games featuring wizards and warriors, even rubber stamps. We list manufacturers of everyday items like mugs, as well as companies looking for fine art for limited edition plates and collectibles. I know your highlighter is poised and ready, but read on. There's more to cracking these markets than meets the eye.

THE MORE YOU KNOW, THE MORE YOU'LL SELL

What difference does it make that women buy 85-90 percent of all cards? Why is it necessary to know the most popular card-sending holidays (in order of popularity) are Christmas, Valentine's Day, Easter, Mother's Day and Father's Day? Should you really care that the average person receives eight birthday cards a year? There's a good reason why you should care. Research helps you sell more and avoid obvious mistakes. Unless you research Hallmark, for example, you won't be aware that well-known company doesn't accept unsolicited submissions. Manned with the right statistics, you can design images that appeal to women, that are appropriate for birthdays and the most popular holidays. And you'll be more likely to sell them.

The best way to research the market (aside from reading this book) is to go shopping—and take a notebook! Jot down everything about the cards and products you see. Study which holidays and occasions have separate sections in greeting card displays. That's how you'll know what images companies want.

Trade publications give you an edge

Reading *Party and Paper Retailer, Greetings, Gift & Decorative Accessories* and other industry trade publications, will place you heads above your competition. (See Publications of Interest, page 681, for addresses.) Read an issue or two in your public library's business section and you'll feel like a real insider. You'll learn about trade shows and be among the first to discover new companies. Refer to the trade show calendars in those publications and plan to attend a show near your city. At shows, you'll meet art buyers in person and find out new trends before they hit the stores.

Diversify your submissions for more sales

Most successful greeting card freelancers diversify. They get work from greeting card companies, but they also pick up assignments in related markets. They might create designs for paper plates or patterns for wrapping paper companies. Many illustrate for advertising agencies and children's book publishers. If you don't crack the greeting card market right away, try submitting to related markets, too. (See the Insider Report on Mary Jo Recker of Crystal Tissue Company on page 61 for the scoop on how to approach a giftwrap manufacturer.) Once you gain experience and have tearsheets to show art directors, greeting card assignments will be easier to land.

CARE ENOUGH TO SEND THE VERY BEST

When sending samples, do not send originals. Companies want to see photographs, photocopies, printed samples, slides or tearsheets. They don't want the artwork itself until they give you a definite assignment.

Don't just send copies of existing paintings or assignments from school. Your samples should be appropriate to the market, so adapt one of your designs by making a few adjustments. When submitting to greeting card companies, render your artwork in watercolor or gouache on illustration board, preferably in the standard industry size, which is 4⅝ × 7½ inches. Leave some space at either the top or bottom of your work, because cards often feature lettering there. Check the cards in stores for an idea of how much space to leave. It isn't necessary to add lettering unless you want to do your own lettering. Card companies usually have staff artists or freelancers who are experts at creating lettering to accompany a card's image.

Artwork should be upbeat, brightly colored, and appropriate for one of the two major divisions in the greeting card market: seasonal or everyday. Seasonal cards express greetings for holidays like Christmas, Easter, Valentine's Day and Mother's Day. Everyday cards are sent to express sympathy, a get well message, birthday greetings or to just say "hi." The market is then further broken down between traditional greetings, humorous or "studio" cards, and "alternative" cards, which feature quirky, sophisticated or offbeat humor. The lines between categories are blurring, but a visit to your nearest card display rack will confirm the divisions still apply.

Once your artwork is complete, have color photographs, photocopies or slides made. Check the listings to see which types of cards a company needs. Then send three to five appropriate samples of your work to the contact person named in the listing. Make sure each sample is labeled with your name, address and phone number. Include a brief (one to two paragraph) cover letter and enclose a self-addressed stamped envelope (see What Should I Submit? page 4 for more information on submitting your work).

As you're preparing your submissions, think not only in terms of individual card ideas, but also in terms of entire lines and related gift items. Like any other company, a card company wants to create an identity for itself and build brand loyalty among its buyers. Consequently, many companies look for artistic styles that they can build into an entire line of products.

BECOME A TREND "DETECTIVE"

Spotting trends—who's sending to whom, which colors and patterns (even pets!) are popular—will help you create marketable cards and gift items. If your images feature popular colors and consider the needs of today's consumer, they'll have wider appeal.

The multicultural movement has fostered greater interest in ethnic art. We're seeing cards celebrating Kwanzaa, an African-American holiday, alongside Christmas and Hanukkah greetings. Current popular images include gardening motifs; food images like chili peppers and coffee; African-inspired batiks; florals paired with stripes, paisleys and small prints. Angels, teddy bears, puppies and kittens continue to be popular with card buyers.

The fastest growing trends reflect our changing society. According to American Greetings more than 1,300 new stepfamilies are created each day and 65 percent of all grandparents will be step-grandparents by the year 2000. American Greetings cards responded to those statistics by offering Mother's Day cards for single mothers, stepmothers, and even "to Dad on Mother's Day!" Though past Father's Day cards concentrated on sports, hunting and fishing images, today's cards increasingly show Dads with their children, reflecting increased parental involvement. There are even cards reflecting the sometimes strained relationships between parents and teenagers.

There are more "friend to friend" cards, empathizing with a fellow dieter, encouraging a friend to quit smoking, and even offering sensitive alternatives to "get well" for friends stricken with a chronic or terminal illness. Sympathy cards for the loss of a pet are now common. We're seeing more cards expressing support for couples who are splitting up. Yet at the same time, a new breed of romantic greeting card is becoming popular. Written in direct, often humorous prose instead of flowery verse, the new cards help the sender communicate feelings on difficult subjects.

The class of 1996 received more than 80 million graduation cards, according to the Greeting Card Association, and 25 percent were humorous cards. Eighty-five percent of graduates receive gifts of money, so card companies are interested in ideas incorporating special flaps for cash and checks. The changing role of women is reflected in cards which express the trials and joys of juggling career and family. Fifty-one percent of women and 31 percent of men had a birthday party on the job in 1995, so we're seeing an increase in the number of birthday cards from the gang at the office, too.

Pay serious attention to trends. Original images and/or words that match trends are not only more saleable, but show your knowledge of the market.

SET THE RIGHT PRICE

Although payment rates of card companies and related industries are comparable to those paid by magazine and book publishers, price is not normally negotiable in this business. Most card and paper companies have set fees or royalty rates that they pay for design and illustration. What has recently become negotiable, however, is rights. In the past, card companies almost always demanded full rights to work, but now some are willing to negotiate for other arrangements, such as greeting card rights only. Keep in mind, however, that if the company has ancillary plans in mind for your work (for example, calendars, stationery, party supplies or toys) they will probably want to buy all rights. In such cases, you may be able to bargain for higher payment.

READ MORE ABOUT IT

The Complete Guide to Greeting Card Design & Illustration by Eva Szela (from North Light Books) features published samples, tips and inside information on creating successful card designs.

If you'd like to try your hand at writing greetings to go with your designs, read *How to Write & Sell Greeting Cards, Bumper Stickers, T-Shirts and Other Fun Stuff* by Molly Wigand (Writer's Digest Books). Marbleizing, paper making and dozens of helpful techniques are described in *Create Your Own Greeting Cards & Gift Wrap with Patricia House* (North Light Books).

THE PLATES AND COLLECTIBLES MARKET

Don't overlook the giant collectible market! Limited edition collectibles—everything from plates to porcelain dolls to English cottages—appeal to a wide audience. Companies like The Hamilton Collection, The Franklin Mint and The Bradford Exchange, all listed in this edition, are the leaders in this multi-million-dollar industry, but there are many more companies producing collectibles these days. If you seek to enter the collectible field, you have to be flexible enough to take suggestions. Companies do heavy market testing to find out which images will sell the best, so they will want to guide you in the creative process. For a collectible plate, for example, your work must fit into a circular format or you'll be asked to extend the painting out to the edge of the plate.

Popular images for collectibles include Native American, wildlife, animals (especially kittens and puppies), children, angels, stuffed animals, dolls and sports images. You can submit slides to the creative director of companies specializing in collectibles. Several are listed in this book. For special insight into the market consider attending one of the industry's trade shows held yearly in South Bend, Indiana; Secaucus, New Jersey; and Anaheim, California.

ABEL LOVE, INC., Dept. AGDM, 20 Lakeshore Dr., Newport News VA 23608. (804)877-2939. Buyer: Abraham Leiss. Estab. 1985. Distributor of books, gifts, hobby, art and craft supplies and drafting material. Clients: retail stores, libraries and college bookstores. Current clients include Hampton Hobby House, NASA Visitors Center, Temple Gift Shops, Hawks Hobby Shop and Army Transportation Museum.
Needs: Approached by 100 freelancers/year. Works with 10 freelance illustrators and 1 designer/year. Uses freelancers for catalog design, illustration and layout. 50% of freelance work demands computer skills.
First Contact & Terms: Designers send brochure. Illustrators send postcard sample. Samples are filed. Reports back ASAP. Art director will contact artist for portfolio review if interested. Pays 10% royalties. Rights purchased vary according to project.

ACME GRAPHICS, INC., 201 Third Ave. SW, Box 1348, Cedar Rapids IA 52406. (319)364-0233. Fax: (319)363-6437. President: Stan Richardson. Estab. 1913. Produces printed merchandise used by funeral directors, such as acknowledgments, register books and prayer cards.
Needs: Approached by 30 freelancers/year. Considers pen & ink, watercolor and acrylic. Art guidelines available. Looking for religious, church window, floral and nature art.
First Contact & Terms: Designers should send query letter with résumé, photocopies, photographs, slides and transparencies. Illustrators send postcard sample or query letter with brochure, photocopies, photographs, slides and tearsheets. Accepts submissions on disk. Samples are not filed and are returned by SASE. Reports back within 10 days. Call or write for appointment to show portfolio of roughs. Originals are not returned. Requests work on spec before assigning a job. Pays by the project or flat fee. Buys all rights.
Tips: "Send samples or prints of work from other companies. No modern art or art with figures. Some designs are too expensive to print."

‡ADVANCE CELLOCARD CO., INC., 1259 N. Wood St., Chicago IL 60622. (312)235-3403. Fax: (312)235-1799. President: Ron Ward. Estab. 1960. Produces greeting cards.
Needs: Considers watercolor, acrylic, oil and colored pencil. Art guidelines for SASE with first-class postage. Produces material for Valentine's Day, Mother's Day, Father's Day, Easter, graduation, birthdays and everyday.
First Contact & Terms: Send query letter with brochure and SASE. Accepts disk submissions compatible with Mac formated Adobe Illustrator 5.5, Adobe Photoshop 3.0 or Power Mac QuarkXPress 3.0. Samples

not filed are returned by SASE. Reports back within weeks. Originals are not returned. Pays average flat fee of $75-150/design. Buys all rights.

Tips: "Send letter of introduction, and samples or photostats of artwork."

ALASKA MOMMA, INC., 303 Fifth Ave., New York NY 10016. (212)679-4404. Fax: (212)696-1340. President: Shirley Henschel. "We are a licensing company representing artists, illustrators, designers and established characters. We ourselves do not buy artwork. We act as a licensing agent for the artist. We license artwork and design concepts to toy, clothing, giftware, textiles, stationery and housewares manufacturers and publishers."

Needs: "We are looking for people whose work can be developed into dimensional products. An artist must have a distinctive and unique style that a manufacturer can't get from his own art department. We need art that can be applied to products such as posters, cards, puzzles, albums, etc. No cartoon art, no abstract art, no b&w art."

First Contact & Terms: "Artists may submit work in any form as long as it is a fair representation of their style." Prefers to see several multiple color samples in a mailable size. No originals. "We are interested in artists whose work is suitable for a licensing program. We do not want to see b&w art drawings. What we need to see are transparencies or color photographs or color photocopies of finished art. We need to see a consistent style in a fairly extensive package of art. Otherwise, we don't really have a feeling for what the artist can do. The artist should think about products and determine if the submitted material is suitable for licensed product. Please send SASE so the samples can be returned. We work on royalties that run from 5-10% from our licensees. We require an advance against royalties from all customers. Earned royalties depend on whether the products sell."

Tips: "Publishers of greeting cards and paper products have become interested in more traditional and conservative styles. There is less of a market for novelty and cartoon art. We need artists more than ever as we especially need fresh talent in a difficult market."

ALEF JUDAICA, INC., 8440 Warner Dr., Culver City CA 90232. (310)202-0024. Fax: (310)202-0940. President: Guy Orner. Estab. 1979. Manufacturer and distributor of a full line of Judaica, including menorahs, Kiddush cups, greeting cards, giftwrap, tableware, etc.

Needs: Approached by 15 freelancers/year. Works with 10 freelancers/year. Buys 75-100 freelance designs and illustrations/year. Prefers local freelancers with experience. Works on assignment only. Uses freelancers for new designs in Judaica gifts (menorahs, etc.) and ceramic Judaica. Also for calligraphy, pasteup and mechanicals. All designs should be upper scale Judaica.

First Contact & Terms: Mail brochure, photographs of final art samples. Art director will contact artist for portfolio review if interested, or portfolios may be dropped off every Friday. Sometimes requests work on spec before assigning a job. Pays $300 for illustration/design; pays royalties of 10%. Considers buying second rights (reprint rights) to previously published work.

AMBERLEY GREETING CARD CO., 11510 Goldcoast Dr., Cincinnati OH 45249-1695. (513)489-2775. Fax: (513)489-2857. Art Director: Dave McPeek. Estab. 1966. Produces greeting cards. "We are a multi-line company directed toward all ages. We publish conventional as well as humorous cards."

Needs: Approached by 20 freelancers/year. Works with 10 freelancers/year. Buys 250 illustrations/year. Works on assignment only. Considers any media.

First Contact & Terms: Send query letter with brochure, color photocopies and SASE. Calligraphers send photocopies of lettering styles. Samples are filed or returned by SASE if requested by artist. Reports back to artist only if interested. Call for appointment to show portfolio of original/final art. Pays illustration flat fee $75-80; pays calligraphy flat fee $20-30. Buys all rights.

Tips: "Understand greeting card art and how it differs from editorial illustration—study what you see in stores."

AMCAL, 2500 Bisso Lane, Bldg. 500, Concord CA 94520. (510)689-9930. Fax: (510)689-0108. Publishes calendars, notecards, Christmas cards and other book and stationery items. "Markets to better gift, book and department stores throughout U.S. Some sales to Europe, Canada and Japan. We look for illustration and design that can be used many ways—calendars, note cards, address books and more so we can develop a collection. We buy art that appeals to a widely female audience." No gag humor or cartoons.

Needs: Needs freelancers for design and production. Art guidelines available. Prefers work in horizontal format.

First Contact & Terms: Designers send query letter with brochure, résumé and SASE. Illustrators send query letter with brochure, résumé, photographs, SASE, slides, tearsheets and transparencies. Samples returned by SASE if requested by artist. Art director will contact artist for portfolio review if interested. Pay for illustration by the project, advance against royalty. Finds artists through word of mouth, magazines, submissions/self-promotions, sourcebooks, visiting artist's exhibitions, art fairs and artists' reps.

Tips: "Know the market. Go to gift shows and visit lots of stationery stores. Read all the trade magazines. Talk to store owners to find out what's selling and what isn't."

AMERICAN GREETINGS CORPORATION, One American Rd., Cleveland OH 44144. (216)252-7300. Director of Creative Resources and Development: Lynne Shlonsky. Estab. 1906. Produces greeting cards, stationery, calendars, paper tableware products, giftwrap and ornaments—"a complete line of social expressions products."
Needs: Prefers local artists with experience in illustration, decorative design and calligraphy.
First Contact & Terms: Send query letter with résumé. "Do not send samples." Pays average flat fee of $350.

AMERICAN TRADITIONAL STENCILS, 442 First New Hampshire Turnpike, Northwood NH 03261. (603)942-8100. Fax: (603)942-8919. Owner: Judith Barker. Estab. 1970. Manufacturer of brass and laser cut stencils and 24 karat gold finish charms. Clients: retail craft, art and gift shops. Current clients include Williamsburg Museum, Old Sturbridge and Pfaltzgraph Co., Henry Ford Museum and some Ben Franklin stores.
Needs: Approached by 1-2 freelancers/year. Works with 1 freelance illustrator/year. Assigns 2 freelance jobs/year. Prefers freelancers with experience in graphics. Works on assignment only. Uses freelancers mainly for stencils. Also for ad illustration and product design. Prefers b&w camera-ready art.
First Contact & Terms: Send query letter with brochure showing art style and photocopies. Samples are filed or are returned. Reports back in 2 weeks. Call for appointment to show portfolio of roughs, original/final art and b&w tearsheets. Pays for design by the hour, $8.50-20; by the project, $15-150. Pays for illustration by the hour, $6-7.50. Rights purchased vary according to project.

AMSCAN INC., 80 Grasslands Rd., Elmsford NY 10523. (914)345-2020. Vice President of Art and Design: Diane A. Spaar. Vice President of Production and Catalog: Katherine A. Kusnierz. Estab. 1954. Designs and manufactures paper party goods. Extensive line includes paper tableware, invitations and thank you cards, giftwrap and bags, decorations. Complete range of party themes for all ages, all seasons and all holidays.
Needs: "Ever expanding department with incredible appetite for fresh design and illustration. Subject matter varies from baby, juvenile, floral type and graphics. Designing is accomplished both in the traditional way by hand (i.e., painting) or on the computer using a variety of programs. Always looking for new talent in both product, surface and catalog design. Layout and production artists who are expert in FreeHand 4.0, Adobe Illustrator, QuarkXPress and Adobe Photoshop are also needed. We are also looking for Full Auto Frames operators in our pre-press department. Opportunity is endless! For design submissions please call for requirements."
First Contact & Terms: "Send samples or copies of artwork to show us range of illustration styles. If artwork is appropriate, we will pursue. Competitive pay; excellent benefits."
Tips: Flexo, offset and letterpress printing are involved. Looking for complex illustrations that will be printed using spot colors and complex screen work.

ANGEL GRAPHICS, 903 W. Broadway, Fairfield IA 52556. (515)472-5481. Fax: (515)472-7353. Project Manager: Susan Cooke. Estab. 1981. Produces full line of posters for wall decor market.
Needs: Approached by hundreds of freelancers/year. Works with 5-10 freelancers/year. Buys 50-100 freelance designs and illustrations/year. Uses freelancers mainly for posters. Also for calligraphy. Considers any media. Looking for realistic artwork. Prefers 16×20 proportions. 10% of work demands knowledge of Adobe Illustrator, Adobe Photoshop and QuarkXPress. Produces material for all holidays and seasons. Submit seasonal material 6 months in advance.
First Contact & Terms: Send query letter with photographs, slides and transparencies. Samples are not filed and are returned by SASE. Company will contact artist for portfolio review if interested. Portfolio should include photographs, slides and transparencies. Negotiates rights purchased. Originals are returned at jobs completion. Pays by the project, $250-400. Finds artists through word of mouth.

APPLE ORCHARD PRESS, P.O. Box 240, Dept. A, Riddle OR 97469. Art Director: Gordon Lantz. Estab. 1988. Produces greeting cards and book products. "We manufacture our products in our own facility and distribute them nationwide. We make it a point to use the artist's name on our products to help them gain recognition. Our priority is to produce beautiful products of the highest quality."
Needs: Works with 4-8 freelancers/year. Buys 50-75 designs/year. Uses freelancers mainly for note cards and book covers. All designs are in color. Considers all media, but prefers watercolor and colored pencil. Looking for florals, cottages, gardens, gardening themes, recipe book art, Christmas themes and animals. "We usually produce four or more images from an artist on the same theme at the same time." Produces material for Christmas, Valentine's Day and everyday. Submit seasonal material 9-12 months in advance,

ALWAYS ENCLOSE a self-addressed, stamped envelope (SASE) with queries and sample packages.

"but will always be considered for the next release of that season's products whenever it's submitted."
First Contact & Terms: Submit photos, slides, brochure or color copies. Must include SASE. "Samples are not filed unless we're interested." Reports back within 1-2 months. Company will contact artist for portfolio review if interested. Portfolio should include slides and/or photographs. Pays one-time flat fee/image. Amount varies. Rights purchased vary according to project.
Tips: "Please do not send pictures of pieces that are not available for reproduction. We must eventually have access to either the original or an excellent quality transparency. If you must send pictures of pieces that are not available in order to show style, be sure to indicate clearly that the piece is not available. We work with pairs of images. Sending quality pictures of your work is a real plus."

‡THE ASHTON-DRAKE GALLERIES, 9200 N. Maryland Ave., Niles IL 60714. (847)581-8107. Procurement Manager: Andrea Ship. Estab. 1985. Direct response marketer of collectible dolls. Clients: consumers, mostly women of all age groups.
Needs: Approached by 300 freelance artists/year. Works with 250 freelance doll artists, sculptors, costume designers and illustrators/year. Works on assignment only. Uses freelancers for concept illustration, wigmaking, porcelain decorating, shoemaking, costume design, collectible design, prototype specifications and sample construction. Prior experience in giftware design and doll design a plus. Subject matter includes babies, toddlers and children. Prefers "cute, realistic and natural human features; animated poses."
First Contact & Terms: Send query letter with résumé and copies of samples to be kept on file. Prefers photographs, tearsheets or photostats as samples. Samples not filed are returned. Reports within 7 weeks. Pays by the hour, $40-50; by the project, $50-300. Concept illustrations are done "on spec." Sculptors receive contract for length of series on royalty basis with guaranteed advances.

THE AVALON HILL GAME CO., 4517 Harford Rd., Baltimore MD 21214. (410)254-9200. Fax: (410)254-0991. E-mail: ahgames@aol.com; avalon.hill@genie.geis.com; 72662.1207@compuserve.com. Art Director: Jean Baer. Estab. 1958. "Produces strategy, sports, family, role playing and military strategy games (for the computer) for adults."
 • This company also publishes the magazine *Girls' Life*.
Needs: Approached by 30 freelancers/year. Works with 5 freelancers/year. Buys less than 10 designs and illustrations from freelancers/year. Prefers freelancers with experience in realistic military art. Works on assignment only. Uses freelancers mainly for cover and interior art. Considers any media. "The styles we are looking for vary from realistic to photographic."
First Contact & Terms: Send query letter with tearsheets, slides, SASE and photocopies. Samples are filed or returned by SASE if requested by artist. Prefers samples that do not have to be returned. Reports back within 2-3 weeks. If Art Director does not report back, the artist should "wait. We will contact the artist if we have an applicable assignment." Art Director will contact artist for portfolio review if interested. Original artwork is not returned. Sometimes requests work on spec before assigning a job. Pays by the project, $500 average for cover art, according to job specs. Buys all rights. Considers buying second rights (reprint rights) to previously published work. Finds artists through word of mouth and submissions.

‡BALLOON WHOLESALERS INTERNATIONAL, 1735 E St., Suite 104, Fresno CA 93706. (209)266-1318. Fax: (209)266-3944. Vice President: T. Adishian. Estab. 1983. Manufacturer of balloons for adults and children.
Needs: Approached by 2-3 freelance artists/year. Uses freelance artists mainly for balloon and gift design. Prefers bright, contemporary, upbeat styles. Also uses freelance artists for P-O-P displays, package and header card displays.
First Contact & Terms: Send query letter with brochure showing art style or résumé, tearsheets, photostats, photographs and SASE. Samples are filed or are returned by SASE only if requested by artist. Reports back within 4-6 weeks. Request portfolio review in original query. Art Director will contact artist for portfolio review if interested. Portfolio should include roughs, photostats, tearsheets and dummies. Requests work on spec before assigning a job. Rights purchased vary according to project.

BARTON-COTTON INC., 1405 Parker Rd., Baltimore MD 21227. (301)247-4800. Contact: Art Buyer. Produces religious greeting cards, commercial all occasion, Christmas cards, wildlife designs and spring note cards.
Needs: Buys 150-200 freelance illustrations/year. Submit seasonal work any time. Free guidelines for SASE with first-class postage and sample cards; specify area of interest (religious, Christmas, spring, etc.).
First Contact & Terms: Send query letter with résumé, tearsheets, photocopies or slides. Submit full-color work only (watercolor, gouache, pastel, oil and acrylic). Previously published work and simultaneous submissions accepted. Reports in 1 month. Pays by the project, $300-2,500 for illustration and design. **Pays on acceptance.**
Tips: "Good draftsmanship is a must. Spend some time studying current market trends in the greeting card industry. There is an increased need for creative ways to paint traditional Christmas scenes with up-to-date styles and techniques."

‡**BEACH PRODUCTS**, 1 Paper Place, Kalamazoo MI 49001. (616)349-2626. Fax: (616)349-6412. Creative Directors: Kathleen Pavlack and Marc Rizzolo. Publishes paper-tableware products; general and seasonal, birthday, special occasion, invitations, announcements, stationery, wrappings and thank you notes for children and adults.

Needs: Approached by 200 freelance artists/year. Uses artists for product design and illustration. Art guidelines for SASE with first-class postage. Prefers flat 4-color designs; 5¼ wide × 5½ high for luncheon napkins. Produces seasonal material for Christmas, Mother's Day, Thanksgiving, Easter, Valentine's Day, St. Patrick's Day, Halloween and New Year's Day. Submit seasonal material before June 1; everyday (not holiday) material before March. 50% of design and 40% of illustration demand knowledge of Adobe Photoshop or Aldus FreeHand.

First Contact & Terms: Send query letter with 9 × 12 SASE so catalog can be sent with response. Accepts submissions on disk. Disclosure form must be completed and returned before work will be viewed. Call or write to schedule an appointment to show portfolio. Portfolio should include original/final art and final reproduction/product. Previously published work OK. Originals not returned to artist at job's completion. "All artwork purchased becomes the property of Beach Products. Items not purchased are returned." Pays average flat fee of $500 or royalties of 5% for illustration and design. Considers product use when establishing payment.

Tips: "Artwork should have a clean, professional appearance and be the specified size for submissions, as well as a maximum of four flat colors."

FREDERICK BECK ORIGINALS, 20644 Superior St., Chatsworth CA 91311. (818)998-0323. Fax: (818)998-5808. Contact: Gary Lainer or Ron Pardo. Estab. 1953. Produces silk screen printed Christmas cards, traditional to contemporary.

• This company is under the same umbrella as Gene Bliley Stationery (see listing). One submission will be seen by both companies, so there is no need to send two mailings. Frederick Beck designs are a little more high end than Gene Bliley designs. The cards are sold through stationery and party stores, where the customer browses through thick binders to order cards, stationery or invitations imprinted with customer's name. Though some of the same cards are repeated or rotated each year, both companies are always looking for fresh images.

Needs: Approached by 20 freelancers/year. Works with 10 freelancers/year. Buys 25-50 freelance designs and illustrations/year. Prefers freelancers with experience in silk screen printing. Uses freelancers mainly for silk screen Christmas card designs. Looking for "artwork compatible with existing line; shape and color are important design elements." Prefers 5⅜ × 7⅞. Produces material for Christmas. Submit holiday material 1 year in advance.

First Contact & Terms: Send query letter with simple sketches. Samples are filed. Portfolio review not required. Usually purchases all rights. Original artwork is not generally returned at job's completion. Sometimes requests work on spec before assigning a job. Pays by project, average flat fee of $175 for illustration/design. Finds artists through word of mouth and submissions/self-promotions.

BEISTLE COMPANY, 1 Beistle Plaza, Box 10, Shippensburg PA 17257. (717)532-2131. Fax: (717)532-7789. Product Manager: C.M. Luhrs-Wiest. Estab. 1900. Manufacturer of paper and plastic decorations, party goods, gift items, tableware and greeting cards. Targets general public, home consumers through P-O-P displays, specialty advertising, school market and other party good suppliers.

Needs: Approached by 15-20 freelancers/year. Prefers artists with experience in designer gouache illustration—fanciful figure work. Looks for full-color, camera-ready artwork for separation and offset reproduction. Works on assignment only. Uses freelance artists mainly for product rendering and brochure design and layout. Prefers designer gouache and airbrush technique for poster style artwork. 50% of freelance design and 10% of illustration demand knowledge of QuarkXPress, Aldus FreeHand, Adobe Illustrator, Adobe Photoshop or Fractal Design PAINTER.

First Contact & Terms: Send query letter with résumé, brochure, SASE and slides. Samples are filed or returned by SASE. Art Director will contact artist for portfolio review if interested. Sometimes requests work on spec before assigning a job. Pays by the project. Considers buying second rights (reprint rights) to previously published work. Finds artists through word of mouth, magazines, submissions/self-promotions, sourcebooks, agents, visiting artists' exhibitions, art fairs and artists' reps.

Tips: "Our primary interest is in illustration; often we receive freelance propositions for graphic design—brochures, logos, catalogs, etc. These are not of interest to us as we are manufacturers of printed decorations. Send color samples rather than b&w. There is a move toward brighter, stronger designs with more vibrant colors and bolder lines. We have utilized more freelancers in the last few years than previously. We predict

● **A BULLET** introduces comments by the editor of *Artist's & Graphic Designer's Market* indicating special information about the listing.

continued and increased consumer interest—greater juvenile product demand due to recent baby boom and larger adult market because of baby boom of the '50s."

‡**BEPUZZLED**, 22 E. Newberry Rd., Bloomfield CT 06002. (203)769-5700. Fax: (203)769-5799. Contact: Sue Tyska. Estab. 1987. Produces games and puzzles for children and adults. "BePuzzled mystery jigsaw games challenge players to solve an original whodunit thriller by matching clues in the mystery with visual clues revealed in the puzzle."
Needs: Works with 8-16 freelance artists/year. Buys 20-40 designs and illustrations/year. Prefers local artists with experience in children's book and adult book illustration. Uses freelancers mainly for box cover art, puzzle images and character portraits. All illustrations are done to spec. Considers many media.
First Contact & Terms: Send query letter with brochure, résumé, SASE, tearsheets, photographs and transparencies. Samples are filed. Reports back within 2 months. Art Director will contact artist for portfolio review if interested. Portfolio should include original/final art and photographs. Original artwork is returned at the job's completion. Sometimes requests work on spec before assigning a job. Pays by the project, $300-3,000. Finds artists through word of mouth, magazines, submissions, sourcebooks, agents, galleries, reps, etc.
Tips: Prefers that artists not "ask that all material be returned. I like to keep a visual in my files for future reference. New and fresh looking illustration styles are key."

BERGQUIST IMPORTS, INC., 1412 Hwy. 33 S., Cloquet MN 55720. (218)879-3343. Fax: (218)879-0010. E-mail: bbergqu106@aol.com. President: Barry Bergquist. Estab. 1948. Produces paper napkins, mugs and tile. Wholesaler of mugs, decorator tile, plates and dinnerware.
Needs: Approached by 5 freelancers/year. Works with 5 freelancers/year. Buys 50 designs and illustrations/year. Prefers freelancers with experience in Scandinavian and wildlife designs. Works on assignment only. Uses freelancers for calligraphy. Produces material for Christmas, Valentine's Day and everyday. Submit seasonal material 6-8 months in advance.
First Contact & Terms: Send query letter with brochure, tearsheets and photographs. Samples are not filed and are returned. Reports back within 2 months. Request portfolio review in original query. Artist should follow-up with a letter after initial query. Portfolio should include roughs, color tearsheets and photographs. Rights purchased vary according to project. Originals are returned at job's completion. Requests work on spec before assigning a job. Pays by the project, $50-300; average flat fee of $50 for illustration/design; or royalties of 5%. Finds artists through word of mouth, submissions/self-promotions and art fairs.

BLACK "INC" GREETINGS, P.O. Box 301248, Houston TX 77230-1248. (713)997-6940. Fax: (713)485-5367. Owner: Frank Williamson. Estab. 1993. Produces greeting cards. Black "Inc" Greetings produces greeting cards that are targeted mainly toward African-Americans and other ethnic groups.
Needs: Approached by 25 freelancers/year. Works with 2-4 freelancers/year. Buys 20 freelance designs and illustrations/year. Prefers local freelancers (but will consider others) with experience in watercolor, gouache, acrylic paints. Works on assignment only. Uses freelancers mainly for illustrations and design. Also for P-O-P displays and mechanicals. Art guidelines for SASE with first-class postage. Considers all media. Looking for styles that are consistent to the appeal of our main target market. Prefers 5×7. Needs computer-literate freelancers for design, illustration and production. Produces material for all holidays and seasons. Submit seasonal material 6 months in advance.
First Contact & Terms: Send query letter with brochure and SASE. Samples are not filed and are returned by SASE if requested by artist. Company will contact artist for portfolio review if interested. Portfolio should include thumbnails, roughs, final art, photostats, tearsheets and photographs. Negotiates rights purchased. Originals are not returned. Pays by the project, $540. Finds artists through word of mouth, art schools and submissions.
Tips: "Show your best strength in a particular media. Present a professional portfolio/image; present quality material."

GENE BLILEY STATIONERY, 20644 Superior St., Chatsworth CA 91311. (818)998-0323. Fax: (818)998-5808. General Manager: Gary Lainer. Sales Manager: Ron Pardo. Estab. 1967. Produces stationery, family-oriented birth announcements and invitations for most events and Christmas cards.
• This company also owns Frederick Beck Originals (see listing). One submission will be seen by both companies.
Needs: Approached by 10-20 freelancers/year. Works with 4-7 freelancers/year. Buys 15-60 designs and illustrations/year. Uses freelancers mainly for invitation and photo card designs. Also for calligraphy and mechanicals. Considers any color media, except photography and oil. Produces material for Christmas, graduation, birthdays, Valentine's Day and Mother's Day. Submit Christmas material 1 year in advance; others reviewed year round.
First Contact & Terms: Send query letter with résumé and color tearsheets, photographs or photocopies. Samples are filed. Portfolio review not required. Original artwork usually not returned at job's completion. Sometimes requests work on spec before assigning a job. Pays flat fee of $100-150 per design on average. Buys all rights.

Tips: "We are open to new ideas and different approaches within our niche. Our most consistent need is designs for Christmas invitations and photo cards. Familiarize yourself with the marketplace."

BLUE SKY PUBLISHING, 6395 Gunpark Dr., Suite M, Boulder CO 80301. (303)530-4654. Fax: (303)530-4627. E-mail: 102200.145@compuserve.com. Art Director: Theresa Brown. Estab. 1989. Produces greeting cards. "At Blue Sky Publishing, we are committed to producing contemporary fine art greeting cards that communicate reverence for nature and all creatures of the earth, that share different cultural perspectives and traditions, and that maintain the integrity of our artists' work."
Needs: Approached by 500 freelancers/year. Works with 30 freelancers/year. Licenses 80 fine art pieces/year. Works with freelancers from all over US. Prefers freelancers with experience in fine art media: oils, oil pastels, vibrant watercolor, fine art photography. "We primarily license existing pieces of art or photography. We rarely commission work." Looking for colorful, contemporary images with strong emotional impact. Art guidelines for SASE with first-class postage. Produces cards for all occasions. 99% of design and 5% of illustration require knowledge of QuarkXPress, Aldus PageMaker and Adobe Illustrator. Submit seasonal material 1 year in advance.
First Contact & Terms: Send query letter with SASE, slides or transparencies. Samples are filed or returned. Reports back within 2-3 months only if interested. Transparencies are returned at job's completion. Pays royalties of 3% with upfront license fee of $250 per image. Buys greeting card rights for 5 years (standard contract; sometimes negotiated).
Tips: "We're interested in seeing artwork with strong emotional impact. Holiday cards are what we produce in biggest volume. We are looking for joyful images, cards dealing with relationships, especially between men and women, with pets, with Mother Nature and folk art. Vibrant colors are important."

‡BONITA PIONEER PACKAGING, 500 Bonita Rd., Portland OR 97224. (503)684-6542. Fax: (503)639-5965. Creative Director: Jim Parker. Estab. 1928. Produces giftwrap, shopping bags, boxes and merchandise bags.
Needs: Approached by 20 artists/year. Works with 10-20 artists/year. Buys 10-20 designs and illustrations/year. Prefers artists with experience in giftwrap. Considers acrylic. Seeks upscale traditional and contemporary styles. Prefers 15″ cylinder circumference. Produces material for all occasions. Considers submissions year-round.
First Contact & Terms: Send query letter with brochure, tearsheets and slides. Samples are not filed and are returned only if requested by artist. Reports back within 3 weeks. To show a portfolio, mail thumbnails, roughs, slides and photographs. Original artwork is not returned to the artist after job's completion. Pays average flat fee of $200-375/design. Buys all rights.
Tips: "Know the giftwrap market and be professional. Understand flexographic printing process limitations." Does not want to see too many colors or process design.

THE BRADFORD EXCHANGE, 9333 Milwaukee Ave., Niles IL 60714. (708)581-8204. Fax: (708)581-8770. Art Acquisition Manager: Susan Collier. Estab. 1973. Produces and markets collectible plates. "Bradford produces limited edition collectors plates featuring various artists' work which is reproduced on the porcelain surface. Each series of 6-8 plates is centered around a concept, rendered by one artist, and marketed internationally."
Needs: Approached by thousands of freelancers/year. Works with approximately 100 freelancers/year. Prefers artists with experience in rendering painterly, realistic, "finished" scenes; best mediums are oil and acrylic. Art guidelines by calling (847)581-6781. Uses freelancers for all work including border designs, sculpture. Considers oils, watercolor, acrylic and sculpture. Traditional representational style is best, depicting scenes of children, pets, wildlife, homes, religious subjects, fantasy art, florals or songbirds in idealized settings. Produces material for all occasions. Submit seasonal material 6-9 months in advance.
First Contact & Terms: Designers send brochure, transparencies, tearsheets, photographs, photocopies or slides. Illustrators and sculptors send query letter with brochure, photocopies, photographs, SASE, slides, tearsheets and transparencies. Samples are filed and are not returned. Art Director will contact artist only if interested. Originals are returned at job's completion. Pays by project. Pays royalties. Rights purchased vary according to project.

BRAZEN IMAGES, INC., 269 Chatterton Pkwy., White Plains NY 10606-2013. (914)949-2605. Fax: (914)683-7927. President/Art Director: Kurt Abraham. Estab. 1981. Produces greeting cards and postcards. "Primarily we produce cards that lean towards the erotic arts; whether that be of a humorous/novelty nature or a serious/fine arts nature. We buy stock only—no assignments."
Needs: Approached by 10-20 freelancers/year. Works with 10 freelancers/year. Buys 10-30 freelance designs and illustrations/year. Uses freelancers mainly for postcards. Considers any media "I don't want to limit the options." Prefers 5×7 (prints); may send slides. Produces material for Christmas, Valentine's Day, Hanukkah, Halloween, birthdays, everyday and weddings.
First Contact & Terms: Send query letter with photographs, slides, SASE and transparencies. Samples are filed or returned by SASE if requested by artist. Reports back ASAP depending on workload. Company will contact artist for portfolio review if interested. Portfolio should include final art, photographs, slides

and transparencies. Buys one-time rights. Originals are returned at job's completion. Pays royalties of 2%. Finds artists through artists' submissions.

BRILLIANT ENTERPRISES, 117 W. Valerio St., Santa Barbara CA 93101. Art Director: Ashleigh Brilliant. Publishes postcards.
Needs: Buys up to 300 designs/year. Freelancers may submit designs for word-and-picture postcards, illustrated with line drawings.
First Contact & Terms: Submit 5½ × 3½ horizontal b&w line drawings and SASE. Reports in 2 weeks. Buys all rights. "Since our approach is very offbeat, it is essential that freelancers first study our line. Ashleigh Brilliant's books include *I May Not Be Totally Perfect, But Parts of Me Are Excellent*; *Appreciate Me Now and Avoid the Rush*; and *I Want to Reach Your Mind. Where Is It Currently Located?* We supply a catalog and sample set of cards for $2 plus SASE." Pays $50 minimum, depending on "the going rate" for camera-ready word-and-picture design.
Tips: "Since our product is highly unusual, familiarize yourself with it by sending for our catalog. Otherwise, you will just be wasting our time and yours."

BRISTOL GIFT CO., INC., P.O. Box 425, 6 North St., Washingtonville NY 10992. (914)496-2821. Fax: (914)496-2859. President: Matt Ropiecki. Estab. 1988. Produces posters and framed pictures for inspiration and religious markets.
Needs: Approached by 5-10 freelancers/year. Works with 2 freelancers/year. Buys 15-30 freelance designs and illustrations/year. Works on assignment only. Uses freelancers mainly for design. Also for calligraphy, P-O-P displays and mechanicals. Prefers 16 × 20 or smaller. 10% of design and 60% of illustration require knowledge of Aldus PageMaker or Adobe Illustrator. Produces material for Christmas, Mother's Day, Father's Day and graduation. Submit seasonal material 6 months in advance.
First Contact & Terms: Send query letter with brochure and photocopies. Samples are filed and are returned. Reports back within 2 weeks. Company will contact artist for portfolio review if interested. Portfolio should include roughs. Requests work on spec before assigning a job. Originals are not returned. Pays by project or royalties of 10%. Rights purchased vary according to project. Interested in buying second rights (reprint rights) to previously published artwork.

‡BRODERBUND SOFTWARE, INC., 500 Redwood Blvd., P.O. Box 6121, Novato CA 94948-6121. Attn: P2 Art, (415)382-4400. E-mail: broder.com. Estab. 1980. Produces educational/entertainment software.
 • Also see Broderbund's listing in Book Publishers.
Needs: Approached by 100 freelancers/year. Works with 25 freelancers/year. Buys 200-700 freelance designs and illustrations/year. Prefers artists with experience in computer art and multimedia design. Works on assignment only. Uses freelancers mainly for computer illustration and design. Also for interface. Considers tearsheets or disks. "We like a variety of styles but we ask that artists look at our products before submitting artwork." 100% of freelance work demands knowledge of Adobe Illustrator 5.5 or 6.0, Aldus FreeHand, Adobe Photoshop. Produces material for all holidays and seasons. Submit seasonal material 6 months in advance.
First Contact & Terms: Send postcard sample or query letter with résumé or tearsheets. Accepts submissions on disk. Samples are filed and are not returned. Will contact for portfolio review if interested. Portfolio should include final art. Rights purchased vary according to project. Payment varies based on assignment. Finds artists through word of mouth, unsolicited samples, design books.
Tips: "Display a familiarity with our purpose and our products."

BRUSH DANCE INC., 100 Ebbtide Ave., Bldg. #1, Sausalito CA 94965. (415)331-9030. Fax: (415)331-9059. Vice President of Marketing: Diana Hill. Estab. 1989. Produces greeting cards, posters, calendars, bookmarks, blank journal books, T-shirts and magnets. "Brush Dance creates products that make 'spiritual' ideas accessible. We do this by combining humor, heartfelt sayings and sacred writings with exceptional art."
Needs: Approached by 60 freelancers/year. Works with 20 freelancers/year. Buys 50 freelance designs and illustrations/year. Art guidelines for 9 × 11 SASE with $1.50 postage. Uses freelancers mainly for illustration and calligraphy. Looking for non-traditional, spiritual work conveying emotion or message. Prefers 5 × 7 or 7 × 5 originals or designs that can easily be reduced or enlarged to these proportions. Produces material for all occasions. Submit seasonal material by November 15 (for following year's Christmas, Hanukkah) or by June 1 (for following year's Valentine's).
First Contact & Terms: Call or write for artist guidelines before submitting. Send query letter. Samples are filed or returned by SASE. Reports back to the artist only if interested. Buys all rights. Originals are returned at job's completion. Pays royalty of 5-7.5% depending on product. Finds artists through word of mouth.

BURGOYNE, INC., 2030 E. Byberry Rd., Philadelphia PA 19116. (215)677-8962. Fax: (215)677-6081. Contact: Art Director. Estab. 1907. Produces greeting cards. Publishes Christmas greeting cards geared towards all age groups. Style ranges from traditional to contemporary to old masters' religious.

Artist ETA's vibrant, stylized floral arrangement "conveys beauty, joy and 'aliveness' " says Diana Hill of Brush Dance. The artist receives 7.5% royalty for the card. ETA created the lettering and illustration, and collaborated on the wording. She learned of the company from another artist working for Brush Dance.

Needs: Approached by 150 freelancers/year. Works with 25 freelancers/year. Buys 50 designs and illustrations/year. Prefers freelancers with experience in all styles and techniques of greeting card design. Art guidelines available free for SASE with first-class postage. Uses freelancers mainly for Christmas illustrations. Also for lettering/typestyle work. Considers watercolor and pen & ink. Produces material for Christmas. Accepts work all year round.

First Contact & Terms: Send query letter with slides, tearsheets, transparencies, photographs, photocopies and SASE. Samples are filed. Creative Director will contact artist for portfolio review if interested. Pays flat fee. Buys first rights or all rights. Sometimes requests work on spec before assigning a job. Interested in buying second rights (reprint rights) to previously published work, first rights or all rights.
Tips: "Send us fewer samples. Sometimes packages are too lengthy."

‡CAN CREATIONS, INC., Box 8576, Pembroke Pines FL 33084. (305)581-3312. President: Judy Rappoport. Estab. 1984. Manufacturer of decorated plastic pails directed to juvenile market. Clients: balloon and floral designers, party planners and suppliers, department stores, popcorn and candy retailers.
Needs: Approached by 8-10 freelance artists/year. Works with 2-3 freelance designers/year. Assigns 5 freelance jobs/year. Prefers local artists only. Works on assignment only. Uses freelance artists mainly for "design work for plastic containers." Also uses artists for advertising design, illustration and layout; brochure design; posters; signage; magazine illustration and layout.
First Contact & Terms: Send query letter with tearsheets and photostats. Samples are not filed and are returned by SASE only if requested by artist. Reports back within 2 weeks. Call or write to schedule an appointment to show a portfolio, which should include roughs and b&w tearsheets and photostats. Pays for design by the project, $75 minimum. Pays for illustration by the project, $150 minimum. Considers client's budget and how work will be used when establishing payment. Negotiates rights purchased.
Tips: "We are looking for cute and very simple designs, not a lot of detail."

CAPE SHORE, INC., 42 N. Elm St., Yarmouth ME 04096. (207)846-3726. Art Director: Joan Jordan. Estab. 1947. "Cape Shore is concerned with seeking, manufacturing and distributing a quality line of gifts and stationery for the souvenir and gift market."
Needs: Approached by 50-75 freelancers/year. Works with 30-40 freelancers/year. Buys 75-80 freelance designs and illustrations/year. Prefers artists with experience in illustration. Uses freelance artists mainly for illustrations for boxed notes and Christmas card designs. Considers watercolor, gouache, acrylics, tempera, pastel, markers, colored pencil. Looking for traditional subjects rendered in a realistic style with strong attention to detail. Prefers final artwork on flexible stock for reproduction purposes.
First Contact & Terms: Send query letter with photocopies and slides. Samples are filed or are returned by SASE. Art Director will contact artist for portfolio review if interested. Portfolio should include slides, finished samples, printed samples. Pays by the project, $150 minimum. Buys reprint rights or varying rights according to project.
Tips: "Cape Shore is looking for realistic detail, good technique, bright clear colors and fairly tight designs of traditional themes."

CARDMAKERS, Box 236, High Bridge Rd., Lyme NH 03768. Phone: (603)795-4422. Fax: (603)795-4222. Principle: Peter Diebold. Estab. 1978. Produces greeting cards. "We produce special cards for special interests and greeting cards for businesses—primarily Christmas. We have now expanded our Christmas line to include 'photo mount' designs, added designs to our everyday line for stockbrokers and are ready to launch a line for boaters."
Needs: Approached by more than 100 freelancers/year. Works with 5-10 freelancers/year. Buys 10-20 designs and illustrations/year. Prefers professional caliber artists. Works on assignment only. Uses freelancers mainly for greeting card design, calligraphy and mechanicals. Also for paste-up. Considers all media. "We market 5×7 cards designed to appeal to individual's specific interest—golf, tennis, etc." Prefers an upscale look. Submit seasonal ideas 6-9 months in advance.
First Contact & Terms: Designers send query letter with SASE and brief sample of work. Illustrators send postcard sample or query letter with brief sample of work. "One good sample of work is enough for us. A return postcard with boxes to check off is wonderful. Phone calls are out; fax is a bad idea." Samples are filed or are returned by SASE. Reports back to artist only if interested. Portfolio review not required. Pays by project. Rights purchased vary according to project. Interested in buying second rights (reprint rights) to previously published work, if not previously used for greeting cards. Finds artists through word of mouth, exhibitions and *Artist's & Graphic Designer's Market*.
Tips: "It's important that you show us samples *before* requesting submission requirements. There's a 'bunker' mentality in business today and suppliers (including freelancers) need to understand the value they add to the finished product in order to be successful. Consumers are getting more for less every day and demanding more all the time. We need to be more precise every day in order to compete."

CARDS FOR A CAUSE, 175 Spencer Place, Ridgewood NJ 07450. Creative Director: Carolyn Ferrari. Estab. 1994. Produces greeting cards. "Cards For A Cause produces greeting cards (everyday note cards and holiday cards) to benefit charitable and nonprofit organizations (including Amnesty International USA, National Committee to Prevent Child Abuse, Environmental Defense Fund, American Foundation for AIDS Research and others). A percentage of all sales revenues goes to the beneficiary organizations."
Needs: Approached by 100 freelancers/year. "This will be our first year buying art." Expects to purchase 10-20 freelance designs and illustrations/year. Works on assignment only. Uses freelancers mainly for greeting card art/design. Considers all media (except photography). "We're looking for artwork that depicts the ideals

of the beneficiary organizations we represent (i.e., environmental/wildlife art for the Environmental Defense Fund) in any style appropriate for greeting cards." Prefers art proportionate to 5×7-inch card format. Produces material for Christmas, Hanukkah and everyday. Submit seasonal material 1 year in advance.

First Contact & Terms: Send query letter with brochure, SASE, photocopies and color copies. Samples are filed or returned by SASE. Reports back within 2 months. Portfolio should include final art, tearsheets and transparencies. Negotiates rights purchased. Originals are returned at job's completion. Pays by the project, $200-300. "We only look at submissions from February through March; only work suited to the cause or style."

Tips: "We use all sources available to locate talent. We encourage artists' submissions because we like to work with artists interested in causes. We are most impressed when artists have done their homework prior to sending us a submission. Because our needs are very specifically tied to causes, we appreciate seeing appropriately specific submissions. We've had a tremendous response to our card line. People are becoming much more cause-conscious in their purchasing decisions."

‡J.F. CAROLL PUBLISHING, 215 Park Ave. S., New York NY 10003. (212)387-7938. Art Director: Glen Hunter. Estab. 1982. Produces greeting cards, games, stationery, paper tableware products, calendars, giftwrap and posters. Manufactures gift items and New York City area products.

Needs: Approached by 40 freelance artists/year. Works with 4 freelance artists/year. Buys 100 designs and illustrations/year. "We are looking for good work that is consumer oriented." Uses freelancers for P-O-P displays, paste-up, mechanicals and color and b&w cartoons. Style must be accessible to those viewing. Produces material for all holidays and seasons.

First Contact & Terms: Send query letter with brochure, résumé, SASE and any type of art sample. Samples are filed or are returned. Reports back within 2 weeks. To show portfolio, mail appropriate materials: thumbnails, roughs, printed samples, b&w or color dummies and photographs. Pays by the project. Rights purchased vary according to project.

Tips: "Call if you have project ideas you'd like to have published for New York area products, calendars or maps."

‡*CARTEL INTERNATIONAL, Box 918, Edinburgh Way, Harlow Essex CM20 2DU England. Phone: 0279 641125. Fax: 0279 635672. Group Publishing Director: Linda Worsfold. Publishes greeting cards, postcards, posters, pop and personality products, stationery, calendars and T-shirts.

Needs: Produces material for everyday, special occasions, Christmas, Valentine's Day, Mother's Day, Father's Day and Easter, plus quality artwork for posters.

First Contact & Terms: Send query letter with brochure, photographs, transparencies, photocopies and slides. Accepts disk submissions compatible with Adobe Illustrator, Apple Macs. Send SyQuest disks. Samples not filed are returned. Reports back within 30 days. To show portfolio, mail roughs, photostats and photographs. Originals returned after job's completion. Pay royalties or pays by the project. Negotiates rights purchased.

CASE STATIONERY CO., INC., 179 Saw Mill River Rd., Yonkers NY 10701. (914)965-5100. President: Jerome Sudnow. Vice President: Joyce Blackwood. Estab. 1954. Produces stationery, notes, memo pads and tins for mass merchandisers in stationery and housewares departments.

Needs: Approached by 10 freelancers/year. Buys 50 designs from freelancers/year. Works on assignment only. Buys design and/or illustration mainly for stationery products. Uses freelancers for mechanicals and ideas. Produces materials for Christmas; submit 6 months in advance. Likes to see youthful and traditional styles, as well as English and French country themes. 10% of freelance work requires computer skills.

First Contact & Terms: Send query letter with résumé and tearsheets, photostats, photocopies, slides and photographs. Samples not filed are returned. Reports back. Call or write for appointment to show a portfolio. Original artwork is not returned. Pays by project. Buys first rights or one-time rights.

Tips: "Find out what we do. Get to know us. We are creative and know how to sell a product."

‡H. GEORGE CASPARI, INC., 225 Fifth Ave., New York NY 10010. (212)995-5710. Contact: Lucille Andriola. Publishes greeting cards, Christmas cards, invitations, giftwrap and paper napkins. "The line maintains a very traditional theme."

Needs: Buys 80-100 illustrations/year. Prefers watercolor and other color media. Produces seasonal material for Christmas, Mother's Day, Father's Day, Easter and Valentine's Day.

First Contact & Terms: Send samples to Lucille Andriola to review. Prefers unpublished original illustrations, slides or transparencies. Art Director will contact artist for portfolio review if interested. **Pays on acceptance**; negotiable. Pays flat fee of $400 for design. Finds artists through word of mouth, magazines, submissions/self-promotions, sourcebooks, agents, visiting artist's exhibitions, art fairs and artists' reps.

Tips: "Caspari and many other small companies rely on freelance artists to give the line a fresh, overall style rather than relying on one artist. We feel this is a strong point of our company. Please do not send verses."

CATCH PUBLISHING, INC., 456 Penn Street, Yeadon PA 19050. (610)626-7770. Fax: (610)626-2778. Contact: Michael Markowicz. Produces greeting cards, stationery, giftwrap, blank books and posters.
Needs: Approached by 200 freelancers/year. Works with 5-10 freelancers/year. Buys 25-50 freelance designs and illustrations/year. Art guidelines for SASE with first-class postage. Works on assignment only. Uses freelancers mainly for design. Considers all media. Produces material for Christmas, New Year and everyday. Submit seasonal material 1 year in advance.
First Contact & Terms: Send query letter with brochure, tearsheets, résumé, slides, SASE and transparencies. Samples are not filed and are returned by SASE if requested by artist. Reports back within 2-6 months. Company will contact artist for portfolio review if interested. Portfolio should include final art, slides and 4×5 and 8×10 transparencies. Rights purchased vary according to project. Originals are returned at job's completion. Pays royalties of 10-12% (may vary according to job). Finds artists through submissions, word of mouth and referrals.

CEDCO PUBLISHING CO., 2955 Kerner Blvd., San Raphael CA 94901. E-mail: sales@cedco.com. Website: http://www.cedco.com. Contact: Art Department. Estab. 1982. Produces 180 upscale calendars and books.
Needs: Approached by 500 freelancers/year. Works with 5 freelancers/year. Buys 48 freelance designs and illustrations/year. Art guidelines for SASE with first-class postage. "We never give assignment work." Uses freelancers mainly for stock material and ideas. "We use either 35mm slides or 4×5s of the work."
First Contact & Terms: "No phone calls accepted." Send query letter with photographs and tearsheets. Samples are filed. "Send non-returnable samples only." Reports back to the artist only if interested. To show portfolio, mail thumbnails and b&w photostats, tearsheets and photographs. Original artwork is returned at the job's completion. Pays by the project. Buys one-time rights. Interested in buying second rights (reprint rights) to previously published work. Finds artists through art fairs and licensing agents.
Tips: "Full calendar ideas encouraged!"

CENTRIC CORP., 6712 Melrose Ave., Los Angeles CA 90038. (213)936-2100. Fax: (213)936-2101. Vice President: Neddy Okdot. Estab. 1986. Produces fashion watches, clocks, mugs, frames, pens for ages 13-60.
Needs: Approached by 40 freelancers/year. Works with 6-7 freelancers/year. Buys 40-50 designs and illustrations/year. Prefers local freelancers only. Works on assignment only. Uses freelancers mainly for watch and clock dials, frames, mugs and packaging. Also for mechanicals. Considers graphics, computer graphics, cartoons, pen & ink, photography. 95% of freelance work demands knowledge of QuarkXPress, Adobe Illustrator, Adobe Photoshop and Adobe Paintbox.
First Contact & Terms: Send postcard sample or query letter with appropriate samples. Accepts submissions on disk. Samples are filed if interested. Reports back to the artist only if interested. Originals are returned at job's completion. Requests work on spec before assigning a job. Pays by project. Pays royalties of 1-10% for design. Rights purchased vary according to project. Finds artists through submissions/self-promotions, sourcebooks, agents and artists' reps.
Tips: "Show us your range."

‡CENTURY REGENCY GREETINGS (formerly Regency & Century Greetings), 1500 W. Monroe St., Chicago IL 60607. (312)666-8686. Fax: (312)243-0590. Art Director: Frank Stockmal. Estab. 1921. Publishes Christmas cards, traditional and some religious.
Needs: Approached by 300 freelance artists/year. Buys 150 freelance illustrations and designs/year. Prefers airbrush, watercolor, acrylic, oil and calligraphy. Prefers traditional themes. Submit seasonal art 8 months in advance.
First Contact & Terms: Send query letter with relevant, current samples. Art Director will contact artist for portfolio review if interested. Originals can be returned to artist at job's completion. Requests work on spec before assigning a job. Pays average flat fee of $300. **Pays on acceptance.** Buys exclusive Christmas card reproduction rights. Interested in buying second rights (reprint rights) to previously published artwork. Finds artists through magazines and art fairs.
Tips: "Request artist's guidelines to become familiar with the products and visit stationery shops for ideas. Portfolio should include published samples. Traditional still sells best in more expensive lines, but will review contemporary designs for new lines." Sees an "increased need for Christmas/holiday cards appropriate for businesses to send their customers."

HOW TO USE your *Artist's & Graphic Designer's Market* offers suggestions for understanding and using the information in these listings. Read this and other articles in the front of this book for important business tips.

‡**CITY MERCHANDISE INC.**, 68 34th St., P.O. Box 320081, Brooklyn NY 11232. (718)832-2931. Fax: (718)832-2939. E-mail: citymuse@aol.com. Production Manager: Jay Marshall. Produces calendars, collectible figurines, gifts, mugs, souvenirs of New York.

Needs: Works with 6-10 freelancers/year. Buys 50-100 freelance designs and illustrations/year. "We buy sculptures for our casting business." Prefers freelancers with experience in graphic design. Works on assignment only. Uses freelancers for most projects. Considers all media. 50% of design and 80% of illustration demand knowledge of Adobe Photoshop, QuarkXPress, Adobe Illustrator. Does not produce holiday material.

First Contact & Terms: Designers send query letter with brochure, photocopies, résumé. Illustrators and/ or cartoonists send postcard sample of work only. Sculptors send résumé and copies of their work. Samples are filed. Reports back within 2 weeks. Portfolios required for sculptors only if interested in artist's work. Buys all rights. Pays by project.

CLARKE AMERICAN, P.O. Box 460, San Antonio TX 78292-0460. (210)662-1449. Fax: (210)662-7503. Product Development: Lecy Benke. Estab. 1874. Produces checks and other products and services sold through financial institutions. "We're a national printer seeking original works for check series, consisting of five, three, or one scene. Looking for a variety of themes, media, and subjects for a wide market appeal."

Needs: Uses freelancers mainly for illustration and design of personal checks. Considers all media and a range of styles. Prefers art twice standard check size.

First Contact & Terms: Send postcard sample or query letter with brochure and résumé. "Indicate whether the work is available; do not send original art." Samples are filed and are not returned. Reports back to the artist only if interested. Rights purchased vary according to project. Payment for illustration varies by the project.

Tips: "Keep red and black in the illustration to a minimum for image processing."

CLAY ART, 239 Utah Ave. S., San Francisco CA 94080. (415)244-4970. Fax: (415)244-4979. Art Director: Thomas Biela. Estab. 1979. Produces giftware and home accessory products: cookie jars, teapots, salt & peppers, mugs, magnets, pitchers, masks, platters and canisters.

Needs: Approached by 70 freelancers/year. Works with 10 freelancers/year. Buys 30 designs and illustrations/year. Prefers freelancers with experience in 3-D design of giftware and home accessory itmes. Works on assignment only. Uses freelancers mainly for illustrations, 3-D design and sales promotion. Also for P-O-P displays, paste-up, mechanicals and product design. Seeks humorous, whimsical, innovative work. 60% of freelance work demands knowledge of Aldus PageMaker, Aldus FreeHand, Adobe Illustrator, Adobe Photoshop.

First Contact & Terms: Send query letter with brochure, résumé, SASE, tearsheets and photocopies. Samples are filed. Reports back to the artist only if interested. Call for appointment to show portfolio of thumbnails, roughs and final art and color photostats, tearsheets, slides and dummies. Negotiates rights purchased. Originals are returned at job's completion. Pays by project.

CLEAR CARDS, 11054 Ventura Blvd., #207, Studio City CA 91604. (818)980-4120. Fax: (818)980-0771. Director of Marketing: André Cheeks. Estab. 1989. Produces greeting cards, CD packaging, collectibles, promotional and advertising products. "Clear Cards produces and markets greeting cards using PVC and high-end graphics. The buying group is women 25-55. The unique concept lends itself to promotional and advertising products."

Needs: Approached by 5-10 freelancers/year. Works with 3-4 freelancers/year. Buys 30-50 freelance designs and illustrations/year. Looking for a humorous style (sketch, ideas and image); cartoonists welcome. Prefers 9×12 images with 1″ margins left/right. 70% of work demands knowledge of Adobe Illustrator, Adobe Photoshop and QuarkXPress. Produces material for Christmas, Valentine's Day, Mother's Day, New Year, birthdays and everyday. Submit seasonal material 4 months in advance.

First Contact & Terms: Send postcard sample of work. Samples are filed. Reports back with 15 working days. Company will contact artist for portfolio review if interested. Portfolio should include final art and photographs. Negotiates rights purchased. Originals are not returned. Pays by the project, $100-500. Finds artists through submissions, via referrals and local art schools.

CLEO, INC., 4025 Viscount Ave., Memphis TN 38118. (901)369-6661. Fax: (901)369-6376. Director of Creative Arts: Harriet Byall. Estab. 1953. Produces greeting cards, calendars, giftwrap, gift bags, valentines (kiddie packs). "Cleo is the world's largest Christmas giftwrap manufacturer. Also provides extensive all occasion product line. Cards are boxed only (no counter cards) and only Christmas. Other product categories include some seasonal product. Mass market for all age groups."

Needs: Approached by 25 freelancers/year. Works with 40-50 freelancers/year. Buys more than 200 freelance designs and illustrations/year. Uses freelancers mainly for giftwrap and greeting cards (designs). Also for calligraphy. Considers most any media. Looking for fresh, imaginative as well as classic quality designs for Christmas. Prefers 5×7 for cards; 30″ repeat for giftwrap. Art guidelines available. Submit seasonal material at least a year in advance.

First Contact & Terms: Send query letter with slides, SASE, photocopies, transparencies and speculative art. Accepts submissions on disk. Samples are filed if interested or returned by SASE if requested by artist.

Reports back to the artist only if interested. Rights purchased vary according to project; usually buys all rights. Pays flat fee. Finds artists through agents, sourcebooks, magazines, word of mouth and submissions.
Tips: "Understand the needs of the particular market to which you submit your work."

‡**CLOUD 9**, 3532 Greenwood Blvd., St. Louis MO 63143. (314)644-3500. Fax: (314)644-1589. President/Creative Director: Pamela Miller. Produces greeting cards.
Needs: Works with 12 freelance artists/year. Buys 150-200 designs and illustrations/year. Seeks artists with strong look that can be shown as a stand alone line. "We want creativity that strikes a chord and mirrors the sentiments and emotions of present day society." Looking for humorous, whimsical and photographic work. Prefers final art 5×7. Produces material for all holidays and seasons.
First Contact & Terms: Send query letter with brochure, color photocopies and slides. Samples are filed or are returned by SASE within 2 months. Artist should follow-up after initial query. Pays flat fee of $200 for illustration/design; or royalty of 5%. Considers buying second rights (reprint rights) to previously published work. Finds artists through word of mouth, magazines, submissions, visiting artist's exhibitions and art fairs.

‡**COLORS BY DESIGN**, 7723 Densmore Ave., VanNuys CA 91406. (818)376-1226. Fax: (818)376-1669. Creative Director: Jane Daly. Produces greeting cards, giftwrap, stationery, imprintables, invitations, desk top accessories, notecards. "Our current products are bright, bold, whimsical, watercolors using calligraphy and quotes and collage cards using gold ink. We are open to new lines, new looks."
Needs: Works with 20-25 freelance artists/year. Buys 100-200 freelance designs and illustrations/year. Uses freelance artists for all products. Considers all media. "Looking for humor cards, photo cards, cards that fit into our current line." Cards are 5×7. Produces material for all holidays and seasons. "Anytime we welcome everyday submissions; in June, submit Mother's Day, Father's Day, Easter, graduation and Valentine's Day; in January, submit Christmas, New Year's, Hanukkah, Passover, Thanksgiving, Halloween, Rosh Hashanah."
First Contact & Terms: "Please write for our submission guidelines and catalogue." Samples are returned by SASE. Reports back within 6 weeks. Art Director will contact artist for portfolio review if interested. Portfolio should include color roughs, final art and photographs. Originals are not returned. Pays royalties of 3-5% and $350 advance against royalties/piece. Buys all rights or negotiates rights purchased, reprint rights.
Tips: "Phone calls are discouraged."

COMSTOCK CARDS, INC., 600 S. Rock Blvd., Suite 15, Reno NV 89502. (702)856-9400. Fax: (702)856-9406. Production Manager: David Delacroix. Estab. 1987. Produces greeting cards, notepads and invitations. Styles include alternative and adult humor, outrageous, shocking and contemporary themes; specializes in fat, age and funny situations. No animals or landscapes. Target market predominately professional females, ages 25-55.
Needs: Approached by 250-350 freelancers/year. Works with 10-12 freelancers/year. "Especially seeking artists able to produce outrageous adult-oriented cartoons." Uses freelancers mainly for cartoon greeting cards. Art guidelines for SASE with first-class postage. No verse or prose. Gaglines must be brief. Prefers 5×7 final art. Produces material for all occasions. Submit holiday concepts 11 months in advance. 50% of illustration requires computer skills.
First Contact & Terms: Send query letter with SASE, tearsheets or photocopies. Samples are not usually filed and are returned by SASE if requested. Reports back only if interested. Portfolio review not required. Originals are not returned. Pays royalties of 5%. Pays by project, $50 minimum; may negotiate other arrangements. Buys all rights.
Tips: "Make submissions outrageous and fun—no prose or poems."

CONCORD LITHO COMPANY, INC., 92 Old Turnpike Rd., Concord NH 03301. (603)225-3328. Fax: (603)225-6120. Vice President/Creative Services: Lester Zaiontz. Estab. 1958. Produces greeting cards, stationery, posters, giftwrap, specialty paper products for direct marketing. "We provide a range of print goods for commercial markets but also supply high quality paper products used for fundraising purposes."
Needs: Approached by 50 freelancers/year. Works with 10 freelancers/year. Buys 300 freelance designs and illustrations/year. Works on assignment only. Uses freelancers mainly for greeting cards, wrap and calendars. Also for calligraphy, P-O-P displays and computer-generated art. Considers all media but prefers watercolor. Art guidelines available. "Our needs range from generic seasonal and holiday greeting cards to religious subjects, florals, nature, scenics, inspirational vignettes. We prefer more traditional designs with occasional contemporary needs." Prefers 10×14. 100% of design and 15% of illustration demand knowledge of Adobe Illustrator, Adobe Photoshop, QuarkXPress, Aldus FreeHand and Aldus PageMaker. Produces material for all holidays and seasons: Christmas, Valentine's Day, Mother's Day, Father's Day, Easter, Hanukkah, Passover, Rosh Hashanah, Thanksgiving, New Year, birthdays, everyday and other religious dates. Submit seasonal material 6 months in advance.
First Contact & Terms: Send introductory letter with résumé, brochure, photographs, slides, photocopies or transparencies. Accepts submissions on disk. Samples are filed. Reports back within 3 months. Portfolio review not required. Rights purchased vary according to project. Originals are returned at job's completion.

Pays by the project, $200-800. "We will exceed this amount depending on project."

Tips: "Keep sending samples or color photocopies of work to update our reference library. Be patient and follow guidelines as noted herein and send quality samples or copies. More and more work is coming in in a digital format."

CONTENOVA GIFTS, INC., 735 Park N. Blvd., Suite 114, Clarkston GA 30021. (404)292-4676. Fax: (404)292-4684. Contact: Creative Director. Estab. 1965. Produces impulse gift merchandise and ceramic greeting mugs.

Needs: Buys 100 freelance designs/year for mugs and other items. Prefers freelancers with experience in full color work and fax capabilities. Works on assignment only. Looking for humorous cartoon work, cute animals and caricatures. Produces material for Father's Day, Christmas, Easter, birthdays, Valentine's Day, Mother's Day and everyday.

First Contact & Terms: Send query letter with brochure, tearsheets, SASE and photocopies. Samples are not filed and are returned by SASE. Art Director will contact artist for portfolio review if interested. Portfolio should include roughs, photostats, slides, color tearsheets and dummies. Sometimes requests work on spec before assigning a job. Pays by the project, $400-500. Buys all rights. Finds artists through submissions/self-promotions and word of mouth.

Tips: "We see steady growth for the future."

COTTAGE ART, P.O. Box 425, Cazenovia NY 13035. Owner: Jeanette Robertson. Estab. 1994. Produces greeting cards and notecards. "All of our designs are one color, silk screened, silhouette designs. Most cards are blank notes. They appeal to all ages and males! They are simple yet bold."

Needs: Uses freelancers mainly for design. Considers flat b&w; ink, marker, paint. Looking for silhouette designs only. Any subjects considered. Art guidelines for SASE with first-class postage. "Remember they are only one color, solid, no tones." Prefers no larger than 8½ × 11. Produces material for Christmas. Submit seasonal material 6 months in advance.

First Contact & Terms: Send query letter with SASE and photocopies. Samples are returned by SASE. "If no SASE, they are not returned." Reports back within 2 weeks with SASE. Portfolio review not required. Pays $1-50 and free cards. Finds artists through submissions.

Tips: "Being a new company we are interested in artists who are willing to work with us and grow with us. Our company seeks out industry 'holes.' Things that are missing, such as designs that appeal to men. We like wildlife, sports, country, coastal, flowers and bird designs."

COURAGE CENTER, 3915 Golden Valley Rd., Golden Valley MN 55422. (612)520-0211. Fax: (612)520-0299. Art & Production Manager: Marylea Osier. Greeting cards from original art first produced in 1970. "Courage Center produces holiday notecards and Christmas cards. Cards are reproduced from fine art aquired through nationwide Art Search. Courage Center is a nonprofit rehabilitation and independent living center helping children and adults with physical, communication and sensory disabilities."

Needs: Approached by 300-500 freelancers/year. Works with 5-10 freelancers/year. Buys 0-10 freelance designs and illustrations/year. Prefers artists with experience in holiday/Christmas designs. Considers all media (no 3-D). Produces material for Christmas, birthdays, Thanksgiving, everyday. "We prefer that art arrives as a result of our Art Search announcement. Information is sent in September with mid-January deadline the following year."

First Contact & Terms: Send query letter with SASE. Samples are not filed and are returned by SASE if requested by artist. Acknowledgment of receipt of artwork is sent immediately. Decisions as to use are made 6-8 weeks after deadline date. Portfolio review not required. Originals are returned at job's completion. Pays $350 honorarium.

CREATE-A-CRAFT, Box 330008, Fort Worth TX 76163-0008. Contact: Editor. Estab. 1967. Produces greeting cards, giftwrap, games, calendars, posters, stationery and paper tableware products for all ages.

Needs: Approached by 500 freelancers/year. Works with 3 freelancers/year. Buys 3-5 freelance designs and illustrations/year. Prefers freelancers with experience in cartooning. Works on assignment only. Uses freelancers mainly for greetings cards and T-shirts. Also for calligraphy, P-O-P display, paste-up and mechanicals. Considers pen & ink, watercolor, acrylic and colored pencil. Prefers humor and "cartoons that will appeal to families. Must be cute, appealing, etc. No religious, sexual implications or offbeat humor." Produces material for all holidays and seasons; submit seasonal material 6 months in advance.

First Contact & Terms: Contact only through artist's agent. "No phone calls from freelancers accepted." Samples are filed and are not returned. Reports back only if interested. Write for appointment to show portfolio of original/final art, final reproduction/product and color and b&w slides and tearsheets. Originals are not returned. Pays by the hour, $6-8; or by the project, $100-200. Pays royalties of 3% for exceptional work on one year basis. "Payment depends upon the assignment, amount of work involved, production costs, etc." Buys all rights.

Tips: "Demonstrate an ability to follow directions exactly. Too many submit artwork that has no relationship to what we produce. Sample greeting cards are available for $2.50 and a #10 SASE. Write, do not call. We cannot tell what your artwork looks like from a phone call."

© Cottage Art

"I was inspired by Maine fisherman pulling lobster into their boats within 100 feet of our cottage by the sea," says artist Jacqueline Tuttle, creator of this silhouette greeting card produced by Cottage Art. The company was attracted to Tuttle's "simple, straight-forward design, expressing a coastal way of life," says Art Director Jeanette Robertson. She discovered Tuttle's work a dozen years ago while vacationing in Maine.

CREATIF LICENSING, 31 Old Town Crossing, Mount Kisco NY 10549. E-mail: jhec@aol.com. President: Paul Cohen. Licensing Manager. "Creatif is a licensing agency that represents artists and concept people."
Needs: Looking for unique art styles and/or concepts that are applicable to multiple products. "The art can range from fine art to cartooning." 20% of freelance work requires computer skills.
First Contact & Terms: Send query letter with brochure, photocopies, photographs, SASE and tearsheets. "If we are interested in representing you, we will present your work to the appropriate manufacturers in the clothing, gift, publishing, home furnishings, paper products (cards/giftwrap/party goods, etc.) areas with the intent of procuring a license. We try to obtain advances and/or guarantees against a royalty percentage of the firm's sales. We will negotiate and handle the contracts for these arrangements, show at several trade shows to promote your style and oversee payments to ensure that the requirements of our contracts are honored. Artists are responsible for providing us with materials for our meetings and presentations and for copyrights, trademarks and protecting their ownership (which is discretionary). For our services, as indicated above, we receive royalties of 50% of all the deals we negotiate as well as renewals. There are no fees if we are not productive."
Tips: Common mistakes illustrators make in presenting samples or portfolios are "sending oversized samples mounted on heavy board and not sending appropriate material. Color photocopies and photos are best."

‡**CREEGAN CO., INC.**, 510 Washington St., Steubenville OH 43952. (614)283-3708-09. Fax: (614)283-4117. President: Dr. G. Creegon. Estab. 1961. Produces animations, costume characters, mall displays and audio-animatronic characters. "The Creegan Company designs and manufactures animated characters, costume characters and life-size air-driven characters. The products are custom made from beginning to end."
Needs: Approached by 10-30 freelance artists/year. Works with 3 freelancers/year. Prefers local artists with experience in sculpting, latex, oil paint, molding, etc. Artists sometimes work on assignment basis. Uses freelancers mainly for design comps. Also for mechanicals. Produces material for all holidays and seasons, Christmas, Valentine's Day, Easter, Thanksgiving, Halloween and everyday. Submit seasonal material 1 month in advance.
First Contact & Terms: Send query letter with résumé. Samples are filed. Does not report back. Write for appointment to show portfolio of final art, photographs. Originals not returned. Rights purchased vary according to project.

THE CROCKETT COLLECTION, P.O. Box 1428, Manchester Center VT 05255-1428. (802)362-2914. Fax: (802)362-5590. President: Sharon Scheirer. Estab. 1929. Publishes mostly traditional, some contemporary, humorous and whimsical silk screen Christmas and everyday greeting cards, postcards, note cards and bordered stationery on recycled paper. Christmas themes are geared to sophisticated, up-scale audience.

Needs: Approached by 100 freelancers/year. Works with 20 freelancers/year. Buys 25-30 designs/year. Produces products by silk screen method exclusively. Considers gouache, cut and pasted paper. Prefers 5×7 or $4\frac{1}{2} \times 6\frac{1}{2}$. Art guidelines free for SASE with first-class postage. Works on assignment only. Produces material for Christmas, Hanukkah and everyday. Submit seasonal material 10 months in advance.

First Contact & Terms: Send query letter with SASE. Request guidelines which are mailed out once a year in February, one year in advance of printing. Submit unpublished, original designs only. Art should be in finished form. Art not purchased is returned by SASE. Reports back in 3 months. Buys all rights. Pays flat fee of $90-140 for illustration/design. Finds artists through *Artist's & Graphic Designer's Market.*

Tips: "Designs must be suitable for silk screen process. Airbrush, watercolor techniques and pen & ink are not amenable to this process. Bold, well-defined designs only. Our look is traditional, mostly realistic and graphic. Request guidelines and submit work according to our instructions."

THE CRYSTAL TISSUE COMPANY, P.O. Box 450, Middletown OH 45042. Art Director: Mary Jo Recker. Estab. 1894. Produces giftwrap, gift bags and printed giftwrapping tissues. "Crystal produces a broad range of giftwrapping items for the mass market. We especially emphasize our upscale gift bags with coordinating specialty tissues and giftwrap. Our product line encompasses all age groups in both Christmas and all occasion themes."

Needs: Approached by 20 freelancers/year. Works with 100 freelancers/year. Buys 200 freelance designs and illustrations/year. Prefers freelancers with experience in greeting cards or giftwrap markets. Works on assignment and "we also purchase reproduction rights to existing artwork." Uses freelancers mainly for gift bag and tissue repeat design. Also for calligraphy, mechanicals (computer only), b&w line illustration and local freelancers for design and production. 100% of design and 10% of illustration require knowledge of QuarkXPress, Adobe Illustrator, Aldus FreeHand, Aldus PageMaker and Adobe Photoshop. Produces seasonal material for Christmas, Valentine's Day, Easter, Hanukkah, Halloween, birthdays and everyday. "We need a variety of styles from contemporary to traditional—florals, geometric, tropical, whimsical, cartoon, upscale, etc."

First Contact & Terms: Send query letter with brochure, résumé, photocopies and SASE. Calligraphers send photocopies of work samples. Submit all samples February 1-March 30. Samples are filed or returned by SASE. Reports back in 1 month. Company will contact artist for portfolio review if interested. Portfolio should include roughs and final art. Originals returned depending on rights purchased. Pays by project, $600-1,200. 3% royalties on gift bag art. Negotiates rights purchased.

Tips: "If you're interested in working with us, send a packet of samples of what you do best during the months indicated. (Don't send a letter asking for guidelines.) We'll keep your work on file if it has potential for us, and return it if it doesn't. Please check out our market before you submit to see if your work is in the ballpark!"

‡CUSTOM STUDIOS INC., 6116 N. Broadway St., Chicago IL 60660-2502. (312)761-1150. President: Gary Wing. Estab. 1960. Custom T-shirt manufacturer. "We specialize in designing and screen printing custom T-shirts for schools, business promotions, fundraising and for our own line of stock."

Needs: Works with 20 freelance illustrators and 20 freelance designers/year. Assigns 50 freelance jobs/year. Especially needs b&w illustrations (some original and some from customer's sketch). Uses artists for direct mail and brochures/fliers, but mostly for custom and stock T-shirt designs.

First Contact & Terms: Send query letter with résumé, photostats, photocopies or tearsheets. "We will not return originals." Reports in 3-4 weeks. Call or write for appointment to show portfolio or mail b&w tearsheets or photostats to be kept on file. Pays for design and illustration by the hour, $28-35; by the project, $50-150. Considers turnaround time and rights purchased when establishing payment. For designs submitted to be used as stock T-shirt designs, pays 5-10% royalty. Rights purchased vary according to project.

Tips: "Send 5-10 good copies of your best work. We would like to see more black & white, camera-ready illustrations—copies, not originals. Do not get discouraged if your first designs sent are not accepted."

‡DALEE BOOK CO., 129 Clinton Place, Yonkers NY 10701. (800)852-2665. Vice President: Charles Hutter. Estab. 1964. Produces stationery accessories. "We manufacture photo albums and telephone address books for the family and the fine arts market."

Needs: Approached by 5 freelance artists/year. Works with 1 feelance artist/year. Buys 1-3 designs and illustrations/year from freelance artists. Prefers local artists only. Works on assignment only. Uses freelance artists mainly for labels and mechanicals. Considers any media.

First Contact & Terms: Send query letter with photocopies. Samples are not filed and are returned by SASE if requested by artist. Reports back to the artist only if interested. Write to schedule an appointment to show a portfolio or mail roughs and color samples. Original artwork is not returned at the job's completion. Pays by the project, $200-500 average. Buys all rights.

INSIDER REPORT

Go Shopping for a Great New Market

You may imagine your artwork displayed on a gallery wall, in a company's brochure or even across a billboard, but you probably will not visualize the product of your imagination on a gift bag complete with coordinating tissue and tag. However, Mary Jo Recker, art director for the Crystal Tissue Company, wants you to imagine just that.

Mary Jo Recker

The Crystal Tissue Company, based in Middletown, Ohio, specializes in gift wrapping tissues and gift bags. Because her company's products are sold to mass market retailers, Recker prefers designs that have broad appeal and that are somewhat traditional or conservative in subject and style. "I'm always watching for illustrations with a good color sense (usually clean pastels or brights), good composition, accurate drawings and a fresh style."

There's one sure way to find out what type of designs are needed for wrapping paper, says Recker. "Go shopping! That is how you'll learn to position your work." Since trends in giftwrap tend to follow trends in stationery, your first stop should be stores that sell greeting cards. As you study displays, keep an eye out for occasions when people give presents. This will be your key to the market. Wrapping paper and gift bags are needed for any gift-giving occasion.

A major trend these days is gift bags. As lifestyles get busier, people have less time to wrap gifts, but they still want to give attractive presents. Customers started buying gift bags for convenience, but since wider selections appeared on the market, buyers now choose gift bags for their festive appearance.

While researching in stores, note how designers carry the illustrations onto the sides and back of bags. "Don't let a design float in negative space," says Recker. Study gift bags in stores to see how others apply design to the total product.

Look at stationery stores and mass market retailers to uncover trends in colors and motifs. What are they selling? What colors are popular? Garden themes and birdhouses are very much in vogue. Florals are always needed. And Recker believes angels are here to stay, especially in the Christmas season.

Since Christmas is 65 percent or more of her business, Recker is always on the lookout for variations on traditional Christmas motifs. "Santas of varying costumes and nationalities are coming into gift wrap," says Recker. She also cautions freelancers to avoid duplicating or mimicking the same old Santas and angel images. "I would like to see more Christmas subjects handled in fresh

INSIDER REPORT, *continued*

ways." The everyday market comes in a close second to Christmas. Companies need wrapping paper for baby showers, weddings, birthdays for both children and adults, and holidays such as Valentine's Day, Easter and even Halloween.

Recker would like to see more wedding and masculine designs. There is a real need for designs featuring masculine images such as sports cars, geometrics, golf or fishing imagery. "We're looking for bold, graphic styles for all occasions," she says. While humorous illustration is important for greeting cards, it tends not to be of interest for bags and wrap.

When preparing samples for submission to giftwrap companies, Recker suggests sending ten or more designs that are strong in color, concept and composition, showing a solid, consistent design sense. Samples should be accurate color copies or computer-printed materials. Recker considers concepts in sketch form, although not all art directors like to see roughs.

When reviewing work, Recker considers how it will reproduce. Even if your illustration looks great, if it won't reproduce well, it will not be considered. Recker often sees submissions that tell her "no" right away. Certain colors never reproduce well in the four-color process, the process most companies use. "Oranges are the worst. Although they are bestsellers, certain shades of purple and teal can be difficult to achieve." Fluorescent colors, such as hot pink, may look great in the original, but they won't reproduce as the same color, she says. Only strong, clean, saturated color reproduces well. Recker suggests you become familiar with color separation and the printing process. "Purchase a Pantone Process Color Simulator and get to know it well." Although any medium has the potential to reproduce well, work rendered in colored pencils can appear "too soft and grainy" when printed. Anticipating color shifts and a problematic medium will help you avoid getting overlooked.

Crystal Tissue buys all kinds of art for its gift wrapping paper products. The illustrations for these delightful Halloween gift trick-or-treat bags were created by Julie Eubanks. Mary Jo Recker liked the freelancer's samples and called her to produce some roughs for bag designs.

INSIDER REPORT, *Recker*

"The most frustrating mistake is when artists submit work that is completely outside our market," says Recker. If you don't have experience in the gift industry, your sample should show potential for use in the market. "I would rather see unpublished, self-directed illustrations done speculatively and designed for our products than printed samples that are totally unfitting," she says.

Recker also warns against "non-pleasing color," weak drawing skills, amateur technique, a non-professional presentation, and designs that are not composed to fit a space. Free of those common mistakes, designs that are fresh, professional and marketable will catch her eye. "We appreciate the interest and talents of all freelancers and always enjoy reviewing their work," says Recker. "If an artist cannot imagine designing illustrations for the giftwrap industry, she is overlooking an ever-growing market and an invaluable opportunity."

—Kristen Rooks Cross

‡**DAYSPRING CARDS**, Box 1010, Siloam Springs AR 72761. (501)524-9301. Creative Director: Paul Higdon. Produces greeting cards, calendars, stationery and invitations; general, informal, inspirational, contemporary, soft line and studio.
Needs: Works with 60 freelance artists/year. Buys approx. 250 designs from freelance artists/year. Works on assignment only. Also uses artists for calligraphy. Prefers designers' gouache colors and watercolor. "Greeting card sizes range from 4½×6½ to 5½×8½; prefer same size, but not more than 200% size." Produces material for Valentine's Day, Easter, Mother's Day, Father's Day, Confirmation, graduation, Thanksgiving, Christmas; submit seasonal material 1 year in advance.
First Contact & Terms: Send query letter with brochure or photocopies, slides and SASE. Samples are not filed and are returned by SASE. Reports back within 6 weeks. To show a portfolio, mail color final reproduction/product, slides and photographs. Original artwork is not returned after job's completion. Pays average flat fee of $100-350/design. Buys all rights.

DECORCAL INC., 165 Marine St., Farmingdale NY 11735. (516)752-0076 or (800)645-9868. Fax: (516)752-1009. President: Walt Harris. Produces decorative, instant stained glass, as well as sports and wildlife decals.
Needs: Buys 50 designs and illustrations from freelancers/year. Uses freelancers mainly for greeting cards and decals; also for P-O-P displays. Prefers watercolor.
First Contact & Terms: Send query letter with brochure showing art style or résumé and photographs. Samples not filed are returned. Art Director will contact artist for portfolio review if interested. Portfolio should include final reproduction/product and photostats. Originals are not returned. Sometimes requests work on spec before assigning a job. Pays by project. Buys all rights. Finds artists through word of mouth, magazines, submissions/self-promotions, sourcebooks, agents, visiting artists' exhibitions, art fairs and artists' reps.
Tips: "We predict a steady market for the field."

DESIGN DESIGN, INC., P.O. Box 2266, Grand Rapids MI 49501. (616)774-2448. Fax: (616)774-4020. Art Director: Tom Vituj. Estab. 1986. Produces humorous and traditional greeting cards, stationery, journals, address books, calendars, magnets, sticky notes and giftwrap for all ages.
Needs: Approached by 50 freelancers/year. Works with 25 freelancers/year. Works on assignment only. Uses freelancers mainly for greeting cards and giftwrap. Considers most media. Produces material for all holidays and seasons. Submit seasonal material 1 year in advance.
First Contact & Terms: Send query letter with appropriate samples and SASE. Samples are not filed and are returned by SASE if requested by artist. Reports back within 1 month. To show portfolio, mail thumbnails, roughs, color photostats, photographs and slides. Do not send originals. Pays royalties. Negotiates rights purchased.

‡**DESIGNER GREETINGS, INC.**, Box 140729, Staten Island NY 10314. (718)981-7700. Art Director: Fern Gimbelman. Produces greeting cards and invitations. Produces general, informal, inspirational, contemporary, juvenile, soft-line and studio cards.

Needs: Works with 16 freelancers/year. Buys 100-150 designs and illustrations/year. Works on assignment only. Also uses artists for calligraphy, P-O-P displays and airbrushing. Prefers pen & ink and airbrush. No specific size required. Produces material for all seasons; submit seasonal material 6 months in advance.
First Contact & Terms: Send query letter with brochure or tearsheets and photostats or photocopies. Samples are filed or are returned only if requested. Reports back within 3-4 weeks. Call or write for appointment to show portfolio of original/final art, final reproduction/product, tearsheets and photostats. Originals are not returned. Pays flat fee. Buys all rights.
Tips: "We are willing to look at any work through the mail (photocopies, etc.). Appointments are given after I personally speak with the artist (by phone)."

DIMENSIONS, INC., 641 McKnight St., Reading PA 19601. (610)372-8491. Fax: (610)372-0426. Designer Relations Coordinator: Mary Towner. Produces craft kits and leaflets, including but not limited to needlework, iron-on transfer, printed felt projects. "We are a craft manufacturer with emphasis on sophisticated artwork and talented designers. Products include needlecraft kits and leaflets, wearable art crafts, baby products. Primary market is adult women but children's crafts also included."
Needs: Approached by 50-100 freelancers/year. Works with 200 freelancers/year. Develops more than 400 freelance designs and illustrations/year. Uses freelancers mainly for the original artwork for each product. In-house art staff adapts for needlecraft. Considers all media. Looking for fine art, realistic representation, good composition, more complex designs than some greeting card art; fairly tight illustration with good definition; also whimsical, fun characters. Produces material for Christmas; Valentine's Day; Easter; Halloween; everyday; birth, wedding and anniversary records.
First Contact & Terms: Send query letter with color brochure, tearsheets, photographs or photocopies. Samples are filed "if artwork has potential for our market." Samples are returned by SASE only if requested by artist. Reports back within 1 month. Portfolio review not required. Originals are returned at job's completion. Pays by project, royalties of 2-5%; sometimes purchases outright. Finds artists through magazines, trade shows, word of mouth, licensors/reps.
Tips: "Current popular subjects in our industry: florals, country/folk art, garden themes, ocean themes, celestial, Southwest/Native American, Victorian, juvenile/baby and whimsical."

‡THE DUCK PRESS, 216 Country Garden Lane, San Marcos CA 92069. (619)471-1115. Fax: (619)591-0990. Owner: Don Malm. Estab. 1982. Produces greeting cards, calendars and posters for the golfing market only.
Needs: Approached by 12 freelance artists/year. Works with 5 freelance artists/year. Buys 50-100 freelance designs and illustrations/year. Prefers artists with experience in humorous sport art—especially golf. Works on assignment only. Uses freelance artists mainly for illustrations for greeting cards. Considers all media. Looking for full color illustration. Prefers final art scaled to 5×7. Produces material for Christmas and Father's Day. Submit seasonal material 6 months in advance.
First Contact & Terms: Send query letter with brochure, tearsheets, photostats and photographs. Samples are not filed and are returned. Reports back within 2 weeks. To show portfolio, mail thumbnails, roughs and color tearsheets. Original artwork is not returned at job's completion. Pays royalties of 4-6%. Negotiates rights purchased.

‡DUNCAN DESIGNS, 1141 S. Acacia St., Fullerton CA 92631. (714)879-1360. Fax: (714)879-4611. President: Catherine Duncan. Estab. 1969. Produces collectible figurines, decorative housewares, gifts, giftwrap, greeting cards. Specializes in historical figurines.
Needs: Approached by 50 freelancers/year. Works with 10 freelancers/year. Uses freelancers mainly for sculpture/graphic arts. Also for mechanicals, P-O-P displays, paste-up. Considers all media. Prefers historical, traditional. Art guidelines available. Works on assignment only.
First Contact & Terms: Send query letter with photocopies, photographs, résumé. Send follow-up postcard every month. Samples are not filed and are returned. Reports back within 5 days. Portfolios required. They may be dropped off Monday through Friday and should include color final art, photographs, photostats. Request portfolio review in original query. Rights purchased vary according to project. Payment varies.

EARTH CARE, 966 Mazzoni, Ukiah CA 95482. (707)468-9292. Fax: (707)468-0301. E-mail: realgood@well.sf.ca.us. Art Director: Robert Klayman. Estab. 1983. Produces greeting cards, note cards and stationery; primarily mail order. "All of our products are printed on recycled paper and are targeted toward nature enthusiasts and environmentalists."

‡ THE DOUBLE DAGGER before a listing indicates that the listing is new in this edition. New markets are often more receptive to freelance submissions.

Needs: Buys 50-75 freelance illustrations/year. Uses freelancers for greeting cards, giftwrap, note cards, stationery and postcards. Considers all media. Art guidelines for SASE with first-class postage. Produces Christmas cards; seasonal material should be submitted 18 months in advance.

First Contact & Terms: Send photocopies, slides and SASE. "For initial contact, artists should submit samples which we can keep on file." Must include SASE for return. Reports back within 1 month. Originals are returned at job's completion. Pays 3-5% royalties plus a cash advance on royalties; or pays flat fee. Buys reprint rights.

Tips: "In the industry, environmentally sound products (our main focus) are becoming more popular. Ethnic art is also popular. We primarily use nature themes. We accept only professional quality work and consider graphic, realistic or abstract designs. We would like to develop a humor line based on environmental and social issues."

‡ELEGANT GREETINGS, INC., 2330 Westwood Blvd., Suite 102, Los Angeles CA 90064-2127. (310)446-4929. Fax: (310)446-4819. President: S. Steier. Estab. 1981. Produces greeting cards, stationery and children's novelties; a traditional and contemporary mix, including color tinted photography; geared toward children 8-18, as well as schoolteachers and young adults 18-35.

Needs: Approached by 15 freelance artists/year. Works with 3 freelance artists/year. Buys varying number of designs and illustrations/year. Prefers local artists only. Sometimes works on assignment basis only. Uses freelance artists mainly for new designs, new concepts and new mediums. Also uses freelance artists for P-O-P displays, paste-up and mechanicals. Looking for "contemporary, trendy, bright, crisp colors." Produces material for all holidays and seasons. Submit 1 year before holiday.

First Contact & Terms: Send query letter, brochure, photocopies, photographs and SASE. Samples are not filed and are returned. Reports back within 1 month. To show a portfolio, mail appropriate materials. Original artwork returned at the request of the artist. Pay is negotiable. Rights purchased vary according to project.

Tips: "Common mistakes freelance artists make in presenting samples or portfolios is not having enough variety or depth of theme. We review everything. We look for an almost finished product."

‡ENCORE STUDIOS, INC., 17 Industriol West, Clifton NJ 07012. Phone/fax: (201)472-3005. Art Director: Ceil Benjamin. Estab. 1979. Produces personalized wedding, bar/bat mitzvah, party invitations, birth announcements, stationery, Christmas cards and party accessory items.

Needs: Approached by 50-75 freelance artists/year. Works with 20 freelancers/year. Prefers freelancers with experience in designing for holiday cards, invitations, announcements and stationery. "We are interested in designs for any category in our line. Looking for unique type layouts, monograms for stationery and weddings, holiday logos, flowers for our wedding line, Hebrew monograms for our bar/bat mitzvah line." Also for calligraphy, paste-up and mechanicals done on Mac computer. Considers b&w or full-color art. Looking for "high class, graphic, sophisticated contemporary designs." 20% of freelance work demands knowledge of Macintosh: QuarkXPress, Aldus FreeHand, Adobe Illustrator, Adobe Photoshop, Font Studio. Produces material for Christmas, Hanukkah, Rosh Hashanah and New Year. Submit seasonal material all year.

First Contact & Terms: Send query letter with brochure, résumé, SASE, tearsheets, photographs, photocopies or slides. Samples are filed or are returned by SASE if requested by artist. Reports back within 2 weeks only if interested. Write for appointment to show portfolio, or mail appropriate materials. Portfolio should include roughs, finished art samples, b&w photographs, slides and dummies. Negotiates return of originals to the artist. Pays $100-500, by the project. Negotiates rights purchased.

ENESCO CORPORATION, 225 Windsor Dr., Itasca IL 60143. (708)875-5300. Fax: (708)875-5349. Contact: New Submissions/Licensing. Producer and importer of fine giftware and collectibles, such as ceramic, porcelain bisque and earthenware figurines, plates, hanging ornaments, bells, thimbles, picture frames, decorative housewares, music boxes, dolls, tins, crystal and brass. Clients: gift stores, card shops and department stores.

Needs: Works with 300 freelance artists/year. Assigns 1,000 freelance jobs/year. Prefers artists with experience in gift product and packaging development. Uses freelancers for rendering, illustration and sculpture. 50% of freelance work demands knowledge of Adobe Photoshop, QuarkXPress or Adobe Illustrator.

First Contact & Terms: Send query letter with brochure, résumé, tearsheets, photostats and photographs. Samples are filed or are returned. Reports back within 2 weeks. Pays by the project.

Tips: "Contact by mail only. It is better to send samples and/or photocopies of work instead of original art. All will be reviewed by Senior Creative Director, Executive Vice President and Licensing Director. If your talent is a good match to Enesco's product development, we will contact you to discuss further arrangements. Please do not send slides. Have a well thought-out concept that relates to giftware products before mailing your submissions."

‡ENGLISH CARDS, LTD., 5 Delaware Dr., Lake Success NY 11040. (516)775-8100. Fax: (516)775-0101. Produces giftwrap, greeting cards, notes and stationery.

Needs: Prefers freelancers with experience in watercolor. Works on assignment only. Also for calligraphy, watercolor illustrations. Looking for traditional, floral, humorous, "off the wall," sentimental, cute animals,

adult contemporary. Prefers 6×8 or larger. 30% of freelance design work demands computer skills. Produces material for Christmas, birthdays, everyday, get well, friendship, romance, anniversary, thank you, sympathy, thinking of you. Submit seasonal material 2 months in advance.

First Contact & Terms: Send query letter with photocopies. Send follow-up postcard every 3 months. Samples are filed or are returned. Reports back in 6 weeks. Portfolio of color photocopies required from illustrators. Pays by project, $150-350.

ENVIRONMENTAL PRESERVATION INC. (EPI Marketing), 250 Pequot Ave., Southport CT 06490. (203)255-1112. Fax: (203)255-3313. Vice President Marketing: Merryl Lambert. Estab. 1989. Produces greeting cards, posters, games/toys, books, educational children's gifts.

Needs: Works with "many" freelancers/year. Buys "many" designs and illustrations/year. Prefers freelancers with experience in nature images and sports. Works on assignment only. Uses freelancers for P-O-P displays and mechanicals. Freelancers should be familiar with Aldus PageMaker, QuarkXPress, Adobe Illustrator or Adobe Photoshop.

First Contact & Terms: Send query letter with brochure, tearsheets and slides. Samples are filed and are not returned. Reports back to the artist only if interested. Art Director will contact artist for portfolio review if interested. Originals are returned at job's completion. Negotiates rights purchased.

‡EPIC PRODUCTS INC., 17395 Mt. Herrmann, Fountain Valley CA 92708. (714)641-8194. Fax: (714)641-8217. President: Steve DuBow. Estab. 1978. Produces paper tableware products and wine and spirits accessories. "Epic Products manufactures products for the gourmet/housewares market; specifically products that are wine-related. Many have a design printed on them."

Needs: Approached by 50-75 freelance artists/year. Works with 10-15 freelancers/year. Buys 25-50 designs and illustrations/year. Prefers artists with experience in gourmet/housewares, wine and spirits. Uses freelancers mainly for product design. Also for P-O-P displays, paste-up, mechanicals. 25% of freelance work demands knowledge of Aldus PageMaker or Aldus FreeHand.

First Contact & Terms: Send query letter with résumé and photocopies. Samples are filed. Reports back within 1 week. Write for appointment to show portfolio. Portfolio should include thumbnails, roughs, final art, b&w and color. Buys all rights. Originals are not returned. Pays by project, $250.

‡EQUITY MARKETING, INC., 131 S. Rodeo Dr., Suite 300, Beverly Hills CA 90212-2428. (310)887-4300. Fax: (310)887-4400. Director, Creative Services: Katie Cahill. Specializes in design, development and production of promotional, toy and gift items, especially licensed properties from the entertainment industry. Clients include Tyco, Applause, Avanti and Ringling Bros. and worldwide licensing relationships with Disney, Warner Bros., 20th Century Fox and Lucas Film.

Needs: Needs product designers, sculptors, packaging and display designers, graphic designers and illustrators. Prefers whimsical and cartoon styles. Products are typically targeted at children. Works on assignment only.

First Contact & Terms: Send query letter with tearsheets, résumé and slides. Samples are returned by SASE if requested by artist. Reports back within 1 month. To show portfolio, mail thumbnails, roughs, original, final art and samples. Rights purchased vary according to project. Pays for design by the project, $50-1,200. Pays for illustration by the project, $75-3,000. Finds artists through word of mouth, network of design community, agents/reps.

Tips: "Gift items will need to be simply made, priced right and of quality design to compete with low prices at discount houses."

EUROPEAN TOY COLLECTION/CROCODILE CREEK, 6643 Melton Rd., Portage IN 46368. (219)763-3234. Fax: (219)762-1740. President: Mel Brown. Estab. 1984. Produces "high quality, well-designed toys, children's gifts, books and decorative accessories. Works with all major museums, catalogs, department stores and specialty stores. An innovative, creative company committed to imaginative well-designed children's products. Listed in INC 500 as one of the fastest growing small companies in the US. Winner of several Parents' Choice Awards."

Needs: Approached by 100 freelancers/year. Works with 10 freelancers/year. Buys 10-20 designs and illustrations/year. Prefers freelancers with experience in a variety of media. "Over the next few years we plan on expanding and broadening our product development and creative department significantly." Uses freelancers mainly for product development and P-O-P and show display. "Artists can contact us for a free catalog—to get some ideas of our current products."

First Contact & Terms: Send query letter with photographs. Samples are filed. Reports back only if interested. "We currently will contact artist for portfolio review after they've made initial inquiry." Portfolio should include color tearsheets and photographs. Sometimes requests work on spec before assigning a job. Rights purchased vary according to project. Interested in buying second rights (reprint rights) to previously published work. Finds artists through networking, submissions and exhibitions.

Tips: "There are many opportunities for original, creative work in this field."

THE EVERGREEN PRESS, INC., 3380 Vincent Rd., Pleasant Hill CA 94523. (510)933-9700. Fax: (510)256-7782. Art Director: Ann Nielsen. Publishes greeting cards, giftwrap, giftbags, stationery, Christmas

cards, bookmarks and bookplates. "We publish, manufacture and distribute unique products for stationery, gift, book and museum stores."

Needs: Approached by 100-200 freelancers/year. Works with 50-75 freelancers/year. Buys 100-500 designs/ year from freelancers. Uses freelancers mainly for greeting cards, Christmas cards and giftwrap and product design. Also for P-O-P, brochures and catalogs. Uses only full-color artwork in any media. Seeks unusual designs, contemporary, sophisticated art and humor or series with a common theme. No super-sentimental Christmas themes, single greeting card designs with no relation to each other, or single-color pen or pencil sketches. Roughs may be in any size to get an idea of work; final art must meet size specifications. Art can be 100, 150 or 200% for a 5¼×7¼ card. Produces material for Christmas, Easter, Mother's Day, Father's Day, graduation, Halloween, New Year, Thanksgiving, Valentine's Day, birthdays, everyday, sympathy, get well, romantic, thank you, serious illness, secretary's day, bosses day, Grandparent's Day, woman-to-woman, cards for step families, multicultural cards and cards for pets. "We examine artwork at any time of the year to be published for the next following holiday."

First Contact & Terms: Send query letter with photocopies, résumé, slides, photographs, SASE and transparencies. Samples returned by SASE. Reports back only if interested. Originals returned at job's completion. Will contact artist for portfolio review if interested. Negotiates rights purchased. "We usually make a cash down payment against royalties, 5-10%." Pays on publication. Finds freelancers through submissions.

Tips: "Trends are cyclical. Several years ago it was endangered species, frogs—now its angels. Freelancers can peruse the shops, museums, etc. to research current trends. Many artists have the skills to render an image, what we're looking for is that image in a clever, unique, and unusual situation."

‡EVERTHING METAL IMAGINABLE, INC. (E.M.I.), 401 E. Cypress, Visalia CA 93277. (209)732-8126. Contact: Deborah Lopez. Estab. 1967. Wholesale manufacturer. "We manufacture lost wax bronze sculpture. We do centrifugal white metal casting and resin casting (cold cast bronze, alabaster walnut shell, clear resin etc.)." Clients: wholesalers, premium incentive consumers, retailers.

Needs: Approached by 10 freelance artists/year. Works with 20 freelance designers/year. Assigns 5-10 jobs to freelance artists/year. Prefers artists that understand centrifugal casting, bronze casting and the principles of mold making. Uses artists for figurine sculpture and model making. Prefers a tight, realistic style.

First Contact & Terms: Send query letter with brochure or résumé, tearsheets, photostats, photocopies and slides. Samples not filed are returned only if requested. Reports back only if interested. Call for appointment to show portfolio of original/final art and photographs "or any samples." Pays for design by the project, $500-20,000. Buys all rights.

Tips: "Artists must be conscious of detail in their work, be able to work expediently and under time pressure and be able to accept criticism of work from client. Price of program must include completing work to satisfaction of customers."

‡EXECUTIVE GREETINGS/THE DRAWING BOARD, 14901 Trinity Blvd., Ft. Worth TX 76155. (817)283-3455. Fax: (817)545-6235. Art Director: Charles Brannon. Estab. 1967. Produces calendars, greeting cards, stationery, posters, memo pads, advertising specialties. Specializes in Christmas, everyday, dental, healthcare greeting cards and postcards and calendars for businesses and professionals.

Needs: Approached by 5-10 freelancers/year. Works with 10-15 freelancers/year. Buys 200-300 freelance designs and illustrations/year. Prefers freelancers with experience in greeting cards. Works on assignment only. Uses freelancers mainly for illustration, calligraphy, humorous writing, cartoons. Prefers traditional Christmas and contemporary and conservative cartoons. 10% of design work demands knowledge of Adobe Photoshop, Adobe Illustrator, QuarkXPress. Produces material for Christmas, Halloween, Thanksgiving, birthdays, everyday. Submit seasonal material 1 year in advance.

First Contact & Terms: Designers send brochure, résumé, tearsheets. Illustrators and cartoonists send tearsheets. After introductory mailing send follow-up postcard sample every 6 months. Calligraphers send photocopies of their work. Accepts Mac compatible disk submissions. Samples are filed or returned. Buys one-time or all rights. Pays for illustration by the project, $200-450. Finds freelancers through agents, other professional contacts, submissions and recommendations.

‡FAIRCHILD ART/FAIRCHILD PHOENIX, 7508 Hawkstand Lane, Charlotte NC 28109. (704)525-6369. Owner/President: Marilynn Fairchild. Estab. 1985. Produces fine art greeting cards, stationery, posters and art prints.

Needs: Approached by 10-15 artists/year. Works with 1 or 2 artists/year. Buys 10-20 designs and illustrations/ year. Prefers "quality fine artists." Uses freelancers mainly "when artwork is needed to complement our present product line." Considers all media. Prefers "work which is proportionate to 25×38 or 23×35 printing sheets; also sizes useful for printing 2-up, 4-up or 10-up on these size sheets." Produces material for birthdays and everyday. Submit 1 year before holiday. 10-25% of freelance works demands knowledge of Aldus FreeHand, Adobe Illustrator or CorelArt.

First Contact & Terms: Send query letter with brochure, résumé, tearsheets, photographs and photocopies. Samples are filed or are not returned. Reports back to the artist only if interested. Write for appointment to show portfolio, or mail finished art samples, b&w and color photostats, tearsheets and photographs. Pays flat fee for illustration/design or by the hour, $15 minimum. Rights purchased vary according to project.

Tips: This company looks for professionalism in its freelancers.

‡FANTAZIA MARKETING CORP., 65 N. Chicopee St., Chicopee MA 01020. President: Joel Nulman. Estab. 1979. Produces games/toys and high-end novelty products. Produces novelty, lamps, banks and stationery items in over-sized form.
Needs: Approached by 3 freelance artists/year. Works with 1 freelancer/year. Buys 1 design and illustration/year. Prefers artists with experience in product development. "We're looking to increase our molded products." Uses freelancers for P-O-P displays, paste-up, mechanicals. 50% of design requires computer skills.
First Contact & Terms: Send query letter with résumé. Samples are filed. Reports back within 2 weeks. Call for appointment to show portfolio. Portfolio should include roughs and dummies. Rights purchased vary according to project. Originals not returned. Pays by project. Royalties negotiable.

FERNBROOK LANE STATIONERY, 2533 Fernbrook Lane, Plymouth MN 55447. (612)476-6797. Fax: (612)476-2738. General Manager: Michele Netka. Estab. 1987. Produces stationery, giftwrap, packaged cards and tablets. "We manufacture packaged cards, invitations, thank yous, note cards, for all age groups—bold graphic designs to formal."
Needs: Approached by 6 freelancers/year. Works with 3 freelancers/year. Buys 100 freelance designs and illustrations/year. Prefers artists with experience in card designs and giftwrap. Uses freelancers for all product artwork. Considers watercolor, pencil and computer graphics. Prefers 5×7 minimum. Freelancers should be familiar with Adobe Illustrator and Adobe Photoshop. Produces material for Christmas, graduation, birthdays and everyday. Submit seasonal material 3 months in advance.
First Contact & Terms: Designers send query letter. Illustrators send postcard samples. Accepts submissions on disk compatible with Adobe Illustrator or Photoshop 5.0 on Mac. Samples are filed or returned by SASE. Reports back within 1 month. Will contact artist for portfolio review if interested. Rights purchased vary (may buy all rights). Originals not returned. Pays by project, $50-150. Finds artists through trade shows, submissions and word of mouth.
Tips: "Show a variety of abilities."

FINE ART PRODUCTIONS, RICHIE SURACI PICTURES, MULTIMEDIA, INTERACTIVE, 67 Maple St., Newburgh NY 12550-4034. Phone/fax: (914)561-5866. E-mail: richie.suraci@bbs.mhv.net. Website: http://www.geopages.com/Hollywood/1077. Contact: Richie Suraci. Estab. 1994. Produces greeting cards, stationery, calendars, posters, games/toys, paper tableware products, giftwrap, CD-ROMs, video/film backgrounds, magazine, newspaper print. "Our products are fantasy, New Age, sci-fi, outer space, environmental, adult erotica."
Needs: Prefers freelancers with experience in sci-fi, outer space, adult erotica, environmental, fantasy and mystical themes. Uses freelancers for calligraphy, P-O-P displays, paste-up and mechanicals. Art guidelines for SASE with first-class postage. Considers all media. 50% of freelance work demands knowledge of Adobe Illustrator, Adobe Photoshop, QuarkXPress, Aldus FreeHand, Aldus PageMaker, SGI and ImMix. Produces material for all holidays and seasons and Valentine's Day. Submit seasonal material 1 year in advance.
First Contact & Terms: Send postcard sample or query letter with brochure, tearsheets, résumé, photographs, slides, SASE, photocopies and transparencies. Accepts submissions on disk (Macintosh). Samples are filed or returned by SASE if requested by artist. Reports back within 3-4 months if interested. Company will contact artist for portfolio review if interested. Portfolio should include thumbnails, roughs, final art, photostats, tearsheets, photographs, slides and transparencies. Rights purchased vary according to project. Originals are returned at job's completion. Pays by project. Finds artists through agents, sourcebooks, magazines, word of mouth and submissions.
Tips: "Send unique material that is colorful. Send samples in genres we are looking for."

‡FISHER-PRICE, 636 Girard Ave., E. Aurora NY 14052. (716)687-3983. Fax: (716)687-5281. Director, Product Art: Henry Schmidt. Estab. 1931. Manufacturer of toys and other children's products.
Needs: Approached by 10-15 freelance artists/year. Works with 25-30 freelance illustrators and sculptors and 15-20 freelance graphic designers/year. Assigns 100-150 jobs to freelancers/year. Prefers artists with experience in children's style illustration and graphics. Works on assignment only. Uses freelancers mainly for product decoration (label art). Prefers all media and styles except loose watercolor. Also uses sculptors. 25% of work demands knowledge of Aldus FreeHand, Adobe Illustrator, Adobe Photoshop.
● This company has two separate art departments: Advertising and Packaging, which does catalogs and promotional materials; and Product Art, which designs decorations for actual toys. Be sure to specify your intent when submitting material for consideration.
First Contact & Terms: Send query letter with brochure showing art style or slides, photographs and transparencies. Samples are filed. Reports back to the artist only if interested. Call to schedule an appointment to show a portfolio. Portfolio should include original, final art and color photographs and transparencies. Pays for design and illustration by the hour, $25-50. Buys all rights.

‡FOTOFOLIO, INC., 536 Broadway, New York NY 10012. (212)226-0923. Fax: (212)226-0072. Editorial Coordinator: JoAnne Seador. Estab. 1976. Produces greeting cards, calendars, posters, T-shirts, postcards

and a line of products for children including a photographic book, Keith Haring coloring books and notecards.
Needs: Buys 5-60 freelance designs and illustrations/year. Reproduces existing works. Primarily interested in photography. Produces material for Christmas, Valentine's Day, Birthday and everyday. Submit seasonal material 8 months in advance.
First Contact & Terms: Send query letter with SASE c/o Editorial Dept. Samples are filed or are returned by SASE if requested by artist. Editorial Coordinator will contact artist for portfolio review if interested. Originals are returned at job's completion. Pays by the project, 7½-15% royalties. Rights purchased vary according to project. Finds artists through word of mouth, magazines, submissions/self-promotions, source-books, agents, visiting artist's exhibitions, art fairs and artists' reps.

‡THE FRANKLIN MINT, Franklin Center PA 19091-0001. (610)459-6629. Fax:(610)459-7270. Artist Relations Managers: Kate Zabriskie, illustration; Ellen Caggiula, sculpture and dolls. Estab. 1964. Direct response marketing of high quality collectibles. Produces collectible porcelain plates, prints, porcelain and coldcast sculpture, figurines, fashion and traditional jewelry, ornaments, precision diecast model cars, luxury board games, engineered products, heirloom dolls and plush, home decor items and unique gifts. Clients: general public worldwide, proprietary houselist of 8 million collectors and 55 owned and operated retail stores. Markets products in 20 countries worldwide including: USA, Canada, United Kingdom, France, Germany, Australia, New Zealand and Japan.
Needs: Approached by 2,000 freelance artists/year. Contracts 500 artists/sculptors per year to work on 7,000-8,000 projects. Buys approximately 400 sculptures/year. Art guidelines free for SASE with first class postage. Uses freelancers mainly for illustration and sculpture. Considers all media. Considers clay for sculpture; clay or wax for dolls. Considers all styles. 80% of freelance design and 50% of illustration demand knowledge of Aldus PageMaker, Aldus FreeHand, Adobe Photoshop, Adobe Illustrator, QuarkXPress and 3D Studio Eclipse (2D). Accepts work in SGI format. Produces material for Christmas and everyday. Submit seasonal material 6-8 months in advance.
First Contact & Terms: Send query letter, biography, SASE and samples (clear, professional full-color photographs, transparencies, slides, greeting cards and/or brochures and tearsheets.) Sculptors send photographic portfolios. "Please do not send original artwork." Samples are filed or returned by SASE. Reports back within 3 months. Portfolio review required for illustrators and sculptors. Reviews portfolios weekly. Company gives feedback on all portfolios submitted. Portfolios should include color photographs, photostats, slides, tearsheets or transparencies of final art. Buys all rights. Payment varies. Finds artists through word of mouth.
Tips: "In search of artists and sculptors capable of producing high quality work. Those willing to take art direction and to make revisions of their work are encouraged to submit their portfolios."

FRAVESSI GREETINGS, INC., 11 Edison Place, Springfield NJ 07081. (201)564-7700. Fax: (201)376-9371. Art Director: Janet Thomassen. Estab. 1930. Produces greeting cards, packaged goods, notes.
Needs: Approached by 25 freelancers/year. Works with 12 freelancers/year. Uses freelancers for greeting card design. Considers watercolor, gouache and pastel. Especially needs seasonal and everyday designs; prefers cute and whimsical imagery. Produces seasonal material for Christmas, Mother's Day, Father's Day, Thanksgiving, Easter, Valentine's Day, St. Patrick's Day, Halloween, graduation, Jewish New Year and Hanukkah. Submit seasonal art 1 year in advance.
First Contact & Terms: Send query letter and samples of work. Include SASE. Reports in 2-3 weeks. Provide samples to be kept on file for possible future assignments. Art Director will contact artist for portfolio review if interested. Originals are not returned. Requests work on spec before assigning a job. Pays flat fee of $125-250/illustration or design. **Pays on acceptance.** Buys all rights. Finds artists through word of mouth and submissions.
Tips: Must now implement "tighter scheduling of seasonal work to adapt to changing tastes. There is an emphasis on lower priced cards. Check the marketplace for type of designs we publish."

‡FREEDOM GREETINGS, Dept. AM, 1619 Hanford St., Levittown PA 19057. (215)945-3300. President: Jay Levitt. Estab. 1969. Produces greeting cards featuring flowers and scenery.
Needs: Approached by over 100 artists/year. Buys 200 designs from artists/year. Works on assignment only. Considers watercolor, acrylic, etc. Prefers novelty. Call for size specifications. Produces material for all seasons and holidays; submit 14 months in advance.
First Contact & Terms: Send query letter with résumé and samples. Samples are returned by SASE. Reports within 10 days. To show a portfolio, mail roughs. Originals returned to artist at job's completion. Pays average flat fee of $150-275, illustration/design. Buys all greeting and stationery rights.
Tips: "We also seek illustrations of blacks in situations similar to those found on our photographic lines."

FREEMAN SPORTS APPAREL CO., 830 Taylor St., Elyria OH 44035. (216)322-5140. Fax: (216)322-6784. Chief Artist: Mark Brabant. Estab. 1989. Produces sports apparel, particularly golf and ski wear.
Needs: Approached by 20-30 freelancers/year. Works with 2-3 freelancers/year. Buys 5-10 freelance designs and illustrations/year. Prefers artists with experience in Mac-based programs. Uses freelancers mainly for apparel designs. Looking for athletic-oriented appeal. Prefers no larger the 8½×11 to start. 90% of freelance

work demands knowledge of Adobe Illustrator 5.0, Adobe Photoshop 3.0, Aldus FreeHand 5.0 and Aldus PageMaker 5.0. Produces material for Christmas, spring and fall. Submit seasonal material 6-8 months in advance.

First Contact & Terms: Send query letter with tearsheets, résumé, color copies, photographs, SASE and photocopies. Accepts submissions on disk compatible with Aldus FreeHand, Adobe Illustrator. Send TIFF or EPS files. Samples are not filed and returned by SASE if requested by artist. Company will contact artist for portfolio review if interested. Buys all rights. Originals are not returned. Pays by project.

Tips: "Send professional work, professionally presented. There are a lot of unqualified candidates who apply for work. The proper presentation cuts through a lot of clutter. We are always interested in *fresh*, *new*, sports related designs for silk screening."

G.A.I. INCORPORATED, Box 30309, Indianapolis IN 46230. (317)257-7100. President: William S. Gardiner. Licensing agents. "We represent artists to the collectibles and gifts industries. Collectibles include high-quality prints, collector's plates, figurines, bells, etc. There is no up-front fee for our services. We receive a commission from any payment the artist receives as a result of our efforts." Clients: Lenox, Enesco, The Bradford Exchange and The Hamilton Group.

Needs: Approached by 100 freelancers/year. Works with 50 freelance illustrators and 5 designers/year. Works on assignment only. "We are not interested in still lifes or modern art. A realistic—almost photographic—style seems to sell best to our clients. We are primarily looking for artwork featuring people or animals. Young animals and children usually sell best. Paintings must be well done and should have broad emotional appeal."

First Contact & Terms: Send query letter with résumé and color photographs; do *not* send original work. Request portfolio review in original query. Samples not kept on file are returned by SASE. Reports in 1-3 months. Payment: "If we are successful in putting together a program for the artist with a manufacturer, the artist is usually paid a royalty on the sale of the product. This varies from 4-10%. Payment is negotiated individually for each project." Finds artists through word of mouth, magazines, submissions/self-promotions, sourcebooks, agents, visiting artists' exhibitions, art fairs and artists' reps.

GALISON BOOKS/MUDPUPPY PRESS, 36 W. 44th St., New York NY 10036. (212)354-8840. Fax: (212)391-4037. Design Director: Heather Zschock. Estab. 1978. Produces boxed greeting cards, puzzles, address books and specialty journals. Many projects are done in collaboration with museums around the world.

● Galison Books is moving toward more contemporary designs.

Needs: Works with 10-15 freelancers/year. Buys 20 designs and illustrations/year. Art guidelines for SASE with first-class postage. Works on assignment only. Uses freelancers mainly for illustration. Considers all media. Also produces material for Christmas and New Year. Submit seasonal material 1 year in advance. 100% of design and 5% of illustration demand knowledge of QuarkXPress.

First Contact & Terms: Send postcard sample or query letter with brochure, photocopies, résumé and tearsheets (no unsolicited original artwork) and SASE. Accepts submissions on disk compatible with Adobe Photoshop, Adobe Illustrator or QuarkXPress (but not preferred). Samples are filed. Reports back to the artist only if interested. Request portfolio review in original query. Art Director will contact artist for portfolio review if interested. Portfolio should include color photostats, slides, tearsheets and dummies. Originals are returned at job's completion. Pays by project. Rights purchased vary according to project. Finds artists through word of mouth, magazines and artists' reps.

Tips: "Looking for great presentation and artwork we think will sell and be competitive within the gift market."

‡GALLANT GREETINGS CORP., P.O. Box 308, Franklin Park IL 60131. (847)671-6500. Fax: (847)671-7500. Vice President Sales and Marketing: Chris Allen. Estab. 1966. Produces greeting cards, packaged invitations and thank you notes. Creator and publisher of seasonal and everyday greeting cards.

Needs: Approached by hundreds of freelancers/year. Works with 2 freelancers/year. Buys 30 freelance designs and illustrations/year. Looking for traditional and humorous. Produces material for Christmas, Easter, Mother's Day, Father's Day, graduation, Halloween, Thanksgiving, Valentine's Day, birthdays, everyday and most card giving occasions.

First Contact & Terms: Samples are not filed and not returned. Reports back only if interested. Portfolio review not required. Negotiates rights purchased.

‡GARBORG'S, 2060 W. 98th St., Bloomington MN 55431. (612)888-5727. Fax: (612)888-4775. Product Development: Jennifer Parker. Produces inspirational page-a-day perpetual calendars and gift books marketed to giftshops and Christian bookstores. Majority of buyers are women of all ages; line includes masculine and children's products.

Needs: Works with 10-15 freelancers/year. Buys 30 freelance designs and illustrations/year. Prefers freelancers with experience in paper products. Art guidelines available. Uses freelancers mainly for color illustration. Also uses freelancers for calligraphy and P-O-P displays. Considers watercolor, gouache, colored pencil, dyes, mixed media, computer graphics and oils. Prefers art that is reflective of warmth, joy and inspiration. May be elegant, classical, realistic, impressionistic, graphic, as well as innovative. Images often used: Florals,

scenes, still lifes, patterns, borders, wildlife. Main emphasis: everyday themes, may include seasonal themes. Will review product concepts and styling submissions. 100% of design requires knowledge of Aldus Free-Hand, Adobe Photoshop and Adobe Illustrator.

First Contact & Terms: Send postcard sample or query letter with résumé, brochure, photocopies and tearsheets. Accepts submissions on disk. Samples are filed or returned by SASE if requested by artist. Reports back in 1 month. Company will contact artist for portfolio review if interested. Portfolio should include color photostats, photographs, tearsheets and final art. Negotiates rights purchased. Originals not returned at job's completion. Pays by project, $400-1,200.

Tip: "Be innovative."

C.R. GIBSON CO., A division of Thomas Nelson Gifts, 32 Knight St., Norwalk CT 06856-5220. (203)847-4543. Fax: (203)847-1165. Freelance Coordinator: Harriet Richards. Estab. 1870. Produces greeting cards, stationery, paper tableware products, giftwrap, gift books, baby books, wedding books, photo albums, scrap books, kitchen products (recipe books and coupon files). "The C.R. Gibson Company has a very diversified product line. Generally we sell our products to the better markets including department stores, gift shops and stationery stores. Our primary consumers are women buying for themselves or men. Masculine products and designs make up less than 10% of the lines. Our designs are fashionable without being avant-garde, always in good taste."

Needs: Approached by 250-300 freelancers/year. Works with 60-80 freelancers/year. Buys 200 freelance designs and illustrations/year. Prefers artists with experience in traditional materials; rarely uses computer generated art. Art guidelines for SASE with first-class postage. Works on assignment 90% of time. Uses freelancers for everything. Considers all traditional media. Looking for conservative, traditional looks—no abstract or regional themes. Most designs subject-oriented—"pretty," fashionable and in good taste. Uses a very small amount of cartoonists. Does not need computer-literate freelancers, although computer skills are helpful. Produces material for Christmas, New Year, birthdays and everyday. Submit Christmas material 1 year in advance.

First Contact & Terms: Send query letter with brochure, tearsheets, photostats, photographs, slides, SASE, photocopies and transparencies. Samples are sometimes filed or are returned. Reports back within 1 month. Company will contact artist for portfolio review if interested. Portfolio should include "anything appropriate." Rights purchased vary according to project. Originals are returned at job's completion. Pays by the project, $250-1,500; royalties of 2-5%; negotiable with project. Finds artists through word of mouth, submissions and agents.

Tips: "Try to be aware of current design themes and colors. Regional designs should be avoided. Most of our designs are subject-oriented and not abstract prints or designs. Before we can review any artwork we require artists to sign a submission agreement. Look at our line of product. Don't send anything that isn't appropriate. We only use full color work."

GIBSON GREETINGS, INC., 2100 Section Rd., Cincinnati OH 45237. (513)841-6600. Director of Design Development: Wayne Wright. Estab. 1850. Produces greeting cards, giftwrap, stationery, calendars and paper tableware products. "Gibson is a leader in social expression products."

Needs: Approached by 300 freelancers/year. Works with 200 freelancers/year. Buys 3,500 freelance designs and illustrations/year. Prefers freelancers with experience in social expression. Works on assignment only. Uses freelancers mainly for greeting cards. Considers any media and a wide variety of styles. 40% of freelance work demands knowledge of Adobe Illustrator, Adobe Photoshop and QuarkXPress. Produces material for all holidays and seasons. Submit seasonal material 1 year in advance.

First Contact & Terms: Send query letter with résumé, SASE, tearsheets, photographs, photocopies, photostats, slides, transparencies. Samples are filed if accepted or returned by SASE. Reports back within 1 week. Company will contact artist for portfolio review if interested. Portfolio should include final art, tearsheets, photographs, transparencies. "Artwork is bought outright—all rights and art belong to company." Originals are not returned. Pays by the project, or flat fee, varies.

Tips: "Excellent drawing skills are essential. Must be diversified in all media; experience in social expression field is a definite advantage."

‡GLITTERWRAP, INC., 701 Ford Rd., Rockaway NJ 07866. (201)625-4200. Fax: (201)625-9641. Art Director: Danielle Grassi. Estab. 1987. Produces giftwrap, totes, ribbons, bows, wrap accessories (enclosure cards) for all ages—party and special occasion market.

Needs: Approached by 30-50 freelance artists/year. Works with 10-15 freelancers/year. Buys 10-30 designs and illustrations/year. Prefers artists with experience in textile design who are knowledgable in repeat patterns or surface. Uses freelancers mainly for design. Also for calligraphy and mechanicals. Considers gouache, oil, acrylic, cut paper, watercolor and mixed media. Style varies with season and year. Consider trends and designs already in line, as well as up and coming motifs in gift market. 50-60% of freelance work demands knowledge of QuarkXPress, Aldus FreeHand, Adobe Illustrator and Adobe Photoshop. Produces material for Halloween, Christmas, graduation, birthdays, Valentine's Day, Hanukkah and everyday. Submit seasonal material 6-8 months in advance.

First Contact & Terms: Send query letter with brochure, tearsheets, photographs, slides, transparencies or color copies of work. Samples are filed or are returned by SASE if requested. Reports back in 1-2 weeks. Write for appointment to show portfolio or mail appropriate materials, which should include slides, color tearsheets, dummies, mechanicals and finished art samples. Rights purchased vary according to project. Pays by the hour, $10-25; or royalties of 5-6%.

Tips: "Giftwrap generally follows the fashion industry lead with respect to color and design. Adult birthday and baby shower/birth are fast growing categories. There is a need for good/fresh/fun typographic birthday designs in both adult and juvenile categories."

‡**GOES LITHOGRAPHING COMPANY SINCE 1879**, 42 W. 61st St., Chicago IL 60621-3999. (312)684-6700. Fax: (312)684-2065. Contact: W.J. Goes. Estab. 1879. Produces stationery/letterheads to sell to printers and office product stores.

Needs: Approached by 1-2 freelance artists/year. Works woth 2-3 freelance artists/year. Buys 4-30 freelance designs and illustrations/year. Uses freelance artists mainly for designing holiday letterheads. Considers pen & ink, color, acrylic, watercolor. Prefers final art 17×22. Produces material for Christmas and Thanksgiving.

First Contact & Terms: Contact W.J. Goes. "I will send examples for your ideas." Samples are not filed and are returned by SASE. Reports back within 1-2 months. Pays $125-$300 on final acceptance. Buys first rights and reprint rights.

GREAT AMERICAN PUZZLE FACTORY INC., 16 S. Main St., S. Norwalk CT 06854. (203)838-4240. Fax: (203)838-2065. President: Pat Duncan. Estab. 1975. Produces jigsaw puzzles and games for adults and children.

Needs: Approached by 100 freelancers/year. Works with 50 freelancers/year. Buys 120 designs and illustrations/year. Uses freelancers mainly for puzzle material. Art guidelines for SASE with first-class postage. Looking for "fun, involved and colorful" work. 100% of design requires knowledge of QuarkXPress, Adobe Illustrator or Adobe Photoshop.

First Contact & Terms: Send postcard sample or query letter with brochure, tearsheets and photocopies. Do not send originals or transparencies. Samples are filed or are returned. Art Director will contact artist for portfolio review if interested. Original artwork is returned at job's completion. Pays by project. Pays royalties of 5%. Rights purchased vary according to project. Interested in buying second rights (reprint rights) to previously published work.

Tip: "All artwork should be *bright*, cheerful and eye-catching. 'Subtle' is not an appropriate look for our market."

GREAT ARROW GRAPHICS, 2495 Main St., Suite 432, Buffalo NY 14214. (716)836-0408. Fax: (716)836-0702. Art Director: Alan Friedman. Estab. 1981. Produces greeting cards and stationery. "We produce silkscreened greeting cards—seasonal and everyday—to a high-end design-conscious market."

Needs: Approached by 30 freelancers/year. Works with 6-8 freelancers/year. Buys 60-80 images/year. Art guidelines for SASE with first-class postage. Prefers freelancers with experience in hard-separated art. Uses freelancers mainly for greeting card design. Considers all 2-dimensional media. Looking for sophisticated, classic or contemporary styles. 75% of design requires knowledge of QuarkXPress, Adobe Illustrator or Adobe Photoshop. Produces material for all holidays and seasons. Submit seasonal material 6-8 months in advance; Christmas, 1 year in advance.

First Contact & Terms: Send query letter with photocopies and SASE. Accepts submissions on disk compatible with QuarkXPress, Adobe Illustrator or Adobe Photoshop. Samples are filed or returned if requested. Reports back within 1 month. Art Director will contact artist for portfolio review if interested. Portfolio should include color roughs, final art, photographs and transparencies. Originals are returned at job's completion. Pays royalties of 5% of net sales. Rights purchased vary according to project.

Tips: "We are most interested in artists familiar with hand-separated process and with the assets and limitations of screenprinting."

*****GREETWELL**, D-24, M.I.D.C., Satpur, Nasik 422 007 India. Fax: 91-253-351381. Chief Executive: V.H. Sanghavi. Produces greeting cards, calendars and posters.

Needs: Approached by 50-60 freelancers/year. Buys 50 designs/year. Uses freelancers mainly for greeting cards and calendars. Prefers flowers, landscapes, wildlife and general themes.

First Contact & Terms: Send query letters and photocopies to be kept on file. Samples not filed are returned only if requested. Reports within 1 month. Originals are returned at job's completion. Pays flat fee of $25 for design. Buys reprint rights.

Tips: "Send color photos. No SASE."

‡**JAN HAGARA COLLECTABLES, INC.**, 40114 Industrial Park, Georgetown TX 78626. (512)863-8187. Fax: (512)869-2093. Art Director: Kim DeAngel. Estab. 1975. Produces limited-edition collectibles (e.g. prints, plates, figurines, dolls, notecards and stationery products). "We design and market a line of collectible giftware with a romantic Victorian theme. Our products appeal to women in an 'empty nest' situation who prefer 'pretty' things of uniqueness and value."

Needs: Approached by 100 freelance artists/year. Works with 7 or more freelancers/year. Buys 20 designs and illustrations/year. Prefers watercolor or clay or wax sculpture. Works on assignment only. Uses freelancers mainly for executing concepts in two and three dimensions—packaging, inserts, line drawings that resemble old-fashioned engravings and sculpture. Also for calligraphy, P-O-P displays, T-shirt art (mechanical separations), jewelry sculpting (charm bracelets), coffee mug art (mechanical separations), cloisonné pin art, cross-stitch development. For 2-D work, prefers watercolor/colored pencil and pen & ink. For 3-D work, prefers wax, Sculpey, clay. "We're in need of Romantic Victorian work—turn-of-the-century nostalgia. Our subjects are children, flowers, ribbons and bows. We're also interested in the amusements of childhood: toys, dolls, teddy bears."

First Contact & Terms: Send query letter with photostats, photographs, slides, transparencies and SASE. "Do not send original work." Samples are filed or are returned by SASE if requested by artist. Reports back to the artist only if interested. To show portfolio, mail photostats of lettering or one-color artwork and tearsheets or photographs of color work. Originals usually not returned at job's completion. Pays by the project, $35-2,000. Rights purchased vary according to project.

Tips: "Show, don't tell. We don't require 'professionalism,' lawyers, or agents. We simply want creative people with a feel for our style. The only way to know if you've got what we need is to let us see your work. Although we don't require computer skills for our freelancers, we have moved to inhouse prepress ourselves. We have virtually eliminated photography by using a digital studio camera which feeds directly into our computer system. Artists should be aware that digital prepress is very much the trend and should become familiar with software for graphics, particularly QuarkXPress and Adobe Photoshop. We also see a development in prototyping of sculpted items using computers. We are experimenting with x-ray technology and CAD software to develop plastic prototypes outof laser scintering. Sculptors interested in this trend should become familiar with STL files and CAD/CAM."

HALLMARK CARDS, INC., P.O. Box 419580, Drop 216, Kansas City MO 64141-6580.
● Because of Hallmark's large creative staff of fulltime employees and their established base of freelance talent capable of fulfilling their product needs, they are not accepting freelance submissions.

THE HAMILTON COLLECTION, 4810 Executive Park Court, Jacksonville FL 32216-6069. (904)279-1300. E-mail: thc!thc1!postoffice!mcgoldrick@attmail.com. Artist Liaison, Product Development: Kathryn McGoldrick. Direct marketing firm for collectibles: limited edition plates, sculpture, dolls, jewelry and general gifts. Clients: general public, specialized lists of collectible buyers and retail market in US, Great Britain, Canada, France and Germany.

Needs: Approached by 100 freelancers/year. Works with 100-200/year. Assigns all jobs (200-400) to freelancers/year. "No restrictions on locality but must have quality work and flexibility regarding changes." Uses freelancers for product design and illustration for 3-D and 2-D products. Needs fine art or tight illustration for plates. 15% of freelance work demands computer skills.

First Contact & Terms: Send query letter with brochure, photocopies, photographs, SASE, slides, tearsheets and transparencies. Samples will be returned if requested (must include a SASE or appropriate package with sufficient postage). "Please do not send original art; preferences are for photographs, slides, transparencies, and/or tearsheets." Reports within 6-12 weeks. Artist should follow-up with letter after initial query. Sometimes requests work on spec before assigning a job. Pays by project, $100-1,500. Sometimes interested in buying second rights (reprint rights) to previously published work "for product development in regard to collectibles/plates; artwork must be suitable for cropping to a circular format."

Tips: Open to a wide range of styles. "We aggressively seek out new talent for our product development projects through every avenue available. Attitude and turnaround time are important. Be prepared to offer sketches on speculation. This is a strong market (collectibles) that has continued its growth over the years, despite economic slumps."

‡HAMPSHIRE PEWTER COMPANY, 43 Mill St., Box 1570, Wolfeboro NH 03894-1570. (603)569-4944. Fax: (603)569-4524. President: Bob Steele. Estab. 1974. Manufacturer of handcast pewter tableware, accessories and Christmas ornaments. Clients: jewelry stores, department stores, executive gift buyers, tabletop and pewter speciality stores, churches and private consumers.

Needs: Works with 3-4 freelance artists/year. "Prefers New-England based artists." Works on assignment only. Uses freelancers mainly for illustration and models. Also for brochure and catalog design, product design, illustration on product and model-making.

First Contact & Terms: Send query letter with photocopies. Samples are not filed and are returned only if requested. Call for appointment to show portfolio, or mail b&w roughs and photographs. Pays for design and sculpture by the hour or project. Considers complexity of project, client's budget and rights purchased when determining payment. Buys all rights.

Tips: "Inform us of your capabilities. For artists who are seeking a manufacturing source, we will be happy to bid on manufacturing of designs under private license to the artists, all of whose design rights are protected. If we commission a project, we intend to have exclusive rights to the designs by contract as defined in the Copyright Law and we intend to protect those rights."

H&L ENTERPRISES, 1844 Friendship Dr., El Cajon CA 92020. (619)448-0883. Fax: (619)448-7935. Vice President: Carol Lorsch. Estab. 1978. Produces posters, novelty, humorous signs and magnets for all ages (6-adult).
Needs: Approached by 25 freelancers/year. Works with 4 freelancers/year. Prefers freelancers with experience in art for silk screen process. Art guidelines free for SASE with first-class postage. Must have cartoon-like style and imagination in illustrating humorous slogans. Works on assignment only. Uses freelancers mainly for product illustration. Looking for simple, cartoon style.
First Contact & Terms: Send query letter with tearsheets and photocopies. "If you want samples back include SASE." Accepts disk submissions compatible with Adobe Illustrator. Reports back within 15 days. "Be sure to provide phone number." Art Director will contact artist for portfolio review if interested. Artist should follow-up with call after initial query. Requests work on spec before assigning a job. Originals are not returned. Pays flat fee of $25 for quick illustration/design; royalties vary. Considers buying second rights (reprint rights) to previously published work and rights to licensed characters. Finds artists through word of mouth and artists' reps.
Tips: "We're not interested in fine art. Interested in quick-sketch illustrations of humorous sayings. Don't use scanners to copy others' work and plagiarize it."

‡HANNAH-PRESSLEY PUBLISHING, 1232 Schenectady Ave., Brooklyn NY 11203-5828. (718)451-1852. Fax: (718)629-2014. President: Melissa Pressley. Estab. 1993. Produces calendars, giftwrap, greeting cards, stationery, murals. "We offer design, illustration, writing and printing services for advertising, social and commercial purposes. We are greeting card specialists."
Needs: Approached by 10 freelancers/year. Works on assignment only. Uses freelancers mainly for pattern design, invitations, advertising, cards. Also for calligraphy, mechanicals, murals. Considers primarily acrylic and watercolor, but will consider others. Looking for upscale, classic; rich and brilliant colors; traditional or maybe Victorian; also adult humor. Produces material for Christmas, Mother's Day, Father's Day, graduation, Kwanzaa, Valentine's Day, birthdays, everyday, ethnic cards (black, hispanic, Caribbean), get well, thank you, sympathy, secretary's day.
First Contact & Terms: Send query letter with slides, color photocopies, résumé, SASE. Samples are filed or returned by SASE. Reports back only if interested. Company will contact artist for portfolio review if interested. Portfolio should include b&w, color, final art, slides. Rights purchased vary according to project. Payment varies according to project. Finds freelancers through submissions, *Creative Black Book*.
Tips: "Please be honest about your expertise and experience."

‡HERITAGE COLLECTION, 79 Fifth Ave., New York NY 10003. (212)647-1000. Fax: (212)647-0188. President: Reginald Powe. Estab. 1988. Produces greeting cards, gift bags, giftwrap, mugs, placemats, etc., for the African-American.
Needs: Approached by 20-30 freelance artists/year. Works with 3-5 freelance artists/year. Buys 40-80 new freelance designs and illustrations/year. Uses freelance artists mainly for card art and verse. Considers all media. Produces material for all holidays and seasons, birthdays and Kwanzaa. Submit seasonal material 1 year in advance.
First Contact & Terms: Send query letter with SASE, tearsheets, photographs, photocopies and photostats. Samples are filed or are returned by SASE. Reports back within 1 month. Call for appointment to show portfolio of original/final art, color tearsheets. Originals are returned at job's completion. Pays royalty or buys all rights on work-for-hire basis.

HIGH RANGE GRAPHICS, 365 N. Glenwood, P.O. Box 3302, Jackson WY 83001. President: Jan Stuessl. Estab. 1989. Produces T-shirts. "We produce screen-printed garments for recreational sport-oriented markets and resort markets, which includes national parts. Subject matter includes, but is not limited to, skiing, climbing, hiking, biking, fly fishing, mountains, out-of-doors, nature and rafting, Native American, wildlife and humorous sayings that are text only or a combination of text and art. Our resort market customers are men, women and kids looking to buy a souvenir of their vacation experience or activity. People want to identify with the message and/or the art on the T-shirt."
Needs: Approached by 20 freelancers/year. Works with 3-8 freelancers/year. Buys 10-20 designs and illustration/year. Prefers artists with experience in screen printing. Uses freelancers mainly for T-shirt ideas and artwork and color separations. Art guidelines for SASE with first-class postage.
First Contact & Terms: Send query letter with résumé, SASE and photocopies. Accepts submissions on disk compatible with Aldus FreeHand 3.1. Samples are filed or are returned by SASE if requested by artist. Reports back within 3 months. Company will contact artist for portfolio review if interested. Portfolio should include b&w thumbnails, roughs and final art. Originals are returned at job's completion. Pays by project, $300 minimum; royalties of 5%. Buys garment rights.
Tips: "Familiarize yourself with screen printing and T-shirt art that sells. Knowledge of color separations a plus. We look for creative design styles and interesting color applications. Artists need to be able to incorporate the colors of the garments as part of their design thinking, as well as utilize the screen printing medium to produce interesting effects and textures. However, sometimes simple is best. Four-color process

will be considered if highly marketable. Be willing to work with us on design changes to get the most marketable product."

HIXON & FIERING, INC., 3734 W. 95th St., Leawood KS 66206. Fax: (913)438-1201. Art Director: Suzie Turner. Estab. 1987. Produces birth announcements and invitations. "We started out as a birth announcement company, branched off into children's party invitations and now do party invitations for adults as well."
Needs: Approached by 30 freelancers/year. Works with 5 freelancers/year. Buys 20-30 freelance designs and illustrations/year. Uses freelancers mainly for card design. Also interested in calligraphy. Art guidelines available. Buys art outright and by assignment. "If the artist has a style we like and is a good conceptualizer, we will approve a sketch, then he gives us the final product." Considers watercolor, acrylic (soft) and pastels. Also interested in computer generated art using Adobe Illustrator, Adobe Photoshop, QuarkXPress and Fractal Painter. Prefers high quality, whimsical, but not cartoonish artwork for the baby and children's lines. Nothing that could be construed as negative or off-color in any way. Prefers work that is soft, happy and colorful. Produces seasonal material for Christmas, New Year, Valentine's Day, Halloween, graduation and birthdays. Submit seasonal material 6 months in advance.
First Contact & Terms: Send query letter with color copies of work. "Please do not call. Will only take mail or fax inquiries." Samples are filed or are returned. Reports back in 1 month. Company will contact artist for portfolio review of final art if interested. Buys all rights. Originals are not returned at job's completion. Pays flat fee, $100-750.
Tips: "We are starting to work on some lines of elegant, embossed and foil stamped cards for birth, christening and adult invitations. So, we need the soft, warm and cuddly children's things as well as elegant formal designs. We look for refined talent with a sweet look for our birth announcement line."

HOFFMASTER, (formerly Chesapeake Consumer Products Co.) 2920 N. Main St., Oshkosh WI 54903. (414)235-9330. Fax:(414)235-1642. Senior Marketing Manager: Ralph Rich or Creative Managers. Produces decorative paper tableware, placemats, plates, tablecloths and napkins for institutional and consumer markets. Printing includes up to 6-color flexographic napkin printing.
Needs: Approached by 20-30 freelancers/year. Works with 5-10 freelancers/year. Prefers freelancers with experience in paper tableware products. Art guidelines and specific design needs based on current market are available from Creative Managers. Looking for trends and traditional styles. Prefers 9″ round artwork with coodinating 6.5″ square image. Produces material for all holidays and seasons and everyday.
First Contact & Terms: Send query letter with photocopies, résumé, appropriate samples and SASE. Ideas may be sent in a color rough sketch. Accepts disk submissions compatible with Adobe Illustrator and Aldus FreeHand. Samples are files or returned by SASE if requested by artist. Reports back only if interested. Creative Manager will contact artist for portfolio review if interested. Portfolio should include thumbnails, roughs, finished art samples, color photostats, tearsheets, photographs and dummies. Buys artwork outright. Rights purchased vary according to project. Pays by the project $350-1500. Amounts vary according to project. May work on a royalty arrangement for recognized properties. Finds freelancers through art fairs and artists' reps.
Tips: Looking for new trends and designs appropriate for plates and napkins.

‡HOME INTERIORS & GIFTS, 4550 Spring Valley Rd., Dallas TX 75244. (214)386-1000. Fax: (214)233-8825. Artist Representative: Robbin Allen. Art Director: Louis Bazan. Estab. 1957. Produces decorative framed art in volume to public by way of shows in the home. "H.I.& G. is a direct sales company. We sell nationwide with over 35,000 consultants in our sales force. We work with artists to design products for our new product line yearly. We work with some publishers now, but wish to work with more artists on a direct basis."
Needs: Approached by 75 freelance artists/year. Works with 25-30 freelancers/year. "We carry approximately 450-500 items in our line yearly." Prefers artists with knowledge of current colors and the decorative art market. "We give suggestions but we do not dictate exacts. We would prefer the artists express themselves through their individual style. We will make correction changes that will enhance each piece for our line." Uses freelance artists mainly for artwork to be framed (oil and watercolor work mostly). Also for calligraphy. Considers oil, watercolor, acrylic, pen & ink, pastels, mixed media. "We sell to middle America for the most part. Our art needs to be traditional with a sense of wholesomeness to it. For example: a hunter with dog, but no gun. We sell Victorian, country, landscapes, still life, wildlife. Art that tells a story. We also sell a mild contemporary." Produces material for Father's Day, Halloween, Christmas, Easter, graduation, Thanksgiving, Mother's Day. Submit seasonal material 10 months in advance.
First Contact & Terms: Send query letter with résumé, SASE, photographs, slides and transparencies. Samples are filed or are returned by SASE. Art Director will contact artist for portfolio review if interested. Portfolio should include color slides, photographs. Requests work on spec before assigning a job. Pays royalties. Royalties are discussed on an individual basis. Buys reprint rights. Finds artists through word of mouth, magazines, submissions, sourcebooks and visiting artist's exhibitions.
Tips: "This is a great opportunity for the artist who is willing to learn our market. Paint for women because women are our customers. Paintings need softness in form—not rugged and massive/strong or super dark.

Jewel tones are great for us. Study Monét—good colors there. Our art demands are unique. The artist will work with our design department to stay current with our needs."

THE HUMORSIDE OF IT . . . , 7030 Etiwanda Ave., Reseda CA 91335. (310)838-4511. Owner: Lorenzo Griffis. Estab. 1990. Produces greeting cards with personalized printing. Makes "very humorous greeting cards; very colorful, loaded with different fonts; directed to all ages; very modern graphics."
Needs: Approached by 50-60 freelancers/year. Works with 2 freelancers/year. Prefers local artists with experience in humor and graphics cartoons. Art guidelines available. Works on assignment only. Uses free-lancers mainly for cartoons, humor and graphics. 50% of design and 10% of illustration demand knowledge of Aldus PageMaker and CorelDraw. Produces material for all holidays and seasons, Christmas, Valentine's Day, Mother's Day, Father's Day and everyday. Submit seasonal material 3 months in advance.
First Contact & Terms: Send brochure and SASE. Samples are filed. Reports back within 2 weeks. Company will contact artist for portfolio review if interested. Portfolio should include photographs. Rights purchased vary according to project. Originals are returned at job's completion. Pays by project, royalties of 3%. Finds artists through submissions.

HURLIMANN ARMSTRONG STUDIOS, Box 1246, Menlo Park CA 94026. (415)325-1177. Fax: (415)324-4329. Managing General Partner: Mary Ann Hurlimann. Estab. 1987. Produces greeting cards and enclosures, fine art folders, stationery, portfolios and pads.
Needs: Approached by 60 freelance artists/year. Works with 6 freelancers/year. Buys 16 designs/year. Con-siders watercolor, oil and acrylic. No photography. Prefers rich color, clear images, no abstracts. "We have some cards that use words as the central element of the design." Not interested in computer-generated art.
First Contact & Terms: Send query letter with slides. Samples are not filed and are returned by SASE if requested by artist. Art Director will contact artist for portfolio review if interested. Originals are returned at job's completion. Requests work on spec before assigning a job. Pays by project, $250-300; royalties of 5% or fixed fee. Buys all rights.
Tips: "Send good quality slides of your work."

‡idesign **GREETINGS, inc.**, 12020 W. Ripley Ave., Milwaukee WI 53226. (414)475-7176. Fax: (414)475-7566. President: Eileen Grasse. Estab. 1980. Produces greeting cards, stationery. "We direct our market to all ages from birth on. Cards are light and happy with short, sincere messges."
Needs: Prefers artists with experience in watercolor. Works on assignment only. Uses freelancers mainly for greeting card designs. Considers watercolor and colored pencil. "Looking for strong design with border detail—predominately floral." Produces material for all holidays and seasons. Submit seasonal material 1 year in advance.
First Contact & Terms: Send query letter with brochure, résumé, SASE, tearsheets, photographs. Samples are filed. Reports back within 2 months. Call or write for appointment to show portfolio; or mail appropriate materials. Portfolio should include finished art samples, color tearsheets and dummies. Buys all rights. Pays by the project, $200 minimum.

‡**IGPC**, 460 W. 34th St., 10th Floor, New York NY 10001. (212)629-7979 or (800)445-6669. Contact: Art Department. Agent to foreign governments. "We produce postage stamps and related items on behalf of 40 different foreign governments."
Needs: Approached by 50 freelance artists/year. Works with 75-100 freelance illustrators and designers/year. Assigns several hundred jobs to freelancers/year. Prefers artists within metropolitan New York or tri-state area. Must have excellent design and composition skills and a working knowledge of graphic design (mechanicals). Artwork must be focused and alive (4-color) and reproducible to stamp size (usually 4 times up). Works on assignment only. Uses artists for postage stamp art. Prefers airbrush, acrylic and gouache (some watercolor and oil OK).
First Contact & Terms: Send samples. Reports back within 5 weeks. Art Director will contact artist for portfolio review if interested. Portfolio should contain "4-color illustrations of realistic, tight flora, fauna, technical subjects, autos or ships. Also include reduced samples of original artwork." Sometimes requests work on spec before assigning a job. Pays by the project, $1,000-4,000. Consider government allowance per project when establishing payment.
Tips: "Artists considering working with IGPC must have excellent drawing abilities in general or specific topics, i.e., flora, fauna, transport, famous people, etc.; sufficient design skills to arrange for and position type; the ability to create artwork that will reduce to postage stamp size and still hold up with clarity and perfection. Must be familiar with printing process and print call-outs. Generally, the work we require is

FOR A LIST of markets interested in humorous illustration, cartooning and caricatures, refer to the Humor Index at the back of this book.

realistic art. In some cases, we supply the basic layout and reference material; however, we appreciate an artist who knows where to find references and can present new and interesting concepts. Initial contact should be made by phone for appointment."

THE IMAGINATION ASSOCIATION, 8041 Foothill Blvd., Sunland CA 91040. (818)353-0804. Fax: (818)353-8914. Creative Director: E.J. Tobin. Estab. 1992. Produces greeting cards, T-shirts, mugs, aprons and magnets. "We are primarily a freelance design firm that has been quite established with several major greeting card and T-shirt companies who, in fact, produce our work. We have a sub-division that manufactures cutting edge, contemporary aprons and T-shirts for the gourmet food market."
Needs: Works with 12 freelancers/year. Artists must be fax accessible and able to work on fast turnaround. Uses freelancers for everything. Considers all media. "We're open to a variety of styles." 10% of freelance work demands knowledge of Adobe Illustrator, Adobe Photoshop and QuarkXPress. "That is rapidly increasing as many of our publishers are going to disk." Produces material for all holidays and seasons. Submit seasonal material 18 months in advance.
First Contact & Terms: Send query letter with brochure, photographs, SASE and photocopies. Samples are filed or returned by SASE if requested by artist. Company will contact artist for portfolio review if interested. Portfolio should include final art, photographs or any material to give indication of range of artist's style. Negotiates rights purchased. Originals are returned at job's completion. Pays royalties—the amount is variable depending on assignment. Finds artists via word of mouth from other freelancers or referrals from publishers.
Tips: Looking for artist "with a style we feel we can work with and a professional attitude. Understand that sometimes our publishers and manufacturers require several revisions before final art and all under tight deadlines. Shelf space for greeting cards on the retail level is becoming extremely competitive, forcing more publishers to test market products or try to guess what will sell. The bottom line is it's all a crap shoot out there! But it's a good thing because, from a commercial point of view, if there were any sure things, we'd all be forced into following the same trend."

INCOLAY STUDIOS INCORPORATED, 445 North Fox St., San Fernando CA 91340. Fax: (818)365-9599. Art Director: Shari Bright. Estab. 1966. Manufacturer. "Basically we reproduce antiques in Incolay Stone, all handcrafted here at the studio. There were marvelous sculptors in that era, but we believe we have the talent right here in the USA today and want to reproduce living American artists' work."
Needs: Prefers local artists with experience in carving bas relief. Uses freelance artists mainly for carvings. Also uses artists for product design and model making.
First Contact & Terms: Send query letter with résumé, or "call and discuss; 1-800-INCOLAY." Samples not filed are returned. Reports back within 1 month. Call for appointment to show portfolio. Pays royalties; pays by project, $100-2,000. Negotiates rights purchased.
Tips: "Do the best you can Discuss the concept and see if it is right for 'your talent.' "

‡INKADINKADO, INC., 60 Cummings Park, Woburn MA 01801. (617)938-6100. Fax:(617)938-5585. President: Ron Gelb. Produces gifts, greeting cards, mugs, school supplies, stationery, toys, novelty rubber stamps.
Needs: Approached by 20 freelancers/year. Works with 5 freelancers/year. Buys 5 freelance designs and illustrations/year. Prefers freelancers with experience in stamp industry. Uses freelancers mainly for illustration for stamps. Also for freelance production work. Considers pen & ink. Looking for all styles but cute is best. Prefers small; about 2×3. 100% of design work demands knowledge of Adobe Photoshop, QuarkXPress, Adobe Illustrator. Knowledge of Aldus FreeHand, Adobe Illustrator helpful for illustration but not required. Produces material for all holidays and seasons. Submit seasonal material 6-8 months in advance.
First Contact & Terms: Designers send query letter with brochure, résumé and photocopies. Illustrators send postcard sample or query letter with résumé and photocopies. Accepts submissions on disk. Samples are filed and not returned. Reports back only if interested. Artist should follow-up with call after initial query. Company will contact artist for portfolio of b&w and final art review if interested. Pays by project. Buys all rights.

‡INSTANT PRODUCTS INC., P.O. Box 33068, Louisville KY 40232. (502)367-2266. Fax: (502)368-6958. Art Director: R.K.Beck. Estab. 1984. Toy manufacturer of foam encapsulated toys. Clients: retail stores, chain stores. Current clients include WalMart, Walgreens, McKesson Service Merchandisers.
Needs: Approached by 3 freelance artists/year. Prefers experienced illustrators. Works on assignment only. Uses the work of freelance artists mainly for package illustration. Prefers traditional style, any media. Also uses freelance artists for advertising, brochure and catalog illustration and product rendering.
First Contact & Terms: Send query letter with résumé and appropriate samples. Samples are filed. Reports back to the artist only if interested. Write to schedule an appointment to show a portfolio. Portfolio should include roughs, original, final art, tearsheets and photographs. Buys all rights.

INTERCONTINENTAL GREETINGS LTD., 176 Madison Ave., New York NY 10016. (212)683-5830. Fax: (212)779-8564. Creative Marketing Director: Robin Lipner. Sells reproduction rights on a per country,

per product basis. Licenses and syndicates to 4,500-5,000 publishers and manufacturers in 50 different countries. Products include greeting cards, calendars, prints, posters, stationery, books, textiles, heat transfers, giftware, china, plastics, toys and allied industries, scholastic items and giftwrap.

Needs: Approached by 500-700 freelancers/year. Assigns 400-500 jobs and 1,500 designs and illustrations/year. Buys illustration/design mainly for greeting cards and paper products. Also buys illustration for giftwrap, calendars, giftware and scholastic products. Uses traditional as well as humorous and cartoon-style illustrations. Art guidelines available for SASE with first-class postage. Accepts airbrush, watercolor, colored pencil, acrylic, pastel, marker and computer illustration. Prefers "clean work in series format. All card subjects are considered. 20% of freelance work demands knowledge of Adobe Illustrator, Aldus FreeHand or Adobe Photoshop.

First Contact & Terms: Send query letter and/or résumé, brochure, tearsheets, slides, photocopies, photographs and SASE. Request portfolio review in original query. Artist should follow-up after initial query. Portfolio should include color tearsheets and photographs. Pays for original artwork by flat fee. Pays 20% royalties upon sale of reproduction rights on greeting cards, giftwrap and gift items. Contractual agreements made with artists and licensing representatives; will negotiate reasonable terms. Provides worldwide promotion, portfolio samples (upon sale of art) and worldwide trade show display. Finds artists through word of mouth, self-promotions, visiting artists' exhibitions and artists' reps.

Tips: "Perhaps we'll see more traditional/conservative subjects and styles due to a slow economy. More and more of our clients need work submitted in series form, so we have to ask artists for work in a series or possibly reject the odd single designs submitted. Make as neat and concise a presentation as possible with commercial application in mind. Artists often send too few samples, unrelated samples or sloppy, poor quality reproductions. Show us color examples of at least one finished piece as well as roughs."

THE INTERMARKETING GROUP, 29 Holt Rd., Amherst NH 03031. (603)672-0499. President: Linda L. Gerson. Estab. 1985. Licensing agent for greeting cards, stationery, calendars, posters, paper tableware products, tabletop, dinnerware, giftwrap, eurobags, giftware, toys, needle crafts. The Intermarketing Group is a full service merchandise licensing agency representing artists' works for licensing with companies in consumer goods products including the paper product, greeting card, giftware, toy, housewares, needlecraft and apparel industries.

Needs: Approached by 100 freelancers/year. Works with 6 freelancers/year. Licenses work as developed by clients. Prefers freelancers with experience in full-color illustration. Uses freelancers mainly for tabletop, cards, giftware, calendars, paper tableware, toys, bookmarks, needlecraft, apparel, housewares. Will consider all media forms. "My firm generally represents highly illustrated works, characters and humorous illustrations for direct product applications. All works are themed." Prefers 5×7 or 8×10 final art. Produces material for all holidays and seasons and everyday. Submit seasonal material 6 months in advance.

First Contact & Terms: Send query letter with brochure, tearsheets, résumé, slides, SASE or color copies. Samples are not filed and are returned by SASE. Reports back within 3 weeks. Originals are returned at job's completion. Requests work on spec before assigning a job. Pays royalties of 3-10%. Buys all rights. Considers buying second rights (reprint rights) to previously published work. Finds new artists "mostly by referrals and via artist submissions. I do review trade magazines, attend art shows and other exhibits to locate suitable clients."

Tips: "Companies today seem to be leaning towards the tried and true traditional art approach. Economic times are tough so companies are selective in their licenses. A well-organized presentation is very helpful."

‡INTERNATIONAL PRODUCT DEVELOPMENT CORPORATION, 8 Main St., P.O. Box 789, Blairstown NJ 07825. (908)362-7373. Fax: (908)362-9393. Art Director: Jeanna Lane. Estab. 1989. Produces greeting cards. A licensing company selling and publishing art work for greeting cards and paper products for consumers of all ages.

Needs: Approached by 50 freelancers/year. Works with 10 freelancers/year. Buys 1,500 freelance designs and illustrations/year. Prefers freelancers with experience in greeting card and paper products. Uses freelancers mainly for detailed illustrations. Also for calligraphy. Considers all media. Looking for traditional (Christmas and everyday designs) floral. Also needs masculine designs. Prefers in proportion to 5×7. Produces material for Christmas, sympathy, get well, thank you, friendship and everyday. Submit seasonal material 8 months in advance.

First Contact & Terms: Send brochure, photocopies, photographs, photostats, résumé, SASE, slides, tearsheets. After introductory mailing illustrators should send follow-up postcard sample every year. Samples are filed or returned by SASE. Reports in 2 months. Company will contact artist for portfolio review if interested. Buys all rights. Pays flat fee of $150-250/project for illustration or offers yearly contract for 8-10 designs/month.

Tips: "We need fast, quality-minded designers and illustrators."

‡JILLSON & ROBERTS, INC., 5 Watson Ave., Irvine CA 92718. (714)859-8781. Fax: (714)859-0257. Art Director: Josh Neufeld. Estab. 1974. Produces giftwrap and gift bags using more recycled/recyclable products.

Needs: Works with 10 freelance artists/year. Prefers artists with experience in giftwrap design. Considers all media. "We are looking for colorful graphic designs as well as humorous, sophisticated, elegant or contemporary styles." Produces material for Christmas, Valentine's Day, Hanukkah, Halloween, graduation, birthdays, baby announcements and everyday. Submit 3-6 months before holiday.
First Contact & Terms: Send query letter with brochure showing art style, tearsheets and slides. Samples are filed or are returned. Reports back within 3 weeks. To show a portfolio, mail thumbnails, roughs, final reproduction/product, color slides and photographs. Originals not returned. Pays average flat fee of $250; or pays royalties (percentage negotiable).

KEM PLASTIC PLAYING CARDS, INC., Box 1290, Scranton PA 18501. (717)343-4783. Vice President: Mark D. McAleese. Estab. 1937. Produces plastic playing cards. Manufactures high-quality durable cards and markets them worldwide to people of all ages, ethnic backgrounds, etc. Special interest is young people.
Needs: Buys 1-3 designs/illustrations/year. Prefers "freelancers who know composition and colors." Buys freelance design/illustrations mainly for playing cards. Also uses freelancers for calligraphy. Considers watercolor, oil and acrylics. Seeks "good composition with vivid, bouncing colors and color contrasts, always in good taste." Prefers 5½×7. Produces material for all holidays and seasons.
First Contact & Terms: Send query letter with brochure and slides. Samples are not filed and are returned. Reports back within 1 week. To show portfolio, mail roughs and color final reproduction/product, slides, tearsheets and photostats. Originals are returned at job's completion. Pays $500-1,000/illustration. Buys first or one-time rights; negotiates rights purchased.
Tips: "Call Mark D. McAleese at (800)233-4173."

KIPLING CREATIVE DARE DEVILS, P.O. Box 2546, Vista CA 92085-2546. Creative Director: John Kipling. Estab. 1981.
Needs: Approached by 200-250 freelancers/year. Works with 10 freelancers/year. Interested in seeing and working with more freelancers. Prefers freelancers with experience in cartooning and oil painting. Uses freelancers mainly for introduction of new designs, cartoon characters and licensable ideas. Prefers ink renderings, airbrush and watercolor.
First Contact & Terms: Send photocopies and SASE or VHS tapes for animation. Samples are filed. Rights purchased vary according to project. Originals are not returned. Artist will not be given credit— unsigned work only.
Tips: "We need oils of Hawaiian natives, fish, sea, etc."

KOGLE CARDS, INC., 1498 S. Lipan St., Denver CO 80223-3411. President: Patricia Koller. Estab. 1982. Produces greeting cards and postcards for all business situations.
Needs: Approached by 500 freelancers/year. Buys 250 designs and 250 illustrations/year. Art guidelines for SASE with first-class postage. Works on assignment only. Considers all media for illustration. Prefers 5×7 or 10×14 final art. Produces material for Christmas and all major holidays plus birthdays and all occasion; material accepted year-round. Send Attention: Art Director.
First Contact & Terms: Send query letter with brochure, photocopies, photographs and slides. Samples not filed are returned only if SASE included. Reports back within 1 month. To show portfolio, mail color and b&w photostats and photographs. Originals not returned. Pays by project. Pays 5% royalties. Buys all rights.
Tips: "We look for fun work with a hint of business-oriented edge."

L.B.K. MARKETING, (formerly L.B.K. Corp.), 7800 Bayberry Rd., Jacksonville FL 32256-6893. (904)737-8500. Fax: (904)737-9526. Art Director: Barbara McDonald. Estab. 1940. "Four companies feed through L.B.K.: NAPCO and INARCO are involved with manufacturing/distributing for the wholesale floral industry; First Coast Design produces fine giftware; Brinn's produces collectable dolls and seasonal giftware." Clients: wholesale.
 ● L.B.K. Marketing has a higher-end look for their floral market products. They are doing very little decal, mostly dimensional pieces.
Needs: Works with 15 freelance illustrators and designers/year. 50% of work done on a freelance basis. Prefers local freelancers for mechanicals for sizing decals; no restrictions on artists for design and concept. Works on assignment only. Uses freelancers mainly for mechanicals and product design. "Background with a seasonal product such as greeting cards is helpful. 75% of our work is very traditional and seasonal. We're

MARKET CONDITIONS are constantly changing! If you're still using this book and it is 1998 or later, buy the newest edition of *Artist's & Graphic Designer's Market* at your favorite bookstore or order directly from Writer's Digest Books.

also looking for a higher-end product, an elegant sophistication." 10% of freelance work requires computer skills.

First Contact & Terms: Designers send query letter with brochure, résumé, photocopies, photographs, SASE, tearsheets and "any samples we can keep on file." Illustrators send brochure, résumé, photocopies, photographs and SASE. If work in clay, send photographs. Samples are filed or returned by SASE. Reports back in 2 weeks. Artist should follow-up with letter after initial query. Portfolio should include samples which show a full range of illustration style. Sometimes requests work on spec before assigning a job. Pays for design by the project, $25 and up. Pays $15/hour for illustration; or $100-250 by project. Pays $15/hour for mechanicals. Buys all rights. Considers buying second rights (reprint rights) to previously published work. Finds artists through word of mouth and self-promotions.

Tips: "We are very selective in choosing new people. We need artists that are familiar with 3 dimensional giftware and floral containers. We have recently merged with Brinn's. We now will be producing dolls and seasonal giftware. Our market is expanding and so are our needs for qualified artists."

‡THE LANG COMPANIES: Lang Graphics, Main Street Press, Bookmark, Delafield Stamp Company, and R.A. Lang Card Co., 514 Wells St., Delafield WI 53018. (414)646-2211. Fax: (414)646-2224. Product Development: Joyce Quandt. Estab. 1982. Produces high quality linen-embossed greeting cards, stationery, calendars, gift bags, rubber stamps and many more fine paper goods.

Needs: Approached by 300 freelance artists/year. Art guidelines available. Works with 40 freelance artists/year. Buys 600 freelance designs and illustrations/year. Uses freelancers mainly for card and calendar illustrations. Considers watercolor and oil. No photography. Looking for traditional and non-abstract country, folk and fine art styles. Produces material for Christmas, Hanukkah, birthdays and everyday. Submit seasonal material 6 months in advance.

First Contact & Terms: Send query letter with SASE and brochure, tearsheets, photostats, photographs, slides, photocopies or transparencies. Samples are filed or are returned by SASE if requested by artist. Reports back within 6 weeks. "Please do not send originals." Originals are returned at job's completion if requested. Pays royalties based on wholesale sales. Rights purchased vary according to project.

Tips: "Research the company and submit a compatible piece of art. Be patient awaiting a response. A phone call often rushes the review and work may not be seriously considered."

‡LAST UNICORN GAMES, 931 North Front St., #404, Harrisburg PA 17102. (717)221-1119. Fax: (717)221-1042. E-mail: monomyth@lastunicorngames.com. Art Director: Mark Ryberg. Produces fantasy role playing games and card games.

Needs: Approached by 50-100 freelancers/year. Works with approximately 60 freelancers/year. Buys 600 designs and illustrations/year. Prefers freelancers with experience in fantasy, science fiction or horror. Art guidelines available. Uses freelancers mainly for b&w and color illustrations. Considers any color medium, pen & ink, graphite or charcoal. Looking for traditional, gothic, punk, and/or computer generated art (Adobe Photoshop 3.0). "We accept computer-generated art, but the bulk of our needs are met by traditional art."

First Contact & Terms: Send brochure, photocopies, photographs, photostats, résumé, SASE, slides, tearsheets and/or transparencies. Accepts disk submissions formatted for Macintosh file format RGB, Adobe Photoshop 3.0. Samples are filed or returned by SASE. Reports back within 1 month. Portfolios should include "whatever the illustrator has prepared." Artist should follow-up with call and/or letter. Pays flat fee of $25-100 for b&w; $150-500 for color; maximum of $2,000 for color covers. Finds artists through submissions, conventions and word of mouth.

Tips: "Keep us updated on progress and improvement in your portfolio. We have many projects in the works."

‡THE LEMON TREE STATIONERY CORP., 79 Express St., Plainview NY 11803. (516)932-3090. Fax: (516)932-3709. President: I. Mendelsohn. Estab. 1969. Produces greeting cards, birth announcements/invitations.

Needs: Approached by 2-4 freelancers/year. Works with 2 freelancers/year. Buys 10-20 freelance designs and illustrations/year. Buys 100-200 pieces of calligraphy/year. Prefers local designers. Art guidelines available. Works on assignment only. Uses freelancers mainly for paste-up, Mac, designers. Also for calligraphy, mechanicals, paste-up, P-O-P. Looking for traditional, contemporary. 50% of freelance work demands knowledge of Adobe Photoshop, QuarkXPress, Adobe Illustrator.

First Contact & Terms: Send query letter with résumé. Calligraphers send photocopies of work. Samples are not filed and are not returned. Reports back only if interested. Company will contact artist for portfolio review of final art, photostats, thumbnails if interested. Pays for design by the project. Pays flat fee for calligraphy.

‡LOOKINGLASS, INC., 407 N. Paca St., Baltimore MD 21201. (410)547-0333. Fax: (410)547-0336. President: Louis Klaitman. Estab. 1972. Produces greeting cards, games/toys, trendy novelty items. "We are product consultants and recomend new entrepeneurs to different resources for product graphics/3-D construction. We also represent many companies in novelty markets."

Needs: Approached by 2 freelance artists/year. Works with 2 freelancers/year. Prefers artists with experience in trendy novelty items. Works on assignment only. Uses freelancers mainly for logo design, illustration and concepts. Also for P-O-P displays, paste-up, mechanicals and graphics. Produces material for all holidays and seasons. Submit seasonal material 6 months (minimum) in advance.
First Contact & Terms: Send query letter with brochure, résumé, SASE and tearsheets. Samples are returned by SASE only if requested by artist. Reports back to the artist only if interested. To show portfolio, mail tearsheets. Originals not returned. Payment negotiable. Rights purchased vary according to project.

LOVE GREETING CARDS, INC., 1717 Opa Locka Blvd., Opa Locka FL 33054-4221. (305)685-5683. Fax: (305)685-0903. Vice President: Norman Drittel. Estab. 1984. Produces greeting cards, posters and stationery. "We produce cards for the 40- to 60-year-old market, complete lines and photography posters."
● This company has found a niche in targeting middle-aged and older Floridians. Keep this audience in mind when developing card themes for this market. One past project involved a line of cards featuring Florida's endangered wildlife.
Needs: Works with 2 freelancers/year. Buys 20 designs and illustrations/year. Prefers freelancers with experience in greeting cards and posters. Also buys illustrations for high-tech shopping bags. Uses freelancers mainly for greeting cards. Considers pen & ink, watercolor, acrylic, oil and colored pencil. Seeks a contemporary/traditional look. Prefers 5×7 size. Produces material for Hanukkah, Passover, Rosh Hashanah, New Year, birthdays and everyday.
First Contact & Terms: Send query letter, brochure, résumé and slides. Samples are filed or are returned. Reports back within 10 days. Call or write for appointment to show portfolio of roughs and color slides. Originals are not returned. Pays average flat fee of $150/design. Buys all rights.
Tips: "Most of the material we receive from freelancers is of poor quality. We use about 5% of submitted material. We are using a great deal of animal artwork and photographs."

‡MADISON PARK GREETINGS, 1407 11th Ave., Seattle WA 98122-3901. (206)324-5711. Fax: (206)324-5822. Art Director: Mark Jacobsen. Estab. 1984. Produces giftwrap, greeting cards, stationery.
Needs: Approached by 250 freelancers/year. Works with 15 freelancers/year. Buys 400 freelance designs and illustrations/year. Art guidelines available. Works on assignment only. Uses freelancers mainly for greeting cards. Also for calligraphy, reflective art. Considers all paper related media. Prefers finished card size $4\frac{7}{8} \times 7$. 100% of design and 30% of illustration demand knowledge of Aldus PageMaker, Aldus FreeHand, Adobe Photoshop, QuarkXPress, Adobe Illustrator. Produces material for Christmas, Easter, Mother's Day, Father's Day, graduation, New Year, Valentine's Day, birthdays, everyday, sympathy, get well, anniversary, baby congratulations, wedding, thank you, expecting, friendship. Submit seasonal material 10 months in advance.
First Contact & Terms: Designers send photocopies, slides, transparencies. Illustrators send postcard sample or photocopies. Accepts submissions on disk compatible with Adobe Illustrator 5.0. Send EPS files. "Good samples are filed; rest are returned." Company will contact artist for portfolio review of color, final art, roughs if interested. Rights purchased vary according to project. Pays for design by the hour; $20-24 or by the project; pays flat fee of $350-500 and/or royalties of 3-5%.
Tips: "Study European and classic art."

‡MAGIC MOMENTS GREETING CARDS, 10 Connor Lane, Deer Park NY 11729. (516)595-2300. Fax: (516)254-3922. Contact: David Braunstein. Estab. 1938. Produces greeting cards.
Needs: Approached by 20 freelance artists/year. Works with 10 freelance artists/year. Buys 450 freelance designs and illustrations. Prefers artists with experience in greeting cards. Works on assignment basis only. Uses freelance artists for calligraphy. Considers all media. Produces material for all holidays and seasons. Submit seasonal material 9 months in advance.
First Contact & Terms: Send query letter with photostats, photographs, slides and photocopies. Samples are not filed and are returned by SASE. Reports back only if interested. To show a portfolio, mail appropriate materials. Portfolio should include color photographs. Buys all rights. Originals are not returned at job's completion. Pays by the project, $100-125 per design.

MARVART DESIGNS INC., 149 Florida St., Farmingdale NY 11735. (516)420-9765. Fax: (516)420-9784. President: Marvin Kramer. Estab. 1972. Produces plates, engravings and pins.
Needs: Approached by 5-10 freelancers/year. Works with 3-4 freelancers/year. Buys 16-20 freelance designs and illustrations/year. Uses freelancers mainly for new hires. Also uses freelance artists for P-O-P displays, paste-up and mechanicals. Considers all media. Produces material for all holidays and seasons. Submit 6 months in advance.
First Contact & Terms: Send query letter with brochure, résumé, SASE, tearsheets, photographs, photocopies, photostats, slides and transparencies. Samples are filed or are returned by SASE if requested by artist. Reports back within 1 week. Call for an appointment to show portfolio of appropriate samples. Original artwork is returned at the job's completion. Pays royalties of 5-7%. Rights purchased vary according to project.
Tips: "Keep trying."

Linda Hann illustrated this clever thank-you card for Madison Park Greetings/Me Two Co. The inside reads "Thanks a latte." "The colors and art style fit the contemporary look we wanted for this line (called The Daily Grind)," says President Mark Jacobsen. Hann, who has done much work in the greeting card industry, approached the company with her work.

© 1996 Me Two Co.

‡MAYFAIR GAMES, 5641 W. Howard, Niles IL 60714. (847)647-9650. Fax: (847)647-0939. E-mail: mayfair@aol.com. Website: http://www.coolgames.com. Contact: Art Director. Produces board games, card games, collectible cards, role playing games.
Needs: Approached by 150 freelancers/year. Works with 15 freelancers/year. Buys 200 freelance designs and illustrations/year. Art guidelines available. Works on assignment only. Uses freelancers mainly for illustration. Considers all media. 100% of design work demands knowledge of Adobe Photoshop, Adobe Illustrator, QuarkXPress. Produces material for all holidays and seasons.
First Contact & Terms: Designers send query letter with photocopies, résumé. Illustrators send query letter with photocopies, photographs. Accepts disk submissions compatible with Macintosh. Samples are filed. Reports back only if interested. Will contact for portfolio review of b&w, color, final art, photographs if interested. Rights purchased vary according to project. Finds freelancers through schools.

‡FRANCES MEYER, INC., 104 Coleman Blvd., Savannah GA 31408. (912)748-5252. Fax: (912)748-8378. Stationery Manager: Katherine Trosdal. Estab. 1979. Produces giftwrap, stationery and party supplies. "We produce a number of items for the gift and party industry as well as an ever-growing number of stationery-related products. Our products are directed to consumers of all ages. We have everything from birth announcements to shower and wedding invitations."
Needs: Works with 5-6 freelance artists/year. Commissions 100 freelance illustrations and designs/year. Works on assignments only. Uses freelancers mainly for stationery-related products. "Most of our artists work in either watercolor or acrylic. We are open, however, to artists who work in other media." Looking for "everything from upscale and sophisticated adult theme-oriented paper items, to fun, youthful designs for birth announcements, baby and youth products. Diversity of style, originality of work, as well as technical skills are a few of our basic needs." Produces material for Christmas, graduation, Thanksgiving (fall), New Year's, Halloween, birthdays, everyday, weddings, showers, new baby, etc. Submit seasonal material 2-3 months in advance.
First Contact & Terms: Send query letter with tearsheets, slides, SASE, photocopies, transparencies and "as much information as is necessary to show diversity of style and creativity." Samples are not filed and are returned by SASE if requested by artist. Reports back within 2-3 weeks. Company will contact artist for portfolio review if interested. Originals are returned at job's completion. Pays royalty (varies).
Tips: "Generally, we are looking to work with a few talented and committed artists for an extended period of time. Our outside artists are given ample coverage in our catalog as we tend to show collections of each design. We do not 'clean out' our line on an annual basis just to introduce new product. If an item sells, it will remain in the line. Punctuality concerning deadlines is a necessity."

MILLROCK INC., P.O. Box 974, Sanford ME 04073. (207)324-0041. Fax: (207)324-0134. Creative Director: Kristi Kamps. Estab. 1979. Produces store fixtures.
 ● This company is a display manufacturer of "in-stock" items and custom items. They are interested in expanding their P-O-P sales base in the greeting card and gift market, working with artists to create and enhance their material. They also welcome new ideas and merchandising concepts.
Needs: Approached by 10 freelancers/year. Uses freelancers mainly for renderings. Also for P-O-P displays. Considers both electronic and conventional media. Prefers 10×12. 90% of freelance work demands knowledge of Adobe Illustrator, Adobe Photoshop, QuarkXPress, Aldus FreeHand and Painter. Produces material for all holidays and seasons. Submit seasonal material 3 months in advance.
First Contact & Terms: Send query letter with brochure, tearsheets and résumé. Samples are filed. Company will contact artist for portfolio review if interested. Portfolio should include roughs, tearsheets and photographs. Rights purchased vary according to project. Originals are returned at job's completion. Pays by the project. Finds artists through word of mouth.
Tips: "We are looking for artists who have mechanical drawing skills."

‡MIXEDBLESSING, P.O. Box 97212, Raleigh NC 27624-7212. (914)723-3414. President: Elise Okrend. Estab. 1990. Produces interfaith greeting cards combining Jewish and Christian images for all ages.
Needs: Approached by 10 freelance artists/year. Works with 2-3 freelancers/year. Buys 20 designs and illustrations/year. Prefers artists with whimsical style. Art guidelines for SASE with first-class postage. Works on assignment only. Uses freelancers mainly for card illustration. Considers watercolor, pen & ink and pastel. Prefers final art 5×7. Produces material for Christmas and Hanukkah. Submit seasonal material 10 months in advance.
First Contact & Terms: Send query letter with brochure, photocopies, photographs and SASE. Samples are filed. Reports back only if interested. Artist should follow-up with letter after initial query. Originals are returned at job's completion. Sometimes requests work on spec before assigning a job. Pays flat fee of $150-200 for illustration/design. Buys all rights. Finds artists through visiting art schools.
Tips: "I see growth ahead for the industry."

MUG SHANTY, 900 W. Los Vallecitos, Unit C, San Marcos CA 92069. (619)736-3777. Fax: (619)736-3780. President: Bruce Starr. Estab. 1973. Produces ceramic souvenir mugs, containers, ashtrays, steins, etc. "Our company is a leading decorator of souvenir ceramic products usually appealing to over-20 age group."
Needs: Approached by 6 freelancers/year. Works with 4-8 freelancers/year. Buys 36-50 designs and illustrations/year. Prefers freelancers with experience in silkscreen printing. Uses freelancers mainly to create new souvenir designs that will apply to many parts of the country. Also for mechanicals. Considers rough sketches or previously published products/designs. Design must be simple. Especially looking for "great" new designs for mugs. Prefers 5½ high × 6 long. Produces material for Christmas and birthdays. Submit seasonal material 6 months in advance. Freelancers should be familiar with Adobe Illustrator, Aldus Freehand and Adobe Photoshop.
First Contact & Terms: Send query letter with brochure, tearsheets, photographs and slides. Samples are not filed and are returned by SASE if requested by artist. Reports back within 2 weeks. Call for appointment to show portfolio of color roughs. Negotiates rights purchased. Originals returned only if requested. Pays royalties of 8%, no advance.
Tips: Designs must be general so that any city, town or state can be printed underneath the design. Categories include the following: cityscapes, farmscapes, mountain/lake scapes, ocean/lake scapes, desert scapes, hot air balloons. "We're interested in creating a golfing portfolio of designs. They can be scenic, comic, etc."

J.T. MURPHY CO., 200 W. Fisher Ave., Philadelphia PA 19120. (215)329-6655. Fax: (800)457-5838. President: Jack Murphy. Estab. 1937. Produces greeting cards and stationery. "We produce a line of packaged invitations, thank you notes and place cards for retail."
Needs: Approached by 12 freelancers/year. Works with 4 freelancers/year. Buys 8 freelance designs and illustrations/year. Prefers local freelancers with experience in graphics and greeting cards. Uses freelancers mainly for concept, design and finished artwork for invitations and thank yous. Looking for graphic, contemporary or traditional designs. Prefers 4×5⅛ but can work double size. Produces material for graduation, birthdays and everyday. Submit seasonal material 9 months in advance.
First Contact & Terms: Designers send query letter with brochure. Illustrators send query letter with photocopies. Samples are filed and returned with SASE. Reports back within 1 month. Company will contact artist for portfolio review if interested. Rights purchased vary. Originals not returned. Payment negotiated.

‡NATIONAL DESIGN CORP., 16885 Via Del Campo Court, #300, San Diego CA 92127-1724. (619)674-6040. Fax: (619)674-4120. Art Director: Steven Duncan. Estab. 1985. Produces gifts, writing instruments and stationery accoutrements. Multi markets include gift/souvenir, mass market and premium markets.
Needs: Works with 3-4 freelancers/year. Buys 3 freelance designs and illustrations/year. Prefers local freelancers only. Must be Macintosh proficient. Works on assignment only. Uses freelancers mainly for design illustration. Also for prepress production on Mac. Considers computer renderings to mimic traditional medias.

Prefers children's and contemporary styles. 100% of freelance work demands knowledge of Aldus PageMaker 6.0, Aldus FreeHand 5.5, Adobe Photoshop 3.0, QuarkXPress 3.0, Adobe Illustrator 5.5. Produces material for Christmas and everyday.

First Contact & Terms: Send query letter with photocopies, résumé, SASE. Accepts submissions on disk. "Contact by phone for instructions." Samples are filed and are returned if requested. Company will contact artist for portfolio review of color, final art, tearsheets if interested. Rights purchased vary according to project. Payments depends on complexity, extent of project(s).

Tips: "Must be well traveled to identify with gift/souvenir markets internationally. Fresh ideas always of interest."

‡**THOMAS NELSON, INC.—MARKINGS**, P.O. Box 141000, Nashville TN 37214. (615)889-9000. Fax: (615)391-3166. Creative Director: Ann Cummings. Gift book publisher and producer of stationery products. Specializes in baby, children, feminine, sports and kitchen-related subjects. 85-90% require freelance illustration; 50% require freelance design. Book catalog free by request.

Needs: Approached by 50-100 freelance artists/year. Works with 5-15 illustrators and 5-15 designers/year. Assigns 10-20 design and 10-20 illustration jobs/year. Uses freelancers mainly for covers, borders and spots. 50% of freelance work demands knowledge of QuarkXPress, Aldus FreeHand and Adobe Illustrator. Works on assignment only.

First Contact & Terms: Send query letter with brochure, résumé, tearsheets and photocopies. Samples are filed or are returned. Reports back to the artist only if interested. Request portfolio review in original query. Portfolio should include thumbnails, finished art samples, color tearsheets and photographs. Whether originals returned to the artist depends on contract. Sometimes requests work on spec before assigning a job. Interested in buying second rights (reprint rights) to previously published work. "Payment varies due to complexity and deadlines." Finds artists through word of mouth, magazines, artists' submissions/self-promotions, sourcebooks, agents, visiting artist's exhibitions, art fairs and artists' reps.

Tips: "The majority of our mechanical art is executed on the computer with discs and lazer runouts given to the engraver instead of paste up boards."

NEW ENGLAND CARD CO., Box 228, Route 41, West Ossipee NH 03890. (603)539-5095. Owner: Harold Cook. Estab. 1980. Produces greeting cards and prints of New England scenes.

Needs: Approached by 75 freelancers/year. Works with 10 freelancers/year. Buys more than 24 designs and illustrations/year. Prefers freelancers with experience in New England art. Art guidelines available. Considers oil, acrylic and watercolor. Looking for realistic styles. Prefers art proportionate to 5×7. Produces material for all holidays and seasons. "Submit all year."

First Contact & Terms: Send query letter with SASE, photocopies, slides and transparencies. Samples are filed or are returned. Reports back within 2 months. Artist should follow-up after initial query. Pays by project. Rights purchased vary according to project, but "we prefer to purchase all rights."

Tips: "Once you have shown us samples, follow up with new art."

NEW YORK GRAPHIC SOCIETY, P.O. Box 1469, Greenwich CT 06836. (203)661-2400. Fax: (203)661-2480. Vice President: Owen Hickey. Estab. 1925. Produces posters, reproductions and limited editions.

Needs: Approached by hundreds of freelancers/year. Works with 5-10 freelancers/year. Buys 5-10 freelance designs and illustrations/year. Works on assignment only. Uses freelancers mainly for reproductions. Art guidelines free for SASE with first-class postage. Considers oil, watercolor, acrylic, pastel and photography. Looking for landscapes, florals, abstracts and impressionism. Submit seasonal material 6 months in advance.

First Contact & Terms: Send query letter with SASE and transparencies. Samples are not filed and are returned by SASE. Art Director will contact artist for portfolio review if interested. Originals are returned at job's completion. Sometimes requests work on spec before assigning a job. Pays royalties. Buys reprint rights. Finds artists through word of mouth, magazines, submissions/self-promotions, exhibitions and art fairs.

‡**NOBLE WORKS**, 108 Clinton St., Hoboken NJ 07030. (201)420-0095. Fax: (201)420-0679. Contact: Art Department. Estab. 1981. Produces bookmarks, greeting cards, journals. Produces "modern cards for modern people." Trend oriented, hip urban greeting cards.

Needs: Approached by 100-200 freelancers/year. Works with 50 freelancers/year. Buys 250 freelance designs and illustrations/year. Prefers freelancers with experience in illustration. Art guidelines for SASE with first-class postage. We purchase "secondary rights" to illustration. Considers illustration, electronic art. Looking for humorous, "off-the-wall" adult contemporary and editorial illustration. Produces material for Christmas, Easter, Mother's Day, Father's Day, graduation, Halloween, Valentine's Day, birthdays, everyday, thank you, anniversary, get well, astrology, sympathy, etc. Submit seasonal material 18 months in advance.

First Contact & Terms: Designers send query letter with photocopies, SASE, slides, tearsheets, transparencies. Illustrators and cartoonists send query letter with photocopies, tearsheets, SASE. After introductory mailing send follow-up postcard sample every 8 months. Accepts submissions on SyQuest disk (44meg) compatible with QuarkXPress 3.3, Adobe Photoshop 3.0, Adobe Illustrator 5.0. Samples are filed. Reports

back within 3 months. Portfolio review required. Portfolios may be dropped off Monday-Friday and should include anything that will define artist's abilities. Buys reprint rights. Pays for illustration $350 for new art; 5% "secondary rights." Finds freelancers through sourcebooks, illustration annuals, referrals.

‡**NORSE PRODUCTS**, 1000 S. Second St., Plainfield NJ 07063. (908)754-6330. Fax: (908)769-7599. Sales Manager: Larry Spelchler. Estab. 1979. Produces acrylic barware and serveware.
Needs: Works with 1 freelancer/year. Buys 10 designs and illustrations/year. Works on assignment only. Uses freelancers mainly for product design. Seeking trendy styles. Final art should be actual size. Produces material for all seasons. Submit seasonal material 1 year in advance.
First Contact & Terms: Send query letter with brochure and résumé. Samples are filed. Reports back within 1 month or does not report back, in which case the artist should call. Call for appointment to show portfolio. Negotiates rights purchased. Originals returned at job's completion if requested. Pays royalties.

NOTES & QUERIES, 9003 L-M Yellow Brick Rd., Baltimore MD 21237. (410)682-6102. Fax: (410)682-5397. General Manager/National Sales Manager: Barney Stacher. Estab. 1981. Produces greeting cards, stationery, calendars, paper tableware products and giftwrap. Products feature contemporary art.
Needs: Approached by 30-50 freelancers/year. Works with 3-10 freelancers/year. Art guidelines available "pending our interest." Produces material for Christmas, Valentine's Day, Mother's Day, Easter, birthdays and everyday. Submit seasonal material 1 year in advance.
First Contact & Terms: Send query letter with photographs, slides, SASE, photocopies, transparencies, "whatever you prefer." Samples are filed or returned by SASE if requested by artist. Reports back within 1 month. Artist should follow-up with call and/or letter after initial query. Portfolio should include thumbnails, roughs, photostats and 4×6 or 5×7 transparencies. Rights purchased or royalties paid, it varies according to project.

‡**NRN DESIGNS, INC.**, 5362 Bolsa Ave., Huntington Beach CA 92649. (714)898-6363. Fax: (714)898-0015. Art Director: Linda Braun. Estab. 1984. Produces calendars, gifts, greeting cards, stationery. Specializing in high end stationery and gift items—watercolor original feeling.
Needs: Approached by "hundreds" of freelancers/year. Works with 25 freelancers/year. Buys 500 freelance designs and illustrations/year. Prefers freelancers with experience in watercolors. Art guidelines available. Works on assignment only. Uses freelancers mainly for original art. Considers watercolor. Looking for traditional, sweet, floral. Produces material for Christmas, Easter, Mother's Day, Father's Day, graduation, Halloween, Hanukkah, New Year, Thanksgiving, Valentine's Day, birthdays, everyday, (sympathy, get well, etc.). Submit seasonal material 1 year in advance.
First Contact & Terms: Send photocopies. Samples are not filed and are returned. Reports back in 1 month. Portfolios required from designers. Company will contact artist for portfolio review if interested. Rights purchased vary according to project. Pays for design by the project.

OATMEAL STUDIOS, Box 138, Rochester VT 05767. (802)767-3171. Fax: (802)767-9890. Creative Director: Helene Lehrer. Estab. 1979. Publishes humorous greeting cards and notepads, creative ideas for everyday cards and holidays.
Needs: Approached by approximately 300 freelancers/year. Buys 100-150 freelance designs and illustrations/year. Considers all media. Produces seasonal material for Christmas, Mother's Day, Father's Day, Easter, Valentine's Day and Hanukkah. Submit art in May for Christmas and Hanukkah; in January for other holidays.
First Contact & Terms: Send query letter with slides, roughs, printed pieces or brochure/flyer to be kept on file; write for artists' guidelines. "If brochure/flyer is not available, we ask to keep one slide or printed piece; color or b&w photocopies also acceptable for our files." Samples returned by SASE. Reports in 3-6 weeks. No portfolio reviews. Sometimes requests work on spec before assigning a job. Negotiates payment.
Tips: "We're looking for exciting and creative, humorous (not cutesy) illustrations for our everday lines. If you can write copy and have a humorous cartoon style all your own, send us your ideas! We do accept work without copy too. Our seasonal card line includes traditional illustrations, so we do have a need for non-humorous illustrations as well."

‡**OFFRAY**, Rt. 24 Box 601, Chester NJ 07930. (908)879-4700. Design Director: Linda Wagner. Estab. 1900. Produces ribbons. "We're a ribbon company—for ribbon designs we look to the textile design studios and textile-oriented people; children's designs, craft motifs, fabric trend designs, floral designs, Christmas designs, bridal ideas, etc. Our range of needs is wide, so we need various looks."
Needs: Approached by 8-10 freelancers/year. Works with 4 freelancers/year. Buys 30-40 freelance designs and illustrations/year. Artists must be able to work from pencils to finish, various styles—work is small and tight. Works on assignment only. Uses freelancers mainly for printed artwork on ribbons. Also for calligraphy, P-O-P displays, paste-up, mechanicals, other. Art guidelines available. Considers marker, pencil, paint. Looking for artists able to translate a trend or design idea into a 1½ to 2-inch space on a ribbon. 30% of freelance design work demands knowledge of Adobe Illustrator, Adobe Photoshop. Produces material for Christmas, everyday. Submit seasonal material 6 months in advance.

First Contact & Terms: Send postcard sample or query letter with résumé or call. Samples are filed. Reports back to the artist only if interested. Portfolio should include b&w final art. Rights purchased vary according to project. Pays by the hour, $15-20; $200-300 for design.

‡**OPTIMUS DESIGN SYSTEMS**, P.O. Box 1511, Buffalo NY 14215. Phone/fax: (716)881-4525. E-mail: optimus@io.com. Website: http://www.ssdc.com. Art Director: Michael Osadciw. Estab. 1989. Produces games. "We are a role-playing game design company and produce the 'Battlelords of the 23rd Century' and 'Blood Dawn' role-playing games."
Needs: Approached by 10 freelancers/year. Works with 3 freelancers/year. Buys 10 freelance designs and illustrations/year. Art guidelines available. Works on assignment only. Uses freelancers mainly for cover illustrations for books. Also for interior b&w illustrations, pen & ink and pencil. Considers any color media for covers. Looking for dark and moody. 90% of design demands knowledge of Aldus PageMaker, Adobe Photoshop, Adobe Illustrator, Aldus FreeHand, QuarkXPress. 10% of illustration demands knowledge of Adobe Photoshop, Adobe Illustrator, Aldus FreeHand.
First Contact & Terms: Send query letter with photocopies, tearsheets, "anything which will show your best work." Accepts disk submissions, Mac format preferred, compatible with Adobe Photoshop or Adobe Illustrator. Reports back only if interested. Will contact for portfolio review if interested. Portfolio should include b&w and color roughs, tearsheets. Rights purchased vary according to project. Pays for design by the hour, $10-30. Payment for illustration varies by project and medium. Finds freelancers through trade shows and gaming conventions.
Tips: "The trend in the gaming industry right now is that flashy design and a hot look far outweigh the content and quality of the game. This is unfortunate but true. We're very picky as to the look we want for our art, but we don't care who you are or what you have or have not done. If your work is good, we'll use it."

‡**P.S. GREETINGS, INC.**, 5060 N. Kimberly Dr., Chicago IL 60630. (312)725-9308. Fax: (312)725-8655. Art Director: Bill Barnes. Manufacturer of boxed greeting and counter cards.
Needs: Receives submissions from 300-400 freelance artists/year. Works with 20-30 artists/year on greeting card designs. Prefers illustrations be $5 \times 7\frac{3}{4}$ with $\frac{1}{8}''$ bleeds cropped. Publishes greeting cards for everyday and Christmas. 10% of work demands knowledge of QuarkXPress, Adobe Illustrator and Adobe Photoshop.
First Contact & Terms: Send query letter requesting artist's guidelines. All requests as well as submissions must be accompanied by SASE. Reports within 2 months. Pays $100-200 flat fee. Buys exclusive worldwide rights for greeting cards only.
Tips: "Include your name and address on each piece. Our needs are varied: florals, roses, feminine, masculine, humorous, pets (dogs and cats), photos. Also, send ideas for foil stamping and embossing images. We also print Christmas cards with various types of treatments."

‡**PAINTED HEARTS & FRIENDS**, 1222 N. Fair Oaks Ave., Pasadena CA 91103. (818)798-3633. Fax: (818)798-7385. Art Director: Elizabeth Rush. Sales Manager: Richard Crawford. President: Susan Kinney. Estab. 1988. Produces greeting cards, stationery, invitations and note cards.
 • This company also needs freelancers who can write verse. If you can wear this hat, you'll have an added edge.
Needs: Approached by 75 freelance artists/year. Works with 6 freelancers/year. Art guidelines free for SASE with first-class postage. Works on assignment only. Uses freelancers mainly for design. Produces material for all holidays and seasons, birthdays and everyday. Submit seasonal material 1 year in advance.
First Contact & Terms: Send query letter with résumé, SASE and color photocopies. Samples are returned with SASE. Reports back only if interested. Write for appointment to show portfolio, which should include original and published work. Rights purchased vary according to project. Originals returned at job's completion. Pays flat fee of $150-300 for illustration. Pays royalties of 5%.
Tips: "Familiarize yourself with our card line." This company is seeking "young artists (in spirit!) looking to develop a line of cards. We're looking for work that is compatible but adds to our look, which is bright, clean watercolors. We need images that go beyond just florals to illustrate and express the occasion."

PANDA INK, P.O. Box 5129, Woodland Hills CA 91308-5129. (818)340-8061. Fax: (818)883-6193. Art Director: Ruth Ann Epstein. Estab. 1982. Produces greeting cards, stationery, calendars and magnets. Products are Judaic, general, everyday, anniversay, etc.
 • This company has added a metaphysical line of cards.

HOW TO USE your *Artist's & Graphic Designer's Market* offers suggestions for understanding and using the information in these listings. Read this and other articles in the front of this book for important business tips.

Needs: Approached by 8-10 freelancers/year. Works with 1-2 freelancers/year. Buys 3-4 freelance designs and illustrations/year. Uses freelancers mainly for design, card ideas. Art guidelines free for SASE with first-class postage. Considers all media. Looking for bright, colorful artwork, no risque, more ethnic. Prefers 5×7. Produces material for all holidays and seasons, Christmas, Valentine's Day, Mother's Day, Father's Day, Easter, Hanukkah, Passover, Rosh Hashanah, graduation, Thanksgiving, New Year, Halloween, birthdays and everyday. Submit seasonal material 6 months in advance.
First Contact & Terms: Send query letter with résumé, SASE, tearsheets and photocopies. Samples are filed. Reports back within 1 month. Portfolio review not required. Rights purchased vary according to project. Originals are returned at job's completion. Pay is negotiable; royalties of 2% (negotiable). Finds artists through word of mouth and submissions.
Tips: "Looking for bright colors and cute, whimsical art."

PAPEL FREELANCE, INC., 2530 US Highway 130, CN 9600, Cranbury NJ 08512. (609)395-0022, ext. 205. Design Manager: Tina Ashton. Estab. 1955. Produces everyday and seasonal giftware items: mugs, photo frames, magnets, molded figurines, candles and novelty items. Paper items include memo pads, gift bags, journals.
Needs: Approached by about 125 freelancers/year. Buys 250 illustrations/year. Uses freelancers for product design, illustrations on product, calligraphy, paste-up and mechanicals. "Very graphic, easy to interpret, bold, clean colors, both contemporary and traditional looks as well as juvenile and humorous styles." Produces material for Halloween, Christmas, Valentine's Day, Easter, St. Patrick's Day, Mother's Day, Father's Day and everyday lines: graduation, wedding, back to school. Freelancers should be familiar with Adobe Illustrator, Adobe Photoshop and QuarkXPress.
First Contact & Terms: Designers send query letter with photocopies. Illustrators send postcard sample or query letter with photocopies and SASE to be kept on file. Samples not filed are returned by SASE. Will contact for portfolio review if interested. Portfolio should include final reproduction/product and b&w and color tearsheets, photostats and photographs. Originals not returned. Sometimes requests work on spec before assigning a job. Pays by project, $125 minimum; or royalties of 3%. Buys all rights.
Tips: "I look for an artist with strong basic drawing skills who can adapt to specific product lines with a decorative feeling. It is an advantage to the artist to be versatile and capable of doing several different styles, from contemporary to traditional looks, to juvenile and humorous lines. Send samples of as many different styles as you are capable of doing well. Quality and a strong sense of color and design are the keys to our freelance resource. In addition, clean, accurate inking and mechanical skills are important to specific jobs as well. Update samples over time as new work is developed. New ideas and 'looks' are always welcome."

PAPER ANIMATION DESIGN, 33 Richdale Ave., Cambridge MA 02140. (617)441-9600. Fax: (617)646-0657. Art Director: David Whittredge. Estab. 1993. Produces greeting cards and animated tri-dimensional paper products. "We design and produce animated greeting cards and other products for an international market using illustrations and photographs of sophisticated and/or humorous images that move with pull-down tabs."
Needs: Approached by 6-10 freelancers/year. Works with 5 freelancers/year. Buys 50 freelance designs and illustrations/year. Uses freelancers mainly for illustration and design. Also for P-O-P displays and mechanicals. Considers any media. Looking for crisp, representative work with a strong color sense. No cartoons. 30% of freelance work demands computer skills. Produces material for birthdays and everyday.
First Contact & Terms: Send postcard sample or query letter with tearsheets, photographs, slides, SASE, photocopies, transparencies. Samples are filed (if interested) or returned by SASE. Reports back within 6 weeks. Will contact for portfolio review if interested. Portfolio should include final art, photostats, photographs. Buys all rights. Originals returned at job's completion. Pays by project $250-500. Finds artists through sourcebooks, word of mouth and submissions.
Tips: "Exhibit a clear understanding of the contemporary world."

‡THE PAPER COMPANY™, 731 S. Fidalgo St., Seattle WA 98108. (206)762-0982. Fax: (206)762-9128. Contact: Design Manager. Estab. 1979. Manufacturer of fine contemporary stationery and related products. "We produce a wide array of designs from sophisticated florals to simple, fun graphics and everything in between."
Needs: Prefers to work with 8 freelance artists and in-house design staff. Buys approximately 40 designs/year. Produces material for everyday and Christmas. "There are no restrictions to media usage, however please note that we do not use cartoon illustration/design."
First Contact & Terms: Send a query letter including previous work assignments/experience with printed samples and/or color photocoies to indicate style. Reports in 1 month. Art Director will contact artist for portfolio review if interested. Sometimes requests work on spec before assigning a job. Samples are returned upon request. No phone calls accepted. Pays flat fee rate, $150-$600; no licensing considerations. Finds artists through submissions and word of mouth.
Tips: "This is a constantly changing field; new products, new trends; etc. Imprintables will be making a huge impact shortly (if not already)."

‡PAPER MAGIC GROUP INC., 401 Adams Ave., Scranton PA 18510. (717)961-3863. Fax: (717)341-9098. Art Director: Deborah Gallagher. Estab. 1984. Produces greeting cards, stationery, vinyl wall decorations, 3-D paper decorations. "We are publishing seasonal cards and decorations for the mass market. Design is traditional."
Needs: Works with 60 freelance artists/year. Requires artists with a minimum of 5 years experience in greeting cards. Work is by assignment only. Designs products for Christmas, Valentine's Day, Easter and Halloween.
First Contact & Terms: Send query letter with résumé, slides and SASE. Color photocopies are acceptable samples. Samples are filed or are returned by SASE only if requested by artist. Reports back within 2 months. Originals not returned. Pays by the project, $350 average. Buys all rights.
Tips: "Please, experienced illustrators only."

‡PAPER MOON GRAPHICS, INC., Dept. AM, Box 34672, Los Angeles CA 90034. (310)645-8700. Contact: Creative Director. Estab. 1977. Produces greeting cards and stationery. "We publish greeting cards with a friendly, humorous approach—dealing with contemporary issues for an audience 20-35 years old, mostly female."
Needs: Works with 40 artists/year. Buys 200 designs/illustrations/year. Buys illustrations mainly for greeting cards and stationery. Freelance work requires computer skills. Produces material for everyday, holidays and birthdays. Submit seasonal material 1 year in advance.
First Contact & Terms: Send query letter with brochure, tearsheets, photostats, photocopies, slides and SASE. Samples are filed or are returned only if requested by artist and accompanied by SASE. Reports back within 6-8 weeks. To show a portfolio, mail color roughs, slides and tearsheets. Original artwork is returned to the artist after job's completion. Pays average flat fee of $350/design; $350/illustration. Negotiates rights purchased.
Tips: "We're looking for bright, fun style with contemporary look. Artwork should have a young 20s and 30s appeal." A mistake freelance artists make is that they "don't know our product. They send inappropriate submissions, not professionally presented with no SASE."

PAPERPLAINS, 9901 Princeton Rd., Cincinnati OH 45246. (513)874-6350. Creative Director: Richard Hunt. Manufacturer producing Christmas and all-occasion giftwrap and gift bags.
Needs: Approached by 75 freelancers/year. Assigns 75-100 jobs/year. Uses freelancers mainly for giftwrap design. 10% of illustration requires knowledge of latest versions of Adobe Illustrator, QuarkXPress and Adobe Photoshop.
First Contact & Terms: Send query letter with résumé, tearsheets, photocopies and slides. Calligraphers send tearsheets and photocopies. Accepts submissions on disk compatible with Adobe Illustrator, QuarkXPress and Adobe Photoshop. Samples are filed or returned by SASE. Reports back only if interested. Call or write for appointment to show portfolio of roughs, original/final art, final reproduction/product, tearsheets and photostats. Pays average flat fee of $400 for illustration/design; or by the hour, $15 minimum. Considers complexity of project and skill and experience of artist when establishing payment. Negotiates rights purchased.
Tips: "Designs should be appropriate for one or more of the following categories: Christmas, wedding, baby shower, birthday, masculine/feminine and abstracts. Understand our market—the emphasis is on surface design with ability to repeat."

✦PAPERPOTAMUS PAPER PRODUCTS INC., Box 310, Delta, British Columbia V4K 3Y3 Canada. (604)270-4580. Fax: (604)270-1580. Director of Marketing: George Jackson. Estab. 1988. Produces greeting cards for women ages 18-60. "We have also added a children's line."
Needs: Works with 8-10 freelancers/year. Buys 75-100 illustrations from freelancers/year. Also uses freelancers for P-O-P displays, paste-up and inside text. Prefers watercolor, but will look at all color media; no b&w except photographic. Seeks detailed humorous cartoons and detailed nature drawings, i.e. flowers, cats, etc., especially in combination. Also whales, eagles, tigers and other wildlife. "No studio card type artwork." Prefers 5¼×7¼ finished art work. Produces material for Christmas, Valentine's Day, Easter and Mother's Day; submit 18 months before holiday. Works with an artist to put selected work into existing or future lines and possibly develop line based on success of the selected pieces.
First Contact & Terms: Send brochure, résumé, roughs, photocopies and SASE. No slides. Samples are not filed and are returned by SASE only if requested by artist. Reports back within 2 months. Original artwork is returned with SASE. Pays average flat fee of $100/illustration or royalties of 5%. Prefers to buy all rights. Company has a 20-page catalog you may purchase by sending $4 with request for artist's guidelines. Please do not send IRCs in place of SASE.

🍁 THE MAPLE LEAF before a listing indicates that the market is Canadian.

Tips: "Know your market! Find out what is selling well in the card market. Learn why people buy specific types of cards for certain people. Understand the time frame necessary to produce a good card line. Send only your best work and we will show it to the world, with your name on it."

‡PAPERPRODUCTS DESIGN U.S. INC., 33 C Commercial Blvd., Novato CA 94949. (415)883-1888. Fax: (415)883-1999. President: Carol Florsheim. Estab. 1990. Produces giftwrap, greeting cards, paper tableware. Specializes in high end design, fashionable designs.
Needs: Approached by 20-30 freelancers/year. Works with 10 freelancers/year. Buys 30 freelance designs and illustrations/year. Art guidelines available. Uses freelancers mainly for designer paper napkins. Looking for very stylized/clean designs and illustrations. Prefers 6½×6½. Produces material for Christmas, Easter, everyday and birthday (most are blank). Submit seasonal material 6 months in advance.
First Contact & Terms: Designers send brochure, photocopies, photographs, tearsheets. Samples are not filed and are returned. Reports back within 3 weeks. Request portfolio review of color, final art, photostats in original query. Rights purchased vary according to project. Pays for design and illustration by the project in royalties. Finds freelancers through agents, *Workbook*.
Tips: "Shop the stores, study decorative accessories. Read European magazines."

‡PAPILLON INTERNATIONAL GIFTWARE INC., 40 Wilson Rd., Humble TX 77338. (713)446-9606. Fax: (713)446-1945. Vice President Marketing: Michael King. Estab. 1987. Produces decorative accessories, home furnishings and Christmas ornaments. "Our product mix includes figurines, decorative accessories, Christmas ornaments and decor and greeting cards. We use freelance artists primarily for greeting card illustration, catalog design and P-O-P display design."
Needs: Approached by 20 freelance artists/year. Works with 4-6 freelancers/year. Buys 4-6 designs and illustrations/year. Prefers local artists only. Works on assignment only. "We are looking for illustrations appealing to classic and refined tastes for our cards and Christmas ornaments." Prefers 10×14. 60% of work demands knowledge of Aldus PageMaker, Adobe Illustrator and Photoshop. Produces material for Christmas, Valentine's Day, Thanksgiving and Halloween. Submit seasonal material 1 year in advance.
First Contact & Terms: Send query letter with brochure, SASE, tearsheets, photographs, photocopies, photostats and slides. Samples are filed and are returned by SASE if requested by artist. Reports back within 6-8 weeks. To show portfolio, mail roughs, color slides and tearsheets. Originals returned at job's completion. Pays by the project, $400 average. Negotiates rights purchased.

PARAMOUNT CARDS INC., 400 Pine St., Pawtucket RI 02860. (401)726-0800. Fax: (401)727-3890. Contact: Art Coordinator. Estab. 1906. Publishes greeting cards. "We produce an extensive line of seasonal and everyday greeting cards which range from very traditional to whimsical to humorous. Almost all artwork is assigned."
Needs: Works with 50-80 freelancers/year. Uses freelancers mainly for finished art. Also for calligraphy. Considers watercolor, gouache, airbrush and acrylic. Prefers 5½×8⁵⁄₁₆. Produces material for all holidays and seasons. Submit seasonal holiday material 1 year in advance.
First Contact & Terms: Send query letter résumé, SASE (important), photocopies and printed card samples. Samples are filed only if interested, or returned by SASE if requested by artist. Reports back within 1 month if interested. Company will contact artist for portfolio review if interested. Portfolio should include photostats, tearsheets and card samples. Buys all rights. Originals are not returned. Pays by the project, $200-450. Finds artists through word of mouth and submissions.
Tips: "Send a complete, professional package. Only include your best work—you don't want us to remember you from one bad piece. Always include SASE with proper postage and *never* send original art—color photocopies are enough for us to see what you can do. No phone calls please."

‡PASSERINE PRESS, PUBLISHERS, 2425 Virginia Parkway, McKinney TX 75070. (214)542-0922 or (214)548-7817. Fax: (214)542-8362 or (214)562-0525. Publisher: Charles Galbraith. Estab. 1989. Art publisher and distributor. "We are in commercial print market. We are looking for artists (professional) who are prolific, with variety of style and skills." Publishes handpulled originals, limited editions, offset reproductions and Sepragraphs™.
Needs: Seeking artwork with decorative appeal for the serious collector and the commercial market. Considers oil, watercolor, mixed media and acrylic. Prefers landscape, impressionism, representational, realism, Western subject material open to review. Editions created by collaborating with the artist or by working from an existing painting. "Passerine Press is continuing to review printing artists of all categories through the Sepragraph™ division. We anticipate fine art releases of prints, serigraphs, sepragraphs, small editions only."
First Contact & Terms: Send query letter with résumé. "No material unless requested. We will furnish artist our outline questionnaire if we are to be interviewing." Samples are not filed and are returned. Reports back within 1 month. Pays flat fee and royalties (negotiated). Offers advance when appropriate. Negotiates rights purchased. Provides promotion and a written contract. Also publishing, distributing, agent representation-services, trade show exposure. Plus trade publication advertising.
Tips: "We will review an artist only after letter contact and references processed. Need a brief description of his/her work—aims, goals, credentials, present representation if any. Where the artist can be contacted,

galleries, etc. We are attempting to deal with the mature artist/illustrator who is a professional, with a full-time career commitment, and has some familiarity with the trade environment."

‡PHUNPHIT DESIGNS, LTD., 56 Lynncliff Rd., Hampton Bays NY 11946. (516)723-1899. Fax: (516)723-1886. President: Barbara A. Demy. Estab. 1995. Produces mugs, T-shirts, sweatshirts, canvas totes, aprons, puzzles. Producer of novelty items and everyday and seasonal giftware for the mail order, giftware and retail industries.
Needs: Works with 6-10 freelancers/year. Buys 10-12 freelance designs and illustrations/year. Art guidelines available. Uses freelancers mainly for mechanical work and illustrations on product. Looking for fun and slightly whimsical designs. "We also seek more elegant themes and realistic pet designs in cute humorous and whimsical situations." Produces material for Christmas, Valentine's Day, everyday.
First Contact & Terms: Illustrators send query letter with photocopies, photographs, résumé, tearsheets, SASE. Prefers non-returnable samples. Samples are filed or returned by SASE. Reports back within 6-8 weeks. Rights purchased vary according to project. Pays average flat fee of $300 for illustration; royalties of 5%.
Tips: "Our company is growing. Over the next few years we plan on expanding significantly the number of products we have on the market. We prefer working with several talented individuals who can anticipate our needs and grow with us."

‡PICKARD CHINA, 782 Pickard Ave., Antioch IL 60002. (708)395-3800. Fax: (708)395-3827. Director of Marketing: Henry A. Pickard. Estab. 1893. Manufacturer of fine china dinnerware, limited edition plates and collectibles. Clients: upscale specialty stores, department stores, direct mail marketers, consumers and collectors. Current clients include Cartier, Tiffany & Co., Marshall Field's, Bradford Exchange, Hamilton Mint, U.S. Historical Society.
Needs: Assigns 2-3 jobs to freelance artists/year. Uses freelance artists mainly for china patterns and plate art. Prefers designers for china pattern development with experience in home furnishings. Tabletop experience is a plus. Wants painters for plate art who can paint people and animals well—"Rockwellesque" portrayals of life situations. Prefers any medium with a fine art or photographic style. Works on assignment only.
First Contact & Terms: Send query letter with brochure showing art style or résumé and color photographs, tearsheets, slides or transparencies. Samples are filed or are returned if requested. Art Director will contact artist for portfolio review if interested. Pays royalties of 2-3%. Negotiates rights purchased. Interested in buying second rights (reprint rights) to previously published work.

‡PLEASURE GIFT & APPAREL CO., 2900 W. Anderson Lane, Suite 20-150, Austin TX 78757. (800)361-8921. Owner: Myles Barchas. Art Director: Susan McKinnon. Produces shirts, T-shirts, patches and art for lunch boxes.
 • This listing was added at press time. Look for a complete listing in the next edition.
Needs: Illustrators for art that goes on apparel.
First Contact & Terms: Pays $250-400; royalties of 9%.

PLUM GRAPHICS INC., Box 136, Prince Station, New York NY 10012. (212)966-2573. Contact: Yvette Cohen. Estab. 1983. Produces greeting cards. "They are full-color, illustrated, die-cut; fun images for young and old."
Needs: Buys 12 designs and illustrations/year. Prefers local freelancers only. Uses freelancers for greeting cards only. Considers oil, acrylic, airbrush, watercolor and computer generated medias.
First Contact & Terms: Send query letter with photocopies. Samples are filed or are returned by SASE if requested by artist. Reports back to the artist only if interested. "We'll call to view a portfolio." Portfolio should include final art and color tearsheets. Originals are returned at job's completion. Pays average flat fee of $100-400 for illustration/design. Pays an additional fee if card is reprinted. Considers buying second rights (reprint rights) to previously published work; "depends where it was originally published." Finds artists through word of mouth, submissions and sourcebooks.
Tips: "I suggest that artists look for the cards in stores to have a better idea of the style. They are sometimes totally unaware of Plum Graphics and submit work that is inappropriate."

‡PLYMOUTH MILLS, INC., Dept. AM, 330 Tompkins Ave., Staten Island NY 10304. (718)447-6707. President: Alan Elenson. Manufacturer of imprinted sportswear: T-shirts, sweatshirts, fashionwear, caps, aprons and bags. Clients: mass merchandisers/retailers.
Needs: Approached by 100 freelance artists/year. Works with 20 freelance illustrators and 8 freelance designers/year. Assigns 100 jobs to freelance artists/year. Uses freelance artists mainly for screenprint designs. Also uses freelance artists for advertising and catalog design, illustration and layout and product design.
First Contact & Terms: Send brochure and résumé. Reports back only if interested. Pays for design and illustration by the hour or by the project. Considers complexity of the project and how work will be used when establishing payment.

MARC POLISH ASSOCIATES, (formerly Philadelphia T-shirt Museum), P.O. Box 3434, Margate NJ 08402. (609)823-7661. President: Marc Polish. Estab. 1972. Produces T-shirts and sweatshirts. "We specialize

in printed T-shirts and sweatshirts. Our market is the gift and mail order industry, resort shops and college bookstores."

Needs: Works with 6 freelancers/year. Designs must be convertible to screenprinting. Produces material for Christmas, Valentine's Day, Mother's Day, Father's Day, Hanukkah, graduation, Halloween, birthdays and everyday.

First Contact & Terms: Send query letter with brochure, tearsheets, photographs, photocopies, photostats and slides. Samples are filed and are returned. Reports back within 2 weeks. To show portfolio, mail anything to show concept. Originals returned at job's completion. Pays royalties of 6%. Negotiates rights purchased.

Tips: "We like to laugh. Humor sells. See what is selling in the local mall or department store."

‡THE POPCORN FACTORY, 13970 W. Laurel Dr., Lake Forest IL 60045. Vice President, Merchandising and Marketing: Nancy Hensel. Estab. 1979. Manufacturer of popcorn cans and other gift items sold via catalog for Christmas, Valentine's Day, Easter and year-round gift giving needs.

Needs: Works with 6 freelance artists/year. Assigns up to 20 freelance jobs/year. Works on assignment only. Uses freelancers mainly for cover illustration, can design, fliers and ads. Occasionally uses artists for advertising, brochure and catalog design and illustration. 10% of freelance work requires knowledge of QuarkXPress.

First Contact & Terms: Send query letter with photocopies, photographs or tearsheets. Samples are filed. Reports back within 1 month. Write for appointment to show portfolio, or mail finished art samples and photographs. Pays for design by project, $500-2,000. Pays for illustration by project, $500-1,500. Considers complexity of project, skill and experience of artist, and turnaround time when establishing payment. Buys all rights.

Tips: "Send classic illustration, graphic designs or a mix of photography/illustration. We can work from b&w concepts—then develop to full 4-color when selected."

PORTERFIELD'S, 12 Chestnut Pasture Rd., Concord NH 03301. (603)228-1864. Fax: (603)228-1888. President: Lance Klass. Estab. 1994. Produces collector plates and other limited editions. "We produce high-quality limited-edition collector plates sold in the U.S. and abroad through direct response, requiring excellent representational art, primarily wonder of early childhood (under age 6); baby wildlife, foreign and domestic (cats/kittens, puppies/dogs), baby and mother exotic animals (Asian, African); cottages and English country scenes. Also looking for artists who can create realistic representational works from references supplied to them. We also function as a full-service licensing representative for individual artists wishing to find publishers or licensees."

Needs: Approached by 60 freelancers/year. Buys 12 freelance designs and illustrations/year. Prefers representational artists "who can create beautiful pieces of art that people want to look at and look at and look at." Works on assignment only but will consider existing works. Considers any media—oil, pastel, pencil, acrylics. "We want artists who have exceptional talent and who would like to have their art and their talents introduced to the broad public via the highest quality limited edition collector plates." Produces material for Christmas, Valentine's Day and Easter. Submit seasonal material 1 year in advance.

First Contact & Terms: Send postcard sample or query letter with brochure, tearsheets, résumé, photographs, slides, SASE, photocopies and transparencies. Samples are filed or returned by SASE. Reports back within 2 weeks. Will contact for portfolio review if interested. Portfolio should include tearsheets, photographs and transparencies. Rights purchased vary. Generally pays advance against royalties when work accepted, royalties/sale paid after product sales are made.

Tips: "We are impressed first and foremost by level of ability, even if the subject matter is not something that we would use. Thus a demonstration of a competence is the first step; hopefully the second would be that demonstration using subject matter that we feel would be marketable. We work with artists to help them with the composition of their pieces for this particular medium. We treat artists well, give them fair payment for their work, and do what we can to promote them. We also give them something no other collectibles company will give—final approval of the reproduction quality of their work before production gets underway. We want our artists to be completely satisfied that their art is being reproduced in a manner that they like, and would be willing to share professionally and with their friends."

‡PORTFOLIO GRAPHICS, INC., 4060 S. 500 W., Salt Lake City UT 84123. (801)266-4844. Fax: (801)263-1076. Creative Director: Kent Barton. Estab. 1986. Produces greeting cards, fine art posters, prints, limited editions. Fine art publisher and distributor world-wide. Clients include frame shops, galleries, gift stores and distributors.

● Portfolio Graphics also has a listing in the Posters & Print section of this book.

Needs: Approached by 200-300 freelancers/year. Works with 30 freelancers/year. Buys 50 freelance designs and illustrations/year. Art guidelines free for SASE with first-class postage. Considers all media. "Open to large variety of styles." Produces material for Christmas, everyday, birthday, sympathy, get well, anniversary.

First Contact & Terms: Illustrators send résumé, slides, tearsheets, SASE. "Slides are best. Do not send originals." Samples are filed "if interested" or returned by SASE. Reports back in 2-3 weeks. Negotiates rights purchased. Pays 10% royalties. Finds artists through galleries, word of mouth, submissions, art shows and exhibits.

Tips: "Open to a variety of submissions, but most of our artists sell originals as fine art home or office decor. Keep fresh, unique, creative."

POTPOURRI DESIGNS, 6210 Swiggett Rd., Greensboro NC 27419. Mailing address: Box 19566, Greensboro NC 27410. (910)852-8961. Fax: (910)852-1402. Vice President of New Product Development: Janet Pantuso. Estab. 1968. Produces paper products including bags, boxes, stationery and tableware; tins; stoneware items; and Christmas and home decor products for gift shops, the gourmet shop trade and department stores. Targets women age 25 and older.
Needs: Buys 10-20 freelance designs and 10-20 illustrations/year. "Our art needs are increasing. We need freelancers who are flexible and able to meet deadlines." Works on assignment only. Uses freelancers for calligraphy, mechanicals and art of all kinds for product reproduction. Prefers watercolor and acrylic. Also needs mechanical work. Seeking traditional, seasonal illustrations for Christmas introductions and feminine florals for everyday. Submit seasonal material 1-2 years in advance.
First Contact & Terms: Send query letter with résumé and tearsheets, slides or photographs. Samples not filed are returned by SASE. Will contact for portfolio review if interested. Pays average flat fee of $300; or pays by project, $1,000-5,000 average. Buys all rights. Finds artists through word of mouth, magazines, submissions/self-promotions, sourcebooks, agents, visiting artist's exhibitions, art fairs and artists' reps.
Tips: "Our audience has remained the same but our products are constantly changing as we continue to look for new products and discontinue old products. I often receive work from artists that is not applicable to our line. I prefer that artists learn more about the company before submitting work."

PRATT & AUSTIN COMPANY, INC., 642 S. Summer St., Holyoke MA 01040. (413)532-1491. Fax: (413)536-2741. President: Bruce Pratt. Art Director: Lorilee Costello. Estab. 1931. Produces envelopes, children's items, stationery and calendars. "Our market is the modern woman at all ages. Design must be bright, cute busy and elicit a positive response." Using more recycled paper products and endangered species designs.
Needs: Approached by 50 freelancers/year. Works with 20 freelancers/year. Buys 100-150 designs and illustrations/year. Art guidelines available. Uses freelancers mainly for concept and finished art. Also for calligraphy. Produces material for Christmas, birthdays, Mother's Day and everyday. Submit seasonal material 18 months in advance. 40% of freelance work requires knowledge of QuarkXPress and CorelDraw on the Mac.
First Contact & Terms: Send color copies. Samples are filed or are returned by SASE if requested. Will contact for portfolio review if interested. Portfolio should include thumbnails, roughs, color tearsheets and slides. Pays flat fee. Rights purchased vary. Interested in buying second rights (reprint rights) to previously published work. Finds artists through submissions and agents.
Tips: "It is imperative that freelancers submit seasonal/holiday designs 18 months in advance."

‡❧**PRESENCE OF MINE GREETINGS**, 6656 Thornberry Crescent, Windsor, Ontario N8T 2X2 Canada. (519)944-4591. Fax: (519)944-2874. E-mail: jlees@wincom.net. Creative Director: Robbie Burns. Estab. 1995. Produces greeting cards, giftwrap, stationery, gift boxes. "Our company is proudly comprised of a select group of highly innovative designers and artists. Diligently crafted by hand, the products we carry are one of a kind numbered editions, signed by the creator. Framing of cards is encouraged by the purchaser. Clients include museums, gallery shops, paperies and speciality gift and bookstores."
• A percentage of this company's sales goes to support the arts at the college and university levels.
Needs: Approached by 150 freelancers/year. Works with 18 freelancers/year. Works on assignment only. Considers oil, watercolor, acrylic, found objects, collage, fabrics, organic materials, Japanese papers, etc. "Anything that works! Very high end elegant, contemporary, extremely unique designs—but must be 'do-able' in quantity by the artist." Prefers verticle formats. Produces material for all holidays and seasons, 75% are all occasion cards, all cards blank inside. Submit seasonal material 1 year in advance.
First Contact & Terms: Send query letter with résumé, SASE, samples of finished cards at appropriate size. "Package should be professionally put together, as this will determine your committment to high standards, quality control and interest in being successful." Samples are filed or returned by SASE if requested by artist. Reports back within 2 months. Negotiates rights purchased. Pays "40% of the wholesale cost of the card, stationery or gift packaging. Wholesale prices are established by the company." Finds freelancers through advertising in graphic design trade magazines obtaining members' lists of art organizations, through universities and college degreed art programs and part-time study programs and word of mouth.
Tips: "Send a professionally put together package meeting all specs and only what you love."

‡**PRETTY PAPER COMPANY** (Division of Thomas Nelson), Dept. AM, 404 BNA Dr. Bldg. 200, Suite 600, Nashville TN 37217. Creative Director: Phyllis Watson. Estab. 1981. Produces greeting cards, stationery, die-cut pads, pads with designs, calendars, planners, mugs, tins, address and blank books, note holders and gift baskets.
Needs: Approached by 5 artists/year. Works with 20 artists/year. Buys up to 50 designs and illustrations/year. Prefers "artists compelled to do their best consistently with deep understanding of color and regard for deadlines. Should be pleasant to work with." Works on assignment only. Uses freelancers for color illustra-

tion, calligraphy, mechanicals on computer, illustration and border designs. Considers watercolor, pastel, scratchboard, woodcut, oil, colored pencil, mixed media. "If it's exquisite or clever, we'll consider it. We like dramatic, graceful, and/or delicate florals, tropicals, classic, Victorian, impressionistic or fairly detailed and realistic styles." 5-10% of freelance work demands knowledge of Aldus PageMaker or Adobe Illustrator. Produces material for all holidays and seasons. Submit seasonal material 18 months in advance.

First Contact & Terms: Send query letter with brochure, résumé, SASE, tearsheets, photographs, photocopies, photostats, slides, color copies, thumbnails and roughs; "we are interested in seeing evolution of thought process." No originals. Samples are filed or are returned by SASE if requested by artist. Art Director will contact artist for portfolio review if interested. Portfolio should include thumbnails, roughs, color: copies, photostats, tearsheets, photographs and slides. Originals are returned at job's completion if specifically agreed upon. Requests work on spec before a assigning job. Pays average flat fee of $300 for illustration/design; by the project, $100-300 average. Buys all rights.

Tips: "Give a professional presentation of your work."

THE PRINTERY HOUSE OF CONCEPTION ABBEY, Conception MO 64433. (816)944-2632. Fax: (816)944-2582. Art Director: Rev. Norbert Schappler. Estab. 1950. Publishes religious greeting cards. Specializes in religious Christmas and all-occasion themes for people interested in religious, yet contemporary, expressions of faith. "Our card designs are meant to touch the heart. They feature strong graphics, calligraphy and other appropriate styles."

Needs: Approached by 75 freelancers/year. Works with 25 freelancers/year. Art guidelines available for SASE with first-class postage. Uses freelancers for product illustration. Prefers acrylic, pastel, cut paper, oil, watercolor, line drawings and classical and contemporary calligraphy. Looking for dignified styles and solid religious themes. Produces seasonal material for Christmas and Easter "as well as the usual birthday, get well, sympathy, thank you, etc. cards of a religious nature. Creative general message cards are also needed." Strongly prefers calligraphy to type style. 2% of freelance work requires knowledge of Adobe Photoshop or Adobe Illustrator.

First Contact & Terms: Send query letter with résumé, photocopies, photographs, SASE, slides or tearsheets. Calligraphers send any printed or finished work. Non-returnable samples preferred—or else samples with SASE. Accepts submissions on disk compatible with Adobe Photoshop or Adobe Illustrator. Send TIFF or EPS files. Reports back usually within 3 weeks. To show portfolio, mail appropriate materials only after query has been answered. "In general, we continue to work with artists once we have accepted their work." Pays flat fee of $150-300 for illustration/design, and $50-100 for calligraphy. Usually buys exclusive reproduction rights for a specified format; occasionally buys complete reproduction rights.

Tips: "Abstract or semi-abstract background designs seem to fit best with religious texts. Color washes and stylized designs are often appropriate. Remember our specific purpose of publishing greeting cards with a definite Christian/religious dimension but not piously religious. It must be good quality artwork. We sell mostly via catalogs so artwork has to reduce well for catalog." Sees trend towards "more personalization and concern for texts."

‡PRISMATIX, INC., 333 Veterans Blvd., Carlstadt NJ 07012. (201)939-7700. Fax: (201)939-2828. Vice President: Miriam Salomon. Estab. 1977. Produces seasonal window and yard decorations. "We manufacture screen-printed novelties to be sold in the retail market. Our emphasis has been seasonal although we are exploring new markets."

Needs: Works with 3-4 freelancers/year. Buys 20 freelance designs and illustrations/year. Prefers local artists only. Works on assignment only. 90% of freelance work demands computer skills. Produces material for Christmas, Valentine's Day, Easter, Hanukkah, graduation, Thanksgiving, Halloween. Submit seasonal material 1 year in advance.

First Contact & Terms: Send query letter with brochure, résumé. Samples are filed. Reports back to the artist only if interested. Portfolio should include color thumbnails, roughs, final art. Payment negotiable.

PRODUCT CENTRE-S.W. INC./THE TEXAS POSTCARD CO., Box 860708, Plano TX 75086. (214)423-0411. Fax: (214)578-0592. Art Director: Susan Grimland. Produces postcards. Themes range from nostalgia to art deco to pop/rock for contemporary buyers.

Needs: Buys 100 designs from freelancers/year. Uses freelancers for P-O-P display, paste-up and mechanicals. Considers any media, but "we do use a lot of acrylic/airbrush designs." Prefers contemporary styles. Final art must not be larger than 8×10. "Certain products require specific measurements. We will provide these when assigned."

First Contact & Terms: Send résumé, business card, slides, photostats, photographs, photocopies and tearsheets to be kept on file. Samples not filed are returned only by request with SASE including return insurance. Reports within 4 months. Originals are not returned. Call or write to show portfolio. Pays by the project, $100-200. Buys all rights.

Tips: "Artist should be able to submit camera-ready work and understand printer's requirements. The majority of our designs are assigned. No crafty items or calligraphy. No computer artwork."

PRODUCT CONCEPT CONSULTING, INC, 3334 Adobe Court, Colorado Springs CO 80907. (719)632-1089. Fax: (719)632-1613. President: Susan Ross. Estab. 1986. New product development agency. "We work with a variety of companies in the gift and greeting card market in providing design, new product development and manufacturing services."

 • This company has recently added children's books to its product line.

Needs: Works with 20-25 freelancers/year. Buys 400 designs and illustrations/year. Prefers freelancers with 3-5 years experience in gift and greeting card design. Works on assignment only. Buys freelance designs and illustrations mainly for new product programs. Also for calligraphy, P-O-P display and paste-up. Considers all media. 25% of freelance work demands knowledge of Adobe Illustrator, Adobe Streamline, QuarkXPress or Aldus FreeHand. Produces material for all holidays and seasons.

First Contact & Terms: Send query letter with résumé, tearsheets, photostats, photocopies, slides and SASE. Samples are filed or are returned by SASE if requested by artist. Reports back within 1 week. To show portfolio, mail color and b&w roughs, final reproduction/product, slides, tearsheets, photostats and photographs. Originals not returned. Pays average flat fee of $250; or pays by the project, $250-2,000. Buys all rights.

Tips: "Be on time with assignments." Looking for portfolios that show commercial experience.

‡PUNCH ENTERPRISES INC., Suite 200, 5661 Columbia Pike, Falls Church VA 22041. (703)931-4860. Fax: (703)671-5805. President: David Black. Estab. 1987. Produces novelty items for ages 5-adult.

Needs: Approached by 10 freelance artists/year. Works with 2 freelancers/year. Buys 2 designs and illustrations/year. Prefers artists with experience in package design and P-O-P display. Works on assignment only. Needs computer-literate freelancers for design and illustration.

First Contact & Terms: Send query letter with résumé, SASE and photocopies. Samples are filed. Reports back to the artist only if interested. To show portfolio, mail finished art samples and color photographs. Originals are not returned. Pays by the project, $300-5,000. Buys all rights.

PUNKIN' HEAD PETS, 1025 N. Central Expressway, Suite 300-349, Plano TX 75075-8806. (214)491-2435. Owner: Lyn Skaggs. Estab. 1994. Produces greeting cards, stationery, posters, paper tableware products and giftwrap. "Punkin' Head Pets is a greeting card company geared toward pet owners (mostly dogs and cats) of all ages."

Needs: Prefers freelancers with experience in pet drawings. Art guidelines available free for SASE with first-class postage. Considers all media. Good color drawings of dogs and cats in "cute" poses and surroundings. Prefers 3×5. Produces material for all holidays and seasons.

First Contact & Terms: Send query letter with slides, photocopies, photographs and SASE; color photocopies also accepted for initial review. Samples are filed or returned by SASE. Reports back within 1 month. Portfolio review not required. Negotiates rights purchased. Originals are returned with SASE. Pays by flat fee of $20-50.

Tip: "Do not submit 'run-of-the-mill' drawings. Action drawings are best."

PUZZLING POSTCARD COMPANY, P.O. Box 37, Lenni PA 19052. (610)558-7850. Fax: (610)558-7853. President: Thomas J. Judge. Estab. 1991. Produces puzzle greeting cards, greeting cards, stationery, games/toys. "We produce jigsaw puzzle greeting cards—the giver writes a message on the back, breaks card apart and sends. Cards are for all age groups; popular to send to children, young teens, the elderly and the ill."

Needs: Approached by 3-5 freelancers/year. Works with 2-3 freelancers/year. Buys 24-36 freelance designs and illustrations/year. Uses freelancers mainly for greeting designs. Also for P-O-P displays and mechanicals. Considers all media. Looking for "a clean non-cluttered look. Cards cannot have too much small detail because the die cut lines will distract from the image making it difficult to see. We would love to introduce a new cartoon character to the industry via the puzzling postcard." Prefers 4×6. 60% of freelance work demands knowledge of Adobe Illustrator, Adobe Photoshop, QuarkXPress, Aldus FreeHand and Aldus Page-Maker. Produces material for Christmas, Valentine's Day, New Year, birthdays and everyday. Submit seasonal material 6-9 months in advance.

First Contact & Terms: Send query letter with brochure, tearsheets, photostats, résumé, photographs, slides, photocopies and transparencies. Samples are filed. Company will contact artist for portfolio review if interested. Portfolio should include thumbnails, roughs, final art, photostats, tearsheets, photographs, slides and transparencies. Rights purchased vary according to project. Originals are returned at job's completion. Negotiates price and rights. Outright purchase generally ranges from $100-300. Royalties are negotiable; usually pay an advance against royalty. Finds artists through word or mouth and submissions.

Tips: "Be willing to negotiate price/rights at beginning of relationship. We prefer to produce 'series' of cards of 6-12 designs from a particular artist. Our risk as a manufacturer is high when introducing new designs. There seems to be a definite trend toward lower cost greeting cards. Our specialty is alternative greeting cards with added elements at very reasonable cost!"

QUALITY ARTWORKS, INC., 2262 North Penn Rd., P.O. Box 369, Hatfield PA 19440-0369. Creative Director: Linda Tomezsko Morris. Estab. 1985. Manufacturer/distributor producing bookmarks, blank books,

notepads, note cards, stationery and scrolls. Subject matter ranges from classic, traditional to contemporary, fashion-oriented. Clients: bookstores, card and gift shops and specialty stores.

Needs: Works with 20 freelancers/year. Needs 100-200 designs/year. Considers any medium. Freelancers must be able to work within a narrow vertical format (bookmarks). Art guidelines available free for SASE with first-class postage. Works on assignment only. Uses freelancers for product illustration. 2% of design work requires computer skills.

First Contact & Terms: Send query letter with brochure, photocopies, photographs, SASE, transparencies, tearsheets, slides and/or printed pieces. Samples are filed or are returned only if requested by artist with SASE. Creative Director will contact artist for portfolio review if interested. Portfolio should include roughs, original/final art, product samples, tearsheets, slides or color prints. Pays for illustration $50-400. Considers skill and experience of artist, how work will be used and rights purchased when establishing payment.

Tips: "We are looking for creative, fresh looks with strong color and design. Study our product and the market. Design with the consumer in mind—for the most part, a high-end female, age late teens-senior years. You must also have an understanding of the 4-color printing process."

‡RAGNAROK GAMES, P.O. Box 140333, Austin TX 78714. (512)472-6535. Fax: (512)472-6220. E-mail: ragnarokgc@aol.com. Websites: http://www.ccsi.com/~graball/quest and http://www.ccsi.com/~graball/ragnarok. Editorial Director: David Nallie. Estab. 1979. Produces games and books.

 • Also see listing for Ragnarok in the Book Publishers section, and *Abyss* in the Magazines section. Company has formed partnership with Stone Ring Games. David Nallie told *AGDM* they are actively seeking good color artists for spot art and game cards.

Needs: Approached by 80-100 freelancers/year. Works with 15-20 freelancers/year. Buys 150-500 designs and illustrations/year. Uses freelancers mainly for color and b&w topical illustrations. Also for playing card illustrations. 60% of freelance illustration demands knowledge of Adobe Photoshop, Aldus PageMaker, QuarkXPress.

First Contact & Terms: Send postcard sample or query letter with brochure, tearsheets, photostats, photographs, slides, SASE, photocopies, transparencies or e-mail. Samples are filed, or are returned by SASE. Company will contact artist for portfolio review in 2 months if interested. Artist should follow-up with call and/or letter after initial query. Portfolio should include roughs, photostats, tearsheets, photographs, slides, transparencies. Negotiates rights purchased. Originals returned at job's completion. Pays by the project, $20-4,000.

RECO INTERNATIONAL CORPORATION, Collector's Division, Box 951, 138-150 Haven Ave., Port Washington NY 11050. (516)767-2400. Manufacturer/distributor of limited editions, collector's plates, lithographs and figurines. Sells through retail stores and direct marketing.

Needs: Works with freelance and contract artists. Uses freelancers under contract for plate and figurine design and limited edition fine art prints. Prefers romantic and realistic styles.

First Contact & Terms: Send query letter and brochure to be filed. Write for appointment to show portfolio. Art Director will contact artist for portfolio review if interested. Negotiates payment. Considers buying second rights (reprint rights) to previously published work.

Tips: "We are very interested in new artists. We go to shows and galleries, and receive recommendation from artists we work with."

RECYCLED PAPER GREETINGS INC., 3636 N. Broadway, Chicago IL 60613. Fax: (312)281-1697. Art Director: Melinda Gordon. Contact: Lawrence Sneed, Art Coordinator. Publishes greeting cards, adhesive notes and mugs.

Needs: Buys 1,000-2,000 freelance designs and illustrations. Considers b&w line art and color—"no real restrictions." Looking for "great ideas done in your own style with messages that reflect your own slant on the world." Prefers 5×7 vertical format for cards; 10×14 maximum. "Our primary interest is greeting cards." Produces seasonal material for all major and minor holidays including Jewish holidays. Submit seasonal material 18 months in advance; everyday cards are reviewed throughout the year.

First Contact & Terms: Send SASE to Lawrence Sneed for artist's guidelines. "I don't want slides or tearsheets—I am only interested in work done for our products." Reports in 2 months. Portfolio review not required. Originals returned at job's completion. Sometimes requests work on spec before assigning a job. Pays average flat fee of $250 for illustration/design with copy. Some royalty contracts. Buys all rights.

Tips: "Remember that a greeting card is primarily a message sent from one person to another. The art must catch the customer's attention, and the words must deliver what the front promises. We are looking for unique points of view and manners of expression. Our artists must be able to work with a minimum of direction

 ● **A BULLET** introduces comments by the editor of *Artist's & Graphic Designer's Market* indicating special information about the listing.

and meet deadlines. There is a renewed interest in the use of recycled paper—we have been the industry leader in this for more than two decades."

RED FARM STUDIO, 1135 Roosevelt Ave., P.O. Box 347, Pawtucket RI 02862-0347. (401)728-9300. Fax: (401)728-0350. Contact: Creative Director. Estab. 1955. Produces greeting cards, giftwrap and stationery from original watercolor art. Also produces coloring books and paintable sets. Specializes in nautical and traditional themes. Approached by 150 freelance artists/year. Buys 200 freelance designs and illustrations/year. Uses freelancers for greeting cards, notes, Christmas cards. Considers watercolor artwork for cards, notes and stationery; b&w linework and tonal pencil drawings for coloring books and paintable sets. Looking for accurate, detailed, realistic work, though some looser watercolor styles are also acceptable. Produces material for Christmas and everyday occasions. Also interested in traditional, realistic artwork for religious line: Christmas, Easter, Mother's and Father's Day and everyday subjects, including realistic portrait and figure work, such as the Madonna and Child.

First Contact & Terms: First send query letter and #10 SASE to request art guidelines. Submit printed samples, transparencies, color copies or photographs with a SASE. Samples not filed are returned by SASE. Art Director will contact artist for portfolio review if interested. Pays flat fee of $250-350 for card or note illustration/design, or pays by project, $250-1000. Buys all rights.

Tips: "We are interested in clean, bright watercolor work of traditional subjects like florals, birds, kittens, some cutes, puppies, shells and nautical scenes. No photography. Our guidelines will help to explain our needs."

© Red Farm Studio

Artist George Shedd created this holiday card perfect for beach lovers for Red Farm Studio. "Our company takes pride in the realism of our cards," says Red Farm's Steven P. Scott. "In this case we have taken a humorous situation and painted it with a realistic look." The company has gotten a "fantastic" response to Shedd's "sandman" card, painted in watercolor. The inside reads "May jolly times and happy things be what this special season brings! Season's Greetings!"

RENAISSANCE GREETING CARDS, Box 845, Springvale ME 04083. (207)324-4153. Fax: (207)324-9564. Art Director: Janice Keefe. Estab. 1977. Publishes greeting cards; "current approaches" to all-occasion cards, seasonal cards, Christmas cards including nostalgic themes. "Alternative card company with unique variety of cards for all ages, situations and occasions."

Needs: Approached by 500-600 artists/year. Buys 350 illustrations/year. Art guidelines available free for SASE with first-class postage. Full-color illustrations only. Produces materials for all holidays and seasons

and everyday. Submit art 18 months in advance for fall and Christmas material; approximately 1 year in advance for other holidays.
First Contact & Terms: Send query letter with SASE. To show portfolio, mail color copies, tearsheets, slides or transparencies. Packaging with sufficient postage to return materials should be included in the submission. Reports in 2 months. Originals are returned to artist at job's completion. Sometimes requests work on spec before assigning a job. Pays for design by the project, $150-300 advance on royalties or flat fee, negotiable. Finds artists mostly through submissions/self-promotions.
Tips: "Especially interested in humorous concepts and illustration as well as trendy styles. Start by requesting guidelines and then send a small (10-12) sampling of 'best' work, preferably color copies or slides (with SASE for return). Indicate if the work shown is available or only samples. We're doing more designs with special effects like die-cutting and embossing."

‡**RHAPSODY LTD.**, P.O. Box 2165, Placerville CA 95667. (916)642-4295. Fax: (916)642-8737. New Product Design Manager: Sierra Hunter. Estab. 1994. Produces giftbags, giftwrap, journals, gifts, mugs, stationery. Produces high end sophisticated designs ("not cutesy") which are sold in a variety of markets including gift stores and Christian bookstores.
Needs: Approached by 60 freelancers/year. Works with 20 freelancers/year. Buys 50 freelance designs and illustrations/year. Art guidelines free for SASE. Uses freelancers mainly for finished art. Considers color copies, transparencies, Mac disk, CD-ROM. Looking for vibrant colors, detailed, classical, good perspective. Prefers 15×17. Produces material for Christmas, Mother's Day, Father's Day, Valentine's Day, birthdays, everyday. Submit seasonal material 15 months in advance.
First Contact & Terms: Send query letter with brochure and/or photocopies, résumé. After introductory mailing illustrators should send follow-up postcard sample every 3 months. Accepts submissions on disk from illustrators if compatible with latest versions of Adobe Illustrator, Adobe Photoshop or Aldus Page-Maker. Company will contact artist for portfolio review if interested. Rights purchsed vary according to project. Pays for design and illustration by the project; negotiable. Finds freelancers through submissions, exhibitions, trade shows.
Tips: "Please contact by mail only. Do not send any work that needs to be returned. All submissions will be reviewed by president or product design manager."

‡**RIGHTS INTERNATIONAL GROUP**, 463 Firt St. #3C, Hoboken NJ 07030. (201)463-3123. Fax: (201)420-0679. Contact: Robert Hazaga. Estab. 1996. Agency for cross licensing. Licenses images for manufacturers of giftware, stationery, posters, home furnishing.
• This company also has a listing in the Posters & Print section.
Needs: Approached by 50 freelancers/year. Uses freelancers mainly for creative, decorative art for the commercial and designer market. Also for textile art. Considers oil, acrylic, watercolor, mixed media, pastels.
First Contact & Terms: Send brochure, photocopies, photographs, SASE, slides, tearsheets or transparencies. Accepts disk submissions compatible with Adobe Illustrator. Reports back within 2 months. Will contact for portfolio review if interested. Negotiates rights purchased and payment.

THE ROSENTHAL JUDAICA COLLECTION, by Rite Lite, 260 47th St., Brooklyn NY 11220. (718)439-6900. Fax: (718)439-5197. Vice President Product Design: Rochelle Stern. Estab. 1948. Manufacturer and distributor of a full range of Judaica ranging from mass-market commercial goods to exclusive numbered pieces. Clients: department stores, galleries, gift shops, museum shops and jewelry stores.
• Company is looking for new menorah designs.
Needs: Approached by 40 freelancers/year. Works with 4 freelance designers/year. Art guidelines available. Works on assignment only. Uses freelancers mainly for new designs for Judaic giftware. Prefers ceramic, brass and glass. Also uses artists for brochure and catalog design, illustration and layout and product design. 20% of freelance work requires knowledge of QuarkXPress, Adobe Illustrator and Adobe Photoshop.
First Contact & Terms: Send query letter with brochure or résumé and photographs. Do not send originals. Samples are filed. Reports back only if interested. Portfolio review not required. Art Director will contact for portfolio review if interested. Portfolio should include original/final art and color tearsheets, photographs and slides. Pays flat fee or royalties of 5-6%. Buys all rights. "Works on a royalty basis." Finds artists through word of mouth.
Tips: "Know that there is one retail price, one wholesale price and one distributor price. Must be familiar with Jewish ceremonial objects or design."

‡**RUBBERSTAMPEDE**, Box 246, Berkeley CA 94701. (510)420-6800. Fax: (510)420-6880. President: Sam Katzen. Art Director: Deborah Tanaka. Estab. 1978. Produces art and novelty rubber stamps, kits, glitter pens, ink pads.
Needs: Approached by 30 freelance artists/year. Works with 10-20 freelance artists/year. Buys 200-300 freelance designs and illustrations/year. Uses freelance artists for calligraphy, P-O-P displays, and original art for rubber stamps. Considers pen & ink. Looks for cute, feminine style. Produces seasonal material: Christmas, Valentine's Day, Easter, Hanukkah, Thanskgiving, Halloween, birthdays and everyday. Submit seasonal material 6 months in advance.

First Contact & Terms: Send query letter with résumé, SASE, tearsheets, photographs, photocopies, slides and transparencies. Samples are filed or are returned by SASE if requested by artist. Reports back to the artist only if interested. Write to schedule an appointment to show a portfolio, which should include roughs, original/final art, color tearsheets, photographs and dummies. Pays by the hour, $15-50; by the project, $50-1,000. Rights purchased vary according to project. Originals are not returned.

RUSS BERRIE AND COMPANY, 111 Bauer Dr., Oakland NJ 07436. (800)631-8465. Fax: (201)337-7901. Director Paper Goods: Angelica Urra. Produces greeting cards, bookmarks and calendars. Manufacturer of impulse gifts for all age groups.
Needs: Works with average of 50 freelancers/year. Buys average of 500 freelance designs and illustrations/year. Prefers freelancers with experience in industry or greeting cards. Works on assignment only. Uses freelancers mainly for greeting cards. Also for calligraphy. Produces material for all holidays and seasons. 30% of freelance work requires computer skills.
First Contact & Terms: Designers send query letter with résumé, SASE and color photocopies. Illustrator send query letter with photocopies. Samples are filed or returned by SASE. Reports back only if interested. To show portfolio, mail tearsheets and printed samples. Rights purchased vary. Pays flat rate depending on amount of work involved; or royalties of 2%. Do not send b&w samples. Color only.

‡CHARLES SADEK IMPORT COMPANY, INC., P.O. Box 717, New Rochelle NY 10802. (914)633-8090. Fax: (914)633-8552. Product Development Coordinator: Liza Greenwald. Estab. 1936. Produces porcelain, ceramic, metals. "CSIC manufactures traditional, well-priced decorative porcelains, ceramics and metal accessories. Works extensively with museum licensing programs. Wholesale only, customers include department stores, mail order, specialty gift shops and museums."
Needs: Approached by 10 freelancers/year. Works with 1-5 freelancers/year. Buys 1-5 freelance designs and illustrations/year. Prefers artists with experience in tabletop and decorative porcelain. Works on assignment only. Uses freelancers mainly for museum projects. Interested in artists with flora and fauna/wildlife art experience.
First Contact & Terms: Send query letter with brochure, tearsheets, résumé, SASE, photocopies. Samples are filed, if not filed they are returned by SASE if requested by artist. Company will contact artist for portfolio review if interested. Portfolio should include thumbnails, roughs, final art, tearsheets, photographs, 4×5 transparencies. Rights purchased vary according to project. Pays by the project, rate varies. Finds freelancers through word of mouth, submissions.
Tips: "Artists must be able to meet deadlines and have flexibility concerning input."

‡ST. ARGOS CO., INC., 11040 W. Hondo Pkwy., Temple City CA 91780. (818)448-8886. Fax: (818)579-9133. Manager: Roy Liang. Estab. 1987. Produces greeting cards, giftwrap, Christmas decorations, paper boxes, tin boxes, bags, puzzles, cards.
Needs: Approached by 3 freelance artists/year. Works with 2 freelance artists/year. Buys 3 freelance designs and illustrations/year. Prefers artists with experience in Victorian or country style. Uses freelance artists mainly for design. Produces material for all holidays and seasons. Submit seasonal material 6 months in advance.
First Contact & Terms: Send query letter with résumé and slides. Samples are filed. Art Director will contact artist for portfolio review if interested. Portfolio should include color samples. Originals are not returned. Pays royalties of 7.5%. Negotiates rights purchased.

SANGRAY CORPORATION, 2318 Lakeview Ave., Pueblo CO 81004. (719)564-3408. Fax: (719)564-0956. President: James Stuart. Estab. 1971. Produces refrigerator magnets, trivets, wall decor and other decorative accessories—all using full color art.
Needs: Approached by 5-6 freelancers/year. Works indirectly with 6-7 freelancers/year. Buys 25-30 freelance designs and illustrations/year. Prefers florals, scenics, small animals and birds. Uses freelancers mainly for fine art for products. Considers all media. Prefers 7×7. Submit seasonal material 10 months in advance.
First Contact & Terms: Send query letter with examples of work in any media. Samples are filed. Reports back within 30 days. Company will contact artist for portfolio review if interested. Buys first rights. Originals are returned at job's completion. Pays by the project, $250-400. Finds artists through submissions and design studios.

SARUT INC., 107 Horatio, New York NY 10014. (212)691-9453. Fax: (212)691-1077. Vice President Marketing: Frederic Rambaud. Estab. 1979. Produces museum quality science and nature gifts. "Marketing firm with 6 employees. 36 trade shows a year. No reps. All products are exclusive. Medium- to high-end market."
Needs: Approached by 4-5 freelancers/year. Works with 4 freelancers/year. Uses freelancers mainly for new products. Seeks contemporary designs. Produces material for all holidays and seasons.
First Contact & Terms: Samples are returned. Reports back within 2 weeks. Write for appointment to show portfolio. Rights purchased vary according to project.
Tips: "We are looking for concepts; products not automatically graphics."

SCANDECOR INC., 430 Pike Rd., Southampton PA 18966. (215)355-2410. Creative Director: Lauren H. Karp. Produces posters, calendars, greeting cards and art prints.

- Scandecor is looking for artwork for posters geared to three target markets: mother and child (juvenile style); preteen (fairies, dragons); and teens. Art director says there's a greater need for poster art than for greeting cards, but she would like to see art by greeting card artists that could also work for posters. See listing in the Posters and Prints section.

Needs: Looking for cute and trendy designs mainly for posters for boys, girls and teens. Prefers illustrations and airbrush work. Art prints needs are fine art in floral, traditional and contemporary styles.

First Contact & Terms: Samples not filed are returned by SASE. Artist should follow-up after initial query. Art Director will contact artist for portfolio review if interested. Portfolio should include color slides, photostats and photographs. Originals are sometimes returned at job's completion. Requests work on spec before assigning a job. Negotiates rights purchased. Finds artists through magazines, submissions, gift shows and art fairs. Advises artists to attend local gift shows.

Tips: "Artists can look at products in the market to get a feel for how art can be used. Submissions can then show how the artist's work can be used, and this will help the buyer to visualize the art on his or her product."

SCOTT CARDS INC., Box 906, Newbury Park CA 91319. E-mail: scottcards@aol.com. Estab. 1984. Produces contemporary greeting cards for young-minded adults.

Needs: Accepts 50-75 freelance designs/year. Art guidelines for SASE with first-class postage. Needs birthday and romance cards for *Fun & Luv* line. Also looking for Christmas and Valentine designs. Especially needs risque designs for *Naughty Card* line. "Seeking clever risque designs but NO pornography—Naughty Cards are the kind that 'women love to send and men love to get.' "

First Contact & Terms: Send query letter with SASE. Please do not submit artwork until you have reviewed guidelines. Buys first five designs outright for $50 each; pays 5% royalty on subsequent designs accepted.

Tips: "Humor and sensitivity sells in ALL areas. Birthdays and romance cards are particularly fast sellers. When creating risque designs, keep in mind people who enjoy R-rated movies. Once again, humor sells! The key is cleverness, not obscenity. Avoid trying to please an X-rated audience."

SEABRIGHT PRESS, P.O. Box 7285, Santa Cruz CA 95061. (408)457-1568. Fax: (408)459-8059. E-mail: artcards@cruzio.com. Editor: Jim Thompson. Estab. 1990. Produces greeting cards and journals.

Needs: Approached by 20-30 freelancers/year. Works with 5-10 freelancers/year. Buys 10-20 freelance designs and illustrations/year. Uses freelancers mainly for notecard designs. Art guidelines available for SASE with first-class postage. Considers any media. Produces material for all holidays and seasons. Submit seasonal material 4-6 months in advance.

First Contact & Terms: Send query letter with brochure, tearsheets, photographs, photocopies and SASE. Samples are not filed and are returned by SASE if requested by artist. Reports back within 2 months. Portfolio review not required. Negotiates rights purchased. Originals are returned at job's completion. Pays royalties of 5-7%.

Tips: "Be familiar with the notecard market before submitting work. Develop contemporary illustrations/designs that are related to traditional card themes."

***SECOND NATURE, LTD.**, 10 Malton Rd., London, W105UP England. (0181)960-0212. Fax: (0181)960-8700. E-mail: secondnature.co.uk@aol.com. Website: http://www.tcom.co.uk.Secondnature/. Contact: Ron Schragger. Greeting card publisher specializing in unique 3-D/handmade and foiled cards.

Needs: Prefers interesting new contemporary but commercial styles. Produces material for Christmas, Valentine's Day, Mother's Day and Father's Day. Submit seasonal material 18 months in advance.

First Contact & Terms: Send query letter with brochure showing art style. Samples not filed are returned only if requested by artist. Reports back within 2 months. Originals are not returned at job's completion. Pays flat fee.

Tips: "We are interested in all forms of paper engineering."

‡SECURITAG CORP., P.O. Box 812300, Wellesley MA 02181. (508)655-6590. Fax: (508)655-4510. President: Dale Eckerman. Estab. 1978. Produces greeting cards, balloons and gift products.

Needs: Approached by many freelance artists/year. Works with several freelancers/year. Buys several designs and illustrations/year. Prefers artists with experience in party products. Works on assignment only.

 THE ASTERISK before a listing indicates that the market is located outside the United States and Canada.

Uses freelancers mainly for gift product design. Needs computer-literate freelancers with knowledge of QuarkXPress and Adobe Illustrator.
First Contact & Terms: Send query letter with samples. Samples are filed. Reports back to the artist only if interested. Call or write for appointment to show portfolio; or mail appropriate materials. Buys all rights. Payment varies.

SHERRY MFG. CO., INC., 3287 NW 65th St., Miami FL 33147. Fax: (305)691-6132. E-mail: nuthouse@a ol.com. Art Director: Jeff Seldin. Estab. 1948. Manufacturer of silk screen T-shirts with beach and mountain souvenir themes. Label: Sherry's Best. Clients: T-shirt retailers. Current clients include Walt Disney Co., Club Med and Kennedy Space Center.
Needs: Approached by 50 freelancers/year. Works with 15 freelance designers and illustrators/year. Assigns 350 jobs/year. Prefers freelancers that know the T-shirt market and understand the technical aspects of T-shirt art. Prefers colorful graphics or highly stippled detail. Art guidelines available. 25% of freelance work demands knowledge of Adobe Illustrator, Aldus FreeHand 5.0, Adobe Photoshop, Typestyler or Stratavision.
First Contact & Terms: Send query letter with brochure showing art style or résumé and photocopies. Accepts submissions on disk compatible with Aldus FreeHand 5.5 or Adobe Illustrator 5.0. Samples are not filed and are returned only if requested. Art Director will contact artist for portfolio review if interested. Portfolio should include thumbnails, roughs, original/final art, final reproduction/product and color tearsheets, photostats and photographs. Sometimes requests work on spec before assigning a job. Pays by the project. Considers complexity of project, skill and experience of artist, and volume of work given to artist when establishing payment. Buys all rights.
Tips: "Know the souvenir T-shirt market and have previous experience in T-shirt art preparation. Some freelancers do not understand what a souvenir T-shirt design should look like. Send sample copies of work with résumé to my attention."

‡PAULA SKENE DESIGN, 1250 45th St., Suite 240, Emeryville CA 94608. (510)654-3510. Fax: (510)654-3496. President: Paula Skene. Produces greeting cards and stationery designs for corporations, foil stamping and embossing design for cards, marketing pieces and stationery.
Needs: Works with 1-2 freelancers/year. Works on assignment only. Produces material for all holidays and seasons, everyday.
First Contact & Terms: Designers send slides, tearsheets, transparencies. Illustrators send sample, call for appointment. Samples are returned. Reports back within 3 days. Company will contact artist for portfolio review of b&w, color final art if interested. Buys all rights. Pays for design and illustration by the project.

SMART ART, P.O. Box 661, Chatham NJ 07928. (201)635-1690. Fax: (201)635-2011. E-mail: smartartnj@a ol.com. President: Barb Hauck-Mah. Vice President: Wesley Mah. Estab. 1992. Produces photo frame cards. "Smart Art creates unique, premium quality cards for all occasions. We contribute a portion of all profits to organizations dedicated to helping our nation's kids."
 ● Smart Art is continuing to expand its photo frame card line, so they are looking for artists who can do great watercolor, collage or mixed media border designs. The cards are ready-to-use "frames" customers can slip photos into and mail to friends.
Needs: Approached by 40-50 freelancers/year. Works with 6 freelancers/year. Buys 20-25 illustrations/year. Art guidelines available for SASE with first-class postage. Works on assignment only. Uses freelancers for card design/illustration. Considers watercolor, pen & ink and collage or mixed media. Produces material for most holidays and seasons, plus birthdays and everyday. Submit seasonal material 10-12 months in advance.
First Contact & Terms: Send query letter with tearsheets, photocopies, résumé and SASE. Samples are filed or returned by SASE. Reports back within 8-10 weeks. Portfolio review not required. Sometimes requests work on spec before assigning a job. Originals are returned at job's completion. Pays royalties of 5%, based on wholesale money earned. Negotiates rights purchased. Finds artists through word of mouth and trade shows.
Tips: "Send us rough color samples of potential greeting cards or border designs you've created."

‡SPENCER GIFTS, INC., 6826 Black Horse Pike, Egg Harbor Twp. NJ 08234. (609)645-5526. Fax: (609)645-5651. Art Director: James Stevenson. Estab. 1965. Retail gift chain located in approximately 500 malls in 43 states. Includes a new retail chain of 20 stores named "DAPY" (upscaled unique gift items).
 ● Products offered by this chain include posters, T-shirts, games, mugs, novelty items, cards, 14k jewelry, neon art, novelty stationery. Visit a store if you can to get a sense of what they offer.
Needs: Assigns 10-15 freelance jobs/year. Prefers artists with professional experience in advertising. Uses artists for illustration (hard line art, fashion illustration, airbrush). 50% of freelance work demands knowledge of Aldus FreeHand, Adobe Illustrator, Adobe Photoshop and QuarkXPress.
First Contact & Terms: Send postcard sample or query letter with *nonreturnable* brochure, résumé and photocopies including phone number where you can be reached during business hours. Accepts submissions on disk. Art Director will contact artist for portfolio review if interested. Will contact only upon job need. Considers buying second rights (reprint rights) to previously published work. Finds artists through sourcebooks.

‡SQUEEGEE PRINTERS, Box 47, Canaan VT 05903. (802)266-3426. Owner: Pat Beauregard. Estab. 1984. Custom screen printing of wearing apparel, such as pre-printed T-shirts and sweats for the souvenir market and promotional purposes. Clients: stores, hotels, restaurants, resort areas, banks and corporations.
Needs: Works with 3 freelance artists/year. Assigns over 20 jobs/year. Prefers artists with experience in the 4-color process. Works on assignment basis only. Uses freelance artists mainly for producing new stock designs. Also uses artists for advertising illustration and product design.
First Contact & Terms: Send query letter with brochure, résumé, photostats and photographs. Samples are filed. Reports back only if interested. To show a portfolio, mail final reproduction/product, tearsheets, photostats, photographs and color. Pays for design by the project, $50-300. Buys all rights.
Tips: "Send representative samples of work so we can see if it's anything we would be interested in."

‡STANDARD CELLULOSE & NOV CO., INC., 90-02 Atlantic Ave., Ozone Park NY 11416. (718)845-3939. Fax: (718)641-1170. President: Stewart Sloane. Estab. 1932. Produces giftwrap and seasonal novelties and decorations.
Needs: Approached by 10 freelance artists/year. Works with 1 freelance artist/year. Buys 3-4 freelance designs and illustrations/year. Prefers local artists only. Uses freelance artists mainly for design packaging. Also uses freelance artists for P-O-P displays, all media appropriate for display and P-O-P. Produces material for all holidays and seasons, Christmas, Easter, Halloween and everyday. Submit 6 months before holiday.
First Contact & Terms: Send query letter or call for appointment. Samples are not filed and are returned. Reports back to the artist only if interested. Call to schedule an appointment to show a portfolio. "We will then advise artist what we want to see in portfolio." Original artwork is not returned at the job's completion. Payment negotiated at time of purchase. Rights purchased vary according to project.

STUART HALL CO., INC., P.O. Box 200915, Kansas City MO 64120-0915. Website: http://www.stuartha ll.com. Director of Advertising and Art: Judy Riedel. Produces stationery, school supplies and office supplies.
Needs: Approached by 30 freelancers/year. Buys 40 freelance designs and illustrations/year. Artist must be experienced—no beginners. Art guidelines free for SASE with first-class postage. Works on assignment only. Uses freelance artists for design, illustration, calligraphy on stationery, notes and tablets, and paste-up and mechanicals. Considers pencil sketches, rough color, layouts, tight comps or finished art; watercolor, gouache, or acrylic paints are preferred for finished art. Avoid fluorescent colors. "All art should be prepared on heavy white paper and lightly attached to illustration board. Allow at least one inch all around the design for notations and crop marks. Avoid bleeding the design. In designing sheet stock, keep the design small enough to allow for letter writing space. If designing for an envelope, first consult us to avoid technical problems." 100% of design and 50% of illustration demand knowledge of QuarkXPress, Adobe Illustrator, Adobe Photoshop and Aldus FreeHand.
First Contact & Terms: Send query letter with résumé, tearsheets, photostats, slides and photographs. Samples not filed are returned by SASE. Reports only if interested. Will contact for portfolio review if interested. Portfolio should include roughs, original/final art, final reproduction/product, color, tearsheets, photostats and photographs. Originals are not returned. "Stuart Hall may choose to negotiate on price but generally accepts the artist's price." Pays by project. Buys all rights. Finds artists primarily through word of mouth.

SUN HILL INDUSTRIES, INC., 48 Union St., Stamford CT 06906. Fax: (203)356-9233. Creative Director: Nancy Mimoun. Estab. 1977. Manufacturer of Easter egg decorating kits, Halloween novelties (the Giant Stuff-A-Pumpkin®) and Christmas items. Produces only holiday material. Clients: discount chain and drug stores and mail-order catalog houses. Clients include K-Mart, Walmart, Walgreens and Caldor.
Needs: Approached by 10 freelancers/year. Works with 2-3 freelance illustrators and 1-2 designers/year. Assigns 5-6 freelance jobs/year. Works on assignment only. Uses freelancers for product and package design, rendering of product and model-making. Prefers marker and acrylic. 50% of freelance work demands knowledge of Adobe Photoshop, Aldus PageMaker, QuarkXPress and Adobe Illustrator.
First Contact & Terms: Send query letter with brochure and résumé. Accepts submissions on disk compatible with Adobe Illustrator 5.0. Send EPS files. Samples are filed or are returned only if requested by artist. Reports back only if interested. Pays by the hour, $25 minimum; or by the project, $250 minimum. Considers complexity of project and turnaround time when establishing payment. Buys all rights.
Tips: "Send all information; don't call. Include package designs; do not send mechanical work."

SUNRISE PUBLICATIONS INC., Box 4699, Bloomington IN 47402. (812)336-9900. Fax: (812)336-8712. E-mail: jjensen@aviion.com. Contact: Administrative Assistant of Artistic Resources. Estab. 1974. Produces greeting cards, posters, writing papers, gift packaging and related products.
Needs: Approached by 300 freelancers/year. Works with 200 freelancers/year. Buys 400 designs and illustrations/year. Uses freelancers mainly for greeting card illustration. Also for calligraphy. Considers any medium. Looking for "highly detailed, highly rendered illustration, but will consider a range of styles." Also looking for photography and surface design. 2% of freelance work demands computer skills. Produces material for

all holidays and seasons and everyday. Reviews seasonal material year-round.

First Contact & Terms: Send query letter with SASE, tearsheets, photographs, photocopies, photostats, slides and/or transparencies. Samples are not filed and are returned by SASE. Reports back within 2 weeks for queries regarding status; submissions returned within 3 months. Art Director will contact artist for portfolio review if interested. Portfolio should include color tearsheets, photographs and/or slides (duplicate slides or transparencies, please; *not* originals). Originals are returned at job's completion. Negotiates rights purchased. Considers buying second rights (reprint rights) to previously published work.

‡**SUNSHINE ART STUDIOS, INC.**, 45 Warwick St., Springfield MA 01102. (413)781-5500. Contact: Deb Fuller. Estab. 1921. Produces greeting cards, stationery, calendars and giftwrap that are sold in own catalog, appealing to all age groups.

Needs: Works with 100-125 freelance artists/year. Buys 200-250 freelance designs and illustrations/year. Prefers artists with experience in greeting cards. Works on assignment only. Uses freelancers mainly for greeting cards, giftwrap and stationery. Also for calligraphy. Considers gouache, watercolor and acrylic. Looking for "cute animals, florals and traditional motifs." Prefers art 4½×6½ or 5×7. Produces material for Christmas, Easter, birthdays and everyday. Submit seasonal material 6-8 months in advance.

First Contact & Terms: Send query letter with brochure, résumé, SASE, tearsheets and slides. Samples are filed or are returned by SASE if requested by artist. Reports back to the artist only if interested. Portfolio should include finished art samples and color tearsheets and slides. Originals not returned. Pays by the project, $250-400. Buys all rights.

Alan Fishman created this card for Sunshine Art Studio's holiday line. "I've done every type of greeting card ever invented—you name it, I've done it," says the artist, a 40-year veteran of the greeting card industry and illustrator of at least 10,000 cards. Sunshine's Art Director Jo Martino gave Fishman his very first greeting card assignment in 1956. "I've worked for just about everyone in the business," he says.

CURTIS SWANN, Division of Burgoyne, Inc., 2030 E. Byberry Rd., Philadelphia PA 19116. (215)677-8000. Fax: (215)677-6081. Contact: Art Director. Produces greeting cards. Publishes everyday greeting cards based on heavily embossed designs. Style is based in florals and "cute" subjects.

Needs: Works with 10 freelancers/year. Buys 20 designs and illustrations. Prefers freelancers with experience in greeting card design. Art guidelines free for SASE with first-class postage. Considers designs and media that work well to enhance embossing. Produces material for everyday designs as well as Christmas, Valentine's, Easter, Mother's and Father's Day. Accepts work all year round.

First Contact & Terms: Send query letter with brochure, tearsheets, slides, transparencies, photographs, photocopies and SASE. Would like to see a sample card with embossed features. Samples are filed. Creative

Director will contact artist for portfolio review if interested. Sometimes requests work on spec before assigning a job. Pays flat fee. Buys first rights or all rights.

A SWITCH IN ART, Gerald F. Prenderville, Inc., P.O. Box 246, Monmouth Beach NJ 07750. (908)389-4912. Fax: (908)389-4913. President: G.F. Prenderville. Estab. 1979. Produces decorative switch plates. "We produce decorative switch plates featuring all types of designs including cats, animals, flowers, kiddies/baby designs, birds, etc. We sell to better gift shops, museums, hospitals, specialty stores with large following in mail order catalogs."
Needs: Approached by 4-5 freelancers/year. Works with 2-3 freelancers/year. Buys 20-30 designs and illustrations/year. Prefers artists with experience in card industry and cat rendering. Seeks cats and wildlife art. Prefers 8×10 or 10×12. Produces material for Christmas and everyday. Submit seasonal material 6 months in advance.
First Contact & Terms: Send query letter with brochure, tearsheets and photostats. Samples are filed and are returned. Reports back within 3-5 weeks. Pays by the project, $75-150. Interested in buying second rights (reprint rights) to previously published artwork. Finds artists mostly through word of mouth.
Tips: "Be willing to accept your work in a different and creative form that has been very successful. We seek to go vertical in our design offering to insure continuity. We are very easy to work with and flexible. Cats have a huge following among consumers but designs must be realistic."

SYRACUSE CULTURAL WORKERS, Box 6367, Syracuse NY 13217. (315)474-1132. Fax: (315)475-1277. Art Director: Linda Malik. Estab. 1982. Produces notecards, postcards, greeting cards, posters, T-shirts and calendars. "SCW is a nonprofit publisher of artwork that inspires and supports social change. Our *Art with Heart* catalog is distributed to individuals, stores, co-ops and groups in North America."
Needs: Approached by many freelancers/year. Works with 50 freelancers/year. Buys 40-50 freelance designs and illustrations/year. Considers all media (in slide form). Art guidelines free for SASE with first-class postage. Looking for progressive, feminist, liberating, vital, people- and earth-centered themes. Submit holiday material 6 months in advance.
First Contact & Terms: Send postcard sample or query letter with slides, brochures, photocopies, photographs SASE, tearsheets and transparencies. Samples are filed or returned by SASE. Reports back within 1 month. Will contact for portfolio review if interested. Buys one-time rights. Originals returned at job's completion. Pays by project, $85-400; royalties of 6% of gross sales. Finds artists through word of mouth, its own artist list.

TALICOR, INC., Dept. AGDM, 190 Gentry St., Pomona CA 91767. (709)593-5877. President: Lew Herndon. Estab. 1971. Manufacturer and distributor of educational and entertainment games and toys. Clients: chain toy stores, department stores, specialty stores and Christian bookstores.
Needs: Works with 4-6 freelance illustrators and designers/year. Prefers local freelancers. Works on assignment only. Uses freelancers mainly for game design. Also for advertising, brochure and catalog design, illustration and layout; product design; illustration on product; P-O-P displays; posters and magazine design.
First Contact & Terms: Send query letter with brochure. Samples are not filed and are returned only if requested. Reports back only if interested. Call or write for appointment to show portfolio. Pays for design and illustration by the project, $100-5,000. Negotiates rights purchased.

VAGABOND CREATIONS INC., 2560 Lance Dr., Dayton OH 45409. (513)298-1124. Art Director: George F. Stanley, Jr. Publishes stationery and greeting cards with contemporary humor. 99% of artwork used in the line is provided by staff artists working with the company.
Needs: Works with 4 freelancers/year. Buys 30 finished illustrations/year. Prefers local freelancers. Seeking line drawings, washes and color separations. Material should fit in standard size envelope.
First Contact & Terms: Query. Samples are returned by SASE. Reports in 2 weeks. Submit Christmas, Mother's Day, Father's Day, Valentine's Day, everyday and graduation material at any time. Originals are returned only upon request. Payment negotiated.
Tips: "Important! Important! Currently we are *not* looking for additional freelance artists because we are very satisfied with the work submitted by those individuals working directly with us. We do not in any way wish to offer false hope to anyone, but it would be foolish on our part not to give consideration. Our current artists are very experienced and have been associated with us for in some cases over 30 years."

‡VERMONT T'S, Main St., Chester VT 05143. (802)875-2091. President: Thomas Bock. Commercial screen printer, specializing in T-shirts and sweatshirts. Vermont T's produces custom as well as tourist-oriented silkscreened sportwear. Does promotional work for businesses, ski-resorts, tourist attractions and events.
Needs: Works with 5-10 freelance artists/year. Uses artists for graphic designs for T-shirt silkscreening. Prefers pen & ink, calligraphy and computer illustration.
First Contact & Terms: Send query letter with brochure. Samples are filed or are returned only if requested. Reports back within 10 days. To show portfolio, mail photostats. Pays for design by the project, $75-250. Negotiates rights purchased. Finds most artists through portfolio reviews and samples.

Tips: "Have samples showing rough through completion. Understand the type of linework needed for silkscreening."

‡**VINCENT & COMPANY**, 826 W. Avenue H, San Antonio TX 76901. (915)655-7787. Fax: (915)653-9447. President: John S. Pearcy. Estab. 1993. Produces T-shirts, textiles and silk neckties. "We produce high quality art, nature and conversational T-shirts and neckties."
Needs: Approached by 1-2 freelancers/year. Works with 5-6 freelancers/year. Buys 20-40 freelance designs and illustrations/year. Art guidelines available. Uses freelancers mainly for new designs of ties and T-shirts. Also needs freelancers for calligraphy and P-O-P displays. Considers all media. Looking for new ideas. Produces material for Christmas and everyday.
First Contact & Terms: Call for submission information and/or to request portfolio review. Accepts disk submissions. Samples are filed or returned by SASE. Reports back within 2 days. Portfolio review required. Request portfolio review in original query. Portfolio should include color samples. Rights purchased vary according to project. Payment negotiable based on the market. Finds artists through word of mouth, postings and art schools.

VINTAGE IMAGES, Box 228, Lorton VA 22199. (703)550-1881. Fax: (703)550-7992. Art Director: Brian Smolens. Estab. 1987. Produces greeting cards and posters. "We produce social stationery and prints using sophisticated humor." Comic/cartoon line is in production.
Needs: Approached by 10 freelancers/year. Works with 2 freelancers/year. Buys 20-40 freelance designs and illustrations/year. Uses freelancers for whole card lines. Also for calligraphy and P-O-P displays. Considers "any media that can be accurately reproduced." Looking for sophisticated humor, not "computer-looking" designs. "We will also consider a bold, elegant personal style." 15% of freelance work demands knowledge of Aldus PageMaker or Adobe Photoshop. Produces material for Christmas, Valentine's Day and everyday.
First Contact & Terms: Send query letter with brochure, SASE and photostats/samples. Samples are filed or are returned by SASE. Portfolio review not required. Negotiates rights purchased. Originals are returned at job's completion. Pays average flat fee of $100; or pays by the hour, $30; or by the project, $500 minimum; or royalties of 6%.
Tips: "Provide samples we can keep on file." Has observed more direct/explicit greeting cards in the last year, as well as a move to computer graphics. Needs cartoonists. "We have new calligraphic and traditional art lines in development. No fancy portfolios needed—we have to file materials."

‡**WANDA WALLACE ASSOCIATES**, Box 436, Inglewood CA 90306. (213)295-4567. President: Wanda. Estab. 1980. Produces greeting cards and posters for general public appeal. "We produce black art prints, posters, originals and other media."
Needs: Approached by 10-12 freelance artists/year. Works with varying number of freelance artists/year. Buys varying number of designs and illustrations/year from freelance artists. Prefers artists with experience in black art subjects. Uses freelance artists mainly for production of originals and some guest appearances. Considers all media. Produces material for Christmas. Submit seasonal material 4-6 months in advance.
First Contact & Terms: Send query letter with any visual aid. Some samples are filed. Policy varies regarding answering queries and submissions. Call or write to schedule an appointment to show a portfolio. Rights purchased vary according to project. Original artwork is returned at the job's completion. Pays by the project.

WARNER PRESS, INC., 1200 E. Fifth St., Anderson IN 46018. (317)644-7721, ext. 217. Creative Manager: Thom Hunter. Estab. 1884. Produces greeting cards, posters, stationery, calendars, church bulletins and supplies. Warner Press is the publication board of the Church of God. "We produce products for the Christian market including greeting cards, calendars and posters. Our main market is the Christian bookstore, but we are expanding into general market with some items. We provide products for all ages."
Needs: Approached by 50 freelancers/year. Works with 35-40 freelancers/year. Buys 300 freelance designs and illustrations/year. Prefers freelancers with experience in greeting cards, posters, calendars, books and giftware—must adhere to deadline and produce quality work. Works on assignment only. Uses freelancers for all products—cards, coloring books, calendars, stationery, etc. Also for calligraphy. "We use local Macintosh artists with own equipment capable of handling 40 megabyte files in Photoshop, FreeHand and QuarkXPress." Considers all media and photography. Looking for bright florals, sensitive still lifes, landscapes, wildlife, birds, seascapes; all handled with bright or airy pastel colors. 100% of production work demands knowledge of QuarkXPress, Aldus FreeHand, Adobe Illustrator or Adobe Photoshop. Produces material for

‡ **THE DOUBLE DAGGER** before a listing indicates that the listing is new in this edition. New markets are often more receptive to freelance submissions.

Father's Day, Mother's Day, Christmas, Easter, graduation, birthdays, Valentine's Day and everyday. Submit seasonal material 18 months in advance.

First Contact & Terms: Send query letter with brochure, tearsheets and photocopies. Samples are filed and are not returned. Creative manager will contact artist for portfolio review if interested. Portfolio should include b&w and color final art, tearsheets, photographs and transparencies. Originals are not returned. Pays by the project, $250-350. Pays for calligraphy pieces by the project. Buys all rights (occasionally varies).

Tips: "Subject matter must be appropriate for Christian market. We prefer palettes of brights colors as well as clean, pretty pastels for greeting cards and calendars. Dramatic palettes work in our poster line."

WEST GRAPHICS, 385 Oyster Point Blvd., #7, San Francisco CA 94080. (800)648-9378. Website: http://www.west-graphics.com. Contact: Production Department. Estab. 1980. "West Graphics is an alternative greeting card company offering a diversity of humor from 'off the wall' to 'tastefully tasteless.' Our goal is to publish cards that challenge the limits of taste and keep people laughing." Produces greeting cards.
 • West Graphics' focus is adult alternative humor.

Needs: Approached by 100 freelancers/year. Works with 40 freelancers/year. Buys 150 designs and illustrations/year. Art guidelines free for SASE with first-class postage. Uses freelancers for illustration. "All other work is done inhouse." Considers all media. Looking for outrageous contemporary illustration and "fresh new images on the cutting edge." Prefers art proportionate to finished vertical size of 5×7, no larger than 10×14. Produces material for all holidays and everyday (birthday, get well, love, divorce, congratulations, etc.) Submit seasonal material 1 year in advance.

First Contact & Terms: Send query letter with SASE, tearsheets, photocopies, photostats, slides or transparencies. Samples should relate to greeting card market. Accepts submissions on disk. Samples not filed and will be returned by SASE. Reports back within 6 weeks. Will contact for portfolio review if interested. Portfolio should include thumbnails, roughs, photostats, color tearsheets, photographs, slides, dummies and samples of printed work if available. Rights purchased vary. Pays by the project, $100-350, or offers royalties of 5%.

Tips: "We welcome both experienced artists and those new to the greeting card industry. Develop art and concepts with an occasion in mind such as birthday, etc. Your target should be issues that women care about: men, children, relationships, sex, religion, aging, success, money, crime, health, etc. Increasingly, there is a younger market and more cerebral humor. Greeting cards are becoming a necessary vehicle for humorously communicating genuine sentiment that is uncomfortable to express personally."

WHITEGATE FEATURES SYNDICATE, 71 Faunce Dr., Providence RI 02906. (401)274-2149. Contact: Eve Green.
 • This syndicate is looking for fine artists and illustrators. See their listing in Syndicates & Clip Art Firms for more information about their needs.

WILLIAMHOUSE-REGENCY, INC., 28 W. 23rd St., New York NY 10010. Senior Art Director: Nancy Boecker Oates. Estab. 1955. Produces wedding invitations and announcements, Christmas cards and stationery.

Needs: Approached by 30 freelancers/year. Works with 10 freelancers/year. Buys 30 freelance designs and illustrations/year. "Prefers freelancers with experience in our products and techniques (including foil and embossing)." Art guidelines free for SASE with first-class postage. Uses freelancers mainly for design and illustration of wedding invitations. Also for calligraphy. Considers all media. Produces material for personalized Christmas, Rosh Hashanah, New Year, graduation, wedding invitations and birth announcements. Submit seasonal material 1 year in advance.

First Contact & Terms: Send query letter with SASE. Samples are not filed and are returned by SASE. Reports back within 3 weeks. Artist should follow-up with letter after initial query. Pays average flat fee of $200/design; pays more for full color or complicated artwork. Pays by project for calligraphy. Buys reprint rights or all rights. No royalties.

Tips: "Send in any roughs or copies of finished ideas you have, and we'll take a look. Write for specs on size first (with SASE) before submitting any material. In wedding invitations, we seek a non-greeting card look. Have a look at what is out there."

‡CAROL WILSON FINE ARTS, INC., Box 17394, Portland OR 97217. (503)261-1860. Contact: Gary Spector. Estab. 1983. Produces greeting cards and fine stationery products.

Needs: Romantic floral and nostalgic images. "We look for artists with high levels of training, creativity and ability."

First Contact & Terms: Send query letter with résumé, business card, tearsheets, photostats, photocopies, slides and photographs to be kept on file. No original artwork on initial inquiry. Samples not filed are returned by SASE. Reports within 2 months. Negotiates return of original art after reproduction. Payment ranges from flat fee to negotiated royalties.

Tips: "We are seeing an increased interest in romantic fine arts cards and very elegant products featuring foil, embossing and die-cuts."

‡**WINDSOR ART PRODUCTS, INC.**, 9101 Perkins St., Pico Rivera CA 90660. (213)723-6301. Design Director: Pauline Raschella. Estab. 1970. Manufacturer of decorative framed artwork and mirrors for retail stores.

Needs: Works with 5 freelance artists/year. Prefers local artists. Works on assignment only. Uses artists for product design.

First Contact & Terms: Send query letter and SASE with brochure showing art style and photographs. Samples not filed are returned only if requested. Reports only if interested. Call or write to schedule an appointment to show a portfolio, which should include roughs, original/final art, final production/product and photographs. Pays for design and illustration by the project, $300-1,000. Considers complexity of project when establishing payment.

Tips: Portfolio should include "various examples of types of designs that can be done."

‡**WIZARDS OF THE COAST**, 1801 Lind Ave. SW, Renton WA 98055. (206)226-6500. Art Department Coordinator: Adam Smith. Estab. 1990. Produces Deckmaster ™ collectible card games.

Needs: Approached by 300 freelancers/year. Works with 150 freelancers/year. Buys 1,000 freelance designs and illustrations/year. Prefers freelancers with with experience in fantasy art. Art guidelines available. Works on assignment only. Uses freelancers mainly for cards, posters, books. Considers all media. Looking for fantasy, gothic, cyberpunk art. 100% of design demands knowledge of Adobe Photoshop, Adobe Illustrator, Aldus FreeHand, QuarkXPress. 30% of illustration demands computer skills. Produces material for all holidays and seasons.

First Contact & Terms: Illustrators send query letter with 6-10 full color pieces. Accepts submissions on disk. Samples are filed or returned by SASE. Reports back within 1 month. Artist should follow-up with letter after initial query. Will contact for portfolio review if interested. Portfolios should include color, final art, photographs and tearsheets. Rights purchased vary according to project. Pays for design by the project, $300 minimum. Payment for illustration and sculpture depends on project. Finds freelancers through conventions, submissions and referrals.

Magazines

The magazine market is a bonanza for freelancers. Take a look at any newsstand. The colorful publications competing for your attention are filled with interesting illustrations, cartoons, caricatures and collages—all created by freelance talent. Since most magazines are published monthly, art directors need dependable artists to provide a steady supply of images.

Art illustrating magazine or newspaper articles is called editorial illustration. You'll notice that term as you browse the listings. Art directors look for the best visual element to hook the reader into the story. A whimsical illustration can set the tone for a humorous article and a caricature might dress up a short feature about a celebrity. Smaller illustrations, called spot illustrations, are needed to break up text and lead the reader from feature to feature.

Attractive art isn't enough to grab assignments. Your work must not only convey the tone and content of a writer's article, it also must fit in with a magazine's "personality." For example, *Rolling Stone* and *Mother Jones* illustrations have a more edgy quality to them than the illustrations in *Prevention* or *Reader's Digest*, which tend to publish traditional pen & ink renderings with color washes or cheery cartoon-like illustrations. Chances are with a little honing, your artwork would do well in several magazines. It's up to you to determine which ones. The guidelines in this section should help you achieve your goals.

FIFTEEN STEPS TO SUCCESS

1. Read each listing carefully. Within each listing are valuable clues. Knowing how many artists approach each magazine will help you understand how stiff your competition is. (At first, you might do better submitting to art directors who aren't swamped with submissions.) If one magazine buys one illustration an issue and another uses ten, the latter is more likely to hire you. Check for subject matter and submission requirements and develop a mailing list of markets you want to approach. Look at the preferred subject matter to make sure your artwork fits the magazine's needs.

2. Study your competition. Know the styles that are out there. Look at illustrations in magazines and check the illustrator's name in the credit line in small print to the side of the illustration. Notice which illustrators are used often in the publications you wish to work with. If your style is too similar to other illustrators, you might pick up a few assignments from art directors who can't afford those illustrators but who want to use someone similar for a lower price. You're better off creating your own signature style. Art directors need diversity in their publication. They like to show several styles within the same issue. See if you can come up with a style that is different from every other illustrators' style, if only slightly. Maybe it's your use of color, or use of circular swirls for your character's eyes. Illustrator Gary Kelley is a favorite with art directors. His instantly recognizable cubist style, rendered in pastels, has won him plum assignments and dozens of awards. (See the Insider Report on page 200.)

3. Focus on one or two *consistent* styles to present to art directors in sample mailings. Marketing advisors call this "positioning." No matter how versatile you may be, limiting the styles you market will actually get you *more* jobs. Pick a style or styles (maximum two) you enjoy and can work quickly in. Art directors don't like surprises.

If your sample shows a line drawing, they expect you to work in that style when they give you an assignment. They will quickly label you as Don, "the guy who does the squiggly characters" or Sarah, "that woman who draws realistic portraits." For once you should *welcome* being labeled. If they can't identify a recognizable style from your sample, you won't be remembered.

4. Create a sample showing not only a definite style, but the ability to illustrate abstract ideas. It's not enough just to draw or paint a pretty picture. (Although you may pick up some assignments that way.) Your sample must convey a mood—whether happy, somber, playful or dignified. If you create caricatures, make sure your drawing captures the celebrity's *personality*, not just the face.

5. Develop a spot illustration style in addition to your regular style. "Spots"— illustrations that are half-page or smaller—are used in magazine layouts as interesting visual cues to lead readers through large articles, or to make filler articles more appealing. Though the fee for one spot is less than for a full layout, art directors often assign five or six spots within the same issue to the same artist. Those $75 fees quickly add up, making spot illustration a lucrative sideline. Because spots are small in size, they must be all the more compelling. So send art directors a sample showing several power-packed small pieces along with your regular style. *Note: each year the Society of Publication Designers sponsors an annual juried competition called, appropriately, SPOTS. The winners are featured in a prestigious exhibition and in 1995, were highlighted in a book,* The Best of Spot Illustrations *published by Rockport Publishers, Inc. If you would like information about the annual competition, contact the Society of Publication Designers at (212)983-8585.*

6. Send simple, polished samples to the right contact person. After you choose an illustration for your sample, get some good color photocopies made, or make an investment in printed postcards or promotional sheets. Each sample must show your name, address and phone number. (See What Should I Submit?, page 4.) Send your samples to as many magazine art directors as your budget permits. Be sure to use the art director's name in the address line, and spell it correctly!

7. Don't rely on one mailing to win assignments. Wait a few months and create another sample in the same style to send to the art directors on your original mailing list. Successful illustrators report that promotional mailings are cumulative. As a general rule, it takes about three mailings for your name to sink into art directors' brains.

8. Submit to trade magazines and regional publications. While they may not be as glamorous as national consumer magazines, some trade and regional publications are just as lavishly produced. Most pay fairly well and the competition is not as fierce. (See Neil Ferguson's Insider Report on page 149 for the scoop on trade magazines.)

9. Every assignment is valuable. Until you can get some of the higher circulation magazines to notice you, take assignments from smaller magazines. Despite their low payment, there are many advantages. You learn how to communicate with art directors, develop your signature style and learn how to work quickly to meet deadlines. Once the assignments are done, the tearsheets become valuable samples to send to other magazines.

10. Plan regular visits to newsstands and bookstores. Look in the stands for magazines not listed in *Artist's & Graphic Designer's Market*. Check the cover and interior. If illustrations are used, flip to the masthead (usually a box in one of the beginning pages) and note the art director's name. While looking at the masthead, check the circulation figure. As a rule of thumb, the higher the circulation the higher the art director's budget. When an art director has a good budget, he tends to hire more illustrators and pay higher fees.

11. Visit your library. Another great place to find leads is in the business section

of your local library. Ask the librarian to point out the business and consumer editions of the *Standard Rates and Data Serrvice (SRDS)*. The huge directory lists thousands of magazines by category. While the listings contain mostly advertising data and are difficult to read, they do give you an idea of the magnitude of magazines published today. Another good source is a yearly directory called *Samir Husni's Guide to New Consumer Magazines* also available in the business section of the public library.

12. Invest in a fax machine and/or modem. Art directors like to work with illustrators who own faxes, because they can quickly fax a layout with a suggestion. The artist can then fax them a preliminary sketch or "rough" that the art director can OK with changes. A fax machine speeds up the back and forth between illustrator and art director, and will help both of you meet deadlines. More and more illustrators are sending images via computer modem, which also makes working with art directors easier.

13. Get your work into competition annuals and sourcebooks. The term "sourcebook" refers to the creative directories published each year showcasing the work of freelancers. Art directors consult these publications when looking for interesting styles. If an art director uses creative directories, we include that information in the listings to help you understand your competition. Some directories like *Black Book*, *The American Showcase* and *RSVP* carry paid advertisements costing several thousand dollars per page. Other annuals, like the *Print Regional Design Annual* or *Communication Art Illustration Annual* feature award winners of various competitions. An entry fee and some great work can put your work in a competition directory and in front of art directors across the country. (Consult Publications of Interest, page 681 for directory addresses.)

14. Consider hiring a rep. If after working successfully on several assignments you decide to make magazine illustration your career, consider hiring an artists' representative to market your work for you. Be aware that a rep will take at least a 30% cut. Freelancers who hate paperwork and sales do better with reps. However, many illustrators enjoy marketing and do well without one. (See the Artists' Reps section, page 654.)

15. Join an artist's organization. Networking with fellow artists and art directors will help you find additional success strategies. There are many great organizations out there—the Graphic Artist's Guild, The American Institute of Graphic Artists (AIGA), your city's Art Director's Club or branch of the Society of Illustrators hold monthly lectures and networking functions. Attend one event sponsored by each organization in your city to find out which group you are most comfortable with. Then join and become an active member. (For more information about organizations, see the Insider Report featuring Ric Grefé of the AIGA on page 679.)

ATTENTION DESIGNERS:

Some magazines also hire freelance designers and production people to assist with layouts or create and maintain websites. If you are a designer, look for listings featuring a separate heading for design. Needed computer skills and submission preferences vary from magazine to magazine, so read each listing carefully before you approach art directors.

ABERRATIONS, P.O. Box 460430, San Francisco CA 94146-0430. (415)777-3909. Art Director: Eric Turowski. Estab. 1992. Monthly science fiction/fantasy/horror magazine aimed at an adult readership. Circ. 1,500. Originals returned at job's completion. Sample copies available for $3.50 plus 4 first-class stamps. Art guidelines for SASE with first-class postage.

Illustrations: Approached by 58 illustrators/year. Buys 9-22 illustrations/issue. Works on assignment only. Prefers science fiction, fantasy, horror story illustrations. Considers pen & ink, watercolor, collage, airbrush, acrylic, marker, colored pencil, oil, charcoal, mixed media, pastel, "just about anything that's *camera-ready.*" Send query letter with photocopies. Samples are filed. Reports back only if interested. "Mail a portfolio of 3-6 photocopies for our files." Pays on publication; $35 for full color cover; $5-10 for b&w inside. Buys first rights. Finds artists through submissions and queries.
Tips: "We are mainly interested in pulp-styled b&w illustrations for the interior of the magazine. Covers are now full color. Please query for information. Mail your samples *flat.* Tell us the kind of work you like to do, and what you don't like to do. We are eager to work with new artists, and we aren't hard to please. Also, we prefer camera-ready art, or as close to it as you are able. I tend to assign the art for several issues at a time, so don't be discouraged if I don't get back to you right away. We would like to work with artists who are interested in working in and around our text as opposed to a plain box format. Our primary interest is in illustration. Show me an interesting piece that will draw in a reader, without giving away the end. No computer art accepted."

ABYSS MAGAZINE, RAGNAROK PRESS, Box 140333, Austin TX 78714. Fax: (512)472-6220. E-mail: ragnarokgc@aol.com. Editor: David F. 'Nalle. Estab. 1979. Black and white quarterly emphasizing fantasy and adventure games for adult game players with sophisticated and varied interests. Circ. 1,800. Does not accept previously published material. Returns original artwork after publication. Sample copy for $5. Art guidelines free for SASE with first-class postage. 25% of freelance work demands computer skills.
 ● Ragnarok Press is also a book and game publisher. See its listing in the Greeting Card, Games &
 Products section for website information and additional needs.
Illustrations: Approached by 100 illustrators/year. Works with 10-20 illustrators/year. Buys 200-300 illustrations/year. Need editorial, horror, historical and fantasy in tradition of H.J. Ford and John D. Batten. Uses freelancers mainly for covers and spots. Prefers science fiction, fantasy, dark fantasy, horror or mythology themes. Send query letter with samples. Write for appointment to show portfolio. Prefers photocopies or photographs as samples. Samples not filed are returned by SASE. Reports within 1 month. Buys first rights. Pays on publication; $20-40 for b&w, $50-300 for color cover; $3-10 for b&w inside; $10-20 for b&w spots.
Tips: Does not want to see "Dungeons and Dragons-oriented cartoons or crudely created computer art." Notices "more integration of art and text through desktop publishing. We are now using all scanned art in layout either as provided by artists or scanned inhouse. Knowledge of Photoshop helpful."

‡ACCENT ON LIVING, Box 700, Bloomington IL 61702. Fax: (309)378-4420. E-mail: cheeverpub@aol.com. Editor: Betty Garee. Estab. 1956. Quarterly magazine with emphasis on success and ideas for better living for the physically handicapped. 5×7 b&w with 4-color cover. Original artwork returned after publication if requested. Sample copy $3.50.
 ● Also publishes books for physically disabled adults under Cheever Publishing.
Cartoons: Approached by 30 cartoonists/year. Buys approximately 12 cartoons/issue. Receives 5-10 submissions/week from freelancers. Interested in seeing people with disabilities in different situations. Send finished cartoon samples and SASE. Reports in 2 weeks. **Pays on acceptance;** $20 b&w; $35 full page. Buys first-time rights (unless specified).
Illustrations: Approached by 20 illustrators/year. Uses 3-5 freelance illustrations/issue. Works on assignment only. Send SASE and postcard samples to be kept on file for future assignments. Accepts disk submissions compatible with QuarkXPress. Send TIFF or EPS files. Samples not filed are returned by SASE. Reports in 2 weeks. **Pays on acceptance**; $50 minimum for b&w and color cover; $10 minimum for b&w and color inside. Buys first time rights.

AD ASTRA, 922 Pennsylvania Ave. SE, Washington DC 20003-2140. (202)543-1900. E-mail: adastra@ari.net. Website: http://www.global.org/bfreed/nss/nss-home./html. Editor: Pat Dasch. Estab. 1989. Bimonthly feature magazine popularizing and advancing space exploration and development for the general public interested in all aspects of the space program.
Illustrations: Works with 40 freelancers/year. Uses freelancers for magazine illustration. Buys 50 illustrations/year. "We are looking for original artwork on space themes, either conceptual or representing specific designs, events, etc." Prefers acrylics, then oils and collage. Send postcard sample or slides. "Color slides are best." Samples not filed are returned by SASE. Reports back within 6 weeks. Pays $100-300 color, cover; $25-100 color, inside. "We do commission original art from time to time." Fees are for one-time reproduction of existing artwork. Considers rights purchased when establishing payment.
Design: Needs freelancers for multimedia design. 100% of freelance work requires knowledge Adobe Photoshop, QuarkXPress and Adobe Illustrator. Designers send query letter with brochure and photographs. Pays by project.
Tips: "Show a set of slides showing planetary art, spacecraft and people working in space. I do not want to see 'science-fiction' art. Label each slide with name and phone number. Understand the freelance assignments are usually made far in advance of magazine deadline."

‡THE ADVANCING PRACTICE, A Bulletin for the Mental Health Profession, P.O. Box 212309, Martinez GA 30917-2309. Editor: Harold Gardner, PhD. Bimonthly magazine for mental health professionals. Circ. 1,250. Sample copies and art guidelines available for SASE with first-class postage.
Cartoons: Approached by 12 cartoonists/year. Buys 3 cartoons/issue. Prefers mental health themes. Prefers single panel, humorous, b&w washes with gaglines. Send query letter with roughs. Samples are filed. Reports back in 2 weeks. Rights purchased vary according to project. **Pays on acceptance**; $30-50 for b&w.

ADVOCATE, PKA'S PUBLICATION, (formerly *The Advocate*), 301A Rolling Hills Park, Prattsville NY 12468. (518)299-3103. Art Editor: C.J. Karlie. Estab. 1987. Bimonthly b&w literary tabloid. "*Advocate* provides aspiring artists, writers and photographers the opportunity to see their works published and to receive byline credit toward a professional portfolio so as to promote careers in the arts." Circ. 12,000. "Good quality photocopy or stat of work is acceptable as a submission." Sample copies available for $4. Art guidelines for SASE with first-class postage.
Cartoons: Open to all formats except color washes. Send query letter with SASE and submissions for publication. Samples are not filed and returned by SASE. Reports back within 2-6 weeks. Buys first rights. Pays in contributor's copies.
Illustrations: Buys 10-15 illustrations/issue. Considers pen & ink, charcoal, linoleum-cut, woodcut, lithograph, pencil. Also needs editorial and entertainment illustration. Send query letter with SASE and photos of artwork (b&w or color prints only). No simultaneous submissions. Samples are not filed and are returned by SASE. Portfolio review not required. Reports back within 2-6 weeks. Buys first rights. Pays in contributor's copies. Finds artists through submissions and from knowing artists and their friends.
Tips: "Please remember SASE for return of materials. We hope to continue publishing six times per year and will need 10-15 illustrations per issue."

AGING TODAY, 833 Market St., San Francisco CA 94103. (415)974-9619. Fax: (415)974-0300. Editor: Paul Kleyman. Estab. 1979. "*Aging Today* is the bimonthly b&w newspaper of The American Society on Aging. It covers news, public policy issues, applied research and developments/trends in aging." Circ. 15,000. Accepts previously published artwork. Originals returned at job's completion if requested. Sample copies available.
Cartoons: Approached by 50 cartoonists/year. Buys 1-2 cartoons/issue. Prefers political and social satire cartoons; single, double or multiple panel with or without gagline, b&w line drawings. Send query letter with brochure and roughs. Samples returned by SASE. Reports back only if interested. Buys one-time rights. Pays $15-25 for b&w.
Illustrations: Approached by 50 illustrators/year. Buys 1 illustration/issue. Works on assignment only. Prefers b&w line drawings and some washes. Considers pen & ink. Needs editorial illustration. Send query letter with brochure, SASE and photocopies. Samples are not filed and are returned by SASE. Reports back only if interested. Artist should follow-up with call and/or letter after initial query. Buys one-time rights. Pays on publication; $25 for b&w cover; $25 for b&w inside.
Tips: "Send brief letter with two or three applicable samples. Don't send hackneyed cartoons that perpetuate ageist stereotypes."

AIM, Box 20554, Chicago IL 60620. (312)874-6184. Editor-in-Chief: Ruth Apilado. Managing Editor: Dr. Myron Apilado. Estab. 1973. 8½×11 b&w quarterly with 2-color cover. Readers are those "wanting to eliminate bigotry and desiring a world without inequalities in education, housing, etc." Circ. 7,000. Sample copy $4; artist's guidelines for SASE. Reports in 3 weeks. Previously published, photocopied and simultaneous submissions OK. Receives 12 cartoons and 4 illustrations/week from freelancers.
Cartoons: Buys 10-15 cartoons/year. Uses 1-2 cartoons/issue. Prefers education, environment, family life, humor in youth, politics and retirement; single panel with gagline. Especially needs "cartoons about the stupidity of racism." Send samples with SASE. Reports in 3 weeks. Buys all rights on a work-for-hire basis. Pays on publication; $5-15 for b&w line drawings.
Illustrations: Uses 4-5 illustrations/issue; half from freelancers. Prefers pen & ink. Prefers current events, education, environment, humor in youth, politics and retirement. Provide brochure to be kept on file for future assignments. Samples not returned. Reports in 1 month. Prefers b&w for cover and inside art. Buys all rights on a work-for-hire basis. Pays on publication; $25 for b&w cover illustrations.
Tips: "We could use more illustrations and cartoons with people from all ethnic and racial backgrounds in them. We also use material of general interest. Artists should show a representative sampling of their work and target the magazine's specific needs. Nothing on religion."

 THE DOUBLE DAGGER before a listing indicates that the listing is new in this edition. New markets are often more receptive to freelance submissions.

ALASKA BUSINESS MONTHLY, P.O. Box 241288, Anchorage AK 99524-1288. (907)276-4373. Fax: (907)279-2900. Editor: Cliff Gerhart. Estab. 1985. Monthly business magazine. *"Alaska Business Monthly* magazine is written, edited and published by Alaskans for Alaskans and other U.S. and international audiences interested in business affairs of the 49th state. Its goal is to promote economic growth in the state by providing thorough and objective discussion and analyses of the issues and trends affecting Alaska's business sector and by featuring stories on the individuals, organizations and companies that shape the Alaskan economy." Circ. 10,000. Accepts previously published artwork. Originals returned at job's completion if requested. Sample copies available for SASE with first-class postage. Art guidelines available.
Illustrations: Rights purchased vary according to project. Pays on publication; $500 for color cover; $50-250 for b&w inside and $150-300 for color inside.

ALTERNATIVE THERAPIES IN HEALTH AND MEDICINE, 101 Columbia, Aliso Viejo CA 92656. (714)362-2000. Fax: (714)632-2020. Art Director: LeRoy Hinton. Estab. 1995. Bimonthly trade journal. *"Alternative Therapies* is a peer-reviewed medical journal established to promote integration between alternative and cross-cultural medicine with conventional medical traditions." Circ. 20,000. Accepts previously published artwork. Originals returned at job's completion. Sample copies available. 50% of freelance work demands knowledge of Adobe Illustrator, QuarkXPress and Adobe Photoshop.
Cartoons: Prefers alternative or conventional medicine themes. Prefers single panel, political and humorous, b&w washes and line drawings with gagline. Send query letter with roughs. Samples are filed. Reports back within 10 days. Buys one-time rights.
Illustrations: Buys 6 illustrations/year. "We purchase fine art for the covers not graphic art." Send query letter with slides. Samples are filed. Reports back within 10 days. Publication will contact artist for portfolio review if interested. Portfolio should include photographs and slides. Buys one-time and reprint rights. Pays on publication; negotiable. Finds artists through agents, sourcebooks and word of mouth.

AMELIA, 329 E St., Bakersfield CA 93304. (805)323-4064. Editor: Frederick A. Raborg, Jr. Estab. 1983. Quarterly magazine. Also publishes 2 supplements—*Cicada* (haiku) and *SPSM&H* (sonnets) and illustrated postcards. Emphasizes fiction and poetry for the general review. Circ. 1,500. Accepts some previously published material from illustrators. Original artwork returned after publication with SASE. Sample copy $8.95; art guidelines for SASE.
Cartoons: Buys 3-5 cartoons/issue for *Amelia*. Prefers sophisticated or witty themes (see Ford Button's, Earl Engleman's and Vahan Shirvanian's work). Prefers single panel b&w line drawings and washes with or without gagline (will consider multipanel on related themes). Send query letter with finished cartoons to be kept on file. Material not filed is returned by SASE. Reports within 1 week. Usually buys first rights. **Pays on acceptance**; $5-25 for b&w. Occasionally uses captionless cartoons on cover; $50 b&w; $100 color.
Illustrations: Buys 80-100 illustrations and spots/year for *Amelia;* 24-30 spots for *Cicada*; 15-20 spots for *SPSM&H* and 50-60 spots for postcards. Considers all themes. "No taboos, except no explicit sex; nude studies in taste are welcomed, however." Prefers pen & ink, pencil, watercolor, acrylic, oil, pastel, mixed media and calligraphy. Send query letter with résumé, photostats and/or photocopies to be kept on file. Unaccepted material returned immediately by SASE. Reports in 1 week. Portfolio should contain "one or two possible cover pieces (either color or b&w), several b&w spots, plus several more fully realized b&w illustrations." Buys first rights or one-time rights (prefers first rights). **Pays on acceptance**; $50 for b&w, $100 for color, cover; $5-25 for b&w inside. "Spot drawings are paid for on assignment to an issue."
Tips: "In illustrations, it is very difficult to get excellent nude studies. Everyone seems capable of drawing an ugly woman; few capture sensuality, and fewer still draw the nude male tastefully. (See male nudes we've used by Susan Moffett and Miguel Angel Reyes for example.)"

‡**AMERICA**, 106 W. 56th St., New York NY 10019. (212)581-4640. Fax: (212)399-3596. Associate Editor: E.J. Mattimoe. Estab. 1904. Weekly Catholic journal of opinion sponsored by US Jesuits. Circ. 36,000. Sample copies for #10 SASE with first-class postage.
Illustration: Buys 1-3 illustrations/issue. Considers all media. Send query letter with printed samples and tearsheets. Buys first rights. Pays on publication; $100 maximum for b&w cover; $40-60 for b&w inside.
Tips: "We look for illustrators who can do imaginative work for religious or educational articles. We will fax part or all of an article to the artist and usually need finished work in two weeks."

AMERICA WEST AIRLINES MAGAZINE, 4636 E. Elwood St., Suite 5, Phoenix AZ 85040-1963. Art Director: Katharine McGee. Estab. 1986. Monthly inflight magazine for fast-growing national airline; 4-color, "conservative design. Appeals to an upscale audience of travelers reflecting a wide variety of interests and tastes." Circ. 130,000. Accepts previously published artwork. Original artwork is returned after publication. Sample copy $3. Art guidelines for SASE with first-class postage. Needs computer-literate illustrators familiar with Adobe Photoshop, Adobe Illustrator, QuarkXPress and Aldus FreeHand.
Illustrations: Approached by 100 illustrators/year. Buys illustrations mainly for spots, columns and feature spreads. Buys 5 illustrations/issue from freelancers. Uses freelancers mainly for features and columns. Works on assignment only. Prefers editorial illustration in airbrush, mixed media, colored pencil, watercolor, acrylic, oil, pastel, collage and calligraphy. Send query letter with color brochure showing art style and tearsheets.

Looks for the "ability to intelligently grasp idea behind story and illustrate it. Likes crisp, clean colorful styles." Accepts disk submissions. Send EPS files. Samples are filed. Does not report back. Will contact for portfolio review if interested. Sometimes requests work on spec. Buys on publication one-time rights. Pays $500-1,000 for color cover; $75-250, b&w; $150-500, color, inside; $150-500 for spots. "Send lots of good-looking color tearsheets that we can keep on hand for reference. If your work interests us we will contact you."

Tips: "In your portfolio show examples of editorial illustration for other magazines, good conceptual illustrations and a variety of subject matter. Often artists don't send enough of a variety of illustrations; it's much easier to determine if an illustrator is right for an assignment if I have a complete grasp of the full range of abilities. Send high-quality illustrations and show specific interest in our publication."

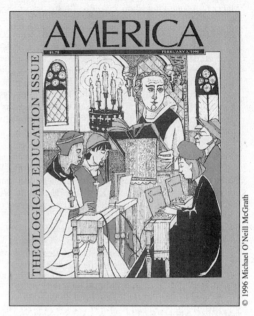

For the cover of *America*'s theological education issue, artist Michael O'Neill McGrath wanted to convey "the heavy seriousness of a medieval theology class (with St. Thomas Aquinas at the lectern), but with a whimsical punchline about the contemporary world." O'Neill McGrath, who has been marketing his work for just a few years, knows the importance of targeting the right market. "My work is religious/sacred, and *America* magazine has proven a wonderful supporter and presenter of my work. I get comments from a broad range of readers. It's been a phenomenal source of exposure for me."

AMERICAN BREWER MAGAZINE, Box 510, Hayward CA 94543-0510. (510)538-9500 (mornings). E-mail: ambrew@ambrew.com. Website: http://www.ambrew.com. Publisher: Bill Owens. Estab. 1985. Quarterly trade journal in b&w with 4-color cover focusing on the micro-brewing industry. Circ. 15,000. Accepts previously published artwork. Original artwork returned after publication. Sample copies for $5. Art guidelines for SASE with first-class postage. 80% of freelance work demands knowledge of Aldus PageMaker.

• Also publishes *BEER*, The Magazine.

Cartoons: Approached by 6-8 cartoonists/year. Buys 2 cartoons/issue. Prefers themes related to drinking or brewing handcrafted beer; single panel. Send query letter with roughs. Samples not filed are returned. Reports back within 2 weeks. Buys reprint rights. Pays $150-200 for color cover; $25-50 for b&w.

Illustrations: Approached by 6-10 illustrators/year. Buys 2 illustrations/issue. Works on assignment only. Prefers themes relating to beer, brewing or drinking; pen & ink. Send postcard sample or query letter with photocopies. Samples are not filed and are returned. Reports back within 2 weeks. Pays $200 for color cover. Buys reprint rights.

Design: Needs freelancers for design. 100% of design requires knowledge of Adobe Photoshop. Send query letter. Pays by project.

Tips: "I prefer to work with San Francisco Bay area artists."

AMERICAN CAREERS, 6701 W. 64th St., Overland Park KS 66202. (913)362-7788 or (800)669-7795. Fax: (913)362-4864. Publisher: Barbara Orwig. Estab. 1990. Quarterly educational magazine for students in middle/high school. Designed to promote vocational technical education, career options, business and industry partnerships. Circ. 500,000. Accepts previously published artwork. Original artwork returned at job's completion on request. Sample copies available. 90% of freelance work demands knowledge of QuarkXPress, Aldus FreeHand and Adobe Photoshop.

Illustrations: Approached by 4-6 illustrators/year. Buys 10 illustrations/year. Works on assignment only. Prefers editorial illustration. Prefers educational-related themes or styles. Send query letter with brochure or résumé and tearsheets or proof of work. Show enough to prove work experience. Samples are filed or are returned by SASE if requested by artist. Reports back only if interested. Negotiates rights purchased. Pays

on publication; $100 for b&w, $300 for color, cover; $100 for b&w, $200 for color, inside.

‡AMERICAN DEMOGRAPHICS, 127 W. State St., Ithaca NY 14850. (607)273-2414. Fax: (607)273-3196. E-mail: jimk@demographics.com. Website: http://www.marketingtools.com. Art Director: Jim Kellfer. Estab. 1979. Monthly trade journal covering consumer trends. Circ. 42,000. Sample copies available.
Illustration: Approached by 300 illustrators/year. Buys 5-8 illustrations/issue. Considers all media. Knowledge of Aldus PageMaker 6, Adobe Photoshop 3, Adobe Illustrator 5.5 helpful, but not required. Send postcard sample. Accepts disk submissions. Samples are filed and not returned. Will contact for portfolio review if interested and should include color tearsheets. Buys one-time rights. **Pays on acceptance**.
Design: Prefers local design freelancers only. 100% of freelance work demands knowledge of Aldus Page-Maker 6, Adobe Photoshop 3, Adobe Illustrator 5.5. Send query letter with tearsheets.

AMERICAN FITNESS, 15250 Ventura Blvd., Suite 200, Sherman Oaks CA 91403. (818)905-0040. Editor-at-Large: Peg Jordan. Managing Editor: Rhonda J. Wilson. Bimonthly magazine emphasizing fitness, health and exercise "for sophisticated, college-educated, active lifestyles." Circ. 33,000. Accepts previously published material. Original artwork returned after publication. Sample copy $1.
Illustrations: Approached by 12 illustrators/month. Assigns 4-6 illustrations/issue. Works on assignment only. Prefers "very sophisticated" 4-color line drawings. Send query letter with thumbnails, roughs or brochure showing art style. Reports back within 2 months. Acquires one-time rights.
Tips: "Excellent source for never-before-published illustrators who are eager to supply full-page lead artwork."

‡THE AMERICAN GARDENER, (formerly *American Horticulturist*), 7931 E. Boulevard Dr., Alexandria VA 22308. (703)768-5700. E-mail: garden@ahs.org. Website: http://eMall.com. Editor: Kathleen Fisher. Estab. 1922. Consumer magazine for advanced and amateur gardeners and horticultural professionals who are members of the American Horticultural Society. Bimonthly, 4-color magazine, "very clean and open, fairly long features." Circ. 20,000. Accepts previously published artwork. Original artwork is returned at job's completion. Sample copies for $4.
Illustrations: Buys 15-20 illustrations/year from freelancers. Works on assignment only. "Botanical accuracy is important for many assignments." Considers pen & ink, colored pencil, watercolor and charcoal. Needs technical illustration. Send query letter with résumé, tearsheets, slides and photocopies. Samples are filed. "We will call artist if their style matches our need." To show a portfolio, mail b&w and color tearsheets and slides. Buys one-time rights. Pays $150, b&w, $300 maximum, color, inside; on publication.
Tips: "We have always been low budget."

‡AMERICAN HEALTH, 28 W. 23rd St., New York NY 10010. Art Director: Lou Dilorenzo. Estab. 1982. Monthly general interest magazine focusing on all aspects of health. Circ. 1,000,000. Accepts previously published artwork. Originals returned at job's completion. Sample copies for SASE with first-class postage. 10% of freelance work demands knowledge of Adobe Illustrator, Adobe Photoshop or Aldus FreeHand.
Illustrations: Approached by 100 illustrators/year. Buys 10-15 illustrations/issue. Works on assignment only. Send query letter with tearsheets, photographs, photocopies and photostats. Samples are filed. Reports back to the artist only if interested. To show a portfolio, mail b&w tearsheets and slides, color photostats and printed samples and photographs, and printed samples. Buys one-time rights. Pays on publication; $350 for b&w and $350 for color inside.
Tips: "Looking for good ideas—not just technique."

THE AMERICAN LEGION MAGAZINE, Box 1055, Indianapolis IN 46206. Contact: Cartoon Editor. Emphasizes the development of the world at present and milestones of history; 4-color general-interest magazine for veterans and their families. Monthly. Original artwork not returned after publication.
Cartoons: Uses 2-3 freelance cartoons/issue. Receives 100 freelance submissions/month. Especially needs general humor in good taste. "Generally interested in cartoons with broad appeal. Prefers action in the drawing, rather than the illustrated joke-type gag. Those that attract the reader and lead us to read the caption rate the highest attention. No-caption gags purchased only occasionally. Because of tight space, we're not in the market for the spread or multipanel cartoons but use both vertical and horizontal single-panel cartoons. Themes should be home life, business, sports and everyday Americana. Cartoons that pertain only to one branch of the service may be too restricted for this magazine. Service-type gags should be recognized and appreciated by any ex-service man or woman. Cartoons that may offend the reader are not accepted. Liquor, sex, religion and racial differences are taboo. No roughs. Send final product for consideration." Usually reports within 1 month. Buys first rights. **Pays on acceptance**; $150.
Illustrations: Send postcard sample or tearsheets.
Design: Needs freelancers for multimedia design. 100% of design requires knowledge of Adobe Photoshop, QuarkXPress or Adobe Illustrator. Send brochure, résumé and tearsheets. Pays by project.
Tips: "Artists should submit their work as we are always seeking new slant and more timely humor. Black & white art is primarily what we seek. Note: Cartoons are separate from the art department."

AMERICAN LIBRARIES, 50 E. Huron St., Chicago IL 60611. (312)280-4216. Fax: (312)440-0901. Editor: Leonard Kniffel. Senior Editor of Design: Edie McCormick. Estab. 1907. Monthly professional 4-color journal of the American Library Association for its members, providing independent coverage of news and major developments in and related to the library field. Circ. 58,000. Original artwork returned at job's completion. Sample copy $6. Art guidelines available.
Cartoons: Approached by 15 cartoonists/year. Buys no more than 1 cartoon/issue. Prefers themes related to libraries. Send query letter with brochure and finished cartoons. Samples are filed. Does not report on submissions. Buys first rights. Pays $35-50 for b&w.
Illustrations: Approached by 20 illustrators/year. Buys 1-2 illustrations/issue. Works on assignment only. Send query letter with brochure, tearsheets and résumé. Samples are filed. Does not report on submissions. To show a portfolio, mail tearsheets, photostats, photographs and photocopies. Portfolio should include broad sampling of typical work with tearsheets of both b&w and color. Buys first rights. **Pays on acceptance**; $75-150 for b&w and $250-300 for color, cover; $75-150 for b&w and $150-250 for color, inside.
Tips: "I suggest inquirer go to a library and take a look at the magazine first." Sees trend toward "more contemporary look, simpler, more classical, returning to fewer elements."

AMERICAN MEDICAL NEWS, 515 N. State, Chicago IL 60610. (312)464-4432. Fax: (312)464-5793. E-mail: amedart@aol.com. Art Director: Jef Capaldi. Estab. 1958. Weekly trade journal. "We're the nation's most widely circulated publication covering socioeconomic issues in medicine." Circ. 375,000. Originals returned at job's completion. Sample copies available. 10% of freelance work demands knowledge of Adobe Photoshop and Aldus FreeHand.
Illustrations: Approached by 250 freelancers/year. Buys 2-3 illustrations/issue. Works on assignment only. Considers mixed media, collage, watercolor, acrylic and oil. Send postcard samples. Samples are filed. Will contact for portfolio review if interested. Buys first rights. **Pays on acceptance**. Pays $300-500 for b&w, $500-850 for color inside. Pays $200-400 for spots. Finds artists through illustration contest annuals, word of mouth and submissions.
Tips: "Illustrations need to convey a strong, clever concept."

AMERICAN MOTORCYCLIST, American Motorcyclist Association, Box 6114, Westerville OH 43081-6114. (614)891-2425. Executive Editor: Greg Harrison. Managing Editor: Bill Wood. Circ. 190,000. Monthly 4-color for "enthusiastic motorcyclists investing considerable time and money in the sport." Sample copy $1.50. Art guidelines free for SASE with first-class postage.
Illustrations: Buys 1-2 illustrations/issue, almost all from freelancers. Receives 1-3 submissions/week. Interested in motorcycling themes. Send query letter with photocopies to be kept on file. Samples returned by SASE. Reports in 3 weeks. Buys first North American serial rights. Pays on publication; $250 minimum for b&w, $350 minimum for color cover; $50-300 for b&w and color inside.

AMERICAN MUSCLE MAGAZINE, Box 6100, Rosemead CA 91770. Art Director: Michael Harding. Monthly 4-color magazine emphasizing bodybuilding, exercise and professional fitness. Features general interest, historical, how-to, inspirational, interview/profile, personal experience, travel articles and experimental fiction (all sports-related). Circ. 338,097. Accepts previously published material. Original artwork returned after publication.
Illustrations: Buys 5 illustrations/issue. Send query letter with résumé, tearsheets, slides and photographs. Samples are filed or are returned. Reports back within 1 week. Buys first rights, one-time rights, reprint rights or all rights. **Pays on acceptance**.
Tips: "Be consistent in style and quality."

‡**THE AMERICAN SPECTATOR**, Box 549, Arlington VA 22216-0549. (703)243-3733. Fax: (703)243-6814. Managing Editor: M.D. Carnegie. Production Manager: Patrick McMahan. Monthly political, conservative, newsworthy literary magazine. "We cover political topics, human interest items and book reviews." Circ. 258,000. Original artwork returned after publication. Sample copies and art guidelines available.
Illustrations: Uses 5-10 illustrations/issue. Interested in "realism with a comic twist." Works on assignment only. Prefers pen & ink, watercolor, acrylic, colored pencil, oil and pastel. Samples are filed or returned by SASE. Reports back on future assignment possibilities. Provide résumé, brochure and tearsheets to be kept on file for future assignments. No portfolio reviews. Reports in 2 weeks. Buys first North American serial rights. Pays on publication; $500 minimum for 4-color line drawings on cover; $100 minimum for b&w line drawings inside.

HOW TO USE your *Artist's & Graphic Designer's Market* offers suggestions for understanding and using the information in these listings. Read this and other articles in the front of this book for important business tips.

AMERICAN WOMAN MOTORSCENE, 1510 11th St., Suite 201-B, Santa Monica CA 90401-2906. (310)260-0192. Fax: (310)260-0175. Editor-in-Chief: Courtney Caldwell. Estab. 1988. Bimonthly automotive and recreational motorsports magazine for today's active women. Feature oriented for women of achievement. Circ. 150,000. Accepts previously published artwork. Originals returned at job's completion only if requested. Sample copies available for 9×12 SASE and 10 first-class stamps. 20% of freelance work demands knowledge of QuarkXPress or Aldus PageMaker.
Cartoons: Approached by 3-5 cartoonists/year. Prefers women in automotive—"classy, no bimbo stuff"; single/double panel humorous cartoons with gaglines. Send query letter with roughs and finished cartoons. Samples are filed. Reports back within 1 month by SASE or if interested. Rights purchased vary. Pays $50 for b&w.
Illustrations: Approached by 3-5 illustrators/year. Works on assignment only. Prefers women of achievement. Open/flexible to all media. Send query letter with résumé, SASE, tearsheets and photocopies. Samples are filed or are returned by SASE. Reports back within 1 month by SASE. Will contact for portfolio review if interested. Portfolio should include b&w tearsheets, roughs, photocopies, final art and photographs. Rights purchased vary according to project. Pays on publication; $50 minimum for b&w inside. Finds artists through submissions, *Artist's & Graphic Designer's Market*.
Tips: "Must have knowledge of cars, trucks, motorcycles, hot rods and how today's women think!"

AMERICA'S COMMUNITY BANKER, (formerly *Savings & Community Banker*), 900 19th St. NW, Washington DC 20006. (202)857-3143. Fax: (202)857-5581. Art Director: Amanda Elliott. Estab. 1992. Monthly trade journal targeting senior executives of community banks. Circ. 12,000. Accepts previously published artwork. Originals returned at job's completion. Sample copies for #10 SASE with first-class postage.
Illustrations: Approached by 150 illustrators/year. Buys 5-6 illustrations/issue. Works on assignment only. Considers all media and any style. Send postcard-size sample. Samples are filed. Does not report back. "Artists should be patient and continue to update our files with future mailings. We will contact artist when the right story comes along." Publication will contact artist for portfolio review if interested. Portfolio should include mostly finished work, some sketches. Buys one-time rights. **Pays on acceptance**; $800-1,200 for color cover; $250-400 for b&w, $250-800 for color inside; $250-300 for spots. Finds artists primarily through word of mouth.

‡ANALOG, 1540 Broadway, New York NY 10036. (212)782-8547. Fax: (212) 782-8309. Art Director: Terri Czeczko. Estab. 1930. Monthly consumer magazine. Circ. 80,000. Art guidelines free for #10 SASE with first-class postage.
Cartoons: Prefers single panel cartoons. Send query letter with photocopies and/or tearsheets and SASE. Samples are not filed and are returned by SASE. Reports back only if interested. Buys one-time rights. **Pays on acceptance**; $35 minimum for b&w cartoons.
Illustrations: Buys 8 illustrations/issue. Prefers science fiction, hardware, robots, aliens and creatures. Considers all media. Send query letter with printed samples or tearsheets and SASE. Send follow-up postcard sample every 4 months. Accepts disk submissions compatible with QuarkXPress 7.5/version 3.3. Send EPS files. Files samples of interest, others are returned by SASE. Reports back only if interested. "No phone calls." Portfolios may be dropped off every Tuesday and should include b&w and color tearsheets and transparencies. "No original art please, especially oversized." Buys one-time rights. **Pays on acceptance**; $1,200 for color cover; $125 minimum for b&w inside; $35-50 for spots. Finds illustrators through *Black Book*, *LA Workbook*, *American Showcase* and other reference books.

‡ANGELS ON EARTH MAGAZINE, 16 E. 34th St., New York NY 10016. (212)251-8127. Fax: (212)684-0679. Website: http://www.guideposts.org. Director of Art & Design: Lawrence A. Laukhuf. Estab. 1995. Bimonthly magazine featuring true stories of angel encounters and angelic behavior. Circ. 500,000.
Illustrations: Approached by 500 illustrators/year. Buys 5 illustrations/issue. Prefers conceptual/realistic, "soft" styles. Considers all media. 2% of illustration demands computer skills. Call for submission information. Accepts disk submissions compatible with Adobe Photoshop, Adobe Illustrator. Samples are filed or returned by SASE. Art director will contact for portfolio review of color slides and transparencies if interested. Buys one-time rights or rights purchased vary. **Pays on acceptance**. Payment varies. Finds artists through reps, *American Showcase*, submissions.
Tips: "If you submit work, know our publications!"

ANIMALS, 350 S. Huntington Ave., Boston MA 02130. (617)522-7400. Fax: (617)522-4885. Contact: Carolina DeBenedictis. Estab. 1868. "*Animals* is a national bimonthly 4-color magazine published by the Massachusetts Society for the Prevention of Cruelty to Animals. We publish articles on and photographs of wildlife, domestic animals, conservation, controversies involving animals, animal-welfare issues, pet health and pet care." Circ. 90,000. Original artwork usually returned after publication. Sample copy $2.95 with SASE ($8\frac{1}{2} \times 11$).
Illustrations: Approached by 1,000 illustrators/year. Works with 5 illustrators/year. Buys 5 or less illustrations/year from freelancers. Uses artists mainly for spots. Prefers pets or wildlife illustrations relating to a

particular article topic. Prefers pen & ink, then airbrush, charcoal/pencil, colored pencil, watercolor, acrylic, oil, pastel and mixed media. Needs editorial and medical illustration. Send query letter with brochure or tearsheets. Samples are filed or are returned by SASE. Reports back within 1 month. Publication will contact artist for portfolio review if interested. Portfolio should include color roughs, original/final art, tearsheets and final reproduction/product. Negotiates rights purchased. **Pays on acceptance**; $300 maximum for color cover; $150 maximum for b&w, $200 for color inside.

Tips: "In your samples, include work showing animals, particularly dogs and cats or humans with cats or dogs. Show a representative sampling."

APPALACHIAN TRAILWAY NEWS, Box 807, Harpers Ferry WV 25425. (304)535-6331. Fax: (304)535-2667. Editor: Judith Jenner. Emphasizes the Appalachian Trail for members of the Appalachian Trail Conference. 5 issues/year; 4 issues b&w, 1 issue color. Circ. 26,000. Sometimes accepts previously published material. Returns original artwork after publication. Sample copy $3 (no SASE); art guidelines for SASE with first-class postage.

Illustrations: Buys 2-5 illustrations/issue. Prefers pen & ink, charcoal/pencil, colored pencil, watercolor, acrylic, oil, pastel and calligraphy. Original artwork must be related to the Appalachian Trail. Send query letter with samples to be kept on file. Prefers photostats, photocopies or tearsheets as samples. Samples not filed are returned by SASE. Reports within 2 months. Negotiates rights purchased. **Pays on acceptance;** $25-200 for b&w, occasional color. Also buys 1-2 cartoons/year; pays $25 and up. Finds most artists through references, word of mouth and samples received through the mail.

AQUA-FIELD PUBLICATIONS, 66 W. Gilbert, Shrewsbury NJ 07702. (908)842-8300. Fax: (908)842-0281. Art Director: Sharon Kissling. Estab. 1974. Magazines emphasizing outdoor recreation: hunting, fishing, scuba, camping, home improvement and gardening. "Geared to the active, outdoors-oriented adult, mid-to-upper income. There is some family material." Publications are 4-color, 2-color and b&w with conservative/classic design. Publishes annuals. Circ. 200,000. Accepts previously published material. Original artwork is returned after publication.

Illustrations: Approached by 30-40 illustrators/year. Works with 3-4 illustrators/year. Buys 4-8 illustrations/issue. Uses freelancers mainly for paste-up, covers and spots, and b&w magazine illustration specific to story subject matter. Works on assignment only. Send postcard sample. Samples are filed or returned by SASE. Reports back within 1 month. Call or write for appointment to show portfolio of final art, tearsheets, photographs and slides. Negotiates rights purchased. Pay is negotiable. Needs technical illustration.

Tips: "Don't send original art. I want to see mostly realistic/painterly work. No totally abstract work or work that doesn't apply to our outdoors theme."

‡AREA DEVELOPMENT MAGAZINE, 400 Post Ave., New York NY 11590. (516)338-0900 ext. 214. Fax: (516)338-0100. E-mail areadev@area-development.com. Website: http://www.area-development.com. Art Director: Marta Sivakoff. Estab. 1965. Monthly trade journal regarding economic development and site selection issues. Circ. 40,000.

Illustration: Approached by 60 illustrators/year. Buys 1-2 illustrations/issue. Prefers business/corporate themes with strong conceptual ideas. Considers all media. 50% of freelance illustration demands knowledge of Adobe Photoshop, Adobe Illustrator and QuarkXPress. Send postcard sample. Accepts disk submissions compatible with QuarkXPress 3.31 for the Mac. Send EPS, TIFF files. Samples are not filed and are returned. Art director will contact artist for portfolio review of b&w, color tearsheets if interested. Rights purchased vary according to project. Pays on publication.

Tips: "Must have corporate understanding and strong conceptual ideas. We are not about pretty images—we address the decision-makers' needs by presenting their perspectives."

ARMY MAGAZINE, 2425 Wilson Blvd., Arlington VA 22201. (703)841-4300. Art Director: Patty Zukerowski. Estab. 1950. Monthly trade journal dealing with current and historical military affairs. Also covers military doctrine, theory, technology and current affairs from a military perspective. Circ. 115,000. Originals returned at job's completion. Sample copies available for $2.25. Art guidelines available.

Cartoons: Approached by 5 cartoonists/year. Buys 1 cartoon/issue. Prefers military, political and humorous cartoons; single or double panel, b&w washes and line drawings with gaglines. Send query letter with brochure and finished cartoons. Samples are filed or are returned by SASE if requested by artist. Reports back to the artist only if interested. Buys one-time rights. Pays $50 for b&w.

Illustrations: Approached by 10 illustrators/year. Buys 1-3 illustrations/issue. Works on assignment only. Prefers military, historical or political themes. Considers pen & ink, airbrush, acrylic, marker, charcoal and mixed media. "Can accept artwork done with Illustrator or Photoshop for Macintosh." Send query letter with brochure, résumé, tearsheets, photocopies and photostats. Samples are filed or are returned by SASE if requested by artist. Publication will contact artist for portfolio review if interested. Portfolio should include b&w and color tearsheets, photocopies and photographs. Buys one-time rights. Pays on publication; $300 minimum for b&w, $500 minimum for color cover; $50 for b&w, $75 for color inside; $35-50 for spots.

ART DIRECTION, 456 Glenbrook Rd., Glenbrook CT 06906-1800. (203)353-1441. Fax: (203)353-1371. Editor: Dan Barron. Estab. 1949. Monthly 4-color trade magazine that emphasizes advertising for art directors.

Circ. 7,014. Accepts previously published artwork. Original work not returned after publication. Sample copy $4.50. Art guidelines available.

Illustrations: Receives 7 illustrations/week from freelancers. Uses 2-3 illustrations/issue. Works on assignment only. Interested in themes that relate to advertising. Needs editorial illustration. Send query letter with brochure showing art styles. Samples are not filed and are returned only if requested. Reports in 3 weeks. Portfolio of tearsheets may be dropped off every Monday-Friday. Sometimes requests work on spec before assigning job. Negotiates rights purchased. Pays on publication; $350 for color cover.

Tips: "Must be about current advertising."

ARTHRITIS TODAY MAGAZINE, 1330 W. Peachtree St., Atlanta GA 30309-2858. (404)872-7100. Fax: (404)872-9559. Art Director: Deb Gaston. Estab. 1987. Bimonthly consumer magazine. "*Arthritis Today* is the official magazine of the Arthritis Foundation. It is an award-winning publication that provides the most comprehensive and reliable source of information about arthritis research, care and treatment. It is written both for people with arthritis and those who care about them." Circ. 600,000. Originals returned at job's completion. Sample copies available. 20% of freelance work demands knowledge of Adobe Illustrator, QuarkXPress or Adobe Photoshop.

Illustrations: Approached by 10-20 illustrators/year. Buys 2-6 illustrations/issue. Works on assignment only. Considers watercolor, collage, airbrush, acrylic, colored pencil, mixed media and pastel. Send query letter with brochure, tearsheets, photostats, slides (optional) and transparencies (optional). Samples are filed. Publication will contact artist for portfolio review if interested. Portfolio should include color tearsheets, photostats, photocopies, final art and photographs. Buys first time North American serial rights. Other usage negotiated. **Pays on acceptance.** Finds artists through sourcebooks, other publications, word of mouth, submissions.

Tips: "No limits on areas of the magazine open to freelancers. Two-three departments, each issue use spot illustrations. Submit tearsheets for consideration. No cartoons."

THE ARTIST'S MAGAZINE, 1507 Dana Ave., Cincinnati OH 45207. Contact: Editor. Monthly 4-color magazine emphasizing the techniques of working artists for the serious beginning, amateur and professional artist. Circ. 275,000. Occasionally accepts previously published material. Returns original artwork after publication. Sample copy $2 with SASE and 3 first-class stamps. Art guidelines available.

• Sponsors annual contest. Send SASE for more information. Also publishes a quarterly issue called *Watercolor Magic*.

Cartoons: Contact Ann Abbott, managing editor. Buys 2-3 "top-quality" cartoons/issue. Most cartoons bought are single panel finished cartoons with or without gagline—b&w line drawings and washes. "We're also on the lookout for color, multipanel (4-6 panels) work with a theme to use on our 'P.S.' page. Any medium." All cartoons should be artist-oriented, appeal to the working artist and should not denigrate art or artists. Avoid cliché situations. For single panel cartoon submissions, send cover letter with 4 or more finished cartoons. For "P.S." submissions, query first with roughs and samples. Material not filed is returned only by SASE. Reports within 6 weeks. Buys first North American serial rights. **Pays on acceptance**; $65 and up for b&w single panels; $200 and up for "P.S." work.

Illustrations: Contact Mike Mitzel, art director. Buys 2-3 illustrations/issue. Works on assignment only. Send postcard sample or query letter with brochure, photocopies, photographs and tearsheets to be kept on file. Prefers photostats or tearsheets as samples. Samples not filed are returned by SASE. Buys first rights. **Pays on acceptance.** Pays $250 for color inside. "We're also looking for b&w spots of art-related subjects. We will buy all rights; pay $25 per spot."

ARTS INDIANA, 47 S. Pennsylvania, #701, Indianapolis IN 46204-3622. (317)632-7894. Fax: (317)632-7966. Editor-in-Chief: Lou Harry. Estab. 1979. Monthly arts magazine. Circ. 12,000. Sample copies available for $4.95. 25% of freelance work demands computer knowledge of Aldus PageMaker.

Cartoons: Approached by 5-10 cartoonists/year. Buys 2 cartoons/issue. Prefers arts-related (all arts) and humorous cartoons; single panel b&w washes and line drawings with or without gaglines. Send query letter with roughs and finished cartoons. Samples are not filed. Reports back within 3 days. Buys one-time rights. Pays $35 for b&w.

Illustrations: Approached by 5-10 illustrators/year. Buys 2 illustrations/issue. Prefers any line drawings for illustrating columns. Considers pen & ink. Send query letter with SASE and photocopies. Reports back within 3 days. Portfolio review not required. Buys one-time rights. Pays on publication; $25-35 per line drawing; $35 for spots.

Tips: "Anticipate lead time better with submissions."

ISAAC ASIMOV'S SCIENCE FICTION MAGAZINE, 1540 Broadway, New York NY 10036. (212)354-6500. Fax: (212) 697-1567. Art Director: Terri Czeczko. Estab. 1977. Monthly b&w with 4-color cover magazine of science fiction and fantasy. Circ. 80,000. Accepts previously published artwork. Original artwork returned at job's completion. Art guidelines available for #10 SASE with first-class postage.

Cartoons: Approached by 20 cartoonists/year. Buys 2 cartoons/issue. Prefers science and fantasy oriented, humorous cartoons. Prefers single panel, b&w washes or line drawings with and without gagline. Send

photocopies and/or tearsheets and SASE. Samples are returned by SASE. Reports back only if interested. Buys one-time rights. **Pays on acceptance**; $35 minimum.
Illustrations: Buys 8 illustrations/issue. Works on assignment only. Considers all media. Send query letter with printed samples, photocopies and/or tearsheets and SASE. Accepts disk submissions compatible with QuarkXPress 7.5 version 3.3. Send EPS files. Reports back only if interested. "No phone calls." Portfolios may be dropped off every Tuesday and should include b&w and color tearsheets and transparencies. "No original art please, especially no oversized paintings." Buys one-time rights. **Pays on acceptance**; $1,200 minimum for color cover; $125 minimum for b&w inside; $35-50 for spots.

ASPCA ANIMAL WATCH, 424 E. 92nd St., New York NY 10128. (212)876-7700, ext. 4441. Art Director: Amber Alliger. Estab. 1960. Quarterly company magazine. Circ. 90,000. Accepts previously published artwork. Original artwork returned at job's completion.
Cartoons: Approached by 20-25 cartoonists/year. Prefers animal-related themes or styles. Send brochure, roughs and photocopies. Samples are filed. Rights purchased vary according to project. Pays $75-100.
Illustrations: Approached by 20 illustrators/year. Buys 3 illustrations/issue. Prefers animal-related themes or styles. Considers all media. Send photocopies. Samples are filed. Reports back within 2 weeks. Rights purchased vary. Pays on publication; $150 for color cover; $75 for b&w and $100 for color inside.

‡ASPEN MAGAZINE, Box G-3, Aspen CO 81612. (970)920-4040. Fax: (970)920-4044. Art Director: Andrew Snider. Bimonthly 4-color city magazine with the emphasis on Aspen and the valley. Circ. 12,000. Accepts previously published artwork. Original artwork returned at job's completion. Samples copies and art guidelines available.
Illustrations: Approached by 15 illustrators/year. Buys 2 illustrations/issue. Themes and styles should be appropriate for editorial content. Considers all media. Send query letter with tearsheets, photostats, photographs, slides, photocopies and transparencies. Samples are filed. Reports back only if interested. Call for appointment to show a portfolio, which should include thumbnails, roughs, tearsheets, slides and photographs. Buys first, one-time or reprint rights. Pays on publication.

‡ASPIRE, 404 BNA Dr., Bldg. 200, Suite 508, Nashville TN 37217. (615)872-8080 ext. 2657. Fax: (615)889-0437. Art Director: Michael Miller. Estab. 1991. Monthly consumer magazine emphasizing women's lifestyles with a Christian slant. Circ. 100,000. Sample copies for #10 SASE with first-class postage.
Illustration: 20% of illustration demands knowledge of Adobe Photoshop, Adobe Illustrator and QuarkXPress. Send query letter with printed samples. "We will accept work compatible with QuarkXPress 7.5 version 3.3. Send EPS files." Samples are filed. Reports back only if interested. Buys first North American serial rights. Pays on publication; $300-1,000 for color inside. Pays $150 for spots.
Design: Needs freelancers for design. Prefers designers with editorial experience. 100% of freelance work demands knowledge of Adobe Photoshop, Adobe Illustrator, QuarkXPress. Send query letter with printed samples.
Tips: "Read our magazine. We need fast workers with quick turnaround."

ASSOCIATION OF COLLEGE UNIONS-INTERNATIONAL, One City Center, 120 W. Seventh St., Bloomington IN 47401. (812)855-8455. Fax: (812)855-0162. E-mail: avest@indiana.edu. Website: http://www.gatech.edu/student.services.acvi/indexntm. Assistant Director of Publishing and Marketing: Ann Vest. Estab. 1914. Professional education association journal. "Covers multicultural issues, creating community on campus, union and activities programming, managing staff, union operation, professional development and student development." Needs computer-literate freelancers with knowledge of CorelDraw for illustration.
 • Also publishes hardcover and trade paperback originals. See listing in the Book Publishers section for more information.
Illustrations: Works on assignment only. Considers pen & ink, pencil, and computer illustration. Send query letter with résumé, photocopies, tearsheets, photographs and color transparencies of college student union activities. Samples are filed. Reports back only if interested. Negotiates rights purchased.
Design: Needs designers for production. Send query letter with résumé and photocopies. Pays by project.
Tips: "We are a volunteer-driven association. Most people submit work on that basis. We are on a limited budget."

‡ASTRONOMY, 21027 Crossroads Circle, Waukesha WI 53187. (414)796-8776. Fax: (414)796-1142. Art Director: Tom Hunt. Estab. 1973. Monthly consumer magazine emphasizing the study and hobby of astronomy. Circ. 200,000.
 • Published by Kalmbach Publishing. Also see listings for *Classic Toy Trains, Finescale Modeler, Model Railroader, Model Retailer, Nutshell News* and *Trains.*
Illustration: Approached by 20 illustrators/year. Buys 2 illustrations/issue. Prefers space art. Considers all media. 10% of freelance illustration demands knowledge of Adobe Photoshop, Adobe Illustrator, QuarkXPress. Send query letter with slides. Accepts submissions on disk compatible with above software. Samples are filed or returned. Reports back within 1 month. Buys one-time rights. Pays on publication; $350 minimum. Finds illustrators through word of mouth and submissions.

ATHLON SPORTS COMMUNICATIONS, INC., 220 25th Ave. N, Suite 200, Nashville TN 37203. (615)327-0747. Fax: (615)327-1149. Contact: Art Director. Estab. 1967. Consumer magazine; college and pro pre-season football annuals, pro baseball and pro basketball pre-season annuals. Circ. 800,000. Accepts previously published artwork. Original artwork is returned at job's completion. Sample copies and/or art guidelines available.
Illustrations: Approached by 6 illustrators/year. Buys 1 illustration/issue. Works on assignment only. Prefers sports figure illustration. Considers all media. Send query letter with brochure, photographs, photocopies, slides, transparencies, samples and pricing information. Samples are filed. Reports back only if interested within 2-3 weeks. Buys one-time rights.

ATLANTIC CITY MAGAZINE, Box 2100, Pleasantville NJ 08232-1324. (609)272-7907. Fax: (609)272-7910. Director of Design & Production: Michael L.B. Lacy. Estab. 1979. 4-color monthly that emphasizes the growth, people and entertainment of the Atlantic City/South Jersey region for residents and visitors. Circ. 50,000.
Illustrations: Approached by 1,000 illustrators/year. Works with 20 illustrators/year. Buys 36 illustrations/year. Uses artists for spots, department and feature illustration. Uses mainly 4-color and some b&w. Works on assignment only. Send query letter with brochure showing art style, tearsheets, slides and photographs to be kept on file. Call or write for appointment to show portfolio of printed samples, final reproduction/product, color and b&w tearsheets and photographs. Buys first rights. Pays on publication; $250 for b&w and $500 for color cover; $125 for b&w and $225 for color inside.
Tips: "We are looking for intelligent, reliable artists who can work within the confines of our budget and time frame. Deliver good art and receive good tearsheets. We are produced completely electronically and have more flexibility with design. Now illustrators who can work with and provide electronic files are a plus."

AUTOMOBILE MAGAZINE, Dept. AGDM, 120 E. Liberty, Ann Arbor MI 48104. (313)994-3500. Art Director: Lawrence C. Crane. Estab. 1986. Monthly 4-color "automobile magazine for upscale life-styles." Traditional, "imaginative" design. Circ. 650,000. Original artwork is returned after publication. *Art guidelines specific for each project.*
Illustrations: Buys illustrations mainly for spots and feature spreads. Works with 5-10 illustrators/year. Buys 2-5 illustrations/issue. Works on assignment only. Considers airbrush, mixed media, colored pencil, watercolor, acrylic, oil, pastel and collage. Needs editorial and technical illustrations. Send query letter with brochure showing art style, résumé, tearsheets, slides, photographs or transparencies. Show automobiles in various styles and media. "This is a full-color magazine, illustrations of cars and people must be accurate." Samples are returned only if requested. "I would like to keep something in my file." Reports back about queries/submissions only if interested. Request portfolio review in original query. Portfolio should include final art, color tearsheets, slides and transparencies. Buys first rights and one-time rights. Pays $200 and up for color inside. Pays up to $2,000 depending on size of illustration. Finds artists through mailed samples.
Tips: "Send samples that show cars drawn accurately with a unique style and imaginative use of medium."

‡AUTOMUNDO, 525 NW 27th Ave., #204, Miami FL 33125. (305)541-4198. Fax: (305)541-5138. Editor: Jorge Koechlin. Estab. 1982. Monthly 4-color Spanish automotive magazine. Accepts previously published artwork. Originals returned at job's completion. Sample copies and art guidelines available.
Cartoons: Approached by 2 cartoonists/year. Buys 1 cartoon/issue. Prefers car motifs. Prefers cartoons without gagline. Send query letter with brochure and roughs. Accepts disk submissions. Samples are filed. Reports back only if interested. Rights purchased vary. Pays $10 for b&w cartoons.
Illustrations: Will contact for portfolio review if interested. Portfolios may be dropped off every Monday. Needs editorial illustrations.
Design: Needs freelancers for design with knowledge of Adobe Photoshop and Adobe Illustrator. Send brochure.

AWARE COMMUNICATIONS, INC., 2720 NW Sixth St., Gainesville FL 32609-2992. (352)378-3879. Vice President-Creative: Scott M. Stephens. Estab. 1984. Semi-annual, annual 4-color company magazines and posters for Fortune 100 companies. Circ. 500,000 to 6.5 million. 30% of freelance work demands knowledge of QuarkXPress, Adobe Photoshop and CorelDraw. Original artwork is not returned.
Illustrations: Approached by 10 illustrators/year. Buys 20 illustrations/year. Works on assignment only. Needs editorial, medical and technical illustration. Prefers realistic styles; very graphic and educational.

MARKET CONDITIONS are constantly changing! If you're still using this book and it is 1998 or later, buy the newest edition of *Artist's & Graphic Designer's Market* at your favorite bookstore or order directly from Writer's Digest Books.

Considers airbrush, acrylic, oil and colored pencil. Send query letter with brochure, tearsheets and photostats. Samples are filed or returned by SASE. Will contact for portfolio review if interested. Portfolio should include printed samples, color tearsheets, photostats, photographs, slides and photocopies. Buys all rights. Sometimes requests work on spec before assigning job. **Pays on acceptance;** $1,500 for color cover; $200 for color inside.

Tips: "Have a universal appealing style. We deal with medical and educational publications, so abstract images and style will not be considered." Must be able to illustrate people and be anatomically accurate.

❦**B.C. OUTDOORS**, 202-1132 Hamilton St., Vancouver, British Columbia V6B 2S2 Canada. (604)687-1581. Editor: Karl Bruhn. 4-color magazine, emphasizing fishing, hunting, RV camping, wildlife/conservation. Published 8 times/year. Circ. 40,000. Original artwork returned after publication unless bought outright. Prefers inquiring freelancers to be familiar with Adobe Illustrator and QuarkXPress.

Illustrations: Approached by more than 10 illustrators/year. Buys 16-20 illustrations/year. Interested in outdoors, creatures and activities as stories require. Format: b&w line drawings and washes for inside and color washes for inside and cover. Works on assignment only. Samples returned by SAE (nonresidents include IRC). Reports back on future assignment possibilities. Arrange personal appointment to show portfolio or send samples of style. Subject matter and the art's quality must fit with publication. Reports in 6-8 weeks. Buys first North American serial rights or all rights on a work-for-hire basis. **Pays on acceptance**; $40 minimum for spots.

Tips: "Send us material on fishing and hunting. We generally just send back non-related work."

‡**THE BABY CONNECTION NEWS JOURNAL**, Drawer 33550, San Antonio TX 78265-3550. Art Director: G.M. Boyd. Illustrations Department, Chairman: Leanna Garcia. Estab. 1986. Publications for new and expectant families with emphasis on infant development, maternity issues, parenting humor, bonding and infant care. Circ. 45,000-60,000. Accepts previously published artwork. Originals are not returned. Sample copies available for $3.75.

• *The Baby Connection* is one of several magazines and journals published by Baby's Mart, a retail baby store and educational center. They also publish *Pitter Patter Chatter, The Smarter Baby Club Newsletter* and *Baby Facts—Fax*. This organization needs a steady supply of cartoons and illustrations.

Cartoons: Approached by 15-30 cartoonists/year. Buys 4-16 cartoons/issue. Cartoons on maternity issues: stages of pregnancy; expectant father in various humorous situations; new dad/new mom humorous situations; cartoons of babies crawling, sitting, laying, eating, fussing, happy. Prefers political and humorous cartoons; single, double or multiple panel, b&w line drawings with or without gaglines. Send query letter with finished cartoons and personal biography. Samples are filed. "Please allow up to 6 months if necessary." Reports back only if interested. Buys one-time rights.. Pays $10 for b&w.

Illustrations: Approached by 12-20 illustrators/year. Buys 6-12 cartoons/issue. Prefers illustrations of babies either humorous or the "oh how cute—how adorable—oh how sweet" type, pregnant moms, expectant dads, new moms, new fathers, drawings of a baby's room, crib, nursery items, medical illustrations or any topic on pregnancy or birthing. Considers pen & ink and marker. Send query letter with SASE, tearsheets, photocopies and biography. Samples are filed. Reports back within 6 months. Portfolio review not required. Buys one-time rights. Pays on publication; $10 for b&w inside.

Tips: "We absolutely encourage all new artists we come in contact with. We do hundreds of brochures for our products and classes each year which all require *lots* of art. Do not call us. Your best chances are to follow our guidelines stated here, have a little patience, take a chance with your own style of creativity and remember we are open to most anything! All submissions should include a brief, personable biography of the artist as we like our readers to get a glimpse into our contributors' personal details—think of something out of the ordinary about yourself, your life, your work, your outlook! If you send a sample, for goodness sake, send one suited to us, you know—babies! There are thousands of artists out there who all send wild, wacky, totally unrelated work to us. Save your postage unless you can actually draw babies."

‡**BACKPACKER MAGAZINE**, 33 E. Minor St., Emmaus PA 18098. (610)967-5171. Fax: (617)967-8181. E-mail: jpepper@aol.com. Art Director: John Pepper. Estab. 1973. Consumer magazine covering non-motorized wilderness travel. Circ. 250,000. Art guidelines free for SASE with first-class postage.

Illustration: Approached by 200-300 illustrators/year. Buys 10 illustrations/issue. Considers all media. 60% of freelance illustration demands knowledge of Aldus FreeHand, Adobe Photoshop, Adobe Illustrator, QuarkXPress. Send query letter with printed samples, photocopies and/or tearsheets. Send follow-up postcard sample every 6 months. Accepts disk submissions compatible with QuarkXPress. Samples are files and are not returned. Artist should follow up with call. Art director will contact artist for portfolio review of color photographs, slides, tearsheets and/or transparencies if interested. Buys first rights or reprint rights. Pays on publication; $200 minimum for b&w or color inside or spots. Finds artists through submissions and other magazines.

Tips: *Backpacker* does not buy cartoons. "Know the subject matter, and know *Backpacker Magazine*."

BALLAST QUARTERLY REVIEW, 2022 X Ave., Dysart IA 52224-9767. Contact: Art Director. Estab. 1985. Quarterly literary and graphic design magazine. "*Ballast* is an acronym for Books Art Language Logic

Ambiguity Science and Teaching. It is a journal of verbal and visual wit. Audience consists mainly of designers, illustrators, writers and teachers." Circ. 600. Accepts previously published artwork. Originals returned at job's completion. Sample copies available for 5 first-class stamps.

Illustrations: Approached by 30 illustrators/year. Publishes 3 illustrations/issue. Seeks b&w line art—no halftones. Send postcard sample or query letter with photocopies and SASE. Samples are sometimes filed or returned by SASE. Reports back only if interested. Payment is 5-10 copies of issue. Finds artists through books, magazines, word of mouth, other illustrators.

Tips: "We rarely use unsolicited artwork. Become familiar with past issues."

BALLOON LIFE MAGAZINE, 2145 Dale Ave., Sacramento CA 95815. (916)922-9648. Fax: (916)922-4730. E-mail: blnlife@scn.org. Website: http://www.aero.com. Editor: Tom Hamilton. Estab. 1985. Monthly 4-color magazine emphasizing the sport of ballooning. "Contains current news, feature articles, a calendar and more. Audience is sport balloon enthusiasts." Circ. 4,000. Accepts previously published material. Original artwork returned after publication. Sample copy for SASE with 8 first-class stamps. Art guidelines for SASE with first-class postage. Needs computer illustrators familiar with Aldus PageMaker, Adobe Illustrator, Adobe Photoshop, Colorit, Pixol Paint Professional and Aldus FreeHand.

Cartoons: Approached by 20-30 cartoonists/year. Buys 1-2 cartoons/issue. Seeks gag, editorial or political cartoons, caricatures and humorous illustrations. Prefers single panel b&w line drawings with or without gaglines. Send query letter with samples, roughs and finished cartoons. Samples are filed or returned. Reports back within 1 month. Buys all rights. Pays on publication; $25 for b&w and $25-40 for color.

Illustrations: Approached by 10-20 illustrators/year. Buys 1-3 illustrations/year. Send postcard sample or query letter with business card and samples. Accepts submissions on disk compatible with Macintosh files. Send EPS files. Samples are filed or returned. Reports back within 1 month. Will contact for portfolio review if interested. Buys all rights. Pays on publication; $50 for color cover; $15-25 for b&w, $25-40 for color inside.

Tips: "Know what a modern hot air balloon looks like! Too many cartoons reach us that are technically unacceptable."

BALTIMORE MAGAZINE, 16 S. Calvert St., Baltimore MD 21202. (410)752-7375. Fax: (410)625-0280. Art Director: Lisa Chune. Production Manager: John Marsh. Estab. 1908. Monthly city magazine featuring news, profiles and service articles. Circ. 57,000. Originals returned at job's completion. Sample copies available for $2.05/copy. 10% of freelance work demands knowledge of QuarkXPress, Aldus FreeHand, Adobe Illustrator or Adobe Photoshop or any other program that is saved as a TIFF or PICT file.

Illustrations: Approached by 60 illustrators/year. Buys 4 illustrations/issue. Works on assignment only. Considers all media, depending on assignment. Send postcard sample. Accepts disk submissions. Samples are filed. Will contact for portfolio review if interested. Buys one-time rights. Pays on publication; $100-400 for b&w, $150-600 for color insides; 60 days after invoice. Finds artists through sourcebooks, publications, word of mouth, submissions.

Tips: All art is freelance—humorous front pieces, feature illustrations, etc. Does not use cartoons.

BARTENDER MAGAZINE, Box 158, Liberty Corner NJ 07938. (908)766-6006. Fax: (908)766-6607. Editor: Jackie Foley. Estab. 1979. Quarterly 4-color trade journal emphasizing restaurants, taverns, bars, bartenders, bar managers, owners, etc. Circ. 147,000.

Cartoons: Approached by 10 cartoonists/year. Buys 3 cartoons/issue. Prefers bar themes; single panel. Send query letter with finished cartoons. Samples are filed. Buys first rights. Pays on publication; $50 for b&w and $100 for color cover; $50 for b&w and $100 for color inside.

Illustrations: Approached by 5 illustrators/year. Buys 1 illustration/issue. Works on assignment only. Prefers bar themes. Considers any media. Send query letter with brochure. Samples are filed. Negotiates rights purchased. Pays on publication; $500 for color cover.

Design: Needs computer-literate designers familiar with QuarkXPress and Adobe Illustrator.

BAY AREA PARENT/BAY AREA BABY, 401 Alberto Way, Suite A, Los Gatos CA 95032. (408)356-4801. Fax: (408)356-4903. Editorial Art Director: Sallie. Estab. 1983. Biannual family and parenting resource magazine. Circ. 75,000. Accepts previously published artwork. Originals are returned at job's completion. Sample copies and art guidelines available. 40% of freelance work demands knowledge of Aldus PageMaker and QuarkXPress.

Cartoons: Approached by 5 cartoonists/year. Prefers fun, cute style: single panel. Send query letter with résumé and finished cartoons. Samples are filed. Reports back only if interested. Negotiates rights purchased. Pays $30 for b&w, $40 for color.

Tips: "Start out cheap, get us hooked, be reliable, work fast, make sure artwork arrives on time. Keep in mind that the work will be printed on newsprint. This can be very muddy. Artist has to compensate for this."

BAY WINDOWS, 1523 Washington St., Boston MA 02118. (617)266-6670. E-mail: epperly@baywindow s.com. Editor: Jeff Epperly. Estab. 1981. A weekly newspaper "targeted to politically-aware lesbians, gay men and other political allies publishing non-erotic news and features"; b&w with 2-color cover. Circ.

46,000. Accepts previously published artwork. Original artwork returned after publication. Sample copies available. Needs computer illustrators familiar with Adobe Illustrator or Aldus FreeHand.

Cartoons: Approached by 25 freelance cartoonists/year. Buys 1-2 freelance cartoons/issue. Buys 50 free-lance cartoons/year. Preferred themes include politics and life-styles. Prefers double and multiple panel, political and editorial cartoons with gagline, b&w line drawings. Send query letter with roughs. Samples are returned by SASE if requested by artist. Reports back to the artist within 6 weeks only if interested. Rights purchased vary according to project. Pays on publication; $75-100 for b&w only.

Illustrations: Approached by 60 freelance illustrators/year. Buys 1 freelance illustration/issue. Buys 50 freelance illustrations/year. Artists work on assignment only. Preferred themes include politics—"humor is a plus." Considers pen & ink and marker drawings. Send query letter with photostats and SASE. Samples are filed. Reports back within six weeks only if interested. Portfolio review not required. Rights purchased vary according to project. Pays on publication; $100-125 for cover; $75-100 for b&w inside; $75 for spots.

‡**BECKETT PUBLICATIONS**, 15850 Dallas Pkwy., Dallas TX 75248. (214)991-6657. Fax: (214)991-8930. E-mail: art_gallery@beckett.com. Website: http://www.beckett.com. Art Editor: Judi Smalling. Estab. 1984. Publishes monthly consumer magazines emphasizing sports card and memorabilia collecting (baseball, football, basketball, hockey and auto racing). "Our readers particularly enjoy sports art of superstar athletes." Circ. 1 million. Art guidelines for #10 SASE with first-class postage.

Illustration: Approached by 150-250 illustrators/year. Buys 1-2 illustrations/issue. Prefers sports art with good likeness, vertical format. Considers all media. Accepts disk submissions. Send high resolution, 5-file EPS files. Samples are filed. Reports back within 1 month. Will contact for portfolio review of slides and transparencies if interested. Buys first North American serial, with option for reprint and electronic rights. **Pays on acceptance**; $300 minimum for color cover; $150 maximum for b&w, $200 maximum for color inside. Finds illustrators through art contest, word of mouth, the Beckett magazines.

Design: Needs freelancers for design and production. Prefers local designers with experience in editorial design. 100% of freelance work demands knowledge of Adobe Photoshop 3.0, Adobe Illustrator 5.0, QuarkX-Press 3.3. Send query letter with photocopies.

Tips: "Read our magazines to determine which superstar athletes are desirable to paint. Vertical format preferred. Submit 4×5 transparencies or 35mm slides. Label submissions. Call or write for our current 'Want List.' "

BEER, The Magazine, Box 717, Hayward CA 94543-0717. (510)538-9500. Fax: (510)538-7644. E-mail: beerthemag@aol.com. Publisher: Bill Owens. Art Director: Dayna Goforth. Estab. 1993. Bimonthly (except January) consumer magazine. "A lifestyle magazine for beer lovers, aficionados and fanatics!" Circ. 60,000. Accepts previously published artwork. Originals returned at job's completion. Samples copies available for $5. Art guidelines free for SASE with first-class postage.

● Also publishes *American Brewer Magazine.*

Cartoons: Approached by 10 freelancers/year. Buys 2 cartoons/issue. Wants cartoons dealing with drinking beer. Prefers single or multiple panel. Send query letter with roughs. Samples are not filed and are returned by SASE if requested by artist. Reports back within 2 months. Negotiates rights purchased. Pays $50-100 for color.

Illustrations: Approached by 10 illustrators/year. Buys 5 illustrations/issue. Works on assignment only. Prefers any style. Considers pen & ink, airbrush, colored pencil, mixed media, collage, charcoal, watercolor, acrylic and oil. Send query letter with brochure, tearsheets, photostats, photographs, slides, photocopies and transparencies. Samples are not filed and are returned by SASE if requested by artist. Reports back to the artist only if interested. Artist should follow-up with call or letter after initial query. Portfolio should include roughs. Buys first rights or negotiates rights purchased. **Pays on acceptance**; $300-500 for color cover; $100-200 for color inside. Pays $50 for spots.

THE BERKELEY MONTHLY, 1301 59th St., Emeryville CA 94608. (510)658-9811. Fax: (510)658-9902. E-mail: themonthly@aol.com. Art Director: Andreas Jones. Estab. 1970. Consumer monthly tabloid; b&w with 4-color cover. Editorial features are general interests (art, entertainment, business owner profiles) for an upscale audience. Circ. 75,000. Accepts previously published artwork. Originals returned at job's completion. Art guidelines for SASE with first-class postage. Sample copy and guidelines for SASE with 5 oz. first-class ($1.24). No nature or architectural illustrations. 100% of freelance design work demands knowledge of Aldus PageMaker, QuarkXPress or Aldus FreeHand.

Cartoons: Approached by 75-100 cartoonists/year. Buys 3 cartoons/issue. Prefers single panel, b&w line drawings; "any style, extreme humor." Send query letter with finished cartoons. Samples are filed or returned by SASE. Reports back only if interested. Buys one-time rights. Pays $35 for b&w.

Illustrations: Approached by 150-200 illustrators/year. Buys 2 illustrations/issue. Prefers pen & ink, water-color, acrylic, colored pencil, oil, charcoal, mixed media and pastel. Send postcard sample or query letter with tearsheets and photocopies. Accepts submissions on disk, Mac compatible with Aldus FreeHand, Adobe Illustrator, Adobe Photoshop, Aldus PageMaker or QuarkXPress. Samples are filed or returned by SASE. Reports back only if interested. Write for appointment to show portfolio of thumbnails, roughs, b&w tear-

sheets and slides. Buys one-time rights. Pays $100-200 for b&w inside; $25-50 for spots. Pays 30 days after publication.

Design: Needs freelancers for design and production. 100% of freelance design requires knowledge of Aldus PageMaker 6.0, Aldus FreeHand 5.0, Adobe Photoshop 3.0, QuarkXPress 3.3 and Adobe Illustrator 3.5. Send query letter with résumé, photocopies or tearsheets. Pays for design by project.

‡BETTER HEALTH MAGAZINE, 1450 Chapel St., New Haven CT 06511. (203)789-3972. Fax: (203)789-4053. Editor: Magaly Olivero. Estab. 1979. Bimonthly, 4-color "consumer health magazine." Circ. 140,000. Accepts previously published artwork. Original artwork returned at job's completion. Sample copies available for $1.25. 25% of freelance work demands knowledge of Adobe Photoshop, QuarkXPress, Aldus FreeHand or Adobe Illustrator.

Illustrations: Approached by 100 illustrators/year. Buys 2-4 illustrations/issue. Works on assignment only. Considers watercolor, collage, airbrush, acrylic, marker, colored pencil, oil, charcoal, mixed media, pastel and computer illustration. Send query letter with tearsheets. Accepts disk submissions compatible with Mac, Adobe Illustrator, Aldus FreeHand or Adobe Photoshop. Samples are filed. Reports back only if interested. Write for appointment to show a portfolio, or mail appropriate materials. Portfolio should include rough, original/final art, color tearsheets, photostats, photographs and photocopies. Buys first rights. **Pays on acceptance**; $600 for color cover; $400 for color inside.

BEVERAGE WORLD MAGAZINE, 150 Great Neck Rd., Great Neck NY 11021. (516)829-9210. E-mail: bevworld@aol.com. Senior Art Director: John Boudreau. Editor: M. Havis Dawson. Monthly magazine covering beverages (beers, wines, spirits, bottled waters, soft drinks, juices) for soft drink bottlers, breweries, bottled water/juice plants, wineries and distilleries. Circ. 33,000. Accepts simultaneous submissions. Original artwork returned after publication if requested. Sample copy $2.50. Art guidelines available.

Illustrations: Buys 3-4 illustrations. Works on assignment only. Send postcard sample, brochure, photocopies and photographs to be kept on file. Write for appointment to show portfolio. Reports only if interested. Negotiates rights purchased. **Pays on acceptance**; $350 for color cover; $50-100 for b&w inside. Uses color illustration for cover, usually b&w for spots inside.

Design: Needs freelancers for design. 98% of design demands knowledge of Adobe Photoshop, Adobe Illustrator or QuarkXPress. Send query letter with brochure, résumé, photocopies and tearsheets. Pays by project.

Tips: "We prefer to work with Macintosh graphic and layout artists."

‡BIRD WATCHER'S DIGEST, Box 110, Marietta OH 45750. (614)373-5285. Editor: William H. Thompson III. Bimonthly magazine covering birds and bird watching for "bird watchers and birders (backyard and field; veteran and novice)." Circ. 90,000. Previously published material OK. Original work returned after publication. Sample copy $3.

Cartoons: Interested in themes pertaining to birds and/or bird watchers. Single panel b&w line drawings with or without gagline. Send roughs. Samples returned by SASE. Reports in 2 months. Buys one-time rights or reprint rights. Pays $20 on publication.

Illustrations: Buys 1-2 illustrations/issue. Send samples or tearsheets. Reports back within 2 months. Buys one-time rights. Pays $50 minimum for b&w; $100 minimum for color.

BLACK BEAR PUBLICATIONS/BLACK BEAR REVIEW, 1916 Lincoln St., Croydon PA 19021-8026. Editor: Ave Jeanne. Associate Editor: Ron Zettlemoyer. Estab. 1984. Publishes semiannual b&w magazine emphasizing social, political, ecological and environmental subjects "for mostly well-educated adults." Circ. 500. Also publishes chapbooks. Accepts previously published artwork. Art guidelines for SASE with first-class postage. Current copy $5 postpaid in US.

Illustrations: Works with 20 illustrators/year. Buys 10 illustrations/issue. Prefers collage, woodcut, pen & ink. Send camera ready pieces with SASE. Samples not filed returned by SASE. Portfolio review not required. Reports within 2 weeks. Acquires one-time rights or reprint rights. Pays in copies, on publication, for the magazine. Pays cash on acceptance for chapbook illustrators. Chapbook illustrators are contacted for assignments. Average pay for chapbook illustrators is $35 for one-time rights. Does not use illustrations over 4×6. Finds artists through word of mouth and submissions.

Tips: "Read our listing carefully. Be familiar with our needs and our tastes in previously published illustrations. We can't judge you by your résumé—send signed copies of b&w artwork. No humor please. If we are interested, we won't let you know without a SASE."

BLACK WARRIOR REVIEW, Box 2936, University of Alabama, Tuscaloosa AL 35486. (205)348-4518. E-mail: warrior@woodsquad.as.ua.edu. Editor: Mindy Wilson. Biannual 4-color literary magazine publishing contemporary poetry, fiction and nonfiction by new and established writers. Circ. 2,000. Accepts previously published artwork. Original artwork is returned at job's completion. Sample copy $6.

Illustrations: Approached by 30 illustrators/year. Buys 1-2 illustrations/issue. Themes and styles vary. Needs editorial illustration. Considers color and b&w photography, pen & ink, watercolor, acrylic, oil, collage

and marker. Send postcard sample. Samples are not filed. Pays on publication; $150 for b&w or color cover; $50 for b&w or color inside.

Tips: "Look at the magazine."

THE B'NAI B'RITH INTERNATIONAL JEWISH MONTHLY, B'nai B'rith, 1640 Rhode Island Ave. NW, Washington DC 20036. (202)857-6645. Editor: Jeff Rubin. Estab. 1886. Specialized magazine published 8 times a year, focusing on issues of interest to the Jewish family. Circ. 200,000. Originals returned at job's completion. Sample copies available for $2.

Illustrations: Approached by 100 illustrators/year. Buys 1-2 illustrations/issue. Works on assignment only. Considers pen & ink, airbrush, colored pencil, mixed media, watercolor, acrylic, oil, pastel, collage, marker, charcoal. Send query letter with brochure and SASE. Samples are filed. Reports back only if interested. Request portfolio review in original query. Portfolio should include final art, color, tearsheets and published work. Buys one-time rights. **Pays on acceptance**; $400 for color cover; $50 for b&w, $100 for color inside. Finds artists through word of mouth and submissions.

Tips: "Have a strong and varied portfolio reflecting a high degree of professionalism. Illustrations should reflect a proficiency in conceptualizing art—not just rendering. Will not be held responsible for unsolicited material."

‡BODY, MIND AND SPIRIT MAGAZINE, Box 701, Providence RI 02901. (401)351-4320. Fax: (401)272-5767. Publisher: James T. Valliere. Editor-in-Chief: Jane Kuhn. Estab. 1982. Bimonthly magazine emphasizing New Age, natural living and metaphysical topics for people looking for tools to improve body, mind and spirit. Circ. 150,000. Original artwork returned after publication. Sample copy for 9 × 12 SASE with $1.07 postage.

Illustrations: Approached by 40 illustrators/year. Works with 3 illustrators/year. Buys 25 illustrations/year. Works on assignment only. Prefers line art with New Age, natural living and metaphysical themes. Send query letter with résumé, tearsheets, photostats, photocopies, slides and photographs. Samples not filed are returned by SASE. Reports within 3 months. To show a portfolio, mail final art and tearsheets. Buys one-time reprint rights. Pays on publication; $75 for b&w and $100 for color inside; $150 for b&w and $250 for color cover.

BOSTONIA MAGAZINE, 10 Lenox St., Brookline MA 02146. (617)353-9711. Art Director: Douglas Parker. Estab. 1900. Quarterly 4-color alumni magazine of Boston University. Audience is "highly educated." Circ. 200,000. Sample copies free for #10 SASE with first-class postage.

Cartoons: Approached by 100 cartoonists/year. Buys 5 cartoons/issue. Prefers single panel, humorous, b&w line drawings with gagline. "Would be interested in creative ideas appropriate for highly educated audience." Send photocopies of unpublished work regularly. Do not send originals. Samples are filed and not returned. Reports back within weeks only if interested. Buys first North American serial rights. Pays $200.

Illustrations: Approached by 500 illustrators/year. Buys 7 illustrations/issue. Considers all media. Works on assignment only. Send query letter with photocopies, printed samples and tearsheets. Samples are filed and not returned. Reports back within weeks only if interested. Will contact for portfolio review if interested. Portfolio should include color and b&w roughs, final art and tearsheets. Buys first North American serial rights. "Payment depends on final use and size." **Pays on acceptance.** "Liberal number of tearsheets available at no cost." Payment varies for cover and inside. Pays $200-400 for spots. Finds artists through magazines, word of mouth and submissions.

Tips: "Portfolio should include plenty of tearsheets/photocopies as handouts. Don't phone; it disturbs flow of work in office. No sloppy presentations. Show intelligence and uniqueness of style." Prefers original illustrations "meant to inform and elucidate."

‡BOW & ARROW HUNTING MAGAZINE, Box 2429, Capistrano Beach CA 92624. (714)493-2101. Fax: (714)240-8680. Editorial Director: Roger Combs. Emphasizes bowhunting and bowhunters. Published 7 times per year. Original artwork returned after publication.

Cartoons: Buys 2-3 cartoons/issue; all from freelancers. Prefers single panel, with gag line; b&w line drawings. Send finished cartoons. Material not kept on file returned by SASE. Reports within 2 months. Buys first rights. **Pays on acceptance**; $10-15, b&w.

Illustrations: Buys 1-2 illustrations/issue; all from freelancers. Prefers live animals/game as themes. Send samples. Prefers photographs or original work as samples. Especially looks for perspective, unique or accurate use of color and shading, and an ability to clearly express a thought, emotion or event. Samples returned by SASE. Reports in 2 months. Portfolio review not required. Buys first rights. **Pays on acceptance**; $100 for color cover; $30 for b&w inside.

BOWLING MAGAZINE, 5301 S. 76th St., Greendale WI 53129. (414)423-3232. Fax: (414)421-7977. Editor: Bill Vint. Estab. 1933. Bimonthly 4-color magazine covering the sport of bowling in its many facets. Circ. 140,000. Sample copies for 9 × 12 SAE with 5 first-class stamps. Art guidelines for SASE with first-class postage.

This pen & ink, airbrush and gouache drawing by Mark Fisher illustrates a story entitled "Record-Making Strides" in *Bostonia*, a quarterly magazine published by Boston University. "Mark has summed up a number of messages here—a researcher who has designed a machine that makes the machines that make CDs, thereby reclaiming a technology for the U.S.," says Art Director Doug Parker. "Placing the technician on an American flag shows the company is local," Fisher says. "The repetition of the CDs shows the mass production aspect and the angularity to the shapes helps lend a feeling of movement."

Illustrations: Approached by 12 illustrators/year. Buys 1-2 illustrations/issue. Works on assignment only. Send query letter with tearsheets, SASE and photocopies. Samples are filed or are returned by SASE. Reports back within 10 days. Rights purchased vary. **Pays on acceptance**; $250-500 for color cover; $75-250 for color inside; $25-75 b&w spots (instructional themed material).

Tips: "Have a thorough knowledge of bowling. We have a specific interest in instructional materials that will clearly illustrate bowling techniques."

BRIDE'S MAGAZINE, Condé-Nast Publications, 140 E. 45th St., New York NY 10017. (212)880-8530. Art Director: Phyllis Cox. Assistant Visual Editor: Liz Guillet Lustig. Estab. 1934. Bimonthly 4-color; "classic, clean, sophisticated design style." Original artwork is returned after publication.

Illustrations: Buys illustrations mainly for spots and feature spreads. Buys 5-10 illustrations/issue. Works on assignment only. Considers pen & ink, airbrush, mixed media, colored pencil, watercolor, acrylic, collage and calligraphy. Needs editorial illustrations. Send postcard sample. In samples or portfolio, looks for "graphic quality, conceptual skill, good 'people' style; lively, young, but sophisticated work." Samples are filed. Will contact for portfolio review if interested. Portfolios may be dropped off every Monday-Thursday and should include color and b&w final art, tearsheets, slides, photostats, photographs and transparencies.

Buys one-time rights or negotiates rights purchased. Pays on publication; $250-350 for b&w or color inside; $250 minimum for spots. Finds artists through word of mouth, magazines, submissions/self-promotions, sourcebooks, artists' agents and reps, attending art exhibitions.

Tips: Sections most open to illustrators are "Something New" (a short subject page with 4-color art); also needs illustrations to accompany feature articles such as "Wedding Nightmare" and "Honeymoon Hotline," travel section features (color).

BRIGADE LEADER, Box 150, Wheaton IL 60189. (708)665-0630. Fax: (708)665-0372. Estab. 1960. Art Director: Robert Fine. Quarterly 2-color magazine for Christian men leading boys in Brigade. Circ. 11,000. Original artwork returned after publication if requested. Sample copy for 6 first-class stamps and large SASE; artist's guidelines for SASE with first-class postage.

Cartoons: Approached by 30 cartoonists/year. Buys 1-2 cartoons/issue. Interested in sports, family life, nature and youth themes; single panel with gagline. Include SASE. Buys first rights only. Pays on publication $35-50 for b&w cartoons.

Illustrations: Approached by 45 illustrators/year. Buys 2-4 illustrations/issue. Uses freelancers for editorial illustrations. Uses editorial illustration in pen & ink, airbrush, pencil and watercolor. Interested in masculine subjects (sports, camping, out of doors, family). Provide business card and photocopies to be kept on file. Works on assignment only. Pays on publication; $150 minimum for b&w cover; $100 minimum for inside.

‡BROOKLYN BRIDGE, 388 Atlantic Ave., Brooklyn NY 11217. (718)596-7400. Fax: (718)852-1290. Contact: Art Director. Estab. 1995. Monthly Brooklyn regional magazine with an emphasis on culture, politics and human interest. Circ. 60,000.

Cartoons: Buys 1 cartoon/issue. Prefers urban life themes. Send query letter with finished cartoons. Samples are filed or returned by SASE. Does not report back. Cartoonist should call. Rights purchased vary according to project. Pays $100-200 for b&w, $200-400 for color.

Illustration: Approached by 200 illustrators/year. Buys 10-15 illustrations/issue. Considers all media. Send postcard sample. Accepts disk submissions. Samples are filed. Reports back only if interested. To arrange portfolio review artist should follow-up with a call. Portfolio should include b&w, color, final art, photographs, slides, tearsheets and transparencies. Buys one-time rights. Pays on publication; $600-1,000 for color cover; $200-400 for color inside. Pays $200 for spots.

Design: Needs freelancers for design and production. Prefers local designers only. 100% of freelance work demands knowledge of Adobe Photoshop, Adobe Illustrator, QuarkXPress. Phone art director.

Tips: "Looking for local talent with an understanding of Brooklyn's diverse cultural makeup."

BUCKMASTERS WHITETAIL MAGAZINE, 10350 Hwy. 80 E., Montgomery AL 36117. (205)215-3337. Fax: (334)215-3535. Vice President of Production: Dockery Austin. Estab. 1987. Magazine covering whitetail deer hunting. Seasonal—6 times a year. Circ. 300,000. Accepts previously published artwork. Originals are not returned. Sample copies and art guidelines available. 80% of freelance work demands knowledge of Adobe Illustrator, QuarkXPress, Adobe Photoshop or Aldus FreeHand.

Cartoons: Approached by 5 cartoonists/year. Buys 1 cartoon/issue. Send query letter with brochure and photos of originals. Samples are filed or returned by SASE. Reports back within 3 months. Rights purchased according to project. Pays $25 for b&w.

Illustrations: Approached by 5 illustrators/year. Buys 1 illustration/issue. Works on assignment only. Considers all media. Send postcard sample. Accepts submissions on disk. Samples are filed. Call or write for appointment to show portfolio. Portfolio should include final art, slides and photographs. Rights purchased vary. Pays on publication; $500 for color cover; $150 for color inside.

Design: Needs freelance designers for multimedia. 100% of freelance work requires knowledge of Adobe Photoshop, QuarkXPress or Adobe Illustrator. Pays by project.

Tips: "Send samples related to whitetail deer or turkeys."

BUILDINGS MAGAZINE, 427 Sixth Ave. SE, Cedar Rapids IA 52406. (319)364-6167. Fax: (319)364-4278. E-mail: elisa-geneser@stamats.com. Website: http://www.buildingsmag.com. Graphic Designer/Art Director: Elisa Geneser. Estab. 1906. Monthly trade journal; magazine format; "information related to current approaches, technologies and products involved in large commercial facilities." Circ. 43,000. Original artwork not returned at job's completion. Sample copies available.

Illustrations: Works on assignment only. Considers all media, themes and styles. Send postcard sample. Accepts submissions on disk compatible with Macintosh, Adobe Photoshop 3.0 or Adobe Illustator 5.5. Samples are filed. Will contact for portfolio review if interested. Portfolio should include thumbnails, b&w/color tearsheets. Rights purchased vary. **Pays on acceptance**, $100-300 for b&w, $300-500 for color cover; $50-100 for b&w; $100-200 for color inside; $30-75 for spots. Finds artists through word of mouth and submissions.

Tips: "Send postcards with samples of your work printed on them. Show us a variety of work (styles), if available."

BUSINESS & COMMERCIAL AVIATION, (Division of the McGraw-Hill Companies), 4 International Dr., Rye Brook NY 10573. (914)939-0300. E-mail: bcaedit@mcimail.com. Art Director: Mildred Stone. Monthly technical publication for corporate pilots and owners of business aircraft. 4-color; "contemporary design." Circ. 55,000.

Illustrations: Works with 12 illustrators/year. Buys 12 editorial and technical illustrations/year. Uses artists mainly for editorials and some covers. Especially needs full-page and spot art of a business-aviation nature. "We generally only use artists with a fairly realistic style. This is a serious business publication—graphically conservative. Need artists who can work on short deadline time." 70% of freelance work demands knowledge of Adobe Photoshop, Adobe Illustrator, QuarkXPress and Aldus FreeHand. Query with samples and SASE. Reports in 1 month. Photocopies OK. Buys all rights, but may reassign rights to artist after publication. Negotiates payment. **Pays on acceptance**; $300 for color; $150-200 for spots.

Tips: "I like to buy based more on style than whether an artist has done aircraft drawings before. Send tearsheets of printed art."

‡BUSINESS LAW TODAY, 750 N. Lake Shore Dr., 8th Floor, Chicago IL 60611. (312)988-6050. Fax: (312)988-6035. Art Director: Tamara Nowak. Estab. 1992. Bimonthly magazine covering business law. Circ. 56,000. Sample copies available.

Cartoons: Buys 20-24 cartoons/year. Prefers business law and business lawyers themes. Prefers single panel, humorous, b&w line drawings, with gaglines. Send photocopies and SASE. Samples are not filed and are returned by SASE. Reports back within several months. Buys one-time rights. Pays on publication; $150 minimum for b&w.

Illustration: Buys 6-9 illustrations/issue. Prefers editorial illustration. Considers all media. 10% of freelance illustration demands knowledge of Adobe Photoshop, Adobe Illustrator and QuarkXPress. Send query letter with printed samples. "We will accept work compatible with QuarkXPress 7.5/version 3.3. Send EPS or TIFF files." Samples are filed and are not returned. Reports back only if interested. Art director will contact artist for portfolio review b&w, color, tearsheets if interested. Buys one-time rights. **Pays on acceptance**; $650-750 for color cover; $350-450 for b&w inside, $450-500 for color inside.

Tips: "Although our payment may not be the highest, accepting jobs from us could lead to other projects, since we produce many publications at the ABA."

BUSINESS NH MAGAZINE, 404 Chestnut St., Suite 201, Manchester NH 03101-1831. (603)626-6354. Fax: (603)626-6359. Art Director: Nikki Bonenfant. Estab. 1982. Monthly magazine with focus on business, politics and people of New Hampshire. Circ. 13,000. Accepts previously published artwork. Originals returned at job's completion. Sample copies free for 9×12 SASE and 5 first-class stamps. 10% of freelance work demands knowledge of Adobe Illustrator or QuarkXPress.

Illustrations: Approached by 4 illustrators/year. Buys 1-4 illustrations/year. Works on assignment only. Prefers bold, contemporary graphics. Considers pen & ink, airbrush, colored pencil and computer-generated illustration. Send postcard sample or query letter with résumé and tearsheets. Samples are filed or are returned by SASE. Will contact for portfolio review if interested. Portfolio should include b&w and color thumbnails, tearsheets, slides and final art. Buys one-time rights and reprint rights. Pays on publication; $50-100 for b&w, $75-150 for color; $25-50 for spots.

Design: Needs freelancers for design production. 75% of freelance work requires knowledge of Adobe Photoshop 3.0, QuarkXPress 3.32 or Adobe Illustrator 5.0. Send query letter with résumé.

Tips: Art Director hires freelancers mostly to illustrate feature stories and for small icon work for departments. Does not use cartoons. "Looking for fast, accurate, detail-oriented work."

BUTTERICK CO., INC., 161 Avenue of the Americas, New York NY 10013. (212)620-2500. Art Director: Joe Vior. Associate Art Director: Lauren Angheld. Quarterly magazine and monthly catalog. "*Butterick Magazine* is for the home sewer, providing fashion and technical information about our newest sewing patterns through fashion illustration, photography and articles. The Butterick store catalog is a guide to all Butterick patterns, shown by illustration and photography." Magazine circ. 350,000. Catalog readership: 9 million worldwide. Originals are returned at job's completion.

Illustrations: "We have two specific needs: primarily fashion illustration in a contemporary yet realistic style, mostly depicting women and children in full-length poses for our catalog. We are also interested in travel, interior, light concept and decorative illustration for our magazine." Considers watercolor and gouache for catalog art; all other media for magazine. Send query letter with tearsheets and color photocopies and promo cards. Samples are filed or are returned by SASE if requested by artist. Does not report back, in which case the artist should call soon if feedback is desired. Portfolio drop off every Monday or mail appropriate materials. Portfolio should include final art, tearsheets, photostats, photocopies and large format transparencies. Rights purchased vary according to project.

Tips: "Send non-returnable samples several times a year—especially if style changes. We like people to respect our portfolio drop-off policy. Repeated calling and response cards are undesirable. One follow-up call by illustrator for feedback is fine."

‡CAMPUS LIFE, 465 Gundersen Dr., Carol Stream IL 60188. Art Director: Doug Johnson. Monthly 4-color publication for high school and college students. "Though our readership is largely Christian, *Campus Life* reflects the interests of all kids—music, activities, photography and sports." Circ. 100,000. Original artwork returned after publication. "No phone calls, please. Send mailers." Uses freelance artists mainly for editorial illustration. 10% of freelance work demands knowledge of Aldus FreeHand and Adobe Illustrator.
Cartoons: Approached by 50 cartoonists/year. Buys 100 cartoons/year from freelancers. Uses 3-8 single-panel cartoons/issue plus cartoon features (assigned) on high school and college education, environment, family life, humor through youth and politics; applies to 13-18 age groups; both horizontal and vertical format. Prefers to receive finished cartoons. Reports in 4 weeks. **Pays on acceptance**; $50, b&w, $75, color.
Illustrations: Approached by 175 illustrators/year. Works with 10-15 illustrators/year. Buys 2 illustrations/issue, 50/year from freelancers. Styles vary from "contemporary realism to very conceptual." Works on assignment only. Send promos or tearsheets. Please no original art transparencies or photographs. Samples returned by SASE. Publication will contact artist for portfolio review if interested. Buys first North American serial rights; also considers second rights. **Pays on acceptance**; $75-350, b&w, $350-500, color, inside.
Tips: "I like to see a variety in styles and a flair for expressing the teen experience. Keep sending a mailer every couple of months."

❦CANADIAN PHARMACEUTICAL JOURNAL, 20 Camelot Dr., Suite 600, Nepean, Ontario K2G 5X8 Canada. (613)727-1364. Fax: (613)727-1714. Editor: Andrew Reinbold. Estab. 1861. Trade journal. Circ. 17,500. Accepts previously published artwork. Originals are returned at job's completion. Sample copies available.
Illustrations: Approached by 20 illustrators/year. Works on assignment only. "Stories are relative to the interests of pharmacists—scientific to life-style." Considers all media. Send query letter with photostats and transparencies. Samples are filed. Reports back only if interested. Call for an appointment to show a portfolio, which should include slides, photostats and photographs. Rights purchased vary. **Pays on acceptance**; $600-1,200 for color cover; $200-1,000 for color inside.

CAREER FOCUS, 106 W. 11th St., 250 Mark Twain Tower, Kansas City MO 64105-1806. (816)221-4404. Fax: (816)221-1112. Contact: Editorial Department. Estab. 1985. Bimonthly educational, career development magazine. "A motivational periodical designed for Black and Hispanic college graduates who seek career development information." Circ. 250,000. Accepts previously published artwork. Originals are returned at job's completion. Sample copies and art guidelines for SASE with first-class postage.
Illustrations: Buys 1 illustration/issue. Send query letter with SASE, photographs, slides and transparencies. Samples are filed. Reports back to the artist only if interested. Buys one-time rights. Pays on publication; $20 for b&w, $25 for color.

CAREER PILOT MAGAZINE, 4971 Massachusetts Blvd., Atlanta GA 30337. (770)997-8097. Fax: (770)997-8111. E-mail: 76517.54@compuserve.com. Art Director: Kellie Frissell. Estab. 1983. "Monthly aviation information magazine covering beginning pilot to retirement. Articles relate to business, lifestyle, health and finance." Circ. 12,500. Accepts previously published artwork. Originals returned at job's completion. Sample copies available (free postage). Art guidelines available. Interested in both computer-generated and conventional illustrations.
Illustrations: Approached by 30 illustrators/year. Buys 2 illustrations/issue. Main subjects: training/education, health, lifestyle, finance (1 or 2/year with an airplane/subject). Open to various media including photographic illustration, 3-D, paper sculpture, etc. Send query letter with brochure, résumé, tearsheets, photocopies, photostats, slides and transparencies. "No phone calls please." Samples are filed or returned if requested. Reports back to the artist only if interested. Buys one-time rights. Pays net 30 days on receipt of invoice. $200 for b&w, $300 for color, full page; $100 for b&w, $200 for color spots.
Tips: "Please use discretion when choosing samples to send. *Career Pilot* is a fairly conservative, professional publication."

CAREERS AND COLLEGES, 989 Sixth Ave., New York NY 10018. (212)563-4688. Fax: (212)967-2531. Art Director: Michael Hofmann. Estab. 1980. Biannual 4-color educational magazine. "Readers are college-bound high school juniors and seniors. Besides our magazine, we produce educational publications for outside companies." Circ. 500,000. Accepts previously published artwork. Original artwork is returned at job's completion. Sample copy for $2.50 and SASE with first-class postage.
Illustrations: "We're looking for contemporary, upbeat, sophisticated illustration. All techniques are welcome." Send query letter with samples. "Please do not call. Will call artist if interested in style." Buys one-time rights. Pays $950, color, cover; $350, color departments; $400-800, color, inside; $200-250 for color spots within 2 months of delivery of final art.

‡CAREERS AND MAJORS MAGAZINE, P.O. Box 14081, Gainesville FL 32604-2081. (904)373-6907. Fax: (904)373-8120. Art Director: Jeffrey L. Riemersma. Estab. 1990. 4-color magazine "targeted toward graduating college seniors, emphasizing career and higher education opportunities." Publishes 2 issues/year.

Circ. 18,000. Accepts previously published artwork. Original artwork returned at job's completion. Sample copies for SASE with first-class postage. Art guidelines available.

• Oxendine Publishing also publishes *Student Leader Magazine, Florida Leader Magazine* and *Florida Leader Magazine for High School Students.*

Illustrations: Approached by 20-30 illustrators/year. Buys 4-5 illustrations/issue. Prefers "satirical or humorous, student or job-related themes." Considers pen & ink, airbrush, acrylic, colored pencil, oil, mixed media pastel and computer generated illustration. 10% of freelance work demands knowledge of Aldus PageMaker and Corel Draw. Send query letter with brochure, tearsheets, photostats or transparencies. Samples are filed or are returned by SASE if requested by artist. Reports back only if interested. Negotiates rights purchased. Pays on publication; $75 for color inside.

Tips: "Be very talented, have a good sense of humor, be easy to work with."

THE CAROLINA QUARTERLY, Greenlaw Hall CB 3520, University of North Carolina, Chapel Hill NC 27599. Editor: Amber Vogel. Triquarterly publishing poetry, fiction and nonfiction. Magazine is "perfect-bound, finely printed, b&w with one- or two-color cover." Circ. 1,500. Send only clear copies of artwork. Sample copy $5 (includes postage and handling). Art guidelines for SASE with first-class postage.

Illustrations: Uses artists for covers and inside illustrations. Approached by 100 illustrators/year. Buys up to 10 illustrations/issue. Prefers small b&w sketches. Send postcard sample with SASE and tearsheets. Prefers b&w prints. Reports within 2 months. Acquires first rights.

Tips: "Bold, spare images often work best in our format. Look at a recent issue to get a clear idea of content and design."

CASINO REVIEW, (formerly *Chicago's Casino Review*), % Hyde Park Media, 635 Chicago Ave., #250, Evanston IL 60202. Contact: Art Editor. Estab. 1994. Bimonthly. Circ. 50,000. Sample copy for $5.

Cartoons: Buys 1 cartoon/issue. Prefers casino and other gambling-related panel cartoons for "Casino Capers" slot. Prefers single, double or multiple panel; b&w line drawings with gagline. Send query letter with photocopies. Samples are returned by SASE "usually within 1 month." Negotiates rights purchased.

Illustrations: Buys 6-12 illustrations/issue. Prefers casino gambling themes. Considers b&w or 2-color (usually red and black) illustrations for articles, features and columns. Also considers 4-color cover art, usually detailed line illustrations that have been painted by computer. Also publishes block art prints. Send query letter with 2-3 photocopies. "Write and request a sample copy. After reviewing the publication call and request a specific image you can develop a non-returnable rough for, then submit it." Pays a flat fee; $10-200.

Tips: "Our pre-press operations are completely desk-top. Once we accept an illustration it can be submitted as either camera-ready art, on a Macintosh floppy, a SyQuest cartridge or via modem."

CAT FANCY, Fancy Publications Inc., Box 6050, Mission Viejo CA 92690. (714)855-8822. Editor: Debbie Phillips-Donaldson. Monthly 4-color magazine for cat owners, breeders and fanciers; contemporary, colorful and conservative. Readers are mainly women interested in all phases of cat ownership. Circ. 303,000. No simultaneous submissions. Sample copy $5.50; artist's guidelines for SASE.

Cartoons: Buys 12 cartoons/year. Seeks single, double and multipanel with gagline. Should be simple, upbeat and reflect love for and enjoyment of cats. "Central character should be a cat." Send query letter with photostats or photocopies as samples and SASE. Reports in 2-3 months. Buys first rights. Pays on publication; $35 for b&w line drawings.

Illustrations: Buys 2-5 b&w spot illustrations/issue. Send query letter with brochure, high-quality photocopies (preferably color), SASE and tearsheets. Article illustrations assigned. Portfolio review not required. Pays $20-35 for spots; $20-100 for b&w; $50-300 for color insides; more for packages of multiple illustrations. Needs editorial, medical and technical illustration and images of cats.

Tips: "We need cartoons with an upbeat theme and realistic illustrations of purebred and mixed-breed cats. Please review a sample copy of the magazine before submitting your work to us."

CATHOLIC FORESTER, 355 W. Shuman Blvd., Box 3012, Naperville IL 60566-7012. (708)983-4920. Editor: Dorothy Deer. Estab. 1883. Magazine. "We are a fraternal insurance company but use general-interest articles, art and photos. Audience is middle-class, many small town as well as big-city readers, patriotic, somewhat conservative distributed nationally." Bimonthly 4-color magazine. Circ. 140,000. Accepts previously published material. Original artwork returned after publication if requested. Sample copy for 9 × 12 SASE with 3 first-class stamps.

Cartoons: Buys approximately 20 cartoons/year from freelancers. Considers "anything *funny* but it must be clean." Prefers single panel with gagline or strip; b&w line drawings. Material returned by SASE. Reports within 2 months; "we try to do it sooner." Buys one-time rights or reprint rights. **Pays on acceptance**; $25 for b&w.

Illustrations: Needs editorial illustration. Will contact for portfolio review if interested. Requests work on spec before assigning job. Pays $50-100 for b&w, $100-300 for color inside.

CATS MAGAZINE, P.O. Box 290037, Port Orange FL 32129. (904)788-2770. Fax: (904)788-2710. E-mail: copeland@nectrl.com. Art Editor: Roy Copeland. Estab. 1945. Monthly 4-color magazine for cat enthusiasts of all types. Circ. 150,000. Sample copies for SASE with $3. Art guidelines available for SASE. Uses freelance artists mainly for inside art. Freelancers should be familiar with Painter, Adobe Photoshop, Adobe Illustrator or Aldus FreeHand.

Illustrations: Buys 15-36 illustrations/year. Prefers "cats" themes. Considers pen & ink, watercolor, oil and other media. Send query letter with SASE and samples. All illustration is assigned to reflect feature articles. Sample illustrations that show the behavioral aspects of cats, typical feline personality and motion are desired as opposed to a static portrait. "Non-cat" illustrations are accepted to determine the artist's quality and style; however, include at least 1 small sketch of a cat if possible. Samples are reviewed upon arrival. Samples accepted are kept on file for possible future assignments. Printed samples are preferred. 35mm slides and photos are also accepted. If a SASE or return postage is enclosed, rejected artwork will be returned within 1-2 months. If no SASE is enclosed, rejected samples will be discarded. Accepted artwork will be filed; however, no response will be sent to the artist without a SASE. Pays $100-700 depending on size. Kill fee dependent upon progress of work. Payment upon publication. Buys first serial rights. Finds artists through submissions and sourcebooks.

Tips: Label material clearly with name, address, phone and fax. Do not send over-sized submissions (no bigger than $9\frac{1}{4} \times 11\frac{3}{4}$). Most frequent reasons for rejection: art is too "wild"; poor depiction of cat; cat is in pain or danger; poor drawing or painting style; uninteresting; style too messy or cluttered; background is ugly or "busy."

CED, 600 S. Cherry St., Suite 400, Denver CO 80222. (303)393-7449. Fax: (303)393-6654. Art Director: Don Ruth. Estab. 1978. Monthly trade journal. "We deal with the engineering aspects of the technology in Cable TV. We try to publish both views on subjects." Circ. 15,000. Accepts previously published work. Original artwork not returned at job's completion. Sample copies and art guidelines available.

Cartoons: Approached by 5-10 freelance illustrators/year. Perfers cable-industry-related themes; single panel, color washes without gagline. Contact only through artist rep. Samples are filed. Rights purchased vary according to project. Pays $200 for b&w; $400 for color.

Illustrations: Buys 1 illustration/issue. Works on assignment only. Prefers cable TV-industry themes. Considers watercolor, airbrush, acrylic, colored pencil, oil, charcoal, mixed media, pastel, computer disk through Adobe Photoshop, Adobe Illustrator or Aldus FreeHand. Contact only through artist rep. Samples are filed. Call for appointment to show portfolio. Portfolio should include final art, b&w/color tearsheets, photostats, photographs and slides. Rights purchased vary according to project. **Pays on acceptance**; $200 for b&w, $400 for color; cover; $100 for b&w, $200 for color inside.

CHEMICAL ENGINEERING, 1221 Avenue of Americas, New York NY 10020. (212)512-3377. Fax: (212)512-4762. Art Director: M. Gleason. Estab. 1903. Monthly 4-color trade journal featuring chemical process, industry technology, products and professional career tips. Circ. 80,000. Accepts previously published artwork. Original artwork returned at job's completion. Sample copies available. "Illustrators should review any issue for guidelines."

● Also publishes *Environmental Engineering World* issued six times/year. Needs cover illustrations.

Illustrations: Approached by 1,000 illustrators/year. Buys 200 illustrations/year. Works on assignment only. Prefers technical information graphics in all media, especially computer art. 80-90% of freelance work demands knowledge of QuarkXPress, Aldus FreeHand, Adobe Illustrator or Adobe Photoshop. Send query letter with samples and SASE. Samples are filed or are returned by SASE. Reports back only if interested. To show a portfolio, mail appropriate representative materials. Buys first rights, one-time rights or reprint rights. Pays on publication; up to $300 for color inside.

Tips: "Have a style and content appropriate to the business of engineering and a fit with our limited budget."

CHEMICAL ENGINEERING PROGRESS, 345 E. 47th St., New York NY 10017. (212)705-8669. Art Director: Paul Scherr. Technical trade magazine published by the American Institute of Chemical Engineering. 100% of freelance work demands knowledge of Adobe Illustrator, QuarkXPress, Adobe Photoshop and Aldus FreeHand.

Illustrations: Approached by 20 illustrators/year. Works on assignment only. Needs technical and editorial illustration. Send query letter with tearsheets. Samples are filed. Publication will contact artist for portfolio review if interested. Artist should follow up with a call or letter after original query. Reports back to the artist only if interested. Buys first or one-time rights. Pays $600 for cover; $300 for b&w, $450 for color inside.

● **A BULLET** introduces comments by the editor of *Artist's & Graphic Designer's Market* indicating special information about the listing.

CHESAPEAKE BAY MAGAZINE, 1819 Bay Ridge Ave., Annapolis MD 21403. (410)263-2662. Fax: (410)267-6924. Art Director: Karen Ashley. Estab. 1972. Monthly 4-color magazine focusing on the boating environment of the Chesapeake Bay—including its history, people, places and ecology. Circ. 35,000. Original artwork returned after publication. Sample copies free for SASE with first-class postage. Art guidelines available. "Please call."

Cartoons: Approached by 12 cartoonists/year. Prefers single panel, b&w washes and line drawings with gagline. Cartoons are nautical humor or appropriate to the Chesapeake environment. Send query letter with finished cartoons. Samples are filed. Reports back to the artist only if interested. Buys one-time rights. Pays $25-30 for b&w.

Illustrations: Approached by 12 illustrators/year. Buys 2-3 technical and editorial illustrations/issue. Considers pen & ink, watercolor, collage, acrylic, marker, colored pencil, oil, charcoal, mixed media and pastel. Usually prefers watercolor or oil for 4-color editorial illustration. "Style and tone are determined by the artist after he/she reads the story." Send query letter with résumé, tearsheets and photographs. Samples are filed. Reports back only if interested. Publication will contact artist for portfolio review if interested. Portfolio should include "anything you've got." No b&w photocopies. Buys one-time rights. "Price decided when contracted." Pays $50-175 for b&w inside; $75-275 for color inside.

Tips: "Our magazine design is relaxed, fun, oriented toward people having fun on the water. Style seems to be loosening up. Boating interests remain the same. But for the Chesapeake Bay—water quality and the environment are more important to our readers than in the past. Colors brighter. We like to see samples that show the artist can draw boats and understands our market environment. Send tearsheets or call for an interview—we're always looking."

CHESS LIFE, 186 Route 9W, New Windsor NY 12553. (914)562-8350. Art Director: Jami Anson. Estab. 1939. Official publication of the United States Chess Federation. Contains news of major chess events with special emphasis on American players, plus columns of instruction, general features, historical articles, personality profiles, cartoons, quizzes, humor and short stories. Monthly b&w with 4-color cover. Design is "text-heavy with chess games." Circ. 70,000. Accepts previously published material and simultaneous submissions. Sample copy for SASE with 6 first-class stamps; art guidelines for SASE with first-class postage.

Cartoons: Approached by 200-250 cartoonists/year. Buys 60-75 cartoons/year. All cartoons must have a chess motif. Prefers single panel with gagline; b&w line drawings. Send query letter with brochure showing art style. Material kept on file or returned by SASE. Reports within 6-8 weeks. Negotiates rights purchased. Pays $25, b&w; $40, color; on publication.

Illustrations: Approached by 100-150 illustrators/year. Works with 4-5 illustrators/year from freelancers. Buys 8-10 illustrations/year. Uses artists mainly for covers and cartoons. All must have a chess motif; uses some humorous and occasionally cartoon-style illustrations. "We use mainly b&w." Works on assignment, but will also consider unsolicited work. Send query letter with photostats or original work for b&w; slides for color, or tearsheets to be kept on file. Reports within 2 months. Call to schedule an appointment to show a portfolio, which should include roughs, original/final art, final reproduction/product and tearsheets. Negotiates rights purchased. Pays $150, b&w; $200, color, cover; $25, b&w; $40, color, inside; on publication.

Tips: "Include a wide range in your portfolio."

CHIC MAGAZINE, 8484 Wilshire Blvd., Suite 900, Beverly Hills CA 90211. (213)651-5400. Art Director: Cynthia Patterson. Estab. 1976. Monthly magazine "which contains fiction and nonfiction; sometimes serious, often humorous. Sex is the main topic, but any sensational subject is possible." Circ. 45,000. Originals returned at job's completion. Sample copies available for $6.

Illustrations: Approached by 15 illustrators/year. Buys 2 illustrations/issue. Works on assignment only. Prefers themes: sex/eroticism, any and all styles. Considers all media. Send query letter with tearsheets, photographs and photocopies. Samples are filed. Artist should follow up with call and/or letter after initial query. Publication will contact artist for portfolio review if interested. Portfolio should include b&w and color slides and final art. Buys all rights. **Pays on acceptance;** $800 for color inside. Finds artists through word of mouth, mailers and submissions.

Tips: "We use artists from all over the country, with diverse styles, from realistic to abstract. Must be able to deal with adult subject matter and have no reservations concerning explicit sexual images. We want to show these subjects in new and interesting ways."

CHICAGO LIFE MAGAZINE, Box 11311, Chicago IL 60611-0311. Publisher: Pam Berns. Estab. 1984. Bimonthly lifestyle magazine. Circ. 60,000. Accepts previously published artwork. Original artwork returned at job's completion. Sample copy for SASE with $3 postage.

Cartoons: Approached by 25 cartoonists/year. Buys 2 cartoons/issue. Prefers sophisticated humor; b&w line drawings. Send query letter with photocopies of finished cartoons. Samples are filed or returned by SASE. Reports back only if interested. Buys one-time rights. Pays $20.

Illustrations: Approached by 30 illustrators/year. Buys 3 illustrations/issue. Prefers "sophisticated, avant-garde or fine art. No 'cute' art, please." Considers all media. Send SASE, slides and photocopies. "Or send

postcards or tearsheets for us to keep." Accepts disk submissions. Samples are filed or returned by SASE. Reports back within 3 weeks. Buys one-time rights. **Pays on acceptance**; $30 for b&w and color inside.

❦**CHICKADEE**, 179 John St., Suite 500, Toronto, Ontario M5T 3G5 Canada. (416)971-5275. Fax: (416)971-5294. Website: http://www.owl.on.ca. Art Director: Tim Davin. Estab. 1979. 10 issues/year. Children's science and nature magazine. Chickadee is a "hands-on" science and nature publication designed to entertain and educate 3-9 year-olds. Each issue contains photos, illustrations, an easy-to-read animal story, a craft project, puzzles, a science experiment, and a pull-out poster. Circ. 150,000 in North America. Originals returned at job's completion. Sample copies available. Uses all types of conventional methods of illustration. Freelancers should be familiar with Adobe Illustrator, CorelDraw or Adobe Photoshop.
Illustrations: Approached by 500-750 illustrators/year. Buys 3-7 illustrations/issue. Works on assignment only. Prefers animals, children, situations and fiction. All styles, loaded with humor but not cartoons. Realistic depictions of animals and nature. Considers all media and computer art. No b&w illustrations. Send postcard sample, photocopies and tearsheets. Accepts disk submissions compatible with Adobe Illustrator 5.0. Send EPS files. Samples are filed or returned by SASE. Will contact for portfolio review if interested. Portfolio should include final art, tearsheets and photocopies. Buys all rights. Pays within 30 days of invoice; $500 for color cover; $100-750 for color/inside; $100-300 for spots. Finds artists through sourcebooks, word of mouth, submissions as well as looking in other magazines to see who's doing what.
Tips: "Please become familiar with the magazine before you submit. Ask yourself whether your style is appropriate before spending the money on your mailing. Magazines are ephemeral and topical. Ask yourself if your illustrations are: A. editorial and B. contemporary. Some styles suit books or other forms better than magazines." Impress this art director by being "fantastic, enthusiastic and unique."

CHILD LIFE, Children's Better Health Institute, 1100 Waterway Blvd., Box 567, Indianapolis IN 46206. (317)636-8881. Fax: (317)684-8094. Contact: Art Director. Estab. 1921. 4-color magazine for children 9-11. Monthly, except bimonthly January/February, April/May, July/August and October/November. Sample copy $1.25. Art guidelines for SASE with first-class postage.
 • Also publishes *Children's Digest, Children's Playmate, Humpty Dumpty's Magazine, Jack and Jill* and *Turtle Magazine.*
Illustrations: Approached by 200 illustrators/year. Works with 30 illustrators/year. Buys approximately 50 illustrations/year on assigned themes. Especially needs health-related (exercise, safety, nutrition, etc.) themes, and stylized and realistic styles of children 9-11 years old. Uses freelance art mainly with stories, recipes and poems. Send postcard sample or query letter with tearsheets or photocopies. Especially looks for an artist's ability to draw well consistently. Reports in 2 months. Buys all rights. Pays $275 for color cover. Pays for inside illustrations by the project, $70-155 (4-color); $60-120 (2-color); $35-90 (b&w); $35-70 for spots. Pays within 3 weeks prior to publication date. "All work is considered work for hire." Finds artists through submissions, occasionally through a sourcebook.
Tips: "Artists should obtain copies of current issues to become familiar with our needs. I look for the ability to illustrate children in group situations and interacting with adults and animals, in realistic styles. Also use unique styles for occasional assignments—cut paper, collage or woodcut art. No cartoons, portraits of children or slick airbrushed advertising work."

THE CHRISTIAN CENTURY, 407 S. Dearborn, Chicago IL 60605. (312)427-5380. Fax: (312)427-1302. Production Coordinator: Matthew Giunti. Estab. 1888. Religious magazine; "a weekly ecumenical magazine with a liberal slant on issues of Christianity, culture and politics." Circ. 35,000. Accepts previously published artwork. Original artwork returned at job's completion. Art guidelines for SASE with first-class postage.
 • Also publishes *The Christian Ministry*, a bimonthly magazine of practical ministry.
Cartoons: Buys 1 cartoon/issue. Prefers religious themes. Line art works best on newsprint stock. Seeks single panel, b&w line drawings and washes. Send query letter with finished cartoons. Samples are filed or are returned by SASE if requested by artist. Reports back within 3 weeks. Buys one-time rights. Pays $25 for b&w; $50 for cover.
Illustrations: Approached by 40 illustrators/year. Buys 30 illustrations/year. Works on assignment only. Needs editorial illustration with "religious, specifically Christian themes and styles that are inclusive, i.e., women and minorities depicted." Considers pen & ink, pastel, watercolor, acrylic and charcoal. Send query letter with tearsheets. Samples are filed or returned by SASE. Reports back within 1 month. Buys one-time rights. Pays on publication; $100 for b&w cover; $50 for b&w inside; $25-50 for spots.

CHRISTIAN HOME & SCHOOL, 3350 E. Paris Ave. SE, Grand Rapids MI 49512. (616)957-1070. Fax: (616)957-5022. Senior Editor: Roger W. Schmurr. Emphasizes current, crucial issues affecting the Christian home for parents who support Christian education. Half b&w, half 4-color magazine; 4-color cover; published 6 times/year. Circ. 58,000. Sample copy for 9×12 SASE with 4 first-class stamps; art guidelines for SASE with first-class postage.
Cartoons: Prefers family and school themes. Pays $50 for b&w.
Illustrations: Buys approximately 2 illustrations/issue. Prefers pen & ink, charcoal/pencil, colored pencil, watercolor, collage, marker and mixed media. Prefers family or school life themes. Works on assignment

only. Send query letter with résumé, tearsheets, photocopies or photographs. Show a representative sampling of work. Samples returned by SASE, or "send one or two samples art director can keep on file." Will contact if interested in portfolio review. Buys first rights. Pays on publication; $75 for b&w; $250 for 4-color full page inside. Finds most artists through references, portfolio reviews, samples received through the mail and artist reps.

CHRISTIAN READER, Dept. AGDM, 465 Gundersen Dr., Carol Stream IL 60188. (708)260-6200. Fax: (708)260-0114. Art Director: Jennifer McGuire. Estab. 1963. Bimonthly general interest magazine. "A digest of the best in Christian reading." Circ. 250,000. Accepts previously published artwork. Originals returned at job's completion. Sample copies and art guidelines for SASE with first-class postage.
Illustrations: Buys 12 illustrations/issue. Works on assignment only. Prefers family, home and church life. Considers all media. Samples are filed or returned by SASE if requested by artist. Reports back only if interested. To show a portfolio, mail appropriate materials. Buys one-time rights. **Pays on acceptance**; $150 for b&w, $250 for color inside.
Tips: "Send samples of your best work, in your best subject and best medium. We're interested in fresh and new approaches to traditional subjects and values."

‡**THE CHRISTIAN SCIENCE MONITOR**, Mailstop P-214, 1 Norway St., Boston MA 02115. (617)450-2361. Fax: (617)450-7575. Design Director: John Van Pelt. Estab. 1910. International 4-color daily newspaper. Originals returned at job's completion. Freelancers should be familiar with Adobe Illustrator, QuarkXPress and Adobe Photoshop.
Cartoons: Prefers international news, commentary and analysis cartoons. Pays $75 for b&w cartoons; $150 for color cartoons.
Illustrations: Approached by 30-40 illustrators/year. Buys 100-150 illustrations/year. Works on assignment only. Needs editorial illustration. Prefers local artists with color newspaper experience. Uses freelancers mainly for opinion illustration. Send query letter with brochure, photocopies and photostats. Samples are filed. Publication will contact artist for portfolio review if interested. Buys one-time rights and national syndication rights. Pays $200 for color. Finds artists through artists' submissions and other publications.

THE CHRONICLE OF THE HORSE, Box 46, Middleburg VA 22117. Editor: John Strassburger. Estab. 1937. Weekly magazine emphasizing horses and English horse sports for dedicated competitors who ride, show and enjoy horses. Circ. 23,500. Sample copy and guidelines available for $2.
Cartoons: Approached by 25 cartoonists/year. Buys 1-2 cartoons/issue. Considers anything about English riding and horses. Prefers single panel b&w line drawings or washes with or without gagline. Send query letter with finished cartoons to be kept on file if accepted for publication. Material not filed is returned. Reports within 4-6 weeks. Buys first rights. Pays on publication $20, b&w.
Illustrations: Approached by 25 illustrators/year. "We use a work of art on our cover every week. The work must feature horses, but the medium is unimportant. We do not pay for this art, but we always publish a short blurb on the artist and his or her equestrian involvement, if any." Send query letter with samples to be kept on file until published. If accepted, insists on high-quality, b&w 8×10 photographs of the original artwork. Samples are returned. Reports within 4-6 weeks.
Tips: Does not want to see "current horse show champions or current breeding stallions."

‡**THE CHURCH HERALD**, 4500 60th St. SE, Grand Rapids MI 49512-9642. (616)698-7071. E-mail: chherald@aol.com. Estab. 1837. Monthly magazine. "The official denominational magazine of the Reformed Church in America." Circ. 110,000. Accepts previously published artwork. Originals returned at job's completion. Sample copies available for $2. Open to computer-literate freelancers for illustration.
Illustrations: Buys up to 2 illustrations/issue. Works on assignment only. Considers pen & ink, watercolor, collage, marker and pastel. Send postcard sample with brochure. Accepts disk submissions compatible with Adobe Illustrator 5.0 or Adobe Photoshop 3.0. Send EPS files. Samples are filed. Reports back to the artist only if interested. Portfolio review not required. Buys one-time rights. Pays on publication; $300 for color cover; $75 for b&w, $125 for color inside.

THE CHURCHMAN'S HUMAN QUEST, 1074 23rd Ave. N., St. Petersburg FL 33704. (813)894-0097. Editor: Edna Ruth Johnson. Magazine is b&w with 2-color cover, conservative design. Published 6 times/year. Circ. 10,000. Sample copy available.
Cartoons: Buys 2-3 cartoons/issue. Interested in religious humanism, political and social themes. Prefers to see finished cartoons. Include SASE. Reports in 1 week. **Pays on acceptance**; $7.
Tips: "Read current-events news so you can cover it humorously."

CICADA, 329 E St., Bakersfield CA 93304. (805)323-4064. Editor: Frederick Raborg. Estab. 1984. A quarterly literary magazine "aimed at the reader interested in haiku and fiction related to Japan and the Orient. We occasionally include excellent Chinese and other Asian poetry forms and fiction so related." Circ. 600. Accepts previously published artwork. Originals returned at job's completion. Sample copies available for the cost of $4.95. Art guidelines for SASE with first-class postage.

Cartoons: Approached by 50-60 cartoonists/year. Buys 2 cartoons/issue. Prefers the "philosophically or ironically funny. Excellent cartoons without gaglines occasionally used on cover." Prefers single panel b&w washes and line drawings with or without gagline. Send good photocopies of finished cartoons. Samples are filed or returned by SASE. Reports back within 2 months. Buys first rights. **Pays on acceptance**; $10 for b&w; $15 if featured.

Illustrations: Approached by 150-175 illustrators/year. Buys 2 illustrations/issue. Prefers Japanese or Oriental, nature themes in pen & ink. Send query letter with photostats of finished pen & ink work. Samples are filed or returned by SASE. Reports back within 2 months. Buys first rights and one-time rights. Pays $15-20 for b&w cover; $10 for b&w inside. Pays on publication for most illustrations "because they are dictated by editorial copy." Finds artists through market listings and submissions.

CINCINNATI MAGAZINE, 409 Broadway, Cincinnati OH 45202. (513)421-4300. Art Director: Tom Hawley. Estab. 1960. Monthly 4-color lifestyle magazine for the city of Cincinnati. Circ. 30,000. Accepts previously published artwork. Original artwork returned at job's completion.

Cartoons: Approached by 20 cartoonists/year. Buys 8 cartoons/issue. "There are no thematic or stylistic restrictions." Prefers single panel b&w line drawings. Send finished cartoons. Samples are filed or returned with SASE. Reports back within 2 months. Buys one-time rights or reprint rights. Pays $25.

Illustrations: Approached by 20 illustrators/year. Buys 6 illustrations/issue from local freelancers. Works on assignment only. Send postcard samples. Accepts disk submissions. Send TIFF or EPS files. Samples are filed or returned by SASE. Reports back only if interested. Buys one-time rights or reprint rights. **Pays on acceptance**; $200-350 for color cover; $50-200 for b&w; $50-200 for color inside; $25 for spots.

Design: Needs freelancers for design and production. 90% of freelance work demands knowledge of Adobe Photoshop, Adobe Illustrator and QuarkXPress. Send brochure, photocopies, photographs, SASE, slides, tearsheets and transparencies. Pays by project.

Tips: "Let the work speak for itself."

CINEFANTASTIQUE, Box 270, Oak Park IL 60303. (708)366-5566. Fax: (708)366-1441. Editor-in-Chief: Frederick S. Clarke. Monthly magazine emphasizing science fiction, horror and fantasy films for "devotees of 'films of the imagination.' " Circ. 60,000. Original artwork not returned. Sample copy $8.

Illustrations: Uses 1-2 illustrations/issue. Interested in "dynamic, powerful styles, though not limited to a particular look." Works on assignment only. Send query letter with résumé, brochure and samples of style to be kept on file. Samples not returned. Reports in 3-4 weeks. Buys all rights. Pays on publication; $150 maximum for inside b&w line drawings and washes; $300 maximum for cover color washes; $150 maximum for inside color washes.

CIRCLE K MAGAZINE, 3636 Woodview Trace, Indianapolis IN 46268. (317)875-8755. Fax: (317)879-0204. Art Director: Dianne Bartley. Estab. 1968. Kiwanis International's youth magazine for (college age) students emphasizing service, leadership, etc. Published 5 times/year. Circ. 12,000. Originals and sample copies returned to artist at job's completion.

Illustrations: Approached by more than 30 illustrators/year. Buys 1-2 illustrations/issue. Works on assignment only. Needs editorial illustration. "We look for variety." Send query letter with photocopies, photographs, tearsheets and SASE. Samples are filed. Will contact for portfolio review if interested. Portfolio should include tearsheets and slides. **Pays on acceptance**; $100 for b&w, $250 for color cover; $50 for b&w, $150 for color inside.

CITY LIMITS, 40 Prince St., New York NY 10012. (212)925-9820. Fax: (212)966-3407. Senior Editor: Kim Nauer. Estab. 1976. Monthly urban affairs magazine covering issues important to New York City's low- and moderate-income neighborhoods, including housing, community development, the urban environment, crime, public health and labor. Circ. 10,000. Originals returned at job's completion. Sample copies for 9 × 12 SASE and 4 first-class stamps.

• Plans to publish more cartoons in the future. Would like to see more submissions.

Cartoons: Buys 5 cartoons/year. Prefers N.Y.C. urban affairs—social policy, health care, environment and economic development. Prefers political cartoons; single, double or multiple panel b&w washes and line drawings without gaglines. Send query letter with finished cartoons and tearsheets. Samples are filed. Reports back within 1 month. Buys first rights and reprint rights. Pays $35-50 for b&w.

Illustrations: Buys 2-3 illustrations/issue. Must address urban affairs and social policy issues, affecting low and moderate income neighborhoods, primarily in New York City. Considers pen & ink, watercolor, collage, airbrush, charcoal, mixed media and anything that works in b&w. Send postcard sample or query letter with tearsheets, photocopies, photographs and SASE. Samples are filed. Reports back within 1 month. Request portfolio review in original query. Buys first rights. Pays on publication; $50-100 for b&w cover; $50 for b&w inside; $25-50 for spots. "Our production schedule is tight, so publication is generally within two weeks of acceptance, as is payment." Finds artists through other publications, word of mouth and submissions.

Tips: "Make sure you've seen the magazine before you submit. Our niche is fairly specific." Freelancers "are welcome to call and talk."

CLASSIC AUTO RESTORER, P.O. Box 6050, Mission Viejo CA 92690. (714)855-8822. Fax: (714)855-3045. Editor: Don Burger. Estab. 1989. Monthly consumer magazine with focus on collecting, restoring and enjoying classic cars. Circ. 100,000. Accepts previously published artwork. Originals returned at job's completion. Sample copies available for $5.50.

Illustrations: Approached by 5-10 illustrators/year. Buys 2-3 illustrations/issue. Prefers technical illustrations and cutaways of classic/collectible automobiles through 1972. Considers pen & ink, watercolor, airbrush, acrylic, marker, colored pencil, oil, charcoal, mixed media and pastel. Send query letter with SASE, slides, photographs and photocopies. Samples are filed or returned by SASE if requested by artist. Reports back to the artist only if interested. Buys one-time rights. Pays on publication; $300 for color cover; $35 for b&w, $100 for color inside; technical illustrations negotiable. Finds artists through submissions.

Tips: Areas most open to freelance work are technical illustrations for feature articles and renderings of classic cars for various sections.

CLASSIC TOY TRAINS, 2107 Crossroads Circle, Waukesha WI 53187. Fax: (414)796-1778. Art Director: Jane Lucius. Estab. 1987. 8 issues/year magazine emphasizing collectible toy trains. Circ. 85,000. Accepts previously published material. Original artwork sometimes returned to artist after publication. Sample copies available. Art guidelines available for SASE with first-class postage.

• Published by Kalmbach Publishing. Also see listings for *Model Railroader*, *Nutshell News*, *Trains*, *Astronomy* and *Finescale Modeler*.

Illustrations: Send postcard sample. Accepts disk submissions compatible with Adobe Illustrator 5.5. Samples are filed or returned only if requested. Reports back only if interested. Negotiates payment and rights purchased.

Design: Needs freelancers for design. 100% of design demands knowledge of Adobe Photoshop 3.0, QuarkXPress 3.3 or Adobe Illustrator 5.5. Send query letter with brochure, résumé or samples. Pay is negotiated.

CLEANING BUSINESS, Box 1273, Seattle WA 98111. (206)622-4241. Fax: (206)622-6876. Publisher: Bill Griffin. Submissions Editor: Jim Saunders. Quarterly magazine with technical, management and human relations emphasis for self-employed cleaning and maintenance service contractors. Circ. 6,000. Prefers first publication material. Simultaneous submissions OK "if to noncompeting publications." Original artwork returned after publication if requested by SASE. Sample copy $3.

Cartoons: Buys 1-2 cartoons/issue. Must be relevant to magazine's readership. Prefers b&w line drawings.

Illustrations: Buys approximately 12 illustrations/issue including some humorous and cartoon-style illustrations. Send query letter with samples. "*Don't* send samples unless they relate specifically to our market." Samples returned by SASE. Buys first publication rights. Reports only if interested. Pays $10-15/hour for design. Pays for illustration by project $3-15. Pays on publication.

Tips: "Our budget is extremely limited. Those who require high fees are really wasting their time. We are interested in people with talent and ability who seek exposure and publication. Our readership is people who work for and own businesses in the cleaning industry, such as maid services; janitorial contractors; carpet, upholstery and drapery cleaners; fire, odor and water damage restoration contractors; etc. If you have material relevant to this specific audience, we would definitely be interested in hearing from you."

CLEVELAND MAGAZINE, Dept. AGDM, 1422 Euclid Ave., Suite 730, Cleveland OH 44115. (216)771-2833. Fax: (216)781-6318. E-mail: clevemag@aol.com. Contact: Gary Sluzewski. Monthly city magazine, b&w with 4-color cover, emphasizing local news and information. Circ. 45,000. 40% of freelance work demands knowledge of QuarkXPress, Aldus FreeHand or Adobe Photoshop.

Illustrations: Approached by 100 illustrators/year. Buys 5-6 editorial illustrations/issue on assigned themes. Sometimes uses humorous illustrations. Send postcard sample with brochure or tearsheets. Accepts disk submissions. Please include application software. Call or write for appointment to show portfolio of printed samples, final reproduction/product, color tearsheets and photographs. Pays $300-700 for color cover; $75-200 for b&w, $150-400 for color inside; $75-150 for spots.

Tips: "Artists used on the basis of talent. We use many talented college graduates just starting out in the field. We do not publish gag cartoons but do print editorial illustrations with a humorous twist. Full page editorial illustrations usually deal with local politics, personalities and stories of general interest. Generally, we are seeing more intelligent solutions to illustration problems and better techniques. The economy has drastically affected our budgets; we pick up existing work as well as commissioning illustrations."

‡CLUBHOUSE, Box 15, Berrien Springs MI 49103. (616)471-9009. Fax: (616)471-4661. Editor: Krista Phillips. Bimonthly b&w magazine emphasizing stories, puzzles and illustrations for children ages 9-15. 8½×11 format, amply illustrated. Circ. 2,000. Accepts previously published material. Returns original artwork after publication if requested. Sample copy for SASE with postage for 3 oz.

Illustrations: Approached by over 100 illustrators/year. Buys 4-5 illustrations/issue from freelancers on assignment only in style of Debora Weber/Victoria Twichell-Jensen. Prefers pen & ink, charcoal/pencil and all b&w media. Assignments made on basis of samples on file. Send query letter with résumé and samples to be kept on file. Portfolio should include b&w final reproduction/product, tearsheets and photostats. Usually buys one-time rights. **Pays on acceptance** according to published size: $30 for b&w cover; $25 full page,

$18 for ½ page, $15 for ⅓ page, $12 for ¼ page b&w inside. Finds most artists through references/word-of-mouth and mailed samples received.

Tips: Prefers "natural, well-proportioned, convincing expressions for people, particularly kids. Children's magazines must capture the attention of the readers with fresh and innovative styles—interesting forms. I continually search for new talents to illustrate the magazine and try new methods of graphically presenting stories. Samples illustrating children and pets in natural situations are very helpful. Tearsheets are also helpful. I do not want to see sketchbook doodles, adult cartoons or any artwork with an adult theme. No fantasy, dragons or mystical illustrations."

‡COBBLESTONE, THE HISTORY MAGAZINE FOR YOUNG PEOPLE, Cobblestone Publishing, Inc., 7 School St., Peterborough NH 03458. (603)924-7209. Fax: (603)924-7380. Art Director: Ann Dillon. Assistant Art Director: Lisa Brown. Monthly magazine emphasizing American history; features nonfiction, supplemental nonfiction, fiction, biographies, plays, activities and poetry for children ages 8-14. Circ. 38,000. Accepts previously published material and simultaneous submissions. Sample copy $3.95 with 8 × 10 SASE. Material must relate to theme of issue; subjects and topics published in guidelines for SASE. Freelance work demands knowledge of Adobe Illustrator and Adobe Photoshop.
- Other magazines published by Cobblestone include *Calliope* (world history), *Faces* (cultural anthropology) and *Odyssey* (science). All for kids ages 8-15.

Illustrations: Buys 1-2 illustrations/issue. Prefers historical theme as it pertains to a specific feature. Works on assignment only. Send query letter with brochure, résumé, business card and b&w photocopies or tearsheets to be kept on file or returned by SASE. Write for appointment to show portfolio. Buys all rights. Pays on publication; $10-125 for b&w, $20-210 for color inside. Artists should request illustration guidelines.

Tips: "Study issues of the magazine for style used. Send samples and update samples once or twice a year to help keep your name and work fresh in our minds."

‡COLLEGE BROADCASTER MAGAZINE, 71 George St., Providence RI 02912-1824. (401)863-2225. Fax: (401)863-2221. Editor: JoAnn Forgit. Estab. 1989. Bimonthly 2-color trade journal; magazine format; "for college radio and television stations, communication and film depts.; anything related to student station operations or careers in electronic media." Circ. 2,000 copies. Accepts previously published artwork. Original artwork is returned at job's completion if requested upon submission. Sample copies available for SASE with first-class postage. Needs computer literate freelancers familiar with Aldus PageMaker, Aldus FreeHand and Adobe Photoshop.

Illustrations: Approached by 1-3 freelance illustrators/year. Needs editorial and technical illustrations. Prefers all "cartoons and funky covers." Considers pen & ink and marker. Contact through artist rep or send query letter with tearsheets and photographs. Samples are filed. Reports back only if interested. Publication will contact artist for porfolio review if interested. Portfolio should include photocopies. Buys one-time rights. Pays 5 copies.

Tips: "Be aware of what's happening in the media industry, especially what's hot in college radio and/or TV. Keep it topical."

COLLISION® MAGAZINE, Box M, Franklin MA 02038. (508)528-6211. Editor: Jay Kruza. Cartoon Editor: Brian Sawyer. Monthly magazine with an audience of new car dealers, auto body repair shops and towing companies. Articles are directed at the managers of these small businesses. Circ. 16,000. Prefers original material but may accept previously published material. Sample copy $4. Art guidelines for SASE with first-class postage.

Cartoons: Buys 3 cartoons/issue. Prefers themes that are positive or corrective in attitude. Prefers single panel b&w line drawings with gagline. Send rough versions or finished cartoons. Reports back in 2 weeks or samples returned by SASE. Buys one-time rights and reprint rights. Pays $10/single panel b&w line cartoon.

Illustrations: Buys about 2 illustrations/issue based upon a 2-year advance editorial schedule. Send query letter including phone number and time to call, with brochure, tearsheets, photostats, photocopies, slides and photographs. Samples are returned by SASE. "We prefer clean pen & ink work but will use color." Reports back within 15-30 days. "**Pays on acceptance** for assigned artwork ranging from $25 for spot illustrations up to $200 for full-page material."

CONCRETE PRODUCTS, 29 N. Wacker Dr., Chicago IL 60606. (312)726-2802. Fax: (312)726-2574. Art Director: Sundée Koffarnus. Estab. 1894. Monthly trade journal. Circ. 28,000.

Illustrations: Approached by 10 illustrators/year. Buys 2 illustrations/year. Works on assignment only. Looking for realistic, technical style. 75% of freelance work demands knowledge of Adobe Illustrator. Send query letter with brochure and samples or slides. Samples are filed or are returned by SASE if requested by artist. Reports back to the artist only if interested. Write for appointment to show portfolio of thumbnails, roughs, final art, b&w and color tearsheets. Rights purchased vary according to project. Pays $300 for color cover; $100 for b&w, $200 for color inside.

Tips: Prefers local artists. "Get lucky, and approach me at a good time. A follow-up call is fine, but pestering me will get you nowhere. Few people ever call after they send material. This may not be true of most art

directors, but I prefer a somewhat casual, friendly approach. Also, being 'established' means nothing. I prefer to use new illustrators as long as they are professional and friendly."

CONDÉ NAST TRAVELER, 360 Madison Ave., 10th Floor, New York NY 10017. (212)880-2142. Fax: (212)880-2190. Design Director: Robert Best. Estab. 1987. Monthly travel magazine with emphasis on "truth in the travel industry." Geared toward upper income 40-50 year olds with time to spare. Circ. 1 million. Originals are returned at job's completion. Sample copies and art guidelines available. Freelance work demands knowledge of QuarkXPress, Adobe Illustrator and Adobe Photoshop.
Illustrations: Approached by 5 illustrators/week. Buys 5 illustrations/issue. Works on assignment only. Considers pen & ink, collage, oil and mixed media. Send query letter with tearsheets. Samples are filed. Does not report back, in which case the artist should wait for assignment. To show a portfolio, mail b&w and color tearsheets. Buys first rights. Pays on publication; $500 quarter page spot, $1,000-2,500 feature.

CONFRONTATION: A LITERARY JOURNAL, English Department, C.W. Post, Long Island University, Brookville NY 11548. (516)299-2391. Fax: (516)299-2735. Editor: Martin Tucker. Estab. 1968. Semiannual literary magazine devoted to the short story and poem, for a literate audience open to all forms, new and traditional. Circ. 2,000. Sample copies available for $3. 20% of freelance work demands computer skills.
Illustrations: Approached by 10-15 illustrators/year. Buys 2-3 illustrations/issue. Works on assignment only. Considers pen & ink and collage. Send query letter with SASE and photocopies. Samples are not filed and are returned by SASE. Reports back within 1-2 months only if interested. Rights purchased vary according to project. Pays on publication; $50-100 for b&w, $100-250 for color cover; $25-50 for b&w, $50-75 for color inside; $25-75 for spots.

‡CONSERVATORY OF AMERICAN LETTERS, Box 298, Thomaston ME 04861. (207)354-0753. Editor: Bob Olmsted. Estab. 1986. Quarterly Northwoods journal emphasizing literature for literate and cultured adults. Original artwork returned after publication.
Cartoons: Pays $5 for b&w cartoons.
Illustrations: Approached by 30-50 illustrators/year. "Very little illustration used. Find out what is coming up, then send something appropriate. Unsolicited 'blind' portfolios are of little help." Portfolio review not required. Buys first rights, one-time rights or reprint rights. **Pays on acceptance**; $5 for b&w, $30 for color cover; $5 for b&w, $30 for color inside.

CONSTRUCTION EQUIPMENT OPERATION AND MAINTENANCE, Construction Publications, Inc., Box 1689, Cedar Rapids IA 52406. (319)366-1597. Editor-in-Chief: C.K. Parks. Estab. 1948. Bimonthly b&w tabloid with 4-color cover. Concerns heavy construction and industrial equipment for contractors, machine operators, mechanics and local government officials involved with construction. Circ. 67,000. Original artwork not returned after publication. Free sample copy.
Cartoons: Buys 8-10 cartoons/issue. Interested in themes "related to heavy construction industry" or "cartoons that make contractors and their employees 'look good' and feel good about themselves"; single panel. Send finished cartoons and SASE. Reports within 2 weeks. Buys all rights, but may reassign rights to artist after publication. Pays $25 for b&w. Reserves right to rewrite captions.

‡CONSUMERS DIGEST, 5705 N. Lincoln, Chicago IL 60659. (312)275-3590. Fax: (312)275-7273. Corporate Art Director: Beth Ceisel. Estab. 1961. Frequency: Bimonthly consumer magazine offering "practical advice, specific recommendations, and evaluations to help people spend wisely." Circ. 1,100,000. Art guidelines available.
Illustration: 50-60% of freelance illustration demands knowledge of Aldus FreeHand, Adobe Photoshop, Adobe Illustrator. Send postcard sample or query letter with printed samples, tearsheets. Accepts disk submissions compatible with QuarkXPress version 3.3, System 7.5 and above programs. Samples are filed or are returned by SASE. Reports back only if interested. Buys first rights. Pays $500 minimum for b&w inside. Pays for $300-400 for spots. Finds illustrators through *American Showcase* and *Workbook*.

‡CONTACT ADVERTISING, Box 3431, Ft. Pierce FL 34948. (407)464-5447. Editor: Herman Nietzche. Estab. 1971. Publishes 26 national and regional magazines and periodicals covering adult oriented subjects and alternative lifestyles. Circ. 1 million. Sample copies available. Art guidelines for SASE with first-class postage.
 • Some titles of publications are *Swingers Today* and *Swingers Update*. Publishes cartoons and illustrations (not necessarily sexually explicit) which portray relationships of a non-traditional number of partners.
Cartoons: Approached by 9-10 cartoonists/year. Buys 3-4 cartoons/issue. Prefers sexually humorous cartoons. Send query letter with finished cartoons. Samples are filed or returned by SASE if requested by artist. Reports back within 30 days. Rights purchased vary according to project. Pays $15 for b&w.
Illustrations: Approached by 9-10 illustrators/year. Buys 2-4 illustrations/issue. Prefers pen & ink drawings to illustrate adult fiction. Considers pen & ink. Send query letter with photocopies and SASE. Accepts ASCII formatted disk submissions. Samples are filed or are returned by SASE. Reports back within 30 days. Will

"I specialize in a traditional American cartoon style with a contemporary twist," says M.E. Cohen of Smart Art in New York City. Cohen rendered this scratching dog to give readers of *Consumers Digest* "an immediate understanding of the subject of the article by delivering a strong concept with a humorous execution." The ink and watercolor illustration accompanied a short article entitled "Defeating Fleas."

© M.E. Cohen/Smart Art

contact for portfolio review if interested. Portfolio should include final art. Rights purchased vary. Pays $15-35 for b&w. Finds artists through word of mouth, referrals and submissions.
Tips: "Meet the deadline."

COOK COMMUNICATIONS MINISTRIES, (formerly David C. Cook Publishing Co.), 7125 Disc Dr., Colorado Springs CO 80918. Director of Design Services: Randy R. Maid. Publisher of magazines, teaching booklets, visual aids and filmstrips for Christians, "all age groups."
Cartoons: Approached by 250 cartoonists/year. Pays $50 for b&w; $65 for color.
Illustrations: Buys about 30 full-color illustrations/week. Send tearsheets, slides or photocopies of previously published work; include self-promo pieces. No samples returned unless requested and accompanied by SASE. Works on assignment only. **Pays on acceptance**; $550 for color cover; $350 for color inside. Considers complexity of project, skill and experience of artist and turnaround time when establishing payment. Buys all rights. Originals can be returned in most cases.
Tips: "We do not buy illustrations or cartoons on speculation. We welcome those just beginning their careers, but it helps if the samples are presented in a neat and professional manner. Our deadlines are generous but must be met. We send out checks as soon as final art is approved, usually within two weeks of our receiving the art. We want art radically different from normal Sunday School art. Fresh, dynamic, the highest of quality is our goal; art that appeals to preschoolers to senior citizens; realistic to humorous, all media."

‡COPING, P.O. Box 682268, Franklin TN 37068. (615)790-2400. Fax: (615)794-0179. Editor: Steve Rogers. Estab. 1987. "*Coping* is a bimonthly, nationally-distributed consumer magazine dedicated to providing the latest oncology news and information of greatest interest and use to its readers. Readers are cancer patients, their loved ones, support group leaders, oncologists, oncology nurses and other allied health professionals. The style is very conversational and, considering its sometimes technical subject matter, quite comprehensive to the layman. The tone is upbeat and generally positive, clever and even humorous when appropriate, and very credible." Circ. 80,000. Accepts previously published artwork. Originals returned at job's completion. Sample copy available for $2.50. Art guidelines for SASE with first-class postage.
● Also publishes *Cope*. All writers and artists who contribute to these publications volunteer their services without pay for the benefit of cancer patients, their loved ones and caregivers.

‡CORPORATE REPORT, 105 S. Fifth St., Suite 100, Minneapolis MN 55402-9018. (612)338-4288. Fax: (612)373-0195. Website: http://citymedia.com/crm/. Art Director: Jonathan Hankin. Estab. 1969. Monthly magazine covering statewide business news for a consumer audience. Circ. 18,000. Samples and art guidelines available.
Cartoons: Approached by 10 cartoonists/year. Buys 5 cartoons/issue. Prefers business or office themes. Prefers single panel, humorous, b&w washes or line drawings, with gaglines. Send query letter with tearsheets. Samples are filed. Reports back only if interested. Buys one-time rights. Pays $50-100 for b&w and color.
Illustration: Approached by 50 illustrators/year. Buys 2 illustrations/issue. Prefers strong graphical content; business metaphors and editorial themes. Considers all media. Send postcard sample. After initial mailing, send follow-up postcard sample every 2 months. "We will accept work compatible with QuarkXPress 3.3., Adobe Illustrator 6.0, Adobe Photoshop." Samples are filed. Reports back only if interested. To arrange portfolio review artist should follow-up with call after initial query. Portfolio should include b&w, color roughs, slides, tearsheets and transparencies. Buys one-time rights. Pays $500-1,000 for cover; $100-400 for

inside. Pays $100 for spots. Finds illustrators through agents, submissions, creative sourcebooks, magazines.
Design: Needs freelancers for production. Prefers local designers with experience in QuarkXPress magazine publication. 100% of freelance work demands knowledge of Adobe Photoshop 3.0, Adobe Illustrator 6.0, QuarkXPress 3.3. Send query letter with printed samples.
Tips: "I like work which has strong graphic qualities and a good sense of mood and color."

COUNTRY AMERICA, 1716 Locust St., Des Moines IA 50309-3023. (515)284-2135. Fax: (515)284-3035. Art Director: Ray Neubauer. Estab. 1989. Consumer magazine "emphasizing entertainment and life-style for people who enjoy country life and country music." Bimonthly 4-color magazine. Circ. 900,000.
Illustrations: Approached by 10-20 illustrators/year. Buys 1-2 illustrations/issue, 10-15 illustrations/year from freelancers on assignment only. Contact through artist rep or send query letter with brochure, tearsheets, slides and transparencies. Samples are filed. Reports back only if interested. Buys all rights. **Pays on acceptance**; negotiable.

THE COVENANT COMPANION, 5101 N. Francisco Ave., Chicago IL 60625. (312)784-3000. Editor: John E. Phelan, Jr. Monthly b&w magazine with 4-color cover emphasizing Christian life and faith. Circ. 23,500. Original artwork returned after publication if requested. Sample copy $2.25. Freelancers should be familiar with Aldus PageMaker and CorelDraw. Art guidelines available.
Cartoons: Needs cartoons with contemporary Christian themes—church life, personal life, theology. Pays $15 for b&w.
Illustrations: Uses b&w drawings or photos about Easter, Advent, Lent and Christmas. Works on submission only. Write or submit art 10 weeks in advance of season. Send query letter with brochure, photocopies, photographs, slides, transparencies and SASE. Reports "within a reasonable time." Buys first North American serial rights. Pays 1 month after publication; $75 for color cover; $20 for b&w, $50 for color inside. More photos than illustrations.
Tips: "We usually have some rotating file, if we are interested, from which material may be selected. Submit copies/photos, etc. which we can hold on file."

‡**CRAFTS 'N THINGS**, 2400 Devon, Suite 375, Des Plaines IL 60018-4618. (847)635-5800. Fax: (847)635-6311. Editorial Director: Julie Stephani. Estab. 1975. General crafting magazine published 10 times yearly. Circ. 305,000. Originals returned at job's completion. Sample copies available. Art guidelines for SASE with first-class postage.
 • *Crafts 'n Things* is a "how to" magazine for crafters. The magazine is open to crafters submitting designs and step-by-step instruction for projects such as Christmas ornaments, cross-stitched pillows, stuffed animals and quilts. They do not buy cartoons and illustrations.
Design: Needs freelancers for design. Send query letter with photographs. Pays by project $50-300. Finds artists through submissions.
Tips: "Our designers work freelance. Send us photos of your *original* craft designs with clear instructions. Skill level should be beginning to intermediate. We concentrate on general crafts and needlework. Call or write for submission guidelines."

CRICKET, The Magazine for Children, Box 300, Peru IL 61354. Senior Art Director: Ron McCutchan. Estab. 1973. Monthly magazine emphasizes children's literature for children ages 6-14. Design is fairly basic and illustration-driven; full-color with 2 basic text styles. Circ. 110,000. Original artwork returned after publication. Sample copy $2; art guidelines for SASE with first-class postage.
Cartoons: "We rarely run cartoons, but those we have run are 1-2 pages in format (7×9 page dimension); we have more short picture stories rather than traditional cartoons; art styles are more toward children's book illustration."
Illustrations: Approached by 600-700 illustrators/year. Works with 75 illustrators/year. Buys 600 illustrations/year. Needs editorial (children's) illustration in style of Trina Schart Hyman, Charles Mikolaycak, Troy Howell, Janet Stevens and Quentin Blake. Uses artists mainly for cover and interior illustration. Prefers realistic styles (animal or human figure); occasionally accepts caricature. Works on assignment only. Send query letter with SASE and samples to be kept on file, "if I like it." Prefers photocopies and tearsheets as samples. Samples not kept on file are returned by SASE. Reports within 4-6 weeks. To show a portfolio, include "several pieces that show an ability to tell a continuing story or narrative." Does not want to see "overly slick, cute commercial art (i.e., licensed characters and overly sentimental greeting cards)." Buys reprint rights. Pays 45 days from receipt of final art; $750 for color cover; $50-150 for b&w, $100-250 for color inside.
Tips: "Since a large proportion of the stories we publish involve people, particularly children, *please* try to include several samples with *faces* and full figures in an initial submission (that is, if you are an artist who can draw the human figure comfortably). It's also helpful to remember that most children's publishers need artists who can draw children from many different racial and ethnic backgrounds."

‡**CURRENTS**, 212 W. Cheyenne Mountain Blvd., Colorado Springs CO 80906. (719)579-8759. Fax: (719)576-6238. Editor: Greg Moore. Estab. 1979. Quarterly magazine with emphasis on kayaking, rafting

or river canoeing and conservation of rivers. Circ. 10,000. Originals returned at job's completion. Sample copies available for $1. Art guidelines available.

Cartoons: Prefers humorous cartoons; single panel b&w line drawings. Send query letter with finished cartoons. Samples are filed or are returned by SASE if requested by artist. Reports back to the artist only if interested. Negotiates rights purchased. Pays $30-60 for b&w.

Illustrations: Send query letter with SASE, tearsheets and photographs, Samples are filed or returned by SASE if requested by artist. Publication will contact artist for portfolio review if interested. Portfolio should include b&w final art, tearsheets and photographs. Negotiates rights purchased. Pays on publication; $30-60 for b&w inside.

Tips: "Please send appropriate materials on areas of above focus only. We prefer artists with river experience."

‡CURRICULUM VITAE, Rd. #1, Box 226A, Polk PA 16342-9204. (814)671-1361. Fax: (814)432-3344. E-mail: proof114@aol.com. Website: http://www.well.com/user/ruz/cv/cv3toc.htm. Editor: Michael Dittman. Estab. 1995. Quarterly literary magazine. "We're a Gen-X magazine dedicated to intellectual discussion of pop-culture in a satirical vein." Circ. 2,500. Sample copies available for 6×9 SASE and 3 first-class stamps. Art guidelines available for #10 SASE with first-class postage.

Cartoons: Approached by 7 cartoonists/year. Buys 12 cartoons/year. Prefers satirical but smart not *New Yorker*. Must be topical but timeless, twisted also works." Prefers single, double, or multiple panel, political and humorous, b&w washes or line drawings, with or without gaglines. Send query letter with photocopies and SASE. Samples are filed or returned by SASE. Reports back in 2 months. Negotiates rights purchased. Pays on publication; $5-25.

Illustration: Approached by 12 illustrators/year. Buys 12-15 illustrations/year. Open to all themes and styles. Considers all media. Send query letter with photocopies and SASE. Samples are filed or returned by SASE. Reports back within 2 months. Negotiates rights purchased. Pays on publication; $25-100 for cover; $5-15 for inside. Finds illustrators through word of mouth and submissions.

Tips: "Read our magazines. We like edgy, smart new-looking art. We love first timers and b&w work. We're very eager to work with young hungry artists (like seeks like)."

DAKOTA OUTDOORS, P.O. Box 669, Pierre SD 57501-0669. (605)224-7301. Fax: (605)224-9210. E-mail: 73613.3456@compuserve.com. Editor: Kevin Hipple. Managing Editor: Rachel Engbrecht. Estab. 1978. Monthly outdoor magazine covering hunting, fishing and outdoor pursuits in the Dakotas. Circ. 7,500. Accepts previously published artwork. Original artwork is returned at job's completion. Sample copies and art guidelines for SASE with first-class postage.

Cartoons: Approached by 10 cartoonists/year. Buys 1-2 cartoons/issue. Prefers outdoor, hunting and fishing themes. Prefers cartoons with gagline. Send query letter with appropriate samples and SASE. Samples are not filed and are returned by SASE. Reports back within 1-2 months. Rights purchased vary. Pays $5 for b&w.

Illustrations: Approached by 2-10 illustrators/year. Buys 1 illustration/issue. Prefers outdoor, hunting/fishing themes, depictions of animals and fish native to the Dakotas. Prefers pen & ink. Accepts submissions on disk compatible with Macintosh in Adobe Illustrator, Aldus FreeHand and Adobe Photoshop. Send TIFF, EPS and PICT files. Send postcard sample or query letter with tearsheets, SASE and copies of line drawings. Reports back within 1-2 months. To show a portfolio, mail "high-quality line art drawings." Rights purchased vary according to project. Pays on publication; $5-25 for spots.

Tips: "We especially need line-art renderings of fish, such as walleye."

‡DATA COMMUNICATIONS MAGAZINE, 1221 Avenue of the Americas, New York NY 10020. Fax: (212)512-6833. Website: http://www.ksurabia@data.com. Art Director: Ken Surabian. Estab. 1972. Monthly trade journal emphasizing global enterprise networking for corporate network managers. Circ. 90,000.

Illustration: Approached by 250 illustrators/year. Buys 4 illustrations/year. Prefers conceptual style. Considers all media. 75% of freelance illustration demands computer skills. Send postcard sample. Accepts disk submissions compatible with QuarkXPress 7.5/version 3.3. Send EPS files. Samples are filed. Does not report back. Will contact for portfolio review if interested. Buys one-time rights. **Pays on acceptance**: $1,000-1,500 for color cover; $250-750 for color inside. Pays $350 for spots.

Design: Needs freelancers for design, production. 100% of freelance work demands knowledge of Adobe Photoshop, Adobe Illustrator, QuarkXPress. Send query letter with printed samples.

DATAMATION, Dept. AGDM, 275 Washington St., Newton MA 02158. (617)558-4682. Fax: (617)558-4506. Senior Art Director: Susan Pulaski. Associate Art Director: Dave Gordon. Bimonthly trade journal; magazine format, "computer journal for corporate computing professionals worldwide." Circ. 200,000. Accepts previously published artwork. Original artwork is returned at job's completion. Sample copies available.

Cartoons: Approached by 60 cartoonists/year. Buys 2 cartoons/issue. Prefers "anything with a computer-oriented theme; people in businesses; style: horizontal cartoons"; single panel, b&w line drawings and

washes. Send query letter with finished cartoons. "All cartoons should be sent *only* to Andrea Ovans, Assistant Managing Editor." Samples are not filed and are returned by SASE. Reports back within 1 month. Buys first rights. Pays $125 for b&w.

Illustrations: Approached by 100-200 illustrators/year. Buys 1-2 illustrations/issue. Works on assignment only. Open to most styles. Considers pen & ink, watercolor, collage, airbrush, acrylic, marker, colored pencil, mixed media and pastel. Send query letter with non-returnable brochure, tearsheets and photocopies. Samples are filed and are not returned. Does not report back. To show a portfolio, mail b&w/color tearsheets, photostats and photocopies. Buys first rights. **Pays on acceptance**; $150 for b&w, $1,000 for color inside.

Tips: "Send non-returnable samples only by mail; do not wish to meet and interview illustrators."

DAUGHTERS OF SARAH, 2121 Sheridan Rd., Evanston IL 60201-3298. (847)866-3882. Editor: Liz Anderson. Estab. 1974. Quarterly magazine with focus on religious/social justice/Christian feminist theology. Audience is Christian and feminist. Supports ordination of women and inclusive language for God. Circ. 5,000. Accepts previously published artwork. Originals are returned at job's completion. Sample copies available for $5. Art guidelines for SASE with first-class postage; address to Trevor Bechtel, Design Director.

Illustrations: Approached by 10 illustrators/year. Buys 4 illustrations/issue. Works on assignment only. Prefers Christian feminist themes. Considers pen & ink. Send postcard sample or query letter with brochure, résumé, photocopies, photographs, SASE, slides, tearsheets and transparencies. Samples are not filed and are returned by SASE. Reports back within 1 month. Buys one-time rights. Pays on publication; $30-50 for b&w cover; $30 for b&w; $15 for spots inside. Finds artists through submissions, word of mouth.

Tips: Each quarterly issue has a different theme. Artists should send for list of future themes and guidelines. "Please have some understanding of Christian feminism. Do not send generic religious art—it is usually not relevant to our themes. Please do not send more than one or two samples."

DEAD OF NIGHT MAGAZINE, 916 Shaker Rd., Suite 228, Longmeadow MA 01106-2416. E-mail: genie@lstein1. Editor: Lin Stein. Estab. 1989. Annual magazine which "offers variety to fans of horror, fantasy, mystery, science fiction and vampire-related fiction." Circ. 3,000. Sample copies available for $5. Art guidelines available for SASE with first-class postage.

Illustrations: Approached by 20 illustrators/year. Buys 5-10 illustrations/year. Considers pen & ink and marker, and four-color covers. Send query letter with SASE and dark, unfolded photocopies. Samples are filed. Reports back within 6 weeks. Portfolio review not required. Buys first rights. Pays on publication; $75-100 for b&w back cover; $100-150 plus two contributor copies for color cover; $10-15 for b&w inside; $15 for spots. Finds artists through market listings, advertising and flier mailings.

Design: Needs freelance designers. 20% of freelance work demands computer skills. Send query letter with photocopies and SASE. Pays by project (negotiable fee).

Tips: "We can't say this often enough—artists should familiarize themselves with the fiction/nonfiction we publish for a clear idea of the type of illustration/photos that will meet our needs. At the very least, they should look over a back issue or study our guidelines. Though the guidelines do not show the type of art we use, they do give information on our fiction needs. "

DECORATIVE ARTIST'S WORKBOOK, 1507 Dana Ave., Cincinnati OH 45207. Art Director: Scott Finke. Estab. 1987. "A step-by-step bimonthly decorative painting workbook. The audience is primarily female; slant is how-to." Circ. 89,000. Does not accept previously published artwork. Original artwork is returned at job's completion. Sample copy available for $4.65.

Cartoons: Approached by 5-10 cartoonists/year. Buys 1-5 cartoons/year. Prefers themes and styles related to the decorative painter; single panel b&w line drawings with and without gagline. Send query letter with finished cartoons. Samples are not filed and are returned by SASE if requested by artist. Reports back within 1 month. Buys first rights. Pays $50 for b&w.

Illustrations: Approached by 100 illustrators/year. Buys occasional illustration; 3-4/year. Works on assignment only. Prefers realistic and humorous themes and styles. Prefers pen & ink, watercolor, airbrush, acrylic, colored pencil, mixed media and pastel. Send postcard sample or query letter with tearsheets. Accepts disk submissions compatible with the major programs. Send EPS or PICT files. Samples are filed. Reports back to the artist only if interested. Buys first rights or one-time rights. Pays on publication; $50-100 for b&w, $100-300 for color inside.

DELAWARE TODAY MAGAZINE, 201 N. Walnut St., 3 Christina Centre, Suite 1204, Wilmington DE 19801. Fax: (302)656-5843. Art/Design Director: Ingrid Hansen-Lynch. Monthly 4-color magazine emphasizing regional interest in and around Delaware. Features general interest, historical, humorous, interview/profile, personal experience and travel articles. "The stories we have are about people and happenings in and around Delaware. Our audience is middle-aged (40-45) people with incomes around $79,000, mostly educated. We try to be trendy in a conservative state." Circ. 25,000. Original artwork returned after publication. Sample copy available. Needs computer-literate freelancers for illustration.

Cartoons: Works on assignment only. Do not send gaglines. Do not send folders of pre-drawn cartoons. Samples are filed. Reports back only if interested. Buys first rights or one-time rights

Illustrations: Buys approximately 3-4 illustrations/issue. "I'm looking for different styles and techniques of editorial illustration!" Works on assignment only. Open to all styles. Send postcard sample. "Will accept work compatible with QuarkXPress 7.5/version 3.3. Send EPS files (CMYK, not RGB)." Send printed color promos. Publication will contact artist for portfolio review if interested. Portfolio should include printed samples and color and b&w tearsheets and final reproduction/product. Pays on publication; $200-400 for cover; $100-150 for inside; $75 for spots. Finds artists through submissions and self-promotions.

DETROIT MONTHLY MAGAZINE, Dept AGDM, 1400 Woodbridge, Detroit MI 48207. (313)446-6000. Editor: Megan Swoyer. Design Director: Marge Kelly. Emphasizes "features on political, economic, style, cultural, lifestyles, culinary subjects, etc., relating to Detroit and region for middle and upper-middle class, urban and suburban, mostly college-educated professionals." Circ. approximately 100,000. "Very rarely" accepts previously published material. Sample copy for SASE.
Cartoons: Approached by 25 cartoonists/year. No editorial cartoons. Pays $150, b&w; $200, color.
Illustrations: Approached by 1,300 illustrators/year. Buys 10/issue. Works on assignment only. Send query letter with samples and tearsheets to be kept on file. Write for appointment to show portfolio. Prefers anything *but* original work as samples. Samples not kept on file are returned by SASE. Reports only if interested. Pays on publication; $1,000 for color cover; $500-600 for color full page, $300-400 for b&w full page, $100 for spot illustrations.
Tips: A common mistake freelancers make in presenting their work is to "send too much material or send badly printed tearsheets." Sees trends toward Russian/European poster style illustrations, postmodern "big type" designs.

‡DIVERSION MAGAZINE, 1790 Broadway, 6th Floor, New York NY 10019. (212)969-7520. Fax: (212)969-7557. E-mail: shohl@hearst.com. Art Director: Susan Hohl. Estab. 1976. Monthly travel magazine for physicians. Circ. 176,000.
Cartoons: Approached by 50 cartoonists/year. Buys 100 cartoons/year. Prefers travel, food/wine, sports, lifestyle, family, animals, technology, art and design, performing arts, gardening. Prefers single panel, humorous, b&w line drawings, with or without gaglines. Send query letter with finished cartoons. Samples are not filed and are returned by SASE. Reports back in 5 days. Buys first North American serial rights. **Pays on acceptance**; $100.
Illustration: Buys 2-10 illustrations/issue. Considers all media. "I use computer and traditional artwork depending on illustrators' preference." Send postcard sample and then a follow-up postcard every few months. Accepts disk submissions compatible with QuarkXPress. Samples are filed and are not returned. Does not report back. Will contact for portfolio review if interested. Portfolio should include b&w, color, slides, tearsheets, transparencies. Buys first North American serial rights. **Pays on acceptance**; $100-3,000 for color inside. Pays $100-400 for spots. Finds illustrators through mailers, *Workbook, American Showcase*.
Design: Needs freelancers for design, production. 100% of freelance work demands knowledge of Aldus FreeHand, Adobe Photoshop, QuarkXPress, Adobe Illustrator. "Use most recent versions of software. Quark is essential—other programs a plus." Send query letter with printed samples, photocopies, tearsheets.

ELECTRICAL APPARATUS, Barks Publications, Inc., 400 N. Michigan Ave., Suite 1016, Chicago IL 60611-4198. (312)321-9440. Fax: (312)321-1288. Contact: Cartoon Editor. Estab. 1948. Monthly 4-color trade journal emphasizing industrial electrical/mechanical maintenance. Circ. 16,000. Original artwork not returned at job's completion. Sample copy $4.
Cartoons: Approached by several cartoonists/year. Buys 3-4 cartoons/issue. Prefers themes relevant to magazine content; with gagline. "Captions are typeset in our style." Send query letter with roughs and finished cartoons. "Anything we don't use is returned." Reports back within 2-3 weeks. Buys all rights. Pays $15-20 for b&w and color.
Illustrations: "We have staff artists so there is little opportunity for freelance illustrators, but we are always glad to hear from anyone who believes he or she has something relevant to contribute."

ELECTRONICS NOW, 500-B Bi-County Blvd., Farmingdale NY 11735. (516)293-3000. Fax: (516)293-3115. Editor: Brian Fenton. Estab. 1939. Monthly b&w magazine with 4-color emphasizing electronic and computer construction projects and tutorial articles; practical electronics for technical people including service technicians, engineers and experimenters in TV, hi-fi, computers, communications and industrial electronics. Circ. 133,000. Previously published work OK. Free sample copy. Art guidelines available. Needs computer-literate freelancers for illustration.

FOR A LIST of markets interested in humorous illustration, cartooning and caricatures, refer to the Humor Index at the back of this book.

Cartoons: Approached by 20-25 cartoonists/year. Buys 70-80 cartoons/year on electronics, computers, communications, robots, lasers, stereo, video and service; single panel. Send query letter with finished cartoons. Samples are filed or returned by SASE. Reports in 1 week. Buys first or all rights. **Pays on acceptance**; $25 minimum for b&w washes.

Illustrations: Approached by 10 illustrators/year. Buys 3 illustrations/year. Works on assignment only. Needs editorial and technical illustration. Preferred themes or styles depend on the story being illustrated. Considers airbrush, watercolor, acrylic and oil. Send postcard samples. Accepts disk submissions. Samples are filed or returned by SASE. Will contact for portfolio review if interested. Portfolio should include roughs, tearsheets, photographs and slides. Buys all rights. **Pays on acceptance**; $400 for color cover, $100 for b&w or color inside. Finds artists through submissions/self-promotions.

Tips: "Artists approaching *Electronics Now* should have an innate interest in electronics and technology that shows through in their work."

EMERGENCY MEDICINE MAGAZINE, 105 Raider Blvd., Bellemeade NJ 08502. (908)874-8550. Fax: (908)874-6096. Art Director: Robert Hazelrigg. Estab. 1969. Emphasizes emergency medicine for primary care physicians, emergency room personnel, medical students. Bimonthly. Circ. 129,000. Returns original artwork after publication. Art guidelines are available.

Illustrations: Works with 70 illustrators/year. Buys 3-12 illustrations/issue. Prefers all media except marker and computer illustration. Works on assignment only. Send postcard sample or query letter with brochure, photocopies, photographs, tearsheets, original art or photostat to be kept on file. Samples not filed are not returned. Accepts disk submissions. To show a portfolio, mail appropriate materials. Reports only if interested. Buys first rights. **Pays on acceptance**; $800-1,200, color cover; $200-500, b&w, $400-800, color inside; $400-800 for spots.

Design: Needs freelancers for design and production. 25% of freelance work demands knowledge of Aldus FreeHand, Adobe Photoshop, Adobe Illustrator. Send brochure, résumé, photocopies and/or tearsheets. Pays by the project.

Tips: "Portfolios may be dropped off Tuesdays only and picked up Thursdays. Do not show marker comps. At least show 4×5 transparencies; 8×10 is much better. In general, slides are too small to see in a review. I like to see variety and versatility in an artist. We only use clean, contemporary designs."

‡ENTREPRENEUR MAGAZINE, 2392 Morse Ave., Irvine CA 92714. Fax: (714)755-4211. Editor: Rieva Lesonsky. Design Director: Richard R. Olson. Creative Director: Mark Kozak. Monthly 4-color magazine offers how-to information for starting a business, plus ongoing information and support to those already in business. Circ. 360,000. Original artwork returned after publication. 1% of freelance work demands computer skills.

Illustrations: Approached by 36+ illustrators/year. Uses varied number of illustrations/issue; buys varied number/issue. Needs editorial illustration "some serious, some humorous depending on the article. Illustrations are used to grab readers' attention." Style of John McKinley, David Bamundo or David Turner. Works on assignment only. Send query letter with résumé, samples and tearsheets to be kept on file. Does not want to see photocopies. Write for appointment to show portfolio. Buys first rights. **Pays on acceptance**; $200-300 for b&w and color inside.

Tips: Freelancers should "have a promo piece to leave behind." A developing trend is the "use of a combination of different media—going away from airbrush to a more painterly style."

ENVIRONMENT, 1319 18th St. NW, Washington DC 20036. (202)296-6267, ext. 236. Fax: (202)296-5149. E-mail: env@heldraf.org. Graphics/Production Manager: Jennifer Crock. Estab. 1958. Emphasizes national and international environmental and scientific issues. Readers range from "high school students and college undergrads to scientists, business and government leaders and college and university professors." Black & white magazine with 4-color cover; "relatively conservative" design. Published 10 times/year. Circ. 12,500. Original artwork returned after publication. Sample copy $7; art guidelines for SASE with first-class postage.

Cartoons: Buys 1-2 cartoons/issue. Receives 5 submissions/week. Interested in single panel line drawings or b&w washes with or without gagline. Send finished cartoons and SASE. Reports in 2 months. Buys first North American serial rights. Pays on publication; $50 for b&w cartoon.

Illustrations: Buys 2-10/year. Uses illustrators mainly for cover design, promotional work, feature illustration and occasional spots. Send postcard sample, SASE, tearsheets and photocopies. Accepts disk submissions compatible with Mac. Will contact for portfolio review if interested. Portfolio should include printed samples. Pay is negotiable.

Tips: "Regarding cartoons, we prefer witty or wry comments on the impact of humankind upon the environment. Stay away from slapstick humor." For illustrations, "we are looking for an ability to communicate complex environmental issues and ideas in an unbiased way."

‡EUROPE, MAGAZINE OF THE EUROPEAN COMMUNITY, 2300 M St. NW, Washington DC 20037. (202)862-9500. Editor-in-Chief: Robert J. Guttman. Emphasizes European affairs, US-European relations—particularly economics, politics and culture; 4-color. Readers are businessmen, professionals, academ-

ics, government officials and consumers. Published 10 times/year. Circ. 65,000. Free sample copy.
Cartoons: Occasionally uses cartoons, mostly from a cartoon service. "The magazine publishes articles on US-European relations in economics, trade, business, industry, politics, energy, inflation, etc." Considers single panel b&w line drawings or b&w washes with or without gagline. Send résumé, SASE, plus finished cartoons and/or samples. Reports in 3-4 weeks. Buys one-time rights. Pays $25 on publication.
Illustrations: Uses 3-5 illustrations/issue. "We look for economic graphs, tables, charts and story-related statistical artwork"; b&w line drawings and washes for inside. 30% of freelance work demands knowledge of Aldus PageMaker and QuarkXPress. Send résumé, SASE and photocopies of style. Reports in 3-4 weeks. To show a portfolio, mail printed samples. Buys all rights on a work-for-hire basis. Pays on publication.

EVANGELIZING TODAY'S CHILD, Box 348, Warrenton MO 63383-0348. (314)456-4321. Fax: (314)456-2078. Art Director: Dwane Carter. Estab. 1942. Bimonthly magazine for Sunday school teachers, Christian education leaders and children's workers in every phase of Christian ministry for children 4-11. Circ. 22,000. Accepts previously published artwork "if we are informed." Sample copies available. Art guidelines for SASE with first-class postage.
Illustrations: Approached by 10-15 illustrators/year. Buys 8 illustrations/issue. Works on assignment only. Prefers bright, clean, realistic art with child appeal, sometimes Bible figures or contemporary and historical people. Needs to be clear from distance of 8-15 ft. for teaching purpose. Considers all media. Send query letter with résumé, tearsheets, photographs and photocopies. Accepts disk submissions compatible with Mac, Aldus FreeHand 5.0. Send EPS files. Samples are filed or returned by SASE. Reports back only if interested. Portfolio review not required. Buys all rights (negotiable). Pays on publication; $50-100 for b&w, $100-200 for color cover; $50-100 for b&w, $100-200 for color inside. Finds artists through submissions, word of mouth, personal contacts.
Design: Needs freelancers for multimedia design. 50% of freelance work demands knowledge of Aldus FreeHand. Send brochure, photocopies, SASE and tearsheets. Pays by project.
Tips: "Realism, lively color and action are key items we look for. An understanding of Christian themes is very helpful. Computer knowledge helpful, but not essential."

✦**EVENT**, Douglas College, Box 2503, New Westminster, British Columbia V3L 5B2 Canada. (604)527-5293. Editor: David Zieroth. Estab. 1971. For "those interested in literature and writing"; b&w with 4- or 2-color cover. Published 3 times/year. Circ. 1,100. Original artwork returned after publication. Sample copy for $5.
Illustrations: Buys approximately 3 illustrations/year. Uses freelancers mainly for covers. "Interested in drawings and prints, b&w line drawings, photographs and lithographs for cover, and thematic or stylistic series of 12-20 works. Work must reproduce well in one color." SAE (nonresidents include IRCs). Reporting time varies; at least 4 months. Buys first North American serial rights. Pays on publication; $50 for b&w, $100 for color cover.

EXECUTIVE FEMALE, 30 Irving Place, New York NY 10003. (212)477-2200. Art Director: Dorian Burder. Estab. 1972. Association magazine for National Association for Female Executives, 4-color. "Get ahead guide for women executives, which includes articles on managing employees, personal finance, starting and running a business." Circ. 200,000. Accepts previously published artwork. Original artwork is returned after publication.
Illustrations: Buys illustrations mainly for spots and feature spreads. Buys 7 illustrations/issue. Works on assignment only. Send samples (not returnable). Samples are filed. Responds only if interested. Buys first or reprint rights. Pays on publication; $100-800.

EXECUTIVE REPORT, 3 Gateway Center, Pittsburgh PA 15222. (412)471-4585. Art/Production Director: Deanna Marra. Estab. 1981. Monthly 4-color trade/consumer magazine; business reporting and analysis for mid- to upper-level managers. Circ. 26,000. Sample copies available. Freelancers should be familiar with QuarkXPress and Adobe Illustrator.
Illustrations: Approached by 15-20 illustrators/year. Buys 0-5 illustrations/issue. Prefers business topics. Considers all media. Send query letter with tearsheets. Samples are filed. Reports back only if interested. Call or write for appointment to show portfolio, or mail thumbnails, printed samples, b&w and color tearsheets. Rights purchased vary. Pays on publication; $500 for color cover; $75 minimum for b&w, $75 and up for color inside.

FAMILY CIRCLE, Dept. AGDM, 110 Fifth Ave., New York NY 10011. (212)463-1000. Art Director: Doug Turshen. Circ. 7,000,000. Supermarket-distributed publication for women/homemakers covering areas of food, home, beauty, health, child care and careers. 17 issues/year. Does not accept previously published material. Original artwork returned after publication.
Illustrations: Buys 20 illustrations/issue. Works on assignment only. Provide query letter with samples to be kept on file for future assignments. Prefers slides or tearsheets as samples. Samples returned by SASE. Reports only if interested. Prefers to see finished art in portfolio. Submit portfolio on "portfolio days," every

Wednesday. All art is commissioned for specific magazine articles. Buys all rights on a work-for-hire basis. **Pays on acceptance.**

FASHION ACCESSORIES, 65 W. Main St., Bergenfield NJ 07621. (201)384-3336. Fax: (201)384-6776. Publisher: Sam Mendelson. Estab. 1951. Monthly trade journal; tabloid; emphasizing costume jewelry and accessories. Publishes both 4-color and b&w. Circ. 10,000. Accepts previously published artwork. Original artwork is returned to the artist at the job's completion. Sample copies for $3. Freelance work demands knowledge of QuarkXPress.
Cartoons: Pays $75 for b&w cartoons.
Illustrations: Works on assignment only. Needs editorial illustration. Prefers mixed media. Send query letter with brochure and photocopies. Samples are filed. Reports back within 2 weeks. Portfolio review not required. Rights purchased vary according to project. **Pays on acceptance**; $50-100 for b&w, $100-150 for color cover; $50-100 for b&w, $100-150 for color inside.

FICTION INTERNATIONAL, Dept. of English, San Diego State University, San Diego CA 92182-8140. (619)594-5469. E-mail: mjaffe@mail.sdsu.edu Art Editor: Maggie Jaffe. Estab. 1970. Biannual, b&w with 2-color cover, literary magazine with "twin interests: left politics and experimental fiction and art." Accepts previously published artwork. Original artwork is returned to the artist at the job's completion. Sample copies are available.
 • Next focus issue is on "Pain."
Illustrations: Prefers political artwork. Prefers pen & ink and photos. Send query letter with photographs and slides. Reports back within 1 month. To show a portfolio, mail b&w tearsheets, slides and photographs. "We pay in copies."
Tips: "We have published art by Jenny Holzer, Rupert Garcia, Kim Abeles, Peter Kennard, Klaus Staeck, Deborah Small, Christer Themptander, Juan Sanchez, John Fekner, David Avalos, Alison Saar, Emma Amos, Emilya Naymark, Joseph Beuys, Joel Lipman, Norman Conquest, Jaune Quick-To-See Smith."

FIELD & STREAM MAGAZINE, Dept. AGDM, 2 Park Ave., New York NY 10016. (212)779-5294. Art Director: Danial McClaim. Monthly magazine emphasizing wildlife hunting and fishing. Circ. 10 million. Original artwork returned after publication. Sample copy and art guidelines for SASE.
Illustrations: Approached by 200-250 illustrators/year. Buys 9-12 illustrations/issue. Works on assignment only. Prefers "good drawing and painting ability, realistic style, some conceptual and humorous styles are also used depending on magazine article." Wants to see "emphasis on strong draftsmanship, the ability to draw wildlife and people equally well. Artists who can't, please do not apply." Send query letter with brochure showing art style or tearsheets and slides. Samples not filed are returned only if requested. Reports only if interested. Call or write for appointment to show portfolio of roughs, final art, final reproduction/ product and tear sheets. Buys first rights. **Pays on acceptance**; $75-300 for simple spots; $500-1,000 for single page, $1,000 and up for spreads, $1,500 and up for covers.
Tips: Wants to see "more illustrators who are knowledgeable about hunting and fishing and can handle simple pen & ink and 2-color art besides 4-color illustrations."

‡FIFTY SOMETHING MAGAZINE, 1168 Beachview, Willoughby OH 44094. (216)951-2468. Editor: Linda L. Lindeman. Estab. 1990. Bimonthly magazine; 4-color. "We cater to the fifty-plus age group with upbeat information, feature stories, travel, romance, finance and nostalgia." Circ. 25,000. Accepts previously published artwork. Original artwork is returned at the job's completion. Sample copies for SASE, 10×12, with $1 postage.
Cartoons: Approached by 50 cartoonists/year. Buys 3 cartoons/issue. Prefers funny issues on aging. Prefers single panel b&w line drawings with gagline. Send query letter with brochure, roughs and finished cartoons. Samples are filed. Reports back only if interested. Buys one-time rights. Pays $10, b&w and color.
Illustrations: Approached by 50 illustrators/year. Buys 2 illustrations/issue. Prefers old-fashioned, nostalgia. Considers all media. Send query letter with brochure, photographs, photostats, slides and transparencies. Samples are filed. Reports back only if interested. To show a portfolio, mail thumbnails, printed samples, b&w photographs, slides and photocopies. Buys one-time rights. Pays on publication; $25 for b&w, $100 for color cover; $25 for b&w, $75 for color inside.

FINESCALE MODELER, 21027 Crossroads Circle, Waukesha WI 53187. Fax: (414)796-1383. Art Director: Lawrence Luser. Estab. 1972. Magazine emphasizing plastic modeling. Circ. 73,000. Accepts previously published material. Original artwork is returned after publication. Sample copy and art guidelines available.
 • Published by Kalmbach Publishing. Also see listings for *Classic Toy Trains, Astronomy, Model Railroader, Model Retailer, Nutshell News* and *Trains*.
Illustrations: Prefers technical illustration "with a flair." Send query letter with "samples, either postcard, 8×10 sheet, color copy or photographs. Currently running Illustrator 5.0. Accepts submissions on disk." Samples are filed or returned only if requested. Reports back only if interested. Write for appointment to show portfolio or mail color and b&w tearsheets, final reproduction/product, photographs and slides. Negotiates rights purchased.

Tips: "Show b&w and color technical illustration. I want to see automotive, aircraft and tank illustrations."

FIRST FOR WOMEN, 270 Sylvan Ave., Englewood Cliffs NJ 07632. (201)569-6699. Fax: (201)569-6264. Art Director: Rosemarie Wyer. Estab. 1988. Mass market consumer magazine for the younger woman published every 3 weeks. Circ. 1.4 million. Originals returned at job's completion. Sample copies and art guidelines not available.
Cartoons: Buys 10 cartoons/issue. Prefers women's issues. Prefers humorous cartoons; single panel b&w washes and line drawings. Send query letter with photocopies. Samples are filed. Reports back to the artist only if interested. Buys one-time rights. Pays $150 for b&w.
Illustrations: Approached by 100 illustrators/year. Buys 1 illustration/issue. Works on assignment only. Preferred themes are humorous, sophisticated women's issues. Considers all media. Send query letter with any sample or promo we can keep. Publication will contact artist for portfolio review if interested. Buys one-time rights. **Pays on acceptance**; $200 for b&w, $300 for color inside. Finds artists through promo mailers and sourcebooks.
Tips: Uses humorous or conceptual illustration for articles where photography won't work. "Use the mail—no phone calls please."

‡**FIRST HAND MAGAZINE**, P.O. Box 1314, Teaneck NJ 07666. (201)836-9177. Fax: (201)836-5055. Estab. 1980. Monthly consumer magazine emphasizing gay erotica. Circ. 60,000. Originals returned at job's completion at artist's request. Sample copies available for $5. Art guidelines for SASE with first-class postage.
Cartoons: Approached by 10 cartoonists/year. Buys 5 cartoons/issue. Prefers gay male themes—erotica; humorous; single panel b&w line drawings with gagline. Send query letter with finished cartoons. Samples are not filed and are returned by SASE. Reports back within 6 weeks. Buys all rights. Pays $20 for b&w.
Illustrations: Approached by 30 illustrators/year. Buys 12 illustrations/issue. Prefers gay male erotica. Considers pen & ink, airbrush, marker, colored pencil and charcoal. Send query letter with photostats. Samples are not filed and are returned by SASE. Reports back within 6 weeks. Portfolio review not required. Buys first rights. Pays on publication; $50 for b&w inside.

FLORIDA KEYS MAGAZINE, P.O. Box 6524, Key West FL 33041. (305)296-7300. Fax: (305)296-7414. Art Director: Roschelle Gonzales. Estab. 1978. Bimonthly magazine targeted at residents and frequent visitors to the area; covers most subjects of interest to the region. Circ. 60,000. Accepts previously published work. Originals returned at job's completion. Sample copies free for SASE with first-class postage (1st copy only).
Cartoons: Approached by 2 freelance cartoonists/year. Rarely purchases cartoons. Prefers regional issues and style; single panel b&w line drawings with gagline. Send query letter with brochure and published samples. Samples are filed. Reports back within 3 months. Rights purchased vary. Pays $20 for b&w.
Illustrations: Approached by 5 freelance illustrators/year. Number purchased each year varies. Will consider all styles, themes. Interested in tropical living and environmental issues. Accepts any media. Send query letter with résumé and tearsheets. Samples are filed. Reports back within 3 months. Write for appointment to show portfolio of final art, b&w and color tearsheets, photostats, photocopies and photographs. Rights vary. Pays on publication; $20 for b&w, $25 for color.

FOLIO: MAGAZINE, COWLES BUSINESS MEDIA, 911 Hope St., Stamford CT 06907-0949. (203)358-9900. Fax: (203)357-9014. Contact: Annette Webb. Trade magazine covering the magazine publishing industry. Sample copies for SASE with first-class postage.
• This company publishes a total of 24 magazines. Also uses Mac-literate freelancers for production work on catalogs and direct mail pieces. Send SASE for more information.
Illustrations: Approached by 50 illustrators/year. Buys 150-200 illustrations/year. Works on assignment only. 75% of freelance work demands knowledge of Adobe Illustrator, QuarkXPress, and Adobe Photoshop. Send query letter with résumé, tearsheets or other samples. No originals. Samples are filed and returned by SASE if requested by artist. Reports back to the artist only if interested. Call for appointment to show portfolio of tearsheets, slides, final art, photographs and transparencies. Buys one-time rights. Pays by the project.
Tips: "Art director likes to see printed 4-color and b&w sample illustrations. Do not send originals unless requested. Computer-generated illustrations are used but not always necessary. Charts and graphs must be Macintosh-generated."

FOOD & SERVICE, Box 1429, Austin TX 78767. (512)472-3666. E-mail: tra@onr.com. Editor: Julie Sherrier. Art Director: Neil Ferguson. Estab. 1940. Official trade publication of Texas Restaurant Association. Seeks illustrations (but not cartoons) dealing with business issues of restaurant owners and food-service operators, primarily in Texas, and including managers of clubs, bars and hotels. Published 8 times/year. Circ. 6,500. Simultaneous submissions OK. Originals returned after publication. Sample copy for SASE, art guidelines for SASE with first-class postage.
Illustrations: Works with 15 illustrators/year. Buys 36-48 illustrations/year. Uses artwork mainly for covers and feature articles. Seeks high-quality b&w or color artwork in variety of styles (airbrush, watercolor, pastel,

pen & ink, Adobe Illustrator, Photoshop). Seeks versatile artists who can illustrate articles about food-service industry, particularly business aspects. "Humor is a plus; we seldom use realistic styles." Works on assignment only. Send query letter with SASE and tearsheets. Accepts disk submissions compatible with Adobe Ilustrator 5.0. Send EPS files. Will contact for portfolio review if interested. Pays $250-300 for color cover; $150-250 for b&w, $200-275 for color inside. Negotiates rights and payment upon assignment. Finds artists through submissions and occasionally other magazines.

Tips: "In a portfolio, show samples of color work and tearsheets. Common mistakes made in presenting work include sloppy presentation and typos in cover letter or résumé. Request a sample of our magazine (include a 10×13 SASE), then send samples that fit the style or overall mood of our magazine. We do not run illustrations or photos of food, so don't send or create samples specific to a food theme. We are a business-issues magazine, not a food publication."

FOR SENIORS ONLY, FOR GRADUATES ONLY, 339 N. Main St., New City NY 10956. (914)638-0333. Executive Editor: Judi Oliff. Estab. 1970. Biannual and annual guidance-oriented magazines for high school seniors and 2-year-college graduates and includes features on travel. Circ. 350,000. Accepts previously published artwork. Originals are not returned. Sample copies and art guidelines free for SASE with first-class postage. 75% of freelance work demands knowledge of Aldus PageMaker.

Cartoons: Buys 10 cartoons/issue. Prefers single panel b&w line drawings with gagline. Send brochure, roughs, finished cartoon samples. Samples sometimes filed and are returned by SASE if requested. Reports back if interested. Rights purchased vary according to project. Pays $15 for b&w, $25 for color.

Illustrations: Buys 3 illustrations/issue. Works on assignment only. Considers pen & ink, airbrush, charcoal and mixed media. Send query letter with résumé, SASE and samples. Samples sometimes filed and are returned by SASE if requested. Reports back only if interested. Rights purchased vary according to project.

Pays on acceptance; $75 for b&w, $125 for color cover; $50 for b&w, $100 for color inside.

FORBES MAGAZINE, 60 Fifth Ave., New York NY 10011. (212)620-2200. Art Director: Everett Halvorsen. Established 1917. Biweekly business magazine. Circ. 765,000. "*Forbes* is a magazine for readers who are interested in business and investing. Most stories use photography but this does not rule out illustrations that are appropriate to the story. We do not use, nor are we liable for ideas submitted in the hope that they will be published. *Forbes* does not use previously published illustrations nor does it use cartoons."

Illustrations: Contacted by 100 illustrators/year. Buys 5-6 illustrations/issue. "We prefer contemporary illustrations that are lucid and convey an unmistakable idea. Covers are usually illustrated. The medium is optional as long as the artwork is rendered on a material and size that can be separated on a drum scanner."

Pays on acceptance whether reproduced on not. Pays up to $2,500 for a cover assignment and an average of $450 to $600 for an inside illustration depending on complexity and reproduction size. "Discuss the fee with art director when you are contacted about doing an assignment."

Tips: "Address samples or portfolios to Everett Halvorsen. If you can, drop off your portfolio. Deliver by 11 a.m. Call first. Attach local phone number to outside of portfolio. Besides the art director, *Forbes* has four associate art directors who make assignments. It is helpful if you address by name those you want to contact. Listed on the masthead are the art director and four associate art directors. Send printed or scanned samples or photocopies. Samples are filed if they are interesting and returned only if requested, otherwise they are discarded. Do not mail original artwork. We don't report back unless we have an assignment. It's preferrable and advantageous to leave your portfolio, to allow those art directors who are available to look at your work. We discourage appointments but if circumstance requires a meeting, call Roger Zapke, the Deputy Art Director."

FOREIGN SERVICE JOURNAL, 2101 E St. NW, Washington DC 20037. (202)338-4045. Contact: Graphic Designer. Estab. 1924. Monthly magazine emphasizing foreign policy for foreign service employees; 4-color with design in *"Harpers'* style." Circ. 11,000. Returns original artwork after publication. Art guidelines available.

Illustrations: Works with 6-10 illustrators/year. Buys 20 illustrations/year. Needs editorial illustration. Uses artists mainly for covers and article illustration. Works on assignment only. Send postcard samples. Accepts disk submissions. "Mail in samples for our files." Publication will contact artist for portfolio review if interested. Buys first rights. Pays on publication; $500 for color cover; $100 and up for b&w inside. Finds artists through sourcebooks.

‡FOUNDATION NEWS & COMMENTARY, 1828 L St. NW, Washington DC 20036. (202)466-6512. Executive Editor: Jody Curtis. Estab. 1959. Bimonthly 4-color nonprofit association magazine that "covers news and trends in the nonprofit sector, with an emphasis on foundation grantmaking and grant-funded projects." Circ. 12,000. Accepts previously published artwork. Original artwork returned after publication. Sample copy available.

Cartoons: Prefers single panel b&w line drawings. Send query letter with brochure, finished cartoons and other samples. Samples are filed "if good"; none are returned. Payment negotiated.

Illustrations: Approached by 50 illustrators/year. Buys 3 illustrations/issue. Considers all formats. Send query letter with tearsheets, photostats, slides and photocopies. Samples are filed "if good"; none are returned.

INSIDER REPORT

Trade Magazines Have a Big Appetite for Illustration

Here's an illustration market you may not have considered—trade association magazines. There are countless associations all over the country, from the San Diego Floral Association to the Northwestern Loggers Association. Most have publications in need of freelance illustration. The Texas Restaurant Association's magazine *Food & Service*, for example, is heavy with beautiful, colorful, humorous, sometimes quirky, always fun artwork, and Art Director Neil Ferguson tries to use at least one illustrator new to the magazine in every issue.

Neil Ferguson

"There are just tons of associations out there, and most of them have some kind of publication," Ferguson says. He advises freelancers to visit libraries to locate publications that aren't available on newsstands. "You'd be amazed at what libraries have." Ferguson also suggests contacting the chamber of commerce in your state capital to find out what associations are based in your state and where they are located.

"I didn't know there were so many associations until I moved to Austin and started working for a printing company that just prints magazines for associations. There's even one called the Association of Women Dentists, and they have a magazine. You would never know that [if you didn't research]," Ferguson says.

Food & Service covers business issues of interest to association members, anything from economic forecasts and workmen's compensation to using computers in the food service industry. "Because of our title, I get a lot of samples from artists saying 'Hey, I draw great food,' but that's not what this magazine is about. It's really important to do the research. I always appreciate when artists write to ask for a copy of our magazine before sending samples. They can point out in their letter that they know we're business-related, and these are the things they've done that fit that."

When submitting to any market, Ferguson urges illustrators to "read the listings in *Artist's & Graphic Designer's Market* carefully and pay attention to them. Do what they say. Have a professional presentation. Get the spelling of the names right, and don't have typos in your letters." And as obvious as this may sound, be sure to include your current phone number and address on your submissions. "It's really sad to get a good piece with no identification. I've gotten some with outdated addresses. I'll call the number and they're not there anymore."

Magazines like his are good places for new artists to cut their teeth, says Ferguson, who's been with *Food & Service* for more than eight years. "Obviously,

INSIDER REPORT, *continued*

if you don't have a lot of experience, you're not going to get assignments from *Rolling Stone.*" Smaller, lower-paying markets give artists a chance to learn what's required of them from art directors. "It's not just your artistic technique," he says, "but your ability to conceptualize—to read an article and come up with something that illustrates the article, that is really important [to art directors]."

Ferguson likes artists to send something that's been printed with a little bit of the article, or at least an explanation of the piece. He points out, though, that it's an artist's individual style that catches his eye, but typically, conceptualizing is an aspect of that style. "I like to see that they've drawn something that relates to a theme. I'll get some really nice illustrations, and even though I'm impressed with the style, if it doesn't show they can take an article and come up with something, I'll pass them up."

Once an assignment is given, illustrators working for smaller publications tend to have freedom to decide how an illustration will come out, which aspect of an article to depict. "I give artists the assignments and I usually leave them alone," says Ferguson. "I'll guide them if there's something they need to avoid or if there's something controversial that they need to include or avoid. They come up with the sketches, and I let them have the fun. Because we don't pay a lot, that's one of the better aspects of working for us, and for a lot of other trade magazines. You might have a little more leeway, a little more input. Whereas, I would imagine with bigger magazines, you're pretty much told 'Do this,' and you do it."

Another advantage *Food & Service* offers illustrators is extra tearsheets. "Our budget is very small, but it's fairly inexpensive for me to ask the printer to print 100 extra copies of the form that has the illustration on it, and leave those flat with nothing on the back of them. I cut those out and give them to the illustrators.

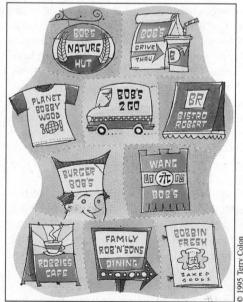

© 1995 Terry Colon

Terry Colon is one of a number of illustrators hired regularly by *Food & Service* Art Director Neil Ferguson. Colon, who specializes in humorous illustration (he writes and draws cartoons for *Cracked* magazine) received $300 for this pen & ink, watercolor, gouache, and colored pencil Bob-themed illustration. The artist found *Food & Service* through *Aritst's & Graphic Designer's Market.*

Buys first rights. **Pays on acceptance**: $750 for color cover; $250 for b&w.
Tips: The magazine is "clean, uncluttered, sophisticated, simple but attractive. It's high on concept and originality. Somwhat abstract, not literal."

THE FUTURIST, Dept. AGDM, 7910 Woodmont Ave., Suite 450, Bethesda MD 20814. Art Director: Mariann Seriff. Managing Editor: Cynthia Wagner. Emphasizes all aspects of the future for a well-educated, general audience. Bimonthly b&w magazine with 4-color cover; "fairly conservative design with lots of text." Circ. 30,000. Accepts simultaneous submissions and previously published work. Return of original artwork following publication depends on individual agreement.
Illustrations: Approached by 50-100 illustrators/year. Buys 3-4 illustrations/issue. Needs editorial illustration. Uses a variety of themes and styles "usually b&w drawings, often whimsical. We like an artist who can read an article and deal with the concepts and ideas." Works on assignment only. Send samples or tearsheets to be kept on file. Accepts disk submissions compatible with Mac, Adobe Illustrator or Adobe Photoshop. Send EPS files. Will contact for portfolio review if interested. Rights purchased negotiable. **Pays on acceptance**; $500-750 for color cover; $75-350 for b&w, $200-400 for color inside; $100-125 for spots.
Tips: "Send samples that are strong conceptually with skilled execution. When a sample package is poorly organized, poorly presented—it says a lot about how the artists feel about their work." Sees trend of "moving away from realism; highly stylized illustration with more color." This publication does not use cartoons.

GALLERY MAGAZINE, Dept. AGDM, 401 Park Ave. S., New York NY 10016. (212)779-8900. Creative Director: Jana Krenova. Emphasizes "sophisticated men's entertainment for the middle-class, collegiate male; monthly 4-color with flexible format, conceptual and sophisticated design." Circ. 375,000. Accepts previously published artwork. Interested in buying second rights (reprint rights) to previously published artwork. 100% of freelance work demands knowledge of QuarkXPress and Adobe Illustrator.
Cartoons: Approached by 100 cartoonists/year. Buys 3-8 cartoons/issue. Interested in sexy humor; single, double or multiple panel, color and b&w washes, b&w line drawings with or without gagline. Send finished cartoons. Enclose SASE. Contact: J. Linden. Reports in 1 month. Buys first rights. Pays on publication; $75 for b&w, $100 for color.
Illustrations: Approached by 300 illustrators/year. Buys 30 illustrations/year. Works on assignment only. Needs editorial illustrations. Interested in the "highest creative and technical styles." Especially needs slick, high-quality, 4-color work. Send flier, samples and tearsheets to be kept on file for possible future assignments. Prefers prints over transparencies. Samples returned by SASE. Publication will contact artist for portfolio review if interested. Negotiates rights purchased. Pays on publication; $350 for b&w, $800 for color inside. Finds artists through submissions and sourcebooks.
Tips: A common mistake freelancers make is that "often there are too many samples of literal translations of the subject. There should also be some conceptual pieces."

GAME & FISH PUBLICATIONS, 2250 Newmarket Pkwy., Marietta GA 30067. (404)953-9222. Fax: (404)933-9510. Graphic Artist: Allen Hansen. Estab. 1975. Monthly b&w with 4-color cover. Circ. 500,000 for 30 state-specific magazines. Original artwork is returned after publication. Sample copies available.
Illustrations: Approached by 50 illustrators/year. Buys illustrations mainly for spots and feature spreads. Buys 1-8 illustrations/issue. Considers pen & ink, watercolor, acrylic and oil. Send query letter with photocopies. "We look for an artist's ability to realistically depict North American game animals and game fish or hunting and fishing scenes." Samples are filed or returned only if requested. Reports back only if interested. Portfolio review not required. Buys first rights. Pays 2½ months prior to publication; $25 and up for b&w, $75-100 for color inside.
Tips: "We do not publish cartoons, but we do use some cartoon-like illustrations, which we assign to artists to accompany specific humor stories. Send us some samples of your work, showing as broad a range as possible, and let us hold on to them for future reference. Being willing to complete an assigned illustration in a 4-6 week period, and provide what we request, will make you a candidate for working with us."

‡GENT, Dugent Publishing Corp., 14411 Commerce Way, Suite 420, Miami Lakes FL 33016. Publisher: Douglas Allen. Editor: Bruce Arthur. Managing Editor: Nye Willden. For men "who like big-breasted women." 96 pages 8½×11, 4-color. Sample copy $3.
Cartoons: Buys humor and sexual themes; "major emphasis of magazine is on large D-cup-breasted women. We prefer cartoons that reflect this slant." Mail cartoons. Buys first rights. Pays $75, b&w spot drawing; $100, page.
Illustrations: Buys 3-4 illustrations/issue from freelancers on assigned themes. Submit illustration samples for files. Portfolio should include "b&w and color, with nudes/anatomy." Buys first rights. Pays $125-150, b&w; $300, color.
Tips: "Send samples designed especially for our publication. Study our magazine. Be able to draw erotic anatomy. Write for artist's guides and cartoon guides *first*, before submitting samples, since they contain some helpful suggestions."

‡GENTRY MAGAZINE, 618 Santa Cruz Ave., Menlo Park CA 94025. (415)324-1818 ext. 204. Fax: (415)324-1888. Art Director: Elyse Kaplan Steinberger. Estab. 1993. Monthly community publication for affluent audience of designers and interior designers. Circ. 35,000. Sample copies and art guidelines available.
Cartoons: Approached by 5 cartoonists/year. Buys 1 cartoon/issue. Prefers political and humorous, b&w line drawings, without gaglines. Send query letter with tearsheets. Samples are filed. Reports back only if interested. Buys first rights. Pays on publication; $50-100.
Illustration: Approached by 10 illustrators/year. Buys 1 illustrations/issue. Considers all media. Knowledge of Adobe Photoshop, Adobe Illustrator, Aldus FreeHand and QuarkXPress helpful. Send postcard sample. Accepts disk submissions if Mac compatible. Send EPS files. Samples are filed. Portfolios may be dropped off Monday-Friday or art director will contact artist for portfolio review if interested. Buys first rights. Pays $600 for cover; $100-200 for inside. Pays $100-150 for spots. Finds illustrators through *Creative Black Book*, *LA Workbook*, on-line services, magazines and word of mouth.
Design: Needs freelancers for design and production. Prefers local designers. 100% of freelance work demands knowledge of Adobe Photoshop, Adobe Illustrator, Aldus FreeHand and QuarkXPress. Send query letter with printed samples, photocopies, tearsheets or phone art director.
Tips: "Lots of intern possibilities here. Need aggressive competent people who are eager to learn the business, willing to file and watch."

GLAMOUR, 350 Madison Ave., New York NY 10017. Art Director: Kati Korpijaakko. Monthly magazine. Covers fashion and issues concerning working women (ages 20-35). Originals returned at job's completion. Sample copies available on request. 5% of freelance work demands knowledge of Adobe Illustrator, QuarkX-Press, Adobe Photoshop and Aldus FreeHand.
Cartoons: Buys 1 cartoon/issue. Prefers feminist humor. Prefers humorous b&w line drawings with gagline. Send postcard-size sample. Samples are filed and not returned. Reports back to the artist only if interested. Rights purchased vary according to project.
Illustrations: Buys 7 illustrations/issue. Works on assignment only. Considers pen & ink, airbrush, colored pencil, mixed media, collage, charcoal, watercolor, acrylic, oil, pastel and marker. Send postcard-size sample. Samples are filed and not returned. Publication will contact artist for portfolio review if interested. Portfolio should include final art, color photographs, tearsheets, color photocopies and photostats. Rights purchased vary according to project. Pays on publication.

GLASS FACTORY DIRECTORY, Box 2267, Hempstead NY 11557. (516)481-2188. Manager: Liz Scott. Annual listing of glass manufacturers in US, Canada and Mexico.
Cartoons: Receives an average of 1 submisson/week. Buys 5-10 cartoons/issue. Cartoons should pertain to glass manufacturing (flat glass, fiberglass, bottles and containers; no mirrors). Prefers single and multiple panel b&w line drawings with gagline. Prefers roughs or finished cartoons. Send SASE. Reports in 1-3 months. Buys all rights. **Pays on acceptance**; $25.
Tips: "Learn about making glass of all kinds. We rarely buy broken glass jokes. There *are* women working in glass plants. Glassblowing is overdone. What about flat glass, autoglass, bottles?"

‡GOLF ILLUSTRATED, P.O. Box 5300, Jenks OK 74037-5300. (918)491-6100. Fax: (918)491-9424. E-mail: 73172.2054@compuserve.com. Website: http://www.Golfillustrated.com. Managing Editor: Jason Sowards. Estab. 1914. Bimonthly golf lifestyle magazine with instruction, travel, equipment reviews and more. Circ. 250,000. Sample copies free for 9×11 SASE and 6 first-class stamps. Art guidelines available for #10 SASE with first-class postage.
Cartoons: Approached by 25 cartoonists/year. Prefers golf. Prefers single panel, b&w washes or line drawings. Send photocopies. Samples are filed. Reports back in 1 month. Buys first North American serial rights. **Pays on acceptance**; $50 minimum for b&w.
Illustration: Approached by 50 illustrators/year. Buys 10 illustrations/issue. Prefers instructional, detailed figures, course renderings. Considers all media. 30% of freelance illustration demands knowledge of Adobe Photoshop, Adobe Illustrator and QuarkXPress. Send query letter with photocopies, SASE and tearsheets. Accepts disk submissions. Samples are filed. Reports back within 1 month. Portfolios may be dropped off

Monday-Friday. Buys first North American serial and reprint rights. **Pays on acceptance**; $100-200 for b&w, $250-400 for color inside. Finds illustrators through sourcebooks, magazines, word of mouth and submissions.
Tips: "Read our magazine. We need fast workers with quick turnaround."

GOLF JOURNAL, Golf House, Far Hills NJ 07931. (908)234-2300. Editor: Brett Avery. Readers are "literate, professional, knowledgeable on the subject of golf." Published 9 times/year. Circ. 600,000. Original artwork not returned after publication. Free sample copy.
Cartoons: Buys 1-2 cartoons/issue. "The subject is golf. Golf must be central to the cartoon. Drawings should be professional and captions sharp, bright and literate, on a par with our generally sophisticated readership." Formats: single or multiple panel, color line drawings with gagline. Prefers to see finished cartoons. Send SASE. Reports in 1 month. Buys one-time rights. **Pays on acceptance**; $125-175, for color cartoons.
Illustrations: Buys several illustrations/issue. "We maintain a file of samples from illustrators. Our needs for illustrations are based almost solely on assignments, illustrations to accompany specific stories. We need talent with a light artistic touch, and we would assign a job to an illustrator who is able to capture the feel and mood of a story. A sense of humor is a useful quality in the illustrator, but this sense shouldn't lapse into absurdity." Uses color washes. Send samples of style to be kept on file for future assignments. Reports in 1 month. Buys all rights on a work-for-hire basis. Payment varies, "usually $300 for page, $500 for color cover."
Tips: Wants to see "a light touch, identifiable, relevant, rather than nitwit stuff showing golfballs talking to each other." Does not want to see "willy-nilly submissions of everything from caricatures of past presidents to meaningless art. Know your market; we're a golf publication, not an art gazette."

‡GOVERNING, 2300 North St. NW, Suite 760, Washington DC 20037-1122. (202)862-1146. Fax: (202)862-0032. Art Director: Richard Steadham. Estab. 1987. Monthly magazine. "Our readers are executives of state and local governments nationwide. They include governors, mayors, state legislators, county executives, etc." Circ. 86,000.
Illustration: Approached by hundreds of illustrators/year. Buys 5-10 illustrations/issue. Prefers conceptual editorial illustration dealing with public policy issues. Considers all media. 10% of freelance illustration demands knowledge of Adobe Photoshop, Adobe Illustrator, Aldus FreeHand. Send postcard sample with printed samples, photocopies and tearsheets. Send follow-up postcard sample every 3 months. "No phone calls please. We work in QuarkXPress, so we accept any format that can be imported into that program." Samples are filed. Reports back only if interested. Art director will contact artist for portfolio review if interested. Buys one-time rights. Pays on publication; $700-1,200 for cover; $250-700 for inside. Pays $250-350 for spots. Finds illustrators through *Black Book, LA Workbook*, on-line services, magazines, word of mouth, submissions.
Tips: "We are not interested in working with artists who can't take some direction. If your work is so precious, take it to a gallery. If you can collaborate with us in communicating our words visually, then we can do business."

GRAPHIC ARTS MONTHLY, 249 W. 17th St., New York NY 10011. (212)463-6579. Fax: (212)463-6530. Art Director: Rani Levy. Estab. 1930. Monthly 4-color trade magazine for management and production personnel in commercial and specialty printing plants and allied crafts. Design is "direct, crisp and modern." Circ. 95,000. Accepts previously published artwork. Originals returned at job's completion. Needs computer-literate freelancers for illustration.
Illustrations: Approached by 150 illustrators/year. Buys 6 illustrations/issue. Works on assignment only. Considers all media, including computer. Send postcard-sized sample to be filed. Accepts disk submissions compatible with Adobe Photoshop 3.0, Adobe Illustrator 6.0 or EPS/TIFF files. Will contact for portfolio review if interested. Portfolio should include final art, photographs, tearsheets. Buys one-time and reprint rights. **Pays on acceptance**; $750-1200 for color cover; $250-350 for color inside; $250 for spots. Finds artists through submissions.

GRAY AREAS, P.O. Box 808, Broomall PA 19008-0808. E-mail: 76042.3624@compuserve.com. Website: http://www.gti.net/grayarea. Publisher: Netta Gilboa. Estab. 1991. Quarterly magazine examining gray areas of law and morality in the fields of music, law, technology and popular culture. Accepts previously published artwork. Originals not returned. Sample copies available for $8. 50% of freelance work demands knowledge of Aldus PageMaker 6.0 or CorelDraw 6.0.
Cartoons: Approached by 5 cartoonists/year. Buys 2-5 cartoons/issue. Prefers "illegal subject matter" humorous cartoons; single, double or multiple panel b&w line drawings. Send query letter with brochure, roughs, photocopies or finished cartoons. Samples are filed. Reports back within 1 week only if SASE provided. Buys one-time rights.
Illustrations: Works on assignment only. "Illegal subject matter like sex, drugs, computer criminals." Considers "any media that can be scanned by a computer, up to 8½×11 inches." Send postcard sample or query letter with SASE and photocopies. Accepts disk submissions compatible with IBM/PC. Samples are filed. Reports back within 1 week only if SASE enclosed. Portfolio review not required. Buys one-time

rights. Pays on publication; $500 for color cover; negotiable b&w. Pays 5 copies of issue and masthead listing for spots.

Design: Needs freelancers for design. 50% of freelance work demands knowledge of Aldus PageMaker 6.0, Aldus FreeHand 5.0 or CorelDraw 6.0. Send query letter with photocopies. Pays by project.

Tips: "Most of the artists we use have approached us after seeing the magazine. All sections are open to artists. We are only interested in art which deals with our unique subject matter. Please do not submit without having seen the magazine. We have a strong 1960s style. Our favorite artists include Robert Crumb and Rick Griffin. We accept all points of view in art, but only if it addresses the subject we cover. Don't send us animals, statues or scenery."

GROUP PUBLISHING—MAGAZINE DIVISION, 2890 N. Monroe, Loveland CO 80538. (970)669-3836. Fax: (970)669-3269. Publishes *Group Magazine*, Art Director: Joel Armstrong (6 issues/year; circ. 50,000; 4-color); *Jr. High Ministry Magazine*, Art Director: Rich Martin (5 issues/year, 4-color) for adult leaders of Christian youth groups; *Children's Ministry Magazine*, Art Director: Rich Martin (6 issues/year; 4-color) for adult leaders who work with kids from birth to sixth grade. Previously published, photocopied and simultaneous submissions OK. Original artwork returned after publication. Sample copy $1 with 9 × 12 SAE.

• This company also produces books and clip art. See listings under those sections.

Cartoons: Generally buys one spot cartoon per issue that deals with youth or children ministry. Pays $50 minimum.

Illustrations: Buys 2-10 illustrations/issue. Send postcard samples, SASE, slides or tearsheets to be kept on file for future assignments. Accepts disk submissions compatible with Mac. Send EPS files. Reports only if interested. To show a portfolio, mail color and b&w photostats and slides with SASE. Pays $400 minimum, color cover (negotiable). **Pays on acceptance**; $35-450, from b&w/spot illustrations (line drawings and washes) to full-page color illustrations inside. Buys first publication rights and occasional reprint rights.

Tips: "We prefer contemporary, nontraditional (not churchy), well developed styles that are appropriate for our innovative, youth-oriented publications. We appreciate artists who can conceptualize well and approach difficult and sensitive subjects creatively."

GUIDEPOSTS MAGAZINE, 16 E. 34th St., New York NY 10016. (212)251-8127. Fax: (212)684-0679. Art Director: Lawrence A. Laukhuf. Estab. 1945. Monthly nonprofit inspirational, consumer magazine. *Guideposts* is a "practical interfaith guide to successful living. Articles present tested methods for developing courage, strength and positive attitudes through faith in God." Circ. 4 million. Sample copies and guidelines are available.

• Also publishes *Angels on Earth*, a bimonthly magazine buying 4-7 illustrations/issue. They feature more conceptual art.

Illustrations: Buys 3-5 illustrations/issue. Works on assignment only. Prefers realistic, reportorial. Considers watercolor, collage, airbrush, acrylic, colored pencil, oil, mixed media and pastel. Send postcard sample with SASE, tearsheets, photocopies and slides. Accepts disk submissions compatible with QuarkXPress, Adobe Illustrator, Adobe Photoshop (Mac based). Samples are returned by SASE if requested by artist. To arrange portfolio review artist should follow up with call after initial query. Portfolio should include color transparencies 8 × 10. Buys one-time rights. **Pays on acceptance**. Finds artists through sourcebooks, other publications, word of mouth, artists' submissions and Society of Illustrators' shows.

Tips: Sections most open to freelancers are illustrations for action/adventure stories. "Do your homework as to our needs. At least see the magazine!"

GUITAR PLAYER, 411 Borel Ave., Suite #100, San Mateo CA 94402. (415)358-9500. Fax: (415)358-9527. Art Director: Richard Leeds. Estab. 1975. Monthly 4-color magazine focusing on technique, artist interviews, etc. Circ. 150,000. Original artwork is returned at job's completion. Sample copies and art guidelines not available.

Illustrations: Approached by 15-20 illustrators/year. Buys 3 illustrations/issue. Works on assignment only. Prefers conceptual, "outside, not safe" themes and styles. Considers pen & ink, watercolor, collage, airbrush, computer based, acrylic, mixed media and pastel. Send query letter with brochure, tearsheets, photographs, photocopies, photostats, slides and transparencies. Accepts disk submissions compatible with Mac. Samples are filed. Reports back only if interested. Will contact for portfolio review if interested. Portfolio should include printed samples and tearsheets. Buys first rights. Pays on publication; $100-600 for color inside; $100-250 for spots.

‡GULFSHORE LIFE MAGAZINE, 2975 S. Horseshoe Dr., Suite 100, Naples FL 33942. (941)643-3933. Fax: (941)643-5007. Creative Director: Richard Cerrina. Estab. 1970. "Monthly 4-color emphasizing lifestyle of southwest Florida for an affluent, sophisticated audience, traditional design." Circ. 20,000. Accepts previously published material. Original artwork returned after publication. Sample copy for $3.95. Art guidelines for SASE with first-class postage.

Illustrations: Approached by 15-20 illustrators/year. Buys 1 illustration/issue. Prefers watercolor, collage, airbrush, acrylic, colored pencil, mixed media and pastel. Send postcard sample or query letter with brochure,

résumé, tearsheets, photostats and photocopies. Accepts disk submissions compatible with Adobe Illustrator or QuarkXPress. Samples not filed are returned by SASE. Reports back only if interested. Write to schedule appointment to show a portfolio, which should include thumbnails, printed samples, final/reproduction/product and tearsheets. Negotiates rights purchased. Buys one-time rights. Pays on publication; $500-1000 for color cover; $100-350 for b&w inside; $150-500 for color inside. $50-150 for spots. Needs technical illustration. Needs freelancers familiar with Aldus PageMaker, Adobe Illustrator, QuarkXPress or Aldus FreeHand.
Design: Needs freelancers for design. 95% of freelance work demands knowledge of Adobe Photoshop, QuarkXPress or Adobe Illustrator. Send query letter with résumé and tearsheets. Pays by project, by hour.

HABITAT MAGAZINE, 928 Broadway, New York NY 10010. (212)505-2030. Editor-in-Chief: Carol J. Ott. Estab. 1982. "We are a how-to magazine for cooperative and condominium boards of directors in New York City, Long Island, New Jersey and Westchester." Published 11 times a year; b&w with 4-color cover. Circ. 18,000. Original artwork is returned after publication. Sample copy $5. Art guidelines free for SASE with first-class postage.
Cartoons: Cartoons appearing in magazine are "line with some wash highlights." Pays $75-100 for b&w.
Illustrations: Approached by 50 illustrators/year. Buys illustrations mainly for spots and feature spreads. Buys 1-3 illustrations/issue from freelancers. Needs editorial and technical illustration that is "ironic, whimsical, but not silly." Works on assignment only. Prefers pen & ink. Considers marker. Send query letter with brochure showing art style, résumé, tearsheets, photostats, photocopies, slides, photographs and transparencies (fee requirements). Looks for "clarity in form and content." Samples are filed or are returned by SASE. Reports back about queries/submissions only if interested. For a portfolio review, mail original/final art and b&w tearsheets. Pays $75-125, b&w.
Tips: "Read our publication, understand the topic. Look at the 'Habitat Hotline' and 'Case Notes' sections." Does not want to see "tired cartoons about Wall Street board meetings and cute street beggars."

HADASSAH MAGAZINE, 50 W. 58th St., New York NY 10019. (212)688-1809. Fax: (212)446-9521. Estab. 1914. Consumer magazine. *Hadassah Magazine* is a monthly magazine chiefly of and for Jewish interests—both here and in Israel. Circ. 340,000.
Cartoons: Buys 1-2 freelance cartoons/issue. Preferred themes include the Middle East/Israel, domestic Jewish themes and issues. Send query letter with sample cartoons. Samples are filed or returned by SASE. Buys first rights. Pays $50, b&w; $100, color.
Illustrations: Approached by 15 freelance illustrators/year. Works on assignment only. Prefers themes of Jewish/Israeli issues, holidays. Send postcard sample or query letter with tearsheets. Samples are filed or are returned by SASE. Write for appointment to show portfolio of original/final art, tearsheets and slides. Buys first rights. Pays on publication; $400-800 for color cover; $100-200 for b&w, $200-250 for color inside; $100-250 for spots.

HAWAII MAGAZINE, 1400 Kapiolani Blvd., #A25, Honolulu HI 96814. (808)942-2556. E-mail: hawaiiedit@aol.com. Editor: Jim Borg. Estab. 1984. Bimonthly "written for and directed to the frequent visitor and residents who travel frequently among the Hawaiian Islands. We try to encourage people to discover the vast natural beauty of these Islands." Circ. 70,000. Original artwork is returned after publication. Sample copies $3.95.
Illustrations: Buys illustrations mainly for spots and feature spreads. Buys 1-2 illustrations/issue. Works on assignment only. Considers pen & ink, airbrush, watercolor, acrylic, oil, charcoal pencil and calligraphy. Send query letter with photocopies. Samples are not filed and are returned. Reports back about queries/submissions within 1 month. To show a portfolio mail printed samples and tearsheets. Buys first rights. Pays $75 for b&w; $150 for color, inside.

‡HEALTHCARE FINANCIAL MANAGEMENT, 2 Westbrook Corp. Center, Suite 700, Westchester IL 60154-5700. (708)531-9600. Fax: (708)531-0032. Publisher: Cheryl Stachura. Estab. 1946. Monthly association magazine for chief financial officers in healthcare, managers of patient accounts, healthcare administrators. Circ. 35,000. Sample copies available.
Cartoons: Buys 1 cartoon/issue. Prefers single panel, humorous, b&w line drawings, with gaglines. Send query letter with photocopies. Samples are filed or returned. Reports back only if interested. Pays on publication.
Illustration: All freelance illustration should be sent to James Lienhart Design, 155 N. Harbor Drive, Suite 3008, Chicago IL 60601. Considers acrylic, air brush, color washed, colored pencil, marker, mixed media,

ALWAYS ENCLOSE a self-addressed, stamped envelope (SASE) with queries and sample packages.

oil, pastel, watercolor. Send query letter with printed samples, photocopies and tearsheets. Samples are filed. Will contact artist for portfolio review if interested.

‡HEALTHCARE FORUM JOURNAL, 425 Market St., 16th Floor, San Francisco CA 94105-2406. (415)356-4300. Fax: (415)356-9300. Art Director: Bruce Olson. Estab. 1936. Bimonthly trade journal for healthcare executive administrators, a publication of the Healthcare Forum Association. Circ. 25,000. Accepts previously published artwork. Originals are returned at job's completion. Sample copies available.
Illustrations: Approached by 15-20 illustrators/year. Buys 3-5 illustrations/issue. Works on assignment only. Preferred styles vary, usually abstract and painterly; watercolor, collage, acrylic, oil and mixed media. Send query letter with SASE, tearsheets, photostats and photocopies. Samples are filed and returned by SASE if requested by artist. Reports back only if interested. Buys one-time rights. **Pays on acceptance**; $600-700 for color cover; $350 for b&w, $500 for color inside.

HEARTLAND BOATING MAGAZINE, P.O. Box 1067, Martin TN 38237-1067. (901)587-6791. Fax: (901)587-6893. Website: http://www.gsn.com/heartland_boating.htm. Editor: Molly Lightfoot Blom. Estab. 1988. Specialty magazine published 7 times per year devoted to power (cruisers, houseboats) and sail boating enthusiasts throughout middle America. The content is both humorous and informative and reflects "the challenge, joy and excitement of boating on America's inland waterways." Circ. 20,000. Occasionally accepts previously published artwork. Originals are returned at job's completion. Sample copies available for $5. Art guidelines for SASE with first-class postage. 50% of freelance work demands knowledge of Adobe Illustrator, QuarkXPress or Adobe Photoshop.
Cartoons: Approached by 10-12 cartoonists/year. Buys 2-3 cartoons/issue. Prefers boating; single panel without gaglines. Send query letter with roughs. Samples are filed or returned by SASE. Reports back within 2 months. Negotiates rights purchased. Pays $30 for b&w.
Illustrations: Approached by 2-3 illustrators/year. Buys 2-3 illustrations/issue. Works on assignment only. Prefers boating-related. Considers pen & ink. Send postcard sample or query letter with SASE, photocopies and tearsheets. Accepts disk submissions compatible with Adobe Illustrator 5.0. Send EPS files. Samples are filed or returned by SASE. Reports back within 2 months. Portfolio review not required. Negotiates rights purchased. Pays on publication. Pay is negotiated. Finds artists through submissions.
Tips: "Submit professional cover letters with no typos. Grammar is important too!"

HERBALGRAM, P.O. Box 201660, Austin TX 78720-1660. (512)331-8868. Fax: (512)331-1924. E-mail: gingerhm@herbalgram.org. Website: http://www.herbalgram.org. Art Director: Ginger Hudson-Maffei. Estab. 1983. Quarterly journal. "We're a non-commercial education and research journal with a mission to educate the public on the uses of beneficial herbs and plants. Fairly technical. For the general public, pharmacists, educators and medical professions." Circ. 27,000. Accepts previously published artwork. Originals are returned at job's completion. Sample copies and art guidelines available. 90% of freelance work demands knowledge of Adobe PageMaker 6.0, Adobe Photoshop 3.0, Aldus Freehand 3.11 and 4.0 and Adobe Illustrator.
Cartoons: Buys 3-4 cartoons/year. Prefers medical plant, general plant, plant regulation themes; single panel, political, humorous b&w line drawings with gaglines. Send query letter with brochure or roughs. Samples are filed. Buys one-time rights. Pays $50-100 for b&w.
Illustrations: Approached by 10 illustrators/year. Buys 2 illustrations/year. Works on assignment only. Prefers plant/drug themes. Considers acrylic, mixed media, collage or computer-generated images. Send query letter with photographs, tearsheets, photocopies and transparencies. Accepts disk submissions compatible with Aldus PageMaker 6.0, QuarkXPress 3.11 and Adobe Illustrator 5.0. Samples are filed. Will contact for portfolio review if interested. Portfolio should include final art, tearsheets and photocopies. Buys one-time rights. **Pays on acceptance**; $50-200 for b&w, $50-500 for color inside; $50-300 for b&w, $5-700 for color cover. Pays $25-200 for spot illustrations. Finds artists through submissions, word of mouth and *Austin Creative Directory*.
Design: Needs freelancers for production and multimedia. 95% of design demands knowledge of Aldus PageMaker 6.0, Aldus FreeHand 3.11, Adobe Photoshop 3.0, QuarkXPress 3.1 or Adobe Illustrator 5.0. Send query letter with photocopies, photographs or transparencies. Pays $50-300 by project.
Tips: Have a "good knowledge of CMYK process, good knowledge of computer to service bureau process."

HIGHLIGHTS FOR CHILDREN, 803 Church St., Honesdale PA 18431. (717)253-1080. Fax: (717)253-0179. Art Director: Janet K. Moir. Cartoon Editor: Rich Wallace. Monthly 4-color magazine for ages 2-12. Circ. 3 million. Art guidelines for SASE with first-class postage.
Cartoons: Receives 20 submissions/week. Buys 2-4 cartoons/issue. Interested in upbeat, positive cartoons involving children, family life or animals; single or multiple panel. Send roughs or finished cartoons and SASE. Reports in 4-6 weeks. Buys all rights. **Pays on acceptance**; $20-40 for line drawings. "One flaw in many submissions is that the concept or vocabulary is too adult, or that the experience necessary for its appreciation is beyond our readers. Frequently, a wordless self-explanatory cartoon is best."
Illustrations: Buys 30 illustrations/issue. Works on assignment only. Prefers "realistic and stylized work; upbeat, fun, more graphic than cartoon." Pen & ink, colored pencil, watercolor, marker, cut paper and mixed

media are all acceptable. Discourages work in fluorescent colors. Send query letter with photocopies, SASE and tearsheets. Samples to be kept on file. Request portfolio review in original query. Will contact for portfolio review if interested. Buys all rights on a work-for-hire basis. **Pays on acceptance**; $1,025 for color front and back covers; $50-500 for color inside. "We are always looking for good hidden pictures. We require a picture that is interesting in itself and has the objects well-hidden. Usually an artist submits pencil sketches. In no case do we pay for any preliminaries to the final hidden pictures." Submit hidden pictures to Jody Taylor.
Tips: "We have a wide variety of needs, so I would prefer to see a representative sample of an illustrator's style or styles."

ALFRED HITCHCOCK MAGAZINE, 1540 Broadway, New York NY 10036. (212)354-6500. Fax: (212) 697-1567. Art Director: Terri Czeczko. Estab. 1956. Monthly b&w magazine with 4-color cover emphasizing mystery fiction. Circ. 200,000. Accepts previously published artwork. Original artwork returned at job's completion. Art guidelines available for #10 SASE with first-class postage.
Cartoons: Approached by 20 cartoonists/year. Buys 2 cartoons/issue. Prefers crime oriented, humorous cartoons. Prefers single panel, b&w washes or line drawings with and without gagline. Send photocopies of finished cartoons and/or tearsheets and SASE. Samples are returned by SASE. Reports back only if interested. Buys one-time rights. **Pays on acceptance**; $35 minimum.
Illustrations: Buys 7 illustrations/issue. Works on assignment only. Considers acrylic, air brush, charcoal, color washes, mixed media, pen & ink and watercolor. Send query letter with printed samples, photocopies and/or tearsheets and SASE. Send follow-up postcard sample every 3 months. Accepts disk submissions. Samples are filed or returned by SASE. Reports back only if interested. "No phone calls." Portfolios may be dropped off every Tuesday and should include b&w and color tearsheets and transparencies. "No original art please." Buys first rights. **Pays on acceptance**; $1,200 minimum for color cover; $150 minimum for b&w inside; $35-50 for spots. Finds artists through agents and sourcebooks such as *Black Book*, *LA Workbook* and *American Showcase*.
Tips: "I like work that is colorful and a little edgy. I look for artists who are reliable. It helps if you read our magazine or read mysteries in general."

HOBSON'S CHOICE, Box 98, Ripley OH 45167. Editor: Susannah West. Estab. 1974. Bimonthly b&w newsletter emphasizes science fiction, fantasy and nonfiction of scientific and technological interest. 16-20 pages; two-column format; 8½ × 11 saddle-stitched. Circ. 2,500. Sample copy $2.50; art guidelines for SASE; tipsheet packet which contains all guidelines $1.50.
Cartoons: Approached by 10-12 cartoonists/year. Buys 17-20 cartoons/year. Interested in science fiction, science and fantasy subjects; single and multi-panel b&w line drawings. Prefers finished cartoons. Include SASE. Reports in 2-3 months. Buys first North American serial rights. Pays on publication; $5.
Illustrations: Approached by 20-30 illustrators/year. Buys 35 illustrations/year. Needs editorial, technical and story illustrations. Illustrators whose work appears in the SF press exemplify the style, tone and content: Brad Foster, Alfred Klosterman, Janet Aulisio. Sometimes uses humorous and cartoon-style illustrations depending on the type of work being published. Works on assignment only. Samples returned by SASE. Reports back on future assignment possibilities. Send query letter with photocopies, SASE, résumé or brochure and samples of style to be kept on file. Illustrates stories rather extensively (normally an 8 × 11 and an interior illustration). Format: b&w line drawings, camera-ready artwork. Reports in 2-3 months. Buys first North American rights. Pays on publication; $15-25 for b&w cover; $5-25 for b&w inside; $5 for spots.
Tips: "We first of all look for work that falls into science fiction genre; if an artist has a feel for and appreciation of science fiction he/she is more likely to be able to meet our needs. We are especially attracted to work that is clean and spare, not cluttered, and that has a finished, not sketchy quality. If an artist also does technical illustrations, we are interested in seeing samples of this style too. Would specifically like to see samples of work that we'd be capable of reproducing and that are compatible with our magazine's subject matter. We prefer to see photocopies rather than slides. We also like to be able to keep samples on file, rather than have to return them. Send us photocopies of your typical work. If you specialize in a specific genre (i.e., traditional fantasy or hard science fiction) make sure your samples emphasize that."

‡HOME EDUCATION MAGAZINE, Box 1083, Tonasket WA 98855. (509)486-1351. E-mail: homeedm ag@aol.com. Website: http://www.home-ed-press.com. Managing Editor: Helen Hegener. Estab. 1983. "We publish one of the largest magazines available for home schooling families." Desktop bimonthly published in 2-color; b&w with 4-color cover. Circ. 7,200. Original artwork is returned after publication upon request. Sample copy $4.50. Art guidelines for SASE with first-class postage.
Cartoons: Approached by 20-30 cartoonists/year. Buys 1-2/year. Style preferred is open, but theme must relate to home schooling. Prefers single, double or multiple panel b&w line drawings and washes with or without gagline. Send query letter with samples of style, roughs and finished cartoons, "any format is fine with us." Samples are filed or returned by SASE. Reports back within 3 weeks. Buys reprint rights, one-time rights or negotiates rights purchased. **Pays on acceptance**; $10-20 for b&w.
Illustrations: Approached by 100 illustrators/year. Buys illustrations mainly for spots and feature spreads. Considers pen & ink, mixed media, markers, charcoal pencil or any good sharp b&w or color media. Send

postcard sample or query letter with brochure, résumé, slides, transparencies, tearsheets, photocopies or photographs. Accepts disk submissions. "We're looking for originality, clarity, warmth. Children, families and parent-child situations are what we need." Samples are filed or are returned by SASE. Will contact for portfolio review if interested. Buys one-time rights, reprint rights or negotiates rights purchased. **Pays on acceptance**; $50 for color cover; $10-50 for color inside; $5-20 for spots. Finds artists primarily through submissions and self-promotions.

Design: Needs freelancers for design. 100% of freelance work demands knowledge of Adobe Photoshop or QuarkXPress. Send query letter with any samples. Pays by project.

Tips: "Most of our artwork is produced by staff artists. We receive very few good cartoons. Study what we've done, suggest how we might improve it."

‡**HOME OFFICE COMPUTING MAGAZINE**, Dept. AM, 411 Lafayette St., 4th Floor, New York NY 10003. (212)505-4244. Fax: (212)505-4256. Art Director: Judy Kamilar. Estab. 1980. Monthly magazine of small business/home office advice; 4-color. Circ. 380,000. Accepts previously published artwork. Originals are returned at job's completion "when possible." Sample copies available.

Cartoons: Interested in *New Yorker* style; buys very few. Pays $200 for b&w inside.

Illustrations: Approached by 45 illustrators/year. Buys 12 illustrations/issue. Works on assignment only. Prefers pen & ink, watercolor, collage, acrylic, colored pencil and mixed media. Freelance work demands knowledge of Adobe Photoshop and QuarkXPress. Send query letter with tearsheets. Samples are filed. Reports back only if interested. To show a portfolio, call for appointment. Portfolio should include tearsheets and slides. Buys one-time rights. Pays $250 for b&w and color "spot" art, $500-600 for color cover.

‡**HOME TIMES**, P.O. Box 16096, West Palm Beach FL 33416. (407)439-3509. Editor and Publisher: Dennis Lombard. Estab. 1988. Weekly conservative local newpaper tabloid with some national distribution. Circ. 5,000. Sample issue available for $1 and 9×12 SASE with 3 stamps.

Cartoons: Approached by 20 cartoonists/year. Buys 8-10 cartoons/issue. Prefers conservative politics, family life, warm family humor. Prefers political cartoons; single and multiple panel b&w line drawings. Send query letter with finished cartoons. Samples are filed or returned by SASE. Buys one-time rights. Pays $5-10 for b&w; $5-10 for spots. Finds artists through submissions.

Tips: Does not generally buy illustrations, but about 8-10 cartoons an issue. "Read the paper to understand the editorial slant."

HOMEPC, 600 Community Dr., Manhasset NY 11030. (516)562-5000. Fax: (516)562-7007. Art Director: David Loewy. Estab. 1994. Monthly consumer magazine. A magazine for home computer users. Easy to read, non-technical; covering software and hardware, entertainment and personal products. Circ. 350,000. Originals are returned at job's completion. Sample copies available. 50% of freelance work demands knowledge of Adobe Photoshop.

Illustrations: Approached by 200 illustrators/year. Buys 30 illustrations/issue. Works on assignment only. Considers pen & ink, airbrush, colored pencil, mixed media, collage, acrylic, oil and computer illustration. Send postcard sample with tearsheets. Accepts Mac compatible disk submissions. Samples are filed and are not returned. Publication will contact artist for portfolio review if interested. Portfolio should include final art and tearsheets. Buys one-time and reprint rights; rights purchased vary according to project. **Pays on acceptance**; $2,000-3,000 for color cover; $500-1,500 for color inside; $200-500 for spots.

Design: Needs freelancers for production. 100% of design work demands knowledge of Aldus FreeHand, Adobe Photoshop, QuarkXPress and Adobe Illustrator. Send résumé and tearsheets. Pays by the hour, $15-25.

Tips: Finds 75 percent of illustrators through sourcebooks; 25 percent through mailers and chance discovery.

‡**HONOLULU MAGAZINE**, 36 Merchant St., Honolulu HI 96813. (808)524-7400. Art Director: Teresa J. Black. "Monthly 4-color city/regional magazine reporting on current affairs and issues, people profiles, lifestyle. Readership is generally upper income (based on subscription). Contemporary, clean, colorful and reader-friendly" design. Original artwork is returned after publication. Sample copies for SASE with first-class postage. Art guidelines available.

Illustrations: Buys illustrations mainly for spots and feature spreads. Buys 1-3 illustrations/issue. Works on assignment only. Prefers airbrush, colored pencil and watercolor. Considers pen & ink, mixed media, acrylic, pastel, collage, charcoal, pencil and calligraphy. Send postcard sample showing art style. Looks for local subjects, conceptual abilities for abstract subjects (editorial approach)—likes a variety of techniques. Looks for strong b&w work. Samples are filed or are returned only if requested. Reports back only if interested. Write to schedule an appointment to show a portfolio which should include original/final art and color and b&w tearsheets. Buys first rights or one-time rights. Pays on publication; $300-500 for cover; $75-350 for inside; $50-75 for spots. Finds artists through word of mouth, magazines, submissions, attending art exhibitions.

Tips: "Needs both feature and department illustration—best way to break in is with small spot illustration."

HOPSCOTCH, The Magazine for Girls, Box 164, Bluffton OH 45817. (419)358-4610. Contact: Flo Weber. Estab. 1989. A bimonthly magazine for girls between the ages of 6 and 12; 2-color with 4-color

cover; 50 pp.; 7×9 saddle-stapled. Circ. 9,000. Original artwork returned at job's completion. Sample copies available for $3. Art guidelines for SASE with first-class postage. 20% of freelance work demands computer skills.

● Also publishes *Boys' Quest*.

Illustrations: Approached by 200-300 illustrators/year. Buys 6-7 freelance illustrations/issue. Artists work mostly on assignment. Needs story illustration. Prefers traditional and humor; pen & ink. Send query letter with photocopies. Samples are filed. Reports back within 2 months. Buys first rights and reprint rights. **Pays on acceptance**; $35 for full-page b&w; $25 for smaller b&w; $150 for color cover.

HORSE ILLUSTRATED, P.O. Box 6050, Mission Viejo CA 92690. (714)855-8822. Editor: Moira C. Harris. Associate Editor: Jennifer I. Oltman. Estab. 1975. Monthly consumer magazine providing "information for responsible horse owners." Circ. 187,000. Originals are returned after job's completion. Sample copies available for $4. Art guidelines for SASE with first-class postage.

Cartoons: Approached by 200 cartoonists/year. Buys 1 or 2 cartoons/issue. Prefers satire on horse ownership ("without the trite clichés"); single panel b&w line drawings with gagline. Send query letter with brochure, roughs and finished cartoons. Samples are not filed and are returned by SASE. Reports back within 6 weeks. Buys first rights and one-time rights. Pays $35 for b&w.

Illustrations: Approached by 60 illustrators/year. Buys 1 illustration/issue. Prefers realistic, mature line art, pen & ink spot illustrations of horses. Considers pen & ink. Send query letter with SASE and photographs. Accepts disk submissions. Samples are not filed and are returned by SASE. Reports back within 6 weeks. Portfolio review not required. Buys first rights or one-time rights. Pays on publication; $35 for b&w inside. Finds artists through submissions.

Tips: "We only use spot illustrations for breed directory and classified sections. We do not use much, but if your artwork is within our guidelines, we usually do repeat business."

HOSPITAL MEDICINE MAGAZINE, 105 Raider Blvd., Bellemeade NJ 08502. (908)874-8550. Fax: (908)874-6096. E-mail: s8@rbp.co.uk. Art Director: Manuel Vila, Jr. Estab. 1964. Illustrated review of clinical medicine for primary care physicians and medical students. Monthly. Circ. 119,000. Returns original artwork after publication. Art guidelines available.

Illustrations: Works with 20 illustrators/year. Buys 3-12 illustrations/issue. Prefers all media except marker and computer illustration. Works on assignment only. Send postcard sample or query letter with brochure or tearsheets to be kept on file. Accepts submissions on disk compatible with Adobe Illustrator 5.5, Adobe Photoshop 3.0. Samples not filed are not returned. To show a portfolio, mail appropriate materials. Reports only if interested. Buys first rights. **Pays on acceptance**; $650-800 for b&w, $750-1,400 for color cover; $150-500 for b&w, $250-600 for color inside; $250-400 for spots.

Design: Needs freelancers for production. Freelance work demands knowledge of Aldus FreeHand, Adobe Photoshop, QuarkXPress or Adobe Illustrator. Pays by the hour, $17-24.

Tips: "Portfolios may be dropped off Tuesdays only and picked up Thursdays. Do not show marker comps. At least show 4×5 transparencies; 8×10 is much better. In general, slides are too small to see in a review. Be concise and precise with latest softwares and tools for desktop."

HOUSE BEAUTIFUL, 1700 Broadway, 29th Floor, New York NY 10019. (212)903-5229. Fax: (212)765-8292. Art Director: Andrzej Janerka. Estab. 1896. Monthly consumer magazine. *House Beautiful* is a magazine about interior decorating—emphasis is on classic and contemporary trends in decorating, architecture and gardening. The magazine is aimed at both the professional and non-professional interior decorator. Circ. 1.3 million. Originals returned at job's completion. Sample copies available.

Illustrations: Approached by 75-100 illustrators/year. Buys 2-3 illustrations/issue. Works on assignment only. Prefers contemporary, conceptual, interesting use of media and styles. Considers pen & ink, mixed media, collage, watercolor, acrylic, oil, pastel, computer generated art and photo-illustration. Send postcard-size sample. Samples are filed only if interested and are not returned. Portfolios may be dropped off every Monday-Friday. Publication will contact artist for portfolio review of final art, photographs, slides, tearsheets and good quality photocopies if interested. Buys one-time rights. Pays on publication; $600-700 for color inside; $600-700 for spots (99% of illustrations are done as spots).

Tips: "We find most of our artists through artist submissions of either portfolios or postcards. Sometimes we will contact an artist whose work we have seen in another publication. Some of our artists are found through artist reps and annuals."

HOW, The Bottomline Design Magazine, 1507 Dana Ave., Cincinnati OH 45207. Associate Art Director: Scott Finke. Estab. 1985. Bimonthly trade journal covering "how-to and business techniques for graphic design professionals." Circ. 35,000. Original artwork returned at job's completion. Sample copy $8.50.

● Sponsors annual conference for graphic artists. Send SASE for more information.

Illustrations: Approached by 100 illustrators/year. Buys 2 illustrations/issue. Works on assignment only. Considers all media, including photography and computer illustration. Send postcard sample or query letter with brochure, tearsheets, photocopies and slides. Accepts disk submissions. Samples are filed or are returned by SASE if requested. Reports back only if interested. To show a portfolio, mail slides. Buys first rights or

reprint rights. Pays on publication; $500-1,000 for color cover; $50-200 for b&w; $100-500 for color inside.
Tips: "Send good samples that apply to the work I use. Be patient, art directors get a lot of samples."

HSUS NEWS, 700 Professional Dr., Gaithersburg MD 20814. Art Director: Theodora T. Tilton. Estab. 1954. Quarterly 4-color magazine focusing on Humane Society news and animal protection issues. Circ. 450,000. Accepts previously published artwork. Originals are returned at job's completion.
Illustrations: Buys 1-2 illustrations/issue. Works on assignment only. Themes vary. Send query letter with samples. Samples are filed or returned. Reports back within 1 month. To show a portfolio, mail appropriate materials. Portfolio should include printed samples, b&w and color tearsheets and slides. Buys one-time rights and reprint rights. **Pays on acceptance**; $250 for b&w, $400 for color cover; $150 for b&w, $300 for color inside.

HUMPTY DUMPTY'S MAGAZINE, Children's Better Health Institute, 1100 Waterway Blvd., Box 567, Indianapolis IN 46206. (317)636-8881. Art Director: Rebecca Ray. A health-oriented children's magazine for ages 4-7; 4-color; simple and direct design. Published 8 times a year. Circ. 300,000. Originals are not returned at job's completion. Sample copies available for $1.25 Art guidelines for SASE with first-class postage.
• Also publishes *Child Life*, *Children's Digest*, *Children's Playmate*, *Jack and Jill* and *Turtle Magazine*.
Illustrations: Approached by 300-400 illustrators/year. Buys 20 illustrations/issue. Works on assignment only. Preferred styles are mostly cartoon and some realism. Considers any media as long as finish is done on scannable (bendable) surface. Send query letter with slides, brochure, photographs, photocopies, tearsheets and SASE. Samples are filed or returned by SASE if not kept on file. Reports back only if interested. To show a portfolio, mail color tearsheets, photostats, photographs and photocopies. Buys all rights. Pays on publication; $275 for color cover; $35-90 for b&w, $70-155 for color inside.

‡I.E. MAGAZINE, P.O. Box 73403, Houston TX 77273-3403. (409)321-2223. E-mail: zippy@flex.net. Magazine Editor: Yolande Gottlieb. Art Editors: Charlie Sartwelle and John Runnels. Estab. 1990. Quarterly literary magazine. "We aim to present quality literature and art. Our audience is mostly writers, poets and artists." Circ. 200. Sample copies for $6.10. Art guidelines for SASE with first-class postage.
• This publication also seeks fine art.
Cartoons: Approached by 10 cartoonists/year. Prefers b&w line drawings. Send query letter with postcard-size sample or finished cartoons. Samples are returned by SASE. Reports back in 1-2 months. Buys one-time and first rights. Pays $1-2 plus copies.
Illustration: Considers pen & ink, charcoal. Send postcard-size sample, photographs or finished cartoons and SASE. Samples are filed or returned by SASE. Reports back in 1-3 months. Buys first rights. Pays $2-5 plus copies.
Fine Arts: Considers drawings, paintings, sculptures, photographs and mixed media. Send b&w prints, bio and artist's statement. Pays $2-5 plus copies.

IDEALS MAGAZINE, Box 305300, Nashville TN 37230. (615)333-0478. Fax: (615)781-1447. Editor: Lisa Ragan. 4-color magazine, published 6 times/year, emphasizing poetry and light prose. Accepts previously published material. Sample copy $4.
Illustrations: Buys 6-8 illustrations/issue. Uses freelancers mainly for flowers, plant life, wildlife and people illustrations. Prefers seasonal themes rendered in a nostalgic style. Prefers pen & ink, airbrush, colored pencil, oil, watercolor and pastel. "We are interested in seeing examples of what illustrators can do with Fractal Design Painter. Must *look* as hand-drawn as possible." Send query letter with brochure showing art style or tearsheets. Samples not filed are returned by SASE. Do not send originals or slides. Buys artwork outright. Pays on publication.
Tips: "In submissions, target our needs as far as style is concerned, but show representative subject matter. Artists should be familiar with our magazine before submitting samples of work."

‡IEEE SPECTRUM, 345 E. 47th St., New York NY 10017. (212)705-7568. Fax: (212)705-7453. Art Director: Mark Montgomery. Estab. 1963. Monthly nonprofit trade magazine serving the electrical and electronics engineers worldwide. Circ. 320,000.
Illustration: Approached by 100 illustrators/year. Buys 2 illustrations/issue. Considers all media. 40% of illustration demands knowledge of Adobe Photoshop, Adobe Illustrator, Aldus FreeHand or "any high-end 3-D software." Send postcard sample or query letter with printed samples and tearsheets. Accepts disk submissions: 3.5 Mac disk; file compressed with STUFFIT. Send RGB, TIFF or EPS files. Samples are filed and are not returned. Reports back only if interested. Artist should follow-up with call and/or letter after initial query. Portfolio should include color, final art and tearsheets. Buys first rights. **Pays on acceptance**; $1,200 minimum for cover, negotiable if artwork is highly complex; $400 minimum for inside. Finds illustrators through Graphic Artist Guild book, *American Showcase*, *Workbook*.

Design: Needs freelancers for design and multimedia. Prefers local design freelancers only. 100% of freelance work demands knowledge of Adobe Photoshop 3.05, Adobe Illustrator 5.5, QuarkXPress 3.31 and Quar Publishing System. Send query letter with printed samples.
Tips: "As our subject matter is varied, *Spectrum* uses a variety of illustrators. Artists should have a well-defined and provocative style—not imitating existing illustrators."

ILLINOIS ENTERTAINER, 124 W. Polk, #103, Chicago IL 60605. (312)922-9333. Fax: (312)922-9369. E-mail: ieeditors@aol.com. Editor: Michael C. Harris. Estab. 1975. Sleek consumer/trade-oriented monthly entertainment magazine focusing on local and national alternative music. Circ. 80,000. Accepts previously published artwork. Originals are not returned. Sample copies for SASE with first-class postage.
Illustrations: Approached by 1-5 freelance illustrators/year. Works on assignment only. Send postcard sample or query letter with photocopies and photographs. Will contact for portfolio review if interested. Buys first rights. Pays on publication; $100-140 for color cover; $20-30 for b&w, $20-30 for color inside. Finds artists through word of mouth and submissions.
Tips: "Send some clips and be patient."

ILLINOIS MEDICINE, 20 N. Michigan Ave., Suite 700, Chicago IL 60602. (312)782-1654. Fax: (312)782-2023. Production Design Manager: Carla Nolan. Estab. 1989. Biweekly 4-color company tabloid published for the physician members of the Illinois State Medical Society featuring nonclinical socio-economic and legislative news; conservative design. Circ. 20,000. Accepts previously published artwork. Illustrations are returned at job's completion. Sample copies available.
Cartoons: Approached by 20 cartoonists/year. Buys 1 cartoon/issue. Prefers medical themes—geared to physicians; single panel, b&w washes and line drawings with gagline. Send query letter with finished cartoons. Samples are not filed and are returned. Reports back within 2 months. Buys one-time rights. Pays $50 for b&w, $100 for color.
Illustrations: Approached by 30 illustrators/year. Buys 1 illustration/issue. Works on assignment only. Send postcard sample or query letter with brochure, tearsheets, photostats or photographs. Accepts disk submissions. Samples are filed. Will contact for portfolio review if interested. Artist should follow up with call or letter. Portfolio should include roughs, printed samples, b&w and color tearsheets, photostats and photographs. Buys one-time rights. **Pays on acceptance**; $500 for b&w, $800-1,200 for color. Finds artists mostly through self-promotions.

IN TOUCH FOR MEN, 13122 Saticoy St., North Hollywood CA 91605-3402. (818)764-2288. Fax: (818)764-2307. Editor: Alan Mills. Estab. 1973. "*In Touch* is a monthly erotic magazine for gay men that explores all aspects of the gay community (sex, art, music, film, etc.)." Circ. 60,000. Accepts previously published work (very seldom). Originals returned after job's completion. Sample copies available. Art guidelines for SASE with first-class postage. Needs computer-literate freelancers for illustration.
 • This magazine is open to working with illustrators who create work on computers and transfer it via modem. Final art must be saved in a Macintosh-readable format.
Cartoons: Approached by 10 cartoonists/year. Buys 1-2 cartoons/issue. Prefers humorous, gay lifestyle related (not necessarily sexually explicit in nature); single and multiple panel b&w washes and line drawings with gagline. Send query letter with finished cartoons. Samples are filed. Reports back within 1 month. Buys one-time rights. Pays $50 for b&w, $100 for color.
Illustrations: Approached by 10 illustrators/year. Buys 3-5 illustrations/issue. Works on assignment only. Prefers open-minded, lighthearted style. Considers all types. Send query letter with photocopies and SASE. Accepts disk submissions. Samples are filed. Reports back within 2 weeks. Will contact for portfolio review if interested. Portfolio should include b&w and color final art. Rights vary. **Pays on acceptance**; $35-75 for b&w inside, $100 for color inside.
Tips: "Most artists in this genre will contact us directly, but we get some through word-of-mouth and occasionally we will look up an artist whose work we've seen and interests us. Areas most open to freelancers are 4-color illustrations for erotic fiction stories, humorous illustrations and stand-alone comic strips/panels depicting segments of gay lifestyle. Understanding of gay community and lifestyle a plus."

INCOME OPPORTUNITIES, 1500 Broadway, New York NY 10036-4015. (212)642-0600. E-mail: inco meed@aol.com. Website: http://www.incomeops.com/online. Contact: Andrew Bass. Estab. 1956. Monthly consumer magazine for small business investors. Circ. 350,000. Originals returned at job's completion. Sample copies available. 5% of freelance work demands knowledge of QuarkXPress and Adobe Illustrator 5.0-5.5.
Illustrations: Approached by 10 illustrators/year. Buys 10 illustrations/issue. Works on assignment only. Considers watercolor and airbrush. Send postcard sample or query letter with brochure, tearsheets and photocopies. Accepts disk submissions compatible with Adobe Illustrator 5.0. Send EPS files only. Samples are filed. Reports back to the artist only if interested. To arrange portfolio review artist should follow up with call and letter after initial query. Portfolio should include tearsheets, final art and photographs. Buys first rights. Pays on publication; $1,200-2,000 for color cover; $500-1,000 color inside; $350-500 for spots. Finds artists through sourcebooks like *American Showcase*, also through submissions.

Design: Needs freelances for design. Freelancers require knowledge of Adobe Photoshop, QuarkXPress and Adobe Ilustrator. Send query letter with résumé and photocopies. Pays by project.
Tips: Mostly hires artists for humorous illustrations for the departments. "Send mailing cards." Looking for "strong design skills with the experience of previous clients."

‡**INTERNATIONAL BUSINESS**, 9 E. 40th St., New York NY 10016. (212)683-2426. Fax: (212)683-3426. E-mail: editib@ibnet.com. Production Director: Steve Rothman. Estab. 1988. Monthly business magazine geared to large and midsize companies doing business internationally. Circ. 60,000. Sample copies, art guidelines available.
Illustration: 90% of freelance illustration demands knowledge of Adobe Photoshop, QuarkXPress, Adobe Illustrator. Send postcard samples. Accepts disk submissions compatible with Adobe Illustrator 5.5 or Adobe Photoshop 3.0. Send EPS files on 3.5 disk or 44/88 SyQuest disks. Samples are filed. Art director will contact artist for portfolio review of color tearsheets if interested. Buys one-time rights. Pays on publication. Finds illustrators through word of mouth, submissions.

INTERRACE, P.O. Box 12048, Atlanta GA 30355-2048. (409)364-9590. Fax: (404)364-9965. Associate Publisher: Gabe Grosz. Estab. 1989. Consumer magazine published 8 times/year. "Magazine of interracial/multiracial/biracial theme for couples and people. Reflects the lives and lifestyles of interracial couples and people." Circ. 25,000. Accepts previously published artwork. Originals are returned at job's completion with SASE if requested. Sample copies available for $2 and 9×12 SASE. Guidelines available for SASE with first-class postage.
 • *Interrace* launched *Biracial Child* magazine ("the only one if its kind in the U.S.") in 1994 for parents of mixed-race children, interracial stepfamilies and transracial adoption. This publication is in need of illustrators. Submit to above address.
Cartoons: Approached by 10 cartoonists/year. Buys 10 cartoons/year. Prefers interracial couple/family, multiracial people themes; any format. Send query letter with roughs or finished cartoons. Samples are filed or are returned by SASE if requested. Reports back if interested within 1 month. Negotiated rights purchased. Pays $10 for b&w, $15 for color.
Illustrations: Approached by 20 illustrators/year. Uses 2-3 illustrations/issue. Prefers interracial couple/family, multiracial people themes. Considers pen & ink, airbrush, colored pencil, mixed media, watercolor, acrylic, pastel, collage, marker and charcoal. Send SASE, slides and photocopies. Accepts disk submissions compatible with Adobe Illustrator 5.0. Samples are filed or are returned by SASE if requested. Reports back if interested within 1 month. Request portfolio review in original query. Artist should follow-up with letter after initial query. Portfolio should include photocopies and any samples; "it's up to the artist." Negotiates rights purchased. Pays on publication; $50 for b&w, $50-75 for color cover; $10-25 for b&w, $20-30 for color inside. Finds artists through submissions.
Tips: "We are looking for artwork for interior or cover that is not only black and white couples/people, but all mixtures of black, white, Asian, Native American, Latino, etc."

IOWA WOMAN, Box 680, Iowa City IA 52244. (319)987-2879. Editor: Joan Taylor. Estab. 1979. Quarterly b&w with 4-color cover literary magazine. "A magazine for every woman who has a mind of her own and wants to keep it that way, with fine literature and visual art by women everywhere." Circ. 2,400. Accepts previously published artwork. Originals are returned at job's completion. Sample copies $6.95. Art guidelines for SASE with first-class postage. Amount of freelance work demanding computer skills varies. Freelancers should be familiar with QuarkXPress.
Cartoons: Approached by 2 cartoonists/year. "Have bought none yet, but we would use 10 cartoons/year." Preferred theme/style is narrative, political and feminist "without male-bashing"; single, double and multiple panel b&w line drawings with or without gagline. Send query letter with roughs, finished cartoons and SASE. Samples are filed or are returned by SASE if requested. Reports back within 1 month. Buys first rights. Pays $15 and 2 copies.
Illustrations: Approached by 30 illustrators/year. Buys 6 illustrations/issue. Prefers incidental sketches and scenes; pen & ink, watercolor, collage, mixed media, b&w photos. Send query letter with tearsheets or slides, letter of introduction, SASE and photocopies. Accepts disk submissions, please include hard copy also. Samples are filed or returned by SASE if requested. Reports back within 1 month. Portfolio review not required. Buys first rights. Pays $15 for inside; $50 for cover.
Tips: "We consider Iowa (or former Iowa) women artists only for the cover; women artists from everywhere else for inside art. We prefer to work on assignment, except for cartoons."

‡**ISLANDS**, Dept. AM, 3886 State St., Santa Barbara CA 93105. (805)682-7177. Fax: (805)569-0349. Art Director: Albert Chiang. Estab. 1981. Bimonthly magazine of "international travel with an emphasis on islands." 4-color with contemporary design. Circ. 160,000. Original artwork returned after publication. Sample copies available. Art guidelines for SASE with first-class postage. 100% of freelance work demands knowledge of QuarkXPress, Aldus FreeHand, Adobe Illustrator and Adobe Photoshop.
Illustrations: Approached by 20-30 illustrators/year. Buys 1-2 illustrations/issue. Needs editorial illustration. No theme or style preferred. Considers pen & ink, watercolor, collage, colored pencil, charcoal, mixed media,

and pastel. Send query letter with brochure, tearsheets, photographs and slides. "We prefer samples of previously published tearsheets." Samples are filed. Reports back only if interested. Write for appointment to show portfolio or mail printed samples and color tearsheets. Buys first rights or one-time rights. **Pays on acceptance**; $500-1,000 for color cover; $300 for b&w, $100 for color inside.

Tips: A common mistake freelancers make is that "they show too much, not focused enough. Specialize!" Notices "no real stylistic trends, but desktop publishing is affecting everything in terms of how a magazine is produced."

JACK AND JILL, Children's Better Health Institute, 1100 Waterway Blvd., Box 567, Indianapolis IN 46206. (317)636-8881. Fax: (317)684-8094. Art Director: Mary Stropoli. Emphasizes entertaining articles written with the purpose of developing the reading skills of the reader. For ages 7-10. Monthly except bimonthly January/February, April/May, July/August and October/November. Magazine is 32 pages, 4-color and 16 pages, b&w. The editorial content is 50% artwork. Buys all rights. Original artwork not returned after publication (except in case where artist wishes to exhibit the art; art must be available to us on request). Sample copy $1.25. "Freelancers can work in Aldus FreeHand, PageMaker or Quark programs."

● Also publishes *Child Life*, *Children's Digest*, *Children's Playmate*, *Humpty Dumpty's Magazine* and *Turtle*.

Illustrations: Approached by more than 100 illustrators/year. Buys 25 illustrations/issue. Uses freelance artists mainly for cover art, story illustrations and activity pages. Interested in "stylized, realistic, humorous illustrations for mystery, adventure, science fiction, historical and also nature and health subjects." Style of Len Ebert, Les Gray, Fred Womack, Phil Smith and Clovis Martin. Prefers editorial illustration in mixed media. Works on assignment only. Send query letter with brochure showing art style and résumé, tearsheets, photostats, photocopies, slides and photographs to be kept on file; include SASE. Accepts disk submissions. Publication will contact artist for portfolio review if interested. Portfolio should include printed samples, tearsheets, b&w and 2-color pre-separated art. Pays $275 cover, $155 full page, $100 ½ page, $70 for 4-color spots. For 4-color pre-separation art pays $190 full page, $115 ½ page and $80 for spots. Pays $120 full page, $90 ½ page, $60 for 2-color spots. Pays $90 full page, $60 ½ page, $35 for b&w spots. Buys all rights on a work-for-hire basis. On publication date, each contributor is sent 2 copies of the issue containing his or her work. Finds artists through artists' submissions and self-promotion pieces.

Tips: Portfolio should include "illustrations composed in a situation or storytelling way, to enhance the text matter. I do not want to see samples showing *only* single figures, portraits or landscapes, sea or air. Send samples of published story for which you did illustration work, or samples of puzzles, hidden pictures, mazes, etc."

JACKSONVILLE, 1032 Hendricks Ave., Jacksonville FL 32207. (904)396-8666. Creative Director: Carolyn Richardson. Estab. 1983. City/regional lifestyle magazine covering Florida's First Coast. 10 times/yearly. Circ. 25,000. Accepts previously published artwork. Originals returned at job's completion. Sample copies available for $5 (includes postage). Art guidelines for SASE with first-class postage.

Illustrations: Approached by 50 illustrators/year. Buys 4 illustrations/issue. Prefers editorial illustration with topical themes and sophisticated style. Send tearsheets. Will accept computer-generated illustrations compatible with Macintosh programs: Adobe Illustrator and Adobe Photoshop. Samples are filed and are returned by SASE if requested. Reports back within 2-4 weeks. Request portfolio review in original query. Publication will contact artist for portfolio review if interested. Portfolio should include b&w and color tearsheets and slides. Buys all rights. Pays on publication; $800 for color cover; $175 for b&w, $225 for color inside; $100-125 for spots. Finds artists through illustration annuals.

Tips: "We are very interested in seeing new talent—people who are part of the breaking trends."

‡JAPANOPHILE, Box 223, Okemos MI 48864. (517)349-1795. E-mail: japanlove@aol.com. Website: http://www.voyager.net/japanophile. Editor: Earl R. Snodgrass. Quarterly emphasizing cars, bonsai, haiku, sports, etc. for educated audience interested in Japanese culture. Circ. 800. Accepts previously published material. Original artwork not returned at job's completion. Sample copy $4; art guidelines for SASE.

Cartoons: Approached by 7-8 cartoonists/year. Buys 1 cartoon/issue. Prefers single panel b&w line drawings with gagline. Send finished cartoons. Material returned only if requested. Reports only if interested. Buys all rights. Pays on publication; $5-20 for b&w.

Illustrations: Buys 1-5 illustrations/issue. Needs humorous editorial illustration. Prefers sumie or line drawings. Send postcard sample to be kept on file if interested. Samples returned only if requested. Reports only if interested. Buys all rights. Pays on publication; $20-30 for b&w cover; $5-20 for b&w inside; $5-10 for spots.

Design: Needs freelancers for design. Send query letter with brochure, photocopies, SASE, résumé. Pays by the project, $10-20.

Tips: Would like cartoon series on American foibles when confronted with Japanese culture. "Read the magazine. Tell us what you think it needs."

JEMS, Journal of Emergency Medical Services, 1947 Camino Vida Roble, Suite 200, Carlsbad CA 92008. (619)431-9797. Managing Editor: Julie Ann Rach. Estab. 1980. Monthly trade journal aimed at

paramedics/paramedic instructors. Circ. 45,000. Accepts previously published artwork. Originals returned at job's completion. Sample copies available. Art guidelines for SASE. 75% of freelance work demands knowledge of QuarkXPress, Adobe Illustrator and Adobe Photoshop.
Illustrations: Approached by 20 illustrators/year. Buys 2-6 illustrations/issue. Works on assignment only. Prefers medical as well as general editorial illustration. Considers pen & ink, airbrush, colored pencil, mixed media, collage, watercolor, acrylic, oil and marker. Send postcard sample or query letter with photocopies. Accepts disk submissions compatible with most current versions of Adobe Illustrator or Adobe Photoshop. Samples are filed and are not returned. Portfolio review not required. Publication will contact artist for portfolio review of final art, tearsheets and printed samples if interested. Rights purchased vary according to project. Pays on publication. Pays $50-1,000 for color, $50-350 for b&w inside; $50-300 for spots. Finds artists through directories, agents, direct mail campaigns.
Tips: "Review magazine samples before submitting. We have had most mutual success with illustrators who can complete work within one to two weeks and send finals in computer format. We use black & white and 4-color medical illustrations on a regular basis."

‡JEWISH NEWS OF WESTERN MASSACHUSETTS, (formerly *Jewish Weekly News*), P.O. Box 269, Northampton MA 01061-1269. (413)582-9870. Publisher: Kenneth White. Estab. 1945. Biweekly regional journal of news, arts, and opinion serving the Jewish communities of western Massachusetts. Circ. 5,000. Accepts previously published artwork. Originals returned at job's completion. Sample copies available for 9×12 SASE and 65¢ postage. Art guidelines available for SASE and first-class postage. Freelancers should be familiar with Adobe Illustrator, QuarkXPress and Adobe Photoshop.
Cartoons: Prefers political humor within a Jewish context. Prefers political and humorous cartoons; single panel. Send query letter with brochure. Samples are filed or are returned by SASE if requested by artist. Reports back within 2 months. Buys one-time rights. Pays $5-10 for b&w.
Illustrations: Buys 3-5 illustrations/year. Considers pen & ink. Send query letter with brochure, tearsheets and photocopies. Samples are filed. Reports back within 2 months. Portfolio review not required. Pays on publication; $10-20 for b&w cover. Buys one-time rights.
Tips: Sections most open to freelancers are special sections on Jewish life-cycle events.

JOURNAL OF ACCOUNTANCY, AICPA, Harborside 201 Plaza III, Jersey City NJ 07311. (201)938-3450. Art Director: Jeryl Ann Costello. Monthly 4-color magazine emphasizing accounting for certified public accountants; corporate/business format. Circ. 350,000. Accepts previously published artwork. Original artwork returned after publication. 35% of freelance work demands knowledge of Adobe Illustrator, QuarkXPress and Aldus FreeHand.
Illustrations: Approached by 200 illustrators/year. Buys 2-6 illustrations/issue. Prefers business, finance and law themes. Prefers mixed media, then pen & ink, airbrush, colored pencil, watercolor, acrylic, oil and pastel. Works on assignment only. Send query letter with brochure showing art style. Samples not filed are returned by SASE. Portfolio should include printed samples, color and b&w tearsheets. Buys first rights. Pays on publication; $1,200 for color cover; $200-600 for color (depending on size) inside. Finds artists through submissions/self-promotions, sourcebooks and magazines.
Tips: "I look for indications that an artist can turn the ordinary into something extraordinary, whether it be through concept or style. In addition to illustrators, I also hire freelancers to do charts and graphs. In portfolios, I like to see tearsheets showing how the art and editorial worked together."

JOURNAL OF ASIAN MARTIAL ARTS, 821 W. 24th St., Erie PA 16502-2523. (814)455-9517. Fax: (814)838-7811. Publisher: Michael A. DeMarco. Estab. 1991. Quarterly journal covering all historical and cultural aspects of Asian martial arts. Interdisciplinary approach. College-level audience. Circ. 6,000. Accepts previously published artwork. Sample copies available for $10. Art guidelines for SASE with first-class postage. Freelancers should be familiar with Aldus PageMaker and QuarkXPress.
Illustrations: Buys 60 illustrations/issue. Prefers b&w wash; brush-like Oriental style; line. Considers pen & ink, watercolor, collage, airbrush, marker and charcoal. Send query letter with brochure, résumé, SASE and photocopies. Accepts disk submissions compatible with Adobe PageMaker, QuarkXPress and Adobe Illustrator. Samples are filed. Reports back within 4-6 weeks. Publication will contact artist for portfolio review if interested. Portfolio should include b&w roughs, photocopies and final art. Buys first rights and reprint rights. Pays on publication; $100 for color cover; $25-100 for b&w inside.
Tips: "Usually artists hear about or see our journal. We can be found in bookstores, libraries, or in listings of publications. Areas most open to freelancers are illustrations of historic warriors, weapons, castles, battles—any subject dealing with the martial arts of Asia. If artists appreciate aspects of Asian martial arts and/ or Asian culture, we would appreciate seeing their work and discuss the possibilities of collaboration."

JOURNAL OF HEALTH EDUCATION, 1900 Association Dr., Reston VA 22091. Editor: Patricia Lyle. Estab. 1970. "Bimonthly trade journal for school and community health professionals, keeping them up-to-date on issues, trends, teaching methods, and curriculum developments in health." Conservative; b&w with 4-color cover. Circ. 10,000. Original artwork is returned after publication if requested. Sample copies avail-

Oscar Ratti created this soft yet strong painting in mixed media for the cover of *Journal of Asian Martial Arts.* "The style fits our publication perfectly in subject, content and method," says Art Director Mike DeMarco. "The illustration symbolically portrays not only the initial contacts of East and West, and the richly profound martial traditions of Japan, but leads the viewer to further question the mysteries held within this complex tradition." DeMarco welcomes other artists with knowledge of Asian martial arts traditions.

able. Art guidelines not available. 70% of freelance work demands knowledge of Aldus PageMaker, Adobe Illustrator, QuarkXPress and Aldus FreeHand.

Illustrations: Approached by 50 illustrators/year. Buys 6 illustrations/year. Uses artists mainly for covers. Wants health-related topics, any style; also editorial and technical illustrations. Prefers watercolor, pen & ink, airbrush, acrylic, oil and computer illustration. Works on assignment only. Send query letter with brochure showing art style or photostats, photocopies, slides or photographs. Samples are filed or are returned by SASE. Publication will contact artist for portfolio review if interested. Portfolio should include color and b&w thumbnails, roughs, printed samples, photostats, photographs and slides. Negotiates rights purchased. **Pays on acceptance**; $45 for b&w; $250-500 for color cover.

THE JOURNAL OF LIGHT CONSTRUCTION/TOOLS OF THE TRADE, RR 2, Box 146, Richmond VT 05477. (802)434-4747. Fax: (802)434-4467. Art Director: Theresa Emerson. Monthly magazine emphasizing residential and light commercial building and remodeling. Focuses on the practical aspects of building technology and small-business management. Circ. 45,000. Accepts previously published material. Original artwork is returned after publication. Sample copy free. 80% of freelance work demands knowledge of QuarkXPress and Adobe Photoshop.

Cartoons: Buys cartoons relevent to construction industry, especially business topics.

Illustrations: Buys 10 illustrations/issue. "Lots of how-to technical illustrations are assigned on various construction topics." Send query letter with SASE, tearsheets or photocopies. Samples are filed or are returned only if requested by artist. Reports back within 2 weeks. Call or write for appointment to show portfolio of printed samples, final reproduction/product and b&w tearsheets. Buys one-time rights. **Pays on acceptance**; $500 for color cover; $100 for b&w, $200 for color inside; $150 for spots.

Design: Needs freelancers for design and production. 100% of freelance work demands knowledge of Adobe Photoshop, Adobe Illustrator and QuarkXPress. Send photocopies and résumé. Pays by the hour, $20-30.

Tips: "Write for a sample copy. We are unusual in that we have drawings illustrating construction techniques. We prefer artists with construction and/or architectural experience. We prefer using freelancers with home computers."

JUDICATURE, 180 N. Michigan Ave., Suite 600, Chicago IL 60601-7401. Contact: David Richert. Estab. 1917. Journal of the American Judicature Society. Black & white bimonthly with 4-color cover and conservative design. Circ. 12,000. Accepts previously published material and computer illustration. Original artwork

returned after publication. Sample copy for SASE with $1.47 postage. Freelance work demands knowledge of Aldus PageMaker and Aldus FreeHand.

Cartoons: Approached by 10 cartoonists/year. Buys 1-2 cartoons/issue. Interested in "sophisticated humor revealing a familiarity with legal issues, the courts and the administration of justice." Send query letter with samples of style and SASE. Reports in 2 weeks. Buys one-time rights. Pays $35 for unsolicited b&w cartoons.

Illustrations: Approached by 20 illustrators/year. Buys 2-3 illustrations/issue. Works on assignment only. Interested in styles from "realism to light humor." Prefers subjects related to court organization, operations and personnel. Send query letter, SASE, photocopies, tearsheets or brochure showing art style. Publication will contact artist for portfolio review if interestsed. Portfolio should include roughs and printed samples. Wants to see "b&w and color and the title and synopsis of editorial material the illustration accompanied." Buys one-time rights. Negotiates payment. Pays $250-375 for 2-, 3- or 4-color cover; $250 for b&w full page, $175 for b&w half page inside; $75-100 for spots.

Design: Needs freelancers for design. 100% of freelance work demands knowledge of Aldus PageMaker and Aldus FreeHand. Pays by the project.

Tips: "Show a variety of samples, including printed pieces and roughs."

JUGGLER'S WORLD, Box 443, Davidson NC 28036. (704)892-1296. Fax: (704)892-2499. E-mail: bigiduz@davidson.edu. Editor: Bill Giduz. Estab. 1981. Quarterly magazine publishing news, features and how-to information on juggling and jugglers. Circ. 3,500. Accepts previously published artwork. Originals not returned. Sample copies free for 9×12 SASE and 5 first-class stamps. Art guidelines available for SASE with first-class postage.

Cartoons: Approached by 15 cartoonists/year. Buys 2 cartoons/issue. Prefers cartoons about juggling. Prefers humorous cartoons; single panel with gagline. Send query letter with roughs and finished cartoons. Samples are not filed and are not returned. Reports back within 1 week. Buys one-time rights. Pays $15 for b&w.

Illustration: Pays $15 for spots.

Tips: "Send work that demonstrates insight into juggling, rather than simply reflecting popular conception of the art."

KALEIDOSCOPE: International Magazine of Literature, Fine Arts, and Disability, 326 Locust St., Akron OH 44302. (216)762-9755. Editor-in-Chief: Darshan Perusek. Estab. 1979. Black & white with 4-color cover. Semiannual. "Elegant, straightforward design. Unlike medical, rehabilitation, advocacy or independent living journals, explores the experiences of disability through lens of the creative arts. Specifically seeking work by artists with disabilities. Work by artists without disabilities must have a disability focus." Circ. 1,500. Accepts previously published artwork. Sample copy $4. Art guidelines for SASE with first-class postage.

Illustrations: Freelance art occasionally used with fiction pieces. More interested in publishing art that stands on its own as the focal point of an article. Approached by 15-20 artists/year. Send query letter with résumé, photocopies, photographs, SASE and slides. Do not send originals. Prefers high contrast, b&w glossy photos, but will also review color photos or 35mm slides. Include sufficient postage for return of work. Samples are not filed. Publication will contact artist for portfolio review if interested. Acceptance or rejection may take up to a year. Pays $25-100 for color covers; $10-25 for b&w or color insides. Rights return to artist upon publication. Finds artists through submissions/self-promotions and word of mouth.

Tips: "Inquire about future themes of upcoming issues. Considers all mediums, from pastels to acrylics to sculpture. Must be high quality art."

‡KALLIOPE, a journal of women's art, 3939 Roosevelt Blvd., Jacksonville FL 32205. (904)387-8211. Editor: Mary Sue Koeppel. Estab. 1978. Literary b&w triannual which publishes an average of 18 pages of art by women in each issue. "Publishes poetry, fiction, reviews, and visual art by women and about women's concerns; high-quality art reproductions; visually interesting design." Circ. 1,600. Accepts previously published "fine" artwork. Original artwork is returned at the job's completion. Sample copy for $7. Art guidelines available for SASE with first-class postage.

Cartoons: Approached by 1 cartoonist/year. Uses 1 cartoon/issue. Topics should relate to women's issues. Send query letter with roughs. Samples are not filed and are returned by SASE. Reports back within 2 months. Rights acquired vary according to project. Pays 1 year subscription or 3 complimentary copies for b&w cartoon.

Illustrations: Approached by 35 fine artists/year. Buys 18 photos of fine art/issue. Looking for "excellence in fine visual art by women (nothing pornographic)." Send query letter with résumé, SASE, photographs (b&w glossies) and artist's statement (50-75 words). Samples are not filed and are returned by SASE. Reports back within 2 months. Rights acquired vary according to project. Pays 1 year subscription or 3 complimentary copies for b&w cover or inside.

Tips: Seeking "excellence in theme and execution and submission of materials. Previous artists have included Louise Fishman, Nancy Azara, Rhonda Roland Shearer and Lorraine Bodger. We accept 3-6 works from a featured artist. We accept only b&w high quality photos of fine art."

KANSAS CITY MAGAZINE, 7007 College Blvd., Suite 430, Overland Park KS 66211. (913)338-0900. Fax: (913)338-1148. Director of Design: Kevin Swanson. Estab. 1994. Bimonthly lifestyle-oriented magazine, celebrating living in Kansas City. "We try to look at things from a little different angle (for added interest) and show the city through the eyes of the people." Circ. 33,000. Sample copies available for #10 SASE with first-class postage. Art guidelines not available.
Illustrations: Approached by 100-200 illustrators/year. Buys 3-5 illustrations/issue. Works on assignment only. Prefers conceptual editorial style. Considers all media. 25% of freelance illustration demands knowledge of Adobe Illustrator and Adobe Photoshop. Send postcard-size sample or query letter with tearsheets, photocopies and printed samples. "I just need to see sample of work." Accepts disk submissions compatible with Macintosh files (EPS, TIFF, Adobe Photoshop, etc.). Samples are filed. Will contact artist for portfolio review if interested. Portfolio should include final art, photographs, tearsheets, photocopies and photostats. Buys reprint rights. **Pays on acceptance**; $500-800 for color cover; $50-200 for b&w, $150-300 for color inside. Pays $50-150 for spots. Finds artists through sourcebooks, word of mouth, submissions.
Design: Needs freelancers for design and production. Prefers local freelancers only. 100% of freelance work demands knowledge of Adobe Photoshop, Adobe Illustrator and QuarkXPress. Send query letter with printed samples, photocopies, SASE and tearsheets.
Tips: "Our magazine is new, we have a high quality, clean, cultural, creative format. Look at magazine before you submit."

‡KASHRUS MAGAZINE—The Periodical for the Kosher Consumer, Box 204, Brooklyn NY 11204. (718)336-8544. Fax: (718)336-8550. Editor: Rabbi Wikler. Estab. 1980. Bimonthly b&w magazine with 2-color cover which updates consumer and trade on issues involving the kosher food industry, especially mislabeling, new products and food technology. Circ. 10,000. Accepts previously published artwork. Original artwork is returned after publication. Sample copy $2.
Cartoons: Buys 2 cartoon/issue. Pays $25-35 for b&w. Seeks "kosher food and Jewish humor."
Illustrations: Buys illustrations mainly for covers. Works on assignment only. Prefers pen & ink. Send query letter with photocopies. Reports back within 7 days. Request portfolio review in original query. Portfolio should include tearsheets and photostats. Pays $75-100 for b&w cover; $50 for b&w inside. Finds artists through submissions and self-promotions.
Tips: "Send general food or Jewish food- and travel-related material. Do not send off-color material."

THE KETC GUIDE, (formerly *STL Magazine: The Art of Living in St. Louis*), 6996 Millbrook Blvd., St. Louis MO 63130. (314)726-7685. Fax: (314)726-0677. Creative Director: Suzanne Griffin. Art Director: Kathy Sewing. Estab. 1991. Company magazine of KETC/Channel 9. Monthly 4-color magazine and program guide going to over 50,000 members of Channel 9, a PBS station. Age group of members is between ages 35 and 64, with a household income of $50,000 average. Circ. 52,000. Accepts previously published artwork. Originals returned at job's completion. Sample copies available. 100% of freelance work demands knowledge of Adobe Illustrator, QuarkXPress or Adobe Photoshop.
Illustrations: Buys 1 illustration/issue. Works on assignment only. Looking for unusual and artistic approaches to story illustration. Considers pen & ink, collage, acrylic, colored pencil, oil, mixed media and pastel. Send postcard sample or query letter with brochure, SASE, tearsheets, photographs and photocopies. Accepts disk submissions compatible with Adobe Illustrator 5.0. Send EPS files. Samples are filed or returned by SASE. Publication will contact artist for portfolio review if interested. Portfolio should include final art samples, color tearsheets and slides. Rights purchased vary according to project. **Pays on acceptance**; $150-300 for color cover; $75-100 for b&w, $75-150 for color inside; $25-75 for spots. Finds artists through word of mouth, magazines, artists' submissions/self-promotions and artists' agents and reps.
Design: Needs freelancers for design and production. 100% of freelance work demands knowledge of Adobe Photoshop 3.0, Adobe Illustrator 5.0 and QuarkXPress 3.3. Send query letter with photocopies and résumé. Pays by the hour, $20-25.
Tips: Send printed samples of work to Creative or Art Director. "There is no point in cold-calling if we have no visual reference of the work. We have a limited budget, but a high circulation. We offer longer deadlines, so we find many good illustrators will contribute."

KEYBOARD MAGAZINE, 411 Borel Ave., Suite #100, San Mateo CA 94402. (415)358-9500. Fax: (415)358-9527. Art Director: Paul Martinez. Estab. 1975. Monthly 4-color magazine focusing on keyboard and electronic instruments, technique, artist interviews, etc. Circ. 100,000. Original artwork is returned at job's completion.
Illustrations: Approached by 15-20 illustrators/year. Buys 3 illustrations/issue. Works on assignment only. Prefers conceptual, "outside, not safe" themes and styles. Considers pen & ink, watercolor, collage, airbrush, computer-based, acrylic, mixed media and pastel. Send query letter with brochure, tearsheets, photographs, photocopies, photostats, slides and transparencies. Samples are filed. Reports back only if interested. Publication will contact artist for portfolio review if interested. Portfolio should include printed samples and tearsheets. Buys first rights. Pays on publication; $100-250 for b&w, $100-600 for color inside.

KEYNOTER, Kiwanis International, 3636 Woodview Trace, Indianapolis IN 46268. (317)875-8755. Executive Editor: Julie Carson. Art Director: Jim Patterson. Official publication of Key Club International, nonprofit high school service organization. 4-color; "contemporary design for mature teenage audience." Published 7 times/year. Circ. 170,000. Previously published, photocopied and simultaneous submissions OK. Original artwork returned after publication. Free sample copy with SASE and 65¢ postage.
Illustrations: Buys 3 editorial illustrations/issue. Works on assignment only. Include SASE. Reports in 2 weeks. "Freelancers should call our Production and Art Department for interview." Buys first rights. **Pays on receipt of invoice**; $500 for b&w, $700 for color, cover; $200 for b&w, $500 for color, inside.

KID CITY MAGAZINE, 1 Lincoln Plaza, New York NY 10023. Art Director: Michele Weisman. For ages 6-10.
Illustrations: Approached by 1,000 illustrators/year. Buys 100 illustrations/year from freelancers. Query with color photocopied samples. Buys one-time rights. **Pays on acceptance**; $300 for b&w full page, $450 for color full page, $700 for color spread.
Tips: A common mistake freelancers make in presenting their work is "sending samples of work too babyish for our acceptance."

KIPLINGER'S PERSONAL FINANCE MAGAZINE, 1729 H St. NW, Washington DC 20006. (202)887-6416. Contact: Jenifer Walter. Estab. 1937. A monthly 4-color magazine covering personal finance issues including investing, saving, housing, cars, health, retirement, taxes and insurance. Circ. 1,300,000. Originals are returned at job's completion. Sample copies available.
Illustrations: Approached by 1,000 illustrators/year. Buys 15 illustrations/issue. Works on assignment only. Looking for original conceptual art. Interested in editorial illustration in new styles, including computer illustration. Send query letter with tearsheets and photocopies. Samples are filed or are returned by SASE if requested by artist. Publication will contact artist for portfolio review if interested. Portfolio should include tearsheets. Buys first rights. **Pays on acceptance**; $250-350 for spots.
Tips: "Send us high-caliber original work that shows creative solutions to common themes."

KIWANIS, 3636 Woodview Trace, Indianapolis IN 46268. (317)875-8755. Fax: (317)879-0204. Managing Editor: Chuck Jonak. Art Director: Jim Patterson. Estab. 1918. 4-color magazine emphasizing civic and social betterment, business, education and domestic affairs for business and professional persons. Published 10 times/year. Original artwork returned after publication. Art guidelines available for SASE with first-class postage.
Cartoons: Buys 30 cartoons/year. Interested in "daily life at home or work. Nothing off-color, no silly wife stuff, no blue-collar situations." Prefers finished cartoons. Send query letter with brochure showing art style or tearsheets, slides, photographs and SASE. Reports in 3-4 weeks. **Pays on acceptance**; $50 for b&w.
Illustrations: Works with 20 illustrators/year. Buys 3-6 illustrations/issue. Prefers pen & ink, airbrush, colored pencil, watercolor, acrylic, mixed media, calligraphy and paper sculpture. Interested in themes that correspond to themes of articles. Works on assignment only. Keeps material on file after in-person contact with artist. Include SASE. Reports in 2 weeks. To show a portfolio, mail appropriate materials (out of town/state) or call or write for appointment. Portfolio should include roughs, printed samples, final reproduction/product, color and b&w tearsheets, photostats and photographs. Buys first rights. **Pays on acceptance**; $800-1,000 for cover; $400-800 for inside; $50-75 for spots. Finds artists through talent sourcebooks, references/word-of-mouth and portfolio reviews.
Tips: "We deal direct—no reps. Have plenty of samples, particularly those that can be left with us. Too many student or unassigned illustrations in many portfolios."

L.A. PARENT MAGAZINE, 443 E. Irving Dr., Burbank CA 91504. (818)846-0400. Fax: (818)841-4380. E-mail: 73311.514@compuserve.com. Editor: Jack Bierman. Estab. 1979. Tabloid. A monthly city magazine for parents of young children, b&w with 4-color cover; "bold graphics and lots of photos of kids and families." Circ. 100,000. Accepts previously published artwork. Originals are returned at job's completion. Art guidelines available. 80% of freelance work demands knowledge of Aldus PageMaker, Adobe Illustrator, QuarkXPress, Aldus FreeHand, MacPaint or MacDraw.
Cartoons: Uses cartoons relating to parenting issues. Include SASE with first-class postage. Pays $25 for b&w.
Illustrations: Buys 2 freelance illustrations/issue. Works on assignment only. Send postcard sample. Accepts disk submissions compatible with Adobe Illustrator 5.0 and Adobe Photoshop 3.0. Samples are filed or returned by SASE. Reports back within 2 months. To show a portfolio, mail thumbnails, tearsheets and photostats. Buys one-time rights or reprint rights. **Pays on acceptance**; $300 color cover (may use only 1 color cover/year); $50-75 for b&w inside; $50 for spots.
Design: Needs freelancers for design and multimedia. 100% of freelance work demands knowledge of Adobe Photoshop, Adobe Illustrator and QuarkXPress. Send photocopies and tearsheets. Pays by the project.
Tips: "Show an understanding of our publication. Since we deal with parent/child relationships, we tend to use fairly straightforward work. Read our magazine and find out what we're all about."

‡**L.A. WEEKLY,** 6715 Sunset Blvd., Los Angeles CA 90028. (213)465-9909. Fax: (213)465-1550. Associate Art Director: Jeff Monzel. Estab. 1978. Weekly alternative arts and news tabloid. Circ. 200,000. Art guidelines available.

Cartoons: Approached by over 100 cartoonists/year. "We contract about 1 new cartoonist per year." Prefers Los Angeles, alternative lifestyle themes. Prefers b&w line drawings without gagline. Send query letter with photocopies. Samples are filed or returned by SASE. Reports back only if interested. Rights purchased vary according to project. Pays on publication; $100-200 for b&w.

Illustration: Approached by over 200 illustrators/year. Buys 4 illustrations/issue. Themes vary according to editorial needs. Considers all media. Send postcard sample or query letter with photocopies. Accepts submissions on disk. "We accept 3.5 high density disks (Mac or PC) or 88mb SyQuest (Mac of PC). TIFF format using L2W compression is preferred." Samples are filed or returned by SASE. Reports back only if interested. Portfolio may be dropped off Monday-Friday and should include any samples except original art. Artist should follow-up with call and/or letter after initial query. Buys first rights. Pays on publication. Pays $400-1,000 for cover; $100-400 for inside. Pays $100 for spots. Finds illustrators through submissions, *Black Book, American Illustration*, various Los Angeles and New York publications.

Tips: Wants "less polish and more content. Gritty is good, quick turnaround and ease of contact a must."

LACROSSE MAGAZINE, 113 W. University Pkwy., Baltimore MD 21210-3300. (410)235-6882. Fax: (410)366-6735. E-mail: jparvis@lacrosse.org. Website: http://Lacrosse.org. Art Director: Jen Parvis. Estab. 1978. "*Lacrosse Magazine* includes opinions, news, features, 'how-to's' for fans, players, coaches, etc. of all ages." Published 8 times/year. Circ. 13,000. Accepts previously published work. Originals returned at job's completion. Sample copies available. Freelancers should be familiar with Adobe Illustrator, Aldus FreeHand or QuarkXPress.

Cartoons: Prefers ideas and issues related to lacrosse. Prefers single panel, b&w washes or b&w line drawings with gagline. Send query letter with finished cartoon samples. Samples are filed or returned by SASE if requested. Reports back within 2 weeks. Rights purchased vary according to project. Pays $40 for b&w.

Illustrations: Approached by 1 freelance illustrator/year. Buys 3-4 illustrations/year. Works on assignment only. Prefers ideas and issues related to lacrosse. Considers pen & ink, collage, marker and charcoal. Send postcard sample or query letter with tearsheets or photocopies. Accepts disk submissions compatible with Mac. Samples are filed. Reports back within 2 weeks. Call for appointment to show portfolio of final art, b&w and color photocopies. Rights purchased vary according to project. Pays on publication; $100 for b&w, $150 for color cover; $75 for b&w, $100 for color inside.

Tips: "Learn/know as much as possible about the sport. Be patient."

LADYBUG, the Magazine for Young Children, Box 300, Peru IL 61354. Associate Art Director: Suzanne Beck. Estab. 1990. Monthly 4-color magazine emphasizing children's literature and activities for children, ages 2-7. Design is "geared toward maximum legibility of text and basically art-driven." Circ. 120,000. Accepts previously published material. Original artwork returned after publication. Sample copy $4; art guidelines for SASE.

Illustrations: Approached by 600-700 illustrators/year. Works with 40 illustrators/year. Buys 200 illustrations/year. Examples of artists used: Marc Brown, Cyndy Szekeres, Rosemary Wells, Tomie de Paola, Diane de Groat. Uses artists mainly for cover and interior illustration. Prefers realistic styles (animal, wildlife or human figure); occasionally accepts caricature. Works on assignment only. Send query letter with photocopies, photographs and tearsheets to be kept on file, "if I like it." Prefers photostats and tearsheets as samples. Samples are returned by SASE if requested. Publication will contact artist for portfolio review if interested. Portfolio should show a strong personal style and include "several pieces that show an ability to tell a continuing story or narrative." Does not want to see "overly slick, cute commercial art (i.e., licensed characters and overly sentimental greeting cards)." Buys reprint rights. Pays on publication; $750 for color cover; $250 for color full page; $100 for color, $50 for b&w spots.

Tips: "Has a need for artists who can accurately and attractively illustrate the movements for finger-rhymes and songs and basic informative features on nature and 'the world around you.' Multi-ethnic portrayal is also a *very* important factor in the art for *Ladybug*."

LAW PRACTICE MANAGEMENT, Box 11418, Columbia SC 29211-1418. (803)754-3563. Website: http://www.abanet.org/lpm. Managing Editor/Art Director: Delmar L. Roberts. 4-color trade journal for the practicing lawyer. Estab. 1975. Published 8 times/year. Circ. 21,066. Previously published work rarely used. 15% of freelance work demands computer skills.

Cartoons: Primarily interested in cartoons "depicting situations inherent in the operation and management of a law office, e.g., operating computers and other office equipment, interviewing, office meetings, lawyer/office staff situations, and client/lawyer situations. We use 2-4 cartoons/issue. Cartoons depicting courtroom situations are not applicable to an office management magazine." Send cartoons for consideration. Reports in 3 months. Usually buys all rights. **Pays on acceptance;** $50 for all rights.

Illustrations: Uses inside illustrations and, rarely, cover designs. Pen & ink, watercolor, acrylic, oil, collage and mixed media used. Currently uses all 4-color artwork. Send postcard sample or query letter with brochure.

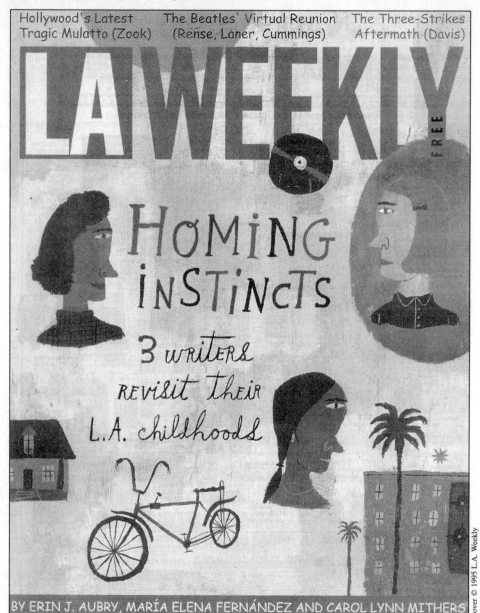

Calef Brown painted this cover illustration for an issue of *L.A. Weekly* for which three writers revisited their childhood digs in the city of angels. "The way Calef applied the paints gives a sense of age to the piece—like a building cracked and peeling—which is what the cover story is about, L.A. of yesterday," says Art Director Bill Smith. "But the forms themselves had an alternative edge that would connect with our audience and convey the new." Brown, who received $500 for the illustration, sold the original work after the cover appeared.

Reports in 3 months. Usually buys all rights. Pays on publication; $75-125 for b&w, $200-300 for 4-color inside.

Tips: "There's an increasing need for artwork to illustrate high-tech articles on technology in the law office. (We have two or more such articles each issue.) We're especially interested in computer graphics for such articles."

✤**LEISURE WORLD**, 1253 Ouellette Ave., Windsor, Ontario N8X 1J3 Canada. (519)971-3209. Fax: (519)977-1197. Editor: Douglas O'Neil. Estab. 1988. Bimonthly magazine. Reflects the leisure time activities of members of the Canadian Automobile Association. "Upscale" 4-color with travel spreads; b&w club news is 8-page insert. Circ. 340,000. Accepts previously published artwork. Original artwork returned at the job's completion. Sample copy for SASE with first-class postage. Art guidelines available.
Illustrations: Needs people, travel illustration. Needs computer-literate freelancers for design and production in PC compatible format. Send query letter with photographs, slides, transparencies or disks. Most samples are filed. Those not filed are returned. Reports back in 1 month. Call or write for appointment to show portfolio or mail thumbnails, roughs, original/final art, b&w or color tearsheets, photostats, photographs, slides and photocopies. Pays $200 for b&w and color cover; $75 for b&w, $100 for color inside; $75 for spots.

LISTEN MAGAZINE, 55 W. Oak Ridge Dr., Hagerstown MD 21740. (301)791-7000. Editor: Lincoln Steed. Monthly magazine for teens with specific aim to educate against alcohol and other drugs and to encourage positive life choices. Circ. 50,000. Accepts previously published artwork. Originals returned at job's completion. Sample copies available. Art guidelines for SASE with first-class postage. 10% of freelance work demands knowledge of CorelDraw, QuarkXPress and Aldus PageMaker.
Cartoons: Buys 1 cartoon/issue. Prefers single panel b&w washes and line drawings. Send query letter with brochure and roughs. Samples are filed. Reports back to the artist only if interested. Buys reprint rights. Pays $30 for b&w, $150 for color.
Illustrations: Approached by 50 illustrators/year. Buys 6 illustrations/issue. Works on assignment only. Considers all media. Send postcard sample or query letter with brochure, résumé and tearsheets. Accepts submissions on disk. Samples are filed or are returned by SASE. Publication will contact artist for portfolio review if interested. Buys reprint rights. **Pays on acceptance**; $200-500 for b&w, $350-700 for color cover; $50-150 for b&w, $100-200 for color inside.
Design: Needs freelancers for design. Send query letter.

LOG HOME LIVING, 4200-T Lafayette Center Dr., Chantilly VA 22021. (800)826-3893 or (703)222-9411. Fax: (703)222-3209. E-mail: 70544.3633@compuserve.com. Art Director: Randy Pope. Estab. 1989. Bimonthly 4-color magazine "dealing with the aspects of buying, building and living in a log home. We emphasize upscale living (decorating, furniture, etc.)." Circ. 108,000. Accepts previously published artwork. Sample copies not available. Art guidelines for SASE with first-class postage. 20% of freelance work demands knowledge of QuarkXPress, Adobe Illustrator and Adobe Photoshop.
Cartoons: Prefers playful ideas about logs and living and wanting a log home.
Illustrations: Buys 2-4 illustrations/issue. Works on assignment only. Prefers editoral illustration with "a strong style—ability to show creative flair with not-so-creative a subject." Considers watercolor, airbrush, colored pencil and pastel. Send postcard sample. Accepts disk submissions compatible with Adobe Illustrator, Adobe Photoshop and QuarkXPress. Samples are filed. Publication will contact artist for portfolio review if interested. Portfolio should include thumbnails, roughs, printed samples, or color tearsheets. Buys all rights. **Pays on acceptance**; $100-200 for b&w, $200-400 for color inside; $100-200 for spots. Finds artists through submissions/self-promotions, sourcebooks.
Design: Needs freelancers for design and production. 80% of freelance work demands knowledge of Adobe Photoshop, Adobe Illustrator and QuarkXPress. Send query letter with brochure, résumé, photographs and slides. Pays by the project.

LONG ISLAND UPDATE, 990 Motor Parkway, Central Islip NY 11722. (516)435-8890. Fax: (516)435-8925. Editor: Cheryl A. Meglio. Estab. 1990. Monthly consumer magazine which covers events, entertainment and other consumer issues for general audience, ages 21-40, of Long Island area. Circ. 58,000. Originals returned at job's completion.
Illustrations: Approached by 25-30 illustrators/year. Buys 1 illustration/issue. Considers watercolor. Send postcard sample or query letter with tearsheets. Samples filed. Reports back within 1 month. Portfolio review not required. Buys first rights. Pays on publication; $25 for color inside.
Tips: Area most open to freelancers is humor page illustrations.

LONGEVITY, 277 Park Ave., New York NY 10172-0003. (212)702-6000. Art Director: Hilde Kron. Estab. 1988. Monthly 4-color lifestyle publication with a practical guide to the art and science of staying young. Reaches women readers ages 25 to 50 years old. "This is not a magazine for the elderly." Accepts previously published artwork. Originals are returned at job's completion.
• *Longevity* has a new format and now uses fewer illustrations.
Illustrations: Buys 5-10 illustrations/year. "Artists should come up with good solutions to problems." Needs editorial, technical and medical illustration. Send query letter with tearsheets, photographs, photocopies and slides. Samples are filed and are not returned. Publication will contact artist for portfolio review if interested. Portfolio should include tearsheets, slides, photostats and photographs. Buys first rights. Pays on publication; $1,500 for color cover.

LOS ANGELES MAGAZINE, 11100 Santa Monica Blvd., 7th Floor, Los Angeles CA 90025. (310)477-1181. Fax: (310)996-6833. Design Director: Michael Brock. Art Director: Holly Caporale. Monthly 4-color magazine with a contemporary, modern design, emphasizing life-styles, cultural attractions, pleasures, problems and personalities of Los Angeles and the surrounding area. Circ. 170,000. Especially needs very localized contributors—custom projects needing person-to-person concepting and implementation. Previously published work OK. Pays on publication. Sample copy $3. 10% of freelance work demands knowledge of QuarkXPress, Adobe Illustrator and Adobe Photoshop.

Illustrations: Buys 10 illustrations/issue on assigned themes. Prefers general interest/life-style illustrations with urbane and contemporary tone. To show a portfolio, send or drop off samples showing art style (tearsheets, photostats, photocopies and dupe slides). Pays on publication; negotiable.

Tips: "Show work similar to that used in the magazine—a sophisticated style. Study a particular publication's content, style and format. Then proceed accordingly in submitting sample work. We initiate contact of new people per *Showcase* reference books or promo fliers sent to us. Portfolio viewing is all local."

THE LUTHERAN, 8765 W. Higgins Rd., Chicago IL 60631. (312)380-2540. E-mail: lutheran_magazine.p artl@ecunet.org. Website: http://www.elca.org/lu/luthermag.html. Art Director: Michael D. Watson. Estab. 1988. Monthly general interest magazine of the Evangelical Lutheran Church in America; 4-color, "contemporary" design. Circ. 850,000. Previously published work OK. Original artwork returned after publication on request. Free sample copy for 9×12 SASE and 5 first-class stamps. Freelancers should be familiar with Adobe Illustrator, QuarkXPress or Adobe Photoshop. Art guidelines available.

Cartoons: Approached by 100 cartoonists/year. Buys 2 cartoons/issue from freelancers. Interested in humorous or thought-provoking cartoons on religion or about issues of concern to Christians; single panel b&w washes and line drawings with gaglines. Prefers finished cartoons. Send query letter with photocopies or finished cartoons and SASE. Reports usually within 2 weeks. Buys one time rights. Pays on publication; $50-100 for b&w line drawings and washes.

Illustrations: Buys 6 illustrations/year from freelancers. Works on assignment. Does not use spots. Send query letter with brochure and tearsheets to keep on file for future assignments. Buys all rights on a work-for-hire basis. Accepts disk submississions compatible with Adobe Illustrator 5.0. Samples returned by SASE if requested. Portfolio review not required. Pays on publication; $400 for color cover; $150-350 for b&w, $400 for color inside. Finds artists mainly through submissions.

Tips: "Include your phone number with submission. Send samples that can be retained for future reference. We are partial to computer illustrations. Would like to see samples of charts and graphs."

‡MADE TO MEASURE, 600 Central Ave., Highland Park IL 60035. (312)831-6678. Publisher: William Halper. Semiannual trade journal emphasizing manufacturing, selling of uniforms, career clothes, men's tailoring and clothing. Magazine distributed to retailers, manufacturers and uniform group purchasers. Circ. 25,000. Art guidelines available.

Cartoons: Buys 15 cartoons/issue. Prefers themes relating to subject matter of magazine; also general interest. Prefers single panel b&w line drawings with or without gagline. Send query letter with samples of style or finished cartoons. Any cartoons not purchased are returned. Reports back. Buys first rights. **Pays on acceptance**; $30-50 for b&w.

‡MADEMOISELLE, 350 Madison Ave., New York NY 10017. (212)880-6966. Art Director: Charlene Benson. Monthly young womens' fashion and upscale magazine for the 18-25 year old market.

Cartoons: Approached by 50 cartoonists/year. Buys 1 cartoon/issue. Prefers Lynda Barry style cartoons. Prefers humorous. Samples are filed and not returned. Reports back only if interested. Buys reprint rights. Pays $250-900 for b&w and color cartoons.

Illustration: Approached by 300 illustrators/year. Buys 10 illustrations/issue. Prefers new looking work (modern, young, hip). Considers all media. 40% of freelance illustration demands knowledge of Adobe Photoshop, Adobe Illustrator and Aldus FreeHand. Send postcard sample. Samples are filed and are not returned. Reports back only if interested. Portfolio may be dropped off every Wednesday and should include final art and tearsheets. Buys reprint rights. Pays on publication. Pays $200-950 for inside. Pays $200 for spots. Finds illustrators through magazines and submissions.

Design: Needs freelancers for design and production. Prefers local designers. 100% of freelance work demands knowledge of Adobe Photoshop, Adobe Illustrator and QuarkXPress. Send query letter with photocopies.

MANAGEMENT ACCOUNTING, 10 Paragon Dr., Montvale NJ 07645. (201)573-6269. Assistant Publisher: Robert F. Randall. Estab. 1919. Monthly 4-color with a 3-column design emphasizing management accounting for management accountants, controllers, chief accountants and treasurers. Circ. 85,000. Accepts simultaneous submissions. Originals are returned after publication. Sample copy free for SASE.

Cartoons: Approached by 15 cartoonists/year. Buys 12 cartoons/year. Prefers single panel b&w line drawings with gagline. Topics include office, financial, business-type humor. Send finished cartoons. Material not kept on file is returned by SASE. Reports within 2 weeks. Buys one-time rights. **Pays on acceptance**; $25 for b&w.

Illustrations: Approached by 6 illustrators/year. Buys 1 illustration/issue.
Tips: No sexist cartoons.

MANAGEMENT REVIEW, 135 W. 50th St., New York NY 10020. (212)903-8168. Fax: (212)903-8083. E-mail: s_newton@amanet.org. Art & Production Director: Seval Newton. Estab. 1921. Monthly company "business magazine for senior managers. A general, internationally-focused audience." 64-page 4-color publication. Circ. 80,000. Original artwork returned after publication. Tearsheets available.
Cartoons: Approached by 10-20 cartoonists/year. Buys 1-2 cartoons/issue. Prefers "business themes and clean drawings of minority women as well as men." Prefers double panel; washes and line drawings. Send query letter with copies of cartoons. Selected samples are filed. Will call for b&w or 4-color original when placed in an issue. (Do not send originals.) Buys first rights. Pays $100 for b&w, $200 for color.
Illustrations: Approached by 50-100 illustrators/year. Buys 10-20 illustrations/issue. Electronic chart and graph artists welcome. Works on assignment only. Prefers business themes and strong colors. Considers airbrush, watercolor, collage, acrylic, oil and electronic art. 25% of illustration and 100% of design demand knowledge of Adobe Illustrator, QuarkXPress, Adobe Photoshop or Deltagraph. Send query letter with printed samples, tearsheets and SASE. Will accept submissions on disk in Adobe Illustrator using EPS files, Adobe Photoshop using TIFF, or QuarkXPress 3.31. Samples are filed. Reports back only if interested. To show a portfolio, mail printed samples and b&w tearsheets, photographs and slides or "drop off portfolio at the above address, 15th floor, Office Services window. Portfolio will be ready to pick up after two days." Rights purchased vary according to project, usually buys multiple usage rights. **Pays on acceptance**; $800-900 for color cover; $250-300 for b&w, $350-700 for color inside.
Tips: "Send tearsheets; periodically send new printed material. The magazine is set on the Mac. Any computer illustration helps cut down scanning costs."

MARRIAGE PARTNERSHIP, Christianity Today, Inc., 465 Gundersen Dr., Carol Stream IL 60188. (708)260-6200. Fax: (708)260-0114. Art Director: Gary Gnidovic. Estab. 1988. Quarterly consumer magazine. "We seek to strengthen and encourage healthy marriages. Read by couples aged 23-55 most of them Christians with kids at home." Circ. 75,000. Accepts previously published artwork. Original artwork is returned after publication. Sample copies available upon assignment. Art guidelines available.
Cartoons: Contact Barbara Calvert, editorial coordinator. Approached by 20 cartoonists/year. Buys 5 freelance cartoons/issue. Preferred themes are marriage, home life, family relationships. Prefers single panel. Send query letter with finished cartoons. Samples are not filed and are returned by SASE. Reports back within 1 month. Buys first rights. Pays $75, b&w.
Illustrations: Approached by 50 illustrators/year. Buys 20 illustrations/issue. Works on assignment only. Themes/styles vary. Accepts any medium. Send query letter with tearsheets and photocopies. Samples are filed. Reports back only if interested. To show a portfolio, mail tearsheets, photocopies and promo pieces. Buys first rights. **Pays on acceptance;** $275-600, color and b&w.

‡MEDICAL ECONOMICS COMPANY, Five Paragon Dr., Montvale NJ 07645. (201)358-7366. Design Coordinator: Nancy McGarry. Estab. 1909. Publishes 16 health related publications and several annuals. Interested in all media, including electronic and traditional illustrations. Accepts previously published material. Originals are returned at job's completion. Uses freelance artists for "all editorial illustration in the magazines." 25% illustration and 100% production freelance work demand knowledge of QuarkXPress, Adobe Illustrator and Adobe Photoshop.
Cartoons: Prefers editorial illustration with medically related themes. Prefers single panel b&w line drawings and washes with gagline. Send query letter with finished cartoons. Material not filed is returned by SASE. Reports within 2 months. Buys all rights.
Illustrations: Prefers all media including 3-D illustration. Needs editorial and medical illustration that varies, "but is mostly on the conservative side." Works on assignment only. Send query letter with résumé and samples. Samples not filed are returned by SASE. Reports only if interested. Publication will contact artist for portfolio review if interested. Buys one-time rights. **Pays on acceptance**; $1,000-1,500 for color cover; $200-600 for b&w, $250-800 for color inside.

‡MEDIPHORS, A Literary Journal of the Health Professions, P.O. Box 327, Bloomsburg PA 17815-0327. Editor: Eugene D. Radice, MD. Estab. 1993. Semiannual literary magazine/journal publishing short story, essay and poetry which broadly relate to medicine and health. Circ. 800. Sample copy and art guidelines free for SASE with first-class postage.
Cartoons: Approached by 6 cartoonists/year. Buys 6-12 cartoons/issue. Prefers health/medicine related. Prefers single panel, humorous, b&w line drawings. Samples are returned by SASE. Reports back in 1 month. Buys first North American serial rights. Pays on publication; 2 publication copies.
Illustration: Approached by 6 illustrators/year. Buys 5 illustrations/issue. Considers charcoal, collage, marker, pen & ink. Send query letter with photocopies and SASE. Samples are filed or returned by SASE. Reports back in 1 month if interested. Buys first North American serial rights. Pays on publication; 2 copies of publication.

Tips: "We enjoy publishing work from beginning artists who would like to see their work published, but do not require cash payment."

‡**MICHIGAN LIVING**, 1 Auto Club Dr., Dearborn MI 48126. (313)336-1330. Fax: (313)336-1344. Executive Editor: Ron Garbinski. Estab. 1918. Monthly magazine emphasizing travel and lifestyle. Circ. 1.1 million. Sample copies and art guidelines available.
Illustration: Approached by 20 illustrators/year. Prefers travel related. Considers all media. Knowledge of Aldus FreeHand, Adobe Photoshop, QuarkXPress, Adobe Illustrator helpful, but not required. Send query letter with printed samples, photocopies, SASE, tearsheets. Accepts disk submissions compatible with QuarkXPress 7.0. Samples are not filed and are returned by SASE or not returned. Reports back in 6 weeks. Art director will contact artist for portfolio review of b&w and color final art, photographs, photostats, roughs, slides, tearsheets, thumbnails, transparencies if interested. Buys first North American serial rights or reprint rights. Pays $400 maximum for cover and inside. Payment for spots depends on size. Finds illustrators through sourcebooks, such as *Creative Black Book*, word or mouth, submissions.
Tips: "Read our magazine, we need fast workers with quick turnaround."

MICHIGAN NATURAL RESOURCES, 30600 Telegraph Rd., Suite 1255, Bingham Farms MI 48025. (810)642-9580. Fax: (810)642-5290. E-mail: knrink@aol.com. Creative Director: Kathleen Kolka. Estab. 1930. Bimonthly consumer magazine. "*Michigan Natural Resources Magazine* is the official publication of Michigan's Department of Natural Resources. It's Michigan's oldest outdoor publication." Circ. 90,000. Accepts previously published artwork. Originals returned at job's completion. Art guidelines available. 100% of freelance work demands knowledge of Adobe Illustrator, QuarkXPress and Adobe Photoshop.
Cartoons: Approached by 3 cartoonists/year. Buys 2-6 cartoons/year. Prefers double panel, humorous drawings, b&w and color washes. Send query letter with slides or laser copies of finished work. Samples are filed or returned by SASE if requested by artist. Reports back to the artist only if interested. Buys reprint rights or negotiates rights purchased. Pays $150-250 for b&w, $250-300 for color covers; $50-100 for b&w, $75-200 for color insides; $25-75 for spots.
Illustrations: Approached by 8-12 illustrators/year. Buys 9-16 illustrations/issue. Prefers bright, crisp and loose style—decorative art, wildlife, flowers, natural outdoor scenery. Considers pen & ink, mixed media, watercolor, acrylic, oil and pastel. Send query letter with résumé, slides, brochure, SASE, tearsheets, transparencies, photographs and photocopies. Accepts disk submissions compatible with Mac, Adobe Illlustrator and Adobe Photoshop. Send DAT 8mm, SyQuest or 128 3.5 floppy disk. Samples are filed. Publication will contact artist for portfolio review if interested. Portfolio should include b&w and color tearsheets, slides (duplicates for files). Rights purchased vary according to project. Pays on publication. Finds artists through submissions.
Design: Needs freelancers for design. 100% of freelance work demands knowledge of Adobe Photoshop 3.0, Adobe Illustrator 5.5, QuarkXPress 3.31, Streamline Adobe 3.0. Send query letter with brochure, photocopies, SASE, tearsheets, résumé, photographs, slides, transparencies. Pays by the project or by the hour $20-35.

‡**MICHIGAN OUT OF DOORS**, Box 30235, Lansing MI 48909. Contact: Kenneth S. Lowe. 4-color magazine emphasizing outdoor recreation, especially hunting and fishing, conservation and environmental affairs. "Conventional" design. Sample copy $2.50.
Illustrations: "Following the various hunting and fishing seasons we have a need for illustration material; we consider submissions 6-8 months in advance." Reports as soon as possible. **Pays on acceptance**; $25 for pen & ink illustrations in a vertical treatment.

‡**MID-AMERICAN REVIEW**, English Dept., Bowling Green State University, Bowling Green OH 43403. (419)372-2725. Editor-in-Chief: George Looney. Estab. 1980. Twice yearly literary magazine publishing "the best contemporary poetry, fiction, essays, and work in translation we can find. Each issue includes poems in their original language and in English." Circ. 700. Originals are returned at job's completion. Sample copies available for $5.
Illustrations: Approached by 10-20 illustrators/year. Buys 1 illustration/issue. Considers pen & ink, watercolor, collage, charcoal and mixed media. Send query letter with brochure, SASE, tearsheets, photographs and photocopies. Samples are filed or are returned by SASE if requested by artist. Reports back within 3 months. Buys first rights. Pays on publication. Pays $50 for b&w or color.
Tips: "*MAR* only publishes artwork on its cover. We like to use the same artist for one volume (two issues)."

MILLER FREEMAN, INC., 600 Harrison St., San Francisco CA 94107. (415)905-2200. Fax: (415)905-2236. E-mail: abrokeri@mfi.com. Graphics Operations Manager: Amy R. Brokering. Publishes over 75 monthly and quarterly 4-color business and special-interest consumer and trade magazines serving the paper, travel, retail, real estate, sports, design, forest products, computer, music, electronics and medical markets. Circ. 20,000-150,000. Returns original artwork after publication. 75% of freelance work demands knowledge of QuarkXPress, Adobe Illustrator or Adobe Photoshop.
Illustrations: Approached by 500 illustrators/year. Uses freelancers mainly for illustration of feature articles. Needs editorial, technical and medical illustration. (No cartoons please.) Buys numerous illustrations/year.

Works on assignment only. Send query letter with printed samples to be kept on file. Do not send photocopies or original work. Samples not filed are returned by SASE only. Reports back only if interested. "No phone queries, please." Negotiates rights purchased. **Pays on acceptance**.

‡**MODEL RAILROADER**, P.O. Box 1612, 21027 Crossroads Circle, Waukesha WI 53187. (414)786-8776. Fax: (414)796-1778. Art Director: Philip Schroeder. Monthly magazine for hobbiests, rail fans. Circ. 230,000. Sample copies available for 9×12 SASE with first-class postage. Art guidelines available.
 • Published by Kalmbach Publishing. Also see listings for *Classic Toy Trains*, *Astronomy*, *Finescale Modeler*, *Model Retailer*, *Nutshell News* and *Trains*.
Cartoons: Prefers railroading themes. Prefers b&w line drawings with gagline. Send photocopies and tearsheets. Samples are filed and not returned. Reports back only if interested. Buys one-time rights. **Pays on acceptance**; $30 for b&w cartoons.
Illustration: Prefers railroading, construction, how-to. Considers all media. 90% of freelance illustration demands knowledge of Adobe Photoshop 3.0, Adobe Illustrator 5.5, Aldus FreeHand 3.0, QuarkXPress 3.31 and Fractal Painter. Send query letter with printed samples, photocopies, SASE and tearsheets. Accepts disk submissions compatible with QuarkXPress 5.5. (Send EPS files.) Call first. Samples are filed and are not returned. Will contact for portfolio review of final art, photographs and thumbnails if interested. Buys all rights. Pays on publication; negotiable.

‡**MODEL RETAILER**, 21027 Crossroads Circle, Waukesha WI 53187. (414) 796-8776. Monthly consumer trade journal for hobby shop owners. Circ. 8,000. Sample copies available. Published by Kalmbach Publishing, which also publishes *Astronomy*, *Finescale Modeler*, *Nutshell News* and *Trains*. See individual listings for each magazine's needs.
Illustration: Approached by 20-30 illustrators/year. Buys 0-2 illustrations/issue. Considers all media. 20% of illustration demands knowledge of Adobe Photoshop and Adobe Illustrator. Send postcard sample and/or printed samples or photocopies. Send follow-up postcard every 6-8 months. Accepts disk submissions compatible with Adobe Illustrator 5.5 and Adobe Photoshop 3.0. Samples are filed or returned by SASE. Reports back only if interested. Portfolio review required if interested in artist's work. Prefers to see portfolios on disk. Negotiates rights purchased. **Pays on acceptance**. Payment negotiable. Finds artists through word of mouth and submissions.
Design: Needs freelancers for design. Prefers local designers with experience in Quark 3.31, Adobe Illustrator 5.5 and/or Photoshop 3.0. Send query letter with printed samples or color copies.
Tips: "Know the subject matter. Be in the hobby."

‡**MODERN DRUMMER**, 12 Old Bridge Rd., Cedar Grove NJ 07009. (201)239-4140. Editor-in-Chief: Ronald Spagnardi. Art Director: Scott Bienstock. Monthly magazine for drummers, "all ages and levels of playing ability with varied interests within the field of drumming." Circ. 95,000. Previously published work OK. Original artwork returned after publication. Sample copy for $3.95.
Cartoons: Buys 3-5 cartoons/year. Interested in drumming themes; single and double panel. Prefers finished cartoons or roughs. Include SASE. Reports in 3 weeks. Buys first North American serial rights. Pays on publication; $5-25.
Tips: "We want strictly drummer-oriented gags."

MODERN MATURITY, Dept. AM, 3200 E. Carson, Lakewood CA 90712. (310)496-2277. Art Director: James H. Richardson. Estab. 1956. Bimonthly 4-color magazine emphasizing health, lifestyles, travel, sports, finance and contemporary activities for members 50 years and over. Circ. 20 million. Previously published work OK "in some instances." Originals are returned after publication. Sample copy available for SASE.
Illustrations: Approached by 200 illustrators/year. Buys 8 freelance illustrations/issue. Works on assignment only. Considers watercolor, collage, oil, mixed media and pastel. Samples are filed "if I can use the work. Do not send anything you wish to have returned." Reports back to the artist only if interested. Publication will contact artist for portfolio review if interested. Portfolio should include original/final art, tearsheets, slides and photocopies. Buys first rights. **Pays on acceptance**; $600 for b&w; $2,000 for color cover; $1,200 for color inside, full page.
Tips: "We generally use people with a proven publications track record. I request tearsheets of published work when viewing portfolios."

MODERN PLASTICS, 1221 Avenue of Americas, New York NY 10020. (212)512-3491. Art Director: Anthony Landi. Monthly trade journal emphasizing technical articles for manufacturers of plastic parts and machinery; 4-color with contemporary design. Circ. 60,000. 20% of freelance work demands knowledge of Adobe Illustrator, QuarkXPress or Aldus FreeHand.
Illustrations: Works with 4 illustrators/year. Buys 4 illustrations/year. Prefers airbrush and conceptual art. Works on assignment only. Send brochure. Samples are filed. Does not report back. Call for appointment to show a portfolio of tearsheets, photographs, slides, color and b&w. Buys all rights. **Pays on acceptance**; $800-1,000 for color cover; $150 for color inside.

‡**MONTANA MAGAZINE**, P.O. Box 5630, Helena MT 59604. (406)443-2824. Fax: (406)443-5480. Editor: Beverly Magley. Estab. 1970. Bimonthly magazine covering Montana recreation, history, people, wildlife. Geared to Montanans. Circ. 45,000.
 • Art director reports this magazine has rarely used illustration in the past, but would like to use more.
Cartoons: Prefers single panel, humorous, b&w and color washes or b&w line drawings. Send query letter with photocopies. Samples are filed and not returned. Reports back only if interested. Buys one-time rights. Pays on on publication; $35-50 for b&w, $50-125 for color.
Illustration: Approached by 15-20 illustrators/year. Buys 1-2 illustrations/year. Prefers outdoors. Considers all media. Knowledge of Aldus PageMaker, Adobe Photoshop, Adobe Illustrator helpful but not required. Send query letter with photocopies. Accepts disk submissions combatible with Pagemaker 5.0. Send EPS files. Samples are filed and are not returned. Buys one-time rights. Pays on publication, $225 for cover; $35-50 for b&w; $50-125 for color. Pays $35-50 for spots. Finds illustrators through submissions, word of mouth.
Tips: "We work with local artists usually because of convenience and turnaround."

MOTHER JONES, 731 Market St., San Francisco CA 94103. (415)665-6637. Fax: (415)665-6696. Creative Director: Kerry Tremain. Estab. 1976. Bimonthly magazine. Focuses on progressive politics and exposés. Circ. 122,000. Accepts previously published artwork. Originals returned at job's completion. Sample copies available. Freelancers should be familiar with QuarkXPress and Adobe Photoshop.
Cartoons: Approached by 25 cartoonists/year. Buys 1 cartoon/issue. Prefers single panel, political b&w line drawings. Send query letter with postcard-size sample or finished cartoons. Samples are filed or returned by SASE if requested by artist. Reports back to the artist only if interested. Buys first rights.
Illustrations: Approached by hundreds of illustrators/year. Works on assignment only. Considers pen & ink, colored pencil, mixed media, watercolor, acrylic and oil. Send postcard-size sample or query letter with any samples. Samples are filed or returned by SASE if requested by artist. Reports back to the artist only if interested. Portfolio should include photographs, slides and tearsheets. Buys first rights. Pays on publication; payment varies widely. Finds artists through illustration books; other magazines; "word of mouth is always key."

‡**MOTHERING MAGAZINE**, P.O. Box 1690, Santa Fe NM 87504. (505)984-8116. Fax: (505)986-8335. Art Director: Madeleine Tilin. Estab. 1976. Consumer magazine focusing on natural family living, and natural/alternative practices in parenting. Circ. 75,000. Sample copies and art guidelines available.
Illustration: Knowledge of Adobe Photoshop 3.1, QuarkXPress 3.31 helpful, but not required. Send query letter and/or postcard sample. We will accept work compatible with QuarkXPress 3.31 for Power Mac. Send EPS files. Samples are filed. Reports back only if interested. Buys first rights. Pays on publication; $500 maximum for b&w cover; $275-450 for b&w inside. Payment for spots depends on size. Finds illustrators through submissions, sourcebooks, magazines, word of mouth.
Tips: "Become familiar with tone and subject matter of our magazine. We give you ample turnaround time. Be able to work creatively in b&w."

MOTOR MAGAZINE, Dept. AGDM, 5600 Crooks Rd., Troy MI 48098. (810)879-8600. Art Director: Don Wilbur. Estab. 1903. Emphasizes automotive technology, repair and maintenance for auto mechanics and technicians. Monthly. Circ. 140,000. Accepts previously published material. Original artwork returned after publication if requested. Never send unsoliticed original art.
Illustrations: Buys 5-15 illustrations/issue. Works on assignment only. Prefers realistic, technical line renderings of automotive parts and systems. Send query letter with résumé and photocopies to be kept on file. Will call for appointment to see further samples. Samples not filed are not returned. Reports only if interested. Buys one-time rights. Write for appointment to show a portfolio of final reproduction/product and color tearsheets. **Pays on acceptance**; negotiable for cover, basically $300-1,500; $50-500 for b&w inside.
Tips: "*Motor* is an educational, technical magazine and is basically immune to illustration trends because our drawings *must* be realistic and technical. As design trends change we try to incorporate these into our magazine (within reason). Though *Motor* is a trade publication, we approach it, design-wise, as if it were a consumer magazine. We make use of white space when possible and use creative, abstract and impact photographs and illustration for our opening pages and covers. But we must always retain a 'technical look' to reflect our editorial subject matter. Publication graphics is becoming like TV programming, more calculating and imitative and less creative."

MUSHING, P.O. Box 149, Ester AK 99725-0149. (907)479-0454. Fax: (907)479-3137. E-mail: mushing@p olarnet.com. Website: http://www.polarnet.com/users/mushing. Publisher: Todd Hoener. Estab. 1988. Bimonthly "year-round, international magazine for all dog-powered sports, from sledding to skijoring to weight pulling to carting to packing. We seek to educate and entertain." Circ. 10,000. Photo/art originals are returned at job's completion. Sample copies available for $5. Art guidelines available for SASE with first-class postage.
Cartoons: Approached by 10 cartoonists/year. Buys 1 cartoon/issue. Prefers humorous cartoons; single panel b&w line drawings with gagline. Send query letter with roughs. Samples are not filed and are returned

by SASE if requested by artist. Reports back with 1-6 months. Buys first rights and reprint rights. Pays $25 for b&w and color.

Illustrations: Approached by 10 illustrators/year. Buys 0-1 illustrations/issue. Prefers simple; healthy, happy sled dogs; some silhouettes. Considers pen & ink and charcoal. Send query letter with SASE and photocopies. Accepts disk submissions if Mac compatible. Send EPS or TIFF files with hardcopy. Samples are returned by SASE if requested by artist. Reports back within 1-6 months. Portfolio review not required. Buys first rights. Pays on publication; $130 for color cover; $25 for b&w, $25 for color inside; $25 for spots. Finds artists through submissions.

Tips: "Be familiar with sled dogs and sled dog sports. We're most open to using freelance illustrations with articles on dog behavior, adventure stories, health and nutrition. Illustrations should be faithful and/or accurate to the sport. Cartoons should be faithful and tasteful (e.g., not inhumane to dogs)."

© Dan Kennedy

To illustrate an article entitled "Breakthrough" for *Mushing* magazine, Dan Kennedy called on a childhood memory. "I tried to remember what it felt like when, and after, falling through the ice on a cold winter day," says Kennedy, who plunged through ice at age 10. He sought to portray a cold, frustrated feeling in the animals as well as the human figure in this pen & ink piece. This was the artist's first illustration for a magazine article.

‡**MUTUAL FUNDS MAGAZINE**, 2200 SW 10th St., Deerfield Beach FL 33442-8799. (954)421-1000. Fax: (954)570-8200. E-mail: gaunder@mfmag.com. Website: http://www. mfmag.com. Art Director: Jan

Gaunder. Estab. 1994. Monthly consumer magazine covering mutual funds. Circ. 350,000.
Cartoons: Approached by 10 cartoonists/year. Buys 1 cartoon/issue. Prefers mutual fund themes. Prefers single panel, humorous, color washes, with gaglines. Send query with photocopies, tearsheets. Samples are filed or returned by SASE. Reports back only if interested. Buys all rights. Pays on publication; $150-400 for color.
Illustration: Approached by 100 illustrators/year. Buys 10 illustrations/issue. Prefers detailed, pen & ink, wash. 20% of freelance illustration demands knowledge of any Mac based software. Send postcard sample or query letter with printed samples, photocopies and tearsheets; or contact through artists' rep. Send follow-up postcard sample every month. Accepts disk submissions compatible with Mac. Send EPS or TIFF files. Samples are filed or returned by SASE. Reports back only if interested. Art director will contact artist for portfolio review of color final art, photographs, tearsheets, transparencies if interested. Buys all rights. Pays on publication; $400-1,000 for color cover; $175-1,000 for color inside; $150-250 for spots. Finds illustrators through sourcebooks, other magazines, direct mail.
Tips: "Look at *Mutual Funds* before you contact me. Know the product and see if you fit in."

MY FRIEND, 50 St. Paul's Ave., Boston MA 02130-3491. (617)522-8911. Website: http://www.pauline.org. Contact: Graphic Design Dept. Estab. 1979. Monthly Catholic magazine for kids, b&w with 4-color cover, containing information, entertainment, and Christian information for young people ages 6-12. Circ. 14,000. Originals returned at job's completion. Sample copies free for 9×12 SASE with first-class postage. Art guidelines available.
Illustrations: Approached by 60 illustrators/year. Buys 6 illustrations/issue; 60/year. Works on assignment only. Prefers humorous, realistic portrayals of children. Considers pen & ink, watercolor, airbrush, acrylic, marker, colored pencil, oil, charcoal, mixed media and pastel. Send query letter with résumé, SASE, tearsheets, photocopies. Accepts disk submissions compatible with Windows 3.1, Aldus PageMaker 5.0 or Corel-Draw 5.0. Send TIFF files. Samples are filed or are returned by SASE if requested by artist. Reports back to the artist within 1-2 months only if interested. Portfolio review not required. Rights purchased vary according to project. Pays on publication; $200 for color cover; $100 for full page b&w and color inside.
Design: Needs freelancers for design, production and multimedia projects. Design demands knowledge of Aldus PageMaker, Aldus FreeHand and CorelDraw 5.0. Send query letter with résumé, photocopies and tearsheets. Pays by project.

‡NATIONAL BUS TRADER, 9698 W. Judson Rd., Polo IL 61064. (814) 946-2341. Fax: (815) 946-2347. Editor: Larry Plachno.
 • Also publishes books. See listing for Transportation Trails in Book Publishers section. Editor is
 looking for artists to commission oil paintings for magazine covers. He is also looking for artists who
 can render historic locomotives. He uses mostly paintings or drawings. He also considers silhouettes
 of locomotives and other historic transportation. He is open to artists who work on Adobe Illustrator
 and QuarkXPress.

NATIONAL BUSINESS EMPLOYMENT WEEKLY, P.O. Box 300, Princeton NJ 08543-0300. (609)520-7311. Fax: (609)520-4309. Art Director: Larry Nanton. Estab. 1981. Weekly newspaper covering job search and career guidance for middle-senior level executives. Circ. 33,000. Originals returned at job's completion. Art guidelines available.
Cartoons: Buys 1 cartoon/issue. Subject must pertain to some aspect of job hunting; single panel b&w washes and line drawings with or without gagline. Send query letter with finished cartoons. Samples are not filed and are returned by SASE. Reports back to the artist only if interested. Buys first rights. Pays $50 for b&w.
Illustrations: Approached by 12 illustrators/year. Buys 2 illustrations/issue. Works on assignment only. Prefers b&w images and designs of people in all stages of the job search. Considers pen & ink, watercolor, airbrush and pencil. Send postcard sample or query letter with tearsheets. Samples are filed. Reports back to the artist only if interested. Portfolio review not required. Buys one-time rights and reprint rights. Pays on publication; $125 for b&w inside.
Tips: "Artist should have a good imagination, nice sense of design and be competent in drawing people."

NATIONAL DRAGSTER, 2220 E. Alosta Ave., Suite 101, Glendora CA 91740. Fax: (818)335-6651. E-mail: ndragster@aol.com or ndrag@ix.netcom.com. Website: http://www.goracing.com/nhra/. Art Director: Jill Flores. Estab. 1959. Weekly drag racing b&w tabloid with 4-color cover and "tabazine" style design distributed to 80,000 association (NHRA) members. "The nation's leading drag racing weekly." Circ. 80,000. Accepts previously published artwork. Originals are not returned after publication. Sample copies available upon request. Art guidelines available.
Cartoons: Buys 5-10 cartoons/year. Prefers drag racing theme. Prefers single panel b&w line drawings and washes with gagline. Send query letter with samples of style. Samples are filed. Reports back only if interested. Negotiates rights purchased. Pays on publication; minimum $50 for b&w.
Illustrations: Buys illustrations for covers, full-page special features and spots. Buys 10-20 illustrations/year. Style is modern creative image, line or wash, sometimes humorous, style of Don Weller. Needs editorial

and technical illustration. Prefers drag racing-oriented theme, rendered in pen & ink, airbrush, mixed media or markers, with vibrant use of color. Send query letter with brochure showing art style, tearsheets, slides, transparencies, photostats or photocopies. Looks for realistic automotive renderings. Accepts disk submissions compatible with Mac except Aldus PageMaker files. Samples are filed. Reports back only if interested. Publication will contact artist for portfolio review if interested. Portfolio can include printed copies, tearsheets, photostats and photographs. Negotiates rights purchased. Pays on publication; $100 for b&w; up to $1,000 for color inside.
Design: Needs freelancers for production. Freelance work demands knowledge of Adobe Photoshop, Adobe Illustrator, Aldlus FreeHand and QuarkXPress. Send query letter with photocopies, tearsheets, résumé, photographs, slides and transparencies. Pays by the project.
Tips: Looking for "bright colors, in a wide range of styles, techniques and mediums." Send "concept drawings, drag racing illustrations (actual cars, cut-aways, etc.). Send me samples that knock me out of my chair. Do not have to be drag racing-related, but should be automotive-related. I love to get samples."

NATIONAL ENQUIRER, Dept. AGDM, Lantana FL 33464. (407)586-1111, ext. 2274. Assistant Editor: Joan Cannata-Fox. A weekly tabloid. Circ. 3.8 million. Originals are returned at job's completion.
Cartoons: "We get 1,000-1,500 cartoons weekly." Buys 300 cartoons/year. Prefers animal, family, husband/wife and general themes. Nothing political or off-color. Prefers single panel b&w line drawings and washes with or without gagline. Computer-generated cartoons are not accepted. Prefers to do own coloration. Send query letter with finished cartoons and SASE. Samples are not filed and are returned only by SASE. Reports back within 2-3 weeks. Buys first and one-time rights. Pays $300 for b&w plus $40 each additional panel.
Tips: "Study several issues to get a solid grasp of what we buy. Gear your work accordingly."

NATIONAL GARDENING, 180 Flynn Ave., Burlington VT 05401. (802)863-1308. Fax: (802)863-5962. E-mail: 76711.345@compuserve.com. Art Director: Linda Provost. Estab. 1980. Bimonthly magazine "specializing in edible and ornamental gardening; environmentally conscious; fun and informal but accurate; a gardener-to-gardener network." 4-color design is "crisp but not slick, fresh but not avant-garde—colorful, informative, friendly, practical." Circ. 200,000. Sometimes accepts previously published artwork. Original artwork returned after publication. Sample copies available. 5% of freelance work demands knowledge of Adobe Illustrator, QuarkXPress, Aldus FreeHand, Adobe Photoshop or Fractal Painter.
Illustrations: Approached by 200 illustrators/year. Buys 1-7 illustrations/issue. Works on assignment only. Needs editorial and technical illustration. Preferred themes or styles "range from botanically accurate how-to illustrations to less literal, more interpretive styles. See the magazine. We use all media." Style of Kim Wilson Eversz, Andrea Eberbach, Amy Bartlett Wright. Send postcard sample or sample sheet. Accepts disk submissions. Send EPS files. Samples are filed or returned by SASE if requested. Reports back only if interested "i.e. ready to assign work." Publication will contact artist for portfolio review if interested. Portfolio should include "your best work in your best form." Buys one-time rights. Pays within 30 days of acceptance; $50-350 for b&w, $100-700 for color inside; approximately $125 for spots. Finds artists through submissions/self-promotions and *American Showcase*.
Tips: "Send me a printed promotional four-color (stiff) sheet with your name, address, phone. Something I can see at a glance and file easily. We're interested in computer illustrations in *whatever* program. Artist should be able to help decode any computer problems that arise innputting into QuarkXPress and printing."

NATIONAL GEOGRAPHIC, 17th and M Streets NW, Washington DC 20036. (202)857-7000. Art Director: Chris Sloan. Estab. 1888. Monthly. Circ. 10 million. Original artwork returned 1 year after publication.
Illustrations: Works with 20 illustrators/year. Buys 50 illustrations/year. Interested in "full-color, representational renderings of historical and scientific subjects. Nothing that can be photographed is illustrated by artwork. No decorative, design material. We want scientific geological cut-aways, maps, historical paintings." Works on assignment only. Prefers to see portfolio and samples of style. Samples are returned by SASE. "The artist should be familiar with the type of painting we use." Provide brochure, flier or tearsheet to be kept on file for future assignments. **Pays on acceptance**; varies according to project.
Tips: "Send historical and scientific illustrations, ones that are very informative and very accurate. No decorative, abstract portraits."

‡**THE NATIONAL NOTARY**, 8236 Remmet Ave., Box 7184, Canoga Park CA 91304-7184. (818)713-4000. Contact: Production Editor. Emphasizes "notaries public and notarization—goal is to impart knowledge, understanding, and unity among notaries nationwide and internationally." Readers are notaries of varying primary occupations (legal, government, real estate and financial), as well as state and federal officials

 THE DOUBLE DAGGER before a listing indicates that the listing is new in this edition. New markets are often more receptive to freelance submissions.

and foreign notaries. Bimonthly. Circ. 80,000. Original artwork not returned after publication. Sample copy $5.

Cartoons: Approached by 5-8 cartoonists/year. Cartoons "must have a notarial angle"; single or multiple panel with gagline, b&w line drawings. Send samples of style. Samples not returned. Reports in 4-6 weeks. Call to schedule an appointment to show a portfolio. Buys all rights. Pays on publication; pay is negotiable.

Illustrations: Approached by 3-4 illustrators/year. Uses about 3 illustrations/issue; buys all from local freelancers. Works on assignment only. Themes vary, depending on subjects of articles. 100% of freelance work demands knowledge of Adobe Illustrator, QuarkXPress or Aldus FreeHand. Send business card, samples and tearsheets to be kept on file. Samples not returned. Reports in 4-6 weeks. Call for appointment. Buys all rights. Negotiates pay; on publication.

Tips: "We are very interested in experimenting with various styles of art in illustrating the magazine. We generally work with Southern California artists, as we prefer face-to-face dealings."

NATIONAL REVIEW, 150 E. 35th St., New York NY 10016. (212)679-7330. Contact: Art Director. Emphasizes world events from a conservative viewpoint; bimonthly b&w with 4-color cover, design is "straight forward—the creativity comes out in the illustrations used." Originals are returned after publication. Uses freelancers mainly for illustrations of articles and book reviews, also covers.

Cartoons: Buys 17 cartoons/issue. Interested in "light political, social commentary on the conservative side." Send appropriate samples and SASE. Reports in 2 weeks. Buys first North American serial rights. Pays on publication; $50 for b&w.

Illustrations: Buys 15 illustrations/issue. Especially needs b&w ink illustration, portraits of political figures and conceptual editorial art (b&w line plus halftone work). "I look for a strong graphic style; well-developed ideas and well-executed drawings." Style of Tim Bower, Jennifer Lawson, Janet Hamlin, Alan Nahigian. Works on assignment only. Send query letter with brochure showing art style or tearsheets and photocopies. No samples returned. Reports back on future assignment possibilities. Call for an appointment to show portfolio of final art, final reproduction/product and b&w tearsheets. Include SASE. Buys first North American serial rights. Pays on publication; $100 for b&w inside; $500 for color cover.

Tips: "Tearsheets and mailers are helpful in remembering an artist's work. Artists ought to make sure their work is professional in quality, idea and execution. Recent printed samples alongside originals help. Changes in art and design in our field include fine art influence and use of more halftone illustration." A common mistake freelancers make in presenting their work is "not having a distinct style, i.e., they have a cross sample of too many different approaches to rendering their work. This leaves me questioning what kind of artwork I am going to get when I assign a piece."

NATIONAL RURAL LETTER CARRIER, 1630 Duke St., 4th Floor, Alexandria VA 22314. (703)684-5545. Managing Editor: RuthAnn Saenger. Emphasizes news and analysis of federal law and current events for rural letter carriers and family-oriented, middle-Americans; many are part-time teachers, businessmen and farmers. Biweekly; b&w, 8¼×11. Circ. 80,000. Mail art and SASE. Reports in 1 month. Original artwork returned after publication. Previously published, photocopied and simultaneous submissions OK. Buys first rights. Sample copy 55¢. Art guidelines available.

Illustrations: Receives 1 cartoon and 2 illustrations/month from freelance artists. Buys 12 covers/year on rural scenes, views of rural mailboxes and rural people. Buys 1 illustration/issue from freelancers. Interested in pen & ink or pencil on rural, seasonal and postal matter. Especially needs rural mailboxes and sketches of scenes on rural delivery. Works on assignment only. Send query letter with brochure showing art style or résumé, tearsheets, photocopies, slides and photographs. Samples returned by SASE. Reports in 1 week, if accepted; 1 month if not accepted. Write for appointment to show portfolio of original/final art, final reproduction/product, color and b&w tearsheets, photostats and photographs. Buys all rights on a work-for-hire basis. Pays on publication; $100 for b&w cover.

Tips: "Please send in samples when you inquire about submitting material." Has a definite need for "realistic painting and sketches. We need a clean, crisp style. Subjects needed are rural scenes, mailboxes, animals and faces. We need fine b&w, pen & ink and watercolor."

‡NATURE CONSERVANCY, 1815 N. Lynn St., Arlington VA 22209. Fax: (703)841-9692. E-mail: demibold@aol.com. Website: http://www.tnc.org. Art Director: Kelly Johnson. Estab. 1951. Bimonthly membership magazine of nonprofit conservation organization. "The intent of the magazine is to educate readers about broad conservation issues as well as to inform them about the Conservancy's specific accomplishments. The magazine is achievement-oriented without glossing over problems, creating a generally positive tone. The magazine is rooted in the Conservancy's work and should be lively, engaging and readable by a lay audience." Sample copies available.

Illustration: Approached by 100 illustrators/year. Buys 1-5 illustrations/issue. Considers all media. 10% of freelance illustration demands knowledge of Adobe Photoshop, Adobe Illustrator and QuarkXPress. Send query letter with photocopies and tearsheets. Samples are sometimes filed and are not returned. Reports back only if interested. Rights purchased vary according to project. **Pays on acceptance**. Payment varies. Finds illustrators through sourcebooks, magazines and submissions.

‡NETWORK COMPUTING, 600 Community Dr., Manhasset NY 11030. (516)562-5000. Fax: (516)562-7293. E-mail: editor@nwc.com. Website: http://www.techweb.cmp.com/nwc. Editorial Assistant: Debbie Rizzo. Monthly trade magazine for those who professionally practice the art and business of networkology (a technology driver of networks). Circ. 185,500. Sample copies available. Contact art director for art guidelines. **Illustration:** Approached by 30-50 illustrators/year. Buys 6-7 illustrations/issue. Considers all media. 60% of freelance illustration demands knowledge of Aldus FreeHand, Adobe Photoshop, Adobe Illustrator. Send postcard sample with follow-up sample every 3-6 months. Contact through artists' rep. Accepts disk submissions compatible with QuarkXPress 7.5/version 3.3. Send EPS files. Samples are returned. Reports back only if interested. Art director will contact artist for portfolio review of tearsheets if interested. Buys one-time rights. **Pays on acceptance:** $700-1,000 for b&w, $1,000-1,500 for color cover; $300 miniminum for b&w, $350-500 for color inside. Pays $350-500 for spots. Finds illustrators through agents, sourcebooks, word of mouth, submissions.
Tips: "I like artists with a unique looking style—colorful but with one-two weeks turnaround."

NETWORK WORLD, 161 Worcester Rd., The Meadows, Framingham MA 01701. (508)875-6400. Fax: (508)820-3467. Art Director: Rob Stave. Weekly 4-color tabloid with "conservative but clean computer graphics intensive (meaning lots of charts)." Emphasizes news and features relating to the communications field. Accepts previously published artwork. Interested in buying second rights (reprint rights) to previously published artwork. Originals are returned after publication. 10% of freelance work demands knowledge of Aldus FreeHand.
Illustrations: Themes depend on storyline. Works on assignment only. Send query letter with brochure and photocopies to be kept on file. Reports only if interested. Publication will contact artist for portfolio review if interested. Buys first rights. **Pays on acceptance**; $175 and up for b&w, $300 and up for color inside; $1,000 for color cover.
Tips: "All of our inhouse charts and graphics are done on the Mac. But most freelance illustration is not done on the Mac. My need for freelance artists to do illustration has actually increased a bit. Use one-three illustrations per week on average."

‡NEW FRONTIER MAGAZINE, 41 White Oak, Arden NC 28704. (704)684-0334. Fax: (704)684-2571. E-mail: newfrontier@aol.com. Website: http://www.newfrontier.com. Editor: Swami Virato. Estab. 1980. Bimonthly holistically oriented consumer magazine with a metaphysical, environmental slant focusing on consciousness for a new age. Circ. 60,000. Sample copies available for 9×12 envelope and $1.24 postage.
Illustration: 90% of freelance illustration demands knowledge of Aldus PageMaker and CorelDraw. Send query letter with photocopies. After initial mailing, send follow-up postcard sample every 6 months. "We can accept Aldus PageMaker 6 files or PM5 or CorelDraw for Windows 95." Returned by SASE. Reports back only if interested. Buys one-time and reprint rights. Pays on publication; $100-300 for color cover; $25-100 for b&w, $50-200 for color inside. Pays $10-25 for spots.
Design: Needs freelancers for design, production and multimedia projects. Prefers designers with experience in computer/HTML. 100% of freelance work demands knowledge of Aldus PageMaker, CorelDraw, Photo-Paint. Send query letter with photocopies.
Tips: "We love transcendental, space art and art that inspires. No violence, but sensuality fine."

NEW MYSTERY MAGAZINE, 175 Fifth Ave., Room 2001, New York NY 10010. (212)353-1582. E-mail: newmyst@aol.com. Website: http://www.mysterynew.com/mystnew. Art Director: Dana Irwin. Estab. 1989. Quarterly literary magazine—a collection of mystery, crime and suspense stories with b&w drawings, prints and various graphics. Circ. 100,000. Accepts previously published artwork. Originals are returned at job's completion. Sample copies available for $7 plus $1.24 postage and SASE. Art guidelines for SASE with first-class postage. Needs computer-literate freelancers for illustration.
Cartoons: Approached by 100 cartoonists/year. Buys 1-3 cartoons/issue. Prefers themes relating to murder, heists, guns, knives, assault and various crimes; single or multiple panel, b&w line drawings. Send query letter with finished cartoon samples. Samples are filed and are returned by SASE if requested. Reports back within 1-2 months. Rights purchased vary according to project. Pays $20-50 for b&w, $20-100 for color.
Illustrations: Approached by 100 illustrators/year. Buys 12 illustrations/issue. Prefers themes surrounding crime, murder, suspense, noir. Considers pen & ink, watercolor and charcoal. Send postcard sample with SASE. Accepts disk submissions compatible with IBM. Send TIFF and GIF files. Samples are filed. Reports back within 1-2 months. To show a portfolio, mail appropriate materials: b&w photocopies and photographs. Rights purchased vary according to project. Pays on publication; $100-200 for covers; $25-50 for insides; $10-25 for spots.
Design: Needs freelancers for multimedia. Freelance work demands knowledge of Adobe Photoshop and QuarkXPress. Send query letter with SASE and tearsheets. Pays by the project, $100-200.
Tips: "Study an issue and send right-on illustrations. Do not send originals. Keep copies of your work. *NMM* is not responsible for unsolicited materials."

THE NEW PHYSICIAN, 1902 Association Dr., Reston VA 22091. (703)620-6600, ext. 246. Art Director: Julie Cherry. For physicians-in-training; concerns primary medical care, political and social issues relating

to medicine; 4-color, contemporary design. Published 9 times/year. Circ. 22,000. Original artwork returned after publication. Buys one-time rights. Pays on publication.

Illustrations: Approached by 100-200 illustrators/year. Buys 3 illustrations/issue from freelancers, usually commissioned. Samples are filed. Submit résumé and samples of style. Accepts disk submissions compatible with QuarkXPress 3.3, Adobe Illustrator 5.5, Adobe Photoshop 3.0, Aldus FreeHand. Send EPS files. Reports in 6-8 weeks. Buys one-time rights. Pays $800-1,000 for color cover; $100 for b&w $250 minimum for color, inside; $200 minimum for spots.

THE NEW REPUBLIC, 1220 19th St. NW, Washington DC 20036. (202)331-7494. Art Editor: Jed Perl. Estab. 1914. Weekly political/literary magazine; political journalism, current events in the front section, book reviews and literary essays in the back; b&w with 4-color cover. Circ. 100,000. Original artwork returned after publication. Sample copy for $3.50. 15% of freelance work demands computer skills.

Illustrations: Approached by 400 illustrators/year. Buys up to 5 illustrations/issue. Uses freelancers mainly for cover art. Works on assignment only. Prefers caricatures, portraits, 4-color, "no cartoons." Style of Vint Lawrence. Considers airbrush, collage and mixed media. Send query letter with tearsheets. Samples returned by SASE if requested. Publication will contact artist for portfolio review if interested. Portfolio should include color photocopies. Rights purchased vary according to project. Pays on publication; up to $600 for color cover; $250 for b&w and color inside.

NEW WRITER'S MAGAZINE, Box 5976, Sarasota FL 34277. (941)953-7903. E-mail: newriter@aol.com. Editor/Publisher: George J. Haborak. Estab. 1986. Bimonthly b&w magazine. Forum "where all writers can exchange thoughts, ideas and their own writing. It is focused on the needs of the aspiring or new writer." Rarely accepts previously published artwork. Original artwork returned after publication if requested. Sample copies for $3. Art guidelines for SASE with first-class postage.

Cartoons: Approached by 2-3 cartoonists/year. Buys 1-3 cartoons/issue. Prefers cartoons "that reflect the joys or frustrations of being a writer/author"; single panel b&w line drawings with gagline. Send query letter with samples of style. Samples are sometimes filed or returned if requested. Reports back within 1 month. Buys first rights. Pays on publication; $10 for b&w.

Illustrations: Buys 1 illustration/issue. Works on assignment only. Prefers line drawings. Considers watercolor, mixed media, colored pencil and pastel. Send postcard sample. Samples are filed or returned if requested by SASE. Reports within 1 month. To show portfolio, mail tearsheets. Buys first rights or negotiates rights purchased. Pays $10 for spots. Payment negotiated.

NEW YORK MAGAZINE, 755 Second Ave., New York NY 10017. (212)880-0700. Design Director: Robert Newman. Art Director: Syndi Becker. Emphasizes New York City life; also covers all boroughs for New Yorkers with upper-middle income and business people interested in what's happening in the city. Weekly. Original artwork returned after publication.

Illustrations: Works on assignment only. Send query letter with tearsheets to be kept on file. Prefers photostats as samples. Samples returned if requested. Call or write for appointment to show portfolio (drop-offs). Buys first rights. Pays $1,000 for b&w and color cover; $800 for 4-color, $400 for b&w full page inside; $225 for 4-color, $150 for b&w spot inside.

THE NEW YORKER, 20 W. 43rd St., 16th Floor, New York NY 10036. (212)840-3800. Emphasizes news analysis and lifestyle features.

Cartoons: Buys b&w cartoons. Receives 3,000 cartoons/week. Mail art or deliver sketches on Wednesdays. Include SASE. Strict standards regarding style, technique, plausibility of drawing. Especially looks for originality. Pays $575 minimum for cartoons. Contact cartoon editor.

Illustrations: All illustrations are commissioned. Portfolios may be dropped off Wednesdays between 10-6 and picked up on Thursdays. Mail samples, no originals. "Because of volume of submissions we are unable to respond to all submissions." No calls please. Emphasis on portraiture. Contact illustration department.

Tips: "Familiarize yourself with *The New Yorker.*"

‡NEXT PHASE, 5A Green Meadow Dr., Nantucket MA 02554. (508)325-0411. Editor: Kim Guarnaccia. Estab. 1989. Triannual literary magazine with "trend-setting design. *Next Phase* features quality fiction and artwork by undiscovered artists and writers. Environmental and humane topics preferred." Circ. 2,000. Accepts previously published work. Originals are returned at job's completion. Sample copies available for $3.95. Art guidelines free for SASE with first-class postage.

Illustrations: Approached by 30 illustrators/year. Buys 6 illustrations/issue. Open to computer-generated (Mac) artwork. Prefers pen & ink, watercolor, collage, airbrush and mixed media. Needs editorial illustration. Send query letter with SASE, tearsheets, photographs, photocopies and photostats. Samples are filed. Reports back within 3 weeks. Portfolio review not required. Requests work on spec before assigning a job. Pays 3 contributor copies.

Tips: Will not respond to submission unless SASE is included.

THE NORTH AMERICAN REVIEW, University of Northern Iowa, Cedar Falls IA 50614. (319)273-2077. Art Directors: Gary Kelley and Osie L. Johnson, Jr. Estab. 1815. "General interest bimonthly, especially

known for fiction (twice winner of National Magazine Award for fiction)." Accepts previously published work. Original artwork returned at job's completion. "Sample copies can be purchased on newsstand or examined in libraries."

Illustrations: Approached by 500 freelance artists/year. Buys 15 freelance illustrations/issue. Artists primarily work on assignment. Looks for "well-designed illustrations in any style. The magazine has won many illustration awards because of its insistence on quality. We prefer to use b&w media for illustrations reproduced in b&w and color for those reproduced in color. We prefer camera ready line art for spot illustrations." Send query letter with SASE, tearsheets, photocopies, slides, transparencies. Samples are filed if of interest or returned by SASE if requested by artist. Reports back to the artist only if interested. No portfolio reviews. Buys one-time rights. Contributors receive 2 copies of the issue. Pays on publication $300 for color, cover plus 50 tearsheets of cover only; $10 for b&w inside spot illustrations; $65 for b&w large illustration. No color inside.

Tips: "Send b&w photocopies of spot illustrations (printed size about 2×2). For the most part, our color covers and major b&w inside illustrations are obtained by direct assignment from illustrators we contact, e.g., Gary Kelley, Osie Johnson, Chris Payne, Skip Liepke and others. Write for guidelines for annual cover competition."

NORTH AMERICAN WHITETAIL MAGAZINE, 2250 Newmarket Pkwy., Suite 110, Marietta GA 30067. (404)953-9222. Fax: (404)933-9510. Editorial Director: Ken Dunwoody. Estab. 1982. Consumer magazine; "designed for serious hunters who pursue whitetailed deer." 8 issues/year. Circ. 175,000. Accepts previously published artwork. Original artwork is returned at job's completion. Sample copies available for $3. Art guidelines not available.

Illustrations: Approached by 30 freelance illustrators/year. Buys 1-2 freelance illustrations/issue. Works on assignment only. Considers pen & ink and watercolor. Send postcard sample and/or query letter with brochure and photocopies. Samples are filed or are returned by SASE if requested by artist. Reports back only if interested. To show a portfolio, mail appropriate materials. Rights purchased vary according to project. Pays 10 weeks prior to publication; $25 minimum for b&w, $75 minimum for color inside.

NOTRE DAME MAGAZINE, 415 Main Bldg., Notre Dame IN 46556. (219)631-4630. E-mail: donald.j.ne lson.4@nd.edu. Website: http://www.ND.EDU/~NDMAG. Art Director: Don Nelson. Estab. 1971. Quarterly 4-color university magazine that publishes essays on cultural, spiritual and ethical topics, as well as research news of the university for Notre Dame alumni and friends. Circ. 130,000. Accepts previously published artwork. Original artwork returned after publication.

Illustrations: Approached by 40 illustrators/year. Buys 5-8 illustrations/issue. Works on assignment only. Tearsheets, photographs, slides, brochures and photocopies OK for samples. Accepts disk submissions compatible with PC or Mac files. Samples are returned by SASE if requested. "Don't send submissions—only tearsheets and samples." To show portfolio, mail published editorial art. Buys first rights. Pays $2,000 maximum for color covers; $150-400 for b&w; $200-700 for color inside; $75-150 for spots.

Tips: "Looking for noncommercial style editorial art by accomplished, experienced editorial artists. Conceptual imagery that reflects the artist's awareness of fine art ideas and methods is the type of thing we use. Sports action illustrations not used. Cartoons not used."

NOW AND THEN, Box 70556 ETSU, Johnson City TN 37614-0556. (615)929-5348. Fax: (615)929-5348. Editor: Jane Harris Woodside. Estab. 1984. Magazine covering Appalachian issues and arts, published 3 times a year. Circ. 1,000. Accepts previously published artwork. Originals are returned at job's completion. Sample copies available for $4.50. Art guidelines available. Freelancers should be familiar with Aldus FreeHand or Aldus PageMaker.

Cartoons: Approached by 25 cartoonists/year. Prefers Appalachia issues, political and humorous cartoons; b&w washes and line drawings. Send query letter with brochure, roughs and finished cartoons. Samples not filed and are returned by SASE if requested by artist. Reports back within 4-6 months. Buys one-time rights. Pays $25 for b&w.

Illustrations: Approached by 3 illustrators/year. Buys 1-2 illustrations/issue. Prefers Appalachia, any style. Considers b&w or 2- or 4-color pen & ink, collage, airbrush, marker and charcoal. Send query letter with brochure, SASE and photocopies. Samples are not filed and are returned by SASE if requested by artist. Reports back within 4-6 months. Publication will contact artist for portfolio review if interested. Portfolio should include b&w tearsheets, slides, final art and photographs. Buys one-time rights. Pays on publication; $25-50 for b&w or color cover.

Tips: "We have special theme issues, illustrations have to have something to do with theme. Write for guidelines, enclose SASE."

NUGGET, Dugent Publishing Co., 14411 Commerce Way, Suite 420, Miami Lakes FL 33016-1598. Editor: Christopher James. Illustration Assignments: Nye Willden. 4-color "electic, modern" magazine for men and women with fetishes. Published 10 times/year. Art guidelines for SASE with first-class postage.

Cartoons: Buys 5 cartoons/issue. Receives 50 submissions/week. Interested in "funny fetish themes." Black & white only for spots and for page. Prefers to see finished cartoons. Include SASE. Reports in 2

weeks. Buys first North American serial rights. Pays $75 for spot drawings; $125 for full page.
Illustrations: Buys 2 illustrations/issue. Interested in "erotica, cartoon style, etc." Works on assignment only. Prefers to see samples of style. Send query letter with photocopies and tearsheets. Samples to be kept on file for future assignments. No samples returned. Publication will contact artist for portfolio review if interested. Buys first North American serial rights. Pays $200 for b&w inside; $75 for spots. Finds artists through submissions/self-promotions.
Tips: Especially interested in "the artist's anatomy skills, professionalism in rendering (whether he's published or not) and drawings which relate to our needs." Current trends include "a return to the 'classical' realistic form of illustration, which is fine with us because we prefer realistic and well-rendered illustrations."

‡NUTSHELL NEWS, 21027 Crossroads Circle, Waukesha WI 53187. (414) 796-8776. Monthly consumer magazine for miniature hobbyists. Circ. 40,000. Sample copies available.
 • Published by Kalmbach Publishing, which also publishes *Astronomy*, *Finescale Modeler*, *Model Railroader*, and *Trains*. See individual listings for each magazine's needs.
Illustration: Approached by 20-30 illustrators/year. Buys 0-2 illustrations/issue. Considers all media. 20% of illustration demands knowledge of Adobe Photoshop and Adobe Illustrator. Send postcard sample and/or printed samples or photocopies. Send follow-up postcard every 6-8 months. Accepts disk submissions compatible with Adobe Illustrator 5.5 and Adobe Photoshop 3.0. Samples are filed or returned by SASE. Reports back only if interested. Portfolio review required if interested in artist's work. Prefers to see portfolios on disk. Negotiates rights purchased. **Pays on acceptance**. Payments negotiable. Finds artists through word of mouth and submissions.
Design: Needs freelancers for design. Prefers local designers with experience in QuarkXPress 3.31, Adobe Illustrator 5.5 and/or Adobe Photoshop 3.0. Send query letter with printed samples or color copies.
Tips: "Know the subject matter. Be in the hobby."

‡OFF OUR BACKS, a woman's journal, 2337B 18th St., Washington DC 20009. (202)234-8072. E-mail: 73613.1256@compuserve.com. Office Coordinator: Jennie Ruby. Estab. 1970. Monthly feminist news journal; tabloid format; covers women's issues and the feminist movement. Circ. 10,000. Accepts previously published artwork. Original artwork is returned at the job's completion. Sample copies available. Art guidelines free for SASE with first class postage.
Cartoons: Approached by 6 freelance cartoonists/year. Buys 2 freelance cartoons/issue. Prefers political, feminist themes. Send query letter with roughs. Samples are filed. Reports back to the artist if interested within 1 month.
Illustrations: Approached by 20 freelance illustrators/year. Prefers feminist, political themes. Considers pen & ink. Send query letter with photocopies. Samples are filed. Reports back to the artist only if interested. To show a portfolio, mail appropriate materials.
Tips: "Ask for a sample copy. Preference given to feminist, woman-centered, multicultural line drawings."

OHIO MAGAZINE, 62 E. Broad St., Columbus OH 43215. (614)461-5083. Art Director: Brooke Wenstrup. 10 issues/year emphasizing feature material of Ohio "for an educated, urban and urbane readership"; 4-color; design is "clean, with white-space." Circ. 90,000. Previously published work OK. Original artwork returned after publication. Sample copy $2.50. 20% of freelance work demands knowledge of Adobe Illustrator, QuarkXPress, Adobe Photoshop or Aldus FreeHand.
Cartoons: Approached by 2 cartoonists/year. Buys 2 cartoons/year. Prefers b&w line drawings. Send brochure. Samples are filed or are returned by SASE. Reports back within 1 month. Buys one-time rights. Pays $50 for b&w and color.
Illustrations: Approached by 70 illustrators/year. Buys 2 illustrations/issue. Works on assignment only. Considers pen & ink, watercolor, collage, acrylic, marker, colored pencil, oil, mixed media and pastel. Send postcard sample or brochure, SASE, tearsheets and slides. Accepts disk submissions. Send Mac EPS files. Samples are filed or are returned by SASE. Reports back within 1 month. Request portfolio review in original query. Portfolio should include b&w and color tearsheets, slides, photostats, photocopies and final art. Buys one-time rights. **Pays on acceptance**; $250-400 for cover; $50-500 for inside; $50-100 for spots. Finds artists through submissions and gallery shows.
Design: Needs freelancers for design and production. 100% of freelance work demands knowledge of Adobe Photoshop, Adobe Illustrator and QuarkXPress. Send query letter with tearsheets and slides.
Tips: "Using more of a fine art-style to illustrate various essays—like folk art-style illustrators. Please take time to look at the magazine if possible before submitting."

OKLAHOMA TODAY MAGAZINE, 401 Will Rogers Bldg., Oklahoma City OK 73105. (405)521-2496. Fax: (405)522-4588. Editor: Jeanne Devlin. Estab. 1956. Bimonthly regional, upscale consumer magazine focusing on all things that define Oklahoma and interest Oklahomans. Circ. 43,000. Accepts previously published artwork. Originals are returned at job's completion. Sample copies and art guidelines available. 20% of freelance work demands knowledge of Aldus PageMaker, Adobe Illustrator and Adobe Photoshop.
Cartoons: Buys 1 cartoon/issue. Prefers humorous cartoons focusing on Oklahoma, oil, cowboys or Indians with gagline. Send query letter with roughs. Samples are filed. Reports back within days if interested; months

if not. Buys one-time rights. Pays $50 minimum for b&w, $75 minimum for color.

Illustrations: Approached by 24 illustrators/year. Buys 2-3 illustrations/issue. Considers pen & ink, watercolor, collage, airbrush, acrylic, marker, colored pencil, oil, charcoal and pastel. Send query letter with brochure, résumé, SASE, tearsheets and slides. Accepts Mac compatible disk submissions. Samples are filed. Reports back within days if interested; months if not. Portfolio review required if interested in artist's work. Portfolio should include b&w and color thumbnails, tearsheets and slides. Buys one-time rights. Pays $200-500 for b&w, $200-750 for color cover; $50-500 for b&w, $75-750 for color inside. Finds artists through sourcebooks, other publications, word of mouth, submissions and artist reps.

Tips: Illustrations to accompany short stories and features are most open to freelancers. "Read the magazine; have a sense of the 'New West' spirit and do an illustration or cartoon that exhibits your understanding of *Oklahoma Today.*"

‡**OLD BIKE JOURNAL**, 1010 Summer St., Stamford CT 06905. (203)425-8777. Fax: (203)425-8775. Art Director: Todd Mitchell. Estab. 1989. Monthly international classic and collectible motorcycle magazine dedicated to classics of yesterday, today and tomorrow. Includes hundreds of classified ads for buying, selling or trading bikes and parts worldwide. Circ. under 100,000. Originals are returned at job's completion if requested. Sample copy $4 (US only). Art guidelines available. Computer-literate freelancers for illustration should be familiar with Adobe Photoshop, Adobe Illustrator or QuarkXPress.

Cartoons: Approached by 12 cartoonists/year. Buys 1-2 cartoons/issue. Prefers vintage motorcycling and humorous themes; single panel, b&w line drawings. Send query letter with copies of finished work. Samples are filed or are returned by SASE if requested by artist. Reports back within 1 month. Buys one-time rights. Pays $50 for b&w, $100 for color.

Illustrations: Approached by 50-100 illustrators/year. Buys 1-5 illustrations/issue. Considers pen & ink, watercolor, airbrush, marker and colored pencil. Send query letter with brochure, SASE, tearsheets, photographs, photocopies, photostats, slides and transparencies. Samples are filed or are returned by SASE if requested. Reports back within 1 month. Call for appointment to show portfolio. Portfolio should include tearsheets, slides, photostats, photocopies and photographs. Buys one-time rights. Pays on publication; $25 for b&w, $100 for color.

Tips: "Send copies or photos of final art pieces. If they seem fit for publication, the individual will be contacted and paid upon publication. If not, work will be returned with letter. Often, artists are contacted for more specifics as to what might be needed."

ONLINE ACCESS MAGAZINE, 900 N. Franklin St., #700, Chicago IL 60610. (312)573-1700. Fax: (312)573-0520. Editor-in-Chief: Kathy McCabe. Estab. 1986. Monthly consumer magazine focusing on online computer services. "Your connection to Online Services, Bulletin Boards and the Internet. Magazine that makes modems work." Circ. 70,000. Accepts previously published artwork. Sample copies and art guidelines not available.

Illustrations: Approached by 10 illustrators/year. Buys 8 illustrations/issue. Prefers colorful computer-related artwork. Considers pen & ink, watercolor, collage, airbrush, acrylic, marker, colored pencil, oil and mixed media. Needs computer-literate freelancers for illustration. Send query letter with tearsheets. Samples are filed. Publication will contact artist for portfolio review if interested. Portfolio should include b&w and color tearsheets. Buys reprint rights. **Pays on acceptance**; $500 for color cover; $100 for color inside.

OPTIONS, P.O. Box 470, Port Chester NY 10573. Contact: Wayne Shuster. E-mail: natway@aol.com. Estab. 1981. Bimonthly consumer magazine featuring erotic stories and letters, and informative items for gay and bisexual males and females. Circ. 60,000. Accepts previously published artwork. Originals are returned at job's completion. Sample copies available for $3.50 and 6×9 SASE with first-class postage.

Cartoons: Approached by 10 cartoonists/year. Buys 5 cartoons/issue. Prefers well drawn b&w, ironic, humorous cartoons; single panel b&w line drawings with or without gagline. Send query letter with finished cartoons. Samples are not filed and are returned by SASE if requested by artist. Reports back within 3 weeks. Buys all rights. Pays $20 for b&w.

Illustrations: Approached by 2-3 illustrators/year. Buys 2-4 illustrations/issue. Prefers gay male sexual situations. Considers pen & ink, airbrush b&w only. Also buys color or b&w slides (35mm) of illustrations. Send postcard sample. "OK to submit computer illustration—Adobe Photoshop 3.0 and Adobe Illustrator 5.0 (Mac)." Samples are not filed and are returned by SASE if requested by artist. Reports back to the artist only if interested. Portfolio review not required. Buys all rights. Pays on publication; $25-50 for b&w inside; $25 for spots. Finds artists through submissions.

OREGON QUARTERLY, 5228 University of Oregon, Eugene OR 97403-5228. (503)346-5048. Fax: (503)346-2220. E-mail: quarterly@oregon.uoregon.edu. Website: http://www.uoregon.edu/~oqrtly/oq.html. Editor: Guy Maynard. Estab. 1919. Quarterly 4-color alumni magazine. "The Northwest perspective. Regional issues and events as addressed by UO faculty members and alumni." Circ. 95,000. Accepts previously published artwork. Originals are returned at job's completion. Sample copies available for SASE with first-class postage.

Illustrations: Approached by 25 illustrators/year. Buys 1 illustration/issue. Prefers story-related themes and styles. Interested in all media. Send query letter with résumé, SASE and tearsheets. Samples are filed unless accompanied by SASE. Reports back only if interested. Buys one-time rights. Portfolio review not required. **Pays on acceptance**; $250 for b&w, $500 for color cover; $100 for b&w, $250 for color inside; $100 for spots.
Tips: "Send postcard, not portfolio."

OREGON RIVER WATCH, Box 294, Rhododendron OR 97049. (503)622-4798. Editor: Michael P. Jones. Estab. 1985. Quarterly b&w books published in volumes emphasizing "fisheries, fishing, camping, rafting, environment, wildlife, hiking, recreation, tourism, mountain and wilderness scenes and everything that can be related to Oregon's waterways. Down-home pleasant look, not polished, but practical—the '60s still live on." Circ. 2,000. Accepts previously published material. Original artwork returned after publication. Art guidelines for SASE with first-class postage.
Cartoons: Approached by 400 cartoonists/year. Buys 1-25 cartoons/issue. Cartoons need to be straightforward, about fish and wildlife/environmental/outdoor-related topics. Prefers single, double or multiple panel b&w line drawings, b&w or color washes with or without gagline. Send query letter with SASE, samples of style, roughs or finished cartoons. Samples are filed or are returned by SASE. Reports back within 2 months "or sooner—depending upon work load." Buys one-time rights. Pays in copies.
Illustrations: Approached by 600 illustrators/year. Works with 100 illustrators/year. Buys 225 illustrations/year. Needs editorial, humorous and technical illustration related to the environment. "We need b&w pen & ink sketches. We look for artists who are not afraid to be creative, rather than those who merely go along with trends." Send query letter with brochure, résumé, photocopies, SASE, slides, tearsheets and transparencies. "Include enough to show me your true style." Samples not filed are returned by SASE. Reports back within 2 weeks. Buys one-time rights. Pays in copies. 20% of freelance work demands computer skills.
Design: Needs freelancers for design and production. Send brochure, photocopies, SASE, tearsheets, résumé, photographs, slides and transparencies. Pays in copies.
Tips: "Freelancers must be patient. We have a lot of projects going on at once but cannot always find an immediate need for a freelancer's talent. Being pushy doesn't help. I want to see examples of the artist's expanding horizons, as well as their limitations. Make it really easy for us to contact you. Remember, we get flooded with letters and will respond faster to those with a SASE."

ORGANIC GARDENING, 33 E. Minor St., Emmaus PA 18098. (610)967-8065. Art Director: Kimberly Harris. Magazine emphasizing gardening; 4-color; "uncluttered design." Published 9 times/year. Circ. 800,000. Original artwork returned after publication unless all rights are bought. Sample copies available only with SASE.
Illustrations: Buys 10 illustrations/issue. Works on assignment only. Prefers botanically accurate plants and, in general, very accurate drawing and rendering. Send query letter with brochure, tearsheets, slides and photographs. Samples are filed or are returned by SASE only. Reports back within 1 month. Call or write for appointment to show portfolio of color or b&w final reproduction/product. Occasionally needs technical illustration. Buys first rights or one-time rights. Pays $50-300 for b&w, $75-600 for color for spots art only. "We will pay more if size is larger than ¼ to ⅓ page."
Tips: "Work should be very accurate and realistic. Our emphasis is 'how-to' gardening; therefore illustrators with experience in the field will have a greater chance of being published. Detailed and fine rendering quality is essential. We send sample issues to artists we publish."

ORLANDO MAGAZINE, 260 Maitland Ave., Altamonte Springs FL 32701. (407)767-8338. Fax: (407)767-8348. Art Director: Bruce Borich. Estab. 1946. "We are a 4-color monthly city/regional magazine covering the Central Florida area—local issues, sports, home and garden, business, entertainment and dining." Circ. 30,000. Accepts previously published artwork. Originals are returned at job's completion. Sample copies available.
Illustrations: Buys 3-4 illustrations/issue. Works on assignment only. Needs editorial illustration. Send postcard, brochure or tearsheets. Samples are filed and are not returned. Reports back to the artist only if interested with a specific job. Portfolio review not required. Buys first rights, one-time rights or all rights (rarely). Pays on publication; $400 for color cover; $200-250 for color inside.
Tips: "Send appropriate samples. Most of my illustration hiring is via direct mail. The magazine field is still a great place for illustration."

♣**OUTDOOR CANADA MAGAZINE**, 703 Evans Ave., Suite 202, Toronto, Ontario M9C 5E9 Canada. Editor: James Little. 4-color magazine for the Canadian sports enthusiast and their family. Stories on fishing, camping, hunting, canoeing, wildlife and outdoor adventures. Readers are 81% male. Publishes 7 regular issues/year and a fishing special in February. Circ. 95,000.
Illustrations: Approached by 12-15 illustrators/year. Buys approximately 10 drawings/issue. Uses freelancers mainly for illustrating features and columns. Uses pen & ink, airbrush, acrylic, oil and pastel. Send postcard sample, brochure and tearsheets. Accepts disk submissions compatible with Adobe Illustrator 5.0. Send EPS, TIFF and PICT files. Buys first rights. Pays $150-300 for b&w, $300-500 for color inside; $150-

300 for spots. Artists should show a representative sampling of their work, including fishing illustrations. Finds most artists through references/word of mouth.

Design: Needs freelancers for multimedia. 20% of freelance work demands knowledge of Adobe Photoshop, Adobe Illustrator and QuarkXPress. Send brochure, tearsheets and postcards. Pays by the project.

Tips: "Meet our deadlines and our budget. Know our product."

‡**OUTPOSTS, WINGTIPS, COASTINES**, 1200 N. Seventh St., Minneapolis MN 55411. (612)522-1200. Fax: (612)522-1182. Art Director: Kristine Mattson. Bimonthly magazines. Circ. 500,000. Sample copies and art guidelines available.

• All three are inflight magazines for SkyWest, Comair and Business Express (all Delta Connections).

Cartoons: Approached by 2-3 cartoonists/year. Buys 10-15 cartoons/year. Prefers humor, political cartoons. Prefers single panel, political and humorous, color washes. Send query letter with photocopies and roughs. Samples are filed or returned. Reports back in 2 weeks. Buys all rights. **Pays on acceptance**; $50-250.

Illustration: Approached by 10 illustrators/year. Buys 10-15 illustrations/year. Prefers political, humor, trend issues. Considers all media. 50% of freelance illustration demands knowledge of Adobe Photoshop, Adobe Illustrator, QuarkXPress and Painter. Send postcard sample or query letter with printed samples and photocopies. After initial mailing, send follow-up postcard sample every 2-3 months. Accepts disk submissions. "We are Mac compatible and have the most updated versions of the programs." Samples are filed or returned. Reports back within 2-3 weeks. Request portfolio review in original query. Art director will contact artist for portfolio review of b&w and color thumbnails and transparencies if interested. Buys all rights. Pays on publication. Pays $50-250. Finds illustrators through word of mouth.

Tips: "See the magazines. We will often base an article on good art or ideas."

PARADE MAGAZINE, 711 Third Ave., New York NY 10017. (212)450-7000. Director of Design: Ira Yoffe. Photo Editor: Miriam White-Lorentzen. Weekly emphasizing general interest subjects. Circ. 38 million (readership is 81 million). Original artwork returned after publication. Sample copy and art guidelines available.

Illustrations: Uses varied number of illustrations/issue. Works on assignment only. Send query letter with brochure, résumé, business card and tearsheets to be kept on file. Call or write for appointment to show portfolio. Reports only if interested. Buys first rights, occasionally all rights.

Tips: "Provide a good balance of work."

‡**PC MAGAZINE**, One Park Ave., New York NY 10016. (212)503-5222. Assistant to Art Director: Frieda Smallwood. Estab. 1983. Bimonthly consumer magazine featuring comparative lab-based reviews of current PC hardware and software. Circ. 1.2 million. Sample copies available.

Illustration: Approached by 100 illustrators/year. Buys 10-20 illustrations/issue. Considers all media. 50% of freelance illustration demands knowledge of Adobe Photoshop, Adobe Illustrator. Send postcard sample and/or printed samples, photocopies, tearsheets. Accepts disk submissions compatible with Adobe Photoshop or Adobe Illustrator. Samples are filed. Portfolios may be dropped on Wednesday and should include tearsheets and transparencies. **Pays on acceptance**. Payment negotiable for cover and inside; $300 for spots.

PEDIATRIC ANNALS, 6900 Grove Rd., Thorofare NJ 08086. (609)848-1000. E-mail: mjerrell@slackinc. com. Managing Editor: Mary L. Jerrell. Monthly 4-color magazine emphasizing pediatrics for practicing pediatricians. "Conservative/traditional design." Circ. 33,000. Considers previously published artwork. Original artwork returned after publication. Sample copies available.

Illustrations: Prefers "technical and conceptual medical illustration which relate to pediatrics." Considers watercolor, acrylic, oil, pastel and mixed media. Send query letter with brochure, tearsheets, slides and photographs to be kept on file. Publication will contact artist for portfolio review if interested. Buys one-time rights or reprint rights. Pays $250-600 for color cover. Finds artists through submissions/self-promotions and sourcebooks.

Tips: "Illustrators must be able to treat medical subjects with a high degree of accuracy. We need people who are experienced in medical illustration, who can develop ideas from manuscripts on a variety of topics, and who can work independently (with some direction) and meet deadlines. Non-medical illustration is also used occasionally. We deal with medical topics specifically related to children. Include color work, previous medical illustrations and cover designs in a portfolio. Show a representative sampling of work."

PENNSYLVANIA MAGAZINE, Box 576, Camp Hill PA 17001-0576. (717)761-6620. Editor: Matthew K. Holliday. Estab. 1981. "Bimonthly magazine for readers, ages 35-60, interested in Pennsylvania history, travel and personalities." Circ. 40,000. Sample copy for $2.95. Art guidelines for SASE with first-class postage.

Illustrations: Buys 25 illustrations/year on history and travel-related themes. Send query letter with SASE and examples of previous work and prices for typical work. Reports in 3 weeks. Previously published, photocopied and simultaneous submissions OK. Buys first serial rights, one-time use. **Pays on acceptance**; $100 for color cover; $15-60 for b&w, $20-125 for color inside; $15-25 for spots.

PENNSYLVANIA SPORTSMAN, Box 90, Lemoyne PA 17043. (717)761-1400. Publisher: Sherry Ritchey. Editorial Director: Scott Rupp. Estab. 1959. Regional 4-color magazine featuring "outdoor sports, hunting, fishing, where to go, what to do, how to do it." 8 issues per year. Circ. 67,000. Original artwork is returned after publication. Sample copies available for $2. Art guidelines for SASE with first-class postage.
Illustrations: Buys editorial illustrations mainly for covers and feature spreads. Buys 2 or 3 illustrations/issue. Considers pen & ink and acrylics. Send query letter with brochure showing art style or tearsheets. Samples are filed. Samples not filed are returned by SASE. Publication will contact artist for portfolio review if interested. Portfolio should include slides. Requests work on spec before assigning job. Pays $150 for color cover. Buys one-time rights.
Tips: "Features needed in these areas: deer, turkey, bear, trout and bass. Buys little in way of illustrations—mainly photography."

‡**PERSIMMON HILL**, 1700 NE 63rd St., Oklahoma City OK 73111. (405)478-6404. Fax: (405)478-4714. Director of Publications: M.J. Van Deventer. Estab. 1963. Quarterly 4-color journal of Western heritage "focusing on both historical and contemporary themes. It features nonfiction articles on notable persons connected with pioneering the American West; art, rodeo, cowboys, flora and animal life; or other phenomena of the West of today or yesterday. Lively articles, well written, for a popular audience. "Contemporary design follows style of *Architectural Digest* and *European Travel and Life*." Circ. 15,000. Original artwork returned after publication. Sample copy for $7. Art guidelines for SASE with first-class postage. 50% of freelance work demands knowledge of Aldus PageMaker.
Illustrations: Approached by 75-100 illustrators/year. Buys 5 illustrations/issue. Works on assignment only. Prefers Western-related themes and pen & ink sketches. Send query letter with tearsheets, SASE, slides and transparencies. Samples are filed or returned by SASE if requested. Publication will contact artist for portfolio review if interested. Portfolio should include original/final art, photographs or slides. Buys first rights. Requests work on spec before assigning job. Pay varies. Finds artists through word of mouth and submissions.
Tips: "We are a museum publication. Most illustrations are used to accompany articles. Work with our writers, or suggest illustrations to the editor that can be the basis for a freelance article or a companion story. More interest in the West means we have to provide more contemporary photographs and articles about what people in the West are doing today. Study the magazine first—at least four issues."

‡**PERSONNEL JOURNAL**, 245 Fischer Ave., B-2, Costa Mesa CA 92626. (714)751-1883. Fax: (714) 751-4106. Design Director: Steve Stewart. Estab. 1922. Monthly trade journal for human resource business executives. Circ. 30,000. Sample copies available in libraries.
Illustrations: Approached by 100 illustrators/year. Buys 10 illustrations/issue. Prefers business themes. Considers all media. 40% of freelance illustration demands knowledge of Adobe Photoshop, QuarkXPress and Adobe Illustrator. Send postcard sample. Send follow-up postcard sample every 3 months. Samples are filed and are not returned. Does not report back, artist should call. Art director will contact for portfolio review if interested. Rights purchased vary according to project. **Pays on acceptance**: $350-500 for color cover; $100-400 for b&w and/or color inside; $75-150 for spots. Finds artists through agents, sourcebooks such as *LA Workbook*, magazines, word of mouth and submissions.
Tips: "Read our magazine."

PHANTASM, 235 E. Colorado Blvd., Suite 1346, Pasadena CA 91101. E-mail: phantasmug@aol.com. Editor and Publisher: J.F. Gonzales. Estab. 1990. Biannual horror fiction magazine. Circ. 1,000. Sometimes accepts previously published artwork. Originals returned at job's completion. Sample copies available for $4.95. Art guidelines for SASE with first-class postage.
Illustrations: Approached by 10 illustrators/year. Buys 6-8 illustrations/issue. Works on assignment only. Prefers horrific, surrealism. Considers pen & ink, oil, airbrush and pencil. Send postcard sample or query letter with résumé, brochure, transparencies, SASE, tearsheets, photographs, photocopies and slides. Samples are filed or are returned by SASE if requested by artist. Publication will contact artist for portfolio review if interested. Portfolio should include b&w thumbnails, tearsheets, slides, final art and photographs. Buys first rights. Pays on publication; $20 for b&w cover; $10 for b&w inside; $5-10 for spots. Finds artists through word of mouth and submissions.
Tips: "We are a small publication and tend to use the same artists each issue, but will use someone new if the work impresses us. Be original, be familiar with other artists of this genre (horror)—Michael Whelan, J.K. Potter, Alan Clark, etc. Illustrations are done by assignment to illustrate the fiction we publish. We usually ask for one illustration per story. Illustration usually reflects some mood/theme of piece."

PHI DELTA KAPPAN, Box 789, Bloomington IN 47402. E-mail: kappan@pdkintl.org. Design Director: Carol Bucheri. Emphasizes issues, policy, research findings and opinions in the field of education. For members of the educational organization Phi Delta Kappa and subscribers. Black & white with 4-color cover and "conservative, classic design." Published 10 times/year. Circ. 150,000. Include SASE. Reports in 2 months. "We return cartoons after publication." Sample copy for $4.50. "The journal is available in most public and college libraries."

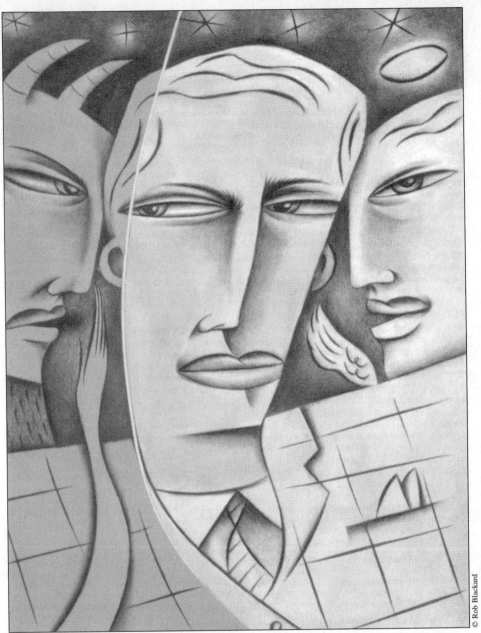

Rob Blackard created this bold angel/devil illustration to accompany an article in *Personnel Journal* about ethics and business practices. The assignment was Blackard's first job for the magazine, which he landed as a result of promotional mailings. (He sends postcards three or four times a year.) The artist, who does design work in addition to his editorial assignments, got a positive response from *Personnel Journal*'s readers. "People liked it, which is always nice to hear," he says.

Cartoons: Approached by over 100 cartoonists/year. Looks for "finely drawn cartoons, with attention to the fact that we live in a multi-racial, multi-ethnic world."

Illustrations: Approached by over 100 illustrators/year. Uses one 4-color cover and spread and approximately seven b&w illustrations/issue, all from freelancers who have worked on assignment. Prefers style of Rob Colvin, Mario Noche. Most illustrations depict some aspect of the education process (from pre-kindergar-

ten to university level), often including human figures. Send postcard sample. Samples returned by SASE. To show a portfolio, mail a few slides or photocopies with SASE. "We can accept computer illustrations that are Mac formatted (EPS or TIFF files. Adobe Photoshop 2.5.1 or Adobe Illustrator 5.0.1)." Buys one-time rights. Payment varies.

Tips: "We look for artists who can create a finely crafted image that holds up when translated onto the printed page. Our journal is edited for readers with master's or doctoral degrees, so we look for illustrators who can take abstract concepts and make them visual, often through the use of metaphor."

PHYSICIAN'S MANAGEMENT, 7500 Old Oak Blvd., Cleveland OH 44130. (216)243-8100. Fax: (216)891-2683. Editor-in-Chief: Robert A. Feigenbaum. Art Director: Lecia Landis. Monthly 4-color magazine emphasizing business, practice management and legal aspects of medical practice for primary care physicians. Circ. 120,000.

Cartoons: Receives 50-70 cartoons/week. Buys 5 cartoons/issue. Themes typically apply to medical and financial situations "although we do publish general humor cartoons." Prefers camera-ready, single and double panel b&w line drawings with gagline. Uses "only clean-cut line drawings." Send cartoons with SASE. **Pays on acceptance**; $90.

Illustrations: Buys 2-4 illustrations/issue. Accepts b&w and color illustrations. All work done on assignment. Send a query letter to editor or art director first or send examples of work. Publication will contact artist for portfolio review if interested. Fees negotiable. Buys first rights.

Tips: "Become familiar with our publication. Cartoons should be geared toward the physician—not the patient. No cartoons about drug companies or medicine men. No sexist cartoons. Illustrations should be appropriate for a serious business publication. We do not use cartoonish or comic book styles to illustrate our articles. We work with artists nationwide." Impressed by freelancers who "do high quality work, have an excellent track record, charge reasonable fees and are able to work under deadline pressure."

PLANNING, American Planning Association, 122 S. Michigan Ave., Suite 1600, Chicago IL 60603. (312)431-9100. Editor and Associate Publisher: Sylvia Lewis. Art Director: Richard Sessions. Monthly b&w magazine with 4-color cover for urban and regional planners interested in land use, housing, transportation and the environment. Circ. 30,000. Previously published work OK. Original artwork returned after publication, upon request. Free sample copy and artist's guidelines available.

Cartoons: Buys 2 cartoons/year on the environment, city/regional planning, energy, garbage, transportation, housing, power plants, agriculture and land use. Prefers single panel with gaglines ("provide outside of cartoon body if possible"). Include SASE. Reports in 2 weeks. Buys all rights. Pays on publication; $50 minimum for b&w line drawings.

Illustrations: Buys 20 illustrations/year on the environment, city/regional planning, energy, garbage, transportation, housing, power plants, agriculture and land use. Send roughs and samples of style with SASE. Reports in 2 weeks. Buys all rights. Pays on publication; $250 maximum for b&w cover drawings; $100 minimum for b&w line drawings inside.

Tips: "Don't send portfolio. No corny cartoons. Don't try to figure out what's funny to planners. All attempts seen so far are way off base."

PLAYBOY MAGAZINE, 680 Lakeshore Dr., Chicago IL 60611. (312)751-8000. Managing Art Director: Kerig Pope. Estab. 1952. Monthly magazine. Circ. 3.5 million. Originals returned at job's completion. Sample copies available.

Cartoons: Cartoonists should contact Michelle Urry, Playboy Enterprises Inc., Cartoon Dept., 730 Fifth Ave., New York NY 10019. "Please do not send cartoons to Kerig Pope!" Samples are filed or returned. Reports back within 2 weeks. Buys all rights.

Illustrations: Approached by 700 illustrators/year. Buys 30 illustrations/issue. Prefers "uncommercial looking" artwork. Considers all media. Send query letter with slides. Does not accept originals. Samples are filed or returned. Reports back within 2 weeks. Buys all rights. **Pays on acceptance**; $1,200/page; $2,000/spread; $250 for spots.

PN/PARAPLEGIA NEWS, (formerly *Paraplegia News*), 2111 E. Highland Ave., Suite 180, Phoenix AZ 85016-4702. (602)224-0500. Fax: (602)224-0507. E-mail: pvapub@aol.com. Art Director: Susan Robbins. Estab. 1947. Monthly 4-color magazine emphasizing wheelchair living for wheelchair users, rehabilitation specialists. Circ. 27,000. Accepts previously published artwork. Original artwork not returned after publication. Sample copy free for large-size SASE with $3 postage. 50% of freelance work demands knowledge of QuarkXPress, Adobe Photoshop or Adobe Illustrator.

Cartoons: Buys 3 cartoons/issue. Prefers line art with wheelchair theme. Prefers single panel b&w line drawings with or without gagline. Send query letter with finished cartoons to be kept on file. Write for appointment to show portfolio. Material not kept on file is returned by SASE. Reports only if interested. Buys all rights. **Pays on acceptance**; $10 for b&w.

Illustrations: Works with 1 illustrator/year. Buys 1 illustration/year from freelancers. Needs editorial and medical illustration "well executed and pertinent." Prefers wheelchair living or medical and financial topics as themes. Send postcard sample. Accepts disk submissions compatible with Adobe Illustrator 5.0. Send

EPS files. Samples not filed are returned by SASE. Publication will contact artist for portfolio review if interested. Portfolio should include final reproduction/product, color and b&w tearsheets, photostats, photographs. Pays $250 for color covers; $10 for b&w, $25 for color insides.
Tips: "When sending samples, include something that shows a wheelchair-user. We have not purchased an illustration or used a freelance designer for several years. We do regularly purchase cartoons that depict wheelchair users."

POCKETS, Box 189, 1908 Grand Ave., Nashville TN 37202. (615)340-7333. E-mail: 102615.3127@compu serve.com. Editor: Janet Knight. Devotional magazine for children 6-12. 4-color with some 2-color. Monthly except January/February. Circ. 100,000. Accepts previously published material. Original artwork returned after publication. Sample copy for SASE with 4 first-class stamps. Art guidelines available for SASE with first-class postage.
Illustrations: Approached by 50-60 illustrators/year. Uses variety of styles; 4-color, 2-color, flapped art appropriate for children. Realistic, fable and cartoon styles. Send postcard sample, brochure, photocopies, SASE and tearsheets. Also open to more unusual art forms: cut paper, embroidery, etc. Samples not filed are returned by SASE. Reports only if interested. Buys one-time or reprint rights. **Pays on acceptance**: $600 flat fee for 4-color covers; $50-250 for b&w, $75-350 for color inside.
Tips: "Decisions made in consultation with out-of-house designer. Send samples to our designer: Chris Schechner, 3100 Carlisle Plaza, Suite 207, Dallas, TX 75204."

POTATO EYES, Box 76, Troy ME 04987. (207)948-3427. Co-Editor: Carolyn Page. Estab. 1988. Biannual literary magazine; b&w with 2-color cover. Design features "strong art showing rural places, people and objects in a new light of respect and regard. Focuses on the Appalachian chain from the Laurentians to Alabama but not limited to same. We publish people from all over the U.S. and Canada." Circ. 800. Original artwork returned at job's completion. Sample copies available: $5 for back issues, $6 for current issue. Art guidelines available.
Illustrations: Prefers detailed pen & ink drawings or block prints, primarily realistic. No cartoons. Send query letter with photocopies. Samples are filed and are not returned. Reports back within 2 months. Acquires one-time rights. Requests work on spec before assigning job. Pays on publication; $25 and up for b&w, $100 for color cover; contributor's copy for inside. Inside illustrations are paid for in contributor's copies.
Tips: "Our *Artist's & Graphic Designer's Market* listing has sent us hundreds of artists. The rest have come through word of mouth or our magazine display at book fairs. We hope to utilize more b&w photography to complement the b&w artwork. An artist working with quill pens and a bottle of India ink could do work for us. A woodcarver cutting on basswood using 19th-century tools could work for us. Published artists include Sushanna Cohen, Megan Lane, Lynn Foster Hill, Patrick Dengate and Roxanne Burger. A Vermont artist, Kathryn DiLego, has done four 4-color covers for us." Also publishes occasionally *The Nightshade Short Story Reader*, same format, and 5 poetry chapbooks.
Tips: "We look for only the highest quality illustration. If artists could read a sample issue they would save on time and energy as well as postage."

POWER AND LIGHT, 6401 The Paseo, Kansas City MO 64131. (816)333-7000 ext. 2243. Fax: (816)333-4439. Editor: Beula Postlewait. Associate Editor: Melissa Hammer. Estab. 1992. "*Power and Light* is a weekly 8 page, 2- and 4-color story paper that focuses on the interests and concerns of the preteen (11- to 12-year-old). We try to connect what they learn in Sunday School with their daily lives." Circ. 41,000. Originals are not returned. Sample copies and art guidelines free for SASE with first-class postage.
Cartoons: Buys 1 cartoon/issue. Prefers humor for the preteen; single panel b&w line drawings with gagline. Send query letter with brochure, roughs and finished cartoon samples. Samples are filed or are returned by SASE if requested. Reports back within 90 days. Buys multi-use rights. Pays $15 for b&w.
Illustrations: Buys 1 illustration/issue. Works on assignment only. Should relate to preteens. Considers airbrush, marker and pastel. Send query letter with brochure, résumé, SASE and photocopies. Request portfolio review in original query. Accepts submissions on disk (write for guidelines). Samples are filed. Reports back only if interested. Artist should follow up with letter after initial query. Portfolios may be dropped off every Monday-Thursday. Portfolio should include roughs, final art samples, b&w, color photographs. Buys all rights. Sometimes requests work on spec before assigning job. Pays on publication; $40 for b&w cover and inside; $75 for color cover and inside. Finds artists through submissions.
Tips: "Send a résumé, photographs or photocopies of artwork and a SASE to the office. A follow-up call is appropriate within the month. Adult humor is not appropriate. Keep in touch. Show us age-appropriate, color, quality or b&w materials."

‡❦**PRAIRIE JOURNAL TRUST**, P.O. Box 61203 Brentwood P.O., Calgary, Alberta T2L 2K6 Canada. Estab. 1983. Biannual literary magazine. Circ. 600. Sample copies available for $6. Art guidelines for SAE with IRCs only.
Illustrations: Approached by 8 illustrators/year. Buys 5 illustrations/issue. Considers b&w only. Send query letter with photocopies. Samples are not filed and are returned by SASE if requested by artist. Reports back within 6 months. Portfolio review not required. Acquires first rights. Pays honorarium for b&w cover.

Tips: Canadian freelancers preferred.

PREMIERE MAGAZINE, Dept. AGDM, 1633 Broadway, 41st Floor, New York NY 10019. (212)767-6000. Art Director: David Matt. Estab. 1987. "Monthly popular culture magazine about movies and the movie industry in the U.S. and the world. Of interest to both a general audience and people involved in the film business." Circ. 500,000. Original artwork is returned after publication.

Illustrations: Approached by 250 illustrators/year. Works with 150 illustrators/year. Buys 5-10 illustrations/issue. Buys illustrations mainly for spots and feature spreads. Works on assignment only. Considers all styles depending on needs. Send query letter with tearsheets, photostats and photocopies. Samples are filed. Samples not filed are returned by SASE. Reports back about queries/submissions only if interested. Drop-offs Monday through Friday, and pick-ups the following day. Buys first rights or one-time rights. Pays $350 for b&w, $375-1,200 for color inside.

Tips: "I do not want to see originals or too much work. Show only your best work."

♣**THE PRESBYTERIAN RECORD**, 50 Wynford Dr., North York, Ontario M3C 1J7 Canada. (416)441-1111. E-mail: perecord@web.net. Production and Design: Tim Faller. Published 11 times/year. Deals with family-oriented religious themes. Circ. 60,000. Original artwork returned after publication. Simultaneous submissions and previously published work OK. Free sample copy and artists' guidelines.

Cartoons: Approached by 12 cartoonists/year. Buys 1-2 cartoons/issue. Interested in some theme or connection to religion. Send roughs and SAE (nonresidents include IRC). Reports in 1 month. Pays on publication; $25-50 for b&w.

Illustrations: Approached by 6 illustrators/year. Buys 1 illustration/year on religion. "We are interested in excellent color artwork for cover." Any line style acceptable—should reproduce well on newsprint. Works on assignment only. Send query letter with brochure showing art style or tearsheets, photocopies and photographs. Will accept computer illustrations compatible with QuarkXPress 3.31, Adobe Illustrator 5.5, Adobe Photoshop 3.0. Samples returned by SAE (nonresidents include IRC). Reports in 1 month. To show a portfolio, mail final art and color and b&w tearsheets. Buys all rights on a work-for-hire basis. Pays on publication; $50-100 for color washes and opaque watercolors cover; $30-50 for b&w line drawings inside.

Tips: "We don't want any 'cute' samples (in cartoons). Prefer some theological insight in cartoons; some comment on religious trends and practices."

PRESBYTERIANS TODAY, 100 Witherspoon St., Louisville KY 40202. (502)569-5636. Fax: (502)596-8073. Art Director: Linda Crittenden. Estab. 1830. 4-color; official church magazine emphasizing religious world news and inspirational features. Publishes 10 issues year. Circ. 90,000. Originals are returned after publication if requested. Sample copies for SASE with first-class postage.

Cartoons: Approached by 20-30 cartoonists/year. Buys 1-2 freelance cartoons/issue. Prefers general religious material; single panel. Send query letter with brochure, roughs and/or finished cartoons. Samples are filed or are returned. Reports back within 1 month. Rights purchased vary according to project. Pays $20-25, b&w.

Illustrations: Approached by more than 50 illustrators/year. Buys 2-6 illustrations/issue, 50 illustrations/year from freelancers. Works on assignment only. Prefers ethnic, mixed groups and symbolic world unity themes. Media varies according to need. Send query letter with slides. Samples are filed or are returned by SASE. Reports back only if interested. Buys one-time rights. Pays $150-350, cover; $80-250, inside.

‡**PREVENTION**, 33 E. Minor St., Emmaus PA 18098. (610)967-8418. Fax: (610)967-7654. E-mail: wrong a.@aol.com. Contact: Wendy Ronga. Estab. 1950. Monthly consumer magazine covering health and fitness, women readership. Circ. 3.25 million. Art guidelines available.

Cartoons: Approached by 150 cartoonists/year. Buys 5 cartoons/year. Prefers health and fitness. Prefers single panel, b&w washes. Send finished cartoons. Samples are not filed and are returned. Reports back only if interested. Buys first North American serial rights. **Pays on acceptance.**

Illustration: Approached by 500-750 illustrators/year. Buys 15 illustrations/issue. Considers all media. 30% of freelance illustration demands knowledge of Adobe Photoshop, QuarkXPress, Adobe Illustrator. Send query letter with photocopies, tearsheets. Accepts submissions on disk. Samples are filed or are returned. Reports back only if interested. Art director will contact artist for portfolio review of b&w, color, photographs, photostats, tearsheets, transparencies if interested. Buys first North American serial rights. Pays $50-250 for b&w, $100-1,500 for color. Pays $100-300 for spots. Finds illustrators through *Black Book*, *LA Workbook*, magazines, submissions.

♣ **THE MAPLE LEAF** before a listing indicates that the market is Canadian.

Design: Needs freelancers for design, production, multimedia projects. 100% of freelance work demands knowledge of Adobe Photoshop, QuarkXPress, Adobe Illustrator, Director, Demension. Send query letter with printed samples.
Tips: "Read our magazine."

‡**PRINCETON ALUMNI WEEKLY**, 194 Nassau St., Princeton NJ 08542. (609)258-4722. Fax: (609)258-2247. E-mail: wszola@princeton.edu. Art Director: Stacy Wszola. Estab. 1896. Biweekly alumni magazine, published independent of the university. Circ. 57,000. Sample copies available.
Illustration: Approached by 20 illustrators/year. Buys 25-30 illustrations/year. Considers all media. "We prefer hand drawn—use computer graphics only for charts, graphs." 5% of freelance illustration demands knowledge of Aldus PageMaker, Adobe Photoshop, Adobe Illustrator. Send postcard sample. After initial mailing, send follow-up postcard sample every 2 months. Samples are filed and are not returned. Reports back only if interested. Art director will contact artist for portfolio review if interested. Portfolio should include "what artist feels will best show work. In phone call to set up appointment artist will be told what art director is looking for." Buys first or one-time rights; varies according to project. **Pays on acceptance**. Pays $250-1,200 for color cover; $100-400 for b&w, $150-1,000 for color inside; $100-250 for spots. Finds illustrators through agents, submissions and *Graphic Artists Guild Directory of Illustration*.
Tips: Artist must be able to take art direction.

‡✹**PRISM INTERNATIONAL**, Department of Creative Writing, U.B.C., Buch E462—1866 Main Mall, Vancouver, British Columbia V6T 1Z1 Canada. (604)822-2514. Fax: (604)822-3616. E-mail: prism@unixg.u bc.ca. Website: http://www.arts.ubc.ca/crwr/prism/prism.html. Editor: Sara O'Leary. Estab. 1959. Quarterly literary magazine. "We use cover art for each issue." Circ. 1,200. Original artwork is returned to the artist at the job's completion. Sample copies for $5, art guidelines for SASE with first-class postage.
Illustrations: Approached by 20 illustrators/year. Buys 1 cover illustration/issue. "Most of our covers are full color; however, we try to do at least 1 b&w cover/year." Send postcard sample. Accepts submissions on disk compatible with CorelDraw 5.0 (or lower) or other standard graphical formats. Most samples are filed. Those not filed are returned by SASE if requested by artist. Reports back within 3 months. Portfolio review not required. Buys first rights. Pays on publication; $150 for b&w and color cover; $10 for b&w and color inside. Finds artists through word of mouth and going to local exhibits.
Tips: "We are looking for fine art suitable for the cover of a literary magazine."

PRIVATE PILOT, Box 6050, Mission Viejo CA 92690. (714)855-8822. Contact: Editor. Estab. 1965. Monthly magazine for owners/pilots of private aircraft, student pilots and others aspiring to attain additional ratings and experience. Circ. 105,000. Receives 5 cartoons and 3 illustrations/week from freelance artists.
Cartoons: Buys 1 cartoon/issue on flying. Send finished artwork and SASE. Accepts submissions on disk (call first). Reports in 3 months. Pays on publication; $35 for b&w.
Illustrations: Works with 2 illustrators/year. Buys 12-18 illustrations/year. Uses artists mainly for spot art. Send query letter with photocopies, tearsheets and SASE. Accepts submissions on disk (call first). Reports in 3 months. Pays $50-300 for color inside. "We also use spot illustrations as column fillers." Buys 1-2 spot illustrations/issue. Pays $35/spot."
Tips: "Know the field you wish to represent; we specialize in general aviation aircraft, not jets, military or spacecraft."

PROCEEDINGS, U.S. Naval Institute, 118 Maryland Ave., Annapolis MD 21402-5035. (301)268-6110. Art Director: LeAnn Bauer. Monthly b&w magazine with 4-color cover emphasizing naval and maritime subjects. "*Proceedings* is an independent forum for the sea services." Design is clean, uncluttered layout, "sophisticated." Circ. 110,000. Accepts previously published material. Sample copies and art guidelines available.
Cartoons: Buys 23 cartoons/year from freelancers. Prefers cartoons assigned to tie in with editorial topics. Send query letter with samples of style to be kept on file. Material not filed is returned if requested by artist. Reports within 1 month. Negotiates rights purchased. Pays $25-50 for b&w, $50 for color.
Illustrations: Buys 1 illustration/issue. Works on assignment only. Needs editorial and technical illustration. "Like a variety of styles if possible. Do excellent illustrations and meet the requirement for military appeal." Prefers illustrations assigned to tie in with editorial topics. Send query letter with brochure, résumé, tearsheets, photostats, photocopies and photographs. Accepts submissions on disk (call production manager for details). Samples are filed or are returned only if requested by artist. Artist should follow up after initial query. Publication will contact artist for portfolio review if interested. Negotiates rights purchased. Sometimes requests work on spec before assigning job. Pays $50 for b&w, $50-75 for color, inside; $150-200 for color cover; $25 minimum for spots. "Contact us first to see what our needs are."
Tips: "Magazines such as *Proceedings* that rely on ads from defense contractors will have rough going in the future."

THE PROGRESSIVE, 409 E. Main St., Madison WI 53703. Art Director: Patrick JB Flynn. Estab. 1909. Monthly b&w plus 4-color cover. Circ. 35,000. Originals returned at job's completion. Free sample copy and art guidelines.

Illustrations: Works with 50 illustrators/year. Buys 12 b&w illustrations/issue. Needs editorial illustration that is "smart, bold, expressive." Works on assignment only. Send query letter with tearsheets and/or photocopies. Samples returned by SASE. Reports in 6 weeks. Portfolio review not required. Pays $400 for cover; $100-200 for b&w line or tone drawings/paintings/collage inside. Buys first rights.

Tips: Do not send original art. Send direct mail samples, postcards or photocopies and appropriate return postage. "The successful art direction of a magazine allows for personal interpretation of an assignment."

‡**PROTOONER**, P.O. Box 2270, Daly City CA 94017-2270. (415)755-4827. Fax: (415)997-0714. Editor: Joyce Miller. Estab. 1995. Monthly trade journal for the professional cartoonist and gagwriter. Circ. 350. Sample copy $5. Art guidelines for #10 SASE with first-class postage.

Cartoons: Approached by tons of cartoonists/year. Buys 5 cartoons/issue. Prefers good visual humorous impact. Prefers single panel, humorous, b&w line drawings, with or without gaglines. Send query letter with roughs, SASE, tearsheets. "SASE a must!" Samples are filed. Reports back in 1 month. Buys reprint rights. **Pays on acceptance**; $10-25 for b&w cartoons.

Illustration: Approached by 6-12 illustrators/year. Buys 3 illustrations/issue. Prefers humorous, original. Avoid vulgarity. Considers pen & ink. 50% of freelance illustration demands computer knowledge. Query for programs. Send query letter with printed samples and SASE. Samples are filed. Reports back within 1 month. Buys reprint rights. **Pays on acceptance**: $10-25 for b&w cover. Pay for spots varies according to assignment.

PSYCHOLOGY TODAY, 49 E. 21st St., 11th Floor, New York NY 10010. (212)260-7210. Fax: (212)260-7445. Picture Editor: Jennifer Lipshy. Estab. 1991. Bimonthly consumer magazine for professionals and academics, men and women. Circ. 200,000. Accepts previously published artwork. Originals returned at job's completion.

Illustrations: Approached by 250 illustrators/year. Buys 5 illustrations/issue. Works on assignment only. Prefers psychological, humorous, interpersonal studies. Considers all media. Needs editorial, technical and medical illustration. 20% of freelance work demands knowledge of QuarkXPress or Adobe Photoshop. Send query letter with brochure, photostats and photocopies. Samples are filed and are not returned. Reports back only if interested. Call for an appointment to show portfolio of b&w/color tearsheets, slides and photographs. Buys one-time rights. Pays on publication; $400 for ¼ page, $800 for full page inside; cover negotiable.

PUBLIC CITIZEN, 1600 20th St., NW, Washington DC 20009. (202)588-1000. Editor: Peter Nye. Contact: Elizabeth Schramm. Bimonthly magazine emphasizing consumer issues for the membership of Public Citizen, a group founded by Ralph Nader in 1971. Circ. 100,000. Accepts previously published material. Returns original artwork after publication. Sample copy available with 9 × 12 SASE with first-class postage.

Illustrations: Buys up to 10 illustrations/issue. Prefers contemporary styles in pen & ink; uses computer illustration also. "I use computer art when it is appropriate for a particular article." Send query letter with samples to be kept on file. Samples not filed are returned by SASE. Reports only if interested. Buys first rights or one-time rights. Pays on publication. Payment negotiable.

Tips: "Frequently commission more than one spot per artist. Also, send several keepable samples that show a range of styles and the ability to conceptualize."

PUBLISHERS WEEKLY, Dept. AGDM, 249 W. 17th St., 6th Floor, New York NY 10011. (212)645-9700. Art Director: Karen E. Jones. Weekly magazine emphasizing book publishing for "people involved in the creative or the technical side of publishing." Circ. 50,000. Original artwork is returned to the artist after publication.

Illustrations: Buys 75 illustrations/year. Works on assignment only. "Open to all styles." Send query letter with brochure, tearsheets, photostats, photocopies, slides and photographs. Samples are not returned. Reports back only if interested. To show a portfolio, mail appropriate materials. **Pays on acceptance**; $350-500 for color inside; $10-150 for spots.

‡**QUEEN OF ALL HEARTS**, 26 S. Saxon Ave., Bay Shore NY 11706. (516)665-0726. Fax: (516)665-4349. Managing Editor: Rev. Roger Charest. Estab. 1950. Bimonthly Roman Catholic magazine on Marian theology and spirituality. Circ. 4,500. Accepts previously published artwork. Sample copy available.

Illustrations: Buys 1 or 2 illustrations/issue. Works on assignment only. Prefers religious. Considers pen & ink and charcoal. Send postcard samples. Samples are not filed and are returned by SASE if requested by artist. Buys one-time rights. **Pays on acceptance**; $50 minimum for b&w inside.

Tips: Area most open to freelancers is illustration for short stories. "Be familiar with our publication."

ELLERY QUEEN'S MYSTERY MAGAZINE, 1540 Broadway, New York NY 10036. (212)782-8546. Art Director: Terri Czeczko. Emphasizes mystery stories and reviews of mystery books. Art guidelines for SASE with first-class postage.

• Also publishes *Alfred Hitchcock Mystery Magazine*, *Analog* and Isaac Asimov's *Science Fiction Magazine*. See individual listings for needs.

AUGUST 1995

ELLERY QUEEN

THE WORLD'S LEADING
MYSTERY MAGAZINE

THE ROOT OF ALL EVIL?
Stories by MWA Finalists

PLUS

Ian Rankin
Stuart Kaminsky
Edward D. Hoch

$2.50 U.S./$3.25 CAN.

This intriguing illustration in acrylic was created by Earl Keleny for the cover of an issue of *Ellery Queen* with an English mysteries theme. The artist has a great deal of editorial experience, working for the likes of *The Chicago Tribune* and *U.S. News & World Report*. He's done other work for Dell Magazines, whose publications include *Ellery Queen*, *Isaac Asimov's Science Fiction Magazine*, *Alfred Hitchcock's Mystery Magazine* and *Analog*.

Cartoons: "We are looking for cartoons with an emphasis on mystery, crime and suspense."
Illustrations: Prefers line drawings. All other artwork is done inhouse. Send SASE and tearsheets or transparencies. Accepts disk submissions. Reports within 3 months. **Pays on acceptance**; $1,200 for color covers; $125 for spots.

RACQUETBALL MAGAZINE, 1685 W. Uintah, Colorado Springs CO 80904-2921. (719)535-9648. Fax: (719)535-0685. E-mail: rbzine@interseve.com. Director of Communications/Editor: Linda Mojer. Bimonthly publication of The American Amateur Racquetball Association. "Distributed to members of AARA and industry leaders in racquetball. Focuses on both amateur and professional athletes." Circ. 50,000. Accepts previously published artwork. Originals returned at job's completion. Sample copies and art guidelines available. Freelancers should be familiar with Aldus PageMaker.
Cartoons: Needs editorial illustration. Prefers racquetball themes. Send query letter with roughs. Samples are filed. Reports back within 2 months. Publication will contact artist for portfolio review if interested. Negotiates rights purchased. Pays $50 for b&w, $50 for color (payment negotiable).
Illustrations: Approached by 5-10 illustrators/year. Usually works on assignment. Prefers racquetball themes. Send postcard samples. Accepts disk submissions compatible with Aldus PageMaker 5.1. Samples are filed. Publication will contact artist for portfolio review if interested. Negotiates rights purchased. Pays on publication; $200 for color cover; $50 for b&w, $50 for color inside (all fees negotiable).

R-A-D-A-R, 8121 Hamilton Ave., Cincinnati OH 45231. Editor: Elaina Meyers. Weekly 4-color magazine for children 3rd-6th grade in Christian Sunday schools. Original artwork not returned after publication.
Cartoons: Buys 1 cartoon/month on animals, school and sports. "We want cartoons that appeal to children—but do not put down any group of people; clean humor." Prefers to see finished cartoons. Reports in 1-2 months. **Pays on acceptance**, $17.50.
Illustrations: Buys 5 or more illustrations/issue. "Art that accompanies nature or handicraft articles may be purchased, but almost everything is assigned." Send query letter with photocopies, photographs and tearsheets to be kept on file. Samples returned by SASE. Publication will contact artist for portfolio review if interested. Buys all rights on a work-for-hire basis. Sometimes requests work on spec before assigning job. Pays $150 for full-color cover; $70-100 for inside. Finds artists through word of mouth, submissions/self-promotions.
Tips: "Know how to illustrate 3rd to 6th grade children well. Recently I have been giving art assignments to several new (to me, at least) freelance artists—and I have been impressed with their work. I encourage freelance artists to send me samples of their work. Generally, if I like the samples, I will give an assignment."

RADIANCE, The Magazine for Large Women, P.O. Box 30246, Oakland CA 94604. Phone/fax: (510)482-0680. E-mail: radmag2@aol.com. Publisher/Editor: Alice Ansfield. Estab. 1984. Quarterly consumer magazine "for women *all* sizes of large—encouraging them to live fully *now*." Circ. 8,000-10,000. Accepts previously published artwork. Original artwork returned at job's completion. Sample copy for $3.50 plus postage. 10% of freelance works demands knowledge of Adobe Illustrator, QuarkXPress, Adobe Photoshop, Aldus FreeHand on Macintosh.
Cartoons: Approached by 200 cartoonists/year. Buys 1-3 cartoons/issue. Wants empowering messages for large women, with humor and perspective on women's issues; single, double or multiple panel b&w or 2-color line drawings with gagline. "We'd like to see any format." Send query letter with brochure, roughs and finished cartoons or postcard-size sample. Samples are filed or are returned by SASE if requested by artist. Buys one-time rights. Pays $15-100 for b&w.
Illustrations: Approached by 200 illustrators/year. Buys 3-5 illustrations/issue. Considers pen & ink, watercolor, airbrush, acrylic, colored pencil, collage and mixed media. Send postcard sample or query letter with brochure, photocopies, photographs, SASE and tearsheets. Samples are filed or are returned by SASE if requested by artist. Reports back in 3-4 months. Buys one-time rights. Pays on publication; $100 for b&w, $200 for color cover; $20 for b&w, $100 for color inside; $35 for spots.
Design: Needs freelancers for design, production, multimedia. 50% of freelance work demands knowledge of Adobe Photoshop, Adobe Illustrator, Aldus FreeHand, QuarkXPress. Send query letter with brochure, photocopies, SASE, tearsheets, résumé, photographs. Pays for design by the project; pay is negotiable.
Tips: "Read our magazine. Find a way to help us with our goals and message. We welcome new and previously published freelancers to our magazine. I'd recommend reading *Radiance* to get a feel for our design, work, editorial tone and philosophy. See if you feel your work could contribute to what we're doing and send us a letter with samples of your work or ideas on what you'd like to do!"

RAPPORT, 5265 Fountain Ave., Los Angeles CA 90029. (213)660-0433. Art Director: Crane Jackson. Estab. 1974. Bimonthly entertainment magazine featuring book and CD reviews; music focus is on jazz, some popular music. Circ. 60,000. Originals not returned. Samples copies are available.
Illustrations: Approached by 12 illustrators/year. Buys 6 illustrations/issue. Works on assignment only. Prefers airbrush and acrylic. Send postcard sample and brochure. Send samples are filed. Reports back within 2 months. Pays $50 minimum for b&w, $100 for color cover; $50-100 for b&w, $100 for color inside.

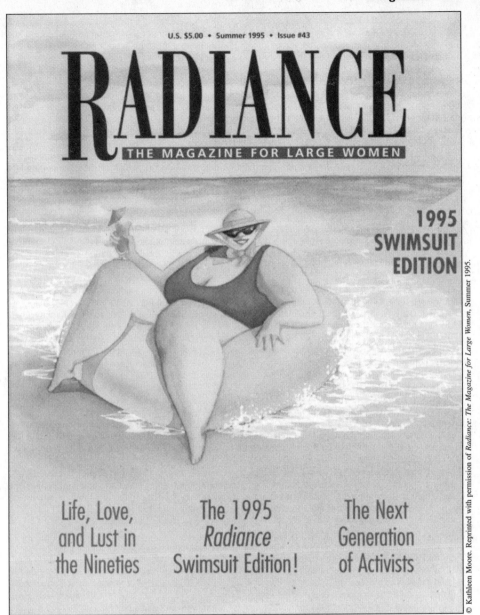

U.S. \$5.00 • Summer 1995 • Issue #43

RADIANCE
THE MAGAZINE FOR LARGE WOMEN

**1995
SWIMSUIT
EDITION**

Life, Love,
and Lust in
the Nineties

The 1995
Radiance
Swimsuit Edition!

The Next
Generation
of Activists

"When I saw this drawing, I flipped! It was just what I wanted for the cover of our swimsuit edition," says Alice Ansfield of *Radiance: The Magazine for Large Women.* "I wanted it to be fun, colorful with a beautiful large woman who was relaxed and confident, having a good time in her swimsuit at the beach," says Kathleen Moore, illustrator of the piece. Ansfield says the illustration tells readers "You have every right to enjoy the sun and water on your body, no matter what its size. We're still getting calls and letters about this cover. Readers love it. And I still chuckle when I look at it and say to myself, 'A swimsuit edition for large women. Isn't that incredible!' Watch out *Sports Illustrated!*"

Tips: "As a small publication, we try to pay the best we can. We do not want artists who have a fixed amount for payment when they see us. We give good exposure for artists who will illustrate our articles. If we find good artists, they'll get a lot of work plus payment on receipt plus plenty of copies of the magazine to fill their portfolios. Several artists have been recruited by book publishers who have seen their work in our magazine, which reviews more than 100 books from all publishers. One mistake illustrators frequently

make is that they don't adapt their artwork to our needs. We often OK a rough then find them deviating from that rough. Many times we will explain or give the article to the illustrator to come up with a concept and find they don't serve the article. Art for art's sake is disappearing from magazines. We'll suggest art to illustrate articles, or will supply article."

REDBOOK MAGAZINE, Dept. AGDM, 224 W. 57th St., New York NY 10019. (212)649-2000. Art Director: Ed Melnitsky. Monthly magazine "geared to baby boomers with busy lives. Interests in fashion, food, beauty, health, etc." Circ. 7 million. Accepts previously published artwork. Original artwork returned after publication with additional tearsheet if requested.
Illustrations: Buys 3-4 illustrations/issue. "We prefer photo illustration for fiction and more serious articles, loose or humorous illustrations for lighter articles. Illustrations can be in any medium. Portfolio drop off any day, pick up 2 days later. To show a portfolio, mail work samples that will represent the artist and do not have to be returned. This way the sample can remain on file, and the artist will be called if the appropriate job comes up." Buys reprint rights or negotiates rights.
Tips: "Look at the magazine before you send anything, we might not be right for you. Generally, illustrations should look new, of the moment, intelligent."

REFORM JUDAISM, 838 Fifth Ave., New York NY 10021-7064. (212)650-4210. Managing Editor: Joy Weinberg. Estab. 1972. Quarterly magazine. "The official magazine of the Reform Jewish movement. It covers development within the movement and interprets world events and Jewish tradition from a Reform perspective." Circ. 295,000. Accepts previously published artwork. Originals returned at job's completion. Sample copies available for $3.50. 5% of freelance work demands computer skills.
Cartoons: Prefers political themes tying into editorial coverage. Send query letter with finished cartoons. Samples are filed. Reports back within 3-4 weeks. Buys first rights, one-time rights and reprint rights.
Illustrations: Buys 8-10 illustrations/issue. Works on assignment. Send query letter with brochure, résumé, SASE and tearsheets. Samples are filed. Reports back within 3-4 weeks. Publication will contact artist for portfolio review if interested. Portfolio should include tearsheets, slides and final art. Rights purchased vary according to project. **Pays on acceptance**; varies according to project. Finds artists through sourcebooks and artists' submissions.

RELIX MAGAZINE, P.O. Box 94, Brooklyn NY 11229. (718)258-0009. Fax: (718)692-4345. Publisher: Toni Brown. Estab. 1974. Bimonthly consumer magazine emphasizing the Grateful Dead and psychedelic music. Circ. 70,000. Does not accept previously published artwork.
Cartoons: Approached by 20 cartoonists/year. Prefers Grateful Dead-related humorous cartoons, single or multiple panel b&w line drawings. Send query letter with finished cartoons. Samples are not filed and are returned by SASE if requested by artist. Reports back to the artist only if interested. Pays $25-75 for b&w, $100-200 for color. Buys all rights.
Illustrations: Approached by 100 illustrators/year. Buys multiple illustrations/issue. Prefers Grateful Dead-related. Considers pen & ink, airbrush and marker. Send query letter with SASE and photocopies. Samples are not filed and are returned by SASE if requested by artist. Reports back to the artist only if interested. Portfolio review not required. Buys all rights. Pays on publication; $75-150 for b&w, $100-200 for color cover; $15-75 for b&w inside; $15-25 for spots. Finds artists through word of mouth.
Tips: "Looking for skeleton artwork—happy, not gorey."

THE REPORTER, Women's American ORT, 315 Park Ave. S., New York NY 10010. (212)505-7700. Fax: (212)674-3057. Editor: Terese Loeb Kreuzer. Estab. 1966. Quarterly organization magazine for Jewish women emphasizing issues, lifestyle, education. *The Reporter* is the magazine of Women's ORT, a membership organization supporting a worldwide network of technical and vocational schools. Circ. 80,000. Original artwork returned at job's completion. Sample copies for SASE with first-class postage.
Illustrations: Approached by 25 illustrators/year. Buys 1 illustration/issue. Works on assignment only. Prefers contemporary art. Considers pen & ink, mixed media, watercolor, acrylic, oil, charcoal, airbrush, collage and marker. Send postcard sample or query letter with brochure, SASE and photographs. Samples are filed or returned by SASE if requested by artist. Reports back to the artist only if interested. Rights purchased vary according to project. Pays on publication; $150 for color cover; $75-100 for b&w, $75-250 for color inside.

‡REPRO REPORT, 800 Enterprise Dr., #202, Oak Brook IL 60521-1929. (708)571-4685. Fax: (708)571-4731. Editor: Jennifer Karabetsos. Estab. 1928. Trade journal of the International Reprographic Association. Circ. 1,000.
Illustration: Send postcard sample or query letter with printed samples and tearsheets. Art director will contact artist for portfolio review if interested. Negotiates rights purchased. **Pays on acceptance**. Pays $300-400 for color cover. Finds illustrators through word of mouth, computer users groups, direct mail.
Tips: "We demand a fast turnaround and thus usually only work with artists/designers in the Chicagoland area. We prefer art utilizing the computer."

THE RESIDENT, 6900 Grove Rd., Thorofare NJ 08086. (609)848-1000. Fax: (609)853-5991. Art Director: Linda Baker. Estab. 1990. "This is a series of bimonthly publications (11 in total) directed at medical residents in 11 different subspecialties. Articles deal with 'lifestyle' issues facing people during their residency years." Circ. 13,000 Accepts previously published artwork. Originals returned at job's completion. Sample copies and art guidelines available. 10% of freelance work demands knowledge of Adobe Illustrator.
Illustrations: Approached by 50 illustrators/year. Buys 5 illustrations/issue. Works on assignment only. Prefers watercolor, airbrush, acrylic, oil and mixed media. Send query letter with tearsheets, photographs, photocopies, slides and transparencies. Samples are filed and are returned by SASE if requested by artist. Reports back to the artist only if interested. To show a portfolio, mail b&w and color tearsheets, slides, photostats, photocopies and photographs. Negotiates rights purchased. Pays on publication; $400 for color cover; $200 for b&w, $300 for color inside.

RESIDENT AND STAFF PHYSICIAN, 80 Shore Rd., Port Washington NY 11050. (516)883-6350. Executive Editor: Anne Mattarella. Monthly publication emphasizing hospital medical practice from clinical, educational, economic and human standpoints. For hospital physicians, interns and residents. Circ. 100,000.
Cartoons: Buys 3-4 cartoons/year from freelancers. "We occasionally publish sophisticated cartoons in good taste dealing with medical themes." Reports in 2 weeks. Buys all rights. **Pays on acceptance**; $25.
Illustrations: "We commission qualified freelance medical illustrators to do covers and inside material. Artists should send sample work." Send query letter with brochure showing art style or résumé, tearsheets, photostats, photocopies, slides and photographs. Call or write for appointment to show portfolio of color and b&w final reproduction/product and tearsheets. **Pays on acceptance**; $700 for color cover; payment varies for inside work.
Tips: "We like to look at previous work to give us an idea of the artist's style. Since our publication is clinical, we require highly qualified technical artists who are very familiar with medical illustration. Sometimes we have use for nontechnical work. We like to look at everything. We need material from the *doctor's* point of view, *not* the patient's."

‡RIVER STYX, 3207 Washington, St. Louis MO 630103. (314)533-4541. Editor: Richard Newman. Estab. 1975. *River Styx* is a triannual, not-for-profit literary arts organization that produces a multiculturally-oriented, internationally distributed literary arts journal that features poetry, fiction, essays, interviews and visual art. Does not accept previously published artwork. Originals returned at job's completion. Sample copies available for $7.
• Does not buy cartoons and illustrations per se, but features the work of fine artists in its pages.

ROCK PRODUCTS, 29 N. Wacker Dr., Chicago IL 60606. (312)609-4206. Fax: (312)726-2574. E-mail: bryan_bedell@intchi9.ccmail.compuserve.com. Art Director: Bryan O. Bedell. Estab. 1894. Monthly 4-color trade journal. Circ. 30,000. Accepts previously published artwork. 75% of freelance illustration demands knowledge of Adobe Illustrator.
Cartoons: "We use very few cartoons. They would need to be industry-related."
Illustrations: Approached by 30 illustrators/year. Buys 3 illustrations/year. Works on assignment only. Usually looking for realistic, technical style. Send brochure or postcard samples. Accepts disk submissions compatible with Adobe Illustrator 5.0 or multimedia sample disks. Samples are filed or are returned by SASE if requested by artist. Publication will contact artist for portfolio review if interested. Portfolio should include thumbnails, roughs, final art, b&w and color tearsheets. Rights purchased vary according to project. Pays $300 for color cover; $100 for b&w, $200 for color inside. Finds artists through word of mouth and self-promotion.
Design: Needs freelancers for design. 100% of freelance work demands knowledge of Adobe Illustrator, QuarkXPress. Send query letter with brochure, tearsheets, résumé. Pays by the porject or by the hour.
Tips: Prefers local artists. "I prefer a casual, friendly approach. Also, being 'established' means nothing. I prefer to use new illustrators as long as they are professional and original."

ROCKFORD REVIEW, P.O. Box 858, Rockford IL 61105. Editor: David Ross. Estab. 1971. Triquarterly literary magazine emphasizing literature and art which contain fresh insights into the human condition. Circ. 1,000. Sample copy for $5. Art guidelines free for SASE with first-class postage. Needs computer-literate freelancers for illustration.
Illustrations: Approached by 8-10 illustrators/year. Buys 1-2 illustrations/issue. Prefers satire/human condition. Considers pen & ink and marker. Send query letter with photographs, SASE and photocopies. Samples are not filed and are returned by SASE. Reports back within 2 months. Portfolio review not required. Publication will contact artist for portfolio review if interested. Portfolio should include final art and photocopies. Buys first rights. Pays on publication; 1 copy plus eligiblity for $25 Editor's Choice Prize (6 each year)— and guest of honor at fall party. Finds artists through word of mouth and submissions.

ROLLING STONE MAGAZINE, 1290 Avenue of the Americas, New York NY 10104. (212)484-1655. Estab. 1967. Bimonthly magazine. Circ. 1.4 million. Originals returned at job's completion. Sample copies

INSIDER REPORT

Fine Art vs. Illustration: Challenging the Labels

Gary Kelley

Gary Kelley is one of the best known and most widely admired illustrators of our time. He has worked with *Time*, *Rolling Stone*, *The New Yorker*, *Playboy* and a long list of major book publishers. His murals depicting famous American writers appear on the walls of Barnes and Noble bookstores throughout the country. Kelley has won 20 medals from the Society of Illustrators in New York, including, in 1992, the society's highest honor, the prestigious Hamilton King Award. Like many illustrators, Kelley works hard to make every one of his commissioned illustrations a work of art. Yet why, he wonders, are illustrators derisively called "commercial artists" while artists who show exclusively in galleries are called "fine artists"?

Surrounded by stacks of original work in his studio, located on the second floor of a turn-of-the-century storefront in Cedar Falls, Iowa, Kelley speaks openly and passionately about his views on illustration as art. To Kelley, there is no significant difference between illustration (art for publication) and fine art (art for exhibition). In his experience, selling artwork through galleries is every bit as commercial as illustrating for magazines and book publishers. "The real difference isn't between fine art and illustration, but between good artists and mediocre artists," he says.

When he first started as an illustrator, Kelley admits it was necessary at times to work for clients who wanted unimaginative, prosaic illustrations that appealed to the lowest common denominator. "And granted, there's a lot of that in illustration, but few people admit that there is an equal amount in fine art."

But what about the limitations of illustrating text? Isn't that a major difference, and doesn't he find it restrictive at times, even frustrating? "Actually, the thing I like most about being an illustrator is the challenge of working within a given framework, a set of restrictions, but manipulating them to my own point of view. That challenge is everything to me. If I were to quit 'illustrating' today and begin 'painting' instead, my paintings would still be illustrations in the sense that I would still create assignments for myself, just as in illustrating.

"The same basic elements go into illustration that go into painting." He advises aspiring illustrators to learn to draw and paint and study the rules of composition and color. He also stresses the importance of studying the *history* of art, illustration and design, although he regrets most aspiring illustrators fail to realize the importance of studying the art of the past.

INSIDER REPORT, *Kelley*

This lush pastel portrait of Madonna typifies Kelley's style. Fred Woodward, art director for *Rolling Stone*, commissioned the dramatic illustration to accompany a review of the movie, *Truth or Dare*.

INSIDER REPORT, *continued*

Illustrators who think the rules don't apply to them because they want to do radical, funky-looking illustrations, are just hurting their own work when they ignore the basics. "You have to know the rules before you can break them," says Kelley. Academic knowledge gives you so many more options to choose from when creating your work. "All great painters, even those who broke the rules or were considered avant-garde—Matisse, Picasso, Chagall—started out as academics."

© Gary Kelley

Art Director Michael Walsh of Turner Publishing asked Kelley to capture the mystery and glamour of *Casablanca* to commemorate the 50th anniversary of the movie classic. The portrait of Bogie, as Rick, surrounded by Sam, Ilsa and images of Rick's Cafe Americain was used for a poster, book cover and video package.

When Kelley began as a freelance illustrator, he used an interesting technique to help him get excited about even the most mundane assignment. "I'd ask myself how Albrecht Dürer would have handled it and suddenly the assignment became more interesting. I remember once I had to draw a farmer out working in his fields and I tried to imagine how Degas would have drawn him." That approach lifted his bread-and-butter assignments to a higher level, and gave each assignment new meaning.

You could use Kelley's trick to make mundane assignments more interesting. Better still, says Kelley, find art directors who assign the kind of work you dream of creating. The way to find them is by poring over illustration annuals and

INSIDER REPORT, *Kelley*

competition annuals. Next to each winning illustration is a credit line that lists the magazine, book publisher or ad agency, and the art director who assigned the illustration. That's who you should send your query letters and samples to, says Kelley.

Another clue to getting great assignments is to enter your work in competitions. When your work is good enough to start winning, you'll have no problem getting work, says Kelley. Art directors will seek *you* out. And with today's technology, it won't matter whether you live in New York, Cleveland or Cedar Falls.

Unlike some artists who separate their "commercial" work from their "fine art" work, Kelley strives to create works that can grace book covers or illustrate articles, yet are strong enough to hold their own on gallery walls. His work is frequently exhibited. "Throughout my career I have consistently tried to achieve an integration of the two categories. I want *everything* I do to be provocative, interesting and personal, whether it's reproduced in a publication or exhibited in a gallery." ✉

available. 100% of freelance work demands knowledge of Adobe Illustrator, QuarkXPress and Adobe Photoshop.
Illustrations: Approached by "tons" of illustrators/year. Buys 8 illustrations/issue. Works on assignment only. Considers pen & ink, airbrush, colored pencil, mixed media, collage, charcoal, watercolor, acrylic, oil and pastel. Send query letter with tearsheets and photocopies. Samples are filed. Does not report back. Portfolios may be dropped off every Tuesday 11-3 and should include final art and tearsheets. Publication will contact artist for portfolio review if interested. Buys first and one-time rights. **Pays on acceptance**; payment for cover and inside illustration varies; pays $250-400 for spots. Finds artists through word of mouth, *American Illustration, California Illustration* and drop-offs.

‡✹ROOM OF ONE'S OWN, Box 46160, Station D, Vancouver, British Columbia V6J 5G5 Canada. Contact: Editor. Estab. 1975. Quarterly literary journal. Emphasizes feminist literature for women and libraries. Circ. 700. Original artwork returned after publication if requested. Sample copy for $7; art guidelines for SAE (nonresidents include 3 IRCs).
Cartoons: "Cartoons need to be 'feminist, affirmative and simple.' " Pays $25 minimum for b&w and color.
Illustrations: Buys 3-5 illustrations/issue from freelancers. Prefers good b&w line drawings. Prefers pen & ink, then charcoal/pencil and collage. Send photostats, photographs, slides or original work as samples to be kept on file. Samples not kept on file are returned by SAE (nonresidents include IRC). Reports within 6 months. Buys first rights. Pays $25-50, b&w, color; on publication.
Tips: "Artwork usually appears on the cover only."

THE ROTARIAN, 1560 Sherman Ave., Evanston IL 60201. Editor: Willmon L. White. Art Director: F. Sanchez. Estab. 1911. Monthly 4-color publication emphasizing general interest, business and management articles. Service organization for business and professional men and women, their families, and other subscribers. Accepts previously published artwork. Sample copy and editorial fact sheet available.
Cartoons: Approached by 14 cartoonists/year. Buys 5-8 cartoons/issue. Interested in general themes with emphasis on business, sports and animals. Avoid topics of sex, national origin, politics. Send query letter to Cartoon Editor, Charles Pratt, with brochure showing art style. Reports in 1-2 weeks. Buys all rights. **Pays on acceptance**; $75.
Illustrations: Approached by 8 illustrators/year. Buys 10-20 illustrations/year; 7-8 humorous illustrations/year from freelancers. Uses freelance artwork mainly for covers and feature illustrations. Most editorial illustrations are commissioned. Send query letter to art director with photocopies or brochure showing art style. Artist should follow-up with a call or letter after initial query. Portfolio should include original/final art, final reproduction/product, color and photographs. Sometimes requests work on spec before assigning job. Buys all rights. **Pays on acceptance**; payment negotiable, depending on size, medium, etc.; $800-1,000 for color cover; $75-150 for b&w, $200-700 for color inside.

Tips: "Preference given to area talent. We're looking for a wide range of styles, although our subject matter might be considered somewhat conservative by those steeped in the avant-garde."

ROUGH NOTES, P.O. Box 1990, 11690 Technology Dr., Carmel IN 46032-5600. Publications Production Manager: Evelyn Egan. Estab. 1878. Monthly 4-color magazine with a contemporary design. Does not accept previously published artwork.
Cartoons: Buys 3-5 cartoons/6 months on property and casualty insurance, automation, office life (manager/subordinate relations) and general humor. No risqué material. Receives 30-40 cartoons/week from freelance artists. Submit art every 6 months. Include SASE. Reports in 1 month. Buys all rights. Prefers 5×8 or 8×10 finished art. Will accept computer generated work compatible with QuarkXPress 3.3 and Adobe Illustrator 5.0. **Pays on acceptance**; $20, line drawings and halftones.
Tips: "Do not submit sexually discriminating materials. I have a tendency to disregard all of the material if I find any submissions of this type. Send several items for more variety in selection. We would prefer to deal only in finished art, not sketches."

RUNNER'S WORLD, 33 E. Minor St., Emmaus PA 18098. (610)967-5171. Fax: (610)967-7725. Website: http://www.RUNNERSWORLD.com. Art Director: Ken Kleppert. Estab. 1965. Monthly 4-color with a "contemporary, clean" design emphasizing serious, recreational running. Circ. 470,000. Accepts previously published artwork "if appropriate." Returns original artwork after publication. 30% of freelance work demands knowledge of Adobe Illustrator, Adobe Photoshop or Aldus FreeHand.
Illustrations: Approached by hundreds of illustrators/year. Works with 50 illustrators/year. Buys average of 10 illustrations/issue. Needs editorial, technical and medical illustrations. "Styles include tightly rendered human athletes, graphic and cerebral interpretations of running themes. Also, *RW* uses medical illustration for features on biomechanics." Styles range from Sam Hundley to Robert Zimmerman. Prefers pen & ink, airbrush, charcoal/pencil, colored pencil, watercolor, acrylic, oil, pastel, collage and mixed media. "No cartoons or originals larger than 11×14." Works on assignment only. Send postcard samples to be kept on file. Accepts submissions on disk compatible with Adobe Illustrator 5.0. Send EPS files. Publication will contact artist for portfolio review if interested. Buys one-time international rights. Pays $350 and up for color inside. Finds artists through word of mouth, magazines, submissions/self-promotions, sourcebooks, artists' agents and reps, and attending art exhibitions.
Tips: Portfolio should include "a maximum of 12 images. Show a clean presentation, lots of ideas and few samples. Don't show disorganized thinking. Portfolio samples should be uniform in size. Be patient!"

RUNNING TIMES, 98 N. Washington St., Boston MA 02114. (617)367-2228. Fax: (617)367-2350. E-mail: rtjohnh@aol.com. Art Director: John Hall. Estab. 1977. Monthly consumer magazine. Publication covers sports, running. Circ. 70,000. Originals returned at job's completion. Sample copies available. 100% of freelance work demands knowledge of QuarkXPress, Adobe Photoshop and Aldus FreeHand.
Cartoons: Used occasionally.
Illustrations: Buys 3-4 illustrations/issue. Works on assignment only. Considers pen & ink, colored pencil, mixed media, collage, charcoal, acrylic, oil. Send postcard sample or query letter with tearsheets. Accepts disk submissions compatible with Adobe Photoshop, Aldus FreeHand or Adobe Illustrator. Samples are filed. Publication will contact artist for portfolio review of roughs, final art and tearsheets if interested. Buys one-time rights. Pays on publication; $200-600 for color inside. Finds artists through illustration annuals, mailed samples, published work in other magazines.
Design: Needs freelancers for design and production. 100% of design demands knowledge of Aldus Free-Hand 4.0, Adobe Photoshop 3.1, QuarkXPress 3.3 and Adobe Illustrator 5.0. Send query letter with résumé and tearsheets. Pays by the hour, $20. Finds artists through illustration annuals, mailed samples, published work in other magazines.
Tips: "Look at previous issues to see that your style is appropriate. Send multiple samples and send samples regularly. I don't usually give an assignment based on one sample."

RUTGERS MAGAZINE, Alexander Johnston Hall, New Brunswick NJ 08903. Fax: (908)932-8412. Editor: Lori Chambers. Estab. 1987. Quarterly 4-color general interest magazine covering people, issues and ideas that relate to Rutgers University. Readership consists of alumni, faculty and friends of Rutgers. Circ. 110,000. Accepts previously published artwork. Original artwork is returned after publication. Sample copies available. Needs computer-literate freelancers for illustration.
Illustrations: Buys illustrations for feature spreads and spots. Buys 8 illustrations/issue, 32 illustrations/year. Considers mixed media, watercolor, pastel and collage. Send query letter with brochure. "Show a strong conceptual approach." Editorial illustration "varies from serious to humorous, conceptual to realistic." Samples are filed. Publication will contact artist for portfolio review if interested. Buys one-time rights. Pays on publication. Finds artists through sourcebooks and submissions.
Tips: "Open to new ideas. See a trend away from perfect realism in illustration. See a willingness to experiment with type in design."

SACRAMENTO MAGAZINE, 4471 D Street, Sacramento CA 95819. (916)452-6200. Fax: (916)452-6061. Art Director: Debbie Hurst. Estab. 1975. Monthly consumer lifestyle magazine with emphasis on home

and garden, women, health features and stories of local interest. Circ. 20,000. Accepts previously published artwork. Originals returned to artist at job's completion. Sample copies available.

Illustrations: Approached by 100 illustrators/year. Buys 1-2 illustrations/issue. Works on assignment only. Considers pen & ink, collage, airbrush, acrylic, colored pencil, oil, collage, marker and pastel. Send postcard sample with tearsheets. Accepts disk submissions. Send EPS files. Samples are filed and are not returned. Publication will contact artist for portfolio review if interested. Portfolio should include b&w and color tearsheets and final art. Buys one-time rights. Pays on publication; $350 for b&w or color cover; $200-500 for b&w or color inside; $100-200 for spots. Finds artists through submissions.

Tips: Sections most open to freelancers are departments and some feature stories. "We have a cartoonist who we publish regularly."

SACRAMENTO NEWS & REVIEW, 1015 20th St., Sacramento CA 95814. (916)498-1234. Fax: (916)489-7920. E-mail: newsreview@aol.com. Art Director: Don Button. Estab. 1989. "An award-winning b&w with 4-color cover alternative newsweekly for the Sacramento area. We combine a commitment to investigative and interpretive journalism with coverage of our area's growing arts and entertainment scene." Circ. 90,000. Occasionally accepts previously published artwork. Originals returned at job's completion.

Illustrations: Approached by 50 illustrators/year. Buys 1 illustration/issue. Works on assignment only. For cover art, needs themes that reflect content. Send postcard sample or query letter with photocopies, photographs, SASE, slides and tearsheets. Accepts disk submissions compatible with Photoshop 3.0. Samples are filed. Publication will contact artist for portfolio review if interested. Portfolio should include tearsheets, slides, photocopies, photographs or Mac floppy disk. Buys first rights. **Pays on acceptance**; $75-100 for b&w and $150-300 for color cover; $20-100 for b&w inside. Finds artists through submissions.

Tips: "Looking for colorful, progressive styles that jump off the page."

SALT WATER SPORTSMAN, 77 Franklin St., Boston MA 02210. (617)338-2300. Fax: (617)338-2309. Art Director: Chris Powers. Estab. 1939. Monthly consumer magazine describing the how-to and where-to of salt water sport fishing in the US, Caribbean and Central America. Circ. 140,000. Accepts previously published artwork. Originals returned at job's completion. Sample copies for 8½ × 11 SASE and 6 first-class stamps. Art guidelines available for SASE with first-class postage.

Illustrations: Buys 4-5 illustrations/issue. Works on assignment only. Considers pen & ink, watercolor, acrylic and charcoal. Send query letter with tearsheets, photocopies, SASE and transparencies. Samples are not filed and are returned by SASE if requested by artist. Publication will contact artist for portfolio review if interested. Portfolio should include b&w and color tearsheets and final art. Buys first rights. **Pays on acceptance**; $500-1,000 for color cover; $50 for b&w, $100 for color inside. Finds artists mostly through submissions.

Design: Needs freelancers for design. 10% of freelance work demands knowledge of Photoshop, Adobe Illustrator, QuarkXPress. Send query letter with photocopies, SASE, tearsheets, transparencies. Pays by the project.

Tips: Areas most open to freelancers are how-to, semi-technical drawings for instructional features and columns; occasional artwork to represent fishing action or scenes. "Look the magazine over carefully to see the kind of art we run—focus on these styles."

‡THE SATURDAY EVENING POST, Dept. AM, The Saturday Evening Post Society, 1100 Waterway Blvd., Indianapolis IN 46202. (317)636-8881. Estab. 1897. General interest, family-oriented magazine. Published 6 times/year. Circ. 500,000. Sample copy $4.

Cartoons: Cartoon Editor: Steven Pettinga. Buys about 35 cartoons/issue. Uses freelance artwork mainly for humorous fiction. Prefers single panel with gaglines. Receives 100 batches of cartoons/week. "We look for cartoons with neat line or tone art. The content should be in good taste, suitable for a general-interest, family magazine. It must not be offensive while remaining entertaining. We prefer that artists first send SASE for guidelines and then review recent issues. Political, violent or sexist cartoons are not used. Need all topics, but particularly medical, health, travel and financial." SASE. Reports in 1 month. Buys all rights. Pays on publication; $125 for b&w line drawings and washes, no pre-screened art.

Illustrations: Art Director: Chris Wilhoite. Uses average of 3 illustrations/issue. Send query letter with brochure showing art style or résumé and samples. To show a portfolio, mail final art. Buys all rights, "generally. All ideas, sketchwork and illustrative art are handled through commissions only and thereby controlled by art direction. Do not send original material (drawings, paintings, etc.) or 'facsimiles of' that you wish returned." Cannot assume any responsibility for loss or damage. "If you wish to show your artistic capabilities, please send nonreturnable, expendable/sampler material (slides, tearsheets, photocopies, etc.)." Pays $1,000 for color cover; $175 for b&w, $450 for color inside.

Tips: "Send samples of work published in other publications. Do not send racy or too new wave looks. Have a look at the magazine. It's clear that 50 percent of the new artists submitting material have not looked at the magazine."

‡**THE SCHOOL ADMINISTRATOR**, %American Association of School Administrators, 1801 N. Moore St., Arlington VA 22209. (703)875-0753. Fax: (703)528-2146. Managing Editor: Liz Griffin. Monthly association magazine focusing on education. Circ. 16,000.
Cartoons: Approached by 8-10 cartoonists/year. Buys 0-2 cartoons/year. Prefers humorous, b&w/color washes or b&w line drawings. Send photocopies and SASE. Samples are filed. Reports back only if interested. Buys one-time rights. **Pays on acceptance**.
Illustration: Approached by 6 illustrators/year. Buys 6 illustrations/issue. Considers all media. 50% of freelance illustration demands knowledge of Aldus PageMaker 4.2, Photoshop 3, Adobe Illustrator 5.5, Aldus FreeHand 5.5, QuarkXPress 3.31. Send query letter with printed samples or photocopies. Send follow-up postcard every 6-8 months. Samples are filed. Reports back only if interested. Art director will contact artist for portfolio of b&w or color photographs, tearsheets and transparencies if interested. Buys one-time rights. **Pays on acceptance**; $10-200 for b&w, $10-300 for color cover; $10-75 for inside. Finds illustrators through word of mouth, submissions.
Design: Needs freelancers for design and production. Prefers designers with experience in magazine covers. Freelance work demands knowledge of above programs. Send query letter with printed samples or photocopies.
Tips: "Read our magazine. I like work that takes a concept and translates it into a simple, powerful image."

SCHOOL BUSINESS AFFAIRS, 11401 N. Shore Dr., Reston VA 22090-4232. (703)478-0405. Fax: (703)478-0205. Production Coordinator: Eric Mion. Monthly trade publication for school business managers. Circ. 6,000. Accepts previously published artwork. Originals are returned at job's completion. Sample copies available. Art guidelines not available.
Illustrations: Buys 2 illustrations/issue. Prefers business-related themes. Send query letter with tearsheets. Accepts disk submissions compatible with IBM format; Adobe Illustrator 4.0. Samples are filed. Reports back to the artist only if interested. Portfolio review not required. Rights purchased vary according to project.
Tips: "Tell me your specialties, your style—do you prefer realistic, surrealistic, etc. Include range of works with samples."

SCIENCE NEWS, 1719 N St. NW, Washington DC 20036. (202)785-2255. Art Director: Dan Skripkar. Weekly magazine emphasizing all sciences for teachers, students and scientists. Circ. 261,000. Accepts previously published material. Original artwork returned after publication. Sample copy for SASE with 42¢ postage.
Illustrations: Buys 6 illustrations/year. Prefers realistic style, scientific themes; uses some cartoon-style illustrations. Works on assignment only. Send query letter with photostats or photocopies to be kept on file. Samples returned by SASE. Reports only if interested. Buys one-time rights. Write for appointment to show portfolio of original/final art. **Pays on acceptance**; $50-200; $50 for spots.

SCREEN ACTOR, 5757 Wilshire Blvd., Los Angeles CA 90036. (213)954-1600. Managing Editor: Elyse Glickman. Estab. 1934. Quarterly trade journal; magazine format. Publishes the national and Hollywood "Call Sheet" newsletters, covering issues of concern to performers. Circ. 82,000. Accepts previously published work. Sample copies available.

SCUBA TIMES MAGAZINE, 14110 Perdido Key Dr., Pensacola FL 32507. (904)492-7805. Fax: (904)492-7807. E-mail: 73241.1037@compuserve.com. Website: http://www.scubatimes.com. Art Director: Scott Bieberich. Bimonthly magazine for scuba enthusiasts. Originals returned at job's completion. Editorial schedule is available.
Cartoons: Approached by 2 cartoonists/year. Buys 0-1 cartoon/issue. Prefers humorous cartoons, single panel b&w and color washes with gagline. Send query letter with finished cartoons. Samples are filed. Reports back to the artist only if interested. Pays $25 for b&w/color.
Illustrations: Approached by 10 illustrators/year. Buys 0-1 illustration/issue. Considers all media. Send postcard sample or query letter with SASE and slides. Accepts disk submissions compatible with IBM. Send EPS or TIFF files. Samples are filed. Publication will contact artist for portfolio review if interested. Portfolio should include b&w and color tearsheets, slides and final art. Buys one-time rights. Pays on publication; $150 for color cover; $25-75 for b&w/color inside; $25-50 for spots. Finds artists through submissions and word of mouth.
Tips: "Be familiar with our magazine. Show us you can draw divers and their gear. Our readers will catch even the smallest mistake. Also a good thing to try would be to get an old issue and pick a story from either the advanced diving journal or the departments where we used a photo and show us how you would have used your art instead. This will show us your ability to conceptualize and your skill as an artist. Samples do not have to be dive-related to win assignments."

THE SECRETARY®, 2800 Shirlington Rd., Suite 706, Arlington VA 22206. (703)998-2534. Fax: (703)379-4561. Managing Editor: Catherine P. O'Keefe. Estab. 1945. Trade journal published 9 times/year. Publication directed to the office support professional. Emphasis is on workplace technology, issues and trends. Readership is 98% female. Circ. 40,000. Accepts previously published artwork. Originals returned at job's comple-

tion upon request only. Samples copies available (contact subscription office at (816)891-6600, ext. 235). Needs computer-literate freelancers for illustration.

Illustrations: Approached by 50 illustrators/year. Buys 25-30 illustrations/year. Works on assignment only. Prefers communication, travel, meetings and international business themes. Considers pen & ink, airbrush, colored pencil, mixed media, collage, charcoal, watercolor, acrylic, oil, pastel, marker and computer. Send postcard-size sample or send query letter with brochure, tearsheets and photocopies. Samples are filed. Reports back to the artist only if interested. Publication will contact artist for portfolio review if interested. Portfolio should include final art and tearsheets. Buys one-time rights usually, but rights purchased vary according to project. **Pays on acceptance** (net 30 days); $500-600 for color cover; $60-150 for b&w, $200-400 for color inside; $60 for b&w spots. Finds artists through word of mouth and artists' samples.

SEEK, 8121 Hamilton Ave., Cincinnati OH 45231. (513)931-4050, ext. 365. Cartoon editor: Eileen H. Wilmoth. Emphasizes religion/faith. Readers are young adult to middle-aged adults who attend church and Bible classes. Quarterly in weekly issues. Circ. 45,000. Sample copy and art guidelines for SASE.
Cartoons: Approached by 6 cartoonists/year. Buys 8-10 cartoons/year. Buys "church or Bible themes—contemporary situations of applied Christianity." Prefers single panel b&w line drawings with gagline. Send finished cartoons, photocopies and photographs. Include SASE. Reports in 3-4 months. Buys first North American serial rights. **Pays on acceptance**; $15-18.
Illustration: Send b&w 8 × 10 glossy photographs.

‡SELLING, 477 Madison Ave., New York NY 10022. (212)224-3425. Fax: (212)224-3433. Art Director: Linda Root. Estab. 1993. Monthly business magazine for sales people. Circ. 100,000. Sample copies available.
Illustration: Approached by many illustrators/year. Buys 10-20 illustrations/issue. Considers all media. 10% of freelance illustration demands knowledge of Aldus Pagemaker, Aldus FreeHand, Adobe Photoshop, QuarkXPress, Adobe Illustrator. Send postcard sample. Accepts disk submissions. Samples are filed. Reports back only if interested. Art director will contact artist for portfolio review if interested. Rights purchased vary according to project. Pays $1,000 maximum for color cover; $300-1,000 for color inside. Pays $300 for spots. Finds illustrators through magazines, submissions.
Tips: "Read our magazine."

THE $ENSIBLE SOUND, 403 Darwin Dr., Snyder NY 14226. (716)833-0930. Fax: (716)833-0929 (5p.m.-9a.m.). E-mail: sensisound@aol.com. Publisher: John A. Horan. Editor: Karl Nehring. Quarterly publication emphasizing audio equipment for hobbyists. Circ. 10,500. Accepts previously published material and simultaneous submissions. Original artwork returned after publication. Sample copy for $2.
Cartoons: Uses 4 cartoons/year. Prefers single panel, with or without gagline; b&w line drawings. Send samples of style and roughs to be kept on file. Material not kept on file is returned by SASE. Will accept material on mal-formatted disk or format via e-mail. Reports within 1 month. Negotiates rights purchased. Pays on publication; rate varies.
Tips: "Learn how your work is printed; provide camera-ready material."

SHEEP! MAGAZINE, 128 E. Lake St., W., P.O. Box 10, Lakemills WI 53551. (414)648-8285. Fax: (414)648-3770. Estab. 1980. A monthly tabloid covering sheep, wool and woolcrafts. Circ. 15,000. Accepts previously published work. Original artwork returned at job's completion. Sample copies available.
Cartoons: Approached by 30 cartoonists/year. Buys 6-8 cartoons/issue. Considers all themes and styles. Prefers single panel with gagline. Send query letter with brochure and finished cartoons. Samples are returned. Reports back within 3 weeks. Buys first rights or all rights. Pays $15-25 for b&w; $50-100 for color.
Illustrations: Approached by 10 illustrators/year. Buys 5 illustrations/year. Works on assignment only. Considers pen & ink, colored pencil, watercolor. Send query letter with brochure, SASE and tearsheets. Samples are filed or returned. Reports back within 3 weeks. To show a portfolio, mail thumbnails and b&w tearsheets. Buys first rights or all rights. **Pays on acceptance**; $45-75 for b&w, $75-150 for color cover; $45-75 for b&w, $50-125 for color inside.
Tips: "Demonstrate creativity and quality work. We're eager to help out beginners."

SHOFAR, 43 Northcote Dr., Melville NY 11747. (516)643-4598. Publisher: Gerald H. Grayson. Estab. 1984. Monthly magazine emphasizing Jewish religious education published October through May—double issues December/January and April/May. Circ. 15,000. Accepts previously published artwork. Originals returned at job's completion. Sample copies free for 9 × 12 SASE and 3 first-class stamps. Art guidelines available.
Illustrations: Buys 3-4 illustrations/issue. Works on assignment only. Send query letter with tearsheets. Reports back to the artist only if interested. Pays on publication; $25-100 for b&w, $50-150 for color cover.

‡SHOW BIZ NEWS AND MODEL NEWS, 244 Madison Ave., #393, New York NY 10016-2817. (212)683-0244. Publisher: John King. Estab. 1975. "Our newspaper is read by show people—models and the public—coast to coast." Circ. 300,000. Accepts previously published artwork. Originals are returned at job's completion. Sample copies and art guidelines free for SASE with first-class postage.

Cartoons: Approached by 20 cartoonists/year. Buys 10 cartoons/issue. Prefers caricatures of show people and famous models; single or multiple panel b&w line drawings with gagline. Contact through artist rep or send query letter with finished cartoon samples. Samples are returned by SASE. Reports back within 10 days only if interested. Payment negotiable.

Illustrations: Approached by 20-30 illustrators/year. Buys 10 illustrations/year. Artists sometimes work on assignment. Considers pen & ink, collage, airbrush, marker, colored pencil, charcoal and mixed media. Contact only through artist rep or send query letter with brochure, résumé, SASE, tearsheets, photographs and photocopies. Samples are filed or returned by SASE. Reports back within 10 days only if interested. Call or write to show a portfolio or mail appropriate materials: thumbnails, final art samples, b&w and color tearsheets and photographs. Buys first rights, one-time rights or reprint rights. Pays on publication.

Tips: "Keep up with the top cebebrities and models. Try to call and send data first. No drop-ins. Face shots are big."

‡**SIERRA MAGAZINE**, 730 Polk St., San Francisco 94109. (415)923-5558. Art Director: Martha Geering. Bimonthly consumer magazine featuring environmental and general interest articles. Circ. 500,000.

Illustration: Buys 8 illustrations/issue. Considers all media. 10% of freelance illustration demands computer skills. Send postcard samples or printed samples, SASE and tearsheets. Samples are filed and are not returned. Reports back only if interested. Call for specific time for drop off. Art director will contact artist for portfolio review if interested. Buys one-time rights. **Pays on acceptance** or publication. Finds illustrators through illustration and design annuals, sourcebooks. submissions, magazines, word of mouth.

SIGNS OF THE TIMES, 1350 N. King's Rd., Nampa ID 83687. (208)465-2500. Fax: (208)465-2531. Art Director: Merwin Stewart. A monthly Seventh-day Adventist 4-color publication that examines contemporary issues such as health, finances, diet, family issues, exercise, child development, spiritual growth and end-time events. "We attempt to show that Biblical principles are relevant to everyone." Circ. 225,000. Original artwork returned to artist after publication. Art guidelines available for SASE with first-class postage.

• They accept illustrations produced or converted to electronic form on a 3.5″ optical disk or a 5.25″ removable hard disk cartridge.

Illustrations: Buys 6-10 illustrations/issue. Works on assignment only. Prefers contemporary "realistic, stylistic, or humorous styles (but not cartoons)." Considers any media. Send postcard sample, brochure, photographs, slides, tearsheets or transparencies. Samples are not returned. "Tearsheets or color photos (prints) are best, although color slides are acceptable." Samples are filed for future consideration and are not returned. Publication will contact artist for more samples of work if interested. Buys first-time North American publication rights. **Pays on acceptance** (30 days); $600-800 for color cover; $100-600 for b&w, $300-700 for color inside. Fees negotiable depending on needs and placement, size, etc. in magazine. Finds artists through submissions, sourcebooks, and sometimes by referral from other art directors.

Tips: "Most of the magazine illustrations feature people. Approximately 20 visual images (photography as well as artwork) are acquired for the production of each issue, half in b&w, half in color, and the customary working time frame is three weeks. Quality artwork and timely delivery are mandatory for continued assignments. It is customary for us to work with highly-skilled and dependable illustrators for many years."

‡**THE SILVER WEB**, P.O. Box 38190, Tallahassee FL 32315. E-mail: annk@freenet.fsv.edu. Publisher/Editor: Ann Kennedy. Estab. 1989. Semi-annual literary magazine. Subtitled "A Magazine of the Surreal." Circ. 1,000. Accepts previously published artwork. Originals returned at job's completion. Sample copies available for $5.95. Art guidelines for SASE with first-class postage.

Illustrations: Approached by 50-100 illustrators/year. Buys 15-20 illustrations/issue. Prefers works of the surreal, horrific or bizarre but not traditional horror/fantasy (dragons or monsters are not desired). Considers pen & ink, collage, charcoal and mixed media, all only in b&w. Send query letter with samples and SASE. Samples are filed or are returned by SASE if requested by artist. Reports back within 1 week. Publication will contact artist for portfolio review if interested. Rights purchased vary according to project. **Pays on acceptance**; $25-50 for b&w cover; $10-25 for b&w inside; $5-10 for spots.

‡**SILVERFISH REVIEW**, Box 3541, Eugene OR 97403. (503)344-5060. Editor/Publisher: Rodger Moody. Estab. 1979. Semiannual literary magazine that publishes poetry, fiction, translations, essays, reviews, interviews and poetry chapbooks. Published December and June. Circ. 1,000. Sample copies available for $4, regular issue; $6, chapbook; plus $1.50 for postage. Art guidelines for SASE with first-class postage.

Illustrations: Buys 1 freelance illustration/issue. Prefers pen & ink and charcoal. Send query letter with photocopies and SASE. Samples are filed. Reports back within 1 month. To show a portfolio, mail photocopies. Buys one-time rights. Pays $25-50 for b&w cover or inside.

‡**SINISTER WISDOM**, Box 3252, Berkeley CA 94703. Contact: Art Director. Estab. 1976. Literary magazine. Triannual multicultural lesbian feminist journal of arts and politics, international distribution; b&w with 2-color cover. Design is "tasteful with room to experiment. Easy access to text is first priority." Circ. 3,500. Accepts previously published artwork. Original artwork returned at job's completion. Sample copies available

for $6.50. Art guidelines for SASE with first-class postage. 20% of freelance work demands computer skills in PageMaker, Adobe Illustrator or Aldus FreeHand.

Cartoons: Approached by 15 cartoonists/year. Buys 0-2 cartoons/issue. Prefers lesbian/feminist themes, any style. Prefers single panel, b&w line drawings. Send query letter with roughs. Samples are filed or returned by SASE. Reports back within 9 months. Buys one-time rights. Pays 2 copies upon publication.

Illustrations: Approached by 30-75 illustrators/year. Buys 6-15 illustrations/issue. Prefers lesbian themes, images of women, abstraction and fine art. Considers any media for b&w reproduction. Send postcard sample, photographs and slides. Accepts disk submissions. Samples are filed or returned by SASE. Reports back within 9 months. Does not review portfolios. Buys one-time rights. Pays on publication; 2 copies; "will pay for production or lab costs."

Tips: "Read it and note the guidelines and themes of upcoming issues. We want work by lesbians only."

SKI MAGAZINE, Dept. AGDM, 2 Park Ave., New York NY 10016. (212)779-5000. Art Director: Rob Dybec. Estab. 1936. Emphasizes instruction, resorts, equipment and personality profiles. For new, intermediate and expert skiers. Published 8 times/year. Circ. 600,000. Previously published work OK "if we're notified."

Illustrations: Approached by 30-40 freelance illustrators/year. Buys 25 illustrations/year. Mail art and SASE. Reports immediately. Buys one-time rights. **Pays on acceptance**; $1,000 for color cover; $150-500 for b&w and color inside.

Tips: "The best way to break in is an interview and showing a consistent style portfolio. Then, keep us on your mailing list."

SKYDIVING MAGAZINE, 1725 N. Lexington Ave., DeLand FL 32724. (904)736-4793. Fax: (904)736-9786. Designer: Sue Clifton. Estab. 1979. "Monthly magazine on the equipment, techniques, people, places and events of sport parachuting." Circ. 12,300. Originals returned at job's completion. Sample copies and art guidlines available.

Cartoons: Approached by 10 cartoonists/year. Buys 2 cartoons/issue. Prefers skydiving themes; single panel, with gagline. Send query letter with roughs. Samples are filed. Reports back within 2 weeks. Buys one-time rights. Pays $25 for b&w.

SMART MONEY, 1790 Broadway, New York NY 10019. (212)492-1300. Fax: (212)399-2119. Art Director: Amy Rosenfeld. Estab. 1992. Monthly consumer magazine. Circ. 600,000. Originals returned at job's completion. Sample copies available.

Illustrations: Approached by 200-300 illustrators/year. Buys 10 illustrations/issue. Works on assignment only. Considers pen & ink, airbrush, colored pencil, mixed media, collage, charcoal, watercolor, acrylic, oil, pastel and digital. Send postcard-size sample. Samples are filed. Publication will contact artist for portfolio review if interested. Portfolio should include tearsheets and photocopies. Buys first and one-time rights. Pays 30 days from invoice; $1,500 for color cover; $400-700 for spots. Finds artists through sourcebooks and submissions.

SOAP OPERA DIGEST, 45 W. 25th St., New York NY 10010. (212)645-2100. Creative Director: Catherine Connors. Art Director: Virginia Bassett. Estab. 1976. Emphasizes soap opera and prime-time drama synopses and news. Biweekly. Circ. 1 million. Accepts previously published material. Returns original artwork after publication upon request. Sample copy available for SASE.

Illustrations: Buys 25 freelance illustrations/year. Works on assignment only. Prefers humor; pen & ink, airbrush and watercolor. Send query letter with brochure showing art style or résumé, tearsheets and photocopies to be kept on file. Negotiates rights purchased. Pays on publication; $50-100 for b&w, $200-400 for color, inside. All original artwork is returned after publication.

Tips: "Review the magazine before submitting work."

SOAP OPERA UPDATE MAGAZINE, 270 Sylvan Ave., Englewood Cliffs NJ 07632. (201)569-6699, ext. 226. Fax: (201)569-2510. Art Director: Catherine McCarthy. Estab. 1988. Biweekly consumer magazine geared toward fans of soap operas and the actors who work in soaps. It is "the only full-size, all color soap magazine in the industry." Circ. 700,000. Originals are not returned.

Illustrations: Approached by 100 illustrators/year. Works on assignment only. Prefers illustrations showing a likeness of an actor/actress in soap operas. Considers any and all media. Send postcard sample. Samples are filed. Publication will contact artist for portfolio review if interested. Portfolio should include color tearsheets and final art. Buys all rights usually. Pays on publication; $50-200 maximum for color inside and/or spots. Finds artists through promo pieces.

Tips: Needs caricatures of actors in storyline-related illustration. "Please send self-promotion cards along with a letter if you feel your work is consistent with what we publish."

SOAP OPERA WEEKLY, 41 W. 25th St., New York NY 10010. (212)645-2100. Creative Director: S. Rohall. Estab. 1989. Weekly 4-color consumer magazine; tabloid format. Circ. 600,000-700,000. Original artwork returned at job's completion.

Illustrations: Approached by 50 freelance illustrators/year. Works on assignment only. Send query letter with brochure and soap-related samples. Samples are filed. Request portfolio review in original query. Publication will contact artist for portfolio review if interested. Portfolio should include original/final art. Buys first rights. **Pays on acceptance**; $2,000 for color cover; $750 for color, full page.

SOCIAL POLICY, 25 W. 43rd St., New York NY 10036. (212)642-2929. Managing Editor: Audrey Gartner. Estab. 1970. Emphasizes the human services—education, health, mental health, self-help, consumer action, voter registration, employment. Quarterly magazine for social action leaders, academics and social welfare practitioners. Black & white with 2-color cover. Circ. 5,000. Accepts simultaneous submissions. Original artwork returned after publication. Sample copy for $2.50.
Illustrations: Approached by 10 illustrators/year. Works with 4 illustrators/year. Buys 6-8 illustrations/issue. Accepts b&w only, illustration "with social consciousness." Prefers pen & ink and charcoal/pencil. Send query letter with photocopies and tearsheets to be kept on file. Call for appointment to show portfolio, which should include b&w final art, final reproduction/product and tearsheets. Reports only if interested. Buys one-time rights. Pays on publication; $100 for cover; $25 for b&w inside.
Tips: When reviewing an artist's work, looks for "sensitivity to the subject matter being illustrated."

SOLIDARITY MAGAZINE, Published by United Auto Workers, 8000 E. Jefferson, Detroit MI 48214. (313)926-5291. E-mail: 71112.363@compuserve.com. Website: http:/www.uaw.org. Editor: David Elsila. Four-color magazine for "1.3 million member trade union representing U.S. workers in auto, aerospace, agricultural-implement, public employment and other areas." Contemporary design.
Cartoons: Carries "labor/political" cartoons. Pays $75 for b&w, $125 for color.
Illustrations: Works with 10-12 illustrators/year for posters and magazine illustrations. Interested in graphic designs of publications, topical art for magazine covers with liberal-labor political slant. Especially needs illustrations for articles on unemployment and economy. Looks for "ability to grasp publication's editorial slant." Send postcard sample or tearsheets and SASE. Samples are filed. Pays $500-600 for color cover; $200-300 for b&w, $300-450 for color inside.

SONGWRITER'S MONTHLY, 332 Eastwood Ave., Feasterville PA 19053. Phone/fax: (215)953-0952. E-mail: a1foster@aol.com. Editor/Publisher: Allen Foster. Estab. 1992. Monthly trade journal. "We are a cross between a trade journal and a magazine—our focus is songwriting and the music business." Circ. 1,000. Accepts previously published artwork. Originals returned at job's completion with SASE. Sample copy free. Art guidelines free for SASE with first-class postage.
Cartoons: Approached by 8-10 cartoonists/year. Buys 1 cartoon/issue. Cartoons must deal with some aspect of songwriting or the music business. Prefers single panel, humorous, b&w line drawings with or without gagline. Send query letter with finished cartoons. Samples are not filed and are returned by SASE if requested by artist. Reports back within 2-4 weeks. Buys one-time rights. Pays $5 for b&w.
Illustration: Prefers music themes. Considers pen & ink. Send query letter with SASE and photocopies. Samples are filed. Reports back within 2-4 weeks. Portfolio review not required. Buys one-time rights. **Pays on acceptance**; $5 for b&w inside; $5 for spots.
Tips: "Query letters are important to us. Our primary needs are for artists who can find a creative way to illustrate articles dealing with songwriting concepts."

SOUTH CAROLINA WILDLIFE, Box 167, Columbia SC 29202. (803)734-3972. Editor: John Davis. Art Director: Linda Laffitte. Bimonthly 4-color magazine covering wildlife, water and land resources, outdoor recreation, natural history and environmental concerns. Circ. 70,000. Accepts previously published artwork.
 • *South Carolina Wildlife* is low-key, relying on photos and art to attract/support editorial content.
Illustrations: Uses 5-10 illustrations/issue. Interested in wildlife art; all media; b&w line drawings, washes, full-color illustrations. "Particular need for natural history illustrations of good quality. They must be technically accurate." Subject matter must be appropriate for South Carolina. Prefers to see printed samples or slides of work, which will be filed with résumé. *Please note that samples will not be returned.* Publication will contact artist for portfolio review if interested. Sometimes requests work on spec before assigning job. Payment is negotiable. Acquires one-time rights. Finds artists through word of mouth, magazines, submissions/self-promotions, books and publications other than magazines.
Tips: "We are interested in unique illustrations—something that would be impossible to photograph. Make sure proper research has been done and that the art is technically accurate."

SOUTHERN EXPOSURE, Box 531, Durham NC 27702. (919)419-8311. Editor: Pat Arnow. Estab. 1972. A quarterly magazine of Southern politics and culture. Circ. 5,000. Accepts previously published artwork.

 A BULLET introduces comments by the editor of *Artist's & Graphic Designer's Market* indicating special information about the listing.

Original artwork returned at job's completion. Sample copies available for $5. Guidelines available for SASE with first-class postage.
Illustrations: Buys 2 freelance illustrations/issue. Send postcard sample or query letter with brochure, résumé, photographs and photocopies. Samples are nonreturnable. Pays $100, color, cover; $25-50, b&w inside.
Tips: This company "prefers artists working in the South with Southern themes, but please avoid stereotypes."

SOUTHERN LIVING, 2100 Lakeshore Dr., Birmingham AL 35209. (205)877-6000. Fax: (205)877-6700. Art Director: Lane Gregory. Monthly 4-color magazine emphasizing interiors, gardening, food and travel. Circ. 3 million. Original artwork returned after publication.
Illustrations: Approached by 30-40 illustrators/year. Buys 3-4 illustrations/issue. Uses freelance artists mainly for illustrating monthly columns. Works on assignment only. Considers all media. Needs editorial and technical illustration. Send query letter with brochure showing art style or résumé and samples. Send follow-up postcard sample every 2-3 months. Samples returned only if requested. Publication will contact artist for portfolio review if interested. Portfolio should include color tearsheets and slides. Rights purchsed vary according to project. **Pays on acceptance**; $500-2,000, b&w or color. Pays $350 for spots.
Tips: In a portfolio include "four to five best pieces to show strengths and/or versatility. Smaller pieces are much easier to handle than large. It's best not to have to return samples but to keep them for reference files." Don't send "too much. It's difficult to take time to plow through mountains of examples." Notices trend toward "lighter, fresher illustration."

SPITBALL, The Literary Baseball Magazine, 5560 Fox Rd., Cincinnati OH 45239. (513)385-2268. Editor: Mike Shannon. Quarterly 2-color magazine emphasizing baseball exclusively, for "well-educated, literate baseball fans." Sometimes prints color material in b&w on cover. Returns original artwork after publication if the work is donated; does not return if purchases work. Sample copy for $2.
• *Spitball* has a regular column called "Brushes with Baseball" that features one artist and his work. Chooses artists for whom baseball is a major theme/subject. Prefers to buy at least one work from the artist to keep in its collection.
Cartoons: Prefers single panel b&w line drawings with or without gagline. Prefers "old fashioned *Sport Magazine/New Yorker* type. Please, cartoonists . . . make them funny, or what's the point!" Query with samples of style, roughs and finished cartoons. Samples not filed are returned by SASE. Reports back within 1 week. Negotiates rights purchased. Pays $10, minimum.
Illustrations: "We need two types of art: illustration (for a story, essay or poem) and filler. All work must be baseball-related; prefers pen & ink, airbrush, charcoal/pencil and collage. Interested artists should write to find out needs for specific illustration." Buys 3 or 4 illustrations/issue. Send query letter with b&w illustrations or slides. Target samples to magazine's needs. Samples not filed are returned by SASE. Reports back within 1 week. Negotiates rights purchased. **Pays on acceptance**; $20-40 b&w inside. Needs short story illustration.
Tips: "Usually artists contact us and if we hit it off, we form a long-lasting mutual admiration society. Please, you cartoonists out there, drag your bats up to the *Spitball* plate! We like to use a variety of artists."

‡SPORTS AFIELD, Hearst Magazines, 250 W. 55th, New York NY 10019. (212)649-4000. Fax: (212)581-3923. Website: http://www.sportsafield.com. Art Director: Michael Lawton. Estab. 1887. Monthly magazine. "*SA* is edited for outdoor enthusiasts with special interests in fishing and hunting. We are the oldest outdoor magazine and continue as the authority on all traditional sporting activities including camping, boating and wilderness travel." Sample copies available for 10×13 SASE. Art guidelines available for #10 SASE with first-class postage.
Cartoons: Buys 7-10 cartoons/issue. Prefers outdoors/hunting, fishing themes. Prefers single, double or multiple panel humorous b&w and color washes or b&w line drawings with or without gagline. Send photocopies and SASE. Samples are filed. Reports back if interested. Buys first North American serial rights. Pays on publication.
Illustration: Buys 2-3 illustrations/issue. Prefers outdoor themes. Considers all media. Freelancers should be familiar with Adobe Photoshop, Adobe Illustrator, QuarkXPress. Send postcard sample or query letter with photocopies and tearsheets. Accepts disk submissions. Samples are filed. Reports back only if interested. Will contact for portfolio of b&w or color photographs, slides, tearsheets and transparencies if interested. Buys first North American serial rights. Pays on publication; negotiable. Finds illustrators through *Black Book*, magazines, submissions.

‡SPORTS ILLUSTRATED PRESENTS, 1271 Avenue of Americas, Time/Life, New York NY 10020. (212)522-3961. Fax: (212)522-0203. Art Director: Darrin Perry. Designer: Mike Schinnerer. Seasonal magazine focusing on athletics: sport previews and championship commemoratives. Circ. 350,000. Sample copies available.
Illustration: Prefers sports-related caricatures. Considers all media. 15% of freelance illustration demands knowledge of Adobe Photoshop, Adobe Illustrator. Send query letter with printed samples, tearsheets. Sam-

ples are filed. Reports back only if interested. Will contact artist for portfolio review if interested. Rights purchased vary according to project. Payment varies on size of reproduction and on issue. Finds illustrators through research, examples of work, word of mouth.

SPORTS 'N SPOKES, 2111 E. Highland Ave., Suite 180, Phoenix AZ 85016-4702. (602)224-0500. Fax: (602)224-0507. E-mail: snsmagaz@aol.com. Art and Production Director: Susan Robbins. Bimonthly consumer magazine with emphasis on sports and recreation for the wheelchair user. Circ. 15,000. Accepts previously published artwork. Sample copies for 11×14 SASE and 6 first-class stamps. 50% of freelance work demands knowledge of Adobe Illustrator, QuarkXPress or Adobe Photoshop.
Cartoons: Approached by 10 cartoonists/year. Buys 3-5 cartoons/issue. Prefers humorous cartoons; single panel b&w line drawings with or without gagline. Send query letter with finished cartoons. Samples are filed or returned by SASE if requested by artist. Reports back within 3 months. Buys all rights. Pays $10 for b&w.
Illustrations: Approached by 5 illustrators/year. Works on assignment only. Considers pen & ink, watercolor and computer-generated. Send postcard sample or query letter with résumé and tearsheets. Accepts disk submissions compatible with Adobe Illustrator 5.0. Send EPS files. Samples are filed or returned by SASE if requested by artist. Reports back to the artist only if interested. Publication will contact artist for portfolio review if interested. Portfolio should include color tearsheets. Buys one-time rights and reprint rights. Pays on publication; $250 for color cover; $10 for b&w, $25 for color inside. Finds artists through word of mouth.
Tips: "We have not purchased an illustration or used a freelance designer for more than three years. We regularly purchase cartoons with wheelchair sports/recreation theme."

SPY MAGAZINE, 49 E. 21st St., New York NY 10010. (212)260-7210. Fax: (212)260-7445. Design Director: Lisa Giodani. Estab. 1986. Bimonthly consumer magazine of humor, parody, satirical observation. Originals returned at job's completion. Sample copies free for #10 SASE with first-class postage. 95% of freelance work demands knowledge of Adobe Illustrator, QuarkXPress, Adobe Photoshop, Aldus FreeHand and Fontographer.
Cartoons: Approached by 100 cartoonists/year. Buys 1 cartoon/issue. Prefers humorous. Send postcard-size sample. Samples are filed. Reports back to the artist only if interested. Buys one-time rights. Pays $100 for b&w, $150 for color.
Illustrations: Approached by 200 illustrators/year. Buys 10 illustrations/issue. Works on assignment only. Considers pen & ink, mixed media, collage, watercolor, acrylic and oil. Send postcard-size sample or query letter with tearsheets. Samples are filed. Reports back to the artist only if interested. Buys one-time rights. Pays on publication; $600-750 for b&w, $750-1,000 for color cover; $150-300 for b&w, $300-500 for color inside; $100 for spots. Finds artists through most of the creative competitive annuals, mailers, word of mouth.

STANFORD MAGAZINE, Bowman Alumni House, Stanford CA 94305-4005. (415)725-1085. Fax: (415)725-8676. Art Director: Paul Carstensen. Estab. 1973. Consumer magazine, "geared toward the alumni of Stanford University. Articles vary from photo essays to fiction to academic subjects." Circ. 105,000. Accepts previously published artwork. Original artwork is returned at job's completion. Sample copies available.
Illustrations: Approached by 200-300 illustrators/year. Buys 4-6 illustrations/issue. Works on assignment only. Interested in a variety of themes "but a few are scientific research, historical, fiction, photo essays." Interested in all styles. Send samples only. Samples are filed. "Follow-up with a phone call." Reports back within 2 weeks. Call for appointment to show portfolio of b&w tearsheets, slides, photocopies and photographs. Buys one-time rights. **Pays on acceptance**.
Tips: "We're always looking for unique styles, as well as excellent traditional work. We like to give enough time for the artist to produce the piece."

STONE SOUP, The Magazine by Young Writers and Artists, P.O. Box 83, Santa Cruz CA 95063. (408)426-5557. E-mail: editor@stonesoup.com. Website: http://www.stonesoup.com. Editor: Gerry Mandel. Bimonthly 4-color magazine with "simple and conservative design" emphasizing writing and art by children through age 13. Features adventure, ethnic, experimental, fantasy, humorous and science fiction articles. "We only publish writing and art by children through age 13. We look for artwork that reveals that the artist is closely observing his or her world." Circ. 20,000. Original artwork is returned after publication. Sample copies available for $3. Art guidelines for SASE with first-class postage.
Illustrations: Buys 8 illustrations/issue. Prefers complete and detailed scenes from real life. Send query letter with photocopies. Samples are filed or are returned by SASE. Reports back within 1 month. Buys all rights. Pays on publication; $25 for color cover; $8-13 for b&w or color inside; $8-25 for spots.
Tips: "We accept artwork by children only, through age 13."

STRAIGHT, 8121 Hamilton Ave., Cincinnati OH 45231. (513)931-4050. Fax: (513)931-0904. Editor: Heather E. Wallace. Estab. 1950. Weekly Sunday school take-home paper for Christian teens ages 13-19. Circ. 35,000. Sample copies for #10 SASE with first-class postage.
Illustrations: Approached by 40-50 illustrators/year. Buys 50-60 illustrations/year. Prefers realistic and cartoon. Considers pen & ink, watercolor, collage, airbrush, colored pencil and oil. Send postcard sample or

tearsheets. Accepts disk submissions. Single file EPS format or CMYKTIFF. Samples are filed. Reports back to the artist only if interested. Portfolio review not required. Buys all rights. **Pays on acceptance**; $150 for 1-page inside illustration; $325 for 2-page inside illustration. Finds artists through submissions, other publications and word of mouth.
Tips: Areas most open to freelancers are "realistic and cartoon illustrations for our stories and articles."

STUDENT LAWYER, 750 N. Lake Shore Dr., Chicago IL 60611. (312)988-6049. Art Director: Mary Anne Kulchanik. Estab. 1972. Trade journal, 4-color, emphasizing legal education and social/legal issues. "*Student Lawyer* is a legal affairs magazine published by the Law Student Division of the American Bar Association. It is not a legal journal. It is a features magazine, competing for a share of law students' limited spare time—so the articles we publish must be informative, lively, good reads. We have no interest whatsoever in anything that resembles a footnoted, academic article. We are interested in professional and legal education issues, sociolegal phenomena, legal career features, profiles of lawyers who are making an impact on the profession and the (very) occasional piece of fiction." Monthly (September-May). Circ. 35,000. Accepts previously published material. Original artwork is returned to the artist after publication. Sample copies for $4. Art guidelines for SASE with first-class postage. Needs computer-literate freelancers for illustration.
Illustrations: Approached by 20 illustrators/year. Buys 8 illustrations/issue. Needs editorial illustration with an "innovative, intelligent style." Works on assignment only. Send postcard sample, brochure, tearsheets and printed sheet with a variety of art images (include name and phone number). Samples are filed or returned by SASE. Reports back within 3 weeks only if interested. Call for appointment to show portfolio of final art and tearsheets. Buys one-time rights. **Pays on acceptance**; $500-700 for color cover; $300-400 for b&w, $450-550 for color inside; $125-150 for spots.
Tips: "In your portfolio, show a variety of color and b&w, plus editorial work."

SUNSHINE MAGAZINE, 200 E. Las Olas Blvd., Ft. Lauderdale FL 33301. (305)356-4690. E-mail: gcarannante@tribune.com. Art Director: Greg Carannante. Estab. 1983. Consumer magazine; the Sunday magazine for the *Sun Sentinel* newspaper; "featuring anything that would interest an intelligent adult reader living on South Florida's famous 'gold coast.'" Circ. 350,000. Accepts previously published artwork. Original artwork returned to artist at the job's completion. Sample copies and art guidelines available.
Illustrations: Approached by 100 illustrators/year. Buys 60-70 freelance illustrations/year. Works on assignment only. Preferred themes and styles vary. Considers all color media. Send postcard sample. Will accept computer art—Quark/Photoshop interface. Samples are filed or are returned by SASE. Reports back to the artist only if interested. To show a portfolio, mail color cards, disks, tearsheets, photostats, slides and photocopies. Buys first rights, one-time rights. **Pays on acceptance**; $600-700 for color cover; $250-700 for color inside.
Tips: Looking for stylized, colorful dramatic images "with a difference."

‡TAPPI JOURNAL, 15 Technology Pkwy., Norcross GA 30092. (770)446-1400. Fax: (770)368-9774. Production Manager: Elizabeth Compton. Monthly trade journal covering pulp and paper industry. Circ. 50,000. Sample copies available.
Illustration: Approached by 3 illustrators/year. Buys 1 illustration/year. Prefers pulp and paper/manufacturing and engineering themes. Considers all media. Knowledge of Adobe Photoshop, QuarkXPress, Adobe Illustrator helpful, but not required. Send query letter with printed samples. Send follow-up postcard sample every 3 months. Accepts disk submissions compatible with latest version of Photoshop, QuarkXPress. Send EPS. Reports back within 1 month. Buys all rights. **Pays on acceptance**; $1,000 maximum for color. Finds illustrators through word of mouth, magazines.

TECHNICAL ANALYSIS OF STOCKS & COMMODITIES, 4757 California Ave. SW, Seattle WA 98116-4499. (206)938-0570. Publisher: Jack K. Hutson. Estab. 1982. Monthly traders' magazine for stocks, bonds, futures, commodities, options, mutual funds. Circ. 45,000. Accepts previously published artwork. Sample copies available for $5. Art guidelines for SASE with first-class postage. 10% of freelance work demands knowledge of Adobe Photoshop or Illustrator.
Cartoons: Approached by 10 cartoonists/year. Buys 1 cartoon/issue. Prefers humorous cartoons, single panel b&w line drawings with gagline. Send query letter with finished cartoons. Samples are filed or are returned by SASE if requested by artist. Reports back within 3 weeks. Buys one-time rights and reprint rights. Pays $30 for b&w.
Illustrations: Approached by 25 illustrators/year. Buys 6 illustrations/issue. Works on assignment only. Send query letter with brochure, tearsheets, photographs, photocopies, photostats, slides. Accepts disks compatible with any Adobe product on TIFF or EPS files. Samples are filed or are returned by SASE if requested by artist. Reports back within 3 weeks. Publication will contact artist for portfolio review if interested. Portfolio should include b&w and color tearsheets, slides, photostats, photocopies, final art and photographs. Buys one-time rights and reprint rights. Pays on publication; $135-350 for color cover; $135-175 for color, $60-110 for b&w inside, $30-60 for spots.
Tips: Areas most open to freelancers are caricatures with market charts or computers.

TENNIS, Dept. AGDM, 5520 Park Ave., Trumbull CT 06611. (203)373-7000. Art Director: Lori Wendin. For young, affluent tennis players. Monthly. Circ. 800,000.
Illustrations: Works with 15-20 illustrators/year. Buys 50 illustrations/year. Uses artists mainly for spots and openers. Works on assignment only. Send query letter with tearsheets. Mail printed samples of work.
Pays on acceptance; $400-800 for color.
Tips: "Prospective contributors should first look through an issue of the magazine to make sure their style is appropriate for us."

TEXAS CONNECTION MAGAZINE, P.O. Box 2743, Corpus Christi TX 78403. (512)884-3445. Fax: (512)884-8868. E-mail: firstpub@sat.net. Website: http://www.firstpub.com. Editor: Nanci Drewer. Estab. 1985. Monthly adult magazine. Circ. 25,000. Originals returned at job's completion. Sample copies available for $10. Art guidelines available for SASE with first-class postage.
Cartoons: Buys 4-6 cartoons/issue. Prefers adult; single panel b&w washes and line drawings with gagline. Send query letter with finished cartoons. Samples are filed, not filed or returned at artist's request. Reports back to the artist only if interested. Buys first rights. Pays $25 for b&w.
Illustrations: Approached by 50 illustrators/year. Buys 12 illustrations/issue. Prefers adult. Send query letter with photocopies, tearsheets and SASE. Accepts disk submissions compatible with PageMaker6 (Windows), CorelDraw. Samples that are not filed are returned. Publication will contact artist for portfolio review if interested. Portfolio should include b&w and color photocopies and final art. Buys one-time rights. Pays on publication; $25-50 for b&w, $100 for color inside; $25 for spots. Finds artists through submissions.
Design: Needs freelancers for production and multimedia. 100% of freelance work demands knowledge of Windows versions of Aldus Pagemaker 6, Adobe Photoshop, CorelDraw. Send query letter with photocopies, tearsheets and SASE.
Tips: Areas most open to freelancers are "adult situations normally—some editorial and feature illustrations. Give us something fresh—some new twist on adult situations—not the same old, tired grind. Artists willing to relocate to Corpus Christi to become part of expanding in-house design team are welcome to submit résumés with samples and references."

TEXAS MONTHLY, P.O. Box 1569, Austin TX 78767-1569. (512)320-6900. Fax: (512)476-9007. Art Director: D.J. Stout. Estab. 1973. Monthly general interest magazine about Texas. Circ. 350,000. Accepts previously published artwork. Originals are returned to artist at job's completion.
Illustrations: Approached by hundreds of illustrators/year. Works on assignment only. Considers all media. Send postcard sample of work or send query letter with tearsheets, photographs, photocopies. Samples are filed "if I like them," or returned by SASE if requested by artist. Publication will contact artist for portfolio review if interested. Portfolio should include tearsheets, photographs, photocopies. Buys one-time rights. Pays on publication; $1,000 for color cover; $800-2,000 for color inside; $150-400 for spots.

‡THEDAMU ARTS MAGAZINE, 13217 Livernois, Detroit MI 48238-3162. (313)931-3427. Publisher: David Rambeau. Estab. 1970. Quarterly b&w "general adult multi-disciplinary afro-centric urban arts magazine." Circ. 1,000. Accepts previously published graphic artwork "for our covers." Send copies only. Sample copies and art guidelines for SASE with first-class postage.
Cartoons: Approached by 5-10 cartoonists/year. "We do special cartoon issues featuring a single artist like a comic book (40-80, 8×11 horizontal drawings) with adult, urban, contemporary themes with a storyline that can be used or transferred to video and would fill seven tab pages and a cover." Prefers b&w graphics or color line drawings. Send query letter with 3-6 story cartoons. Reports back within 3 months only if interested. Buys one-time rights usually, but rights purchased sometimes vary according to project. Pays $25 for b&w and color. Finds artists through word of mouth and other magazines.
Illustrations: Send résumé, photocopies, SASE; "whatever the illustrator is happy with." Accepts disk submissions. Payment negotiable; usually copies.
Design: Needs freelancers for design projects. Send query letter with photocopies and SASE. Pays by the project; negotiable.
Tips: "We're the first or second step on the publishing ladder for artists and writers. Submit same work to others also. Be ready to negotiate. I see electronic computer bulletin board magazines ahead. More small (500-1,000 copies) magazines given computer advances, linkages with video, particularly with respect to cartoons. Be ready to accept copies to distribute. Do cover graphics and story cartoons. Be computer literate."

THEMA, Box 74109, Metairie LA 70033-4109. (504)568-6268. Editor: Virginia Howard. Estab. 1988. Triquarterly. Circ. 300. Sample copies are available for $8. Art guidelines for SASE with first-class postage. Freelancers should be familiar with CorelDraw.
 • Each issue of *Thema* is based on a different, unusual theme, such as "Is it a Fossil, Higgins?" Upcoming themes and deadlines include "Scrawled in a Library Book" (March 1, 1997); "Eureka!" (July 1, 1997); "An Unexpected Guest" (November 1, 1997).
Cartoons: Approached by 10 cartoonists/year. Buys 1 cartoon/issue. Preferred themes are specified for individual issue (see **Tips** and Editorial Comment). Prefers humorous cartoons; b&w line drawings without

gagline. Send query letter with finished cartoons. Samples are filed or are returned by SASE if requested by artist. Buys one-time rights. Pays $10 for b&w.

Illustrations: Approached by 10 illustrators/year. Buys 1 illustration/issue. Preferred themes are specified for target issue (see **Tips** and Editorial Comment). Considers pen & ink. Send query letter specifying target theme with photocopies, photographs and SASE. Samples are returned by SASE if requested by artist. Portfolio review not required. Buys one-time rights. **Pays on acceptance**; $25 for b&w cover; $10 for b&w inside; $5 for spots. Finds artists through word of mouth.

Tips: "Generally, artwork goes on the left-hand page facing the first story. It should try to depict the theme for that issue. With more submissions, we would expand the use of art throughout the journal. Request list of upcoming themes (with SASE) before submitting work. Submit b&w renderings only."

THE TOASTMASTER, 23182 Arroyo Vista, Rancho Santa Margarita CA 92688. (714)858-8255. Editor: Suzanne Frey. Estab. 1924. Monthly trade journal for association members. "Language, public speaking, communication are our topics." Circ. 170,000. Accepts previously published artwork. Originals returned at job's completion. Sample copies available.

Illustrations: Buys 6 illustrations/issue. Works on assignment only. Prefers communications themes. Considers watercolor and collage. Send postcard sample. Accepts disk submissions. Samples are filed or returned by SASE if requested by artist. Reports back to the artist only if interested. Portfolio should include b&w tearsheets and photocopies. Negotiates rights purchased. **Pays on acceptance**; $500 for color cover; $50-200 for b&w, $100-250 for color inside.

‡TODAY'S FIREMAN, Box 875108, Los Angeles CA 90087. Editor: Jayney Mack. Estab. 1960. Quarterly b&w trade tabloid featuring general interest, humor and technical articles and emphasizing the fire service. "Readers are firefighters—items should be of interest to the fire service." Circ. 10,000. Accepts previously published material. Original artwork is not returned after publication.

Cartoons: Buys 12 cartoons/year from freelancers. Prefers fire-service oriented single panel with gagline; b&w line drawings. Send query letter with samples of style, roughs or finished cartoons. Reports back only if interested. Buys one-time rights. Pays $4.

Illustration: Send postcard sample or query letter with brochure. Pays $4-10 for b&w inside.

Tips: "Everything should relate to the fire service."

TOLE WORLD, 1041 Shary Circle, Concord CA 94518. (510)671-9852. Editor: Judy Swager. Estab. 1977. Bimonthly 4-color magazine with creative designs for decorative painters. "*Tole* incorporates all forms of craft painting including folk art. Manuscripts on techniques encouraged." Circ. 100,000. Accepts previously published artwork. Original artwork returned after publication. Sample copies available. Art guidelines available for SASE with first-class postage.

Illustrations: Buys illustrations mainly for step-by-step project articles. Buys 8-10 illustrations/issue. Prefers acrylics and oils. Considers alkyds, pen & ink, mixed media, colored pencil, watercolor and pastels. Needs editorial and technical illustration. Send query letter with photographs. Samples are not filed and are returned. Reports back about queries/submissions within 1 month. Pay is negotiable.

Tips: "Submissions should be neat, evocative and well-balanced in color scheme with traditional themes, though style can be modern."

TRAINING & DEVELOPMENT MAGAZINE, 1640 King St., Box 1443, Alexandria VA 22313-2043. (703)683-8146. Fax: (703)683-9203. Art Director: Elizabeth Z. Jones. Estab. 1945. Monthly trade journal that covers training and development in all fields of business. Circ. 30,000. Accepts previously published artwork. Original artwork is returned at job's completion. Sample copies available.

Illustrations: Approached by 20 freelance illustrators/year. Buys 7-9 freelance illustrations/issue. Works on assignment only. Prefers sophisticated business style, Anthony Russo style. Considers collage, pen & ink, airbrush, acrylic, oil, mixed media, pastel. Send postcard sample. Accepts disks compatible with Adobe Illustrator 5.5, Aldus FreeHand 5.0. Send EPS or TIFF files. Use 4-color (process) settings only. Samples are filed. Reports back to the artist only if interested. Write for appointment to show portfolio of tearsheets, slides. Buys one-time rights or reprint rights. Pays on publication; $400-600 for b&w, $600-900 for color cover; $200-300 for b&w, $400-600 for color inside; $100-300 for spots.

Tips: "Send more than one image if possible. Do not keep sending the same image."

TRAINING MAGAZINE, The Human Side of Business, 50 S. Ninth St., Minneapolis MN 55402. (612)333-0471. Fax: (612)333-6526. Art Director: Nancy Eato. Estab. 1964. Monthly 4-color trade journal covering job-related training and education in business and industry, both theory and practice. Audience: training directors, personnel managers, sales and data processing managers, general managers, etc. "We use a variety of styles, but it is a business-looking magazine." Circ. 51,000. Sample copies for SASE with first-class postage.

Cartoons: Approached by 20-25 cartoonists/year. Buys 1-2 cartoons/issue. "We buy a wide variety of styles. The themes relate directly to our editorial content, which is training in the workplace." Prefers single panel, b&w line drawings or washes with and without gagline. Send query letter with brochure and finished

cartoons. Samples are filed or are returned by SASE if requested by artist. Reports back within 1 month. Buys first rights or one-time rights. Pays $25 for b&w.

Illustrations: Buys 6-8 illustrations/issue. Works on assignment only. Prefers themes that relate directly to editorial content. Styles are varied. Considers pen & ink, airbrush, mixed media, watercolor, acrylic, oil, pastel and collage. Send postcard sample, tearsheets, photocopies and SASE. Accepts disk submissions. Samples are filed or are returned by SASE if requested by artist. Reports back to the artist only if interested. Call or write for appointment to show portfolio of final art and b&w and color tearsheets, photostats, photographs, slides and photocopies. Buys first rights or one-time rights. **Pays on acceptance**; $700-1,200 for color cover; $200-250 for color inside; $50 for spots.

Tips: "Show a wide variety of work in different media and with different subject matter. Good renditions of people are extremely important."

‡**TRAINS**, P.O. Box 1612, 21027 Crossroads Circle, Waukesha WI 53187. (414)796-8776. Fax: (414)796-1778. E-mail: lzehner@kalmbach.com. Art Director: Lisa A. Zehner. Estab. 1940. Monthly magazine about trains, train companies, tourist RR, latest railroad news. Art guidelines available.
 • Published by Kalmbach Publishing. Also see listings for *Classic Toy Trains, Astronomy, Finescale Modeler, Model Railroader, Model Retailer* and *Nutshell News.*

Illustration: 100% of freelance illustration demands knowledge of Adobe Photoshop 3.0, Adobe Illustrator 5.5. Send query letter with printed samples, photocopies and tearsheets. Accepts disk submissions (opticals), CDs, using programs above. Samples are filed. Art director will contact artist for portfolio review of color tearsheets if interested. Buys one-time rights. Pays on publication.

Tips: "Quick turnaround and accurately-built files are a must."

TRAVEL & LEISURE, Dept. AM, 1120 Sixth Ave., New York NY 10036. (212)382-5600. Art Director: Pamela Berry. Associate Art Director: Gaemer Gutierrez. Monthly magazine emphasizing travel, resorts, dining and entertainment. Circ. 1 million. Original artwork returned after publication. Art guidelines for SASE. Needs freelancers fluent in QuarkXPress, Aldus FreeHand, Adobe Photoshop and Fontographer.

Illustrations: Approached by 250-350 illustrators/year. Buys 1-15 illustrations/issue. Interested in travel and leisure-related themes. Prefers pen & ink, airbrush, colored pencil, watercolor, acrylic, oil, pastel, collage, mixed media and calligraphy. Does not use b&w work. "Illustrators are selected by excellence and relevance to the subject." Works on assignment only. Provide business card to be kept on file for future assignment; samples returned by SASE. Reports in 1 week. Buys world serial rights. Pays on publication; $800-1,500 maximum for color inside; $1,500 for color cover.

Tips: No cartoons.

TRIQUARTERLY, 2020 Ridge Ave., Evanston IL 60208-4302. (847)491-3490. Fax: (847)467-2096. Editor: Reginald Gibbons. Estab. 1964. Triquarterly literary magazine, "dedicated to publishing writing and graphics which are fresh, adventurous, artistically challenging and never predictable." Circ. 5,000. Originals returned at job's completion. Sample copies for $5.

Illustrations: Approached by 10-20 illustrators/year. Considers only work that can be reproduced in b&w as line art or screen for pages; all media; 4-color for cover. Send query letter with SASE, tearsheets, photographs, photocopies and brochure. Samples are filed or are returned by SASE. Reports back within 3 months (if SASE is supplied). Publication will contact artist for portfolio review if interested. Portfolio should include b&w and color thumbnails, tearsheets, slides, photostats, photocopies, final art and photographs. Buys first rights. Pays on publication; $300 for b&w/color cover; $30-50 for b&w inside.

TRUE WEST/OLD WEST, Box 2107, Stillwater OK 74076. (405)743-3370. Editor: John Joerschke. Monthly/quarterly b&w magazine with 4-color cover emphasizing American Western history from 1830 to 1910. For a primarily rural and suburban audience, middle-age and older, interested in Old West history, horses, cowboys, art, clothing and all things Western. Circ. 30,000. Accepts previously published material and considers some simultaneous submissions. Original artwork returned after publication. Sample copy for $2. Art guidelines for SASE.

Illustrations: Approached by 75 illustrators/year. Buys 5-10 illustrations/issue (2 or 3 humorous). "Inside illustrations are usually, but not always, pen & ink line drawings; covers are Western paintings." Send query letter with photocopies to be kept on file; "We return anything on request. For inside illustrations, we want samples of artist's line drawings. For covers, we need to see full-color transparencies." Publication will contact artist for portfolio review if interested. Buys one-time rights. Sometimes requests work on spec before assigning job. "**Pays on acceptance for new artists, on assignment for established contributors.**" Pays $125-150 for color cover; $20-50 for b&w inside.

Tips: "We think the mainstream of interest in Western Americana has moved in the direction of fine art, and we're looking for more material along those lines. Our magazine has an old-fashioned Western history design with a few modern touches. We use a wide variety of styles so long as they are historically accurate and have an old-time flavor. We must see samples demonstrating historically accurate details of the Old West."

TURTLE MAGAZINE, For Preschool Kids, Children's Better Health Institute, 1100 Waterway Blvd., Box 567, Indianapolis IN 46206. (317)636-8881. Art Director: Bart Rivers. Estab. 1979. Emphasizes health, nutrition, exercise and safety for children 2-5 years. Published 8 times/year; 4-color. Original artwork not returned after publication. Sample copy for 5 first-class stamps; art guidelines for SASE with first-class postage. Needs computer-literate freelancers familiar with Aldus FreeHand and Adobe Photoshop for illustrations.
 • Also publishes *Child Life, Children's Digest, Children's Playmate, Humpty Dumpty's Magazine* and *Jack and Jill.*
Illustrations: Approached by 100 illustrators/year. Works with 20 illustrators/year. Buys 15-30 illustrations/issue. Interested in "stylized, humorous, realistic and cartooned themes; also nature and health." Works on assignment only. Send query letter with good photocopies and tearsheets. Accepts disk submissions. Samples are filed or are returned by SASE. Reports only if interested. Portfolio review not required. Buys all rights. Pays on publication; $275 for color cover; $35-90 for b&w, $70-155 for color inside; $35-70 for spots. Finds most artists through samples received in mail.
Tips: "Familiarize yourself with our magazine and other children's publications before you submit any samples. The samples you send should demonstrate your ability to support a story with illustration."

‡**TV GUIDE**, 1211 Sixth Ave., New York NY 10036. (212)852-7500. Fax: (212)852-7470. Art Director: Ken Feisel. Estab. 1953. Weekly consumer magazine for television viewers. Circ. 13,000,000. Sample copies available.
Illustration: Approached by 200 illustrators/year. Buys 15-20 illustrations/year. Considers all media. Send postcard sample. Accepts disk submissions (216 DPI, CMYK, TIFF). Samples are filed. Art director will contact artist for portfolio review of color tearsheets if interested. Negotiates rights purchased. **Pays on acceptance**; $1,500-4,000 for color cover; $1,000-2,000 for color inside; $200-500 for spots. Finds artists through sourcebooks, magazines, word of mouth, submissions.
Design: Needs freelancers for design. Prefers designers with experience in editorial design. 100% of design work demands knowledge of Aldus FreeHand 5.5, Adobe Photoshop 3.0 and/or QuarkXPress 3.31. Send query letter with printed samples and tearsheets.

TWINS MAGAZINE, 6740 Antioch, Suite 155, Merriam KS 66204. (913)722-1090. Fax: (913)722-1767. Art Director: Cindy Himmelberg. Estab. 1984. Bimonthly 4-color international magazine designed to give professional guidance to multiples, their parents and professionals who care for them. Circ. 55,000. Sample copies available. Art guidelines for SASE with first-class postage.
Cartoons: Pays $25 for b&w, $50 for color.
Illustrations: Approached by 10 illustrators/year. Buys 10 illustrations/issue. Works on assignment only. Prefers children (twins) in assigned situations. Considers watercolor, airbrush, acrylic, marker, colored pencil and pastel. Send query letter with résumé, tearsheets, photocopies, slides. Samples are filed or returned by SASE if requested by artist. Request portfolio review in original query. Reports back to the artist only if interested. Portfolio should include final art, color tearsheets, photographs and photocopies. Buys all rights. Pays on publication; $150 for color cover; $100 for color inside. Finds artists through submissions.

‡**U. THE NATIONAL COLLEGE MAGAZINE**, 1800 Century Park E. #820, Los Angeles CA 90067-1511. (310)551-1381. Fax: (310)551-1659. E-mail: editor@umagazine.com. Website: http://www.umagazine.com. Editor: Frances Huffman. Estab. 1987. Consumer magazine published 9 times/year. News, lifestyle and entertainment magazine geared to college students. Magazine is for college students by college students. Circ. 1.5 million. Sample copies and art guidelines available.
Cartoons: Approached by 20 cartoonists/year. Buys 1 cartoon/issue. Prefers college-related themes. Prefers color washes. Send query letter with photocopies and tearsheets. Samples are filed and not returned. Reports back only if interested. Buys all rights. **Pays on acceptance**; $25 for color.
Illustration: Approached by 50 illustrators/year. Buys 10 illustrations/issue. Prefers bright, light, college-related, humorous, color only, no b&w. Considers air brush, collage, color washed, colored pencil, marker, mixed media or watercolor. 25% of freelance illustration demands knowledge of Adobe Photoshop, Adobe Illustrator. Send query letter with photocopies and tearsheets. Accepts disk submissions. Photoshop files should be 220 DPI minimum, TIFF or EPS format, CMYK color. Include fonts if any used. Samples are filed and are not returned. Reports back only if interested. Buys all rights. Pays on publication; $100 for color cover; $25 for color inside; $25 for spots. Finds illustrators through college campus newspapers and magazines.
Tips: "We work with college students only."

UNIQUE OPPORTUNITIES, The Physicians' Resource, 455 S. Fourth Ave., Louisville KY 40202-2582. (502)589-8250. Fax: (502)587-0848. E-mail: bettuo@aol.com. Publisher and Design Director: Barbara Barry. Estab. 1991. Bimonthly trade journal. "Our audience is physicians looking for jobs. Editorial focus is on practice-related issues." Circ. 80,000. Originals returned at job's completion. Freelancers should be familiar with QuarkXPress, Adobe Photoshop and Aldus FreeHand.

Illustrations: Approached by 10 illustrators/year. Buys 1-2 illustrations/issue. Works on assignment only. Considers pen & ink, mixed media, collage and pastel. Send postcard-size sample or query letter with tearsheets. Samples are filed and are not returned. Publication will contact artist for portfolio of final art, tearsheets, eps files on a floppy disk if interested. Buys first or one-time rights. **Pays on acceptance** plus 30 days; $700 for color cover; $400 for color inside; $100 for spots. Finds artists through sourcebooks such as *Workbook*, submissions and other magazines.

‡**USA SOFTBALL MAGAZINE**, (formerly *Balls & Strikes Softball*), 2801 NE 50th St., Oklahoma City OK 73111. (405)424-5266. Fax: (405)424-4734. Editor-in-Chief: Ronald A. Babb. Estab. 1933. Monthly sports consumer magazine emphasizing amateur and Olympic softball. Circ. 310,000. Originals returned at job's completion. Sample copies and art guidelines available. 50% of freelance work demands knowledge of Aldus PageMaker, Adobe Illustrator, QuarkXPress, Adobe Photoshop or Aldus FreeHand.
Cartoons: Approached by 10 cartoonists/year. Buys 1 cartoon/issue. Only sports-softball single panel cartoons. Send query letter with roughs. Samples are not filed and are returned by SASE if requested by artist. Reports back to the artist only if interested. Buys first rights. Pays $50-100 for b&w.
Illustrations: Approached by 10 illustrators/year. Sports-softball only. Considers pen & ink, watercolor, collage, airbrush, acrylic, marker, colored pencil, oil, charcoal, mixed media and pastel. Send query letter with tearsheets and photostats. Samples are not filed and are returned by SASE if requested by artist. Publication will contact artist for portfolio review if interested. Portfolio should include b&w and color roughs and tearsheets. Buys first rights. Pays on publication; $350 for color cover; $50 for b&w, $100 for color inside.

VANITY FAIR, 350 Madison Ave., New York NY 10017. (212)880-8800. Fax: (212)880-6707. E-mail: vfmail@vf.com. Art Director: David Harris. Estab. 1983. Monthly consumer magazine. Circ. 1.1 million. Does not use previously published artwork. Original artwork returned at job's completion. 100% of freelance design work demands knowledge of QuarkXPress and Adobe Photoshop.
Illustrations: Approached by "hundreds" of illustrators/year. Buys 3-4 illustrations/issue. Works on assignment only. "Mostly uses artists under contract."

‡**VARBUSINESS**, Dept. AM, One Jericho Plaza, Wing A, Jericho NY 11753. (516)733-6700. Contact: Art Director. Estab. 1985. Emphasizes computer business, for and about value added resellers. "The art is in a lighter, less technical vein"; monthly 4-color with an "innovative, contemporary, progressive, very creative" design. Circ. 95,000. Original artwork is returned to the artist after publication. Art guidelines not available.
Illustrations: Approached by 100+ illustrators/year. Works with 30-50 illustrators/year. Buys 150 illustrations/year. Needs editorial illustrations. Artists should have a "pop illustrative style." Style of Lou Brooks, Robert Risko, Mark Fredrickson, Bill Mayer. Uses artists mainly for covers, full and single page spreads and spots. Works on assignment only. Prefers airbrush, then pen & ink, colored pencil, acrylic, pastel and computer illustration. Send postcard sample or query letter with tearsheets. Accepts disk submissions. Samples are filed or are returned only if requested. Reports back only if interested. Call or write for appointment to show portfolio, which should include tearsheets, final reproduction/product and slides. Buys one-time rights. Payment varies. 20% of freelance work demands knowledge of Adobe Photoshop.
Design: Needs freelancers for multimedia projects. 20% of design demands knowledge of Adobe Photoshop, Adobe Illustrator, QuarkXPress. Send query letter with tearsheets. Pays by project.
Tips: "Show printed pieces or suitable color reproductions. Concepts should be imaginative, not literal. Sense of humor is important."

VEGETARIAN JOURNAL, P.O. Box 1463, Baltimore MD 21203-1463. (410)366-8343. Editor: Debra Wasserman. Estab. 1982. Bimonthly nonprofit vegetarian magazine that examines the health, ecological and ethical aspects of vegetarianism. "Highly educated audience including health professionals." Circ. 27,000. Accepts previously published artwork. Originals returned at job's completion upon request. Sample copies available for $3.
Cartoons: Approached by 4 cartoonists/year. Buys 1 cartoon/issue. Prefers humorous cartoons; single panel b&w line drawings. Send query letter with roughs. Samples are not filed and are returned by SASE if requested by artist. Reports back within 2 weeks. Rights purchased vary according to project. Pays $25 for b&w.
Illustrations: Approached by 20 illustrators/year. Buys 6 illustrations/issue. Works on assignment only. Prefers strict vegetarian food scenes (no animal products). Considers pen & ink, watercolor, collage, charcoal and mixed media. Send query letter with photostats. Samples are not filed and are returned by SASE if requested by artist. Reports back within 2 weeks. Portfolio review not required. Rights purchased vary according to project. **Pays on acceptance**; $25 for b&w/color inside. Finds artists through word of mouth and job listings in art schools.
Tips: Areas most open to freelancers are recipe section and feature articles. "Review magazine first to learn our style. Send query letter with photocopy sample of line drawings of food."

VENTURE, Box 150, Wheaton IL 60189. (708)665-0630. Fax: (708)665-0372. Art Director: Robert Fine. Estab. 1959. 4-color magazine for boys 8-11; published 5 times a year. "Our aim is to promote Christian

values and awareness of social and ethical issues." Circ. 20,000. Accepts previously published artwork. Original artwork returned after publication if requested. Sample copy $1.85 with large SASE; art guidelines for SASE with first-class postage.

Cartoons: Send to attention of cartoon editor. Approached by 20 cartoonists/year. Buys 1-3 cartoons/issue on nature, family life, sports, school, camping, hiking. Prefers single panel with gagline. Send finished cartoons. Include SASE. Reports in 1 month. Buys first-time rights. **Pays on acceptance**; $30 minimum.

Illustrations: Approached by 50 illustrators/year. Buys 3-4 color illustrations/issue. Subjects include education, nature, family life, sports and camping. Works on assignment only. Send business card, tearsheets and photocopies of samples to be kept on file for future assignments. Samples returned by SASE. Publication will contact artist for portfolio review if interested. Buys one-time rights. Pays on publication; $200 minimum for color cover; $200 minimum for color inside.

VERMONT MAGAZINE, 2 Maple St., Suite 400, Middlebury VT 05753. (802)388-8480. Fax: (802)388-8485. Art Director: Susan Romanoff. Estab. 1989. Bimonthly regional publication "aiming to explore what life in Vermont is like: its politics, social issues and scenic beauty." Circ. 50,000. Accepts previously published artwork. Original artwork returned at job's completion. Sample copies and art guidelines for SASE with first-class postage.

Illustrations: Approached by 100-150 illustrators/year. Buys 2-3 illustrations/issue. Works on assignment only. "Particularly interested in creativity and uniqueness of approach." Considers pen & ink, watercolor, colored pencil, oil, charcoal, mixed media and pastel. Send query letter with tearsheets, "something that I can keep." Materials of interest are filed. Publication will contact artist for portfolio review if interested. Portfolio should include final art and tearsheets. Buys one-time rights. Considers buying second rights (reprint rights) to previously published work. Pays $800 for color cover; $250 for b&w, $600 for color inside depending on assignment and size. Finds artists mostly through submissions/self-promos and from other art directors.

Tips: "Please send me a personalized note that indicates you've seen our magazine and you think your artwork would fit in; give reasons. Handwritten and informal is just fine. We will continue to see lean times in the magazine field. Assignment fees for most magazines will probably stay where they are for awhile and contributors who are unwilling to work in this tough market will probably lose jobs. In return, art directors will begin to give illustrators more creative freedom."

VIBE, 205 Lexington Ave., New York NY 10016. (212)522-7092. Fax: (212)522-4578. Art Director: Lee Ellen Fanning. Estab. 1993. Monthly consumer magazine focused on music, urban culture. Circ. 400,000. Accepts previously published artwork. Originals returned at job's completion. Sample copies available. 100% of freelance work demands knowledge of QuarkXPress and Adobe Photoshop.

Cartoons: Approached by 20 cartoonists/year. Buys 1 cartoon/issue. Prefers humorous urban culture themes. Send postcard-size sample or query letter with brochure and finished cartoons. Samples are filed. Reports back to the artist only if interested. Buys one-time rights.

Illustrations: Approached by 50 illustrators/year. Buys 2 illustrations/quarter (every three issues). Works on assignment only. Prefers urban culture themes. Considers all media. Send postcard-size sample or query letter with photocopies. Samples are filed. Portfolios may be dropped off every Thursday. Publication will contact artist for portfolio review of roughs, final art and photocopies if interested. Buys one-time or all rights. Finds artists through portfolio drop-off.

VICA JOURNAL, 14001 James Monroe Hwy., Box 3000, Leesburg VA 22075. (703)777-8810. Fax: (703)777-8999. E-mail: dialogvica@aol.com. Editor: Tom Hall. Estab. 1965. Quarterly tabloid, b&w with 4-color cover and center spread. "*VICA Journal* helps high school and post-secondary students learn about careers, educational opportunities and activities of VICA chapters. VICA is an organization of 250,000 students and teachers in trade, industrial, technical and health occupations education." Circ. 250,000. Accepts previously published artwork. Originals returned at job's completion (if requested). Sample copies available.

Illustrations: Approached by 4 illustrators/year. Works on assignment only. Prefers positive, youthful, innovative, action-oriented images. Considers pen & ink, watercolor, collage, airbrush and acrylic. Send postcard sample. Accepts disks compatible with Aldus FreeHand 5.0 and PageMaker 6.0. Send EPS files. Samples are filed. Portfolio should include printed samples, b&w and color samples and photographs. Rights purchased vary according to project. **Pays on acceptance**; $100-300 for b&w, $200-400 for color cover; $50-150 for b&w and $100-200 for color inside; $50-150 for spots.

Tips: "Send samples or a brochure. These will be kept on file until illustrations are needed. Don't call! Fast turnaround helpful. Due to the unique nature of our audience, most illustrations are not re-usable; we prefer to keep art."

VIDEOMAKER MAGAZINE, Box 4591, Chico CA 95927. (916)891-8410. Fax: (916)891-8443. E-mail: jsouza@videomaker.com. Art Director: Janet Souza. Monthly 4-color magazine for video camera users with "contemporary, stylish yet technical design." Circ. 150,000. Accepts previously published artwork. Original artwork returned at job's completion. Sample copies and art guidelines available. 75% of freelance work demands knowledge of Aldus PageMaker, Adobe Illustrator or Aldus FreeHand.

Cartoons: Prefers technical illustrations with a humorous twist. Pays $30-200 for b&w, $200-800 for color.
Illustrations: Approached by 30 illustrators/year. Buys 3 illustrations/issue. Works on assignment only. Likes "illustration with a humorous twist." Considers pen & ink, airbrush, colored pencil, mixed media, watercolor, acrylic, oil, pastel, collage, marker and charcoal. Needs editorial and technical illustration. Send postcard sample and/or query letter with photocopies, brochure, SASE and tearsheets. Samples are filed. Publication will contact artist for portfolio review. Portfolio should include thumbnails, tearsheets and photographs. Negotiates rights purchased. Sometimes requests work on spec before assigning job. Pays on publication; $30-800 for b&w, $50-1,000 for color inside; $30-50 for spots. Finds artists through submissions/self-promotions.
Design: Needs freelancers for design. Freelance work demands knowledge of Aldus PageMaker and Aldus FreeHand. Send query letter with brochure, photocopies, SASE, tearsheets. Pays by the project, $30-1,000.
Tips: "Read a previous article from the magazine and show how it could have been illustrated. The idea is to take highly technical and esoteric material and translate that into something the layman can understand. Since our magazine is mostly designed on desktop, we are increasingly more inclined to use computer illustrations along with conventional art. We constantly need people who can interpret our information accurately for the satisfaction of our readership."

VIM & VIGOR, 1010 E. Missouri Ave., Phoenix AZ 85014. (602)395-5850. Fax: (602)395-5853. Managing Art Director: Randi Karabin. Estab. 1985. Quarterly consumer magazine focusing on health. Circ. 900,000. Originals returned at job's completion. Sample copies available. Art guidelines available.
 • *Salud y Vigor*, a Spanish version of this magazine, is published twice a year. The company also publishes a business magazine called *Future* three times a year.
Illustrations: Approached by 50 illustrators/year. Buys 12 illustrations/issue. Works on assignment only. Considers mixed media, collage, charcoal, acrylic, oil, pastel and computer. Send postcard sample with tearsheets. Accepts disk submissions. Samples are filed. Publication will contact artist for portfolio review of slides and photocopies if interested. Rights purchased vary according to project. **Pays on acceptance**; $700-1,100 for color inside; $300-400 for spots. Finds artists through agents, sourcebooks, word of mouth and submissions.
Design: Needs freelancers for design and production. 100% of freelance work demands knowledge of Adobe Photoshop, Adobe Illustrator and QuarkXPress. Send résumé and tearsheets. Pays for design by the project, by the day or by the hour.

‡VISIONS—INTERNATIONAL, THE WORLD OF ILLUSTRATED POETRY, Black Buzzard Press, 1110 Seaton Lane, Falls Church VA 22046. Editors: Bradley R. Strahan, Brad Ross and Shirley Sullivan. Emphasizes literature and the illustrative arts for "well educated, very literate audience, very much into art and poetry." Published 3 times/year. Circ. 750. Original artwork returned after publication *only if requested*. Sample copy for $4 (latest issue $5); art guidelines for SASE.
Illustrations: Approached by 40-50 illustrators/year. Acquires approximately 21 illustrations/issue. Needs poetry text illustration. Works on assignment only. Representational to surrealistic and some cubism. Black & white only. Send query letter with SASE and photocopies that clearly show artist's style and capability; no slides or originals. Samples not filed are returned by SASE. Reports within 2 months. Portfolio review not required. Acquires first rights. "For information of releases on artwork, please contact the editors at the above address." Pays in copies or up to $10.
Tips: "Finds new artists through our editor or people submitting samples. Don't send slides. We might lose them. We don't use color, anyway. No amateurs."

WASHINGTON PHARMACIST, 1501 Taylor Ave. SW, Renton WA 98055-3139. (206)228-7171. Fax: (206)277-3897. E-mail: wspa@u.washington.edu. Website: http://www.weber.u.washington.edu:80/~wspa/wspahome.html. Publications Director: Sheri Ray. Estab. 1959. Quarterly association trade magazine, b&w with 2- and 4-color covers, emphasizing pharmaceuticals, professional issues and management for pharmacists. Circ. 2,000. Accepts previously published artwork. Sample copies available.
Cartoons: Approached by 15 cartoonists/year. Buys fewer than 5 cartoons/year. Themes vary. Send query letter with brochure and roughs. Samples are filed. Reports back only if interested. Rights purchased vary according to project. Pays $15 for b&w.
Illustrations: Approached by 15 illustrators/year. Buys 2-5 illustrations/year. Send postcard sample or query letter with brochure. Publication will contact artist for portfolio review if interested. Rights purchased vary according to project. **Pays on acceptance**; $25-75 cover, $15-25 inside. Finds artists through submissions and word of mouth.

‡THE WASHINGTON POST MAGAZINE, Dept. AM, 1150 15th St. NW, Washington DC 20071. (202)334-7585. Fax: (202)334-5693. Art Director: Kelly Doe. Estab. 1986. Weekly magazine; general interest. Circ. 1,200,000. Original artwork returned after publication.
Illustrations: Approached by 500 illustrators/year. Buys 3 illustrations/issue. Works on assignment only. Prefers any media. Send query letter with tearsheets. Samples are filed. Does not report back. To show a

portfolio, mail tearsheets and slides. Buys one-time rights. **Pays on acceptance**; $1,000 for color cover; $300 for color, "little pieces," inside.

‡**THE WATER SKIER**, 799 Overlook Dr., Winter Haven FL 33884-1679. (813)324-4341. Fax: (813)325-8259. E-mail: 76774.1141. Editor: Don Cullimore. Estab. 1950. Bimonthly association publication covering both competitive and recreational water skiing. Circ. 35,000. Originals not returned. Sample copies available. Art guidelines not available. 75% of freelance work demands computer knowledge of Aldus PageMaker, Adobe Photoshop or Aldus FreeHand.

Cartoons: Approached by 2 cartoonists/year. Send query letter with brochure and finished cartoons. Samples are filed. Reports back to the artist only if interested. Buys first rights.

Illustrations: Approached by 20 illustrators/year. Buys 1-2 illustrations/issue. Works on assignment only. Prefers specific to waterskiing. Considers pen & ink, watercolor and charcoal. Send query letter with photocopies. Accepts disk submissions compatible with Aldus FreeHand. Send EPS files. Samples are filed. Publication will contact artist for portfolio review if interested. Portfolio should include b&w and color tearsheets, photostats, photocopies, final art and photographs. Buys first rights. Pays on publication.

WEEKLY READER/SECONDARY, Weekly Reader Corp., 245 Long Hill Rd., Middletown CT 06457. (203)638-2420. Fax: (203)346-5964. Contact: Mike DiGiorgio. Estab. 1928. Educational newspaper, magazine, posters and books. *Weekly Reader* and *Secondary* periodicals have a newspaper format. The *Weekly Reader* emphasizes news and education for children 4-14. The philosophy is to connect students to the world. Publications are 4-color or 2-color; b&w with 4-color or 2-color cover. Design is "clean, straight-forward." Accepts previously published artwork. Original artwork is returned at job's completion. Sample copies are available.

Cartoons: Approached by 10 cartoonists/year. Prefers contempory, humorous line work. Preferred themes and styles vary according to the needs of the story/articles; single panel. Send query letter with printed samples. Samples filed or are returned by SASE if requested by artist. Rights purchased vary according to project. Pays $75 for b&w; $250-300 for color (full page).

Illustrations: Needs editorial, technical and medical illustration. Style should be "contemporary and age level appropriate for the juvenile audience. Style of Janet Hamlin, Janet Street, Joe Locco, Joe Klein and Mas Mianot." Approached by 60-70 illustrators/year. Buys more than 50/week. Works on assignment only. Prefers pen & ink, airbrush, colored pencil, mixed media, watercolor, acrylic, pastel, collage and charcoal. Send query letter with brochure, tearsheets, slides, SASE and photocopies. Samples are filed or are returned by SASE if requested by artist. Request portfolio review in original query. Artist should follow up with letter after initial query. Payment is usually made within 3 weeks of receiving the invoice. Pays $250 for b&w, $300 for color cover; $250 for b&w, $300 for color inside. Finds artists through artists' submissions/self-promotions, sourcebooks, agents and reps.

Tips: "Our primary focus is the children's marketplace; figures must be drawn well if style is realistic. Art should reflect creativity and knowledge of audience's sophistication needs. Our budgets are tight and we have very little flexibility in our rates. We need artists who can work with our budgets. Still seeking out artists of all styles—professionals!"

WESTERN TALES MAGAZINE, P.O. Box 33842, Granada Hills CA 91394. Publisher: Dorman Nelson. Estab. 1993. Quarterly magazine featuring Western fiction and poetry. Circ. 5,000. Originals returned at job's completion. Sample copies available for $6. Art guidelines available for SASE with first-class postage.

Cartoons: Approached by 10 cartoonists/year. Buys 2 cartoons/issue. Prefers Western/Native American genre humorous cartoons; single panel b&w line drawings with gagline. Send query letter with roughs or finished cartoons. Samples are not filed and are returned by SASE. Reports in 2 months. Buys first rights. Pays $10-50 for b&w.

Illustrations: Approached by 10-15 illustrators/year. Buys 30 illustrations/issue. Prefers Western genre—animals, 1800s depictions, horse-oriented. Considers pen & ink, watercolor and collage. Send postcard sample or query letter with brochure, SASE and photocopies. Samples are not filed and are returned by SASE. Reports back within 2 months. Artist should follow up with call and/or letter after initial query. Portfolio should include b&w and color roughs and final art. Buys first rights. Pays on publication; $250 for color cover; $15-50 for b&w inside; $10-15 for spots. Finds artists through word of mouth, art galleries and art shows.

Tips: Work most open to freelancers is art for color cover, b&w pen & ink or brush watercolor in reference to stories and poetry. Looking for Western genre depictions of animals, ranch and range life, along with Native Americans and Native American art. "I keep a file on all artists and illustrators who send information, queries and work."

WESTWAYS, 2601 S. Figueroa, Los Angeles CA 90007. (213)741-4850. Fax: (213)741-3033. Art Director: Daphna Shalev. Estab. 1918. A monthly magazine covering travel and people; reaches an upscale audience through AAA membership as well as newsstand and subscription sales. Circ. 450,000. Original artwork returned at job's completion. Sample copies and art guidelines available for SASE.

Illustrations: Approached by 20 illustrators/year. Buys 2-6 illustrations/issue. Works on assignment only. Preferred style is arty-tasteful, colorful. Considers pen & ink, watercolor, collage, airbrush, acrylic, colored pencil, oil, mixed media and pastel. Send query letter with brochure, tearsheets and samples. Samples are filed. Reports back within 1-2 weeks only if interested. To show a portfolio, mail appropriate materials. Portfolio should include thumbnails, final art, b&w and color tearsheets. Buys first rights. Pays on publication; $250 minimum for color inside.

‡**WILDLIFE ART**, (formerly *Wildlife Art News*), P.O. Box 16246, St. Louis Park MN 55416-0246. (612)927-9056. Fax: (612)927-9353. Publisher: Robert Koenke. Estab. 1982. Bimonthly 4-color trade journal with award-winning design. Many two-page color art spreads. "The largest magazine in wildlife art originals, prints, duck stamps, artist interviews and industry information." Circ. 55,000. Accepts previously published artwork. Original artwork returned to artist at job's completion. Sample copy for $6. Art guidelines for SASE with first-class postage.
 • This magazine won an Ozzie award in 1995.
Cartoons: Buys up to 6 cartoons/year. Prefers nature, wildlife and environmental themes; single panel. Send query letter with roughs. Samples are not filed and are returned by SASE. Reports back within 1 month. Buys first rights. Pays $50 for b&w.
Illustrations: Approached by 100 illustrators/year. Works on assignment only. Prefers nature and animal themes. Considers pen & ink and charcoal. Send postcard sample or query letter. Accepts disk submissions compatible with Mac—QuarkXPress, Adobe Illustrator and Adobe Photoshop. Send EPS files. Samples are not filed and are returned by SASE if requested by artist. Reports back within 1 to 2 months. To show a portfolio, mail color tearsheets, slides and photocopies. Buys first rights. "We do not pay artists for illustration in publication material."
Tips: "Interested wildlife artists should send SASE, three to seven clearly-marked slides or transparencies, short biography and be patient! Also publish annually *1997 Art Collector's Edition*, now the seventh issue, the largest source book of wildlife artists' biographies, color reproductions, print prices and calendar of events for wildlife art shows. Sculptors, photographers, painters, scratchboard, and pastel artists are invited to participate in the international volume."

WILDLIFE CONSERVATION/BRONX ZOO, 185th and Southern Blvd., Bronx NY 10460. (718)220-5121. Fax: (718)584-2625. Art Director: Julie Maher. Estab. 1895. Bimonthly magazine that covers endangered species and conservation issues. Circ. 200,000. Accepts previously published artwork. Original artwork returned at job's completion. Sample copies and art guidelines available for SASE.
Cartoons: Approached by 100 cartoonists/year. Buys 5 cartoons/issue. Prefers color washes. Send query letter with brochure, roughs, finished cartoon samples. Samples are filed. Does not report back on queries and submissions. Buys first rights. Pays $350-850 for color.
Illustrations: Approached by 100 illustrators/year. Buys 10 illustrations/issue. Works on assignment only. Prefers animal illustrations. Considers watercolor, collage, acrylic, mixed media. Send query letter with brochure, résumé, tearsheets. Samples are filed. Does not report back on queries and submissions. Write for appointment to show portfolio or mail appropriate materials. Portfolio should include photostats, photocopies, photographs. Buys first rights. **Pays on acceptance**; $75-350 for color cover; $350-850 for color inside (payment varies with size of art).

WIN, 120 S. San Fernando Blvd., Suite 439, Burbank CA 91502. Fax: (818)845-0325. E-mail: ag497@lafn.o rg. Art Director: Joey Sinatra. A monthly 4-color consumer magazine. "The only magazine in the country devoted to all aspects of legal gambling." Accepts previously published artwork. Original artwork returned at job's completion.
Cartoons: Buys 5-12 freelance cartoons/year. Must be gambling related, hip/insider gags. Prefers single panel, with gagline, b&w line drawings, color washes. Send query letter with finished cartoons. Samples are filed or returned by SASE if requested by artist. Reports back to the artist only if interested. Buys first rights.
Illustrations: Buys 1-2 freelance illustrations/issue. Works on assignment only. Prefers a contemporary look. Considers pen & ink, watercolor, collage, airbrush, acrylic, color pencil and mixed media. Send query letter with SASE, slides, tearsheets, CD-ROMs. Accepts disk submissions. Samples are filed. Publication will contact artist for portfolio review if interested. Portfolio should include b&w and color tearsheets and slides. Buys first rights. Pay is negotiable.
Design: Needs designers for multimedia projects.

‡**WINDOWS NT MAGAZINE**, 221 E. 29th St., Loveland CO 80538. (970)663-4700. Fax: (970)667-2321. E-mail: adamssw@duke.com. Design Director: Steven Adams. Estab. 1995. Monthly technical publication for users of Windows NT. Circ. 30,000.
Illustrations: Buys 5-6 illustrations/issue. Considers all media. 80% of freelance illustration demands knowledge of Aldus FreeHand, Adobe Photoshop, Adobe Illustrator. Send postcard sample. Accepts 3.5″ floppy, 44-88-250mb SyQuest disk, optical disk and CD-ROM for Mac. Reports back only if interested. Art director will contact artist for portfolio review of tearsheets if interested. Rights purchased vary according to project.

Pays on acceptance; $600-1,500 for color cover; $250-500 for b&w inside; $350-1,000 color inside. Pays $350 for spots. Finds artist through the *Workbook* and samples.
Tips: "We're looking for illustrators who understand how to bring technical material to life, are professional and 'push the envelope' with their style and technique."

‡**WIRE JOURNAL INTERNATIONAL**, 1570 Boston Post Rd., Guilford CT 06437. (203)453-2777. Contact: Art Director. Emphasizes the wire industry worldwide, members of Wire Association International, industry suppliers, manufacturers, research/developers, engineers, etc. Monthly 4-color. Circ. 12,500. Design is "professional, technical and conservative." Original artwork not returned after publication. Free sample copy and art guidelines.
Illustrations: Illustrations are "used infrequently." Works on assignment only. Provide samples, business card and tearsheets to be kept on file for possible assignments. To submit a portfolio, call for appointment. Reports "as soon as possible." Buys all rights. Pay is negotiable; on publication. 85% of freelance work demands computer literacy in IBM/Ventura/CorelDraw.
Tips: "Show practical artwork that relates to industrial needs; and avoid bringing samples of surrealism, for example. Also, show a variety of techniques—and know something about who we are and the industry we serve."

WISCONSIN TRAILS, Box 5650, Madison WI 53705. (608)231-2444. Production Manager: Nancy Mead. 4-color publication concerning travel, recreation, history, industry and personalities in Wisconsin. Published 6 times/year. Circ. 35,000. Previously published and photocopied submissions OK. Art guidelines for SASE.
Illustrations: Buys 6 illustrations/issue. "Art work is done on assignment, to illustrate specific articles. All articles deal with Wisconsin. We allow artists considerable stylistic latitude." Send postcard samples or query letter with brochure, photocopies, SASE, tearsheets, résumé, photographs, slides and transparencies. Samples kept on file for future assignments. Indicate artist's favorite topics; name, address and phone number. Include SASE. Publication will contact artist for portfolio review if interested. Buys one-time rights on a work-for-hire basis. Pays on publication; $50-150 for b&w; $50-400 color inside. Finds artists through magazines, submissions/self-promotions, artists' agents and reps and attending art exhibitions.
Tips: Keep samples coming of new work.

‡**WOMENWISE**, 38 S. Main St., Concord NH 03301-4817. (603)225-2739. Fax: (603)228-6255. Editor: Luita D. Spangler. Estab. 1978. Quarterly consumer magazine. "We are a feminist, pro-choice, pro-animal rights health journal offering articles, book reviews, poetry and feminist analysis and news." Circ. 1,000. Sample copies available. Art guidelines available for SASE with first-class postage.
Illustration: Approached by 8-12 illustrators/year. Buys 40 illustrations/year. Prefers line drawings of women, marginalia. Considers pen & ink. Send query letter with photocopies. Samples are filed. Reports back in 1 month. Negotiates rights purchased. Pays on publication. Pays $15 for b&w and 1 year subscription for cover; subscription and 5 portfolio copies for inside b&w.

WONDER TIME, 6401 The Paseo, Kansas City MO 64131. (816)333-7000. Fax: (816)3331-4439. Editor: Lois Perrigo. Estab. 1969. Weekly 4-color Sunday school "story paper" emphasizing inspiration and character-building material for first and second graders, 6-8 years old, for Sunday School curriculum. Circ. 40,000. Sample copies for SASE with 56¢ postage.
Illustrations: Buys 1 illustration/issue. Works on assignment only. Send query letter with tearsheets or photocopies to be kept on file. Buys all rights. **Pays on acceptance**; $40 for b&w; $75 for color.
Tips: "Include illustrations of 6-8 year old ethnic children in your portfolio. We use some full-color cartoons to illustrate our Bible-in-Action stories."

WOODENBOAT PUBLICATIONS, Box 78, Brooklin ME 04616. (207)359-4651. E-mail: greg@hyper net.com. Website: http://www.woodenboat.com. Art Director: Gregory Summers. Concerns designing, building, repairing, using and maintaining wooden boats. Bimonthly. Circ. 106,000. Previously published work OK. Sample copy for $4.
Illustrations: Buys 48 illustrations/year on wooden boats or related items. Send postcard sample or query letter with résumé, slides and tearsheets. Accepts disk submissions compatible with Mac. Reports in 1-2 months. "We are always in need of high quality technical drawings. Buys first North American serial rights. Pays on publication. Rates vary, but usually $50-400 for spots."
Design: Needs freelancers for design. 100% of freelance work demands knowledge of Adobe Photoshop, Adobe Illustrator, QuarkXPress. Send query letter with tearsheets, résumé and slides. Pays by project.
Tips: "We work with several professionals on an assignment basis, but most of the illustrative material that we use in the magazine is submitted with a feature article. When we need additional material, however, we will try to contact a good freelancer in the appropriate geographic area."

WORDPERFECT MAGAZINE and WORDPERFECT FOR WINDOWS MAGAZINE, 270 W. Center St., Orem UT 84057-4683. (801)226-5555. Fax: (801)226-8804. E-mail: donla@wpmag.com. Website: http://www.wpmag.com. Assistant Art Director: Don Lambson. Estab. 1989. Monthly 4-color consumer

magazine for WordPerfect users (nearly 10,000,000 in the US). Circ. 250,000. Accepts previously published artwork. Originals and 10 tearsheets returned at job's completion.
- These publications have been awarded Certificates of Design Excellence in *PRINT's Regional Design Annual* for 1994 and 1995. They have also been honored for best magazine design in the Society of Publication Design's 29th design annual.

Illustrations: Approached by 100 illustrators/year. Buys 10 illustrations/issue. Works on assignment only. Prefers conceptual work in any style or medium. Send postcard sample and tearsheets. Accepts disk submissions. Samples filed or returned by SASE if requested. Publication will contact artist for portfolio review if interested. Portfolio should include color tearsheets and finished art samples. Buys one-time rights. **Pays on acceptance**; $1,500 for color cover; $800 for color inside; $500-600 for spots. Finds artists through *Showcase*, *Workbook* and self-promotions.

Tips: "In the future, increased availability of stock illustrations will result in extra reimbursement for quality conceptual illustrations."

WORKBENCH, K.C. Publishing, Inc., 700 W. 47th St., Suite 310, Kansas City MO 64112. Executive Editor: A. Robert Gould. Estab. 1957. Bimonthly 4-color magazine for woodworkers and do-it-yourselfers. Circ. 550,000. 100% of freelance work demands knowledge of Adobe Illustrator or QuarkXPress on the Macintosh.

Cartoons: Buys 5 cartoons/year. Interested in woodworking and do-it-yourself themes; single panel with gagline. Submit samples with SASE. Reports in 1 month. Buys all rights, but may reassign rights to artist after publication. **Pays on acceptance**; $40 minimum for b&w line drawings.

Illustrations: Works with 10 illustrators/year. Buys 100 illustrations/year. Artists with experience in the area of technical drawings, especially house plans, exploded views of furniture construction, power tool and appliance cutaways, should send SASE for sample copy and art guidelines. Style of Eugene Thompson, Don Mannes and Mario Ferro. Publication will contact artist for portfolio review if interested. Sometimes requests work on spec before assigning job. Pays $50-1,200 for b&w, $100-1,500 for color inside.

Tips: "We have cut back on the number of stories purchased, though not necessarily the amount of art."

WORKING MOTHER MAGAZINE, 230 Park Ave., New York NY 10169. (212)551-9533. Fax: (212)551-9757. Creative Director: Alberto Orta. Estab. 1979. "A monthly service magazine for working mothers focusing on work, money, children, food and fashion." Original artwork is returned at job's completion. Sample copies and art guidelines available.

Illustrations: Approached by 100 illustrators/year. Buys 3-5 illustrations/issue. Works on assignment only. Prefers light humor and child/parent, work themes. Considers watercolor, collage, airbrush, acrylic, colored pencil, oil, mixed media and pastel. Send query letter with brochure and tearsheets. Samples are filed and are not returned. Does not report back, in which case the artist should call or drop off portfolio. Portfolio should include tearsheets, slides and photographs. Buys first rights. **Pays on acceptance**; $150-2,000 for color inside.

WRITER'S DIGEST, 1507 Dana Ave., Cincinnati OH 45207. Art Director: Daniel T. Pessell. Editor: Tom Clark (for cartoons). Monthly magazine emphasizing freelance writing for freelance writers. Circ. 250,000. Original artwork returned after publication. Sample copy for $3.
- Cartoons submitted are also considered for inclusion in annual *Writer's Yearbook*.

Cartoons: Buys 3 cartoons/issue. Theme: the writing life. Needs cartoons that deal with writers and the trials of writing and selling their work. Also, writing from a historical standpoint (past works), language use and other literary themes. Prefers single panel with or without gagline. Send finished cartoons. Material returned by SASE. Reports back within 1 month. Buys first rights or one-time rights. **Pays on acceptance**; $50-85 for b&w.

Illustrations: Buys 5 illustrations/month. Theme: the writing life. Prefers b&w line art primarily. Works on assignment only. Send postcard or any printed/copied samples to be kept on file (limit size to 8½×11). Accepts Mac-formatted disk submissions. "EPS, PICT, TIFF or JPEG OK for viewing—for reproduction we need EPS." Buys one-time rights. **Pays on acceptance**; $400-500 for color cover; $75-350 for inside b&w.

Tips: "We're also looking for b&w spots of writing-related subjects. We buy all rights; $15-25/spot."

WRITER'S YEARBOOK, 1507 Dana Ave., Cincinnati OH 45207. Submissions Editor: Amanda Boyd. Annual publication featuring "the best writing on writing." Topics include writing and marketing techniques, business issues for writers and writing opportunities for freelance writers and people getting started in writing.

THE MULTIMEDIA INDEX preceding the General Index in the back of this book lists markets seeking freelancers with multimedia, CD-ROM skills.

Original artwork returned with 1 copy of the issue in which it appears. Sample copy $6.25. Affiliated with *Writer's Digest*. Cartoons submitted to either publication are considered for both.
Cartoons: Uses 3-6 cartoons in yearbook. "All cartoons must pertain to writing—its joys, agonies, quirks. All styles accepted, but high-quality art is a must." Prefers single panel, with or without gagline, b&w line drawings or washes. Send finished cartoons. Samples returned by SASE. Reports in 1-2 months. Buys first North American serial rights for one-time use. **Pays on acceptance**; $50 minimum for b&w.
Tips: "A cluttery style does not appeal to us. Send finished, not rough art, with clearly typed gaglines. Cartoons without gaglines must be particularly well-executed."

‡**WY'EAST HISTORICAL JOURNAL**, P.O. Box 294, Rhododendron OR 97049. (503)622-4798. Fax: (503)622-4798. Publisher: Michael P. Jones. Estab. 1994. Quarterly historical journal. "Our readers love history and nature, and this is what we are about. Subjects include America, Indians, fur trade, Oregon Trail, etc., with a focus on the Pacific Northwest." Circ. 2,500. Accepts previously published artwork. Originals returned at job's completion if accompanied by SASE. Sample copies and art guidelines for SASE with first-class postage. 50% of freelance work demands computer skills.
Cartoons: Approached by 50 cartoonists/year. Buys 6 cartoons/issue. Prefers Northwest Indians, Oregon Trail, wildlife; single panel. Send query letter with brochure, roughs and finished cartoons. Samples are filed or are returned by SASE. Reports back within 2 weeks. Buys reprint rights. Pays in copies.
Illustrations: Approached by 100 illustrators/year. Buys 10 illustrations/issue. Prefers Northwest Indians, Oregon Trail, fur trade, wildlife. Considers pen & ink, airbrush and charcoal. Send query letter with brochure, résumé, SASE, tearsheets, photographs, photocopies, slides and transparencies. Samples are filed or are returned by SASE if requested by artist. Reports back within 2 weeks. Publication will contact artist for portfolio review if interested. Portfolio should include b&w and color thumbnails, tearsheets, slides, roughs, photostats, photocopies, final art and photographs. Buys first rights. Pays in copies. Finds artists through submissions, sourcebooks and word of mouth.
Design: Needs freelancers for design and production. 50% of freelance work demands computer skills. Send brochure, photocopies, SASE, tearsheets, résumé, photographs, slides, transparencies. Pays in published copies.
Tips: Uses freelancers for "feature articles in need of illustrations. However, we will consider doing a feature on the artist's work. Artists find us. Send us a good selection of your samples, even if they are not what we are looking for. Once we see what you can do, we will give an assignment."

‡**YELLOW SILK: Journal of Erotic Arts**, Box 6374, Albany CA 94706. (510)644-4188. Publisher: Lily Pond. Estab. 1981. Annual magazine emphasizing "erotic literature and arts for well educated, highly literate readership, generally personally involved in arts field." Returns original artwork after publication. Sample copy for $7.50.
Illustrations: Acquires 10-20 illustrations/issue by 1 artist if possible. Considers "anything in the widest definitions of eroticism except brutality, bondage or S&M. We're looking for work that is beautiful, artistic. We are really fine arts as opposed to illustration. No pornography. All sexual persuasions represented." Prefers acrylic, then pen & ink, watercolor, oil, pastel, collage and mixed media. Send originals, photocopies, slides, photostats, good quality photographs. Color and b&w examples in each submission are preferred. Include name, address and telephone number on all samples. Samples not filed are returned by SASE. Reports back within 3 months. Buys first rights or reprint rights. Negotiates payment plus copies. Pays on publication.
Tips: "Artistic quality is of equal or higher importance than erotic content. There are too many people doing terrible work thinking it will sell if it's sexual. Don't send it to me! Disturbingly, hard-edge S&M images seem more frequent. Don't send us those, either!!"

‡**YM**, Dept. AM, 28th Floor, 685 3rd Ave., New York NY 10017. (212)878-8602. Fax: (212)286-0935. Creative Director: Henry Connell. A fashion magazine for teen girls between the ages of 14-21. Ten issues (monthly and 2 joint issues—June-July and December-January.) Original artwork returned at job's completion. Sample copies available.
Cartoons: Buys 1-3 cartoons/issue. Prefers funny, whimsical illustrations related to girl/guy problems. Prefers single and double panel, color washes. Send query letter with promo card. Samples are filed or not filed (it depends on how good). Samples are not returned. Reports back to the artist only if interested. Buys one-time rights.
Illustrations: Buys 1-2 illustrations/issue. Buys 12-36 illustrations/year. Preferred themes include horoscope and dreams. Considers watercolor, collage, acrylic, colored pencil, oil, charcoal, mixed media, pastel. Samples are filed or not filed (depending on quality). Samples are not returned. Reports back to the artist only if interested. Call for appointment to show portfolio, which should include roughs and final art, color tearsheets and photocopies. Buys one-time rights. **Pays on acceptance** or publication. Offers one half of original fee as kill fee.

YOGA JOURNAL, 2054 University Ave., Berkeley CA 94704-1082. (510)841-9200. Fax: (510)644-3101. E-mail: yogajml@aol.com. Website: http://www.yogajournal.com. Art Director: Jonathan Wieder. Estab. 1975. Bimonthly consumer magazine emphasizing health, consciousness, yoga, holistic healing, transpersonal

psychology, body work and massage, martial arts, meditation and Eastern spirituality. Circ. 80,000. Originals returned at job's completion. Sample copies available.

Illustrations: Approached by 50 illustrators/year. Buys 8 illustrations/issue. Works on assignment only. Considers all media, including electronic (Mac). Send query letter with any reproductions. Accepts disk submissions compatible with Adobe Illustrator 5.5. Send EPS files. Samples are filed. Publication will contact artist for portfolio review if interested. Buys one-time rights. **Pays on acceptance**; $800-1,500 for color cover; $500-1,000 for b&w, $800-1,200 for color inside; $150-400 for spots.

Tips: "Send plenty of samples in a convenient form (i.e. 8½×11 color photocopies with name and phone number on each sample) that don't need to be returned. Printed samples are always desirable."

YOUR HEALTH, 5401 NW Broken Sound Blvd., Boca Raton FL 33487. (407)989-1176. Fax: (407)997-9210. E-mail: yhealth@aol.com. Photo Editor: Judy Browne. Estab. 1960. Biweekly health and fitness magazine for the general public. Circ. 50,000. Accepts previously published artwork. Originals returned at job's completion. Sample copies available. Art guidelines available for SASE with first-class postage.

Cartoons: Approached by 30 cartoonists/year. Buys 10 cartoons/year. Prefers health and fitness humorous cartoons; b&w line drawings. Send query letter with roughs. Samples are filed. Reports back within 1 month. Buys one-time rights. Pays $50 for b&w/color.

Illustrations: Approached by 100 illustrators/year. Buys 2 illustrations/issue. Prefers health and fitness themes. Considers all media. Send query letter with tearsheets, photographs and photocopies. Samples are filed. Reports back within 1 month. Publication will contact artist for portfolio review if interested. Portfolio should include any samples. Buys one-time rights. Pays on publication; $100-125 for b&w, $200-250 for color inside; $50-75 for spots. Finds artists through other publications.

Tips: Features and departments are both open to freelancers.

YOUR HEALTH & FITNESS, 60 Revere Dr., Northbrook IL 60062-1574. (847)205-3000. Fax:(847)564-8197. Supervisor of Art Direction: Pam Pannucci. Estab. 1978. Quarterly consumer and company magazine. *"Your Health & Fitness* is a magazine that allows clients to customize up to eight pages. Clients consist of hospitals, HMOs and corporations." Circ. 600,000. Accepts previously published artwork. Originals are returned at job's completion. Sample copies available. 70% of freelance work demands knowledge of Adobe Illustrator, QuarkXPress, Adobe Photoshop and Aldus Freehand.

Cartoons: Approached by 12 cartoonists/year. Buys 1 cartoon/issue. Prefers humorous, health, fitness and food cartoons; single panel, b&w line drawings with gaglines. Send query letter with finished cartoons. Samples are filed or are returned. Reports back to the artist only if interested. Buys one-time or reprint rights. Pays $150 for b&w, $200 for color.

Illustrations: Approached by 200 illustrators/year. Buys 6 illustrations/issue. Works on assignment only. Prefers exercise, fitness, psychology, drug data, health cost, first aid, diseases, safety and nutrition themes; any style. Send postcard sample and tearsheets. Accepts disk submissions compatible with Mac, Adobe Illustrator or Adobe Photoshop. Samples are filed or are returned. Reports back to the artist only if interested. Publication will contact artist for portfolio review if interested. Portfolio should include b&w and color tearsheets and slides. Buys one-time or reprint rights. Pays on publication; $400-600 for color cover; $75-150 for b&w, $150-400 for color inside; $100-150 for spots. Finds artists through sourcebooks and submissions.

Design: Needs freelancers for design. 100% of freelance work demands knowledge of Adobe Illustrator or QuarkXPress. Send query letter with tearsheets and résumé. Pays by the project.

Tips: "Fast Facts" section of magazine is most open to freelancers; uses health- or fitness-related cartoons.

YOUR MONEY MAGAZINE, 5705 N. Lincoln Ave., Chicago IL 60659. (312)275-3590. Art Director: Beth Ceisel. Estab. 1980. Bimonthly 4-color personal finance magazine. "Provides useful advice on saving, investing and spending. Design is accessible and reader-friendly." Circ. 500,000. Original artwork returned after publication. Art guidelines for SASE with first-class postage. Needs computer-literate freelancers for illustration, charts/graphs. 30% of freelance work demands knowledge of Aldus FreeHand, Adobe Illustrator or Photoshop.

Illustrations: Buys 10-12 illustrations/issue. Works on assignment only. Editorial illustration is based upon specific needs of an article, therefore style, tone and content will vary. Send postcard sample or tearsheets. Accepts disk submissions compatible with QuarkXPress, Adobe Illustrator, Aldus FreeHand or Adobe Photoshop. Samples not filed are returned by SASE. Publication will contact artist for portfolio review if interested. Buys first rights or one-time rights. Sometimes requests work on spec before assigning job. Pays $300-800 for b&w, $300-1,000 for cover; $300-1,100 for color inside; $200-400 for spots. Finds artists through other magazines, submissions and sourcebooks.

Tips: "Show only your best work. Include tearsheets in portfolio. Computers are taking on a very important role in magazine publishing."

‡ZYMURGY, 736 Pearl St., Boulder CO 80306. (303)447-0816. Fax: (303)447-2825. E-mail: vicki@aob.org. Art Director: Vicki Hopewell. Estab. 1978. Magazine for nonprofit organization published 5 times/year. *"Zymurgy* is a journal of the American Homebrewers Assoc. Our goal is to promote public awareness and

appreciation of the quality and variety of beer through education, research and the collection and dissemination of information." Circ. 45,000.

Cartoons: Approached by 1-2 cartoonists/year. Buys 1-2 cartoons/issue. Prefers humorous, b&w and color washes, b&w line drawings, with or without gagline. Send finished cartoons, photographs, photocopies, roughs, tearsheets, any samples. Samples are filed. Buys one-time rights. **Pays on acceptance**, 30 day net; $100-300 for b&w cartoons; $150-350 for color cartoons.

Illustration: Approached by 20 illustrators/year. Prefers beer and homebrewing themes. Buys 10 illustrations/issue. Considers all media. Send postcard sample or query letter with printed samples, photocopies, tearsheets; follow-up sample every 3 months. Accepts disk submissions with EPS or TIFF files. "We prefer samples we can keep." Reports back only if interested. Art director will contact artist for portfolio review of b&w, color, final art, photographs, photostats, roughs, slides, tearsheets, thumbnails, transparencies; whatever media best represents art. Buys one-time rights. **Pays 30 day net on acceptance**; $600-2,000 for color cover; $200-600 for b&w inside; $200-800 for color. Pays $200-1,500 for spots. Finds artists through agents, sourcebooks (Society of Illustrators, *Graphis*, *Print*, *Colorado Creative*), mags, word of mouth, submissions.

Design: Needs freelancers for multimedia projects. Prefers local design freelancers only with experience in Adobe Photoshop 3.0, QuarkXPress 3.31, Adobe Illustrator 5.0. Send query letter with printed samples, photocopies, tearsheets. Phone art director.

Tips: "Keep sending promotional material for our files. Anything beer-related for subject matter is a plus. We look at all styles."

Posters & Prints

If you look at the careers of well-known artists (sculptors as well as painters) you will notice that in addition to their favored media, most of them produce multiples of their work. Producing multiple editions is attractive to both artists and collectors for several reasons. Have you ever noticed, perhaps at an opening of an exhibition, or at an art fair, that though there are many paintings on display, everybody wants to buy the same one? Certain images have a wide appeal and will sell again and again.

Artists and collectors appreciate the print and poster option because it makes artwork more affordable. Artists charge a lot more for original paintings than for prints. However, they sell a lot more prints because more people can afford them.

Artists who produce intricate, detailed work that is very time consuming to paint, find prints are an ideal solution. If it takes months to create a painting, the artist is not going to have many original works to sell. But if the artist creates six images a year and turns them into prints he can make hundreds of sales from the same images.

Posters and prints increase your visibility. You can sell your work all over the country at various galleries and commercial outlets. You or your gallery dealer can market more of your work to corporations, hotel chains and hospitals. When your work is on display in more spaces your name becomes more recognizable. In time, the exposure you gain from prints will make your original paintings more valuable.

Your gallery will appreciate your venture into prints also. Your gallery dealer may even offer to publish your work. (You'll notice that some of the art publishers in this section are also galleries.) Often potential buyers will enter a gallery, admire a painting and ask if the artist also sells prints. Gallery dealers love to answer "yes" to this question because it usually leads to a sale. So if you already are represented by a gallery, inquire if they would also sell prints of your work. Chances are they have a flat drawer in back for the specific purpose of storing prints for sale. If you do not have a gallery yet, informing potential dealers that you also create print editions can only add value to your submission.

FIRST, EXPLORE YOUR OPTIONS

There are several ways to produce posters or prints. Each method has its advantages. It's a good idea to talk to several artists who have used each method. (If you see a print you like in a local gallery, write the artist a note. Most artists are only too happy to help fellow artists.) After you talk to artists, evaluate each method based on your own temperament and marketing skills.

Art Publishers & Poster Companies

Most of the companies listed in this section are art publishers and/or poster companies. These companies contract with artists to put a piece of artwork in print form. The companies pay for and supervise the production and marketing of work. Sometimes a publisher will agree to run prints of pre-existing images, while other times they will ask the artist to create a new piece of art. The resulting work will either be an original print, a poster, a limited edition print or offset reproduction, depending on how it is produced and where it is sold.

The benefit of working with a publisher/distributor is that they will take on the

expense and duties of printing and marketing. (There are companies listed who are only distributors and do not publish, so be sure to take note which you are sending to.) Be sure to research art publishers thoroughly before you sign with them. Examine their catalog for examples of their prints to make sure the colors are true and that paper quality is high. Find out how they plan to market your work and what outlets it will be sold to before you sign a contract.

Fine Art or Decorative?

Another factor to consider before choosing a publisher is whether you want to market your work to the fine art market or the decorative market. Visit galleries, frame shops, furniture stores and other retail outlets that carry prints to see where your art might fit in. You may also want to visit designer showrooms and interior decoration outlets. Visit trade shows such as ArtExpo in New York City, and Art Buyers Caravan (known as the ABC show) in Atlanta, and read *Decor* magazine to get a sense of what sells in both markets. (See Publications of Interest, page 681 for *Decor's* address).

Some of the listings in this section are for fine art presses. Other presses are more commercial. The way to distinguish them is by reading the listings carefully to determine if they create their editions for the fine art market or for the decorative market.

If you don't mind creating commercial images, and following current trends, the decorative market can be quite lucrative. Read Lauren Karp's Insider Report on page 274 to discover how artists must keep up with trends to appeal to international companies like Scandecor.

Once you've selected a list of potential publishers, send for artist's guidelines or catalogs if they are available. Some larger publishers will not send their catalogs because they are too expensive, but you can often ask to see one at your local poster shop, print gallery, upscale furniture store or frame shop.

APPROACHING AND WORKING WITH PUBLISHERS

To approach a publisher, send a brief query letter, a short bio, a list of galleries that represent your work and five to ten slides. It helps to send printed pieces or tearsheets as samples, as these show publishers that your work can be reproduced effectively and that you have some understanding of the publication process.

A few publishers will buy work outright for a flat fee, but most pay on a royalty basis. Royalties for handpulled prints are usually based on retail price and range from 5 to 20 percent, while percentages for offset reproductions are lower (from 2½ to 5 percent) and are based on the wholesale price. Be aware that some publishers may hold back royalties to cover promotion and production costs. This is not uncommon.

As in other business transactions, make sure you understand all the terms of your contract before you sign. The publisher should provide a description of the print ahead of time, including the size, printing method, paper and number of images to be produced. Other things to watch for include insurance terms, marketing plans, and a guarantee of a credit line and copyright notice.

Always retain ownership of your original work, and try to work out an arrangement in which you're selling publication rights only. You'll also want to sell rights only for a limited period of time. Such arrangements will leave you with the option to sell the image later as a reprint, or to license it for other use (for example as a calendar or note card).

Most publishers will arrange for the artist to see a press proof and will give the artist final approval of a print. The more you know about the printing process and what can and cannot be done in certain processes, the better. If possible, talk to a printer ahead

of time about your concerns. Knowing what to expect beforehand will eliminate surprises and headaches for the printer, publisher and you.

EXPLORE ADDITIONAL OPTIONS

• **Working at a co-op press.** You can skip the middleman entirely and learn to make your own hand-pulled original prints—such as lithographs, monoprints, etchings or silkscreens. If there is a co-op press in your city, you can rent time on a printing press and create your own editions. It is rewarding to learn printing skills and have the hands-on experience. You also gain total control of your work. The drawback is you have to market your images yourself, by approaching galleries or other clients.

• **Self-publishing with a printing company.** Several national printing concerns advertise heavily in artists' magazines, encouraging artists to publish their own work. If you are a savvy marketer, who understands the ins and outs of trade shows and direct marketing, this can be an attractive option. However it takes a large investment up front. You could end up with a thousand prints taking up space in your basement, or if you are a good marketer you could end up selling them all and making a much larger profit from your work than if you had gone through a major art publisher or poster company. (Jan Mayer, our Insider Report subject on page 262 worked with a printer to publish editions that she sells to the corporate market.)

• **Marketing through distributors.** If you choose the self-publishing route, but don't have the resources to market your prints, contact one of the distributors listed in this section. Distributors will market your self-published work to outlets around the country in exchange for a percentage of sales. Distributors are particularly good at marketing posters. They have connections with all kinds of outlets you might not have thought of, like college bookstores and museum shops.

• **Working with a fine art press.** Fine art presses are different from commercial presses in that the artist and press operators (usually artists themselves) work side by side to create the edition every step of the way. The artist working on the press will share her experience and knowledge of the printing process. You will pay a fee for the time your work is on the press and for the expert advice of the printer, but you do not pay a commission on prints sold.

A NOTE ABOUT SCULPTURE

Some publishers also handle limited editions of sculptural pieces and market them through fine art galleries. Sculptural editions are made by casting several forms from the same mold. Check the listings in this section for more targeted information about this publishing option.

UNDERSTANDING PRINT JARGON

• **Why "working in a series" helps sales.** It is often easier to market a series of small prints exploring a single theme or idea than it is to market larger images. If you already are represented by a gallery, your dealer might advise you on what sizes and themes she can sell. A series of similar prints works well on walls in long hospital corridors, in office meeting rooms or restaurants. Also marketable are "paired" images. Hotels often purchase two similar prints for each of their rooms.

• **Signing and numbering your editions.** Before you enter the print arena, you will need to know the proper method of signing and numbering your editions. You can get an idea of how this is done by visiting galleries and museums and talking to fellow

artists. Perhaps you already learned the procedure in art school.

If you are creating a limited edition, with a specific set number of prints, all prints are numbered, such as 100/35. The largest number is the total number of prints in the edition; the smaller number is the number of the print. Some artists hold out 10% as artist's proofs and number them separately with AP after the number (such as 5/100 AP). Many artists sign and number their prints in pencil.

• **Original prints.** Original prints may be woodcuts, engravings, linocuts, mezzotints, etchings, lithographs or serigraphs. What distinguishes them is that they are produced by hand by the artist (and consequently often referred to as hand-pulled prints). In a true original print the work is created specifically to be a print. Each print is considered an original because the artist creates the artwork directly on the plate, woodblock, etching stone or screen. Original prints are sold through specialized print galleries, frame shops and high-end decorating outlets, as well as fine art galleries.

• **Offset reproductions and posters.** Offset reproductions, also known as posters and image prints, are reproduced by photochemical means. Since plates used in offset reproductions do not wear out, there are no physical limits on the number of prints made. Quantities, however, may still be limited by the publisher in order to add value to the edition. Many of the companies listed in this section offer this option.

PRICING CRITERIA FOR LIMITED EDITIONS AND POSTERS

Original prints are always sold in limited editions and consequently command higher prices than posters (which usually are not numbered). Since plates for original prints are made by hand, and as a result can only withstand a certain amount of use, the number of prints that can be pulled is limited by the number of impressions that can be made before the plate wears out. Some publishers impose their own limits on the number of impressions to increase a print's value. These limits may be set as high as 700 to 1,000 impressions, but some prints are limited to just 250 to 500, making them highly prized by collectors.

Prices for reproductions vary widely depending on the quantity available; the artist's reputation; the popularity of the image; the quality of the paper, ink and printing process. Since prices are lower than for original prints, publishers tend to select images with high-volume sales potential.

THE CANVAS TRANSFER OPTION

Canvas transfers are becoming increasingly popular. Instead of, and often in addition to, printing an image on paper, the publisher transfers your image onto canvas so the work has the look and feel of a painting. Some publishers market limited editions of 750 prints on paper, along with a smaller edition of 100 of the same work on canvas. The edition on paper might sell for $150 per print, while the canvas transfer would be priced higher, perhaps selling for $395.

DON'T OVERLOOK THE COLLECTIBLES MARKET

If your artwork has wide appeal, and you are flexible, success might be waiting for you in the multi-million dollar plates and collectibles market. You will be asked to adjust your work to fit into a circular format if it is chosen for a collectible plate, so be prepared to work with the company's creative staff to develop the final image. Consult the Greeting Cards, Games & Products section for companies specializing in collectibles.

POPULAR COLORS MAKE YOUR WORK MARKETABLE

The Color Association of the United States (CAUS), the association that tracks and discovers color trends and reports them to the industry, forecasts a focus on tonalism for 1997-98. Tonalism is the varying shades within a hue category. Margaret Walch, associate director of CAUS, reports on four tonal "stories" that will be prominent in the coming year:
1. Charcoal gray and taupe through light gray.
2. Reddish tones
3. Purples from grapes to lilacs to overcast sky blues.
4. A continuing direction in yellow-greens. Yellow tonalities include bronze tones and buffs all the way to creamy white.

The popular tones, no matter what color, will appear soft and accommodating. Interestingly enough, according to the association's forecast, the new hues are often placed against a silver background, or used in combinations that emphasize the importance of lesser metals like silver, aluminum, copper, brass and bronze. (For more information about CAUS, call Margaret Walch at (212)582-6884.)

AARON ASHLEY, INC., 230 Fifth Ave., Suite 400, New York NY 10001. (212)532-9227. Fax: (212)481-4214. Contact: Philip D. Ginsburg or Budd Wiesenburg. Produces unlimited editions, 4-color offset and hand-colored reproductions for distributors, manufacturers, museums, schools and galleries. Clients: major US and overseas distributors, museums, galleries and frame manufacturers.
Needs: Seeking decorative art for the designer market. Considers oil paintings and watercolor. Prefers realistic or representational works. Artists represented include French-American Impressionists, Bierstadt, Russell Remington, Jacqueline Penney, Ron McKee, Carolyn Blish and Urania Christy Tarbot. Editions created by working from an existing painting or chrome. Approached by 100 artists/year. Publishes more than 100 editions/year.
First Contact & Terms: Query with SASE and slides or photos. "Do not send originals." Artist should follow up with call and/or letter after initial query. Reports immediately. Pays royalties or fee. Offers advance. Negotiates rights purchased. Requires exclusive representation for unlimited editions. Provides written contract.
Tips: Advises artists to attend Galeria in New York City.

AARON FINE ARTS, 1809 Reisterstown Rd., #134, Baltimore MD 21208. (410)484-8900. Fax: (410)484-3965. Contact: Aaron Young or Merritt Young. Art publisher, distributor, gallery. Publishes and distributes handpulled originals, limited editions, offset reproductions and posters. Clients: wholesale, retail; national, international.
Needs: Seeking creative and decorative art for the commercial and designer markets. Considers oil, watercolor, mixed media, pastel and acrylic. Prefers contemporary, colorful abstracts, unusual landscapes, florals, figuratives. Artists represented include Laurie Fields, Zule, Alvarez, Susan Mackey, John O'Brien, Barbieri, Ghambaro, Amanda Watt. Editions created by collaborating with the artist or by working from an existing painting. Approached by 50 artists/year.
First Contact & Terms: Send query letter with brochure, résumé, tearsheets, slides, photographs and photocopies. Samples are filed or returned by SASE if requested by artist. Reports back within 2 weeks. Publisher/Distributor will contact artist for portfolio review if interested. Portfolio should include color thumbnails, final art and photographs. Negotiates payment. No advance. Requires exclusive representation of artist. Provides advertising, insurance while work is at firm and shipping from firm.
Tips: Recommends artists attend Art Expo New York City.

ADDI FINE ART PUBLISHING, 961 Matley Lane, Suite 105, Reno NV 89502. (800)845-2950. Fax: (702)324-4066. Director: Winifred Wilson. Estab. 1989. Art publisher, distributor and gallery. Publishes posters, canvas reproductions and limited editions. Clients: galleries and distributors. Current clients include Prints Plus, London Contemporary Art and Endangered Species Stores.
Needs: Seeking art for the serious collector and the commercial market. Considers oil and acrylic. Prefers wildlife, landscapes and marine themes. Artists represented include David Miller, Ken Conragan, Scott Jacobs and John Cosby. Editions created by collaborating with the artist or by working from an existing painting. Approached by 25 artists/year. Publishes/distributes the work of 1-2 emerging, 1-2 mid-career and 2-3 established artists/year. Distributes the work of 2-3 established artists/year.

First Contact & Terms: Send query letter with slides, photocopies, résumé, transparencies, tearsheets and photographs. Samples are not filed and are returned. Reports back within 1 month. Publisher/Distributor will contact artist for portfolio review if interested. Pays variable royalties. Buys reprint rights. Provides promotion, shipping from firm, insurance while work is at firm, and written contract.

Tips: Advises artists to attend Art Expo in New York and Las Vegas and ABC in Atlanta. "Submit photos or slides of work presently available. We usually request that originals be sent if we are interested in art."

‡**AERODROME PRESS, INC.,** 3121 S. Seventh St., Tacoma WA 98405-2506. (206)761-8022. Fax: (206)761-8026. E-mail: wfpp@aol.com. President: Steve W. Sherman. Estab. 1987. Art publisher, distributor. Publishes/distributes limited editions, unlimited editions, canvas transfers, fine art prints, offset reproductions. Clients: art galleries, aviation museums, frame shops and interior decorators.

Needs: Seeking aviation-related art for the serious collector and commercial market. Considers oil and acrylic. Artists represented include John Young, Ross Buckland, Mike Machat, James Dietz and Jack Fellows. Editions created by collaboarating with the artist or working from an existing painting. Approached by 15-20 artists/year. Publishes the work of 1 emerging, 2-3 mid-career and established artists/year. Distributes the work of 1-3 emerging and 2-3 mid-career and established artists/year.

First Contact & Terms: Send query letter with photographs, slides, tearsheets and transparencies. Samples are filed or sometimes returned by SASE. Artist should follow-up with call. Portfolio should include color photographs, transparencies and final art. Pays royalties of 20% or 50% commission of wholesale price. Buys one-time or reprint rights. Provides advertising, in-transit insurance, insurance while work is at firm, promotion, shipping from firm and written contract.

❧**KEITH ALEXANDER EDITIONS,** 102-1445 W. Georgia St., Vancouver, British Columbia V6G 2T3 Canada. (604)682-1234. Fax: (604)682-6004. President: Barrie Mowatt. Estab. 1978. Art publisher, distributor and gallery. Publishes and distributes limited editions, handpulled originals and posters. Clients: galleries and other distributors.

Needs: Prefers original themes. Publishes and distributes the work of 11 artists/year.

First Contact & Terms: Send query letter with résumé, tearsheets and transparencies. Samples are not filed and are returned. Reports back within 6-12 weeks. Write for appointment to show portfolio of transparencies. Pays flat fee or on consignment basis; payment method is negotiated. Buys all rights. Requires exclusive representation of the artist. Provides insurance, promotion, shipping from firm and a written contract.

Tips: "Present a professional portfolio which accurately reflects the real work. Also have goals and objectives about lifestyle expectations."

‡**ALEXANDRE A DU M,** P.O. Box 34, Upper Marlboro MD 20773. (301)856-3217. Fax: (301)856-2486. Artistic Director: Walter Mussienko. Estab. 1972. Art publisher and distributor. Publishes and distributes handpulled originals, limited editions and originals. Clients: retail art galleries, collectors and corporate accounts.

Needs: Seeking creative and decorative art for the serious collector and designer market. Considers oil, watercolor, acrylic, pastel, ink, mixed media, original etchings and colored pencil. Prefers landscapes, wildlife, abstraction, realism and impressionism. Artists represented include Cantin and Gantner. Editions created by collaborating with the artist. Approached by 30 artists/year. Publishes the work of 2 emerging, 2 mid-career and 3-4 established artists/year. Distributes the work of 2-4 emerging, 2 mid-career and 24 established artists/year.

First Contact & Terms: Send query letter with résumé, tearsheets and photographs. Samples are filed. Reports back with 4-6 weeks only if interested. Call to schedule an appointment to show a portfolio or mail photographs and original pencil sketch. Payment method is negotiated: consignment and/or direct purchase. Offers an advance when appropriate. Negotiates rights purchased. Provides promotion, a written contract and shipping from firm.

Tips: "Artist must be properly trained in the basic and fundamental principles of art and have knowledge of art history. Have work examined by art instructors before attempting to market your work."

‡**ALLIGATOR ARTWORKS,** P.O. Box 310, Cashtown PA 17310-0310. (800)791-3356. Fax: (717)337-3138. Marketing Director: Randall Pierce. Estab. 1994. Poster company, art publisher. Publishes limited editions, unlimited editions, offset reproduction posters. Clients: galleries, frame shops, distributors, gift shops, furniture galleries. Current clients include: Ethan Allen Inc., Robo Associates, This End Up, Balangier, Museum of American Folk Art.

✝ **THE DOUBLE DAGGER** before a listing indicates that the listing is new in this edition. New markets are often more receptive to freelance submissions.

Needs: Seeking creative and decorative art for the serious collector, commercial and designer markets. Considers oil, acrylic, watercolor, pen & ink and colored pencil. Artists represented include Vicki Bruner, Cris Pool, Sharon Pierce McCullough. Editions created by collaborating with the artist or by working from an existing painting. Approached by 20 artists/year. Publishes/distributes the work of 5 established artists/year.

First Contact & Terms: Send query letter with brochure, photographs, slides and transparencies. Samples are not filed and are returned. Reports back within 6 weeks. Company will contact artist for portfolio review of final art, photographs, slides, tearsheets and transparencies if interested. Pays royalties. Rights purchased vary according to project. Provides advertising, insurance while work is at firm, promotion, shipping from firm and written contract.

ALTERNATIVES, 5528 N. Lacasita, Tuscon AZ 85718. (602)529-8847. Marketing Rep: Stan Everhart. Estab. 1979. Art publisher, distributor. Publishes and distributes handpulled originals and marbled papers. Clients: galleries, design and trade.

Needs: Seeking decorative art for the serious collector and commercial market. Considers original prints. Prefers landscapes and florals. Artists represented include Loudermilk, Howard, Fare. Editions created by collaborating with the artist. Approached by 3-6 artists/year. Publishes the work of 1-2 and distributes the work of 3-4 established artists/year.

First Contact & Terms: Send postcard size sample of work or send query letter with brochure and tearsheets. Samples are returned. Publisher/Distributor will contact artist for portfolio review if interested. Portfolio should include final art. Buys work outright (50% of wholesale). No advance. Rights purchased vary according to project. Provides promotion and shipping from firm. Finds artists through trade shows.

Tips: Suggest artists "work through agent or sales force."

AMCAL FINE ART, 2500 Bisso Lane, Bldg. 500, Concord CA 94520. (510)689-9930. Fax: (510)689-0108. Website: http://www.artmall.com. Development Manager: Julianna Ross. Art publisher. Publishes limited editions and offset reproductions. Clients: print galleries.

Needs: Seeking creative art for the serious collector. Also needs designers. Considers oil, watercolor, mixed media, pastel and acrylic. Prefers traditional, impressionistic, nostalgic work. Artists represented include Charles Wysocki, Sueellen Ross and Michael Stack. Editions created by collaborating with the artist or by working from an existing painting. Approached by hundreds of artists/year. Publishes the work of 0-1 emerging, 0-2 mid-career and 2-3 established artists/year.

First Contact & Terms: Send postcard size sample of work or query letter with brochure, slides, photocopies, transparencies, tearsheets and photographs. Samples are not filed and are returned by SASE if requested by artist. Reports back within 3 months. Publisher will contact artist for portfolio review if interested. Portfolio should include color slides, tearsheets, transparencies, final art and photographs. Negotiates payment. Offers advance when appropriate. Provides advertising, in-transit insurance, insurance while work is at firm, promotion, shipping firm and written contract. Finds artists through researching trade, art magazines, attending shows, visiting galleries.

Tips: Suggest artists read *US Art* magazine, *Art Business News*, *GSB*, also home decor magazines.

‡AMERICAN QUILTING ART, Box S-3283, Carmel CA 93921. (408)659-0608. Sales Manager: Erica Summerfield. Art publisher of offset reproductions, unlimited editions and handpulled originals. Clients: galleries. Current clients include Quilts Ltd. and the Smithsonian.

Needs: Seeking decorative art. Considers watercolor, oil, acrylic, pastel, tempera and mixed media. Prefers traditional and folk art. Artists represented include Mary Rutherford. Publishes/distributes the work of 1 emerging, 1 mid-career and 1 established artist/year.

First Contact & Terms: Send query letter with brochure showing art style or "any available material." Samples are filed or are returned by SASE. Reports back within 2 weeks. Write for an appointment to show portfolio. Payment method is negotiated. Offers advance when appropriate. Buys all rights. Prefers exclusive representation of the artist. Provides in-transit insurance, insurance while work is at firm and shipping from firm.

AMERICAN VISION GALLERY, 625 Broadway, 4th Floor, New York NY 10012. (212)925-4799. Fax: (212)431-9267. Contact: Acquisitions. Estab. 1974. Art publisher and distributor. Publishes and distributes posters and limited editions. Clients: galleries, frame shops, museum shops. Current clients include Museum of Modern Art, The Studio Museum.

Needs: African-American art and designer markets. Considers collage, oil, watercolor, pastel, pen & ink, acrylic. Prefers depictions of African-Americans, Carribean scenes or African themes. Artists represented include Romare Bearden, Jacob Lawrence and several Hatian artists.

First Contact & Terms: Send query letter with slides and bio. Samples are returned by SASE if requested by artist. Reports back only if interested. Pays flat fee, $400-1,500 maximum, or royalties of 10%. Offers advance when appropriate. Negotiates rights purchased. Interested in buying second rights (reprint rights) to previously published artwork.

Tips: "If you don't think you're excellent, wait until you have something excellent."

‡**ANGEL GRAPHICS, A Division of Angel Gifts, Inc.**, 903 W. Broadway, P.O. Box 530, Fairfield IA 52556. Project Manager: Susan Cooke. Estab. 1981. Publisher of wall decor art (photographic and graphic images) in mini poster (16×20) and smaller sizes. Clients: wholesale gift market, international, picture framers.

Needs: Ethnic (African-American, African, Spanish, Native American); Western/Southwestern; inspirational/religious (with biblical or inspiring captions); fantasy (unicorns, wizards, etc.); cute; country/folk; florals/still life; angels; Victorian images. Seeking detailed artwork, realistic subjects with general appeal. No abstract or surrealism. Publishes 50-100 new subjects each year.

First Contact & Terms: Send query letter with photographs or slides and SASE. Pays $200-600. Successful artists can arrange royalties. Works with artists to develop proper look.

Tips: "Send $5 for current catalog to see types of images we publish."

HERBERT ARNOT, INC., 250 W. 57th St., New York NY 10107. (212)245-8287. President: Peter Arnot. Vice President: Vicki Arnot. Art distributor of original oil paintings. Clients: galleries, design firms.

Needs: Seeking creative and decorative art for the serious collector and designer market. Considers oil and acrylic paintings. Has wide range of themes and styles—"mostly traditional/impressionistic, not modern." Artists represented include An He, Malva, Willi Bauer, Gordon, Yoli and Lucien Delarue. Distributes the work of 250 artists/year.

First Contact & Terms: Send query letter with brochure, résumé, business card, slides or photographs to be kept on file. Samples are filed or are returned by SASE. Reports within 1 month. Portfolios may be dropped off every Monday-Friday or mailed. Pays flat fee, $100-1,000. Provides promotion and shipping to and from distributor.

Tips: "Check colors currently in vogue."

‡**ART A'LA CARTE**, 25 Harveston, Mission Viejo CA 92692-5117. (714)455-0957. Contact: G. Dalmand. Estab. 1993. Art publisher/distributor. Publishes handpulled originals, limited and unlimited editions fine art prints, monoprints, monotypes, offset reproductions, posters, sculpture and copper reliefs. Clients include: galleries, interior designers, framers, architects, gift shops. Current clients include Intercontinental Art, Z Gallerie.

Needs: Seeking creative, fashionable, decorative, trendsetting art for the serious collector, commercial and designer markets. Considers oil, acrylic, watercolor, mixed media, pastel, pen & ink and sculpture. Considers all themes and styles. Artists represented include Bruce Wood, Endrew Szasz, Guy Begin, Csaba Markus, Marton Varo. Editions created by collaborating with the artist and working from existing painting. Approached by 30 artists/year. Distributes the work of many artists/year.

First Contact & Terms: Send query letter with brochure, photocopies, photographs, résumé. Samples are filed or are returned by SASE. Artists should follow up with call or letter. Company will contact artist for portfolio review if interested. Negotiates payment: royalties from 10-33% or consignment basis: firm receives 33%. Rights vary according to project. Provides promotion. Also works with freelance designers. Prefers designers who own Macs. Finds artists through art exhibitions, submissions.

‡**ART ATTACK**, 831 Oakton, Elk Grove IL 60007. (847)593-5655. Fax: (847)593-5550. President: Cupps of Chicago. Estab. 1976. Art publisher, distributor. Publishes/distributes limited editions, unlimited editions, canvas transfers. Clients: galleries, decorators, frame shops, distributors, architects, corporate curators, museum shops and giftshops.

Needs: Seeking creative, fashionable, decorative art for the serious collector, commercial and designer markets. Considers oil and acrylic. Editions created by collaborating with the artist. Publishes/distributes 6 emerging, 2 mid-career and 2 established artists/year.

First Contact & Terms: Send photographs and résumé. Samples are returned. Reports back in 3 weeks only if interested. Artist should call. Company will contact artist for portfolio review of final art if interested. Pays in royalties. Buys first or reprint rights. Provides advertising, in-transit insurance, insurance while work is at firm, promotion and written contract.

ART BEATS, INC., P.O. Box 1469, Greenwich CT 06836-1469. (800)338-3315. Fax: (203)661-2480. Production Coordinator: Helen Redfield. Estab. 1983. Art publisher. Publishes and distributes unlimited editions, posters, limited editions, offset reproductions and gift/fine art cards. Clients: framers, gallery owners, gift shops. Current clients include Prints Plus, Intercontinental Art.

Needs: Seeking creative, fashionable and decorative art for the commercial and designer markets. Considers oil, watercolor, mixed media, pastel and acrylic. Artists represented include Gary Collins, Nancy Lund, Mark Arian, Robert Duncan and Tracy Taylor. Approached by 1,000 artists/year. Publishes the work of 45 established artists/year.

First Contact & Terms: Send query letter with résumé, color correct photographs, transparencies and tearsheets. Samples are not filed and are returned by SASE if requested by artist. Reports back within 3 months. Publisher will contact artist for portfolio review if interested. Portfolio should include photostats, slides, tearsheets, photographs and transparencies; "no originals please." Pays royalties of 10% gross sales.

No advance. Buys first rights, one-time rights or reprint rights. Provides promotion and written contract. Finds artists through art shows, exhibits, word of mouth and submissions.

ART BROKERS OF COLORADO, 2419 W. Colorado Ave., Colorado Springs CO 80904. (719)520-9177. Contact: Nancy Anderson. Estab. 1990. Art publisher and gallery. Publishes limited editions and offset reproductions. Clients: galleries, commercial and retail.
Needs: Seeking decorative art by established artists for the serious collector. Prefers oil, watercolor, acrylic and pastel. Open to most themes and styles (no abstract). Editions created by collaborating with the artist or working from an existing painting. Approached by 50-75 artists/year. Publishes and distributes the work of 8 established artists/year.
First Contact & Terms: Send query letter with résumé, slides and photographs. Samples are filed or are returned by SASE if requested by artist. Reports back within 4-6 weeks. Call or write for appointment to show portfolio of slides and photographs. Payment method is negotiated. Buys all rights. Provides insurance while work is at firm and shipping from firm.
Tips: Advises artists to attend all the trade shows and to participate as often as possible.

‡ART CLASSICS LTD., 1490 Frontage Rd., O'Fallon IL 62269. (618)632-1183. Fax: (618)632-1555. Acquisitions Coordinator: Mary Mizerany. Estab. 1993. Art publisher and manufacturer of art reproductions on canvas. Clients: retail, contract, hospitality industry.
Needs: Seeking fashionable, decorative art for the commericial and designer markets. Considers oil, watercolor, mixed media, pastel and acrylic. Considers all styles and themes. Editions created by working from an existing painting or transparencies. Approached by 50 artists/year. Publishes the work of 10-15 artists/year.
First Contact & Terms: Send query letter with brochures, slides, photocopies, résumés, transparencies, tearsheets and photographs. Samples are filed or returned by SASE. Reports back within1 month. Publisher will contact artist for portfolio review of slides, tearsheets and/or 4×5 transparencies. Negotiates payment of flat fee and/or 8-10% royalties and samples. Offers advance when appropriate.

‡ART DALLAS INC., 1400 Hi Line Dr., Suite 1, Dallas TX 75207. (214)745-1105. Fax: (214)748-5145. President: Judy Martin. Estab. 1988. Art publisher, distributor and gallery. Publishes and/or distributes hand-pulled originals, offset reproductions. Clients: designers, architects.
Needs: Seeking creative art for the commercial and designer markets. Considers mixed media. Prefers abstract, landscapes. Artists represented include Tarran Caldwell, Jim Colley, Tony Bass. Editions created by working from an existing painting. Approached by 10 artists/year. Publishes the work of 2 and distributes the work of 4 established artists/year.
First Contact & Terms: Send query letter with résumé, photocopies, slides, photographs and transparencies. Samples are filed and are returned. Reports back within 2 weeks. Call for appointment to show portfolio of slides and photographs. Pays flat fee: $50-5,000. Offers advance when appropriate. Negotiates rights purchased.

ART EDITIONS, INC., 352 W. Paxton Ave., Salt Lake City UT 84101. (801)466-6088. Contact: Ruby Reece. Art printer for limited and unlimited editions, offset reproductions, posters, advertising materials, art labels, business cards, magazine ad set up and art folios. Clients: artists, distributors, galleries, publishers and representatives.
First Contact & Terms: Send photographs, slides, transparencies (size 4×5—8×10) and/or originals. "Contact offices for specific pricing information. Free information packet available upon request."
Tips: "We see trends going to softness of prints and advertising materials. Less and less do we get requests for super shiny 'glitzy' type of sales aids. The art seems to be the statement now, not the hype of glossy papers."

ART EMOTION CORP., 729 Pinecrest St., Prospect Heights IL 60070. (847)397-9300. Fax: (847)397-0206. E-mail: gperez@artemo.com. Website: http://www.artemo.com. President: Gerard V. Perez. Estab. 1977. Art publisher and distributor. Publishes and distributes limited editions. Clients: corporate/residential designers, consultants and retail galleries.
Needs: Seeking decorative art. Considers oil, watercolor, acrylic, pastel and mixed media. Prefers representational, traditional and impressionistic styles. Artists represented include Garcia, Johnson and Sullivan. Editions created by working from an existing painting. Approached by 50-75 artists/year. Publishes and distributes the work of 2-5 artists/year.
First Contact & Terms: Send query letter with slides or photographs. "Supply a SASE if you want materials returned to you." Samples are filed. Does not necessarily report back. Pays royalties of 10%.
Tips: "Send visuals first."

ART IMAGE INC., 1400 Everman Pkwy., Ft. Worth TX 76140. (817)568-5222. Fax: (817)568-5254. President: Charles Albany. Art publisher and distributor. Publishes and produces unlimited and limited editions that are pencil signed and numbered by the artist. Also distributes etchings, engravings, serigraphs,

lithographs and watercolor paintings. "We also publish and distribute handmade paper, cast paper, paper weavings and paper construction." All work sold to galleries, frame shops, framed picture manufacturers, interior decorators and auctioneers.

Needs: Seeking decorative art for the designer market and art galleries. "We prefer subject matter in all media in pairs or series of companion pieces." Prefers contemporary, traditional and transitional artists. Artists represented include Robert White, Peter Wong, Larry Crawford, David Olson, Marsha Kramer, Arthur Nevin, Nancy Nevin and Laura Nevin. Editions created by collaborating with the artist. Approached by 36 artists/year. Publishes and distributes the work of 18 emerging, 18 mid-career and 18 established artists/year.

First Contact & Terms: Send query letter with brochure showing art style, tearsheets, slides, photographs and SASE. Reports within 1 month. Write for appointment to show portfolio or mail appropriate materials. Portfolio should include photographs. Negotiates payment. Requires exclusive representation. Provides shipping and a written contract.

Tips: "We are publishing and distributing more and more subject matter from offset limited editions to monoprints, etchings, serigraphs, lithographs and original watercolor paintings. We will consider any work that is commercially acceptable."

✿**ART IN MOTION**, 800 Fifth Ave., Suite 150, Seattle WA 98104; or 1612 Ingleton, Burnaby, British Columbia V5C 5R9 Canada. (604)299-8787. Fax: (604)299-5975. President: Garry Peters. Art publisher and distributor. Publishes and distributes limited editions, original prints, offset reproductions and posters. Clients: galleries, distributors world wide and picture frame manufacturers.

Needs: Seeking creative, fashionable and decorative art for the serious collector, commercial and designer markets. Considers oil, watercolor, acrylic, and mixed media. Prefers decorative styles. Artists represented include Marilyn Simandle, Corinne Hartley and Art LaMay. Editions created by collaborating with the artist or by working from an existing painting. Approached by 100 artists/year. Publishes the work of 5-7 emerging, mid-career and established artists/year. Distributes the work of 2-3 emerging and established artists/year.

First Contact & Terms: Send query letter with brochure showing art style or résumé and tearsheets, slides, photostats, photographs and transparencies. Samples are filed or are returned by SASE if requested by artist. Reports back within 2 weeks if interested. If does not report back the artist should call. Call for appointment to show portfolio, or mail photostats, slides, tearsheets, transparencies and photographs. Pays royalties up to 15%. Payment method is negotiated. "It has to work for both parties. We have artists making $200 a month and some that make $10,000 a month or more." Offers an advance when appropriate. Negotiates rights purchased. Requires exclusive representation of artist. Provides in-transit insurance, insurance while work is at firm, promotion, shipping to and from firm and a written contract.

Tips: "We are looking for a few good artists; make sure you know your goals, and hopefully we can help you accomplish them, along with ours."

‡**ART REPS, INC.**, (formerly Art Buyers Club, Inc.), 7 Hemlock Hill Rd., Upper Saddle River NJ 07458. (201)825-0028. Fax: (201)327-5278. President: Al Di Felice. Estab. 1988. Art publisher, distributor and framers. Publishes/distributes posters and limited editions. Clients: galleries, furniture stores, chains, etc.

Needs: Seeking contemporary artwork with decorative appeal, art for the serious collector, the commercial market, and the designer market. Also needs designers. Media depends on subject matter. Artists represented include Roger Hinjosa, Jack Herlan and Campos. Editions created by collaborating with the artist or working from an existing painting. Distributes the work of 3 emerging and several established artists/year.

First Contact & Terms: Send query letter with brochure showing art style or résumé and tearsheets, photocopies, slides and photographs. Designers should send slides. Samples are not filed and are returned by SASE. Reports back within 2 weeks. Call to schedule an appointment to show a portfolio. Portfolio should include original/final art, b&w and color slides, transparencies and photographs. Pays royalties of 10%. Offers an advance when appropriate. Buys reprint rights. Requires exclusive representation. Provides promotion and a written contract.

Tips: "Be realistic in analyzing your work. Publishers are primarily interested in top-notch work or specialty art."

ART RESOURCES INTERNATIONAL, LTD./BON ART, Fields Lane, Brewster NY 10509. (914)277-8888. Fax: (914)277-8602. E-mail: 103630.1013@compuserve.com. Vice President: Robin E. Bonnist. Estab. 1980. Art publisher. Publishes unlimited edition offset lithographs and posters. Does not distribute previously published work. Clients: galleries, department stores, distributors, framers worldwide.

Needs: Considers oil, acrylic, pastel, watercolor, mixed media and photography. Artists represented include Carolyn Bucha, Barbara Wilson, Kathy Davis, Julia Rowntree, Martin Wiscombe, Mary Ann Vessey, Maggie Zander, Sue Zipkin, Judy Hand, Daniel Dayley, Kate Bergquist. Editions created by collaborating with the artist or by working from an existing painting. Approached by hundreds of artists/year. Publishes the work of 10-20 emerging, 5-10 mid-career and 5-10 established artists/year.

First Contact & Terms: Send query letter with bio, brochure, tearsheets, slides and photographs to be kept on file. Samples returned by SASE only if requested. Portfolio review not required. Prefers to see slides or transparencies initially as samples, then reviews originals. Reports within 1 month. Appointments arranged only after work has been sent with SASE. Pays flat fee, $250-1,000 or 3-10% royalties. Offers advance in

some cases. Requires exclusive representation for prints/posters during period of contract. Provides in-transit insurance, insurance while work is at publisher, shipping to and from firm, promotion and a written contract. Artist owns original work.

Tips: "Please submit decorative, fine quality artwork. We prefer to work with artists who are creative, professional and open to art direction." Advises artists to attend all art buyers caravan shows and Art Expo New York City.

ARTHURIAN ART GALLERY, 4646 Oakton St., Skokie IL 60076-3145. Owner: Art Sahagian. Estab. 1985. Art distributor and gallery. Handles limited editions, handpulled originals, bronze, watercolor, oil and pastel. Current clients include Gerald Ford, Nancy Reagan, John Budnik and Dave Powers.

Needs: Seeking creative, fashionable and decorative art for the serious collector and commercial market. Artists represented include Robert Barnum, Nancy Fortunato, Art Sahagian and Christiana. Editions created by collaborating with the artist. Approached by 25-35 artists/year. Publishes and distributes the work of 5-10 emerging, 1-3 mid-career and 2-5 established artists/year.

First Contact & Terms: Send query letter with brochure showing art style and résumé, slides and prices. Samples not filed returned by SASE. Reports within 30 days. Write for appointment to show portfolio of original/final art, final reproduction/product and color photographs. Pays flat fee of $25-2,500; royalties of 3-5%; or on a consignment basis (firm receives 25% commission). Rights purchased vary. Provides insurance while work is at firm, promotion and written contract.

Tips: Sees trend toward animal images and bright colors.

ARTHUR'S INTERNATIONAL, 2613 High Range Dr., Las Vegas NV 89134. President: Marvin C. Arthur. Estab. 1959. Art distributor handling original oil paintings primarily. Publishes and distributes limited and unlimited edition prints. Clients: galleries, corporate and private collectors, etc.

Needs: Seeking creative art for the serious collector. Considers all types of original work. Artists represented include Wayne Takazono, Wayne Stuart Shilson, Paul J. Lopez, Ray Shry-Ock and Casimir Gradomski. Editions created by collaborating with the artist or by working from an existing painting. Purchases have been made in pen & ink, charcoal, pencil, tempera, watercolor, acrylic, oil, gouache and pastel. "All paintings should be realistic to view, though may be expressed in various manners."

First Contact & Terms: Send brochure, slides or photographs to be kept on file; no originals unless requested. Artist biographies appreciated. Samples not filed are returned by SASE. Reports back normally within 1 week. "We pay a flat fee to purchase the original. Payment made within 5 days. Then we pay 30% of our net profit made on reproductions. The reproduction royalty is paid after we are paid. We automatically raise artist's flat fee as demand increases."

Tips: "Do not send any original paintings unless we have requested them. Having a track record is nice, but it is not a requirement."

ARTISTS' MARKETING SERVICE, 160 Dresser Ave., Prince Frederick MD 20678. President: Jim Chidester. Estab. 1987. Distributor of limited and unlimited editions, offset reproductions and posters. Clients: galleries, frame shops and gift shops.

Needs: Seeking decorative art for the commercial and designer markets. Prefers traditional themes: landscapes, seascapes, nautical, floral, wildlife, Americana, impressionistic and country themes. Artists represented include Lena Liu and Barbara Hails. Approached by 200-250 artists/year. Distributes the work of 10-15 emerging artists and 5-10 mid-career artists/year.

First Contact & Terms: Send query letter with brochure, tearsheets and photographs. Samples are filed or returned by SASE if requested by artist. Reports back within weeks. To show portfolio, mail tearsheets and slides. Pays on consignment basis (50% commission). Offers an advance when appropriate. Purchases one-time rights. Does not require exclusive representation of artist.

Tips: "We are only interested in seeing work from self-published artists who are interested in distribution of their prints. We are presently *not* reviewing originals for publication. A trend seems to be larger edition sizes for limited editions prints."

ARTISTWORKS WHOLESALE INC., 456 Penn St., Yeadon PA 19050. (610)626-7770. Fax: (610)626-2778. Art Coordinator: Helen Casale. Estab. 1981. Art publisher. Publishes and distributes posters and cards. Clients: galleries, decorators and distributors worldwide.

Needs: Seeking creative, fashionable and decorative art for the commercial and designer markets. Considers oil, watercolor, acrylic, pastel, mixed media and photography. Prefers contemporary and popular themes, realistic and abstract. Artists representated include Margaret Babbitt, Martha Bradford, Yoli Salmona and Harry Bartnick. Editions created by collaborating with artist and by working from an existing painting. Approached by 100 artists/year. Publishes and distributes the work of 1-2 emerging, 1-2 mid-career and 1-2 established artists/year.

First Contact & Terms: Send query letter with brochure showing art style or résumé, slides, photographs and transparencies. Samples are not filed and are returned by SASE. Reports back within 1 month. Write for appointment to show portfolio or mail finished art samples, photographs and slides. Payment method is negotiated. Offers advance when appropriate. Negotiates rights purchased. Requires exclusive representation

of artist. Provides in-transit insurance, insurance while work is at firm, promotion, shipping to and from firm and a written contract.

Tips: "Publishers are now more discriminating about what they publish. Distributors are much more careful about what and how much they buy. Everyone is more conservative."

‡ARTS UNIQ' INC., 1710 S. Jefferson Ave., Box 3085, Cookeville TN 38502. (615)526-3491. Fax: (615)528-8904. Contact: Lee Lindsey. Estab. 1985. Art publisher. Publishes limited and open editions. Clients: art galleries, gift shops, furniture stores and department stores.
Needs: Seeking creative and decorative art for the designer market. Considers all media. Artists represented include Debbie Kingston Baker, D. Morgan, Janice Sumler, Gay Talbott and Carolyn Wright. Editions created by collaborating with the artist or by working from an existing painting.
First Contact & Terms: Send query letter with slides or photographs. Samples are filed or are returned by request. Reports back within 1-2 months. Pays royalties monthly. Requires exclusive representation rights. Provides promotion, framing and shipping from firm.

‡ARTS UNIQUE INTERNATIONAL, 24443 Hillsdale Ave., Laguna Hills CA 92653-8222. (714)751-9444. Owner: Lynne Spencer. Estab. 1990. Distributor. Distributes handpulled originals, limited and unlimited editions, offset reproductions, posters and originals. Clients: galleries, designers and businesses. Current clients include The Designer's Art Resource, Lido Art Dimensions, Fast Frame and Price Point Microtechnology.
Needs: Seeking creative and decorative art for the commercial and designer markets. Prefers abstraction, mixed media, water-related images. Considers contemporary, marine and sports themes. Artists represented include Scott Kennedy, William Robert Woolery, Larry Taugher and Bjorn Richter. Approached by 10-20 artists/year. Distributes the work of 1-2 emerging artists, 2-3 established artists and 1-2 mid-career artists/year.
First Contact & Terms: Send query letter with brochure showing art style or résumé, tearsheets, slides and photographs. Samples are filed or returned by SASE if requested by artist. Request portfolio review in original query. Reports back only if interested. Pays $50-1,000 on consignment basis (30-50% commission) or royalties of 50%. Does not offer an advance. Negotiates rights purchased. Provides insurance while work is at firm and shipping from firm.

BENJAMANS ART GALLERY, 419 Elmwood Ave., Buffalo NY 14222. (716)886-0898. Fax: (716)886-0546. Estab. 1970. Art publisher, distributor, gallery, frame shop and appraiser. Publishes and distributes handpulled originals limited and unlimited editions, posters, offset reproductions and sculpture. Clients come from every walk of life.
Needs: Seeking creative, fashionable and decorative art for the serious collector and the commercial and designer markets. Considers oil, watercolor, mixed media and sculpture. Prefers traditional to abstract work. Artists represented include J.C. Litz, Mike Hamby and Smadar Livine. Editions created by collaborating with the artist or by working from an existing painting. Approached by 20-30 artists/year. Publishes and distributes the work of 2 emerging, 2 mid-career and 2 established artists/year.
First Contact & Terms: Send query letter with brochure showing art style, slides, photocopies, résumé, photostats, transparencies, tearsheets and/or photographs. Samples are filed. Reports back within 2 weeks. Write for appointment to show portfolio. Pays royalties of 30-50% on consignment basis. No advance. Buys all rights. Sometimes requires exclusive representation of artist. Provides promotion, shipping from firm and insurance while work is at firm.
Tips: "Keep trying to join a group of artists."

BENTLEY HOUSE FINE ART PUBLISHERS, Box 5551, 1410-J Lesnick Lane, Walnut Creek CA 94596. (510)935-3186. Fax: (510)935-0213. E-mail: alp@bentleyhouse.com. Director: Mary Sher. Estab. 1986. Art publisher of open and limited editions of offset reproductions, posters and canvas replicas; also agency (Art Licensing Partners) for cross-licensing of artists' images worldwide. Clients: framers, galleries, distributors and framed picture manufacturers.
Needs: Seeking decorative fine art for the residential, commercial and designer markets. Considers oil, watercolor, acrylic, gouache and mixed media from accomplished artists. Prefers traditional, classic, or contemporary styles in realism and impressionism. Artists represented include Barbara Mock, Carl Valente, Richard Judson Zolan, Waltraud Schwarzbek and Egidio Antonaccio. Editions created by collaborating with

the artist or by working from an existing painting. Approached by 1,000 artists/year. Publishes the work of 30 established and emerging artists/year.

First Contact & Terms: Send query letter with brochure showing art style or résumé, advertisements, slides and photographs. Samples are filed or are returned by SASE if requested by artist. Reports back within 3 months. Pays royalties of 10% monthly plus 50 artist proofs of each edition. Obtains all reproduction rights. Usually requires exclusive representation of artist. Provides national trade magazine promotion, a written contract, worldwide agent representation, 6 annual trade show presentations, insurance while work is at firm and shipping from firm.

Tips: Advises artists to attend the Art Buyers' Caravan. "Customers know that fine art prints from Bentley are 'from a market leader in decorative art and with the quality they have come to expect.' Bentley is looking for experienced artists, with images of universal appeal, to continue filling that need."

BERGQUIST IMPORTS INC., 1412 Hwy. 33 S., Cloquet MN 55720. (218)879-3343. Fax: (218)879-0010. President: Barry Bergquist. Estab. 1946. Distributor. Distributes unlimited editions. Clients: gift shops.

Needs: Seeking creative and decorative art for the commercial market. Considers oil, watercolor, mixed media and acrylic. Prefers Scandinavian or European styles. Artists represented include Jacky Briggs and Cyndi Nelson. Editions created by collaborating with the artist or by working from an existing painting. Approached by 20 artists/year. Publishes the work of 2-3 emerging, 2-3 mid-career and 2 established artists/year. Distributes the work of 2-3 emerging, 2-3 mid-career and 2 established artists/year.

First Contact & Terms: Send brochure, résumé and tearsheets. Samples are not filed and are returned. Reports back within 2 months. Artist should follow-up. Portfolio should include color thumbnails, final art, photostats, tearsheets and photographs. Pays flat fee: $50-300, royalties of 5%. Offers advance when appropriate. Negotiates rights purchased. Provides advertising, promotion, shipping from firm and written contract. Finds artists through art fairs.

Tips: Suggests artists read *Giftware News Magazine*.

BERKSHIRE ORIGINALS, P.O. Box 951, Eden Hill, Stockbridge MA 01263. (413)298-3691. Fax: (413)298-3583. Program Design Assistant: Stephanie Wilcox-Hughes. Estab. 1991. Art publisher and distributor of offset reproductions and greeting cards.

Needs: Seeking creative art for the commercial market. Considers oil, watercolor, acrylic, pastel and pen & ink. Prefers religious themes, but also considers florals, holiday and nature scenes.

First Contact & Terms: Send query letter with brochure showing art style or other art samples. Samples are filed or are returned by SASE if requested by artist. Reports within 1 month. Write for appointment to show portfolio of slides, color tearsheets, transparencies, original/final art and photographs. Pays flat fee; $50-500. Buys all rights.

Tips: "Good draftsmanship is a must, particularly with figures and faces. Colors must be harmonious and clearly executed."

BERNARD PICTURE COMPANY, 911 Hope St., Stamford CT 06907. (203)357-7600. Fax: (203)967-9100. Art Director: Wolfgang Otto. Estab. 1953. Art publisher. Publishes unlimited editions and posters. Clients: picture frame manufacturers, distributors, manufacturers, galleries and frame shops.

Needs: Seeking creative, fashionable and decorative art for commercial and designer markets. Considers oil, watercolor, acrylic, pastel, mixed media and printmaking (all forms). Prefers multicultural themes, cultural artifacts, inspirational art, contemporary nonobjective abstracts. Editions created by collaborating with the artist or by working from an existing painting. Artists represented include Bob Bates, Lily Chang, Shelly Rasche, Steven Klein and Michael Harrison. Approached by hundreds of artists/year. Publishes the work of 8-10 emerging, 10-15 mid-career and 100-200 established artists/year.

First Contact & Terms: Send query letter with brochure showing art style and/or résumé, tearsheets, photostats, photocopies, slides, photographs or transparencies. Samples are returned by SASE. Reports back within 2-8 weeks. Call or write for appointment to show portfolio of thumbnails, roughs, original/final art; b&w and color photostats, tearsheets, photographs, slides and transparencies. Pays royalties of 10%. Offers an advance when appropriate. Buys all rights. Usually requires exclusive representation of artist. Provides in-transit insurance, insurance while work is at firm, promotion, shipping from firm and a written contract. Finds artists through submissions, sourcebooks, agents, art shows, galleries and word of mouth.

Tips: "We try to look for subjects with a universal appeal. Some subjects that would be appropriate are landscapes, still lifes, animals in natural settings, religious themes and florals to name a few. Please send enough examples of your work that we can get a feel for your style and technique."

BIG, (Division of the Press Chapeau), Govans Station, Box 4591, Baltimore City MD 21212-4591. Director: Elspeth Lightfoot. Estab. 1976. Specifier of original tapestries, sculptures, crafts and paintings to architects, interior designers, facility planners and corporate curators. Makes individual presentations to clients.

Needs: Seeking art for the serious and commercial collector and the designer market. "We distribute what corporate America hangs in its board rooms; highest quality traditional, landscapes, contemporary abstracts. But don't hesitate with unique statements, folk art or regional themes. In other words, we'll consider all categories as long as the craftsmanship is there." Prefers individual works of art. Editions created by collabo-

rating with the artist. Approached by 50-150 artists/year. Distributes the work of 10 emerging, 10 mid-career and 10 established artists/year.
First Contact & Terms: Send query letter with slides. Samples are filed or are returned by SASE. Reports back within 5 days. Request portfolio review in original query. Artist should follow up with letter after initial query. Pays $500-30,000. Payment method is negotiated (artist sets net pricing). Offers advance. Does not require exclusive representation. Provides in-transit insurance, insurance while work is at firm, promotion, shipping to firm, and a written contract. Finds artists through agents.

THE BILLIARD LIBRARY CO., 1570 Seabright Ave., Long Beach CA 90813. (310)432-8264. Fax: (310)436-8817. E-mail: dlar@earthlink.com. Production Coordinator: Darian Baskin. Estab. 1972. Art publisher and distributor. Publishes unlimited and limited editions and posters. Clients: poster print stores, billiard retailers. Current clients include Deck the Walls, Prints Plus, Adventure Shops.
Needs: Seeking creative, fashionable and decorative art for the commercial and designer markets. Considers oil, watercolor, mixed media, pastel, pen & ink and acrylic. Prefers themes that center on billiard-related ideas. Artists represented include Melia Taylor, ProShot Gallery and Lance Slaton. Approached by 10-15 artists/year. Publishes and distributes the work of 3-5 emerging artists/year. Distributes the work of 10 mid-career and 10 established artists/year. Also uses freelancers for design. 60% of projects require freelance design.
First Contact & Terms: Send query letter with slides, photocopies, résumé, photostats, transparencies, tearsheets and photographs. Designers send samples, along with any ideas related to billiard market. Samples are filed or are returned by SASE if requested. Reports back within 1 month. Publisher/Distributor will contact artists for portfolio review if interested. Pays flat fee, $500 minimum; or royalties of 10%. Negotiates rights purchased. Provides promotion, insurance while work is at firm and a written contract.
Tips: "The Billiard Library Co. publishes and distributes artwork of all media relating to the sport of pool and billiards. Themes and styles of any type are reviewed with an eye towards how the image will appeal to a general audience of enthusiasts. We are experiencing an increasing interest in nostalgic pieces, especially oils. Will also review any image relating to bowling or darts."

WM. BLACKWELL & ASSOCIATES, 638 S. Governor St., Iowa City IA 52240-5626. (800)366-5208. Fax: (319)338-1247. Contact: William Blackwell. Estab. 1979. Distributor. Distributes handpulled originals. Clients: gallery and design (trade only).
Needs: Seeking decorative art for the designer market. Considers etchings (hand-colored). Prefers traditional and representational. Artists represented include Alice Scott, Charles Leonard, Dan Mitra, Rick Loudermilk. Approached by 10-15 artists/year.
First Contact & Terms: Send query letter with photographs, samples of actual impressions. Samples are not filed and are returned by SASE if requested by artist. Reports back within 1 month. Distributor will contact artists for portfolio review if interested. Portfolio should include final art. Pays on consignment basis or buys work outright. No advance. Provides promotion, shipping from firm and distribution (primarily eastern and central US).
Tips: "Artists generally approach us via trade shows, trade ads or referral."

‡BRINTON LAKE EDITIONS, Box 888, Brinton Lake Rd., Concordville PA 19331-0888. (610)459-5252. President: Lannette Badel. Estab. 1991. Art publiser, distributor, gallery. Publishes/distributes limited editions and canvas transfers. Clients: independent galleries and frame shops. Current clients include: over 100 galleries, mostly East Coast.
Needs: Seeking fashioniable art. Considers oil, acrylic, watercolor, mixed media and pastel. Prefers realistic landscape and florals. Artists represented include Gary Armstrong and Lani Badel. Editions created by collaborating with the artist. Approached by 20 artists/year. Publishes/distributes the work of 1 emerging, and 1 established artist/year.
First Contact & Terms: Send query letter with samples. Samples are not filed and are returned. Reports back within 2 months. Company will contact artist for portfolio review of final art, photographs, slides, tearsheets and transparancies if interested. Negotiates payment. Rights purchased vary according to project. Requires exclusive representation of artist.
Tips: "Artists submitting must have good drawing skills no matter what medium used."

‡BROWN'S FINE ART & FRAMING, 630 Fondren Place, Jackson MS 39216. (601)982-4844 or (800)737-4844. Fax: (601)982-0030. Contact: Joel Brown. Estab. 1965. Gallery/frame shop. Sells originals, limited editions, unlimited editions, fine art prints, monoprints, offset reproductions, posters, sculpture, and "original art by Mississippi artists. We publish Mississippi duck stamp and print." Current clients include: doctors, lawyers, accountants, insurance firms, general public, other frame shops and distributors, decorators and architects, local companies large and small.
Needs: Seeking creative, decorative and investment quality art for the serious collector, commercial and designer markets. Considers oil, acrylic, watercolor, mixed media, pastel, pen & ink and sculpture. Prefers landscapes, florals, unique, traditional and contemporary. Artists represented include Emmitt Thames, Sharon Richardson, Jackie Meena, "plus 25 other Mississippi artists."

First Contact & Terms: Call to make appointment to bring original work. Samples are returned. Request portfolio review of final art and originals in original query. Pays on consignment basis: firm receives 50% commission. Requires exclusive representation of artist. Provides advertising, in-transit insurance, insurance while work is at firm, promotion, shipping from our firm and all framing.
Tips: "*Decor* magazine is the bible of our industry. Also look at what is going on nearby or in the world (i.e., Monet exhibition, Russian influences). Don't be afraid to branch out and try something new and different."

‡**JOE BUCKALEW**, 1825 Annwicks Dr., Marietta GA 30062. (800)971-9530. Fax: (770)971-6582. Contact: Joe Buckalew. Estab. 1990. Distributor. Distributes limited editions, canvas transfers, fine art prints and posters. Clients: 500-600 frame shops and galleries.
Needs: Seeking creative, fashionable, decorative art for the serious collector. Considers oil, acrylic and watercolor. Prefers florals, landscapes, Civil War and sports. Artists represented include B. Sumrall, R.C. Davis, F. Buckley, M. Ganeck, D. Finley. Approached by 25-30 artists/year. Distributes work of 10 emerging, 10 mid-career and 50 established artists/year.
First Contact & Terms: Send sample prints. Accepts disk submissions. "Please call. Currently using a 460 commercial computer." Samples are filed or are returned. Does not reports back. Artist should call. Artist should follow-up with call after initial query. Portfolio should include sample prints. Pays on consignment basis: firm receives 50% commission paid net 30 days. Provides advertising, shipping from our firm and company catalog. Finds artists through ABC shows, regional art & craft shows, frame shops, other artists.

❦**BUSCHLEN MOWATT GALLERY**, 1445 W. Georgia St., Vancouver, British Columbia V6G 2T3 Canada. (604)682-1234. Fax: (604)682-6004. Gallery Director: Greg Lejnieks. Assistant Director: Sherri Kajiwara. Estab. 1979 (gallery opened 1987). Art publisher, distributor and gallery. Publishes and distributes handpulled originals and limited editions. Clients are beginning to advanced international collectors and dealers.
Needs: Seeking creative art for the serious collector and the designer market. Considers all media. Artists represented include Cathelin, Brasilier, Moore, Motherwell, Frankenthaler, Olitski, Cassigneu, Bill Reid, Fenwick Lansdowne, Bernard Gantner. Editions created by collaborating with the artist." Approached by 1,000 artists/year. Publishes the work of 2 emerging and 5 established artists/year. Distributes the work of 4 emerging and 5-10 established artists/year.
First Contact & Terms: Send query letter with résumé and photographs. Do not contact through agent. Samples are filed or are returned by SASE if requested by artist. Reports back within 3 months. Publisher/Distributor will contact artist for portfolio review if interested. Portfolio should include color tearsheets and photographs. Negotiates payment. Buys all rights. Requires exclusive representation of artist. Provides advertising, insurance while work is at firm, promotion and written contract. Finds artists through art exhibitions, art fairs, word of mouth, sourcebooks, publications, and submissions."

‡❦**CANEY CREEK PUBLISHING INC.**, P.O. Box 3398, Tecumseh, Ontario N8N 3C4 Canada. (519)727-3220. Fax: (519)727-3143. Contact: Manager. Estab. 1989. Poster company, art publisher, distributor and gallery. Publishes/distributes limited editions, fine art prints, offset reproductions, posters and originals. Clients: galleries, frame shops, corporate curators and gift shops. Current clients include: Artic Rose (Alaska).
Needs: Seeking art for the serious collector. Considers oil, watercolor and pastel. Prefers realism with emotion. Artists represented include Paul Murray, Ken Jackson, Bev Spicel and William Kyluk. Editions created by working from an existing painting. Approached by 150 artists/year. Publishes the work of 1 emerging, 1 mid-career and 3 established artists/year. Distributes the work of 3-4 emerging, 1 mid-career and 3 established artists/year.
First Contact & Terms: Samples are not filed or returned. Reports back only if interested. Pays royalty of 20-25%; negotiates payment. Negotiates rights purchased. Requires exclusive representation of artist. Provides advertising, in-transit insurance, promotion, shipping from firm, written contract. Terms vary with contract and artist.

CARIBE CONCEPTS GALLERY, 14135 SW 142nd Ave., Miami FL 33186. Phone/fax: (305)235-8919. President: Diana Emerick. Estab. 1992. Art licensor and artist representative. Publishes and distributes unlimited editions, offset reproductions, posters and T-shirts. Clients: art licensees. Current clients include: Global Impressions, CTM Mfg., Barker & Co.
Needs: Seeking creative art for the commercial market. Considers oil, watercolor, mixed media, pastel, pen & ink and acrylic. Artists represented include Philip Rote and Darlene Emerick. Editions created by collaborating with the artist or by working from an existing painting. Approached by 8 artists/year. Publishes and distributes the work of 2 emerging artists/year.
First Contact & Terms: Send query letter with brochure, résumé, tearsheets, photographs and photocopies. Samples are filed or returned (if rejected). Reports back within 2 weeks. Publisher/Distributor will contact artist for portfolio review if interested. Portfolio should include color final art, photostats, tearsheets and

photographs. Negotiates payment. Offers advance when appropriate. Rights purchased vary according to project. Provides promotion and written contract. Finds artists through juried art shows, word of mouth, submissions.

Tips: Suggests artists read *Art Business News*.

‡CASS CONTEMPORARY ART, 555 116th Ave. NE, Suite 118, Bellevue WA 98004. (206)646-6666. Fax: (206)646-6667. Contact: Rob Paterson. Estab. 1978. Distributor. Distributes handpulled originals, limited editions, fine art prints. Clients: art galleries and decorators.

Needs: Seeking art for the serious collector, commercial and designer markets. Considers all media. Artists represented include Lowell Nesbitt, Kuaujansky, Philippe Noyer. Editions created by working from an existing painting. Approached by 20 artists/year. Distributes the work of 3 established artists/year. Also needs freelancers for design.

First Contact & Terms: Send query letter with slides. Accepts disk submissions. Samples are filed. Reports back within 2 weeks only if interested. Artist should follow-up with letter after initial query. Company will contact artist for portfolio review of slides if interested. Pays in royalties. Rights purchased vary according to project. Requires exclusive representation of artist. Provides advertising, in-transit insurance, insurance while work is at firm, promotion, shipping from our firm and written contract. Finds artists through art exhibitions.

CHALK & VERMILION FINE ARTS, 200 Greenwich Ave., Greenwich CT 06830. (203)869-9500. Fax: (203)869-9520. Contact: Michael Lisi. Estab. 1975. Art publisher. Publishes original paintings, handpulled serigraphs and lithographs, posters, limited editions and offset reproductions. Clients: international retailers, distributors, art brokers.

Needs: Publishes creative and decorative art for the serious collector and the commercial and designer markets. Considers oil, watercolor, mixed media, pastel and acrylic. Artists represented include Erte, McKnight, Alex Katz, Kondakova, Hallam, Kiraly, Sally Caldwell Fisher, Brennan and Robert Williams. Editions created by collaborating with the artist or working from an existing painting. Approached by 500-1,000 artists/year.

First Contact & Terms: Send query letter with slides, résumé and photographs. Samples are filed or are returned by SASE if requested by artist. Reports back within 3 months. Publisher will contact artist for portfolio review if interested. Pay "varies with artist, generally fees and royalties." Offers advance. Requires exclusive representation of artist. Provides in-transit insurance, promotion, shipping from firm, insurance while work is at firm and written contract. Finds artists through exhibitions, trade publications, catalogs, submissions.

‡THE CHASEN PORTFOLIO, 259½ Morris Ave., Springfield NJ 07081-1218. (201)376-1101. Fax: (201)376-1126. Contact: Douglas Rappel. Estab. 1983. Art publisher/distributor. Publishes limited editions and originals. Clients: galleries, decorators, designers, art consultants, trade professionals and corporate art buyers.

Needs: Considers oil paintings, acrylic paintings, pastels, watercolor, monoprints, lithographs, serigraphs, etchings and mixed media. Prefers classical, formal look. Artists represented include Rafferty, Amarger, Suchy and Tay. Distributes the work of 50 emerging, 150 mid-career and 100 established artists/year.

First Contact & Terms: Send query letter with brochure or tearsheets, photographs and slides. Samples are filed or returned by SASE if requested. Publisher/Distributor will contact artists for portfolio review if interested. Portfolio should include original/final art. Payment is on consignment basis; firm receives a varying commission. Negotiates payment and rights purchased. Does not require exclusive representation. Provides in-transit insurance, insurance while work is at firm, promotion, shipping from firm and a written contract. Finds artists through word of mouth and visiting art fairs.

CIRRUS EDITIONS, 542 S. Alameda St., Los Angeles CA 90013. President: Jean R. Milant. Produces limited edition handpulled originals. Clients: museums, galleries and private collectors.

Needs: Seeking contemporary paintings and sculpture. Prefers abstract, conceptual work. Artists represented include Lari Pittman, Joan Nelson, John Millei, Charles C. Hill and Bruce Nauman. Publishes and distributes the work of 6 emerging, 2 mid-career and 1 established artists/year.

First Contact & Terms: Prefers slides as samples. Samples are returned by SASE.

‡CLASSIC COLLECTIONS FINE ART, 1 Bridge St., Irvington NY 10533. (914)591-4500. Fax: (914)591-4828. Acquisition Manager: Larry Tolchin. Estab. 1990. Art publisher. Publishes unlimited editions and offset reproductions. Clients: galleries, interior designers, hotels.

Needs: Seeking decorative art for the commercial and designer markets. Considers oil, acrylic, watercolor, mixed media and pastel. Prefers landscapes, still lifes, florals. Artists represented include Harrison Rucker, Henrietta Milan, Sid Willis and Charles Zhan. Editions created by collaborating with the artist and by working with existing painting. Approached by 100 artists/year. Publishes the work of 6 emerging, 6 mid-career and 6 established artists/year.

First Contact & Terms: Send slides and transparencies. Samples are filed. Reports back within 3 months. Company will contact artist for portfolio review if interested. Offers advance when appropriate. Buys first and reprint rights. Provides advertising, insurance while work is at firm and written contract. Finds artists through art exhibitors, art fairs and art competitions.

‡**CLASSIC EDITIONS PUBLISHING, INC.**, 5673 W. Las Positas Blvd., #216, Pleasanton CA 94588. (510)225-1122. Fax: (510)225-1123. President: Jeff Tichenor. Estab. 1994. Art publisher. Publishes limited editions, hand retouched canvas reproductions. Clients: galleries, frame shops and gift shops.
Needs: Seeking creative, fashionable, decorative art for the serious collector, commercial and designer markets. Wants "timeless, traditional, well-composed" work. Considers oil, acrylic, watercolor, pastel and pen & ink. Artists represented include Charles H. White, Deborah Wardrope. Editions created by collaborating with the artist or by working from an exisiting painting. Approached by 20-30 artists/year. Publishes the work of 1-2 emerging, 1-2 mid-career and 1-2 established artists/year.
First Contact & Terms: Send brochure, photographs, résumé, SASE, slides, tearsheets and transparencies. Samples are returned by SASE. Reports back only if interested. Company will contact artist for portfolio review if interested. Negotiates payment. Offers advance when appropriate. Rights purchased vary according to project. Requires exclusive representation of artist. Provides advertising, in-transit insurance, promotion, shipping to and from firm, written contract.

‡**THE COLONIAL ART CO.**, 1336 NW First St., Oklahoma City OK 73106. (405)232-5233. Owner: Willard Johnson. Estab. 1919. Publisher and distributor of offset reproductions for galleries. Clients: retail and wholesale. Current clients include Osburns, Grayhorse and Burlington.
Needs: Artists represented include Felix Cole, Dennis Martin, John Walch and Leonard McMurry. Publishes the work of 2-3 emerging, 2-3 mid-career and 3-4 established artists/year. Distributes the work of 10-20 emerging, 30-40 mid-career and hundreds of established artists/year. Prefers realism and expressionism—emotional work.
First Contact & Terms: Send sample prints. Samples not filed are returned only if requested by artist. Publisher/Distributor will contact artist for portfolio review if interested. Pays negotiated flat fee or royalties, or on a consignment basis (firm receives 33% commission). Offers an advance when appropriate. Does not require exclusive representation of the artist. Considers buying second rights (reprint rights) to previously published work.
Tips: "The current trend in art publishing is an emphasis on quality."

‡**COLOR CIRCLE ART PUBLISHING, INC.**, P.O. Box 190763, Boston MA 02119. (617)437-1260. Fax: (617)437-9217. Estab. 1990. Art publisher. Publishes limited editions, unlimited editions, fine art prints, offset reproductions, posters. Clients: galleries, art dealers, distributors, museum shops. Current clients include: Deck the Walls, Things Graphis, Essence Art.
Needs: Seeking creative, decorative art for the serious collector, for the commercial market. Considers oil, acrylic, watercolor, mixed media, pastel, pen & ink. Prefers ethnic themes. Artists represented include Paul Goodnight, Essud Fuhgcap, Charly and Dorothea Palmer. Editions created by collaborating with the artist or by working from an existing painting. Approached by 12-15 artists/year. Publishes the work of 2 emerging, 1 mid-career artists/year. Distributes the work of 4 emerging, 1 mid-career artists/year.
First Contact & Terms: Send query letter with slides. Samples are filed or returned by SASE. Reports back within 2 months. Negotiates payment. Rights purchased vary according to project. Provides advertising, insurance while work is at firm, promotion, shipping from our firm and written contract. Finds artists through submissions, trade shows and word of mouth.
Tips: "We like to present at least two pieces by a new artist that are similar in either theme, treatment or colors."

‡**COLVILLE PUBLISHING**, 1315 Third St., Promenade #300, Santa Monica CA 90401. (310)451-1030. Fax: (310)458-0575. Chairman: Christian Title. Estab. 1982. Art publisher. Publishes limited edition serigraphs. Clients: art galleries.
Needs: Seeking creative art for the serious collector. Considers oil and pastel. Prefers impressionism and American Realism. Artists represented include John Powell, Henri Plisson and Don Hatfield. Publishes and distributes the work of varying number of emerging, 2 mid-career and 4 established artists/year.
First Contact & Terms: Send query letter with résumé, slides, photographs, transparencies, biography and SASE. Samples are not filed. Reports back within 1 month. To show a portfolio, mail appropriate materials. Payment method is negotiated. Does not offer an advance. Requires exclusive representation of artist. Provides in-transit insurance, insurance while work is at firm, promotion, shipping to and from firm and a written contract.

CRAZY HORSE PRINTS, 23026 N. Main St., Prairie View IL 60069. (708)634-0963. Owner: Margaret Becker. Estab. 1976. Art publisher and gallery. Publishes limited editions, offset reproductions and greeting cards. Clients: Native American art collectors.

Needs: "We publish only Indian authored subjects." Considers oil, pen & ink and acrylic. Prefers and nature themes. Editions created by working from an existing painting. Approached by 10 artists/year. Publishes the work of 2 and distributes the work of 20 established artists/year.

First Contact & Terms: Send résumé and photographs. Samples are filed. Reports back to the artist only if interested. Portfolio review not required. Publisher will contact artist for portfolio review if interested. Portfolio should include photographs and bio. Pays flat fee: $250-1,500 or royalties of 5%. Offers advance when appropriate. Buys all rights. Provides promotion and written contract. Finds artists through art shows and submissions.

THE CREATIVE AGE, 2824 Rhodes Circle, Birmingham AL 35205. (205)933-5003. President: Finley Eversole. Creative Director: Anastasia Rose Eversole. Estab. 1991. Art publisher. Publishes and distributes unlimited editions. Clients: distributors, ready-framers, frame stores and decorators. Current clients include Paragon, Carolina Mirror, Art Dreams, Art Image Inc., Graphique de France, The Bombay Co. Mainly publishes master artists of the 19th and early 20th centuries.
 • The Creative Age will soon be moving into the fine art T-shirt field and will be looking for appropriate designs.

Needs: Seeking creative art for the serious collector, commercial, ready-framed and designer markets. Considers oil, watercolor, acrylic, pastel, lithographs and engravings. Prefers animals, children, romantic themes, landscapes, sports, seascapes, marines, still lifes and florals. Editions created by collaborating with the artist or working from an existing painting. Publishes the work of 1-2 emerging and 1-2 mid-career artists/year.

First Contact & Terms: Send query letter with résumé and tearsheets, slides, photographs and transparencies. Samples are filed or are returned by SASE if requested by artist. Reports back only if interested. Pays royalties of 10%. Offers advance when appropriate. Provides return in-transit insurance, promotion, shipping from firm and written contract.

Tips: Advises artists to attend Atlanta ABC show, which is the largest in the industry. Finds mid-career and emerging artists through submissions. "Work must be of very high quality with good sense of color, light and design. Artist should be willing to grow with young company. We are looking for work in the styles of 19th century florals, still lifes, landscapes; Victorian art; and French and American Impressionism."

‡CREGO EDITIONS, 3960 Dewey Ave., Rochester NY 14616. (716)621-8803. Fax: (716)621-7465. Owner: Paul Crego Jr. Publishes and distributes limited editions and originals.

Needs: Seeking African-American and ethnic artwork with decorative appeal for the serious collector, commercial and designer markets. Considers oil, watercolor, acrylic, pen & ink and mixed media. Artists represented include David Kibuuka. Editions created by collaborating with the artist. Approached by 25 artists/year. Publishes and distributes the work of 1 emerging, 1 mid-career and 2 established artists/year.

First Contact & Terms: Send query letter with brochure showing art style or résumé, photocopies and photographs. Samples are filed or returned by SASE if requested by artist. Reports back only if interested. To show portfolio, mail finished art samples, photographs and slides. Pays royalties of 25%. Also pays on a consignment basis: firm receives 25% commission. Negotiates rights purchased. Requires exclusive representation. Provides in-transit insurance, insurance while work is at firm, promotion, shipping to and from firm and a written contract.

CROSS GALLERY, INC., 180 N. Center, P.O. Box 4181, Jackson Hole WY 83001. (307)733-2200. Fax: (307)733-1414. Director: Mary Schmidt. Estab. 1982. Art publisher and gallery. Publishes handpulled originals, limited and unlimited editions, offset reproductions and canvas reproductions. Clients: wholesale and retail.

Needs: Seeking creative art for the serious collector. Considers oil, watercolor, mixed media, pastel, pen & ink, sculpture and acrylic. Prefers realism, contemporary, western and portraits. Artists represented include Penni Anne Cross, Val Lewis, Joe Geshick, Michael Chee, Andreas Goft and Kevin Smith. Editions created by collaborating with the artist or by working from an existing painting. Approached by 100 artists/year.

First Contact & Terms: Send query letter with brochure, résumé, tearsheets, slides, photostats, photographs, photocopies and transparencies. Samples are not filed and are returned by SASE if requested by artist. Reports back within 2 days. Publisher will contact artist for portfolio review if interested. Portfolio should include b&w and color thumbnails, roughs, final art, photostats, tearsheets, photographs, slides and transparencies. Pays royalties or on consignment basis (firm receives 33⅓% commission). No advance. Rights purchased vary according to project. Requires exclusive representation of artist. Provides advertising, insurance while work is at firm, promotion, shipping from firm and written contract.

CUPPS OF CHICAGO, INC., 831 Oakton St., Elk Grove IL 60007. (708)593-5655. Fax: (708)593-5550. President: Gregory Cupp. Estab. 1967. Art publisher, distributor and wholesaler of original oil paintings. Clients: galleries, frame shops, designers and home shows.
 • Pay attention to contemporary/popular colors when creating work for this design-oriented market.

Needs: Seeking creative, fashionable and decorative art for the serious collector, commercial and designer markets. Artists represented include Gloria Rose and Jorge Tarallo Braun. Editions created by collaborating

with the artist. Considers oil and acrylic paintings in "almost any style—only criterion is that it must be well done." Prefers individual works of art. Approached by 50 artists/year. Publishes and distributes the work of 6 emerging, 2 mid-career and 2 established artists/year.

First Contact & Terms: Send query letter with brochure showing art style or résumé and photographs. Do not submit slides. Samples are filed or are returned by SASE if requested. Reports back only if interested. Call or write for appointment to show portfolio of original/final art. Pays royalties of 10%. No advance. Buys first rights or reprint rights. Provides advertising, in-transit insurance, promotion, shipping from firm, insurance while work is at firm and written contract.

Tips: This distributor sees a trend toward traditional work.

DAUPHIN ISLAND ART CENTER, 1406 Cadillac Ave., Box 699, Dauphin Island AL 36528. Phone/fax: (334)861-5701. Owner: Nick Colquitt. Estab. 1984. Wholesale producer and distributor of marine and nautical decorative art. Clients: West, Gulf and eastern coastline retailers.

Needs: Approached by 12-14 freelance artists/year. Works with 8-10 freelance artists/year. Prefers local artists with experience in marine and nautical themes. Uses freelancers mainly for wholesale items to be retailed. Also for advertising, brochure and catalog illustration, and design. 1% of projects require freelance design.

First Contact & Terms: Send query letter with brochure and samples. Samples not filed are returned only if requested by artist. Reports back within 3 weeks. To show portfolio, mail final reproduction/product. Pays for design and illustration by the finished piece price. Considers skill and experience of artist and "retailability" when establishing payment. Negotiates rights purchased.

Tips: Advises artists to attend any of the Art Expo events especially those held in Atlanta Merchandise Mart. "We're noticing a move away from white as mat or decorative bordering. Use complementary colors instead of white."

DAVID MARSHALL, Box 410246, St. Louis MO 63141. (314)781-5224. E-mail: carol@hmgbbs.com. President: Marshall Gross. Estab. 1972. Art distributor/gallery handling original acrylic paintings, serigraphs, paper construction, cast paper and sculpture. Clients: designer showrooms, architects, interior designers, galleries, furniture and department stores.

Needs: "We're seeking product designs for decorative mirrors, lamps, tables and chairs (wood or wrought iron), rugs, pedestals, cocktail tables, wall placques, large ceramic urns, vases. "We can use contemporary and classic clay sculpture." Special consideration to South American Native designs and themes. After reviewing your work we will advise product groups we wish you to develop for us to purchase."

First Contact & Terms: Send query letter with brochure showing art style or photographs. Samples are not filed and are returned only if requested by artist. Call for instructions to show portfolio of roughs, slides and color photos.

Tips: "Glass and mirror designs are given special consideration. We represent all types of art from professional gallery quality to street fairs. We're especially looking for ethnic South American designs. Awareness of current color trend in the home furnishings industry is a must."

DECORATIVE EXPRESSIONS, INC., 2158 Tucker Industrial Blvd., Tucker GA 30084. (770)493-6858. Fax: (770)493-6838. President: Robert Harris. Estab. 1984. Distributor. Distributes original oils. Clients: galleries, designers, antique dealers.

Needs: Seeking creative and decorative art for the designer market. Styles range from traditional to contemporary to impressionistic. Artists represented include Henri Hess, J. Hovener, D. Karasek, Ad DeRoo, E. Payes, J. Ripoll, Barbera, Gerry Groeneveld, Peter VanBerke and Cornelis LeMair. Approached by 6 artists/year. Distributes the work of 2-6 emerging, 2-4 mid-career and 10-20 established artists/year.

First Contact & Terms: Send photographs. Samples are returned by SASE if requested by artist. Reports back to the artist only if interested. Portfolios may be dropped off every Monday. Portfolio should include final art and photographs. Negotiates payment. Offers advance when appropriate. Negotiates rights purchased. Requires exclusive representation of artist. Provides advertising, in-transit insurance, promotion and distribution through sale force and trade shows. Finds artists through word of mouth, exhibitions, travel.

Tips: "The design market is major source for placing art. We seek art that appeals to designers."

✿**DEL BELLO GALLERY**, 788 King St. W., Toronto, Ontario 1N6 M5V Canada. (416)504-2422. Fax: (416)504-2433. Owner: Egidio Del Bello. Art publisher and gallery handling handpulled originals for private buyers, department stores and galleries.

● **A BULLET** introduces comments by the editor of *Artist's & Graphic Designer's Market* indicating special information about the listing.

• Del Bello is organizer of the Annual International Exhibition of Miniature Art. Send $2 postage and handling for prospectus.

First Contact & Terms: Send query letter with résumé, photographs and slides. Samples are filed or are returned by SASE within 2 weeks. Call for appointment to show portfolio of original/final art and slides. Payment method is negotiated. Offers an advance when appropriate. Negotiates rights purchased. Provides promotion. Publishes the work of 10 artists/year.

‡**DEVON EDITIONS**, 6015 6th Ave. S., Seattle WA 98108. (206)763-9544. Fax: (206)762-1389. Director of Production Development: Buster Morris. Estab. 1987. Art publisher and distributor. Publishes offset reproductions. Clients: architects, designers, specifiers, frame shops.

Needs: Seeking creative and decorative art for the designer market. Considers oil, watercolor, acrylics, pastels, mixed media and photography. "Open to a wide variety of styles." Editions created by collaborating with the artist or by working from an existing painting. Approached by 200 artists.

First Contact & Terms: Send query letter with slides, résumé, transparencies and photographs. Samples are filed or are returned by SASE. Reports back within 6 weeks if SASE enclosed. To show portfolio, mail slides and transparencies. Pays flat fee or royalties and advance. Offers advance when appropriate. Buys first-rights or negotiates rights purchased. Provides in-transit insurance, promotion, shipping from firm, insurance while work is at firm and a written contract.

© Directional Publishing

David Nichols of Directional Publishing says the company serves the decorative art market with images current in color scheme and subject matter with mass appeal. This watercolor and pen & ink piece by Mary Beth Zeitz fits perfectly in their line. According to Nichols they've enjoyed "great sales" from the work.

DIRECTIONAL PUBLISHING, INC., 2616 Commerce Circle, Birmingham AL 35210. (205)951-1965. Fax: (205)951-3250. President: David Nichols. Estab. 1986. Art publisher. Publishes limited and unlimited

editions and offset reproductions. Clients: galleries, frame shops and picture manufacturers.

Needs: Seeking decorative art for the designer market. Considers oil, watercolor, acrylic and pastel. Prefers floral, sporting, landscapes and still life themes. Artists represented include Evans, H. Brow, R. Lewis, M. Parker, A. Nichols, D. Nichols, M.B. Zeitz and N. Raborn. Editions created by working from an existing painting. Approached by 50 artists/year. Publishes and distributes the work of 5-10 emerging, 5-10 mid-career and 3-5 established artists/year.

First Contact & Terms: Send query letter with slides and photographs. Samples are not filed and are returned by SASE. Reports back within 3 months. Pays royalties. Buys all rights. Provides in-transit insurance, insurance while work is at firm, promotion, shipping from firm and written contract.

Tips: "Always include SASE. Do not follow up with phone calls. All work published is first of all *decorative*. The application of artist designed borders to artwork can sometimes greatly improve the decorative presentation. We follow trends in the furniture/accessories market."

DODO GRAPHICS, INC., 145 Cornelia St., P.O. Box 585, Plattsburgh NY 12901. (518)561-7294. Fax: (518)561-6720. Manager: Frank How. Art publisher of offset reproductions, posters and etchings for galleries and frame shops.

Needs: Considers pastel, watercolor, tempera, mixed media, airbrush and photographs. Prefers contemporary themes and styles. Prefers individual works of art, 16×20 maximum. Publishes the work of 5 artists/year.

First Contact & Terms: Send query letter with brochure showing art style or photographs and slides. Samples are filed or are returned by SASE. Reports back within 3 months. Write for appointment to show portfolio of original/final art and slides. Payment method is negotiated. Offers an advance when appropriate. Buys all rights. Requires exclusive representation of the artist. Provides written contract.

Tips: "Do not send any originals unless agreed upon by publisher."

DOUBLE J ART & FRAME SHOP, P.O. Box 66304, Baltimore MD 21239. Phone/fax: (410)433-2137. Owner: Jesse Johnson. Estab. 1989. Art publisher, distributor and custom framer. Publishes and distributes handpulled originals and limited editions. Clients: retail customers, galleries, frame shops and distributors.

Needs: Needs creative art for the serious collector, commercial and designer markets. Considers oil, watercolor, mixed media, pastel, pen & ink, sculpture and acrylic. Prefers African-American themes. Artists published include Wynston Edun, Poncho Brown. Editions created by collaborating with the artist or working from an existing painting. Approached by 5-10 artists/year. Publishes the work of 1-2 emerging, 1-2 mid-career and 1-2 established artists/year. Distributes the work of 10 emerging, 5 mid-career and 3 established artists/year.

First Contact & Terms: Send query letter with brochure, résumé, tearsheets, photostats, photographs and photocopies. Samples are not filed and are returned. Reports back within 2 weeks. Publisher/Distributor will contact artist for portfolio review if interested. Portfolio should include b&w and color thumbnails, roughs, final art, photostats, tearsheets, photographs, slides and transparencies. Negotiates payment. Offers advance when appropriate. Rights purchased vary according to project. Provides advertising, promotion, shipping to firm, shipping from firm and written contract. Finds artists through word of mouth, referral by other artists.

Tips: Recommends *Decor* and Art Buyers Caravan shows.

***DUTCH ART STUDIOS BV.**, 210 Industrieweg 210, 5683 Ch Best, Netherlands. Phone: 01131 499 397300. Fax: 01131 499 399660. President: Hem Brekoo. Estab. 1972. Art publisher and distributor. Publishes and distributes handpulled originals, limited and unlimited editions and offset reproductions. Clients: art galleries, art shops. Current clients include: Decorative Expressions.

● Hem Brekoo urges artists to keep up with the latest trends in furniture and upholstery markets and to create work that will lend itself well to decorative purposes. He is particularly interested in publishing print series (four at a time).

Needs: Seeking fashionable and decorative art for the commercial market. Considers oil, watercolor, acrylic and mixed media. Prefers contemporary interpretation of landscapes, seascapes, florals, townscenes, etc. Artists represented include Corsius, Le Mair, Groeneveld and Hovener. Editions created by collaborating with the artist. Approached by 50 artists/year. Publishes the work of 10 emerging, 10 mid-career and 5 established artists/year. Distributes the work of 20 emerging, 20 mid-career and 15 established artists/year.

First Contact & Terms: Send query letter with brochure showing art style. Samples are filed or are returned by SASE (nonresidents include IRC) if requested by artist. Reports back within 1 month. Artist should follow up with letter after initial query. To show portfolio, mail photographs and slides. Payment method is negotiated. Requires exclusive representation of artist. Provides promotion and written contract.

Tips: Advises artists to attend Art Expo show.

EDELMAN FINE ARTS, LTD., 386 W. Broadway, Third Floor, New York NY 10012. (212)226-1198. Vice President: H. Heather Edelman. Art distributor of original oil paintings. "We now handle watercolors, lithographs, serigraphs, sculpture and 'works on paper' as well as original oil paintings." Clients: galleries, dealers, consultants, interior designers and furniture stores worldwide.

● The president of Edelman Fine Arts says the mainstream art market is demanding traditional work with great attention to detail. She feels impressionism is still in vogue but with a coral, peach color

tone with a Cortes, Couret or Turner feel. She says Renaissance large nudes, pictured in a typical scene are being requested.

Needs: Seeking creative and decorative art for the serious collector and designer markets. Considers oil and acrylic paintings, watercolor, sculpture and mixed media. Especially likes Old World themes and impressionist style. Distributes the work of 150 emerging, 70 mid-career and 150 established artists.

First Contact & Terms: Send six 3×5 photos (no slides), résumé, tearsheets. Samples are filed. Portfolios may be dropped off every Monday-Thursday upon request. Portfolio should include original/final art and photographs. Reports as soon as possible. Pays royalties of 40% or works on consignment basis (20% commission). Buys all rights. Provides in-transit insurance, insurance while work is at firm, promotion and shipping from firm.

EDITION D'ART PONT-AVEN, 2746 Feirfield Ave., Bridgeport CT 06605. (203)333-1099. Fax: (203)366-2925. Manager: Danica. Estab. 1984. Art publisher and gallery. Publishes limited and unlimited editions, offset productions. Clients: galleries and framers.

Needs: Needs decorative art for the commercial and designer markets. Considers oil, watercolor and pastel. Artists represented include Glazer, Huchet and Rindom. Editions created by collaborating with the artist. Approached by 5 artists/year. Publishes the work of 2 emerging, 2 mid-career and 2 established artists/year.

First Contact & Terms: Send tearsheets, slides and photographs. Samples are filed. Reports back within 3 months. Portfolios may be dropped off every Thursday. Portfolio should include photostats, photographs and slides. Negotiates payment. Buys first or all rights. Provides advertising, in-transit insurance and promotion. Finds artists through submissions.

EDITIONS LIMITED GALLERIES, INC., 625 Second St., Suite 400, San Francisco CA 94107. (415)543-9811. Fax: (415)777-1390. Director: Michael Ogura. Art publisher and distributor of limited edition graphics and fine art posters. Clients: galleries, framing stores, art consultants and interior designers.

Needs: Seeking creative art for the designer market. Considers oil, acrylic and watercolor painting, monoprint, monotype, photography and mixed media. Prefers landscape and abstract imagery. Artists represented include Peter Kitchell, Elba Alvarez and Jack Roberts. Editions created by collaborating with the artist or by working from an existing painting.

First Contact & Terms: Send query letter with résumé, slides and photographs. Samples are filed or are returned by SASE. Reports back within 2 months. Publisher/distributor will contact artist for portfolio review if interested. Payment method is negotiated. Offers advance when appropriate. Negotiates rights purchased. Provides in-transit insurance, insurance while work is at firm, promotion, shipping to and from firm and written contract.

Tips: "We deal both nationally and internationally, so we need work with wide appeal. No figurative or cute animals. When sending slides or photos, send at least six so we can see an overview of the work. We publish artists, not just images." Advises artists to attend Art Expo, New York City and Art Buyers Caravan, Atlanta.

‡ESSENCE ART, 1708 Church St., Holbrook NY 11741-5918. (516)589-9420. President: Mr. Jan Persson. Estab. 1989. Art publisher and distributor of posters, limited editions and offset reproductions. "All are African-American images." Clients: galleries and framers. Current clients include Deck the Walls and Fast Frame.

Needs: Seeking artwork with creative expression and decorative appeal for the commercial market. Considers all media. Prefers African-American themes and styles. Artists represented include Dane Tilghman, Cal Massey, Brenda Joysmith, Carl Owens and Synthia Saint-James. Editions created by collaborating with artist or by working from an existing painting. Approached by 20 artists/year. Publishes and distributes the work of 6-20 emerging and up to 5 established artists/year.

First Contact & Terms: Send query letter with slides, photographs and transparencies. Samples are filed or are returned by SASE if requested by artist. Reports back within 2 months. Pays royalties of 10% or payment method negotiated. No advance. Buys reprint rights. Provides insurance while work is at firm, promotion, shipping from firm and a written contract.

Tips: "We are looking for artwork with good messages; family-oriented art is popular."

ELEANOR ETTINGER INCORPORATED, 119 Spring St., New York NY 10012. (212)925-7474. Fax: (212)925-7734. President: Eleanor Ettinger. Estab. 1975. Art publisher of limited edition lithographs, limited edition sculpture and unique works (oil, watercolor, drawings, etc.).

Needs: Seeks creative, fashionable and decorative art for the serious collector, commercial collector and designer markets. Considers oil, watercolor, acrylic, pastel, mixed media, pen & ink and pencil drawings.

THE ASTERISK before a listing indicates that the market is located outside the United States and Canada.

Prefers American realism. Editions created by collaborating with the artist. Approached by 100-150 artists/year. Currently distributes the work of 12 artists.

First Contact & Terms: Send query letter with visuals (slides, photographs, etc.), a brief biography, résumé (including a list of exhibitions and collections) and SASE for return of the materials. Reports within 2 weeks.

Tips: "All lithographs are printed on one of our Voirin presses, flat bed lithographic presses hand built in France over 100 years ago. The work must be unique and non-derivative. We look for artists who can create 35-50 medium to large scale works per year and who are not already represented in the fine art field."

‡S.E. FEINMAN FINE ARTS LTD., 448 Broome St., New York NY 10013. (212)431-6820. Fax: (212)431-6495. President: Stephen E. Feinman. Estab. 1965. Art publisher/distributor, gallery. Publishes/distributes handpulled originals and fine art prints. Clients: galleries, designers.

Needs: Seeking creative art for the serious collector. Considers oil, acrylic, watercolor, pastel, original prints. Artists represented include Mikio Watanabe, Miljenko Bengez, Felix Sherman, J.C. Picard, Karine Boulanger. Approached by hundreds of artists/year. Publishes/distributes the work of 1 emerging and 1 mid-career artist/year.

First Contact & Terms: Send photographs, résumé, SASE, slides. Samples are not filed and are returned by SASE. Reports back within 2 weeks. Company will contact artist for portfolio review of color, final art and photographs if interested. Pays on consignment basis; negotiable. Offers advance when appropriate. Rights purchased vary according to project. Provides insurance while work is at firm, promotion. Finds artists through reps, exhibitions, expos, sourcebooks and word of mouth.

FOXMAN'S OIL PAINTINGS LTD., 1550 Carmen Dr., Elk Grove Village IL 60007. (708)427-8555 or (800)323-2004. Fax: (708)427-8594. President: Wayne Westfall. Art distributor of limited and unlimited editions and oil paintings. Clients: galleries and national chains.

Needs: Considers oil, airbrush and acrylic. Prefers simple themes: children, barns, countrysides; African-American art and other contemporary themes and styles. Prefers individual works of art. Maximum size 36×48. Artists represented include H. Hargrove, Kugler, D. Michelle, Betty Walt. Publishes the work of 3-5 emerging, 3-5 mid-career and 3-5 established artists/year. Distributes the work of 5-10 emerging, 5-10 mid-career and 5-10 established artists/year.

First Contact & Terms: Send query letter with résumé, tearsheets, photographs and slides. Samples are not filed and are returned. Reports back within 1 month. Negotiates payment method and rights purchased. Provides promotion, shipping from firm and a written contract. Finds artists through word of mouth.

FRONT LINE GRAPHICS, INC., 9808 Waples St., San Diego CA 92121. (619)552-0944. Creative Director: Todd Haile. Estab. 1981. Publisher/distributor of posters, prints and limited editions. Clients: galleries, decorators and poster distributors worldwide.

Needs: Seeking fashionable and decorative art reflecting popular trends for the commercial collector and designer market. Considers oil, acrylic, pastel, watercolor and mixed media. Prefers contemporary interpretations of landscapes, seascapes, florals, abstracts and African-American subjects. Prefers pairs. Minimum size 22×30. Editions created by collaborating with the artist. Approached by 300 artists/year. Publishes the work of 50 and distributes the work of 100 artists/year.

First Contact & Terms: Send query letter with slides. Samples not filed are returned if requested by artist. Reports back within 1 month. Call for appointment to show portfolio of original/final art and slides. Payment method is negotiated. Requires exclusive representation of the artist. Provides promotion and a written contract.

Tips: "Front Line Graphics is looking for artists who are flexible and willing to work with us to develop art that meets the specific needs of the print and poster marketplace. We actively seek out fresh new art and artists on an on-going basis."

GALAXY OF GRAPHICS, LTD., 460 W. 34th St., New York NY 10001. (212)947-8989. Art Director: Elizabeth Tuckman. Estab. 1983. Art publisher and distributor of unlimited editions. Clients: galleries, distributors, and picture frame manufacturers.

Needs: Seeking creative, fashionable and decorative art for the commerical market. Artists represented include Hal and Fran Larsen, Glenna Kurz and Christa Keiffer. Editions created by collaborating with the artist or by working from an existing painting. Considers any media. "Any currently popular and generally accepted themes." Approached by several hundred artists/year. Publishes and distributes the work of 20 emerging and 20 mid-career and established artists/year.

First Contact & Terms: Send query letter with résumé, tearsheets, slides, photographs and transparencies. Samples are not filed and are returned by SASE. Reports back within 1-2 weeks. Call for appointment to show portfolio. Pays royalties of 10%. Offers advance. Buys rights only for prints and posters. Provides insurance while material is in house and while in transit from publisher to artist/photographer. Provides written contract to each artist.

Tips: "There is a trend toward strong jewel-tone colors."

ROBERT GALITZ FINE ART, 166 Hilltop Court, Sleepy Hollow IL 60118. (847)426-8842. Fax: (847)426-8846. Owner: Robert Galitz. Estab. 1986. Distributor of handpulled originals, limited editions and watercolors. Clients: designers, architects, consultants and galleries—in major cities of seven states.
Needs: Seeking creative, fashionable and decorative art for the serious collector and commercial and designer markets. Considers all media. Prefers contemporary and representational imagery. Editions created by collaborating with the artist. Publishes the work of 1-2 established artists/year. Distributes the work of 100 established artists/year.
First Contact & Terms: Send query letter with slides and photographs. Samples are filed or are returned by SASE. Reports back within 1 month. Call for appointment to show portfolio of original/final art. Pays flat fee of $200 minimum, or pays on consignment basis (25-40% commission). No advance. Buys all rights. Provides a written contract.
Tips: Advises artists to attend an Art Expo event in New York City, Las Vegas, Miami or Chicago. Finds artists through galleries, sourcebooks, word of mouth, art fairs. "Be professional. I've been an art broker or gallery agent for 26 years and very much enjoy bringing artist and client together!"

‡GALLERIA FINE ARTS & GRAPHICS, 14719 Catalina St., San Leandro CA 94577. (510)483-4926. Fax: (510)483-2274. Director: Thomas Leung. Estab. 1985. Art publisher/distributor. Publishes/distributes limited editions, unlimited editions, canvas transfers, fine art prints, offset reproductions, posters.
Needs: Seeking creative, decorative art for the serious collector and the commercial market. Considers oil, acrylic, watercolor. Artists represented include H. Leung and Thomas Leong. Editions created by collaborating with the artist or by working from an existing painting. Approached by 50 artists/year.
First Contact & Terms: Send query letter with photographs. Samples are filed. Reports back only if interested. Company will contact artist for portfolio review of color photographs, slides, transparencies if interested. Negotiates payment. Buy all rights. Requires exclusive representation of artist. Provides advertising, in-transit insurance, insurance while work is at firm, promotion, shipping to and from our firm, written contract.
Tips: "Color/composition/subject are important."

GALLERY GRAPHICS, 227 Main, P.O. Box 502, Noel MO 64854. (417)475-6191. Fax: (417)475-3542. Contact: Terri Galvin. Estab. 1980. Wholesale producer and distributor of Victorian memorabilia. Clients: frame shops and gift shops.
Needs: Seeking decorative Victorian art. Especially looking for Victorian guardian angels. Considers oil, watercolor, mixed media, pastel and pen & ink. Needs freelancers for design. 10% of editions created by collaborating with artist. 90% created by working from an existing painting.
First Contact & Terms: Send query letter with brochure showing art style and slides (dupes only) and tearsheets. Designers send photographs, slides, photocopies and tearsheets. Accepts disk submissions compatible with IBM. Samples are filed and are returned by SASE. Reports back within 2 month. To show portfolio, mail finished art samples, slides, color tearsheets. Pays flat fee: $100 minimum. Offers advance when appropriate. Buys all rights. Provides insurance while work is at firm, promotion and a written contract.
Tips: "Study Victorian art. Know Victorian art. Submit Victorian art."

GANGO EDITIONS, 351 NW 12th, Portland OR 97209. (503)223-9694. Contact: Artist Submissions. Estab. 1982. Publishes posters. Clients: poster galleries, art galleries, contract framers and major distributors. Current clients include Bruce McGaw Graphics, Graphique de France, Image Conscious, Editions Limited and In Graphic Detail.
Needs: Seeking creative art for the commercial and designer markets. Considers, oil, watercolor, acrylic, pastel and mixed media. Prefers still life, floral, some whimsical, abstract and landscape styles. Artists represented include Carol Grigg, Nancy Coffelt, Bill Kucha, Jennifer Winship Mark, Linda Holt, Roberta Nadeau, C.W. Potzz, Gregg Robinson, Lise Shearer, Irana Shepherd and Karen Rae. Editions created by working from an existing painting or work. Publishes and distributes the work of emerging and established artists.
First Contact & Terms: Send query letter with slides and/or photographs. Samples returned by SASE. Artist is contacted by mail. Reports back within 6 weeks. Write for appointment to show portfolio or mail appropriate materials. Pays royalties (negotiated). Requires exclusive representation of artist. Provides written contract.
Tips: "We are always actively seeking new artists and are eager to work with fresh ideas, colors and presentations."

GEME ART INC., 209 W. Sixth St., Vancouver WA 98660. (360)693-7772. Fax: (360)695-9795. Art Director: Gene Will. Estab. 1966. Art publisher. Publishes fine art prints and reproductions in unlimited and limited editions. Clients: galleries, frame shops, art museums.
Needs: Considers oil, acrylic, pastel, watercolor and mixed media. "We use a variety of styles from realistic to whimsical." Artists represented include Lois Thayer, Crystal Skelley, Rice-Bonin, Campbell, Steve Nelson, Lary McKee, Clancy and Susan Scheewe (plus 25 other artists).

First Contact & Terms: Send color slides, photocopies or brochure. Include SASE. Publisher will contact artist for portfolio review if interested. Simultaneous submissions OK. Payment is negotiated on a royalty basis. Purchases all rights. Provides promotion, shipping from publisher and contract.
Tips: Caters to "Mid-America art market."

GENESIS FINE ARTS, 4808 164th St., SE, Bothell WA 98012. (206)481-1581. Fax: (206)487-6766. Art Consultant: Marcia Strickland. Art publisher handling limited editions (maximum 250 prints), offset reproductions and posters for residential and commercial clients.
Needs: Considers watercolor, mixed media and oil—abstract and traditional landscapes. Also interested in artists who specialize in stationery design. Prefers individual works of art. Maximum size 38×50. Artists represented include Steve Strickland, Nancy Rankin and Melinda Cowdery. Publishes and distributes the work of 2-3 emerging and 1 mid-career artist/year.
First Contact & Terms: Send query letter with transparencies. Samples not filed are returned. Reports back within 2 months. Payment method is negotiated. Provides promotion, a written contract and shipping. Buys first rights.

GESTATION PERIOD, Box 2408, Columbus OH 43216-2408. (800)800-1562. General Manager: John R. Ryan. Estab. 1971. Importer and distributor of unlimited editions and posters. Clients: art galleries, framers, campus stores, museum shops and bookstores.
Needs: Seeking published creative art—especially fantasy and surrealism.
First Contact & Terms: Send query letter with résumé, tearsheets, pricing list and published samples. Samples are filed or returned by SASE. Reports back within 2 months. Negotiates rights purchased. Provides promotion.
Tips: "We do not publish. We are seeking pre-published open edition prints that will retail from $5-30."

‡GGRAFI INC., P.O. Box 179, Charlottesville VA 22902. (800)221-2669. Fax: (804)971-1799. Distributor. Distributes handpulled originals, limited editions, unlimited editions, offset reproduction posters, serigraphs. Clients: galleries, decorators, frame shops, distributors, architects, corporate curators, museum shops, gift-shops; "we only distribute wholesale to over 3,000 clients."
Needs: Seeking art for the commercial and designer markets. Editions usually created by working from an existing painting. Approached by 10 artists/year.
First Contact & Terms: Send query letter with brochure, photocopies or photographs. Samples are filed. Reports back only if interested. Company will contact artist for portfolio review if interested. Negotiates payment. Offers advance when appropriate. Rights purchased vary according to project. Provides advertising, insurance while work is at firm, shipping from our firm.
Tips: Advises artists to attend ABC trade show and be aware of current color trends.

GOES LITHOGRAPHING CO. EST 1879, 42 W. 61st St., Chicago IL 60621-3999. (773)684-6700. Fax: (773)684-2065. Contact: W.J. Goes. Estab. 1879. Supplier to printers/office product stores. Current clients include: Kwik Kopy, Sir Speedy.
Needs: Seeking creative art. Considers watercolor, mixed media and acrylic. Prefers holiday themes. Editions created by collaborating with the artist.
First Contact & Terms: Reports back within 1 month. Publisher/distributor will contact artist for portfolio review if interested. Portfolio should include color thumbnails, roughs and final art. Pays flat fee $150 or negotiates payment. Rights purchased vary according to project. Finds artists through artists' submissions.

‡GOLDEN ENTERPRISE OF DENVER, 1101 Albion Dr., Thornton CO 80233. (303)450-5464. Owner: Keith Golden. Estab. 1990. Art publisher/distributor. Publishes/distributes handpulled originals, limited editions, unlimited editions, fine art prints, offset reproductions, posters. Clients: galleries, frame shops and decorators.
Needs: Seeking African-American art. Considers oil, acrylic, watercolor, mixed media, pastel. Prefers cubism, impressionism, realism, etc. Artists represented include LaShun Beal, Earl Jackson and George Hunt. Editions created by working from an existing painting. Approached by hundreds of artists/year. Publishes/distributes the work of 6-10 emerging, 2 mid-career and 3 established artists/year.
First Contact & Terms: Send photographs, slides, tearsheets. Samples are filed. Reports back within 2 weeks. Company will contact artist for portfolio review of color photographs and slides if interested. Negotiates payment. Offers advance when appropriate. Buys reprint or all rights. Requires exclusive representation of artist. Provides advertising, insurance while work is at firm, promotion, shipping from firm, written contract. Finds artists through art exhibitions, word of mouth, submissions.
Tips: Advises artists to attend ABC trade show and be aware of current color trends.

GRAPHIQUE DU JOUR, INC., 1661 Defoor Ave. NW, Atlanta GA 30318. President: Daniel Deljou. Estab. 1980. Art publisher/distributor of limited editions (maximum 250 prints), handpulled originals and monoprints/monotypes and paintings on paper and canvas. Clients: galleries, designers, corporate buyers and architects. Current clients include Coca Cola, Xerox, Exxon, Marriott Hotels, General Electric, Charter

Hospitals, AT&T and more than 3,000 galleries worldwide, "forming a strong network throughout the world." **Needs:** Seeking creative, fine and decorative art for the serious and commercial collector and designer market. Considers oil, acrylic, pastel, watercolor and mixed media. Prefers transitional contemporary themes. Prefers individual works of art pairs or unframed series. Artists represented include Lee White, Ken Weaver, Lyda Claire, Sergey Cherepakhin, John Pittman, Matt Lively, Alexa Kelemen, Ralph Groff, Yasharel, Denis Assayac, Cameron Scott, Chemiakin, Bika, Kamy Babak Emanuel and T.L. Lange. Editions created by collaborating with the artist or by working from an existing painting. Approached by 100 artists/year. Publishes and distributes the work of 25 emerging, 15 mid-career artists/year and 50 established artists/year.
First Contact & Terms: Send query letter with photographs, slides, SASE and transparencies. Samples not filed are returned only if requested by artist. Reports back only if interested. Publisher/Distributor will contact artist for portfolio review if interested. Pays flat fee or royalties; also sells on consignment basis or commission. Payment method is negotiated. Offers an advance when appropriate. Negotiates rights purchased. Has exclusive and non-exclusive representation. Provides promotion, a written contract and shipping from firm. Finds artists through visiting galleries.
Tips: "We would like to add a line of traditional art with a contemporary flair. Earth-tone and jewel-tone colors are in. We need landscape artists, monoprint artists, strong figurative artists, strong abstracts and soft-edge abstracts. We are also beginning to publish sculptures and are interested in seeing slides of such. We have had a record year in sales, and have recently relocated into a brand new gallery, framing and studio complex."

THE GREENWICH WORKSHOP, INC., One Greenwich Place, Shelton CT 06484. Marketing Assistant: Beth Griswold. Art publisher and gallery. Publishes limited and unlimited editions, offset productions, fine art lithographs, serigraphs, canvas reproductions and fine art porcelains and furnishings. Clients: independent galleries in US, Canada and United Kingdom.
Needs: Seeking creative, fashionable and decorative art for the serious collector, commercial and designer markets. Considers oil, watercolor, mixed media, pastel and acrylic. Considers all but abstract. Artists represented include James C. Christensen, Howard Terpning, James Reynolds, James Bama, Thomas Blackshear, Scott Gustafson, Braldt Bralds. Editions created by collaborating with the artist or by working from an existing painting. Approached by 100 artists/year. Publishes the work of 4-5 emerging, 15 mid-career and 25 established artists. Distributes the work of 4-5 emerging, 15 mid-career and 25 established artists/year.
First Contact & Terms: Send query letter with brochure, slides, photographs and transparencies. Samples not filed and are returned. Reports back within 1-2 months. Publisher will contact artist for portfolio review if interested. Portfolio should include final art, tearsheets, photographs, slides and transparencies. Pays royalties. No advance. Rights purchased vary according to project. Requires exclusive representation of artist. Provides advertising, insurance while work is at firm, promotion, shipping to and from firm, and written contract. Finds artists through art exhibits, submissions and word of mouth.

GREGORY EDITIONS, 18333 Hatteras St., Unit 32, Tarzana CA 91356. (818)705-3820. Fax: (818)705-2824. President: Mark Eaker. Estab. 1988. Art publisher and distributor of originals, limited editions, serigraphs and bronze sculptures. Clients: Retail art galleries.
Needs: Seeking contemporary, creative artwork. Considers oil and acrylic. Artists represented include G. Harvey, J.D. Challenger, Atkinson, L. Gordon, Stan Solomon, James Talmadge, Denis Paul Noyer, Liliana Frasca and sculptures by Ting Shao Kuang. Editions created by working from an existing painting. Publishes and distributes the work of 5 emerging, 2 mid-career and 2 established artists/year.
First Contact & Terms: Send query letter with brochure showing art style. Call for appointment to show portfolio of photographs and transparencies. Purchases paintings outright; pays percentage of sales. Requires exclusive representation of artist. Provides in-transit insurance, insurance while work is at firm, promotion, shipping from firm and written contract.

GUILDHALL, INC., Dept. AM, 3505-07 NW Loop 820, Fort Worth TX 76106. (817)740-0000, (800)356-6733. Fax: (817)740-9600. Website: http://www.guildhall.com/artprints. President: John M. Thompson III. Art publisher/distributor of limited and unlimited editions, offset reproductions and handpulled originals for galleries, decorators, offices and department stores. Current clients include over 500 galleries and collectors nationwide.
Needs: Seeking creative art for the serious and commercial collector and designer market. Considers pen & ink, oil, acrylic, watercolor, and bronze and stone sculptures. Prefers historical Native American, Western, equine, wildlife, landscapes and religious themes. Prefers individual works of art. Artists represented include Chuck DeHaan, Wayne Baize, Greg Beecham, Lisa Danielle, Jack Hines, Ralph Wall, John Potocschnik and Jessica Zemski. Editions created by collaborating with the artist and by working from an existing painting. Approached by 150 artists/year. Also for design. 15% of projects require freelance design.
First Contact & Terms: Send query letter with résumé, tearsheets, photographs, slides and 4×5 transparencies, preferably cowboy art in photos or printouts. Samples are not filed and are returned only if requested. Reports back within 1 month. Call or write for appointment to show portfolio, or mail thumbnails, color and b&w tearsheets, slides and 4×5 transparencies. Pays $200-15,000 flat fee; 10-20% royalties; 35% commission on consignment; or payment method is negotiated. Negotiates rights purchased. Requires

exclusive representation for contract artists. Provides insurance while work is at firm, promotion, shipping from firm and written contract.

Tips: "The new technologies in printing are changing the nature of publishing. Self-publishing artists have flooded the print market. Many artists are being told to print themselves. Most of them, in order to sell their work, have to price it very low. In many markets this has caused a glut. Some art would be best served if it was only one of a kind. There is no substitute for scarcity and quality."

HADDAD'S FINE ARTS INC., 3855 E. Miraloma Ave., Anaheim CA 92806. President: Paula Haddad. Estab. 1953. Art publisher and distributor. Produces unlimited edition offset reproductions and posters. Clients: galleries, art stores, museum stores and manufacturers. Sells to the trade only—no retail.
Needs: Seeking creative and decorative art for the commercial and designer markets. Prefers traditional, realism with contemporary flair; unframed individual works and pairs; all media. Editions created by collaborating with the artist or by working from an existing painting. Approached by 200-300 artists/year. Publishes the work of 10-15 emerging artists/year. Also uses freelancers for design. 20% of projects require freelance design. Design demands knowledge of QuarkXPress and Adobe Illustrator.
First Contact & Terms: Illustrators should send query letter with brochure, transparencies, slides, photos representative of work for publication consideration. Include SASE. Designers send query letter explaining skills. Reports back within 90 days. Publisher/distributor will contact artist for portfolio review if interested. Portfolio should include slides, roughs, final art, transparencies. Pays royalties quarterly, 10% of base net price. No advance. Rights purchased vary according to project. Provides advertising and written contract.
Tips: Advises artists to attend Art Buyers Caravan and Art Expo.

‡HADLEY HOUSE PUBLISHING, 11001 Hampshire Ave. S., Bloomington MN 55438. (612)943-5270. Fax: (612)943-8098. Director of Art Publishing: Lisa Laliberte Belak. Estab. 1974. Art publisher, distributor and 30 retail galleries. Publishes and distributes handpulled originals, limited and unlimited editions and offset reproductions. Clients: wholesale and retail.
Needs: Seeking artwork with creative artistic expression and decorative appeal for the serious collector. Considers oil, watercolor, acrylic, pastel and mixed media. Prefers wildlife, florals, landscapes and nostalgic Americana themes and styles. Artists represented include Olaf Wieghorst, Steve Hanks, Les Didier, Al Agnew, John Vanovich, Brent Berger, Darrell Bush, Dave Barnhouse, Michael Capser, Lesley Harrison, Jon Van Zyle, Nancy Howe, Steve Hamrick, Terry Redlin, Bryan Moon and Ozz Franca. Editions created by collaborating with artist and by working from an existing painting. Approached by 200-300 artists/year. Publishes the work of 3-4 emerging, 15 mid-career and 8 established artists/year. Distributes the work of 1 emerging and 2 mid-career artists/year. Also needs designers. 10% of projects require freelance design. Designers send slides or photographs of original artwork.
First Contact & Terms: Send query letter with brochure showing art style or résumé and tearsheets, slides, photographs and transparencies. Samples are filed or are returned. Reports back within 4-6 weeks. Call for appointment to show portfolio of slides, original final art and transparencies. Pays royalties. Requires exclusive representation of artist and/or art. Provides insurance while work is at firm, promotion, shipping from firm, a written contract and advertising through dealer showcase.

HOOF PRINTS, P.O. Box 1917, Dept. A & G., Lenox MA 01240. Phone/fax: (413)637-4334. Proprietor: Judith Sprague. Estab. 1991. Mail order art retailer and wholesaler. Handles handpulled originals, limited and unlimited editions, offset reproductions, posters and engravings. Clients: individuals, galleries, tack shops and pet stores.
Needs: Considers only horse, dog, fox and cat prints.
First Contact & Terms: Send brochure, tearsheets, photographs and samples. Samples are filed. Will contact artist for portfolio review if interested. Pays per print. No advance. Provides advertising and shipping from firm. Finds artists through sourcebooks, magazine ads, word of mouth.

ICART VENDOR GRAPHICS, 8512 Whitworth Dr., Suite 103, Los Angeles CA 90035. (310)659-1023. Fax: (310)659-1025. Director: John Pace. Estab. 1972. Art publisher and distributor of limited and unlimited editions of offset reproductions and handpulled original prints. Clients: galleries, picture framers, decorators, corporations, collectors.
Needs: Considers oil, acrylic, airbrush, watercolor and mixed media, also serigraphy and lithography. Seeking unusual, appealing subjects in Art Deco period styles as well as wildlife and African-American art. Prefers individual works of art, pairs, series; 30×40 maximum. Artists represented include J.W. Ford, Neely Taugher, Louis Icart and Maxfield Parrish. Publishes the work of 2 emerging, 3 mid-career and 1 established artists/year. Distributes the work of 4 emerging, 20 mid-career and 50 established artists/year.
First Contact & Terms: Send brochure and photographs. Do not send slides. Samples returned by SASE. Reports back within 1 month. Pays flat fee, $500-1,000; royalties (5-10%) or negotiates payment method. Sometimes offers advance. Buys all rights. Usually requires exclusive representation of the artist. Provides insurance while work is at publisher. Negotiates ownership of original art.

Tips: "Be original with your own ideas. Give clean, neat presentations in original or photographic form (no slides). No abstracts please. Popular styles include impressionism and landscapes. Posters are becoming less graphic; more of a fine art look is popular."

IMAGE CONSCIOUS, 147 Tenth St., San Francisco CA 94103. (415)626-1555. Creative Director: Cindy Bardy. Estab. 1980. Art publisher and domestic and international distributor of offset and poster reproductions. Clients: poster galleries, frame shops, department stores, design consultants, interior designers and gift stores. Current clients include Z Gallerie, Deck the Walls and Decor Corporation.
Needs: Seeking creative and decorative art for the designer market. Considers oil, acrylic, pastel, watercolor, tempera, mixed media and photography. Prefers individual works of art, pairs or unframed series. Artists represented include Mary Silverwood, Aleah Koury, Monica Stewart, Charles McVicker, Dennis Barloga, Alan Blaustein, Joseph Holmes, and Dorothy Spangler. Editions created by collaborating with the artist and by working from an existing painting. Approached by hundreds of artists/year. Publishes the work of 2-3 emerging, 2-3 mid-career and 4-5 established artists/year. Distributes the work of 50 emerging, 200 mid-career and 700 established artists/year.
First Contact & Terms: Send query letter with brochure, résumé, tearsheets, photographs, slides and/or transparencies. Samples are filed or are returned by SASE. Reports back within 1 month. Publisher/distributor will contact artist for portfolio review if interested. No original art. Payment method is negotiated. Negotiates rights purchased. Provides promotion, shipping from firm and a written contract.
Tips: "Research the type of product currently in poster shops. Note colors, sizes and subject matter trends."

‡IMAGE SOURCE INTERNATIONAL, 460 Corporate Park, Pembroke MA 02359. (617)829-0897. Fax: (617)829-0995. E-mail: southndr@aol.com. Art Editor: Mario Testa. Estab. 1992. Poster company, art publisher, distributor, foreign distributor. Publishes/distributes unlimited editions, fine art prints, offset reproductions, posters. Clients: galleries, decorators, frame shops, distributors, architects, corporate curators, museum shops, gift shops, foreign distributors (Germany, Holland, Asia, South America).
Needs: Seeking fashionable, decorative art for the designer market. Considers oil, acrylic, pastel. Prefers flowers painted on silk. Fauve bright tropicals. Artists represented include Micarelli. Editions created by collaborating with the artist or by working from an existing painting. Approached by hundreds of artists/year. Publishes the work of 6 emerging, 2 mid-career and 2 established artists/year. Distributes the work of 50 emerging, 25 mid-career, 50 established artists/year. Also needs freelancers for design. Prefers local designers.
First Contact & Terms: Send query letter with brochure, photocopies, photographs, résumé, slides, tearsheets, transparencies, postcards. Samples are filed and are not returned. Reports back only if interested. Artist should follow-up with call after initial query. Company will contact artist for portfolio review if interested. Pays flat fee: depends on artist and work and risk. Offers advance when appropriate. Buy all rights. Requires exclusive representation of artist.
Tips: Notes trends as "sports art, tropical, oversize editions."

IMAGES INTERNATIONAL DIRECT SALES CORPORATION, P.O. Box 1130, Honolulu HI 96807. (808)531-7051. Fax: (808)521-4341. President: Stevenson C. Higa. Estab. 1977. Art publisher and gallery. Publishes limited editions, offset reproductions and originals. Clients: retail galleries, shows and wholesale galleries. Current clients include Hansons Galleries, The Mas Charles Gallery, Shipstore Galleries, C&M Galleries, Images West Galleries and Lahaina Galleries.
Needs: Seeking decorative art for the serious collector and commercial market. Considers oil, watercolor, acrylic and painting on fabric. Prefers oriental themes. Artists represented include Otsuka, Caroline Young and Gary Hostallero. Editions created by collaborating with the artist or by working from an existing painting. Publishes the work of 1 emerging, 1 mid-career and 2 established artists/year.
First Contact & Terms: Send query letter with brochure showing art style or résumé and photographs. Samples are not filed and are returned by SASE if requested by artist. Reports back within 2 months. Payment method is negotiated. Offers an advance when appropriate. Buys one-time rights. Provides in-transit insurance, insurance while work is at firm, promotion, shipping to firm and written contract.

‡IMAGES OF AMERICA PUBLISHING COMPANY, P.O. Box 608, Jackson WY 83001. (800)451-2211. Fax: (307)739-1199. Manager: Karen Flint. Estab. 1990. Art publisher. Publishes limited editions, posters. Clients: galleries, frame shops, distributors, gift shops, National Park, Natural History Associations.
 • This company publishes the winning images in the Art for the Parks competition which was created in 1986 by the National Park Academy of the Arts in cooperation with the National Park Foundation. The program's purpose is to celebrate representative artists and to enhance public awareness of the Park System. The top 100 paintings tour the country and receive cash awards and consideration for the National Park Stamp. Special purchase awards include the Yellowstone National Park Award ($6,000) and the Grand Canyon Naitonal Park Award ($6,000); over $92,000 in prizes in all.
Needs: Seeking National Park images. Considers oil, acrylic, watercolor, mixed media, pastel, pen & ink. Prefers nature and wildlife images from one of the sites administered by the National Park Service. Artists represented include Jim Wilcox, Linda Tippetts, Howard Hanson, Tom Antonishak, Steve Hanks. Editions

created by collaborating with the artist. Approached by over 2,000 artists/year.

First Contact & Terms: Submit by entering the Arts for the Parks contest for a $40 entry fee. Entry form and transparencies must be postmarked by June 1 each year. Send for prospectus before May 1st. Samples are filed. Reports back within 1 month. Portfolio review not required. Pays flat fee. Buy one-time rights. Provides advertising.

IMCON, RR 3, Box, Oxford NY 13830. (607)843-5130. Fax: (607)843-2130. President: Fred Dankert. Estab. 1986. Fine art printer of handpulled originals. "We invented the waterless litho plate, and we make our own inks." Clients: galleries, distributors.

Needs: Seeking creative art for the serious collector. Editions created by collaborating with the artist "who must produce image on my plate. Artist given proper instruction."

First Contact & Terms: Call or send query letter with résumé, photographs and transparencies.

Tips: "Artists should be willing to work with me to produce original prints. We do *not* reproduce; we create new images. Artists should have market experience."

IMPACT, 4961 Windplay Dr., El Dorado Hills CA 95762. (916)933-4700. Fax: (916)933-4717. Contact: Benny Wilkins. Estab. 1975. Publishes calendars, postcards, posters and 5×7, 8×10 and 16×20 prints. Clients: international distributors, poster stores, framers, plaque companies, tourist businesses, retailers, national parks, history associations and theme parks. Current clients inlcude Royal Doulton, Image Conscious, Prints Plus, Plaquefactory and Deck the Walls.

Needs: Seeking traditional and contemporary artwork. Considers acrylics, pastels, watercolors, mixed media and airbrush. Prefers contemporary, original themes, humor, fantasy, autos, animals, children, western, country, floral, aviation, ethnic, wildlife and suitable poster subject matter. Prefers individual works of art. "Interested in licensed subject matter." Artists represented include Jonnie Kostoff, Tom Kidd, Dan McMannis and Tom Brakefield. Publishes the work of 5-10 emerging and 2-4 mid-career artists/year.

First Contact & Terms: Send query letter with brochure, tearsheets, photographs, slides and transparencies. Samples are filed. Reports back within 2 weeks. Call or write for appointment to show portfolio, or mail original/final art, tearsheets, slides, transparencies, final reproduction/product, color and b&w. Pays flat fee; $100-700; royalties of 7%; payment method is negotiated. Offers an advance when appropriate. Negotiates rights purchased. Does not require exclusive representation of the aritst. Provides insurance while work is at firm, shipping from firm, written contract and artist credit.

Tips: "In the past we have been 'trendy' in our art; now we are a little more conservative and traditional. This year we are looking to develop a inspirational and religious line."

INSPIRATIONART & SCRIPTURE, P.O. Box 5550, Cedar Rapids IA 52406. (319)365-4350. Fax: (319)366-2573. Division Manager: Lisa Edwards. Estab. 1993. Produces poster prints. "We create and produce jumbo-sized (24×36) posters targeted at pre-schoolers, pre-teens (10-14), teens (15-18) and young adults (18-30). A Christian message is contained in every poster. Some are fine art and some are very commercial. We prefer very contemporary images."

Needs: Approached by 200-300 freelance artist/year. Works with 10-15 freelancers/year. Buys 10-15 designs, photos, illustrations/year. Christian art only. Uses freelance artists for posters. Considers all media. Looking for "something contemporary or unusual that appeals to teens or young adults." Art guidelines available for SASE with first-class postage.

First Contact & Terms: Send query letter with photographs, slides, SASE or transparencies. Accepts submissions on disk (call first). Samples are filed or are returned by SASE. Reports back within 3-4 months. Company will contact artist for portfolio review if interested. Portfolio should include color roughs, final art, photographs and transparencies. "We need to see the artist's range. It is acceptable to submit 'secular' work, but we also need to see work that is Christian-inspired." Originals are returned at job's completion. Pays by the project, $50-500. Pays royalties of 5% "only if the artist has a body of work that we are interested in purchasing in the future." Rights purchased vary according to project.

Tips: "The better the quality of the submission, the better we are able to determine if the work is suitable for our use (slides are best). The more complete the submission (e.g., design, art layout, scripture, copy), the more likely we are to see how it may fit into our poster line. We do accept traditional work, but are looking for work that is more commercial and hip (think MTV with values). A poster needs to contain a Christian message that is relevant to teen and young adult issues and beliefs."

INTERCONTINENTAL GREETINGS LTD., 176 Madison Ave., New York NY 10016. Art Director: Robin Lipner. Estab. 1967. Sells reproduction rights of design to publisher/manufacturers. Handles offset reproductions, greeting cards, stationery and gift items. Clients: paper product, gift tin, ceramic and textile manufacturers. Current clients include: Franklin Mint, Scandecor, Verkerke, Simon Elvin, others in Europe, Latin America, Japan and Asia.

Needs: Seeking creative, fashionable and decorative art for the commercial and designer markets. Considers oil, watercolor, mixed media, pastel, acrylic, computer and photos. Approached by several hundred artists/year. Publishes the work of 30 emerging, 100 mid-career and 100 established artists/year. Also needs freelance

design (not necessarily designers). 100% of freelance design demands knowledge of Adobe Photoshop, Adobe Illustrator and Painter.

First Contact & Terms: Send query letter with brochure, tearsheets, slides, photographs, photocopies and transparencies. Samples are filed or returned by SASE if requested by artist. Artist should follow-up with call. Portfolio should include color final art, photographs and slides. Pays flat fee: $30-500, or royalties of 20%. Offers advance when appropriate. Rights purchased vary according to project. Requires exclusive representation of artist, "but only on the artwork we represent." Provides promotion, shipping to firm and written contract. Finds artists through attending art exhibitions, word of mouth, sourcebooks or other publications and submissions.

Tips: Recommends New York Stationery Show held annually in New York. "In addition to having good painting/designing skills, artists should be aware of market needs."

‡**INTERNATIONAL BLACK ART DISTRIBUTORS**, 1431 S. LaBrea Ave., Los Angeles CA 90019. (213)939-0843. Owner: D. Cooper. Distributor and gallery. Publishes limited editions and fine art prints. Clients: galleries, distributors.

Needs: Seeking art for the commercial market. Considers mixed media. Prefers black art by black artists. Artists represented include Ernie Barnes, Tom McKinney, Annie Lee, George Porter and Ray Batcheloe.

First Contact & Terms: Send query letter with brochure and photographs. Samples are not filed. Reports back only if interested. Portfolio review not required. Artist should follow up with call after initial query. Portfolio should include color samples. Negotiates payment. Offers advance when appropriate. Rights purchased vary according to project. Also needs freelancers for design.

✦**ISLAND ART**, 6687 Mirah Rd., Saanichton, British Columbia Y8M 1Z4 Canada. (604)652-5181. Fax: (604)652-2711. E-mail: islandart@islandart.com. Website: http://www.islandart.com/IslandArt/. President: Myron D. Arndt. Estab. 1985. Art publisher and distributor. Publishes and distributes limited and unlimited editions, offset reproductions, posters and art cards. Clients: galleries, department stores, distributors, gift shops. Current clients include: Disney, Host-Marriott, Ben Franklin.

Needs: Seeking creative and decorative art for the serious collector, commercial and designer markets. Considers oil, watercolor and acrylic. Prefers lifestyle themes/Pacific Northwest. Also needs designers. 10% of products require freelance design and demand knowledge of Adobe Photoshop. Artists represented include Sue Coleman and Lissa Calvert. Editions created by working from an existing painting. Approached by 100 artists/year. Publishes the work of 2 emerging, 2 mid-career and 2 established artists/year. Distributes the work of 4 emerging, 10 mid-career and 5 established artists/year.

First Contact & Terms: Send résumé, tearsheets, slides and photographs. Designers send photographs, slides or transparencies (do not send originals). Accepts submissions on disk compatible with Adobe Photoshop. Send EPS of TIFF files. Samples are not filed and are returned by SASE if requested by artist. Reports back within 3 months. Publisher/distributor will contact artist for portfolio review if interested. Portfolio should include color roughs, final art, slides and 4×5 transparencies. Pays royalties of 5-10%. Offers advance when appropriate. Buys reprint rights. Requires exclusive representation of artist. Provides insurance while work is at firm, promotion, shipping from firm, written contract, trade fair representation and Internet service. Finds artists through art fairs, referrals and submissions.

Tips: Recommends artists attend Art Expo. "Color trends vary—artists should consider vivid colors and representational images. We work 6 months to 12 months in advance of major projects. Send at least 6-12 photos or slides. If sending art on spec, please request our submission guidelines first."

‡**ISLAND INTERNATIONAL ARTISTS**, 430 Guemies Island Rd., Anacortes WA 98221. (360)293-9572. Fax: (360)299-9215. Owner: Ria Foster. Estab. 1965. Art publisher and artist's representative. Publishes handpulled originals, etchings only. Clients: galleries, decorators, frame shops, architects. Current clients include: The Nature Company.

Needs: Seeking creative and decorative art for the commercial and designer markets. Considers pen & ink. "Artist must have a well-developed style and must be able to draw well." Publishes/distributes the work of 4-5 emerging and 38 established artists/year.

First Contact & Terms: Send résumé, slides and photographs. Samples are not filed and are not returned. Reports back within 1 week. Company will contact artist for portfolio review if interested. Portfolio should include final art, slides and thumbnails. Negotiates payment. Requires exclusive representation of artist. Provides promotion.

J.B. FINE ARTS/CENTRAL GALLERIES, 420 Central Ave., Cedarhurst NY 11516. (516)569-5686. Fax: (516)569-7114. President: Jeff Beja. Estab. 1983. Art publisher, distributor and gallery. Publishes and distributes limited editions.

 THE MAPLE LEAF before a listing indicates that the market is Canadian.

Needs: Seeking creative art for the serious collector and commercial market. Considers oil, mixed media and acrylic. Editions created by collaborating with the artist or working from an existing painting. Approached by 100 artists/year. Publishes the work of 1 emerging artist/year. Distributes the work of 5 emerging, 10 mid-career and 20 established artists/year.

First Contact & Terms: Send query letter with résumé, tearsheets and photographs. Samples are filed or returned by SASE if requested by artist. Reports back within 2 months if interested. Portfolio review not required. Publisher/distributor will contact artist for portfolio review if interested. Negotiates payment. Offers advance when appropriate. Rights purchased vary according to project. Requires exclusive representation of artist. Provides advertising, in-transit insurance, insurance while work is at firm, promotion, shipping from firm and written contract.

JANNES ART PUBLISHING, INC., 3318 N. Lincoln Ave., Chicago IL 60657. (312)404-5090. Fax: (312)404-0150. Owner: Nicholas Jannes. Estab. 1986. Art publisher and distributor. Publishes and distributes limited editions and posters. Clients: galleries, art shops, framing shops and retail. Current clients include: Graphique de France and Modernart Editions.

Needs: Seeking creative art for the serious collector and the commercial market. Considers oil and watercolor. Prefers automotive, floral and landscape. Artists represented include Scott Mutter, G. Padginton, B. Fuchs, Vargas and Gary Michael. Editions created by working from an existing painting. Approached by 10 artists/year. Publishes the work of 1 emerging, 10 mid-career and 3 established artists/year. Distributes the work of 5 emerging, 23 mid-career and 5 established artists/year.

First Contact & Terms: Send brochure and tearsheets. Samples are filed and are returned. Publisher/Distributor will contact artist for portfolio review if interested. Portfolio should include slides and transparencies. Pays royalties of 10-20%; negotiates payment. No advance. Rights purchased vary according to project. Provides advertising, promotion and shipping from firm.

Tips: Recommends artists attend Art Expo.

MARTIN LAWRENCE LIMITED EDITIONS, 16250 Stagg St., Van Nuys CA 91406. (818)988-0630. Fax: (818)785-4330. President: Barry R. Levine. Estab. 1976. Art publisher, distributor and gallery. Publishes and distributes limited editions, offset reproductions and posters.

Needs: Seeking creative and decorative art for the serious collector and commercial market. Considers oil, watercolor, mixed media, pastel, sculpture and acrylic. Prefers impressionist, naive, Americana, pop art. Artists represented include Mark King, Susan Rios, Linnea Percola, Laurie Zeszut and Mark Kostabi. Editions created by collaborating with the artist or working from an existing painting. Approached by 100 artists/year. Publishes and distributes the work of 2 emerging artists/year.

First Contact & Terms: Send slides, photographs and transparencies. Samples are not filed and are returned by SASE if requested by artist. Publisher/distributor will contact artist for portfolio review if interested. Portfolio should include photographs. Requires exclusive representation of artist. Provides advertising.

Tips: Suggests artist attend Art Expo New York.

‡LAWRENCE UNLIMITED, 8721 Darby Ave., Northridge CA 91324. (818)349-4120. Fax: (818)349-0450. Owner: Lawrence. Estab. 1966. Art publisher, distributor and manufacturer. Publishes and/or distributes hand-pulled originals and offset reproductions. Clients: furniture stores, designers, commercial markets.

Needs: Seeking artwork with creative expression, fashionableness and decorative appeal for the commercial and designer markets. Considers watercolor, mixed media, pastel, pen & ink and intaglio. Artists represented include Jeanne Down, Nancy Cowan and M. Duval. Editions created by collaborating with the artist. Approached by 20 artists/year. Distributes the work of 4 emerging and 2 mid-career artists/year.

First Contact & Terms: Send query letter with brochure showing art style, photocopies, résumé, transparencies, tearsheets and photographs. Samples are not filed and are returned. Reports back within 2 weeks. Call for appointment to show portfolio. Portfolio should include roughs, final art, tearsheets and photographs. Pays flat fee. Offers advance when appropriate. Negotiates rights purchased. Provides promotion.

Tips: "Have pricing in mind for distributing and quantity."

LESLI ART, INC., Box 6693, Woodland Hills CA 91365. (818)999-9228. President: Stan Shevrin. Estab. 1965. Artist agent handling paintings for art galleries and the trade.

Needs Considers oil paintings and acrylic paintings. Prefers realism and impressionism—figures costumed, narrative content, landscapes, still lifes and florals. Maximum size 36×48, unframed. Works with 20 artists/year.

First Contact & Terms: Send query letter with photographs and slides. Samples not filed are returned by SASE. Reports back within 1 month. To show portfolio, mail slides and color photographs. Payment method is negotiated. Offers an advance. Provides national distribution, promotion and written contract.

Tips: "Considers only those artists who are serious about having their work exhibited in important galleries throughout the United States and Europe."

LESLIE LEVY FINE ART PUBLISHING, INC., 1505 N. Hayden, Suite J10, Scottsdale AZ 85257. (602)945-8491. Fax: (602)945-8104. Director: Gary Massey. Estab. 1976. Art publisher and distributor of

posters and miniature prints. Our publishing customers are mainly frame shops, galleries, designers, framed art manufacturers, distributors and department stores. Current major distributors include Art Source, Bruce McGaw, Graphique de France, Joan Cawley, Image Conscious, Editions Limited, Gango, Museum Editions West, Poster Porters, Lieberman's, Vanguard and Paragon. We distribute in over 30 countries."

Needs Seeking creative, fashionable and decorative art. Artists represented include: Steve Hanks, Doug Oliver, Robert Staffolino, Kent Wallis, Michael Workman, Doug West, Patricia Hunter, Jean Crane and many others. Editions created by collaborating with the artist or by working from an existing painting. Considers oil, acrylic, pastel, watercolor, tempera and mixed media. Prefers art with a universal appeal and popular colors. Approached by hundreds of artists/year. Publishes the work of 5-8 new artists/year.

First Contact & Terms: Send query letter with résumé, slides or transparencies. Samples are returned by SASE. "Portfolio will not be seen unless interest is generated by the materials sent in advance." Posters and prints "are sold quarterly. Pays royalties based on retail and popularity of artist." Sells original art on a consignment basis: (firm receives 50% commission). Insists on acquiring reprint rights for posters. Requires exclusive representation of the artist for the image being published.

Tips: "First, don't call us. After we review your materials, we will contact you or return materials within 6-8 weeks. We are looking for floral, figurative, impressionist, landscapes, children's art and any art of exceptional quality. Please, if you are a beginner or are in the process of meeting your potential, do not go through the time and expense of sending materials."

LOLA LTD./LT'EE, 1811 Egret St. SW, S. Brunswick Islands, Ocean Isle Beach NC 28469. (910)754-8002. Owner: Lola Jackson, Art publisher and distributor of limited editions, offset reproductions, unlimited editions and handpulled originals. Clients: art galleries, architects, picture frame shops, interior designers, major furniture and department stores, industry and antique gallery dealers.

• This art publisher also carries antique prints, etchings and original art on paper and is interested in buying/selling to trade.

Needs: Seeking creative and decorative art for the commercial and designer markets. "Handpulled graphics are our main area." Also considers oil, acrylic, pastel, watercolor, tempera or mixed media. Prefers unframed series, 30×40 maximum. Artists represented include White, Brent, Jackson, Mohn, Baily, Carlson, Coleman. Approached by 100 artists/year. Publishes the work of 5 emerging, 5 mid-career and 5 established artists/year. Distributes the work of 40 emerging, 40 mid-career and 5 established artists/year.

First Contact & Terms: Send query letter with brochure showing art style or résumé, tearsheets, photostats, photographs, photocopies or transparencies as well as the price the artists needs. "Actual sample is best." Samples are filed or are returned only if requested. Reports back within 2 weeks. Payment method is negotiated. "Our standard commission is 50% less 50% off retail." Offers an advance when appropriate. Provides insurance while work is at firm, shipping from firm and written contract.

Tips: "We find we cannot sell b&w only; red, orange and yellow are also hard to sell unless included in abstract subjects. Best colors: emerald, mauve, pastels, blues. Send all samples before end of May each year as our main sales are targeted for summer."

LONDON CONTEMPORARY ART, 729 Pinecrest Dr., Prospect Heights IL 60070. (708)459-3990. Fax: (708)459-3997. Website: http://www.artcom.com/lca/. Sales Manager: Susan Gibson Brown. Estab. 1978. Art publisher. Publishes limited editions. Clients: art galleries, dealers, distributors, furniture stores and interior designers.

Needs: Seeking art for the commercial market. Prefers figurative, landscapes, some abstract expressionism. Artists represented include Roy Fairchild, David Dodsworth, Janet Treby, Alexander Ivanov and Csaba Markus. Editions created by working from an existing painting. Approached by hundreds of artists/year. Publishes the work of 1-10 emerging, 1-10 mid-career and 20 established artists/year. Distributes the work of 1-10 emerging, 1-10 mid-career, 20-50 established artists/year.

First Contact & Terms: Send brochure, résumé, tearsheets, photographs and photocopies. Samples are filed or returned by SASE. Publisher/distributor will contact artist for portfolio review if interested. Portfolio should include final art, tearsheets and photographs. Negotiates payment. Rights purchased vary according to project. Provides advertising, in-transit insurance, insurance while work is at firm, promotion, shipping from firm and written contract. Finds artists through attending art exhibitions and art fairs, word of mouth and submissions.

Tips: Recommends artists read *Art Business News* and *U.S. Art.* "Pay attention to color trends and interior design trends. Artists need discipline and business sense and must be productive.

‡LOST STEEPLE ORIGINALS, 411 Walnut St., New Richmond OH 45157-1138. (513)553-4541. Estab. 1985. Art self-publisher/distributor, producer of fine art. Publishes/distributes handpulled originals, limited editions, monotypes. Clients: frame shops, galleries. Current clients include: James Haney Gallery (Amarillo, Texas), Smith Gallery (South Carolina).

Needs: Seeking decorative art. Prefers landscapes, still life, abstract. Artists represented include Susan Naylor, Barbara Young, Arnelle Dow, Mary Mark.

First Contact & Terms: Provides in-transit insurance, shipping to and from our firm. Finds artists through friends and festivals.

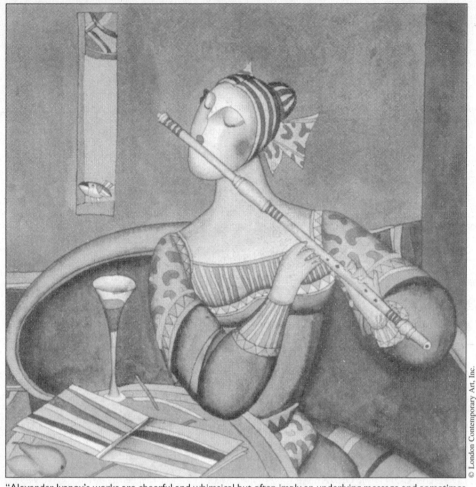

"Alexander Ivanov's works are cheerful and whimsical but often imply an underlying message and sometimes even a political theme," says Susan Gibson Brown of London Contemporary Art. The publisher, who deals in limited edition graphic works by artists from around the world, handles the work of the Russian artist who they discovered at an European exhibit. Ivanov's pieces, such as *The Music Lesson* (12 × 11½), are hand-tinted linoleum block etchings.

Tips: Notes that recent trends include "cleaner palette, interiors, pattern on pattern."

LYNESE OCTOBRE, INC., 22121 US 19 N. Clearwater FL 34625. (813)724-8800. Fax: (813)724-8352. President: Jerry Emmons. Estab. 1982. Distributor. Distributes unlimited editions, offset reproductions and posters. Clients: picture framers and gift shops. Current clients include: Deck the Walls, Ambers Stores, Crafts & Stuff.
Needs: Seeking fashionable and decorative art for the commercial and designer markets. Considers oil, watercolor, mixed media, pastel, pen & ink and acrylic. Artists represented include James W. Harris, Mark Winter, Roger Isphording, Betsy Monroe, Paul Brendt, Sherry Vintson, Jean Grastorf, AWS. Approached by 50 artists/year. Publishes the work of 2-5 emerging and 1-3 established artists/year. Distributes the work of 2-5 emerging and 1-3 established artists.
First Contact & Terms: Send brochure, tearsheets, photographs and photocopies. Samples are sometimes filed or are returned. Reports back within 1 month. Distributor will contact artist for portfolio review if interested. Portfolio should include final art, photographs and transparencies. Negotiates payment. No advance. Rights purchased vary according to project. Provides written contract.
Tips: Recommends artists attend Art Buyers Caravan by Decor. "The trend is toward quality, color-oriented regional works.

BRUCE MCGAW GRAPHICS, INC., 389 W. Nyack Rd., West Nyack NY 10994. (914)353-8600. Fax: (914)353-3155. E-mail: 75300.2226@compuserve.com. Acquisitions: Martin Lawlor. Clients: poster shops, galleries, I.D., frame shops.
Needs: Artists represented include Ty Wilson, Betsy Cameron, Yuriko Takata, Art Wolfe, Diane Romanello, Patrick Nagel, Jacques Lamy, Tim Cox, Peter Kitchell and Terry Rose. Publishes the work of 10 emerging and 20 established artists/year.
First Contact & Terms: Send slides, transparencies or any other visual material that shows the work in the best light. "We review all types of art with no limitation on media or subject. Review period is 1 month, after which time we will contact you with our decision. If you wish the material to be returned, enclose a SASE. Contractual terms are discussed if work is accepted for publication."
Tips: "Simplicity is very important in today's market (yet there still needs to be 'a story' to the image). Form and palette are critical to our decision process. We have a tremendous need for decorative pieces, especially new abstracts and florals. Environmental images which feature animals and landscapes are very popular, and much needed as well."

MACH 1, INC., P.O. Box 7360, Chico CA 95927. (916)893-4000. Fax: (916)893-9737. Vice President Marketing: Paul Farsai. Estab. 1987. Art publisher. Publishes unlimited and limited editions and posters. Clients: museums, galleries, frame shops and mail order customers. Current clients include the Smithsonian Museum, the Intrepid Museum, Deck the Walls franchisers and Sky's The Limit.
Needs: Seeking creative and decorative art for the commercial and designer market. Considers mixed media. Prefers aviation related themes. Artists represented include Jarrett Holderby and Jay Haiden. Editions created by collaborating with the artist or by working from an existing painting. Publishes the work of 2-3 emerging, 2-3 mid-career and 2-3 established artists/year.
First Contact & Terms: Send query letter with résumé, slides and photographs. Samples are not filed and are returned. Reports back within 1 month. To show a portfolio, mail slides and photographs. Pays royalties. Offers an advance when appropriate. Requires exclusive representation of the artist. Provides promotion, shipping to and from firm and a written contract.

‡SEYMOUR MANN, INC., 230 Fifth Ave., Suite #1500, New York NY 10001. (212)683-7262. Fax: (212)213-4920. Manufacturer.
Needs: Seeking fashionable and decorative art for the serious collector and the commercial and designer markets. Also needs freelancers for design. 15% of products require freelance design. Considers watercolor, mixed media, pastel, pen & ink and 3-D forms. Editions created by collaborating with the artist. Approached by "many" artists/year. Publishes the work of 2-3 emerging, 2-3 mid-career and 4-5 established artists/year.

‡MANOR ART ENTERPRISES, LTD., 555 E. Boston Post Rd., Mamaroneck NY 10543. (914)738-8569. Fax: (914)738-8581. President: Greg Croston. Estab. 1992. Art publisher of unlimited editions and offset reproductions. Clients: framing, manufacturing, world-wide distributors.
Needs: Seeking artwork with creative expression, fashionableness and decorative appeal for the commercial market. Considers oil, watercolor, acrylic, mixed media. Prefers traditional and realistic. Artists represented include Anton Pieck, Reina, Ruth Morehead, Bill Morehead, Craig Sprovach, Carol Lawson, Jean Barton and Brian Paterson, creator of the Foxwood Tales. Editions created by collaborating with the artist. Approached by 100 artists/year. Publishes the work of 2-4 emerging, 2-4 mid-career and 2-4 established artists/year.
First Contact & Terms: Send query letter with brochure showing art style or résumé and tearsheets, slides and photographs. Samples are not filed and are returned. Reports back within 2 weeks. Write for appointment to show portfolio, which should include slides, tearsheets, transparencies, original/final art and photographs. Pays flat fee or royalties of 7-10%. Offers advance. Negotiates rights purchased. Requires exclusive representation. Provides in-transit insurance and insurance while work is at firm.
Tips: "The focus of our publishing is towards traditional with worldwide appeal—tight and realistic."

‡MARGIEART, 5111 Winewood, Milford MI 48382-1543. (810)684-6538. E-mail: margieartii@aol.com. Vice President, Marketing: Sheryl Inglefield. Estab. 1993. Distributor. Distributes limited editions, unlimited editions, fine art prints, offset reproductions, posters. Clients: galleries, frame shops. Current clients include: Town Center Gallery, Water Street Gallery, Moynihans and Creative Framing.
Needs: Seeking creative, fashionable, decorative art for the commerical and designer markets. Considers oil, acrylic, watercolor, mixed media, pastel, pen & ink. Artists represented include Guy Begin, Pascal, Sussanne Lawrence and Richard Zucco. Editions created by working from an existing painting. Approached by 3-6 artists/year. Distributes the work of 6-8 emerging, 12-15 mid-career and 2-3 established artists/year.
First Contact & Terms: Send query letter with brochure, photographs, SASE, tearsheets. Samples are not filed and are returned by SASE. Reports back within 6 weeks. Company will contact artist for portfolio review of color photographs if interested. Pays on consignment basis: firm receives 50% commission. Rights purchased vary according to project. Provides promotion, shipping from our firm, written contract. Finds artists through attending art exhibitions, art fairs, word of mouth, other publications, submissions.
Tips: Sees trends in "traditional subject and colors. Midsize, modest priced limited editions sell best."

INSIDER REPORT

Conquering the Corporate Market

Jan Mayer

As Jan Mayer stands back to survey the walls of an office space where her work is being installed, she feels a surge of pride and accomplishment. Even more rewarding than seeing her watercolors and prints elegantly matted, framed and in place, is the knowledge that her artwork will make a difference in people's lives. What was once an empty office with blank walls is suddenly transformed into vibrant, inviting surroundings.

Mayer, who up to ten years ago sold through galleries in Arizona, Colorado, Florida and Michigan, now sells almost exclusively to the corporate market. Her watercolors and prints grace the boardrooms of large corporations such as the Chrysler Corporation in Detroit, the lobbies of several banks and utility companies, law offices, eye clinics and hospitals as well as private homes. According to Mayer, there is a continuing need for art in the business environment. "There is a market for corporate art," says Mayer, "but you have to seek it out." Half the battle is knowing where to look.

"I have always been observant, ever since I was a little girl," says Mayer. It is a quality that helps her in the creation of artwork because she is always noticing color and form. The quality also helps in sales. Wherever Mayer goes, whether on an errand at the bank or to a doctor's appointment, she looks for art on the walls. If it is dull, dreary or non-existent, Mayer takes the opportunity to call the company or business and ask them if they would be interested in looking at her portfolio.

The business section of the newspaper is another source for leads. "When I read that a company is moving its headquarters, I immediately contact them because they will be needing art for their new building." Sometimes by the time she calls, they have already chosen new artwork, but often, her call is right on time.

Sometimes a call will not result in immediate sales, but can lead to later sales. When Mayer read that a local interior design firm would be decorating a hospital, she contacted the designer and said, "I've got just the artwork for the new wing." Though the designer didn't use Mayer's work for the hospital, the two kept in touch and have worked on several projects together.

Why don't more artists take a more proactive approach to selling? "Many artists are uncomfortable about selling their work," says Mayer, who admits it is still difficult for her to call companies. "Sometimes people will be really receptive and ask to see your work. Some people will just say 'No, not interested.' That can be really discouraging." That's why, when her husband retired, Mayer asked him to start making calls to set appointments. "When Frank first started calling companies, he'd average about five appointments for every 30 calls." Today,

INSIDER REPORT, *Mayer*

because Mayer receives so many referrals from businesses, her husband no longer has to make sales calls at all.

Although some corporations have curators assigned to their art collections, some only purchase art when they are moving their offices or redecorating. So when calling on businesses and corporations in your city, ask for the purchasing department first, says Mayer. Once you reach purchasing, ask for the person in charge of buying furnishings or art. Tell that individual that you are an artist and want to come in and show your portfolio. It's fairly common to get the run-around. Remember, these people are busy. They might tell you to call back in a month or two. You may have to make several follow-up calls to get an appointment.

"Once I get the appointment, I arrive at the office with a portfolio of about six 22×30 original pieces and ten 4×6 photographs of additional works. Sometimes I'll mount the photos on foam core. You shouldn't bring too many at one time—it tends to confuse them." Although some art reps and artists bring slides and set up a projector, Mayer has found people can't afford the time for an elaborate viewing. At the first appointment Mayer usually wears a business suit. "I try to keep it professional and friendly—but not 'pat-you-on-the-back' friendly. My main goal is to get them to trust me." When her work is being installed, Mayer feels freer to dress "a little more artsy."

Jan Mayer chose *Winter Magic*, 20½ × 26½ inches watercolor, for her second venture into self-publishing. The original painting is not for sale, but Mayer sells a limited edition of signed and numbered prints at an affordable price. The snow scene sells well to doctors, who like to hang it in their examining rooms. It seems the soothing blues are "just what the doctor ordered" for patients awaiting test results or treatments.

INSIDER REPORT, *continued*

Occasionally, the people in charge of purchasing furnishings for offices are not knowledgeable about art. Once you assure them of your expertise, they are usually relieved. Try not to take it personally when companies don't buy your work. "They're either going to like it or not. People have very different tastes. Some companies, like banks, choose very conservative, traditional styles and themes. Other companies like abstract art."

Once your work is in a few collections, art reps, interior decorators and other business people will see it and you will start getting calls. Sometimes they will ask for a variety of themes, for example a mixture of landscapes, florals and city scapes. Some will be looking for a series of similar work.

Mayer refuses to paint from a photograph or create work to match the sofa—although some artists are happy to work that way. "I can't just paint in any color the client wants—I have to be free. But as I tell my clients, I am sensitive to the surroundings. They trust me to provide works that will complement their office."

Another practice that leads to corporate sales is donating to fundraisers, such as charity auctions. It makes you feel good to give back to the community and it is an excellent opportunity for public relations, says Mayer. "I often get calls as a direct result of charity auctions."

Some of Mayer's favorite corporate accounts are medical facilities. There is a smile in her voice as she relates how doctors, nurses and patients often thank her. When they tell her how much it means to be surrounded by her restful, sensitive colors, Mayer knows she's made a difference. "There's really nothing quite like that feeling."

—Mary Cox

‡**THE MARKS COLLECTION**, 1590 N. Roberts Rd., Suite 308, Kennesaw GA 30144-3683. (770)425-7982. Fax: (770)425-7982. President: Jim Marks. Estab. 1981. Art publisher of unlimited and limited editions. Clients: persons interested in the Civil War; Christian and secular.
Needs: Seeking art for the serious collector. Considers oil, acrylic and mixed media. Prefers Christian, nature and Civil War themes. Artists represented include John DeMott, Hang Min Zou, William Maugham and Charles Gehm. Editions created by collaborating with the artist. Publishes and distributes the work of 1 emerging and 2 established artists/year.
First Contact & Terms: "Phone first to give an overview of your style, subject matter, etc." Send query letter with brochure showing art style, slides and photographs. Samples are filed. Reports back only if interested. Payment depends upon the use and distribution, pays royalties of 10% or accepts work on consignment (firm receives 40% commission). Provides a written contract.
Tips: "We are publishing Civil War images aimed at the romance, human interest and religious themes rather than 'blood and guts' action. Our Christian subjects for the Christian market are constantly growing."

‡**METROPOLITAN ART ASSOCIATES**, 877 E. Jericho Turnpike, Huntington Station NY 11746-7523. (516)549-8300. Fax: (516)549-6833. President: Richard Greenberg. Estab. 1977. Distributor and gallery for limited editions and signed posters. Clients: auctioneers, gallery dealers.
Needs: Seeking artwork with decorative appeal for the serious collector. Artists represented include Agam, Erte, Delacroix, McKnight.
First Contact & Terms: Send query letter with brochure showing art style. Samples are filed. To show portfolio, mail tearsheets and photographs. Pays on consignment basis. Offers advance when appropriate. Negotiates rights purchased. Provides shipping from firm and insurance while work is at firm.

MIXED-MEDIA, LTD., 3355 S. Highland Dr., Suite 109, Las Vegas NV 89109-3490. (702)796-8282 or (800)772-8282. Fax: (702)794-0292. E-mail: mmlasvegas@aol.com. Contact: Brad Whiting. Estab. 1969. Distributor of posters. Clients: galleries, frame shops, decorators, hotels, architects and department stores.

Needs: Considers posters only. Artists represented include Adams, Behrens, Erte, Kimble, McKnight and many others. Distributes the work of hundreds of artists/year.

First Contact & Terms: Send finished poster samples. Samples not returned. Negotiates payment method and rights purchased.

Tips: "We have been in business for over 26 years. The style of artists and their art have changed many times through the years. Just because we may not accept one thing today, does not mean we will not accept it tomorrow. Don't give up!

MODERNART EDITIONS, 100 Snake Hill Rd., West Nyack NY 10994. (914)358-7605. Contact: Jim Nicoletti. Estab. 1973. Art publisher and distributor of "top of the line" unlimited edition posters and offset reproductions. Clients: galleries and custom frame shops nationwide.

Needs: Seeking decorative art for the commercial and designer markets. Considers oil, watercolor, mixed media, pastel and acrylic. Prefers fine art landscapes, abstracts, representational, still life, decorative, collage, mixed media. Minimum size 18×24. Artists represented include M.J. Mayer, Carol Ann Curran, Diane Romanello, Pat Woodworth, Jean Thomas and Carlos Rios. Editions created by collaboration with the artist or by working from an existing painting. Approached by 150 artists/year. Publishes the work of 10-15 emerging artists/year. Distributes the work of 300 emerging artists/year.

First Contact & Terms: Send postcard size sample of work, contact through artist rep, or send query letter with slides, photographs, brochure, photocopies, résumé, photostats, transparencies. Reports within 6 weeks. Request portfolio review in original query. Publisher/distributor will contact artist for portfolio review if interested. Portfolio should include color photostats, photographs, slides and trasparencies. Pays flat fee of $200-300 or royalties of 10%. Offers advance against royalties. Buys all rights. Requires exclusive representation of artist. Provides insurance while work is at firm, shipping to firm and written contract.

Tips: Advises artists to attend Art Expo New York City and Atlanta ABC.

‡MONROE FINE ART PUBLISHING, 1200 Prospect St., #125-B, La Jolla CA 92037. (619)456-7691. Fax: (619)456-1794. Partner: Antonello Nervo. Estab. 1995. Art publisher, gallery. Publishes limited editions, etchings. Clients: galleries, decorators, frame shops, distributors, architects, corporate curators, museum shops.

Needs: Seeking art for the serious collector. Considers oil, acrylic, watercolor, mixed media, pastel. Prefers surrealistic, neo-impressionistic. Artists represented include Elvio Mainardi. Editions created by collaborating with the artist and by working from an existing painting.

First Contact & Terms: Send query letter with brochure, photographs and résumé. Samples are filed. Reports back only if interested. Company will contact artist for portfolio review of photographs if interested. Buys all rights. Requires exclusive representation of artist. Provides advertising, promotion, written contract. Finds artists through word of mouth, submissions, watching art competitions.

Tips: "Be yourself."

MORIAH PUBLISHING, INC., 23500 Mercantile Rd., Unit B, Beechwood OH 44122. (216)289-9653. Fax: (216)595-3140. Contact: President. Estab. 1989. Art publisher and distributor of limited editions. Clients: wildlife art galleries.

Needs: Seeking artwork for the serious collector. Editions created by working from an existing painting. Approached by 100 artists/year. Publishes the work of 6 and distributes the work of 15 emerging artists/year. Publishes and distributes the work of 10 mid-career artists/year. Publishes the work of 30 and distributes the work of 10 established artists/year.

First Contact & Terms: Send query letter with brochure showing art style, slides, photocopies, résumé, photostats, transparencies, tearsheets and photographs. Reports back within 2 months. Write for appointment to show portfolio or mail appropriate materials: rough, b&w, color photostats, slides, tearsheets, transparencies and photographs. Pays royalties. No advance. Buys reprint rights. Requires exclusive representation of artist. Provides in-transit insurance, promotion, shipping to and from firm, insurance while work is at firm, and a written contract.

Tips: "Artists should be honest, be patient, be courteous, be themselves, and make good art."

‡MULTIPLE IMPRESSIONS, LTD., 128 Spring St., New York NY 10012. (212)925-1313. Fax: (212)431-7146. President: Elizabeth Feinman. Estab. 1972. Art publisher and gallery. Publishes handpulled originals. Clients: young collectors, established clients, corporate, mature collectors.

Needs: Seeking creative art for the serious collector. Considers oil, watercolor, mixed media and printmaking. Prefers figurative, abstract, landscape. Editions created by collaborating with the artist. Approached by 100 artists/year. Publishes the work of 1 emerging, 1 mid-career and 1 established artist/year.

First Contact & Terms: Send query letter with slides and transparencies. Samples are not filed and are returned by SASE. To show a portfolio, send transparencies. Pays flat fee. Offers advance when appropriate. Buys all rights. Requires exclusive representation of artist.

‡MUSEUM EDITIONS WEST, 1800 Stewart St. A, Santa Monica CA 90404. (310)829-4428. Fax: (310)829-7046. E-mail: jordanarts@aol.com. Director: Harvey L. Jordan. Poster company, distributor, gal-

lery. Distributes unlimited editions, canvas transfers, posters. Clients: galleries, decorators, frame shops, distributors, architects, corporate curators, museum shops, giftshops. Current clients include: San Francisco Modern Art Museum and The National Gallery, etc.

Needs: Seeking creative, fashionable art for the commercial and designer markets. Considers oil, acrylic, watercolor, pastel. Prefers landscape, floral, abstract. Artists represented include John Botzy and Carson Gladson. Editions created by working from an existing painting. Approached by 150 artists/year. Publishes/distributes the work of 5 mid-career and 20 established artists/year. Also needs freelancers for design.

First Contact & Terms: Send query letter with brochure, photocopies, photographs, résumé, SASE, slides, tearsheets, transparencies. Samples are not filed and are returned by SASE. Reports back within 3 months. Company will contact artist for portfolio review of photographs, slides, tearsheets and transparencies if interested. Pays royalties of 8-10%. Offers advance when appropriate. Rights purchased vary according to project. Provides advertising, insurance while work is at firm, promotion, shipping from our firm, written contract. Finds artists through art exhibitions, art fairs, word of mouth, submissions.

Tips: "Look at our existing catalog for samples."

‡MUSEUM MASTERS INTERNATIONAL, (formerly Museum Boutique Intercontinental, Ltd.), 26 E. 64th St., New York NY 10021. (212)759-0777. President: Marilyn Goldberg; Director of License: Lauren Rossan; Director of Administration: Lynn Miller. Distributor handling limited editions, posters, tapestry and sculpture for galleries, museums and gift boutiques. Current clients include the Boutique/Galeria Picasso in Barcelona, Spain and The Hakone Museum in Japan.

Needs: Seeking artwork with decorative appeal for the designer market. Considers oil, acrylic, pastel, watercolor and mixed media. Prefers individual works of art in unframed series. Also reproduces art images on boutique product. Artists represented include Pablo Picasso and Ichiro Tsuruta. Editions created by collaborating with the artist. Approached by 100 artists/year. Publishes and distributes the work of 3 emerging, mid-career and established artists/year.

First Contact & Terms: Send query letter with résumé, brochures and samples. Samples are filed or returned. Reports within 2 weeks. Call or write for appointment to show portfolio or mail slides and transparencies. Payment method is negotiated. Offers advance when appropriate. Negotiates rights purchased. Exclusive representation is not required. Provides insurance while work is at firm, shipping to firm and a written contract.

Tips: "We presently have demand for landscapes."

NATIONAL ART PUBLISHING CORP., 11000-32 Metro Pkwy., Ft. Myers FL 33912-1293. Fax: (813)939-7518. (813)936-2788. President: David H. Boshart. Estab. 1978. Art publisher, catalog publisher/marketer. Publishes limited and unlimited editions, offset reproductions, posters, sculpture, coins and medallic collectibles.

Needs: Seeking artwork for the serious collector, commercial and designer markets. Considers oil, watercolor, mixed media, pastel, sculpture and acrylic. Considers all styles from realism to impressionism. Artists represented include Vivi Crandall, Richard Luce, Diane Pierce. Brent Townsend and Plasschaert. Editions created by working from an existing painting. Approached by 100 artists/year. Publishes 2-3 emerging, 2-3 mid-career and 2-3 established artists/year. Distributes the work of 10 emerging, 20 mid-career and 30 established artists/year.

First Contact & Terms: Send brochure, résumé, slides, photographs and transparencies. Samples returned by SASE if requested by artist. Reports back within 2 weeks. Publisher will contact artist for portfolio review if interested. Portfolio should include slides. Consignment basis or negotiates payment. No advance. Rights purchased vary according to project. Provides advertising, in-transit insurance, shipping from firm, written contract, color catalog, videotape and access on the internet. Finds artists through sourcebooks, other publications and submissions.

NEW YORK GRAPHIC SOCIETY, Box 1469, Greenwich CT 06836. (203)661-2400. President: Richard Fleischmann. Publisher of offset reproductions, posters and handpulled originals. Clients: galleries, frame shops and museums shops. Current clients include Deck The Walls, Ben Franklin, Prints Plus.

Needs: Considers oil, acrylic, pastel, watercolor, mixed media and colored pencil drawings. Publishes reproductions, posters. Publishes and distributes the work of numerous emerging artists/year.

First Contact & Terms: Send query letter with transparencies, slides or photographs. Write for artist's guidelines. All submissions returned to artists by SASE after review. Reports within 3 weeks. Pays flat fee or royalty. Offers advance. Buys all print reproduction rights. Provides in-transit insurance from firm to artist,

HOW TO USE your *Artist's & Graphic Designer's Market* offers suggestions for understanding and using the information in these listings. Read this and other articles in the front of this book for important business tips.

insurance while work is at firm, promotion, shipping from firm and a written contract; provides insurance for art if requested. Finds artists through submissions/self promotions, magazines, visiting art galleries, art fairs and shows.
Tips: "We publish a broad variety of styles and themes. We actively seek all sorts of fine decorative art."

‡**NORTHWOODS CRAFTSMAN**, AM, N87 W17317 Main St., Menomonee Falls WI 53051. (414)255-7750. Fax: (414)255-5824. Owner: Bob Unger. Estab. 1977. Art publisher. Publishes limited and unlimited editions, offset reproductions, posters and bronze sculptures. Clients: galleries and frame shops.
Needs: Seeking artwork with decorative appeal for the serious collector and the commercial market. Considers oil, watercolor and acrylic. Prefers realism, wildlife and rural or city scenes. Artists represented include Jerry Gadamus, George Korach and Mary Singleton. Editions created by collaborating with the artist or working from an existing painting. Approached by 50 artists/year. Publishes the work of 2-3 emerging, 4-6 mid-career and 3-4 established artists/year.
First Contact & Terms: Send query letter with brochure showing art style or résumé and tearsheets, slides and photographs. Samples are not filed and are returned by SASE if requested by artist. Reports back within 2 weeks. Payment method is negotiated. Requires exclusive representation of the artist. Provides promotion, shipping from firm and a written contract.
Tips: "Major original paintings must sell for at least $2,000."

‡**NOTTINGHAM FINE ART**, 73 Gebig Rd., W. Nottingham NH 03291-0073. Phone/fax: (603)942-7089. President: Robert R. Lemelin. Estab. 1992. Art publisher, distributor. Publishes/distributes handpulled originals, limited editions, fine art prints, monoprints, monotypes, offset reproductions. Clients: galleries, frame shops, architects.
Needs: Seeking creative, fashionable, decorative art for the serious collector. Considers oil, acrylic, watercolor, mixed media, pastel. Prefers landscape, floral, creative, musical and lifestyle. Artists represented include Edward Gordon and Kathleen Cantin. Editions created by collaborating with the artist or by working from an existing painting. Approached by 10 artists/year.
First Contact & Terms: Send query letter with brochure, photographs, slides. Samples are filed or returned by SASE. Reports back within 2 months. Company will contact artist for portfolio review of color photographs, slides and transparencies if interested. Pays in royalties. Rights purchased vary according to project. Requires exclusive representation of artist. Provides advertising, insurance while work is at firm, promotion, shipping from our firm, written contract. Finds artists through art fairs, submissions and referrals from existing customers.

‡**NOVA MEDIA INC.**, 1724 N. State, Big Rapids MI 49307. Phone/fax: (616)796-7539. Editor: Tom Rundquist. Estab. 1981. Poster company, art publisher, distributor. Publishes/distributes limited editions, unlimited editions, fine art prints, posters. Current clients include: various galleries.
Needs: Seeking creative art for the serious collector. Considers oil, acrylic. Prefers expressionism, impressionism, abstract. Editions created by collaborating with the artist or by working from an existing painting. Approached by 14 artists/year. Publishes/distributes the work of 2 emerging, 2 mid-career and 1 established artists/year. Also needs freelancers for design. Prefers local designers.
First Contact & Terms: Send query letter with photographs, résumé, SASE, slides, tearsheets. Samples are returned by SASE. Reports back within 2 weeks. Request portfolio review in original query. Company will contact artist for portfolio review of color photographs, slides, tearsheets if interested. Pays royalties of 10% or negotiates payment. No advance. Rights purchased vary according to project. Provides promotion.
Tips: Predicts colors will be brighter in the industry.

‡**OAK TREE ART AGENCY**, P.O. Box 1180, Dewey AZ 86327. (520)775-5077. Fax: (520)775-5585. Manager: William F. Lupp. Estab. 1989. Art publisher, distributor. Publishes/distributes limited editions, unlimited editions, canvas transfers, offset reproductions, posters. Clients: galleries, frame shops, distributors.
Needs: Seeking creative, decorative art for the commercial and designer markets. Considers oil, acrylic, mixed media. Artists represented include Jorge Tarallo Braun. Editions created by working from an existing painting.
First Contact & Terms: Send brochure, photographs, SASE, slides. Reports back only if interested. Company will contact artist for portfolio review of transparencies if interested. Pays flat fee. No advance. Rights purchased vary according to project. Provides advertising, insurance while work is at firm, shipping from our firm.

OLD WORLD PRINTS, LTD., 468 South Lake Blvd., Richmond VA 23236. (804)378-7833. Fax: (804)378-7834. President: John Wurdeman. Estab. 1973. Art publisher and distributor of primarily open edition hand printed reproductions of antique engravings. Clients: retail galleries, frame shops and manufacturers.
 ● Old World Prints reports the top-selling art in their 2,500-piece collection includes African animals, urns and parrots.

Needs: Seeking traditional and decorative art for the commercial and designer markets. Specializes in handpainted prints. Considers "b&w (pen & ink or engraved) art which can stand by itself or be hand painted by our artists or originating artist." Prefers traditional, representational, decorative work. Editions created by collaborating with the artist. Distributes the work of more than 500 artists.

First Contact & Terms: Send query letter with brochure showing art style or résumé and tearsheets and slides. Samples are filed. Reports back within 6 weeks. Write for appointment to show portfolio of photographs, slides and transparencies. Pays flat fee of $100 and royalties of 10% or on a consignment basis: firm receives 50% commission. Offers an advance when appropriate. Negotiates rights purchased. Provides in-transit insurance, insurance while work is at firm, promotion, shipping from firm and a written contract. Finds artists through word of mouth.

Tips: "We are a specialty art publisher, the largest of our kind in the world. We reproduce only b&w engraving, pen & ink and b&w photogravures. All of our pieces are handpainted."

OPUS ONE/SCANDECOR DEVELOPMENT AB, 790 Riverside Dr., Suite 2E, New York NY 10032. (212)862-4095. Fax: (212)862-3767. Publishing Director: James Munro. Estab. 1970. Art Publisher. Publishes unlimited editions, offset reproductions, posters, cards and calenders.

- Opus One is distributed by New York Graphic Society. Scandecor Development AB is the parent company of Opus One and Scandecor, and is based in Sweden. Higher end fine art images are more appropriate for this division, while cute or trendy images should be sent to Scandecor's Pennsylvania division, which is also listed in this section.

Needs: Seeking creative, fashionable and decorative art for the commercial and designer markets. Considers all media. Artists represented include Kate Frieman, Jack Roberts, licensed characters such as Disney, Harley Davidson. Approached by 100 artists/year. Publishes the work of 20% emerging, 20% mid-career and 60% established artists.

First Contact & Terms: Send brochure, tearsheets, slides, photographs, photocopies, transparencies. Samples are not filed and are returned. Reports back within 1 month. Artist should follow up with call after initial query. Portfolio should include final art, slides, transparencies. Negotiates payment. Offers advance when appropriate. Rights purchased vary according to project.

Tips: "Please attend the Art Expo New York City trade show."

PANACHE EDITIONS LTD, 234 Dennis Lane, Glencoe IL 60022. (312)835-1574. President: Donna MacLeod. Estab. 1981. Art publisher and distributor of offset reproductions and posters. Clients: galleries, frame shops, domestic and international distributors. Current clients are mostly individual collectors.

Needs: Considers acrylic, pastel, watercolor and mixed media. "Looking for contemporary compositions in soft pastel color palettes; also renderings of children on beach, in park, etc." Artists represented include Bart Forbes, Peter Eastwood and Carolyn Anderson. Prefers individual works of art and unframed series. Publishes and distrubutes work of 1-2 emerging, 2-3 mid-career and 1-2 established artists/year.

First Contact & Terms: Send query letter with brochure showing art style or photographs, photocopies and transparencies. Samples are filed. Reports back only if interested. To show portfolio, mail roughs and final reproduction/product. Pays royalties of 10%. Negotiates rights purchased. Requires exclusive representation of artist. Provides in-transit insurance, insurance while work is at firm, promotion, shipping to and from firm and written contract.

Tips: "We are looking for artists who have not previously been published (in the poster market) with a strong sense of current color palettes. We want to see a range of style and coloration. Looking for a unique and fine art approach to collegiate type events, i.e., Saturday afternoon football games, Founders Day celebrations, homecomings, etc. We do not want illustrative work but rather an impressionistic style that captures the tradition and heritage of one's university. We are very interested in artists who can render figures."

‡PENNY LANE PUBLISHING INC., 7179 South St. Rt. 201, Tipp City OH 45371. (513)845-1300. Fax: (513)845-8786. Contact: Melissa Elleman. Estab. 1993. Art publisher, distributor. Publishes/distributes limited editions, unlimited editions. Clients: galleries, frame shops, distributors, corporate curators.

Needs: Seeking creative, fashionable, decorative art for the commercial market. Considers oil, acrylic, watercolor, mixed media, pastel. Artists represented include L. Spivey, M. McMenamin, J.O. Yearby and D. Lovitt. Editions created by collaborating with the artist or working from an existing painting. Approached by 30-50 artists/year. Publishes the work of 2-3 emerging, 18 mid-career and 18 established artists/year. Distributes the work of 18 emerging artists/year.

First Contact & Terms: Send query letter with photocopies, photographs, slides, tearsheets. Samples are filed or returned. Reports back within 10 days. Company will contact artist for portfolio review of color, final art, photographs, slides, tearsheets if interested. Pays royalties. Buys all rights. Requires exclusive representation of artist. Provides advertising, insurance while work is at firm, promotion, written contract. Finds artists through art exhibitions, art fairs, word of mouth, submissions, watching art competitions.

Tips: Advises artists to be aware of current color trends and work in a series.

‡**PLANET WEST PUBLISHERS**, P.O. Box 34033, Las Vegas NV 89133-4033. Phone/fax: (702)242-6752. E-mail: asktoddart@aol.com. Contact: Todd Bingham. Estab. 1995. Art publisher. Publishes graphics and reproductions. Clients: galleries and direct consumer sales.

• Todd Bingham offers marketing advice to artists on his Website (Path: AOL, Keyword *Image Exchange*; Galleries; Member's Showcase; ASKTODDART.)

Needs: Seeking creative art. Artists represented include Bedard, Cassidy, Greer, Morton. Editions created by collaborating with the artist and by working from an existing painting. Publishes the work of 1 emerging, 1 mid-career and 1 established artists/year. Also needs freelancers for design. Prefers designers who own Mac computers and are experienced in Adobe Illustrator and Adobe Photoshop.

First Contact & Terms: Send letter with résumé, SASE and transparencies. Accepts disk submissions compatible with Mac format, Adobe Illustrator, Adobe Photoshop. Samples are not filed and are returned by SASE. Reports back within 10 days. Company will contact artist for portfolio review if interested. Payment negotiable. Offers advance when appropriate. Rights purchased vary according to project. Provides advertising, in-transit insurance, insurance while work is at firm, promotion, shipping from our firm, written contract, career direction.

***PORTER DESIGN—EDITIONS PORTER**, 19 Circus Place, Bath Avon BA1 2PE, England. (01144)225-424910. Fax: (01144)225-447146. Partners: Henry Porter, Mary Porter. Estab. 1985. Publishes limited and unlimited editions and offset productions and hand-colored reproductions. Clients: international distributors, interior designers and hotel contract art suppliers. Current clients include Devon Editions, Art Group and Harrods.

Needs: Seeking fashionable and decorative art for the designer market. Considers watercolor. Prefers 17th-19th century traditional styles. Artists represented include Alexandra Churchill, Caroline Anderton, Victor Postolle, Joseph Hooker and Adrien Chancel. Editions created by working from an existing painting. Approached by 10 artists/year. Publishes and distributes the work of 10-20 established artists/year.

First Contact & Terms: Send query letter with brochure showing art style or résumé and photographs. Accepts disk submissions compatible with QuarkXPress on Apple Mac. Samples are filed or are returned. Reports back only if interested. To show portfolio, mail photographs. Pays flat fee or royalties. Offers an advance when appropriate. Negotiates rights purchased.

PORTFOLIO GRAPHICS, INC., 4060 S. 500 W., Salt Lake City UT 84123. (800)843-0402. Fax: (801)263-1076. Website: http://www.sisna.com/graph/home.htm. Creative Director: Kent Barton. Estab. 1986. Publishes and distributes limited editions, unlimited editions and posters. Clients: galleries, designers, poster distributors (worldwide) and framers.

Needs: Seeking creative, fashionable and decorative art for commercial and designer markets. Considers oil, watercolor, acrylic, pastel, mixed media and photography. Publishes 30-50 new works/year. Artists represented include Dawna Barton, Ovanes Berberian, Del Gish, Jodi Jensen and Kent Wallis. Editions created by working from an existing painting or transparency.

First Contact & Terms: Send query letter with résumé, biography, slides and photographs. Accepts disk submissions compatible with Adobe Illustrator and QuarkXPress. Send TIFF (preferred) or EPS files. Samples are not filed. Reports back within months. To show portfolio, mail slides, transparencies and photographs with SASE. Pays $100 advance against royalties of 10%. Buys reprint rights. Provides promotion and a written contract.

Tips: They are currently adding 50 new images to their binder catalog "and we'll continue to add new supplemental pages twice yearly. We find artists through galleries, magazines, art exhibits, submissions. We're looking for a variety of artists and styles/subjects." Advises artists to attend Art Expo New York City and Art Buyer Caravan (at various locations throughout the year).

‡**POSNER FINE ART**, 940 Westmount Dr. #204, West Hollywood CA 90069. (310)260-8858. Fax: (310)260-8860. Estab. 1994. Poster company, art publisher, distributor, gallery. Publishes/distributes posters. Clients: galleries, frame shops, distributors, architects, corporate curators, museum shops. Current clients include: Bruce McGaw Graphics, Graphique de France, International Graphics and Prints Plus.

Needs: Seeking creative, fashionable, decorative art for the serious collector, commercial and designer markets. Considers oil, acrylic, watercolor, mixed media, pastel, sculpture. Prefers contemporary and traditionsl. Artists represented include Crane, Edelmann, Peticov, Coffmann, Gallagher, Haskell. Editions created by collaborating with the artist or by working from an existing painting. Approached by hundreds of artists/year. Publishes/distributes the work of 10 emerging, 10 mid-career and 5 established artists/year. Also needs freelancers for design.

First Contact & Terms: Send slides. "Must enclose self-addressed stamped return envelope." Samples are not filed. Reports back within a few weeks. Company will contact artist for portfolio review of final art if interested. Pays 50¢/poster sold. Buys all rights. Provides advertising, promotion, written contract. Finds artists through art fairs, word of mouth.

Tips: Sees trend toward Victorian themes. "Know color trends of design market."

‡❋POSTERS INTERNATIONAL, 1200 Castlefield Ave., Toronto, Ontario M6B 1G2. (416)789-7156. Fax: (416)789-7159. President: Esther Cohen. Estab. 1976. Poster company, art publisher. Publishes hand-pulled originals, limited editions, fine art prints, posters. Clients: galleries, decorators, distributors, hotels, restaurants etc., in US, Canada and International. Current clients include: McDonalds, Holiday Inn.
Needs: Seeking creative, fashionable art for the commercial market. Considers oil, acrylic, watercolor, mixed media. Prefers landscapes, florals, collage, architecturals, classical (no figurative). Artists represented include Elizabeth Berry, Catherine Hobart, Fenwick Bonnell, Julie McCarroll. Editions created by collaborating with the artist or by working from an existing painting. Approached by 100 artists/year. Publishes the work of 12 emerging, 10 mid-career artists. Distributes the work of 50 emerging artists/year.
First Contact & Terms: Send query letter with brochure, photographs, slides, transparencies. Samples are filed or returned by SASE. Reports back within 1-2 months. Company will contact artist for portfolio review of photographs, photostats, slides, tearsheets, thumbnails, transparencies if interested. Pays flat fee or royalties. Offers advance when appropriate. Rights purchased vary according to project. Requires exclusive representation of artist for posters. Provides advertising, promotion, shipping from our firm, written contract. Finds artists through art fairs, art reps, submissions.
Tips: "Be aware of current color trends—work in a series (of two)."

THE PRESS CHAPEAU, Govans Station, Box 4591, Baltimore City MD 21212-4591. Director: Elspeth Lightfoot. Estab. 1976. Publishes and distributes original prints only, "in our own atelier or from printmaker." Clients: architects, interior designers, corporations, institutions and galleries.
Needs: Considers original handpulled etchings, lithographs, woodcuts and serigraphs. Prefers professional, highest museum quality work in any style or theme. "Suites of prints are also viewed with enthusiasm." Prefers unframed series. Publishes the work of 2 emerging, 5 mid-career and 10 established artists/year.
First Contact & Terms: Send query letter with slides. Samples are filed. Samples not filed are returned by SASE. Reports back within 5 days. Write for appointment to show portfolio of slides. Pays flat fee of $100-2,000. Payment method is negotiated. Offers advance. Purchases 51% of edition or right of first refusal. Does not require exclusive representation. Provides insurance, promotion, shipping to and from firm and a written contract. Finds artists through agents.
Tips: "Our clients are interested in investment quality original handpulled prints. Your résumé is not as important as the quality and craftsmanship of your work."

PRESTIGE ART GALLERIES, INC., 3909 W. Howard St., Skokie IL 60076. (847)679-2555. E-mail: 76751-1327@compuserve.com. President: Louis Schutz. Estab. 1960. Art gallery. Publishes and distributes paintings and mixed media artwork. Clients: retail professionals and designers.
● This gallery represents a combination of 18th and 19th century work and contemporary material. Clientele seems to be currently most interested in figurative art and realism.
Needs: Seeking art for the serious collector. Prefers surrealism, New Age visionary, realism and French Impressionism in oil. Artists represented include Erte, Simbari, Agam and King. Editions created by collaborating with the artist or by working from an existing painting. Approached by 100 artists/year. Publishes 1 emerging, 1 mid-career and 1 established artist/year. Distributes the work of 5 emerging, 7 mid-career and 15 established artists/year.
First Contact & Terms: Send query letter with résumé and tearsheets, photostats, photocopies, slides, photographs and transparencies. Accepts disk submissions. Samples are not filed and are returned by SASE. Reports back within 2 weeks. Pays on consignment (firm receives 50% commission). Offers an advance. Buys all rights. Provides insurance while work is at firm, promotion, shipping from firm and written contract.
Tips: "Be professional. People are seeking better quality, lower-sized editions, less numbers per edition— 1/100 instead of 1/750."

‡PRIME ART PRODUCTS, 5772 N. Ocean Shore Blvd., Palm Coast FL 32137. (904)445-3851. Fax: (904)445-6057. Co-Owner: Dee Abraham. Estab. 1989. Art publisher, distributor. Publishes/distributes limited editions, unlimited editions, fine art prints, offset reproductions. Clients: galleries, decorators, frame shops, distributors, architects, corporate curators, museum shops and giftshops.
Needs: Seeking creative, fashionable, decorative art for the commercial and design markets. Considers oil, acrylic, watercolor. Prefers wildlife, magnolias and shore birds. Artists represented include John Akers, J.J. Audubon, Art LaMay and Della Storms. Editions created by collaborating with the artist or by working from an existing painting. Approached by 50 artists/year. Publishes the work of 1-2 emerging, 1-2 mid-career artists/year. Distributes the work of 1-2 emerging, 2 mid-career, 4 established artists/year.
First Contact & Terms: Send photographs, SASE, slides, tearsheets, transparencies. Samples are filed or returned by SASE. Reports back within 10 days. Company will contact artist for portfolio review if interested. Negotiates payment per signature. Offers advance when appropriate. Rights purchased vary according to project. Provides promotion, written contract.
Tips: "Color is extremely important."

PRIMROSE PRESS, Box 302, New Hope PA 18938-1302. (215)862-5518. President: Patricia Knight. Estab. 1980. Art publisher. Publishes limited edition reproductions for galleries. Clients: galleries, decorators,

framers, designers, consultants, distributors, manufacturers, museum shops and catalogs.
Needs: Seeks creative, decorative art for the serious collector, commercial and designer markets. Considers pen & ink line drawings, oil and acrylic paintings, watercolor and mixed media. Prefers traditional landscapes. Publishes representational themes. Artists represented include Peter Keating, E.W. Redfield, Daniel Garber, George Booey. Editions created by working from an existing painting. Approached by 25-35 artists/year. Publishes the work of 2-3 emerging, 2-3 mid-career and 30 established artists/year. Distributes the work of 6 emerging, 6 mid-career and 30 established artists/year.
First Contact & Terms: Send query letter with tearsheets, slides and SASE. Prefers slides as samples. Do not send original art. Samples returned by SASE if not kept on file. Reports within 1 month. Pays royalties to artist. Buys all rights. Provides in-transit insurance, insurance while work is at publisher, advertising, promotion and a written contract. Artist owns original art. Finds artists through exhibitions and submissions.

‡**QUANTUM MECHANICS**, 2595 Lake Meadow Dr., Monument CA 80132. (719)481-9593. Fax: (719)481-9804. E-mail: gino@mdminc.com. Sales Manager: Gene Ashe. Estab. 1986. Art publisher. Publishes and produces PC-generated graphics packages. Clients: software companies, ad agencies and distributors.
Needs: Seeking artwork with creative expression for the commercial market. Considers mixed media. Themes and styles are "whatever the client requests." Editions created by collaborating with the artist.
First Contact & Terms: Send query letter with résumé and disk with graphic files. Accepts disk submissions. Samples are filed. Reports back within 1 month. Payment rights purchased and services are negotiable. Offers advance when appropriate. Requires exclusive representation.
Tips: "We believe that this marketing idea is so unique that any and all approaches are considered. We only encourage artists who would welcome editing suggestions to their work to make submissions."

‡**RIGHTS INTERNATIONAL GROUP**, 463 First St., #3C, Hoboken NJ 07030. (201)463-3123. Fax: (201)420-0679. Contact: Robert Hazaga. Estab. 1996. Agency for cross licensing. Represents artists for licensing into publishing, stationery, giftware, home furnishing. Clients: galleries, decorators, frame shops, distributors, giftware manufacture, stationery, poster, limited editions publishers, home furnishing manufacturers. Clients include: Scandecor, Portal, Noblework.
● This company is also listed in the Greeting Card, Gifts & Products section.
Needs: Seeking creative art, decorative art for the commercial and designer markets. Also looking for textile art. Considers oil, acrylic, watercolor, mixed media, pastel. Prefers commercial. Artists represented include Gillian Campbell, Phoenix Art Group. Approached by 50 artists/year.
First Contact & Terms: Send brochure, photocopies, photographs, SASE, slides, tearsheets, transparencies. Accepts disk submissions compatible with Adobe Illustrator. Samples are not filed and are returned by SASE. Reports back within 2 months. Company will contact artist for portfolio review if interested. Negotiates payment.

‡❦**RIVER HEIGHTS PUBLISHING INC.**, 720 Spadina Ave., Suite 501, Toronto, Ontario M5S 2T9 Canada. (416)922-0500. Fax: (416)922-6191. Publisher: Paul Swartz. Art publisher. Publishes limited editions, unlimited editions, canvas transfers, fine art prints, offset reproductions, sculpture. Clients: galleries, frame shops, marketing companies, corporations, mail order, chain stores, barter exchanges.
Needs: Seeking decorative art for the commercial market. Considers oil, acrylic, watercolor, sculpture. Prefers wildlife, Southwestern, American Indian, impressionism and Victorian (architecture). Artists represented include A.J. Casson, Paul Rankin, George McLean, Rose Marie Condon. Editions created by collaborating with the artist. Approached by 50 artists/year. Publishes the work of 1 emerging, 2 mid-career, 1 established artists/year. Distributes the work of 3 emerging, 2 mid-career and 3 established artists/year.
First Contact & Terms: Send photographs, résumé, SAE (nonresidents include IRC), slides, tearsheets. Samples are not filed and are returned by SAE. Reports back within 3 weeks. Company will contact artist for portfolio review of final art if interested. Pays flat fee, royalties and/or consignment basis. Rights purchased vary according to project. Requires exclusive representation of artist. Provides advertising, insurance, promotion, shipping from our firm, written contract and samples on greeting cards, calendars.

ROMM ART CREATIONS, LTD., Maple Lane, P.O. Box 1426, Bridgehampton NY 11932. (516)537-1827. Fax: (516)537-1752. Contact: Steven Romm. Estab. 1987. Art publisher. Publishes unlimited editions, posters and offset reproductions. Clients: distributors, galleries, frame shops.
Needs: Seeking decorative art for the commercial and designer markets. Considers oil, watercolor, mixed media, pastel, acrylic and photography. Prefers traditional and contemporary. Artists represented include Tarkay, Wohlfelder, Switzer. Editions created by collaborating with the artist or by working from an existing painting. Publishes the work of 10 emerging, 10 mid-career and 10 established artists/year.
First Contact & Terms: Send query letter with slides and photographs. Samples are not filed and are returned by SASE if requested by artist. Reports back to the artist only if interested. Publisher will contact artist for portfolio review if interested. Pays royalties of 10%. Offers advance. Rights purchased vary according to project. Requires exclusive representation of artist for posters only. Provides promotion and written contract.

Tips: Advises artists to attend Art Expo and to visit poster galleries to study trends. Finds artists through attending art exhibitions, agents, sourcebooks, publications, submissions.

RUSHMORE HOUSE PUBLISHING, 101 E. 38th St., Box 1591, Sioux Falls SD 57101. (605)334-5253. Fax: (605)334-6630. Publisher: Stan Cadwell. Estab. 1989. Art publisher and distributor of limited editions. Clients: art galleries and picture framers.
Needs: Seeking artwork for the serious collector and commercial market. Considers oil, watercolor, acrylic, pastel and mixed media. Prefers realism, all genres. Artists represented include John C. Green, Mary Groth and Tom Phillips. Editions created by collaborating with the artist. Approached by 100 artists/year. Publishes the work of 1-5 emerging artists and 1-5 established artists/year.
First Contact & Terms: Send query letter with résumé, tearsheets, photographs and transparencies. Samples are filed or are returned by SASE if requested by artist. Reports back within 1 month. Write for appointment to show portfolio of original/final art, tearsheets, photographs and transparencies. Payment method is negotiated. Offers an advance when appropriate. Negotiates rights purchased. Exclusive representation of artist is negotiable. Provides in-transit insurance, insurance while work is at firm, promotion, shipping and written contract. "We market the artist and their work."
Tips: "We are looking for artists who have perfected their skills and have a definite direction in their work. We work with the artist on developing images and themes that will succeed in the print market and aggressively promote our product to the market. Current interests include: wildlife, sports, Native American, Western, landscapes and florals."

ST. ARGOS CO., INC., 11040 W. Hondo Pkwy., Temple City CA 91780. (818)448-8886. Fax: (818)579-9133. Manager: Roy Liang. Estab. 1987. Manufacturer, publishes gift catalog. Clients: gift shops.
Needs: Seeking decorative art. Prefers Victorian, sculpture and seasonal. Editions created by working from an existing painting. Approached by 6-8 artists/year. Publishes the work or 3 emerging and 2 established artists/year.
First Contact & Terms: Send résumé, slides and photographs. Samples not filed and are returned by SASE if requested by artist. Will contact artist for portfolio review if interested. Portfolio should include color slides and transparencies. Pays royalties of 10%. No advance. Rights purchased vary according to project. Provides advertising. Finds artists by attending art exhibitions.

THE SAWYIER ART COLLECTION, INC., 3445-D Versailles Rd., Frankfort KY 40601. (800)456-1390. Fax: (502)695-1984. President: William H. Coffey. Distributor. Distributes limited and unlimited editions, posters and offset reproductions. Clients: retail art print and framing galleries.
Needs: Seeking fashionable and decorative art. Prefers floral and landscape. Artists represented include Lena Liu, Mary Bertrand. Approached by 100 artists/year. Distributes the work of 10 emerging, 50 mid-career and 10 established artists/year.
First Contact & Terms: Send query letter with tearsheets. Samples are not filed and are not returned. Reports back to the artist only if interested. Distributor will contact artist for portfolio review if interested. Portfolio should include color tearsheets. Buys work outright. No advance. Finds artists through publications (*Decor, Art Business News*), retail outlets.

SCAFA-TORNABENE ART PUBLISHING CO. INC., 100 Snake Hill Rd., West Nyack NY 10994. (914)358-7600. Fax: (914)358-3208. Art Coordinator: Susan Murphy. Produces unlimited edition offset reproductions. Clients: framers, commercial art trade and manufacturers worldwide.
Needs: Seeking decorative art for the wall decor market. Considers unframed decorative paintings, posters, photos and drawings. Prefers pairs and series. Artists represented include T.C. Chiu, Jack Sorenson, Kay Lamb Shannon and Marianne Caroselli. Editions created by collaborating with the artist and by working from a pre-determined subject. Approached by 100 artists/year. Publishes and distributes the work of dozens of artists/year. "We work constantly with our established artists, but are always on the lookout for something new."
First Contact & Terms: Send query letter first with slides or photos and SASE. Reports in about 3-4 weeks. Pays $200-350 flat fee for some accepted pieces. Royalty arrangements with advance against 5-10% royalty is standard. Buys only reproduction rights. Provides written contract. Artist maintains ownership of original art. Requires exclusive publication rights to all accepted work.
Tips: "Do not limit your submission. We are interested in seeing your full potential. Please be patient. All inquiries will be answered."

SCANDECOR INC., 430 Pike Rd., Southampton PA 18966. (215)355-2410. Fax: (215)364-8737. Product Manager: Lauren Karp. Poster company, art publisher/distributor. Publishes/distributes fine art prints and posters. Clients include gift and stationery stores, craft stores and frame shops.
Needs: Seeking fashionable, decorative art. Considers acrylic, watercolor and pastel. Themes and styles vary according to current trends. Editions created by working from existing painting. Approached by 150 artists/year. Publishes the work of 5 emerging, 10 mid-career and 10 established artists/year.

First Contact & Terms: Send query letter with brochure, photocopies, photographs, slides, tearsheets, transparencies and SASE. Reports back within 2 months. Company will contact artist for portfolio review if interested. Portfolio should include color photographs, slides, tearsheets and/or transparencies. Negotiates payment. Offers advance when appropriate. Rights vary according to project. Provides written contract. Finds artists through art exhibitions, art and craft fairs, art reps, submissions and looking at art already in the marketplace in other forms (e.g., collectibles, greeting cards, puzzles).

Tips "Watch for current trends and incorporate them into your work. (Some current trends are Victorian motifs and florals; foods such as chili peppers; angels and gardening.) Be aware of gift and stationery market trends. Look at poster/print displays in stores and attend gift shows if possible."

‡SCHIFTAN INC., 406 W. 31st St., New York NY 10001. (212)532-1984. Fax: (212)465-8635. President: Harvey S. Cohen. Estab. 1903. Art publisher, distributor. Publishes/distributes unlimited editions, fine art prints, offset reproductions, posters and hand-colored prints. Clients: galleries, decorators, frame shops, architects, wholesale framers to the furniture industry.

Needs: Seeking fashionable, decorative art for the commercial market. Considers watercolor, mixed media. Prefers traditional, landscapes, botanicals, wild life, Victorian. Editions created by collaborating with the artist. Approached by 15-20 artists/year. Also needs freelancers for design.

First Contact & Terms: Send query letter with transparencies. Samples are not filed and are returned. Reports back within 1 week. Company will contact artist for portfolio review of final art, roughs, transparencies if interested. Pays flat fee or royalties. Offers advance when appropriate. Negotiates rights purchased. Provides advertising, written contract. Finds artists through art exhibitions, art fairs, submissions.

SEGAL FINE ART, 4760 Walnut St., #100, Boulder CO 80301. (800)999-1297. (303)939-8930. Fax: (303)939-8969. E-mail: sfineart@aol.com. Artist Liason: Andrea Bianco. Estab. 1986. Art publisher. Publishes limited editions. Clients: galleries.

Needs: Seeking creative and fashionable art for the serious collector and commercial market. Considers oil, watercolor, mixed media and pastel. Artists represented include Lu Hong, Sassone, Scott Jacobs and Ting Shao Kuang. Editions created by working from an existing painting. Publishes limited edition serigraphs, mixed media pieces and posters. Publishes and distributes the work of 1 emerging artist/year. Publishes the work of 7 and distributes the work of 3 established artists/year.

First Contact & Terms: Send query letter with slides, résumé and photographs. Samples are not filed and are returned by SASE. Reports back in 2 months. To show portfolio, mail slides, color photographs, bio and résumé. Offers advance when appropriate. Negotiates payment method and rights purchased. Requires exclusive representation of artist. Provides promotion.

Tips: Advises artists to attend New Trends Expos and Art Expo in New York and California or Art Buyers Caravan.

‡SIERRA SUN EDITIONS, 5090 Robert J. Mathews Pkwy., Suite 2, El Dorado Hills CA 95762. (916)933-2228. Fax: (916)933-6224. Art Director: Ravel Buckley. Art publisher, distributor. Publishes/distributes hand-pulled originals, limited editions, unlimited editions, canvas transfers, fine art prints, offset reproductions. Clients: galleries, decorators, frame shops, distributors, architects, corporate curators, museum shops, gift-shops, and sports memorabilia and collectibles stores. Current clients include: Sports Legacy, Field of Dreams, Deck the Walls and Sports Forum.

Needs: Seeking creative, fashionable, decorative art for the serious collector, commercial and designer markets. "We publish/distribute primarily professional team sports art—i.e., celebrity athletes of major leagues—National Football League, Major League Baseball. We accept submissions of all subject matter for our licensing division which deals primarily with placing artworks on giftwares." Considers oil, acrylic, watercolor, mixed media, pastel. Artists represented include Daniel M. Smith, Stephen Holland, Vernon Wells, Eric Franchimon. Rick Rush. Editions created by collaborating with the artist or by working from an existing painting. Approached by 60 artists/year. Publishes the work of 1-2 emerging, 2-3 mid-career and 7 established artists/year. Distributes the work of 3-8 emerging, 3-8 mid-career and 4-8 established artists/year. Also needs freelancers for design. Prefers local designers who own Mac computer.

First Contact & Terms: Send query letter with brochure, résumé, SASE, slides, tearsheets, photographs. Samples are filed or returned by SASE. Reports back within 1-3 months. Company will contact artist for portfolio review of color, final art, thumbnails, transparencies if interested. Pays royalties of 10-20%; or on a consignment basis: firm receives 20-40% commission. Negotiates payment regarding licensing of works. Offers advance when appropriate. May require exclusive representation of artist. Provides advertising, promotion, shipping from our firm, written contract, trade shows, gallery shows. Finds artists through word of mouth, art trade shows, gallery owners.

Tips: "Unique and original concepts in sports art other than portrait style, is a growing trend and crosses over into the collectible market."

‡SIGNATURE PUBLISHING, 12558 Darkwood, San Diego CA 92129. (619)538-5777. Fax: (619)538-5778. Vice President: Heidi Humphreys. Estab. 1995. Art publisher. Publishes limited editions, unlimited editions, fine art prints, posters. Clients: galleries, frame shops, mass merchant, wholesale framers.

INSIDER REPORT

Follow Trends in the Print and Poster Market

You're likely to get a smile and a quick, thoughtful response from Lauren Karp, creative director of Scandecor Inc., if you follow her two marketing musts: send a SASE and "do a little research first." The former is a courtesy and a time-saver for busy art directors. The latter saves you, the artist, from wasting your energies and, well, lots of paper. More important, doing your homework can boost your chances of success in the dynamic poster market.

With six years at the international poster company behind her and an earlier successful run as a small business owner in the gift industry, Karp has marketing experience from both ends of the spectrum. Though she has no formal artistic training (she holds a degree in marketing and management),

Lauren Karp

Karp has become an expert at spotting marketable poster images.

In scouting artwork, creative directors keep their company's product lines in mind, says Karp. So, before submitting to companies, you should examine their product lines to make sure your style fits their needs. Scandecor, for example, has three separate poster lines. Miniposters, $16\frac{1}{2} \times 23\frac{1}{4}$, are "soft and fluffy" images, targeted primarily to mothers and children. Funsters, or fun posters, are $11\frac{1}{2} \times 16\frac{1}{4}$ and cover a variety of humorous subjects. Scandecor's full-size poster line, 27×39, targeted to teens, is the area most influenced by current trends. Karp currently buys a lot of fantasy images—wizards, dragons and the like. Soccer and roller hockey are on the upswing in the capricious teen market, however, that could change.

Karp identifies four areas that influence trends: advertising, film, music and books. If you want to sell your work to poster companies and gift manufacturers, you'd be wise to check out what's hot in these areas. The simplest research method? Examine what's on shelves, particularly greeting cards. "Go to gift stores. One trip to the mall and I can spot a lot of things," says Karp. For instance, you'll undoubtedly see a wide selection of posters featuring food. Chili peppers and coffee images are very popular. Gardening and country images are also big.

The poster market has recently seen the most growth in the fine art genre, says Karp. Scandecor is introducing two new art lines to its mass market prints. The most popular medium for Scandecor's art lines is watercolor, although Karp considers and purchases images created in other media. Karp looks for "finished pieces." She rarely commissions works, although some poster companies do.

INSIDER REPORT, *Karp*

Since Scandecor markets abroad, Karp has learned that what sells overseas can be different from what sells in the U.S. For example, Americans tend to be more conservative than Europeans. "Nudes are not as shocking in Europe. We can't sell those types of images here," she says. An image that spans cultures has a greater chance of living a long market life. "Some pieces have been in our line for ten years," adds Karp. As a general rule, trends hit Europe a year later than in the U.S. The exception is the music field. Trends in music sometimes take off in Europe before hitting the U.S.

The gift and poster field can be very lucrative for artists with plenty of hot products on the market. "The more countries that use the piece, the more money [we pay]," she says. Every company structures its pay standards differently. Karp agrees to few royalty deals, although this differs slightly depending on the product line. "Generally, I'll buy poster rights for a flat fee, usually for two years," she says.

If Karp chooses not to purchase an image, she tactfully tries to explain her reason. She is more likely to respond in detail if an artist takes care with his or her submission. "I have always tried to be fair and responsive to artists—to be a critic. But it gets a little overwhelming if they don't do their research."

Check the *Artist's & Graphic Designer's Market* for companies that sell the type of images you create. Also, consider attending national and regional trade shows, such as the New York Stationery Show, to get a feel for product lines and upcoming trends. One word of warning, however, these shows can be pricey jaunts. "Don't expect companies to look at your work there," Karp says. The

"This poster had to appeal to both boys and girls," says illustrator Michael Mace. "I chose bright colors and tried to stay away from a strict realistic approach." Mace landed the assignment as a result of a promotional mailer sent to Scandecor, and has since done several projects for the company. "The original art was shown at a stationery show in London, which lead to my being approached by several potential clients, clients I doubt would have noticed me any other way."

Needs: Seeking creative, fashionable, decorative art for the serious collector, commercial and designer markets "in current colors and trends." Considers oil, acrylic, watercolor, mixed media, pastel. Artists represented include Jason Denaro, Laurie Karsgarden, Harold Lyon, Judith Moore-Knapp. Editions created by collaborating with the artist and accepting artwork previously done by artists. Approached by hundreds of artists/year. Also needs freelancers for design.

First Contact & Terms: Send query letter with slides, photocopies, tearsheets, photographs, SASE or transparencies. Samples are filed and are returned by SASE. Reports back only if interested. Negotiates payment. Offers advance when appropriate. Negotiates rights purchased. May require exclusive representation of artist. Provides insurance while work is at firm, promotion, shipping from our firm, written contract.

Tips: "Keep an eye on the color guides and what is going on in the material and china arenas."

‡✳**SIMON ART LTD.**, 5456 Tomken Rd., Unit #10, Mississauga, Ontario L4W 2Z5 Canada. (416)599-9371. Fax: (416)595-5093. Marketing Coordinator: Julie Insley. Estab. 1981. Art publisher and distributor of posters and limited editions. Clients: galleries, framing shops.

Needs: Considers oil, watercolor, pastel and acrylic. Prefers representational, nostalgic, sports. Artists represented include Mark Farand, Samantha Wendell, Mehrdad Samimi, Heather Cooper, Jose Trinidad. Editions created by collaborating with the artist. Approached by 50-75 artists/year. Publishes and distributes the work of 0-1 emerging artist/year. Publishes and distributes the work of 8-10 established artists/year.

First Contact & Terms: Send query letter with slides, résumé and photographs. Accepts disk submissions compatible with CorelDraw III and Aldus PageMaker. Samples are not filed and are returned. Reports back in 2-3 months. To show a portfolio, mail appropriate materials: photostats, slides, tearsheets and photographs. Pays royalties. Offers advance when appropriate. Requires exclusive representation of artist. Provides promotion and a written contract.

‡**SIPAN LLC**, 300 Glenwood Ave., Raleigh NC 27603. Phone/fax: (919)833-2535. Member: Owen Walker III. Estab. 1994. Art publisher. Publishes handpulled originals. Clients: galleries and frame shops.

Needs: Seeking art for the serious collector and the commercial market. Considers oil, acrylic, watercolor. Prefers traditional themes. Artists represented include Altino Villasante. Editions created by collaborating with the artist. Approached by 5 artists/year. Publishes/distributes the work of 1 emerging artist/year.

First Contact & Terms: Send photographs, SASE and transparencies. Samples are not filed and are returned by SASE. Reports back within 2 weeks. Company will contact artist for portfolio review of color final art if interested. Negotiates payment. Offers advance when appropriate. Buy all rights. Requires exclusive representation of artist. Provides advertising, in-transit insurance, insurance while work is at firm, promotion, written contract.

‡✳**SJATIN BV**, P.O. Box 4028, 5950 AA Belfeld/Holland. 3177 475 1998. Fax: 31774 475 1965. Vice President: Monique van den Hurk. Estab. 1920. Art publisher. Publishes handpulled originals, limited editions, unlimited editions, fine art prints, offset reproductions, greeting cards. Clients: furniture stores, department stores. Current clients include: Karstadt (Germany), Morres Meubel-Hulst (Holland).

● Sjatin actively promotes worldwide distribution for artists they sign.

Needs: Seeking decorative art for the commercial market. Considers oil, acrylic, watercolor, mixed media, pastel. Prefers romantic themes, florals, landscapes/garden scenes, women. Artists represented include Willem Haenraets, Peter Motz, Reint Withaar. Editions created by collaborating with the artist or by working from an existing painting. Approached by 50 artists/year. "We work with 20 artists only, but publish a very wide range from cards to oversized prints and we sell copyrights."

First Contact & Terms: Send brochure and photographs. Reports back only if interested. Company will contact artist for portfolio review of color photographs (slides) if interested. Negotiates payment. Offers advance when appropriate. Buys all rights. Provides advertising, promotion, shipping from our firm and written (if requested).

Tips: "Be aware of current color trends. Work in series."

SOHO GRAPHIC ARTS WORKSHOP, 433 W. Broadway, Suite 5, New York NY 10012. (212)966-7292. Director: Xavier H. Rivera. Estab. 1977. Art publisher, distributor and gallery. Publishes and distributes limited editions.
Needs: Seeking art for the serious collector. Considers prints. Editions created by collaborating with the artist or working from an existing painting. Approached by 10-15 artists/year.
First Contact & Terms: Send résumé. Reports back within 2 weeks. Artist should follow-up with letter after initial query. Portfolio should include slides and 35mm transparencies. Negotiates payment. No advance. Buys first rights. Provides written contract.

SOMERSET HOUSE PUBLISHING, 10688 Haddington Dr., Houston TX 77043. (713)932-6847. Fax: (713)932-7861. Contact: Shirley Jackson. Estab. 1972. Art publisher of fine art limited editions, handpulled originals, offset reproductions and canvas transfers.
Needs: Seeking creative fashionable and decorative art for the serious collector and designer market. Artists represented include G. Harvey, Charles Fracé, Larry Dyke, L. Gordon, Nancy Glazier, Phillip Crowe, Greg Beecham, Tom duBois, Michael Atkinson. Editions created by collaborating with the artist or by working from an existing painting. Approached by 150-200 artists/year.
First Contact & Terms: Send query letter with brochure, tearsheets, résumé, slides or photographs with SASE. Samples are not filed and are returned by SASE if requested by artist. Reports back in about 45 days. Publisher will contact artist for portfolio review if interested. Portfolio should include color tearsheets, photographs and slides. Pays royalties. Rights purchased vary according to project. Provides advertising, in-transit insurance, promotion, shipping to and from firm, written contract.
Tips: Artists should be aware of colors which affect the decorator market and subject matter trends. Recommends artists attend the Art Buyers Caravan trade shows in cities near them. Recommends artists read *Decor*, *USART* and *Art Business News*, publications that follow current trends in styles, color, subject matter, etc.

‡*JACQUES SOUSSAN GRAPHICS**, 37 Pierre Koenig St., Jerusalem Israel. (02)782678. Fax: (02)782426. Estab. 1973. Art publisher. Publishes handpulled originals, limited editions, sculpture. Clients: galleries, decorators, frame shops, distributors, architects. Current clients include: Rozembaum Galleries, Royal Beach Hotel.
Needs: Seeking decorative art for the serious collector and designer market. Considers oil, watercolor and sculpture. Artists represented include Calman Shemi. Editions created by collaborating with the artist. Approached by 20 artists/year. Publishes/distributes the work of 5 emerging, 3 mid-career and 2 established artists/year.
First Contact & Terms: Send query letter with brochure, slides. Artist should follow-up with letter after initial query. Portfolio should include color photographs.

‡SPORTMAN SPECIALTIES, (formerly Portraits of Nature), Box 217, Youngwood PA 15697. (412)834-2768. Owner: Mr. Burrick. Estab. 1975. Art publisher handling limited editions for galleries.
Needs: Considers oil, acrylic, pastel, watercolor, tempera and mixed media. Prefers contemporary, floral and outdoor themes. Prefers individual works of art. Publishes/distributes the work of 7 artists/year.
First Contact & Terms: Send query letter with résumé and slides—at least 20—of most recent work. Samples not filed are returned by SASE only. Reports back within 2 months. Write to schedule an appointment to show a portfolio that should include original/final art. Payment method is negotiated. Buys reprint rights. Does not require exclusive representation of the artist. Provides promotion and contract while work is at firm.

‡SPORTS ART INC, Dept. AM, 513 SW 5th St., P.O. Box 1360, Willmar MN 56201. (800)626-3147. President: Dennis LaPoint. Estab. 1989. Art publisher and distributor of limited and unlimited editions, offset reproductions and posters. Clients: over 2,000 active art galleries, frame shops and specialty markets.
Needs: Seeking artwork with creative artistic expression for the serious collector and the designer market. Considers oil, watercolor, acrylic, pastel, pen & ink and mixed media. Prefers sports themes. Artists represented include Ken Call, Anne Peyton, Tom McKinney and Terrence Fogarty. Editions created by collaborating with the artist or working from an existing painting. Approached by 150 artists/year. Publishes the work of 2 emerging and 4 mid-career artists/year. Distributes the work of 30 emerging, 60 mid-career and 30 established artists/year.

‡ **THE DOUBLE DAGGER** before a listing indicates that the listing is new in this edition. New markets are often more receptive to freelance submissions.

First Contact & Terms: Send query letter with brochure showing art style or résumé, tearsheets, SASE, slides and photographs. Accepts submissions on disk. Samples are filed or returned by SASE if requested by artist. To show a portfolio, mail thumbnails, slides and photographs. Pays royalties of 10%. Offers an advance when appropriate. Negotiates rights purchased. Sometimes requires exclusive representation of the artist. Provides promotion and shipping from firm.

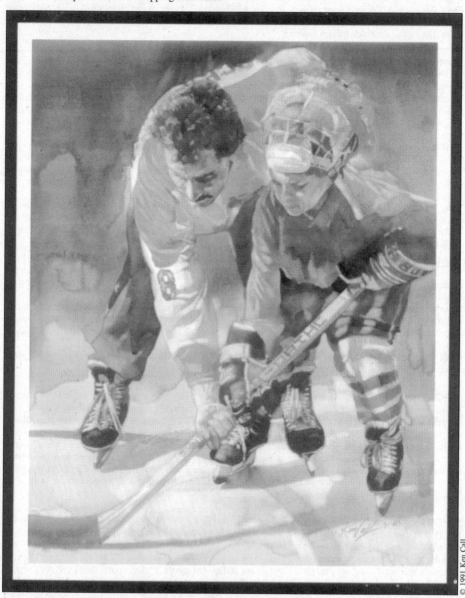

Sports Art Inc. publishes and distributes thousands of sports images to galleries and frameshops across the U.S. and Canada. Ken Call's print, *The Finer Points*, has been one of their best-selling hockey pieces. (It sells for $75.) "Ken captures the total feel of learning to play the game," says Sharon LaPoint of SAI. "The interpretation of the image is in the eye of the beholder—a coach and his player, or possibly a father and a son." The work was painted in watercolor.

‡**SUMMERFIELD EDITIONS**, 2019 E. 3300 S., Salt Lake City UT 84109. (801)484-0700. Fax: (800)485-7172. Contact: Kathleen Morrow. Publishes limited editions, fine art prints, posters. Clients: galleries, decorators, frame shops and gift shops.

Needs: Seeking decorative art for the designer market. Considers oil, acrylic, watercolor, mixed media and pastel. Prefers traditional themes. Artists represented include Karen Christensen, Ann Cowdell and Pat Enk. Editions created by collabortaing with the artist or by working from an existing painting. Approached by 24 artists/year. Samples are not filed and are not returned. Reports back only if interested. Company will contact artists for portfolio review of color sample; "good presentation of work." Negotiates payment. Offers advance when appropriate. Rights purchased vary according to project; prefers all rights. Provides advertising and written contract. Finds artists through art exhibitions, art fairs, word of mouth.
Tips: Sees trend toward "sporting themes without being cute; rich colors. Artwork should come from the heart."

JOHN SZOKE GRAPHICS INC., 164 Mercer St., New York NY 10012. Director: John Szoke. Produces limited edition handpulled originals for galleries, museums and private collectors.
Needs: Original prints, mostly in middle price range, by up-and-coming artists. Artists represented include James Rizzi, Jean Richardson, Asoma, Scott Sandell and Bauman. Publishes the work of 2 emerging, 10 mid-career and 2 established artists/year. Distributes the work of 10 emerging, 10 mid-career and 5 established artists/year.
First Contact & Terms: Send slides with SASE. Request portfolio review in original query. Reports within 1 week. Charges commission, negotiates royalties or pays flat fee. Provides promotion and written contract.

‡THINGS GRAPHICS & FINE ART, 1522 14th St. NW, Washington DC 20005. (202)667-4028. Fax: (202)328-2258. Special Assistant—New Acquisitions: Michael Robertson. Estab. 1984. Art publisher and distributor. Publishes/distributes limited and unlimited editions, offset reproductions and posters. Clients: gallery owners. Current clients include Savacou Gallery and Deck the Walls.
Needs: Seeking artwork with creative expression for the commercial market. Considers oil, watercolor, acrylic, pen & ink, mixed media and serigraphs. Prefers Afro-American, Caribbean and "positive themes." Artists represented include James Denmark and Leroy Campbell. Editions created by working from an existing painting. Approached by 60-100 artists/year. Publishes the work of 1-5 emerging, 1-5 mid-career and 1-5 established artists/year. Distributes the work of 10-20 emerging, 10-20 mid-career and 60-100 established artists/year.
First Contact & Terms: Send query letter with résumé, tearsheets, photostats, photocopies, slides, photographs, transparencies and full-size print samples. Samples are filed. Reports back within 2-3 weeks. To show a portfolio, mail thumbnails, tearsheets, photographs, slides and transparencies. Payment method is negotiated. Does not offer an advance. Negotiates rights purchased. Provides promotion and a written contract.
Tips: "Continue to create new works; if we don't use the art the first time, keep trying us."

‡V.F. FINE ARTS, INC., 1737 Siebbins, #240B, Houston TX 77043. (713)461-1944. Fax: (713)461-2557. President: John Ruck. Estab. 1985. Art publisher of limited editions. Clients: collectible shops and galleries. Current clients include Lawrence Galleries, Georgia's Gift Gallery.
Needs: Seeking artwork for the serious collector. Considers oil. Prefers Victorian themes and style. Artists represented include Sandra Kuck. Editions created by collaborating with artist. Approached by 5 artists/year.
First Contact & Terms: Send query letter with brochure showing art style and tearsheets. Samples are filed. Reports back only if interested. To show a portfolio, mail photographs. Pays royalties. Offers advance when appropriate. Buys all rights. Provides promotion, shipping from firm and a written contract.

VARGAS FINE ART PUBLISHING, INC., (formerly Vargas & Associates Art Publishing, Inc.), 4461 Nicole Dr., Lanham MD 20706. (301)731-5175. Fax: (301)731-5712. President: Elba Vargas-Colbert. Estab. 1988. Art publisher and worldwide distributor of serigraphs, limited and open edition offset reproductions. Clients: galleries, frame shops, museums, decorators, movie sets and TV.
Needs: Seeking creative art for the serious collector and commercial market. Considers oil, watercolor, acrylic, pastel pen & ink and mixed media. Prefers ethnic themes. Artists represented include Joseph Holston, Kenneth Gatewood, Tod Haskin Fredericks, Betty Biggs, Norman Williams, Sylvia Walker, James Ransome, Leroy Campbell, William Tolliver, Sylvia Walker and Paul Goodnight. Approached by 100 artists/year. Publishes/distributes the work of about 80 artists.
First Contact & Terms: Send query letter with résumé, slides and/or photographs. Samples are filed. Reports back only if interested. To show portfolio, mail photographs. Payment method is negotiated. Requires exclusive representation of the artist.
Tips: "Vargas Fine Art Publishing is standing as a major publisher committed to publishing artists of the highest caliber, totally committed to their craft and artistic development."

VIBRANT FINE ART, 3444 Hillcrest Dr., Los Angeles CA 90016. (213)766-0818. Fax: (213)737-4025. Art Director: Phyliss Stevens. Estab. 1990. Art pubisher and distributor. Publishes and distributes handpulled serigraphs, originals, limited and unlimited editions and offset reproductions. Clients: galleries, designers, giftshops and frame shops. Current clients include MTM Productions (Hollywood), Kaiser Permanente Hospi-

tal (Los Angeles), McPherson Enterprises (Los Angeles), Joseph's Restaurant, Traps Boutique, Designer's Network.

Needs: Seeking decorative and ethnic art for the commercial and designer markets. Considers sculptures, textiles, wearable art, oil, watercolor, mixed media, pastel and acrylic. Prefers African-American, Native American, Latino. Artists represented include Sonya A. Spears, Edgar Arcenaux, Maurice Goens, Van Johnson, Tom Feelings, Ma Yemba, Williaim Crite. Editions created by collaborating with the artist or by working from an existing painting. Approached by 30 artists/year. Publishes the work of 15 emerging and 10 established artists/year. Distributes the work of 30 emerging artists and 20 established artists/year. Also needs freelancers for design. 20% of products require design work. Should be familiar with Adobe Illustrator and Mac applications.

First Contact & Terms: Send postcard size sample of work or send query letter with brochure, résumé, tearsheets and slides. Designers send 35mm slides and/or sharp 4×5 color photos of the artist's work. Samples not filed and are returned by SASE. Publisher/distributor will contact artist for portfolio review if interested. Portfolio should include color tearsheets, photographs, slides and biographical sketch. Negotiates payment. Offers advance when appropriate. Rights vary according to project. Provides advertising, in-transit insurance, promotion, written contract and publication in catalog. Finds artists through trade shows, art exhibitions and referrals.

Tips: "Pay attention to current color trends. Be flexible and willing to work with the client and create art that communicates." Recommends artists attend Art Buyers Caravan and Art Expo and read *Decor, American Visions* and *Sunshine Artist Magazine.*

WATERMARK FINE ARTS, Lafayette Court, Suite 402, Kennebunk ME 04043. (207)985-6134. Fax: (207)985-7633. Publisher: Alexander Bridge. Estab. 1989. Art publisher. Publishes and distributes limited and unlimited editions, posters, offset reproductions and stationery. Clients: framers, galleries.

Needs: Seeking creative art for the commercial market. Specializes in rowing and sporting art. Considers oil, watercolor, mixed media, pen & ink, acrylic and b&w photography. Artists and photographers represented include John Gable, David Foster and Amy Wilton. Editions created by collaborating with the artist. Approached by 100 artists/year. Publishes and distributes the work of 3 mid-career artists and photographers 2 established artists/year. Also uses freelancers for design. 15% of projects require freelance design. Send slides.

‡WEBSTER FINE ART LTD., 1185 Tall Tree Rd., Clemmons NC 27012. (910)712-0900. Fax: (910)712-0974. President: John Stephenson. Art publisher. Estab. 1987. Publishes unlimited editions, offset reproductions. Clients: galleries, decorators, frame shops, distributors, giftshops. Current clients include: Bombay Co. to Pier 1.

Needs: Seeking creative, decorative art. Considers acrylic, watercolor, pastel. Prefers classic decorative. Artists represented include Fiona Butler, Gaye Fate Noble. Editions created by collaborating with the artist or by working from an existing painting. Approached by 50 artists/year. Publishes the work of 5 emerging, 5 mid-career and 5 established artists/year. Also needs freelancers for design. Prefers local designers who own IBM computer.

First Contact & Terms: Send brochure, photocopies, photographs, slides, tearsheets, transparencies. Samples are returned. Reports back within 1 month. Company will contact artist for portfolio review of b&w, color, photographs, photostats, roughs, slides and transparencies. Pays $250 advance plus 10% royalty on net invoice value. Offers advance when appropriate. Negotiates rights purchased. Provides advertising, in-transit insurance, insurance while work is at firm, shipping from our firm. Finds artists by advertising in trade magazines, ABC Shows, foreign travel, word of mouth.

Tips: "Check decorative home magazines—*Southern Accents, Architectural Digest, House Beautiful,* etc.— for trends."

‡THE WHITE DOOR PUBLISHING COMPANY, P.O. Box 427, New London MN 56273. (320)796-2209. Fax: (320)796-2968. President: Mark Quale. Estab. 1988. Art publisher. Publishes limited editions, offset reproductions. Clients: 1,000 galleries (authorized dealer network).

Needs: Seeking creative art for the commercial market. Considers oil, acrylic, watercolor, mixed media, pastel. Prefers "traditional" subject matter. Artists represented include Charles L. Patterson, Bradley J. Parrish, Dan Mieduch and D. Edward Kucera. Editions created by collaborating with the artist or by working from an existing painting. Approached by 250 artists/year. Publishes the work of 2-3 emerging, 2-3 mid-career and 4-6 established artists/year.

First Contact & Terms: Send photographs, SASE, slides, tearsheets, transparencies. Samples are not filed and are returned by SASE. Reports back within 2 weeks. Company will contact artist for portfolio review of color photographs, slides, transparencies. Pays royalties. Buys one-time and reprint rights. Requires exclusive representation of artist. Provides advertising, in-transit insurance, insurance while work is at firm, shipping to and from our firm, written contract. Finds artists through attending art exhibitions, word of mouth, submissions and art publications.

Tips: "Nostalgia and images reflecting traditional values are good subjects. Versatility not important. Submit only the subjects and style you love to paint."

Lavender

Fiona Butler's *Lavender* displays "timeless elegance and simplicity. The lavender appears to be 'waving' in the breeze and releasing its delicate bouquet," says John Stephenson of Webster Fine Art Ltd. This watercolor work is a best seller for the publisher, who released *Lavender* with five other images, a set of six prints of healing herbs. The work also appears on the cover of a 1997 calendar.

WHITEGATE FEATURES SYNDICATE, 71 Faunce Dr., Providence RI 02906. (401)274-2149. Talent Manager: Eve Green.
• This syndicate is looking for fine artists and illustrators. See listing in Syndicates & Clip Art firms section for information on their needs.
First Contact & Terms: "Please send (non-returnable) slides or photostats of fine arts works. We will call if a project suits your work."

WILD APPLE GRAPHICS, LTD., HCR 68 Box 131, Woodstock VT 05091. (802)457-3003. Fax: (802)457-3214. Art Director: Laurie Chester. Estab. 1989. Art publisher and distributor of posters and unlimited editions. Clients: frame shops, interior designers and furniture companies. Current clients include Deck the Walls, Pier 1, Bed & Bath Shops, The Bombay Company and many catalog and furniture companies.
Needs: Seeking decorative art for the commercial and designer markets. Considers all media. Artists represented include Warren Kimble, Charles Lynn Bragg, Kathy Jakobsen, Nancy Pallan, Deborah Schenck and Coco Dowley. Editions created by working from an existing painting or transparency. Approached by 1,000 artists/year. Publishes and distributes the work of 6-8 emerging and mid-career and 10-12 established artists/year.
First Contact & Terms: Send query letter with résumé and slides, photographs or transparencies. Samples are returned by SASE. Reports back within 2 months. Negotiates payment method and rights purchased. Provides in-transit insurance, insurance while work is at firm, promotion, shipping to and from firm and a written contract.
Tips: "Don't be trendy. Paint images that will have broad appeal and can stay on walls for a long time. Power Ranger or alien art (which we have, in fact, received) is not saleable for a company like ours."

WILD WINGS INC., S. Highway 61, Lake City MN 55041. (612)345-5355. Fax: (612)345-2981. Merchandising Manager: Sara Koller. Estab. 1968. Art publisher, distributor and gallery. Publishes and distributes limited editions and offset reproductions. Clients: retail and wholesale.
Needs: Seeking artwork for the commercial market. Considers oil, watercolor, mixed media, pastel and acrylic. Prefers fantasy, military, golf, variety and wildlife. Artists represented include David Maass, Lee Kromschroeder, Ron Van Gilder, Robert Abbett, Michael Sieve and Persis Clayton Weirs. Editions created by working from an existing painting. Approached by 300 artists/year. Publishes the work of 36 artists/year. Distributes the work of numerous emerging artists/year.
First Contact & Terms: Send query letter with slides and résumé. Samples are filed and held for 6 months then returned. Reports back within 3 weeks if uninterested or 6 months if interested. Publisher will contact artist for portfolio review if interested. Pays royalties for prints. Accepts original art on consignment and takes 40% commission. No advance. Buys first-rights or reprint rights. Requires exclusive representation of artist. Provides in-transit insurance, promotion, shipping to and from firm, insurance while work is at firm and a written contract.

WINN ART GROUP, 6015 Sixth Ave. S., Seattle WA 98108. (206)763-9544. Fax: (206)762-1389. Direct Product Develop: Buster Morris. Estab. 1976. Art publisher and wholesaler. Publishes limited editions and posters. Clients: mostly trade, designer, decorators, galleries, poster shops. Current clients include: Pier 1, Z Gallerie, Intercontinental Ads, Cramton International.
Needs: Seeking decorative art for the designer market. Considers oil, watercolor, mixed media, pastel, pen & ink and acrylic. Artists represented include Buffet, de Claviere, Dench, Gunn, Hayslette, Horning, Hall, Wadlington, Singley, Schaar. Editions created by working from an existing painting. Approached by 300-400 artists/year. Publishes and distributes the work of 0-3 emerging, 3-8 mid-career and 8-10 established artists/year.
First Contact & Terms: Send query letter with brochure, slides, photocopies, résumé, photostats, transparencies, tearsheets or photographs. Samples are returned by SASE if requested by artist. Reports back within 4-6 weeks. Publisher will contact artist for portfolio review if interested. Portfolio should include "whatever is appropriate to communicate the artist's talents." Pay varies. Offers advance when appropriate. Rights purchased vary according to project. Provides written contract. Finds artists through attending art exhibitions, agents, sourcebooks, publications, submissions.
Tips: Advises artists to attend Art Expo New York City, ABC Atlanta. "I would advise artists to attend just to see what is selling and being shown, but keep in mind that this is not a good time to approach publishers/exhibitors with your artwork."

Book Publishers

The illustrations you see on covers and within the pages of books are for the most part created by freelance artists. If you like to read and work creatively to solve problems, the world of publishing could be a great market for you.

Every year thousands of books are published, and each must compete with all the other titles for the public's attention. As the saying goes, "You can't judge a book by its cover," but every publisher knows an intriguing cover can coax the reader to pick up a book and look inside.

The interior of a book is important, too. Designers create the page layouts that direct us through the text. This is particularly important in children's books and textbooks. Many publishing companies hire freelance designers with computer skills to design interiors of books on a contract basis. Look within each listing for the subheading Book Design, to find the number of design jobs assigned each year, and how much is paid per project. Look under the Needs heading to find out what computer software the company uses. If you have a home computer with compatible software, your chances of winning an assignment increase.

Most assignments are for jackets/covers. The illustration on the cover, combined with typography and the layout choices of the designer, announce to the prospective reader at a glance the style and content of a book. If it is a romance novel, it will show a windswept couple in a passionate "clinch." (Read illustrator Harry Burman's Insider Report on page 325 to find out how he creates dramatic romance novel covers.) Suspenseful spy novels tend to feature stark, dramatic lettering and symbolic covers. Covers for fantasy and science fiction novels, as well as murder mysteries and historical fiction tend to show a scene from the story. Visit a bookstore and then decide which kind of book you'd like to work on.

WHO'S BUYING WHAT

As you read the listings in this section, you'll see that within the first paragraph of each listing, we describe the type of books each publisher specializes in. This may seem obvious, but submit only to publishers who specialize in the type of book you want to illustrate or design. There's no use submitting to a publisher of textbooks on higher geometry if you want to illustrate bunny rabbits and puppy dogs for children's picture books.

You'll notice a few terms, such as "trade books" and "mass market," keep cropping up in our listings. Though it's hard to pin down accurate definitions because the terms overlap a bit, here's a short overview of market terms that might clear up some confusion:

• **Mass market** books are sold everywhere, in supermarkets, newsstands, drugstores, bookstores and department stores. Picture the racks of shiny covered paperbacks by popular authors like Stephen King, hardcover "unauthorized" biographies, and books describing the latest diet craze. Mass market outlets also carry colorful picture books for preschoolers, often featuring licensed characters like Barney, Bugs Bunny, Mickey and Minnie.

• **Trade books** are the hardcover and paperback kind you generally find only in bookstores and libraries. The paperbacks are larger than those on the mass market racks.

Often tagged "quality" paperbacks, they are printed on higher quality paper, and feature matte-paper jackets. Children's trade books are of a superior quality and feature beautiful illustrations.

• **Textbooks** are, of course, sold to schools and colleges. They feature plenty of illustrations, photographs, and charts to explain their subjects.

• **Small press** books are books not produced by a larger, commercial house, but by a small, independent publisher. Many are literary or scholarly in theme, and often feature fine art on the cover.

• **Backlist titles** or **reprints** refer to publishers' titles from past seasons that continue to sell year after year. These books are often updated and republished with freshly designed covers to make them more attractive to readers.

For further information on book publishing refer to *Writer's Market*, *Novel & Short Story Writer's Market*, *Literary Market Place* and *Books in Print*. The trade magazines *Publishers Weekly* and *Small Press* provide updates on the industry.

THE BEST APPROACH

Most publishers keep extensive files of art samples and refer to these files each time they're ready to make an assignment. To earn a place in these files, first target your submission to match the unique style of the publisher you're approaching. Send five to ten nonreturnable samples along with a brief letter and a SASE. Never send originals (see What Should I Submit? on page 4). Most art directors prefer samples that are 8½ × 11 or smaller that can fit in file drawers. Bulky submissions are often considered a nuisance.

GETTING PAID

A few publishers purchase existing art, but most will make assignments for specific projects. Payment for freelance design and illustration varies depending on the size of the publisher, the type of project and the rights bought. Most publishers pay on a per-project basis, although some publishers of highly illustrated books (such as children's books) pay an advance plus royalties. A few very small presses may only pay in copies.

ILLUSTRATING FOR CHILDREN'S BOOKS

The children's book industry is another outlet for freelance designers and illustrators. It's important to understand, however, that working in children's books requires a specific set of skills. Illustrators must be able to draw the same characters in a variety of action poses and situations. More and more kids' books now include unique design elements such as acetate overlay inserts, textured pages, pop out projects and die cuts. Like other publishers, many children's publishers are expanding their product lines to include multimedia projects (CD-ROM and software). A number of children's publishers are listed in this book. If you plan to make children's books your focus, *Children's Writer's & Illustrator's Market*, published by Writer's Digest Books (800)289-0963, is a great resource for anyone entering this field.

AAIMS PUBLISHERS, (formerly McKinzie Publishing Company), 11000 Wilshire Blvd., P.O. Box 241777, Los Angeles CA 90024-9577. (213)934-7685. Fax: (213)931-7217. Director of Art: Nancy Freeman. Estab. 1969. Publishes hardcover, trade and mass market paperback originals and textbooks. Publishes all types of fiction and nonfiction. Publishes 15 titles/year. Recent titles include *A Message from Elvis*, by Harry McKinzie; and *USMC Force Recon: A Black Hero's Story*, by Amankwa Adeduro. Book catalog for SASE.
Needs: Uses freelancers for jacket/cover design and illustration. Also for text illustration, multimedia projects and direct mail and book catalog design. Works on assignment only. 80% of freelance work requires knowledge of Microsoft Word and WordPerfect.
First Contact & Terms: Send query letter with SASE, photographs and photocopies. Samples are filed or are returned by SASE. Portfolio should include thumbnails and roughs. Sometimes requests work on spec before assigning a job. Buys all rights. Originals are not returned. Pays by the project, negotiated.
Tips: "Looking for design and illustration that is appropriate for the general public. Book design is becoming smoother, softer and more down to nature with expression of love of all—humanity, animals and earth."

HARRY N. ABRAMS, INC., 100 Fifth Ave., New York NY 10011. (212)206-7715. Art Director: Dirk Luykx. Estab. 1951. Company publishes hardcover originals, trade paperback originals and reprints. Types of books include fine art and illustrated books and textbooks. Publishes 150 titles/year. 5% require freelance design. Book catalog available for $5.
Needs: Approached by 250 freelancers/year. Works with few freelance illustrators and less than 10 designers/year. Uses freelancers mainly for textbook diagrams, maps and occasional text illustration. 90% of freelance design and 50% of illustration demands knowledge of Adobe Illustrator, QuarkXPress and Adobe Photoshop. Works on assignment only.
First Contact & Terms: Send query letter with résumé, tearsheets, photocopies. Accepts disk submissions. Samples are filed "if work is appropriate." Samples are returned by SASE if requested by artist. Portfolios may be dropped off every Monday-Thursday. Art Director will contact artist for portfolio review if interested. Portfolio should include printed samples, tearsheets and/or photocopies. Buys all rights. Originals are returned at job's completion, with published product. Finds artists through word of mouth, submissions, attending art exhibitions and seeing published work.
Book Design: Assigns 10 freelance design jobs/year. Pays by the project.
Text Illustration: Rarely assigns. Pays by the project.
Tips: "Most art that we would buy would be to decorate title or chapter openers, or binding stamping, in the style of art(ist) being published."

ADAMS MEDIA CORPORATION (formerly Adams Publishing), 260 Center St., Holbrook MA 02343. (617)767-8100. Fax: (617)767-0994. Managing Editor: Christopher Ciaschini. Estab. 1980. Company publishes hardcover originals, trade paperback originals and reprints. Types of books include biography, cookbooks, history, humor, instructional, New Age, nonfiction, reference, self-help and travel. Specializes in business and careers. Publishes 100 titles/year. 10% require freelance illustration; 100% require freelance design. Book catalog free by request.
Needs: Approached by 20 freelancers/year. Works with 3 freelance illustrators and 7-10 designers/year. Buys less than 100 freelance illustrations/year. Uses freelancers mainly for jacket/cover illustration, text illustration and jacket/cover design. 100% of freelance work demands computer skills. Freelancers should be familiar with QuarkXPress 3.3 and Adobe Photoshop, preferably Windows-based.
First Contact & Terms: Send postcard sample of work. Samples are filed. Art Director will contact artist for portfolio review if interested. Portfolio should include tearsheets. Rights purchased vary according to project, but usually buys all rights.
Jackets/Covers: Assigns 70 freelance design jobs/year. Pays by the project, $700-1,500.
Text Illustration: Assigns 10 freelance illustration jobs/year.

AFRICA WORLD PRESS, INC., 11 Princess Rd., Suite D, Lawrenceville NJ 08648. (609)844-9583. Fax: (609)844-0198. E-mail: africawpress@nyo.com. Art Director: Linda Nickens. Estab. 1984. Publishes hardcover and trade paperback originals. Types of books include biography, preschool, juvenile, young adult and history. Specializes in any and all subjects that appeal to an Afrocentric market. Publishes 50 titles/year. Recent titles include *Blacks Before America*, by Mark Hyman; and *Too Much Schooling Too Little Education*, by Mwalimu J. Shujaa. 60% require freelance illustration; 10% require freelance design. Book catalog available by request. Approached by 50-100 freelancers/year. Works with 5-10 illustrators and 4 designers/year. Buys 50-75 illustrations/year. Prefers artists with experience in 4-color separation and IBM-compatible Aldus PageMaker. Uses freelancers mainly for book illustration. Also for jacket/cover design and illustration. Uses designers for typesetting and formatting.
Needs: "We look for freelancers who have access to or own their own computer for design and illustration purposes but are still familiar and proficient in creating mechanicals, mock-ups and new ideas by hand." 50% of freelance work demands knowledge of Aldus PageMaker 5.0, CorelDraw 4.0 and Word Perfect 6.0. Works on assignment only.

First Contact & Terms: Send query letter with brochure, tearsheets, photostats, bio, résumé, SASE, photocopies and transparencies. Samples are filed or are returned by SASE if requested by artist. Reports back within 4-6 weeks. Write for appointment to show portfolio, or mail b&w and color photostats, tearsheets and 8½×11 transparencies. Rights purchased vary according to project. Originals are returned at job's completion if artist provides SASE and instructions.
Book Design: Assigns 100 freelance design jobs/year. Pays by the project, $400-3,000.
Jackets/Covers: Assigns 100 freelance design and 50-75 illustration jobs/year. Prefers 2- or 4-color process covers. Pays by the project.
Text Illustration: Assigns 25 illustration jobs/year. Prefers "boards and film with proper registration and color specification." Pays by the project.
Tips: "Artists should have a working knowledge of the Windows 3.1 platform of the IBM computer; be familiar with the four-color process (CMYK) mixtures and changes (5-100%) and how to manipulate them mechanically as well as on the computer; have a working knowledge of typefaces and styles, the ability to design them in an appealing manner; swift turn around time on projects from preliminary through the manipulation of changes and a clear understanding of African-centered thinking, using it to promote and professionally market books and other cultural items creatively. Work should be colorful, eyecatching and controversial."

ALFRED PUBLISHING CO., INC., 16380 Roscoe Blvd., Box 10003, Van Nuys CA 91410-0003. (818)891-5999. Fax: (818)891-2182. Art Director: Ted Engelbart. Estab. 1922. Book publisher. Publishes trade paperback originals. Types of books include instructional, juvenile, young adult, reference and music. Specializes in music books. Publishes approximately 300 titles/year. Recent titles include *Heavy Metal Lead Guitar; Bach: An Introduction to His Keyboard Works*; and *Singing with Young Children*. Book catalog free by request.
Needs: Approached by 40-50 freelancers/year. Works with 10 freelance illustrators and 15 designers/year. "We prefer to work directly with artist—local, if possible." Uses freelancers mainly for cover art, marketing material, book design and production. Also for jacket/cover and text illustration. Works on assignment only.
First Contact & Terms: Send résumé, SASE and tearsheets. "Photocopies are fine for line art." Samples are filed. Reports back only if interested. "I appreciate paid reply cards." To show portfolio, include "whatever shows off your work and is easily viewed." Originals are returned at job's completion.
Book Design: Assigns 10 freelance design jobs/year. Pays by the hour, $20-25, or by the project.
Jackets/Covers: Assigns 20 freelance design and 50 illustration jobs/year. Pays by the project, $150-800. "We generally prefer fairly representational styles for covers, but anything upbeat in nature is considered."
Text Illustration: Assigns 15 freelance illustration jobs/year. Pays by the project, $350-2,500. "We use a lot of line art for b&w text, watercolor or gouache for 4-color text."

ALLYN AND BACON INC., College Division, 160 Gould St., Needham MA 02194. (617)455-1200. Fax: (617)455-1294. Art Director: Linda Knowles. Publishes more than 300 hardcover and paperback textbooks/year. 60% require freelance cover designs. Subject areas include education, psychology and sociology, political science, theater, music and public speaking.
Needs: Designers must be strong in book cover design and contemporary type treatment. 50% of freelance work demands knowledge of Adobe Illustrator, Adobe Photoshop and Aldus FreeHand.
Jackets/Covers: Assigns 100 design jobs and 2-3 illustration jobs/year. Pays for design by the project, $300-750. Pays for illustration by the project, $150-500. Prefers sophisticated, abstract style in pen & ink, airbrush, charcoal/pencil, watercolor, acrylic, oil, collage and calligraphy. "Always looking for good calligraphers."
Tips: "Keep stylistically and technically up to date. Learn *not* to over-design: read instructions and ask questions. Introductory letter must state experience and include at least photocopies of your work. If I like what I see, and you can stay on budget, you'll probably get an assignment. Being pushy closes the door. We primarily use designers based in the Boston area."

AMERICA WEST PUBLISHERS, INC., P.O. Box 3300, Bozeman MT 59772. (406)585-0700. Fax: (406)585-0703. Manager: G. Green. Estab. 1985. Publishes trade paperback originals. Types of books include reference and history. Specializes in history. Publishes 40 titles/year. Recent titles include *PAN AM-103, The Lockerbie Coverup, Civil War II*. 10% require freelance illustration; 10% require freelance design. Book catalog available by request.

HOW TO USE your *Artist's & Graphic Designer's Market* offers suggestions for understanding and using the information in these listings. Read this and other articles in the front of this book for important business tips.

Needs: Approached by 5 freelancers/year. Works with 2 freelance designers/year. Buys 15 illustrations/year. Uses freelancers for jacket/cover illustration. Works on assignment only.
First Contact & Terms: Designers send query letter with brochure and photocopies. Illustrators send query letter with photocopies and photographs. Samples are filed or are returned by SASE if requested by artist. Reports back to the artist only if interested. To show portfolio, mail roughs. Buys all rights. Originals are not returned.
Book Design: Assigns 5 freelance illustration jobs/year. Pays by the project, $200-500.
Jackets/Covers: Assigns 10 freelance design and 10 illustration jobs/year. Prefers 4-color work. Pays by the project, $200-500.
Text Illustration: Assigns 2 freelance design and 2 illustration jobs/year. Prefers b&w illustration. Pays according to contract.

THE AMERICAN BIBLE SOCIETY, 1865 Broadway, New York NY 10023. (212)408-1200. Fax: (212)408-1435. Product Design: Christina Murphy. Estab. 1868. Company publishes religious products including Bibles/books, portions, leaflets, calendars, bookmarks. Types of books include religious children's books. Specializes in contemporary applications to the Bible. Publishes 60-80 titles/year. Recent titles include *Peace!* and *Justice Now!* 50% require freelance illustration; 90% require freelance design. Book catalog free by request.
Needs: Approached by 100 freelancers/year. Works with 20-30 freelance illustrators and 20 designers/year. Uses freelancers for jacket/cover illustration and design, text illustration, book design and children's activity books. 25% of freelance work demands knowledge of Adobe Illustrator, QuarkXPress, Adobe Photoshop. Works on assignment only.
First Contact & Terms: Send postcard samples of work or send query letter with brochure and tearsheets. Samples are filed and/or returned. Please do not call for appointment. Reports back within 2 months. Product Design will contact artist for portfolio review if interested. Portfolio should include final art and tearsheets. Buys all rights. Originals are returned at job's completion. Finds artists through artists' submissions, *The Workbook* (by Scott & Daughters Publishing) and *RSVP Illustrator*.
Book Design: Assigns 5 freelance design jobs/year. Pays by the project, $350-1,000.
Jackets/Covers: Assigns 60 freelance design and 40 freelance illustration jobs/year. Pays by the project, $350-2,000.
Text Illustration: Assigns 2 freelance illustration jobs/year. Pays by the project.
Tips: "Looking for contemporary, multicultural artwork/designs."

‡AMERICAN BIOGRAPHICAL INSTITUTE, 5126 Bur Oak Circle, Raleigh NC 27612. (919)781-8710. Fax: (919)781-8712. Executive Vice President: Janet Evans. Estab. 1967. Publishes hardcover reference books and biography. Publishes 5 titles/year. Recent titles include *2,000 Notable American Women; Five Hundred Leaders of Influence*. 75% require freelance illustration and design. Books are "mostly graphic text." Book catalog not available.
Needs: Approached by 4-5 freelance artists/year. Works with 2 illustrators and 2 designers/year. Buys 10 illustrations/year. Prefers artists with experience in graphics and copy design. Uses freelancers mainly for brochures (direct mail pieces). Also uses freelancers for book and direct mail design and jacket/cover illustration. 95% of freelance work demands knowledge of QuarkXPress or Adobe Photoshop. Works on assignment only.
First Contact & Terms: Send query letter with brochure, résumé, SASE and photocopies. Samples are filed. Art Director will contact artists for portfolio review if interested. Portfolio should include art samples, b&w and color dummies and photographs. Sometimes requests work on spec before assigning job. Originals are not returned. Finds artists mostly through word of mouth.
Book Design: Pays by the hour, $35-50; or by the project, $250-500.

‡AMERICAN EAGLE PUBLICATIONS, INC., P.O. Box 1507, Show Low AZ 85901. (602)888-4957. E-mail: ameagle@seagull.rtd.com. President: Mark Ludwig. Estab. 1988. Publishes hardcover originals and reprints and trade paperback originals and reprints. Types of books include historical fiction, history and computer books. Publishes 10 titles/year. Titles include *Artificial Life & Evolution*; *Computer Viruses*; *The War Nobody Won*. 100% require freelance illustration and design. Book catalog free for large SAE with 2 first-class stamps.
Needs: Approached by 10 freelance artists/year. Works with 4 illustrators and 4 designers/year. Buys 20 illustrations/year. Uses freelancers mainly for covers. Also for text illustration. 100% of design and 25% of illustration demand knowledge of Ventura Publisher and CorelDraw. Works on assignment only.
First Contact & Terms: Send query letter with résumé, SASE and photocopies. Accepts disk submissions compatible with CorelDraw or Ventura Publisher on PC. Send TIFF files. Samples are filed. Reports back only if interested. Call for appointment to show portfolio, which should include final art, b&w and color photostats, slides, tearsheets, transparencies and dummies. Buys all rights. Originals are returned at job's completion.
Jackets/Covers: Assigns 10 design and 10 illustration jobs/year. Payment negotiable (roughly $20/hr minimum). "We generally do 2-color or 4-color covers composed on a computer."

Text Illustration: Assigns 7 illustration jobs/year. Pays roughly $20/hr minumum. Prefers pen & ink.
Tips: "Show us good work that demonstrates you're in touch with the kind of subject matter in our books. Show us you can do good, exciting work in two colors."

AMERICAN INSTITUTE OF CHEMICAL ENGINEERING, 345 E. 47th St., New York NY 10017-2395. (212)705-7966. E-mail: joer@aiche.org. Website: http://www.aiche.org. Creative Director: Joseph A. Roseti. Estab. 1925. Book and magazine publisher of hardcover originals and reprints, trade paperback originals and reprints and magazines. Specializes in chemical engineering.
Needs: Approached by 30 freelancers/year. Works with 17-20 freelance illustrators/year. Prefers freelancers with experience in technical illustration. Macintosh experience a must. Uses freelancers for concept and technical illustration. Also for multimedia projects. 100% of design and 50% of illustration demand knowledge of all standard Mac programs.
First Contact & Terms: Send query letter with tearsheets. Accepts disk submissions. Samples are filed. Reports back only if interested. Call for appointment to show portfolio of color tearsheets and 3.5 Mac disk. Buys first rights or one-time rights. Originals are returned at job's completion.
Jackets/Covers: Payment depends on experience, style.
Text Illustration: Assigns 250 jobs/year. Pays by the hour, $15-40.

AMERICAN PSYCHIATRIC PRESS, INC., 1400 K St. NW, 11th Floor, Washington DC 20005. (202)682-6219. Fax: (202)682-6341. E-mail: vdove@appi.org. Website: http://www.appi.org. Promotions Coordinator: Veronica Dove. Estab. 1981. Imprint of American Psychiatric Association. Company publishes hardcover originals and textbooks. Specializes in psychiatry and its subspecialties. Publishes 60 titles/year. Recent titles include *Posttraumatic Stress Disorder*, *Textbook of Psychiatry* and *Textbook of Psychopharmacology*. 10% require freelance illustration; 10% require freelance design. Book catalog free by request.
Needs: Uses freelancers for jacket/cover design and illustration. Needs computer-literate freelancers for design. 100% of freelance work demands knowledge of QuarkXPress, Adobe Illustrator 3.0, Aldus Page-Maker 5.0. Works on assignment only.
First Contact & Terms: Designers send query letter with brochure, photocopies, photographs and/or tearsheets. Illustrators send postcard sample. Samples are filed. Promotions Coordinator will contact artist for portfolio review if interested. Portfolio should include final art, slides and tearsheets. Rights purchased vary according to project.
Book Design: Pays by the project.
Jackets/Covers: Assigns 10 freelance design and 10 illustation jobs/year. Pays by the project.
Tips: Finds artists through sourcebooks. "Book covers are now being done in Corel Draw! 5.0 but will work with Mac happily. Book covers are for professional books with clean designs. Type treatment design are done in-house."

AMHERST MEDIA, INC., 418 Homecrest Dr., Amherst NY 14226. (716)874-4450. Fax: (716)874-4508. Publisher: Craig Alesse. Estab. 1985. Company publishes trade paperback originals. Types of books include instructional and reference. Specializes in photography, videography, how-to. Publishes 8 titles/year. Recent titles include *Camcorder Tricks*, by Michael Storros; and *McBroom's Camera Bluebook*, by Mike McBroom. 20% require freelance illustration; 50% require freelance design. Book catalog free for 9 × 12 SAE with 3 first-class stamps.
Needs: Approached by 12 freelancers/year. Works with 3 freelance illustrators and 3 designers/year. Uses freelance artists mainly for illustration and cover design. Also for jacket/cover illustration and design and book design. 80% of freelance work demands knowledge of QuarkXPress or Adobe Photoshop. Works on assignment only.
First Contact & Terms: Send brochure, résumé and photographs. Samples are filed. Reports back only if interested. Art Director will contact artist for portfolio review if interested. Portfolio should include slides. Rights purchased vary according to project. Originals are returned at job's completion. Finds artists through word of mouth.
Book Design: Assigns 4 freelance design jobs/year. Pay is negotiable.
Jackets/Covers: Assigns 6 freelance design and 4 illustration jobs/year. Pay is negotiable. Prefers computer illustration (QuarkXPress/Adobe Photoshop).
Text Illustration: Assigns 3 freelance illustration job/year. Pays by the project. Prefers computer illustration (QuarkXPress).
Tips: First-time assignments are usually covers.

AMISTAD PRESS, 1271 Avenue of the Americas, Room 4634, New York NY 10020. (212)522-2675. Fax: (212)522-7282. Creative Director: Gilbert Flectcher. Estab. 1991. Company publishes hardcover originals, trade paperback originals and reprints and mass market paperback originals. Types of books include biography, cookbooks, experimental fiction, historical fiction, history, mainstream fiction, nonfiction and reference. Publishes 25 titles/year. Recent titles include *Essence Brings You Great Cooking*; and *Bruised Hibiscus*. 40% require freelance illustration; 20% require freelance design. Book catalog free by request.

Needs: Approached 30 freelancers/year. Works with 7 freelance illustrators and 3 designers/year. Buys 8-12 freelance illustrations/year. Uses freelancers for jacket/cover illustration and design, text illustration, book and catalog design. 80% of freelance work demands knowledge of Adobe Illustrator, QuarkXPress and Adobe Photoshop. Works on assignment only.
First Contact & Terms: Send postcard sample of work. Samples are filed or are returned. Portfolios may be dropped off every Monday. Art Director will contact artist for portfolio review if interested. Portfolio should include final art, photographs, photostats, slides and tearsheets. Rights purchased vary according to project. Originals are returned at job's completion. Finds artists mainly through artist directories such as *Graphic Artist Guild's Directory of Illustration, The Workbook* and *American Showcase*.
Book Design: Pays by the project, $500-2,500.
Jacket Covers: Assigns 3-5 freelance design and 4-7 illustration jobs/year. Pays by the project, $750-2,500.
Text Illustration: Assigns 10 freelance illustration jobs/year. Pays by the project, $750-2,500.

‡**AQUINO INTERNATIONAL**, (formerly Aquino Productions), P.O. Box 15760, Stamford CT 06901. (203)967-9952. Fax: (203)353-9661. Publisher: Andres Aquino. Estab. 1983. Book and magazine publisher of hardcover, trade and mass market paperback originals. Types of books include travel and photography. Publishes 10 titles/year. 10% require freelance illustration and design. Book catalog free for SASE with 2 first-class stamps.
Needs: Approached by 200-500 freelance artists/year. Works with 10-20 illustrators and 10-20 designers/year. Buys 30 illustrations/year. Uses freelance artists mainly for spot fillers, text illustration and covers. Also for direct mail, book and catalog design. 10% of freelance work demands knowledge of Aldus PageMaker.
First Contact & Terms: Send query letter with brochure, SASE, tearsheets, photographs and slides. Samples are filed. Reports back within 3-6 weeks only if interested. To show portfolio, mail appropriate materials: tearsheets, transparencies (35mm) and photographs. Rights purchased vary according to project. Originals returned at job's completion.
Jackets/Covers: Assigns 5-10 design jobs/year. Pays by the project, $50-150. Prefers mixed media and watercolor.
Text Illustration: Assigns 10-20 illustration jobs/year. Pays by the project, $50-150. Prefers b&w line drawings.
Tips: "Become familiar with our publications. Send $4 to receive sample designs, covers and guidelines."

ARDSLEY HOUSE PUBLISHERS, INC., 320 Central Park W., New York NY 10025. (212)496-7040. Assistant Editor: Chris Miragliotta. Publishes college textbooks. Specializes in math and music. Publishes 8 titles/year. Recent titles include *Music Melting Round*, by Edith Borroff; and *Ethics in Thought and Action*, by Warren Cohen. 100% require freelance illustration and design.
Needs: Works with 3-4 freelance illustrators and 3-4 designers/year. Prefers experienced local freelancers. Uses freelancers mainly for cover illustrations and technical drawing. Also for direct mail and book design. 50% of freelance work demands computer skills. Works on assignment only.
First Contact & Terms: Send query letter with brochure and résumé. Samples are filed and are not returned. Reports back only if interested.
Book Design: Assigns 3-4 freelance design jobs/year. Pays by the project.
Jackets/Covers: Assigns 8 freelance design jobs/year. Pays by the project.
Text Illustration: Assigns 8 freelance jobs/year. Pays by the project.
Tips: "We'd like to see snappy, exciting, but clear designs. We expect freelancers to have a sense of responsibility and show evidence of ability to meet deadlines."

ARJUNA LIBRARY PRESS, 1025 Garner St., D, Space 18, Colorado Springs CO 80905-1774. Director: Captain Baron Joseph A. Uphoff, Jr. Estab. 1979. Company publishes trade paperback originals and monographs. Types of books include experimental fiction, fantasy, horror, nonfiction and science fiction. Specializes in surrealism and metamathematics. Publishes 1 or more titles/year. Recent titles include *English Is a Second Language* and *Spider Lands*. 100% require freelance illustration. Book catalog available for $1.
Needs: Approached by 1-2 freelancers/year. Works with 1-2 freelance illustrators/year. Buys 1-2 freelance illustrations/year. Uses freelancers for jacket/cover and text illustration.
First Contact & Terms: Send query letter with brochure, résumé, SASE, tearsheets, slides, photographs and photocopies. Samples are filed. Reports back if interested. Portfolio review not required. Originals are not returned.
Book Design: Pays contributor's copy and "royalties by agreement if work becomes profitable."
Jackets/Covers: Pays contributor's copy and "royalties by agreement if work becomes profitable."
Text Illustration: Pays contributor's copy and "royalties by agreement if work becomes profitable."
Tips: "In terms of publishing and computer processing, art has become information. There is yet an Art that presents the manifestation of the object as being a quality. This applies to sculpture, ancient relics, and anything with similar material value. These things should be treated with respect; curatorial values will always be important."

ART DIRECTION BOOK CO., 456 Glenbrook Rd., Glenbrook CT 06906. (203)353-1441. Fax: (203)353-1371. Art Director: Doris Gordon. Publishes hardcover and paperback originals on advertising design and photography. Publishes 12-15 titles/year. Titles include disks of *Scan This Book* and of *Most Happy Clip Art*; book and disk of *101 Absolutely Superb Icons* and *American Corporate Identity #11*. Book catalog free on request.

Needs: Works with 2-4 freelance designers/year. Uses freelancers mainly for graphic design.

First Contact & Terms: Send query letter to be filed, and arrange to show portfolio of 4-10 tearsheets. Portfolios may be dropped off Monday-Friday. Samples returned by SASE. Buys first rights. Originals are returned to artist at job's completion. Advertising design must be contemporary. Finds artists through word of mouth.

Book Design: Pays $100 minimum.

Jackets/Covers: Pays $100 minimum.

ARTIST'S & GRAPHIC DESIGNER'S MARKET, Writer's Digest Books, 1507 Dana Ave., Cincinnati OH 45207. Editor: Mary Cox. Annual hardcover directory of markets for designers, illustrators and fine artists. Buys one-time rights.

Needs: Buys 35-45 illustrations/year. "I need examples of art that have been sold to the listings in *Artist's & Graphic Designer's Market*. Look through this book for examples. The art must have been freelanced; it cannot have been done as staff work. Include the name of the listing that purchased or exhibited the work, what the art was used for and, if possible, the payment you received. Bear in mind that interior art is reproduced in b&w, so the higher the contrast, the better."

First Contact & Terms: Send printed piece, photographs or tearsheets. "Since *Artist's & Graphic Designer's Market* is published only once a year, submissions are kept on file for the upcoming edition until selections are made. Material is then returned by SASE if requested." Pays $50 to holder of reproduction rights and free copy of *Artist's & Graphic Designer's Market* when published.

ASSOCIATION OF COLLEGE UNIONS-INTERNATIONAL, 400 E. Seventh St., Bloomington IN 47405. (812)855-8550. Fax: (812)855-0162. E-mail: avest@indiana.edu. Website: http://www.gatech.edu/student.services/aciu/index.htmp. Assistant Director of Publishing and Marketing: Ann Vest. Estab. 1914. Professional education association. Publishes hardcover and trade paperback originals. Specializes in multicultural issues, creating community on campus, union and activities programming, managing staff, union operations, and professional and student development. Recent titles include *Building Community on Campus*, by Susan Young Maul. Book catalog free for SAE with $3 postage.

 ● This association also publishes a magazine (see Magazines section for listing). Note that most illustration and design are accepted on a volunteer basis. This is a good market if you're just looking to build or expand your portfolio.

Needs: "We are a volunteer-driven association. Most people submit work on that basis." Uses freelancers mainly for illustration. Freelancers should be familiar with CorelDraw. Works on assignment only.

First Contact & Terms: Send query letter with tearsheets. Samples are filed. Reports back to the artist only if interested. Negotiates rights purchased. Originals are returned at job's completion.

Tips: Looking for color transparencies of college student union activities.

ATHENEUM BOOKS FOR YOUNG READERS, 866 Third Ave., 25th Floor, New York NY 10022. (212)702-5656. Art Assistant: Ethan Trask. Imprint of Simon & Schuster. Imprint publishes hardcover originals, picture books for young kids, nonfiction for ages 8-12. Types of books include biography, fantasy, historical fiction, history, instructional, nonfiction, and reference for preschool, juvenile and young adult. Publishes 60 titles/year. Recent titles include *Tutankhamen's Gift*; *The Alphabet from Z to A*; and *Bats, Bugs and Biodiversity*. 100% require freelance illustration; 25% require freelance design. Book catalog free by request.

Needs: Approached by hundreds of freelance artists/year. Works with 40-60 freelance illustrators and 3-5 designers/year. Buys 40 freelance illustrations/year. "We are interested in artists of varying media and are trying to cultivate those with a fresh look appropriate to each title." Uses freelancers for jacket design and illustration for novels; picture books in their entirety. 90% of freelance work demands knowledge of Adobe Illustrator 5.5, QuarkXPress 3.31 and Adobe Photoshop 2.5.1. Works on assignment only.

First Contact & Terms: Send postcard sample of work or send query letter with tearsheets, résumé and photocopies. Samples are filed. Portfolios may be dropped off every Thursday between 9 a.m. and noon. Art Director will contact artist for portfolio review if interested. Portfolio should include final art if appropriate, tearsheets and folded & gathered sheets from any picture books you've had published. Rights purchased vary according to project. Originals are returned at job's completion. Finds artists through submissions, magazines ("I look for interesting editorial illustrators"), word of mouth.

Book Design: Assigns 2-5 freelance design jobs/year. Pays by the project, $750-1,500.

Jackets/Covers: Assigns 1-2 freelance design and 20 freelance illustration jobs/year. Pays by the project, $1,200-1,800. "I am not interested in generic young adult illustrators."

Text Illustration: Pays by the project, $500-2,000.

AUGSBURG FORTRESS PUBLISHERS, Box 1209, 426 S. Fifth St., Minneapolis MN 55440. (612)330-3300. Contact: Director of Design, Design Services. Publishes hard cover and paperback Protestant/Lutheran books (90 titles/year), religious education materials, audiovisual resources, periodicals. Recent titles include *Ecotheraphy*, by Howard Clinebell; and *Thistle*, by Walter Wangerin.
Needs: Uses freelancers for advertising layout, design, illustration and circulars and catalog cover design. Freelancers should be familiar with QuarkXPress 3.31, Adobe Photoshop 3.0 and Adobe Illustrator 5.0.
First Contact & Terms: "Majority, but not all, of our freelancers are local." Works on assignment only. Reports back on future assignment possibilities in 5-8 weeks. Call, write or send brochure, flier, tearsheet, good photocopies and 35mm transparencies; if artist is not willing to have samples filed, they are returned by SASE. Buys all rights on a work-for-hire basis. May require designers to supply overlays on color work.
Jackets/Covers: Uses designers primarily for cover design. Pays by the project, $600-900. Prefers covers on disk using QuarkXPress.
Text Illustration: Negotiates pay for 1-, 2- and 4-color. Generally pays by the project, $25-500.
Tips: Be knowledgeable "of company product and the somewhat conservative contemporary Christian market."

AUGUST HOUSE, INC., 201 E. Markham, Plaza Level, Little Rock AR 72201. (501)372-5450. Fax: (501)372-5579. Art Director: Ted Parkhurst. Estab. 1980. Company publishes hardcover and trade paperback originals. Types of books include humor and juvenile. Specializes in folktales, folklore and storytelling. Publishes 15-20 titles/year. Recent titles include *Fair is Fair* and *Still Catholic After All These Fears*. 90% require freelance illustration; 90% require freelance design. Book catalog free by request.
Needs: Approached by 50 freelancers/year. Works with 10 freelance illustrators and 10 designers/year. Prefers artists with experience in watercolor, pen & ink. Uses freelancers mainly jacket/cover illustration. Also for jacket/cover design. 70% of freelance work demands knowledge of QuarkXPress and Adobe Photoshop. Works on assignment only.
First Contact & Terms: Send query letter with brochure, photographs and photocopies. Samples are returned by SASE if requested artist. Art Director will contact artist for portfolio review if interested. Portfolio should include book dummy and photographs. Rights purchased vary according to project. Originals are returned at job's completion. Finds artists through word of mouth and submissions.
Book Design: Assigns 10 freelance design jobs/year.
Jackets: Covers: Assigns less than 5 freelance design and 5-10 illustration jobs/year.
Text Illustration: Assigns 8 freelance illustration jobs/year.

AVALON BOOKS, 401 Lafayette St., New York NY 10003. Publisher: Marcia Markland. Estab. 1953. Company publishes hardcover originals. Types of books include romance, western and mystery. Publishes 60 titles/year. 100% require freelance illustration.
Needs: Prefers local freelancers only. Uses freelancers for jacket/cover illustration. Works on assignment only.
First Contact & Terms: Send postcard sample of work. Samples are not filed and are not returned. Reports back only if interested. Portfolio review not required. Rights purchased vary according to project. Originals are returned at job's completion. Finds artists through submissions.
Jackets/Covers: Assigns 60 freelance design jobs/year.

‡AVON BOOKS, 1350 Avenue of the Americas, New York NY 10019. (212)261-6888. Fax: (212)261-6925. Art Director: Tom Egner. Estab. 1941. Publishes hardcover, trade and mass market paperback originals and reprints. Types of books include adventure, biography, cookbooks, fantasy, history, horror, humor, juvenile, mainstream fiction, New Age, nonfiction, romance, science fiction, self-help, travel, young adult. Specializes in romance, mystery, upscale fiction. Publishes 400-450 titles/year. Recent titles include: *Love Me Forever*, Johanna Lindsey; *Sanctuary*, by Faye Kellerman. 85% requires freelance illustration; 10% requires freelance design.
Needs: Approached by 150 illustrators and 25 designers/year. Works with 125 illustrators and 5-10 designers/year. Prefers freelancers experienced in illustration. Uses freelancers mainly for illustration. 80% of freelance design and 5% of freelance illustration demand knowledge of Adobe Photoshop, Adobe Illustrator and QuarkXPress.
First Contact & Terms: Designers send query letter with slides, tearsheets, transparencies. Illustrators send postcard sample and/or query letter with printed samples, slides, tearsheets and transparencies. Accepts disk submissions from designers, not illustrators, compatible with QuarkXPress 7.5, version 3.3. Send EPS files. Samples are filed or returned. Reports back within days if interested. Portfolios may be dropped off every Thursday. Will contact for portfolio review of slides and transparencies of work in all genres if interested. Rights purchsed vary according to project.
Book Design: Assigns 25 freelance design jobs/year. Pays by the project, $700-1,500.
Jackets/Covers: Assigns 25 freelance design jobs and 325 illustration jobs/year. Pays for design by the project, $700-1,500. Pays for illustration by the project, $1,000-5,000. Prefers all mediums.

BAEN BOOKS, Box 1403, Riverdale NY 10471. (718)548-3100. Website: http://baen.com. Publisher: Jim Baen. Editor: Toni Weisskopf. Estab. 1983. Publishes science fiction and fantasy. Publishes 84-96 titles/year. Titles include *Mirror Dance* and *The Fire Rose*, by Mercedes Lackey and *Paths to Otherwhere*, by James P. Hogan. 75% require freelance illustration; 80% require freelance design. Book catalog free on request.
First Contact & Terms: Approached by 1,000 freelancers/year. Works with 10 freelance illustrators and 4 designers/year. 20% of work demands computer skills. Designers send query letter with résumé, color photocopies, tearsheets (color only) and SASE. Illustrators send query letter with color photocopies, SASE, slides and tearsheets. Samples are filed. Originals are returned to artist at job's completion. Buys exclusive North American book rights.
Jackets/Covers: Assigns 64 freelance design and 64 illustration jobs/year. Pays by the project—$200 minimum, design; $1,000 minimum, illustration.
Tips: Wants to see samples within science fiction, fantasy genre only. "Do not send b&w illustrations or surreal art. Please do not waste our time and your postage with postcards. Serious submissions only."

BANDANNA BOOKS, 319B Anacapa St., Santa Barbara CA 93101. Fax: (805)564-3278. E-mail: bandan nas@aol.com. Publisher: Sasha Newborn. Estab. 1981. Publishes supplementary textbooks, nonfiction and fiction trade paperback originals and reprints. Types of books include language, classics. Publishes 3 titles/year. Recent titles include *Benigna Machiavelli*, by Charlotte Perkins Gilman; *Italian for Opera Lovers*. 100% of freelance design demands knowledge of QuarkXPress on Mac.
Needs: Approached by 150 freelancers/year. Uses illustrators mainly for woodblock or scratchboard and pen & ink art. Also for cover and text illustration.
First Contact & Terms: Send postcard sample or query letter with résumé and photocopies. Accepts disk submissions compatible with Mac Adobe Photoshop. Send EPS or TIFF files. Samples are filed and are returned by SASE only if requested. Reports back within 6 weeks if interested. Originals are not returned. To show portfolio mail thumbnails and sample work. Considers project's budget when establishing payment.
Jackets/Covers: Prefers b&w (scratchboard, woodblock, silhouettes). Pays by the project, $50-200.
Text Illustration: Pays by the project, $50-200.
Tips: "Include at least five samples in your submission. Make sure work done for us is equal in quality and style to the samples sent. Make sure samples are generally related to our topics published. We're interested in work that is innovative without being bizarre, quality without looking too 'slick' or commercial. Simplicity and character are important."

BANTAM BOOKS, 666 Fifth Ave., New York NY 10103. Does not need freelance artists at this time.

BARBOUR & CO., INC., 1810 Barbour Dr., P.O. Box 719, Uhrichsville OH 44683. (614)922-6045, ext. 125. Fax: (614)922-5948. Creative Director: Robyn Martins. Estab. 1981. Publishes hardcover, trade paperback and mass market paperback originals and reprints. Types of books include contemporary and historical fiction, romance, self help, young adult, reference and juvenile. Publishes 60 titles/year. Titles include *Heroes of the Faith Series* and *Young Reader's Christian Library Series*. 60% require freelance illustration. Book catalog available for $1.
Needs: Approached by 15 freelancers/year. Works with 10 freelance illustrators/year. Prefers freelancers with experience in people illustration. Uses freelancers mainly for fiction romance jacket/cover illustration. 50% of freelance work demands knowledge of Adobe Illustrator. Works on assignment only.
First Contact & Terms: Send query letter with photocopies and SASE. Accepts Mac disk submissions compatible with Illustrator 5.5. Samples are filed. Reports back within 1 week. Write for appointment to show portfolio of thumbnails, roughs, final art, dummies. Sometimes requests work on spec before assigning a job. Buys all rights. Originals are not returned. Finds artists through word of mouth, recommendations and placing ads.
Jackets/Covers: Pays by the project, $300-600.
Tips: "Submit a great illustration of people suitable for a romance cover or youth cover in a photorealistic style. As a publisher of bargain books, I am looking for top-quality art on a tight budget."

‡BEDFORD BOOKS OF ST. MARTIN'S PRESS, 29 Winchester St., Boston MA 02116. (617)426-7440. Fax: (617)426-8582. Advertising and Promotion Manager: Donna Dennison. Estab. 1981. Imprint of St. Martin's Press. Publishes college textbooks. Specializes in English and history. Publishes 52 titles/year. Recent titles include *A Writer's Reference, Third Edition*; *The Bedford Companion to Shakespeare*; *The Press of Ideas*. Books have "contemporary, classic design." 5% require freelance illustration; 90% require freelance design.
Needs: Approached by 25 freelance artists/year. Works with 2-4 illustrators and 6-8 designers/year. Buys 4-6 illustrations/year. Prefers artists with experience in book publishing. Uses freelancers mainly for cover and brochure design. Also for jacket/cover and text illustration and book and catalog design. 75% of design work demands knowledge of Aldus PageMaker, QuarkXPress, Aldus FreeHand or Adobe Illustrator.
First Contact & Terms: Send query letter with brochure, tearsheets and SASE. Samples are filed or are returned by SASE if requested by artist. Reports back only if interested. Request portfolio review in original query. Art Director will contact artists for portfolio review if interested. Portfolio should include roughs,

original/final art, color photostats and tearsheets. Rights purchased vary according to project. Interested in buying second rights (reprint rights) to previously published work. Originals are returned at job's completion.
Jackets/Covers: Assigns 50 design jobs and 2-4 illustration jobs/year. Pays by the project. Finds artists through magazines, self-promotion and sourcebooks.
Tips: "Regarding book cover illustrations, we're usually interested in buying reprint rights for artistic abstracts or contemporary, multicultural scenes."

BEHRMAN HOUSE, INC., 235 Watchung Ave., West Orange NJ 07052. (201)669-0447. Fax: (201)669-9769. Projects Editor: Adam Siegel. Estab. 1921. Book publisher. Publishes textbooks. Types of books include preschool, juvenile, young adult, history (all of Jewish subject matter) and Jewish texts. Specializes in Jewish books for children and adults. Publishes 12 titles/year. Recent titles include *Partners with God*, by Gila Gevirtz and *It's a Mitzvah*, by Brad Artson. "Books are contemporary with lots of photographs and artwork; colorful and lively. Design of textbooks is very complicated." 50% require freelance illustration; 100% require freelance design. Book catalog free by request.
Needs: Approached by 6 freelancers/year. Works with 6 freelance illustrators and 6 designers/year. Prefers freelancers with experience in illustrating for children; "Jewish background helpful." Uses freelancers for textbook illustration and book design. 25% of freelance work demands knowledge of QuarkXPress. Works on assignment only.
First Contact & Terms: Send query letter with brochure, résumé and tearsheets. Samples are filed. Reports back only if interested. Buys reprint rights. Sometimes requests work on spec before assigning a job. Originals are returned at job's completion.
Book Design: Assigns 6 freelance design and 3 illustration jobs/year. Pays by project, $800-1,500.
Jackets/Covers: Assigns 6 freelance design and 4 illustration jobs/year. Pays by the project.
Text Illustration: Assigns 6 freelance design and 4 illustration jobs/year. Pays by the project.

ROBERT BENTLEY PUBLISHERS, 1033 Massachusetts Ave., Cambridge MA 02138. (617)547-4170. Publisher: Michael Bentley. Publishes hardcover originals and reprints and trade paperback originals—reference books. Specializes in automotive technology and automotive how-to. Publishes 20 titles/year. Recent titles include *Jeep Owner's Bible*. 50% require freelance illustration; 80% require freelance design and layout. Book catalog for 9×12 SAE.
Needs: Works with 5-10 illustrators and 15-20 designers/year. Buys 1,000 illustrations/year. Prefers artists with "technical illustration background, although a down-to-earth, user-friendly style is welcome." Uses freelancers for jacket/cover illustration and design, text illustration, book design, page layout, direct mail and catalog design. Also for multimedia projects. 50% of design work requires computer skills. Works on assignment only.
First Contact & Terms: Send query letter with résumé, SASE, tearsheets and photocopies. Accepts disk submissions. Samples are filed. Reports in 3-5 weeks. To show portfolio, mail thumbnails, roughs and b&w tearsheets and photographs. Buys all rights. Originals are not returned.
Book Design: Assigns 10-15 freelance design and 20-25 illustration jobs/year. Pays by the project.
Jackets/Covers: Pays by the project.
Text Illustration: Prefers ink on mylar or Adobe Illustrator files.
Tips: "Send us photocopies of your line artwork and résumé."

‡BICYCLE BOOKS, INC., 1282 Seventh Ave., San Francisco CA 94112. (415)665-8214. Fax: (415)753-8572. Editor: Rob Van der Plas. Estab. 1985. Book publisher. Publishes trade paperback originals. Types of books include instructional and travel. Specializes in subjects relating to cycling and bicycles. Publishes 6 titles/year. Recent titles include *Cycling in Cyberspace* and *Mountain Biking the National Parks*. 20% require freelance illustration. Book catalog for SASE with first-class postage.
Needs: Approached by 5 freelance artists/year. Works with 2 freelance illustrators/year. Buys 100 freelance illustrations/year. Uses freelance artists mainly for technical (perspective) and instructions (anatomically correct hands, posture). Also uses freelance artists for text illustration; line drawings only. Also for design. 50% of freelance work demands knowledge of CorelDraw and Aldus FreeHand. Works on assignment only.
First Contact & Terms: Send query letter with tearsheets. Accepts disk submissions. Please include printout with EPS files. Samples are filed. Call "but only after we have responded to query." Portfolio should include photostats. Rights purchased vary according to project. Originals are not returned to the artist at the job's completion.
Book Design: Pays by the project.
Text Illustration: Assigns 5 freelance illustration jobs/year. Pays by the project.
Tips: "Show competence in line drawings of technical subjects and 2-color maps."

 THE DOUBLE DAGGER before a listing indicates that the listing is new in this edition. New markets are often more receptive to freelance submissions.

BLUE BIRD PUBLISHING, 2266 Dobson, Suite 275, Mesa AZ 85202. (602)831-6063. Owner/Publisher: Cheryl Gorder. Estab. 1985. Publishes trade paperback originals. Types of books include young adult, reference and general adult nonfiction. Specializes in parenting and home education. Publishes 12 titles/year. Titles include: *Multicultural Education*. 50% require freelance illustration; 25% require freelance design. Book catalog free for #10 SASE.
Needs: Approached by 12 freelancers/year. Works with 3 freelance illustrators and 1 designer/year. Uses freelancers for illustration. Also for jacket/cover and catalog design. Works on assignment only.
First Contact & Terms: Send query letter with brochure and photocopies. Samples are filed. To show portfolio, mail b&w samples and color tearsheets. Rights purchased vary according to project. Originals not returned.
Jackets/Covers: Assigns 1 freelance design and 1 illustration job/year. Pays by the project, $50-200. Style preferences vary per project."
Text Illustration: Assigns 3 freelance illustration jobs/year. Pays by the project, $20-250. Prefers line art.

‡BLUE DOLPHIN PUBLISHING, INC., P.O. Box 8, Nevada City CA 95959. (916)265-6925. Fax: (916)265-0787. E-mail: bdolphin@netshel.net. President: Paul M. Clemens. Estab. 1985. Publishes hardcover and trade paperback originals. Types of books include biography, cookbooks, humor and self-help. Specializes in comparative spiritual traditions, lay psychology and health. Publishes 15 titles/year. Recent titles include *Mary's Message of Hope*; *The Way It Is: One Water, One Air, One Mother Earth*; *You Will Live Again*; and *Dolphin Divination Cards and Text*. Books are "high quality on good paper, with laminated dust jacket and color covers." 10% require freelance illustration; 30% require freelance design. Book catalog free upon request.
Needs: Works with 5-6 freelance illustrators and designers/year. Uses freelancers mainly for book cover design. Also for jacket/cover and text illustration. More hardcovers and mixed media are requiring box design as well. 50% of freelance work demands knowledge of Aldus PageMaker, QuarkXPress, Aldus FreeHand, Adobe Illustrator, Adobe Photoshop, CorelDraw and other IBM compatible programs. Works on assignment only.
First Contact & Terms: Send postcard sample or query letter with brochure and photocopies. Samples are filed or are returned by SASE if requested. Reports back within 1-2 months. Originals are returned to artist at job's completion. Sometimes requests work on spec before assigning job. Considers project's budget when establishing payment. Negotiates rights purchased. Considers buying second rights (reprint rights) to previously published work.
Book Design: Assigns 3-5 jobs/year. Pays by the hour, $10-15; or by the project, $300-900.
Jackets/Covers: Assigns 5-6 design and 5-6 illustration jobs/year. Pays by the hour, $10-15; or by the project, $300-900.
Text Illustration: Assigns 1-2 jobs/year. Pays by the hour, $10-15; or by the project, $300-900.
Tips: "Send query letter with brief sample of style of work. We usually use local people, but always looking for something special. Learning good design is more important than designing on the computer, but we are very computer-oriented."

BONUS BOOKS, INC., 160 E. Illinois St., Chicago IL 60611. (312)467-0580. Fax: (312)467-9271. E-mail: mcclain@bonus-books.com. Website: http://www.bonus-books.com. Associate Publisher: Michael McClain. Imprints include Precept Press, Teach'em. Company publishes textbooks and hardcover and trade paperback originals. Types of books include instruction, biography, self-help, cookbooks and sports. Specializes in sports, biography, medical, fundraising. Publishes 40 titles/year. Recent titles include *Second to Home*, by Ryne Sandberg; and *Call of the Game*, by Gary Bender. 1% require freelance illustration; 80% require freelance design. Book catalog free by request.
Needs: Approached by 30 freelancers/year. Works with 0-1 freelance illustrator and 10 designers/year. Prefers local freelancers with experience in designing on the computer. Uses freelancers for jacket/cover illustration and design and direct mail design. Also for multimedia projects. 100% if desugb abd 90% of illustration demand knowledge of Aldus PageMaker, Adobe Photoshop, CorelDraw. Works on assignment only.
First Contact & Terms: Designers send brochure, résumé and tearsheets. Illustrators send postcard sample or query letter with brochure, résumé. "We would like to see all rough sketches and all design process, not only final product." Accepts disk submissions. Samples are filed. Reports back only if interested. Artist should follow up with call. Portfolio should include color final art, photostats and tearsheets. Rights purchased vary according to project. Finds artists through artists' submissions and authors' contacts.
Book Design: Assigns 4 freelance design jobs/year.
Jackets/Covers: Assigns 10 freelance design and 0-1 illustration job/year. Pays by the project, $250-1,000.
Tips: First-time assignments are usually regional, paperback book covers; book jackets for national books are given to "proven" freelancers.

BOOK DESIGN, Box 193, Moose WY 83012. Art Director: Robin Graham. Specializes in hardcover and paperback originals of nonfiction, natural history. Publishes more than 3 titles/year. Recent titles include

Tales of the Wolf, *Wildflowers of the Rocky Mountains*, *Mattie: A Woman's Journey West*, *Teton Skiing* and *Bonney's Guide to Jackson's Hole*.
Needs: Works with 20 freelance illustrators and 10 designers/year. Works on assignment only. "We are looking for top-notch quality only." 90% of freelance work demands knowledge of Aldus PageMaker and Aldus FreeHand.
First Contact & Terms: Send query letter with "examples of past work and one piece of original artwork which can be returned." Samples not filed are returned by SASE if requested. Reports back within 20 days. Originals are not returned. Write for appointment to show portfolio. Negotiates rights purchased.
Book Design: Assigns 6 freelance design jobs/year. Pays by the project, $50-3,500.
Jackets/Covers: Assigns 2 freelance design and 4 illustration jobs/year. Pays by the project, $50-3,500.
Text Illustration: Assigns 26 freelance jobs/year. Prefers technical pen illustration, maps (using airbrush, overlays etc.), watercolor illustration for children's books, calligraphy and lettering for titles and headings. Pays by the hour, $5-20, or by the project, $50-3,500.

‡THOMAS BOUREGY & CO., INC. (AVALON BOOKS), 401 Lafayette St., New York NY 10003. (212)598-0222. Vice President/Publisher: Marcia Markland. Estab. 1950. Book publisher. Publishes hardcover originals. Types of books include romance, mysteries and Westerns. Publishes 60 titles/year. 100% require freelance illustration and design. Prefers local artists and artists with experience in dust jackets. Works on assignment only.
First Contact & Terms: Send samples. Samples are filed if appropriate. Reports back if interested.

‡BOWLING GREEN UNIVERSITY POPULAR PRESS, Bowling Green University, Bowling Green OH 43403. (419)372-7867. Fax: (419)372-8095. Director: Pat Browne. Publishes hardcover and paperback originals on popular culture, folklore, women's studies, science fiction criticism, detective fiction criticism, music and drama. Publishes 15-20 titles and 8 journals/year.
First Contact & Terms: Send previously published work and SASE. Reports in 2 weeks. Buys all rights. Free catalog.
Jackets/Covers: Assigns 20 jobs/year. Pays $250 minimum, color washes, opaque watercolors, gray opaques, b&w line drawings and washes.

BOYDS MILLS PRESS, 815 Church St., Honesdale PA 18431. Art Director: Tim Gillner. Estab. 1990. A division of Highlights for Children, Inc. Imprint publishes hardcover originals and reprints. Types of books include fiction, picture books and poetry. Publishes 50 titles/year. Recent titles include *Bitter Bananas*, by Isaac Olaleye (illustrated by Ed Young); *Bingleman's Midway*, by Karen Ackerman (illustrated by Barry Moser).
Needs: Approached by hundreds of freelancers/year. Works with 25-30 freelance illustrators and 5 designers/ year. Prefers freelancers with experience in book publishing. Uses freelancers mainly for picture books. Also for jacket/cover design and illustration, text illustration and book design. 25% of freelance work demands knowledge of QuarkXPress. Works on assignment only.
First Contact & Terms: Send query letter with tearsheets, photographs, photocopies, slides and transparencies. Samples are filed and not returned. Artist should follow up with call. Portfolio should include b&w and color final art, photostats, tearsheets and photographs. Rights purchased vary according to project. Originals are returned at job's completion. Finds artists through agents, sourcebooks, submissions, other publications.
Book Design: Assigns 10 freelance design jobs/year. Pays by the project.
Jackets/Covers: Assigns 6 freelance design/illustration jobs/year. Pays by the project.
Text Illustration: Pays by the project.
Tips: First-time assignments are usually poetry books (b&w illustrations); picture books are given to "proven" freelancers.

‡BROADMAN & HOLDMAN PUBLISHERS (formerly Broadman Press), 127 9th Ave. N., Nashville TN 37234. (615)251-2644. Art Director: David Shepherd. Estab. 1891. Religious publishing house. Publishes 104 titles/year. 20% of titles require freelance illustration. Recent titles include *Breaking Through*; *Mentoring* and *Marriage 911*. Books have contemporary look. Book catalog free on request.
First Contact & Terms: Works with 15 freelance illustrators and 20 freelance designers/year. Artist must be experienced, professional. 50% of freelance work demands knowledge of QuarkXPress, Aldus FreeHand, Adobe Illustrator or Adobe Photoshop. Works on assignment only. Send query letter with brochure and samples to be kept on file. Call or write for appointment to show portfolio. Send slides, tearsheets, photostats or photocopies; "samples *cannot* be returned." Reports only if interested. Pays for illustration by the project, $250-1,500. Negotiates rights purchased.
Book Design: Pays by the project, $750-1,500.
Jackets/Covers: "75% of our cover designs are now done on computer." Pays by the project, $500-1,650
Text Illustration: Pays by the project, $150-300.
Tips: "We are looking for computer-literate experienced book designers with extensive knowledge of biblical archaeology." Looks for "the ability to illustrate scenes with multiple figures, to accurately illustrate people of all ages, including young children and babies, and to illustrate detailed scenes described in text."

‡**BRODERBUND SOFTWARE, INC.**, 500 Redwood Blvd., Attn: P2 Art, P.O. Box 6121, Novato CA 94948-6121. (415)382-4400. E-mail: broder.com. Estab. 1980. Publishes educational/entertainment software. Specializes in education and personal reference. Publishes 9-10 titles/year. Recent titles include *Print Shop Deluxe v. 4.0* and *Amazing Writing Machine*. 75% requires freelance illustration; 40% requires freelance design. Book catalog free by request.

• Also see Broderbund's listing in the Greeting Cards, Games & Products section.

Needs: Approached by 100 illustrators/designers/year. Works with 25 illustrators and 15 designers/year. Purchases 200-700 freelance illustrations/year. Prefers freelancers experienced in computer art and multimedia design. Uses freelancers mainly for illustration including text illustration and design and clip art illustrations inserted into software programs. 100% of freelance work demands knowledge of Adobe Illustrator, Adobe Photoshop, Aldus FreeHand, Macromedia Director.

First Contact & Terms: Send postcard sample of work, query letter with résumé and tearsheets. Samples are filed. Reports back only if interested. Art Director will contact artist for portfolio review of final art, tearsheets if interested. Rights purchased vary according to projdect.

Software Design: Assigns 50 freelance design jobs/year.

Software Illustration: Assigns 100 illustration jobs/year. Pay varies based on assignment.

‡**BROOKS/COLE PUBLISHING COMPANY**, 511 Forest Lodge Rd., Pacific Grove CA 93950. (408)373-0728. Art Director: Vernon T. Boes. Art Coordinator: Lisa Torri. Estab. 1967. Specializes in hardcover and paperback college textbooks on mathematics, psychology, chemistry and counseling. Publishes 100 titles/year. 85% require freelance illustration. Books are bold, contemporary textbooks for college level.

Needs: Works with 25 freelance illustrators and 25 freelance designers/year. Uses freelance artists mainly for interior illustration. Uses illustrators for technical line art and covers. Uses designers for cover and book design and text illustration. Also uses freelance artists for jacket/cover illustration and design. Works on assignment only.

First Contact & Terms: Send query letter with brochure, résumé, tearsheets, photostats and photographs. Samples are filed or are returned by SASE. Art Director will contact artist for portfolio review if interested. Portfolio should include roughs, photostats, tearsheets, final reproduction/product, photographs, slides and transparencies. Considers complexity of project, skill and experience of artist, project's budget and turnaround time in determining payment. Negotiates rights purchased. Not interested in second rights to previously published work unless first used in totally unrelated market. Finds illustrators and designers through word of mouth, magazines, submissions/self promotion, sourcebooks, and agents.

Book Design: Assigns 70 design and many illustration jobs/year. Pays by the project, $500-1,500.

Jackets/Covers: Assigns 90 design and many illustration jobs/year. Pays by the project, $500-1,200.

Text Illustration: Assigns 85 freelance jobs/year. Prefers ink/Macintosh. Pays by the project, $20-2,000.

Tips: "Provide excellent package in mailing of samples and cost estimates. Follow up with phone call. Don't be pushy. Would like to see more abstract photography/illustration; all age, unique, interactive people photography; single strong, bold images."

‡**ARISTIDE D. CARATZAS, PUBLISHER**, Box 210, 30 Church St., New Rochelle NY 10802. (914)632-8487. Editor: Evan Allen. Publishes books about archaeology, art history, natural history and classics for specialists in the above fields in universities, museums, libraries and interested amateurs.

Needs: Works with 6 freelance designers/year. Uses freelance artists mainly for book jacket design. Also uses freelance artists for book design.

First Contact & Terms: Send letter with brochure showing artwork. Request portfolio review in original query. Samples not filed are returned by SASE. Reports only if interested. Buys all rights or negotiates rights purchased. Interested in buying second rights (reprint rights) to previously published work.

Book Design: Pays by the project, $200-3,000.

Jackets/Covers: Pays by the project, $150-600.

CAROLINA WREN PRESS/LOLLIPOP POWER BOOKS, 120 Morris St., Durham NC 27701. (919)560-2738. Art Director: Martha Scotford. Estab. 1973. Publishes trade paperback originals. Types of books include contemporary fiction, experimental fiction, preschool and juvenile. Specializes in books for children in a multi-racial and non-sexist manner, and women's and black literature. Publishes 3 titles/year. Recent titles include *Journey Proud*, edited by Agnes MacDonald; and *In the Arms of Our Elders*, by W.H. Lewis. 50% require freelance illustration.

Needs: Approached by 20 freelancers/year. Works with 2 freelance illustrators/year. Prefers freelancers with experience in children's literature. Uses freelancers for jacket/cover and text illustration. Works on assignment only.

First Contact & Terms: Send query letter with résumé, tearsheets, photocopies and illustrations of children and adults. No cartoons. Samples are filed or are returned by SASE if requested by artist. To show portfolio, mail b&w and color tearsheets. Rights purchased vary according to project. Originals returned at job's completion.

Jacket/Covers: Assigns 2 freelance jobs/year. Pays by the project, $50-150.
Text Illustration: Assigns 2 freelance illustration jobs/year. Payment is 10% of print run.
Tips: "Understand the world of children in the 1990s. Draw realistically so racial types are accurately represented and the expressions can be interpreted. Our books have a classical, modern and restrained look."

‡**MARSHALL CAVENDISH**, 99 White Plains Rd., Tarrytown NY 10591. (914)332-8888. Fax: (914)332-1888. Art Director: Jean Krulis. Imprints include Benchmark Books and as yet untitled new imprint. Publishes hardcover originals. Types of books include juvenile, preschool and young adult. Publishes 24 titles/year. First trade titles to be published in Fall 1997. 80% requires freelance illustration.
Needs: Uses freelancers mainly for illustration.
First Contact & Terms: Send photocopies and/or printed samples. Samples are filed. Will contact artist for portfolio review of artwork portraying children, adults, animals, artwork of characters in sequence, book dummy, photocopies. Negotiates rights purchased. Finds freelancers mostly through agents.
Jacket/Covers: Assigns 5 illustration jobs/year. Pays by the project; negotiable.
Text Illustration: Assigns 10 freelance jobs/year. Pays by the project; offers royalty.

CCC PUBLICATIONS, 20306 Tau Place, Chatsworth Park CA 91311. (805)375-7700. Fax: (818)709-1283. Senior Editorial Director: Cliff Carle. Estab. 1984. Company publishes trade paperback originals and manufactures accessories (T-shirts, mugs, caps). Types of books include self-help and humor. Specializes in humor. Publishes 20 titles/year. Recent titles include *Are We Dysfunctional Yet?*, by Randy Glasbergen; and *Are You a Sports Nut?*, by Eric Schuman. 90% require freelance illustration; 90% require freelance design. Book catalog free for SAE with $1 postage.
Needs: Approached by 200 freelancers/year. Works with 20-30 freelance illustrators and 10-20 designers/year. Buys 100 freelance illustrations/year. Prefers artists with experience in humorous or cartoon illustration. Uses freelancers mainly for color covers and b&w interior drawings. Also for jacket/cover and book design. 80% of design and 50% of illustration demand computer skills.
First Contact & Terms: Send query letter with brochure, résumé, SASE. Samples are filed or are returned by SASE if requested by artist. Reports back only if interested. Art Director will contact artist for portfolio review if interested. Portfolio should include b&w and color samples. Rights purchased vary according to project. Finds artists through agents and unsolicited submissions.
Book Design: Assigns 20-30 freelance design jobs/year. Pay negotiated based on artist's experience and notoriety.
Jackets/Covers: Assigns 20-30 freelance design and 20-30 illustration jobs/year. Pay negotiated on project by project basis.
Text Illustration: Assigns 30-40 freelance illustration jobs/year. Pay negotiated.
Tips: First-time assignments are usually b&w text illustration; cover illustration is given to "proven" freelancers. "Sometimes we offer royalty points and partial advance. Also, cartoon characters should have 'hip' today look."

THE CENTER FOR WESTERN STUDIES, Box 727, Augustana College, Sioux Falls SD 57197. (605)336-4007. Managing Editor: Harry F. Thompson. Estab. 1970. Publishes hardcover originals and trade paperback originals and reprints. Types of books include western history. Specializes in history and cultures of the Northern Plains, especially Plains Indians, such as the Sioux and Cheyenne. Publishes 2-3 titles/year. Recent titles include *Princes, Potentates, and Plain People*, by Reuben Goertz; and *Driftwood in Time of War*, by Marie Christopherson. 75% require freelance design. Books are conservative, scholarly and documentary. Book catalog free by request.
Needs: Approached by 4 freelancers/year. Works with 1-2 freelance designers and 1-2 illustrators/year. Uses freelancers mainly for cover design. Also for book design and text illustration. 25% of freelance work demands knowledge of QuarkXPress. Works on assignment only.
First Contact & Terms: Send query letter with résumé, SASE and photocopies. Samples are filed. Request portfolio review in original query. Reports back only if interested. Portfolio should include roughs and final art. Sometimes requests work on spec before assigning a job. Rights purchased vary according to project. Originals are not returned. Finds illustrators and designers through word of mouth and submissions/self promotion.
Book Design: Assigns 1-2 freelance design jobs/year. Pays by the project, $500-750.
Jackets/Covers: Assigns 2-3 freelance design jobs/year. Pays by the project, $250-500.
Text Illustration: Pays by the project, $100-500.
Tips: "We are a small house, and publishing is only one of our functions, so we usually rely on the work of graphic artists with whom we have contracted previously. Send samples."

‡**CHARIOT FAMILY PUBLISHING**, Cook Communication Ministries, 4050 Lee Vance View, Colorado Springs CO 80918. (719)536-3271. Creative Director: Brenda Franklin. Estab. late 1800s. Imprints include Chariot Family Publishing, Lion Publishing and Rainfall Educational Toys. Imprint publishes hardcover and trade paperback originals and mass market paperback originals. Also toys. Types of books include contemporary and historical fiction, mystery, self-help, religious, juvenile, some teen and preschool. Recent titles

include *King Without a Shadow*. 100% require freelance illustration; 70% require freelance design.
Needs: Approached by dozens of freelance artists/year. Works with 20 freeelance illustrators and 20-30 freelance designers/year. Buys 350-400 freelance illustrations/year. Prefers artists with experience in children's publishing and/or packaging. Uses freelance artists mainly for covers, educational products and picture books. Also uses freelance artists for and text illustration, jacket/cover and book design. 50% of design work demands knowledge of Adobe Illustrator, QuarkXPress, Adobe Photoshop or Aldus FreeHand. Works on assignment only.
First Contact & Terms: Send query letter with résumé, tearsheets and photocopies. "Only send samples you want me to keep." Samples are not returned. Reports back only if interested. Artist should follow up with call. Rights purchased vary according to project. Originals are "usually" returned at the job's completion. Finds artists through submissions and word of mouth.
Jackets/Covers: Assigns 150 freelance design/illustration jobs/year. Pays by the project, $300-1,500. Prefers computer design for comps, realistic illustration for fiction, cartoon or simplified styles for children's.
Text Illustration: Assigns 50 freelance illustration jobs/year. Pays by the project, $2,000-5,000 buyout for 32-page picture books. "Sometimes we offer royalty agreement." Prefers from simplistic, children's styles to realistic.
Tips: "First-time assignments are frequently available as we are always looking for a fresh look. However, our larger 'A' projects usually are assigned to those who we've worked with in the past."

‡**CHERUBIC PRESS**, P.O. Box 5036, Johnstown PA 15904-5036. (814)535-4300. Submission Editor: Juliette Gray. Estab. 1995. Publishes quality paperback originals. Publishes specialty cookbooks, instructional, juvenile, New Age, preschool picture books and self-help. Specializes in "anything that uplifts, inspires or is self-help." Publishes 2-3 titles/year. Recent titles include *Grandpa's Berries: A Story to Help Children Understand Grief & Loss* and *The Single Man's Survival Cookbook*. 90% require freelance illustration; 10% require freelance design. Book catalog free for 4×9½ SASE with 2 first-class stamps.
Needs: Approached by 50 freelancers/year. Works with 2-3 freelance illustrators and 1-2 designers/year. Commissions 25-50 illustrations/year. Uses freelancers mainly for illustrating children's picture books. Also for jacket/cover design and illustration and text illustration. Works on assignment only.
First Contact & Terms: Send query letter with résumé, SASE and photocopies. Samples are filed or returned by SASE. Reports back within 1-2 months. Will contact for portfolio review if interested. Buys first rights.
Jackets/Covers: Assigns 1 freelance design and 2-3 illustration jobs/year. Pays by the project, amount varies.
Text Illustration: Assigns 2-3 freelance illustration jobs/year. Pays by the project. Payment varies.
Tips: "Cherubic Press is small so we can't pay big bucks but we can get you published and on your way! Show us your style—send photocopies of your pen & ink, pencil or charcoal portraits capturing the expressions of children and their parents, grandparents. We need to see emotion on the subjects' faces and in their body postures. Also send a few other examples such as animals, a house, landscapes, a yard, a car, 'whatever,' so we get the feeling of your work."

CHICAGO REVIEW PRESS, Dept. AGDM, 814 N. Franklin, Chicago IL 60610. (312)337-0747. Fax: (312)337-5985. Art Director: Joan Sommers. Editor: Linda Matthews. Publishes hardcover and paperback originals. Specializes in trade nonfiction: how-to, travel, cookery, popular science, Midwest regional. Publishes 12 titles/year. Recent titles include *Westward Ho!*, by Laurie Carlson; and *Creative Nonfiction*, by Lee Gutkind. 30% require freelance illustration; 100% require jacket cover design.
Needs: Approached by 50 freelancers/year. Works with 15 freelance illustrators and 5 designers/year. Uses freelancers for jacket/cover illustration and design, text illustration. 100% of design and 10% of illustration demand knowledge of QuarkXPress, Adobe Photoshop and Adobe Illustrator.
First Contact & Terms: Call or send postcard sample or query letter with résumé and color tearsheets. Samples are filed or are returned by SASE. Art Director will contact artist for portfolio review if interested. Call for appointment to show portfolio of tearsheets, final reproduction/product and slides. Considers project's budget when establishing payment. Buys one-time rights. Finds artists through magazines, submissions/self promotions, sourcebooks and galleries.
Jackets/Covers: Assigns 10 freelance design and 10 illustration jobs/year. Pays by project, $500-1,000.
Text Illustration: Pays by the project, $500-3,000.
Tips: "Our books are interesting and innovative. Design and illustration we use is sophisticated, above average and unusual. Fine art has become very marketable in the publishing industry."

‡**CHILDREN'S MEDIA GROUP**, P.O. Box 1382, Healdsburg CA 95448. (707)577-1645. Art Director: Kim Victoria. Estab. 1991. Imprints include Starting Line Books, Crystal River Press, Excalibur Books, Reading Tree Audio Productions. Publishes hardcover, trade and mass market paperback originals. Types of books include adventure, biography, fantasy, history, humor, juvenile, mainstream fiction, nonfiction, preschool, young adult. Specializes in juvenile. Publishes 10-14 titles/year. Recent titles include *Jenny's Locket*, *A Monster I Want to Be*, *How a Picture is Created*. 100% require freelance illustration. Book catalog not available yet.

Needs: Approached by 700-900 freelancers/year. Works with 5 freelance illustrators and designers/year. Uses freelancers mainly for book illustration. Also for jacket/cover illustrations, text illustration, jacket/cover design, companion items of the books such as T-shirts, posters, etc.

First Contact & Terms: Send query letter with SASE with proper postage and samples. Samples are filed if appropriate to needs or returned by SASE if requested by artist. Art director will contact artist for portfolio review if interested. Portfolio should include photographs, photostats, slides, tearsheets, "whatever artist has to show." Rights purchased vary according to project.

Jacket/Covers: Assigns 4 freelance illustration jobs/year. Pays 3-4% royalty of wholesale—negotiable.

Text Illustration: Assigns 10-11 freelance illustration jobs/year. Pays 5-7% royalty of wholesale—negotiable.

Tips: "We work directly with artist and usually author and artist work together. Willing to work with new talented artists. We are looking for illustrations of whales, cats, dragons and children."

CHINA BOOKS & PERIODICALS, 2929 24th St., San Francisco CA 94110. (415)282-2994. Fax: (415)282-0994. Art Director: Linda Revel. Estab. 1960. Publishes hardcover and trade paperback originals. Types of books include contemporary fiction, instrumental, biography, juvenile, reference, history and travel. Specializes in China-related books. Publishes 5-7 titles/year. Recent titles include *Insect Musicians and Cricket Champions*, by Lisa Ryan; and *Mutant Mandarin*, by James Wang. 10% require freelance illustration; 75% require freelance design. Books are "tastefully designed for the general book trade." Free book catalog.

Needs: Approached by 50 freelancers/year. Works with 5 freelancers illustrators and 3 designers/year. Prefers freelancers with experience in Chinese topics. Uses freelancers mainly for illustration, graphs and maps. 50% of freelance work demands knowledge of QuarkXPress.

First Contact & Terms: Send query letter with brochure, résumé and SASE. Samples are filed. Reports back within 1 month. Write for appointment to show portfolio of thumbnails, b&w slides and photographs. Originals are returned at job's completion.

Book Design: Assigns 5 freelance jobs/year. Pays by the hour, $20-30; or by the project, $500-2,000.

Jackets/Covers: Assigns 5 freelance design and 5 illustration jobs/year. Pays by the project, $700-2,000.

Text Illustration: Assigns 2 freelance jobs/year. Pays by the hour, $15-30; or by the project, $100-2,000. Prefers line drawings, computer graphics and photos.

CHRONICLE BOOKS, 85 Second St., San Francisco CA 94105. Design Director: Michael Carabetta. Estab. 1979. Company publishes high quality, affordably priced hardcover and trade paperback originals and reprints. Types of books include cookbooks, art, design, architecture, contemporary fiction, travel guides, gardening and humor. Publishes approximately 150 titles/year. Recent best-selling titles include the *Griffin & Sabine* trilogy, by Nick Bantock. Book catalog free on request (call 1-800-722-6657).

● Chronicle has a separate children's book division, and a division called GiftWorks™, to produce letter boxes and a variety of other gift items.

Needs: Approached by hundreds of freelancer/year. Works with 15-20 illustrators and 30-40 designers/year. Uses artists for cover and interior design and illustration. Also for GiftWorks™ items. 99% of design work demands knowledge of Aldus PageMaker, QuarkXPress, Aldus FreeHand, Adobe Illustrator or Adobe Photoshop; "mostly QuarkXPress—software is up to discretion of designer." Works on assignment only.

First Contact & Terms: Send query letter with tearsheets, color photocopies or printed samples no larger than 8½×11. Samples are filed or are returned by SASE. Reports back only if interested. Art Director will contact artist for portfolio review if interested. Portfolio should include thumbnails, roughs, final art, photostats, tearsheets, slides, tearsheets and transparencies. Buys all rights. Originals are returned at job's completion. Finds artists through submissions, *Communication Arts* and sourcebooks.

Book Design: Assigns 30-50 freelance design jobs/year. Pays by the project; $750-1200 for covers; varying rates for book design depending on page count.

Jackets/Covers: Assigns 30 freelance design and 30 illustration jobs/year. Pays by the project, $750-1200.

Text Illustration: Assigns 25 freelance illustration jobs/year. Pays by the project.

Tips: "Please write instead of calling; don't send original material."

CLARION BOOKS, 215 Park Ave., 11th Floor, New York NY 10003. (212)420-5889. Fax: (212)420-5855. Website: http://www.hmco.com/trade/. Designer: Eleanor Hoyt. Imprint of Houghton Mifflin Company. Imprint publishes hardcover originals and trade paperback reprints. Specializes in picture books, chapter books, middle grade novels and nonfiction, including historical and animal behavior. Publishes 60 titles/year. Titles include *Piggie Pie!*, by Margie Palatini, illustrated by Howard Fine. 90% of titles require freelance illustration. Book catalog free for SASE.

● Publisher of *The Midwife's Apprentice*, by Karen Cushman, 1996 Newberry Award Winner.

Needs: Approached by "countless" freelancers. Works with 48 freelance illustrators/year. Uses freelancers mainly for picture books and novel jackets. Also for jacket/cover and text illustration.

First Contact & Terms: Send query letter with résumé, tearsheets, photocopies and SASE. Samples are filed "if suitable to our needs." Reports back only if interested. Portfolios may be dropped off every Thursday. Art Director will contact artist for portfolio review if interested. Rights purchased vary according to project. Originals are returned at job's completion.

Text Illustration: Assigns 48 freelance illustration jobs/year. Pays by the project.
Tips: "Be familiar with the type of books we publish before submitting. Send a SASE for a catalog or look at our books in the bookstore. Send us children's book-related samples."

‡**COFFEE HOUSE PRESS**, 27 N. Fourth St., Minneapolis MN 55401-1782. (612)338-0125. Fax: (612)338-4004. Production Manager: Jinger Peissig. Publishes hardcover and trade paperback originals. Types of books include experimental and mainstream fiction and poetry. Publishes 14 titles/year. Recent titles include: *A .38 Special and a Broken Heart, Happiness, The Ivory Crocodile*. 15% requires freelance illustration. Book catalog free for SASE.
Needs: Approached by 20 illustrators and 10 designers/year. Works with 4 illustrators and 2 designers/year. Prefers freelancers experienced in book covers.
First Contact & Terms: Designers send query letter with photocopies and résumé. Illustrators send postcard sample and/or photocopies and printed samples. After introductory mailing send follow-up postcard samples every 2 months. Samples are filed. Will contact artist for portfolio review if interested. Rights purchased vary according to project.
Jackets/Covers: Pays for illustration by the project, $150-300.
Text Illustration: Finds illustrators through sourcebooks, word of mouth, self promos.
Tips: "We are nonprofit, so we can't pay too much, [but we appreciate] effort [put forth] for the amount we can pay."

CONTEMPORARY BOOKS, Dept. AGDM, 180 N. Stetson, Chicago IL 60601. (312)540-4590. Art Director: Kim Bartko. Book publisher. Publishes hardcover originals and trade paperback originals. Publishes nonfiction and fiction. Types of books include biography, cookbooks, instructional, humor, reference, self-help, romance, historical and mainstream/contemporary. Publishes 70 titles/year. 10% require freelance illustration. Recent titles include *The Game That Was*, by Richard Cahan and Mark Jacob; *Body Defining*, by Ellington Darden; *More Pasta Light*, by Norman Kolpas; and *Smart Parenting*, by Dr. Peter Favaro. Book catalog not available.
Needs: Approached by 150 freelancers/year. Works with 10 freelance illustrators/year. Works with freelance illustrators for covers and interiors. Book interiors require spot illustrations in 1 and 2-color, also icon-type illustration for interiors. Works on assignment only. 100% design and 40% illustration demand knowledge of QuarkXPress 3.31, Adobe Photoshop 3.0 and Adobe Illustrator 5.5.
First Contact & Terms: Designer send query letter with tearsheets and résumé. Illustrators should send postcard sample, query letter with tearsheets. Accepts disk submissions compatible with above programs. Samples are filed or are not returned. Does not report back. To show portfolio, mail tearsheets and final reproduction/product. Considers complexity of project, skill and experience of artist and project's budget when establishing payment. Buys reprint rights.
Jackets/Covers: Assigns 7 freelance illustration jobs/year. Pays by the project, $500-1,000.
Text Illustration: Assigns 3 freelance jobs/year.

COOL HAND COMMUNICATIONS, INC., 1050 #28 NW First St., Boca Raton FL 33432. (407)750-9826. Fax: (407)750-9869. Contact: Peter Ackerman. Estab. 1992. Company publishes hardcover, trade paperback and trade paperback reprints. Types of books include contemporary, experimental, mainstream fiction, biography, travel, self-help, history, children's picture books and cookbooks. Publishes 2-5 titles/year. Recent titles include *Men The Handbook*, by Mindi Rudan; and *The College Student's Cookbook*, by David Bahr. 100% require freelance illustration; 100% require freelance design.
Needs: Approached by 50 freelancers/year. Works with 10 freelance illustrators and 5 designers/year. Uses freelancers for jacket/cover design and illustration, catalog design, text illustration, promotion and advertising. 75% of freelance work demands knowledge of Adobe Illustrator, QuarkXPress, Adobe Photoshop or Aldus FreeHand. Works on assignment only.
First Contact & Terms: Send query letter with brochure, résumé, SASE, tearsheets and photocopies. Samples are filed or returned by SASE if requested by artist. Reports back only if interested. Will contact artist for portfolio review if interested. Portfolio should include roughs, final art, slides, mock-ups, tearsheets, transparencies and photographs. Rights purchased vary according to project. Originals are not returned. Finds artists through word of mouth and submissions.
Book Design: Assigns 2-4 freelance design jobs/year. Pays by the project, $100-5,000.
Jackets/Covers: Assigns 2-4 freelance design and 5-10 illustration jobs/year. Pays by the project, $250-1,000. Prefers computer-generated designs for covers or mixed media.
Text Illustration: Assigns 5-10 freelance illustration jobs/year. Pays by the project, $100-1,000. Prefers b&w line art, either hand drawn or computer-generated.
Tips: First-time assignments are usually text illustrations; book jacket designs are given to "proven" freelancers.

‡**CORWIN PRESS, INC.**, 2455 Teller Rd., Thousand Oaks CA 91320-2218. (805)499-9734. Fax: (805)499-0871. Senior Graphic Designer: Marcia Finlayson. Estab. 1990. Imprint of Sage Publications Co. Publishes hardcover originals and textbooks. Types of books include professional/scholarly. Specializes in

educational books aimed at administrators of schools and districts and for teacher reference. Publishes 70 titles/year. Recent titles include *Learning through Real-World Problem Solving*, by Nancy G. Nagel and *Going Against the Grain*, by Elizabeth Aaronsohn. Book catalog free by request.

Needs: Just beginning to seek outside freelance help. Prefers local artists with experience in direct mail marketing and book design. Uses freelancers for jacket/cover illustration and design, and book, direct mail and catalog design. Freelancers should be familiar with Aldus PageMaker or CorelDraw. (We operate in IBM environment only.) Works on assignment only.

First Contact & Terms: Send query letter with résumé and 2-3 samples. Reports back within 2-4 weeks. To show portfolio, mail photographs. Buys all rights. "Return of originals at job's completion is negotiable."

Book Design: Pays by the project, $200 minimum.

Tips: "We can work long distance; but the talent pool within this area is huge, so the odds favor artists who can stop by for a visit."

THE COUNTRYMAN PRESS (Division of W.W. Norton & Co., Inc.), Box 748, Woodstock VT 05091. (802)457-4826. Production Manager: Fred Lee. Production Editor: Margaret Hanshaw. Estab. 1976. Book publisher. Publishes hardcover originals and reprints, and trade paperback originals and reprints. Types of books include contemporary and mainstream fiction, mystery, biography, history, travel, humor, cookbooks and recreational guides. Specializes in mysteries, recreational (biking/hiking) guides. Publishes 35 titles/year. Recent titles include *One Dead Tory* and *Connecticut, An Explorer's Guide*. 10% require freelance illustration; 100% require freelance cover design. Book catalog free by request.

Needs: Works with 4 freelance illustrators and 7 designers/year. Uses freelancers for jacket/cover and book design. Works on assignment only. Prefers working with computer-literate artists/designers within New England/New York with knowledge of Aldus PageMaker 5.0, Adobe Photoshop 2.5, Adobe Illustrator 3.2, QuarkXPress 3.3 or Aldus FreeHand 3.1.

First Contact & Terms: Send query letter with appropriate samples. Samples are filed. Reports back to the artist only if interested. To show portfolio, mail best representations of style and subjects. Negotiates rights purchased.

Jackets/Covers: Assigns 30 freelance design jobs/year.

CRC PRODUCT SERVICES, 2850 Kalamazoo Ave. SE, Grand Rapids MI 49560. (616)246-0780. Fax: (616)246-0834. Art Director: Dean Heetderks. Estab. 1866. Publishes hardcover and trade paperback originals. Types of books include instructional, religious, young adult, reference, juvenile and preschool. Specializes in religious educational materials. Publishes 8-12 titles/year. 85% require freelance illustration.

Needs: Approached by 30-45 freelancers/year. Works with 12-16 freelance illustrators/year. Prefers freelancers with religious education, cross-cultural sensitivities. Uses freelancers for jacket/cover and text illustration. 95% of freelance work demands knowledge of Adobe Illustrator, QuarkXPress, Adobe Photoshop or Aldus FreeHand. Works on assignment only.

First Contact & Terms: Send query letter with brochure, résumé, tearsheets, photographs, photocopies, photostats, slides and transparencies. Samples are filed. Request portfolio review in original query. Portfolio should include thumbnails, roughs, finished samples, color slides, tearsheets, transparencies and photographs. Buys one-time rights. Interested in buying second rights (reprint rights) to previously published artwork. Originals are returned at job's completion. Finds artists through word of mouth.

Jackets/Covers: Assigns 2-3 freelance illustration jobs/year. Pays by the project, $200-1,000.

Text Illustration: Assigns 50-100 freelance illustration jobs/year. Pays by the project, $75-100. "This is high volume work. We publish many pieces by the same artist."

Tips: "Be absolutely professional. Know how people learn and be able to communicate a concept clearly in your art."

CROSS CULTURAL PUBLICATIONS, INC., P.O. Box 506, Notre Dame IN 46556. Estab. 1980. Imprint is Cross Roads Books. Company publishes hardcover and trade paperback originals and textbooks. Types of books include biography, religious and history. Specializes in scholarly books on cross-cultural topics. Publishes 10 titles/year. Recent titles include *New Testament of the Inclusive Language Bible*, edited by Charles Stiles; and *Scaling the Dragon*, by Janice Moulton and George Robinson. Book catalog free for SASE.

Needs: Approached by 25 freelancers/year. Works with 2 freelance illustrators/year. Prefers local artists only. Uses freelance artists mainly for jacket/cover illustration.

First Contact & Terms: Send query letter with résumé and photocopies. Samples are not filed and are not returned. Reports back only if interested. Art Director will contact artist for portfolio review if interested. Portfolio should include b&w samples. Rights purchased vary according to project. Originals are not returned. Finds artists through word of mouth.

Jackets/Covers: Assigns 4-5 freelance illustration jobs/year. Pays by the project.

Tips: First-time assignments are usually book jackets.

CROSSWAY BOOKS, A Division of Good News Publishers, 1300 Crescent St., Wheaton IL 60187. Contact: Arthur Guye. "Please, no phone calls." Nonprofit Christian book publisher. Publishes hardcover and

trade paperback originals and reprints. Specializes in Christian fiction (contemporary, mainstream, historical, science fiction, fantasy, adventure, mystery). Also publishes biography, juvenile, young adult, reference, history, and books on issues relevant to contemporary Christians. Publishes 40-50 titles/year. Titles include *Prophet , Tell Me the Secrets*, *Ashamed of the Gospel*, *The Singreale Chronicles*, *Always in September* and *Never Dance With a Bobcat*. 50% require freelance illustration; 15% require freelance design. Book catalog free for 9×12 SAE with adequate postage.

Needs: Approached by 150-200 freelancers/year. Works with 15 freelance illustrators and 8 designers/year. Uses freelancers mainly for book cover illustration/design. Also for text illustration (minimal), layout and production. 100% of freelance work demands knowledge of QuarkXPress, Aldus FreeHand, Adobe Photoshop or Adobe Illustrator.

First Contact & Terms: Send query letter with 5-10 nonreturnable samples or quality color photocopies of printed or original art for files. Reports back only if interested. Portfolio review not required. Considers complexity of project, proficiency of artist and the project's budget when establishing payment. Finds artists through word of mouth, magazines, submissions/self promotions, sourcebooks.

Book Design: Pays by the hour, $15 minimum; by the project, $100 minimum.

Jackets/Covers: Assigns 10-15 freelance illustration and 6 design jobs/year. Prefers realistic and semi-realistic color illustration in all media. Looks for ability to consistently render the same children or people in various poses and situations (as in series books). Pays by the project, $200-2,000. Average budget: $1,000.

Text Illustration: Pays by the project, $100-500.

Tips: "We are looking for Christian artists who are committed to spreading the Gospel of Jesus Christ through quality literature. Since we are a nonprofit organization, we may not always be able to afford an artist's 'going rate.' Quality and the ability to meet deadlines are critical. A plus would be a designer who could handle all aspects of a job from art direction to illustration to final keyline/mechanical. If you are interested in production work (type spec and keylining) please include your hourly rate and a list of references. Also looking for designers who can create imaginative typographic design treatments and inspired calligraphic approaches for covers."

CROWN PUBLISHERS, INC., 201 E. 50th St., 5th Floor, New York NY 10022. Design Director: Ken Sansone. Vice President/Creative Director: Whitney Cookman. Specializes in fiction, nonfiction and illustrated nonfiction. Publishes 250 titles/year. Recent titles include *Beauty*, by Susan Wilson; and *Politically Correct American History*, by Edward P. Moser.

● Crown is an imprint of the larger Crown Publishing Group. Within that parent company several imprints, including Clarkson Potter; Crown Arts & Letters; and Harmony maintain separate art departments.

Needs: Approached by several hundred freelancers/year. Works with 15-20 illustrators and 25 designers/year. Prefers local artists. 100% of design demands knowledge of QuarkXPress and Adobe Illustrator. Works on assignment only.

First Contact & Terms: Send query letter with samples showing art style. Reports only if interested. Originals are not returned. Rights purchased vary according to project.

Jackets/Covers: Assigns 15-20 design and/or illustration jobs/year. Pays by the project.

Tips: "There is no single style. We use different styles depending on nature of the book and its perceived market. Become familiar with the types of books we publish. For example, don't send juvenile, sci-fi or romance. Book design has changed to Mac-generated layout."

CRUMB ELBOW PUBLISHING, P.O. Box 294, Rhododendron OR 97049. (503)622-4798. Publisher: Michael P. Jones. Estab. 1982. Imprints include Oregon Fever Books, Tyee Press, Research Centrex, Read'n Run Books. Silhouette Imprints, Wildlife Research Group. Company publishes hardcover, trade paperback and mass market originals and reprints, textbooks, coloring books, poetry, cards, calendars, prints and maps. Types of books include adventure, biography, coffee table books, cookbooks, experimental fiction, fantasy, historical fiction, history, horror, humor, instructional, juvenile, mainstream fiction, New Age, nonfiction, preschool, reference, religious, romance, science fiction, self-help, textbooks, travel, western, and young adult. Specializes in Indians, environment, American history. Publishes 50 titles/year. Recent titles include *Ghost*, by Jerome K. Jerome, and *Confessions of Charles Linkworth*, by E.F. Benson. 75% require freelance illustration; 75% require freelance design. Book catalog available for $3.

Needs: Approached by 250 freelancers/year. Works with 50 freelancers and 35 designers/year. Uses freelancers for jacket/cover design and illustration, text illustration, book and catalog design, calendars, prints, note cards. 50% of freelance work demands computer skills. Works on assignment only.

First Contact & Terms: Send query letter with brochure, SASE, tearsheets and photocopies. Samples are filed or returned by SASE if requested by artist. Reports back within 1 month. Request portfolio review in original query. Portfolio should include book dummy, final art, photographs, roughs, slides and tearsheets. Buys one-time rights. Originals are returned at job's completion.

This cover illustration by Dan Brown "combines realism and romanticism, and establishes a mood for the novel. Book buyers are attracted to the single image," says Jim Davis, Crown Publishers' art director. "Dan has a reputation for work done for book jackets and covers, advertising, editorial and corporate." Brown got the assignment for *Beauty* through his agent, Artworks, New York.

Book Design: Assigns 60 freelance design jobs/year. Pays in published copies.
Jackets/Covers: Assigns 30 freelance design and 50 illustration jobs/year. Pays in published copies.
Text Illustration: Assigns 50 freelance illustration jobs/year. Pays in published copies. Prefers pen & ink.
Tips: "We find talented individuals to illustrate our projects any way we can. Generally artists hear about us and want to work with us. We are a very small company who gives beginners a chance to showcase their talents in a book project; and yet, more established artists are in touch with us because our projects are interesting (like American Indian mythology, The Oregon Trail, wildlife, etc.) and we do not art-direct anyone to death."

THE DANCING JESTER PRESS, 3411 Garth Rd., Suite 208, Baytown Texas 77521. (713)427-9560. E-mail: djpress@aol.com. Art Director: Nile Lienad. Imprints include Dancing Dagger Publications and Gesture Graphic Design Books. Company publishes hardcover and trade paperback originals and reprints. Types of books include coffee table books, cookbooks, historical fiction, history, humor, instructional, juvenile, mainstream fiction, preschool, reference, religious, romance, science fiction, self-help, textbooks, western and young adult. Specializes in fiction, mystery, nonfiction, texts, nutrition/cookbook (low-fat vegetarian). Publishes 15 titles/year. Recent titles include *The Dancing Jester Tarot*. 50% require freelance design. Book catalog available for $2 with 4×9½ SASE with 2 first-class stamps.
Needs: Uses freelancers for book and catalog design, jacket/cover and text illustration. 100% of freelance work demands knowledge of Aldus PageMaker, Adobe Illustrator, Adobe Photoshop and Aldus FreeHand.
First Contact & Terms: Send postcard sample of work or send query letter with brochure, résumé, SASE, tearsheets, photographs, photocopies and slides. Samples are returned by SASE if requested by artist. Art Director will contact artist for portfolio review if interested. Portfolio should include book dummy, final art, photographs, photostats, roughs, slides and tearsheets. Rights purchased vary according to projects. Originals are not returned.
Book Design: Payment is negotiable.
Jackets/Covers: Payment is negotiable. Considers all media.
Text Illustration: Assigns 10 freelance illustration jobs/year. Payment is negotiable. Considers all media.

JONATHAN DAVID PUBLISHERS, 68-22 Eliot Ave., Middle Village NY 11379. (718)456-8611. Fax: (718)894-2818. Production Coordinator: Fiorella de Lima. Estab. 1948. Company publishes hardcover originals. Types of books include biography, religious, young adult, reference, juvenile and cookbooks. Specializes in Judaica, sports, cooking. Publishes 25 titles/year. Recent titles include *Classic Jewish Humor In America*;

and *Cooking Kosher The New Way.* 50% require freelance illustration; 75% require freelance design. Book catalog free by request.

Needs: Approached by 15-20 freelancers/year. Works with 5 freelance illustrators and 5 designers/year. Prefers local freelancers with experience in book jacket design and jacket/cover illustration. 100% of design and 5% of illustration demand knowledge of Adobe Illustrator, QuarkXPress or Adobe Photoshop. Works on assignment only.

First Contact & Terms: Designers send query letter with résumé and photocopies. Illustrators send postcard sample and/or query letter with photocopies, résumé. Samples are filed. Reports back within 2 weeks. Production Coordinator will contact artist for portfolio review if interested. Portfolio should include color final art and photographs. Buys all rights. Originals are not returned. Finds artists through submissions.

Book Design: Assigns 15-20 freelance design jobs/year. Pays by the project.

Jackets/Covers: Assigns 15-20 freelance design and 4-5 illustration jobs/year. Pays by the project.

Tips: First-time assignments are usually book jackets, mechanicals and artwork.

DAW BOOKS, INC., 375 Hudson St., 3rd Floor, New York NY 10014-3658. (212)366-2096. Fax: (212)366-2090. Art Director: Betsy Wollheim. Estab. 1971. Publishes hardcover and mass market paperback originals and reprints. Specializes in science fiction and fantasy. Publishes 72 titles/year. Recent titles include *Crown of Shadows*, by C.S. Friedman; and *Storm Rising*, by Mercedes Lackey. 50% require freelance illustration. Book catalog free by request.

Needs: Works with several illustrators and 1 designer/year. Buys more than 36 illustrations/year. Works with illustrators for covers. Works on assignment only.

First Contact & Terms: Send postcard sample or query letter with brochure, résumé, tearsheets, transparencies, photocopies, photographs and SASE. Samples are filed or are returned by SASE only if requested. Reports back about queries/submissions within 2-3 days. Originals returned at job's completion. Call for appointment to show portfolio of original/final art, final reproduction/product and transparencies. Considers complexity of project, skill and experience of artist and project's budget when establishing payment. Buys first rights and reprint rights.

Jacket/Covers: Pays by the project, $1,500-8,000. "Our covers illustrate the story."

Tips: "We have a drop-off policy for portfolios. We accept them on Tuesdays, Wednesdays and Thursdays and report back within a day or so. Portfolios should contain science fiction and fantasy color illustrations *only*. We do not want to see anything else. Look at several dozen of our covers."

‡**ALDINE DE GRUYTER, NEW YORK**, 200 Saw Mill R. Rd., Hawthorne NY 10532. (914)747-0110. Production Manager: Anne Obuck. Estab. 1978. Imprint of Walter de Gruyter Inc. Publishes scholarly books and graduate level textbooks (cloth and paper dual editions). Specializes in sociology. Publishes 15-20 titles/year. 0% requires illustration; 100% requires freelance design. Book catalog free on request.

Needs: Works with 2 designers/year. Prefers local freelancers experienced in scholarly covers and jackets. Design demands knowledge of Adobe Illustrator and QuarkXPress, "or subject to prior discussion. Strong typographic skills essential."

First Contact & Terms: Designers send photocopies, résumé. Samples are filed. Will contact artist for portfolio review of printed samples if interested.

Jackets/Covers: Assigns 15-20 design jobs/year. Pays by the project; negotiable.

DIAL BOOKS FOR YOUNG READERS, 375 Hudson St., New York NY 10014. (212)366-2803. Fax: (212)366-2020. Editor: Toby Sherry. Specializes in juvenile and young adult hardcovers. Publishes 80 titles/year. Titles include *Brother Eagle, Sister Sky*; *Amazing Grace, Ryan White: My Own Story*; and *Rosa Parks*. 100% require freelance illustration. Books are "distinguished children's books."

Needs: Approached by 400 freelancers/year. Works with 40 freelance illustrators/year. Prefers freelancers with some book experience. Works on assignment only.

First Contact & Terms: Send query letter with photocopies, tearsheets and SASE. Samples are filed and returned by SASE. Reports only if interested. Originals returned at job's completion. Send query letter with samples for appointment to show portfolio of original/final art and tearsheets. Considers complexity of project, skill and experience of artist and project's budget when establishing payment. Rights purchased vary.

Book Design: Assigns 10 freelance design jobs/year. Pays by the project.

Jackets/Covers: Assigns 2 freelance design and 8 illustration jobs/year. Pays by the project.

Text Illustration: Assigns 40 freelance illustration jobs/year. Pays by the project.

DISCOVERY COMICS, (formerly Custom Comic Services), P.O. Box 1863, Austin TX 78767. Contact: Scott Deschaine. Estab. 1985. Specializes in educational comic books for promotion and advertising for use by business, education and government. "Our main product is full-color comic books, 16-32 pages long." Prefers pen & ink, airbrush and watercolor. Publishes 12 titles/year. Titles include *Way to Grow!* and *Blue Block*.

Needs: Approached by 150 freelancers/year. Works with 24 freelancers/year. "We are looking for freelancers who can produce finished artwork for educational comic books from layouts provided by the publisher. They

should be able to produce consistently high-quality illustrations for mutually agreeable deadlines, with no exceptions." Works on assignment only.

First Contact & Terms: Send query letter with business card and nonreturnable samples to be kept on file. Samples should be of finished comic book pages; prefers photostats. Reports within 6 weeks; must include SASE for reply. Considers complexity of project and skill and experience of artist when establishing payment. Buys all rights.

Text Illustration: Assigns 18 freelance jobs/year. "Finished artwork will be b&w, clean and uncluttered. Artists can have styles ranging from the highly cartoony to the highly realistic." Pays $100-250/comic book page of art.

Tips: "Send only samples of comic book pages. No reply without a SASE."

‡**DOVE BOOKS**, 8955 Beverly Blvd., West Hollywood CA 90048. (310)273-7722. Fax: (310)777-7667. Website: http://www.doveaudio.com/dove/. Art Director: Rick Penn-Kraus. Estab. 1985. Imprint of Dove Entertainment. Imprints include Dove Audio, Dove International, Dove Kids, Dove Multimedia. Publishes hardcover, trade paperback and mass market paperback originals, hardcover reprints, audio tapes and CD-ROM. Types of books include biography, cookbooks, experimental fiction, humor, juvenile, mainstream fiction, New Age, nonfiction, religious, self help. Specializes in biography, current events. Publishes 50 titles/year. Recent titles include *You'll Never Make Love in This Town Again*; *Inside the NRA*; *Shattered, Memories of Madison County*. 40% requires freelance illustration; 25% requires freelance design. Book catalog free.

Needs: Approached by 100 illustrators and 40 designers/year. Works with 40 illustrators and 30 designers/year. Prefers local designers. 100% of freelance design demands knowledge of Adobe Photoshop, Adobe Illustrator or QuarkXPress. 15% of freelance illustration demands knowledge of Adobe Photoshop or Adobe Illustrator.

First Contact & Terms: Designers send photocopies, résumé, SASE, tearsheets. Illustrators send postcard sample or query letter with SASE and tearsheets. Samples are filed or returned by SASE. Portfolios may be dropped off every Thursday or art director will contact artist for portfolio review of photocopies, tearsheets, thumbnails or transparencies if interested. Finds freelancers through promo cards, *Workbook*.

Book Design: Assigns 15 jobs/year. Pays by the project.

Jackets/Covers: Assigns 40 design and 65 illustration jobs/year. Pays by project.

Tips: "We look for 1. solid illustration abilities; 2. knowledge of production needs (bleed, etc.); 3. excellent communication skills."

‡**DRAMA BOOK PUBLISHERS**, 260 Fifth Ave., New York NY 10001. (212)725-5377. Estab. 1967. Publishes hardcover originals and reprints, trade paperback reprints and textbooks. Specializes in costume, theater and performing arts books. Publishes 8 titles/year. 10% require freelance illustration; 25% require freelance design.

Needs: Works with 2-3 freelance designers/year. Prefers local artists only. Uses freelancers mainly for jackets/covers. Also for book, direct mail and catalog design and text illustration. Works on assignment only.

First Contact & Terms: Send query letter with brochure and tearsheets. Samples are filed. Reports back to the artist only if interested. Rights purchased vary according to project. Originals not returned. Pays by the project.

‡**EDITORIAL CARIBE, INC.**, P.O. Box 14100, Nashville TN 37214. (615)391-3937 ext. 2376. E-mail: 76711,3125@compuserve.com. Website: CompuServe(Go CCity). Production Manager: Sam Rodriguez. Publishes hardcover originals, trade paperback originals and reprints and mass market paperback originals and reprints. Types of books include self-help and religious. Specializes in commentary series and Bibles. Publishes 80 titles/year. Recent titles include *Renuevame* and *Cuidado con los extremos!* 90% require freelance illustration; 100% require freelance design. Book catalog free by request.

Needs: Approached by 10 freelance artists/year. Works with 12-18 illustrators and 12 designers/year. Buys 20 freelance illustrations/year. Uses freelancers mainly for cover design. Also uses freelance artists for jacket/cover illustration. 100% of freelance desigin and 40% of illustration demand knowledge of Adobe Photoshop and Adobe Illustrator. Works on assignment only.

First Contact & Terms: Designers send query letter with brochure. Illustrators send postcard sample and/or brochure. Samples are filed. Reports back within 2 weeks. Artist should follow up with call and/or letter after initial query. Requests work on spec before assigning job. Buys all rights. Interested in buying second rights (reprint rights) to previously published work. Originals not returned. Finds artists through word of mouth, submissions and work already done.

THE MULTIMEDIA INDEX preceding the General Index in the back of this book lists markets seeking freelancers with multimedia, CD-ROM skills.

Book Design: Assigns 30 design jobs/year. Pays by the project, $300-1,000.
Jackets/Covers: Assigns 40 design and 40 illustration jobs/year. Pays by the project, $400-700.
Tips: "Show creativity at a reasonable price. Keep in touch with industry and know what is out in the marketplace. Visit a large book store."

EDUCATIONAL IMPRESSIONS, INC., 210 Sixth Ave., Hawthorne NJ 07507. (201)423-4666. Fax: (201)423-5569. Art Director: Karen Sigler. Estab. 1983. Publishes original workbooks with 2-4 color covers and b&w text. Types of books include instructional, juvenile, young adult, reference, history and educational. Specializes in all educational topics. Publishes 4-12 titles/year. Recent titles include *Multicultural Legends and Tales*; and *Weekly Writing Activities for the Middle Grades*. Books are bright and bold with eye-catching, juvenile designs/illustrations.
Needs: Works with 1-5 freelance illustrators/year. Prefers freelancers who specialize in children's book illustration. Uses freelancers for jacket/cover and text illustration. Also for jacket/cover design. 50% of illustration demands knowledge of QuarkXPress, Aldus FreeHand and Adobe Photoshop. Works on assignment only.
First Contact & Terms: Send query letter with tearsheets, SASE, résumé and photocopies. Samples are filed. Art Director will contact artist for portfolio review if interested. Buys all rights. Interested in buying second rights (reprint rights) to previously published work. Originals are not returned. Prefers line art for the juvenile market. Sometimes requests work on spec before assigning a job.
Book Design: Pays by the project, $20 minimum.
Jackets/Covers: Pays by the project, $20 minimum.
Text Illustration: Pays by the project, $20 minimum.
Tips: "Send juvenile-oriented illustrations as samples."

‡ELLIOTT & CLARK PUBLISHING, 1745 Kalorama Rd. NW, Suite B-1, Washington DC 20009. (202)387-9805. Fax: (202)483-0355. E-mail: ecp@dgsys.com. Vice Pres. & Publisher: Carolyn Clark. Estab. 1991. Small press. Publishes hardcover and trade paperback originals. Types of books include biography, history, coffee table books and illustrated histories. Specializes in Americana, history, natural history. Publishes 4 titles/year. Recent titles include *Dorothea Lange's Ireland* and *Daffodils for American Gardens*. 20% require freelance illustration; 100% require freelance design. Book catalog free for SAE with 2 first-class stamps.
Needs: Works with 2-3 illustrators and 3-4 designers/year. Prefers local artists only. Uses freelancers mainly for text illustration. Also for jacket/cover, book and catalog design. 100% of freelance work demands knowledge of Aldus PageMaker or Adobe Illustrator. Works on assignment only.
First Contact & Terms: Send query letter with brochure, résumé, SASE, tearsheets and slides. Samples are filed. Reports back within 2 months. Write for appointment to show portfolio. Rights purchased vary according to project.
Book Design: Assigns 7 illustration jobs/year. Pays by the project, $5,000-15,000.
Text Illustration: Assigns 1-2 jobs/year. Pays by the project.
Tips: They don't publish children's books, so unfortunately have no need for children's books illustrations.

ELYSIUM GROWTH PRESS, 814 Robinson Rd., Topanga CA 90290. (310)455-1000. Fax: (310)455-2007. Art Director: Chris Moran. Estab. 1961. Small press. Publishes hardcover originals and reprints and trade paperback originals and reprints. Specializes in nudism/naturism, travel and lifestyle. Publishes 4 titles/year. Titles include *Nudist Magazines of the '50s* and *'60s, Books 1-4*. 10% require freelance illustration; 10% require freelance design. Book catalog free for SAE with 2 first-class stamps.
Needs: Approached by 5 freelancers/year. Works with 2 freelance illustrators and 2 designers/year. Prefers freelancers with experience in rendering the human body and clothing. Uses freelancers mainly for covers and interior illustration. Also for jacket and book design. 100% of freelance work demands knowledge of Macintosh. Works on assignment only.
First Contact & Terms: Send query letter with brochure, tearsheets and photocopies. Samples are filed. Reports back within 2 weeks. Artist should follow up with call after initial query. Sometimes requests work on spec before assigning a job. Buys one-time rights. Interested in buying second rights (reprint rights) to previously published artwork. Finds artists through submissions ("nonreturnable color photocopies preferred").
Book Design: Assigns 1 freelance design job/year. Pays by the hour, $20-50.
Jackets/Covers: Assigns 2 freelance design and 2 illustration jobs/year. Pays by the hour, $20-50.
Text Illustration: Assigns 8 freelance jobs/year. Pays by the hour, $20-50.

M. EVANS AND COMPANY, INC., 216 E. 49th St., New York NY 10016. (212)688-2810. Fax: (212)486-4544. Managing Editor: Charles de Kay. Estab. 1956. Publishes hardcover and trade paperback originals. Types of books include contemporary fiction, biography, health and fitness, history, self-help and cookbooks. Specializes in general nonfiction. Publishes 30 titles/year. Recent titles include *Robert Crayhon's Nutrition Made Simple*, by Robert Crayhon; and *An Inquiry into the Existence of Guardian Angels*, by Pierre Jovanovic. 50% require freelance illustration and design.

Needs: Approached by 25 freelancers/year. Works with approximately 3 freelance illustrators and 10 designers/year. Buys 20 illustrations/year. Prefers local artists. Uses freelance artists mainly for jacket/cover illustration. Also for text illustration and jacket/cover design. Works on assignment only.
First Contact & Terms: Send query letter with brochure and résumé. Samples are filed. Art Director will contact artist for portfolio review if interested. Portfolios may be dropped off every Friday. Portfolio should include original/final art and photographs. Rights purchased vary according to project. Originals are returned at job's completion upon request.
Book Design: Assigns 20 freelance jobs/year. Pays by project, $200-500.
Jackets/Covers: Assigns 20 freelance design jobs/year. Pays by the project, $600-1,200.
Text Illustration: Pays by the project, $50-500.

‡FABER AND FABER, INC., 53 Shore Rd., Winchester MA 01890. (617)721-1427. Fax: (617)729-2783. Editorial Assistant: Adrian Wood. Estab. 1976. Publishes hardcover originals, trade paperback originals and reprints. Types of books include biography, cookbooks, history, mainstream fiction, nonfiction, self help and travel. Publishes 90 titles/year. 30% require freelance design.
Needs: Approached by 60 illustrators and 40 designers/year. Works with 2 illustrators and 7 designers/year. Uses freelancers mainly for book jacket design. 80% of freelance design demands knowledge of Adobe Photoshop and QuarkXPress.
First Contact & Terms: Designers send query letter with photocopies. Illustrators send postcard sample or photocopies. Samples are filed or returned by SASE. Will contact artist for portfolio review if interested. Rights purchased vary according to project.
Jackets/Covers: Assigns 20 freelance design and 4 illustration jobs/year. Pays by project.

FAIRCHILD FASHION & MERCHANDISING GROUP, BOOK DIVISION, Dept. AM, 7 W. 34th St., New York NY 10010. (212)630-3880. Fax: (212)630-3868. Art Director: David Jaenisch. Estab. 1966. Book publisher. Publishes "highly visual and design sensitive" hardcover originals and reprints and textbooks. Types of books include fashion, instruction, reference and history. Specializes in all areas of fashion, textiles and merchandising. Publishes 5-10 titles/year. Recent titles include *Visual Merchandising & Display*, third edition; and *Whos Who in Fashion*, third edition. 50% require freelance illustration; 50% require freelance design. Book catalog free by request.
Needs: Works with freelance illustrators and 8 designers/year. Prefers, but not restricted to freelancers with experience in fashion illustration, technical drawing, clothing and design. Uses freelancers mainly for book design. Also for jacket/cover design, text illustration and direct mail design. 100% of design and 50% of illustration demand knowledge of Adobe Illustrator, QuarkXPress or Adobe Photoshop.
First Contact & Terms: Send résumé, tearsheets and photocopies. Accepts disk submissions containing two portfolios of work. Disks not returned. Samples are filed. Reports back to the artist only if interested. Write for appointment to show portfolio, or mail color tearsheets and as many printed samples as possible. Buys all rights. Originals not returned.
Book Design: Assigns 6 freelance design jobs/year. Pays by the project, $3,000-7,000.
Jackets/Covers: Assigns 4 freelance design and 4 illustration jobs/year. Pays by the project, $1,000-3,000. "Work is usually computer-generated but could also be done traditionally. Must have very strong type sensibilities."
Text Illustration: "Prefers computer-generated work for technical illustration; any media for fashion." Pays by the project, $500-5,000.
Tips: "Be punctual; bring portfolio and ask questions about the project. We'd like to see more technical illustrators who do computer work and fashion illustrators who work in any medium."

‡FALCON PRESS PUBLISHING CO., INC., 48 N. Last Chance Gulch, Helena MT 59601. (406)442-6597. Fax: (406)442-2995. Art/Production Director: Kathy Springmeyer. Estab. 1978. Book publisher. Publishes hardcover originals and reprints, trade paperback originals and reprints, and mass market paperback originals and reprints. Types of books include instruction, preschool, juvenile, travel and cookbooks. Specializes in recreational guidebooks, high-quality, four-color photo books. Publishes 60 titles/year. Titles include *On My Mind State series*, *A Field guide to Cows* and *Return of the Eagle*. Book catalog free by request.
Needs: Approached by 250 freelance artists/year. Works with 2-5 freelance illustrators/year. Buys 100 freelance illustrations/year. Prefers artists with experience in illustrating children's books. Uses freelance artists mainly for illustrating children's books and map making. 100% of freelance work demands knowledge of Adobe Illustrator, Aldus PageMaker or QuarkXPress.
First Contact & Terms: Send postcard sample or query letter with résumé, tearsheets, photographs, photocopies or photostats. Samples are filed if it fits their style. Accepts disk submissions compatible with Aldus PageMaker, QuarkXPress or Adobe Illustrator. Reports back to the artist only if interested. Do not send anything you need returned. Buys all rights. Originals are returned at job's completion.
Text Illustration: Assigns approximately 5 freelance design and 5 freelance illustration jobs/year. Pays by the project, $500-1,500. No preferred media or style.
Tips: "If we use freelancers, it's usually to illustrate nature-oriented titles. These can be for various children's titles or adult titles. We tend to look for a more 'realistic' style of rendering, but with some interest."

F&W PUBLICATIONS INC., 1507 Dana Ave., Cincinnati OH 45207. Art Director: Clare Finney. Imprints: Writers Digest Books, North Light Books, Betterway Books, Story Press. Publishes 100-120 books annually for writers, artists and photographers, plus selected trade (lifestyle, home improvement) titles. Recent titles include: *The Fiction Dictionary*, *Capturing Light in Oils* and *Creative Bedroom Decorating*. Books are heavy on type-sensitive design.
Needs: Works with 10-20 freelance illustrators and 5-10 designers/year. Uses freelancers for text illustration and cartoons. Also for jacket/cover design and illustration, text illustration, direct mail and book design. 95% of freelance work demands knowledge of QuarkXPress. Works on assignment only.
First Contact & Terms: Send nonreturnable photocopies of printed work to be kept on file. Art Director will contact artist for portfolio review if interested. Interested in buying second rights (reprint rights) to previously published. "We like to know where art was previously published." Finds illustrators and designers through word of mouth and submissions/self promotions.
Book Design: Pays by the project, $500-1,000.
Jackets/Covers: Pays by the project, $400-850.
Text Illustration: Pays by the project, $100 minimum.
Tips: "Don't call. Send a brief letter with appropriate samples we can keep. Clearly indicate what type of work you are looking for. If you're looking for design work, don't send illustration samples."

FANTAGRAPHICS BOOKS, INC., 7563 Lake City Way, Seattle WA 98115. Phone/fax: (206)524-1967. Publisher: Gary Groth. Estab. 1976. Publishes hardcover and trade paperback originals and reprints. Types of books include contemporary, experimental, mainstream, historical, humor and erotic. "All our books are comic books or graphic stories." Publishes 100 titles/year. Recent titles include *Love & Rockets*, *Hate*, *Eightball*, *Acme Novelty Library*, *JIM* and *Naughty Bits*. 10% require freelance illustration. Book catalog free by request.
Needs: Approached by 500 freelancers/year. Works with 25 freelance illustrators/year. Must be interested in and willing to do comics. Uses freelancers for comic book interiors and covers.
First Contact & Terms: Send query letter addressed to submissions editor with résumé, SASE, photocopies and finished comics work. Samples are not filed and are returned by SASE. Reports back to the artist only if interested. Call or write for appointment to show portfolio of original/final art and b&w samples. Buys one-time rights or negotiates rights purchased. Originals are returned at job's completion. Pays royalties.
Tips: "We want to see completed comics stories. We don't make assignments, but instead look for interesting material to publish that is pre-existing. We want cartoonists who have an individual style, who create stories that are personal expressions."

FARRAR, STRAUS & GIROUX, INC., Dept. AGDM, 19 Union Square W., New York NY 10003. (212)741-6900. Art Director: Michael Kaye. Production Coordinator: Harvey Hoffman. Book publisher. Estab. 1946. Publishes hardcover and trade paperback originals and trade paperback reprints. Publishes nonfiction and fiction. Publishes 120 titles/year. 20% require freelance illustration; 40% freelance design.
Needs: Works with 12 freelance designers/year. Uses artists for jacket/cover and book design.
First Contact & Terms: Send brochure, tearsheets and photostats. Samples are filed and are not returned. Reports back only if interested. Originals are returned at job's completion. Call or write for appointment to show portfolio of photostats and final reproduction/product. Considers complexity of project and budget when establishing payment. Buys one-time rights.
Book Design: Assigns 40 freelance design jobs/year. Pays by the project, $300-450.
Jackets/Covers: Assigns 40 freelance design jobs/year. Pays by the project, $750-1,500.
Tips: The best way for a freelance illustrator to get an assignment is "to have a great portfolio."

‡FOCUS ON THE FAMILY, 8605 Explorer Dr., Colorado Springs CO 80920. (719)531-3400. Senior Art Director, Periodicals: Tim Jones. Estab. 1977. Publishes hardcover, trade paperback and mass market paperback originals, audio tapes and periodicals. Types of books include adventure, history, instructional, juvenile, nonfiction, religious, self-help. Specializes in religious-Christian. Publishes 20 titles/year. 30% require freelance illustration; 30% require freelance design. Book catalog free.
Needs: Approached by 60 illustrators and 12 designers/year. Works with 150 illustrators and 1 designer/year. Prefers local designers. Prefers designers experienced in Macintosh. Uses designers mainly for periodicals, publication design/production. 100% of design and 20% illustration demands knowledge of Aldus FreeHand, Adobe Photoshop, Adobe Illustrator, QuarkXPress.
First Contact & Terms: Send query letter with photocopies, printed samples, résumé, SASE and tearsheets. Send follow-up postcard every year. Samples are filed. Reports back within 2 weeks. Will contact artist for portfolio review of photocopies of artwork portraying family themes if interested. Buys first, one-time or reprint rights. Finds freelancers through agents, sourcebooks and submissions.
Book Design: Assigns 6-8 freelance design jobs/year. Pays by the project.
Jackets/Covers: Assigns 6-8 freelance design jobs and 4 illustration jobs/year. Pays by the project. Prefers realistic and stylized work.
Text Illustration: Assigns 150 illustration jobs/year. Pays by project. Prefers realistic, abstract, cartoony styles.

FOREST HOUSE PUBLISHING CO., INC. & HTS BOOKS, P.O. Box 738, Lake Forest IL 60045-0738. (847)295-8287. President: Dianne Spahr. Children's book publisher. Types of books include instructional, fantasy, mystery, self-help, young adult, reference, history, juvenile, preschool and cookbooks. Specializes in early readers, sign language, bilingual dictionaries, Spanish children's titles, moral lessons by P.K. Hallinan and Stephen Cosgrove. Publishes 5-10 titles inhouse, and as many as 26 titles with other trade publishers. Recent titles include *The Missing Money* and *Mystery of the UFO* (both in The Red Door Detective Club series by Janet Riehecky, illustrated by Lydia Halverson). 90% require freelance illustration and design. Book catalog free by request.
Needs: Approached by 20 freelance artists/year. Works with 5 illustrators and 5 designers/year. Prefers artists with experience in children's illustration. Uses freelancers for jacket/cover and text illustration, book and catalog design. 25% of freelance work demands computer skills. Works on assignment only.
First Contact & Terms: Send query letter with brochure, résumé, photographs, photocopies and 4-color and b&w illustrations. Samples are not filed and are returned by SASE if requested by artist. Reports back within 6 months only if interested. Send portfolio or b&w and color roughs, one piece of final art, dummies. Rights purchased vary according to project. Originals are returned at job's completion, if requested.
Book Design: Assigns 10 freelance design jobs/year. Pays by the project.
Jackets/Covers: Assigns 10 freelance design and 10 illustration jobs/year. Pays by the project.
Text Illustration: Assigns 10 freelance jobs/year. Pays by the project.
Tips: "Send samples, with a SASE, which we will keep on file."

FORWARD MOVEMENT PUBLICATIONS, 412 Sycamore St., Cincinnati OH 45202. (513)721-6659. Fax: (513)421-0315. E-mail: forward.movement@ecunet.org. Associate Director: Sally B. Sedgwick. Estab. 1934. Publishes trade paperback originals. Types of books include religious. Publishes 24 titles/year. Recent titles include *Holy Days and Holidays*, by Lee Gibbs and *Joy*. 75% require freelance illustration. Book illustration is usually suggestive, not realistic. Book catalog free for SAE with 3 first-class stamps.
Needs: Works with 2-4 freelance illustrators and 1-2 designers/year. Uses freelancers mainly for illustrations required by designer. "We also keep original clip art-type drawings on file to be paid for as used."
First Contact & Terms: Send query letter with tearsheets, photographs, photocopies and slides. Samples are sometimes filed. Art Director will contact artist for portfolio review if interested. Sometimes requests work on spec before assigning a job. Interested in buying second rights (reprint rights) to previously published work. Rights purchased vary according to project. Originals sometimes returned at job's completion. Finds artists mainly through word of mouth.
Jackets/Covers: Assigns 18 freelance design and 6 illustration jobs/year. Pays by the project, $25-175.
Text Illustration: Assigns 1-4 freelance jobs/year. Pays by the project, $10-200; pays $5-25/picture. Prefers pen & ink.
Tips: If you send clip art, include fee you charge for use.

FRIENDSHIP PRESS PUBLISHING CO., 475 Riverside Dr., New York NY 10115. (212)870-2280. Art Director: E. Paul Lansdale (Room 552). Specializes in hardcover and paperback originals, reprints and textbooks; "adult and children's books on social issues from an ecumenical perspective." Publishes more than 10 titles/year; many require freelance illustration. Recent titles include *Families Valued, First We Must Listen, The Community of Nations* and *Remembering the Future*.
Needs: Approached by more than 75 freelancers/year. Works with 5-10 freelance illustrators and 4-8 designers/year. Works on assignment only. 75% of design requires knowledge of Adobe Photoshop, QuarkXPress or Adobe Illustrator.
First Contact & Terms: Send brochure showing art style or résumé, tearsheets, and "even black & white photocopies. Send nonreturnable samples." Samples are filed and are not returned. Reports back only if interested. Originals are returned to artist at job's completion. Call or write for appointment to show portfolio, or mail thumbnails, roughs, original/final art, photostats, tearsheets, final reproduction/product, photographs, slides, transparencies or dummies. Considers skill and experience of artist, project's budget and rights purchased when establishing payment.
Book Design: Pays by the hour, $12-20.
Jackets/Covers: Assigns 10 freelance design and over 5 illustration jobs/year. Pays by the project, $300-400.
Text Illustration: Assigns more than 8 freelance jobs/year. Pays by the project, $25-75, b&w.

FULCRUM PUBLISHING, 350 Indiana St., Suite 350, Golden CO 80401. (303)277-1623. Fax: (303)279-7111. Production Director: Patty Maher. Estab. 1986. Book and calendar publisher. Publishes hardcover originals and trade paperback originals and reprints. Types of books include biography, reference, history, self help, travel, humor, gardening and nature. Specializes in history, nature, travel and gardening. Publishes 50 titles/year. Recent titles include *The Undaunted Garden*, by Lauren Springer; and *Stifled Laughter*, by Claudia Johnson. 15% require freelance illustration; 85% require freelance design. Book catalog free by request.
Needs: Approached by 50 freelancers/year. Works with 4 freelance illustrators and 6 designers/year. Uses freelancers mainly for cover and interior illustrations for gardening books and images for calendars. Also

for other jacket/covers, text illustration and book design. Works on assignment only.
First Contact & Terms: Send query letter with tearsheets, photographs, photocopies and photostats. Samples are filed. Reports back to the artist only if interested. To show portfolio, mail b&w photostats. Buys one-time rights. Originals are returned at job's completion.
Book Design: Assigns 25 freelance design and 6 illustration jobs/year. Pays by the project, $350-2,000.
Jackets/Covers: Assigns 20 freelance design and 4 illustration jobs/year. Pays by the project.
Text Illustration: Assigns 10 freelance design and 1 illustration jobs/year. Pays by the project.

‡GALLOPADE PUBLISHING GROUP/CAROLE MARSH FAMILY CD-ROM, Suite 100, 359 Milledge Ave., Atlanta GA 30312-3238. Contact: Art Department. Estab. 1979. Publishes hardcover and trade paperback originals, textbooks and interactive multimedia. Types of books include contemporary fiction, western, instructional, mystery, biography, young adult, reference, history, humor, juvenile and sex-education. Publishes 1,000 titles/year. Titles include *Alabama Jeopardy* (and other states), *A Trip to the Beach* (CD-ROM). 20% require freelance illustration; 20% require freelance design.
Needs: Works almost exclusively with paid or unpaid interns. Company selects interns from applicants who send nonreturnable samples, résumé and internship availability. Interns work on an initial unpaid project, anything from packaging and book covers to multimedia and book design. Students can receive credit and add commercial work to their portfolio. Prefers artists with Macintosh experience.
First Contact & Terms: Send non-returnable samples only. Usually buys all rights.

GEM GUIDES BOOK CO., 315 Cloverleaf Dr., Suite F, Baldwin Park CA 91706. (818)855-1611. Fax: (818)855-1610. Editor: Robin Nordhues. Estab. 1964. Book publisher and wholesaler of trade paperback originals and reprints. Types of books include earth sciences, western, instructional, travel, history and regional (western US). Specializes in travel and local interest (western Americana). Publishes 6 titles/year. Recent titles include *Gem Trails of Southern California*, by James R. Mitchell; and *The Nevada Trivia Book*, by Richard Moreno. 75% require freelance illustration and design. Book catalog free for SASE.
Needs: Approached by 24 freelancers/year. Works with 3 freelance illustrators and 3 designers/year. Buys 12 illustrations/year. Uses freelancers mainly for covers. Also for text illustration and book design. 100% of freelance work demands knowledge of Aldus PageMaker 5.0, Aldus FreeHand 4.0, Appleone Scanner and Omnipage Professional. Works on assignment only.
First Contact & Terms: Send query letter with brochure, résumé and SASE. Samples are filed. Art Director will contact artist for portfolio review if interested. Requests work on spec before assigning a job. Buys all rights. Originals are not returned. Finds artists through word of mouth and "our files."
Book Design: Assigns 6 freelance design jobs/year. Pays by the project.
Jackets/Covers: Pays by the project.
Text Illustration: Assigns 2 freelance jobs/year. Pays by the project.

‡GENERAL PUBLISHING GROUP, 2701 Ocean Park Blvd. #140, Santa Monica CA 90405-5200. (310)314-4000. Fax: (310-314-8080. E-mail: genpub@aol.com. Projects Manager: Trudi Hope Schlomowitz. Estab. 1993. Publishes hardcover and trade paperback originals and reprints. Publishes biography, coffee table books, cookbooks and retrospectives. Specializes in entertainment. Publishes 30 titles/year. Recent titles include: *As The World Turns, Sammy Davis, Pamela Anderson*. 25% require freelance design. Catalog available free for 8½×11 SASE with 1 first-class stamp.
Needs: Approached by 2 freelance designers/year. Works with 2 freelance designers/year. Prefers local freelancers. Uses freelancers mainly for design, layout, production. 100% of freelance design demands knowledge of Adobe Photoshop 3.0.4 and Adobe Illustrator 6.0 and QuarkXPress 6.0 and QuarkXPress 3.32.
First Contact & Terms: Send query letter with brochure, photocopies, photographs, photostats, résumé, printed samples, tearsheets and SASE. Accepts disk submissions compatible with QuarkXPress, Adobe Photoshop and Adobe Illustrator (TIFF, EPS files). Samples are filed and are not returned. Will contact artist for portfolio review of artwork portraying entertainment subjects, photocopies, photographs, photostats, roughs and tearsheets. Rights purchased vary according to project. Finds artists through portfolio reviews, recommendations, *LA Times* employment ads.
Book Design: Assigns 2 book design jobs/year. Pays by the hour, $15-25.
Jackets/Covers: Assigns 2 design jobs/year. Pays by the hour $15-25 for design and illustration.
Tips: "We look for unrestrained design approaches that are fresh. It is a definite plus if you possess good production skills and have typesetting experience."

GIBBS SMITH, PUBLISHER, P.O. Box 667, Layton UT 84041. (801)544-2958. Editorial Director: Madge Baird. Estab. 1969. Imprints include Peregrine Smith Books. Company publishes hardcover and trade paperback originals. Types of books include coffee table books, cookbooks, humor, juvenile, textbooks, western. Specializes in home/interior, gardening, humor. Publishes 50-60 titles/year. Recent titles include *The Living Wreath* and *Don't Squat with Yer Spurs On!* 20% require freelance illustration; 100% require freelance design. Book catalog free for 9×12 SASE with first class stamps.
Needs: Approached by 100 freelance illustrators and 25 freelance designers/year. Works with 10 freelance illustrators and 20 designers/year. Prefers freelancers experienced in book illustration. Uses freelancers mainly

for cover design and book layout, cartoon illustration, children's book illustration. 100% of freelance design demands knowledge of Aldus PageMaker, Aldus FreeHand, Adobe Photoshop, Adobe Illustrator, QuarkXPress. 10% of freelance illustration demands knowledge of Adobe Photoshop, Adobe Illustrator.

First Contact & Terms: Designers send query with brochure, photocopies, photostats, résumé, SASE, slides (not originals) and tearsheets. Illustrators send postcard sample and/or query letter with photocopies, photographs, photostats, printed samples, résumé, slides and tearsheets. Send follow-up postcard sample every 6-12 months. Samples are filed. Request portfolio review in original. Reports back only if interested. Artist should follow-up with call and/or letter after initial query. Portfolio should include artwork portraying nature, cartoon characters, children, book dummy, photocopies, photographs, photostats, tearsheets, transparencies. Rights purchased vary according to project. Finds freelancers through word of mouth, submissions.

Book Design: Assigns 50-60 freelance design jobs/year. Pays by the project, $1,000-3,000; $700 cover design plus per page fee.

Jackets/Covers: Assigns 50-60 freelance design jobs and 5-10 illustration jobs/year. Pays for design by the project, $500-800. Pays for illustration by the project, $250-400. Prefers watercolor or oil, or pastels.

Text Illustration: Assigns 10-15 freelance illustration jobs/year. Pays by the project, $400-3,000. Prefers line art, watercolor, pastel.

GLENCOE/McGRAW-HILL PUBLISHING COMPANY, Dept. AGDM, 15319 Chatsworth St., Mission Hills CA 91345. (818)898-1391. Fax: (818)837-3668. Art/Design/Production Manager: Sally Hobert. Vice President, Art/Design/Production: Donna Faull. Estab. 1965. Book publisher. Publishes textbooks. Types of books include foreign language, career education, art and music, health, religious education. Specializes in most el-hi (grades 7-12) subject areas. Publishes 350 titles/year. Recent titles include *Marketing Essentials* and *Teen Health*. 80% require freelance illustration; 40% require freelance design.

• Glencoe also has a division in Peoria, Illinois, with its separate art department.

Needs: Approached by 50 freelancers/year. Works with 20-30 freelance illustrators and 10-20 designers/year. Prefers experienced artists. Uses freelance artists mainly for illustration and production. Also for jacket/cover design and illustration, text illustration and book design. 100% of design and 50% of illustration demand knowledge of QuarkXPress on Mac. Works on assignment only.

First Contact & Terms: Send query letter with nonreturnable brochure, tearsheets, photocopies or slides to Sally Hobert. Accepts disk submissions compatible with above program. Samples are filed. Sometimes requests work on spec before assigning a job. Negotiates rights purchased. Originals are not returned.

Book Design: Assigns 10-20 freelance design and many illustration jobs/year. Pays by the project.

Jackets/Covers: Assigns 5-10 freelance design and 5-20 illustration jobs/year. Pays by the project.

Text Illustration: Assigns 20-30 freelance design jobs/year. Pays by the project.

GLENCOE/McGRAW-HILL PUBLISHING COMPANY, 3008 W. Willow Knolls Rd., Peoria IL 61615. (309)689-3200. Fax: (309)689-3211. Contact: Ardis Parker, Design and Production Manager, and Art and Photo Editors. Specializes in secondary educational materials (hardcover, paperback, filmstrips, software), especially in industrial and computer technology, home economics and family living, social studies, career education, etc. Publishes more than 100 titles/year.

Needs: Works with over 30 freelancers/year. 60% of freelance work demands knowledge of Adobe Illustrator, QuarkXPress or Adobe Photoshop. Works on assignment only.

First Contact & Terms: Send query letter with brochure, résumé and "any type of samples." Samples not filed are returned if requested. Reports back in weeks. Originals are not returned; works on work-for-hire basis with rights to publisher. Considers complexity of the project, skill and experience of the artist, project's budget, turnaround time and rights purchased when establishing payment. Buys all rights.

Book Design: Assigns 30 freelance design jobs/year. Pays by the project.

Jackets/Covers: Assigns 50 freelance design jobs/year. Pays by the project.

Text Illustration: Assigns 50 freelance jobs/year. Pays by the hour or by the project.

Tips: "Try not to cold call and never drop in without an appointment."

GLOBE PEQUOT PRESS, 6 Business Park Rd., P.O. Box 833, Old Saybrook CT 06475. (203)395-0440. E-mail: efoote@globe-pequot.com. Production manager: Kevin Lynch. Estab. 1947. Publishes hardcover and trade paperback originals and reprints. Types of books include business, cookbooks, instruction, self-help, history and travel. Specializes in regional subjects: New England, Northwest, Southeast bed-and-board country inn guides. Publishes 150 titles/year. 20% require freelance illustration; 75% require freelance design. Recent titles include *Enduring Harvests, Family Adventure Guides* and *Romantic City*. Design of books is "classic and traditional, but fun." Book catalog free.

Needs: Works with 10-20 freelance illustrators and 15-20 designers/year. Uses freelancers mainly for cover and text design and production. Also for jacket/cover and text illustration and direct mail design. Needs computer-literate freelancers for production. 100% of design and 75% of illustration demand knowledge of QuarkXPress 3.2, Adobe Illustrator 5.5 or Adobe Photoshop 3.0. Works on assignment only.

First Contact & Terms: Send query letter with résumé, photocopies and photographs. Accepts disk submissions compatible with QuarkXPress 3.2, Adobe Illustrator 5.5 or Adobe Photoshop 3.0. Samples are filed and not returned. Request portfolio review in original query. Artist should follow up with call after

initial query. Art Director will contact artist for portfolio review if interested. Portfolio should include roughs, original/final art, photostats, tearsheets and dummies. Requests work on spec before assigning a job. Considers complexity of project, project's budget and turnaround time when establishing payment. Buys all rights. Originals are not returned. Finds artists through word of mouth, submissions, self promotion and sourcebooks.
Book Design: Pays by the hour, $15-25 for production; or by the project, $200-600 for cover design.
Jackets/Covers: Prefers realistic style. Pays by the hour, $20-35; or by the project, $500-800.
Text Illustration: Prefers pen & ink line drawings. Pays by the project, $25-150.
Tips: "More books are being produced using the Macintosh. We like designers who can use the Mac competently enough that their design looks as if it *hasn't* been done on the Mac."

♣GOOSE LANE EDITIONS LTD., 469 King St., Fredericton, New Brunswick E3B 1E5 Canada. (506)450-4251. Art Director: Julie Scriver. Estab. 1958. Publishes trade paperback originals of poetry, fiction and nonfiction. Types of books include biography, cookbooks, fiction, reference and history. Publishes 10-15 titles/year. 10% require freelance illustration. Titles include *A Guide to Animal Behavior* and *Pete Luckett's Complete Guide to Fresh Fruit and Vegetables*. Books are "high quality, elegant, generally with full-color fine art reproduction on cover." Book catalog free for SAE with Canadian first-class stamp or IRC.
Needs: Approached by 3 freelancers/year. Works with 1-2 illustrators/year. Prefers to work with freelancers in the region. Works on assignment only.
First Contact & Terms: Send query letter with résumé, slides, transparencies and SASE. Samples are filed or are returned by SASE. Reports back in 1 month. Call or write for appointment to show portfolio of roughs, original/final art, final reproduction/product and slides. Negotiates rights purchased.
Jackets/Covers: Assigns 1-2 freelance illustration jobs/year. Prefers painting (dependent on nature of book). Pays by the project, $200-400.
Text Illustration: Assigns 1-2 freelance jobs/year. Prefers line drawing. Pays by the project, $300-1,500.
Tips: "A sensibility to individual house styles *and* market trends is a real asset."

‡GORSUCH SCARISBRICK, PUBLISHERS, 8233 Via Paseo del Norte F400, Scottsdale AZ 85258-3746. (602)991-7881. Fax: (602)991-4770. E-mail: colettek@enet.net. Production Manager: Mary B. Cullen. Estab. 1987. Imprints include Publishing Horizons, Prospect Press. Publishes trade paperback originals, textbooks, audio tapes, test banks/programs on disk. Types of books include college textbooks. Specializes in real estate, career, communications, education, physical fitness. Publishes 30-45 titles/year. Recent titles include *Career Fitness Program*, *Real Estate Principles & Practices*, *Choices in Wellness for Life*. 25% require freelance illustration; 100% require freelance design. Book catalog free.
Needs: Approached by 30 illustrators and 15 designers/year. Works with 3 illustrators and 5 designers/year. Prefers freelancers experienced in trade book and college text covers. Uses freelancers mainly for cover design. 100% of freelance design and 50% of illustration demand knowledge of Adobe Photoshop, Adobe Illustrator, QuarkXPress and Postscript.
First Contact & Terms: Designers send query letter with brochure, résumé and 4-color book cover and interior samples. Illustrators send postcard sample or query letter with printed samples. Send follow-up postcard samples every 3 months. Accepts disk submissions compatible with QuarkXPress version 3.31. Samples are filed and are not returned. Will contact for portfolio review of artwork portraying physical fitness exercises, book dummy, book covers and photographs if interested. Rights purchased vary according to project. Finds artists through submissions.
Book Design: Pays by the project.
Jackets/Covers: Assigns 30-45 freelance design jobs/year. Pays by the project. Prefers disk or film we can send to printer.
Text Illustration: Assigns 5 freelance illustration jobs/year. Pays by project.
Tips: "We look for freelancers who are knowledgable about printing/color, display, good use of type and have understanding of trapping on disk."

GOSPEL LIGHT PUBLICATIONS, 2300 Knoll Dr., Ventura CA 93003. (805)644-9721. Fax: (805)644-4729. Art Director: B. Fisher. Estab. 1932. Book publisher. Publishes hardcover, trade paperback and mass market paperback originals. Types of books include instructional, preschool, juvenile, young adult, reference, self-help and history. Specializes in Christian issues. Publishes 15 titles/year. Recent titles include *Victory Over the Darkness*, by Neil Anderson; *The Measure of a Man*, by Gene Getz; and *Bible Verse Coloring Pages*. 25% require freelance illustration; 10% require freelance design. Book catalog available for SASE.
Needs: Approached by 300 artists/year. Works with 10 illustrators and 4 designers/year. Buys 10 illustrations/year. Uses freelancers mainly for jacket/cover illustration and design. Also for text illustration; direct mail, book and catalog design. 100% of freelance design and 50% of illustration require knowledge of QuarkXPress, Adobe Illustrator and Adobe Photoshop. Works on assignment only.
First Contact & Terms: Send SASE, tearsheets, photographs and samples. Samples are filed or are returned by SASE if requested by artist. Reports back to the artist only if interested. Art Director will contact artist for portfolio review if interested. Portfolio should include color photostats, tearsheets, photographs, slides or transparencies. Negotiates rights purchased. Originals are returned to artist at job's completion.

Book Design: Assigns 4 freelance design and 5 illustration jobs/year. Pays by the project.
Jackets/Covers: Assigns 5 freelance design and 5 freelance illustration jobs/year. Accepts all types of styles and media for jacket/cover design and illustration. Pays by the project.
Text Illustration: Assigns 6 freelance design and 8 illustration jobs/year. Prefers line art and cartoons. Pays by the project.
Tips: "Computer operators are not necessarily good designers, yet many are designing books. Know the basics of good typography before trying to use the computer."

THE GRADUATE GROUP, P.O. Box 370351, W. Hartford CT 06137-0351. (203)233-2330. President: Mara Whitman. Estab. 1967. Publishes trade paperback originals. Types of books include instructional and reference. Specializes in internships and career planning. Publishes 25 titles/year. Recent titles include *New Internships for 1996*, by Robert Whitman; and *Careers in Law Enforcement*, by Lt. Jim Nelson. 10% require freelance illustration and design. Book catalog free by request.
Needs: Approached by 20 freelancers/year. Works with 1 freelance illustrator and 1 designer/year. Prefers local freelancers only. Uses freelancers for jacket/cover illustration and design; direct mail, book and catalog design. 5% of freelance work demands computer skills. Works on assignment only.
First Contact & Terms: Send query letter with brochure and résumé. Samples are not filed. Reports back only if interested. Write for appointment to show portfolio.

‡**GRAYWOLF PRESS**, 2402 University Ave., St. Paul MN 55114. (612)641-0077. Fax: (612)641-0036. Design and Production Manager: Ellen Foos. Estab. 1985. Publishes hardcover originals and trade paperback originals and reprints of contemporary and experimental literary fiction. Specializes in novels, poetry, essays. Publishes 17 titles/year. 60% require freelance design. Books use solid typography, strikingly beautiful and well-integrated artwork. Book catalog free by request.
 • Graywolf is recognized as one of the finest small presses in the nation.
Needs: Approached by 50 freelance artists/year. Works with 5 designers/year. Buys 20 illustrations/year (existing art only). Prefers artists with experience in literary titles. Uses freelancers mainly for text and cover design. Also uses for direct mail and catalog design. 80% of freelance work demands knowledge of Aldus PageMaker, QuarkXPress or Aldus FreeHand. Works on assignment only.
First Contact & Terms: Send query letter with résumé and photocopies. Samples are returned by SASE if requested by artist. Art Director will contact artist for portfolio review if interested. Portfolio should include b&w, color photostats and tearsheets. Negotiates rights purchased. Interested in buying second rights (reprint rights) to previously published work. Originals are returned at job's completion. Pays by the project, $300-800. Finds artists through submissions and word of mouth.
Jackets/Covers: Assigns 25 design jobs/year. Pays by the project, $400-1,000. "We use existing art—both contemporary and classical—and emphasize fine typography."
Tips: "Have a strong portfolio of literary (fine press) design. Desktop needs by small publishers are still in infancy, so designer should be able to provide some guidance."

GREAT QUOTATIONS PUBLISHING, 1967 Quincy Court, Glendale Heights IL 60139. (708)582-2800. Fax: (708)582-2813. Editor: Ringo Suek. Estab. 1985. Imprint of Greatime Offset Printing. Company publishes hardcover, trade paperback and mass market paperback originals. Types of books include coffee table books, humor and self-help. Specializes in humor and inspiration. Publishes 40 titles/year. Recent titles include *Let's Talk Decorative*, *Kid Bit*. 90% require freelance illustration and design. Book catalog available for $1.50 with SASE.
Needs: Approached by 100 freelancers/year. Works with 10 freelance illustrators/year and 10 designers/year. Prefers local artists. Uses freelancers for jacket/cover illustration and design; book and catalog design. 50% of freelance work demands knowledge of QuarkXPress and Adobe Photoshop. Works on assignment only.
First Contact & Terms: Send query letter with brochure, résumé, SASE, photographs and photocopies. Accepts disk submissions compatible with Adobe Illustrator 5.0. Send EPS files. Samples are filed or returned by SASE if requested by artist. Reports back within 1 month. Art Director will contact artist for portfolio review if interested. Portfolio should include book dummy and final art. Rights purchased vary according to project. Originals are returned at job's completion. Finds artists through word of mouth and *Creative Black Book*.
Book Design: Assigns 20 freelance design jobs/year. Pays by the project, $300-3,000.
Jackets/Covers: Assigns 10 freelance design jobs/year and 10 illustration jobs/year. Pays by the project, $300-3,000.
Text Illustration: Assigns 10 freelance illustration jobs/year. Pays by the project, $100-1,000.
Tips: "We're looking for bright, colorful cover design on a small size book cover (around 6×6). Outstanding humor or inspirational titles will be most in demand."

GROSSET & DUNLAP, 200 Madison Ave., New York NY 10016. (212)951-8736. Art Director: Ronnie Ann Herman. Publishes hardcover, trade paperback and mass market paperback originals and board books for preschool and juvenile audience (ages 1-10). Specializes in "very young mass market children's books."

Publishes 90 titles/year. Recent titles include *Behind the Mask*, by Ruth Heller and *Stars*, by Jennifer Dussling. 100% require freelance illustration; 10% require freelance design.
- Many books by this publisher feature unique design components such as acetate overlays, 3-D pop-up pages, or actual projects/toys that can be cut out of the book.

Needs: Works with 50 freelance illustrators and 1-2 freelance designers/year. Buys 80 books' worth of illustrations/year. "Be sure your work is appropriate for our list." Uses freelance artists mainly for book illustration. Also for jacket/cover and text illustration and design. 50% of design and 10% of illustration demand knowledge of Adobe Illustrator 5.5, QuarkXPress 3.3, and Adobe Photoshop 2.5.

First Contact & Terms: Designers send query letter with résumé and tearsheets. Illustrators send postcard sample and/or query letter with résumé, photocopies, SASE, slides and tearsheets. Samples are filed. Reports back to the artist only if interested. Call for appointment to show portfolio, or mail slides, color tearsheets, transparencies and dummies. Rights purchased vary according to project. Originals are returned at job's completion.

Book Design: Assigns 20 design jobs/year (mechanicals only). Pays by the hour, $15-22 for mechanicals.

Jackets/Covers: Assigns approximately 10 cover illustration jobs/year. Pays by the project, $1,500-2,500.

Text Illustration: Assigns approximately 80 projects/year. Pays by the project, $4,000-10,000.

Tips: "We are always looking for people who can illustrate wonderful babies and children. We are looking for good strong art."

GROUP PUBLISHING—BOOK & CURRICULUM DIVISION, 2890 N. Monroe, Loveland CO 80539. (303)669-3836. Fax: (303)669-3269. Art Director: Lisa Chandler. Company publishes books, Bible curriculum products (including puzzles and posters), clip art resources and audiovisual materials for use in Christian education for children, youth and adults.
- This company also produces magazines. See listing in Magazines section for more information.

Needs: Uses freelancers for cover illustration and design. 100% of design and 50% of illustration demand knowledge of QuarkXPress 3.0, Aldus Freehand 5.0, Adobe Photoshop 4.0, Adobe Illustrator 5.0. Occasionally uses cartoons in books and teacher's guides. Uses b&w and color illustration on covers and in book interiors.

First Contact & Terms: Contact Liz Howe, Marketing Art Director, if interested in cover design or illustration. Send query letter with non-returnable b&w or color photocopies, slides, tearsheets or other samples. Accepts disk submissions compatible with above programs. Send EPS files. Samples are filed, additional samples may be requested upon receipt of assignment. Reports back only if interested. Rights purchased vary according to project.

Text Illustration: Pays on acceptance: $35-150 for b&w (from small spot illustrations to full page). Fees for color illustration vary and are negotiable. Prefers b&w line or line and wash illustrations to accompany lesson activities.

Tips: "We prefer contemporary, nontraditional styles appropriate for our innovative and upbeat products and the creative Christian teachers and students who use them. We seek artists who can help us achieve our goal of presenting biblical material in fresh, new and engaging ways."

GRYPHON PUBLICATIONS, P.O. Box 209, Brooklyn NY 11228. Publisher: Gary Lovisi. Estab. 1983. Book and magazine publisher of hardcover originals, trade paperback originals and reprints, reference and magazines. Types of books include science fiction, mystery and reference. Specializes in crime fiction and bibliography. Publishes 10 titles/year. Titles include *Difficult Lives*, by James Sallis; *Vampire Junkies*, by Norman Spinrad. 40% require freelance illustration; 10% require freelance design. Book catalog free for #10 SASE.
- Also publishes *Hardboiled*, a quarterly magazine of noir fiction and *Paperback Parade* on collectible paperbacks.

Needs: Approached by 50-100 freelancers/year. Works with 10 freelance illustrators and 2 designers/year. Prefers freelancers with "professional attitude." Uses freelancers mainly for book and magazine cover and interior illustrations. Also for jacket/cover, book and catalog design. Works on assignment only.

First Contact & Terms: Send query letter with brochure, résumé, SASE, tearsheets, photographs and photocopies. Samples are filed. Reports back within 2 weeks only if interested. Portfolio should include thumbnails, roughs, b&w tearsheets. Buys one-time rights. "I will look at reprints if they are of high quality and cost effective." Originals are returned at job's completion if requested.

Jackets/Covers: Assigns 2 freelance design and 6 illustration jobs/year. Pays by the project, $25-150.

Text Illustration: Assigns 4 freelance jobs/year. Pays by the project, $10-100. Prefers b&w line drawings.

● **A BULLET** introduces comments by the editor of *Artist's & Graphic Designer's Market* indicating special information about the listing.

✦**GUERNICA EDITIONS**, P.O. Box 117, Station P, Toronto, Ontario M5S 2S6 Canada. (416)657-8885. Fax: (416)657-8885. Publisher/Editor: Antonio D'Alfonso. Estab. 1978. Book publisher and literary press specializing in translation. Publishes trade paperback originals and reprints. Types of books include contemporary and experimental fiction, biography, young adult and history. Specializes in ethnic/multicultural writing and translation of European and Quebecois writers into English and Italian/Canadian and Italian/American. Publishes 16-20 titles/year. Recent titles include *Astoria*, by Robert Viscusi; *Where I Come From*, by Maria Mazziotti Gillan; and *The Countess Plays*, by Daniel Sloate. 40-50% require freelance illustration. Book catalog available for SAE; nonresidents send IRC.
Needs: Approached by 6 freelancers/year. Works with 6 freelance illustrators/year. Uses freelancers mainly for jacket/cover illustration.
First Contact & Terms: Send query letter with résumé, SASE (or SAE with IRC), tearsheets, photographs and photocopies. Samples are filed or are returned by SASE if requested by artist. Reports back only if interested. To show portfolio, mail photostats, tearsheets and dummies. Buys one-time rights. Originals are not returned at job completion.
Jackets/Covers: Assigns 10 freelance illustration jobs/year. Pays by the project, $150-200.

HARMONY HOUSE PUBLISHERS—LOUISVILLE, P.O. Box 90, Prospect KY 40059. (502)228-4446. Fax: (502)228-2010. Art Director: William Strode. Estab. 1980. Publishes hardcover originals. Specializes in general books, cookbooks and education. Publishes 20 titles/year. Titles include *The Saddlebred—America's Horse of Distinction* and *Sandhurst—The Royal Military Academy*. 10% require freelance illustration.
Needs: Approached by 10 freelancers/year. Works with 2-3 freelance illustrators/year. Prefers freelancers with experience in each specific book's topic. Uses freelancers mainly for text illustration. Also for jacket/cover illustration. Usually works on assignment basis.
First Contact & Terms: Send query letter with brochure, résumé, SASE and appropriate samples. Samples are filed or are returned. Reports back to the artist only if interested. "We don't usually review portfolios, but we will contact the artist if the query interests us." Buys one-time rights. Sometimes returns originals at job's completion. Assigns 2 freelance design and 2 illustration jobs/year. Pays by the project.

‡✦**HARPERCOLLINS PUBLISHERS LTD. (CANADA)**, 55 Avenue Rd., Toronto, Ontario M5R 3L2 Canada. (416)975-9334. Fax: (416)975-9884. Website: http://www.harpercollins.com. Creative Director: Richard Bingham. Publishes hardcover, trade paperback and mass market paperback originals and reprints. Types of books include adventure, biography, coffee table books, cookbooks, fantasy, history, horror, humor, instructional, juvenile, mainstream fiction, New Age, nonfiction, preschool, reference, religious, romance, science fiction, self-help, travel, western and young adult. Publishes 100 titles/year. 50% require freelance illustration; 25% require freelance design.
Needs: Prefers freelancers experienced in mixed media. Uses freelancers mainly for illustration, cover design. 100% of freelance design demands knowledge of Adobe Photoshop, Adobe Illustrator, QuarkXPress. 25% of freelance illustration demands knowledge of Adobe Photoshop and Adobe Illustrator.
First Contact & Terms: Designers send query letter with brochure, photocopies, tearsheets. Illustrators send postcard sample and/or query letter with photocopies, tearsheets. Accepts disk submissions compatible with QuarkXPress. Send EPS or TIFF files. Samples are filed. Will contact artist for portfolio review "only after review of samples if I have a project they might be right for." Portfolio should include book dummy, photocopies, photographs, slides, tearsheets, transparencies. Rights purchased vary according to project.
Book Design: Assigns 5 freelance design jobs/year. Pays by the project.
Jackets/Covers: Assigns 20 freelance design and 50 illustration jobs/year. Pays by the project.
Test Illustration: Assigns 10 freelance illustration jobs/year. Pays by the project.

HARVEST HOUSE PUBLISHERS, 1075 Arrowsmith, Eugene OR 97402. (503)343-0123. Fax: (503)342-6410. Cover Director: Barbara Sherrill. Specializes in hardcover and paperback editions of adult fiction and nonfiction, children's books and youth material. Publishes 95 titles/year. Recent titles include *Where the Wild Rose Blooms*; *The Legend of Robin Brodie*; and *Quiet Moments for Couples*. Books are of contemporary designs which compete with the current book market.
Needs: Works with 10 freelance illustrators and 4-5 freelance designers/year. Uses freelance artists mainly for cover art. Also uses freelance artists for text illustration. Works on assignment only.
First Contact & Terms: Send query letter with brochure, résumé, tearsheets and photographs. Art Director will contact artist for portfolio review if interested. Requests work on spec before assigning a job. Originals may be returned at job's completion. Buys all rights. Finds artists through word of mouth and submissions/self-promotions.
Book Design: Pays by the project.
Jackets/Covers: Assigns 85 design and 10 illustration jobs/year. Pays by the project.
Text Illustration: Assigns 5 jobs/year. Pays by the project.

‡**HAY HOUSE, INC.**, P.O. Box 5100, Carlsbad CA 92018-5100. (800)654-5126. Art Director: Christy Allison. Publishes hardcover originals and reprints, trade paperback originals and reprints, audio tapes, CD-ROM. Types of book include coffee table books, New Age, astrology, metaphysics, psychology. Specializes

in self-help. Publishes 40 titles/year. Recent titles include *You Can Heal Your Life*; *Losing Your Pounds of Pain*; and *Astrology Really Works!* 20% require freelance illustration; 50% require freelance design. Book catalog free on request.

Needs: Approached by 10 freelance illustrators and 5 freelance designers/year. Works with 2-3 freelance illustrators and 2-5 freelance designers/year. Uses freelancers mainly for cover design. 80% of freelance design demands knowledge of Adobe Photoshop, Adobe Illustrator, QuarkXPress.

First Contact & Terms: Designers send photocopies (color), résumé, SASE if you want your samples back. Illustrators send photocopies. "We accept TIFF and EPS images compatible with the latest versions of QuarkXPress, Adobe Photoshop and Adobe Illustrator. Samples are filed and are returned by SASE or not returned. Art director will contact artist for portfolio review of printed samples or original artwork if interested. Buys all rights. Finds freelancers through word of mouth, submissions.

Jacket/Covers: Assigns 20 freelance design jobs and 3-5 illustration jobs/year. Pays for design by the project, $800-1,200. Payment for illustration varies for covers.

Tips: "We look for freelancers with experience in graphic design, desktop publishing, printing processes, production."

HEARTLAND SAMPLERS, INC., 5555 W. 78th St., Suite. P, Edina MN 55439. (612)942-7754. Fax: (612)942-6307. Art Director: Nancy Lund. Estab. 1987. Book publisher. Types of products include perpetual calendars, books and inspirational gifts. Publishes 50 titles/year. Titles include *Share the Hope* and *Tea Time Thoughts*. 100% require freelance illustration and design. Book catalog for SAE with first-class postage.

Needs: Approached by 4 freelancers/year. Works with 10-12 freelance illustrators and 2-4 designers/year. Prefers freelancers with experience in the gift and card market. Uses freelancers for illustrations; jacket/cover illustration and design; direct mail, book and catalog design.

First Contact & Terms: Send query letter with brochure, résumé, SASE, tearsheets, photographs and photocopies. Samples are filed or are returned by SASE if requested by artist. Art Director will contact artist for portfolio review if interested. Portfolio should include thumbnails, roughs, 4-color photographs and dummies. Sometimes requests work on spec before assigning a job. Rights purchased vary according to project.

Book Design: Assigns 12 freelance design jobs/year. Pays by the project, $35-300.

Jackets/Covers: Assigns 15-40 freelance design jobs/year. Prefers watercolor, gouache and acrylic. Pays by the project, $50-350.

Text Illustration: Assigns 2 freelance design jobs/year. Prefers watercolor, gouache and acrylic. Pays by the project, $50-200.

***HEMKUNT PUBLISHERS LTD.**, A-78 Naraina Indl. Area Ph.I, New Delhi 110028 India. Phone: 011-91-11 579-2083, 579-0032. Fax: 301-3705, 579-5079. Chief Executive: Mr. G.P. Singh. Specializes in educational text books, illustrated general books for children and also books for adults. Subjects include religion and history. Publishes 30-50 new titles/year. Recent titles include *Tales of Birbal and Ahbar*, by Vernon Thomas.

Needs: Works with 30-40 freelance illustrators and 3-5 designers/year. Uses freelancers mainly for illustration and cover design. Also for jacket/cover illustration. Works on assignment only. Freelancers should be familiar with Ventura.

First Contact & Terms: Send query letter with résumé and samples to be kept on file. Prefers photographs and tearsheets as samples. Samples not filed are not returned. Art Director will contact artist for portfolio review if interested. Requests work on spec before assigning a job. Originals are not returned. Considers complexity of project, skill and experience of artist and project's budget when establishing payment. Buys all rights. Interested in buying second rights (reprint rights) to previously published artwork.

Book Design: Assigns 40-50 freelance design jobs/year. Payment varies.

Jackets/Covers: Assigns 30-40 freelance design jobs/year. Pays $20-50.

Text Illustration: Assigns 30-40 freelance jobs/year. Pays by the project.

HILL AND WANG, 19 Union Square West, New York NY 10003. (212)741-6900. Fax: (212)633-9385. Art Director: Michael Ian Kay. Imprint of Farrar, Straus & Giroux. Imprint publishes hardcover, trade and mass market paperback originals and hardcover reprints. Types of books include biography, coffee table books, cookbooks, experimental fiction, historical fiction, history, humor, mainstream fiction, New Age, nonfiction and self-help. Specializes in literary fiction and nonfiction. Publishes 120 titles/year. Recent titles include *Bird Artist, Grace Paley Collected Stories*. 20% require freelance illustration; 10% require freelance design.

Needs: Approached by hundreds of freelancers/year. Works with 10-20 freelance illustrators and 10-20 designers/year. Prefer artist without rep with a strong portfolio. Uses freelancers for jacket/cover illustration and design. Works on assignment only.

First Contact & Terms: Send postcard sample of work or query letter with portfolio samples. Samples are filed and are not returned. Reports back only if interested. Artist should continue to send new samples. Portfolios may be dropped off every Tuesday and should include printed jackets. Rights purchased vary

according to project. Originals are returned at job's completion. Finds artists through word of mouth and submissions.
Book Design: Pays by the project.
Jackets/Covers: Assign 10-20 freelance design and 10-20 illustration jobs/year. Pays by the project, $500-1,500.
Text Illustration: Assigns 10-20 freelance illustration jobs/year. Pays by the project, $500-1,500.

HOLIDAY HOUSE, 425 Madison Ave., New York NY 10017. (212)688-0085. Editorial Director: Regina Griffin. Specializes in hardcover children's books. Publishes 50 titles/year. 75% require freelance illustration. Recent titles include *From Pictures to Words*, by Janet Stevens; and *Comus*, by Margaret Hodges.
Needs: Approached by more than 125 freelancers/year. Works with 20-25 freelancers/year. Prefers art suitable for children and young adults. Uses freelancers mainly for interior illustration. Also for jacket/cover illustration. Works on assignment only.
First Contact & Terms: Send query letter with photocopies and SASE. Samples are filed or are returned by SASE. Request portfolio review in original query. Artist should follow up with call after initial query. Reports back only if interested. Considers complexity of project, skill and experience of artist and project's budget when establishing payment. Buys one-time rights. Originals are returned at job's completion. Finds artists through submissions and agents. "Show samples of everything you do well and like to do."
Jackets/Covers: Assigns 5-10 freelance illustration jobs/year. Pays by the project, $900-1,200.
Text Illustrations: Assigns 5-10 freelance jobs/year. Pays royalty.

HOLLOW EARTH PUBLISHING, P.O. Box 1355, Boston MA 02205-1355. (603)433-8735. Fax: (603)433-8735. E-mail: hep2@aol.com. Publisher: Helian Yvette Grimes. Estab. 1983. Company publishes hardcover, trade paperback and mass market paperback originals and reprints, textbooks, electronic books and CD-ROMs. Types of books include contemporary, experimental, mainstream, historical and science fiction, instruction, fantasy, travel and reference. Specializes in mythology, photography, computers (Macintosh). Publishes 5 titles/year. Titles include *Norse Mythology*, *Legend of the Niebelungenlied*. 50% require freelance illustration; 50% require freelance design. Book catalog free for #10 SAE with 1 first-class stamp.
Needs: Approached by 250 freelancers/year. Prefers freelancers with experience in computer graphics. Uses freelancers mainly for graphics. Also for jacket/cover design and illustration, text illustration, book design and multimedia projects. 100% of freelance work demands knowledge of Adobe Illustrator, QuarkXPress, Adobe Photoshop, Aldus FreeHand, Director or rendering programs. Works on assignment only.
First Contact & Terms: Send postcard and/or query letter with brochure, résumé, photocopies, photographs, slides, tearsheets, transparencies and SASE. Accepts disk submissions. Send EPS or TIFF files. Samples are filed or are returned by SASE if requested by artist. Reports back within 1 month. Art Director will contact artist for portfolio review if interested. Portfolio should include color thumbnails, roughs, tearsheets and photographs. Buys all rights. Originals are returned at job's completion. Finds artists through submissions and word of mouth.
Book Design: Assigns 12 book and magazine covers/year. Pays by the project, $100 minimum.
Jackets/Covers: Assigns 12 freelance design and 12 illustration jobs/year. Pays by the project, $100 minimum.
Text Illustration: Assigns 12 freelance illustration jobs/year. Pays by the project, $100 minimum.
Tips: Recommends being able to draw well. First-time assignments are usually article illustrations; covers are given to "proven" freelancers.

HENRY HOLT BOOKS FOR YOUNG READERS, 115 W. 18th St., 6th Floor, New York NY 10011. (212)886-9200. Fax: (212)645-5832. Art Director: Martha Rago. Estab. 1866. Imprint of Henry Holt and Company, Inc. Imprint publishes hardcover and trade paperback originals and reprints. Types of books include juvenile, preschool and young adult. Specializes in picture books and young adult nonfiction and fiction. Publishes 75-100 titles/year. Recent titles include *The Maestro Plays*, *Cool Salsa*, *My House*, *Barnyard Banter* and *Phoenix Rising*. 100% require freelance illustration. Book catalog free by request.
Needs: Approached by 1,300 freelancers/year. Works with 30-50 freelance illustrators and designers/year. Uses freelancers for jacket/cover and text illustration. Works on assignment only.
First Contact & Terms: Send postcard sample of work or query letter with tearsheets, photostats and SASE. Samples are filed or returned by SASE if requested by artist. Reports back within 1-3 months if interested. Portfolios may be dropped off every Monday. Art Director will contact artist for portfolio review if interested. Portfolio should include photostats, final art, roughs and tearsheets. "Anything artist feels represents style, ability and interests." Rights purchased vary according to project. Originals are returned at job's completion. Finds artists through word of mouth, artists' submissions and attending art exhibitions.
Jackets/Covers: Assigns 20-30 freelance illustration jobs/year. Pays $800-1,000.
Text Illustration: Assigns 30-50 freelance illustration jobs/year. Pays $5,000 minimum.

HOLT, RINEHART & WINSTON, 6277 Sea Harbor Dr., Orlando FL 32887. Does not need freelance artists at this time.

HOMESTEAD PUBLISHING, Box 193, Moose WY 83012. Art Director: Carl Schreier. Estab. 1980. Publishes hardcover and paperback originals. Types of books include nonfiction, natural history, Western art and general Western regional literature. Publishes more than 30 titles/year. Recent titles include *Tales of the Wolf, Wildflowers of the Rocky Mountains, The Ape & The Whale, Never Too Late For Love, Rocky Mountain Wildlife* and *Robert E. Lee: A Portrait*. 75% require freelance illustration. Book catalog free for SAE with 4 first-class stamps.

Needs: Works with 20 freelance illustrators and 10 designers/year. Prefers pen & ink, airbrush, charcoal/pencil and watercolor. 25% of freelance work demands knowledge of Aldus PageMaker or Aldus FreeHand. Works on assignment only.

First Contact & Terms: Send query letter with printed samples to be kept on file or write for appointment to show portfolio. For color work, slides are suitable; for b&w, technical pen, photostats. "Include one piece of original artwork to be returned." Samples not filed are returned by SASE only if requested. Reports back within 10 days. Rights purchased vary according to project. Originals are not returned.

Book Design: Assigns 6 freelance design jobs/year. Pays by the project, $50-3,500.

Jackets/Covers: Assigns 2 freelance design and 4 illustration jobs/year. Pays by the project, $50-3,500.

Text Illustration: Assigns 50 freelance illustration jobs/year. Prefers technical pen illustration, maps (using airbrush, overlays, etc.), watercolor illustrations for children's books, calligraphy and lettering for titles and headings. Pays by the hour, $5-20 or by the project, $50-3,500.

Tips: "We are using more graphic, contemporary designs and looking for the best quality."

HOUGHTON MIFFLIN COMPANY, Children's Book Department, 222 Berkeley St., Boston MA 02116. (617)351-5000. Art Director: Celia Chetham. Estab. 1940. Company publishes hardcover originals. Types of books include juvenile, preschool and young adult. Publishes 50 titles/year. Recent titles include *Our Granny, One Cow Coughs, A Book of Fruit, The Egyptian Polar Bear* and *Fireman Small*. 100% require freelance illustration; 10% require freelance design.

Needs: Approached by 400 freelancers/year. Works with 50 freelance illustrators and 10 designers/year. Prefer artists with interest in or experience with children's books. Uses freelancers mainly for jackets, picture books. Also for jacket/cover design and illustration, text illustration, book and catalog design. 100% of freelance work demands knowledge of QuarkXPress.

First Contact & Terms: Send postcard sample of work or send query letter with tearsheets, photographs, slides, SASE, photocopies and transparencies. Samples are filed or returned by SASE. Reports back within 1 month. Art Director will contact artist for portfolio review if interested. Portfolio should include book dummy, slides, transparencies, roughs and tearsheets. Rights purchased vary according to project. Works on assignment only. Finds artists through sourcebooks, word of mouth, submissions.

Book Design: Assigns 10 freelance design jobs/year. Pays by the project.

Jackets/Covers: Assigns 8 freelance illustration jobs/year. Pays by the project.

Text Illustration: Assigns 40 freelance illustration jobs/year. Pays by the project.

HOWELL PRESS, INC., 1147 River Rd., Suite 2, Charlottesville VA 22901. (804)977-4006. Fax: (804)971-7204. President: Ross Howell. Estab. 1985. Company publishes hardcover and trade paperback originals. Types of books include history, transportation, coffee table books, cookbooks, gardening and transportation. Publishes 5-6 titles/year. Recent titles include *Davey Allison*, by Liz Allison; and *Black Brass*, by Henry Dobbs. 100% require freelance illustration and design. Book catalog free by request.

Needs: Approached by 6-8 freelancers/year. Works with 0-1 freelance illustrator and 1-2 designers/year. "It's most convenient for us to work with local freelance designers." Uses freelancers mainly for graphic design. Also for jacket/cover, direct mail, book and catalog design. 100% of freelance work demands knowledge of Aldus PageMaker, Adobe Illustrator, Adobe Photoshop or QuarkXPress.

First Contact & Terms: Designers send query letter with résumé, SASE, slides and tearsheets. Illustrators send query letter with résumé, photocopies, SASE and tearsheets. Samples are not filed and are returned by SASE if requested by artist. Reports back within 1 month. Art Director will contact artist for portfolio review if interested. Portfolio should include color tearsheets and slides. Negotiates rights purchased. Originals are returned at job's completion. Finds artists through submissions.

Book Design: Assigns 5-6 freelance design jobs/year. Pays for design by the hour, $15-25; by the project, $500-5,000.

HUMANICS LIMITED, 1482 Mecaslin St. NW, Atlanta GA 30309. (404)874-2176. Fax: (404)874-1976. Acquisitions Editor: W. Arthur Bligh. Estab. 1976. Publishes soft and hardcover children's books, trade paperback originals and educational activity books. Publishes 12 titles/year. Recent titles include *Creatures of an Exceptional Kind*, by Dorothy B. Whitney; and *The Tao of Learning*, by Pamela Metz and Jacqueline Tobin. Learning books are workbooks with 4-color covers and line art within; Children's House books are high-quality books with full color; trade paperbacks are 6×9 with 4-color covers. Book catalog for 9×12 SASE. Specify which imprint when requesting catalog: Learning, Children's House or trade paperbacks.

Needs: Works with 3-5 freelance illustrators and designers/year. Needs computer-literate freelancers for design, production and presentation. "Artists must provide physical mechanicals or work on PC compatible disk." Works on assignment only.

First Contact & Terms: Send query letter with résumé, SASE and photocopies. Samples are filed or are returned by SASE if requested by artist. Rights purchased vary according to project. Originals are not returned.
Book Design: Pays by the project, $250 minimum.
Jackets/Covers: Pays by the project, $150 minimum.
Text Illustration: Pays by the project, $150 minimum.

HUNTER HOUSE PUBLISHERS, P.O. Box 2914, Alameda CA 94501-0914. Production Manager: Paul J. Frindt. Specializes in hardcover and paperback originals; adult and young adult nonfiction. Specializes in health and psychology. Publishes 6-11 titles/year.
Needs: Works with 2-3 freelancers/year. Prefers local freelancers. Needs computer-literate freelancers for design and production. Works on assignment only.
First Contact & Terms: Send query letter with résumé, slides and photographs. Samples are filed or are returned by SASE. Reports back within weeks. Write for appointment to show portfolio of thumbnails, roughs, original/final art, photographs, slides, transparencies and dummies. Buys all rights. Originals are not returned.
Book Design: Assigns 2-3 freelance design jobs/year. Pays by the hour, $7.50-15; or by the project, $250-750.
Jackets/Covers: Assigns 6-11 freelance design and 4-8 illustration jobs/year. Pays by the hour, $10-25; or by the project, $250-750.
Text Illustration: Assigns 1-3 jobs/year. Pays by the hour, $10-18; or by the project, $150-450.
Tips: "We work closely with freelancers and prefer those who are open to suggestion, feedback and creative direction. Much of the time may be spent consulting; we don't appreciate impatient or excessively defensive responses. In book design we are conservative; in cover and illustration rather conceptual and somewhat understated, but interested in originality."

HUNTINGTON HOUSE PUBLISHERS, P.O. Box 53788, Lafayette LA 70505. (318)237-7049. Fax: (318)237-7060. Managing Editor: Mark Anthony; Marketing Director: Floyd Robinson; Executive Vice President of Sales: Mark Zobrosky. Estab. 1979. Book publisher. Publishes hardcover, trade paperback and mass market paperback originals. Types of books include contemporary fiction, juvenile, religious and political issues. Specializes in politics, personal stories and religion. Publishes 30 titles/year. Recent titles include *The First Lady*, by Peter and Timothy Flaherty; *Legacy Builders*, by Jim Burton; and *The Gender Agenda*, by Dale O'Leary. 5% require freelance illustration. Book catalog free upon request.
Needs: Approached by 15 freelancers/year. Works with 2 freelance illustrators/year. Uses freelancers for jacket/cover illustration and design and text illustration. Works on assignment only.
First Contact & Terms: Send query letter with brochure, résumé and photocopies. Samples are filed. Reports back to the artist only if interested. To show a portfolio, mail thumbnails, roughs and dummies. Buys all rights. Originals are returned at job's completion.
Text Illustration: Assigns 1 freelance design and 1 illustration job/year. Payment "is arranged through author."

IDEALS PUBLICATIONS INC., P.O. Box 305300, Nashville TN 37230. (615)333-0478. Editor: Lisa C. Ragan. Estab. 1944. Company publishes hardcover originals and *Ideals* magazine. Specializes in nostalgia and holiday themes. Publishes 5-7 titles/year. Recent titles include *Easter Ideals* and *First Ladies of the White House*. 100% require freelance illustration; 30% require freelance design. Guidelines free for #10 SASE with 1 first-class stamp.
Needs: Approached by 100 freelancers/year. Works with 10-12 freelance illustrators and 1-3 designers/year. Prefers freelancers with experience in illustrating people, nostalgia, botanical flowers. Uses freelancers mainly for flower borders (color), people and spot art. Also for text illustration, jacket/cover and book design. 10% of freelance work demands knowledge of Adobe Illustrator, QuarkXPress and Adobe Photoshop. Works on assignment only.
First Contact & Terms: Send query letter with tearsheets and SASE. Samples are filed or returned by SASE. Reports back only if interested. Buys all rights. Finds artists through submissions.
Book Design: Assigns 3 freelance design jobs/year.
Jackets/Covers: Assigns 3 freelance design jobs/year.
Text Illustration: Assigns 75 freelance illustration jobs/year. Pays by the project, $125-400. Prefers oil, watercolor, gouache, colored pencil or pastels.

IGNATIUS PRESS, Catholic Publisher, 2515 McAllister St., San Francisco CA 94118. Production Editor: Carolyn Lemon. Art Editor: Roxanne Lum. Estab. 1978. Company publishes Catholic theology and devotional books for lay people, priests and religious readers. Recent titles include *Father Elijah: An Apocalypse*; and *Angels (and Demons): What Do We Really Know About Them?*
Needs: Works with 2-3 freelance illustrators/year. Works on assignment only.
First Contact & Terms: Will send art guidelines "if we are interested in the artist's work." Accepts previously published material. Send brochure showing art style or résumé and photocopies. Samples not

filed are not returned. Reports only if interested. To show a portfolio, mail appropriate materials; "we will contact you if interested." **Pays on acceptance**.

Jackets/Covers: Buys cover art from freelance artists. Prefers Christian symbols/calligraphy and religious illustrations of Jesus, saints, etc. (used on cover or in text). "Simplicity, clarity, and elegance are the rule. We like calligraphy, occasionally incorporated with Christian symbols. We also do covers with type and photography." Pays by the project.

Text Illustration: Pays by the project.

Tips: "I do not want to see any schmaltzy religious art. Since we are a nonprofit Catholic press, we cannot always afford to pay the going rate for freelance art, so we are always appreciative when artists can give us a break on prices and work *ad maiorem Dei gloriam*."

INCENTIVE PUBLICATIONS INC., 3835 Cleghorn Ave., Nashville TN 37215. (615)385-2934. Art Director: Marta Johnson Drayton. Specializes in supplemental teacher resource material, workbooks and arts and crafts books for children K-8. Publishes 15-30 titles/year. Recent titles include *Integrating Instruction in Science* and *The Middle School Mathematician*. 40% require freelance illustration. Books are "cheerful, warm, colorful, uncomplicated and spontaneous."

Needs: Works with 3-6 freelance illustrators and 1-2 designers/year. Uses freelancers mainly for covers and text illustraion. Also for promo items (occasionally). Works on assignment only primarily with local artists. 10% of design work demands knowledge of Adobe Illustrator, QuarkXPress, Adobe Photoshop or Aldus FreeHand.

First Contact & Terms: Designers send query letter with photocopies and SASE. Illustrators send query letter with photocopies, SASE and tearsheets. Samples are filed. Samples not filed are returned by SASE. Art Director will contact artist for portfolio review if interested. Portfolio should include original/final art, photostats, tearsheets and final reproduction/product. Sometimes requests work on spec before assigning a job. Considers complexity of project, project's budget and rights purchased when establishing payment. Buys all rights. Originals are not returned.

Jackets/Covers: Assigns 4-6 freelance illustration jobs/year. Prefers 4-color covers in any medium. Pays by the project, $200-350.

Text Illustration: Assigns 4-6 freelance jobs/year. Black & white line art only. Pays by the project, $175-1,250.

Tips: "We look for a warm and whimsical style of art that respects the integrity of the child. Freelancers should be able to illustrate to specific age-groups and be aware that in this particular field immediate visual impact and legibility of title are important."

‡INNER TRADITIONS INTERNATIONAL, 1 Park St., Rochester VT 05767. (802)767-3174. Fax: (802)767-3726. E-mail: gotoit.com. Website: http://www.gotoit.com. Art Director: Timothy Jones. Estab. 1975. Publishes hardcover originals and trade paperback originals and reprints. Types of books include self-help, psychology, esoteric philosophy, alternative medicine, and art books. Publishes 40 titles/year. Recent titles include *The Great Book of Hemp*, *The Lakota Sweat Lodge Cards*, and *Nicholas Rorich: a Russian Master*. 60% require freelance illustration; 60% require freelance design. Book catalog free by request.

Needs: Works with 8-9 freelance illustrators and 10-15 freelance designers/year. 100% of freelance design demands knowledge of QuarkXPress 3.3, Adobe Illustrator, Aldus FreeHand and Adobe Photoshop. Buys 30 illustrations/year. Uses freelancers for jacket/cover illustration and design. Works on assignment only.

First Contact & Terms: Send query letter with résumé, SASE, tearsheets, photocopies, photographs and slides. Accepts disk submissions. Samples filed if interested or are returned by SASE if requested by artist. Reports back to the artist only if interested. To show portfolio, mail tearsheets, photographs, slides and transparencies. Rights purchased vary according to project. Originals returned at job's completion. Pays by the project.

Jackets/Covers: Assigns approximately 32 design and 26 illustration jobs/year. Pays by the project.

INSTRUCTIONAL FAIR • TS DENISON, (formerly Instructional Fair, Inc.), Box 1650, Grand Rapids MI 49501. Product Development/Creative Director: Annette Hollister Papp. Publishes supplemental education print materials and software for preschool, elementary and middle school levels in all curriculum areas for teachers, parents and the home school educators.

 • This company also has a division in Minneapolis. Each division maintains its own art department, so submit material to both divisions.

Needs: Works with several freelancers/year. 20% of freelance work demands knowledge of Aldus Page-Maker, Adobe Illustrator, QuarkXPress or Aldus FreeHand. Works on assignment only.

First Contact & Terms: Designers send query letter with photocopies. Illustrators send postcard sample and/or photocopies. Accepts disk submissions compatible with Adobe Illustrator or Adobe Photoshop/Quicktime. Samples are filed or are returned if requested. Reports back within 1-2 months only if interested. Write for appointment to show portfolio, or mail samples. Pays by the project (amount negotiated). Considers client's budget and how work will be used when establishing payment. Buys all rights.

INSTRUCTIONAL FAIR/T.S. DENISON, (formerly T.S. Denison), 9601 Newton Ave., Minneapolis MN 55431. (612)888-6404. Fax: (612)888-6318. Art Director: Darcy Bell-Myers. Estab. 1876. Publishes trade paperback originals and textbooks. Types of books include instructional, preschool, reference and Christian. Specializes in teacher resource books, pre-kindergarten to grade 6. Recently added new Christian line, "In Celebration," and a multimedia line. Publishes 100 titles/year. 70% require freelance illustration; 10% require freelance design. Book catalog free with SASE with first-class postage.

• Instructional Fair/T.S. Denison has a separate division in Grand Rapids, Michigan. Both art departments accept submissions.

Needs: Approached by 50 freelancers/year. Works with 20 freelance illustrators and 2 designers/year. Prefers freelancers with experience. Uses freelancers mainly for 4-color covers and inside b&w line drawings. Also for 2 multimedia projects/year ("need illustrators/animators familiar with work done for computer"). 100% of design and 10% of illustration demand knowledge of Adobe Photoshop, Adobe Illustrator, QuarkXPress or Director.

First Contact & Terms: Send query letter with SASE and photocopies. Accepts disk submissions of above programs. Samples are filed or are returned by SASE. Reports back within 1 month. Call or write for appointment to show portfolio of "what best shows work." Buys all rights. Originals are not returned.

Jackets/Covers: Assigns 5 freelance design and 50 illustration jobs/year. Prefers oil, watercolor, markers and computer art. Pays by the project, $300-400 for color cover.

Text Illustration: Pays by the hour, $20-25 for b&w interior.

Tips: Looking for "bright color work, quick turnaround and versatility. Style covers wide range—from 'cute' for preschool to graphic for upper elementary."

INTERCULTURAL PRESS, INC., 16 U.S. Route 1, Yarmouth ME 04096. (207)846-5168. Fax: (207)846-5181. Production Manager: Patty Topel. Estab. 1982. Company publishes trade paperback originals. Types of books include contemporary fiction, travel and reference. Specializes in intercultural and multicultural. Publishes 12 titles/year. Recent titles include *Survival Kit for Overseas Living* (3rd ed.), by L. Robert Kohls; and *Culture and the Clinical Encounter*, by Rena Gropper. 100% require freelance illustration. Book catalog free by request.

Needs: Approached by 20 freelancers/year. Works with 3-4 freelance illustrators/year. Prefers freelancers with experience in trade books, multicultural field. Uses freelancers mainly for jacket/cover design and illustration. Also for book design. 50% of freelance work demands knowledge of Aldus PageMaker or Adobe Illustrator. "If a freelancer is conventional (i.e., not computer driven) they should understand production and pre-press."

First Contact & Terms: Send query letter with brochure, tearsheets, résumé and photocopies. Samples are filed or are returned by SASE if requested by artist. Does not report back. Will contact artist for portfolio review if interested. Portfolio should include b&w final art. Buys all rights. Originals are not returned. Finds artists through submissions and word of mouth.

Jackets/Covers: Assigns 10 freelance illustration jobs/year. Pays by the project, $300-500.

Text Illustration: Assigns 1 freelance illustration job/year. Pays "by the piece depending on complexity." Prefers b&w line art.

Tips: First-time assignments are usually book jackets only; book jackets with interiors (complete projects) are given to "proven" freelancers.

INTERNATIONAL MARINE/RUGGED MOUNTAIN PRESS, Box 220, Camden ME 04843. (207)236-4837. Art & Production Director: Molly Mulhern. Estab. 1969. Imprint of McGraw-Hill. Specializes in hardcovers and paperbacks on marine (nautical) topics. Publishes 35 titles/year. Recent titles include *Sailmaker's Apprentice*, by Marino; *A Snowalker's Companion*, by Conover. 50% require freelance illustration. Book catalog free by request.

Needs: Works with 20 freelance illustrators and 20 designers/year. Uses freelancers mainly for interior illustration. Prefers local freelancers. Works on assignment only.

First Contact & Terms: Send résumé and tearsheets. Samples are filed. Reports back within 1 month. Considers project's budget when establishing payment. Buys one-time rights. Originals are not returned.

Book Design: Assigns 20 freelance design jobs/year. Pays by the project, $150-550; or by the hour, $12-30.

Jackets/Covers: Assigns 20 freelance design and 3 illustration jobs/year. Pays by the project, $100-500; or by the hour, $12-30.

Text Illustration: Assigns 20 jobs/year. Prefers technical drawings. Pays by the hour, $12-30; or by the project, $30-80/piece.

Tips: "Do your research. See if your work fits with what we publish. Write with a résumé and sample; then follow with a call; then come by to visit."

FOR A LIST of markets interested in humorous illustration, cartooning and caricatures, refer to the Humor Index at the back of this book.

IRON CROWN ENTERPRISES, P.O. Box 1605, Charlottesville VA 22902. (804)295-3918. Fax: (804)977-4811. Art Director: Jessica Ney-Grimm. Estab. 1980. Company publishes fantasy role playing games, supplements and collectible card games. Specializes in fantasy in a variety of genres. Publishes 24 titles/year. Recent titles include *Moria, Elves, Dol Guldur, Spell Law* and *Middle-earth: The Wizards.* 100% require freelance illustration; 50% require freelance design. Book catalog free by request.

Needs: Approached by 120 freelancers/year. Works with 75 freelance illustrators and 4 designers/year. Buys 1,500 freelance illustrations/year. Prefers freelancers with experience in fantasy illustration and sci-fi illustration; prefer local freelancers for book design. Uses freelancers mainly for full color cover art and b&w interior illustration. Also for jacket/cover and text illustration and page design for interior. 5% of freelance work demands knowledge of QuarkXPress and Adobe Photoshop.

First Contact & Terms: Send query letter with photographs and photocopies. Samples are filed or returned by SASE if requested by artist. Reports back within 3 months. Art Director will contact artist for portfolio review if interested. Portfolio should include photographs, slides and tearsheets. Buys all rights. Originals are returned at job's completion. Finds artists through submissions.

Book Design: Assigns 20 freelance design jobs/year. Pays by the hour, $8.

Jackets/Covers: Assigns 24 freelance illustration jobs/year. Pays by the hour, $15. Prefers paintings for cover illustrations, QuarkXPress for cover design.

Text Illustration: Assigns 24 freelance jobs/year. Pays per published page. Prefers pen & ink.

Tips: "Send me 6-12 samples of your current work and present it neatly."

‡**IVORY TOWER BOOKS**, 111 Bauer Dr., Oakland NJ 07436. (201)337-9000. Contact: Angelica Berrie. Imprint of Russ Berrie & Company, Inc. Publishes trade paperback originals. Types of books include humor, small gift books—light, humorous, inspirational. Specializes in humorous treatments of special occasions, momentos, events, holidays. Publishes 20-50/year. Recent titles include *You Know You've Been Married 25 Years When. . . .* 100% require freelance design.
 • Russ Berrie acquired Ivory Tower in 1996. They are hoping to find artists who can both illustrate and design.

Needs: Approached by 100 illustrators and 50 designers/year. Prefers freelancers experienced in illustration and design of books (gift and humor books). Uses freelancers mainly for camera-ready art.

First Contact & Terms: Send brochure, photocopies, photographs, photostats, résumé, SASE and tearsheets. Samples are filed. Rejections are returned by SASE within 3 months. Will contact artist for portfolio review of light whimsical humorous characters, book dummy, photocopies, photographs and tearsheets if interested. Rights purchased vary according to project. Finds freelancers through agents and word of mouth.

Book Design: Pays by project; rates vary.

Jackets/Covers: Pays by the project.

Tips: "We look for creativity, imagination, ability to prepare professional camera-ready materials and speed."

JAIN PUBLISHING CO., Box 3523, Fremont CA 94539. (510)659-8272. Fax: (510)659-0501. E-mail: jainpub@ix.netcom.com. Website: http://www.jainpub.com. Publisher: M.K. Jain. Estab. 1986. Publishes hardcover originals, trade paperback originals and reprints and textbooks. Types of books include business, gift, cookbooks and computer. Publishes 10 titles/year. Recent titles include *Hands On Web Page Design*, by Andreas Ramos; and *Stock Market 101*, by Clark Holloway. Books are "uncluttered, elegant, using simple yet refined art." 25% require freelance illustration; 100% require freelance design. Free book catalog.

Needs: Approached by 50 freelancers/year. Works with 4 freelance illustrators and designers/year. Prefers freelancers with experience in cartoons and computer art. Uses freelancers mainly for jacket/cover design. Also for jacket/cover illustration and catalog design. 100% of freelance work demands knowledge of Adobe Illustrator, Adobe Photoshop and QuarkXPress.

First Contact & Terms: Send postcard sample or query letter with brochure. Accepts disk submissions. Samples are filed. Reports back to the artist only if interested. Rights purchased vary according to project. Originals are not returned.

Book Design: Assigns 10 freelance design jobs/year. Pays by the project.

Jackets/Covers: Assigns 10 freelance design and 20 illustration jobs/year. Prefers "color separated disk submissions." Pays by the project, $200-500.

Tips: Expects "a demonstrable knowledge of art suitable to use with business, computers, cookbooks and gift books."

JALMAR PRESS, 2675 Skypark Dr., Suite 204, Torrance CA 90505-5330. (310)784-0016. Fax: (310)784-1379. President: Bradley L. Winch. Project and Production Director: Jeanne Iler. Estab. 1971. Publishes books emphasizing positive self-esteem. Recent titles include *Hilde Knows Someone Cries for the Children*, by Lisa Kent, illustrated by Nickki Machlin; and *Vortex of Fear*, by Al Benson. Books are contemporary, yet simple.

Needs: Works with 3-5 freelance illustrators and 5 designers/year. Uses freelancers mainly for cover design and illustration. Also for direct mail and book design. Works on assignment only.

First Contact & Terms: Send query letter with brochure showing art style. Samples not filed are returned by SASE. Artist should follow up after initial query. 80% of freelance work demands knowledge of Adobe

Photoshop, Adobe Illustrator and QuarkXPress. Buys all rights. Considers reprints but prefers original works. Considers complexity of project, budget and turnaround time when establishing payment.

Book Design: Pays by the project, $200 minimum.

Jackets/Covers: Pay by the project, $400 minimum.

Text Illustration: Pays by the project, $25 minimum.

Tips: "Portfolio should include samples that show experience. Don't include 27 pages of 'stuff.' Stay away from the 'cartoonish' look. If you don't have any computer design and/or illustration knowledge—get some! If you can't work on computers, at least understand the process of using traditional artwork with computer generated film. For us to economically get more of our product out (with fast turnaround and a minimum of rough drafts), we've gone exclusively to computers for total book design; when working with traditional artists, we'll scan their artwork and place it within the computer generated document."

KALMBACH PUBLISHING CO., 21027 Crossroads Circle, P.O. Box 1612, Waukesha WI 53187. (414)796-8776. Fax: (414)796-1142. Books Art Director: Kristi L. Ludwig. Estab. 1934. Imprints include Greenberg Books. Company publishes hardcover and trade paperback originals. Types of books include instruction, reference and history. Specializes in hobby books. Publishes 26 titles/year. Recent titles include *20 Custom Designed Track Plans*, by John Armstrong; and *Tips & Tricks for Toy Train Operators*, by Peter H. Riddle. 20-30% require freelance illustration; 10-20% require freelance design. Book catalog free by request.

Needs: Approached by 10 freelancers/year. Works with 5 freelance illustrators and 4 designers/year. Prefers freelancers with experience in the hobby field. Uses freelance artists mainly for book layout, line art illustrations. Also for book design. 90% of freelance work demands knowledge of Adobe Illustrator, QuarkXPress or Adobe Photoshop. "Freelancers should have most updated versions." Works on assignment only.

First Contact & Terms: Send query letter with résumé, tearsheets and photocopies. Samples are filed. Reports back within 2 weeks. Art Director will contact artist for portfolio review if interested. Portfolio should include slides and final art. Rights purchased vary according to project. Originals are returned at job's completion. Finds artists through word of mouth, submissions.

Book Design: Assigns 10-12 freelance design jobs/year. Pays by the project, $1,000-3,000.

Text Illustration: Assigns 10-20 freelance illustration jobs/year. Pays by the project, $500-2,000.

Tips: First-time assignments are usually text illustration, simple book layout; complex track plans, etc., are given to "proven" freelancers. Admires freelancers who "present an organized and visually strong portfolio; meet deadlines (especially when first working with them) and listen to instructions."

KAR-BEN COPIES, INC., 6800 Tildenwood Lane, Rockville MD 20852. Fax: (301)881-9195. E-mail: karben@aol.com. Editor: Madeline Wikler. Estab. 1975. Company publishes hardcovers and paperbacks on juvenile Judaica. Publishes 10-12 titles/year. Recent titles include *A Costume for Noah;* by Sue Topek, illustrations by Sally Springer. Books contain "colorful illustrations to appeal to young readers." 100% require freelance illustration. Book catalog free on request.

Needs: Uses 10-12 freelance illustrators/year. Uses freelancers mainly for book illustration. Also for jacket/cover design and illustration, book design and text illustration.

First Contact & Terms: Send query letter with photostats, brochure or tearsheets to be kept on file or returned. Samples not filed are returned by SASE. Reports within 2 weeks only if SASE included. Originals are returned at job's completion. Sometimes requests work on spec before assigning a job. Considers skill and experience of artist and turnaround time when establishing payment. Pays by the project, $500-3,000 average, or advance plus royalty. Buys all rights. Considers buying second rights (reprint rights) to previously published artwork.

Tips: Send samples showing active children, not animals or still life. Don't send original art. "Look at our books and see what we do. We are using more full-color as color separation costs have gone down."

KITCHEN SINK PRESS, 320 Riverside Dr., Northampton MA 01060. (413)586-9525. Fax: (413)586-7040. Editors: Chris Cough and Robert Boyd. Art Director: Amy Brockway. Estab. 1969. Book and comic book publisher of hardcover and trade paperback originals and reprints. Types of books include science fiction, adventure, humor, graphic novels and comic books. Publishes 24 books and 48 comic books/year. Recent titles include Al Capp's *Li'l Abner*, Mark Schultz's *Cadillacs & Dinosaurs®* and *Twisted Sisters*. 10% require freelance illustration; 10% require freelance design.

Needs: Approached by more than 100 freelancers/year. Works with 10-20 illustrators and 4-5 designers/year. Buys 300 illustrations/year. Prefers artists with experience in comics. Uses freelancers mainly for covers, contributions to anthologies and new series. Also for comic book covers and text illustration. Works on assignment only, although "sometimes a submission is accepted as is."

First Contact & Terms: Send query letter with tearsheets, SASE and photocopies. Samples are filed or are returned by SASE. Reports back within 3-4 weeks. Rights purchased vary according to project. Originals are returned at job's completion.

Book Design: Assigns 2-3 freelance design jobs/year. Pays by the project, $600-1,000.

Jackets/Covers: Assigns 6-8 freelance design jobs/year. Pays by the project, $200-600. Prefers line art with color overlays.

Tips: "We are looking for artist-writers."

KRUZA KALEIDOSCOPIX INC., Box 389, Franklin MA 02038. (508)528-6211. Editor: J.A. Kruza. Estab. 1980. Publishes hardcover and mass market paperback originals. Types of books include adventure, biography, juvenile, reference and history. Specializes in children's books for ages 3-10 and regional history for tourists and locals. Publishes 12 titles/year. Titles include *Lighthouse Handbook for New England*. 75% require freelance illustration.
Needs: Approached by 150 freelancers/year. Works with 8 freelance illustrators/year. Uses freelancers for magazine editorial. Also for text illustration. Works on assignment only.
First Contact & Terms: Send query letter with brochure, tearsheets, photostats and SASE. Samples are filed or returned by SASE. Reports back to the artist only if interested. Buys all rights.
Book Design: Pays by the project.
Text Illustration: Assigns 30 freelance illustration jobs/year. Pays $50-100/illustration. Prefers watercolor, airbrush, pastel, pen & ink.
Tips: "Submit sample color photocopies of your work every five or six months. We're looking to fit an illustrator together with submitted and accepted manuscripts. Each manuscript calls for different techniques."

‡LAREDO PUBLISHING CO., 8907 Wilshire Blvd. 102, Beverly Hills CA 90211. (310)358-5288. Fax: (310)358-5282. E-mail: slaredo@online.2000.com. Art Director: Silvana Cervera. Estab. 1991. Publishes juvenile, preschool textbooks. Specializes in Spanish texts educational/readers. Publishes 12 titles/year Recent titles include *Barriletes*, *Kites*. 30% require freelance illustration; 30% require freelance design. Book catalog free on request.
Needs: Approached by 10 freelance illustrators and 2 freelance designers/year. Works with 2 freelance designers/year. Uses freelancers mainly for book development. 100% of freelance design demands knowledge of Adobe Photoshop, Adobe Illustrator, QuarkXPress.
First Contact & Terms: Designers send query letter with brochure, photocopies. Illustrators send photocopies, photographs, résumé, slides, tearsheets. Samples are not filed and are returned by SASE. Reports back only if interested. Portfolio review required for illustrators. Art director will contact artist for portfolio review if interested. Portfolio should include artwork portraying children, book dummy, photocopies, photographs, tearsheets. Buys all rights, negotiates rights purchased.
Book Design: Assigns 5 freelance design jobs/year. Pays for design by the project.
Jacket/Covers: Pays for illustration by the project, page.
Text Illustration: Pays by the project, page.

‡LAUGH LINES PRESS, Box 259, Bala Cynwyd PA 19004. Publisher: Roz Warren. Estab. 1992. Types of books include women's humor. Specializes in "the best book-length contemporary humor by women, with a special emphasis on cartoon collections." Publishes 2 cartoon collections/year. Recent titles include: *Kicking the Habit: Cartoons About the Catholic Church*, by Rina Piccolo and *Weenie-Toons* (both cartoon collections).
Needs: Approached by 1,000 cartoonists/year. Prefers feminist cartoons. Accepts previously published work.
First Contact & Terms: Cartoonists send query letter with finished cartoons. Samples are filed or returned by SASE if requested by artist. Reports back within 5 days.

LEE & LOW BOOKS, 95 Madison Ave., New York NY 10016-7801. (212)779-4400. Editor-in-Chief: Elizabeth Szabla. Publisher: Philip Lee. Estab. 1991. Book publisher. Publishes hardcover originals and reprints for the juvenile market. Specializes in multicultural children's books. Publishes 6-10 titles/year. First list published in spring 1993. Recent titles include *Zora Hurston and the Chinaberry Tree*, by William Miller; and *Heroes*, by Ken Mochizuki. 100% require freelance illustration and design. Book catalog available.
Needs: Approached by 100 freelancers/year. Works with 6-10 freelance illustrators and 1-3 designers/year. Uses freelancers mainly for illustration of children's picture books. Also for direct mail and catalog design. 100% of design work demands computer skills. Works on assignment only.
First Contact & Terms: Contact through artist rep or send query letter with brochure, résumé, SASE, tearsheets, photocopies and slides. Samples are filed. Art Director will contact artist for portfolio review if interested. Portfolio should include b&w and color tearsheets, slides and dummies. Rights purchased vary according to project. Originals are returned at job's completion.
Book Design: Pays by the project.
Text Illustration: Pays by the project.
Tips: "We want an artist who can tell a story through pictures and is familiar with the children's book genre. Lee & Low Books makes a special effort to work with writers and artists of color and encourages new voices. We prefer filing samples that feature children."

LEISURE BOOKS/LOVE SPELL, Divisions of Dorchester Publishing Co., Inc., 276 Fifth Ave., Suite 1008, New York NY 10001. (212)725-8811. E-mail: dorkcarlon@aol.com. Director of Publishing: Katherine Carlon. Estab. 1970. Specializes in paperback, originals and reprints, especially mass market category fiction—realistic historical romance, western, adventure, horror. Publishes 170 titles/year. Recent titles include

Master the Art of Romance

Half of all mass-market paperbacks sold are romance novels. The industry pulls in upwards of $800 million yearly. Twenty million women read them. Publishers issue about 1,700 romances every year. And whether contemporary, historical, mystery, futuristic, or time travel novels, all romances have something in common—a beautiful cover painting.

Harry Burman

New Yorker Harry Burman has been the artist behind many of these sensuous cover illustrations, which feature two gorgeous, lustful lovers in a romantic "clinch." For the past 15 years, he's worked for all the major players in the industry, including Harlequin, Leisure, Zebra and Avon.

Working as a romance cover artist happened by chance for Burman, who enrolled in an evening class at Parson's School of Design that was taught by the vice president of Simon & Schuster's Pocket Books division. After two years of classes, Burman's teacher hired him to do some romance covers, and his career "took off from there."

Burman contends, and most in the romance industry would agree, that the book cover has a great impact on the sales of a book, especially when the author is not well known. "There are hundreds of books on the shelves at any one time, so there is a great deal of competition for the readers' attention."

Competition exists among artists vying for romance cover illustration jobs as well—jobs that can fetch artists anywhere from $1,500 to $7,500 per cover. (Burman works in the $3,000-5,000 range.) Artists retain the original paintings, which can be sold (sometimes to authors) or shown in galleries.

"There is an unbelievable amount of talented artists working in publishing today," says Burman. "They come from not only every corner of the U.S., but from all over the world." To stand out among the competition, Burman suggests gearing your portfolio largely to what a particular art director is buying, creating samples that look like actual romance covers.

Romance illustration work differs from other cover work in that the artist first hires models and directs a costumed photo shoot. (The expense is covered by the publisher.) The photos are then used as reference for the cover painting. (Burman has had photo shoots with Fabio, Corbin Bernsen, major male models and female soap stars.)

So for artists trying to break in, it may be difficult to produce samples similar to the romance covers you see on bookstore shelves due to lack of reference photos. "If you have friends who are attractive it might work, but they probably won't feel comfortable posing and will look stiff, or won't be as photogenic as you expected," Burman says.

INSIDER REPORT, *continued*

This beautiful and romantic piece by Harry Burman is the cover painting for *The Perfect Wife*, a historical romance published by Leisure Books.

INSIDER REPORT, *Burman*

As an alternative, he suggests checking movie memorabilia shops for photos of old and current movie and TV show stars. "When you're making samples, do them as if you're working on an actual assignment," Burman says. "Keep in mind the proportions of a paperback. Be aware of the type—you don't have to set the type, but don't place important things in spots that would be covered by title, author's name, the blurb on the back, etc."

Studying what illustrators working in the field are doing is a must. "I think the aspiring romance illustrator should be as familiar with his or her own local bookstore as they are with their own studio. Bookstores have become my home away from home." Burman studies all the publishers, the different genres, and the variety of styles in stores.

Research doesn't stop after an assignment is landed. Burman usually receives a one-page fact sheet about the book he's working on so he knows what must be included in an illustration. Some companies, he says, give very detailed instructions on what they want, even choosing the pose for the models. Others leave it up to the artist. From there he researches the time period, including clothing, location and setting, from his own library of reference, costume and travel books. "It's important for an illustrator to have an extensive picture file. You never know what you'll need for the next assignment, so you should always be adding to your files. I have over a dozen books on costumes alone."

Burman then chooses models, sets up the shoot with one of the four or five photographers in his area who work for publishers, rents costumes, and directs the models in the shoot. He has a light, medium and dark print made of the photo he'll work from, and comes up with an initial rough sketch for the art director.

Once the sketch is approved, he begins work on his illustration. Burman recently switched from oils to pastels because he likes the versatility and quickness of the medium, but romance illustrators can use whatever medium they feel comfortable with. "The majority are using oils," he says. "But acrylics, gouache, and even computers are being used. Some are mounting photos of the models on boards and painting the backgrounds around the models."

Getting a reaction to a finished illustration from an art director makes Burman a little anxious. "Some will let you know what they think of your illustration as you're removing it from your portfolio," he says. "Others will look at it without saying a word for ten minutes. I think this is the hardest part of the job, but it's important that you get the personal contact with the art director. You lose this if you have an agent."

While Burman is concerned about his art director's opinion, he doesn't worry how others feel about his chosen profession. "I think it's important if you are painting covers for romance novels that you treat your job seriously, even though many people look down upon these books and will kid you about what you're painting," he says. "You have to remember that the author has spent a great deal of time researching and writing the story. It's a serious business to her and the publisher you're working for."

—*Alice P. Buening*

Chase the Wind, by Madeline Baker; and *Savage Shadows*, by Cassie Edwards. 90% require freelance illustration.

Needs: Works with 24 freelance illustrators and 6 designers/year. Uses freelancers mainly for covers. "We work with freelance art directors; editorial department views all art initially and refers artists to art directors. We need highly realistic, paperback illustration; oil or acrylic. No graphics, fine art or photography." Works on assignment only.

First Contact & Terms: Send samples by mail. Accepts disk submissions from illustrators on SyQuest or Zip disks compatible with Adobe Photoshop 3.0. No samples will be returned without SASE. Reports only if samples are appropriate and if SASE is enclosed. Call for appointment to drop off portfolio. Portfolios may be dropped off Monday-Thursday. Sometimes requests work on spec before assigning a job. Considers complexity of project and project's budget when establishing payment. Usually buys first rights, but rights purchased vary according to project. Interested in buying second rights (reprint rights) to previously published work "for contemporary romance and westerns only." Originals returned at job's completion.

Jackets/Covers: Pays by the project.

Tips: "Talented new artists are welcome. Be familiar with the kind of artwork we use on our covers. If it's not your style, don't waste your time and ours."

‡LIBRARIES UNLIMITED/TEACHER IDEAS PRESS, Box 6633 Englewood CO 80155-6633. (303)770-1220. Fax: (303)220-8843. E-mail: lu-marketing@lu.com. Contact: Publicity Department. Estab. 1964. Specializes in hardcover and paperback original reference books concerning library science and school media for librarians, educators and researchers. Also specializes in resource and activity books for teachers. Publishes more than 60 titles/year. Book catalog free by request.

Needs: Works with 4-5 freelance artists/year.

First Contact & Terms: Designers send query letter with brochure, résumé and photocopies. Illustrators send query letter with photocopies. Samples not filed are returned only if requested. Reports within 2 weeks. Considers complexity of project, skill and experience of artist, and project's budget when establishing payment. Buys all rights. Originals not returned.

Text Illustration: Assigns 2-4 illustration jobs/year. Pays by the project, $100 minimum.

Jackets/Covers: Assigns 4-6 design jobs/year. Pays by the project, $250 minimum.

Tips: "We look for the ability to draw or illustrate without overly-loud cartoon techniques. Freelancers should have the ability to use two-color effectively, with screens and screen builds. We ignore anything sent to us that is in four-color. We also need freelancers with a good feel for typefaces."

LITTLE AMERICA PUBLISHING CO., 9725 SW Commerce Circle, Wilsonville OR 97070. (503)682-0173. Fax: (503)682-0175. Production Manager: Heather Kier. Estab. 1986. Imprint of Beautiful America Publishing Co. Publishes hardcover originals for preschool and juvenile markets. Titles include *Melody's Mystery* and *Journey of Hope* both by Diane Kelsay Harvey and Bob Harvey. 50% require freelance illustration. Book catalog available by request.

Needs: Approached by 20 freelancers/year. Uses 3 freelance illustrators and 2 designers/year. Uses freelancers for jacket/cover and text illustration. Works on assignment only.

First Contact & Terms: Send query letter with brochure, résumé, tearsheets, photocopies, photographs and SASE. Samples are filed or are returned by SASE. Art Director will contact artist for portfolio review if interested. Portfolio should include tearsheets and color copies. Sometimes requests work on spec before assigning a job. Generally pays royalty. Negotiates rights purchased. Originals are returned at job's completion. Finds artists generally through word of mouth.

Tips: "Be patient with us, we are small, needing very little freelance work."

THE LITURGICAL PRESS, St. John's Abbey, Collegeville MN 56321. (612)363-2213. Fax: (612)363-3278. Art Director: Ann Blattner. Estab. 1926. Publishes hardcover and trade paperback originals and textbooks. Specializes in liturgy and scripture. Publishes 150 titles/year. 50% require freelance illustration and design. Book catalog available for SASE.

Needs: Approached by 100 freelancers/year. Works with 10 freelance illustrators and 15 designers/year. Uses freelancers for book cover design, jacket/cover illustration and design and text illustration. Also for multimedia projects. 50% of freelance work demands computer skills.

First Contact & Terms: Send query letter with brochure, photographs, photocopies and slides. Samples are filed. Reports back to the artist only if interested. To show portfolio, mail b&w photostats and photographs. Rights purchased vary according to project. Originals are returned at job's completion.

Jackets/Covers: Assigns 100 freelance design and 50 illustration jobs/year. Pays by the project, $150-450.

Text Illustration: Assigns 25 freelance illustration jobs/year. Pays by the project, $45-500.

LLEWELLYN PUBLICATIONS, Box 64383, St. Paul MN 55164. Art Director: Lynne Menturweck. Estab. 1901. Book publisher. Publishes trade paperback and mass market originals, tarot kits and reprints and calendars. Types of books include reference, self-help, metaphysical, occult, mythology, health, women's spirituality and New Age. Publishes 80 titles/year. Books have photography, realistic painting and computer

generated graphics. 60% require freelance illustration. Book catalog available for large SASE and 5 first-class stamps.
Needs: Approached by 200 freelancers/year. Buys 150 freelance illustrations/year. Prefers freelancers with experience in book covers, New Age material and realism. Uses freelancers mainly for realistic paintings and drawings. Works on assignment only.
First Contact & Terms: Send query letter with brochure, SASE, tearsheets, photographs and photocopies. Samples are filed or are returned by SASE. Art Director will contact artist for portfolio review if interested. Sometimes requests work on spec before assigning a job. Negotiates rights purchased.
Jackets/Covers: Assigns 40 freelance illustration jobs/year. Pays by the illustration, $150-700. Media and style preferred "are usually realistic, well-researched, airbrush, watercolor, acrylic, oil, colored pencil. Artist should know our subjects."
Text Illustration: Assigns 25 freelance illustration jobs/year. Pays by the project, or $30-100/illustration. Media and style preferred are pencil and pen & ink, "usually very realistic; there are usually people in the illustrations."
Tips: "I need artists who are aware of occult themes, knowledgeable in the areas of metaphysics, divination, alternative religions, women's spirituality, and who are professional and able to present very refined and polished finished pieces. Knowledge of history, mythology and ancient civilization is a big plus."

LODESTAR BOOKS, an affiliate of Dutton Children's Books, 375 Hudson St., New York NY 10014. (212)366-2626. Executive Editor: Rosemary Brosnan. Publishes young adult fiction (12-16 years) and nonfiction hardcovers; fiction and nonfiction for ages 9-11 and 10-14; and nonfiction and fiction picture books. Publishes 25 titles/year. Recent titles include *Wiley and the Hairy Man* and *Like Sisters on the Homefront*.
Needs: Works with approximately 30 illustrators and 5 designers/year. Uses freelance artists mainly for jackets for middle grade and young adult novels. Especially looks for "knowledge of book requirements, previous jackets, good color, strong design and ability to draw people and action." Needs computer-literate designers. Prefers to buy all rights.
First Contact & Terms: Send samples. Art Director will contact artist for portfolio review or more samples if interested.
Book Design: Pays by the hour, $20-35; by the project, $2,000-4,000.
Jackets/Covers: Assigns approximately 10-12 jackets/year to freelancers. Pays by the project, $800-1,200 for color.
Text Illustration: Pays royalty.
Tips: "We often work through an artists' rep to find new illustrators; occasionally an artist's portfolio is so outstanding that we keep him or her in mind for a project. Book design is becoming bolder and more graphic. Nonfiction jackets usually have a strong single image or a photograph and are often 3-color jackets. Fiction tends to the dramatic and realistic and jackets are always in full color."

‡♣LUGUS PUBLICATIONS, 48 Falcon St., Toronto, Ontario M4S 2P5 Canada. (416)322-5113. Fax: (416)484-9512. E-mail: lugust@tvo.org. President: Gethin James. Estab. 1981. Publishes hardcover, trade paperback and mass market paperback originals and reprints and textbooks. Types of books include coffee table books, cookbooks, fantasy, history, humor, instructional, juvenile, mainstream fiction, nonfiction, pre-school, romance, science fiction, self help, textbooks, travel and young adult. Specializes in school guidance. Publishes 20 titles/year. Recent titles include: *Children as Storytellers*. 10% require freelance illustration; 10% require freelance design. Book catalog free.
Needs: Approached by 5 illustrators and 2 designers/year. Works with 2 illustrators and 1 designer/year. Prefers freelancers experienced in educational publishing. Uses freelancers mainly for covers and illustration. 100% of freelance work demands knowledge of Adobe Photoshop, QuarkXPress and Color It.
First Contact & Terms: Designers send query letter with brochure. Illustrators send postcard sample. Accept disk submissions compatible with Ready Set Go! Samples are not filed and are not returned. Reports back only if interested. Buys all rights or rights purchased vary according to project. Finds freelancers through submissions.
Book Design: Assigns 2 freelance design jobs/year. Pays by the project.
Jackets/Covers: Assigns 5 freelance design and 5 illustration jobs/year. Pays by the project. Prefers complete artwork on disk or SyQuest cartridge.
Text Illustration: Assigns 5 freelance illustration jobs/year. Pays by the project. Prefers artwork stored on disk or SyQuest cartridge.
Tips: "It is helpful if artist has familiarity with Docutech and high speed color copying."

‡McCLANAHAN BOOK CO., 23 W. 26th St., New York NY 10010. (212)725-1515. Fax: (212)725-5911. E-mail: mccbook@aol.com. Creative Director: David Werner. Estab. 1990. Publishes mass market paperback originals. Types of books include board books, work books, sticker books, children's books. Specializes in categories appealing to 2- to 8-year-olds. Publishes 50-90 titles/year. Recent titles include: *Princesses, Mother Goose Rhymes, Velveteen Rabbit*. 100% require freelance illustration; 10% require freelance design.

Needs: Approached by 1,000 illustrators and 100 designers/year. Works with 50 illustrators and 10 designers/year. Prefers freelancers experienced in traditional and computer mechanicals. Uses freelancers mainly for book mechanicals. Freelance design demands knowledge of Adobe Photoshop, Adobe Illustrator and QuarkXPress.
First Contact & Terms: Send photocopies, printed samples and tearsheets. Accepts disk submissions compatible with "latest Quark version." Samples are filed if appropriate or returned by SASE. Will contact for portfolio review of artwork portraying anthropomorphic animals, cute children and tearsheets only if interested in artist's work. Buys all rights. Finds freelancers through word of mouth and submissions.
Book Design: Pays for design by the hour, $25.
Jackets/Covers: Pays for design/illustration by the project, $200-500. "Trend is toward computer 3-D."
Text Illustration: Assigns 50-90 freelance illustration jobs/year. Pays $3,000-10,000 for picture books (24-64 pages). "Guoache is very good. No fluorescent color."
Tips: "Illustrators must know children's book mass market. Designers must have book experience."

McFARLAND & COMPANY, INC., PUBLISHERS, Box 611, Jefferson NC 28640. (910)246-4460. Fax: (910)246-5018. Sales Manager: Chris Robinson. Estab. 1979. Company publishes hardcover and trade paperback originals. Specializes in nonfiction reference and scholarly monographs, including film and sports. Publishes 130 titles/year. Recent titles include *The British Empire*, and *Hammer Films*. Book catalog free by request.
Needs: Approached by 50 freelancers/year. Works with 5-8 freelance illustrators/year. Prefers freelancers with experience in catalog and brochure work in performing arts and school market. Uses freelancers mainly for promotional material. Also for direct mail and catalog design. Works on assignment only. 20% of illustration demands knowledge of QuarkXPress, version 3.3.
First Contact & Terms: Send query letter with résumé, SASE, tearsheets and photocopies. "Send relevant samples. We aren't interested in children's book illustrators, for example, so we do not need such samples." Samples are filed. Reports back within 2 weeks. Portfolio review not required. Buys all rights. Originals are not returned.
Tips: First-time assignments are usually school promotional materials; performing arts promotional materials are given to "proven" freelancers. "Send materials relevant to our subject areas, otherwise we can't fully judge the appropriateness of your work."

McGRAW HILL, INC., 1221 Avenue of the Americas, New York NY 10020. Does not need freelance artists at this time.

MACMILLAN COMPUTER PUBLISHING, 201 W. 103rd St., Indianapolis IN 46290. (317)581-3500. Operations Specialist: Angela Bannan. Imprints include Que, New Riders, Sams, Hayden, Adobe Press, Que Education and Training. Company publishes instructional computer books. Publishes 550 titles/year. 5-10% require freelance illustration; 3-5% require freelance design. Book catalog free by request with SASE.
• Company acquired Ziff-Davis and Waite Group in 1995, and continues to grow.
Needs: Approached by 100 freelancers/year. Works with 20 freelance illustrators and 10 designers/year. Buys 100 freelance illustrations/year. Uses freelancers for jacket/cover illustration and design, text illustration, direct mail and book design. 50% of freelance work demands knowledge of Aldus PageMaker, QuarkXPress, Aldus FreeHand, Adobe Illustrator and Adobe Photoshop. Finds artists through agents, sourcebooks, word of mouth, submissions and attending art exhibitions.
First Contact & Terms: Send query letter with brochure, tearsheets, photostats, résumé, photographs, slides, photocopies or transparencies. Samples are filed or returned by SASE if requested by artist. Art Director will contact artist for portfolio review if interested. Portfolio should include final art, photographs, photostats, roughs, slides, tearsheets and transparencies. Rights purchased vary according to project.
Book Design: Assigns 10 freelance design jobs/year. Pays by the project, $1,000-4,000.
Jackets/Covers: Assigns 15 freelance design and 25 illustration jobs/year. Pays by the project, $1,000-3,000.
Text Illustration: Pays by the project, $100-300.

MADISON BOOKS, Dept. AGDM, 4720 Boston Way, Lanham MD 20706. (301)731-9534. Fax: (301)459-3464. Vice President, Design: Gisele Byrd Henry. Estab. 1984. Publishes hardcover and trade paperback originals. Specializes in biography, history and popular culture. Publishes 16 titles/year. Titles include *Keys to the White House, Written Out of Television* and *The Art of Drawing*. 40% require freelance illustration; 100% require freelance jacket design. Book catalog free by request.
Needs: Approached by 20 freelancers/year. Works with 4 freelance illustrators and 12 designers/year. Prefers freelancers with experience in book jacket design. Uses freelancers mainly for book jackets. Also for catalog design. 80% of freelance work demands knowledge of Adobe Illustrator, QuarkXPress, Adobe Photoshop or Aldus FreeHand. Works on assignment only.
First Contact & Terms: Send query letter with tearsheets, photocopies and photostats. Samples are filed or are returned by SASE if requested by artist. Reports back to the artist only if interested. Call for appointment to show portfolio of roughs, original/final art, tearsheets, photographs, slides and dummies. Buys all rights.

Interested in buying second rights (reprint rights) to previously published work.

Jackets/Covers: Assigns 16 freelance design and 2 illustration jobs/year. Pays by the project, $400-1,000. Prefers typographic design, photography and line art.

Text Illustration: Pays by project, $100 minimum.

Tips: "We are looking to produce trade-quality designs within a limited budget. Covers have large type, clean lines; they 'breathe.' If you have not designed jackets for a publishing house but want to break into that area, have at least five 'fake' titles designed to show ability. I would like to see more Eastern European style incorporated into American design. It seems that typography on jackets is becoming more assertive, as it competes for attention on bookstore shelf. Also, trends are richer colors, use of metallics."

MEADOWBROOK PRESS, 18318 Minnetonka Blvd., Deephaven MN 55391. (612)473-5400. Fax: (612)475-0736. Production Manager: Amy Unger. Company publishes hardcover and trade paperback originals. Types of books include instruction, humor, juvenile, preschool and parenting. Specializes in parenting, humor. Publishes 10-15 titles/year. Titles include *New Adventures of Mother Goose*, *Funny Side of Parenthood* and *Practical Parenting Tips*. 80% require freelance illustration; 30% require freelance design. Book catalog free by request.

Needs: Approached by 100 freelancers/year. Works with 5 freelance illustrators and 3 designers/year. Uses freelancers mainly for children's fiction, medical-type illustrations, activity books, spot art. Also for jacket/cover and text illustration. 100% of design work demands knowledge of QuarkXPress, Adobe Photoshop or Adobe Illustrator. Works on assignment only.

First Contact & Terms: Designers send query letter with résumé and photocopies. Illustrators send query letter with photocopies. Accepts disk submissions from illustrators. Samples are filed and are not returned. Reports back only if interested. Art Director will contact artist for portfolio review if interested. Portfolio should include b&w and color final art and transparencies. Buys all rights. Originals are returned at job's completion. Finds artists through agents, sourcebooks and submissions.

Book Design: Assigns 2 freelance design jobs/year. "Pay varies with complexity of project."

Jackets/Covers: Assigns 3 freelance design and 6 freelance illustration jobs/year. Pays by the project, $300-600.

Text Illustration: Assigns 6 freelance illustration jobs/year. Pays by the project, $80-150.

Tips: First-time assignments are usually text illustration; cover art is given to "proven" illustrators.

MENNONITE PUBLISHING HOUSE/HERALD PRESS, 616 Walnut Ave., Scottdale PA 15683. (412)887-8500, ext. 244. Fax: (412)887-3111. E-mail: jim%5904477@mcimail.com. Art Director: James M. Butti. Estab. 1918. Publishes hardcover and paperback originals and reprints; textbooks and church curriculum. Specializes in religious, inspirational, historical, juvenile, theological, biographical, fiction and nonfiction books. Publishes 24 titles/year. Recent titles include *Ellie* series, *A Winding Path* and *A Joyous Heart*. Books are "fresh and well illustrated." 30% require freelance illustration. Catalog available free by request.

Needs: Approached by 150 freelancers each year. Works with 8-10 illustrators/year. Prefers oil, pen & ink, colored pencil, watercolor, and acrylic in realistic style. "Prefer artists with experience in publishing guidelines who are able to draw faces and people well." Uses freelancers mainly for book covers. 10% of freelance work demands knowledge of Adobe Illustrator, QuarkXPress or CorelDraw. Works on assignment only.

First Contact & Terms: Send query letter with résumé, tearsheets, photostats, slides, photocopies, photographs and SASE. Samples are filed ("if we feel freelancer is qualified") and are returned by SASE if requested by artist. Reports back only if interested. Art Director will contact artist for portfolio review of final art, photographs, roughs and tearsheets. Buys one-time or reprint rights. Originals are not returned at job's completion "except in special arrangements." To show portfolio, mail photostats, tearsheets, final reproduction/product, photographs and slides and also approximate time required for each project. Considers complexity of project, skill and experience of artist and project's budget when establishing payment. Buys all rights.

Jackets/Covers: Assigns 8-10 illustration jobs/year. Pays by the project, $200 minimum. "Any medium except layered paper illustration will be considered."

Text Illustration: Assigns 6 jobs/year. Pays by the project. Prefers b&w, pen & ink or pencil.

Tips: "Design we use is colorful, realistic and religious. When sending samples, show a wide range of styles and subject matter—otherwise you limit yourself."

MERIWETHER PUBLISHING LTD., Box 7710, Colorado Springs CO 80933. (719)594-4422. Executive Art Director: Tom Myers. Estab. 1969. Publishes plays, musicals and theatrical books for schools and churches. Recent titles include *Acting Games*, by Marsh Cassady; and *Joy to the World!*, by L.G. and Annie Enscoe.

Needs: Approached by 10-20 freelancers/year. Works with 1-2 freelance illustrators/year. Uses freelancers for jacket/cover and text illustration. Also local freelancers for catalog production using QuarkXPress 3.31. Needs computer-literate freelancers with knowledge of Adobe Photoshop 2.5.1 and Aldus FreeHand 3.11.

First Contact & Terms: Send photostats and photographs (Mac files are okay). Rarely needs loose line humorous cartooning. Samples are returned by SASE if requested by artist.

Text Illustration: Negotiable rate.

‡**MILKWEED EDITIONS**, 430 First Ave. N., Suite 400, Minneapolis MN 55401. (612)332-3192. Estab. 1979. Publishes hardcover and trade paperback originals of contemporary fiction, poetry, essays and children's novels (ages 8-12). Publishes 12-14 titles/year. Recent titles include *Montana 1948*; *I Am Lavina Cumming*; *Drive, They Said*; and *Transforming a Rape Culture*. 70% require freelance illustration; 20% require freelance design. Books have "colorful, quality" look. Book catalog available for SASE with 2 first-class stamps.
Needs: Works with 10 illustrators and designers/year. Buys 100 illustrations/year. Prefers artists with experience in book illustration. Uses freelancers mainly for jacket/cover illustration and text illustration. Needs computer-literate freelancers for design. Works on assignment only.
First Contact & Terms: Send query letter with résumé, SASE and tearsheets. Samples are filed or are returned by SASE if requested by artist. Editor will contact artists for portfolio review if interested. Portfolio should include best possible samples. Rights purchased vary according to project. Interested in buying second rights (reprint rights) to previously published work. Originals are returned at job's completion. Finds artists primarily through word of mouth, submissions and "seeing their work in already published books."
Jackets/Covers: Assigns 10-14 illustration jobs and 5 design jobs/year. Pays by the project, $250-800 for design. "Prefer a range of different media—according to the needs of each book."
Text Illustration: Assigns 10-14 jobs/year. Pays by the project. Prefers various media and styles.
Tips: "Show quality drawing ability, narrative imaging and interest—call back. Design and production is completely computer-based. Budgets have been cut so any jobs tend to neccesitate experience."

MODERN LANGUAGE ASSOCIATION, 10 Astor Place, New York NY 10003-6981. (212)475-9500. Fax: (212)477-9863. Marketing Coordinator: David Cloyce Smith. Estab. 1883. Non-profit educational association. Publishes hardcover and trade paperback originals, trade paperback reprints and textbooks. Types of books include instructional, reference and literary criticism. Specializes in language and literature studies. Publishes 10-15 titles/year. Recent titles include *MLA Handbook for Writers of Research Papers*, 4th edition, by Joseph Gibaldi; and *Ourika*, by Claire de Duras. 5-10% require freelance design. Book catalog free by request.
Needs: Approached by 5-10 freelancers/year. Works with 2-3 freelance designers/year. Prefers freelancers with experience in academic book publishing and textbook promotion. Uses freelancers mainly for jackets and direct mail. Also for book and catalog design. 100% of freelance work demands knowledge of QuarkXPress. Works on assignment only.
First Contact & Terms: Send query letter with brochure. Reports back to the artist only if interested. To show portfolio, mail finished art samples and tearsheets. Originals returned at job's completion if requested.
Book Design: Assigns 1-2 freelance design jobs/year. Payment "depends upon complexity and length."
Jackets/Covers: Assigns 3-4 freelance design jobs/year. Pays by the project, $750-1,500.
Tips: "Most freelance designers with whom we work produce our marketing materials rather than our books. We are interested in seeing samples only of direct mail pieces related to publishing. We do not use illustrations for any of our publications."

MODERN PUBLISHING, Dept. AGDM, 155 E. 55th St., New York NY 10022. (212)826-0850. Editorial Director: Kathy O'Hehir. Specializes in children's hardcovers, paperbacks, coloring books and novelty books. Publishes approximately 200 titles/year. Recent titles include *World of Knowledge*, and Fisher Price books and Disney books.
Needs: Approached by 10-30 freelancers/year. Works with 25-30 freelancers/year. Works on assignment and royalty.
First Contact & Terms: Send query letter with résumé and samples. Samples not filed are returned only if requested. Reports only if interested. Originals are not returned. Considers turnaround time and rights purchased when establishing payment.
Jackets/Covers: Pays by the project, $150-250/cover, "usually four books/series."
Text Illustration: Pays by the project, $15-25/page; line art, "24-382 pages per book, always four books in series." Pays $50-125/page; full color art.
Tips: "Do not show samples that don't reflect the techniques and styles we use. Research our books and book stores to know our product line better."

‡**MONDO PUBLISHING**, One Plaza Rd., Greenvale NY 11548. (516)484-7812. Fax: (516)484-7813. Senior Editor: Louise May. Estab. 1992. Publishes hardcover and trade paperback originals and reprints and audio tapes. Types of books include juvenile. Specializes in fiction, nonfiction. Publishes 75 titles/year. Recent titles include *Zoo-looking*, by Mem Fox; *The Dancing Dragon*, by Marcia Vaughan; *Look at the Moon*, by May Garelick. Book catalog free for 9×12 SASE with 78¢ postage.
Needs: Approached by 12 illustrators and 5 designers/year. Works with 40 illustrators and 10 designers/year. Prefers freelancers experienced in children's hardcovers and paperbacks, plus import reprints. Uses freelancers mainly for illustration, art direction, design. 50% of freelance design demands knowledge of Aldus PageMaker, Adobe Photoshop, Adobe Illustrator, QuarkXPress.
First Contact & Terms: Send query letter with photocopies, printed samples and tearsheets. Accepts disk submissions from designers. Samples are filed. Will contact for portfolio review if interested. Portfolio should include artist's areas of expertise, book dummy, photocopies, tearsheets. Rights purchased vary according to

project. Finds freelancers through agents, sourcebooks, illustrator shows, submissions, recommendations of designers and authors.
Book Design: Assigns 40 jobs/year. Pays by project.
Jackets/Covers: Assigns 25 freelance design and 25 freelance illustration jobs/year. Pays by project.
Text Illustration: Assigns 45-50 freelance illustration jobs/year. Pays by project.

MOREHOUSE PUBLISHING, 871 Ethan Allen Hwy., Suite 204, Ridgefield CT 06877. (203)431-3927. Fax: (203)431-3964. Promotion/Production Director: Karolyn Kelly-O'Keefe. Estab. 1884. Company publishes trade paperback originals and reprints. Books are religious. Specializes in spirituality, religious history, Christianity/contemporary issues. Publishes 20 titles/year. Recent titles include *A Good Day for Listening*, by Maryellen King; and *Knowing Jesus in Your Life*, by Carol Anderson. 50% require freelance illustration; 40% require freelance design. Book catalog free by request.
Needs: Works with 7-8 illustrators and 7-8 designers/year. Prefers freelancers with experience in religious (particularly Christian) topics. Uses freelancers for jacket/cover illustration and design. Freelancers should be familiar with Aldus PageMaker, Adobe Illustrator, QuarkXPress, Adobe Photoshop or Aldus FreeHand. Also uses original art—all media. Works on assignment only.
First Contact & Terms: Send query letter with tearsheets, photographs, photocopies and photostats. "Show samples particularly geared for our 'religious' market." Samples are filed or are returned. Reports back only if interested but returns slides/transparencies that are submitted. Portfolio review not required. Usually buys one-time rights. Originals are returned at job's completion. Finds artists through freelance submissions, *Literary Market Place* and mostly word of mouth.
Jackets/Covers: Pays by the hour, $25 minimum; by the project, $450 maximum. "We are looking for diversity in our books covers, although all are of a religious nature."

MORGAN KAUFMANN PUBLISHERS, INC., 340 Pine St., Sixth Floor, San Francisco CA 94104. (415)392-2665. Fax: (415)982-2665. E-mail: design@mkp.com. Production Manager: Yonie Overton. Estab. 1984. Company publishes hardcover and trade paperback originals (technical trade in computer science) and textbooks. Types of books include reference (technical), textbooks and professional monographs. Specializes in computer science. Publishes 30 titles/year. Recent titles include *Database: Principles, Programming, and Performance*, by Patrick O'Neil; *Computer Organization and Design: The Hardware/Software Interface*, by David A. Patterson and John L. Hennessy; *Principles of Digital Image Synthesis*, by Andrews S. Glassner; and *The PowerPC Architecture*, by IBM, Inc. 50% require freelance illustration; 80-100% require freelance design. Book catalog free for 8½×11 SASE with $1.44 postage.
Needs: Approached by 150-200 freelancers/year. Works with 7-10 freelance illustrators and 20 designers/year. Prefers local freelancers with experience in book design. Uses freelancers mainly for covers, text design and technical illustration. Also for jacket/cover illustration. 100% of freelance work demands knowledge of either Adobe Illustrator, QuarkXPress, Adobe Photoshop, Aldus PageMaker, Ventura, Framemaker, laTEX (multiple software platform). Works on assignment only.
First Contact & Terms: Send query letter with tearsheets, photostats, résumé, photographs, slides, photocopies, transparencies or printed samples. "No calls, please." Samples are filed. Production Manager will contact artist for portfolio review if interested. Portfolio should include final art. Buys reprint or all rights (dependent upon the book, its promotion and extent of design job). Finds artists primarily through word of mouth and submissions.
Book Design: Assigns freelance design jobs for 25-30 books/year. Pays by the project.
Jackets/Covers: Assigns 30-40 freelance design; 3-5 illustration jobs/year. Pays by the project. Prefers QuarkXPress file for covers; Adobe Illustrator for art programs; modern; emphasis on typography. "We're interested in an approach that is different from the typical technical publication." Prefers modern clean, spare design, fine line weight, very readable labels in illustrations.
Tips: "Although experience with book design is an advantage, sometimes artists from another field bring a fresh approach, especially to cover design. We also use all of the sourcebooks and attend the major computer shows like Mac World and Seybold."

‡WILLIAM MORROW & CO. INC., (Lothrop, Lee, Shepard Books), 1350 Avenue of the Americas, New York NY 10019. (212)261-6642. Art Director: Rachel Simon. Specializes in hardcover originals and reprint children's books. Publishes 70 titles/year. 100% require freelance illustration. Book catalog free for 8½×11″ SASE with 3 first-class stamps.
First Contact & Terms: Works with 30 freelance artists/year. Uses artists mainly for picture books and jackets. Works on assignment only. Send query letter with résumé and samples, "followed by call." Samples are filed. Reports back within 3-4 weeks. Originals returned to artist at job's completion. Portfolio should include original/final art and dummies. Considers complexity of project and project's budget when establishing payment. Negotiates rights purchased.
Book Design: "Most design is done on staff." Assigns 1 or 2 freelance design jobs/year. Pays by the project.

Jackets/Covers: Assigns 1 or 2 freelance design jobs/year. Pays by the project.
Text illustration: Assigns 70 freelance jobs/year. Pays by the project.
Tips: "Be familiar with our publications."

‡**MOUNTAIN PRESS PUBLISHING CO.**, P.O. Box 2399, Missoula MT 59806. (406)728-1900. Fax: (406)728-1635. Editor: Kathleen Ort. Estab. 1960s. Company publishes hardcover originals and reprints; trade paperback originals and reprints. Types of books include instruction, biography, history, geology, natural history/nature. Specializes in geology, natural history, history, horses, western topics. Publishes 12 titles/year. Recent titles include Roadside Biology series, Roadside History series, regional photographic field guides. Book catalog free by request.
Needs: Approached by 40 freelance artists/year. Works with 5-10 freelance illustrators and 1-2 freelance designers/year. Buys 10-50 freelance illustrations/year. Prefers artists with experience in book illustration and design, book cover illustration. Uses freelance artists for jacket/cover design and illustration, text illustration and book design. 100% of design work demands knowledge of Aldus PageMaker or Aldus FreeHand. Works on assignment only.
First Contact & Terms: Send query letter with brochure, résumé, SASE and any samples. Samples are filed or are returned by SASE. Reports back only if interested. Art Director will contact artist for portfolio review if interested. Buys one-time rights or reprint rights depending on project. Originals are returned at job's completion. Finds artists through submissions, word of mouth, sourcebooks and other publications.
Book Design: Pays by the project.
Jackets/Covers: Assigns 2-3 freelance design and 10-12 freelance illustration jobs/year. Pays by the project.
Text Illustration: Assigns 1-2 freelance illustration jobs/year. Pays by the project. Prefers b&w: pen & ink, scratchboard, ink wash, pencil.
Tips: First-time assignments are usually book cover/jacket illustration or design; text illustration, cover design/illustration and book design projects are given to "proven" freelancers.

‡**MOYER BELL**, Kymbolde Way, Wakefield RI 02879. (401)789-0074. Fax: (401)789-3793. E-mail: moyer bell@genie.com. Contact: Britt Bell. Estab. 1984. Imprints include Asphodel Press. Publishes hardcover originals, trade paperback originals and reprints. Types of books include biography, coffee table books, history, instructional, mainstream fiction, nonfiction, reference, religious, self-help. Publishes 20 titles/year. 25% require freelance illustration; 25% require freelance design. Book catalog free.
Needs: Works with 5 illustrators and 5 designers/year. Prefers electronic media. Uses freelancers mainly for illustrated books and book jackets. 100% of design and illustration demand knowledge of Adobe Photoshop, Adobe Illustrator, QuarkXPress and Postscript.
First Contact & Terms: Designers send query letter with photocopies. Illustrators send postcard sample and/or photocopies. Accepts disk submissions. Samples are filed or returned by SASE. Rights purchased vary according to project.
Book Design: Assigns 5 freelance design jobs/year. Pays by project; rates vary.
Jackets/Covers: Assigns 5 design jobs and 5 illustration jobs/year. Pays by project; rates vary. Prefers Postscript.
Text Illustration: Assigns 5 freelance illustration jobs/year. Payment varies. Prefers Postscript.

JOHN MUIR PUBLICATIONS, Box 613, Santa Fe NM 87504. (505)982-4078. Graphics Manager: Sarah Horowitz. Production Manager: Nikki Rooker. Publishes trade paperback nonfiction. "We specialize in travel books and children's books, and are always actively looking for new illustrations in these fields." Publishes 70 titles/year. Recent titles include *Kids Who Walk on Volcanoes* (kids).
Needs: Works with 10-15 freelancers/year and 8-10 designers/year. Prefers local layout artists. Must be computer-literate. 100% of freelance layout and design demand knowledge of QuarkXPress. Illustrations can be camera-ready or digital in EPS or TIFF format.
First Contact & Terms: Send query letter with résumé and samples to be kept on file. Accepts any type of sample "as long as it's professionally presented." Samples not filed are returned by SASE. Originals are not returned.
Book Design: Pays by the project. Fees vary between $250-750 per series or project. Considers complexity of project, project's budget, number of books in series and rights purchased when establishing payment. Buys all rights.
Jackets/Covers: Assigns 10-20 freelance design and illustration jobs/year, mostly 4-color. Pays by the project. Fees vary, most between $250 and $750.
Text Illustration: Assigns approximately 20 freelance jobs/year. Many are maps. Fees vary.

NBM PUBLISHING CO., 185 Madison Ave., Suite 1504, New York NY 10016. (212)545-1223. Publisher: Terry Nantier. Publishes graphic novels for an audience of 18-34 year olds. Types of books include adventure, fantasy, mystery, science fiction, horror and social parodies. Recent titles include *Jack the Ripper*, by Rick Geary; and *Kafka Stories*, by Peter Kuper. Circ. 5,000-10,000.

Needs: Approached by 60-70 freelancers/year. Works with 2 freelance designers/year. Uses freelancers for lettering, paste-up, layout design and coloring. Prefers pen & ink, watercolor and oil for graphic novels submissions.
First Contact & Terms: Send query letter with résumé and samples. Samples are filed or are returned by SASE. Reports back within 2 weeks. To show portfolio, mail photocopies of original pencil or ink art. Originals are returned at job's completion.
Tips: "We are interested in submissions for graphic novels. We do not need illustrations or covers only!"

♣NELSON CANADA, 1120 Birchmount Rd., Scarborough, Ontario M1K 5G4 Canada. (416)752-9100 ext. 343. Fax: (416)752-7144. E-mail: lbarasymczuk@nelson.com. Art Director: Liz Harasymczak. Estab. 1931. Company publishes hardcover originals and reprints and textbooks. Types of books include instructional, juvenile, preschool, reference, high school math and science, primary spelling, textbooks and young adult. Specializes in a wide variety of education publishing. Publishes 150 titles/year. Recent titles include *Financial Account, Science Probe, Language to Go* and *The Clean Path.* 70% require freelance illustration; 25% require freelance design. Book catalog free by request.
Needs: Approached by 50 freelancers/year. Works with 30 freelance illustrators and 10-15 designers/year. Prefers Canadian artists, but not a necessity. Uses freelancers for jacket/cover design and illustration, text illustration and book design. Also for multimedia projects. 100% of design and 40% of illustration demand knowledge of Adobe Illustrator, QuarkXPress and Adobe Photoshop. Works on assignment only.
First Contact & Terms: Designers send query letter with tearsheets and résumé. Illustrators send postcard sample, brochure and tearsheets. Accepts disk submissions. Samples are filed. Art Director will contact artist for portfolio review if interested. Portfolio should include book dummy, transparencies, final art, tearsheets and photographs. Rights purchased vary according to project. Originals usually returned at the job's completion. Finds artists through *American Showcase, Creative Source,* submissions, designers' suggestions (word of mouth).
Book Design: Assigns 15 freelance design jobs/year. Pays by the project, $800-1,200 for interior design, $800-1,200 for cover design.
Jackets/Covers: Assigns 15 freelance design and 40 illustration jobs/year. Pays by the project, $800-1,300.
Text Illustration: Pays by the project, $30-450.

‡THOMAS NELSON PUBLISHERS, Nelson Place at Elm Hill Pike, P.O. Box 141000, Nashville TN 37214-1000. Estab. 1798. Book publisher. Publishes hardcover and trade paperback originals and reprints. Types of books include contemporary, experimental and historical fiction; mystery; juvenile; young adult; reference; self-help; humor; and inspirational. Specializes in Christian living, apologetics and fiction. Publishes 120 titles/year. Recent titles include *Fifty to Forever,* by Hugh Downs; *Antioxidant Revolution,* by Dr. Kenneth Cooper; and *Prayer: My Soul's Adventure with God,* by Robert Schuller. 20-30% require freelance illustration; 90% require freelance design. Book catalog available by request.
Needs: Approached by 10-30 artists/year. Works with 6-8 freelance illustrators and 4-6 freelance designers/year. Buys 15-20 freelance illustrations/year. Prefers artists with experience in full-color illustration, computer graphics and realism. Uses freelance artists mainly for cover illustration. Also uses freelance artists for jacket/cover design. Works on assignment only. 100% of design and 25% of illustration demand knowledge of QuarkXPress, Adobe Illustrator, Adobe Photoshop, Aldus FreeHand (Mac only).
First Contact & Terms: Designers send query letter with brochure, SASE, tearsheets, photographs, slides and photocopies. Illustrators send postcard sample or query letter with photocopies, photographs, SASE, slides, tearsheets and transparencies. Accepts disk submissions compatible with Mac QuarkXPress or Abobe Photoshop. Samples are filed or are returned by SASE if requested by artist. Reports back to the artist only if interested. Call to schedule an appointment to show a portfolio. Portfolio should include roughs, color photostats, tearsheets, photographs and slides. Rights purchased vary according to project. Originals returned to artist at job's completion unless negotiated otherwise.
Jackets/Covers: Assigns 25-30 freelance design and 15-20 freelance illustration jobs/year. Prefers various media, including airbrush, acrylic, ink and multimedia. No pastels or abstract art." Pays for design by the project, $600-1,500; illustration fees vary by project.
Tips: "Request a catalog and see if your style fits our materials. I want to see new ideas, but there are some styles of illustration that just don't fit who we are. I don't have a great deal of time to spend looking through art submissions, but those artists who catch my eye are usually hired soon after."

‡THE NEW ENGLAND PRESS, Box 575, Shelburne VT 05482. (802) 863-2520. Managing Editor: Mark Wanner. Specializes in paperback originals on regional New England subjects and nature. Publishes 12 titles/year. Recent titles include *Lake Champlain: A Photographic Discovery* and *Railroads of Vermont: A Pictorial.* 50% require freelance illustration. Books have "traditional, New England flavor."
First Contact & Terms: Approached by 20 freelance artists/year. Works with 3-6 illustrators and 1-2 designers/year. Northern New England artists only. Send query letter with brochure, photocopies and tearsheets. Samples are filed. Reports back only if interested. Considers complexity of project, skill and experience of artist, project's budget and turnaround time when establishing payment. Negotiates rights purchased. Originals not usually returned to artist at job's completion, but negotiable.

Book Design: Assigns 8-10 jobs/year. Payment varies.
Jackets/Covers: Assigns 4-5 illustration jobs/year. Payment varies.
Text Illustration: Assigns 4-5 jobs/year. Payment varies.
Tips: Send a query letter with your work, which should be "more folksy than impressionistic."

‡THE NOBLE PRESS INC., Suite 508, 213 W. Institute Place, Chicago IL 60610. (312)642-1168. Fax: (312)642-7682. Publisher: David Driver. Estab. 1988. Publishes hardcover originals and reprints and trade paperback originals. Specializes in books by and/or about African Americans. Publishes 12 titles/year. Recent titles include *Going Off the Beaten Path* and *Eco-Warriors*. Book catalog free on request with SASE.
Needs: Approached by 1-5 freelance artists/year. Works with 2 illustrators and 4 designers/year. Buys 1-2 illustrations/year. Prefers artists with experience in trade book design and photography. Uses artists mainly for book cover design and layout. Also for jacket/cover and text illustration. Works on assignment only.
First Contact & Terms: Send query letter with brochure, résumé, SASE, tearsheets, photographs, photocopies, photostats, slides and transparencies. Samples are filed. Reports back to the artist only if interested. Call for appointment to show portfolio, which should include original/final art and b&w and color tearsheets, photographs, slides and dummies. Buys all rights. Originals returned at job's completion.
Book Design: Assigns 1-2 jobs/year. Pays by the project.
Jackets/Covers: Assigns 5-6 design and 2-3 illustration jobs/year. Pays by the project.
Text Illustration: Assigns 1-2 illustration jobs/year. Pays by the project.
Tips: "Show samples of actual nonfiction, trade book design done for general topics."

NORTHLAND PUBLISHING, 2900 N. Fort Valley Rd., Flagstaff AZ 86001. (520)774-5251. Fax: (520)774-0592. Contact: Lisa Brownfield. Estab. 1958. Company publishes hardcover and trade paperback originals. Types of books include western, juvenile, natural history, Native American art and cookbooks. Specializes in Native America, Western Americana. Publishes 25 titles/year. Recent titles include *The Worry Stone*, by Marianna Dengler; and *The Buffalo Jump*, by Peter Roop. 50% require freelance illustration; 25% require freelance design. Book catalog free for 9×12 SASE ($2.13 postage).
Needs: Approached by 40-50 freelancers/year. Works with 5-10 freelance illustrators and 4-6 designers/year. Buys 140 freelance illustrations/year. Prefers freelancers with experience in illustrating children's titles. Uses freelancers mainly for children's books. Also for jacket/cover design and illustration, text illustration and book design. 100% of freelance work demands knowledge of Adobe Illustrator, QuarkXPress, Adobe Photoshop or Aldus FreeHand. Works on assignment only.
First Contact & Terms: Send query letter with résumé, SASE, tearsheets, slides and transparencies. Samples are filed or are returned by SASE if requested by artist. Reports back only if interested. Will contact artist for portfolio review if interested. Portfolio should include color tearsheets and transparencies. Rights purchased vary according to project. Originals are returned at job's completion. Finds artists mostly through submissions.
Book Design: Assigns 4-6 freelance design jobs/year. Pays by the project, $500-4,500.
Jackets/Covers: Assigns 4-6 freelance design and 5-10 illustration jobs/year. "We prefer realistic, more representational styles in any medium. We have not used collage styles thus far."
Text Illustration: Assigns 5-10 freelance illustration jobs/year. Pays by the project, $1,000-6,000. Royalties are preferred—gives cash advances against royalties. "We prefer more realistic, representational styles in any medium. We prefer artwork to be bendable so we can scan from original art—page dimensions no larger than 19×26."
Tips: "Creative presentation and promotional pieces really make me remember an illustrator."

‡NORTHWOODS PRESS, P.O. Box 298, Thomaston ME 04561. Division of the Conservatory of American Letters. Editor: Robert Olmsted. Estab. 1972. Specializes in hardcover and paperback originals of poetry. Publishes approximately 6 titles/year. Titles include *Dan River Anthology, 1991*, *Broken Dreams* and *Bound*. 10% require freelance illustration. Book catalog for SASE.
- The Conservatory of American Letters now publishes the *Northwoods Journal*, a quarterly literary magazine. They're seeking cartoons and line art and pay cash on acceptance. Send SASE for complete submission guidelines.
Needs: Approached by 40-50 freelance artists/year. Works with 2-3 illustrators and 1-2 designers/year. Uses freelance artists mainly for cover design and illustration. Also uses freelance artists for text illustration.
First Contact & Terms: Send query letter to be kept on file. Art Director will contact artist for portfolio review if interested. Sometimes requests work on spec before assigning a job. Considers complexity of project, skill and experience of artist, project's budget, turnaround time and rights purchased when establishing payment. Buys one-time rights and occasionally all rights. Originals are returned at job's completion.
Book Design: Pays by the project, $30-200.
Jackets/Covers: Assigns 2-3 design jobs and 4-5 illustration jobs/year. Pays by the project, $30-200.
Text Illustration: Pays by the project, $5-40.
Tips: Portfolio should include "art suitable for book covers—contemporary, usually realistic."

‡**NORTHWORD PRESS, INC.**, Dept. AM, Box 1360, Minocqua WI 54548. (715)356-9800. Fax: (715)356-9762. Art Director: Russ Kuepper. Estab. 1984. Book publisher with 2 imprints: Northword (coffee-table books); Heartland (regional). Publishes hardcover originals and reprints and trade paperback originals and reprints. Types of books include juvenile, history, travel, natural histories and nature guides. Specializes in nature, wildlife and environmental. Publishes about 40 titles/year. Recent titles include *Brother Wolf, Trout Country* and *Shared Spirit*. 20% require freelance illustration; 80% require freelance design. Book catalog free by request.

Needs: Approached by 10-15 freelance artists/year. Works with 1-2 illustrators and 3-4 designers/year. "We commission packages of 30-40 illustrations for 1-2 titles/year, possibly a cover here and there. Most books are illustrated with photos." Prefers artists with experience in wildlife art. Uses freelancers mainly for illustration. Works on assignment only.

First Contact & Terms: Send query letter with brochure, SASE, tearsheets, photographs, photocopies, photostats, slides and transparencies. "No originals, and make sure they fit in standard-size folders." Samples are filed or are returned by SASE. Reports back only if interested. "I prefer samples mailed and will call to contact the artist if I want to see a portfolio." Negotiates rights purchased. Originals returned at job's completion "unless we purchase all rights."

Text Illustration: Assigns 4-6 illustration jobs/year. Pays by the project, $50-2,000. Prefers color pen & ink or wash, some charcoal.

Tips: "I usually make decisions about who I'm going to work with for books in February and in September/October. Sales materials are assigned throughout the year. I need calligraphers—good, professional ones."

W.W. NORTON & CO., INC., 500 Fifth Ave., New York NY 10110. Does not need freelance artists at this time.

OCTAMERON PRESS, 1900 Mount Vernon Ave., Alexandria VA 22301. Editorial Director: Karen Stokstod. Estab. 1976. Specializes in paperbacks—college financial and college admission guides. Publishes 10-15 titles/year. Titles include *College Match* and *The Winning Edge*.

Needs: Approached by 25 freelancers/year. Works with 1-2 freelancers/year. Local freelancers only. Works on assignment only.

First Contact & Terms: Send query letter with brochure showing art style or résumé and photocopies. Samples not filed are returned. Reports within one month if SASE included. Considers complexity of project and project's budget when establishing payment. Rights purchased vary according to project.

Jackets/Covers: Works with 1-2 designers and illustators/year on 15 different projects. Pays by the project, $300-700.

Text Illustration: Works with variable number of artists/year. Pays by the project, $35-75. Prefers line drawings to photographs.

Tips: "The look of the books we publish is friendly! We prefer humorous illustrations."

ORCHARD BOOKS, 95 Madison Ave., Room 701, New York NY 10016. Book publisher. Division of Franklin Watts. Art Director: Jean Krulis. Estab. 1987. Publishes hardcover children's books only. Specializes in picture books and novels for children and young adults. Also publishes nonfiction for young children. Publishes 60 titles/year. Recent titles include *More Than Anything Else*, by Marie Bradby and *Daring to Be Abigail*, by Rachel Vail. 100% require freelance illustration; 25% require freelance design. Book catalog free for SAE with 2 first-class stamps.

Needs: Works with 50 illustrators/year. Works on assignment only.

First Contact & Terms: Designers send brochure and/or photocopies. Illustrators send brochure, photocopies and/or tearsheets. Samples are filed or are returned by SASE only if requested. Reports back about queries/submissions only if interested. Originals returned to artist at job's completion. Call or write for appointment to show portfolio or mail appropriate materials. Portfolio should include thumbnails, tearsheets, final reproduction/product, slides and dummies or whatever artist prefers. Considers complexity of project, skill and experience of artist and project's budget when establishing payment. Buys all rights.

Book Design: Assigns 15 freelance design jobs/year. Pays by the project, $650 minimum.

Jackets/Covers: Assigns 20 freelance design jobs/year. Pays by the project, $650 minimum.

Text Illustration: Assigns 5 freelance jobs/year. Pays by the project, minimum $2,000 advance against royalties.

Tips: "Send a great portfolio."

‡**OREGON HISTORICAL SOCIETY PRESS**, 1200 SW Park Ave., Portland OR 97205. (503)222-1741. Fax: (503)221-2035. Managing Editor: Adair Law. Estab. 1898. Imprints include Eager Beaver Books. Company publishes hardcover originals, trade paperback originals and reprints, mars, posters, plans, postcards. Types of books include biography, travel, reference, history, reprint juvenile and fiction. Specializes in Pacific Northwest history, geography, natural history. Publishes 10-12 biography titles/year. Recent titles include *So Far From Home: An Army Bride on the Western Frontier; Hail, Columbia; Journal of Travels;* and *Oregon Geographic Names*, Sixth Edition. 25% require freelance illustration; 50% require freelance design. Book catalog free by request.

Needs: Approached by 10-50 freelance artists/yaer. Works with 8-10 freelance illustrators and 2-5 freelance designers/year. Buys 0-50 freelance illustrations/year. Prefers local artists only. Uses freelance artists mainly for illustrations and maps. Also uses freelance artists for jacket/cover and text illustration, book design. 20% of freelance work demands knowledge of Aldus PageMaker. Works on assignment only.

First Contact & Terms: Send query letter with brochure, résumé, tearsheets and photocopies. Samples are filed or are returned by SASE. Reports back within 10 days. Art Director will contact artist for portfolio review if interested. Portfolio should include b&w thumbnails, roughs, final art, slides and photographs. Buys one-time rights or rights purchased vary according to project. Originals are returned at job's completion.

Book Design: Assigns 2-5 freelance design jobs/year. Pays by the project.

Jackets/Covers: Assigns 2-5 freelance design and 2-5 freelance illustration jobs/year. Pays by the project.

Text Illustration: Assigns 8-10 freelance illustration jobs/year. Pays by the hour or by the project.

‡**ORTHO BOOKS**, 2527 Camino Ramon, Suite 200, San Ramon CA 94583-0906. (510)355-3374. Fax: (510)355-3530. E-mail: rjbeck@monsanto.com. Home Improvement Editor: Robert Beckstrom. Garden Editor: Mike Smith. Publishes hardcover and mass market paperback originals. Types of books include self-help and do-it-yourself. Specializes in gardening, home improvement. Publishes 12-20 titles/year. Recent titles include: *Affordable Landscaping*; *How to Design & Build Decks*. 100% require freelance illustration; 15% require freelance design.

Needs: Works with 6-8 illustrators and 2-3 designers/year. Prefers freelancers experienced in home improvement or gardening subject matter. Uses freelancers mainly for all illustration, some book and cover design. 100% of freelance design demands knowledge of QuarkXPress. 100% of freelance illustation demands knowledge of Adobe Illustrator.

First Contact & Terms: Send query letter with printed samples and résumé. Accepts disk submissions compatible with QuarkXPress 7.1 version 3.31. Samples are filed and are not returned. Will contact for portfolio review if interested. Buys all rights. Finds freelancers through word of mouth, submissions.

Book Design: Assigns 1-2 freelance design jobs/year. Pays by negotiated bid.

Jackets/Covers: Assigns 2 freelance design jobs/year. Pays by negotiated bid.

Text Illustration: Assigns 12 freelance illustration jobs/year. Pays by negotiated bid.

Tips: "We look for a strong interest and expertise in the subject matter; ability to rework art to strict specifications."

‡**OTTENHEIMER PUBLISHERS, INC.**, 10 Church Lane, Baltimore MD 21208. (301)484-2100. Art Director: Anna Burgard. Estab. 1890. Book producer. Specializes in mass market and trade, hardcover, pop and paperback originals—cookbooks, children's, encyclopedias, dictionaries, novelty and self-help. Publishes 200 titles/year. Titles include *Ancient Healing Secrets* and *Santa's Favorite Sugar Cookies*. 80% require freelance illustration.

Needs: Works with 100 illustrators and 3 freelance designers/year. Prefers professional graphic designers and illustrators. 100% of design demands knowledge of the latest versions of Adobe Illustrator, QuarkXPress and Adobe Photoshop.

First Contact & Terms: Designers send résumé, client list, photocopies or tearsheets to be kept on file. Illustrators send postcard sample and/or photocopies, tearsheets and client list. Accepts disk submissions from designers, not illustrators. Samples not filed are returned by SASE. Reports back only if interested. Call or write for appointment to show portfolio. No unfinished work or sketches. Considers complexity of project, project's budget and turnaround time when establishing payment. Buys all rights. Originals are returned at job's completion. No phone calls.

Book Design: Assigns 20-40 design jobs/year. Pays by the project, $500-4,000.

Jackets/Covers: Assigns 25 design and 25 illustration jobs/year. Pays by the project, $500-1,500, depending upon project, time spent and any changes.

Text Illustration: Assigns 30 jobs/year, both full color media and b&w line work. Prefers graphic approaches as well as very illustrative. "We cater more to juvenile market." Pays by the project, $500-10,000.

Tips: Prefers "art geared towards children—clean work that will reproduce well. I also look for the artist's ability to render children/people well. We use art that is realistic, stylized and whimsical but not cartoony. The more samples, the better. Take schedules seriously. Maintain a sense of humor."

RICHARD C. OWEN PUBLICATIONS INC., P.O. Box 585, Katonah NY 10536. (914)232-3903. Fax: (914)232-3977. Art Director: Janice Boland. Estab. 1986. Company publishes children's books. Types of books include juvenile fiction and nonfiction. Specializes in books for 5-, 6- and 7-year-olds. Publishes 3-10 titles/year. Recent titles include: *Once Upon a Time*, by E. Bunting; *Firetalking*, by PaPolaco; *Meet the Author* collection; and *Books For Young Learners* collection. 100% require freelance illustration.

Needs: Approached by 200 freelancers/year. Works with 3-10 freelance illustrators/year. Prefers freelancers with experience in children's books. Uses freelancers for jacket/cover and text illustration. Works on assignment only.

First Contact & Terms: First request guidelines. Send samples of work (brochure, tearsheets and photocopies). Samples are filed. Art Director will contact artist if interested. Buys all rights. Original illustrations are returned at job's completion.

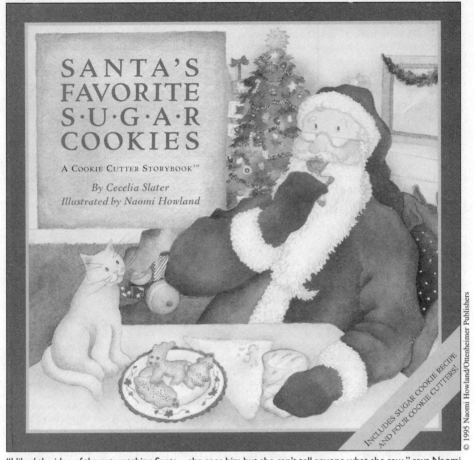

SANTA'S
FAVORITE
S·U·G·A·R
COOKIES

A Cookie Cutter Storybook™

By Cecelia Slater
Illustrated by Naomi Howland

INCLUDES SUGAR COOKIE RECIPE
AND FOUR COOKIE CUTTERS!

"I liked the idea of the cat watching Santa—she sees him but she can't tell anyone what she saw," says Naomi Howland, illustrator of the cover and interior illustrations for *Santa's Favorite Sugar Cookies*, from Ottenheimer Publishers. "I wanted Santa to look like he was enjoying the cookies that are featured in this book," which includes a story, a cookie recipe, and green plastic cookie cutters. "The book was a big hit," says Art Director Anna Burgard. "We're doing additional titles with this format, thanks in part to Naomi's style being harmonious with the concept and language of the book. Santa's expression is really inviting." Howland received $4,750 for this assignment.

Text Illustration: Assigns 3-10 freelance illustration jobs/year. Pays by the project.
Tips: "Show adequate and only best samples of work."

PAPIER-MACHE PRESS, 135 Aviation Way, #14, Watsonville CA 95076. (408)763-1420. Fax: (408)763-1421. Acquisitions Editor: Shirley Coe. Estab. 1984. Publishes hardcover and trade paperback originals. Types of books include contemporary fiction, poetry, creative nonfiction and anthologies. Specializes in women's issues and the art of growing older for both men and women. Publishes 6-8 titles/year. Recent titles include *I Am Becoming the Woman I've Wanted*, by Sandra Haldeman Martz; and *Late Summer Break*, by Ann B. Knox. Books have fine art on the covers, attractive and accessible designs inside and out. Book catalog and submission guidelines available for SASE with first-class postage.
Needs: Approached by 40-50 freelancers/year. Works with 6-8 freelance fine artists and 1-2 designers/year. Uses freelancers mainly for covers.
First Contact & Terms: Send query letter with color photocopies or slides. Samples are filed or are returned by SASE if requested. Art Director will contact artist for portfolio review if interested. Portfolio should include slides, tearsheets or photographs. Buys first rights. Considers buying second rights (reprint rights) to previously published work. "We usually work from transparencies." Finds artists through submissions, author references and local gallery listings.

Jackets/Covers: Selects 6-8 pieces of art/year. Pays by the project, $350-600. "We are most interested in fine art for reproduction on jacket covers, generally of people."
Tips: "After looking at our catalog to see the type of cover art we use, artists should send color photocopies of representative pieces for our file. In addition we will put their names on our mailing list for information about future projects."

PARADIGM PUBLISHING INC., 280 Case Ave., St. Paul MN 55101. (612)771-1555. Production Director: Joan Silver. Estab. 1989. Book publisher. Publishes textbooks. Types of books include business and office, communications, software-specific manuals. Specializes in basic computer skills. Publishes 40 titles/year. Recent titles include *Key to Success*, JoAnn Sheeron; and *Word Perfect 6.0*, by Nita Rutkosky. 100% require freelance illustration and design. Books have very modern high-tech design, mostly computer-generated. Book catalog free by request.
Needs: Approached by 50-75 freelancers/year. Works with 14 freelance illustrators and 20 designers/year. Uses freelance artists mainly for covers. Works on assignment only.
First Contact & Terms: Send brochure and slides. Samples are filed. Slides are returned. Art Director will contact artist for portfolio review if interested. Portfolio should include b&w and color transparencies. Rights purchased vary according to project. Interested in buying second rights (reprint rights) to previously published work. Finds artists through submissions, agents and recommendations.
Book Design: Assigns 10 freelance design jobs and 30 illustration jobs/year. Pays by the project, $500-1,500.
Jackets/Covers: Assigns 20 freelance design jobs and 20 illustration jobs/year. Pays by the project, $400-1,500.
Text Illustration: Pays $25-100/illustration.
Tips: "All work is being generated by the computer. I don't use any art that is done by hand, however, I am not interested in computer techies who think they are now designers."

PAULINE BOOKS & MEDIA, 50 St. Paul's Ave., Boston MA 02130. (617)522-8911. Fax: (617)541-9805. Website: http://www.pauline.org. Contact: Graphic Design Dept. Estab. 1932. Book publisher. "We also publish 2 magazines and produce audio and video cassettes." Publishes hardcover and trade paperback originals and reprints and textbooks. Also electronic books and software. Types of books include contemporary and historical fiction, instructional, biography, preschool, juvenile, young adult, reference, history, self-help, prayer and religious. Specializes in religious topics. Publishes 20 titles/year. Art guidelines available. Sample copies for SASE with first-class postage.
Needs: Approached by 50 freelancers/year. Works with 10-20 freelance illustrators/year. Also needs freelancers for multimedia projects. 65% of freelance work demands knowledge of Aldus PageMaker 5.0 and CorelDraw 5.0.
First Contact & Terms: Send query letter with résumé, SASE, tearsheets and photocopies. Accepts disk submissions compatible with Windows 3.1. Send EPS, TIFF, GIF or TARGA files. Samples are filed or are returned by SASE. Reports back within 1-3 months only if interested. Rights purchased vary according to project. Originals are returned at job's completion.
Jackets/Covers: Assigns 1-2 freelance illustration jobs/year. Pays by the project.
Text Illustration: Assigns 3-10 freelance illustration jobs/year. Pays by the project.

PAULIST PRESS, 997 Macarthur Blvd., Mahwah NJ 07430. (201)825-7300. Fax: (201)825-8345. Managing Editor: Don Brophy. Estab. 1869. Company publishes hardcover and trade paperback originals and textbooks. Types of books include biography, juvenile and religious. Specializes in academic and pastoral theology. Publishes 95 titles/year. 5% require freelance illustration; 5% require freelance design.
Needs: Works with 6-8 freelance illustrators and 15-20 designers/year. Prefers local freelancers. Uses freelancers for juvenile titles, jacket/cover and text illustration. 10% of freelance work demands knowledge of QuarkXPress. Works on assignment only.
First Contact & Terms: Send query letter with brochure, résumé and tearsheets. Samples are filed. Reports back only if interested. Portfolio review not required. Negotiates rights purchased. Originals are returned at job's completion if requested.
Book Design: Assigns 10-12 freelance design jobs/year.
Jackets/Covers: Assigns 90 freelance design jobs/year. Pays by the project, $400-800.
Text Illustration: Assigns 3-4 freelance illustration jobs/year. Pays by the project.

‡**PEANUT BUTTER PUBLISHING**, Dept. AM, 226 Second Ave. W., Seattle WA 98119. (206)281-5965. E-mail: pnutpub@aol.com. Website: http://www.pbpublishing.com. Editor: Elliott Wolf. Estab. 1972. Specializes in paperback regional and speciality cookbooks for people who like to dine in restaurants and try the recipes at home. Publishes 30 titles/year. 100% require freelance illustration. Titles include *A Wok with Mary Pang*, *Lentil and Split Pea Cookbook* and *Miss Ruby's Southern Creole and Cajun Cuisine*. Book catalog free for SASE with first-class postage.

Needs: Approached by 70 freelance artists/year. Needs freelancers for multimedia projects. 95% of design demands computer skills.

First Contact & Terms: Works on assignment only. Send résumé and brochure showing art style or tearsheets, photostats and photocopies. Accepts disk submissions. Samples not filed are returned only if requested. Reports only if interested. To show portfolio, mail appropriate materials.

Book Design: Pays by the hour, $15-25; by the project, $200-3,500.

Jackets/Covers: Pays by the hour, $15-25; by the project, $200-3,000

Text Illustration: Pays by the hour, $15-25; by the project, $200-2,000.

Tips: Books contain pen & ink and 4-color photos. "Don't act as if you know more about the work than we do. Do exactly what is assigned to you."

PELICAN PUBLISHING CO., 1101 Monroe St., Box 3110, Gretna LA 70054. (504)368-1175. Fax: (504)368-1195. Contact: Production Manager. Publishes hardcover and paperback originals and reprints. Publishes 60-70 titles/year. Types of books include travel guides, cookbooks and children's books. Books have a "high-quality, conservative and detail-oriented" look.

Needs: Approached by 200 freelancers/year. Works with 20 freelance illustrators/year. Uses freelancers for illustration and multimedia projects. Works on assignment only. 100% of design and 50% of illustration demand knowledge of QuarkXPress. Aldus FreeHand and CorelDraw.

First Contact & Terms: Designers send photocopies, photographs, SASE, slides and tearsheets. Illustrators send postcard sample or query letter with photocopies, SASE, slides and tearsheets. Samples are not returned. Reports back on future assignment possibilities. Buys all rights. Originals are not returned.

Book Design: Pays by the project, $500 minimum.

Jackets/Covers: Pays by the project, $150-500.

Text Illustration: Pays by the project, $50-250.

Tips: "Show your versatility. We want to see realistic detail and color samples."

‡**PEN NOTES, INC.**, 61 Bennington Ave., Freeport NY 11520-5499. (516)868-5753. Fax: (516)868-8441. President: Lorette Konezny. Produces learning books and calligraphy kits for children ages 3 and up, teenagers and adults. Clients: Bookstores, toy stores and parents.

Needs: Prefers New York artists with book or advertising experience. Works on assignment only. Each year assigns 1-2 books (with 24 pages of art) to freelancers. Uses freelancers for children's illustration, P-O-P display and design and mechanicals for catalog sheets for children's books. 100% of freelance design and up to 50% of illustration demand computer skills. Prefers knowledge of press proofs on first printing. Prefers imaginative, realistic style with true perspective and color.

First Contact & Terms: Designers send brochure, résumé, SASE, tearsheets and photocopies. Illustrators send postcard sample with brochure, résumé and tearsheets. Samples are filed. Call or write for appointment to show portfolio or mail final reproduction/product, color and b&w tearsheets and photostats. Pays for design by the hour, $15-36; by the project, $60-125. Pays for illustration by the project, $60-500/page. Buys all rights. Originals not returned.

Tips: "Work must be clean, neat and registered for reproduction. The style must be geared for children's toys. Looking for realistic/cartoon outline with flat color. You must work on deadline schedule set by printing needs. Must have full range of professional and technical experience for press proof. All work is property of Pen Notes, copyright property of Pen Notes."

‡**PENGUIN BOOKS**, 375 Hudson St., New York NY 10014. (212)366-2000. Art Director: Paul Buckley. Publishes hardcover, trade paperback and mass market paperback originals.

Needs: Works with 10-20 freelance illustrators and 10-20 freelance designers/year. Uses freelancers mainly for jackets, catalogs, etc.

First Contact & Terms: Send query letter with tearsheets, résumé, photocopies and SASE. Write for appointment to show portfolio. Rights purchased vary according to project.

Book Design: Pays by the project; amount varies.

Jackets/Covers: Pays by the project; amount varies.

Text Illustration: Pays by the project; amount varies.

PETER PAUPER PRESS, INC., 202 Mamaroneck Ave., White Plains NY 10601. (914)681-0144. Fax: (914)681-0389. Contact: Creative Director. Estab. 1928. Company publishes hardcover originals. Types of books include small format illustrated gift books. Specializes in friendship, love, self-help, celebrations, holidays, topics of interest to women. Publishes 40 titles/year. Recent titles include *Your Secret Angel*, *The*

Key To Life, and *Jane Austen's Little Instruction Book*. 85% require freelance illustration; 40% require freelance design.

Needs: Approached by 25-30 freelancers/year. Works with 12-15 freelance illustrators and 3-5 designers/year. Uses freelancers for jacket/cover and text illustration. 40% of freelance design demands knowledge of QuarkXPress. Works on assignment only.

First Contact & Terms: Send query letter with brochure, résumé, SASE, photographs, tearsheets or photocopies. Samples are not filed and are returned by SASE. Reports back within 1 month with SASE. Art Director will contact artist for portfolio review if interested. Portfolio should include book dummy, final art photographs and photostats. Rights purchased vary according to project. Originals are returned at job's completion. Finds artists through submissions, gift and card shows.

Book Design: Assigns 20-25 freelance design jobs/year. Pays by the project, $400-2,500.

Jackets/Covers: Assigns 15-20 freelance design and 25-30 illustration jobs/year. Pays by the project, $500-2,000.

Text Illustration: Assigns 35-40 freelance illustration jobs/year. Pays by the project, $500-1,500.

THE PILGRIM PRESS/UNITED CHURCH PRESS, 700 Prospect Ave. E., Cleveland OH 44115-1100. (216)736-3726. Art Director: Martha Clark. Production: Madrid Tramble. Estab. 1957. Company publishes hardcover originals and trade paperback originals and reprints. Types of books environmental ethics, human sexuality, devotion, women's studies, justice, African-American studies, world religions, Christian education, curriculum, reference and social and ethical philosophical issues. Specializes in religion. Publishes 45-50 titles/year. Recent titles include *Gifts of Many Cultures: Worship Resources for the Global Community*, *In Good Company: A Woman's Journal for Spiritual Reflection*. 50% require freelance illustration; 50% require freelance design. Books are progressive, classic, exciting, sophisticated—conceptually looking for "high design." Book catalog free by request.

Needs: Approached by 50 freelancers/year. Works with 20 freelance illustrators and 10 designers/year. Buys 50 illustrations/year. Prefers freelancers with experience in book publishing. Uses freelancers mainly for covers, catalogs and illustration. Also for book design. Works on assignment only.

First Contact & Terms: Send query letter with résumé, tearsheets and photocopies. Samples are filed and are not returned. Art Director will contact artist for portfolio review if interested. Artist should follow up with letter after initial query. Portfolio should include thumbnails, roughs and color tearsheets and photographs. Negotiates rights purchased. Interested in buying second rights (reprint rights) to previously published work based on need, style and concept/subject of art and cost. "I like to see samples." Originals are returned at job's completion. Finds artists through agents.

Book Design: Assigns 6-20 freelance design and 50 illustration jobs/year. Pays by the project, $500.

Jackets/Covers: Assigns 6-20 freelance design and 6-20 illustration jobs/year. Prefers contemporary styles. Pays by the project, $500-700.

Text Illustration: Assigns 15-20 design and 15-20 illustration jobs/year. Pays by the project, $200-500; negotiable, based on artist estimate of job, number of pieces and style.

Tips: "I also network with other art directors/designers for their qualified suppliers/freelancers. If interested in curriculum illustration, show familiarity with illustrating biblical art and diverse races and ages."

‡PINCUSHION PRESS, 6001 Johns Rd., Suite 148, Tampa FL 33634-4448. (813)855-3071. Fax: (813)855-4213. Art Director: Jeffrey Lawrence. Estab. 1990. Publishes hardcover and trade paperback originals. Types of books include coffee table books and nonfiction. Specializes in antiques and collectibles. Publishes 8 titles/year. Recent titles include: *Collecting Tin Toys*. 10% require freelance illustration; 90% require freelance design. Book catalog free for $1.01 postage.

Needs: Approached by 10 illustrators and 10 designers/year. Works with 1 freelance illustrator and 5 designers/year. Uses freelancers mainly for book jacket and book interior design. 75% of freelance design and 50% of illustration demands knowledge of Aldus PageMaker, Aldus FreeHand, Adobe Photoshop, Adobe Illustrator, QuarkXPress.

First Contact & Terms: Designers send query letter with photocopies and photographs. Illustrators send printed samples. Samples are not filed and are returned by SASE. Portfolio review required from designers. Request portfolio review in original query. Portfolio should include book dummy, photocopies, photographs. Negotiates rights purchased, rights purchased vary according to project. Finds freelancers through word of mouth and artists' submissions.

Book Design: Assigns 8 freelance design jobs/year. Pays by project.

Jackets/Covers: Pays by project. Prefers fully rendered art.

Text Illustration: Pays by project.

‡PIPPIN PRESS, 229 E. 85th St., Gracie Station Box 1347, New York NY 10028. (212)288-4920. Fax: (908)225-1562. Publisher: Barbara Francis. Estab. 1987. Company publishes hardcover juvenile originals. Publishes 4-6 titles/year. Recent titles include *Abigail's Drums*, *The Spinner's Daughter*, *The Sounds of Summer* and *Windmill Hill*. 100% require freelance illustration; 50% require freelance design. Book catalog free for SAE with 2 first-class stamps.

Needs: Approached by 50-75 freelance artists/year. Works with 6 freelance illustrators and 2 designers/year. Prefers artists with experience in juvenile books for ages 4-10. Uses freelance artists mainly for book illustration. Also uses freelance artists for jacket/cover illustration and design and book design.

First Contact & Terms: Send query letter with résumé, tearsheets, photocopies. Samples are filed "if they are good" and are not returned. Reports back within 2 weeks. Portfolio should include selective copies of samples and thumbnails. Buys all rights. Originals are returned at job's completion.

Book Design: Assigns 3-4 freelance design jobs/year.

Text Illustration: All text illustration assigned to freelance aritsts.

Tips: Finds artists "through exhibits of illustration and looking at recently published books in libraries and bookstores."

PLAYERS PRESS, Box 1132, Studio City CA 91614. Associate Editor: Marjorie Clapper. Specializes in plays and performing arts books. Recent titles include *Men's Garments 1830-1900*, by R.I. Davis; and *Tangled Garden*, by David Crawford.

Needs: Works with 3-15 freelance illustrators and 1-3 designers/year. Uses freelancers mainly for play covers. Also for text illustration. Works on assignment only.

First Contact & Terms: Send query letter with brochure showing art style or résumé and samples. Samples are filed or are returned by SASE. Request portfolio review in original query. Art Director will contact artist for portfolio review if interested. Portfolio should include thumbnails, final reproduction/product, tearsheets, photographs and as much information as possible. Sometimes requests work on spec before assigning a job. Buys all rights. Considers buying second rights (reprint rights) to previously published work, depending on usage. "For costume books this is possible."

Book Design: Pays by the project, rate varies.

Jackets/Covers: Pays by the project, rate varies.

Text Illustration: Pays by the project, rate varies.

Tips: "Supply what is asked for in the listing and don't waste our time with calls and unnecessary cards. We usually select from those who submit samples of their work which we keep on file. Keep a permanent address so you can be reached."

‡❀**THE PRAIRIE PUBLISHING COMPANY**, Box 2997, Winnipeg MB R3C 4B5 Canada. (204)885-6496. Publisher: Ralph E. Watkins. Specializes in paperback juvenile fiction and local history. Publishes 3 titles/year. Recent titles include *The Tale of Jonathan Thimblemouse* and *The Small Straw Goat*.

First Contact & Terms: Approached by 5 freelance artists/year. Works with 4 freelance illustrators and 1 freelance designer/year. Works on assignment only. Send query letter with résumé and tearsheets. Samples are filed or are returned. Reports back within weeks. Originals not returned at job's completion. To show a portfolio, mail roughs. Considers skill and experience of artist and project's budget when establishing payment. Negotiates rights purchased.

Jackets/Covers: Pays by the project, $200-300.

Text Illustration: Prefers line drawings. Pays by the project, $150-200.

Tips: "The work should not appear too complete. What I look for is open-ended art. Artists have to aim at being less dramatic and more focused on the subject."

PRAKKEN PUBLICATIONS, INC., 275 Metty Dr., Box 8623, Suite 1, Ann Arbor MI 48107. (313)769-1211. Fax: (313)769-8383. Production and Design Manager: Sharon Miller. Estab. 1934. Imprints include The Education Digest, Tech Directions. Company publishes textbooks, educator magazines and reference books. Types of books include reference, texts, especially vocational and technical educational. Specializes in vocational, technical education, general education reference. Publishes 2 magazines and 3 new book titles/year. Titles include *High School-to-Employment Transition*, *Exploring Solar Energy, II: Projects in Solar Electricity*, and *Technology Past*. Book catalog free by request.

Needs: Rarely uses freelancers. 50% of freelance work demands knowledge of Aldus PageMaker. Works on assignment only.

First Contact & Terms: Send samples. Samples are filed or are returned by SASE if requested by asrtist. Reports back only if interested. Art Director will contact artist for portfolio review if interested. Portfolio should include b&w and color final art, photostats and tearsheets.

PRENTICE HALL COLLEGE DIVISION, 445 Hutchinson Ave., Columbus OH 43235. (614)841-3700. Fax: (614)841-3645. Production Services Manager: Connie Geldis. Imprint of Simon & Schuster. Specializes in college textbooks in education, career and technology. Publishes 300 titles/year. Recent titles include *Exceptional Children*, by Heward; and *Electronics Fundamentals*, by Floyd.

Needs: Approached by 25-40 freelancers/year. Works with 30 freelance illustrators/year. Uses freelancers mainly for book cover illustrations in all types of media. Also for jacket/cover design. 100% of freelance design and 70% of illustration demand knowledge of QuarkXPress 3.31 or 5.0; Aldus FreeHand 5.0 only, Adobe Illustrator 5.5 or Adobe Photoshop.

First Contact & Terms: Send query letter with résumé and tearsheets. Accepts submissions on disk in Mac files only (not PC) in software versions stated above. Samples are filed and portfolios are returned.

Reports back within 3 days. To show portfolio, mail tearsheets and transparencies. Rights purchased vary according to project. Originals are returned at job's completion.

Book Design: Pays by the project, $200-1,500.

Jackets/Covers: Assigns 200 illustration jobs/year.

Tips: "Send a style that works well with our particular disciplines. All covers are produced with a computer, but the images from freelancers can come in whatever technique they prefer. We are looking for new art produced on the computer."

PRICE STERN SLOAN, 11835 Olympic Blvd., Suite 500, Los Angeles CA 90064. (310)477-6100. Fax: (310)445-3933. Art Director: Sheena Needham. Estab. 1971. Book publisher. Publishes hardcover, trade paperback and mass market paperback originals and reprints. Types of books include instructional, pre-school, juvenile, young adult, calendars, games, crafts, novelty and pop-up books. Publishes 100 titles/year. Recent titles include *The Boo Boo Book*, by Joe Boddy; *Take A Stand*; and *How to Hide An Elephant in Your Room*. 75% require freelance illustration; 10% require freelance design. Books vary from cute to quirky to illustrative.

• Price Stern Sloan is a division of the Putnam Berkley Group which is owned by MCA/Universal Studios. It does quite a few license tie-in books with the film and TV industries.

Needs: Approached by 300 freelancers/year. Works with 20-30 freelance illustrators and 10-20 designers/year. Prefers freelancers with experience in book or advertising art. Uses freelancers mainly for illustration. Also for jacket/cover and book design. Needs computer-literate freelancers for production.

First Contact & Terms: Send query letter with brochure, résumé and photocopies. Samples are filed or are returned by SASE if requested by artist. Art Director will contact artist for portfolio review if interested. "Please don't call." Portfolios may be dropped off every Thursday. Portfolio should include b&w and color tearsheets. Rights purchased vary according to project. Finds artists through word of mouth, magazines, submissions/self-promotion, sourcebooks and agents.

Book Design: Assigns 5-10 freelance design jobs and 20-30 illustration jobs/year. Pays by the project.

Jackets/Covers: Assigns 5-10 freelance design jobs and 10-20 illustration jobs/year. Pays by the project, rate varies.

Text Illustration: Pays by the project and occasionally by participation.

Tips: "Do not send original art. Become familiar with the types of books we publish. We are always looking for excellent book submissions. We are extremely selective when it comes to children's books, so please send only your best work. Any book submission that does not include art samples should be sent to our editorial department. Book design is branching out into new markets—CD-ROM, computers, audio, video."

‡**PROLINGUA ASSOCIATES**, 15 Elm St., Brattleboro VT 05301. (802)257-7779. Fax: (802)257-5117. E-mail: prolingu@sover.net. President: Arthur A. Burrows. Estab. 1980. Company publishes textbooks. Specializes in language textbooks. Publishes 3-8 titles/year. Recent titles include *Living in Mexico* and *Conversation Strategies*. 100% require freelance illustration. Book catalog free by request.

Needs: Approached by 5 freelance artists/year. Works with 2-3 freelance illustrators/year. Uses freelance artists mainly for pedagogical illustrations of various kinds. Also uses freelance artists for jacket/cover and text illustration. Works on assignment only.

First Contact & Terms: Send postcard sample and/or query letter with brochure, photocopies and photographs. Samples are filed. Reports back within 1 month. Portfolio review not required. Buys all rights. Originals are returned at job's completion if requested. Finds artists through word of mouth and submissions.

Text Illustration: Assigns 5 freelance illustration jobs/year. Pays by the project, $100-1,000.

‡**PUFFIN BOOKS**, Dept. AM, 375 Hudson St., New York NY 10014. (212)366-2000. Fax: (212)366-2040. Art Director: Deborah Kaplan. Division estab. 1941. Book publisher. (Imprint of Penguin USA.) Division publishes trade paperback originals and reprints and mass market paperback originals. Types of books include contemporary, mainstream, historical fiction, adventure, mystery, biography, preschool, juvenile and young adult. Specializes in juvenile novels. Publishes 120 titles/year. Titles include *Roll of Thunder, Hear My Cry*; *The Westing Game*; *The Karate Club*; and *Woodsong*. 50% require freelance illustration; 5% require freelance design.

Needs: Approached by 20 artists/year. Works with 35 illustrators/year. Buys 60 illustrations/year. Prefers artists with experience in realistic juvenile renderings. Uses freelancers mainly for paperback cover 4-color art. Also for text illustration. Works on assignment only.

First Contact & Terms: Send query letter with tearsheets and transparencies. Samples are filed or are returned by SASE if requested by artist. Reports back to the artist only if interested. Call for appointment to show portfolio. Portfolio should include color tearsheets and transparencies. Rights purchased vary according to project. Originals returned to artist at job's completion.

Book Design: Assigns 5 illustration jobs/year.

Jackets/Covers: Assigns 60 illustration jobs/year. Prefers oil, acrylic, watercolor and 4-color. Pays by the project, $900-2,000.

Text Illustration: Assigns 5 illustration jobs/year. Prefers b&w line drawings. Pays by the project, $500-1,500.

Tips: "I need you to show that you have experience in painting tight, realistic, lively renderings of kids ages 6-18."

G.P. PUTNAM'S SONS, PHILOMEL BOOKS, PAPERSTAR BOOKS, 200 Madison Ave., New York NY 10016. (212)951-8733. Art Director, Children's Books: Cecilia Yung. Assistant to Art Director: Tony Sahara. Publishes hardcover and paperback juvenile books. Publishes 100 titles/year. Free catalog available.
Needs: Works on assignment only.
First Contact & Terms: Provide flier, tearsheet, brochure and photocopy or stat to be kept on file for possible future assignments. Samples are returned by SASE. "We take drop-offs on Tuesday mornings. Please call in advance with the date you want to drop of your portfolio."
Jackets/Covers: "Uses full-color paintings, realistic painterly style."
Text Illustration: "Uses a wide cross section of styles for story and picture books."

PYX PRESS, P.O. Box 922648, Sylmar CA 91392-2648. Editor: C. Darren Butler. Estab. 1990. Company publishes experimental fiction, fantasy, horror, humor, juvenile, nonfiction and reference. Specializes in magic realism, folklore, literary fantasy. Publishes 2-10 titles/year. Recent titles include *One Thick Black Cord*, by Brian Everson; *Back at the Civsa Shore*, by Batya Weinbaum. 50% require freelance illustration. Book catalog free for #10 SASE with 1 first-class stamp.
 • Pyx Press publishes several serials including *Avatar*, *North-American Magic Realism* and *Strike Through the Mask* which are also in need of artwork. The publications pay in copies or up to $200 for illustrations. Contact the press for more information.
Needs: Approached by 200 freelancers/year. Works with 3-30 freelance illustrators/year. Uses freelancers mainly for covers and spot illustrations. Also for text illustration.
First Contact & Terms: Send postcard sample of work or send query letter with SASE. Samples are filed or returned by SASE if requested by artist. Reports back in 1 month on query; 2-6 months on submissions. Request portfolio review in original query (reviews photocopies by mail). Buys first or one-time rights. Originals are returned at job's completion.
Jackets/Covers: Assigns 2-4 freelance illustration jobs/year. Pays by the project, $5-100.

RAGNAROK PRESS, Box 140333, Austin TX 78714. Fax: (512)472-6220. E-mail: ragnarokgc@aol.com. Editor: David F. Nall.
 • Ragnarok Press is primarily a book and game publisher, but also publishes *Abyss Magazine*. See listing for *Abyss* in Magazines section for more information. According to Editor David Nall, Ragnarok Press is buying more art than *Abyss* and has different needs. *Abyss* is more open to new artists; Ragnarok is higher paying. Ragnarok Games is looking for good color artists to do card illustration. See Greeting Cards, Games & Products section for additional needs and websites.

RANDOM HOUSE, INC., (Juvenile), 201 E. 50th St., New York NY 10022. (212)940-7664. Associate Art Director: Vicki Kalajian. Specializes in hardcover and paperback originals and reprints. Publishes 200 titles/year. 100% require freelance illustration.
Needs: Works with 100-150 freelancers/year. Works on assignment only.
First Contact & Terms: Send query letter with résumé, tearsheets and photostats; no originals. Samples are filed or are returned. "No appointment necessary for portfolio drop-offs. Come in on Wednesdays only, before noon." Considers drop-offs, complexity of project, skill and experience of artist, budget, turnaround time and rights purchased when establishing payment. Negotiates rights purchased.
Book Design: Assigns 5 freelance design jobs/year. Pays by the project.
Text Illustration: Assigns 150 illustration jobs/year. Pays by the project.

RANDOM HOUSE VALUE PUBLISHING, 40 Engelhard Ave., Avenel NJ 07001. (908)827-2672. Fax: (908)827-2694. E-mail: gpapadopoulos@randomhouse.com. Art Director: Gus Papadopoulos. Creative Director: Don Bender. Imprint of Random House, Inc. Other imprints include Wings, Gramercy, Crescent, Jellybean. Imprint publishes hardcover, trade paperback and mass market paperback reprints and trade paperback originals. Types of books include adventure, coffee table books, cookbooks, fantasy, historical fiction, history, horror, humor, instructional, juvenile, mainstream fiction, New Age, nonfiction, reference, religious, romance, science fiction, self-help, travel, western and young adult. Specializes in contemporary authors' work. Recently published titles by John Saul, Mary Higgins Clark, Tom Wolfe, Dave Barry and Michael Chrichton (all omnibuses). 80% require freelance illustration; 50% require freelance design. Book catalog free by request.
Needs: Approached by 70 freelancers/year. Works with 60-70 freelance illustrators and 20-25 designers/year. Uses freelancers mainly for jacket/cover illustration and design for fiction and romance titles. 100% of design and 50% of illustration demand knowledge of Adobe Illustrator, QuarkXPress, Adobe Photoshop and Aldus FreeHand. Works on assignment only.
First Contact & Terms: Designers send query letter with résumé and tearsheets. Illustrators send postcard sample, brochure, résumé and tearsheets. Accepts disk submissions compatible with Adobe Illustrator and

Adobe Photoshop. Samples are filed. Reports back within 2 weeks. Request portfolio review in original query. Art Director will contact artist for portfolio review if interested. Portfolio should include tearsheets. Buys first rights. Originals are returned at job's completion. Finds artists through *American Showcase*, *Workbook*, *The Creative Illustration Book*, artist's reps.

Book Design: Pays by the project.

Jackets/Covers: Assigns 30-40 freelance design and 75 illustration jobs/year. Pays by the project, $500-2,500.

Tips: "Study the product to make sure styles are similar to what we have done: new, fresh, etc."

READ'N RUN BOOKS, Box 294, Rhododendron OR 97049. (503)622-4798. Publisher: Michael P. Jones. Estab. 1985. Specializes in fiction, history, environment and wildlife books for children through adults. "Books for people who do not have time to read lengthy books." Publishes 2-6 titles/year. Recent titles include *Romany Remedies and Recipes*, by Gipsy Petulengro; and *Sauvie Island Adventure*, by Skyline School's 4th Grade Students. "Our books, printed in b&w or sepia, are both hardbound and softbound, and are not slick looking. They are home-grown-looking books that people love." Accepts previously published material. Art guidelines for #10 SASE.

Needs: Works with 55 freelance illustrators and 10 designers/year. Prefers pen & ink, airbrush, charcoal/pencil, markers, calligraphy and computer illustration. Uses freelancers mainly for illustrating books. Also for jacket/cover, direct mail, book and catalog design. 50% of freelance work demands computer skills.

First Contact & Terms: Send query letter with brochure, tearsheets, photocopies and SASE. Samples not filed are returned by SASE. Request portfolio review in original query. Art Director will contact artist for portfolio review if interested. Artist should follow up after initial query. Portfolio should include thumbnails, roughs, final reproduction/product, color and b&w tearsheets, photostats and photographs. Buys one-time rights. Interested in buying second rights (reprint rights) to previously published work. Originals are returned at job's completion. Pays in copies, on publication.

Tips: "Generally, the artists find us by submitting samples—lots of them, I hope. Artists may call us, but we will not return calls. We will be publishing short-length cookbooks. I want to see a lot of illustrations showing a variety of styles. There is little that I actually don't want to see. We have a tremendous need for illustrations on the Oregon Trail (i.e., oxen-drawn covered wagons, pioneers, mountain men, fur trappers, etc.) and illustrations depicting the traditional way of life of Plains Indians and those of the North Pacific Coast and Columbia River with emphasis on mythology and legends. Pen & ink is coming back stronger than ever! Don't overlook this. Be versatile with your work. We will also evaluate your style and may utilize your work through another imprint that is under us, or even through our 'Wy-East Historical Journal.'"

‡✎RED DEER COLLEGE PRESS, 56 Ave. & 32nd St., Box 5005, Red Deer Alberta T4N 5H5 Canada. (403)342-3321. Fax: (403)340-8940. E-mail: vicki.mix@rdc.ab.ca. Managing Editor: Dennis Johnson. Estab. 1975. Book publisher. Publishes hardcover and trade paperback originals. Types of books include contemporary and mainstream fiction, fantasy, biography, preschool, juvenile, young adult, humor and cookbooks. Specializes in contemporary adult and juvenile fiction, picture books and natural history for children. Recent titles include *Josepha: A Prairie Boy's Story* and *A Roundup of Cowboy Humor*. 100% require freelance illustration; 30% require freelance design. Book catalog available for SASE with first-class postage.

Needs: Approached by 50-75 freelance artists/year. Works with 10-12 freelance illustrators and 2-3 freelance designers/year. Buys 100+ freelance illustrations/year. Prefers artists with experience in book and cover illustration. Also uses freelance artists for jacket/cover and book design and text illustration. Works on assignment only.

First Contact & Terms: Send query letter with résumé, tearsheets, photographs and slides. Samples are filed. Reports back within 1 month. To show a portfolio, mail b&w slides and dummies. Rights purchased vary according to project. Originals returned at job's completion.

Book Design: Assigns 3-4 design and 6-8 illustration jobs/year. Pays by the project.

Jackets/Covers: Assigns 6-8 design and 10-12 illustration jobs/year. Pays by the project, $300-1,000.

Text Illustration: Assigns 3-4 design and 4-6 illustration jobs/year. Pays by the project. May pay advance on royalties.

Tips: Looks for freelancers with a proven track record and knowledge of Red Deer College Presss. "Send a quality portfolio, preferably with samples of book projects completed."

RIO GRANDE PRESS, P.O. Box 71745, Las Vegas NV 89170-1745. Editor/Publisher: Rosalie Avara. Estab. 1989. Small press. Publishes trade paperback originals. Types of books include poetry journal and anthologies. Publishes 7 titles/year. 95% require freelance illustration; 90% require freelance design. Book catalog for SASE with first-class postage. Artist guidelines available.

Needs: Approached by 30 freelancers. Works with 5-6 freelance illustrators and 1 designer/year. Prefers freelancers with experience in spot illustrations for poetry and b&w cartoons about poets, writers, etc. Uses freelancers for jacket/cover illustration and design and text illustration.

First Contact & Terms: Send query letter with résumé, SASE, tearsheets, photocopies and cartoons, no postcards. Samples are filed. Reports back within 1 month. To show portfolio, mail roughs, finished art samples and b&w tearsheets. Buys first rights or one-time rights. Originals are not returned.

Book Design: Assigns 2-3 freelance illustration jobs/year. Pays by the project; $4 or copy.
Jackets/Covers: Pays by the project, $4; or copy.
Text Illustration: Assigns 4 freelance illustration jobs/year. Prefers small b&w line drawings to illustrate poems. Pays by the project; $4 or copy.
Tips: "We are currently seeking cover designs for *The Story Shop V* (short stories) and *Summer's Treasures V, Winter's Games VI* (poetry anthologies). Send copies of very small b&w drawings of everyday objects, nature, animals, seasonal drawings, small figures and/or faces with emotions expressed. Pen & ink preferred."

‡ROUTLEDGE, 29 W. 35th St., New York NY 10001-2291. (212)244-3336. Estab. 1979. Book publisher. Publishes trade paperback originals. Types of books include business, politics and cultural studies. Specializes in science, gay and lesbian studies, women's studies, anthropology, archaeology, literature criticism and statistics. Publishes 1,000 titles/year. Desktop publishing only. Books are text oriented. Book catalog free by request.
Needs: Approached by 20 freelance artists/year. Works with 4-8 freelance designers/year. Prefers artists with experience in catalog and display advertisement design. Uses freelance artists mainly for catalogs, direct mail and print display advertisement. Also uses freelance artists for desktop publishing and book design. Works on assignment only.
First Contact & Terms: Send query letter with brochure to art department. Samples are filed. Reports back to the artist only if interested. Finds artists through word of mouth.
Jackets/Covers: Prefers "either type solutions or simple illustrations."

SAUNDERS COLLEGE PUBLISHING, Public Ledger Bldg., Suite 1250, 150 S. Independence Mall West, Philadelphia PA 19106. (215)238-5500. Manager of Art & Design: Carol Bleistine. Imprint of Harcourt Brace College Publishers. Company publishes textbooks. Specializes in sciences. Publishes 30-45 titles/year. 100% require freelance illustration; 100% require freelance design. Book catalog not available.
Needs: Approached by 10-20 freelancers/year. Works with 10-20 freelance illustrators and 10-20 designers/year. Prefers local freelancers with experience in hard sciences (biology, chemistry, physics, math, etc.). Uses freelancers mainly for design of text interiors, covers, artwork, page layout. Also for jacket/cover and text illustration, jacket/cover and book design. Needs computer-literate freelancers for design and illustration. 95% of freelance work demands knowledge of Adobe Illustrator, QuarkXPress, Adobe Photoshop and Aldus FreeHand. Works on assignment only.
First Contact & Terms: Send query letter with brochure, résumé, tearsheets, photographs, photocopies or color copies. Samples are filed or returned by SASE if requested by artist. Request portfolio review in original query. Art Director will contact artist for portfolio review if interested. Portfolio should include book dummy, final art, photographs, roughs, slides, tearsheets and transparencies. Buys all rights. Finds artists through sourcebooks, word of mouth and submissions.
Books Design: Assigns 30-45 freelance design jobs/year. Pays by the project.
Jackets/Covers: Assigns 30-45 freelance design and 1-2 illustration jobs/year. Pays by the project.
Text Illustration: Assigns 30-45 freelance illustration jobs/year. Pays by the project or per figure. Prefers airbrush reflective; electronic art, styled per book requirements—varies.

SCHOLASTIC INC., 555 Broadway, New York NY 10012. Executive Art Director: David Tommasino. Specializes in hardcover and paperback originals and reprints of young adult, biography, classics, historical romance and contemporary teen romance. Publishes 250 titles/year. Titles include *Goosebumps, Animorphs* and *Pony Pals*. 80% require freelance illustration. Books have "a mass-market look for kids."
Needs: Approached by 100 freelancers/year. Works with 75 freelance illustrators and 2 designers/year. Prefers local freelancers with experience. Uses freelancers mainly for mechanicals. Also for jacket/cover illustration and design and book design. 90% of freelance design and 5% of illustration demand knowledge of QuarkXPress, Adobe Illustrator, Adobe Photoshop.
First Contact & Terms: Designers send query letter with résumé and tearsheets. Illustrators send postcard sample and tearsheets. Accepts disk submissions compatible with Adobe Illustrator 5.0. Samples are filed or are returned only if requested. Art Director will contact artist for portfolio review if interested. Considers complexity of project and skill and experience of artist when establishing payment. Originals are returned at job's completion. Finds artists through word of mouth, *American Showcase, RSVP* and Society of Illustrators.
Book Design: Pays by the project, $2,500-4,000.
Jackets/Covers: Assigns 200 freelance illustration jobs/year. Pays by the project, $1,800-3,500.
Text Illustration: Pays by the project, $500-1,500.
Tips: "In your portfolio, show tearsheets or proofs only of printed covers. I want to see oil, acrylic tightly rendered; illustrators should research the publisher. Go into a bookstore and look at the books. Gear what you send according to what you see is being used."

‡SILVER BURDETT & GINN AND MODERN CURRICULUM, 299 Jefferson Rd., Parsippany NJ 07054-0480. (201)739-8000. Creative Director: Doug Bates. Book publisher. Estab. 1890. Publishes textbooks and nonfiction. Specializes in math, science, social studies, English, music and religion. Publishes approx. 75 titles/year. Books look lively and inviting with fresh use of art and photos. 100% require freelance

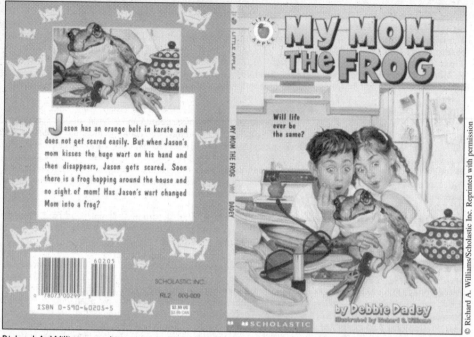

Richard A. Williams sought to convey "the good humor and whimsy of the book" in this cover illustration for *My Mom the Frog*. In the story published by Scholastic, young Jason's mom disappears after kissing a wart on his hand—then he sees a frog jumping around the house and thinks it may be his mother. In addition to children's books, Williams does historical reconstructions, *Mad* magazine covers, corporate and private commissions, and fine art. "I think illustrators generally need to develop more business savvy. They need to diversify if they want to survive. I don't depend on one genre so I don't suffer financially if one area dries up."

illustration; 20% require freelance design. Added new line of children's books/magazines: Ready Reader Series and Africa Kingdom Series. Recent titles include *Science: Discoveryworks*; and *MCP Ready Readers*.
Needs: Approached by 200-500 artists/year. Works with 50-200 illustrators and 1-5 designers/year. Buys 1,000 illustrations/year. Uses artists mainly for text illustration and page layout. Also works with artists for jacket/cover illustration and design and book, catalog, packaging and ad design. 100% of freelance design and 20% of illustration demand knowledge of QuarkXPress or Adobe Illustrator. Works on assignment only.
First Contact & Terms: Send query letter with résumé, photocopies, SASE and tearsheets. Accepts disk submissions compatible with Adobe Illustrator 5.0 or Adobe Photoshop 3.0. Samples are filed or are returned by SASE only if requested. Reports back only if interested. Originals are returned to artist at job's completion. Art Director will contact artist for portfolio review if interested. Portfolio should include thumbnails, roughs, final art, tearsheets and final reproduction/product. Sometimes requests work on spec before assigning a job. Considers complexity of project and skill and experience of artist when establishing payment. Considers buying second rights (reprint rights) to previously published artwork. Negotiates rights purchased.
Book Design: Assigns approximately 5 design jobs/year. Pays by the hour, $20-30.
Jackets/Covers: Pays by the project, $500-1,000.
Text Illustration: Assigns 1,000 illustrations jobs/year. Pays by the project, $350-1,000.
Tips: "Educational print materials need to compete with design intensive non-educational media. Submit samples periodically as new work is done. Timing can be everything."

SIMON & SCHUSTER, 1230 Avenue of the Americas, New York NY 10020. (212)698-7556. Fax: (212)698-7455. Art Director: Gina Bonanno. Imprints include Pocket Books, Minstrel and Archway. Company publishes hardcover, trade paperback and mass market paperback originals and reprints and textbooks. Types of books include juvenile, preschool, romance, self-help, young adult and many others. Specializes in young adult, romance and self help. 95% require freelance illustration; 80% require freelance design.
Needs: Works with 50 freelance illustrators and 5 designers/year. Prefers freelancers with experience working with models and taking direction well. Uses freelancers for hand lettering, jacket/cover illustration and design and book design. 100% of design and 75% of illustration demand knowledge of Adobe Illustrator and Adobe Photoshop. Works on assignment only.

First Contact & Terms: Send query letter with tearsheets. Accepts disk submissions. Samples are filed and are not returned. Reports back only if interested. Portfolios may be dropped off every Monday and Wednesday and should include tearsheets. Buys all rights. Originals are returned at job's completion.
Text Illustration: Assigns 50 freelance illustration jobs/year.

SIMON & SCHUSTER BOOKS FOR YOUNG READERS, 866 Third Ave., 25th Floor, New York NY 10022. (908)702-2019. Art Director: Lucille Chomowicz. Imprint of Simon & Schuster. Other imprints include Atheneum, Macmillan and McElderry. Imprint publishes hardcover originals and reprints. Types of books include picture books, nonfiction and young adult. Publishes 86 titles/year. Recent titles include *Zin Zin A Violin* and *The Faithful Friend*. 100% require freelance illustration; 1% require freelance design.
Needs: Approached by 200 freelancers/year. Works with 40 freelance illustrators and 2-4 designers/year. Uses freelancers mainly for jackets and picture books ("all illustration work is freelance"). 100% of design work demands knowledge of Adobe Illustrator, QuarkXPress and Adobe Photoshop. Works on assignment only.
First Contact & Terms: Designers send query letter with résumé and photocopies. Illustrators send postcard sample, query letter with brochure, photocopies, SASE and tearsheets. Accepts disk submissions. Art Director will contact artist for portfolio review if interested. Portfolio should include original art, photographs and transparencies. Originals are returned at job's completion.
Book Design: Assigns 6 freelance design jobs/year. Pays by the project.
Jackets/Covers: Assigns 15 freelance illustration jobs/year. Pays by the project, $800-2,000. "We use full range of media: collage, photo, oil, watercolor, etc."
Text Illustration: Assigns 30 freelance illustration jobs/year. Pays by the project.
Tips: Finds artists through submissions, agents, scouting in nontraditional juvenile areas such as painters, editorial artists.

SMITH AND KRAUS, INC., P.O. Box 127, Lyme NH 03768. (603)795-4340. Fax: (603)795-4427. Production Manager: Julia Hill. Company publishes hardcover and trade paperback originals. Types of books include young adult, drama and acting. Specializes in books for actors. Publishes 45 titles/year. Recent titles include *The Best Men's/Women's Monologues of 1995*, *The Sanford Meisner Approach*, and *Auditioning for Musical Theatre*. 20% require freelance illustration. Book catalog free for SASE with 3 first-class stamps.
Needs: Approached by 2 freelancers/year. Works with 2-3 freelance illustrators/year. Uses freelancers mainly for cover art, inside illustration. Also for text illustration. 10% of freelance work demands knowledge of Adobe Illustrator, QuarkXPress and Adobe Photoshop. Works on assignment only.
First Contact & Terms: Send postcard sample of work or send query letter with brochure, résumé. Samples are filed. Art Director will contact artist for portfolio review if interested. Portfolio should include book dummy and roughs. Buys one-time and reprint rights. Originals are returned at job's completion. Finds artists through word of mouth.
Text Illustration: Assigns 1-3 freelance illustration jobs/year. Pays by the project. Prefers pen & ink, oil, pastel.

SOUNDPRINTS, P.O. Box 679, 165 Water St., Norwalk CT 06856. (203)838-6009. Fax: (203)866-9944. Editorial Assistant: Dierdre Langeland. Estab. 1989. Company publishes hardcover originals. Types of books include juvenile. Specializes in wildlife. Publishes 12 titles/year. Recent titles include *Dolphin's First Day* and *Fawn at Woodland Way*, both by Kathleen Weidner Zoehfeld. 100% require freelance illustration. Book catalog free for 9 × 12 SAE with $1.05 postage.
Needs: Approached by 15 freelancers/year. Works with 9 freelance illustrators/year. Prefers freelancers with experience in realistic wildlife illustration and children's books. Uses freelancers for illustrating children's books (cover and interior).
First Contact & Terms: Send query letter with tearsheets, résumé, slides and SASE. Samples are filed or returned by SASE if requested by artist. Reports back within 1 month. Art Director will contact artist for portfolio review if interested. Portfolio should include color final art and tearsheets. Rights purchased vary according to project. Originals are returned at job's completion. Finds artists through agents, sourcebooks, reference, unsolicited submissions.
Text Illustration: Assigns 14 freelance illustration jobs/year. Prefers watercolor, colored pencil.
Tips: Wants realism. "We are not looking for cartoons."

SOURCEBOOKS, INC., 121 N. Washington, Suite 2 Naperville IL 60540. (708)961-3900. Fax: (708)961-2168. Estab. 1987. Company publishes hardcover and trade paperback originals and ancillary items. Types of books include New Age, nonfiction, preschool, reference, self-help and gift books. Specializes in business books and gift books. Publishes 20 titles/year. Recent titles include *Mancuso's Small Business Basics, Letters to Mead* and *365 Days of Creative Play*. Book catalog free for SASE with 4 first-class stamps.
Needs: Uses freelancers mainly for ancillary items, journals, jacket/cover design and illustration, text illustration, direct mail, book and catalog design. 100% of design and 25% of illustration demand knowledge of QuarkXPress 3.31, Adobe Photoshop 3.04 and Adobe Illustrator 6.0. Works on assignment only.

First Contact & Terms: Designers send query letter with photocopies. Illustrators send postcard sample. Accepts disk submissions compatible with Adobe Illustrator 6.0, Adobe Photoshop 3.0. Send EPS files. Reports back only if interested. Request portfolio review in original query. Negotiates rights purchased.
Book Design: Pays by the project.
Jackets/Covers: Pays by the project.
Text Illustration: Pays by the project.
Tips: "We have expanded our list tremendously and are, thus, looking for a lot more artwork. We have terrific distribution in retail outlets and are looking to provide more great looking material."

‡SOUTH END PRESS, 116 St. Botolph St., Boston MA 02115. (617)266-0629. Contact: Dionne Brooks. Specializes in hardcover and paperback books on contemporary problems, alternatives to oppression, movements for change. Publishes 15 titles/year. Recent titles include *Dying from Dioxin*, *Chaos or Community*, *Zapata's Revenge*, *Democracy in Mexico* and *Breaking Bread: Insurget Black Intellectual Life*. Uses artists for jacket/cover illustration and design.
First Contact & Terms: Works with varying number of freelance artists/year. "Artist must read the book and understand left/feminist, multicultural issues." Send samples of jacket covers of similar books. Prefers photostats as samples. Pays for design by the project, $350.
Tips: Looks for "ability to work creatively with few colors; good political instinct."

THE SPEECH BIN, INC., 1965 25th Ave., Vero Beach FL 32960. (407)770-0007. Fax: (407)770-0006. Senior Editor: Jan Binney. Estab. 1984. Publishes textbooks and educational games and workbooks for children and adults. Specializes in tests and materials for treatment of individuals with all communication disorders. Publishes 20-25 titles/year. Recent titles include *Funology Fables*, by R. Sunderbruch; and *Techniques for Aphasia Rehabilitation*, by M.J. Santo Pietro and R. Goldfarb. 75% require freelance illustration; 50% require freelance design. Book catalog available for 8½ × 11 SAE with $1.48 postage.
Needs: Works with 8-10 freelance illustrators and 2-4 designers/year. Buys 1,000 illustrations/year. Work must be suitable for handicapped children and adults. Uses freelancers mainly for instructional materials, cover designs, gameboards, stickers. Also for jacket/cover and text illustration. Occasionally uses freelancers for catalog design projects. Works on assignment only.
First Contact & Terms: Send query letter with brochure, SASE, tearsheets and photocopies. Samples are filed or are returned by SASE if requested by artist. Reports back to the artist only if interested. Do not send portfolio; query only. Usually buys all rights. Considers buying second rights (reprint rights) to previously published work. Finds artists through "word of mouth, through our authors and submissions by artists."
Book Design: Pays by the project.
Jackets/Covers: Assigns 10-12 freelance design jobs and 10-12 illustration jobs/year. Pays by the project.
Text Illustration: Assigns 6-10 freelance illustration jobs/year. Prefers b&w line drawings. Pays by the project.

SPINSTERS INK, 32 E. First St., #330, Duluth MN 55802. (218)727-3222. Fax: (218)727-3119. E-mail: spinsters@aol.com. Website: http://www.lesbian.org/spinsters-ink. Production Manager: Liz Tufte. Estab. 1978. Company publishes trade paperback originals and reprints. Types of books include contemporary fiction, mystery, biography, young women, reference, history of women, humor and feminist. Specializes in "fiction and nonfiction that deals with significant issues in women's lives from a feminist perspective." Publishes 6 titles/year. Recent titles include *Fat Girl Dances with Rocks*, by Susan Stinson (novel); and *Mother Journeys*, edited by Reddy, Roth and Sheldon (anthology). 50% require freelance illustration; 100% require freelance design. Book catalog free by request.
Needs: Approached by 24 freelancers/year. Works with 2-3 freelance illustrators and 2-3 freelance designers/year. Buys 2-6 freelance illustrations/year. Prefers artists with experience in "portraying positive images of women's diversity." Uses freelance artists for jacket/cover illustration and design, book and catalog design. 100% of freelance work demands knowledge of Adobe Illustrator, Adobe Photoshop, QuarkXPress or Macintosh FrameMaker. Works on assignment only.
First Contact & Terms: Designers send query letter with résumé. Illustrators send postcard sample with photocopies and SASE. Accepts submissions on disk compatible with PageMaker 5.0. Samples are filed or are returned by SASE if requested by artist. Reports back within 1 month. Art Director will contact artist for portfolio review if interested. Portfolio should include b&w and color thumbnails, final art and photographs. Buys first rights. Originals are returned at job's completion. Finds artists through word of mouth and submissions.
Jackets/Covers: Assigns 6 freelance design and 2-6 freelance illustration jobs/year. Pays by the project, $500-1,000. Prefers "original art with appropriate type treatment, b&w to 4-color. Often the entire cover is computer-generated, with scanned image. Our production department produces the entire book, including cover, electronically."
Text Illustration: Assigns 0-6 freelance illustrations/year. Pays by the project, $75-150. Prefers "b&w line drawings or type treatment that can be converted electronically. We create the interior of books completely using desktop publishing technology on the Macintosh."

Tips: "We're always looking for freelancers who have experience portraying celebrating images of diverse women, with current technological experience on the computer."

STAR PUBLISHING, Box 68, Belmont CA 94002. Managing Editor: Stuart Hoffman. Specializes in original paperbacks and textbooks on science, art, business. Publishes 12 titles/year. 33% require freelance illustration. Titles include *Microbiology Techniques*.
First Contact & Terms: Works with 8-10 freelance illustrators and 3-4 designers/year. Send query letter with résumé, tearsheets and photocopies. Samples not filed are returned only by SASE. Reports back only if interested. Rights purchased vary according to project. Originals are not returned.
Book Design: Assigns 5 freelance jobs/year. Pays by the project.
Jackets/Covers: Assigns 12 freelance design jobs/year. Pays by the project.
Text Illustration: Assigns 6 freelance jobs/year. Pays by the project.
Tips: Freelance artists need to be aware of "increased use of graphic elements, striking color combinations, more use of color illustration."

STEMMER HOUSE PUBLISHERS, INC., 2627 Caves Rd., Owings Mills MD 21117. (301)363-3690. Website: http://www.stemmer.com. President: Barbara Holdridge. Specializes in hardcover and paperback fiction, nonfiction, art books, juvenile and design resource originals. Publishes 10 titles/year. Recent titles include *The Marvelous Maze* and *Duck in a Tree*. Books are "well illustrated." 10% require freelance design; 75% require freelance illustration.
Needs: Approached by more than 50 freelancers/year. Works with 4 freelance illustrators and 1 designer/year. Works on assignment only.
First Contact & Terms: Designers send query letter with brochure, tearsheets, SASE, photocopies. Illustrators send postcard sample or query letter with brochure, photocopies, photographs, SASE, slides and tearsheets. Do not send original work. Material not filed is returned by SASE. Call or write for appointment to show portfolio. Reports in 6 weeks. Works on assignment only. Originals are returned to artist at job's completion on request. Negotiates rights purchased.
Book Design: Assigns 1 freelance design and 4 illustration jobs/year. Pays by the project, $300-2,000.
Jackets/Covers: Assigns 4 freelance design jobs/year. Prefers paintings. Pays by the project, $300-1,000.
Text Illustration: Assigns 3 freelance jobs/year. Prefers full-color artwork for text illustrations. Pays by the project on a royalty basis.
Tips: Looks for "draftmanship, flexibility, realism, understanding of the printing process." Books are "rich in design quality and color, stylized while retaining realism; not airbrushed. 1) Review our books. 2) Propose a strong picture-book manuscript with your illustrations."

JEREMY P. TARCHER, INC., 200 Madison Ave., New York NY 10016. (212)951-8400. Fax: (212)951-8543. Art Director: Ann Spinelli. Estab. 1970s. Imprint of G.P. Putnam Co. Imprint publishes hardcover and trade paperback originals and trade paperback reprints. Types of books include instructional, New Age, adult contemporary and self-help. Publishes 25-30 titles/year. Recent titles include *The End of Work*; *The Artist's Way*; *Executive Orders* by Tom Clancy; and *The Temple in the House*. 30% require freelance illustration; 30% require freelance design.
Needs: Approached by 10 freelancers/year. Works with 10-12 freelance illustrators and 4-5 designers/year. Works only with artist reps. Uses jacket/cover illustration. 50% of freelance work demands knowledge of QuarkXPress. Works on assignment only.
First Contact & Terms: Send postcard sample of work or send query letter with brochure, tearsheets and photocopies. Samples are filed. Art Director will contact artist for portfolio review if interested. Portfolio should include book dummy, final art, photographs, roughs, tearsheets and transparencies. Buys first rights or one-time rights. Originals are returned at job's completion. Finds artists through sourcebooks, *Communication Arts*, word of mouth, submissions.
Book Design: Assigns 4-5 freelance design jobs/year. Pays by the project, $800-1,000.
Jackets/Covers: Assigns 4-5 freelance design and 10-12 freelance illustration jobs/year. Pays by the project, $950-1,100.
Text Illustration: Assigns 1 freelance illustration job/year. Pays by the project, $100-500.

‡TECHNICAL ANALYSIS, INC., 4757 California Ave. SW, Seattle WA 98116-4499. (206)938-0570. Art Director: Christine Morrison. Estab. 1982. Magazine, books and software producer. Publishes trade paperback reprints and magazines. Types of books include instruction, reference, self-help and financial. Specializes in stocks, options, futures and mutual funds. Publishes 3 titles/year. Recent titles include *Stock Indicators, Bonds, Commodities—Turning Points in the Stock and Commodity Market*. Books look "technical, but creative; original graphics are used to illustrate the main ideas. 100% require freelance illustration; 10% require freelance design.
Needs: Approached by 100 freelance artists/year. Works with 20 freelance illustrators/year. Buys 100 freelance illustrations/year. Uses freelance artists for magazine illustration. Also uses freelance artists for text illustration and direct mail design. Works on assignment only.

First Contact & Terms: Send query letter with brochure, résumé, SASE, tearsheets, photographs, photocopies, photostats, slides and transparencies. Samples are filed. Reports back within 6-8 weeks. Write to schedule an appointment to show a portfolio or mail tearsheets. Buys first rights or reprint rights. Most originals are returned to artist at job's completion.
Book Design: Assigns 5 freelance design, 100 freelance illustration jobs/year. Pays by project, $30-230.
Jackets/Covers: Assigns 1 freelance design, 15 freelance illustration jobs/year. Pays by project $30-230.
Text Illustration: Assigns 5 freelance design and 100 freelance illustration jobs/year. Pays by the hour, $50-90; by the project, $100-140.

TEHABI BOOKS, INC., 13070 Via Grimaldi, Del Mar CA 92014. (619)481-7600. Fax: (619)481-3247. E-mail: nancy@tehabi.com. Managing Editor: Nancy Cash. Estab. 1992. Specializes in design and production of large-format, visual books. Works hand-in-hand with publishers, corporations, institutions and nonprofit organizations to identify, develop, produce and market high-quality visual books for the international market place. Produces lifestyle/gift books; institutional books; children's books; corporate-sponsored books and CD-ROM publishing.
Needs: Approached by 50 freelancers/year. Works with 75-100 freelance illustrators and 3 designers/year. Freelancers should be familiar with Aldus PageMaker, Adobe Illustrator, QuarkXPress, Adobe Photoshop, Aldus FreeHand and 3-D programs. Works on assignment only.
First Contact & Terms: Send query letter with samples. Rights purchased vary according to project. Finds artists through sourcebooks, publications and submissions.
Text Illustration: Pays by the project, $100-10,000.

❦THISTLEDOWN PRESS LTD., 633 Main St., Saskatoon, Saskatchewan S7H 0J8 Canada. (306)244-1722. Fax: (306)244-1762. Director, Production: Allan Forrie. Estab. 1975. Publishes trade and mass market paperback originals. Types of books include contemporary and experimental fiction, juvenile, young adult and poetry. Specializes in poetry creative and young adult fiction. Publishes 10-12 titles/year. Titles include *The Blue Jean Collection*; *The Big Burn*, by Lesley Choyce; and *The Blue Camaro*, by R.P. MacIntyre. 50% require freelance illustration. Book catalog for SASE.
Needs: Approached by 25 freelancers/year. Works with 8-10 freelance illustrators/year. Prefers local Canadian freelancers. Uses freelancers for jacket/cover illustration. Uses only Canadian artists and illustrators for its title covers. Works on assignment only.
First Contact & Terms: Designers send query letter with résumé and photocopies. Illustrators send postcard samples. Samples are filed or are returned by SASE. Reports back to the artist only if interested. Call for appointment to show portfolio of original/final art, tearsheets, photographs, slides and transparencies. Buys one-time rights.
Jackets/Covers: Assigns 10-12 illustration jobs/year. Prefers painting or drawing, "but we have used tapestry—abstract or expressionist to representational." Also uses 10% computer illustration. Pays by the project, $250-600.
Tips: "Look at our books and send appropriate material. More young adult and adolescent titles are being published, requiring original cover illustration and cover design. New technology (Adobe Illustrator, Photoshop) has slightly altered our cover design concepts."

THOMPSON WORKS, INC., 4600 Longfellow Ave., Minneapolis MN 55407-3638. E-mail: blt@skypoint.com. President: Brad Thompson. Book publisher and independent book producer/packager. Estab. 1980. Publishes trade paperback originals and textbooks. Publishes nonfiction. Types of books include instructional self-help, software, technical and business. Specializes in business and computer. Publishes 10 titles/year. 100% require freelance illustration.
Needs: Works with 20 freelance illustrators and 7 designers/year. Uses illustrators mainly for textbook graphics and cartoons. Also for book design and jacket/cover design. 50% of freelance work demands knowledge of Aldus PageMaker, QuarkXPress and Ventura. Works on assignment only.
First Contact & Terms: Send query letter with résumé and photostats. Samples are filed. Reports back about queries/submissions only if interested. To show portfolio mail photostats. "We will request what we need based on photostats." Considers complexity of project and budget when establishing payment. Negotiates rights purchased. Originals not returned.
Book Design: Assigns 15 freelance design and 20 freelance illustration jobs/year. Pays by the hour, $25 minimum.
Jackets/Covers: Assigns 10 freelance design and 10 freelance illustration jobs/year. Pays by the project, $400-1,200.

 THE MAPLE LEAF before a listing indicates that the market is Canadian.

Text Illustration: Assigns several large freelance jobs/year. Prefers technical (maps, complex tints, obviously beyond computer graphic capabilities). Pays by the hour, $25 minimum.

Tips: "Make sure we have a good representation of the kind of work you want to get. Then be patient. We do not begin shopping for art until the project is underway to avoid wasting time and false starts. We are not shy about using people across the country as long as they take deadline commitments seriously."

TIMES MIRROR HIGHER EDUCATION GROUP, 2460 Kerper Blvd., Dubuque IA 52001. (319)588-1451. Art/Design Supervisor: Donna Slade. Estab. 1944. Publishes hardbound and paperback college textbooks. Produces more than 200 titles/year. 10% require freelance design; 70% require freelance illustration.

Needs: Works with 15-25 freelance designers and 30-50 illustrators/year. Uses freelancers for advertising. 90% of freelance work demands knowledge of Aldus PageMaker, Adobe Illustrator, QuarkXPress, Adobe Photoshop or Aldus FreeHand. Works on assignment only.

First Contact & Terms: Prefers color 35mm slides and color or b&w photocopies. Send query letter with brochure, résumé, slides and/or tearsheets. "Do not send samples that are not a true representation of your work quality." Reports back in 1 month. Accepts disk submissions. Samples returned by SASE if requested. Reports back on future assignment possibilities. Buys all rights. Pays $35-350 for b&w and color promotional artwork. Pays half contract for unused assigned work.

Book Design: Assigns 50-70 freelance design jobs/year. Uses artists for all phases of process. Pays by the project. Payment varies widely according to complexity.

Jackets/Covers: Assigns 70-80 freelance design jobs and 20-30 illustration jobs/year. Pays $350 average and negotiates pay for special projects.

Text Illustration: Assigns 75-100 freelance jobs/year. Considers b&w and color work. Prefers computer-generated, continuous tone, some mechanical line drawings; ink preferred for b&w. Pays $30-500.

Tips: "In the field, there is more use of color. There is need for sophisticated color skills—the artist must be knowlegeable about the way color reproduces in the printing process. Be prepared to contribute to content as well as style. Tighter production schedules demand an awareness of overall schedules. *Must* be dependable."

‡TOR BOOKS, Dept. AM, 175 Fifth Ave., 14th Floor, New York NY 10010. (212)388-0100. Art Director: Irene Gallo (hardcover). Junior Designer: Pete Lutjen (mass market paperback). Specializes in hardcover and paperback originals and reprints: espionage, thrillers, horror, mysteries and science fiction. Publishes 180 titles/year; heavy on science fiction. Recent titles include *The Boat of a Million Years*, by Poul Anderson; *The Eagle and the Raven*, by James Michener and *The Ring of Charon*, by Roger MacBride Allen.

First Contact & Terms: All covers are freelance. Works with 50-100 freelance illustrators and 5-10 freelance designers/year. Works on assignment only. Send query letter with color photographs, slides or tearsheets to be kept on file "unless unsuitable." Portfolios may be dropped off Monday through Friday from 9:30-5:30; 24-hour turnaround. Samples not filed are returned by SASE. Reports back only if interested. Original work returned after job's completion. Considers skill and experience of artist, and project's budget when establishing payment. "We buy the right to use art on all editions of book it is commissioned for and in promotion of book."

Book Design: Pays by the project.

Jackets/Covers: Assigns 180 freelance illustration jobs/year. Pays by the project, $500 minimum.

Text Illustration: Pays by the project.

Tips: "We would like to see more technical proficiency. In science fiction, more realistic renditions of machinery, etc.; less wild, cartoony, colorful 'futuristic' stuff. Hardcover list tends to be a little more experimental in look. If your style is more commercial, send to Pete. If it's more experimental, send to Irene."

TRANSPORTATION TRAILS, National Bus Trader, Inc., 9698 W. Judson Rd., Polo IL 61064. (815)946-2341. Fax: (815)946-2347. Editor: Larry Plachno. Production Manager: Joseph Plachno. Estab. 1977. Imprints include National Bus Trader, Transportation Trails Books; also publishes *Bus Tours Magazine*. Company publishes hardcover and mass market paperback originals and magazines. Types of books include "primarily transportation history but some instruction and reference." Publishes 5-7 titles/year. Titles include *Breezers—A Lighthearted History of The Open Trolley Car in America* and *The Steam Locomotive Directory of North America*. Book catalog free by request.

Needs: Approached by 1 freelancer/year. Works with 3 freelance illustrators/year. Prefers local freelancers if possible with experience in transportation and rail subjects. Uses freelancers mainly for covers and chapter logo lines. Also for text illustration, maps, occasional magazine illustrations, and oil paintings for Christmas magazine covers. Works on assignment only. 20% of freelance work requires knowledge of Adobe Illustrator.

First Contact & Terms: Send query letter with "any reasonable sample." Accepts disk submissions compatible with Adobe Illustrator and QuarkXPress. Samples are returned by SASE if requested by artist. Artist should follow up with letter after initial query. Buys all rights. Originals are not returned.

Jackets/Covers: Assigns 3-6 freelance illustration jobs/year. Pays by the project, $150-700. Prefers b&w pen & ink line drawing of subject with rubylith/amberlith overlays for color.

Text Illustration: Assigns 3-6 freelance illustration jobs/year. Pays by the project, $50-200. Prefers silhouette b&w line drawing approximately 42×6 picas.

Tips: First-time assignments are usually silhouette text illustrations; book jackets and magazine covers are given to "proven" freelancers. "Send samples and ask for our letter, which explains what we want."

TREEHAUS COMMUNICATIONS, INC., 906 W. Loveland Ave., P.O. Box 249, Loveland OH 45140. (513)683-5716. Fax: (513)683-2882. President: Gerard Pottebaum. Estab. 1973. Publisher. Specializes in books, periodicals, texts, TV productions. Product specialties are social studies and religious education.
Needs: Approached by 12-24 freelancers/year. Works with 12 freelance illustrators/year. Prefers freelancers with experience in illustrations for children. Works on assignment only. Uses freelancers for all work. Also for illustrations and designs for books and periodicals. 5% of work is with print ads. Needs computer-literate freelancers for illustration.
First Contact & Terms: Send query letter with résumé, transparencies, photocopies and SASE. Samples sometimes filed or are returned by SASE if requested by artist. Reports back within 1 month. Art Director will contact artist for portfolio review if interested. Portfolio should include final art, tearsheets, slides, photostats and transparencies. Pays for design and illustration by the project. Rights purchased vary according to project. Finds artists through word of mouth, submissions and other publisher's materials.

TROLL ASSOCIATES, Book Division, 100 Corporate Dr., Mahwah NJ 07430. Vice President: Marian Frances. Specializes in hardcovers and paperbacks for juveniles (3- to 15-year-olds). Publishes more than 100 titles/year. 30% require freelance design and illustrations.
Needs: Works with 30 freelancers/year. Prefers freelancers with 2-3 years of experience. Works on assignment only.
First Contact & Terms: Send query letter with brochure/flier, résumé and tearsheets or photostats. Samples returned by SASE only if requested. Reports in 1 month. Write for appointment to show portfolio. Considers complexity of project, skill and experience of artist, budget and rights purchased when establishing payment. Buys all rights or negotiates rights purchased. Originals usually not returned at job's completion.

THE TRUMPET CLUB, SCHOLASTIC INC., (formerly The Trumpet Club/Marketing Services/Bantam Doubleday Dell Publishing Group), 568 Broadway, 8th Floor, New York NY 10036. Art Director: Deborah Thoden. Estab. 1985. Mail-order school book club specializing in paperbacks and related promotional material. Publishes juvenile fiction and nonfiction and original classroom products. Does not publish any original books written outside.
Needs: Works with 5-10 freelance illustrators and 2-3 designers/year. Prefers local computer and non-computer designers and illustrators with children's illustration experience; but out-of-towners okay. Uses freelancers for direct mail and catalog design; poster, sticker, book mark and bookplate illustration; and other original classroom products. 50% of freelance work demands knowledge of Adobe Illustrator, QuarkXPress, Adobe Photoshop or Aldus FreeHand.
First Contact & Terms: Send query letter, résumé and tearsheets. Reports back only if interested. Portfolio should include photostats, final reproduction/product. "No slides please." Considers complexity of project and project's budget when establishing payment. Originals are returned at job's completion.
Illustration: Pays by the project, based on complexity.
Tips: "We are looking for freelance Macintosh designers and illustrators familiar with QuarkXPress, Adobe Illustrator and Adobe Photoshop. Non-computer illustrators are considered as well. We prefer designers who can carry a job through to production."

UAHC PRESS, 838 Fifth Ave., New York NY 10021. (212)249-0100. Director of Publications: Stuart L. Benick. Produces books and magazines for Jewish school children and adult education. Recent titles include *1001 Chickens*, by Seymour Rossel; and *The Matzah Ball Fairy*, by Carla Heymsfeld. Books have "clean" look. Book catalog free on request.
Needs: Approached by 20 freelancers/year.
First Contact & Terms: Send samples or write for interview. Include SASE. Reports within 3 weeks.
Jackets/Covers: Pays by the project, $250-600.
Text Illustration: Pays by the project, $150-200.
Tips: Seeking "clean and catchy" design and illustration.

‡THE UNICORN PUBLISHING HOUSE, INC., Dept. AM, 120 American Rd., Morris Plains NJ 07950. (201)292-6857. Art Director: Jean Scrocco. Specializes in original and reprint hardcovers, preschool through age 8, in watercolor and color pencil, especially juvenile and adult classics. Publishes 14 titles/year for ages 4-adult. Recent titles include *The Velveteen Rabbit*, *The Nutcracker* and *The Gift of the Magi*.
 • They also have the Spider Web Art Gallery on the Internet: http://www.spiderwebgallery.com.
First Contact & Terms: Approached by 750 freelance artists/year. Works with 6 freelance artists/year. Send query letter with brochure, résumé, tearsheets and photocopies. Samples are not returned. Original work returned after job's completion. Considers complexity of project, skill and experience of artist and project's budget when establishing payment. Negotiates rights purchased.

Book Design: Assigns 6 freelance illustration jobs/year. Pays by the project, $300 minimum.
Text Illustration: Assigns 6 freelance jobs/year. "No preference in medium—art must be detailed and realistic." Pays by the project, "depends on the number of pieces being illustrated."
Tips: "In a portfolio, we're looking for realism in a color and b&w medium. We want to see how artists do people, animals, architecture, natural settings, fantasy creatures; in short, we want to see the range that artists are capable of. We do not want to see original artwork. Usually the biggest problem we have is receiving a group of images that doesn't adequately represent the full range of the artist's capabilities."

UNIVELT INC., Box 28130, San Diego CA 92198. (619)746-4005. Fax: (619)746-3139. Manager: R.H. Jacobs. Publishes hardcover and paperback originals on astronautics and related fields; occasionally publishes veterinary first-aid manuals. Specializes in space. Publishes 10 titles/year; all have illustrations. Recent titles include *Spaceflight Mechanics 1994, Guidance and Control 1994 Space Programs and Fiscal Reality*. Books have "glossy covers with illustrations." Book catalog free by request.
Needs: Prefers local freelancers. Sometimes uses freelancers for covers, title sheets, dividers, occasionally a few illustrations.
First Contact & Terms: Please call before making any submissions. "We have been only using local sources." Reports in 1 month on unsolicited submissions. Buys one-time rights. Originals are returned at job's completion.
Jackets/Covers: Assigns 10 freelance design and 10 illustration jobs/year. Pays $50-100 for front cover illustration or frontispiece.
Text Illustration: Pays by the project, $50-100.
Tips: "Books usually include a front cover illustration and frontispiece. Illustrations have to be space-related. We obtain most of our illustrations from authors and from NASA. We usually do not use freelance sources."

THE UNIVERSITY OF ALABAMA PRESS, Box 870380, Tuscaloosa AL 35487-0380. (205)348-1571 or (205)348-1570. Fax: (205)348-9201. E-mail: ebradley@uapress.ua.edu. Production Manager: Rick Cook. Designer: Erin T. Bradley. Specializes in hardcover and paperback originals and reprints of academic titles. Publishes 40 titles/year. Recent titles include *Between the Eagle and the Sun: Traces of Japan*, by Ihab Hassan; and *Scars: American Poetry in the Face of Violence*, by Cynthia Dubin Edelberg. 5% require freelance design.
Needs: Works with 1-2 freelancers/year. Requires book design experience, preferably with university press work. Works on assignment only. 100% of freelance design demands knowledge of Mac PageMaker 5.0, Macromedia FreeHand 5.0 and Adobe Photoshop 3.0.
First Contact & Terms: Send query letter with résumé, tearsheets and slides. Accepts disk submissions if compatible with Macintosh versions of above programs; provided that a hard copy that is color accurate is also included. Samples not filed are returned only if requested. Reports back within a few days. To show portfolio, mail tearsheets, final reproduction/product and slides. Considers project's budget when establishing payment. Buys all rights. Originals are not returned.
Book Design: Assigns several freelance jobs/year. Pays by the project, $250 minimum.
Jackets/Covers: Assigns 1-2 freelance design jobs/year. Pays by the project, $250 minimum.
Tips: Has a limited freelance budget. "We often need artwork that is abstract or vague rather than very pointed or focused on an obvious idea. For book design, our requirements are that they be classy and for the most part conservative."

THE UNIVERSITY OF NEBRASKA PRESS, 312 N. 14th, Lincoln NE 68588-0484. (402)472-3581. Fax: (402)472-0308. Production Manager: Debra K. Turner. Estab. 1941. Publishes hardcover originals and trade paperback originals and reprints. Types of books include history. Specializes in Western history, American Indian ethnohistory, nature, Civil War, women's studies. Publishes 111 titles/year. Titles include *Custer's Last Campaign, Billy the Kid* and *Jubal's Raid*. 5-10% require freelance illustration; 20% require freelance design. Book catalog free by request.
Needs: Approached by 5 freelancers/year. Works with 3 freelance illustrators and 5 designers/year. "We must use Native American artists for books on that subject." Uses freelancers for jacket/cover illustration. Works on assignment only.
First Contact & Terms: Send query letter with appropriate samples. Samples are filed. Reports back to the artist only if interested. Call for appointment to show portfolio of color tearsheets and 4 × 5 transparencies. Negotiates rights purchased. Originals are returned at job's completion.
Book Design: Assigns 10 freelance design and varying number of freelance illustration jobs/year. Pays by the project, $500 minimum.
Jackets/Covers: Usually prefers realistic, western, action styles. Pays by the project, $300-500.

UNIVERSITY OF OKLAHOMA PRESS, 1005 Asp Ave. Norman OK 73019. (405)325-5111. Fax: (405)325-4000. Production Manager: Patsy Willcox. Estab. 1927. Company publishes hardcover and trade paperback originals and reprints and textbooks. Types of books include biography, coffee table books, history, nonfiction, reference, textbooks, western. Specializes in Western/Indian nonfiction. Publishes 80 titles/year.

75% require freelance illustration (for jacket/cover). 5% require freelance design. Book catalog free by request.

Needs: Approached by 15-20 freelancers/year. Works with 40-50 freelance illustrators and 4-5 designers/year. "We cannot commission work, must find existing art." Uses freelancers mainly for jacket/cover illustrations. Also for jacket/cover and book design. 25% of freelance work demands knowledge of Aldus Page-Maker, Adobe Illustrator, QuarkXPress, Adobe Photoshop, Aldus FreeHand, CorelDraw and Ventura.

First Contact & Terms: Send query letter with brochure, résumé and photocopies. Samples are filed. Does not report back. Artist should contact us 1 month after submission. Art Director will contact artist for portfolio review if interested. Portfolio should include book dummy and photostats. Buys reprint rights. Originals are returned at job's completion. Finds artists through submissions, attending exhibits, art shows and word of mouth.

Book Design: Assigns 4-5 freelance design jobs/year. Pays by the project.

Jackets/Covers: Assigns 4-5 freelance design jobs/year. Pays by the project.

‡VIDA PUBLISHERS, 3333 SW 15 St., Pompano FL 33442-8134. (954)570-8765 ext. 211. Creative Director: John Coté. Estab. 1946. Publishes trade paperback originals and reprints, mass market paperback originals, textbooks, audio tapes. Types of book include religious, bibles. Publishes 100 Spanish, 60 Portuguese, 30 French titles/year Recent titles include *Well done*, by Dave Thomas; *Answers to Life's Problems*, by Billy Graham. 10% require freelance design.

Needs: Approached by 3 freelance illustrators and 3 freelance designers/year. Works with 3 freelance illustrators and 5 freelance designers/year. Prefers freelancers experienced in Macintosh environment. Uses freelancers mainly for book cover. 95% of freelance design and 50% of illustration demand knowledge of Adobe Photoshop, Adobe Illustrator, QuarkXPress.

First Contact & Terms: Designers should send query letter with brochure, photographs, résumé, tearsheets. Illustrators should send postcard sample and/or query letter with résumé, photographs, slides, tearsheets and/or transparencies. Accepts disk submissions compatible with above programs. Samples are filed or are returned. Reports back only if interested. Art director will contact artist for portfolio review if interested. Portfolio should include photographs, tearsheets, transparencies. Buys all rights.

Jacket/Covers: Pays for design by the project, $400-1,000. Pays for illustration by the project, $200-500.

Tips: It is helpful if artist has knowledge of producing a finished electronic mechanical creating special effects in Photoshop and most importantly, has knowledge of good design.

‡VISUAL EDUCATION CORPORATION, 14 Washington Rd., Princeton NJ 08543. (609)799-9200. Production Manager: Barbara Kopel. Estab. 1969. Independent book producer/packager of textbooks and reference books. Specializes in social studies, history, geography, vocational, math, science, etc. 10% require freelance illustration; 80% require freelance design.

Needs: Approached by 30 freelance artists/year. Works with 4-5 illustrators and 5-15 designers/year. Buys 5-10 illustrations/year. Prefers artists with experience in textbooks, especially health, medical, social studies. Uses freelancers mainly for interior illustration. Also for jacket/cover illustration. Works on assignment only.

First Contact & Terms: Send query letter with tearsheets and résumé. Samples are filed. Reports back to the artist only if interested. To show portfolio, mail roughs and tearsheets. Rights purchased vary according to project. Originals returned at job's completion.

Book Design: Assigns 5-15 jobs/year. Pays by the project.

Jackets/Covers: Assigns 1-2 design jobs/year. Pays by the project.

Text Illustration: Assigns 2-3 illustration jobs/year. Pays by the project.

Tips: "Designers, if you contact us with samples we will invite you to do a presentation and make assignments as suitable work arises. Graphic artists, when working assignments we review our files. Enclose typical rate structure with your samples."

‡VOYAGEUR PRESS, 123 N. Second St., Stillwater MN 55082. (612)430-2210. Fax: (612)430-2211. Editorial Director: Michael Dregni. Pre-Press Coordinator: Andrea Rud. Estab. 1973. Book publisher. Publishes hardcover and trade paperback originals. Types of books include Americana, collectibles, travel, cookbooks, natural history and regional. Specializes in natural history, travel and regional subjects. Publishes 20 titles/year. Recent titles include *Loons: Song of the Wild* and *Backroads of Colorado*. 10% require freelance illustration; 90% require freelance design. Book catalog free by request.

Needs: Approached by 100 freelance artists/year. Works with 2-5 freelance illustrators and 2-5 freelance designers/year. Prefers artists with experience in maps and book and cover design. Uses freelance artists mainly for cover and book design. Also uses freelance artists for jacket/cover illustration and direct mail and catalog design. 100% of design requires computer skills. Works on assignment only.

First Contact & Terms: Send postcard sample and/or query letter with brochure, photocopies, SASE and tearsheets, list of credits and nonreturnable samples of work that need not be returned. Samples are filed. Reports back to the artist only if interested. "We do not review portfolios unless we have a specific project in mind. In that case, we'll contact artists for a portfolio review." Usually buys first rights. Originals returned at job's completion.

Book Design: Assigns 15-20 freelance design jobs and 2-5 freelance illustration jobs/year.

Jackets/Covers: Assigns 15-20 freelance design and 2-5 freelance illustration jobs/year.

Text Illustration: Assigns 2-5 freelance design and 2-5 design illustration jobs/year.

Tips: "We use more book designers than artists or illustrators, since most of our books are illustrated with photographs."

J. WESTON WALCH PUBLISHING, 321 Valley St., Portland ME 04102. (207)772-2846. Fax: (207)774-7167. Art Director: Kiyo Tabery. Estab. 1927. Company publishes supplementary educational books and other material (video, software, audio, posters, cards, games, etc.). Types of books include instructional and young adult. Specializes in all middle and high school subject areas. Publishes 100 titles/year. Recent titles include *Teaching from a Positive Perspective*, *Glorious Glue*, *Cultural Conflicts* and *Microsoft Works in Your Classroom*. 15-25% require freelance illustration. Book catalog free by request.

• J. Weston Walch Publishing is now producing GeoSafari educational card sets in partnership with Educational Insights.

Needs: Approached by 70-100 freelancers/year. Works with 10-20 freelance illustrators and 5-10 designers/year. Prefers local freelancers only. Uses freelancers mainly for text and/or cover illustrations. Also for jacket/cover design.

First Contact & Terms: Send tearsheets, SASE and photocopies. Samples are filed or returned by SASE. Accepts disk submissions compatible with Adobe Photoshop, QuarkXPress, Aldus FreeHand or Framemaker. Art Director will contact artist for portfolio review if interested. Portfolio should include final art, roughs and tearsheets. Buys one-time rights. Originals are returned at job's completion. Finds artists through submissions, reviewing with other art directors in the local area.

Jackets/Covers: Assigns 10-15 freelance design and 10-20 illustration jobs/year. Pays by the project, $300-600.

Text & Poster Illustration: Pays by the project, $500-4,000.

Tips: "Show a facility with taking subject matter appropriate for middle and high school curriculums and presenting it in a new way.

WARNER BOOKS INC., 1271 Sixth Ave., New York NY 10020. (212)522-7200. Vice President, Publisher/Warner Treasures and Creative Director of Warner Books: Jackie Meyer. Publishes mass market paperbacks and adult trade hardcovers and paperbacks. Publishes 350 titles/year. Recent titles include *101 Ways to Stay Young* and *The Bridges of Madison County*. 20% require freelance design; 80% require freelance illustration.

• Others in the department are Diane Luger, Don Puckey, Rachel McClain and Lisa McGarry. Send them mailers for their files as well.

Needs: Approached by 500 freelancers/year. Works with 150 freelance illustrators and 30 designers/year. Uses freelancers mainly for illustration and handlettering. Works on assignment only.

First Contact & Terms: Do not call for appointment or portfolio review. Mail samples only. Send brochure or tearsheets and photocopies. Samples are filed or are returned by SASE. Art Director will contact artist for portfolio review if interested. Negotiates rights purchased. Considers buying second rights (reprint rights) to previously published work. Originals are returned at job's completion (artist must pick up). "Check for most recent titles in bookstores." Finds artists through books, mailers, parties, lectures, judging and colleagues.

Jackets/Covers: Pays for design and illustration by the project; $1,000 minimum. Uses all styles of jacket illustrations.

Tips: Industry trends include "more graphics and stylized art." Looks for "photorealistic style with imaginative and original design and use of eye-catching color variations. Artists shouldn't talk too much. Good design and art should speak for themselves."

WEBB RESEARCH GROUP, Box 314, Medford OR 97501. (503)664-4442. Owner: Bert Webber. Estab. 1979. Publishes hardcover and trade paperback originals. Types of books include biography, reference, history and travel. Specializes in the history and development of the Pacific Northwest and the Oregon Trail. Recent titles include *Dredging for Gold*, by Bert Webber; and *Top Secret*, by James Martin Davis and Bert Webber. 5% require freelance illustration. Book catalog for SAE with 2 first-class stamps.

Needs: Approached by more than 30 freelancers/year, "but most do not read what subject areas we will look at." Uses freelancers for localizing travel maps and doing sketches of Oregon Trail scenes. Also for jacket/cover and text illustration. Works on assignment only.

First Contact & Terms: Send query letter with SASE and photocopied samples of the artists' Oregon Trail subjects. "We will look only at subjects in which we are interested—Oregon history, development and Oregon Trail." Samples are not filed and are only returned by SASE if requested by artist. Reports back to the artist only if interested and SASE is received. Portfolios are not reviewed. Rights purchased vary according to project. Originals often returned at job's completion.

Jackets/Covers: Assigns about 10 freelance design jobs/year. Payment negotiated.
Text Illustration: Assigns 6 freelance illustration jobs/year. Payment negotiated.
Tips: "Freelancers negatively impress us because they do not review our specifications and send samples unrelated to what we do. We do not want to see 'concept' examples of what some freelancer thinks is 'great stuff.' If the subject is not in our required subject areas, do not waste samples or postage or our time with unwanted heavy mailings. We, by policy do not, will not, will never, respond to postal card inquiries. Most fail to send SASE thus submissions go into the ashcan, never looked at, for the first thing we consider with unsolicited material is if there is SASE. Time is valuable for artists and for us. Let's not waste it."

‡SAMUEL WEISER INC., Box 612, York Beach ME 03910. (207)363-4393. Fax: (207)363-5799. E-mail: weiserbooks@ichange.com. Vice President: B. Lundsted. Specializes in hardcover and paperback originals, reprints and trade publications on metaphysics/oriental philosophy/esoterica. Recent titles include *Helping Heaven Happen*, by Donald Curtis and *Comfort to the Sick*, by Brother Aloysius. "We use visionary art or nature scenes." Publishes 20 titles/year. Catalog available for SASE.
Needs: Approached by approximately 25 artists/year. Works with 10-15 illustrators and 2-3 designers/year. Uses freelancers for jacket/cover design and illustration. 80% of design and 40% of illustration demand knowledge of Adobe Illustrator, Adobe Photoshop and QuarkXPress.
First Contact & Terms: Designers send query letter with résumé, photocopies and tearsheets. Illustrators send query letter with photocopies, photographs, SASE and tearsheets. "We can use art or photos. I want to see samples I can keep." Samples are filed or are returned by SASE only if requested by artist. Reports back within 1 month only if interested. Originals are returned to artist at job's completion. To show portfolio, mail tearsheets, color photocopies or slides. Considers complexity of project, skill and experience of artist, project's budget, turnaround time and rights purchased when establishing payment. Buys one-time nonexclusive rights. Finds most artists through references/word-of-mouth, portfolio reviews and samples received through the mail.
Jackets/Covers: Assigns 20 design jobs/year. Prefers airbrush, watercolor, acrylic and oil. Pays by the project, $100-500.
Tips: "We're interested in buying art that we use to create a cover, or in artists with professional experience with cover film—who can work from inception of design to researching/creating image to type design; we work with old-fashioned mechanicals, film and disk. Don't send us drawings of witches, goblins and demons, for that is not what our field is about. You should know something about us before you send materials."

‡DANIEL WEISS ASSOCIATES INC., 33 W. 17th St., New York NY 10011. (212)645-3865. Fax: (212)633-1236. Art Director: Paul Matarazzo. Independent book producer/packager. Publishes mass market paperback originals. Publishes mainstream fiction, juvenile, young adult, self-help and humor. Recent titles include *Sweet Valley University, Sweet Valley High* and *Sweet Valley Twins* series, *Summer* series and *Bone-chillers* series. 80% require freelance illustration; 25% require freelance design. Book catalog not available.
Needs: Approached by 50 freelance artists/year. Works with 20 freelance illustrators and 5 freelance designers/year. Only uses artists with experience in mass market illustration or design. Uses freelance artists mainly for jacket/cover illustration and design. Also uses freelance artists for book design. Works on assignment only.
First Contact & Terms: Send query letter with résumé, SASE, tearsheets, photographs and photocopies. Samples are filed or returned by SASE if requested by artist. Reports back to the artist only if interested. To show portfolio, mail original/final art, slides dummies, tearsheets and transparencies. Sometimes requests work on spec before assigning a job. Rights purchased vary according to project. Originals are returned at job's completion.
Jackets/Covers: Assigns 10 freelance design and 50-75 freelance illustration jobs/year. Only criteria for media and style is that they reproduce well.
Tips: "Know the market and have the professional skills to deliver what is requested on time. Book publishing is becoming very competitive. Everyone seems to place a great deal of importance on the cover design as that affects a book's sell through in the book stores."

WESTERN PUBLISHING CO., INC., 850 Third Ave., New York NY 10022. (212)753-8500. Fax: (212)371-1091. Art Directors: Sandra Forrest and Remo Cosentino. Contact: Brenda Echiverrias. Printing company and publisher. Imprint is Golden Books. Publishes preschool, juvenile, young adult and adult nature guides. Specializes in picture books themed for infant to 8-year-olds. Publishes 200 titles/year. Titles include *I Love Christmas, Walt Disney's Lion King* and other film releases. 100% require freelance illustration. Book catalog free by request.
Needs: Approached by several hundred artists/year. Works with approximately 100 illustrators/year. Very little freelance design work. Most design is done in-house. Buys enough illustration for 200 plus new titles, the majority being licensed character books. Artists must have picture book experience; illustrations are generally full color. Uses freelancers primarily for picture books for young children, and secondarily for natural science guides, pre-teen covers and interiors. 35% (more if we could find qualified people) of freelance work demands knowledge of Adobe Illustrator, QuarkXPress, Adobe Photoshop. "Quark is a necessity."

First Contact & Terms: Send query letter with SASE and tearsheets. Samples are filed or are returned by SASE if requested by artist. Portfolio drop-off on Thursdays. Will look at original artwork and/or color representations in portfolios, but please do not send original art through the mail. Royalties or work for hire according to project.
Jackets/Covers: All design done in-house. Makes outright purchase of cover illustrations.
Text Illustration: Assigns approximately 250 freelance illustration jobs/year. Payment varies.
Tips: "We are open to a much wider variety of styles than in previous years. However, illustrations that have mass market appeal, featuring appealing multicultural children will get strongest consideration."

‡**WHALESBACK BOOKS**, Box 9546, Washington DC 20016. (202)333-2182. Fax: (202)333-2184. Publisher: W.D. Howells. Estab. 1988. Imprint of Howells House. Company publishes hardcover and trade paperback originals and reprints. Types of books include biography, history, art, architecture, social and human sciences. Publishes 2-4 titles/year. 80% require freelance illustration; 80% require freelance design.
Needs: Approached by 6-8 freelance artists/year. Works with 1-2 freelance illustrators and 1-3 freelance designers/year. Buys 10-20 freelance illustrations/job. Prefers local artists with experience in color and desktop. Uses freelance artists mainly for illustration and book/jacket designs. Also uses freelance artists for jacket/cover illustration and design; text, direct mail, book and catalog design. 20-40% of freelance work demands knowledge of Aldus PageMaker, Adobe Illustrator or QuarkXPress. Works on assignment only.
First Contact & Terms: Send query letter with brochure, SASE and photocopies. Samples are not filed and are returned by SASE if requested by artist. Reports back only if interested. Art Director will contact artist for portfolio review if interested. Portfolio should include b&w roughs and photostats. Rights purchased vary according to project.
Book Design: Assigns 2-4 freelance design jobs/year. Pays by the project, $300-800.
Jackets/Covers: Assigns 2-4 freelance design jobs/year. Pays by the project, $300-800.
Text Illustration: Assigns 6-8 freelance illustration jobs/year. Pays by the project, $100 minimum.

‡**WHITE WOLF PUBLISHING**, 780 Park N. Blvd., Suite 100, Atlanta GA 30021. (404)292-1819. (404)294-1474. Estab. 1986. Imprints include Borealis, World of Darkness. Publishes hardcover originals, trade and mass market papberback originals and reprints. Types of books include experimental fiction, fantasy, horror, science fiction. Specializes in alternative horror and dark fantasy. Publishes 24 titles/year. Recent titles include: *Edgeworks*, by Harlan Ellison; *Resume with Monsters*, *Borderlands*. 65% require freelance illustration. Book catalog free.
Needs: Approached by 50 illustrators/year. Works with 20 illustrators/year. Prefers freelancers experienced in 4-color, b&w, and photo collage. Uses freelancers mainly for book covers and some interior illustration.
First Contact & Terms: Send photocopies, photographs, photostats and/or printed samples. Send follow-up postcard every year. Accepts disk submissions from illustrators. Samples are filed or returned by SASE. Reports back only if interested. Buys all rights.
Jackets/Covers: Assigns 20 freelance illustration jobs/year. Pays for illustration by project, $500-2,000. Prefers collage, figurative, painterly, and/or experimental work.
Text Illustration: Assigns 2 freelance illustration jobs/year. Pays by project, $50-100. Prefers line art and figurative work. Finds freelancers through submissions, conventions and word of mouth.
Tips: "We are looking for work that is experimental and unusual."

ALBERT WHITMAN & COMPANY, 6340 Oakton, Morton Grove IL 60053-2723. Editor: Kathleen Tucker. Art Director: Scott Piehl. Specializes in hardcover original juvenile fiction and nonfiction—many picture books for young children. Publishes 25 titles/year. Recent titles include *Two of Everything*, by Lily Toy Hong; and *Do Pirates Take Baths*, by Kathy Tucker. 100% require freelance illustration. Books need "a young look—we market to preschoolers mostly."
Needs: Works with 30 illustrators and 3 designers/year. Prefers working with artists who have experience illustrating juvenile trade books. Freelancers should be familiar with QuarkXPress or Adobe Photoshop. Works on assignment only.
First Contact & Terms: Designers send résumé. Illustrators send postcard sample and tearsheets. "One sample is not enough. We need at least three. Do *not* send original art through the mail." Accepts disk submissions. Samples are not returned. Reports back "if we have a project that seems right for the artist. We like to see evidence that an artist can show the same children and adults in a variety of moods, poses and environments." Rights purchased vary. Original work returned at job's completion "if artist holds the copyright."
Cover/Text Illustration: Cover assignment is usually part of text illustration assignment. Assigns 30 freelance jobs/year. Prefers realistic and semi-realistic art. Pays by flat fee or royalties.
Tips: Especially looks for "an artist's ability to draw people, especially children and the ability to set an appropriate mood for the story."

WILD HONEY, An Ottenheimer Publishers Company, 10 Church Lane, Baltimore MD 21208. (410)484-2100. Contact: Art Director. Estab. 1994. Specializing in literature, picture books, and trade novelty books for children. Some adult titles, also art and literature oriented. Produces 4-6 titles/year. Titles include *Guten-*

berg's Gift, by Nancy Willard, illustrated by Bryan Leister; and *Animals A to Z*, by James Balog.

Needs: Hires up to 6 illustrators/year; also hires calligraphy/lettering artists regularly. 100% of design demands knowledge of QuarkXPress, Adobe Illustrator, Adobe Photoshop and Aldus FreeHand (latest versions).

First Contact & Terms: Designers send query letter. Illustrators send postcard sample or query letter with slides or photocopies to be kept on file. Accepts submissions on disk, but not preferable. Samples not filed are returned by SASE. Reports back only if interested.

Book Design: Assigns up to 2 freelance design jobs/year. Pays by the project, $800-4,000.

Jackets/Covers: Assigns 2 freelance design and 8 illustration jobs/year. Pays by the project, $800-10,000 depending upon project, time spent and any changes.

Text Illustration: Assigns up to 6 freelance illustration jobs/year.

‡WILLIAMSON PUBLISHING, P.O. Box 185, Charlotte VT 05445. (802)425-2102. Fax: (802)425-2199. Editorial Director: Susan Williamson. Estab. 1983. Publishes hardcover and trade paperback originals. Types of books include juvenile, nonfiction, preschool. Specializes in children's activity and hands-on learning. Publishes 12 titles/year. Recent titles include: *Tales of the Shimmering Sky*; *The Kids Multicultural Art Book*. Book catalog free for 8½×11 SASE with 5 first-class stamps.

Needs: Approached by 50 illustrators and 10 designers/year. Works with 6 illustrators and 3 designers/year. 100% of freelance design demands computer skills.

First Contact & Terms: Designers send query letter with brochure, photocopies, résumé, SASE. Illustrators send postcard sample and/or query letter with photocopies, résumé and SASE. Samples are filed. Reports back only if interested.

Tips: "We are looking for both b&w and 4-color illustration—everything from step-by-step how-to (always done with personality as opposed to technical drawings) to full page pictorial interpretational with folk tales."

‡WILLOWISP PRESS, 801 94th Ave. N., St. Petersburg FL 33702-2426. (813)578-7600. Fax: (813)578-3105. Art Director: Michael Petty. Estab. 1982. Imprint of PAGES, Inc. Imprints include Riverbank Press, Hamburger Press, Worthington Press. Publishes trade paperback originals and reprints, mass market paperback originals and reprints, audio tapes, CD-ROM. Types of book include adventure, biography, comic books, fantasy, history, horror, humor, juvenile, mainstream, nonfiction, preschool, romance, science fiction, young adult, calendars, activity kits, bookmarks, posters, diary books, etc. Specializes in juvenile and young adult fiction and nonfiction. Publishes 30-35 titles/year. Recent titles include *The Little Princess*, *Jane Goodall Story*, *Legend of Sleepy Hollow*, *Johnny Appleseed*, *The Time Machine*. 90% require freelance illustration. Book catalog free for 9×11 SASE with 6 first-class stamps.

Needs: Approached by 80 freelance illustrators and 10 freelance designers/year. Works with 20 freelance illustrators/year. Prefers freelancers experienced in children's book publishing. Uses freelancers mainly for illustration work for picture books and covers.

First Contact & Terms: Illustrators send query letter with photocopies, photographs, photostats, printed samples, résumé, SASE and/or tearsheets. Send postcard sample and follow-up postcards every year. Accepts disk submissions compatible with QuarkXPress 7.5/version 3.3. or Adobe Photoshop. Send EPS files. Samples are filed and are returned by SASE. Art director will contact artist for portfolio review if interested. Rights vary according to project. Finds freelancers through agents, submissions.

Jacket/Covers: Assigns 30 freelance illustration jobs/year. Pays for illustration by the project $500-2,600.

Text Illustration: Assigns 30 freelance illustration jobs/year. Pays by the project, $50-6,000.

Tips: It is helpful if artist is knowledgeable about the way color reproduces in the printing process.

WILSHIRE BOOK CO., 12015 Sherman Rd., North Hollywood CA 91605. (818)765-8579. President: Melvin Powers. Company publishes trade paperback originals and reprints. Types of books include biography, humor, instructional, New Age, psychology, self help, inspirational and other types of nonfiction. Publishes 25 titles/year. Recent titles include *Think Like a Winner!*, *The Princess Who Believed in Fairy Tales*, and *The Knight in Rusty Armor*. 100% require freelance design. Catalog for SASE with first-class stamps.

Needs: Uses freelancers mainly for book covers, to design cover plus type. Also for direct mail design. "We need graphic design ready to give to printer. Computer cover designs are fine."

First Contact & Terms: Send query letter with fee schedule, tearsheets, photostats, photocopies (copies of previous book covers). Portfolio may be dropped off every Monday-Friday. Portfolio should include book dummy, slides, tearsheets, transparencies. Buys first, reprint or one-time rights. Interested in buying second rights (reprint rights) to previously published work. Negotiates payment.

Book Design: Assigns 25 freelance design jobs/year.

Jackets/Covers: Assigns 25 cover jobs/year.

WOODSONG GRAPHICS INC., Box 304, Lahaska PA 18931-0304. (215)794-8321. President: Ellen Bordner. Specializes in paperback originals covering a wide variety of subjects, "but no textbooks or technical material so far." Publishes 3-6 titles/year. Titles include *Snowflake Come Home*, by John Giegling. Books are "usually 5½×8½ format, simple text style with 4-color laminated covers and good halftone illustrations accompanying text where appropriate."

Needs: Approached by several hundred freelancers/year. Works with 1-5 freelance illustrators/year depending on projects and schedules; works with "only a couple of designers, but we expect to expand in this area very soon." Works on assignment only.

First Contact & Terms: Send query letter with brochure and samples to be kept on file. Any format is acceptable for samples, except originals. Samples not filed are returned by SASE. Reports only if interested. Originals are returned to artist at job's completion. Considers complexity of assignment, skill and experience of artist, project's budget and turnaround time when establishing payment. Rights purchased vary according to project.

Book Design: Assigns 2-3 freelance jobs/year. Pays by the project, $400 minimum.

Jackets/Covers: Assigns 3-6 freelance illustration jobs/year. Pays by the project, $150 minimum.

Text Illustration: Assigns 2-3 freelance illustration jobs/year. Medium and style vary according to job. Pays by the project, $250 minimum.

Tips: "As small publishers, we are not necessarily on the 'cutting edge' regarding new trends. We still want art that is beautiful or exciting, and conveys the style and quality of the publication. We are also considering a line of cards and stationery at this time, as well as some traditional 'gallery' art—portraits, serious landscapes, wildlife art, etc."

WORD PUBLISHING, 1501 LBJ Freeway, Suite 650, Dallas TX 75234. (214)488-9673. Fax: (214)488-1311. Senior Art Director: Tom Williams. Estab. 1951. Imprints include Word Bibles and Word Kids. Company publishes hardcover, trade paperback and mass market paperback originals and reprints; audio; and video. Types of books include adventure (children's), biography, fiction, juvenile, nonfiction, preschool, religious, self-help, young adult and sports biography. "All books have a strong Christian content—including fiction." Publishes 120 titles/year. Recent titles include *Storm Warning*, by Billy Graham; *The Body*, by Charles Colson; and *Miracle Man*, by Nolan Ryan. 30-35% require freelance illustration; 100% require freelance design.

Needs: Approached by 1,500 freelancers/year. Works with 20 freelance illustrators and 30 designers/year. Buys 35-50 freelance illustrations/year. Uses freelancers mainly for book cover and packaging design. Also for jacket/cover illustration and design and text illustration. Also for multimedia projects. 90% of design and 5% of illustration demand knowledge of Adobe Illustrator, QuarkXPress and Adobe Photoshop. Works on assignment only.

First Contact & Terms: Send query letter with SASE, tearsheets, photographs, photocopies, photstats, "whatever shows artist's work best." Accepts disk submissions, but not preferred. Samples are filed or are returned by SASE if requested by artist. Art Director will contact artist for portfolio review if interested. Portfolio should include tearsheets and transparencies. Rights purchased vary according to project; usually first rights. Originals are returned at job's completion. Finds artists through agents, *Creative Black Book*, *American Showcase*, word of mouth and artists' submissions.

Jacket/Covers: Assigns 120 freelance design and 35-50 freelance illustration jobs/year. Pays by the project $1,200-5,000. Considers all media—oil, acrylic, pastel, watercolor, mixed.

Text Illustration: Assigns 10 freelance illustration jobs/year. Pays by the project $75-250. Prefers line art.

Tips: "Please do not phone."

‡YE GALLEON PRESS, Box 25, Fairfield WA 99012. (509)283-2422. Editorial Director: Glen Adams. Estab. 1937. Publishes hardcover and paperback originals and reprints. Types of books include rare Western history, Indian material, antiquarian shipwreck and old whaling accounts and town and area histories. Publishes 20 titles/year. 10% require freelance illustration. Book catalog for SASE.

First Contact & Terms: Works with 2 freelance illustrators/year. Query with samples and SASE. No advance. Pays promised fee for unused assigned work. Buys book rights.

Text Illustration: Buys b&w line drawings (pen & ink) of a historical nature; prefers drawings of groups with facial expressions and some drawings of sailing and whaling vessels. Pays for illustration by the project, $7.50-35.

Tips: " 'Wild' artwork is hardly suited to book illustration for my purposes. Many correspondents wish to sell oil paintings. At this time we do not buy them. It costs too much to print them for short edition work."

♣ZAPP STUDIO INC., 338 St. Antoine St. E., #300, Montreal, Quebec H2Y 1A3 Canada. (514)871-4707. Fax: (514)871-4803. Art Director: Hélène Cousineau. Estab. 1986. Company publishes hardcover originals and reprints. Types of books include cookbooks, instructional, juvenile, preschool and textbooks. Specializes in children's books. Publishes 40 titles/year. Recent titles include *Telephone Fun (with Cellular*

ALWAYS ENCLOSE a self-addressed, stamped envelope (SASE) with queries and sample packages.

Phones) and *Geo Mania*. 50% require freelance illustration; 30% require freelance design.

Needs: Approached by 30 freelancers/year. Works with 15 freelance illustrators and 7 designers/year. Prefers freelancers with experience in children's illustration. Uses freelancers for jacket/cover illustration and design and book design. 50% of freelance work demands knowledge of Adobe Illustrator, QuarkXPress and Adobe Photoshop. Works on assignment only.

First Contact & Terms: Send postcard sample or query letter with brochure, résumé, photographs, SASE, tearsheets and photocopies. Accepts disk submissions compatible with Adobe Illustrator 5.0 and Adobe Photoshop. Send EPS files. Samples are filed and are not returned. Reports back within 1 month. Art Director will contact artist for portfolio review if interested. Portfolio should include book dummy, final art and transparencies. Buys first rights. Originals are not returned. Finds artists through sourcebooks, word of mouth, submissions and attending art exhibitions.

Book Design: Assigns 15 freelance design jobs/year. Pays by the project, $500-2,000.

Jackets/Covers: Assigns 15 freelance design and 30 illustration jobs/year. Pays by the project.

Text Illustration: Assigns 30 freelance illustration jobs/year. Pays by the project.

Tips: "Our studio does its major publications concerning children's books and cookbooks."

ZOLAND BOOKS, INC., 384 Huron Ave., Cambridge MA 02138. (617)864-6252. Design Director: Lori Pease. Estab. 1987. Publishes hardcover and trade paperback originals and reprints. Types of books include literary mainstream fiction, biography, juvenile, travel, poetry, fine art and photography. Specializes in literature. Publishes 10-12 titles/year. Recent titles include *Rosalind: A Family Romance*, by Myra Goldberg; and *The Country Road*, poems by James Laughlin. Books are of "quality manufacturing with full attention to design and production, classic with a contemporary element." 10% require freelance illustration; 80% require freelance design. Book catalog with SASE.

Needs: Works with 2 freelance illustrators and 6 freelance designers/year. Buys 3 illustrations/year. Uses freelancers mainly for book and jacket design. Also for jacket/cover illustration and catalog design. 100% of design work demands knowledge of Aldus PageMaker or QuarkXPress. Works on assignment only.

First Contact & Terms: Send query letter with brochure, résumé, tearsheets, photocopies or photostats. Samples are filed or are returned by SASE if requested by artist. Design Director will contact artist for portfolio review if interested. Rights purchased vary according to project. Originals are returned at job's completion.

Book Design: Assigns 10-12 jobs/year. Pays by the project, $500 minimum.

Jacket/Covers: Assigns 10-12 design and 1-3 freelance illustration jobs/year. Pays by the project, $500 minimum.

Tips: "We love to see all styles appropriate for a literary publisher."

Galleries

That dream of showing your work in a gallery can be closer than you realize. The majority of galleries are actually quite approachable and open to new artists. So don't be intimidated. If you approach them in the right way, they'll be happy to take a look at your slides. If they feel your artwork doesn't fit their gallery, most will gently let you know, often steering you toward a more appropriate one. Whenever you meet rejection (and you will), tell yourself it's all part of being an artist.

It may take months, maybe years, for you to find a gallery to represent you. As you submit your work and get feedback you might find out your style hasn't developed enough to grab a gallery's interest. But don't worry, there are plenty of other venues for you to show in until you are accepted in a commercial gallery. If you get involved with your local art community, attend openings, read the arts section of your local paper, you'll see there are hundreds of opportunities right in your city.

Enter group shows every chance you get. Go to the art department of your local library and check out the bulletin board, then ask the librarian to steer you to regional arts magazines that list "calls to artists" and other opportunities to exhibit your work. Join a co-op gallery and show your work in a space run by artists for artists. Is there a restaurant in your town that shows the work of local artists? Ask the manager how you can show your work. Become an active member in an arts group. They often mount exhibitions of their members' work. Show your work whenever and wherever you can until you find the right commercial gallery for you.

CHOOSE THE BEST APPROACH

The first thing you should know about galleries is that they probably won't come knocking at your door asking to see your artwork. You will have to make the effort to approach them. Gallery owners are people who love the arts and enjoy their involvement with artists, but they are also business people. The artists they choose to represent must not only be talented, but experienced and highly professional as well.

When we ask gallery directors for pet peeves they always discuss the talented newcomers walking into the gallery with paintings in hand. No matter how talented you are, do not walk into a gallery with your paintings. Send a polished package of about 8 to 12 neatly labeled, mounted slides of your work submitted in plastic slide sheet format (refer to the listings for more specific information on each gallery's preferred submission method).

You don't have to move to New York City to find a gallery. Whether you live in a small town or a big city, the easiest galleries to try first are the ones closest to you. It's much easier to begin developing a reputation within a defined region. New artists rarely burst onto the scene on a national level.

Before you decide whether or not to submit your slides to a particular gallery, try to make a visit to the gallery. Browse for a while and see what type of work they sell. Do you like the work? Is it similar to yours in quality and style? What about the staff? Are they friendly and professional? Do they seem to know about the artists the gallery handles? Do they have convenient hours? Sign the register book to get on their mailing list. That's one good way to make sure the gallery sends out professional mailings to prospective collectors.

Don't visit just one gallery. Check out all the galleries in your area before making a decision. If a gallery is listed in this book, read the listing for more information about how the gallery works and how it prefers being approached.

FIND THE BEST VENUE

As you search for the perfect gallery, it's important to understand the different types of spaces and how they operate. There are advantages and disadvantages to each type of space. The route you choose depends on your needs, the type of work you do, your long term goals, and the audience you're trying to reach.

• **Retail or commercial galleries.** The goal of the retail gallery is to sell and promote artists while turning a profit. Work in retail galleries is handled by a professional sales staff, because selling the work is the gallery's major concern. Retail galleries take a commission of 40 to 50 percent of all sales.

• **Co-op galleries.** Like retail galleries, co-ops exist to sell and promote artists' work, but they are run by artists, and have no professional sales staff. Members of co-ops exhibit their own work in exchange for a fee, which covers the gallery's overhead. Some co-ops also take a small commission of 20 to 30 percent on work sold to cover expenses. This type of arrangement also requires a time commitment. Members share the responsibilities of gallery-sitting, housekeeping and maintenance.

• **Rental galleries.** In this type of arrangement, the artist rents space from an organization or individual in which to display work. The gallery makes its profit primarily through rent and consequently may not take a commission on sales (or will take only a very small commission). Some rental spaces provide publicity for artists, while others do not.

• **Nonprofit galleries.** The mission of the nonprofit gallery is often to provide a forum for public discussion through art. Many nonprofits exist solely for the benefit of the public: to make art and culture accessible to all people. A show in this type of space will provide the artist an opportunity to sell work and gain publicity, but the nonprofit will not market the work aggressively, as its goals are not necessarily sales-oriented. Nonprofits normally take a small commission of 20 to 30 percent.

• **Museums.** It is not appropriate to submit to most museums unless they publicize a special competition or arts event. The work in museums is by established artists and is usually donated by collectors or purchased through art dealers.

• **Art consultancies.** Generally, art consultants act as liaisons between fine artists and buyers. Most represent artists and take a commission on sales (as would a gallery). Some even maintain small gallery spaces and show work to clients by appointment. Corporate consultants, however, are sometimes paid by the corporations they serve and consequently do not take a cut of the artist's sale. (See the Artists' Reps section, page 654.)

Explore Regional Options

Once you have achieved representation on a local level, you are ready to broaden your scope by querying galleries in other cities. Many artists have had success showing in multiple galleries. You may decide to concentrate on galleries in surrounding states, becoming a "regional" artist. Some artists like to have an East Coast and a West Coast gallery. When submitting to galleries outside your city, if you can't manage a personal visit before you submit, read the listing carefully to make sure you understand what type of work is shown in that gallery and get a feel for what the space is like. Ask a friend or relative who lives in that city to check out the gallery for you. If the type of work you do would be appropriate for the scope of the gallery, you could develop a rewarding connection.

 To develop a sense of various galleries, look to the myriad of art publications that contain reviews and advertising. A few such publications are *ARTnews*, *Art in America*, *The New Art Examiner* and regional publications such as *ARTweek* (West Coast), *Southwest Art*, *Dialogue* and *Art New England*. Lists of galleries can be found in *Art in America's Guide to Galleries, Museums and Artists* and *Art Now, U.S.A.'s National Art Museum and Gallery Guide*.

 After you have identified galleries that interest you, check their listings to find out exactly how they prefer to be approached. For a first contact, most galleries prefer a cover letter, slides, résumé and SASE. Realize, however, that slides alone won't get you into a gallery. Follow Holly Solomon's advice from the Insider Report on page 472 and become an active member of the arts community. The visibility factor holds a lot of weight with galleries.

SET THE RIGHT PRICE

A common question of beginning artists is "What do I charge for my paintings?" There are no hard and fast rules. The better known you become, the more people will pay for your work. Though you should never underprice your work, you must take into consideration what people are willing to pay. (See Negotiating the Best Deal page 11.)

Alabama

CORPORATE ART SOURCE, 2960-F Zelda Rd., Montgomery AL 36106. (334)271-3772. Owner: Jean Belt. Retail gallery and art consultancy. Estab. 1983. Interested in emerging, mid-career and established artists. "I don't represent artists, but keep a slide bank to draw from as resources." Curates 3 exhibits/year. Open Monday-Friday, 10-5; Saturday by appointment. Located in exclusive shopping center. Clientele: corporate upscale, local. 10% private collectors, 90% corporate collectors. Overall price range: $100-12,000. Most work sold at $400-1,000.
Media: Considers all media and all types of prints. Most frequently exhibits oil/acrylic paintings on canvas, pastel and watercolor. Also interested in sculpture.
Style: Exhibits expressionism, painterly abstraction, minimalism, color field, impressionism, photorealism, hard-edge geometric abstraction, realism and imagism. Genres include landscapes and figurative work. Prefers expressionism and painterly abstraction.
Terms: Artwork is accepted on consignment (50% commission). Retail price set by artist. Gallery provides contract, shipping costs from gallery. Prefers artwork unframed.
Submissions: Send query letter with résumé, slides or photographs and SASE. Call for appointment to show portfolio of slides and photographs. Replies in 6 weeks.

‡EASTERN SHORE ART CENTER, 401 Oak St., Fairhope AL 36532. (334)928-2228. Executive Director: B.G. Hinds. Museum. Estab. 1957. Exhibits emerging, mid-career and established artists. Average display time 1 month. Open all year. Located downtown; 8,000 sq. ft. of galleries.
 • Artists applying to Eastern Shore should expect to wait at least a year for exhibits.
Media: Considers all media and prints.
Style: Exhibits all styles and genres.
Terms: Accepts works on consignment (25% commission). Retail price set by artist. Gallery provides insurance, promotion and contract. Prefers artwork framed.
Submissions: Send query letter with résumé and slides. Write for appointment to show portfolio of originals and slides.
Tips: "Conservative, realistic art is appreciated more and sells better."

MOBILE MUSEUM OF ART, 4850 Museum Dr., Mobile AL 36689. (334)343-2667. Director: Joe Schenk. Clientele: tourists and general public. Sponsors 6 solo and 12 group shows/year. Average display time 6-8

weeks. Interested in emerging, mid-career and established artists. Overall price range: $100-5,000; most artwork sold at $100-500.

Media: Considers all media and all types of visual art.

Style: Exhibits all styles and genres. "We are a general fine arts museum seeking a variety of style, media and time periods." Looking for "historical significance."

Terms: Accepts work on consignment (20% commission). Retail price set by artist. Exclusive area representation not required. Gallery provides insurance, promotion, contract; shipping costs are shared. Prefers framed artwork.

Submissions: Send query letter with résumé, brochure, business card, slides, photographs, bio and SASE. Write to schedule an appointment to show a portfolio, which should include slides, transparencies and photographs. Replies only if interested within 3 months. Files résumés and slides. All material is returned with SASE if not accepted or under consideration.

Tips: A common mistake artists make in presenting their work is "overestimating the amount of space available." Recent gallery developments are the "prohibitive costs of exhibition—insurance, space, transportation, labor, etc. Our city budget has not kept pace with increased costs."

‡MARCIA WEBER/ART OBJECTS, INC., 1050 Woodley Rd., Montgomery AL 36106. (334)262-5349. Fax: (334)288-4042. E-mail: weberart@mindspring.com. Owner: Marcia Weber. Retail, wholesale gallery. Estab. 1991. Represents 21 emerging, mid-career and established artists/year. Exhibited artists include: Woodie Long, Jimmie Lee Sudduth. Sponsors 6 shows/year. Open all year except July by appointment only. Located in Old Cloverdale near downtown in older building with hardwood floors in section of town with big trees and gardens. 90% of space for special exhibitions; 10% of space for gallery artists. Clientele: tourists, upscale. 90% private collectors, 10% corporate collectors. Overall price range: $300-3,000; most work sold at $300-2,000.

• This gallery owner displays the work of self-taught folk artists or outsider artists. The artists she shows generally are illiterate and "live down dirt roads without phones," so a support person contacts the gallery. Marcia Weber moves the gallery to New York's Soho district three weeks each winter.

Media: Considers all media except prints. Must be original one-of-a-kind works of art. Most frequently exhibits acrylic, oil, found metals, found objects, mud and paint.

Style: Exhibits genuine contemporary folk/outsider art.

Terms: Accepts work on consignment (variable commission) or buys outright. Gallery provides insurance, promotion and contract if consignment is involved. Prefers artwork unframed.

Submissions: Folk/outsider artists usually do not contact dealers. If they have a support person or helper, they might write or call. Send query letter with photographs, artist's statement. Call or write for appointment to show portfolio of photographs, original material. Finds artists through word of mouth, other artists and "serious collectors of folk art who want to help an artist get in touch with me."

Tips: "One is not a folk artist or outsider artist just because their work resembles folk art. They have to *be* folks or outsiders to create folk art."

Alaska

STONINGTON GALLERY, 621 W. Sixth Ave., Anchorage AK 99501-2127. (907)272-1489. Fax: (907)272-5395. Manager: Julie Decker. Retail gallery. Estab. 1983. Interested in emerging, mid-career and established artists. Represents 50 artists. Sponsors 15 solo and group shows/year. Average display time 3 weeks. Clientele: 90% private collectors, 10% corporate clients. Overall price range: $100-5,000; most work sold at $500-1,000.

Media: Considers oil, acrylic, watercolor, pastel, mixed media, collage, works on paper, sculpture, ceramic, craft, fiber, glass and all original handpulled prints. Most frequently exhibits oil, mixed media and all types of craft.

Style: Exhibits all styles. "We have no pre-conceived notions as to what an artist should produce." Specializes in original works by artists from Alaska and the Pacific Northwest. "We are the only source of high-quality crafts in the state of Alaska. We continue to generate a high percentage of our sales from jewelry and ceramics, small wood boxes and bowls and paper/fiber pieces. We push the edge to avante garde."

Terms: Accepts work on consignment (40% commission). Retail price set by artist. Exclusive area representation required. Gallery provides insurance, promotion.

HOW TO USE your *Artist's & Graphic Designer's Market* offers suggestions for understanding and using the information in these listings. Read this and other articles in the front of this book for important business tips.

Submissions: Send letter of introduction with résumé, slides, bio and SASE.
Tips: Impressed by "high quality ideas/craftsmanship—good slides."

Arizona

‡ARIZONA STATE UNIVERSITY ART MUSEUM, Nelson Fine Arts Center and Matthews Center, Arizona State University, Tempe AZ 85287-2911. (602)965-ARTS. Website: http://asuam.fa.asu.edu/homepa ge.htm. Director: Marilyn Zeitlin. Museum. Estab. 1950. Represents mid-career and established artists. Sponsors 12 shows/year. Average display time 2 months. Open all year. Located downtown Tempe ASU campus. Nelson Fine Arts Center features award-winning architecture, designed by Antoine Predock. "The Matthews Center, located in the center of campus, features the Experimental Gallery, showing contemporary art that explores challenging materials, subject matter and/or content."
Media: Considers all media. Greatest interests are contemporary art, crafts, and work by Latin American and Latin artists.
Submissions: "Interested artists should submit slides to the director or curators."
Tips: "With the University cutbacks, the museum has scaled back the number of exhibitions and extended the average show's length. We are always looking for exciting exhibitions that are also inexpensive to mount."

‡JOAN CAWLEY GALLERY, LTD., 7135 E. Main St., Scottsdale AZ 85251. (602)947-3548. Fax: (602)947-7255. President: Joan M. Cawley. Retail gallery and print publisher. Estab. 1974. Represents 20 emerging, mid-career and established artists/year. Exhibited artists include: Carol Grigg, Adin Shade. Sponsors 5-10 shows/year. Average display time 2-3 weeks. Open all year; Monday-Saturday, 10-5; Thursday, 7-9. Located in art district, center of Scottsdale; 2,730 sq. ft. (about 2,000 for exhibiting); high ceilings, glass frontage and interesting areas divided by walls. 50% of space for special exhibitions; 75% of space for gallery artists. Clientele: tourists, locals. 90% private collectors. Overall price range: $100-12,000; most work sold at $3,500-5,000.
Media: Considers all media except fabric or cast paper; all graphics. Most frequently exhibits acrylic on canvas, watercolor, pastels and chine colle.
Style: Exhibits expressionism, painterly abstraction, impressionism. Exhibits all genres. Prefers Southwestern and contemporary landscapes, figurative, wildlife.
Terms: Accepts work on consignment (50% commission.) Gallery provides insurance, promotion and contract; shipping costs are shared. Prefers artwork framed.
Submissions: Prefers artists from west of Mississippi. Send query letter with bio and slides or photos. Call or write for appointment to show portfolio of photographs, slides or transparencies. Replies as soon as possible.
Tips: "We are a contemporary gallery in the midst of traditional western galleries. We are interested in seeing new work always. I do like to have appointments made by artists showing their work."

COCONINO CENTER FOR THE ARTS, 2300 N. Fort Valley Rd., Flagstaff AZ 86001. (520)779-6921. Fax: (520)779-2984. Director: Keye McCulloch. Nonprofit retail gallery. Estab. 1981. Represents/exhibits emerging, mid-career and established artists. Sponsors 7 shows/year. Average display time 6 weeks. Open all year; Tuesday-Saturday, 10-5 (winter); Tuesday-Sunday 10-5, (summer). Located US Highway 180 N., 1.3 miles north of Flagstaff. 4,000 sq. ft. Clientele: tourists, local community and students.
Media: Considers all media and all types of prints. Most frequently exhibits visual, 3-D and installation.
Style: Exhibits all styles and genres.
Terms: Retail price set by the artist. Gallery provides insurance and promotion. Artist pays for shipping costs. Prefers artwork framed.
Submissions: Send query letter with slides and bio. Call or write for appointment to show portfolio. Finds artists through word of mouth, referrals by other artists and submissions.

EL PRESIDIO GALLERY, 7000 E. Tanque Verde Rd., Tucson AZ 85715. (520)733-0388. E-mail: tucart@a zstarnet.com. Director: Henry Rentschler. Retail gallery. Estab. 1981. Represents 30 artists; emerging, mid-career and established. Sponsors 5-6 group shows/year. Average display time 2 months. Located at upscale Santa Fe Square Shopping Plaza; 7,000 sq. ft. of exhibition space. Accepts mostly artists from the West and Southwest. Clientele: locals and tourists. 70% private collectors, 30% corporate clients. Overall price range: $500-20,000; most artwork sold at $1,000-5,000.
Media: Considers oil, acrylic, watercolor, mixed media, works on paper, sculpture, ceramic, glass, egg tempera and original handpulled prints. Most frequently exhibits oil, watercolor and acrylic.
Style: Exhibits impressionism, expressionism, realism, photorealism and painterly abstraction. Genres include landscapes, Southwestern, Western, wildlife and figurative work. Prefers realism, representational works and representational abstraction.

Terms: Accepts work on consignment (50% commission). Retail price set by the gallery and the artist. Exclusive area representation required. Gallery provides insurance, promotion and contract; artist pays for shipping. Prefers framed artwork.

Submissions: Send query letter with résumé, brochure, slides, photographs with sizes and retail prices, bio and SASE. Call or write to schedule an appointment to show a portfolio, which should include originals, slides, transparencies and photographs. A common mistake is artists overpricing their work. Replies in 2 weeks.

Tips: "Work hard. Have a professional attitude. Be willing to spend money on good frames."

ELEVEN EAST ASHLAND INDEPENDENT ART SPACE, 11 E. Ashland, Phoenix AZ 85004. (602)257-8543. Director: David Cook. Estab. 1986. Represents emerging, mid-career and established artists. Exhibited artists include Vernita Nemic, A&A Morris and Keith Bennett. Sponsors 1 juried, 1 invitational and 13 solo and mixed group shows/year. Average display time 3 weeks. Located in "two-story old farm house in central Phoenix, off Central Ave." Overall price range: $100-5,000; most artwork sold at $100-800.

• An anniversary exhibition is held every year in April and is open to national artists. Work must be submitted by March. Work will be for sale, and considered for permanent collection and traveling exhibition.

Media: Considers all media. Most frequently exhibits photography, painting, mixed media and sculpture.

Style: Exhibits all styles, preferably contemporary. "This is a non-traditional proposal exhibition space open to all artists excluding Western and Southwest styles (unless contemporary style)."

Terms: Accepts work on consignment (25% commission); rental fee for space covers 1 month. Retail price set by artist. Artist pays for shipping.

Submissions: Accepts proposal in person or by mail to schedule shows 6 months in advance. Send query letter with résumé, brochure, business card, slides, photographs, bio and SASE. Call or write for appointment to show portfolio of slides and photographs. Be sure to follow through with proposal format. Replies only if interested within 1 month. Samples are filed or returned if not accepted or under consideration.

Tips: "Be yourself, avoid hype and commercial glitz. Be sincere and have a positive attitude."

‡FIREHOUSE GALLERY, 6 Naco Rd., P.O. Box CX, Bisbee AZ 85603. (520)432-1224. Fax: (520)432-2882. Director: Patricia Anne Steward. Retail, wholesale gallery, art consultancy. Estab. 1993. Represents 16 emerging, mid-career and established artists/year. Exhibited artists include: Feliciano Bejar, Judith Stafford. Sponsors 4 shows/year. Average display time 6 weeks. Open all year; Sunday-Thursday, 10-6; Friday-Saturday, 10-10. Located downtown, old Bisbee; 4,000 sq. ft. Building is historical landmark: firehouse built in 1906. 50% of space for special exhibitions; 50% of space for gallery artists. Overall price range: $150-12,000; most work sold at $2,000.

Media: Considers all media. Most frequently exhibits oil, collage, acrylic.

Terms: Accepts work on consignment (commission.) Retail price set by the gallery and the artist. Gallery provides promotion and contract; artist pays for shipping.

Submissions: Send query letter with résumé, slides, bio, brochure, photographs, artists's statement. Write for appointment to show portfolio of photographs. Replies only if interested within 3 weeks.

Tips: "Be persistent."

GALERIA MESA, 155 N. Center, Box 1466, Mesa AZ 85211-1466. (602)644-2056. Fax: (602)644-2901. Website: http://www.ftgi.com/iar/12.html. Owned and operated by the City of Mesa. Estab. 1981. Exhibits the work of emerging, mid-career and established artists. "We only do national juried shows and curated invitationals. We are an exhibition gallery, NOT a commercial sales gallery." Sponsors 8 shows/year. Average display time 4-6 weeks. Closed August. Located downtown; 3,600 sq. ft., "wood floors, 14' ceilings and monitored security." 100% of space for special exhibitions. Clientele: "cross section of Phoenix metropolitan area." 95% private collectors, 5% gallery owners. "Artists selected only through national juried exhibitions." Overall price range: $100-10,000; most artwork sold at $200-400.

Media: Considers all media and original handpulled prints, woodcuts, engravings, lithographs, wood engravings, mezzotints, monotypes, serigraphs, linocuts and etchings.

Style: Exhibits all styles and genres. Interested in seeing contemporary work.

Terms: Charges 25% commission. Retail price set by artist. Gallery provides insurance, promotion and contract; pays for shipping costs from gallery. Requires framed artwork.

Submissions: Send a query letter or postcard with a request for a prospectus. "We do not offer portfolio review. Artwork is selected through national juried exhibitions." Files slides and résumés. Finds artists through gallery's placement of classified ads in various art publications, mailing news releases and word of mouth.

Tips: "Have professional quality slides."

‡GALLERY THREE, 3819 N. Third St., Phoenix AZ 85012. (602)277-9540. Owner: Sherry Manoukian. Retail gallery. Estab. 1969. Represents 20 emerging, mid-career and established artists/year. Exhibited artists include: Gus Kniffin and David Pontbriand. Open all year; Monday-Friday, 9-5. Located in central Phoenix;

3,500 sq. ft.; interesting architecture. 100% of space for gallery artists. Clientele: corporate, design, upscale. 20% private collectors, 80% corporate collectors. Overall price range: $15-5,000; most work sold at $300-1,000.

Media: Considers all media except computer generated artwork; types of prints include woodcuts, wood engravings, engravings, mezzotints, etchings, lithographs and serigraphs. Most frequently exhibits very large acrylic, mixed media and watercolor.

Style: Exhibits all styles. Genres include landscapes, florals and figurative work. Prefers large acrylic landscape/abstract, postmodern, watercolor florals and landscapes.

Terms: Accepts work on consignment (50% commission). Retail price set by the gallery and the artist. Artist pays for shipping. Prefers artwork unframed.

Submissions: Send query letter with résumé, photographs, SASE, dimensions and prices of artwork. Call for appointment to show portfolio of photographs and slides. Replies in 1 month "only if provided with SASE." Files résumé, one slide or photograph representing work. Finds artists through submissions and referrals.

Tips: "We do not consider work that does not include the dimensions of the pieces as well as the price of each submitted piece. We do not return materials if SASE has not been provided."

‡**THE HUB GALLERY**, 130 N. Central Ave., B-100, Phoenix AZ 85004-2300. (602)253-6282. Fax: (602)973-4741. E-mail: aeakins@netzone.com. Owner: Alan Eakins. Retail gallery. Estab. 1995. Represents 16 emerging, mid-career and established artists. Exhibited artists include: Roberta Hancock and Douglas Utter. Sponsors 9 shows/year. Average display time 1 month. Open all year; Tuesday-Saturday, 11-3; and by appointment. Located downtown in arts/financial district; 1,500 sq. ft.; basement setting with industrial feel—open exhibit space. 75% of space for special exhibitions; 25% of space for gallery artists. Clientele: professionals, students, tourists and politicians. 75% private collectors; 25% corporate collectors. Overall price range: $200-9,000; most work sold at $1,200-5,000.

Media: Considers all media and all types of prints. Most frequently exhibits oils, mixed media, prints.

Style: Exhibits all styles. Genres include florals, portraits, landscapes, Americana, figurative work. Prefers impressionism, surrealism, realism.

Terms: Artwork is accepted on consignment (35% commission). Retail price set by the gallery. Gallery provides insurance, promotion and contract; shipping costs are shared. Prefers artwork framed.

Submissions: Send query letter with résumé, slides, bio, brochure, photographs. Call or write for appointment to show portfolio of photographs, slides and transparencies. Replies in 1 month. Files "whatever artist does not need back."

Tips: Be prepared with a consistent body of work. Some common mistakes artists make are "submitting unfinished work, work not in slide or photo format and unrealistic demands (usually from emerging artists with no track record)."

‡**TEMPE ARTS CENTER**, P.O. Box 549, Tempe AZ 85280. (602)968-0888. Exhibition/Education Coordinator: Patty Haberman. Nonprofit gallery. Estab. 1982. 250-300 members: emerging artists. Exhibited artists include Bertil Vallien and Tom Philabaum. Sponsors 6-7 shows/year. Average display time 6-7 weeks. Open all year. Located in downtown Tempe, near Arizona State University. "Beautiful, historic riverfront park grounds also feature an outdoor sculpture garden." 100% of space for special exhibitions. Clientele: college students, retirees, families and couples. 75% private collectors, 25% corporate collectors. Overall price range: $500-10,000; most work sold at $750-2,000.

• This gallery also has space at the Tempe Public Library. The same submission requirements apply.

Media: Considers mixed media, sculpture, ceramic, craft, fiber, glass and installation. Prefers only 3D media: crafts and sculpture. Most frequently exhibits sculpture, clay and fiber.

Style: Exhibits all contemporary styles and all genres.

Terms: Accepts work on consignment (25% commission). Retail price is set by artist. Gallery provides insurance, promotion and shipping costs from gallery. Prefers artwork framed and/or ready for display.

Submissions: Send query letter with résumé, slides, bio, photographs and SASE.

‡**VANIER & ROBERTS, LTD. FINE ART**, 7106 E. Main St., Scottsdale AZ 85251. (602)946-7507. Fax: (602)945-2448. President: Stephanie Roberts. Retail gallery. Estab. 1994. Represents 70 emerging, mid-career and established artists/year. Sponsors 7 shows/year. Average display time 1 month. Open all year; Monday-Saturday, 10-6; Tuesday-Thursday, 7-9 pm; Sunday, 12-4. Located in Old Town (downtown) Scottsdale; 6,500 sq. ft.; multi-levels, multiple rooms, 25 foot ceilings. Clientele: tourists, upscale, local. 90% private collectors, 10% corporate collectors. Overall price range: $100-295,000; most work sold at $2,000-10,000.

Media: Considers oil, pen & ink, drawing, sculpture, watercolor, mixed media, pastel and photography. Most frequently exhibits oil, sculpture and watercolor.

Style: Exhibits: photorealism and realism. Exhibits all genres. Prefers landscape, florals and portrait.

Terms: Accepts work on consignment (50% commission). Retail price set by the artist. Gallery provides insurance, promotion and contract; shipping costs are shared. Prefers artwork framed.

Submissions: Send query letter with résumé, brochure, business card, slides, photographs, reviews, artist's statement, bio, SASE and price range. Write for appointment to show portfolio of photographs and slides. Replies in 2 months. Finds artists through out of town (state) shows, referrals by other artists, national publications.

‡RIVA YARES GALLERY, 3625 Bishop Lane, Scottsdale AZ 85251. (602)947-3251. Fax: (602)947-4251. Retail gallery. Estab. 1963. Represents 30-40 emerging, mid-career and established artists/year. Exhibited artists include: Rodolfo Morales and Fritz Scholder. Sponsors 12-16 shows/year. Average display time 3-6 weeks. Open all year; Tuesday-Saturday, 10-5 by appointment. Located in downtown area; 8,000 sq. ft.; national design award architecture; international artists. 50% of space for special exhibitions; 50% of space for gallery artists. Clientele: collectors. 90% private collectors; 10% corporate collectors. Overall price range: $1,000-1,000,000; most work sold at $20,000-50,000.
Media: Considers all media except craft and fiber and all types of prints. Most frequently exhibits paintings (all media), sculpture and drawings.
Style: Exhibits expressionism, photorealism, neo-expressionism, minimalism, pattern painting, color field, hard-edge geometric abstraction, painterly abstraction, realism, surrealism and imagism. Prefers abstract expressionistic painting and sculpture, surrealistic sculpture and modern schools painting and sculpture.
Terms: Accepts work on consignment (50% commission). Retail price set by the artist. Gallery provides insurance, promotion and contract; gallery pays for shipping from gallery; artist pays for shipping to gallery. Prefers artwork framed.
Submissions: Send query letter with résumé, brochure, slides, photographs, artist's statement, bio and SASE. Write for appointment to show portfolio of photographs, transparencies and slides. Usually finds artists by referral from trusted source.
Tips: "Few artists take the time to understand the nature of a gallery and if their work even applies."

Arkansas

AMERICAN ART GALLERY, 724 Central Ave., Hot Springs National Park AR 71901. (501)624-0550. Retail gallery. Estab. 1990. Represents 22 emerging, mid-career and established artists. Exhibited artists include Jimmie Tucek and Jimmie Leach. Sponsors 12 shows/year. Average display time 1 month. Open all year. Located downtown; 4,000 sq. ft.; 40% of space for special exhibitions. Clientele: private, corporate and the general public. 85% private collectors, 15% corporate collectors. Overall price range: $50-12,000; most work sold at $250-500.
Media: Considers oil, acrylic, watercolor, pastel, pen & ink, sculpture, ceramic, photography, original hand-pulled prints, woodcuts, wood engravings, lithographs and offset reproductions. Most frequently exhibits oil, wood sculpture and watercolor.
Style: Exhibits all styles and genres. Prefers realistic, abstract and impressionistic styles; wildlife, landscapes and floral subjects.
Terms: Accepts work on consignment (35% commission). Retail price set by gallery and the artist. Gallery provides promotion and contract; artist pays for shipping. Offers customer discounts and payment by installments. Prefers artwork framed.
Submissions: Prefers Arkansas artists, but shows 5-6 others yearly. Send query letter with résumé, slides, bio and SASE. Call or write for appointment to show portfolio of originals and slides. Reports in 6 weeks. Files copy of résumé and bio. Finds artists through agents, by visiting exhibitions, word of mouth, various art publications and sourcebooks, submissions/self promotions and art collectors' referrals.
Tips: "We have doubled our floor space and have two floors which allows us to separate the feature artist from the regular artist. We have also upscaled in the quality of art work exhibited. Our new gallery is located between two other galleries. It's a growing art scene in Hot Springs."

ARKANSAS STATE UNIVERSITY FINE ARTS CENTER GALLERY, P.O. Drawer 1920, State University AR 72467. (501)972-3050. E-mail: csteele@uztec.astate.edu. Chair, Gallery Committee: Curtis Steele. University—Art Department Gallery. Estab. 1968. Represents/exhibits 3-4 emerging, mid-career and established artists/year. Sponsors 3-4 shows/year. Average display time 1 month. Open fall, winter and spring; Monday-Friday, 10-4. Located on university campus; 160 sq. ft.; 60% of time devoted to special exhibitions; 40% to faculty and student work. Clientele: students/community.
Media: Considers all media. Considers all types of prints. Most frequently exhibits painting, sculpture and photography.
Style: Exhibits conceptualism, photorealism, neo-expressionism, minimalism, hard-edge geometric abstraction, painterly abstraction, postmodern works, realism, impressionism and pop. "No preference except quality and creativity."
Terms: Exhibition space only; artist responsible for sales. Retail price set by the artist. Gallery provides insurance, promotion and contract; shipping costs are shared. Prefers artwork framed.

Submissions: Send query letter with résumé, slides and SASE. Portfolio should include photographs, transparencies and slides. Replies only if interested within 2 months. Files résumé. Finds artists through call for artists published in regional and national art journals.

Tips: "Show us only your best slides of your best work. Don't overload us with lots of collateral materials (reprints of reviews, articles, etc.). Make your vita as clear as possible."

HERR-CHAMBLISS FINE ARTS, 718 Central Ave., Hot Springs National Park AR 71901-5333. (501)624-7188. Director: Malinda Herr-Chambliss. Retail gallery. Estab. 1988. Represents emerging, mid-career and established artists. Sponsors 12 shows/year. Average display time 1 month. Open all year. Located downtown; 3 floors, 5,000-5,500 sq. ft.; "turn-of-the-century building with art-deco remodeling done in 1950." Overall price range: $50-24,000.

Media: Considers oil, acrylic, watercolor, pastel, pen & ink, drawings, mixed media, sculpture, fiber, glass, etchings, charcoal and large scale work.

Style: Exhibits all styles, specializing in Italian contemporary art.

Terms: "Negotiation is part of acceptance of work, generally commission is 40%." Gallery provides insurance, promotion and contract (depends on negotiations); artist pays for shipping to and from gallery. Prefers artwork framed.

Submissions: Prefers painting and sculpture of regional, national and international artists. Send query letter with résumé, slides, bio, brochure, photographs, SASE, business card and reviews. Do not send any materials that are irreplaceable. Write for appointment to show portfolio of originals, slides, photographs and transparencies. Replies in 4-6 weeks.

Tips: "Slides should include the date, title, medium, size, and directional information. Also, résumé should be succinct and show the number of one-person shows, educational background, group shows, list of articles (as well as enclosure of articles). The neater the presentation, the greater chance the dealer can glean important information quickly. Put yourself behind the dealer's desk, and include what you would like to have for review."

INDIAN PAINTBRUSH GALLERY, INC., Highway 412 W., Siloam Springs AR 72761. (501)524-6920. Owner: Nancy Van Poucke. Retail gallery. Estab. 1979. Represents over 50 emerging, mid-career and established artists. Interested in seeing the work of emerging artists. Exhibited artists include Troy Anderson and Merlin Little Thunder. Sponsors 2-3 shows/year. Average display time 2 weeks. Open all year. Located on bypass; 1,800 sq. ft.; 66% of space for special exhibitions. Clientele: Indian art lovers. 80% private collectors, 20% corporate collectors. Overall price range: $5-5,000; most work sold at $5-2,000.

 ● Artists submitting to this gallery need to have entered competative Indian art shows and prove they are promoting themselves.

Media: Considers oil, acrylic, watercolor, pastel, pen & ink, drawings, mixed media, works on paper, sculpture, ceramic, woodcuts, lithographs, etchings, posters, serigraphs and offset reproductions. Most frequently exhibits paintings, sculpture, knives, baskets, pottery.

Style: Exhibits Native American. Genres include Americana, Southwestern, Western.

Terms: Accepts work on consignment (60-70% commission). Buys outright for 50% of retail price. Retail price set by gallery. Offers payment by installments. Gallery provides insurance and promotion; artist pays for shipping. Prefers unframed artwork.

Submissions: Send personal information. Call for appointment to show portfolio of "prints, etc." Replies in 2 weeks. Finds artists through visiting exhibitions and word of mouth.

‡PALMER'S GALLERY 800, 800 Central Ave., Hot Springs National Park AR 71901. Phone/fax: (501)623-8080. Owner: Linda Palmer. Retail gallery. Estab. 1992. Represents emerging, mid-career and established artists. Exhibited artists include George Dombek, Charles Banks Wilson and Linda Palmer. Sponsors 10 shows/year. Average display time 1 month. Open all year, Tuesday-Saturday 11-6, Sunday 1-5. Space is 2,200 sq. ft.; features high ceilings, wide spaces, moveable walls, contemporary decor in an older building. 33⅓% of space for special exhibitions; 66⅔% of space for gallery artists. Clientele: 75% private collectors, 25% corporate collectors.

Media: Considers all media. Most frequently exhibits sculpture, oil, pastel, watercolor and mixed media.

Style: All styles and genres. "I'm interested in quality work with strong composition, whether abstract or subjective. Contemporary sculpture—stone, steel, bronze, or mixed media."

Terms: Accepts work on consignment (50% commission). Retail price set by gallery and artist. Payment by installment is available. Gallery provides promotion and contract; artist pays for shipping costs. Prefers work framed.

Submissions: Send query letter with résumé, slides, photographs, reviews, bio and SASE. Portfolio review requested if interested in artist's work. Replies in 6 months. Files slides and info with artist's permission. "Find artists through submissions and art collectors' referrals.

Tips: "The gallery scene in Hot Springs is growing and we are becoming known as 'City of The Arts.' "

California

BARLETT FINE ARTS GALLERY, 77 West Angela St., Pleasanton CA 94566. (510)846-4322. Owner: Dorothea Barlett. Retail gallery. Estab. 1981. Represents/exhibits 35-50 emerging, mid-career and established artists/year. Sponsors 6-8 shows/year. Average display time 1 month. Open all year Tuesday-Saturday. Located in downtown Pleasanton; 1,800 sq. ft.; excellent lighting from natural source. 70% of space for special exhibitions; 70% of space for gallery artists. Clientele: "wonderful, return customers." 99% private collectors, 1% corporate collectors. Overall price range: $500-3,500; most work sold at under $2,000.
Media: Considers oil, acrylic, watercolor, pastel, drawing, mixed media, collage, paper, sculpture, ceramics, craft, glass, photography, woodcuts, engravings, lithographs, wood engravings, mezzotints, serigraphs, linocuts and etchings. Most frequently exhibits oil, acrylic, etching.
Style: Exhibits painterly abstraction and impressionism. Genres include landscapes, florals and figurative work. Prefers landscapes, figurative and abstract.
Terms: Accepts work on consignment. Retail price set by the gallery. Gallery provides promotion and contract; artist pays shipping costs to and from gallery.
Submissions: Prefers artists from the Bay Area. Send query letter with résumé, 20-30 slides representing current style and SASE. Write for appointment to show portfolio of originals, slides and transparencies. Replies only if interested within 1 month. Files only accepted artists' slides and résumés (others returned). Finds artists through word of mouth and "my own canvassing."
Tips: "I accept artists with large portfolios/works or a body of work (at least 20-30 works) to represent the style or objective the artist is currently producing. Slides must include work currently for sale! Have recent sales of work and know prices they sold for."

COAST GALLERIES, Big Sur, Pebble Beach, CA; Hana, HI. Mailing address: P.O. Box 223519, Carmel CA 93922. (408)625-4145. Fax: (408)625-3575. Owner: Gary Koeppel. Retail gallery. Estab. 1958. Represents 60 emerging, mid-career and established artists. Sponsors 3-4 shows/year. Open all year. Located in both rural and resort hotel locations; 3 separate galleries—square footage varies, from 900-3,000 sq. ft. "The Hawaii galleries feature Hawaiiana; our Big Sur gallery is constructed of redwood water tanks and features Central California Coast artists and imagery." 100% of space for special exhibitions. Clientele: 90% private collectors, 10% corporate collectors. Overall price range: $25-60,000; most work sold at $400-4,000.
● They enlarged their Big Sur Coast Gallery and added a 100-seat restaurant.
Media: Considers all media; engravings, lithographs, posters, etchings, wood engravings and serigraphs. Most frequently exhibits bronze sculpture, limited edition prints, watercolor and oil on canvas.
Style: Exhibits impressionism and realism. Genres include landscapes, marine and wildlife.
Terms: Accepts work on consignment (50% commission), or buys outright for 40% of retail price (net 30 days.) Retail price set by gallery. Gallery provides insurance, promotion and contract; artist pays for shipping. Requires artwork framed.
Submissions: Accepts only artists from Hawaii for Maui galleries; coastal and wildlife imagery for California galleries; interested in Central California Coast imagery for Pebble Beach gallery. Send query letter with résumé, slides, bio, brochure, photographs, SASE, business card and reviews. Write for appointment to show portfolio of photographs, slides and transparencies. Replies in 2 weeks.

COLLECTOR'S CHOICE, 20352 Laguna Canyon Rd., Laguna Beach CA 92651-1164. Fax: (714)494-8215. E-mail: canyonco@aol.com. Director: Beverly Inskeep. Art consultancy. Estab. 1976. Represents 15 emerging and established artists. Accepts only artists from southern California. Interested in emerging and established artists. Clientele: 78% collectors and tourists, 15% corporate clients. Most artwork sold at $1,000. Offers unusual art & crafts at realistic prices.
● Collector's Choice is an art colony with about 150 artists and 3 municipal art organizations that put on summer and winter art festivals.
Media: Considers all media. Most frequently exhibits portraiture, photography and crafts: chairs and furnishings, toys and whirligigs and garden art.
Style: Exhibits color field, painterly abstraction, minimalism, conceptual, post-modernism, surrealism, impressionism, photorealism, expressionism, neo-expressionism, realism and magic realism. Genres include landscapes, florals, portraits and figurative work. Portraiture and folk art only.
Terms: Accepts work on consignment (40% commission). Retail price set by gallery and artist. Exclusive area representation not required.
Submissions: Send query letter with résumé, brochure, slides and SASE. Write for appointment to show portfolio of originals, slides and transparencies; "have a body of work to show." Material is filed for corporate clients.
Tips: "I look for exceptional point of view rendered in photography or folk art . . . could be political, humanistic, humorous or surreal."

CREATIVE GROWTH ART CENTER GALLERY, 355 24th St., Oakland CA 94612. (510)836-2340. Fax: (510)836-2349. Executive Director: Irene Ward Brydon. Nonprofit gallery. Estab. 1978. Represents 100

emerging and established artists; 100 adults with disabilities work in our adjacent studio. Exhibited artists include Dwight Mackintosh, Nelson Tygart. Sponsors 10 shows/year. Average display time 5 weeks. Open all year; Monday-Friday, 10-4. Located downtown; 1,200 sq. ft.; classic large white room with movable walls, track lights; visible from the street. 25% of space for special exhibitions; 75% of space for gallery artists. Clientele: private and corporate collectors. 90% private collectors, 10% corporate collectors. Overall price range: $50-4,000; most work sold at $100-250.

- This gallery concentrates mainly on the artists who work in an adjacent studio, but work from other regional or national artists may be considered for group shows. Only outsider and brut art are shown. Brut art is like Brut champagne—raw and undistilled. Most of the artists have not formally studied art, but have a raw talent that is honest and real with a strong narrative quality.

Media: Considers oil, acrylic, watercolor, pastel, pen & ink, drawing, mixed media, collage, paper, sculpture, ceramics, fiber, woodcuts, engravings, lithographs, wood engravings, mezzotints, serigraphs, linocuts and etchings. Most frequently exhibits (2-D) drawing and painting, (3-D) sculpture, hooked rug/tapestries.

Style: Exhibits expressionism, primitivism, color field, naive, folk art, brut. Genres include landscapes, florals and figurative work. Prefers brut/outsider, contemporary, expressionistic.

Terms: Accepts work on consignment (40% commission). Retail price set by the gallery. Gallery provides insurance, promotion and contract; artist pays shipping costs to and from gallery. Prefers artwork framed.

Submissions: Prefers only brut, naive, outsider; works by adult artists with disabilities. Send query letter with résumé, slides, bio. Write for appointment to show portfolio of photographs and slides. Replies only if interested. Files slides and printed material. Finds artists through agents, by visiting exhibitions, word of mouth, various art publications and sourcebooks, submissions and networking.

Tips: "Peruse publications that feature brut and expressionistic art (example: *Raw Vision*)."

CUESTA COLLEGE ART GALLERY, P.O. Box 8106, San Luis Obispo CA 93403-8106. (805)546-3202. Fax: (805)546-3904. E-mail: efournie@bass.cuesta.cc.ca.us. Director: Marta Peluso. Nonprofit gallery. Estab. 1965. Exhibits the work of emerging, mid-career and established artists. Exhibited artists include William T. Wiley and Catherine Wagner. Sponsors 5 shows/year. Average display time 4½ weeks. Open all year. Space is 750 sq. ft.; 100% of space for special exhibitions. Overall price range: $250-5,000; most work sold at $400-1,200.

Media: Considers all media and all types of prints. Most frequently exhibits painting, sculpture and photography.

Style: Exhibits all styles, mostly contemporary.

Terms: Accepts work on consignment (20% commission). Retail price set by artist. Customer discounts and payment by installment are available. Gallery provides insurance, promotion and contract; shipping costs are shared. Prefers artwork framed.

Submissions: Send query letter with résumé, slides, bio, brochure, SASE and reviews. Call for appointment to show portfolio. Replies in 6 months. Finds artists mostly by reputation and referrals, sometimes through slides.

Tips: "Only submit quality fine art. We have a medium budget, thus cannot pay for extensive installations or shipping. Present your work legibly and simply. Include reviews and/or a coherent statement about the work. Don't be too slick or too sloppy."

RITA DEAN GALLERY, 548 Fifth Ave., San Diego CA 92101. (619)338-8153. Fax: (619)338-0003. Director: J.D. Healy. Retail gallery. Estab. 1988. Represents/exhibits 50 emerging, mid-career and established artists. Exhibited artists include Charles Manson and Kenneth Anger. Sponsors 12 shows/year. Average display time 1 month. Open all year; Tuesday-Sunday 12-10. Closed Mondays. Located in Gaslamp Quarter downtown; 1,000 sq. ft.; 17 ft. high ceilings, located on heavy tourist traffic street. Originally built for a mortuary. 75% of space for special exhibitions; 25% of space for gallery artists. 100% private collectors. Overall price range: $25-15,000; most work sold at $200-500.

Media: Considers all media except craft and ceramics. Most frequently exhibits photography, oil and installation.

Style: Exhibits conceptualism, primitivism and outsider. Genres include erotic, outsider and provocative. Prefers outsider, erotic and conceptualism.

Terms: Artwork is accepted on consignment (50% commission). Retail price set by both gallery and artist. Gallery provides promotion; shipping costs are paid by artist. Prefers artwork framed.

Submissions: Call for appointment to show portfolio of photographs, slides and photocopies. Replies in 6 weeks if SASE is included.

‡DEL MANO GALLERY, 33 E. Colorado Blvd., Pasadena CA 91105. (818)793-6648; or 11981 San Vicente Blvd., W. Los Angeles CA 90049. (310)476-8508. Assistant Director: Chris Drosse. Retail gallery. Estab. 1973. Represents 300+ emerging, mid-career and established artists. Interested in seeing the work of emerging artists. Exhibited artists include Ann Quisty and Josh Simpson. Sponsors 5 shows/year. Average display time 2-6 months. Open 7 days a week in Pasadena; open Tuesday-Sunday in West LA. Located in Old Pasadena (a business district) and San Vicente Blvd. (a scenic corridor). Space is 3,000 sq. ft. in each gallery. 25% of space for special exhibitions; 75% of space for gallery artists. Clientele: professionals and

affluent collectors. 20% private collectors, 5% corporate collectors. Overall price range: $50-20,000; most work sold at $250-5,000.

Media: Considers contemporary art in craft media—ceramics, glass, jewelry, wood, fiber. No prints. Most frequently exhibits wood, glass, ceramics, fiber, metal and jewelry.

Style: Exhibits all styles and genres.

Terms: Accepts work on consignment (50% commission) or 30 days net. Retail price set by gallery and artist. Customer discounts and payment by installment are available. 10-mile exclusive area representation required. Gallery provides insurance, promotion and shipping costs from gallery. Prefers artwork framed.

Submissions: Send query letter with résumé, slides, bio and prices. "Please contact Chris Drosse for details." Portfolio should include slides, price list, artist's statement and bio. Replies in 2-6 weeks. Finds artists mainly through visiting exhibitions and submissions. "Be professional in your submission."

DELPHINE GALLERY, 1324 State St., Santa Barbara CA 93101. Director: Michael Lepere. Retail gallery and custom frame shop. Estab. 1979. Represents/exhibits 10 mid-career artists/year. Exhibited artists include Jim Leonard, Jeff Kelling, Susan Tibbles, Edwin Brewer and Steve Vessels. Sponsors 8 shows/year. Average display time 4-6 weeks. Open all year; Tuesday-Friday, 10-5; Saturday, 10-3. Located downtown Santa Barbara; 300 sq. ft.; natural light (4th wall is glass). 33% of space for special exhibitions. Clientele: upscale, local community. 40% private collectors, 20% corporate collectors. Overall price range: $1,000-4,500; most work sold at $1,000-3,000.

Media: Considers all media except photography, installation and craft. Considers serigraphs. Most frequently exhibits oil on canvas, acrylic on paper and pastel.

Style: Exhibits conceptualism and painterly abstraction. Includes all genres and landscapes.

Terms: Artwork is accepted on consignment (50% commission). Retail price set by the gallery. Gallery provides insurance and promotion; shipping costs are shared. Prefers artwork unframed.

Submissions: Prefers artists from Santa Barbara/Northern California. Send query letter with résumé, slides and SASE. Write for appointment to show portfolio of slides. Replies in 1 month.

Tips: "Keep your day job, it's tough."

DOWNEY MUSEUM OF ART, 10419 Rives, Downey CA 90241. (310)861-0419. Executive Director: Scott Ward. Museum. Estab. 1957. Interested in emerging and mid-career artists. Sponsors 10 shows/year. Average display time: 6 weeks. Open all year. Located in a suburban park: 3,000 sq. ft. Clientele: locals and regional art audience. 60% private collectors, 40% corporate collectors. Overall price range: $100-10,000; most work sold at $400-3,000.

Media: Considers oil, acrylic, watercolor, pastel, pen & ink, drawings, mixed media, collage, works on paper, sculpture, ceramic, craft, fiber, glass, installation, photography, egg tempera, original handpulled prints, woodcuts, wood engravings, linocuts, engravings, mezzotints, etchings, lithographs, pochoir, serigraphs and computer art.

Style: Exhibits all styles and genres. Prefers California-made art in a wide range of styles.

Terms: Accepts work on consignment (30% commission). Retail price set by artist. Sometimes offers customer discounts and payment by installment. Gallery provides insurance and promotion. Artist pays for shipping. Prefers artwork framed.

Submissions: "Contact by phone first to get a better sense of who we are." Send query letter with résumé, slides and SASE. Portfolio review requested if interested in artist's work. Files résumé and slides. Finds artists through visiting exhibitions and submissions.

Tips: "Take care not to underestimate your competition. Submit a complete and professional package."

GALLERY EIGHT, 7464 Girard Ave., La Jolla CA 92037. (619)454-9781. Director: Ruth Newmark. Retail gallery with focus on craft. Estab. 1978. Represents 100 emerging and mid-career artists. Interested in seeing the work of emerging artists. Exhibited artists include Philip Moulthrop, Yoshiro Zkeda and Thomas Mann. Sponsors 6 shows/year. Average display time 6-8 weeks. Open all year; Monday-Saturday, 10-5. Located downtown; 1,200 sq. ft.; slightly post-modern. 25% of space for special exhibitions; 100% of space for gallery artists. Clientele: upper middle class, mostly 35-60 in age. Overall price range: $5-5,000; most work sold at $25-150.

Media: Considers ceramics, metal, wood, craft, fiber and glass. Most frequently exhibits ceramics, jewelry, other crafts.

Terms: Accepts work on consignment (50% commission) or buys outright for 50% of retail price (net 30 days). Retail price set by the gallery and the artist. Gallery provides insurance, promotion and shipping costs from gallery; artist pays shipping costs to gallery.

‡ **THE DOUBLE DAGGER** before a listing indicates that the listing is new in this edition. New markets are often more receptive to freelance submissions.

Submissions: Send query letter with résumé, slides, photographs, reviews and SASE. Call or write for appointment to show portfolio of photographs and slides. Replies in 1-3 weeks. Files "generally only material relating to work by artists shown at gallery." Finds artists by visiting exhibitions, word of mouth, various art publications and sourcebooks, submissions, through agents, and juried fairs.
Tips: "Make appointments. Do not just walk in and expect us to drop what we are doing to see work."

‡**GREENLEAF GALLERY**, 20315 Orchard Rd., Saratoga CA 95070. (408)867-3277. Owner: Janet Greenleaf. Director: Chris Douglas. Collection and art consultancy and advisory. Estab. 1979. Represents 45 to 60 emerging, mid-career and established artists. By appointment only. "Features a great variety of work in diverse styles and media. We have become a resource center for designers and architects, as we will search to find specific work for all clients." Clientele: professionals, collectors and new collectors. 50% private collectors, 50% corporate clients. Prefers very talented emerging or professional full-time artists—already established. Overall price range: $400-15,000; most artwork sold at $500-8,000.
Media: Considers oil, acrylic, watercolor, pastel, mixed media, collage, works on paper, sculpture, glass, original handpulled prints, lithographs, serigraphs, etchings and monoprints.
Style: Deals in expressionism, neo-expressionism, painterly abstraction, minimalism, impressionism, realism or "whatever I think my clients want—it keeps changing." Genres include traditional, landscapes, florals, wildlife and figurative work. Prefers all styles of abstract, still lifes (impressionistic), landscapes and florals.
Terms: Artwork is accepted on consignment. "The commission varies." Artist pays for shipping or shipping costs are shared.
Submissions: Send query letter, résumé, photographs (but slides OK), bio, SASE, reviews and "any other information you wish." Call or write to schedule an appointment for a portfolio review, which should include originals. If does not reply, the artist should call. Files "everything that is not returned. Usually throw out anything over two years old." Finds artists through visiting exhibits, referrals from clients, or artists, submissions and self promotions.
Tips: Mistakes artists make in presenting their work are "not phoning before sending slides, etc. . . . to find what we are currently trying to locate and sending samples that are appropriate; and overpricing their own work."

L. RON HUBBARD GALLERY, 7051 Hollywood Blvd., Suite 400, Hollywood CA 90028. (213)466-3310. Fax: (213)466-6474. Website: http://www.theta.com/asi. Contact: Joni Labaqui. Retail gallery. Estab. 1987. Represents 14 established artists. Interested in seeing the work of emerging artists in the future. Exhibited artists include Frank Frazetta and Jim Warren. Average display time is 4 months. Open all year. Located downtown; 6,000 sq. ft.; "marble floors, brass ceilings, lots of glass, state-of-the-art lighting." Clientele: "business-oriented people." 90% private collectors, 10% corporate collectors. Overall price range: $200-15,000; most work sold at $4,000-6,000.
Media: Considers oil and acrylic. Most frequently exhibits "continuous tone offset lithography."
Style: Exhibits surrealism and realism. Prefers science fiction, fantasy and Western.
Terms: Artwork is bought outright. Retail price set by the gallery.
Submissions: Send query letter with résumé, slides and photographs. Write or call to schedule an appointment to show a portfolio. Replies in 1 week. Files all material, unless return requested.

INTERNATIONAL GALLERY, 643 G St., San Diego CA 92101. (619)235-8255. Director: Stephen Ross. Retail gallery. Estab. 1980. Represents over 50 emerging, mid-career and established artists. Sponsors 6 solo and 6 group shows/year. Average display time is 2 months. Clientele: 99% private collectors. Overall price range: $15-10,000; most artwork sold at $25-500.
Media: Considers sculpture, ceramic, craft, fiber, glass and jewelry.
Style: "Gallery specializes in contemporary crafts (traditional and current), folk and primitive art, as well as naif art."
Terms: Accepts work on consignment. Retail price set by gallery and artist. Exclusive area representation not required. Gallery provides insurance, promotion and contract; shipping costs are shared.
Submissions: Send query letter, résumé, slides and SASE. Call or write for appointment to show portfolio of slides and transparencies. Files résumés, work description and sometimes slides. Common mistakes artists make are using poor quality, unlabeled slides or photography and not making an appointment.

JUDY'S FINE ART CONNECTION, 2880-A Grand Ave., Los Olivos CA 93441-0884. (805)688-1222. Owner: Judy Hale. Retail gallery. Estab. 1987. Represents 50 mid-career and established artists. Exhibited artists include Janice Alvarez, Larry Bees, Joyce Birkenstock and Jan Bullington. Sponsors 4 shows/year. Average display time 6 months. Open all year. Located downtown; 1700 sq. ft.; "the gallery is light and airy, with a woman's touch." 20% of space for special exhibitions which are regularly rotated and rehung. Clientele: homeowners, decorators, collectors. Overall price range: $100-5,000; most work sold at $500-2,000.
● This gallery has almost doubled the number of artists it represents.
Media: Considers oil, acrylic, watercolor, pastel, sculpture, ceramic, fiber, original handpulled prints, offset reproductions, lithographs and etchings. Most frequently exhibits watercolor, oil and acrylic.

Style: Exhibits impressionism and realism. Genres include landscapes, florals, Southwestern, Western, portraits and figurative work. Prefers figurative work, florals, landscapes, structure.

Terms: Accepts work on consignment (40% commission). Retail price set by artist. Offers payment by installments. Gallery provides insurance and promotion; artist pays for shipping. Prefers artwork framed.

Submissions: Send query letter with bio, brochure, photographs, business card and reviews. Call for appointment to show portfolio of photographs. Replies in 2 weeks. Files bio, brochure and business card.

Tips: "I like 'genuine' people who present quality with fair pricing. They need to be sure to rotate artwork in a reasonable time, if unsold. Also bring in their best work, not the 'seconds' after the show circuit."

‡**LINCOLN ARTS**, 540 F St., P.O. Box 1166, Lincoln CA 95648. (916)645-9713. Arts Administrator: Angela Tahti. Nonprofit gallery and alternative space area coordinator. Estab. 1986. Represents 100 emerging, mid-career and established artists/year. 400 members. Exhibited artists include Bob Arneson, Tommie Moller. Sponsors 19 shows/year (9 gallery, 9 alternative and 1 major month-long ceramics exhibition). Average display time 5 weeks. Open all year; Tuesday-Saturday, 10-3, or by appointment. Located in the heart of downtown Lincoln; 900 sq. ft.; housed in a 1926 bungalow overlooking beautiful Beermann Plaza. "Our annual 'Feats of Clay®' exhibition is held inside the 121-year-old Gladding McBean terra cotta factory." 70% of space for gallery artists. 90% private collectors, 10% corporate collectors. Overall price range: $90-7,000; most work sold at $150-2,000.

Media: Considers all media including linocut prints. Most frequently exhibits ceramics and mixed media.

Style: Exhibits all styles, all genres.

Terms: Accepts work on consignment (30% commission)."Membership donation (min. $10) is encouraged but not required." Retail price set by the artist. Gallery provides promotion; artist pays shipping costs to and from gallery. Prefers artwork framed.

Submissions: Send query letter with résumé, slides or photographs, bio and SASE. Call or write for appointment to show portfolio of originals (if possible) or photographs or slides. Replies in 1 month. Artist should include SASE for return of slides/photos. Files bio, résumé, review notes. "Scheduling is done minimum one year ahead in August for following calendar year. Request prospectus for entry information for Feats of Clay© exhibition." Finds artists through visiting exhibitions, word of mouth, art publications and sourcebooks and submissions.

‡**A NEW LEAF GALLERY**, (formerly A New Leaf Garden Gallery), 1286 Gilman St., Berkeley CA 94706. (510)525-7621. Fax: (510)234-6092. Owners: John Denning, Brigitte Micmacker. Retail gallery. Estab. 1990. Represents 40+ emerging and mid-career artists. Exhibited artists include Steve Jensen and Ed Haddaway. Sponsors 4-6 shows/year. Average display time 6 months. Open all year. Located in North Berkeley; 3,500 sq. ft.; "all contemporary outdoor sculptures shown in a garden setting." 30-50% of space for special exhibitions. Clientele: 80% private collectors. Overall price range: $200-20,000; most work sold at $500-3,000. "We are actively looking for more work in the $800-1,500 range."

Media: Considers sculpture, ceramic and glass. Most frequently exhibits sculpture, fountains and art furniture (must be suitable for outdoors).

Style: Exhibits abstract and abstract figurative work.

Terms: Accepts artwork on consignment (50% commission). Exclusive area representation required. Retail price set by artist in cooperation with gallery. Gallery provides insurance, promotion and contract; artist pays for shipping.

Submissions: Send query letter with résumé, slides, bio and SASE. Replies in 4-6 weeks. Files slides and bio.

Tips: "We suggest artists visit us if possible—this is a unique setting." Owners also design landscapes and incorporate sculptures and fountains into designs. Keep in mind that sculpture must be "garden-sized." Space is not large enough to accommodate monumental work.

‡**OFF THE WALL GALLERY**, 18561 Main St., Huntington Beach CA 92648. (714)847-2204. Estab. 1981. Represents 50 emerging, mid-career and established artists. Exhibited artists include Thomas Kinkade, Dave Archer and Howard Behrens. Sponsors 2 shows/year. Average display time 3 weeks. Open all year. Located in outdoor mall; 1,000 sq. ft.; "creative matting and framing with original art hand-cut into mats." 30% of space for special exhibitions. Clientele: 95% private collectors, 5% corporate clients. Overall price range: $10-5,000; most artwork sold at $200-1,000.

Media: Considers mixed media, collage, sculpture, ceramic, craft, original handpulled prints, engravings, etchings, lithographs, pochoir, serigraphs and posters. Most frequently exhibits serigraphs, lithographs and posters.

Style: Exhibits expressionism, primitivism, conceptualism, impressionism, realism and photorealism. Genres include landscapes, florals, Americana, Southwestern and figurative work. Prefers impressionism and realism.

Terms: Accepts work on consignment (50% commission) or buys outright for 50% of retail price (net 30 days). Retail price set by artist. Gallery provides promotion; artist pays for shipping. Prefers framed artwork but will accept unframed art.

Submissions: Send query letter with brochure and photographs. Call for appointment to show portfolio of originals and photographs. "We prefer to see actual art, as we can't use slides." Replies only if interested within 1 week. Files photographs, brochures and tearsheets.

ORLANDO GALLERY, 14553 Ventura Blvd., Sherman Oaks CA 91403. Co-Directors: Robert Gino and Don Grant. Retail gallery. Estab. 1958. Represents 30 emerging, mid-career and established artists. Sponsors 22 solo shows/year. Average display time is 1 month. Accepts only California artists. Overall price range: up to $35,000; most artwork sold at $2,500.
Media: Considers oil, acrylic, watercolor, pastel, pen & ink, drawings, mixed media, collage, works on paper, sculpture, ceramic and photography. Most frequently exhibits oil, watercolor and acrylic.
Style: Exhibits painterly abstraction, conceptualism, primitivism, impressionism, photorealism, expressionism, neo-expressionism, realism and surrealism. Genres include landscapes, florals, Americana, figurative work and fantasy illustration. Prefers impressionism, surrealism and realism. Interested in seeing work that is contemporary. Does not want to see decorative art.
Terms: Accepts work on consignment. Retail price set by artist. Offers customer discounts and payment by installments. Exclusive area representation required. Gallery provides insurance and promotion; artist pays for shipping.
Submissions: Send query letter, résumé and slides. Portfolio should include slides and transparencies. Finds artists through submissions.
Tips: "Be inventive, creative and be yourself."

‡**PAPEL GALLERY**, 17337 Ventura Blvd., Encino CA 91316. (818)789-9119. Fax: (818)789-9171. Proprietor: Stanley Papel. Contact: Beverly Taylor. Retail art and home accents gallery. Represents emerging, mid-career and established artists. Average display time is 1 month. Overall price range $100-5,000; most artwork sold between $200-3,000.
 ● An auxiliary gallery will open in the Beverly Hills/West Hollywood area in 1997.
Media: Considers all media, including sculpture, one-of-a-kind decorative objects and original prints.
Style: Exhibits artwork, objects and sculpture with unusual and contemporary execution. Exhibits realism, tromp l'oeil, impressionism, expressionism, surrealism and photorealism. Genres include landscapes, urban landscapes, interiors, still life, portraits, figurative and erotic work.
Terms: Accepts work on consignment (50% commission). Retail price set by gallery and artist. Artist pays for shipping. Gallery provides insurance, promotion, contract and shipping costs from gallery. Prefers 2-D work framed.
Submissions: Accepts only serious dedicated artists. Send query letter with résumé, one sheet of slides, bio, artist's statement and price list. SASE required for slide return.
Tips: "We are looking for art from diverse communities. Send slides that represent a cohesive body of work."

PEPPERS ART GALLERY, 1200 E. Colton, P.O. Box 3080, Redlands CA 92373-0999. (909)793-2121 ext. 3669. Director: Barbara A. Thomason. Nonprofit university gallery. Estab. 1960s. Represents/exhibits 4-6 mid-career and established artists/year. Work not for sale. Open fall and spring; Tuesday-Saturday, 12-4; Sunday, 2-5. Closed January and September. Located in the city of Redlands; 980 sq. ft.; 12' high walls. 100% of space for special exhibitions. Clientele: local community, students. Overall price range: $1,500-20,000.
Media: Considers all media, all types of prints except posters. Most frequently exhibits sculpture, painting and ceramics.
Style: Exhibits expressionism, neo-expressionism, primitivism, painterly abstraction, postmodern works, realism and imagism.
Terms: Gallery provides insurance and promotion; shipping costs are sometimes shared. Prefers artwork framed.
Submissions: Accepts only artists from Southwest. "No earth, conceptual theory based or pattern." Replies in 6-8 months. Files résumés only. Finds artists through visiting gallerys and referrals.
Tips: "Don't follow trends—be true to yourself."

POGAN GALLERY, 255 North Lake Blvd., Tahoe City CA 96145. (916)583-0553. Owner/Director: Patti Pogan. Retail gallery. Estab. 1992. Represents/exhibits 35 emerging, mid-career and established artists. Exhibited artists include T.M. Nicholas and Doug Oliver. Sponsors 5 shows/year. Average display time 3 months. Open all year; 7 days a week, 10-5. Located downtown Tahoe City overlooking Lake Tahoe; 3,000 sq. ft.; 100% of space for gallery artists. Clientele: tourist, upscale, 2nd home owners. 95% private collectors, 5% corporate collectors. Overall price range: $250-12,000; most work sold at $750-3,000.
Media: Considers oil, pen & ink, acrylic, drawings, sculpture, glass, watercolor, mixed media, ceramics and pastel. Most frequently exhibits oil, watercolor and sculpture.
Style: Exhibits impressionism and realism. Genres include florals, landscapes, Americana and figurative work. Prefers landscapes, florals and Americana.



Terms: Artwork is accepted on consignment and there is a 50% commission. Retail price set by the artist. Gallery provides insurance, promotion and contract; shipping costs are shared. Prefers artwork framed.
Submissions: Send query letter with résumé, slides, photographs and bio. Replies in 3 weeks. Write for appointment to show portfolio of photographs and slides.
Tips: "Several artists were contacted by us from feature articles in art magazines. We have one artist we do very well with from an art fair, the rest are from artists' submissions. Visit the gallery first and make a realistic evaluation of the work displayed in comparison to your work. If you feel your work is of the same caliber then submit a portfolio; otherwise continue looking for a gallery that is more suitable."

‡**THE MARY PORTER SESNON GALLERY**, Porter College, UCSC, Santa Cruz CA 95064. (408)459-2314. Fax: (408)459-3535. Website: http://arts.ucsc.edu/sesnon/svg. Director: Bridget Barnes. University gallery. Estab. 1971. Represents 20 mid-career artists/year. Sponsors 5-10 shows/year. Average display time 6-8 weeks. Open September-June; Tuesday-Sunday, noon-5. Located on campus; 2,400 sq. ft.; ocean views, recently renovated. 80% of space for special exhibitions; 80% of space for gallery artists. Clientele: academic and community-based. 100% private collectors. Overall price range: $30-100,000; most work sold at $30-250.
Media: Considers oil, acrylic, watercolor, pastel, pen & ink, drawings, mixed media, collage, paper, sculpture, ceramics, craft, fiber, glass, installation, photography, woodcuts, engravings, lithographs, wood engravings, mezzotints, serigraphs, linocuts, etchings and posters. Most frequently exhibits painting, drawing, installation.
Style: Exhibits expressionism, primitivism, painterly abstraction, all styles. Genres include landscapes, portraits and figurative work. Prefers figurative, conceptual, ethnic.
Terms: "Exhibitions are for educational purposes." Retail price set by the artist. Gallery provides insurance, promotion, contract and shipping costs to and from gallery. Prefers artwork framed.
Submissions: Send query letter with résumé, slides, bio, SASE and reviews. Write for appointment to show portfolio of slides. Replies only if interested within 6 months. "Material is retained for committee review and returned in SASE." Finds artists through visiting exhibitions and word of mouth.
Tips: "Artists should clearly understand the educational mission of the gallery."

POSNER FINE ART, 1119 Montana Ave., Santa Monica CA 90403. (310)260-8858. Fax: (310)260-8860. E-mail: wbianca@primenet.com. Director: Judith Posner. Retail gallery and art publisher. Estab. 1994. Represents 200 emerging, mid-career and established artists. Sponsors 5 shows/year. Average display time 6 weeks. Open all year, Tuesday-Saturday, 10-6; Sunday, 12-5. Located in shopping district; 1,000 sq. ft.; 80% of space for special exhibitions; 20% of space for gallery artists. Clientele: upscale and collectors. 50% private collectors, 50% corporate collectors. Overall price range: $25-50,000; most work sold at $500-10,000.
Media: Considers oil, acrylic, watercolor, pastel, mixed media, collage, works on paper, sculpture, ceramics, original handpulled prints, engravings, etchings, lithographs, posters and serigraphs. Most frequently exhibits paintings, sculpture and original prints.
Style: Exhibits painterly abstraction, minimalism, impressionism, realism, photorealism, pattern painting and hard-edge geometric abstraction. Genres include florals and landscapes. Prefers abstract, trompe l'oeil, realistic.
Terms: Accepts work on consignment (50% commission). Retail price set by the gallery. Customer discount and payment by installments. Gallery provides insurance and promotion; shipping costs are shared. Prefers artwork unframed.
Submissions: Send query letter with résumé, slides and SASE. Portfolio should include slides. Replies only if interested in 2 weeks. Finds artists through submissions and art collectors' referrals.
Tips: "We are looking for images for our new venture which is poster publishing. We will do a catalog. We pay a royalty on posters created."

SUSAN STREET FINE ART GALLERY, 444 S. Cedros Ave., Studio 100, Solana Beach CA 92075. (619)793-4442. Fax: (619)793-4491. Gallery Director: Jennifer Faist. Retail and wholesale gallery, art consultancy. Estab. 1984. Represents emerging, mid-career and established artists. Exhibited artists include Joseph Maruska, Marcia Burtt. Sponsors 8 shows/year. Average display time 6 weeks. Open all year; Monday-Friday, 9:30-5; Saturday, 12-4 and by appointment. Located in North San Diego County coastal; 2,000 sq. ft.; 16 foot ceiling lobby, unique artist-designed counter, custom framing design area. 50% of space for special exhibitions; 50% of space for gallery artists. Clientele: corporate, residential, designers. 30% private collectors, 70% corporate collectors. Overall price range: $125-15,000; most work sold at $400-2,000.
 ● This gallery has doubled the number of shows it sponsors each year but shortened the display time.
Media: Considers oil, acrylic, watercolor, pastel, pen & ink, mixed media, collage, sculpture, ceramics, glass and photography. Considers all types of prints. Most frequently exhibits painting (oil/acrylic/mixed media), sculpture.
Style: Exhibits all styles, all genres. Prefers impressionism, abstract expressionism and minimalism.
Terms: Accepts work on consignment (50% commission). Retail price set by the artist. Gallery provides insurance, promotion; shipping costs are shared. Prefers artwork unframed.

Submissions: Send query letter with résumé, slides, bio, business card, reviews, price list and SASE. Call for appointment to show portfolio of slides. Replies in 1 month. Finds artists through referrals, scouting fairs and exhibitions, slide submissions.

THIRD FLOOR GALLERY, California State University, Chico-Bell Memorial Union, Chico CA 95929-0750. (916)898-5079. Fax: (916)898-4717. E-mail: jslaughter@oavax.csuchico.edu. Gallery Coordinator: Marlys Williams. Owned and operated by Associated Students. Represents emerging, mid-career and established artists. Sponsors 7 shows/year. Average display time 1 month. Open all year. Call (916)898-INFO for hours. Located on downtown campus. 100% of space for special exhibitions.
Media: Considers oil, acrylic, watercolor, pastel, pen & ink, drawing, mixed media, collage, paper, wall sculpture, ceramics, craft, fiber, glass, photography, woodcut, engraving, lithograph, wood engraving, mezzotint, serigraphs, linocut, etching and posters. Most frequently exhibits oil, acrylic, watercolor, ceramics.
Style: Exhibits all styles, all genres.
Terms: Accepts work on consignment (20% commission). Retail price set by the artist. Gallery provides reception, promotion, contract, artist pays shipping costs. Prefers artwork framed, ready to hang.
Submissions: Send query letter with résumé, slides, brochure, photographs and SASE. Write for appointment to show portfolio of slides. Replies in "spring months only." Finds artists through visiting exhibitions, word of mouth, submissions.
Tips: "Call first."

RICHARD BARCLAY TULLIS II—ART 9, 1 N. Salsipuedes, #9, Santa Barbara CA 93103. (805)965-1091. Fax: (805)965-1093. E-mail: artnine@aol.com. Director: Richard Tullis II. Wholesale gallery. Specializes in collaborations between artists and master printer. Exploration of material and image making on handmade paper and wood. Estab. 1992. Represents/exhibits 40 emerging, mid-career and established artists. Interested in seeing the work of artists. Exhibited artists include Kirkeby, Millei and Carroll. Sponsors 4 shows/year. Average display time 1 month. Hours are flexible (by appointment) around projects. Located in industrial area; 6,500 sq. ft.; sky lights in saw tooth roof; 27′ ceiling. 65% of space for special exhibitions. Clientele: wholesale and special collectors. 20% private collectors. Overall price range: $1,000-30,000; most work sold at $2,000-6,000.
Media: Considers oil, paper, mixed media and pastel. Most frequently exhibits unique works on paper and photography.
Style: Exhibits conceptualism, minimalism, pattern painting, hard-edge geometric abstraction, painterly abstraction and realism. Genres include landscapes and figurative work. Prefers geometric abstraction, abstraction and figurative/landscape.
Terms: Retail price set by gallery and artist.
Submissions: Send query letter with photographs and reviews. Write for appointment to show portfolio of transparencies. Replies only if interested. Files bio and slides. Finds artists through referrals by artists, visiting exhibitions.

THE WING GALLERY, 13520 Ventura Blvd., Sherman Oaks CA 91423. (818)981-WING and (800)422-WING. Fax: (818)981-ARTS. Director: Robin Wing. Retail gallery. Estab. 1974. Represents 100 + emerging, mid-career and established artists. Exhibited artists include Doolittle and Wysocki. Sponsors 6 shows/year. Average display time 2 weeks-3 months. Open all year. Located on a main boulvard in a charming freestanding building, separate rooms, hardwood floors/carpet, skylights; separate frame design area. 80% of space for special exhibitions. Clientele: 90% private collectors, 10% corporate collectors. Overall price range: $50-50,000; most work sold at $150-5,000.
Media: Considers oil, acrylic, watercolor, pen & ink, drawings, sculpture, ceramic, craft, glass, original handpulled prints, offset reproductions, engravings, lithographs, monoprints and serigraphs. Most frequently exhibits offset reproductions, watercolor and sculpture.
Style: Exhibits primitivism, impressionism, realism and photorealism. Genres include landscapes, Americana, Southwestern, Western, wildlife and fantasy.
Terms: Accepts work on consignment (40-50% commission). Retail price set by gallery and artist. Sometimes offers customer discounts and payment by installments. Gallery provides insurance, promotion and contract; shipping costs are shared. Prefers unframed artwork.
Submissions: Send query letter with résumé, slides, bio, brochure, photographs, SASE, reviews and price list. "Send complete information with your work regarding price, size, medium, etc., and make an appointment before dropping by." Portfolio reviews requested if interested in artist's work. Replies in 1-2 months. Files current information and slides. Finds artists through agents, by visiting exhibitions, word of mouth, various publications, submissions, and referrals.
Tips: Artists should have a "professional presentation" and "consistent quality."

‡**LEE YOUNGMAN GALLERIES**, (formerly Donlee Gallery of Fine Art), 1316 Lincoln Ave., Calistoga CA 94515. (707)942-0585. Fax: (707)942-6657. Also has location at 2933 Grand Ave., Los Olivos CA 93441. (805)686-1088. Owner: Ms. Lee Love Youngman. Retail gallery. Estab. 1985. Represents 40 established artists. Exhibited artists include Ralph Love and Paul Youngman. Sponsors 3 shows/year. Average

display time 2 months. Open all year. Located downtown; 3,000 sq. ft.; "warm Southwest decor, somewhat rustic." Clientele: 100% private collectors. Overall price range: $500-24,000; most artwork sold at $1,000-3,500.

Media: Considers oil, acrylic, watercolor and sculpture. Most frequently exhibits oils, bronzes and alabaster.
Style: Exhibits impressionism and realism. Genres include landscapes, Southwestern, Western and wildlife. Interested in seeing American realism. No abstract art.
Terms: Accepts work on consignment (50% commission). Retail price set by gallery. Customer discounts and payment by installment are available. Gallery provides insurance and promotion. Artist pays for shipping to and from gallery. Prefers framed artwork.
Submissions: Accepts only artists from Western states. "No unsolicited portfolios." Portfolio review requested if interested in artist's work. The most common mistake artists make is coming on weekends, the busiest time, and expecting full attention. Finds artists through publication, submissions and owner's knowledge.
Tips: "Don't just drop in—make an appointment. No agents."

Los Angeles

SHERRY FRUMKIN GALLERY, 2525 Michigan Ave., #T-1, Santa Monica CA 90404-4011. (310)453-1850. Fax: (310)453-8370. Retail gallery. Estab. 1990. Represents 20 emerging, mid-career and established artists. Interested in seeing the work of emerging artists. Exhibited artists include Ron Pippin, David Gilhooly and James Strombotne. Sponsors 11 shows/year. Average display time 1 month. Open all year; Tuesday-Saturday, 10:30-5:30. Located in the Bergamot Station Arts Center; 3,000 sq. ft. in converted warehouse with 16 ft. ceilings, skylights. 25% of space for special exhibitions; 75% of space for gallery artists. Clientele: upscale, creative arts, i.e. directors, actors, producers. 80% private collectors, 20% corporate collectors. Overall price range: $1,000-25,000; most work sold at $2,000-5,000.
Media: Considers oil, acrylic, mixed media, collage, pen & ink, sculpture, ceramic and installation. Most frequently exhibits assemblage sculpture, paintings and photography.
Style: Exhibits expressionism, neo-expressionism, conceptualism, painterly abstraction and postmodern works. Prefers expressionism, painterly abstraction and postmodern.
Terms: Accepts work on consignment (50% commission). Retail price set by gallery and artist. Offers payment by installments. Gallery provides insurance and promotion. Prefers artwork framed.
Submissions: Send query letter with résumé, slides, reviews and SASE. Portfolio review requested if interested in artist's work. Portfolio should include slides and transparencies. Replies in 1 month. Files résumé and slides.
Tips: "Present a coherent body of work, neatly and professionally presented. Follow up, but do not become a nuisance."

‡**GALLERY 825, LA Art Association**, 825 N. La Cienega Blvd., Los Angeles CA 90069. (310)652-8272. Fax: (310)652-9251. Contact: Amy Perez. Nonprofit gallery. Estab. 1925. Exhibits emerging, mid-career and established artists. "Artists must be local LA residents." Interested in seeing the work of emerging artists. Approximately 300 members. Sponsors 10 shows/year. Average display time 4-5 weeks. Open all year; Tuesday-Saturday, 12-5. Located in Beverly Hills/West Hollywood. 25% of space for special exhibitions (2 small rooms); 75% for gallery artists (2 large main galleries). Clientele: set decorators, interior decorators, general public. 90% private collectors.
Media: Considers all media and original handpulled prints. "All serious work. No crafts." Most frequently exhibits mixed media, oil/acrylic and watercolor.
Style: All styles. Prefers painterly abstraction and impressionism.
Terms: Requires $75 annual membership fee plus entry fees. Retail price set by artist. Gallery provides promotion. "No shipping allowed." Accepts only artists from LA area. "Artists must apply via jury process held at the gallery 2 times per year." Phone for information.
Tips: "No commercial work (e.g. portraits/advertisements)."

LIZARDI/HARP GALLERY, 8678 Melrose Ave., Los Angeles CA 90069. (310)358-5680. Fax: (310)358-5683. Director: Grady Harp. Retail gallery and art consultancy. Estab. 1981. Represents 15 emerging, mid-career and established artists/year. Exhibited artists include Christopher James, Christopher Piazza, Stephen Freedman, Kirk Pedersen, Don Bachardy, Stephen De Staebler, Stephen Douglas, Ed Musante, John O'Brien and Jan Saether. Sponsors 9 shows/year. Average display time 1 month. Open all year; Tuesday-Saturday. 80% private collectors, 20% corporate collectors. Overall price range: $900-80,000; most work sold at $2,000-15,000.
Media: Considers oil, acrylic, watercolor, pastel, pen & ink, drawing, mixed media, sculpture, installation, photography, woodcuts, lithographs, serigraphs and etchings. Most frequently exhibits works on paper and canvas, sculpture, photography.

Style: Exhibits expressionism, abstraction, postmodern works, photorealism and realism. Genres include landscapes, figurative work, all genres. Prefers figurative, landscapes and experimental.
Terms: Accepts work on consignment (50% commission). Retail price set by the gallery and the artist. Gallery provides insurance, promotion, contract and shipping costs from gallery; artist pays shipping costs to gallery.
Submissions: Send query letter with résumé, slides, bio, photographs, SASE and reviews. Write for appointment to show portfolio of photographs, slides and transparencies. Replies in 3-4 weeks. Files "all interesting applications." Finds artists through studio visits, group shows, submissions.
Tips: "Timelessness of message is a plus (rather than trendy). Our emphasis is on quality or craftsmanship, evidence of originality . . . and maturity of business relationship concept."

OTIS COLLEGE OF ART AND DESIGN GALLERY, (formerly Otis Gallery), 2401 Wilshire Blvd., Los Angeles CA 90057. (213)251-0555. Fax: (213)480-0059. Director: Dr. Anne Ayres. Nonprofit college gallery. Represents/exhibits 10-50 emerging and mid-career artists/year. Sponsors 4 shows/year. Average display time 2 months. Open fall, winter, spring—sometimes summer; Tuesday-Saturday, 10-5. Located just west of downtown Los Angeles; 3,000 sq. ft.; 14' ceiling. 100% of space devoted to special exhibitions by gallery artists. Clientele: all types. Work is exhibited, not sold.
Media: Considers all media and all types of prints. Most frequently exhibits painting, sculpture and media.
Style: Exhibits conceptualism all styles. Prefers contemporary.
Terms: Gallery provides insurance, promotion, contract and shipping costs.
Submissions: Send query letter with résumé, up to 20 35mm slides and SASE. Finds artists through word of mouth, studio visits and attending other exhibitions.
Tips: "Have patience."

VICTOR SALMONES SCULPTURE GARDEN, 433 N. Camden Dr., Suite 1200, Beverly Hills CA 90210. (310)271-1297. Fax: (310)205-2088. Vice President: Travis Hansson. Retail and wholesale gallery. Estab. 1962. Represents 4 established artists/year. Interested in seeing the work of emerging artists. Exhibited artists include Victor Salmones, Robert Toll. Sponsors 3 shows/year. Average display time 3 months. Open all year; Monday-Saturday, 10-5. Space is 20,000 sq. ft.; very architectural—showing mainly large sculpture. 100% of space for gallery artists. Clientele: corporate and private. 90% private collectors, 10% corporate collectors. Overall price range: $15,000-250,000; most work sold at $15,000-50,000.
Media: Considers sculpture only. Most frequently exhibits bronze, stones, steel.
Style: Exhibits all styles, all genres; prefers figurative work and cubism.
Terms: Retail price set by the gallery. Gallery provides insurance, promotion and contract. Shipping costs are shared.
Submissions: Send query letter with bio and photographs. Write for appointment to show portfolio of photographs. Replies only if interested within 1 week. Files only photos. Finds artists through agents, by visiting exhibitions, word of mouth, various art publications and sourcebooks, submissions.

SYLVIA WHITE CONTEMPORARY ARTISTS' SERVICES, 2022 B Broadway, Santa Monica CA 90404. (310)828-6200. Owner: Sylvia White. Retail gallery, art consultancy and artist's career development services. Estab. 1979. Represents 20 emerging, mid-career and established artists. Interested in seeing work of emerging artists. Exhibited artists include Martin Mull, John White. Sponsors 12 shows/year. Average display time 1 month. Open all year; Tuesday-Saturday, 11-6. Located in downtown Santa Monica; 2,000 sq. ft.; 100% of space for special exhibitions. Clientele: upscale. 50% private collectors, 50% corporate collectors. Overall price range: $1,000-10,000; most work sold at $3,000.
 • Sylvia White also has a location in Soho in New York City, see listing in New York section.
Media: Considers all media, including photography. Most frequently exhibits painting and sculpture.
Style: Exhibits all styles, including painterly abstraction and conceptualism.
Terms: Retail price set by gallery and artist. Gallery provides insurance, promotion and contract. Artist pays for shipping costs.
Submissions: Send query letter with résumé, slides, bio and SASE. Portfolio should include slides.

San Francisco

J.J. BROOKINGS GALLERY, 669 Mission St., San Francisco CA 94025. (415)546-1000. Director: Timothy Duran. Retail gallery. Estab. 1970. Of artists represented 15% are emerging, 25% are mid-career and 60% are established. Exhibited artists include Ansel Adams, Robert Motherwell, Ben Shomzeit, Donald Sultan, Richard Diebenkorn, Ed Baynard, Misha Grodin, Mac Whitney, Lee Tribe, Sandy Skoglund and James Crable. Sponsors 10-12 shows/year. Average display time 40 days in rotation. Open all year; Tuesday-Sunday, 10-6. Located next to San Francisco MOMA and Moscone Center; 7,500 sq. ft.; 60% of space for special exhibitions. Clientele: collectors and private art consultants. 60% private collectors, 10% corporate collectors, 30% private art consultants. Overall price range: $500-40,000; most work sold at $2,000-8,000.

Media: Considers oil, acrylic, sculpture, watercolor, mixed media, pastel, collage, photography, original handpulled prints, woodcuts, wood engravings, linocuts, engravings, mezzotints, etchings, lithographs and serigraphs. Most frequently exhibits high-quality paintings, prints, sculpture and photography.
Style: Exhibits expressionism, conceptualism, photorealism, minimalism, painterly abstraction, realism and surrealism. Genres include landscapes, florals, figurative work and city scapes.
Terms: Retail price set by gallery and artist. Gallery provides insurance, promotion, contract and shipping costs from gallery; artist pays for shipping costs to gallery.
Submissions: Prefers "intellectually mature artists who know quality and who are professional in their creative and business dealings. Artists can no longer be temperamental." Send query letter with résumé, slides, bio, brochure, photographs, SASE, business card and reviews. Replies if interested within 2-3 months; if not interested, replies in a few days.
Tips: "Have a well thought-out presentation that shows consistent work and/or consistent development over a period of time. Must have a minimum of 20 slides and perferably 20 current slides."

EBERT GALLERY, 49 Geart St., San Francisco CA 94108. (415)296-8405. Owner: Dick Ebert. Retail gallery. Estab. 1989. Represents 24 established artists "from this area." Interested in seeing the work of emerging artists. Exhibited artists include Jerrold Ballaine, Boyd Allen. Sponsors 11-12 shows/year. Average display time 1 month. Open all year; Tuesday-Friday, 10:30-5:30; Saturday, 11-5. Located downtown near bay area; 1,200 sq. ft.; one large room which can be divided for group shows. 85% of space for special exhibitions; 15% of space for gallery artists. Clientele: collectors, tourists, art students. 80% private collectors. Overall price range: $500-20,000; most work sold at $500-8,000.
Media: Considers oil, acrylic, watercolor, pastel, pen & ink, drawing, mixed media, collage, paper, sculpture, glass, photography, woodcuts, engravings, mezzotints, etchings and encostic. Most frequently exhibits acrylic, oils and pastels.
Style: Exhibits expressionism, painterly abstraction, impressionism and realism. Genres include landscapes, figurative work, all genres. Prefers landscapes, abstract, realism.
Terms: Accepts work on consignment (50% commission). Retail price set by the artist. Gallery provides promotion. Shipping costs are shared. Prefers artwork framed.
Submissions: San Francisco Bay Area artists only. Send query letter with résumé and slides. "We call the artist after slide and résumé review." Portfolio should include originals and slides. Replies in a few weeks. Finds artists through referral by professors or stable artists.

THE LAB, 2948 16th St., San Francisco CA 94103. (415)864-8855. Website: http://www.igc.apc.org/femact art/FAALab.html. Assistant Director: Zoey Kroll. Nonprofit gallery and alternative space. Estab. 1983. Represents/exhibits 13 emerging, mid-career artists/year. Interested in seeing the work of emerging artists. Sponsors 7 shows/year. Average display time 1 month. Open all year; Wednesday-Saturday, 12-5. 40×55'; 17' height; 2,200 sq. ft.; white walls. Doubles as a performance and gallery space. Clientele: artists and Bay Area communities.
• The LAB often curates panel discussions, performances or other special events in conjunction with exhibitions. They also sponsor an annual conference and exhibition on feminist activism and art.
Media: Considers all media with emphasis on interdisciplinary and experimental art. Most frequently exhibits installation art, interdisciplinary art, media art and group exhibitions.
Terms: Artists receive honorarium from the art space. Work can be sold, but that is not the emphasis.
Submissions: Send SASE for submission guidelines. Finds artists through word of mouth, submissions, calls for proposals.
Tips: Ask to be put on their mailing list to get a sense of the LAB's curatorial approach and interests.

MUSEUM WEST FINE ARTS & FRAMING, INC., 170 Minna, San Francisco CA 94105. (415)546-1113. Retail gallery. Represents/exhibits 14 emerging artists/year. Sponsors 8-11 shows/year. Average display time 3 weeks. Open all year; Monday-Saturday. Located downtown next to San Francisco Museum of Modern Art; 3,500 sq. ft.; 30% of space for special exhibitions. Clientele: upscale tourists, art consultants, sophisticated corporate buyers, collectors. Overall price range: $150-1,200; most work sold at $400-1,000.
Media: Considers all media except very large works under 4 ft.×4 ft. Considers oil, acrylic, watercolor, mixed media, pastel, collage, photography, original hand-pulled prints, woodcuts, wood engravings, linocuts, engravings, mezzotints, etchings, lithographs and serigraphs. Considers all types of prints. Most frequently exhibits hand-colored prints—small editions, photography, paintings and collage.
Style: Exhibits expressionism, painterly abstraction, impressionism, photorealism, pattern painting and realism. Genres include florals, landscapes, figurative work and cityscapes. Prefers colorful still lifes, San Francisco Bay imagery and landscapes.
Terms: Artwork is accepted on consignment (50% commission). Retail price set by the gallery and artist. Gallery provides insurance, promotion and contract; shipping costs are shared or negotiated.
Submissions: No sexually explicit or politically-oriented art. Send query letter with résumé, slidesheet, bio, brochure, photographs, SASE, business card and and reviews. Write for appointment to show portfolio of photographs, slides and transparencies. Replies in 3-5 weeks. Files all material if interested. Finds artists through open studios, mailings, referrals by other artists and collectors.

SAN FRANCISCO ART COMMISSION GALLERY & SLIDE REGISTRY, 401 Van Ness, Civic Center, San Francisco CA 94102. (415)554-6080. Fax: (415)252-2595. E-mail: sfacgallery@sfpl.lib.ca.us. Director: Rupert Jenkins. Nonprofit municipal gallery; alternative space. Estab. 1983. Exhibits work of approximately 150 emerging and mid-career artists/year; 400-500 in Slide Registry. Sponsors 7 indoor group shows/year; 3 outdoor site installations/year. Average display time 5 weeks (indoor); 3 months (outdoor installations) Open all year. Located at the Civic Center; 1,000 sq. ft. (indoor), 4,500 sq. ft. (outdoor); City Site lot across the street from City Hall and in the heart of the city's performing arts complex. 100% of space for special exhibitions. Clientele: cross section of San Francisco/Bay Area including tourists, upscale, local and students. Sales are minimal.

- A newly renovated exhibition space opened in January, '96. The program continues with window installations, site specific projects, the Artists' Slide Registry, artists' talks and special projects.

Media: Considers all media. Most frequently exhibits installation, mixed media and sculpture/3-D, painting, photography.

Style: Exhibits all styles. Prefers cutting-edge, contemporary works.

Terms: Accepts artwork on consignment (20% commission). Retail price set by artist. Gallery provides insurance, promotion and contract; artist pays for shipping.

Submissions: Accepts only artists residing in one of nine Bay Area counties. Write for guidelines to join the slide registry to automatically receive calls for proposals and other exhibition information. Do not send unsolicited slides.

Tips: "The Art Commission Gallery serves as a forum for exhibitions which reflect the aesthetic and cultural diversity of contemporary art in the Bay Area. Temporary installations in the outdoor lot adjacent to the gallery explore alternatives to traditional modes of public art. Gallery does not promote sale of art, as such, but will handle sale of available work if a visitor wishes to purchase it. Exhibit themes, artists, and selected works are recommended by the Gallery Director to the San Francisco Art Commission for approval. Gallery operates for the benefit of the public as well as the artists. It is not a commercial venue for art."

Colorado

CORE NEW ART SPACE, 1412 Wazee St., Denver CO 80202. (303)571-4831. Coordinator: Tracy Weil. Cooperative, alternative and nonprofit gallery. Estab. 1981. Exhibits 30 emerging and mid-career artists. Sponsors 30 solo and 6-10 group shows/year. Average display time: 2 weeks. Open Thursday-Sunday. Open all year. Located "in lower downtown, former warehouse area; 3,400 sq. ft.; large windows, hardwood floor, and high ceilings." Accepts mostly artists from front range Colorado. Clientele: 97% private collectors; 3% corporate clients. Overall price range: $75-3,000; most work sold at $100-600.

Media: Considers all media. Specializes in cutting edge work. Prefers quality rather than marketability.

Style: Exhibits expressionism, neo-expressionism, painterly abstraction, conceptualism; considers all styles and genres, but especially contemporary and alternative (non-traditional media and approach).

Terms: Co-op membership fee plus donation of time. Retail price set by artist. Exclusive area representation not required.

Submissions: Send query letter with SASE. Quarterly auditions to show portfolio of originals, slides and photographs. Request membership or associate membership application. "Our gallery gives an opportunity for emerging artists in the metro-Denver area to show their work. We run four to six open juried shows a year. There is an entry fee charged, but no commission is taken on any work sold. The member artists exhibit in a one-person show once a year. Member artists generally work in more avant-garde formats, and the gallery encourages experimentation. Members are chosen by slide review and personal interviews. Due to time commitments we require that they live and work in the area. There is a yearly Associate Members Show." Finds artists through invitations, word of mouth, art publications.

Tips: "We want to see challenging art. If your intention is to manufacture coffee-table and over-the-couch art for suburbia, we are not a good place to start."

‡SUSAN DUVAL GALLERY, 525 E. Cooper Ave., Aspen CO 81611. (970)925-9044. Fax: (970)925-9046. Owner: Susan Duval. Retail gallery. Estab. 1978. Represents 30 mid-career and established artists/year. Exhibited artists include: Dale Chihuly and Theodore Waddell. Sponsors 5 shows/year. Average display time 3 weeks. Open all year; Monday-Saturday, 10-6. Located downtown; 2,500 sq. ft.; open plan, many windows. 60% of space for special exhibitions; 40% of space for gallery artists. Clientele: tourists, upscale, local community. 90% private collectors, 10% corporate collectors. Overall price range: $500-50,000; most work sold at $2,000-20,000.

Media: Considers oil, paper, acrylic, sculpture, glass, mixed media, ceramics; types of prints include woodcuts and monoprints. Most frequently exhibits oil, acrylic and glass.

Style: Exhibits expressionism, painterly abstraction and realism. Exhitits all genres.

Terms: Accepts work on consignment (50% commission). Retail price set by the artist. Gallery provides promotion and pays for shipping from gallery; artist pays for shipping to gallery.

Submissions: Send query letter with résumé, slides, photographs, reviews, bio and SASE. Write for appointment to show portfolio of photographs and slides. Finds artists through referrals by other artists and visiting art fairs and exhibitions.

‡FOOTHILLS ART CENTER, 809 15th St., Golden CO 80401. (303)279-3922. Fax: (303)279-9470. Executive Director: Carol Dickinson. Nonprofit gallery. Estab. 1968. Represents up to 600 established artists/ year. Sponsors 9 shows/year. Average display time 6 weeks. Open all year; daily (except major holidays); Monday-Saturday, 9-4; Sunday, 1-4. Located downtown; 5 self-contained spaces (under one roof) 2,232 sq. ft. "We are housed in a National Historic Register building of classic Gothic/Victorian design—a church linked to a parsonage and remodeled into modern gallery interior spaces." 100% of space for special exhibitions. 90% private collectors, 10% corporate collectors. Overall price range: $100-30,000; most work sold at $1,500-2,000. Foothill's director urges artists to call or write for prospecti on how to enter their two yearly national shows.
Media: Considers all media and all types of prints (size limitations on sculpture). Most frequently exhibits watermedia and mixed media, sculpture and clay.
Style: Exhibits all genres. Prefers figurative, realism, impressionism and contemporary-experimental.
Terms: Accepts work on consignment (35% commission). Retail price set by the artist. Gallery provides insurance, promotion and contract; shipping costs are shared. Prefers artwork framed.
Submissions: "The exhibition schedule offers opportunities to nationwide artists primarily through the annual North American Sculpture Exhibition (May/June—competitive, juried, catalog, $10,000 in awards) and the annual Rocky Mountain National Watermedia Exhibition (August/September; juried, slide entries and small fee required, $10,000 in awards, catalog published)."
Tips: "Artists often include too much variety when multiple slides are submitted, with the result that jurors are unable to discern a recognizable style or approach, or artists submit poor photography or slides."

PINE CREEK ART GALLERY, 2419 W. Colorado Ave., Colorado Springs CO 80904. (719)633-6767. Owner: Nancy Anderson. Retail gallery. Estab. 1991. Represents 10+ emerging, mid-career and established artists. Exhibited artists include Kirby Sattler, Chuck Mardosz and Don Grzybowski. Sponsors 4 shows/year. Average display time 1 month. Open all year. 2,200 sq. ft.; in a National Historic District. 30% of space for special exhibitions. Clientele: middle to upper income. Overall price range: $30-5,000; most work sold at $100-500.
Media: Considers most media, including bronze, pottery and all types of prints.
Style: Exhibits all styles and genres.
Terms: Accepts artwork on consignment (40% commission). Retail price set by gallery and artist. Gallery provides insurance, promotion and shipping costs from gallery. Prefers artwork "with quality frame only."
Submissions: No fantasy or abstract art. Prefer experienced artists only—no beginners. Send query letter with slides and photographs. Call or write for appointment to show portfolio or originals, photographs, slides and tearsheets. Replies in 2 weeks.
Tips: "We like to include a good variety of work, so show us more than one or two pieces."

‡ROBISCHON GALLERY, 1740 Wazee St., Denver CO 80202. (303)298-7788. Fax: (303)298-7799. Retail gallery, art consultancy. Estab. 1976. Represents 70 emerging, mid-career and established artists/year. Exhibited artists include: Manuel Neri, John Buck. Sponsors 7-8 shows/year. Average display time 5-6 weeks. Open all year; Tuesday-Friday, 10-6, Saturday, 11-5; Monday and evenings by appointment. Located in historic lower downtown; 2,000 sq. ft.; original carriage house for the historic Oxford Hotel across from Union Station. It has historic building status. 50% of space for special exhibitions; 25% of space for gallery artists. 50% private collectors, 50% corporate collectors. Overall price range: $100-40,000; most work sold at $1,000-5,000.
Media: Considers all media and all types of prints. Most frequently exhibits painted works/on canvas or panel, wood or bronze sculpture.
Style: Exhibits: expressionism, neo-expressionism, primitivism, painterly abstraction, surrealism, conceptualism, minimalism, postmodern works, realism, imagism. Exhibits all genres. Prefers representational, abstract, symbolism.
Terms: Accepts work on consignment (negotiable commission). Retail price set by the gallery and the artist. Gallery provides insurance and promotion; shipping costs are shared.
Submissions: Send query letter with résumé, slides, bio, brochure, photographs, SASE, reviews, artist's statement. Write for appointment to show portfolio of photographs, slides, transparencies, résumé, statement, reviews if available. Replies in 4-6 weeks.

SANGRE DE CRISTO ARTS AND CONFERENCE CENTER, 210 N. Santa Fe Ave., Pueblo CO 81003. (719)543-0130. Curator of Visual Arts: Jennifer Cook. Nonprofit gallery and museum. Estab. 1972. Exhibits emerging, mid-career and established artists. Sponsors 25-30 shows/year. Average display time 2 months. Open all year. Located "downtown, right off Interstate I-25"; 7,500 sq. ft.; four galleries, one showing a permanent collection of Western art; changing exhibits in the other three. Also a children's museum with changing, interactive exhibits. Clientele: "We serve a 19-county region and attract 200,000 visitors

yearly. Most art exhibits are not for sale; however, when they are for sale, anyone can buy." Overall price range: $50-100,000; most work sold at $50-13,000.

Media: Considers all media.

Style: Exhibits all styles. Genres include Southwestern.

Terms: Accepts work on consignment (30% commission). Retail price set by artist. Gallery provides insurance, promotion, contract and shipping costs. Prefers artwork framed.

Submissions: "There are no restrictions, but our exhibits are booked into 1997 right now." Send query letter with slides. Write or call for appointment to show portfolio of slides. Replies in 2 months.

PHILIP J. STEELE GALLERY AT ROCKY MOUNTAIN COLLEGE OF ART & DESIGN, 6875 E. Evans Ave., Denver CO 80224. (303)753-6046. Fax: (303)759-4970. Gallery Director: Deborah Horner. Nonprofit college gallery. Estab. 1962. Represents emerging, mid-career and established artists. Sponsors 10-12 shows/year. Exhibited artists include Christo, Jenny Holzer. Average display time 3 weeks. Open all year; Monday-Friday, 8-6; Saturday, 9-4. Located in southeast Denver; 600 sq. ft.; in very prominent location (art college with 350 students enrolled). 100% of space for gallery artists. Clientele: local community, students, faculty.

Media: Considers all media and all types of prints. Most frequently exhibits mixed media, oil/acrylic and work on paper.

Style: Exhibits all styles.

Terms: Artists sell directly to buyer; gallery takes no commission. Retail price set by the artist. Gallery provides insurance and promotion; artist pays shipping costs to and from gallery.

Submissions: Send query letter with résumé, slides, bio, SASE and reviews. Write for appointment to show portfolio of slides. Replies only if interested within 2 weeks.

Tips: Impressed by "professional presentation of materials, good-quality slides or catalog."

‡TREASURE ALLEY, (formerly Carriage House Galleries), 514 San Juan, Alanosa CO 81101-2326. Partners: Carol Demlo and Melody Johnson. Retail gallery and specialty gift shop. Estab. 1995. Represents regional artwork. Open all year. Located in the southern Rocky Mountains in the hub of the San Luis Valley; gallery includes a historic walk-in vault. Overall price range: $40-400.

Media: Considers oil, acrylic, watercolor, pastel, pen & ink, drawings, mixed media, works on paper, sculpture, ceramic, glass posters, linocuts and etchings. Most frequently exhibits watercolor, oil, ceramics and pastels.

Style: Genres include landscapes, florals, Southwestern subjects and still lifes. Prefers realism, impressionism and color field.

Terms: Accepts work on consignment (35% commission). Retail price set by gallery. Customer discounts and payment by installment available. Gallery provides insurance and promotion; artist pays for shipping. Prefers artwork framed.

Submissions: Send query letter with résumé, slides, brochure, photographs and SASE for return. Finds artists through visiting exhibitions and referrals.

‡WHITE HORSE GALLERY, 1218 Pearl St., Boulder CO 80302. (303)443-6116. Fax: (303)443-9966. Director: Rene Jans. Retail gallery. Estab. 1980. Represents 8 emerging, mid-career and established artists/year. Interested in seeing the work of emerging artists. Exhibited artists include Diane Dandeneau, Robert Arnold, Lila Hahn. Sponsors 3-4 shows/year. Average display time 6 months. Open all year; Monday-Saturday, 10-9; Sunday, 12-6. Located on the Pearl St. Pedestrian Mall; 750 sq. ft. "turn-of-the-century building with wonderful old Indian artifacts on display." 100% of space for special exhibitions; 100% of space for gallery artists. Clientele: Western and Indian art collectors. 75% private collectors, 25% corporate collectors. Overall price range: $60-2,000; most work sold at $60-1,500.

Media: Considers all media, all types of print.

Style: Exhibits expressionism, impressionism and realism. Genres include landscapes, Southwestern and Western. Prefers Southwestern, landscape and Western.

Terms: Accepts work on consignment (40% commission). Retail price set by the artist. Gallery provides promotion and shipping costs from gallery; artist pays shipping costs to gallery. Prefers artwork framed.

Submissions: Prefers only Indian or Southwestern subject matter. Send query letter with résumé, slides or photographs and bio. Call for appointment to show portfolio of originals or photographs. Replies in one week. Files bios. Finds artists through attending Indian markets, submissions.

ALWAYS ENCLOSE a self-addressed, stamped envelope (SASE) with queries and sample packages.

Connecticut

MONA BERMAN FINE ARTS, 78 Lyon St., New Haven CT 06511. (203)562-4720. Fax: (203)787-6855. Director: Mona Berman. Art consultancy. Estab. 1979. Represents 50 emerging and mid-career artists. Exhibited artists include David Dunlop, Will McCarthy and S. Wind-Greenbain. Sponsors 1 show/year. Open all year. Located near downtown; 1,000 sq. ft. Clientele: 5% private collectors, 95% coporate collectors. Overall price range: $200-20,000; most artwork sold at $500-5,000.
Media: Considers all media except installation. Considers all limited edition prints except posters and photolithography. Most frequently exhibits works on paper, painting, relief and ethnographic arts.
Style: Exhibits most styles. Prefers abstract, landscape and transitional. No figurative, little still life.
Terms: Accepts work on consignment (50% commission) (net 30 days). Retail price is set by gallery and artist. Customer discounts and payment by installment are available. Gallery provides insurance; artist pays for shipping. Prefers artwork unframed.
Submissions: Send query letter, résumé, "plenty of slides," bio, SASE, reviews and "price list—retail only at stated commission." Portfolios are reviewed only after slide submission. Replies in 1 month. Slides and reply returned only if SASE is included. Finds artists through word of mouth, art publications and sourcebooks, submissions and self-promotions and other professionals' recommendations.
Tips: "Please understand that we are not a gallery, although we do a few exhibits. We are primarily art consultants. We continue to be busy selling high-quality art and related services."

‡**BROOKFIELD CRAFT CENTER GALLERY**, 286 Whisconier Rd., Route 25, Brookfield CT 06804. (203)775-4526. E-mail: brkfldcrft@aol.com. Website: http://www.craftweb.com/org/brookfld/brookfld.sht ml. Retail Manager: Judith Russell. Nonprofit gallery. Estab. 1954. Exhibits the work of over 2,000 emerging, mid-career and established artists. Sponsors 6 shows/year. Average display time 6 weeks. Open all year. Located in suburban area; 1,000 sq. ft.; "housed in restored 1780 grist mill (Connecticut state landmark)." 50% of space for special exhibitions. Clientele: upscale and corporate. 10% private collectors, 5% corporate collectors. Overall price range: $5-5,000; most work sold at $25-100.
Media: Considers paper, fiber, glass, ceramic and craft. No prints or painting. Most frequently exhibits jewelry, glass and ceramics.
Style: Exhibits all contemporary styles and genres.
Terms: Accepts work on consignment (40% commission) or buys outright for 50% of retail price (net 30 days). Retail price set by artist. Gallery provides insurance, promotion and contract; shipping costs are shared. Prefer artwork framed.
Submissions: Send query letter with résumé, slides, brochure and bio. Call or write for appointment to show portfolio of originals, slides, photographs and transparencies. Replies in 2 weeks.

MARTIN CHASIN FINE ARTS, 1125 Church Hill Rd., Fairfield CT 06432. (203)374-5987. Fax: (203)372-3419. Owner: Martin Chasin. Retail gallery. Estab. 1985. Represents 40 mid-career and established artists. Interested in seeing the work of emerging artists. Exhibited artists include Katherine Ace and David Rickert. Sponsors 8 shows/year. Average display time 3 weeks. Open all year. Located downtown; 1,000-1,500 sq. ft. 50% of space for special exhibitions. Clientele: "sophisticated." 40% private collectors; 30% corporate collectors. Overall price range: $1,500-10,000; most work sold at $3,000-5,000.
Media: Considers oil, acrylic, watercolor, pastel, pen & ink, drawings, paper, woodcuts, wood engravings, linocuts, engravings, mezzotints, etchings, lithographs, pochoir and serigraphs. "No sculpture." Most frequently exhibits oil on canvas, etchings/engravings and pastel.
Style: Exhibits expressionism, neo-expressionism, color field, impressionism and realism. Genres include landscapes, Americana, portraits. Prefers landscapes, seascapes and ships/boating scenes. Particularly interested in realistic art.
Terms: Accepts work on consignment (30-50% commission). Retail price set by artist. Offers payment by installments. Gallery provides insurance, promotion and shipping costs from gallery. Prefers artwork unframed.
Submissions: Send query letter with résumé, slides, bio, price list and SASE. Call or write for appointment to show portfolio of slides and photographs. Replies in 3 weeks. Files future sales material. Finds artists through exhibitions, "by artists who write to me and send good slides or transparencies. Send at least 10-15 slides showing all genres of art you produce. Omit publicity sheets and sending too much material."
Tips: "The art scene is less far-out, fewer avant-garde works are being sold. Clients want artists with a solid reputation."

CONTRACT ART, INC., P.O. Box 520, Essex CT 06426. (203)767-0113. Fax: (203)767-7247. Senior Project Manager: Victoria Taylor. "We contract artwork for blue-chip businesses, including Disney, Royal Caribbean Cruise Lines and Raddison." Represents emerging, mid-career and established artists. Approached by hundreds of artists/year. Assigns work to freelance artists based on client needs and preferences. Showroom is open all year to corporate art directors and designers. 1,600 sq. ft.; Clientele: 98% commercial. Overall price range: $500-15,000.

Media: Considers all media and all types of prints. Frequently contracts murals.

Style: Uses artists for brochure design, illustration and layout, model making and posters. Exhibits all styles and genres.

Terms: Pays for design by the project, negotiable; 50% up front. Prefers artwork unframed. Rights purchased vary according to project.

Submissions: Send query letter with résumé, slides, bio, brochure, photographs and SASE. If local, write for appointment to show portfolio; otherwise, mail appropriate materials, which should include slides and photographs. "Show us a good range of what you can do. Also, keep us updated if you've changed styles or media." Replies in 1 week. Files all samples and information in registry.

Tips: "We exist mainly to solicit commissioned artwork for specific projects."

FARMINGTON VALLEY ARTS CENTER'S FISHER GALLERY, 25 Arts Center Lane, Avon CT 06001. (203)678-1867. Manager: Sally Bloomberg. Nonprofit gallery. Estab. 1972. Exhibits the work of 300 emerging, mid-career and established artists. Exhibited artists include Kerr Grabowski and Randall Darwall. Sponsors 5 shows/year. Average display time 2-3 months. Open all year; Wednesday-Saturday, 11-5; Sunday, 12-4; extended hours November-December. Located in Avon Park North just off Route 44; 600 sq. ft.; "in 19th-century brownstone factory building once used for manufacturing." 25% of space for special exhibitions. Clientele: upscale contemporary craft buyers. Overall price range: $100-1,000; most work sold at $100-300.

Media: Considers "primarily crafts," also considers some mixed media, works on paper, ceramic, fiber, glass and small size prints. Most frequently exhibits jewelry, ceramics and fiber.

Style: Exhibits all styles, including craft.

Terms: Accepts artwork on consignment (40% commission). Retail price set by the artist. Gallery provides promotion and contract; shipping costs are shared. Prefers artwork framed.

Submissions: Send query letter with résumé, slides, brochure, photographs, SASE and reviews. Write for appointment to show portfolio of slides and transparencies. Replies only if interested within 2 months. Files a slide or photo, résumé and brochure.

‡ISOA GALLERY, P.O. Box 216, Greenwich CT 06831. (203)622-6434. President: Phyllis Schreiber. Retail gallery. Estab. 1981. Represents established artists. May be interested in seeing the work of emerging artists in the future. Exhibited artists include Alexandra Exter and Paul Dohanos. Average display time 2 months. Open all year by appointment only. 50% private collectors, 50% corporate collectors.

Media: Considers all media except craft, installation and photography. Most frequently exhibits oil, sculpture and mixed media.

Style: Exhibits Russian avant-garde and Russian contemporary.

Terms: Accepts work on consignment. Retail price set by the gallery. Gallery provides insurance, promotion and contract; artist pays shipping costs. Prefers artwork framed.

Submissions: Send query letter with résumé, slides and bio. Write for appointment to show portfolio, résumé and slides.

‡SILVERMINE GALLERY, 1037 Silvermine Rd., New Canaan CT 06840. (203)966-5617. Fax: (203)966-2763. Director: Philip Heilman. Nonprofit gallery. Estab. 1922. Represents 268 emerging, mid-career and established artists/year. Sponsors 20 shows/year. Average display time 1 month. Open all year; Tuesday-Saturday, 11-5; Sunday, 1-5. 5,000 sq. ft. 95% of space for gallery artists. Clientele: tourist, upscale. 40% private collectors, 10% corporate collectors. Overall price range: $250-10,000; most work sold at $1,000-2,000.

Media: Considers all media and all types of prints. Most frequently exhibits paintings, sculpture and ceramics.

Style: Exhibits all styles.

Terms: Accepts work on consignment (50% commission). Co-op membership fee plus donation of time (50% commission.) Retail price set by the gallery and the artist. Gallery provides insurance, promotion and contract; shipping costs are shared. Prefers artwork framed.

Submissions: Send query letter.

SMALL SPACE GALLERY, Arts Council of Greater New Haven, 70 Audubon St., New Haven CT 06511. (203)772-2788. Fax: (203)495-7111. Director: Helen Herzig. Alternative space. Estab. 1985. Interested in emerging artists. Sponsors 10 solo and group shows/year. Average display time: 1 month. Open to Arts Council artist only (Greater New Haven). Overall price range: $35-3,000.

Media: Considers all media.

Style: Exhibits all styles and genres. "The Small Space Gallery was established to provide our artist members with an opportunity to show their work. Particularly those who were just starting their careers. We're not a traditional gallery, but an alternative art space.

Terms: AAS Council requests 10% donation on sale of each piece. Retail price set by artist. Exclusive area representation not required. Gallery provides insurance (up to $10,000) and promotion.

Submissions: Send query letter with résumé, brochure, slides, photographs and bio. Call or write for appointment to show portfolio of originals, slides, transparencies and photographs. Replies only if interested. Files publicity, price lists and bio.

‡**WILDLIFE GALLERY**, 172 Bedford St., Stamford CT 06901. (203)324-6483. Fax: (203)324-6483. Director: Patrick R. Dugan. Retail gallery. Represents 72 emerging, mid-career and established artists. Exhibited artists include R. Bateman and R.T. Peterson. Sponsors 4 shows/year. Average display time 6 months. Open all year. Located downtown; 1,200 sq. ft. 30% of space for special exhibitions. Clientele: 20% private collectors, 10% corporate collectors. Overall price range: $300-10,000; most artwork sold at $500-3,000.
Media: Considers oil, acrylic, watercolor, pastel, woodcuts, wood engravings, engravings, lithographs and serigraphs. Most frequently exhibits acrylic, oil and watercolor.
Style: Prefers realism. Genres include landscapes, florals, Americana, Western, wildlife and sporting art. No "impressionism, over-priced for the quality of the art."
Terms: Accepts work on consignment (50% commission). Retail price set by gallery. Sometimes offers customer discounts and payment by installment. Gallery provides promotion and contract; shipping costs are shared. Prefers unframed artwork.
Submissions: Send query letter with photographs, bio and SASE. Write for appointment to show portfolio of originals and photographs. Replies by SASE only if interested within 2 weeks. Files all material, if interested.
Tips: "Must be work done within last six months. Don't send art that is old that you have not been able to sell." Quote prices on first mailing.

Delaware

DELAWARE ART MUSEUM ART SALES & RENTAL GALLERY, 2301 Kentmere Parkway, Wilmington DE 19806. (302)571-9590. Fax: (302)571-0220. Director, Art Sales & Rental: Alice B. Hupfel. Nonprofit retail gallery, art consultancy and rental gallery. Estab. 1975. Represents 50-100 emerging artists. Open all year; Tuesday-Saturday, 10-5. Located seven minutes from the center of Wilmington; 1,200 sq. ft.; "state-of-the-art gallery and sliding racks." Clientele: 40% private collectors; 60% corporate collectors. Overall price range: $500-8,000; most work sold at $1,500-2,500.
Media: Considers all media and all types of prints except posters and reproductions.
Style: Exhibits all styles.
Terms: Accepts artwork on consignment (20% commission). Rental fee for artwork covers 2 months. Retail price set by artist and consigning gallery. Gallery provides insurance while on premises and contract. Artist pays shipping costs. Artwork must be framed.
Submissions: "Send slides and résumé. Include price and medium.

DELAWARE CENTER FOR THE CONTEMPORARY ARTS, Dept. AGDM, 103 E. 16th St., Wilmington DE 19801. (302)656-6466. Fax: (302)656-6944. Director: Steve Lanier. Nonprofit gallery. Estab. 1979. Exhibits the work of emerging, mid-career and established artists. Sponsors 30 solo/group shows/year of both national and regional artists. Average display time is 1 month. 2,000 sq. ft.; 19 ft. ceilings. Overall price range: $50-10,000; most artwork sold at $500-1,000.
Media: Considers all media, including contemporary crafts.
Style: Exhibits contemporary, abstract, figurative, conceptual, non-representational and contemporary crafts.
Terms: Accepts work on consignment (35% commission). Retail price is set by the gallery and the artist. Exclusive area representation not required. Gallery provides insurance and promotion; shipping costs are shared.
Submissions: Send query letter, résumé, slides and/or photographs and SASE. Write for appointment to show portfolio. Seeking consistency within work as well as in presentation. Slides are filed. Submit up to 20 slides with a corresponding slide sheet describing the work (i.e. media, height by width by depth), artist's name and address on top of sheet and title of each piece in the order in which you would like them reviewed.

‡**REHOBOTH ART LEAGUE, INC.**, 12 Dodds Lane, Henlopen Acres DE 19971. (302)227-8408. Curator: Susan Steele. Nonprofit gallery; offers education in visual arts. Estab. 1938. Exhibits the work of 1,000 emerging, mid-career and established artists. Sponsors 8-10 shows/year. Average display time 3½ weeks. Open January through November. Located in a residential area just north of town; "3½ acres, rustic gardens, built in 1743; listed in the National Register of Historic Places; excellent exhibition and studio space. Regional setting attracts artists and arts advocates." 100% of space for special exhibitions. Clientele: members, artists (all media), arts advocates.
Media: Considers all media (except installation and photography) and all types of prints.
Style: Exhibits all styles and all genres.
Terms: Accepts artwork on consignment (30% commission). Retail price set by the artist. Gallery provides insurance and promotion. Artist pays for shipping. Prefers artwork framed for exhibition, unframed for browser sales.
Submissions: Send query letter with résumé, slides and bio. Write to schedule an appointment to show a portfolio, which should include appropriate samples. Replies in 6 weeks. Files bios and slides in Member's Artist Registry.

District of Columbia

‡**AARON GALLERY**, 1717 Connecticut Ave. NW, Washington DC 20009. (202)234-3311. Manager: Annette Aaron. Retail gallery and art consultancy. Estab. 1970. Represents 35 emerging, mid-career and established artists. Sponsors 10 shows/year. Average display time is 3-6 weeks. Open all year. Located on Dupont Circle; 2,000 sq. ft. Clientele: private collectors and corporations. Overall price range: $100 and up; most artwork sold at $2,000-10,000.
Media: Considers oil, acrylic, watercolor, mixed media, collage, paper, sculpture, ceramic and installation. Most frequently exhibits sculpture, paintings and works on paper.
Style: Exhibits expressionism, painterly abstraction, imagism, color field, post-modern works, impressionism, realism and photorealism. Genres include florals. Most frequently exhibits abstract expressionism, figurative expressionism and post-modern works.
Terms: Accepts work on consignment (50% commission). Retail price set by gallery and artist. Sometimes offers payment by installment. Exclusive area representation required. Gallery provides promotion and contract; artist pays for shipping.
Submissions: Send query letter, résumé, slides or photographs, reviews and SASE. Slides and photos should be labeled with complete information—dimensions, title, media, address, name and phone number. Portfolio review requested if interested in artist's work. Portfolio should include photographs and, if possible, originals. Slides, résumé and brochure are filed. Finds artists through visiting exhibitions, word of mouth, submissions, self-promotions, art collector's referrals.
Tips: "We visit many studios throughout the country."

ATLANTIC GALLERY OF GEORGETOWN, 1055 Thomas Jefferson St. NW, Washington DC 20007. (202)337-2299. Fax: (202)944-5471. Director: Virginia Smith. Retail gallery. Estab. 1976. Represents 10 mid-career and established artists. Exhibited artists include John Stobart, Tim Thompson, John Gable, Frits Goosen and Robert Johnson. Sponsors 5 solo shows/year. Average display time is 2 weeks. Open all year. Located downtown; 700 sq. ft. Clientele: 70% private collectors, 30% corporate clients. Overall price range: $100-20,000; most artwork sold at $300-5,000.
Media: Considers oil, watercolor and limited edition prints.
Style: Exhibits realism and impressionism. Prefers realistic marine art, florals, landscapes and historic narrative leads.
Terms: Accepts work on consignment (40% commission). Retail price set by gallery and artist. Exclusive area representation required. Gallery provides insurance, promotion and contract; artist pays for shipping.
Submissions: Send query letter, résumé and slides. Portfolio should include originals and slides.

‡**BIRD-IN-HAND BOOKSTORE & GALLERY**, 323 7th St. SE, Box 15258, Washington DC 20003. (202)543-0744. Fax: (202)547-6424. Director: Christopher Ackerman. Retail gallery. Estab. 1987. Represents 36 emerging artists. Exhibited artists include Susan Nees, Lise Drost and Richard Pardee. Sponsors 12 shows/year. Average display time 3½ weeks. Located on Capitol Hill at Eastern Market Metro; 300 sq. ft.; space includes small bookstore, art and architecture. "Most of our customers live in the neighborhood." Clientele: 100% private collectors. Overall price range: $75-1,650; most work sold at $75-350.
Media: Considers pen & ink, paper, drawings, sculpture, original handpulled prints, woodcuts, wood engravings, linocuts, engravings, etchings. Prefers small prints. Also places sculpture for clients' home, office and garden.
Terms: Accepts work on consignment (40% commission). Retail price set by gallery. Gallery provides insurance, promotion and contract; shipping costs are shared.
Submissions: Send query letter with résumé, slides and SASE. Write for appointment to show portfolio of originals and slides. Interested in seeing work that is tasteful. Replies in 1 month. Files résumé; slides of accepted artists.
Tips: "The most common mistake artists make in presenting their work is dropping off slides/samples without SASE and without querying first. We suggest a visit to the gallery before submitting slides. We show framed and unframed work of our artists throughout the year as well as at time of individual exhibition."

‡**FOUNDRY GALLERY**, Dept. AM, 9 Hillyer Court, Washington DC 20008. (202)387-0203. Membership Director: Marcia Mayne. Cooperative gallery and alternative space. Estab. 1971. Sponsors 10-20 solo and 2-3 group shows/year. Average display time 3 weeks. Interested in emerging artists. Clientele: 80% private collectors; 20% corporate clients. Overall price range: $100-2,000; most work sold at $100-1,000.
Media: Considers oil, acrylic, watercolor, pastel, pen & ink, drawings, mixed media, collage, paper, sculpture, ceramic, fiber, glass, installation, photography, woodcuts, engravings, mezzotints, etchings, pochoir and serigraphs. Most frequently exhibits painting, sculpture, paper and photography.
Style: Exhibits "expressionism, painterly abstraction, conceptualism and hard-edge geometric abstraction, as well as representational." Prefers non-objective, expressionism and neo-geometric. "Founded to encourage and promote Washington area artists and to foster friendship with artists and arts groups outside the Washington area. The Foundry Gallery is known in the Washington area for its promotion of contemporary works of art."

Terms: Co-op membership fee plus donation of time; 30% commission. Retail price set by artist. Offers customer discounts and payment by installments. Exclusive area representation not required. Gallery provides insurance and a promotion contract. Prefers framed artwork.
Submissions: Send query letter with résumé, slides, and SASE. "Local artists drop off actual work." Call or write for appointment to drop off portfolio. Replies in 1 month. Finds artists through submissions.
Tips: "All works must be delivered by artist."

GALLERY K, 2010 R St. NW, Washington DC 20009. (202)234-0339. Fax: (202)334-0605. Director: Komei Wachi. Retail gallery. Estab. 1976. Represents 47 emerging, mid-career and established artists. Interested in seeing the work of emerging artists. Exhibited artists include Jody Mussoff and Y. David Chung. Sponsors 10 shows/year. Average display time 1 month. Closed mid July through mid-September; Tuesday-Saturday 11-6. Located in DuPont Circle area; 2,500 sq. ft. Clientele: local. 80% private collectors, 10% corporate collectors; 10% other galleries. Overall price range: $100-250,000; most work sold at $200-2,000.
Media: Considers oil, pen & ink, paper, acrylic, drawing, sculpture, watercolor, mixed media, ceramic, pastel, collage, photography, woodcuts, wood engravings, linocuts, engravings, mezzotints, etchings, lithographs and serigraphs. Most frequently exhibits oil, acrylic, drawing.
Style: Exhibits realism and surrealism. Genres include landscapes and figurative work. Prefers surrealism, realism and postmodernism.
Terms: Accepts work on consignment (20-50% commission). Retail price set by gallery and artist. Gallery provides insurance, promotion and contract; artist pays for shipping costs. Prefers artwork framed.
Submissions: Accepts artists mainly from DC area. Send query letter with résumé, slides and SASE. Replies in 4-6 weeks only if SASE enclosed.

GATEHOUSE GALLERY, Mount Vernon College, 2100 Foxhall Rd. NW, Washington DC 20007. (202)625-4640. Associate Professor and Gatehouse Gallery/Director: James Burford. Nonprofit gallery. Estab. 1978. Exhibits the work of emerging, mid-career and established artists. Sponsors 7 solo and 2-3 group shows/year. Average display time: 3 weeks. Clientele: college students and professors.
Media: Considers all media. Most frequently exhibits photography, drawings, prints and paintings.
Style: Exhibits all styles and genres. "The exhibitions are organized to the particular type of art classes being offered and are local."
Terms: Accepts work on consignment (20% commission). Retail price set by artist. Exclusive area representation not required. Gallery provides promotion and contract; artist pays for shipping.
Submissions: Send query letter with résumé, brochure, slides or photographs. All material is returned if not accepted or under consideration.

SPECTRUM GALLERY, 1132 29th St. NW, Washington DC 20007. (202)333-0954. Director: Reagan Neville Kiser. Retail/cooperative gallery. Estab. 1966. Exhibits the work of 29 mid-career artists. Sponsors 10 solo and 2 group shows/year. Average display time 1 month. Accepts only artists from Washington area. Open year round. Located in Georgetown. Clientele: 80% private collectors, 20% corporate clients. Overall price range: $50-5,000; most artwork sold at $450-900.
Media: Considers oil, acrylic, watercolor, pastel, pen & ink, drawings, mixed media, collage, works on paper, sculpture, ceramic, fiber, woodcuts, mezzotints, etchings, lithographs and serigraphs. Most frequently exhibits acrylic, watercolor and oil.
Style: Exhibits impressionism, realism, minimalism, painterly abstraction, pattern painting and hard-edge geometric abstraction. Genres include landscapes, florals, Americana, portraits and figurative work.
Terms: Co-op membership fee plus donation of time; 35% commission. Retail price set by artist. Sometimes offers payment by installment. Exclusive area representation not required. Gallery provides promotion and contract.
Submissions: Artists must live in the Washington area because of the cooperative aspect of the gallery. Bring actual painting at jurying; application forms needed to apply.
Tips: "A common mistake artists make is not knowing we are a cooperative gallery. We were one of the first cooperatives in the Washington area and were established to offer local artists an alternative to the restrictive representation many galleries were then providing. Each artist is actively involved in the shaping of policy as well as maintenance and operation. The traditional, the abstract, the representational and the experimental can all be found here. Shows change every month and each artist is represented at all times. We really appreciate an appointment or slides and information sent to us first, rather than a prospective artist simply visiting the gallery. In order to show an artist's work, he/she must apply and be juried in. It is also best to come to the gallery, see what types of art we show and then decide if you want to apply for membership."

‡HOLLIS TAGGART GALLERIES, INC., 3233 P St. NW, Washington DC 20007. (202)298-7676 and 48 E. 73rd St., New York NY 10021. Gallery Contact: Elizabeth East. Retail gallery. Estab. 1978. Interested in seeing the work of mid-career and established artists. Sponsors 2 shows/year in New York gallery. Average display time 4 weeks. "Interested only in artists working in contemporary realism." Clientele: 80% private

collectors, 10% corporate clients. Overall price range: $1,000-1,000,000; most historical artwork sold at $20,000-500,000; most contemporary artwork sold at $7,000-30,000.

Media: Considers oil, watercolor, pastel, pen & ink and drawings.

Style: Prefers figurative work, landscapes and still lifes. "We specialize in 19th and early 20th century American paintings and contemporary realism. We are interested only in contemporary artists who paint in a realist style. As we handle a limited number of contemporary artists, the quality must be superb."

Terms: Retail price set by gallery and artist. Exclusive area representation required. Insurance, promotion, contract and shipping costs negotiable.

Submissions: "Please call first; unsolicited query letters are not preferred. Looks for technical excellence."

Tips: "Collectors are more and more interested in seeing traditional subjects handled in classical ways. Works should demonstrate excellent draftsmanship and quality."

‡TOUCHSTONE GALLERY, 406 Seventh St. NW, Washington DC 20004. (202)347-2787. Director: Robert Revere. Cooperative gallery. Estab. 1976. Interested in emerging, mid-career and established artists. Represents 36 artists. Sponsors 11 solo and 1 group shows/year. Average display time 1 month. Located in the Seventh Street Gallery District in Penn Quarter; second floor of a building that is home to 5 other art galleries; main exhibition space features 2 solo exhibits, 3 smaller exhibit spaces feature monthly members shows. Clientele: 70% private collectors, 30% corporate clients. Overall price range: $45-9,000. Most artwork sold at $400-4,500.

Media: Considers all media. Most frequently exhibits paintings, sculpture and prints.

Style: Exhibits all styles and genres. "We show contemporary art from the Washington DC area."

Terms: Co-op membership fee plus donation of time; 40% commission. Retail price set by artist. Exclusive area representation not required. Prefers framed artwork.

Submissions: Send query letter with SASE. Portfolio should include originals and slides. All material is returned if not accepted or under consideration. Artists are juried in by the member artists. A 2/3 majority of positive votes is required for acceptance. Voting is by secret ballot. The most common mistake artists make in presenting their work is "showing work from each of many varied periods in their careers."

‡TROYER FITZPATRICK LASSMAN GALLERY, 1710 Connecticut Ave. NW, Washington DC 20009. (202)328-7189. Fax: (202)667-8106. Retail gallery. Estab. 1983. Represents 22 emerging, mid-career and established artists/year; 30 emerging, mid-career and established photographers. Exhibited artists include: Mindy Weisel and Willem de Hooper. Sponsors 8 shows/year. Average display time 5 weeks. Open all year except August; Tuesday-Saturday, 11-5. Located on Dupont Circle; 1,000 sq. ft.; townhouse. Overall price range: $500-10,000.

Media: Considers oil, paper, acrylic, sculpture, watercolor, mixed media, pastel, collage and photography. Most frequently exhibits paintings, photography and sculpture.

Style: Exhibits neo-expressionism, painterly abstraction, surrealism, all styles.

Terms: Accepts work on consignment (50% commission). Gallery provides insurance and promotion; artist pays for shipping.

Submissions: Accepts only Mid-Atlantic artists. Send query letter with résumé, slides and bio. Call for appointment to show portfolio of photographs, transparencies and slides. Files slides. Finds artists through word of mouth, referrals by other artists, visiting art fairs and exhibitions and submissions.

Florida

‡AMBROSINO GALLERY, 3155 Ponce De Leon Blvd., Coral Gables FL 33134-6825. (305)445-2211. Fax: (305)444-0101. Director: Genaro Ambrosino. Retail gallery. Estab. 1991. Represents 22 emerging artists/year. Exhibited artists include: Jaime Palacios and Arturo Duclos. Sponsors 11 shows/year. Average display time 1 month. Open all year; Tuesday-Friday, 10-6:30; Saturday 11-5. Located in downtown Coral Gables (southwest Miami); 3,000 sq. ft.; clean white space, 2 floors, main gallery downstairs and project room upstairs. 80% of space for special exhibitions; 20% of space for gallery artists. Clientele: local, upscale. 90% private collectors, 10% corporate collectors. Overall price range: $1,000-15,000; most work sold at $1,500-5,000.

Media: Considers oil, paper, fiber, acrylic, drawing, sculpture, mixed media, installation, collage, photography and video/film. Most frequently exhibits painting, photography and installation.

Style: Exhibits conceptualism, minimalism, painterly abstraction and postmodern works.

Terms: Accepts work on consignment (50% commission). Buys outright for 50% of retail price. Retail price set by the artist. Gallery provides insurance, promotion and contract; shipping costs are shared. Prefers artwork framed.

Submissions: Accepts contemporary art only. Send query letter with résumé, slides, photographs and SASE. Call for appointment to show portfolio of photographs and slides. Replies in 2 weeks. Files photos and catalogs.

Tips: "Common artists' mistakes include not calling in advance for appointment, submitting poor-quality images, not inquiring before hand about type of work shown at the gallery, not including SASE for reply."

BAKEHOUSE ART COMPLEX, 561 N.W. 32 St., Miami FL 33127. (305)576-2828. Contact: Pola Reydburd. Alternative space and nonprofit gallery. Estab. 1986. Represents 150 emerging and mid-career artists. 150 members. Sponsors 11 shows/year. Average display time 3 weeks. Open all year; Tuesday-Friday, 10-4. Located in Design District; 3,200 sq. ft.; retro fitted bakery preparation area, 17' ceilings, tile floors. Clientele: 80% private collectors, 20% corporate collectors. Overall price range: $500-5,000.
Media: Considers all media and all types of prints.
Style: Exhibits all styles, all genres.
Terms: Co-op membership fee plus donation of time (30% commission). Rental fee for space; covers 1 month. Retail price set by the artist.
Submissions: Accepts only artists from juried membership. Send query letter with résumé, slides, bio, reviews. Write for appointment to show portfolio of slides. Files all accepted members' slides and résumés.
Tips: "Visit facility on open house days (second Sunday of each month) or during openings."

‡BOCA RATON MUSEUM OF ART, 801 W. Palmetto Park Rd., Boca Raton FL 33486. (407)392-2500. Fax: (407)391-6410. Executive Director: George S. Bolge. Museum. Estab. 1950. Represents established artists. 2,500 members. Exhibits change every 2 months. Open all year; Monday-Friday, 10-4; Saturday and Sunday, noon-4. Located one mile east of I-95 on Palmetto Park Road in Boca Raton; 3,000 sq. ft.; three galleries—one shows permanent collection, two are for changing exhibitions. 66% of space for special exhibitions.
Media: Considers all media.
Submissions: "Contact executive director, in writing."

ALEXANDER BREST MUSEUM/GALLERY, 2800 University Blvd., Jacksonville University, Jacksonville FL 32211. (904)744-3950, ext. 7371. Fax: (904)745-7375. Director: David Lauderdale. Museum. Estab. 1970. Represents 4-6 emerging, mid-career and established artists/year. Sponsors 4-6 shows/year. Average display time 6 weeks. Open all year; Monday-Friday, 9-4:30; Saturday, 2-5. "We close 2 weeks at Christmas and University holidays." Located in Jacksonville University, near downtown; 800 sq. ft.; 11½ foot ceilings. 20% of space for special exhibitions. "As an educational museum we have few if any sales. We do not purchase work—our collection is through donations."
Media: "We rotate style and media to reflect the curriculum offered at the institution. We only exhibit media that reflect and enhance our teaching curriculum. (As an example we do not teach bronze casting, so we do not seek such artists.)"
Style: Exhibits expressionism, neo-expressionism, primitivism, painterly abstraction, surrealism, all styles, primarily contemporary.
Terms: Retail price set by the artist. Gallery provides insurance and promotion; artist pays shipping costs to and from gallery. "The art work needs to be ready for exhibition in a professional manner."
Submissions: Send query letter with résumé, slides, brochure, business card and reviews. Write for appointment to show portfolio of slides. "Replies fast when not interested. Yes takes longer." Finds artists through visiting exhibitions and submissions.
Tips: "Being professional impresses us. But circumstances also prevent us from exhibiting all artists we are impressed with."

‡CAPITOL COMPLEX EXHIBITION PROGRAM, Division of Cultural Affairs, The Capitol, Tallahassee FL 32399-0250. (904)487-2980. Fax: (904)922-5259. Arts Consultant: Katie Dempsey. Exhibition spaces (5 galleries). Represents 20 emerging, mid-career and established artists/year. Exhibited artists include: Molly Mabe, Terry Thommes. Sponsors 20 shows/year. Average display time 3 months. Open all year; Monday-Friday, 8-5; Saturday-Sunday, 8:30-4:30. "Four of the galleries are located downtown in the capitol building. One is at our office about 3.5 miles from capitol. One is in the entry way of the Secretary of State's office.
Media: Considers all media and all types of prints. Most frequently exhibits oil, watercolor and acrylic.
Style: Exhibits all genres.
Terms: Free exhibit space—artist sells works. Retail price set by the artist. Gallery provides insurance; artist pays for shipping to and from gallery.
Submissions: Accepts only artists from Florida. Send query letter with résumé, slides, artist's statement and bio. Call or write for appointment to show portfolio of photographs or slides. Replies in 1-2 weeks. Finds artists through word of mouth.

‡THE CENTER FOR EMERGING ART, INC., 800 West Ave. (inside South Bay Club), Miami Beach FL 33139. Executive Director: Ava L. Rado. Retail/nonprofit, professionally administered exhibition studio space for contemporary art. Estab. 1995. Represents/exhibits emerging artists. Exhibited artists include Mifflin Uhlfelder, Rosa Pardo, Lorraine Maxwell and A.R. Harte. Sponsors 6 shows/year. Average display time 1 month. Open all year; or by appointment only. Located inside a luxury condominium on lobby level; 600 sq. ft. 90% of space for special exhibitions. Clientele: local community. 90% private collectors, 10% corporate

collectors. Overall price range: $300-40,000; most work sold at $600-3,000.
- The center is administered by Ava Rado, who owned The Rado Gallery, formerly at this location. It is funded in part by the Florida Department of State, Division of Cultural Affairs and the Florida Arts Council.

Media: Considers all media and all types of prints. Most frequently exhibits acrylic on canvas, oil on canvas, abstract expressionism and ceramics.
Style: Exhibits all styles. Prefers abstract, landscape and minimalism.
Terms: Artwork is accepted on consignment and there is a donation of 30% of sales. Gallery provides promotion and contract. Artist pays for insurance and shipping costs. Prefers artwork framed.
Submissions: Send query letter with résumé, brochure, slides, photographs, reviews, bio, SASE and video. Write for appointment to show portfolio of pertinent material. Replies only if interested within 1 month. Finds artists through word of mouth, submissions and referrals.
Tips: "Have persistence."

‡CREATIONS INTERNATIONAL GALLERY, 48 E. Granada Blvd., Ormond Beach FL 32176. (904)673-8778. E-mail: zbhy42a@prodigy.com or 103221.654@compuserve.com. Website: http://www.our world.compuserve.com/homepages/creations_international_gallery. Director: Victoria Haer. Retail gallery, art consultancy. Estab. 1984. Represents emerging, mid-career and established artists. Exhibited artists include Benton Ledbetter. Sponsors 12 shows/year. Average display time 1 month. Open all year; Tuesday-Friday, 12-5. Located between 2 museums; 850 sq. ft.; historical building in cultural area of town. 100% of space for special exhibitions ("Every month is a different theme.") 90% private collectors, 10% corporate collectors. Overall price range: $500-10,000; most work sold at $50-2,500.
- This gallery maintains several pages on the Internet featuring art shown in the gallery. They have a slide and disk registry to show clients and will assist artists in creating résumés, bios and portfolios. Gallery is active in bringing environmental issues and issues involving children to public attention.

Media: Considers all media and all types of prints. Most frequently exhibits sculpture, pen & ink, oil.
Style: Exhibits surrealism, photorealism, hard-edge geometric abstraction, realism, imagism. Exhibits all genres. Prefers realism, surrealism, imagism.
Terms: Accepts work on consignment (25% commission). "We are selective and require the artist to pay for insurance and a portion of expenses for the exhibition of his/her work." Retail price set by the artist. Gallery provides promotion and contract; artist pays for shipping. Prefers artwork framed.
Submissions: Send query for appointment to show portfolio of photographs, slides. Replies in 2-4 weeks. Files all material. Finds artists through submissions, requests by clients, visiting exhibitions.
Tips: "The most common mistakes artists make is appearing unannounced with work. We have a protocol that must be followed. Send SASE for information about philosophy and services. If you are dedicated to the arts we will be dedicated to you."

‡CULTURAL RESOURCE CENTER METRO-DADE, 111 NW 1st St., Miami FL 33128. (305)375-4635. Director: Patricia Risso. Alternative space/nonprofit gallery. Estab. 1989. Exhibits 800 emerging and mid-career artists. Sponsors 10 shows/year. Average display time 3½ weeks. Open all year; Monday-Friday 10-3. Located in Government Center in downtown Miami.
Media: Most frequently exhibits oil, mixed media and sculpture.
Terms: Retail price set by artist. Gallery provides insurance and promotion; artist pays shipping costs. Prefers artwork framed.
Submissions: Accepts only artists from south Florida. Send query letter with résumé, slides, brochure, SASE and reviews. Call for appointment to show portfolio of slides. Replies only if interested within 2 weeks. Files slides, résumés, brochures, photographs.

‡DUNCAN GALLERY OF ART, Campus Box 8269, Stetson University, DeLand FL 32720. (904)822-7266. Fax: (904)822-7268. Gallery Director: Gary Bolding. Nonprofit university gallery. Represents emerging, mid-career and established artists. Sponsors 9 shows/year. Average display time 6 weeks. Open all year except during university holidays and breaks; Monday-Friday, 10-4; Saturday and Sunday, 1-4. Located in the heart of the Stetson University campus, which is adjacent to downtown; 2,400 sq. ft. in main gallery; 144 cu. ft. in glass display cases in foyer; in 100+-year-old, recently renovated building with Neo-Classical trappings and 16-foot ceilings. 95% of space for special exhibitions. Clientele: students, faculty, community members. 99% private collectors, 1% corporate collectors. Overall price range: $100-35,000.
Media: Considers all media and all types of prints. Most frequently exhibits paintings, ceramics and sculpture.
Style: Exhibits all styles, all genres.
Terms: Accepts work on consignment (25% commission). Retail price set by the artist. Gallery provides insurance and promotion; shipping costs are shared. Prefers artwork framed.
Submissions: "Exhibiting artists tend to be from the Southeast, but there are no restrictions." Send query letter with résumé, slides, SASE and proposal. Write for appointment to show portfolio of originals, photographs, slides or transparencies. Replies in 3-4 months. Files slides, postcards, résumés. Finds artists through proposals, visiting exhibitions and word of mouth.
Tips: Contact them, they will be happy to provide their requirements.

FLORIDA ART CENTER & GALLERY, 208 First St. NW, Havana FL 32333. (904)539-1770. President: Lee Mainella. Retail gallery, studio and art school. Estab. 1993. Represents 30 emerging, mid-career and established artists. Interested in seeing the work of emerging artists. Open all year. Located in small, but growing town in north Florida; 2,100 st. ft.; housed in a large renovated 50-year-old building, 2 blocks long, exposed rafters and beams. Clientele: private collectors. 100% private collectors.
Media: Considers all media and original handpulled prints (a few).
Style: Exhibits all styles, tend toward traditional styles. Genres include landscapes and portraits.
Terms: Accepts work on consignment (45% commission). Retail price set by gallery and artist. Gallery provides insurance, promotion and contract.
Submissions: Send query letter with slides. Call or write for appointment.
Tips: "Prepare a professional presentation for review, (i.e. quality work, good slides, clear, concise and informative backup materials). Size, medium, price and framed condition of painting should be included."

‡FLORIDA STATE UNIVERSITY GALLERY & MUSEUM, Copeland & W. Tennessee St., Tallahassee FL 32306-2055. (904)644-6836. E-mail: jmason@mailer.fsu.edu. Website: http://www.mailer.fsu.edu/~svad/FSUMuseum/FSU_Museum.html. Gallery Director: Allys Palladino-Craig. University gallery and museum. Estab. 1970. Shows work by over 100 artists/year; emerging, mid-career and established. Sponsors 12-22 shows/year. Average display time 3-4 weeks. Located on the university campus; 16,000 sq. ft. 50% of space for special exhibitions.
Media: Considers all media, including electronic imaging and performance art. Most frequently exhibits painting, sculpture and photography.
Style: Exhibits all styles. Prefers contemporary figurative and non-objective painting, sculpture, printmaking.
Terms: "Sales are almost unheard of; the gallery takes no commission." Retail price set by the artist. Gallery provides insurance, promotion and shipping costs to and from gallery for invited artists.
Submissions: Send query letter with résumé, slides, bio, brochure, photographs, reviews and SASE. Write for appointment to show portfolio, which should include slides. Faculty and steering committee replies in 6-8 weeks.
Tips: "The museum offers a yearly competition with an accompanying exhibit and catalog. Artists' slides are kept on file from this competition as a resource for possible inclusion in other shows. Write for prospectus, available late August to October."

GALLERY CONTEMPORANEA, 526 Lancaster, Jacksonville FL 32204. Director: Sally Ann Freeman. Retail gallery and art consultancy. Estab. 1974. Represents/exhibits 120 mid-career and established artists. Exhibited artists include Allison Watson and Gretchen Ebersol. Sponsors 3-4 shows/year. Average display time 2 months. Open all year; Thursday-Saturday, 10-2 or by appointment. Located near downtown—historic neighborhood; 1,100 sq. ft.; "corporate consulting is 50-60% of sales." 65% of space for special exhibitions. Clientele: local area. 40-50% private collectors, 50-60% corporate collectors. Overall price range: $15-12,000; most work sold at $600-12,000.
Media: Considers all media and all types of prints. Most frequently exhibits paintings, original prints, sculpture, clay, fiber and photos.
Style: Exhibits expressionism, painterly abstraction, realism and impressionism. Genres include landscapes and florals. Prefers realism, impressionism and abstraction.
Terms: Artwork is accepted on consignment (50% commission). Retail price set by gallery. Gallery provides insurance, promotion and contract; shipping costs are shared.
Submissions: Accepts only artists from the Southeast. Send query letter with résumé, slides, reviews, bio and SASE. Write for appointment to show portfolio of slides. Replies in 2-3 weeks. Files reviews, bio and slides. Finds artists through word of mouth, referrals by other artists and submissions.
Tips: "Be professional and flexible."

‡GLASS CANVAS GALLERY, INC., 233 4th Ave. NE, St. Petersburg FL 33701. (813)821-6767. Fax: (813)821-1775. President: Judy Katzin. Retail gallery. Estab. 1992. Represents 200 emerging and mid-career artists/year. Exhibited artists from US, Canada, Australia, England. Sponsors 6 shows/year. Average display time 6-8 weeks. Open all year; Monday-Friday, 10-6; Saturday, 10-5; Sunday, 12-5 (closed Sunday June-September). Located by the waterfront downtown; 1,800 sq. ft. 25% of space for special exhibition; 75% of space for gallery artists. 5% private collectors, 5% corporate collectors. Overall price range: $20-5,000; most work sold at $200-700.
Media: Considers mixed media, sculpture, glass and some 2-dimensional work. Most frequently exhibits glass, ceramic and mixed.
Style: Exhibits color field. Prefers unique, imaginative, contemporary, colorful and unusual.
Terms: Accepts work on consignment (50% commission) or buys outright for 50% of retail price (net 30 days). Retail price set by the artist. Gallery provides insurance, promotion, contract and shipping costs from gallery; artist pays shipping costs to gallery. Prefers artwork framed.
Submissions: Prefers only glass. Send query letter with résumé, brochure, photographs and business card. Call for appointment to show portfolio of photographs. Replies in 2 weeks. Files all material.

THE HANG-UP, INC., 45 S. Palm Ave., Sarasota FL 34236. (813)953-5757. President: F. Troncale. Retail gallery. Estab. 1971. Represents 25 emerging and mid-career artists. Sponsors 6 shows/year. Average display time 1 month. Open all year. Located in arts and theater district downtown; 1,700 sq. ft.; "high tech, 10 ft. ceilings with street exposure in restored hotel." 50% of space for special exhibitions. Clientele: 75% private collectors, 25% corporate collectors. Overall price range: $500-5,000; most artwork sold at $500-1,000.
Media: Considers oil, acrylic, watercolor, mixed media, collage, works on paper, sculpture, original hand-pulled prints, lithographs, etchings, serigraphs and posters. Most frequently exhibits painting, graphics and sculpture.
Style: Exhibits expressionism, painterly abstraction, surrealism, impressionism, realism and hard-edge geometric abstraction. All genres. Prefers abstraction, impressionism, surrealism.
Terms: Accepts artwork on consignment (50% commission). Retail price set by artist. Sometimes offers customer discounts and payment by installment. Gallery provides insurance, promotion and contract; shipping costs are shared. Prefers unframed work. Exhibition costs shared 50/50.
Submissions: Send résumé, brochure, slides, bio and SASE. Write for appointment to show portfolio of originals and photographs. "Be organized and professional. Come in with more than slides; bring P.R. materials, too!" Replies in 1 week.

HEIM/AMERICA AT FISHER ISLAND GALLERY. 42102 Fisher Island Dr., Fisher Island FL 33109. (305)673-6809. Fax: (305)532-2789. Director: J.H. Stoneberger. Retail gallery. Estab. 1990. Represents emerging and established artists. Sponsors 4-5 shows/year. Average display time 1 month. Open September 1-July 1; Tuesday-Saturday 11-6. Located in a private community; 1,000 sq. ft. 65% of space for special exhibitions; 65% of space for gallery artists. 50% private collectors, 50% corporate collectors. Overall price range: $800-200,000; most work sold at $10-15,000.
Media: Considers oil, watercolor, pastel, pen & ink, drawing, mixed media, paper and sculpture. Most frequently exhibits oil on canvas, watercolor and drawings.
Style: Exhibits expressionism, painterly abstraction, minimalism, color field and realism. Genres include landscapes, florals, portraits, figurative work, all genres.
Terms: Accepts work on consignment. Retail price set by the gallery and the artist. Gallery provides insurance, promotion and contract. Artwork framed appropriately.
Submissions: Send query letter with résumé, slides and bio. Write for appointment to show portfolio of photographs. Replies only if interested within 2 months. Will return photos. Finds artists through visiting exhibitions and submissions.
Tips: Impressed by "a good exhibition record."

KENDALL CAMPUS ART GALLERY, MIAMI-DADE COMMUNITY COLLEGE, 11011 SW 104 St., Miami FL 33176-3393. (305)237-2322. Fax: (305)237-2901. Director: Robert J. Sindelir. College gallery. Estab. 1970. Represents emerging, mid-career and established artists. Exhibited artists include Komar and Melamid. Sponsors 10 shows/year. Average display time 3 weeks. Open all year except for 2 weeks at Christmas and 3 weeks in August. Located in suburban area, southwest of Miami; 3,000 sq. ft.; "space is totally adaptable to any exhibition." 100% of space for special exhibitions. Clientele: students, faculty, community and tourists. "Gallery is not primarily for sales, but sales have frequently resulted."
Media: Considers all media, all types of original prints. "No preferred style or media. Selections are made on merit only."
Style: Exhibits all styles and genres.
Terms: "Purchases are made for permanent collection; buyers are directed to artist." Retail price set by artist. Gallery provides insurance and promotion; arrangements for shipping costs vary. Prefers artwork framed.
Submissions: Send query letter with résumé, slides, bio, brochure, SASE, and reviews. Write for appointment to show portfolio of slides. "Artists commonly make the mistake of ignoring this procedure." Replies in 2 weeks. Files résumés and slides (if required for future review).
Tips: "Present good-quality slides of works which are representative of what will be available for exhibition."

‡KIRSCHNER HAACK FINE ART, INC., 922 Lincoln Rd., Miami Beach FL 33139. (305)531-7730. Fax: (305)531-8741. Gallery Director: Lee Haack. Retail gallery. Estab. 1994. Represents 20 emerging, mid-career and established artists/year. Sponsors 6 shows/year. Average display time 6-8 weeks. Open all year; Tuesday-Thursday, 2-10; Friday-Saturday, noon-11. Located in downtown Miami Beach; 1,500 sq. ft. 80% of space for special exhibitions; 20% of space for gallery artists. Clientele: tourists, upscale. 80% private collectors, 20% corporate collectors. Overall price range: $500-50,000; most work sold at $500-3,500.
Media: Considers all media and all types of prints.
Style: Exhibits all styles and genres. Prefers surrealism, expressionism, superealism.
Terms: Accepts work on consignment (50% commission). Retail price set by the gallery and the artist. Gallery provides insurance, promotion and contract; shipping costs are shared. Gallery provides insurance; artists pays for shipping costs to and from gallery. Prefers artwork framed.
Submissions: Send query letter with résumé, brochure, business card, slides, photographs, reviews, artist's statement, bio and SASE. Write for appointment to show portfolio of photographs, slides and examples if

possible. Replies in 2 months. Finds artists through word of mouth, referrals by other artists, visiting art fairs and exhibitions, submissions.

Tips: "We prefer only mail-in submissions as first contact, then we arrange to see the work."

KOUCKY GALLERY, 1246 Third St. S., Naples FL 33940. (813)261-8988. Fax: (813)261-8576. Owners: Chuck and Nancy. Retail gallery. Focus is on contemporary American artists and craftsmen. Estab. 1986. Represents/exhibits 175 emerging, mid-career and established artists/year. Exhibited artists include Todd Warner and Jack Dowd. Sponsors 6 shows/year. Open all year; Monday-Saturday. Located downtown; 1,500 sq. ft. Clientele: upscale international, resort. 98% private collectors, 2% corporate collectors. Overall price range: $140-35,000; most work sold at $85-900.

● Koucky Gallery also has a location in Charlevoix, Michigan.

Media: Considers all media. Most frequently exhibits sculpture, painting, jewelry and designer crafts.

Style: Exhibits expressionism, painterly abstraction, impressionism, contemporary works and imagism.

Terms: Artwork is accepted on consignment. Retail price set by the artist. Gallery provides insurance. Artist pays for shipping costs. Prefers artwork framed.

Submissions: Accepts only US artists. Send query letter with slides, photographs, bio and SASE. Call for appointment to show portfolio of photographs. "Replies slowly." Finds artists through word of mouth.

‡LIPWORTH INTERNATIONAL ARTS, INC., 608 Banyan Trail, Boca Raton FL 33431. (407)241-6688. Fax: (407)241-6685. Director: Margaret Lipworth. Retail gallery, private dealer. Estab. 1990. Represents 10-15 established artists/year. Exhibited artists include: Alex Katy, Roy Lichtenstein. Sponsors 6 shows/year. Average display time 1 month. Open all year accept August; Monday-Saturday, 10:30-5:00, December-March; closed Monday April-November. Located in Gallery Center; 2,000 sq. ft. Clientele: upscale, collectors. 100% private collectors. Overall price range: $15,000-100,000.

Media: Considers oil, pen & ink, paper, acrylic, drawing, sculpture, watercolor, mixed media, ceramics, pastel, collage and all types of prints. Prefers sculpture, oil, prints.

Style: Exhibits minimalism, color field, hard-edge geometric abstraction, painterly abstraction, postmodern works.

Submissions: Send query letter with photographs.

‡NUANCE GALLERIES, 720 S. Dale Mabry, Tampa FL 33609. (813)875-0511. Owner: Robert A. Rowen. Retail gallery. Estab. 1981. Represents 70 emerging, mid-career and established artists. Sponsors 3 shows/year. Open all year. 3,000 sq. ft. "We've reduced the size of our gallery to give the client a more personal touch. We have a large extensive front window area."

Media: Specializing in watercolor, original mediums including sculpture.

Style: "Majority of the work we like to see are realistic landscapes, escapism pieces, bold images, bright colors and semitropical subject matter. Our gallery handles quite a selection and it's hard to put us into any one class."

Terms: Accepts work on consignment (50% commission). Retail price set by gallery and artist. Offers customer discounts and payment by installments. Gallery provides insurance and contract; shipping costs are shared.

Submissions: Send query letter with slides and bio. SASE if want slides/photos returned. Portfolio review requested if interested in artist's work.

Tips: "Be professional; set prices (retail) and stick with them. There are still some artists out there that are not using conservation methods of framing. As far as submissions we would like local artists to come by to see our gallery and get the idea what we represent. Tampa has a healthy growing art scene and the work has been getting better and better. But as this town gets more educated it is going to be much harder for up and coming artists to emerge."

ORMOND MEMORIAL ART MUSEUM & GARDENS, 78 E. Granada Blvd., Ormond Beach FL 32176. (904)676-3347. Director: Pierre LeRoy. Nonprofit museum. Estab. 1946. Exhibits emerging and established artists. Charming 1946-era building with wood floors and casement windows in the front; French-style doors overlooking a terraced garden with a wooden deck off the two rear galleries."

Media: Considers all media except performance art. Most frequently exhibits mixed media, watercolor and oil.

Style: Considers all styles.

Submissions: Send query letter with 10 slides of most recent work, artist profile and SASE.

Tips: "We have been exhibiting more contemporary art. We look for original creative work and innovative ideas. We have been known to exhibit non-mainstream art but mix it in with traditional work, both abstract and representational. We are a museum, not a gallery. We occasionally sell artwork through our exhibits."

‡PARADISE ART GALLERY, 1359 Main St., Sarasota FL 34236. (941)366-7155. Fax: (941)366-8729. President: Gudrún Newman. Retail gallery, art consultancy. Represents hundreds of emerging, mid-career and established artists/year. May be interested in seeing the work of emerging artists in the future. Exhibited artists include: John Lennon, Hessam. Open all year; Monday-Wednesday, 9-5:30; Thursday-Friday, 9-9;

Saturday, 10-5. Located in downtown Sarasota; 2,500 sq. ft. 50% of space for special exhibitions. Clientele: tourists, upscale. 90% private collectors, 10% corporate collectors. Overall price range: $500-30,000; most work sold at $1,000.

Media: Considers all media. Most frequently exhibits serigraphs, acrylics, 3-D art.

Style: Exhibits all styles. Prefers contemporary, pop.

Terms: Accepts work on consignment (30% commission). Buys outright for 10-50% of retail price (net 30-60 days). Retail price set by the gallery. Gallery provides promotion and contract; shipping costs are shared. Prefers artwork framed.

Submissions: Send query letter with résumé, brochure, photographs, artists' statement and bio. Call for appointment to show portfolio of photographs. Replies in 2 weeks.

‡PENSACOLA MUSEUM OF ART, 407 S. Jefferson, Pensacola FL 32501. (904)432-6247. Director: Carol Malt, Ph.D. Curator: Gail McKenney. Nonprofit museum. Estab. 1954. Interested in emerging, mid-career and established artists. Sponsors 3 solo and 19 group shows/year. Average display time: 6-8 weeks. Open all year. Located in the historic district; renovated 1906 city jail. Clientele: 90% private collectors; 10% corporate clients. Overall price range: $200-20,000; most work sold at $500-3,000.

Media: Considers all media. Most frequently exhibits painting, sculpture, photography, glass and new-tech (i.e. holography, video art, computer art etc.).

Style: Exhibits neo-expressionism, realism, photorealism, surrealism, minimalism, primitivism, color field, postmodern works, imagism; all styles and genres.

Terms: Retail price set by museum and artist. Exclusive area representation not required. Museum provides insurance, promotion and shipping costs.

Submissions: Send query letter with résumé, slides, SASE and/or videotape. Call or write for appointment to show portfolio of originals slides, transparencies and videotape. "A common mistake of artists is making impromptu drop-ins." Replies in 2 weeks. Files guides and résumé.

‡MICHAEL REIF FINE ART, P.O. Box 025216, Miami FL 33102-5216. Director: Michael Reif. Retail and wholesale gallery. Estab. 1985. Represents 20-30 artists. Exhibited artists include Jais Nillsen and Emil Bisttram. Sponsors 1-2 shows/year. Average display time 18 months. Open all year. "I deal in 20th century modernism out of my 'gallery,' which is also my home." 50% of space for special exhibitions. Clientele: "galleries worldwide and wealthy individuals." 70% private collectors. Overall price range: $3,000-250,000; most work sold at $20,000-75,000.

Media: Considers oil, pen & ink, acrylic, drawings, sculpture, watercolor, mixed media, pastel, collage and photography. Most frequently exhibits oil on canvas or board, tempera or watercolor on paper.

Style: Exhibits expressionism, painterly abstraction, surrealism, hard-edge geometric abstraction and modernism. Genres include cubism, futurism and surrealism.

Terms: Buys outright for 50% of retail price (net 30-90 days). "I own almost all the art that I show." Retail price set by the gallery. Gallery pays for shipping costs. Prefers artwork framed "well."

Submissions: Prefers only "original paintings, drawings, and sculpture by artists that worked between 1910 and 1970—the earlier the better." Send query letter with slides and bio. Write to schedule an appointment to show a portfolio, which should include photographs, transparencies and all possible historical information. Replies in 1-2 weeks.

Tips: "I am interested in older artists who worked between 1920 and 1960, works considered modernist or avant-garde."

RENNER STUDIOS, INC., 4056 S.W. Moores St., Palm City FL 34990, (407)287-1855. Fax: (407)287-0398. Gallery Director/Owner: Ron Renner. Retail gallery. Estab. 1989. Represents 6 emerging and established artists/year. Exhibited artists include Simbari and Ron Renner. Sponsors 4 shows/year. Average display time 1 month. Open all year; Monday-Saturday, 10-6. Located in rural area, barn studios and showroom; 1,200 sq. ft.; 50% of space for special exhibitions; 50% of space for gallery artists. Clientele: upscale. 90% private collectors, 10% corporate collectors. Overall price range: $750-250,000; most work sold at $7,500-10,000.

Media: Considers oil, pen & ink, acrylic, drawing, watercolor, mixed media, pastel, collage, photography, engravings, etchings, lithographs and serigraphs. Most frequently exhibits oil on canvas/linen, acrylic on canvas, serigraphs.

Style: Exhibits expressionism, impressionism, action painting. Genres include Mediterranean seascapes. Prefers abstract expressionism, impressionism and drawings.

Terms: Artwork is accepted on consignment (50% commission). Retail price set by the gallery. Gallery provides insurance, promotion, contract; shipping costs are shared. Prefers artwork framed.

Submissions: Send query letter with résumé, slides, bio and SASE. Write for appointment to show portfolio of slides. Replies only if interested within 3 weeks. Files bio, résumé, photos and slides. Finds artists through submissions and visits to exhibits.

Tips: "Keep producing, develop your style, take good pictures for slides of your work."

SANTE FE TRAILS GALLERY, 1429 Main St., Sarasota FL 34236. (813)954-1972. Owner: Beth Segreti. Retail gallery. Emphasis is on Native American and contemporary Southwestern art. Estab. 1990. Represents/ exhibits 25 emerging, mid-career and established artists/year. May be interested in seeing the work of emerging artists in the future. Exhibited artists include Amado Peña and R.C. Gorman. Sponsors 5-6 shows/year. Average display time 1 month. Open all year; Tuesday-Saturday, 10-5. Located downtown; 1,000 sq. ft.; 100% of space for special exhibitions featuring gallery artists. Clientele: tourists, upscale and local community. 100% private collectors. Overall range: $35-12,000; most work at $500-1,500.
Media: Considers all media, etchings, lithographs, serigraphs and posters. Most frequently exhibits lithographs, mixed media and watercolor.
Style: Prefers Southwestern. "Southwestern art has made a dramatic increase in the past few months. This could be the start of another seven-year cycle."
Terms: Artwork is accepted on consignment (50% commission), or is bought outright for 50% of the retail price. Retail price set by the gallery and the artist. Gallery provides promotion. Shipping costs are shared. Artist pays for shipping costs to gallery. Prefers artwork unframed.
Submissions: Send query letter with résumé, slides or photographs, bio and SASE. Write for appointment to show portfolio of photographs, slides and transparencies. Replies only if interested within 2 weeks. Finds artists through word of mouth, referrals by other artists and submissions.
Tips: "Make an appointment. No walk-ins!!"

Georgia

‡ANTHONY ARDAVIN GALLERY, 309 E. Paces Ferry Rd., Atlanta GA 30305. (404)233-9686. Fax: (404)233-9686. President: Anthony Ardavin. Retail gallery. Estab. 1988. Represents 18 emerging artists/ year. Exhibited artists include Robert Sentz, Lee Bomhoff. Sponsors 10 shows/year. Average display time 3 weeks. Located in midtown Atlanta; 1,400 sq. ft. 50% of space for special exhibitions; 50% of space for gallery artists. Clientele: upscale. 95% private collectors, 5% corporate collectors. Overall price range: $500-6,000; most work sold at $2,000-3,000.
Media: Considers oil, acrylic, drawing, sculpture, watercolor, mixed media, ceramics, pastel. Most frequently exhibits pastel, paintings, mixed media.
Style: Exhibits all styles and genres.
Terms: Accepts work on consignment. Prefers artwork framed.
Submissions: Send query letter with résumé and slides. Write for appointment to show portfolio of slides. Replies in 2 weeks. Files résumés.

ARIEL GALLERY, 75 Bennett St., NW, Atlanta GA 30309. (404)352-5753. Contact: Director. Cooperative gallery. Estab. 1984. Represents 20 emerging, mid-career and established artists/year. 15 members. Exhibited artists include Debra Lynn Gold and Alan Vaughan. Sponsors 8 shows/year. Average display time 6 weeks. Open all year; Tuesday-Saturday, 11-5. Located downtown; 914 sq. ft. Clientele: upscale, urban. 80% private collectors, 20% corporate collectors. Overall price range: $25-6,000; most work sold at $250-1,500.
Media: Considers all media, all types of prints. Most frequently exhibits paintings, sculpture and fine crafts.
Style: Exhibits primitivism, painterly abstraction and pattern painting. Prefers semi-abstract or abstract.
Terms: Accepts work on consignment (40% commission) or Co-op membership fee plus a donation of time (5% commission). Retail price set by the artist. Gallery provides promotion and contract. "Prefers hand delivery."
Submissions: Accepts only member artists from Atlanta area. "Some work taken on consignment. Artist must live outside 50-mile radius of Atlanta." Send query letter with résumé, slides or photographs, and bio. "Applicants for membership are considered at meeting on first Monday of each month." Portfolio should include originals (if possible), photographs or slides. Replies in 2 months. Finds artists through visiting exhibitions, word of mouth, submissions, local advertising in arts publications.
Tips: "Talk with membership chairman or exhibition director and get details. We're approachable and less formal than most."

BRENAU UNIVERSITY GALLERIES, One Centennial Circle, Gainesville GA 30501. (404)534-6263. Fax: (404)534-6114. Gallery Director: Jean Westmacott. Nonprofit gallery. Estab. 1980s. Represents/exhibits emerging, mid-career and established artists. Sponsors 9 shows/year. Average display time 6 weeks. Open all year; Monday-Friday, 10-4; Sunday, 2-5 during exhibit dates. Summer hours are Monday-Friday, 1-4 only. Located near downtown; 3,958 sq. ft., two galleries—the main one in a renovated 1914 neoclassic building, the other in an adjacent renovated Victorian building dating from the 1890s. 100% of space for special exhibitions. Clientele: tourists, upscale, local community, students. "Although sales do occur as a result of our exhibits, we do not currently take any percentage except in our National Invitational Exhibitions. Our purpose is primarily educational."

Media: Considers all media.

Style: Exhibits wide range of styles. "We intentionally try to plan a balanced variety of media and styles."

Terms: Retail price set by the artist. Gallery provides insurance and promotion; shipping costs are shared, depending on funding for exhibits. Prefers artwork framed. "Artwork must be framed or otherwise ready to exhibit."

Submissions: Send query letter with résumé, slides, photographs and bio. Write for appointment to show portfolio of slides and transparencies. Replies within months if possible. Artist should call to follow up. Files one or two slides or photos with a short résumé or bio if interested. Remaining material returned. Finds artists through referrals, direct viewing of work and inquiries.

Tips: "Be persistent, keep working, be organized and patient. Take good slides and develop a body of work. Galleries are limited by a variety of constraints—time, budgets, location, taste and rejection does not mean your work may not be good; it may not 'fit' for other reasons at the time of your inquiry."

‡THE CITY GALLERY AT CHASTAIN, 135 W. Wieuca Rd. NW, Atlanta GA 30342. (404)257-1804. Director: Debra Wilbur. Nonprofit gallery. Estab. 1979. Represents emerging artists. Sponsors 6 shows/year. Average display time 7-8 weeks. Open all year; Tuesday-Friday, 9-5; Saturday, 1-5. Located in Northwest Atlanta; 2,000 sq. ft.; historical building; old architecture with much character. Clientele: local community, students. Overall price range: $50-10,000.

Media: Considers all media and all types of prints. Most frequently exhibits sculpture, painting, mixed media.

Style: Exhibits conceptualism, postmodern works. Genres include social or political. Prefers contemporary/alternative.

Terms: Accepts work on consignment (30% commission). Retail price set by the artist. Gallery provides insurance; gallery pays shipping costs.

Submissions: Send query letter with résumé, brochure, business card, slides, photographs, reviews, artist's statement, bio. Call or write for appointment to show portfolio of photographs, slides. Replies in 2-4 weeks. Finds artists through word of mouth, referrals by other artists, visiting art fairs and exhibitions, submissions.

‡COASTAL CENTER FOR THE ARTS, INC., 2012 Demere Rd., St. Simons Island GA 31522. Phone/fax: (912)634-0404. Executive Director: Mittie B. Hendrix. Nonprofit regional art center. Estab. 1947. Represents over 100 emerging, mid-career and established artists/year. Sponsors 15 shows/year. Average display time 3 weeks. Open all year; Monday-Saturday, 9-5. Located on main thoroughfare; 7,000 sq. ft.; 6 large galleries, 1 small built for display. "We do not hang multiple paintings on wall, but display as in a museum. 90% for special exhibitions. Clientele: tourists, upscale, local community, students. Overall price range: $ 25-7,000; most work sold at $300 minimum.

Media: Considers all media and all types of prints. Most frequently exhibits paintings, sculpture, pottery.

Style: Exhibits all styles and genres. Prefers neo-Impressionism, realism, superrealism.

Terms: Accepts work on consignment (30-50% commission.) Gallery consults the artist about retail price. Gallery provides promotion and contract; artist pays for shipping. Prefers artwork framed or shrink-wrapped for bins.

Submissions: Send query letter with slides, bio, SASE. Write for appointment to show portfolio of photographs. "We have limited clerical staff but reply ASAP." Finds artists through word of mouth, other artists' recommendations.

Tips: "We find our visitors seem to be increasingly more and more discriminating/knowledgable, rather than average commercial- gallery-clients looking for something to match their sofa. Don't be shy, but be realistic about 'breaking into' a community with many local artists. CCA promotes all artists, but outside-the-region-artists take more time to be recognized, and/or noticed." Some of the common mistakes are "awful frames, work of student grade, impossible price structure."

ANN JACOB GALLERY, 3500 Peachtree Rd. NE, Atlanta GA 30326. (404)262-3399. Director: Yvonne J. Spiotta. Retail gallery. Estab. 1968. Represents 35 emerging, mid-career and established artists/year. Sponsors 4 shows/year. Open all year; Monday-Saturday 10-9; Sunday 12-5:30. Located midtown; 1,600 sq. ft. 100% of space for special exhibitions; 100% of space for gallery artists. Clientele: private and corporate. 80% private collectors, 20% corporate collectors.

Media: Considers oil, acrylic, watercolor, sculpture, ceramics, craft and glass. Most frequently exhibits paintings, sculpture and glass.

Style: Exhibits all styles, all genres.

Terms: Accepts work on consignment (50% commission). Retail price set by the gallery and the artist. Gallery provides promotion; artist pays shipping costs.

Submissions: Send query letter with résumé, slides, bio, brochure, photographs and SASE. Write for appointment. Replies in 2 weeks.

KIANG GALLERY, 75 Bennett St., N-2, Atlanta GA 30309. (404)351-5477. Fax: (404)951-8707. Owner: Marilyn Kiang. Retail gallery. Exhibits the work of non-traditional contemporary artists—with a special emphasis on biculturally influenced artists. Estab. 1992. Represents/exhibits 15 emerging and mid-career

artists/year. Exhibited artists include Junco Safo Pollack, Hoang Van Biet and Amy Landesberg. Sponsors 10 shows/year. Average display time 1 month. Open all year; Tuesday-Friday, 11-5; Saturday, 12-5. Located in Buckhead; 2,500 sq. ft.; clean, minimal, authoritative, "white walls-grey floor." 70% of space for special exhibitions; 30% of space for gallery artists. Clientele: upscale. 60% private collectors, 40% corporate collectors. Overall price range: $2,000-10,000; most work sold at $3,000-6,000.

Media: Considers all media, lithography, photography, sculpture, painting.

Style: Exhibits conceptualism, minimalism.

Terms: Artwork is accepted on consignment (50% commission). Retail price set by the gallery and the artist. Gallery provides insurance, promotion and contract; shipping costs are shared. Prefers artwork framed.

Submissions: Prefers serious works. Send query letter with résumé, slides and reviews. Call for appointment to show portfolio of slides. Finds artists through referrals by other artists.

LOWE GALLERY, 75 Bennett St., Suite A-2, Atlanta GA 30309. (404)352-8114. Fax: (404)352-0564. Director: Courtney Maier. Retail gallery. Estab. 1989. Represents/exhibits 45 emerging and mid-career artists/year. Interested in seeing the work of emerging artists. Exhibited artists include Peter Drake, Leslie Lerner, Kathleen Morris and Robert Sherer. Sponsors 10 exhibitions/year. Average display time 1 month. Open all year; Tuesday-Friday, 10:30-5:30; Saturday and Monday; 12-5; Sunday by appointment only. Located uptown (Buckhead); 6,000 sq. ft.; 4 exhibition rooms including a dramatic split-level Grand Salon with 30 ft. high ceiling and 18 ft. high exhibition walls. 100% of space for gallery artists. 75% private collectors, 25% corporate collectors. Overall price range: $800-65,000; most work sold at $2,500-10,000.

Media: Considers any 2- or 3-dimensional medium. Most frequently exhibits painting, drawing and sculpture.

Style: Exhibits a wide range of aesthetics from figurative realism to painterly abstraction. Prefers postmodern works with a humanistic/spiritual content.

Terms: Artwork is accepted on consignment (50% commission). Retail price set by the gallery. Gallery provides promotion and contract; shipping costs are shared. Prefers artwork framed.

Submissions: Send query letter with résumé, slides and SASE. Write for appointment to show portfolio of slides. Replies only if interested within 6 weeks. Finds artists through submissions.

Tips: "Atlanta is a prospering city with a lively expansive art scene. It is an ideal launching pad for emerging artists. Our local venues range from the alternative bohemian warehouse shows to the glitsy uptown blue chip end of the spectrum."

NÕVUS, INC., 495 Woodward Way NW, Atlanta GA 30305. (404)355-4974. Fax: (404)355-2250. Vice President: Pamela Marshall. Art dealer. Estab. 1987. Represents 200 emerging, mid-career and established

As with all her sculpture work, Dana Groemminger's *Passage I* is life-size. "I like the confrontation that occurs when coming into contact with these figures," says the artist. "The scale is intended to make one react to them on a personal level. I believe diminishing or enlarging the scale would make a different and less direct statement." Showing her work at Lowe Gallery gave Groemminger national exposure early in her career. *Passage I* is one of a series of busts by the sculptor in low fire clay and oils. "I hope to continue to explore this format, as well as the possibility of moving these images to the wall in the future."

© 1994 Dana Groemminger

artists. Open by appointment; Monday-Friday, 9-5. Located in Buckhead, GA. 50% of space for gallery artists. Clientele: corporate, hospitality, healthcare. 5% private collectors, 95% corporate collectors. Overall price range: $500-20,000; most work sold at $800-5,000.

Media: Considers oil, acrylic, watercolor, pastel, mixed media, collage, paper, sculpture, ceramics, craft, fiber, glass, photography, and all types of prints. Most frequently exhibits mixed/paper and oil/acrylic.

Style: Exhibits all styles. Genres include landscapes, abstracts, florals and figurative work. Prefers landscapes, abstract and figurative.

Terms: Accepts work on consignment (50% commission). Retail price set by the artist. Gallery provides promotion and contract; shipping costs are shared. Prefers artwork unframed.

Submissions: Artists must have no other representation in our area. Send query letter with résumé, slides, brochure and reviews. Write for appointment to show portfolio of originals, photographs and slides. Replies only if interested within 1 month. Files slides and bio. Finds artists through agents, visiting exhibitions, word of mouth, art publications and sourcebooks, submissions.

Tips: "Send complete information and pricing. Do not expect slides and information back. Keep the dealer updated with current work and materials."

‡**NANCY SOLOMON GALLERY**, 1037 Monroe Dr., Atlanta GA 30306. (404)875-7100. Fax: (404)875-0270. Gallery Assistant: Wendy Given. Retail gallery, art consultancy. Estab. 1994. Represents 30 emerging, mid-career and established artists/year. Exhibited artists include Muntadas, Don Porcaro. Sponsors 9 shows/year. Average display time 5 weeks. Open all year except August; Tuesday-Saturday, 11-6. Located in midtown Atlanta; clean New York-style space, concrete floors; features entire front wall of gallery windows to main street. Clientele: all types. Overall price range: $300-10,000.

Media: Considers all media.

Style: Exhibits conceptualism, minimalism, painterly abstraction and postmodern works. Prefers minimalism, conceptualism and abstraction.

Terms: Accepts work on consignment.

Submissions: Send query letter with résumé, slides, reviews, bio and SASE. "We do not do portfolio reviews unless contacted." Replies in 1-2 months. Files bio. Finds artists through word of mouth, submissions.

Tips: Avoid "poor slide representation, sloppy presentation."

‡**VESPERMANN GLASS GALLERY**, 2140 Peachtree Rd., Atlanta GA 30309. (404)350-9698. Fax: (404)350-0046. Manager: Tracey Loftin. Retail gallery. Estab. 1984. Represents 200 emerging, mid-career and established artists/year. Sponsors 8 shows/year. Average display time 1 month. Open all year; Monday-Saturday, 10-6 and holiday hours. Located between Mid-town and Buckhead; 2,500 sq. ft.; features contemporary art glass. Overall price range: $100-10,000; most work sold at $200-2,000.

Media: Considers glass and craft.

Style: Exhibits contemporary.

Terms: Accepts work on consignment (50% commission). Buys outright for 50% of retail price (net 30 days). Retail price set by the gallery and the artist. Gallery provides insurance, promotion and contract; shipping costs are shared.

Submissions: Send query letter with résumé, slides, bio. Write for appointment to show portfolio of photographs, transparencies and slides. Replies only if interested within 2 weeks. Files slides, résumé, bio.

Hawaii

THE ART CENTRE AT MAUNA LANI, P.O. Box 6303, 2 Mauna Lani Dr., Kohala Coast HI 96743-6303. (808)885-7779. Fax: (808)885-0025. Director: Julie Bancroft. Retail gallery run by nonprofit organization to fund their activities. Estab. 1988. Represents 25 emerging, mid-career and established artists. Sponsors 6 shows/year. Average display time 2 months. Open all year. Located in the Mauna Lani Resort, Big Island of Hawaii; 2,500 sq. ft. 40% of space for special exhibitions. Clientele: tourists and local residents. 90% private collectors, 10% corporate collectors. Overall price range: $50-30,000.

Media: Considers all media and original handpulled prints, engravings, lithographs, mezzotints and serigraphs. Prefers oil, acrylic and watercolor.

Style: Exhibits all styles and genres, including Oriental art. Prefers photorealism, impressionism and expressionism. "Oriental art and antiques make our gallery unique."

Terms: Accepts artwork on consignment (50% commission). Requires exclusive area representation. Retail price set by gallery and artist. Sometimes offers customer discounts and payment by installment. Gallery provides insurance, promotion and contract; artist pays for shipping. Prefers artwork "properly framed."

Submissions: Send query letter with bio, brochure, photographs and SASE. Portfolio review requested if interested in artist's work.

Tips: "Label all works with size, title, medium and retail price (or range)."

COAST GALLERIES, Located in Hana, Hawaii. Also in Big Sur and Pebble Beach, California. Mailing address: P.O. Box 223519, Carmel CA 93922. (408)625-4145. Fax: (408)625-3575. Owner: Gary Koeppel.
• Coast Galleries are located in both Hawaii and California. See listing in San Francisco section for information on the galleries' needs and submission policies.

‡**HONOLULU ACADEMY OF ARTS**, 900 S. Beretania St., Honolulu HI 96814. (808)532-8700. Fax: (808)532-8787. Director: George R. Ellis. Nonprofit museum. Estab. 1927. Exhibits emerging, mid-career and established artists. Interested in seeing the work of emerging artists. Sponsors 40-50 shows/year. Average display time 6-8 weeks. Open all year; Tuesday-Saturday 10:00-4:30, Sunday 1-5. Located just outside of downtown area; 40,489 sq. ft. 30% of space for special exhibition. Clientele: general public and art community. Price range varies.
Media: Considers all media. Most frequently exhibits painting, works on paper, sculpture.
Style: Exhibits all styles and genres. Prefers traditional, contemporary and ethnic.
Terms: "On occasion, artwork is for sale. Artist receives 100% of price." Retail price set by artist. Gallery provides insurance and promotion; museum pays for shipping costs. Prefers artwork framed.
Submissions: Send query letter with résumé, slides and bio directly to curator(s) of Western and/or Asian art. Curators are: Jennifer Saville, Western art; Julia White, Asian art. Write for appointment to show portfolio of slides, photographs and transparencies. Replies in 3-4 weeks. Files résumés, bio.

QUEEN EMMA GALLERY, 1301 Punchbowl St., Honolulu HI 96813. (808)547-4397. Fax: (808)547-4646. Director: Masa Morioka Taira. Nonprofit gallery. Estab. 1977. Exhibits the work of emerging, mid-career and established artists. Average display time is 5½ weeks. Located in the main lobby of The Queen's Medical Center; "intimate ambiance allows close inspection." Clientele: M.D.s, staff personnel, hospital visitors, community-at-large. 90% private collectors. Overall price range: $50-5,000.
Media: Considers all media. "Open to innovation and experimental work appropriate to healing environment."
Style: Exhibits contemporary, abstract, impressionism, figurative, primitive, non-representational, photorealism, realism and neo-expressionism. Specializes in humanities-oriented interpretive, literary, cross-cultural and cross-disciplinary works. Interested in folk art, miniature works and ethnic works. "Our goal is to offer a variety of visual expressions by regional artists. Subject matter and aesthetics appropriate for audience in a healthcare facility is acceptable." Interested in seeing "progressive, honest, experimental works with artist's personal interpretation."
Terms: Accepts work on consignment (30% commission). Retail price set by artist. Offers payment by installments. Exclusive area representation not required. Gallery provides promotion and contract.
Submissions: Send query letter with résumé, brochure, business card, slides, photographs and SASE. Wishes to see a portfolio of slides, blown-up full color reproduction is also acceptable. "Prefer brief proposal or statement or proposed body of works." Preference given to local artists. "Include prices, title and medium information." Finds artists through direct inquiries, referral by art professionals, news media publicity.
Tips: "The best introduction to us is to submit your proposal with a dozen slides of works created with intent to show. Show professionalism, integrity, preparation, new direction and readiness to show. Be honest. Adhere to basics."

‡**RAMSAY GALLERIES**, 1128 Smith St., Honolulu HI 96817. (808)537-ARTS. Fax: (808)533-6690. Artist/Owner: Ramsay. Retail gallery. Estab. 1981. Represents 30 emerging, mid-career and established artists/year. Exhibited artists include John Young, Esther Shimazu. Sponsors 12 solo shows/year. Average display time 1 month. Open all year; Monday-Friday, 10-5; Saturday, 10-4. Located in downtown historic district; 4,000 sq. ft.; historic building with courtyard. 30% of space for special exhibitions; 60% of space for gallery artists. Clientele: 50% tourist, 50% local. 60% private collectors, 40% corporate collectors. Overall price range: $100-100,000; most work sold at $500-25,000.
Media: Considers all media and all types of prints. Most frequently exhibits paintings, sculpture, pottery and prints.
Style: Exhibits all styles and genres. Prefers landscapes, still lifes, painterly abstraction.
Terms: Accepts work on consignment. Retail price set by the artist. Gallery provides promotion; artist pays for shipping. Prefers artwork framed.
Submissions: Prefers only artists from Hawaii. Send query letter with résumé, slides, bio, SASE. Write for appointment to show portfolio of original art. Replies only if interested within 1 month. Files all material that may be of future interest. Finds artists through submissions.
Tips: "A common mistake artists make is they do not include price sheet to correspond with slide sheet. Prepare your gallery presentation packet with the same care that you give to your art creations."

‡**VOLCANO ART CENTER GALLERY**, P.O. Box 104, Hawaii National Park HI 96718. (808)967-7511. Fax: (808)967-8512. Gallery Manager: Natalie Pfeifer. Nonprofit gallery to benefit arts education; nonprofit organization. Estab. 1974. Represents 200 emerging, mid-career and established artists/year. 1,400 member organization. Exhibited artists include Dietrich Varez and Brad Lewis. Sponsors 25 shows/year. Average display time 1 month. Open all year; daily 9-5. Located Hawaii Volcanoes National Park; 3,000 sq. ft.; in

the historic 1877 Volcano House Hotel (gallery uses the entire building). 15% of space for special exhibitions; 90% of space for gallery artists. Clientele: affluent travelers from all over the world. 95% private collectors, 5% corporate collectors. Overall price range: $20-4,500; most work sold at $50-400.
Media: Considers all media, all types of prints. Most frequently exhibits wood, mixed media, ceramics and glass.
Style: Exhibits expressionism, neo-expressionism, primitivism and painterly abstraction. Prefers traditional Hawaiian, contemporary Hawaiian and contemporary fine crafts.
Terms: "Artists must become Volcano Art Center members." Accepts work on consignment (50% commission). Retail price set by the gallery. Gallery provides promotion and contract; artist pays shipping costs to gallery.
Submissions: Prefers only work relating to the area or by Hawaiian artists. Call for appointment to show portfolio. Replies only if interested within 1 month. Files "information on artists we represent."

WAILOA CENTER, 200 Piopio St., Hilo HI 96720. (808)933-4360. Director: Mrs. Pudding Lassiter. Nonprofit gallery and museum. Focus is on propigation of Hawaiian culture. Estab. 1968. Represents/exhibits 300 emerging, mid-career and established artists. Interested in seeing work of emerging artists. Sponsors 60 shows/year. Average display time 1 month. Open all year; Monday-Friday, 8-4:30. Located downtown; 10,000 sq. ft.; 3 exhibition areas: main gallery and two local airports. Clientele: tourists, upscale, local community and students. Overall price range: $25-25,000; most work sold at $1,500.
Media: Considers all media and all types of prints. Most frequently exhibits mixed media.
Style: Exhibits all styles. "We cannot sell, but will refer buyer to seller." Gallery provides promotion. Artist pays for shipping costs. Prefers artwork framed.
Submissions: Send query letter with résumé, slides, photographs and reviews. Call for appointment to show portfolio of photographs and slides. Replies in 3 weeks. Finds artists through word of mouth, referrals by other artists, visiting art fairs and exhibitions, submissions.
Tips: "We welcome all artists, and try to place them in the best location for the type of art they have. Drop in and let us review what you have."

Idaho

‡KNEELAND GALLERY, P.O. Box 2070, Sun Valley ID 83353. (208)726-5512. Fax: (208)726-7495. (800)338-0480. Director: Jennifer Jaros. Retail gallery, art consultancy. Estab. 1981. Represents 40 emerging, mid-career and established artists/year. Exhibited artists include: Ovanes Berberian, Steven Lee Adams. Sponsors 9 shows/year. Average display time 3 weeks. Open all year; Monday-Saturday, 10-5. Located downtown; 2,500 sq. ft.; features a range of artists in several exhibition rooms. 50% of space for special exhibitions; 50% of space for gallery artists. Clientele: tourist, seasonal, local, upscale. 95% private collectors, 5% corporate collectors. Overall price range: $200-25,000; most work sold at $1,000-2,000.
Media: Considers all media and all types of prints. Most frequently exhibits oil, acrylic, watercolor.
Style: Exhibits expressionism, realism. Genres include landscapes, florals, figurative work. Prefers landscapes-realism, expressionism, abstraction.
Terms: Accepts work on consignment (50% commission). Retail price set by the artist. Gallery provides insurance, promotion and contract; shipping costs are shared. Prefers artwork framed.
Submissions: Send query letter with résumé, slides, photographs, artists' statement, bio, SASE. Write for appointment to show portfolio of photographs and slides. Replies in 1-2 months. Files photo samples/business cards. Finds artists through submissions and referrals.

ANNE REED GALLERY, P.O. Box 597, Ketchum ID 83340. (208)726-3036. Fax: (208)726-9630. Director: Jennifer Gately. Retail Gallery. Estab. 1980. Represents mid-career and established artists. Exhibited artists include Jun Kaneko, Theodore Waddell and Deborah Butterfield. Sponsors 8 exhibitions/year. Average display time 1 month. Open all year. Located in the Walnut Avenue Mall. 10% of space for special exhibitions; 90% of space for gallery artists. Clientele: 80% private collectors, 20% corporate collectors.
Media: Most frequently exhibits sculpture, wall art and photography.
Style: Exhibits expressionism, abstraction, conceptualism, impressionism, photorealism, realism. Prefers contemporary and landscapes.

 THE DOUBLE DAGGER before a listing indicates that the listing is new in this edition. New markets are often more receptive to freelance submissions.

Terms: Accepts work on consignment (50% commission). Retail price set by gallery and artist. Sometimes offers customer discounts and payment by installment. Gallery provides insurance, promotion, contract and shipping costs from gallery. Prefers artwork framed.

Submissions: Send query letter with résumé, slides, bio and SASE. Call or write for appointment to show portfolio of originals (if possible), slides and transparencies. Replies in 2 months. Finds artists through word of mouth, exhibitions, publications, submissions and collector's referrals.

THE ROLAND GALLERY, 601 Sun Valley Rd., P.O. Box 221, Ketchum ID 83340. (208)726-2333. Fax: (208)726-6266. Owner: Roger Roland. Retail gallery. Estab. 1990. Represents 100 emerging, mid-career and established artists. Sponsors 8 shows/year. Average display time 1 month. Open all year; daily 11-5. 800 sq. ft. 50% of space for special exhibitions; 50% of space for gallery artists. Clientele: 75% private collectors, 25% corporate collectors. Overall price range: $10-10,000; most work sold at $500-1,500.

Media: Considers oil, pen & ink, paper, fiber, acrylic, sculpture, glass, watercolor, mixed media, ceramic, installation, pastel, collage, craft and photography, engravings, mezzotints, etchings, lithographs. Most frequently exhibits glass, paintings and jewelry.

Style: Considers all styles and genres.

Terms: Accepts work on consignment (50% commission) or buys outright for 50% of the retail price (net 30 days). Retail price set by artist. Gallery provides insurance, promotion, shipping costs from gallery. Prefers artwork framed.

Submissions: Send query letter with résumé, slides, bio, brochure, photographs, SASE, business card and reviews. Write for appointment to show portfolio of photographs, slides and transparencies. Replies only if interested within 2 weeks.

Illinois

ALTER ASSOCIATES INC., 122 Cary, Highland Park IL 60035. (708)433-1229. Fax: (708)433-2220. President: Chickie Alter. Art consultancy. Estab. 1972. Represents 200 emerging, mid-career and established artists through slides. Open all year; Monday-Sunday. Located in suburbs. Clientele: upscale, residential and corporate. 60% private collectors, 40% corporate collectors. Overall price range: $500-10,000; most work sold at $1,000-4,000.

Media: Considers all media except conceptual. Most frequently sells acrylic, oil, mixed media and 3 dimensional work.

Style: Exhibits expressionism, photorealism, neo-expressionism, pattern painting, color field, illustrative, painterly abstraction, realism and imagism.

Terms: Artwork is accepted on consignment (40% commission). Retail price set by the artist. Shipping costs are usually shared. Prefers artwork unframed.

Submissions: Accepts only artists from US. Send query letter with résumé, slides, bio and SASE. Portfolio should include slides and SASE. Reports in 2 weeks.

Tips: Submit clear, well-marked slides and SASE.

‡ARTCO, INCORPORATED, 3148 RFD, Long Grove IL 60047. (847)438-8420. Fax: (847)438-6464. President: Sybil Tillman. Retail and wholesale gallery, art consultancy and artists' agent. Estab. 1970. Represents 60 mid-career and established artists. Interested in seeing the work of emerging artists. Exhibited artists include Ed Paschke and Gary Grotey. Open all year; daily and by appointment. Located "2 blocks outside of downtown Long Grove; 4,500 sq. ft.; unique private setting in lovely estate and heavily wooded area." 50% of space for special exhibitions. Clientele: upper middle income. 65% private collectors, 20% corporate collectors. Overall price range: $500-20,000; most work sold at $2,000-5,000.

Media: Considers paper, sculpture, fiber, glass, original handpulled prints, woodcuts, engravings, pochoir, wood engravings, mezzotints, linocuts, etchings and serigraphs. Most frequently exhibits originals and signed limited editions "with a small number of prints."

Style: Exhibits all styles, including expressionism, abstraction, surrealism, conceptualism, postmodern works, impressionism, photorealism and hard-edge geometric abstraction. All genres. Prefers American contemporary and Southwestern styles.

Terms: Accepts artwork on consignment. Retail prices set by gallery. Customer discounts and payment by installment are available. Gallery provides promotion and contract; artist pays for shipping.

Submissions: Send query letter with résumé, slides, transparencies, bio, brochure, photographs, SASE, business card and reviews. Replies in 2-4 weeks. Files materials sent. Portfolio review required. Finds artists through agents, by visiting exhibitions, word of mouth, various art publications and sourcebooks, submissions/self-promotions and art collectors' referrals.

Tips: "We prefer established artists but will look at all new art."

ARTHURIAN GALLERY, 4646 Oakton, Skokie IL 60076. Owner: A. Sahagian. Retail/wholesale gallery and art consultancy. Estab. 1987. Represents/exhibits 60-80 emerging, mid-career and established artists/

year. Interested in seeing the work of emerging artists. Exhibited artists include Christana-Fortunato. Sponsors 3-4 shows/year. Average display time 4-6 weeks. Open all year; Monday-Sunday, 10-4. Located on main street of Skokie; 1,600 sq. ft. 80-100% of space for gallery artists. 5-10% private collectors, 5-10% corporate collectors. Overall price range: $50-3,000; most work sold at: $200-2,000.
Media: Considers all media and all types of prints. Most frequently exhibits oil, water color, acrylic and pastel.
Style: Exhibits expressionism, painterly abstraction, surrealism, all styles. All genres. Prefers impressionism, abstraction and realism.
Terms: Artwork is accepted on consignment (35% commission). Retail price set by the gallery and the artist. Gallery provides insurance and promotion. Artist pays for shipping costs. Prefers artwork framed.
Submissions: Send query letter with résumé, slides and SASE. Include price and size of artwork. Call or write for appointment to show portfolio of photographs, slides and transparencies. Replies in 2 weeks. Finds artists through word of mouth, referrals by other artists, visiting art fairs and exhibitions, submissions.
Tips: "Be persistent."

FREEPORT ART MUSEUM AND CULTURAL CENTER, 121 N. Harlem Ave., Freeport IL 61032. (815)235-9755. Director: Becky Connors. Estab. 1975. Interested in emerging, mid-career and established artists. Sponsors 9 solo and group shows/year. Clientele: 30% tourists; 60% local; 10% students. Average display time 6 weeks.
Media: Considers all media and prints.
Style: Exhibits all styles and genres. "We are a regional museum serving Northwest Illinois, Southern Wisconsin and Eastern Iowa. We have extensive permanent collections and 8-9 special exhibits per year representing the broadest possible range of regional and national artistic trends. Some past exhibitions include 'Inuit Images of Man & Animals,' 'Gifts for the Table,' 'Picture This: Contemporary Children's Book Illustrations,' and 'Art Bytes: An Introduction to Computer Art.' "
Terms: Gallery provides insurance and promotion; shipping costs are shared. Prefers artwork framed.
Submissions: Accepts mainly Illinois artists. Send query letter with résumé, slides, SASE, brochure, photographs and bio. Write for appointment to show portfolio of originals, slides and photographs. Replies in 3-4 months. Files résumés.
Tips: "The committee reviews slides in January and July."

GALLERY TEN, 514 E. State St., Rockford IL 61104. (815)964-1743. Contact: Charlene Berg. Retail gallery. Estab. 1986. "We are a downtown gallery representing visual artists in all media." Represents emerging, mid-career and established artists. Average display time 6 weeks. Clientele: 50% private collectors, 50% corporate clients. Overall price range: $4-10,000; most artwork sold at $50-300.
Media: Considers all media.
Style: Exhibits fine arts and fine crafts; considers all styles and media. Sponsors national and regional juried exhibits and one-person and group shows. "Part of the gallery is reserved for the sales gallery featuring works by numerous artists and craftspeople and incorporates exhibition space for small shows. All work must be for sale and ready to hang or install."
Terms: Retail price set by artist (40% commission). Offers payment by installments. Exclusive area representation not required. Gallery provides promotion. Prefers artwork framed.
Submissions: Send query letter with slides, photographs and SASE. Portfolio review requested if interested in artist's work. All material is returned by SASE if not accepted or under consideration. Finds artists through agents, by visiting exhibitions, word of mouth, various art publications and sourcebooks, submissions/self-promotions, art collectors' referrals; "also through our juried exhibits."
Tips: Looks for "creative viewpoint—professional presentation and craftsmanship. Common mistakes artists make in their submissions include sloppy presentation, poor-quality slides, paper and/or photocopying and errors in spelling and grammar. Quality of work is paramount. We like to try a couple of pieces from an artist in our sales gallery before committing to a larger exhibit."

MINDSCAPE GALLERY, 1506 Sherman, Evanston IL 60201. (847)864-2660. Contact: Jury Review Panel. Retail gallery and art consultancy. Estab. 1973. Represents 600 emerging, mid-career and established artists. Exhibited artists include Shane Fero and Heinz Brummel. Sponsors 6 shows/year. Average display time 3-4 months. "Hours vary seasonally." Open all year. Located in downtown Evanston, 20 minutes north of downtown Chicago; 10,000 sq. ft.; "large open space with 12' ceiling heights and carpeted walls." 30% of space for special exhibitions. Clientele: 80% private collectors, 10% corporate collectors. Overall price range: $20-15,000; most work sold at $50-300.
Media: Considers mixed media, paper, sculpture, fiber, glass, ceramic, fine contemporary designer crafts, functional and non-functional. Most frequently exhibits glass, fine jewelry and wearable art. Specifically seeking painted clothing and hand-dyed, wearable art for 1996/1997.
Style: Exhibits all styles, especially contemporary and all genres.
Terms: Accepts artwork on consignment (50% commission). Retail prices set by gallery and artist. Gallery provides insurance, promotion and contract; artist pays for shipping. Prefers artwork unframed.

Submissions: Accepts only American contemporary fine craft and sculpture. "One of a kind, limited edition, limited series only." Send query letter with request for jury application. Write for appointment and request jury application. To show portfolio, include slides, photographs, transparencies, promo information and résumé. Replies in 1 month after jury review. Files general artist information.
Tips: "Stop by the gallery to see if you think your work would fit in. Be professional in presentation and understanding of the nature of marketing art in the '90s."

‡**NIU ART MUSEUM**, Northern Illinois University, DeKalb IL 60115. (815)753-1936. Fax: (815)753-0198. Director: Peggy Doherty. University museum. Estab. 1970. Exhibits emerging, mid-career and established artists. Sponsors 10 shows/year. Average display time 6 weeks. Open August-May. Located in DeKalb, Illinois. 50% of space for special exhibitions.
Media: Considers all media and all types of prints.
Style: Exhibits all styles and genres.
Terms: "All sales are referred to the artist." Retail price set by artist. Museum provides insurance and promotion; shipping costs are shared.
Submissions: Send query letter with résumé and slides. Replies ASAP. Files "maybes."

PRESTIGE ART GALLERIES, 3909 W. Howard, Skokie IL 60076. (708)679-2555. E-mail: 76751-1327@ compuserve.com. Website: http://www.prestigeart.com. President: Louis Schutz. Retail gallery. Estab. 1960. Exhibits 100 mid-career and established artists/year. Interested in seeing the work of emerging artists. Exhibited artists include Jean Paul Avisse. Sponsors 4 shows/year. Average display time 4 months. Open all year; Saturday and Sunday, 11-5; Monday-Wednesday, 10-5. Located in a suburb of Chicago; 3,000 sq. ft. 20% of space for special exhibitions; 50% of space for gallery artists. Clientele: professionals. 20% private collectors, 10% corporate collectors. Overall price range: $100-100,000; most work sold at $1,500-2,000.
Media: Considers oil, acrylic, mixed media, paper, sculpture, ceramics, craft, fiber, glass, lithographs and serigraphs. Most frequently exhibits paintings, glass and fiber.
Style: Exhibits surrealism, New Age visionary, impressionism, photorealism and realism. Genres include landscapes, florals, portraits and figurative work. Prefers landscapes, figurative-romantic and floral.
Terms: Accepts work on consignment (50% commission). Retail price set by the gallery and the artist. Gallery provides insurance, promotion and contract; shipping costs are shared. Prefers artwork framed.
Submissions: Send query letter with résumé, slides, bio, SASE and prices/sizes. Call for appointment to show portfolio of photographs. Replies in 2 weeks. "Returns all material if SASE is included."

‡**QUINCY UNIVERSITY GRAY GALLERY**, 1800 College, Quincy IL 62301. (217)222-8020, ext. 5371. Gallery Curator/Professor of Art: Robert Mejer. University gallery. Estab. 1968. Represents emerging, mid-career and established artists. 6-8 invited yearly for exhibitions. Exhibited artists include Shelly Thorstensen, Daniel Burke, Robert Nelson and Byron Burford. Sponsors 1 show/year. Average display time 3-4 weeks. Closed July. Located on campus; 111 ft. linear wall space. 100% of space is devoted to special exhibitions of gallery artists. "Hours and location provide viewer intimacy in seeing art." Clientele: "all levels of society." 98% private collectors, 2% corporate collectors. "Location and size of work and shipping are practical considerations." Overall price range $25-2,500; most work sold at $15-500.
 • Located in the university library, Gray Gallery has long hours and is accessible to students and the public.
Media: Considers all media, original handpulled prints, woodcuts, engravings, lithographs, pochoir, wood engravings, mezzotints, monotypes, serigraphs, linocuts and etchings. Does not consider glass. Most frequently exhibits works on paper, oil, acrylic and sculpture.
Style: Exhibits all styles and genres. Prefers painterly abstraction, realism, minimalism and pattern painting.
Terms: A small honorarium is given and some transportation is covered. Retail price set by the artist. Offers payment by installments. Gallery provides insurance, promotion and contract. Shipping costs are shared.
Submissions: "Location and size of work and shipping are practical considerations." Send query letter with résumé, slides, bio, brochure and SASE. Portfolio review not required. Replies in 1 month. Files résumé, bio, slides (3) and philosophic statement. Finds artists through referrals, slide solicitations, participation in competitive shows, visiting exhibits and meeting artists.
Tips: "Show work that is current, consistent, representative and qualitive. Slides need to be of high quality. Include a SASE. Be flexible—things can be accomplished/negotiated, satisfying both parties. We make every effort to refer artists to other art centers/galleries if we can't handle or afford them."

Chicago

A.R.C. GALLERY, 1040 W. Huron, 2nd Floor, Chicago, IL 60622. (312)733-2787. E-mail: arcgallery@aol. com. Website: http://www.arts-online.com/arcg.htm. President: Julia Morrisroe. Nonprofit gallery. Estab. 1973. Exhibits emerging, mid-career and established artists. Interested in seeing the work of emerging artists. 21 members. Exhibited artists include Miriam Schapiro. Average display time 1 month. Closed August.

Located in the River West area; 3,500 sq. ft. Clientele: 80% private collectors, 20% corporate collectors. Overall price range $50-40,000; most work sold at $200-4,000.
Media: Considers oil, acrylic, drawings, mixed media, paper, sculpture, ceramics, installation, photography and original handpulled prints. Most frequently exhibits painting, sculpture (installation) and photography.
Style: Exhibits all styles and genres. Prefers postmodern and contemporary work.
Terms: Rental fee for space. Rental fee covers 1 month. Gallery provides promotion; artist pays shipping costs. Prefers work framed.
Submissions: Send query letter with résumé, slides, bio and SASE. Call for deadlines for review. Portfolio should include slides.

‡**ARTEMISIA GALLERY**, 700 N. Carpenter, Chicago IL 60622. (312)226-7323. Presidents: Carrie Seid, Sungmi Naylor. Cooperative and nonprofit gallery/alternative space run by women artists. Estab. 1973. 9 active members, 15 associate members. Sponsors 60 solo shows/year. Average display time 4 weeks. Interested in emerging and established artists. Overall price range: $150-10,000; most work sold at $600-2,500.
Media: Considers all traditional media including craft, installation, performance and new technologies. Prefers paintings, sculpture and installation. "Artemisia is a cooperative art gallery run by artists. We try to promote women artists."
Terms: Co-op membership fee plus donation of time; rental fee for space; rental fee covers 1 month. Retail price set by artist. Exclusive area representation not required. Gallery provides insurance; artist pays for shipping.
Submissions: Send query letter with résumé, statement, 15-20 slides and SASE. Portfolios reviewed each month. Replies in 6 weeks. All material is returned if not accepted or under consideration if SASE is included.
Tips: "Send clear, readable slides, labeled and marked 'top' or with red dot in lower left corner."

‡**PETER BARTLOW GALLERY**, 44 E. Superior, Chicago IL 60611. (312)337-1782. Fax: (312)337-2516. Director: Peter Bartlow. Retail gallery. Estab. 1991. Represents 25 emerging, mid-career and established artists/year. Exhibited artists include Willy Ramos, David Blackburn. Sponsors 5 shows/year. Average display time 1 month. Open all year; Tuesday-Friday, 9:30-5:30; Saturday, 10:30-5. Located in North Michigan Ave. area; 2,000 sq. ft.; 1880s Chicago graystone—marble fireplaces, high ceilings, arched doors. 45% of space for special exhibitions; 40% of space for gallery artists. Clientele: national and local collectors. 70% private collectors, 30% corporate collectors. Overall price range: $400-45,000; most work sold at $1,200-5,000.
Media: Considers all media except installation, fiber. Considers all types of prints. Most frequently exhibits works on paper, canvases, graphics.
Style: Exhibits expressionism, painterly abstraction, postmodern works, photorealism, realism. Prefers stylized landscape, modern still life, photorealism.
Terms: Accepts work on consignment (50% commission.) Retail price set by the gallery. Gallery provides insurance and promotion; shipping costs are shared.
Submissions: Send query letter with slides, bio, SASE. Call for appointment to show photographs, slides. Replies only if interested within 1 week. Finds artists through word of mouth, referral, art fairs.
Tips: Some common mistakes artists make are "not including phone number and not calling within one or two weeks to follow up."

‡**BERET INTERNATIONAL GALLERY**, 1550 N. Milwaukee St., Chicago IL 60622. (312)489-6518. Fax: (312)342-5012. Director: Ned Schwartz. Alternative space. Estab. 1991. Represents 20 emerging, mid-career and established artists/year. Exhibited artists include Jno Cook and Dennis Kowalski. Sponsors 8 shows/year. Average display time 5 weeks. Open all year; Thursday, 1-7; Friday and Saturday, 1-5; or by appointment. Located near north west Chicago, Bucktown; 2,500 sq. ft.; shows conceptual art, mechanical sculpture. 100% of space for special exhibitions; backrooms for gallery artists. Clientele: "serious art intellectuals." 90% private collectors, 10% corporate collectors. Overall price range: $25-5,000.
Style: Exhibits conceptualism.
Terms: Accepts work on consignment (40% commission). Retail price set by the gallery and the artist. Gallery provides insurance, promotion and contract; artist pays shipping costs to and from gallery.
Submissions: "All art has strong social relevance. No decorative craft." Send query letter with slides, photographs and SASE. Call or write for appointment. Files résumé, slides and photos. Finds artists through visiting exhibitions, submissions.
Tips: "Neo-critics and post-collectors always welcome."

CAIN GALLERY, 111 N. Marion St., Oak Park IL 60301. (708)383-9393. Owners: Priscilla and John Cain. Retail gallery. Estab. 1973. Represents 75 emerging, mid-career and established artists. "Although we occasionally introduce unknown artists, because of high overhead and space limitations, we usually accept only artists who are somewhat established, professional and consistently productive." Sponsors 6 solo shows/year. Average display time 6 months. Open all year. Recent move triples space, features an on-site interior design consultant. Clientele: 80% private collectors, 20% corporate clients. Overall price range: $100-6,000; most artwork sold at $500-1,000.

Media: Considers oil, acrylic, watercolor, mixed media, collage, sculpture, crafts, ceramic, woodcuts, engravings, mezzotints, etchings, lithographs and serigraphs. Most frequently exhibits acrylic, watercolor and serigraphs.

Style: Exhibits impressionism, realism, surrealism, painterly abstraction, imagism and all styles. Genres include landscapes, florals, figurative work. Prefers impressionism, abstraction and realism. "Our gallery is a showcase for living American artists—mostly from the Midwest, but we do not rule out artists from other parts of the country who attract our interest. We have a second gallery in Saugatuck, Michigan, which is open during the summer season. The Saugatuck gallery attracts buyers from all over the country."

Terms: Accepts artwork on consignment. Retail price set by artist. Sometimes offers customer payment by installment. Exclusive area representation required. Gallery provides insurance, promotion, contract and shipping costs from gallery. Prefers artwork framed.

Submissions: Send query letter with résumé and slides. Portfolio review requested if interested in artist's work. Portfolio should include originals and slides. Finds artists through visiting exhibitions, word of mouth, submissions/self-promotions and art collectors' referrals.

Tips: "We are now showing more fine crafts, especially art glass and sculptural ceramics. The most common mistake artists make is amateurish matting and framing."

‡ALDO CASTILLO GALLERY, 233 W. Huron, Chicago IL 60610. (312)337-2536. Fax: (312)337-3627. Director: Aldo Castillo. Retail gallery, rental gallery. Estab. 1992. Represents emerging and established artists/year. Exhibited artists include Fernando de Szyszlo, Luis Fernando Uribe. Sponsors 4 shows/year. Average display time 6 weeks. Open February-December; Tuesday-Saturday, 11-5:30; 2,600 sq. ft.; elegant interior, set up as museum. 70% of space for special exhibitions; 30% of space for gallery artists. Clientele: tourists, upscale. 70% private collectors, 30% corporate collectors. Overall price range: $350-50,000.

Media: Considers all media. Most frequently exhibits oil on canvas, acrylic on canvas, photography, bronze sculpture.

Style: Exhibits all styles. Prefers abstract, semi-abstract and figurative-contemporary.

Terms: Accepts work on consignment (50% commission). Retail price set by the gallery. Gallery provides insurance, promotion and contract; artist pays for shipping costs. Prefers artwork framed.

Submissions: Accepts only artists from around the world, focusing on artists from Latin America. Send query letter with résumé, slides and artist's statement. Write for appointment to show portfolio of photographs or slides. Replies in 3 weeks. Files everything. Finds artists through other artists or galleries.

CHIAROSCURO, 700 N. Michigan Ave., Chicago IL 60611. (312)988-9253. Proprietors: Ronna Isaacs and Peggy Wolf. Contemporary retail gallery. Estab. 1987. Represents over 200 emerging artists. Average display time 6 months. Located on Chicago's "Magnificent Mile"; 2,500 sq. ft. on Chicago's main shopping boulevard, Michigan Ave. "Space was designed by award winning architects Himmel & Bonner to show art and contemporary crafts in an innovative way." Overall price range: $30-2,000; most work sold at $50-1,000.

Media: All 2-dimensional work—mixed media, oil, acrylic; ceramics (both functional and decorative works); sculpture, art furniture, jewelry. "We moved out of Chicago's gallery district to a more 'retail' environment 3 years ago because many galleries were closing. Paintings seemed to stop selling, even at the $500-1,000 range, where functional pieces (i.e. furniture) would sell at that price."

Style: "Generally we exhibit bright contemporary works. Paintings are usually figurative works either traditional oil on canvas or to the very non-traditional layers of mixed-media built on wood frames. Other works are representative of works being done by today's leading contemporary craft artists. We specialize in affordable art for the beginning collector, and are focusing on 'functional works'. We are currently carrying fewer of the 'funky' brightly painted objects—though we still feature them—and have added more metals and objects with 'cleaner' lines."

Terms: Accepts work on consignment (50% commission). Retail price set by gallery and artist. Customer discounts and payment by installment are available. Gallery provides insurance.

Submissions: Send query letter (Attn: Peggy Wolf) with résumé, slides, photographs, price list, bio and SASE. Portfolio review requested if interested in artist's work. All material is returned if not accepted or under consideration. Finds artists through agents, by visiting exhibitions and national craft and gift shows, word of mouth, various art publications and sourcebooks, submissions/self-promotions and art collectors' referrals.

Tips: "Don't be afraid to send photos of anything you're working on. I'm happy to work with the artist, suggest what's selling (at what prices). If it's not right for this gallery, I'll let them know why."

‡CHICAGO CENTER FOR THE PRINT, 1509 W. Fullerton, Chicago IL 60614. (312)477-1585. Fax: (312)477-1851. Owner/Director: Richard H. Kasvin. Retail gallery. Estab. 1979. Represents 100 mid-career and established artists/year. Interested in seeing the work of emerging artists. Exhibited artists include Hiratsuka, J. Buck, Armin Hoffmann, Herbert Leupin. Sponsors 5-6 shows/year. Average display time 4-6 weeks. Open all year; Tuesday-Saturday, 11-7; Sunday, 12-5. Located in Lincoln Park, Chicago; 2,500 sq. ft. "We represent works on paper, Swiss graphics and vintage posters." 40% of space for special exhibitions; 60%

of space for gallery artists. 90% private collectors, 10% corporate collectors. Overall price range: $300-3,000; most work sold at $500-700.
Media: Considers mixed media, paper, woodcuts, engravings, lithographs, wood engravings, mezzotints, serigraphs, linocuts, etchings and posters. Most frequently exhibits prints and posters.
Style: Exhibits all styles. Genres include landscapes and figurative work. Prefers abstract, figurative and landscape.
Terms: Accepts work on consignment (50% commission) or buys outright for 40-60% of the retail price (30-60 days). Retail price set by the gallery and the artist. Gallery provides promotion; shipping costs are shared. Prefers artwork unframed.
Submissions: Send query letter with résumé, slides and photographs. Write for appointment to show portfolio of originals, photographs and slides. Files everything. Finds new artists through agents, by visiting exhibitions, word of mouth, art publications and sourcebooks, submissions.

‡CIRCA GALLERY, 1800 W. Cornelia Ave., Chicago IL 60657. (312)935-1854. Director: Richard E. Lange. Alternative space, art consultancy, rental gallery. Estab. 1992. Represents 12 emerging artists/year. Exhibited artists include Eric David Hamilton, Kevin Orth. Sponsors 10 shows/year. Average display time 1 month. Open all year; Friday evenings; Saturday afternoon; or by appointment. Located 7 miles northwest of downtown Chicago; 700 sq. ft.; placed in 1910 Ice House factory, 14 ft. ceilings, brick walls. 50% of space for special exhibitions; 50% of space for gallery artists. Clientele: local community, students. 90% private collectors, 10% corporate collectors. Overall price range: $100-1,500; most work sold at $100-500.
Media: Considers all media except installation and all types of prints. Most frequently exhibits photography, paintings and sculpture.
Style: Exhibits expressionism, conceptualism, photorealism, minimalism, pattern painting, color field, hard-edge geometric abstraction, painterly abstraction, postmodern works, realism and surrealism. Exhibits all genres. Prefers cutting edge, figurative and abstract.
Terms: Accepts work on consignment (20% commission). There is a rental fee for space. Retail price set by the artist. Gallery provides promotion and contract; artist pays for shipping. Prefers artwork framed.
Submissions: Send query letter with résumé, business card, slides, photographs, artist's statement, bio and SASE. Call or write for appointment to show portfolio of photographs and slides. Replies in 2 weeks. Files slides. Finds artists through visiting art fairs, word of mouth, friends, local listings.

COLUMBIA COLLEGE ART GALLERY, 72 E. 11th St., Chicago IL 60605. (312)663-1600 ext. 110 or ext. 104. Fax: (312)360-1656. Director: Denise Miller-Clark. Assistant Director: Martha Alexander-Grohmann. Nonprofit gallery. Estab. 1984. Exhibits emerging, mid-career and established artists in the Chicago area. Sponsors 3 shows/year. Average display time 2 months. Open September-April. Located downtown in the 11th St. campus of Columbia College, Chicago; 1,645 sq. ft. 100% of space for special exhibitions.
Media: Considers oil, acrylic, watercolor, pastel, pen & ink, drawing, mixed media, collage, paper, sculpture, ceramic, craft, fiber, glass and installation.
Style: Exhibits all styles and genres.
Terms: Accepts artwork on consignment (25-30% commission). Retail price set by artist. Shipping costs are shared.
Submissions: Send query letter with résumé, slides, bio, SASE and reviews, if any. "Portfolios are reviewed Friday mornings between 9 a.m. and 1 p.m. The Art Gallery staff offices are located at The Museum of Contemporary Photography of Columbia College Chicago in the main campus building at 600 S. Michigan Ave. Chicago-area residents are asked to deliver portfolios, which may include finished artworks or slide reproductions, to the Museum address by 5 p.m. on the preceding Thursday. Portfolios will be available for pick-up by 1 p.m. on Friday. We suggest you telephone the Museum office to let us know when you will be dropping off a portfolio for review, since we are occasionally out of town, or otherwise unavailable. Visitors to Chicago who will not be in town on a Friday may call Martha Alexander-Grohmann at (312)663-5554 to make arrangements for their portfolios to be reviewed on another day." Replies in 1 month. Files slides and bio for future reference, if interested.
Tips: "Portfolio should be of professional quality and show a coherent body of work."

COLUMBIA COLLEGE CHICAGO CENTER FOR BOOK AND PAPER ARTS, (formerly Paper Press), 218 S. Wabash, 7th Floor, Chicago IL 60604. Director: Marilyn Sward. (312)431-8612. Fax: (312)986-8237. Nonprofit gallery. Estab. 1994. Exhibits artists' books, paper art, fine binding and paper sculpture. Sponsors 8 shows/year. Average display time 6 weeks. Open Monday-Friday, 9-5; some weekends; closed August. Located in downtown Chicago, 1 block from the Art Institute; 1,200 sq. ft.; natural light; track lighting; grey carpet; white walls. 100% of space for special exhibitions. Clientele: local community, students. 90% private collectors, 10% corporate collectors. Overall price range: $100-10,000.
 ● Two organizations, Paper Press and Artists Book Works, merged to form this center.
Media: Considers drawing, mixed media, collage, paper, sculpture, craft, fiber, installation and photography. "Everything we show relates to books and/or paper." Most frequently exhibits book arts/paper, installation, typography, design and calligraphy.

Style: Exhibits all styles and genres.

Terms: Accepts work on consignment (40% commission). Retail price set by the artist. "Some artists donate work." Gallery provides insurance; shipping costs are shared.

Submissions: Send query letter with résumé, bio and slides. Write for appointment to show portfolio of slides. Replies only if interested within 2 weeks. Files slides and résumés. "We have a slide registry. There is a $10 fee. We find new artists through the slide registry, recommendations from other artists and our annual national open call for entries."

CONTEMPORARY ART WORKSHOP, 542 W. Grant Place, Chicago IL 60614. (312)472-4004. Director: Lynn Kearney. Nonprofit gallery. Estab. 1949. Interested in emerging and mid-career artists. Average display time is 4½ weeks "if it's a show, otherwise we can show the work for an indefinite period of time." Clientele: art-conscious public. 75% private collectors, 25% corporate clients. Overall price range: $300-5,000; most artwork sold at $1,000 "or less."

Media: Considers oil, acrylic, mixed media, works on paper, sculpture, installations and original handpulled prints. Most frequently exhibits paintings, sculpture and works on paper and fine art furniture.

Style: "Any high-quality work" is considered.

Terms: Accepts work on consignment (33% commission). Retail price set by gallery or artist. "Discounts and payment by installments are seldom and only if approved by the artist in advance." Exclusive area representation not required. Gallery provides insurance and promotion.

Submissions: Send query letter with résumé, slides and SASE. Slides and résumé are filed. "First we review slides and then send invitations to bring in a portfolio based on the slides." Finds artists through call for entries in arts papers; visiting local BFA, MFA exhibits; referrals from other artists, collectors.

Tips: "Looks for a professional approach and a fine art school degree (or higher). Artists a long distance from Chicago will probably not be considered."

‡CORTLAND-LEYTEN GALLERY, 815 N. Milwaukee Ave., Chicago IL 60622. (312)733-2781. Director: S. Gallas. Retail gallery. Estab. 1984. Represents 6 emerging artists/year. Exhibited artists include Martin Geese, Wayne Bertola. Sponsors 4 shows/year. Average display time 1 month. Open all year; Saturday, 12:30-5; Sunday, 12:30-3; and by appointment. Located in "River West" near downtown; 2,000 sq. ft. 50% of space for special exhibitions; 50% of space for gallery artists. Clientele: upscale. 75% private collectors, 25% corporate collectors.

Media: Considers oil, pen & ink, acrylic, drawing, sculpture, mixed media, ceramics, collage, craft, engravings and lithographs. Most frequently exhibits sculpture, oil, mixed media.

Style: Exhibits all styles and all genres. Prefers figurative, oil.

Terms: Accepts work on consignment (50% commission). Retail price set by the gallery. Gallery provides insurance, promotion and contract; artist pays for shipping. Prefers artwork framed.

Submissions: Accepts local artists only. Send query letter with résumé, slides, bio. Write for appointment to show portfolio of slides. Replies only if interested within 2 weeks. Files slides, résumés. Finds artists through word of mouth, submissions.

DEBOUVER FINE ARTS, 2970 N. Lake Shore Dr., Suite 8B, Chicago IL 60657. (312)248-4499. President: Ronald V. DeBouver. Wholesale gallery and art consultancy. Estab. 1981. Clientele: interior designers and wholesale trade only. Represents 200 emerging, mid-career and established artists. Overall price range: $50-8,000; most artwork sold at $500.

Media: Considers oil, acrylic, watercolor, drawings, mixed media, collage, paper and posters. Most frequently exhibits oil, watercolor, graphics.

Style: Exhibits abstraction, color field, painterly abstraction, impressionistic, photorealistic and realism. Genres include landscapes, florals, Americana, English and French school and figurative work. Most frequently exhibits impressionistic, landscapes and floral. Currently seeking impressionistic, realism and abstract work.

Terms: Accepts work on consignment (33-50% commission). Retail price is set by gallery or artist. Offers customer discounts and payment by installments. Exclusive area representation not required.

Submissions: Send résumé, slides, photographs, prices and sizes. Indicate net prices. Portfolio review requested if interested in artist's work. Portfolio should include originals, slides and transparencies. Résumé and photos are filed. Finds artists through Chicago and New York art expos, art exhibits, word of mouth, submissions and collectors' referrals.

Tips: "When submitting pictures please list all information, such as media, size and prices that we would pay the artist. Also, would prefer receiving a phone call before mailing any information or photographs."

‡OSKAR FRIEDL GALLERY, Suite 304, 750 N. Orleans, Chicago IL 60610. (312)337-7550. Fax: (312)337-2466. E-mail: ofried@mes.com. Website: http://www.pg.net/o. Retail gallery. Estab. 1988. Represents 10 emerging, mid-career and established artists. Exhibited artists include (Art)n Laboratory, Miroslaw Regala, Florian Depenthal and Zhou Brothers. Sponsors 6 shows/year. Average display time 7 weeks. Open all year. Located downtown in River North gallery district; 800 sq. ft. Clientele: emerging private collectors.

80% private collectors, 20% corporate collectors. Overall price range: $500-30,000; most work sold at $3,000-8,000.

● This gallery has an emphasis on interactive material and CD-ROM.

Media: Considers oil, acrylic, pastel, pen & ink, drawings, mixed media, collage, sculpture, interactive multimedia, CD-ROM and installation. Most frequently exhibits oil, acrylic and sculpture.

Style: Exhibits expressionism, neo-expressionism, conceptualism and painterly abstraction. Prefers contemporoary, abstract expressionist and conceptualist styles.

Terms: Accepts artwork on consignment (50% commission). Retail price set by gallery and artist. Gallery provides insurance, promotion, contract and some shipping costs from gallery.

Submissions: Send query letter with résumé, slides, bio, brochure, photographs, SASE and reviews. Portfolio review requested if interested in artist's work. Portolio should include photographs, slides and transparencies. Replies in 4-6 weeks.

Tips: "The gallery is less able to show and represent new artists in the future due to expanded shows at the gallery (7-8 weeks) and programming of shows of gallery artist in institutions and different locations."

ROBERT GALITZ FINE ART, 166 Hilltop Court, Sleepy Hollow IL 60118. (708)426-8842. Fax: (708)426-8846. Owner: Robert Galitz. Wholesale representation to the trade. Makes portfolio presentations to corporations. Estab. 1986. Represents 40 emerging, mid-career and established artists. Exhibited artists include Marko Spalatin and Jack Willis. Open by appointment. Located in far west suburban Chicago.

Media: Considers oil, acrylic, watercolor, mixed media, collage, ceramic, fiber, original handpulled prints, engravings, lithographs, pochoir, wood engravings, mezzotints, serigraphs and etchings. "Interested in original works on paper."

Style: Exhibits expressionism, painterly abstraction, surrealism, minimalism, impressionism and hard-edge geometric abstraction. Interested in all genres. Prefers landscapes and abstracts.

Terms: Accepts artwork on consignment (variable commission) or artwork is bought outright (25% of retail price; net 30 days). Retail price set by artist. Customer discounts and payment by installment are available. Gallery provides promotion and shipping costs from gallery. Prefers artwork unframed only.

Submissions: Send query letter with SASE and submission of art. Portfolio review requested if interested in artist's work. Files bio, address and phone.

Tips: "Do your thing and seek representation—Don't drop the ball!—Keep going—Don't give up!"

‡GALLERY E.G.G. (EARTH GODDESS GROUP), 216 N. Clinton, Suite 300, Chicago IL 60661. (312)879-9667. Fax: (312)248-4376. Directors: Analisa Leppanen and Marianne Taylor-Leppanen. Nonprofit gallery, alternative space. Estab. 1993. Represents 10 emerging, mid-career and established artists/year. Exhibited artists include James Mesplé, Maureen Warren. Sponsors 4-6 shows/year. Average display time 6 weeks. Open September-June; Tuesday-Saturday, 12-5. Located River West, 2,000 sq. ft.; large loft space in industrial building. 75% for rotating exhibit, 25% for permanent collection/museum. Clientele: varied. 100% private collectors. Overall price range: $300-10,000; most work sold at $300-2,000.

Media: Considers all media except glass and craft and all types of prints. Most frequently exhibits sculpture, assemblage, oil and acrylic.

Style: Exhibits expressionism, primitivism, surrealism. Genres include environmental and spiritual.

Terms: Accepts work on consignment (40% commission). Buys outright for permanent collection for 60% of retail price. For group shows, there is a participation fee of $35. Retail price set by the gallery and the artist. Gallery provides insurance, promotion and contract; artists pays for shipping. Prefers paintings unframed; drawings, watercolors, etc. framed.

Submissions: Send query letter with résumé, brochure, slides, artists's statement, SASE to P.O. Box 617913, Chicago, IL, 60661-7913. Call for appointment to show portfolio of photographs and slides. Replies in 1 month. Files "anything that the artist wants me to keep, otherwise slides and photos are returned in a SASE. I advertise thematic shows, but I find many artists through word of mouth and referrals by other artists."

Tips: "We are interested in environmental and spiritual artwork, work that expresses a reverence for the earth, as well as artwork that uses found or recycled objects. Call for themes of upcoming shows."

‡GALLERY 312, 312 N. May St., Suite 110, Chicago IL 60607. (312)942-2500. Fax: (312)942-1206. E-mail: gallery312@aol.com. Nonprofit gallery. Estab. 1994. Represents mid-career and established artists/year. Interested in seeing the work of emerging artists only for special shows. Exhibited artists include Harry Callahan, Michiko Itatani. Sponsors 6 shows/year. Average display time 6 weeks. Open all year; Tuesday-Saturday, 11-5. Located in Fulton/Randolph Market District; 7,200 sq. ft.; 28 ft. ceiling. Gallery is in restored boiler room of large warehouse. 100% of space for special exhibitions. Clientele: "museum-goers," educators, artists, collectors, students. 50% private collectors, 50% corporate collectors. Overall price range: $2,000-75,000; most work sold at $5,000-15,000.

Media: Considers oil, acrylic, pastel, pen & ink, drawing, mixed media, collage, paper, sculpture, ceramics, fiber, installation, photography, video. Considers woodcuts and linocuts. Most frequently exhibits oil on canvas, photography and sculpture and museum exhibits on loan.

Style: Exhibits primitivism, conceptualism, minimalism, color field, postmodern works. Prefers contemporrary, book paper art and abstract.

Terms: Accepts work on consignment (50% commission). Retail price set by gallery. Gallery provides insurance, promotion and contract; shipping costs are shared. Gallery provides insurance; artist pays for shipping. Prefers paper and photographs framed; canvas etc. unframed.

Submissions: Send query letter with résumé, brochure, business card, slides, photographs, reviews, artists' statement, bio and SASE. Write for appointment to show portfolio of transparencies. Replies in 6-8 weeks. Files catalogs. Finds artists through referrals by other galleries, museums, guest curators and submissions.

‡GRUEN GALLERIES, 226 W. Superior St., Chicago IL 60610. (312)337-6262. Co-Directors: Bradley Lincoln and Renée Sax. Estab. 1959. Represents 20 emerging, mid-career and established artists. Sponsors 9 solo and 3 group shows/year. Average display time is 1 month. Large space with high ceiling. Overall price range: $500-25,000; most artwork sold at $2,500-5,000.

Media: Considers oil, acrylic, paper and contemporary sculpture. Most frequently exhibits acrylic and oil.

Style: Exhibits painterly abstraction. Genres include landscapes and figurative work.

Terms: Accepts work on consignment (50% commission). Retail price set by gallery or artist. Sometimes offers customer discounts and payment by installment. Exclusive area representation required. Gallery provides promotion; shipping costs are shared.

Submissions: Send query letter, artist's statement, résumé, slides of current work (properly labeled) and SASE. Portfolio review requested if interested in artist's work.

GWENDA JAY GALLERY, 301 W. Superior St., 2nd Floor, Chicago IL 60610. (312)664-3406. Fax: (312)664-3388. Director: Gwenda Jay. Retail gallery. Estab. 1988. Represents 25 mainly mid-career artists, but emerging and established, too. Exhibited artists include Tom Seghi and Heather Becker. Sponsors 8 shows/year. Average display time 5 weeks. Open all year; Tuesday-Friday, 10-5; Saturday, 11-5. Located in River North area; 2,000 sq. ft.; "intimate, warm feeling loft-type space"; 60% of space for 1-2 person and group exhibitions. Clientele: "all types—budding collectors to corporate art collections." 75% private collectors; 10% corporate collectors. Overall price range: $500-5,000; most artwork sold at $2,000.

● The gallery has a small exhibition space but bigger back room, emphasizing more personal contact with collectors and features one-person and group shows.

Media: Considers all media except large-scale sculptures; types of prints include lithographs and mezzotints. Most frequently exhibits paintings, monotypes and "prints by big name artists."

Style: Exhibits expressionism, neo-expressionism, minimalism, painterly abstraction, postmodern works, realism, impressionism, romanticism, poetic architectural classicism. Genres include landscapes and figurative or representational imagery. Styles are contemporary with traditional elements or classical themes.

Terms: Accepts work on consignment (50% commission). Retail price set by the gallery and the artist. Offers customer discounts and payment by installments. Gallery provides insurance and promotion; shipping costs are shared.

Submissions: Send query letter with résumé, slides, bio, reviews, artists' statement and SASE. No unsolicited appointments. Replies in 3 months. Finds artists through visiting exhibitions, referrals and submissions.

Tips: "Please send slides with résumé and SASE first. We will reply and schedule an appointment once slides have been reviewed if we wish to see more. Please be familiar with the gallery's style—for example, we don't typically carry abstract art." Looking for "consistent style and dedication to career. There is no need to have work framed excessively. The work should stand well on its own, initially."

‡JOY HORWICH GALLERY, 226 E. Ontario, Chicago IL 60611. Owner: Joy Horwich. Retail gallery, art consultancy. Estab. 1973. Represents 50 emerging, mid-career and established artists/year. Sponsors 6 shows/year. Average display time 6-8 weeks. Open all year; 10-5:30. Located near North-side; intimate. ⅔ of space for special exhibitions; ⅓ of space for gallery artists. Overall price range: $100-9,000; most work sold at $2,000-5,000.

Media: Considers all media. Most frequently exhibits paintings, works on paper, sculpture, ceramics and furniture.

Style: Exhibits expressionism, primitivism, painterly abstraction, photorealism, pattern painting, hard-edge geometric abstraction, realism. Genres include florals, landscapes, figurative work. Prefers representational, abstract.

Terms: Accepts work on consignment. Retail price set by the artist and gallery. Gallery provides insurance and promotion.

Submissions: Send query letter with slides, bio, SASE. Write for appointment to show portfolio of photographs, slides or transparencies.

Tips: "Know the work in the gallery."

ILLINOIS ART GALLERY, (formerly State of Illinois Art Gallery), Suite 2-100, 100 W. Randolph, Chicago IL 60601. (312)814-5322. Fax: (312)814-3891. Assistant Administrator: Jane Stevens. Museum. Estab. 1985. Exhibits emerging, mid-career and established artists. Sponsors 6-7 shows/year. Average display time 7-8 weeks. Open all year. Located "in the Chicago loop, in the James R. Thompson Center designed by Helmut Jahn." 100% of space for special exhibitions.

Media: All media considered, including installations.
Style: Exhibits all styles and genres, including contemporary and historical work.
Terms: "We exhibit work, do not handle sales." Gallery provides insurance and promotion; artist pays for shipping. Prefers artwork framed.
Submissions: Accepts only artists from Illinois. Send résumé, high quality slides, bio and SASE. Write for appointment to show portfolio of slides.

ILLINOIS ARTISANS PROGRAM, James R. Thompson Center, 100 W. Randolph St., Chicago IL 60601. (312)814-5321. Fax: (312)814-3891. Director: Ellen Gantner. Three retail shops operated by the nonprofit Illinois State Museum Society. Estab. 1985. Represents over 1,000 artists; emerging, mid-career and established. Average display time 6 months. "Accepts only juried artists living in Illinois." Clientele: tourists, conventioneers, business people, Chicagoans. Overall price range: $10-5,000; most artwork sold at $25-100.
Media: Considers all media. "The finest examples in all media by Illinois artists."
Style: Exhibits all styles. "Seeks contemporary, traditional, folk and ethnic arts from all regions of Illinois."
Terms: Accepts work on consignment (50% commission). Retail price set by gallery and artist. Sometimes offers customer discounts. Exclusive area representation not required. Gallery provides promotion and contract.
Submissions: Send résumé and slides. Accepted work is selected by a jury. Résumé and slides are filed. "The finest work can be rejected if slides are not good enough to assess." Portfolio review not required. Finds artists through word of mouth, requests by artists to be represented and by twice yearly mailings to network of Illinois crafters announcing upcoming jury dates.

‡KUNSTWERK GALERIE, 1800 W. Cornelia Ave., #106A, Chicago IL 60657. (312)935-1854. Fax: (708)537-6086. Director: Thomas E. Frerk. Retail gallery, alternative space, art consultancy, Estab. 1993. Represents 12 emerging artists/year. Exhibited artists include James Romeo, Richard E. Lange. Sponsors 6 shows/year. Average display time 1 month. Open all year; Friday evenings, Saturday afternoons by appointment. Located 7 miles northwest of downtown Chicago; 500 sq. ft.; well-lighted, 14 ft. ceilings, located in old factory, lots of brick wall and dry wall to show. Clientele: local community—many diverse groups. 90% private collectors, 10% corporate collectors. Overall price range: $100-2,000; most work sold at $200-500.
Media: Considers all media and all types of prints. Most frequently exhibits paintings, photography, mixed and installations.
Style: Exhibits expressionism, conceptualism, photorealism, pattern painting, color field, hard-edge geometric abstraction, painterly abstraction, realism, surrealism. Genres include portraits, figurative work. Prefers conceptualism, photorealism, hard-edge geometric abstraction.
Terms: Accepts work on consignment (30% commission). Rental fee for space. The rental fee covers 1 month; there is a per event price. Price set by the artist. Gallery provides promotion and contract; artist pays for shipping. Prefers artwork framed.
Submissions: Send query letter with résumé, business card, slides, photographs, artist's statement, bio, SASE. Call for appointment to show portfolio of photographs and slides. Replies in 1 week. Files color photocopies. Finds artists through visiting fairs, referrals and word of mouth.
Tips: "Many artists do not include enough biographical background."

‡LYDON FINE ART, 301 W. Superior St., Chicago IL 60610. (312)943-1133. Fax: (312)943-8090. E-mail: BQVB43A@prodigy.com. Director: Doug Lydon. Assistant Director: Jackie Rush. Retail gallery. Estab. 1989. Represents 15 mid-career and established artists/year. May be interested in seeing the work of emerging artists in the future. Exhibited artists include Stephen Dinsmore, Jeffrey Blondes. Sponsors 5 shows/year. Average display time 1 month. Open all year; Tuesday-Saturday, 10-5. Located in River North Gallery District; 3,000 sq. ft.; features several adjoining spaces allowing for varied exhibition. 70% of space for special exhibitions; 30% of space for gallery artists. Clientele: regional and national collectors, major corporate collections. 60% private collectors, 40% corporate collectors. Overall price range: $1,000-25,000; most work sold at $4,000-12,000.
Media: Considers oil, paper, acrylic, sculpture, watercolor, mixed media, pastel, all types of prints. Most frequently exhibits painting, sculpture, prints.
Style: Exhibits: color field, painterly abstraction, realism. Genres include landscapes. Prefers realism-landscape, abstract painting.
Terms: Accepts work on consignment. Price set by the gallery in consultation with the artists. Gallery provides insurance, promotion and contract; shipping costs are shared. Prefers artwork framed.
Submissions: Send query letter with résumé, slides, reviews, artist's statement, bio, SASE. Write for appointment to show portfolio of photographs, transparencies, slides. Replies in 1 month. Files artists under consideration. Finds artists through submissions.
Tips: "The River North district remains one of the centers for the contemporary art market in the U.S. While, like in all markets, galleries close, they are soon replaced by new galleries with a fresh direction. This healthy environment seems to be the reason that the area continues to draw clients from all over the U.S. and international visitors."

‡LYONS-WIER & GINSBERG GALLERY, 300 W. Superior St., Chicago IL 60610. (312)654-0600. Fax: (312)654-8171. E-mail: chgoartdlr@aol.com. Director: Michael Lyonswier. Retail gallery. Estab. 1993. Represents 15 emerging artists/year. Exhibited artists include Susanna Coffey, Paul Green. Sponsors 11 shows/year. Average display time 5 weeks. Open all year; Tuesday-Saturday, 10-5:30. Located at River North; 1,000 sq. ft. 100% of space for gallery artists. Clientele: local community. 85% private collectors, 15% corporate collectors. Overall price range: $100-18,000; most work sold at $500-2,800.
Media: Considers all media "but is primarily a 2-D painting gallery." Most frequently exhibits oil on canvas, acrylic on canvas, pastel on paper.
Style: Exhibits realism, surrealism, imagism. Genres include figurative work. Prefers figurative, land/sea-scapes, still lifes.
Terms: Accepts work on consignment and there is an agreed commission. Retail price set by the gallery and the artist. Gallery provides insurance, promotion and contract; shipping costs are shared. Prefers works on paper framed; canvas unframed.
Submissions: Shows artists primarily from the Chicago area. Send query letter with résumé, slides, reviews, artist's statement (optional), bio, SASE. Write for appointment to show portfolio of slides. Replies in 6-8 weeks. Finds artists through referrals and personal investigation.
Tips: "Take good slides!"

‡MONGERSON WUNDERLICH GALLERIES, 704 N. Wells, Chicago IL 60610. (312)943-2354. Fax: (312)943-5805. President: R.G. Wunderlich. Retail gallery. Estab. 1972. Represents 300 emerging, mid-career and established artists/year. Exhibited artists include Frederic Remington, Daniel Gerhartz. Sponsors 8-12 shows/year. Average display time 5 weeks. Open all year; Tuesday-Saturdays, 9:30-5:30. Located in River North area, west of Michigan Ave. We have two buildings adjacent to one another and an enormous exhibition apace. 75% of space for special exhibitions; 25% of space for gallery artists. Clientele: upscale. 50% private collectors, 25% corporate collectors. Overall price range: $150-450,000; most work sold at $1,000-100,000.
Media: Considers all media. Considers woodcuts, engravings, wood engravings, mezzotints, etchings. Most frequently exhibits oil, watercolor, bronzes.
Style: Exhibits all styles. Genres include portraits, Western, wildlife, Southwestern, landscapes. Prefers Western, landscapes, wildlife.
Terms: Accepts work on consignment (40-50% commission). Retail price set by the artist. Gallery provides contract; shipping costs are shared. Prefers artwork framed.
Submissions: Accepts primarily American artists. Send query letter with résume, slides, bio, brochure, photographs. Write for appointment to show portfolio of photographs, slides, transparencies. Replies in 2 weeks. Finds artists through word or mouth, referrals by other artists, submissions.

‡MORE BY FAR, 944 N. Noble, Chicago IL 60622-5303. (312)489-4886. Contact: Kimberlie. Alternative space. Estab. 1975. Represents emerging artists. Exhibited artists include Lydia Kirov, Lloyd Altera, Kimberlie J.K., Rosa and Franka. Sponsors 12 shows/year. Work displayed "until it sells." Open all year. Located "15 minutes from the Loop;" 600 sq. ft. "I continue to present other gallerys and co-ops with emerging artists." 75% of space for special exhibitions. Clientele: lawyers, doctors, white and blue collar. 75% private collectors, 15% corporate collectors. Overall price range: $10-10,000; most work sold at $10-5,000.
Media: Considers oil, acrylic, watercolor, pastel, pen & ink, drawing, mixed media, paper, sculpture, ceramics, fiber, glass, photography, metals, jewelry, woodcuts, engravings, lithographs, wood engravings, mezzotints, serigraphs, linocuts, etchings (original or limited editions). Most frequently exhibits metals, stone sculpture, any figurative.
Style: All styles. Genres include landscapes, florals, Americana, Southwestern, Western, wildlife, portraits and figurative work. Prefers realistic.
Terms: Accepts work on consignment (40% commission). Retail price set by the artist. Gallery provides promotion and contract; artist pays shipping to and from gallery.
Submissions: Send query letter with slides, bio, photographs and business card. Call or write for appointment to show portfolio of originals. Replies in 1 month. Files business cards and letters. Finds artists through submissions, word of mouth and referrals.

PORTIA GALLERY, 1702 N. Damen, Chicago IL 60647. (312)862-1700. Director: Elysabeth Alfano. Retail gallery. Estab. 1993. Represents 30 emerging, mid-career and established glass artists/year. Average display time 3 months. Open all year; Tuesday-Friday, 12-7; Saturday and Sunday, 12-5. Located in Chicago's Soho; glass sculpture, interior decor, high-quality paperweights. 100% of space for gallery artists. Clientele: designers, collectors. Overall price range: $50-15,000; most work sold at $300-1,500.
Media: Considers glass only.
Terms: Accepts work on consignment (50% commission). Retail price set by the artist. Gallery provides insurance, promotion, contract and shipping costs from gallery; artist pays shipping costs to gallery.
Submissions: Send query letter with résumé, slides, SASE and reviews (if possible). Replies in 1 month. Files résumé, artist statement, slides—only if accepted.
Tips: "We are very approachable."

RANDOLPH STREET GALLERY, Dept. AGDM, 756 N. Milwaukee, Chicago IL 60622. (312)666-7737. Fax: (312)666-8986. E-mail: randolph@merle.acns.nwu.edu. Contact: Exhibition Committee or Time Arts Committee. Nonprofit artist-run gallery. Estab. 1979. Sponsors 10 group shows/year. Average display time is 1 month. Interested in emerging, mid-career and established artists.
Media: Considers all media. Most frequently exhibits mixed media and performance.
Style: Exhibits hard-edge geometric abstraction, painterly abstraction, minimalism, conceptualism, postmodern, feminist/political, primitivism, photorealism, expressionism and neo-expressionism. "We curate exhibitions which include work of diverse styles, concepts and issues, with an emphasis on works relating to social and critical concerns."
Terms: Retail price is set by artist. Exclusive area representation not required. Gallery provides shipping costs, promotion, contract and honorarium.
Submissions: Send résumé, brochure, slides, photographs and SASE. "Live events and exhibitions are curated by a committee which meets monthly." Résumés, slides and other supplementary material are filed.
Tips: "Some of the most common mistakes artists make in presenting their work are not sending slides, not clearly labeling slides and not sending enough written description of work that is difficult to grasp in slide form."

‡RE SEARCH GALLERY, 750 N. Franklin, #101, Chicago IL 60610. (312)664-4332. Fax: (312)664-5964. Director: Marco Krisanoski. Retail gallery, art consultancy. Estab. 1995. Represents 7 emerging, mid-career and established artists/year. Sponsors 7 shows/year. Average display time 1-2 months. Open February-July and September-December; Tuesday-Friday, 10-5:30; Saturday, 11-5. Located at River North (6 blocks from Michigan Ave.); 1,000 sq. ft.; clean gallery, new hardwood floors, proper track lighting and pedestals and shelving for display. 50% of space for special exhibitions; 50% of space for gallery artists. Clientele: upscale locals and tourists. 100% private collectors. Overall price range: $400-15,000; most work sold at $1,000-5,000.
Media: Considers and exhibits glass only.
Style: Exhibits modern and contemporary.
Terms: Accepts work on consignment (50% commission). Retail price set by the gallery and the artist. Gallery provides insurance, promotion and contract. Gallery pays shipping costs from gallery; artist pays for shipping to gallery.
Submissions: Send query letter with résumé, brochure, photographs, reviews, bio. Replies in 3 weeks. Finds artists through exhibitions, fairs and magazines.

‡SCULPTURE POINT, 299 E. Ontario, Chicago IL 60611. (312)787-8242. Fax: (312)944-1664. Director: Lincoln Schatz. Nonprofit outdoor public gallery. Estab. 1991. Exhibits 10 emerging, mid-career artists. Interested in seeing the work of emerging artists. Sponsors 4 shows/year. Average display time 3 months. Open all year. Located downtown (outside) next to the Museum of Contemporary Art; 500 sq. ft. outside. 100% of space for special exhibitions. 75% private collectors, 25% corporate collectors.
Media: Considers sculpture and installation.
Terms: Accepts work on consignment (30% commission). Retail price set by gallery and artist; artist pays for shipping.
Submissions: Prefers only outdoor sculpture. Send query letter with résumé, slides, bio, brochure, photographs, SASE, business card and reviews. Call for appointment to show portfolio of slides. Replies in 2 months.
Tips: "I am looking for aggressive outdoor sculpture in all media."

‡SOUTHPORT GALLERY, 3755 N. Southport, Chicago IL 60613. (312)327-0372. Owner: Donna Wolfe. Retail gallery. Estab. 1988. Represents 3 artists. Interested in emerging artists. Sponsors 4 solo shows/year. Average display time 1 month. Accepts only artists from Chicago. "I now showcase African and African-American artwork exclusively." Located near Wrigley Field and Music Box Theatre. Clientele: neighborhood people as well as the theatre crowd. Overall price range: $100-1,000; "we do exhibit and sell work for over $1,000."
Media: Considers oil, acrylic, watercolor, pen & ink, drawings, mixed media, collage, sculpture and photography. Most frequently exhibits watercolor, oil, pen & ink and etchings.
Style: Exhibits impressionism, realism, photorealism, surrealism, primitivism, color field, painterly abstraction and figurative work. Prefers realism, surrealism and photorealism. "Ideally, we seek emerging artists, offering them the opportunity to exhibit their work under standards that require it to be presented in a very professional manner. More established artists have found Southport gallery to be the perfect place to have an exhibit of their etchings, drawings or smaller works that fit within our price range."
Terms: Accepts work on consignment (40% commission). Retail price set by gallery and artist. Exclusive area representation not required. Gallery provides promotion and contract, opening reception and announcements. Prefers artwork framed.
Submissions: Send query letter with résumé, slides, brochure, photographs, business card and bio. Call for appointment to show portfolio of originals, slides and photographs. Replies only if interested within 3 weeks. Files résumé, bio and photos.

Tips: "Keep in mind our general price range and the fact that our gallery is small and therefore not suitable for exhibits of entirely large pieces (60×64). Qualities we look for include enthusiasm, professionalism and pride. Present a fair representation of your work and be secure about the way you present it."

VALE CRAFT GALLERY, 230 W. Superior St., Chicago IL 60610. (312)337-3525. Fax: (312)337-3530. Owner: Peter Vale. Retail gallery. Estab. 1992. Represents 50 emerging, mid-career artists/year. Exhibited artists include Tina Fung Holder and Chet Geiselman. Sponsors 7 shows/year. Average display time 2 months. Open all year; Tuesday-Friday, 10:30-5:30; Saturday, 11-5. Located in River North gallery district near downtown; 2,100 sq. ft.; lower level of prominent gallery building; corner location with street-level windows provides great visibility. 40% of space for special exhibitions; 60% of space for gallery artists. Clientele: private collectors, tourists, people looking for gifts, people furnishing and decorating their homes. 50% private collectors, 5% corporate collectors. Overall price range; $25-5,000; most work sold at $50-300.
 • Vale Craft Gallery has moved into a larger space and is interested in handling more expensive work.
Media: Considers paper, sculpture, ceramics, craft, fiber, glass, metal, wood and jewelry. Most frequently exhibits fiber wall pieces, jewelry and ceramic sculpture and vessels.
Style: Exhibits contemporary craft. Prefers decorative, colorful and natural or organic.
Terms: Accepts work on consignment (50% commission). Retail price set by the artist. Gallery provides insurance, promotion, contract and shipping costs from gallery; artist pays shipping costs to gallery.
Submissions: Accepts only artists from US. Only craft media. Send query letter with résumé, slides, bio or artist's statement, photographs, record of previous sales, SASE and reviews if available. Call for appointment to show portfolio of originals and photographs. Replies in 1 month. Files résumé (if interested). Finds artists through submissions, art and craft fairs, publishing a call for entries, artists' slide registry and word of mouth.

SONIA ZAKS GALLERY, 311 W. Superior St., Suite 207, Chicago IL 60610. (312)943-8440. Fax: (312)943-8489. Director: Sonia Zaks. Retail gallery. Represents 25 emerging, mid-career and established artists/year. Sponsors 10 solo shows/year. Average display time is 1 month. Overall price range: $500-15,000.
Media: Considers oil, acrylic, watercolor, drawings, sculpture.
Style: Specializes in contemporary paintings, works on paper and sculpture. Interested in narrative work.
Terms: Accepts work on consignment. Retail price is set by gallery and artist. Exclusive area representation required. Gallery provides insurance and contract.
Tips: "A common mistake some artists make is presenting badly-taken and unmarked slides. Artists should write to the gallery and enclose a résumé, about one dozen well-marked slides and a SASE."

‡ZEITGEIST GALLERY, INC., 2300 W. Diversey Ave., Chicago IL 60647. (312)590-3472. Retail gallery. Estab. 1993. Represents 5-10 established artists/year. May be interested in seeing the work of emerging artists in the future. Exhibited artists include Pierre Redoute, Robert Thornton. Open 7 days a week 11-6. Specializes in 18th- and 19th-Century Botanical Artists. Clientele: Upscale. Overall price range: $150-12,000.
Media: Considers oil, pen & ink, paper, acrylic, drawing, watercolor, pastel, woodcuts, wood engravings, engravings, mezzotints, etchings, lithographs. Most frequently exhibits 18th- and 19th-Century Botanical Artists, contemporary still life/botanical, contemporary.
Style: Exhibits primitivism, realism. Genres include florals. Prefers natural history, antique still lifes, contemporary still lifes.
Terms: Retail price set by the gallery.
Submissions: Send query letter with résumé, slides. Write for appointment to show portfolio of slides. Replies only if interested within 1 month.

Indiana

ARTLINK, 437 E. Berry St., Suite 202, Fort Wayne IN 46802-2801. (219)424-7195. Executive Director: Betty Fishman. Nonprofit gallery. Estab. 1979. Exhibits emerging and mid-career artists. 500 members. Sponsors 8 shows/year. Average display time 5-6 weeks. Open all year. Located 4 blocks from central downtown, 2 blocks from Art Museum and Theater for Performing Arts; in same building as a cinema theater, dance group and historical preservation group; 1,600 sq. ft. 100% of space for special exhibitions. Clientele: "upper middle class." Overall price range: $100-500; most artwork sold at $200.
 • Publishes a newsletter, *Genre*, which is distributed to members. Includes features about upcoming shows, profiles of members and other news. Some artwork shown at gallery is reproduced in b&w in newsletter. Send SASE for sample and membership information.
Media: Considers all media, including prints. Prefers work for annual print show and annual photo show, sculpture and painting.
Style: Exhibits expressionism, neo-expressionism, painterly abstraction, conceptualism, color field, postmodern works, photorealism, hard-edge geometric abstraction; all styles and genres. Prefers imagism, abstraction

and realism. "Interested in a merging of craft/fine arts resulting in art as fantasy in the form of bas relief, photo/books, all experimental media in nontraditional form."

Terms: Accepts work on consignment only for exhibitions (35% commission). Retail price set by artist. Gallery provides insurance, promotion and contract; shipping costs are shared. Prefers framed artwork.

Submissions: Send query letter with résumé, 6 slides and SASE. Reviewed by 14-member panel. Replies in 2-4 weeks. "Jurying takes place 3 times per year unless it is for a specific call for entry. A telephone call will give the artist the next jurying date."

Tips: "Call ahead to ask for possibilities for the future and an exhibition schedule for the next two years will be forwarded." Common mistakes artists make in presenting work are "bad slides and sending more than requested—large packages of printed material. Printed catalogues of artist's work without slides are useless." Sees trend of community-wide cooperation by organizations to present art to the community.

EDITIONS LIMITED GALLERY OF FINE ART, 4040 E. 82nd St., Indianapolis IN 46250-1620. (317)842-1414. Owner: John Mallon. Director: Marta Blades. Retail gallery. Represents emerging, mid-career and established artists. Sponsors 4 shows/year. Average display time 1 month. Open all year. Located "north side of Indianapolis; track lighting, exposed ceiling, white walls." Clientele: 60% private collectors, 40% corporate collectors. Overall price range: $100-8,500; most artwork sold at $200-1,200.

Media: Considers oil, acrylic, watercolor, pastel, pen & ink, drawings, mixed media, collage, works on paper, sculpture, ceramics, craft, fiber, glass, photography, original handpulled prints, woodcuts, engravings, mezzotints, etchings, lithographs, pochoir and serigraphs. Most frequently exhibits mixed media, acrylic and pastel.

Style: Exhibits all styles and genres. Prefers abstract, landscapes and still lifes.

Terms: Accepts work on consignment (50% commission). Retail price set by artist. "I do discuss the prices with artist before I set a retail price." Sometimes offers customer discounts and payment by installment. Gallery provides insurance, promotion and contract; shipping costs are shared. Prefers artwork unframed.

Submissions: Send query letter with slides, SASE and bio. Portfolio review requested if interested in artist's work. Portfolio should include originals, slides, résumé and bio. Files bios, reviews, slides and photos.

Tips: Does not want to see "hobby art."

‡WILLIAM ENGLE GALLERY, 1724 E. 86th St., Indianapolis IN 46240-2360. (317)848-2787. President: William E. Engle. Retail gallery. Estab. 1981. Represents 50 mid-career and established artists; interested in seeing the work of emerging artists. Exhibited artists include Lilian Fendig and Hirokazu Yamaguchi. Sponsors 4-5 shows/year. Open all year. Located downtown in the gallery area, 1,100 sq. ft.; "high ceilings, long walls." 100% of space for special exhibitions. Clientele: 70% private collectors, 30% corporate clients. Overall price range: $100-10,000; most artwork sold at $400.

Media: Considers oil, acrylic, watercolor, pastel, pen & ink, drawings, mixed media, collage, works on paper, sculpture, ceramic, craft, fiber, glass, photography, original handpulled prints, woodcuts, lithographs, serigraphs, linocuts and etchings. Most frequently exhibits ceramic, painting, photography and watercolor.

Style: Exhibits expressionism, painterly abstraction, conceptualism, postmodern works, impressionism, realism and hard-edge geometric abstraction. All genres. Prefers figurative work, landscapes, traditional and Western painting.

Terms: Artwork is accepted on consignment (50% commission). Retail price set by the artist. Gallery provides promotion, contract and shipping costs from gallery. Prefers framed artwork.

Submissions: Send query letter with résumé, slides, bio, brochure, photographs, SASE, business card and reviews. Write to schedule an appointment to show a portfolio, which should include slides and photographs. Replies in 2 weeks.

Tips: "Be imaginative."

‡THE FORT WAYNE MUSEUM OF ART SALES AND RENTAL GALLERY, 311 E. Main St., Ft. Wayne IN 46802. (219)422-6467. Gallery Manager: Louise Rodenbeck. Retail and rental gallery. Estab. 1983. Represents emerging, mid-career and established artists who reside within a 150 mile radius of Fort Wayne. Clientele: 90% private collectors, 10% corporate clients. Overall price range: $15-4,500; most artwork sold at $250-650.

Media: Considers oil, acrylic, watercolor, pastel, pen & ink, sculpture, photography, mixed media, collage, jewelry, ceramics, glass, wearables, fibers, original handpulled prints and computer-generated art.

Style: "We try to show the best regional artists available. We jury by quality, not salability." Exhibits impressionism, expressionism, realism, photorealism and painterly abstraction. Genres include landscapes, florals, Americana, Southwestern, Western and wildlife. Prefers landscapes, abstractions and florals. "We do not do well with works that are predominantly figures." Interested in seeing contemporary designs in jewelry and wearables.

Terms: Accepts work on consignment (40% commission). Retail price set by artist. Exclusive area representation not required. Gallery provides insurance, promotion and contract; artist pays for shipping.

Submissions: Send query letter with résumé, brochure, slides, photographs, bio and SASE. Slides and résumés are filed.

Tips: "Our Club Art seems to be selling quite a bit of merchandise. 'Clever' art at moderate prices sells well in our gift shop."

GREATER LAFAYETTE MUSEUM OF ART, 101 South Ninth St., Lafayette IN 47901. (317)742-1128. E-mail: glmart@aol.com. Director: John Z. Lofgren Ph.D. Curator: Ellen E. Fischer. Museum. Estab. 1909. Exhibits 100 emerging, mid-career and established artists from Indiana and the midwest. 1,340 members. Sponsors 14 shows/year. Average display time 10 weeks. Closed August. Located 6 blocks from city center; 3,318 sq. ft.; 4 galleries. 100% of space for special exhibitions. Clientele: audience includes Purdue University faculty, students and residents of Lafayette/West Lafayette and nine-county area. Clientele: 50% private collectors, 50% corporate collectors. Most work sold at $500-1,000.
Media: Considers all media. Most frequently exhibits paintings, prints and sculpture.
Style: Exhibits all styles. Genres include landscapes, still life, portraits, abstracts, non-objective and figurative work.
Terms: Accepts work on consignment (35% commission). Retail price set by artist. Gallery provides insurance, promotion and contract; artist pays for shipping. Prefers artwork framed.
Submissions: Send query letter with résumé, slides, artist's statement and letter of intent. Write for appointment to show portfolio of slides. "Send good-quality, clearly labeled slides, and include artist's statement, please!" Replies in 1 month. Files artists' statement, résumé. Slides are returned to artists.

INDIANAPOLIS ART CENTER, 820 E. 67th St., Indianapolis IN 46220. (317)255-2464. Fax: (317)254-0486. Exhibitions Curator: Julia Moore. Nonprofit art center. Estab. 1934. Prefers emerging artists. Exhibits approximately 100 artists/year. 1,800 members. Sponsors 15-20 shows/year. Average display time 5 weeks. Open Monday-Friday, 9-10; Saturday, 9-3; Sunday, 12-3. Located in urban residential area; 2,560 sq. ft. in 3 galleries; "Progressive and challenging work is the norm!" 100% of space for special exhibitions. Clientele: mostly private. 90% private collectors, 10% corporate collectors. Overall price range: $50-15,000; most work sold at $100-1,000.
Media: Considers all media and all types of prints. Most frequently exhibits painting, sculpture installations and fine crafts.
Style: All styles. Interested in figurative work. "In general, we do not exhibit genre works. We do maintain a referral list, though." Prefers postmodern works, installation works, conceptualism.
Terms: Accepts work on consignment (35% commission). Commission is in effect for 3 months after close of exhibition. Retail price set by artist. Gallery provides insurance, promotion, contract; artist pays for shipping. Prefers artwork framed.
Submissions: "Special consideration for IN, OH, MI, IL, KY artists." Send query letter with résumé, slides, SASE, reviews and artist's statement. Replies in 5-6 weeks. Season assembled in January.
Tips: "Have slides done by a professional if possible. Stick with one style—no scattershot approaches, please. Have a concrete proposal with installation sketches (if it's never been built). We book two years in advance—plan accordingly. Do not call. Put me on your mailing list one year before sending application so I can be familiar with your work and record—ask to be put on my mailing list so you know the gallery's general approach. It works!"

L B W GALLERY, 1724 E. 86th St., Indianapolis IN 46240. (317)848-ARTS. Director: Linda Walsh. Retail gallery. Estab. 1993. Represents/exhibits 25 mid-career and established aritsts/year. Interested in seeing the work of emerging artists. Sponsors 10 shows/year. Average display time 1 month. Open all year; Monday-Saturday, 10-5. Located on north side of Indianapolis (in a mall); features unique interior decor. 75% of space for special exhibitions, 25% of space for gallery artists. Clientele: tourists, local community. 50% private collectors.
Media: Considers all media and all types of prints. Most frequently exhibits acrylic, crafts and mixed media.
Style: Exhibits realism. Genres include landscapes and Americana. Prefers landscapes, Americana and florals.
Terms: Artwork is accepted on consignment (commission). Gallery provides promotion; shipping costs are shared. Prefers artwork framed.
Submissions: Send query letter with résumé, slides, bio and SASE. Call or write for appointment to show portfolio of photographs and slides. Replies in 2 weeks. Files information; slides are returned if SASE is sent. Finds artists through art fairs, exhibitions, word or mouth, referral by other artists.
Tips: "Be realistic about price."

MIDWEST MUSEUM OF AMERICAN ART, 429 S. Main St., Elkhart IN 46516. (219)262-3603. Director: Jane Burns. Curator: Brian D. Byrn. Museum. Estab. 1978. Represents mid-career and established artists. May be interested in seeing the work of emerging artists in the future. Sponsors 10-12 shows/year. Average display time 5-6 weeks. Open all year; Tuesday-Friday 11 to 5; Saturday and Sunday 1-4. Located downtown; 1,000 sq. ft. temporary exhibits; 10,000 sq. ft. total; housed in a renovated neoclassical style bank building; vault gallery. 10% for special exhibitions. Clientele: general public.

Media: Considers all media and all types of prints.
Style: Exhibits all styles, all genres.
Terms: Acquired through donations. Retail price set by the artist "in those cases when art is offered for sale." Gallery provides insurance, promotion and contract; artist pays shipping costs to and from gallery. Prefers artwork framed.
Submissions: Accepts only art of the Americas, professional artists 18 years or older. Send query letter with résumé, slides, bio, reviews and SASE. Write for appointment to show portfolio of slides. Replies in 6 months. Files résumé, bio, statement. Finds artists through visiting exhibitions, submissions, art publications.
Tips: "Keep portfolio updated."

‡RUSCHMAN GALLERY, 421 Massachusetts Ave., Indianapolis IN 46204. (317)634-3114. Director: Mark Ruschman. Retail gallery. Estab. 1985. Represents 40 emerging and mid-career artists/year. Sponsors 10 shows/year. Average display time 1 month. Open all year; Tuesday-Saturday, 11-5. Located downtown—near Northeast side; 1,800 sq. ft.; two gallery showrooms which allow solo and group exhibitions to run concurrently. 100% of space for gallery artists. Clientele: local individual and corporate collectors. 60% private collectors, 40% corporate collectors. Overall price range: $500-30,000; most work sold at $1,000-4,000.
Media: Considers all media (including all types of prints, small editions) except large run prints and posters. Most frequently exhibits painting, sculpture, textile.
Style: Exhibits all styles. Prefers abstract, landscape, figurative.
Terms: Accepts work on consignment (40-50% commission). Retail price set by the gallery and the artist. Gallery provides promotion and contract; gallery pays shipping costs to gallery; artist pays for shipping from gallery. Prefers artwork framed.
Submissions: Send query letter with résumé, slides, bio, SASE. Call for appointment to show portfolio of slides, bio. Replies in 3 weeks. Files referrals by other artists and submissions.

Iowa

ARTS FOR LIVING CENTER, P.O. Box 5, Burlington IA 52601-0005. Located at Seventh & Washington. (319)754-8069. Executive Director: Lois Rigdon. Nonprofit gallery. Estab. 1974. Exhibits the work of mid-career and established artists. May consider emerging artists. 425 members. Sponsors 10 shows/year. Average display time 3 weeks. Open all year. Located in Heritage Hill Historic District, near downtown; 2,500 sq. ft.; "former sanctuary of 1868 German Methodist church with barrel ceiling, track lights." 35% of space for special exhibitions. Clientele: 80% private collectors, 20% corporate collectors. Overall price range: $25-1,000; most work sold at $75-500.
● Arts For Living Center recently established a co-op artists gallery in downtown location. (Storm Cellar, 416 Jefferson, Burlington IA 52601. (319)752-5259.)
Media: Considers all media and all types of prints. Most frequently exhibits watercolor, intaglio and sculpture.
Style: Exhibits all styles. Prefers landscapes, portraits and abstracts.
Terms: Accepts work on consignment (25% commission). Retail price set by artist. Gallery provides insurance, promotion and contract; artist pays for shipping. Prefers artwork framed.
Submissions: Send query letter with résumé, slides, bio, brochure, photographs, SASE and reviews. Call or write for appointment to show portfolio of slides and gallery experience verification. Replies in 1 month. Files résumé and photo for reference if interested.

CORNERHOUSE GALLERY, 2753 First Ave. SE, Cedar Rapids IA 52402. (319)365-4348. Fax: (319)365-1707. Director: Janelle McClain. Retail gallery. Estab. 1976. Represents 125 emerging, mid-career and established artists. Exhibited artists include John Preston, Grant Wood and Stephen Metcalf. Average display time 6 months. Open all year. 3,000 sq. ft.; "converted 1907 house with 3,000 sq. ft. matching addition devoted to framing, gold leafing and gallery." 15% of space for special exhibitions. Clientele: "residential/commercial, growing collectors." 60% private collectors. Overall price range: $20-75,000; most artwork sold at $400-2,000.
Media: Considers oil, acrylic, watercolor, pastel, drawings, mixed media, collage, works on paper, sculpture, ceramic, fiber, glass, original handpulled prints, woodcuts, wood engravings, linocuts, engravings, mezzotints, jewelry, etchings, lithographs and serigraphs. Most frequently exhibits oil, acrylic, original prints and ceramic works.
Style: Exhibits painterly abstraction, conceptualism, color field, postmodern works and impressionism. All genres. Prefers abstraction, impressionism and postmodern.
Terms: Accepts work on consignment (45% commission). Retail price set by artist and gallery. Offers payment by installments. Gallery provides insurance, promotion and shipping costs from gallery. Prefers artwork unframed.
Submissions: Send résumé, brochure, photographs and bio. Portfolio review requested if interested in artist's work. Replies in 1 month. Files bio and samples. Finds artists through word of mouth, art publications,

sourcebooks, submissions/self promotions, art collectors' referrals and other artists. Do not stop in unannounced.

Tips: "Today's buyer is more concerned with 'budget,' still has money to spend but seems more discriminating."

PERCIVAL GALLERIES, INC., 528 Walnut, Firstar Bank Building, Des Moines IA 50309-4106. (515)243-4893. Fax: (515)243-9716. Director: Bonnie Percival. Retail gallery. Estab. 1969. Represents 100 emerging, mid-career and established artists. Exhibited artists include Mauricio Lasansky and Karen Strohbeen. Sponsors 8 shows/year. Average display time is 3 weeks. Open all year. Located in downtown Des Moines; 3,000 sq. ft. 50-75% of space for special exhibitions.
Terms: Accepts work on consignment (50% commission). Retail price set by gallery. Gallery provides insurance and promotion.
Submissions: Send query letter with résumé, slides, photographs, bio and SASE. Call or write for appointment to show portfolio of originals, photographs and slides. Replies in 1 month. Files only items of future interest.

Kansas

‡ARTFRAMES . . . Bungalo Gallery, 912 Illinois St., Lawrence KS 66044. (913)842-1991. Gallery Coordinator: Jennie Washburn. Retail gallery, cooperative gallery (private), alternative space and art consultancy of community-based fine arts and crafts. Estab. 1989. Represents 25 emerging, mid-career and established artists. Exhibited artists include Gary Hinman, Christine Musgrave, Stan Herd and Kim Webster. Sponsors 4-8 shows/year. Average display time 5-8 weeks. Open all year. Located "near the historic downtown shopping center and the Kansas University campus; 18,000 sq. ft.; (6,000 sq. ft. outdoor sculpture garden center), 3 floors in 65-year-old bungalow with wood floors, woodwork and multi-level spaces." 15% of space for special exhibitions. Clientele: "community leaders, academic, business leaders." 65% private collectors, 20% corporate collectors. Overall price range: $65-21,000; most artwork sold at $65-950.
Media: Considers oil, acrylic, watercolor, pastel, pen & ink, drawings, mixed media, collage, sculpture, ceramic, craft (fine), fiber, glass, photography, original handpulled prints, etchings, lithographs and serigraphs. Most frequently exhibits watercolor, oil, acrylic and mixed media.
Style: Exhibits all styles and genres. Prefers landscapes, literal and abstract.
Terms: Accepts work on consignment (40% commission). Retail price set by gallery and artist. Gallery provides insurance (limited), promotion and contract; shares shipping costs from gallery. Requires framed artwork.
Submissions: Send résumé, bio, brochure, photographs, SASE, business card and reviews. No slides. Call to schedule an appointment to show a portfolio, which should include originals and photographs. Replies in 1 month. Files "full package." Common artists' mistake is providing poorly framed work.
Tips: "Come in person. It is necessary for proper consignment. Coffee is free. We are constantly in need of new 'marketable' art."

GALLERY XII, 412 E. Douglas, Suite A, Wichita KS 67202. (316)267-5915. Consignment Committee: Judy Dove. Cooperative nonprofit gallery. Estab. 1977. Represents 50 mid-career and established artists/year and 20 members. Average display time 1 month. Open all year; Monday-Saturday, 10-4. Located in historic Old Town which is in the downtown area; 1,300 sq. ft.; historic building. 20% of space for special exhibitions; 80% of space for gallery artists. Clientele: private collectors, corporate collectors, people looking for gifts, tourists. Overall price range: $10-2,000.
Media: Considers all painting and drawing media, artists' prints (no mechanical reproductions), weaving, sculpture, ceramics, jewelry.
Style: Exhibits abstract, impressionism, realism, etc.
Terms: Only accepts 3-D work on consignment (35% commission). Co-op membership screened and limited. Annual exhibition fee, 15% commission and time involved. Artist pays shipping costs to and from gallery.
Submissions: Limited to local artists or those with ties to area. Work juried from slides.

PHOENIX GALLERY TOPEKA, 2900-F Oakley Dr., Topeka KS 66614. (913)272-3999. Owner: Kyle Garia. Retail gallery. Estab. 1990. Represents 60 emerging, mid-career and established artists/year. Exhibited artists include Dave Archer, Louis Copt, Nagel, Phil Starke, Ernst Ulmer and Raymond Eastwood. Sponsors 6 shows/year. Average display time 6 weeks-3 months. Open all year, 7 days/week. Located downtown; 2,000 sq. ft. 100% of space for special exhibitions; 100% of space for gallery artists. Clientele: upscale. 75% private collectors, 25% corporate collectors. Overall price range: $500-20,000.
Media: Considers all media and engravings, lithographs, woodcuts, mezzotints, serigraphs, linocuts, etchings and collage. Most frequently exhibits oil, watercolor, ceramic and artglass.

Style: Exhibits expressionism and impressionism, all genres. Prefers regional, abstract and 3-D type ceramic; national glass artists. "We find there is increased interest in original work and regional themes."
Terms: Terms negotiable. Retail price set by the gallery and the artist. Prefers artwork framed.
Submissions: Call for appointment to show portfolio of originals, photographs and slides.
Tips: "We are scouting [for artists] constantly."

THE SAGEBRUSH GALLERY OF WESTERN ART, 115 E. Kansas, P.O. Box 128, Medicine Lodge KS 67104. (316)886-5163. Fax: (316)886-5104. Co-Owners: Earl and Kaye Kuhn. Retail gallery. Estab. 1979. Represents up to 20 emerging, mid-career and established artists. Exhibited artists include Garnet Buster, Lee Cable, H.T. Holden, Earl Kuhn, Gary Morton and David Vollbracht. Sponsors 4 shows/year. Average display time 3-6 months. Open all year. Located ½ block off Main St.; 1,000 sq. ft. 100% of space for special exhibitions. Clientele: 80% private collectors, 20% corporate collectors. Overall price range: $100-7,000; most work sold at $500-4,000.
Media: Considers oil, acrylic, watercolor, pastel, pen & ink, drawings, mixed media, sculpture, original handpulled prints, lithographs and posters. Most frequently exhibits watercolors, acrylics and bronze sculpture.
Style: Exhibits realism. Genres include landscapes, Southwestern, Western and wildlife. Prefers representational works of contemporary and historical Western.
Terms: Accepts artwork on consignment (25% commission). Retail price set by artist. Offers payment by installments. Gallery provides promotion; artist pays for shipping.
Submissions: Send query letter with résumé, slides, brochure, photographs and SASE. Portfolio review requested if interested in artist's work. Files résumés, bio info and photos. Finds artists by any source but the artist's work must speak for itself in quality.
Tips: "Looks for professional presentation of portfolios. Neatness counts a great deal! and of course—quality! We are careful to screen wildlife and Western livestock to be anatomically correct. Ask about the annual Indian Summer Days Western and Wildlife Art Show Sale."

TOPEKA & SHAWNEE COUNTY PUBLIC LIBRARY GALLERY, 1515 W. Tenth, Topeka KS 66604-1374. (913)233-2040. Fax: (913)233-2055. Gallery Director: Larry Peters. Nonprofit gallery. Estab. 1976. Exhibits emerging, mid-career and established artists. Sponsors 8-9 shows/year. Average display time 1 month. Open Memorial Day to Labor Day: Monday-Saturday, 9-6; Sunday, 2-6. Located 1 mile west of downtown; 1,200 sq. ft.; security, track lighting, plex top cases; recently added two moveable walls. 100% of space for special exhibitions. Overall price range: $150-5,000.
Media: Considers oil, fiber, acrylic, sculpture, glass, watercolor, mixed media, ceramic, pastel, collage, metal work, woodcuts, wood engravings, linocuts, engravings, mezzotints, etchings, lithographs. Most frequently exhibits ceramic, oil and watercolor.
Style: Exhibits neo-expressionism, painterly abstraction, postmodern works and realism. Prefers painterly abstraction, realism and neo-expressionism.
Terms: Artwork accepted or not accepted after presentation of portfolio/résumé. Retail price set by artist. Gallery provides insurance; artist pays for shipping costs. Prefers artwork framed.
Submissions: Usually accepts only artists from KS, MO, NE, IA, CO, OK. Send query letter with résumé and slides. Call or write for appointment to show portfolio of slides. Replies in 1-2 months. Files résumé. Finds artists through visiting exhibitions, word of mouth and submissions.
Tips: "Have good quality slides—if slides are bad they probably will not be looked at. Have a dozen or more to show continuity within a body of work. Competition gets heavier each year."

‡EDWIN A. ULRICH MUSEUM OF ART, Wichita State University, Wichita KS 67260-0046. (316)689-3664. Fax: (316)689-3898. Director: Donald E. Knaub. Museum. Estab. 1974. Represents mid-career and established artists. Sponsors 7 shows/year. Average display time 6-8 weeks. Open Tuesday-Friday, 10-5; Sunday-Saturday, 1-5. Located on campus; 4,000 sq. ft.; high ceilings, neutral space. 75% of space for special exhibitions.
Media: Considers sculpture, installation, neon-light, new media.
Style: Exhibits conceptualism and new media.
Submissions: Send query letter with résumé, slides and SASE. Write for appointment to show portfolio of slides, transparencies and statement of intent. Replies only if interested within 6 weeks. Finds artists through word of mouth and art publications.

Kentucky

BANK ONE GALLERY, (formerly Liberty Gallery), 416 W. Jefferson, Louisville KY 40207. (502)566-2081. Fax: (502)566-1800. Director: Jacque Parsley. Nonprofit gallery. Estab. 1976. Represent/exhibits 50 emerging, mid-career and established artists/year. Exhibited artists include Dudley Zopp and Chery Correll. Sponsors 6 shows/year. Average display time 2 months. Open all year; Monday-Thursday, 9-4; Friday, 9-5.

Located downtown in Bank One Kentucky. 100% of space for special exhibitions. Clientele: tourists, local community and students. 20% private collectors, 15% corporate collectors. Overall price range: $200-2,000; most work sold at $300.
Media: Considers all media. Most frequently exhibits crafts—ceramics, oil paintings, watercolors and folk art.
Style: Exhibits expressionism, painterly abstraction and pattern painting. Genres include florals, portraits and landscapes. Prefers abstract, landscapes and fine crafts.
Terms: Artwork is accepted on consignment and there is no commission. Retail price set by the artist. Gallery provides insurance, promotion and contract. Artist pays for shipping costs. Artwork must be framed.
Submissions: Accepts only regional artists from Louisville. Send query letter with résumé, slides, bio and SASE. Write for appointment to show portfolio of slides. Replies in 2 months. Files announcements. Finds artists through referrals by other artists and submissions.
Tips: "Submit professional slides."

BROWNSBORO GALLERY, 4806 Brownsboro Center, Louisville KY 40207. (502)893-5209. Owner: Leslie Spetz; Curator: Rebekah Hines. Retail gallery. Estab. 1990. Represents 20-25 emerging, mid-career and established artists. Exhibited artists include Karen and Charlie Berger and Michaele Ann Harper. Sponsors 9-10 shows/year. Average display time 5 weeks. Open all year; Tuesday-Friday, 10-6; Saturday, 10-3; closed Sunday and Monday. Located on the east end (right off I-71 at I-264); 1,300 sq. ft.; 2 separate galleries for artist to display in give totally different feelings to the art; one is a skylight room. 85% of space for gallery artists. Clientele: upper income. 90% private collectors, 10% corporate collectors. Overall price range: $100-2,500; most work sold at $800-1,000.
Media: Considers oil, acrylic, watercolor, pastel, pen & ink, drawing, mixed media, collage, paper, sculpture, ceramics, fiber, glass, installation, photography, woodcuts, engravings and etchings. Most frequently exhibits oil, mixed (oil or watercolor pastel) and watercolor.
Style: Exhibits painterly abstraction, all styles, color field, postmodern works, impressionism, photorealism and realism. Genres include landscapes, Americana and figurative work. Prefers landscape, abstract and collage/contemporary.
Term: Accepts work on consignment (40% commission). Retail price set by the gallery and the artist. Gallery provides insurance, promotion, contract and shipping costs from gallery; artist pays shipping costs to gallery. Prefers artwork framed.
Submissions: Send query letter with résumé, slides, bio, price list and SASE. Call for appointment to show portfolio of photographs and slides. Replies only if interested within 3-4 weeks. Finds artists through word of mouth and submissions, "sometimes by visiting exhibitions."

‡CAPITAL GALLERY OF CONTEMPORARY ART, 314 Lewis, Frankfort KY 40601. (502)223-2649. Owner: Ellen Glasgow. Retail gallery, art consultancy. Estab. 1981. Represents 20-25 emerging, mid-career and established artists/year. Exhibited artists include Kathleen Kelly, Robert Kipniss. Sponsors 8 shows/year. Average display time 1-2 months. Open all year; Tuesday-Saturday, 10-5. Located downtown, historic district; 1,200 sq. ft.; historic building, original skylights, vaults, turn-of-century. 50% of space for special exhibitions; 50% of space for gallery artists. 60% private collectors; 40% corporate collectors. Overall price range: $30-10,000; most work sold at $300-3,000.
Media: Considers all media except photography; all prints except posters. Most frequently exhibits oil paintings, watercolor, fine printmaking.
Style: Exhibits all styles and genres. Prefers landscapes, floral/figurative, works on paper.
Terms: Accepts work on consignment (40% commission). Retail price set by the artist. Gallery provides insurance and promotion; shipping costs are shared. Prefers artwork framed.
Submissions: Send query letter with résumé, slides, photographs, bio, SASE. Write for appointment to show portfolio of photographs and slides. Replies in 2-4 weeks. Files bios, cards.
Tips: "Visit the gallery first."

‡CENTRAL BANK GALLERY, 300 W. Vine St., Lexington KY 40507. (606)253-6135. Fax: (606)253-6069. Curator: John Irvin. Nonprofit gallery. Estab. 1985. Interested in seeing the work of emerging artists. Represented more than 1,000 artists in the past 10 years. Exhibited artists include Arturo Sandoval and John Tuska. Sponsors 12 shows/year. Average display time 3 weeks. Open all year; Monday-Friday, 9-4:30. Located downtown. 100% of space for special exhibitions. Clientele: local community. 100% private collectors. Overall price range: $100-5,000; most work sold at $350-500.
• Central Bank Gallery considers Kentucky artists only.
Media: Considers all media. Most frequently exhibits oils, watercolor, sculpture.
Style: Exhibits all styles. "Please, no nudes."
Terms: Retail price set by the artist "100% of proceeds go to artist." Gallery provides insurance and promotion; artist pays for shipping. Prefers artwork framed.
Submissions: Call or write for appointment.

‡GALERIE HERTZ, 636 E. Market St., Louisville KY 40202. (502)584-3547. Fax: (502)568-2063. Director: Billy Hertz. Retail gallery specializing in contemporary fine art. Estab. 1991. Represents 35 emerging, mid-career and established artists/year. Exhibited artists include Tom Pfannerstill, Billy Hertz. Sponsors 10 shows/year. Average display time 1 month. Open all year; Wednesday-Saturday, 11-6 and by appointment. Located downtown; 3,000 sq. ft. interior, large outdoor space; outdoor sculpture garden. 50% of space for special exhibitions; 50% of space for gallery artists. 80% private collectors, 20% corporate collectors. Overall price range: $250-20,000; most work sold at $1,500-2,000.
Media: Considers all media. Considers woodcuts, engravings, lithographs, wood engravings, mezzotints, serigraphs, linocuts, etchings. Most frequently exhibits painting and sculpture.
Style: Exhibits all styles.
Terms: Accepts work on consignment (50% commission). Retail price set by the gallery and the artist. Gallery provides insurance, promotion and contract; artist pays for shipping.
Submissions: Send query letter with résumé, slides, bio, SASE. Call or write for appointment to show portfolio of slides. Replies in 6 weeks; "artist should call to follow-up if more." Files inventory, résumé, bio, reviews. Finds artists through referrals, submissions.
Tips: Some common mistakes artists make are "poor slides, no résumé, no bio."

‡KENTUCKY ART & CRAFT GALLERY, 609 W. Main St., Louisville KY 40202. (502)589-0102. Fax: (502)589-0154. Retail Marketing Director: Mary Ellen Hill. Retail gallery operated by the private nonprofit Kentucky Art & Craft Foundation, Inc. Estab. 1984. Represents more than 400 emerging, mid-career and established artists. Exhibiting artists include Arturo Sandoval, Sarah Frederick, Stephen Powell and Rude Osolnik. Sponsors 12 shows/year. Open all year. Located downtown in the historic Main Street district; 5,000 sq. ft.; a Kentucky tourist attraction located in a 120-year-old cast iron building. 33% of space for special exhibitions. Clientele: tourists, the art-viewing public and schoolchildren. 10% private collectors, 5% corporate clients. Overall price range: $3-20,000; most work sold at $25-500.
Media: Considers mixed media, metal, glass, clay, fiber, wood and stone.
Terms: Accepts work on consignment (50% commission). Retail price set by artist. Gallery provides insurance, promotion, contract and shipping costs from gallery.
Submissions: Contact gallery for jury application and guidelines first; then send completed application, résumé and 5 samples. Replies in 2-3 weeks. "If accepted, we file résumé, slides, signed contract, promotional materials and PR about the artist."
Tips: "The artist must live or work in a studio within the state of Kentucky."

LOUISVILLE VISUAL ART ASSOCIATION, 3005 Upper River Rd., Louisville KY 40207. (502)896-2146. Fax: (502)896-2148. Gallery Manager: Janice Emery. Nonprofit sales and rental gallery. Estab. 1989. Represents 70 emerging, mid-career and established regional artists. Average display time 3 months. Open all year; Monday-Friday, 11:30-3:30 and by appointment. Located downtown; 1,500 sq. ft. 10% of space for special exhibitions; 90% of space for gallery artists. Clientele: all ages and backgrounds. 50% private collectors, 50% corporate collectors. Overall price range: $300-4,000; most work sold at $300-1,000.
 • Headquarters for LVAA are at 3005 Upper River Rd.; LVAA Sales and Rental Gallery is at #275 Louisville Galleria (Fourth and Liberty).
Media: Considers oil, acrylic, watercolor, pastel, pen & ink, drawing, mixed media, collage, paper, sculpture, ceramics, craft (on a limited basis), fiber, glass, photography, woodcuts, engravings, lithographs, wood engravings, mezzotints, serigraphs, linocuts, etchings and some posters. Most frequently exhibits oil, acrylic, watercolor, sculpture and glass.
Style: Exhibits contemporary, local and regional visual art, all genres.
Terms: Accepts work on consignment (40% commission). Membership is suggested. Retail price set by the artist. Gallery provides insurance, promotion and contract (nonexclusive gallery relationship). Artist pays shipping costs to and from gallery. Accepts framed or unframed artwork. Framing is offered. Artists should provide necessary special displays. (Ready-to-hang is advised with or without frames.)
Submissions: Accepts only artists from within a 400-mile radius, or former residents or those trained in Kentucky (university credentials). Send query letter with résumé, slides, bio and reviews. Write for appointment to show portfolio of slides. Replies only if interested within 4-6 weeks. Files up to 20 slides (in slide registry), bio, résumé, brief artist's statement, reviews, show announcement. Finds artists through visiting exhibitions, word of mouth, art publications and submissions.
Tips: "Novices and experienced regional artists are welcome to submit slides and résumés."

MAIN AND THIRD FLOOR GALLERIES, Northern Kentucky University, Nunn Dr., Highland Heights KY 41099. (606)572-5148. Fax: (606)572-5566. Gallery Director: David Knight. University galleries. Program established 1975; new main gallery in fall of 1992; renovated third floor gallery fall of 1993. Represents emerging, mid-career and established artists. Sponsors 10 shows/year. Average display time 1 month. Open Monday-Friday, 9-9; Saturday, Sunday, 1-5; closed major holidays and between Christmas and New Years. Located in Highland Heights, KY, 8 miles from downtown Cincinnati; 3,000 sq. ft.; two galleries—one small and one large space with movable walls. 100% of space for special exhibitions. 90% private collectors, 10% corporate collectors. Overall price range; $25-50,000; most work sold at $25-2,000.

Media: Considers all media and all types of prints. Most frequently exhibits painting, printmaking and photography.
Style: Exhibits all styles, all genres.
Terms: Proposals are accepted for exhibition. Retail price set by the artist. Gallery provides insurance, promotion and contract; shipping costs are shared. Prefers artwork framed "but we are flexible."
Submissions: Send query letter with résumé, slides, bio, photographs, SASE and reviews. Write for appointment to show portfolio of originals, photographs and slides. Submissions are accepted in December for following academic school year. Files résumés and bios. Finds artists through agents, visiting exhibitions, word of mouth, art publications and sourcebooks and submissions.

‡RIPE GALLERY, 1731 Frankfort Ave., Louisville KY 40206. (502) 897-9409. Owner: Marsha Ellis. Retail gallery/alternative space. Estab. 1993. Represents 25-30 emerging artists. Exhibited artists include Irena Ilena, Rebecca Gallion. Sponsors 20 shows/year. Average display time 6 weeks. Open all year; Wednesday-Friday, 11-2:30 and 5:30 to 9; Saturday 11-9; Sunday 11-3. Located in Frankfort Avenue Business Corridor; 500 sq. ft.; Victorian building, outdoor garden. 1/3 of space devoted to special exhibitions. 85% of space devoted to gallery artists. Clientele: tourists, mid-scale. 95% private collectors, 5% corporate collectors. Overall price range: $250-300.
Media: Considers all media. Considers woodcuts, engravings, lithographs, mezzotint, serigraphs, linocuts and etchings. "No posters." Most frequently exhibits drawings, paintings and prints.
Style: Exhibits all styles and genres. Prefers contemporary/eclectic work. Most frequently exhibits expressionism, pattern painting and conceptualism.
Terms: Artwork accepted on consignment (30% commission). Retail price set by the artist. Gallery provides promotion and contract. Artist pays shipping costs. Prefers artwork framed.
Submissions: Send résumé, slides, photographs, reviews and artist's statement. Call for portfolio review of photographs and slides. Does not reply. Artist should follow up. All material returned to artist. Finds artists through word of mouth, referrals, personal contacts.
Tips: A common mistake artists make is "not following up on their submissions."

UNIVERSITY ART GALLERIES, (formerly Eagle Gallery), Murray State University, P.O. Box 9, Murray KY 42071-0009. (502)762-6734. Fax: (502)762-3920. Director: Albert Sperath. University gallery. Estab. 1971. Represents emerging, mid-career and established artists. Sponsors 8 shows/year. Average display time 6 weeks. Open Monday, Wednesday, Friday, 8-6; Tuesday, Thursday 8-7:30; Saturday, 10-4; Sunday, 1-4; closed during university holidays. Located on campus, small town; 4,000 sq. ft.; modern multi-level dramatic space. 100% of space for special exhibitions. Clientele: "10,000 visitors per year."
Media: Considers all media and all types of prints.
Style: Exhibits all styles.
Terms: "We supply the patron's name to the artist for direct sales. We take no commission." Retail price set by the artist. Gallery provides insurance, promotion and shipping costs from gallery. Prefers artwork framed.
Submissions: Send query letter with résumé and slides. Replies in 1 month.
Tips: "Do good work that *expresses* something."

YEISER ART CENTER INC., 200 Broadway, Paducah KY 42001. (502)442-2453. Executive Director: Dan Carver. Nonprofit gallery. Estab. 1957. Exhibits emerging, mid-career and established artists. 450 members. Sponsors 8 shows/year. Average display time 6-8 weeks. Open all year. Located downtown; 1,800 sq. ft.; "in historic building that was farmer's market." 90% of space for special exhibitions. Clientele: professionals and collectors. 90% private collectors. Overall price range: $200-8,000; most artwork sold at $200-1,000.
Media: Considers all media except installation. Prints considered include original handpulled prints, woodcuts, wood engravings, linocuts, mezzotints, etchings, lithographs and serigraphs. Most frequently exhibits oil, acrylic and mixed media.
Style: Exhibits all styles. Genres include landscapes, florals, Americana and figurative work. Prefers realism, impressionism and abstraction.
Terms: Accepts work on consignment (35% commission). Retail price set by artist. Gallery provides insurance and promotion; shipping costs are shared. Prefers artwork framed.
Submissions: Send résumé, slides, bio, SASE and reviews. Replies in 1 month.
Tips: "Do not call. Give complete information about the work: media, size, date, title, price. Have good-quality slides of work, indicate availability and include artist statement. Presentation of material is important."

ZEPHYR GALLERY, W. Main St., Louisville KY 40202. (502)585-5646. Directors: Patrick Donley, Peggy Sue Howard. Cooperative gallery and art consultancy with regional expertise. Estab. 1988. Exhibits 18 emerging and mid-career artists. Exhibited artists include Chris Radtke, Dudley Zopp, Kerry Malloy, Kocka, Robert Stagg, Jenni Deame. Sponsors 9 shows/year. Average display time 5 weeks. Open all year. Located downtown; approximately 8,000 sq. ft. Clientele: 25% private collectors, 75% corporate collectors. Most work sold at $200-2,000.

Media: Considers all media. Considers only small edition handpulled print work by the artist. Most frequently exhibits painting, photography and sculpture.
Style: Exhibits individual styles.
Terms: Co-op membership fee plus donation of time (25% commission); outside the Louisville metropolitan area, 50% consignment. Retail price set by artist. Gallery provides insurance, promotion and contract; artist pays for shipping. Prefers artwork framed.
Submissions: No functional art (jewelry, etc.). Send query letter with résumé and slides. Call for appointment to show portfolio of slides; may request original after slide viewing. Replies in 6 weeks. Files slides, résumés and reviews (if accepted).
Tips: "Submit well-organized slides with slide list. Include professional résumé with notable exhibitions."

Louisiana

CASELL GALLERY, 818 Royal St., New Orleans LA 70116. (800)548-5473. Title/Owner-Directors: Joachim Casell. Retail gallery. Estab. 1970. Represents 20 mid-career artists/year. Exhibited artists include J. Casell and Don Picou. Sponsors 2 shows/year. Average display time 10 weeks. Open all year; 10-6. Located in French Quarter; 800 sq. ft. 25% of space for special exhibitions. Clientele: tourists and local community. 20-40% private collectors, 10% corporate collectors. Overall price range: $100-1,200; most work sold at $300-600.
Media: Considers all media, wood engravings, etchings, lithographs, serigraphs and posters. Most frequently exhibits pastel and pen & ink drawings.
Style: Exhibits impressionism. All genres including landscapes. Prefers pastels.
Terms: Artwork is accepted on consignment (50% commission). Retail price set by the artist. Gallery provides promotion and pays for shipping costs. Prefers artwork unframed.
Submissions: Accepts only local area and Southern artists. Replies only if interested within 1 week.

‡**EARTHWORKS FINE ART GALLERY**, (formerly Fine Art Gallery of SW Louisiana), 1424 Ryan, Lake Charles LA 70601. (318)439-1430. Fax: (318)439-1441. Owner: Ray Fugatt. Retail gallery. Estab. 1989. Represents 25-30 emerging, mid-career and established artists. Exhibited artists include Elton Louviere. Sponsors 7 shows/year. Average display time 1 month. Open all year. Located downtown; 4,000 sq. ft.; "a remodeled 50-year-old, art-deco designed grocery building." 40% of space for special exhibitions. Overall price range: $100-15,000; most work sold at $500-8,000.
Media: Considers oil, acrylic, watercolor, pen & ink, drawings, mixed media, sculpture, ceramic, glass, original handpulled prints, woodcuts, etchings and "any repros by artist; no photo lithos." Most frequently exhibits oil, acrylic and watercolor.
Style: Exhibits expressionism, impressionism, realism and photorealism. Genres include landscapes, florals, Americana, Southwestern, Western, wildlife and figurative works.
Terms: 90% of work accepted on consignment (40% commission); 10% bought outright for 50% of the retail price (net 30 days). Exclusive area representation required. Retail price set by artist. Gallery provides insurance, promotion, contract and shipping costs from gallery. Prefers artwork framed.
Submissions: Send query letter with résumé and slides. Call or write for appointment to show portfolio of originals and slides. Replies in 2-4 weeks. Files résumés.
Tips: "Have a body of work available that shows the range of uniqueness of your talent."

GALLERY OF THE MESAS, 2010-12 Rapides Ave., Alexandria LA 71301. (318)442-6372. Artist/Owner: C.H. Jeffress. Retail and wholesale gallery and artist studio. Focus is on Southwest and native American art. Estab. 1975. Represents 6 established artists. Exhibited artists include John White, Charles H. Jeffress, Peña, Gorman, Atkinson, Doug West and Mark Snowden. Open all year. Located on the north edge of town; 2,500 sq. ft. Features new canvas awnings, large gold letters on brick side of buildings and new mini-gallery in home setting next door. Clientele: 95% private collectors, 5% corporate collectors. Overall price range: $165-3,800.
Media: Considers original handpulled prints, watercolor, intaglio, lithographs, serigraphs, Indian jewelry, sculpture, ceramics and drums. Also exhibits Hopi carved and Sierra Small Bird silver Katchina dolls. Most frequently exhibits serigraphs, inkless intaglio, collage and lithographs.
Style: Exhibits realism. Genres include landscapes, Southwestern and figurative work.
Submissions: Handles only work of well-known artists in Southwest field. Owner contacts artists he wants to represent.
Tips: "Mostly interested in landscapes. Indian figures in war paint don't sell in Louisiana."

‡**ANTON HAARDT GALLERY**, 2714 Coliseum St., New Orleans LA 70130. (504)897-1172. Owner: Anton Haardt. Retail gallery. Estab. 1987. Represents 25 established, self-taught artists. Exhibited artists include Mose Tollirer, Sybil Gibson. Open all year by appointment only. Located in New Orleans—Garden District, Montgomery—downtown; 1,000 sq. ft.; self-taught artists—dynamic works. 100% of space for

gallery artists. Clientele: collectors, upscale. 50% private collectors, 50% corporate collectors. Overall price range: $200-10,000; most work sold at $300-1,000.

Media: Considers oil, pen & ink, paper, acrylic, drawing, sculpture, watercolor, mixed media, pastel and collage. Most frequently exhibits paint, pen & ink, mixed media.

Style: Exhibits primitivism, folk art. Prefers folk art.

Terms: Price set by the gallery. Gallery provides promotion; shipping costs to gallery. Prefers artwork unframed.

Submissions: Accepts only artists from the South (mainly). Must be self-taught—untrained. Send query letter with slides, bio. Call for appointment to show portfolio of photographs and slides. Replies in 2 months. Finds artists through word of mouth, newspaper and magazine articles.

Tips: "I have very strict requirements for absolute purist form of self-taught artists."

HILDERBRAND GALLERY, 4524 Magazine St., New Orleans LA 70115. (504)895-3312. Fax: (504)899-9574. Director: Holly Hilderbrand. Retail gallery and art consultancy. Estab. 1991. Represents/exhibits 22 emerging, mid-career and established artists/year. Exhibited artists include Walter Rutkowski and Massimo Boccuni. Average display time 1 month. Open September-June; Tuesday-Saturday, 10-5. Located uptown; 2,300 sq. ft.; 12' walls; pitch open ceiling with exposed steel beams/skylites. 90% of space for special exhibitions; 10% of space for gallery artists. Clientele: collectors, museum and corporate. 70% private collectors, 30% corporate collectors. Overall price range: $500-40,000; most work sold at $500-3,500.

Media: Considers all media, woodcuts, linocuts, engravings, mezzotints and etchings. Most frequently exhibits oil, glass/steel and photography.

Style: Considers all styles. Genres include landscapes, Americana and figurative work. Prefers nontraditional landscapes, conceptualist and abstract figurative.

Terms: Artwork is accepted on consignment (50% commission). Retail price set by the gallery. Gallery provides insurance, limited promotion and contract. Artist pays for shipping costs. Prefers artwork framed.

Submissions: Send query letter with résumé, brochure, slides, reviews, bio and SASE. Replies in 1 month. Finds artists through submissions, studio visits and exhibitions.

‡LE MIEUX GALLERIES, 332 Julia St., New Orleans LA 70130. (504)565-5354. President: Denise Berthiaume. Retail gallery and art consultancy. Estab. 1983. Represents 30 mid-career artists. Exhibited artists include Shirley Rabe Masinter and Kathleen Sidwell. Sponsors 7 shows/year. Average display time 6 months. Open all year. Located in the warehouse district/downtown; 1,400 sq. ft. 20-75% of space for special exhibitions. Clientele: 75% private collectors; 25% corporate clients.

Media: Considers oil, acrylic, watercolor, pastel, drawings, mixed media, works on paper, sculpture, ceramic, glass and egg tempera. Most frequently exhibits oil, watercolor and drawing.

Style: Exhibits impressionism, neo-expressionism, realism and hard-edge geometric abstraction. Genres include landscapes, florals, wildlife and figurative work. Prefers landscapes, florals and paintings of birds.

Terms: Accepts work on consignment (50% commission). Retail price set by artist. Exclusive area representation required. Gallery provides promotion and contract; artist pays for shipping.

Submissions: Accepts only artists from the Southeast. Send query letter with SASE, bio, brochure, résumé, slides and photographs. Write for appointment to show portfolio of originals. Replies in 3 weeks. All material is returned if not accepted or under consideration.

Tips: "Send information before calling. Give me the time and space I need to view your work and make a decision; you cannot sell me on liking or accepting it; that I decide on my own."

Maine

‡GOLD/SMITH GALLERY, 63 Commercial St., BoothBay Harbor ME 04538. (207)633-6252. Owner: Karen Vander. Retail gallery. Estab. 1974. Represents 30 emerging, mid-career and established artists. Exhibited artists include John Vander and Nikki Schumann. Sponsors 6 shows/year. Average display time 6 weeks. Open May-December; Monday-Saturday, 10-6; Sunday, 12-5. Located downtown across from the harbor. 1,500 sq. ft.; traditional 19th century house converted to contemporary gallery. 75% of space for special exhibitions; 25% of space for gallery artists. Clientele: residents and visitors. 90% private collectors, 10% corporate collectors. Overall price range: $350-5,000; most work sold at $350-1,500.

● Artists creating traditional and representational work should try another gallery. The work shown here is strong, self-assured and abstract.

Media: Considers oil, acrylic, watercolor, pastel, pen & ink, drawing, mixed media, collage, paper, sculpture, photography, woodcuts, engravings, lithographs, wood engravings, mezzotints, serigraphs, linocuts and etchings. Most frequently exhibits acrylic and watercolor.

Style: Exhibits expressionism, painterly abstraction "emphasis on nontraditional work." Prefers expressionist and abstract landscape.

Terms: Commission negotiated. Retail price set by the artist. Gallery provides insurance and promotion; artist pays shipping costs to and from gallery. Prefers artwork framed.

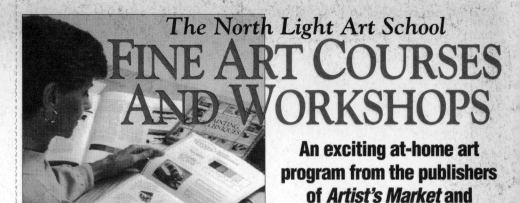

The North Light Art School
FINE ART COURSES AND WORKSHOPS

An exciting at-home art program from the publishers of *Artist's Market* and *The Artist's Magazine*

The North Light Art School Fine Art Courses and Workshops— developed by artists, for artists—offer you the unique opportunity to work one-on-one with professional artists, without leaving your home or studio. As a class of one, you'll receive undivided attention from your own personal art tutors who will show you—through detailed evaluations and specific suggestions—how to improve your artwork. Together, you'll work toward a single goal: making you a more confident, more accomplished artist.

With this detailed, personal feedback from a professional artist, you'll soon see more realism, more depth and more drama in your work.

You're the Boss!

In North Light's outstanding fine art program, you set your own schedule. There's no need to worry about hurrying off to class or rushing an assignment because of a tight deadline. No matter what course or workshop you take, you'll always have plenty of time to work at your own pace.

And if you get stuck or have a question about your assignments, just call our toll-free Artist's Hotline to get immediate feedback.

For free information about the North Light Art School Fine Art Courses and Workshops, return the postage-paid card below, or call toll-free **1-800-825-0963** today.

FREE INFORMATION!

☐ **YES**, I want to train with a professional artist through your unique home-study program. Send me free information about:

☐ The Fundamentals of Fine Art
☐ The Artist's Studio Workshops

Name _____

Address _____

City_____State_____Zip _____

Daytime Phone (_____) _____

Mail this card today! No postage needed.
Or call **1-800-825-0963**
(Outside U.S.: 513-531-2690, ext. 340)

IAMXXXX7

NORTH LIGHT ART SCHOOL

CHOOSE THE RIGHT PROGRAM FOR YOU!

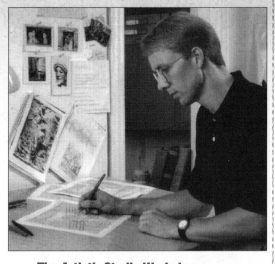

The Fundamentals of Fine Art

A comprehensive program in the basics of drawing and painting. The Fundamentals of Fine Art provides a solid foundation for beginners and an excellent refresher for artists who want to fine tune their drawing, sketching and composition skills.

The Artist's Studio Workshops

Your personal tutor will show you how to perfect your skills in your favorite medium or subject. Choose the class that most interests you from ten exciting drawing or painting workshops. In each you'll submit 12 works for evaluation by your instructor.

Discover how much more satisfying your art can be. For FREE information about these exciting courses and workshops, mail the post-paid card below today!

Submissions: No restrictions—emphasis on artists from Maine. Send query letter with slides, bio, photographs, SASE, reviews and retail price. Write for appointment to show portfolio of originals. Replies in 2 weeks. Artist should write the gallery.

GREENHUT GALLERIES, 146 Middle St., Portland ME 04101. (207)772-2693. President: Peggy Greenhut Golden. Retail gallery. Estab. 1990. Represents/exhibits 20 emerging and mid-career artists/year. Sponsors 6 shows/year. Exhibited artists include Alison Goodwin and Connie Hayes. Average display time 3 weeks. Open all year; Monday-Friday, 10-5:30; Saturday, 10-5. Located in downtown-Old Port; 3,000 sq. ft. with neon accents in interior space. 60% of space for special exhibitions. Clientele: tourists and upscale. 55% private collectors, 10% corporate collectors. Overall price range: $400-5,000; most work sold at $600-1,000.
Media: Considers all media, mezzotints, etchings, lithographs, serigraphs and posters. Most frequently exhibits oil paintings, acrylic paintings and mixed media.
Style: Exhibits contemporary realism. Prefers landscape, seascape and abstract.
Terms: Artwork is accepted on consignment (50% commission). Retail price set by the gallery. Gallery provides insurance and promotion. Artists pays for shipping costs. Prefers artwork unframed.
Submissions: Accepts only artists from Maine or New England area with Maine connection. Send query letter with slides, reviews, bios and SASE. Call for appointment to show portfolio of slides. Replies in 1 month. Finds artists through word of mouth, referrals by other artists, visiting art fairs and exhibitions and submissions.
Tips: "Visit the gallery and see if you feel you would fit in."

‡**NANCY MARGOLIS GALLERY**, 367 Fore St., Portland ME 04101. (207)775-3822. Fax: (207)773-2294. Director: Mary Zanoni. Retail gallery. Estab. 1972. Represents 250 emerging, mid-career and established artists/year. Exhibited artists include: Lisa Orr. Sponsors 10 shows/year. Average display time 3-4 months. Open all year; Monday-Saturday, 10-6; Sunday, 12-5. Located in art district downtown; designed by Portland architect Steven Blatt.
Media: Considers mixed media, paper, sculpture, ceramics, craft, fiber and glass. Considers prints but they are not our focus. Most frequently exhibits ceramics, furniture, jewelry.
Style: Exhibits all styles and genres.
Terms: Retail price set by the gallery. Gallery provides insurance, promotion and contract; gallery pays shipping costs from gallery. Artist pays for shipping costs to gallery.
Submissions: Send query letter with résumé, brochure, slides, artist's statement, bio. Portfolio should include photographs and slides. Finds artists through word of mouth, referrals by other artists, visiting art fairs and exhibitions and submissions.
Tips: "Include a self-addressed and stamped envelope for return of work."

PINE TREE SHOP AND BAYVIEW GALLERY, 33 Bayview St., Camden ME 04843. (207)236-4534. Owner: Betsy Rector. Retail gallery. Estab. 1977. Represents 50 emerging, mid-career and established artists. Exhibited artists include Carol Sebold and Brian Kliewer. Sponsors 12 shows/year. Average display time 1 month. Open all year. Located in downtown; 1,500 sq. ft. 50% of space for special exhibitions. Clientele: 60% private collectors; 40% corporate collectors. Overall price range: $50-5,000; most work sold at $50-500.
Media: Considers oil, acrylic, watercolor, pastel, sculpture, original handpulled prints and offset reproductions. Most frequently exhibits oil, watercolor, pastels and sculpture.
Style: Exhibits primitivism, impressionism and realism. Genres include landscapes, florals, and figurative work. Prefers realism, impressionism and primitivism.
Terms: Accepts work on consignment (45% commission). Retail price set by gallery. Customer discounts and payment by installment are available. Gallery provides insurance, promotion and contract; artist pays for shipping. Prefers artwork framed.
Submissions: Send query letter with résumé, slides, bio, SASE and reviews. Portfolio review not required. "Primarily new artists are acquired from their own submissions. We occasionally pursue artists whose work we are custom framing when its quality and nature would be desirable and marketable additions to the gallery."
Tips: "Make sure work is appropriate for gallery. We are showing a slightly broader range of styles, but we need to show a greater percentage of in-state artists to meet the expectations of our market and to maximize press releases. Most of our artists have survived the economy, although we've had to revise our territorial policy in order to allow artists to show elsewhere within our market territory. 90% of our clientele was hit by the economy, forcing us to consider more emerging artists and more modestly priced artwork. Also, as corporate sales are increasing, choices are made more with their trends in mind. Strong, professional work that is evocative of life and landscape of Maine tends to sell best."

428 Artist's & Graphic Designer's Market '97

Maryland

ARTEMIS, INC., 4715 Crescent St., Bethesda MD 20816. (301)229-2058. Fax: (301)229-2186. Owner: Sandra Tropper. Retail and wholesale dealership, art consultancy and art appraisals. Represents more than 100 emerging and mid-career artists. Does not sponsor specific shows. Clientele: 40% private collectors, 60% corporate clients. Overall price range: $100-10,000; most work sold at $500-1,500.
Media: Considers oil, acrylic, watercolor, mixed media, collage, works on paper, sculpture, ceramics, craft, fiber, glass, installations, woodcuts, engravings, mezzotints, etchings, lithographs, pochoir, serigraphs and offset reproductions.
Style: Carries impressionism, expressionism, realism, minimalism, color field, painterly abstraction, conceptualism and imagism. Genres include landscapes, florals and figurative work. "My goal is to bring together clients (buyers) with artwork they appreciate and can afford. For this reason I am interested in working with many, many artists." Interested in seeing works with a "finished" quality.
Terms: Accepts work on consignment (50% commission). Retail price set by dealer and artist. Exclusive area representation not required. Dealer provides insurance and contract; shipping costs are shared. Prefers artwork unframed.
Submissions: Send query letter with résumé, slides, photographs and SASE. Write for appointment to show portfolio of originals, slides, transparencies and photographs. Indicate net and retail prices. Files slides, photos, résumés and promo material. All material is returned if not accepted or under consideration.
Tips: "Many artists have overestimated the value of their work. Look at your competition's prices."

GOMEZ GALLERY, 836 Leadenhall St., Baltimore MD 21230. (410)752-2080. Director: Diane DiSalvo. Retail gallery. Estab. 1988. Represents 60 emerging and mid-career artists. Exhibited artist includes Deborah Donelson. Sponsors 10 shows/year. Average display time 4-5 weeks. Open all year. Located downtown; 1,350 sq. ft.; "clean, open warehouse space." 70% private collectors; 30% corporate collectors. Overall price range: $100-10,000; most work sold at $1,000-2,500.
Media: Considers painting, sculpture and photography in all media.
Style: Interested in all genres. Prefers figurative, abstract and landscapes with an experimental edge.
Terms: Accepts artwork on consignment (50% commission). Retail price set by the gallery and the artist. Gallery provides insurance and promotion. Artist pays for shipping. Prefers artwork unframed.
Submissions: Send query letter with résumé, slides, bio, brochure, SASE and reviews.
Tips: "Find out a little bit about this gallery first; if work seems comparable, send a slide package. Interested only in quality work."

‡IMAGES INTERNATIONAL ART GALLERY, 4420 Boxwood Rd., Bethesda MD 20816-1818. (301)654-2321. Fax: (301)907-0216. President: Beverley Hill. Retail gallery. Estab. 1985. Represents 25 emerging, mid-career and established artists. Exhibited artists include H. Otsuka and Warren Allin. Sponsors 6 shows/year. Average display time 6 weeks. Open all year. Located in downtown Bethesda; 1,100 sq. ft.; "interior moveable walls, with storage." 80% of space for special exhibitions. Clientele: upper and moderate income. 90% private collectors, 10% corporate collectors. Overall price range: $500-10,000; most work sold at $500-2,500.
Media: Considers oil, acrylic, watercolor, mixed media, paper and sculpture, original handpulled prints, mezzotints, etchings and serigraphs. Most frequently exhibits oil, mixed media and watercolor.
Style: Exhibits expressionism, surrealism, color field, impressionism, realism and hard-edge geometric abstraction. Genres include landscapes, florals, Americana, wildlife and figurative work. Prefers landscapes, Americana and figurative.
Terms: Accepts work on consignment (50% commission); or buys outright for 30% of retail price (net 30 days). Retail price set by the artist. Gallery provides insurance, promotion and contract; shipping costs are shared. Prefers artwork framed.
Submissions: Accepts only artists from the Northeast and mid-Atlantic. Should be contemporary and "gallery compatible." Send query letter with résumé, slides, brochure, photographs, business card and reviews. Write for appointment to show portfolio, which should include photographs and slides. Replies in 2 weeks. Files résumé, brochure, reviews and photos.

LOBBY FOR THE ARTS GALLERY, Cumberland Theatre, 101 Johnson St., Cumberland MD 21502. (301)759-3606. Exhibitions Director: Frank S. deCosta. Alternative space. Estab. 1989. Sponsors 6 shows/year. Average display time 1 month. Open April-October; Monday-Friday, 1-7 during performances in artists Equity Theatre. Located in downtown area; 600 sq. ft.; museum-standard lighting. 100% of space for special exhibitions. 95% private collectors, 5% corporate collectors. Overall $100-2,000; most work sold at $1,000.
Media: Considers all media, woodcuts, wood engravings, linocuts, engravings, mezzotints and etchings. Most frequently exhibits expressionism, neo-expressionism, realism, surrealism, impressionism and imagism. All genres. Prefers expressionism, figurative work, realism and surrealism.
Terms: Artwork is accepted on consignment (25% commission). Retail price set by the artist. Gallery provides promotion and contract. Prefers artwork framed.

Submissions: Accepts only artists who are able to have work hand delivered and hand picked up. Send résumé, slides and bio. Include SASE; all materials returned by May 1st of each year. "All replies made once a year in February; submission deadline is December 15th." Finds artists through submissions.
Tips: "Five slides minimum, ten maximum. Slides must be of the highest quality. Always by very polite and do not ask for exemptions from patterns of operation set down by galleries."

MARLBORO GALLERY, 301 Largo Rd., Largo MD 20772. (301)322-0965-7. Coordinator: John Krumrein. Nonprofit gallery. Estab. 1976. Interested in emerging, mid-career and established artists. Sponsors 4 solo and 4 group shows/year. Average display time 3 weeks. Seasons for exhibition: September-May. 2,100 sq. ft. with 10 ft. ceilings and 25 ft. clear story over 50% of space—track lighting (incandescent) and day light. Clientele: 100% private collectors. Overall price range: $200-10,000; most work sold at $500-700.
Media: Considers all media. Most frequently exhibits acrylics, oils, photographs, watercolors and sculpture.
Style: Exhibits expressionism, neo-expressionism, realism, photorealism, minimalism, primitivism, painterly abstraction, conceptualism and imagism. Exhibits all genres. "We are open to all serious artists and all media. We will consider all proposals without prejudice."
Terms: Accepts artwork on consignment. Retail price set by artist. Exclusive area representation not required. Gallery provides insurance. Artist pays for shipping. Prefers artwork ready for display.
Submissions: Send query letter with résumé, slides, SASE, photographs, artist's statement and bio. Portfolio review requested if interested in artist's work. Portfolio should include slides and photographs. Replies every 6 months. Files résumé, bio and slides. Finds artists through word of mouth, visiting exhibitions and submissions.
Tips: Impressed by originality. "Indicate if you prefer solo shows or will accept inclusion in group show chosen by gallery."

‡ROMBRO'S ART GALLERY, 1805 St. Paul St., Baltimore MD 21202. (410)962-0451. Retail gallery, rental gallery. Estab. 1984. Represents 3 emerging, mid-career and established artists/year. May be interested in seeing the work of emerging artists in the future. Exhibited artists include Dwight Whitley and Judy Wolpert. Sponsors 4 shows/year. Average display time 3 months. Open all year; Tuesday-Saturday, 9-5; closed August. Located in downtown Baltimore; 3,500 sq. ft. Clientele: upscale, local community. Overall price range: $350-15,000.
Media: Considers oil, acrylic, watercolor, pastel, pen & ink, drawing, mixed media, collage, paper, sculpture and ceramics. Considers all types of prints. Most frequently exhibits oil, pen & ink, lithographs.
Style: Exhibits expressionism, painterly abstraction, color field, postmodern works, hard-edge geometric abstraction. Genres include florals and figurative work. Prefers florals and figurative.
Terms: Accepts work on consignment (50% commission) or buys outright for 35% of the retail price; net 45 days. Rental fee for space ($650). Retail price set by the gallery and the artist. Gallery provides promotion and contract; artist pays for shipping costs to gallery. Prefers artwork framed.
Submissions: Send query letter with résumé, brochure, slides and artist's statement. Write for appointment to show portfolio of slides. Files slides. Finds artists through visiting exhibitions.

‡STEVEN SCOTT GALLERY, 515 N. Charles St., Baltimore MD 21201. (410)752-6218. Director: Steven Scott. Retail gallery. Estab. 1988. Represents 15 mid-career and established artists/year. May be interested in seeing the work of emerging artists in the future. Exhibited artists include Hollis Sigler, Gary Bukovnik. Sponsors 6 shows/year. Average display time 2 months. Open all year; Tuesday-Saturday, 12-6. Located downtown; 1,200 sq. ft.; white walls, grey carpet—minimal decor. 80% of space for special exhibitions; 20% of space for gallery artists. 80% private collectors, 20% corporate collectors. Overall price range: $300-15,000; most work sold at $1,000-7,500.
Media: Considers oil, acrylic, watercolor, pastel, pen & ink, drawing, mixed media, collage, paper and photography. Considers all types of prints. Most frequently exhibits oil, prints and photography.
Style: Exhibits expressionism, neo-expressionism, surrealism, postmodern works, photorealism, realism and imagism. Genres include florals, landscapes and figurative work. Prefers florals, landscapes and figurative.
Terms: Retail price set by the gallery and the artist. Gallery provides insurance, promotion and contract; shipping costs are shared. Prefers artwork unframed.
Submissions: Accepts only artists from US. Send query letter with résumé, brochure, slides, photographs, reviews, bio and SASE. Call for appointment to show portfolio of photographs and slides. Replies in 2 weeks.
Tips: "Don't send slides which are unlike the work we show in the gallery, i.e. abstract or minimal."

Massachusetts

ALON GALLERY/ART SERVICES, 1665A Beacon St., Brookline MA 02146. (617)232-3388. Fax: (617)232-9480. Director: Moshe Alon. Retail gallery. Estab. 1976. Represents 20 emerging mid-career and established artists. Exhibited artists include Jason Berger and Amos Yaskil. Sponsors 6-10 shows/year. Aver-

age display time 1 month. Open all year; Tuesday-Saturday, 10-6. Located on a main street, in small town next to Boston; 1,500 sq. ft.; 2 levels; window on street. 100% of space for special exhibitions. Clientele: 80% private collectors, 10% corporate collectors and 10% dealers. Overall price range: $200-10,000; most work sold at $400-2,000.

Media: Considers all media and all types of limited edition prints. Most frequently exhibits oil, graphics and watercolor.

Style: Exhibits expressionism, painterly abstraction and realism. Prefers figurative works, landscapes and expressionism.

Terms: Accepts work on consignment (50% commission). Retail price set by gallery and artist. Gallery provides promotion; artist pays for shipping. Prefers artwork framed.

Submissions: Send query letter with résumé, slides, bio and SASE. "Always label slides with size and title." Write for appointment to show portfolio of photographs and slides. Replies in 1 week. Files all material if interested.

Tips: "We suggest the artist be familiar with our gallery."

BOSTON CORPORATE ART, 470 Atlantic Ave., Boston MA 02210. (617)426-8880. Fax: (617)426-5551. Gallery Director: Elizabeth Erdreich. Retail gallery and art consultancy. Estab. 1986. Represents 2,000 (through consultancy) emerging, mid-career and established artists. Exhibited artists include John Stockwell and Peter Kitchell. Sponsors 6 shows/year. Average display time 2 months. Open all year; Monday-Friday 9-5. Located downtown, waterfront, near financial district; 4,000 sq. ft. "We use our gallery space in conjunction with our offices—for art consulting. Our gallery is more of a display area than a traditional gallery." Clientele: large corporations and small businesses. 5% private collectors; 95% corporate collectors. Overall price range: $1,000-35,000; most work sold at $1,000-10,000.

Media: Considers all media and all types of prints. Most frequently exhibits oil/acrylic on canvas, watercolor, pastel. Most frequently sells works on paper.

Style: Exhibits all styles and genres. Prefers impressionism, realism, painterly abstraction.

Terms: Accepts work on consignment (50% commission). Retail price set by artist. Gallery provides insurance; shipping costs are shared. Prefers artwork unframed.

Submissions: Send query letter with résumé, slides, bio, SASE, price list and reviews. Write for appointment to show portfolio of slides. Replies in 6-8 weeks. Files slides, bio, résumé, price list. Finds artists through word of mouth and referrals.

Tips: "Please fill out a price list that includes price per piece on slides. Mark all slides with name, title, medium, size. When forwarding information, please be sure it's complete—it's impossible to review without complete info."

BROMFIELD GALLERY, 107 South St., Boston MA 02111. (617)451-3605. Director: Christina Lanzl. Cooperative gallery. Estab. 1974. Represents 20 emerging and mid-career artists. Exhibited artists include Barbara Andrus, Erica Licea-Kane, Martin Mugar and Tim Nichols. Sponsors 25 shows/year. Average display time 1 month. Open all year; Tuesday-Friday 12-5; Saturday 11-5. Located downtown; 2,500 sq. ft.; sequence of 3 large gallery spaces. 30% of space for special exhibitions; 70% of space for gallery artists. Clientele: 70% private collectors, 30% corporate collectors. Overall price range: $300-6,000; most work sold at $300-2,000.

Media: Considers all media and original handpulled prints. Most frequently exhibits paintings, prints, sculpture.

Style: Exhibits all styles and genres.

Terms: Co-op membership fee plus donation of time (45% commission). For invitational exhibitions, there is a rental fee for space which covers 12 months. Retail price set by artist. Offers customer discounts and payment by installments. Gallery provides promotion and contract; artist pays for shipping costs.

Submissions: Accepts only artists from New England. Send query letter with résumé, slides and SASE. Write for appointment to show portfolio of originals. Replies in 1 month. Files all info on members and visiting artists. Finds artists through word of mouth, various art publications and sourcebooks, submissions/self-promotions and referrals.

‡BRUSH ART GALLERY, 256 Market St., Lowell MA 01852. (508)459-7819. Contact: E. Linda Poras. Estab. 1984. Represents 35 mid-career and established artists/year. May be interested in seeing the work of emerging artists in the future. Exhibited artists include Vassilios Giavis, Ann Sullivan, Deirdre Grunwald. Sponsors 6 shows/year. Average display time 2 months. Open all year; Tuesday-Sunday, 11-5. Located in National Park Complex; 2,000 sq. ft.; old, restored mill building. 85% of space for special exhibitions; 15% of space for gallery artists. Clientele: tourists, local community. Overall price range: $25-2,500; most work sold at $50-200.

Media: Considers oil, acrylic, watercolor, pastel, pen & ink, mixed media, collage, paper, ceramics, fiber, glass, photography, woodcuts and serigraphs. Most frequently exhibits watercolor, glass and fiber.

Style: Exhibits all styles. Genres include florals, portraits, landscapes, figurative work. Prefers landscapes, florals, figures.

Terms: Accepts work on consignment (40% commission). Rental fee for space; covers 1 year. Retail price set by the artist. Gallery provides insurance, promotion and contract. Gallery pays for shipping from gallery. Artist pays shipping to gallery.
Submissions: Send query letter with résumé, slides and SASE. Call for appointment to show portfolio of photographs. Replies in 1 month. Files résumé and slides.

‡**CHASE GALLERY**, 173 Newbury St., Boston MA 02116. (617)859-7222. Director: Jeffrey Chase. Retail gallery. Estab. 1990. Represents 20 mid-career and established artists/year. Exhibited artists include Enrique Santana, Cynthia Packard. Sponsors 11 shows/year. Average display time 1 month. Open all year; Monday-Saturday, 10-6; Sunday, 1-5. 1,000 sq. ft. 80% of space for special exhibitions; 20% of space for gallery artists. 95% private collectors, 5% corporate collectors. Overall price range: $500-25,000; most work sold at $2,000-10,000.
Media: Considers oil, acrylic and sculpture. Most frequently exhibits oil paintings, alkyd, acrylic.
Style: Exhibits narrative/representational. Genres include landscapes and figurative work.
Terms: Accepts work on consignment (50% commission). Retail price set by the artist. Gallery provides insurance and promotion; artist pays shipping costs. Prefers artwork framed.
Submissions: Prefers only oil, acrylic, alkyd. Send query letter with résumé, brochure, slides, reviews and SASE. Replies in 1 month. Files cards; "SASE should be provided for return of materials." Finds artists through referrals, submissions.
Tips: "Don't send one or two images—20 slides of recent work should be submitted."

DE HAVILLAND FINE ART, 39 Newbury St., Boston MA 02116. (617)859-3880. Fax: (617)859-3973. Contact: Gallery Manager. Retail gallery. Estab. 1989. Represents 40 emerging New England artists. Sponsors 10-12 shows/year. Average display time 1 month. Open all year. Located downtown ½ block from the Ritz Hotel; 1,200 sq. ft. 75% of space for special exhibitions. Clientele: 80% private collectors, 20% corporate collectors. Overall price range: $200-7,000.
Media: Considers oil, acrylic, watercolor, pastel, pen & ink, drawing, mixed media and sculpture. Most frequently exhibits oil/acrylic, watercolor/pastel and mixed media.
Style: Exhibits expressionism, neo-expressionism, primitivism, painterly abstraction, surrealism, postmodern works, impressionism and realism. Genres include landscapes, florals and Americana. Prefers realism and painterly abstraction.
Terms: Accepts artwork on consignment (50% commission). Retail price set by the gallery and artist. Sometimes offers customer discounts. Gallery provides promotion and contract; artist pays for shipping. Prefers artwork framed.
Submissions: Send query letter with résumé, slides, and SASE. "We support emerging artists who reside in New England." Replies in 1 month. Files résumé.

‡**DEPOT SQUARE GALLERY**, 1837 Massachusetts Ave., Lexington MA 02173. (617)863-1597. Membership Chairman: Gayle Levee. Cooperative gallery. Estab. 1981. Represents emerging, mid-career and established artists. 25 members. Exhibited artists include Gracia Dayton and Natalie Warshawer. Sponsors 10 shows/year. Average display time 1 month. Open all year; Tuesday-Saturday, 10-5; open Sunday, 1-4, (September-June only). Located downtown; 2,000 sq. ft.; 2 floors—street level and downstairs. 100% of space for gallery artists. 10% private collectors, 10% corporate collectors. Overall price range: $100-3,000; most work sold at $100-500.
Media: Considers oil, acrylic, watercolor, pastel, pen & ink, drawing, mixed media, collage, paper, sculpture, ceramics, fiber, glass, woodcuts, engravings, wood engravings, mezzotints, serigraphs, linocuts and etchings. Most frequently exhibits watercolor, oil and prints.
Style: Exhibits all styles, all genres. Prefers realism, impressionism (depends on makeup of current membership).
Terms: Co-op membership fee plus donation of time (40% commission). Retail price set by the artist. Gallery provides promotion. Prefers artwork framed.
Submissions: Accepts only local artists—must attend meetings. help hang shows and work in the gallery. Send query letter with résumé, slides, bio, SASE and reviews. Call for appointment to show portfolio of slides and transparencies. Replies in 6 weeks. Files bio and one slide—"if we want to consider artist for future membership." Finds artists through advertising for new members and referrals.

‡**GALLERY 349**, 349 Commercial St., Provincetown MA 02657. (508)487-1200. Director: Kir J. Priore. Estab. 1995. Represents 14 emerging, mid-career and established artists/year. Exhibited artists include Chet Jones, Jennifer Ditacchio. Sponsors 15 shows/year. Average display time 3 weeks. Open in season 1-10; Saturday and Sunday, 12-4 in winter. Located downtown; 1,000 sq. ft.; on Main St., fabulous ocean and harbor views. 100% of space for gallery artists. Clientele: tourists, upscale, some local community. 100% private collectors. Overall price range: $500-4,000; most work sold at $900-2,500.
Media: Considers all media except craft. Considers woodcuts, engravings, lithographs, wood engravings, mezzotints, linocuts and etchings. Most frequently exhibits oil, mixed media and prints.

Style: Exhibits all styles and all genres. Prefers landscape, cityscape and abstract.
Terms: Accepts work on consignment (50% commission). Buys outright for 50% of retail price (net 90 days). Retail price set by the gallery. Gallery provides insurance and promotion; artist pays shipping costs.
Submissions: Accepts only artists New England (Cape Cod, Northeast, Massachusetts). Send query letter with résumé, slides, reviews and SASE. Call for appointment to show portfolio of photographs, transparencies, slides and press. Replies in 2 months. Files slides of interest and résumés. Finds artists through word of mouth, referrals by other artists and submissions.
Tips: "Don't send too many slides and a winded résumé. We're only interested in serious major events in career."

‡**GROHE GLASS GALLERY**, Dock Square, 24 North St., Boston MA 02109. (617)227-4885. Fax: (508)539-0509. Retail gallery. Estab. 1988. Represents 50 mid-career and established artists. Interested in seeing the work of emerging artists. Exhibited artists include Peter Vanderlaan, Lino Taqliapietra, Latchezar Boyadjiev, Jon Kuhn and Cissy McCaa. Sponsors 5 shows/year. Average display time 1 month. Open all year. Located downtown in Faneuil Hall marketplace; 750 sq. ft. 75% of space for special exhibitions. Clientele: glass collectors. 90% private collectors, 10% corporate collectors. Overall price range: $1,500-50,000.
Media: Considers glass.
Terms: Accepts work on consignment (50% commission). Retail price set by artist. Gallery provides insurance, promotion and contract; shipping costs are shared.
Submissions: Prefers only glass artists. Send query letter with résumé, slides, bio, photographs and SASE. Write for appointment to show portfolio. Replies in 2 weeks.

‡**CORTLAND JESSUP GALLERY**, 432 Commercial St., Provincetown MA 02657. Director: Cortland Jessup. Retail gallery. Estab. 1990. Represents emerging, mid-career and established artists. Exhibited artists include Juliet Holland, David Dunlop. Sponsors 12 shows/year. Average display time 2 weeks. Open Memorial Day-Columbus Day; 11-11. Located in Provincetown East End; 900 sq. ft. 75% of space for special exhibitions; 25% of space for gallery artists. 90% private collectors, 10% corporate collectors.
Media: Considers all media except glass; rarely considers craft and fiber. Considers all types of prints. Most frequently frequently exhibits painting, sculpture, photography.
Style: Prefers mixed media painterly abstraction, conceptual neo-expressionism and periodically, traditional landscape, still life, figurative works by mid-career or established artists.
Terms: Accepts work on consignment.
Submissions: Send résumé, slides, bio and SASE. Replies only if interested. Files material of interest or for consideration for future projects. Finds artists through word of mouth, referrals by other artists, travel and submissions.
Tips: "Don't walk in with slides and/or art under arm and expect to be seen. We will look only if sent by mail (or dropped off) with SASE—and we will never look at original art work carried in without appointment."

KAJI ASO STUDIO/GALLERY NATURE AND TEMPTATION, 40 St. Stephen St., Boston MA 02115. (617)247-1719. Fax: (617)247-7564. Administrator: Kate Finnegan. Nonprofit gallery. Estab. 1975. Represents 40-50 emerging, mid-career and established artists. 35-45 members. Exhibited artists include Kaji Aso and Katie Sloss. Sponsors 10 shows/year. Average display time 3 weeks. Open all year; Tuesday, 1-8; Wednesday-Saturday, 1-5; and by appointment. Located in city's cultural area (near Symphony Hall and Museum of Fine Arts); "intimate and friendly." 30% of space for special exhibitions; 70% of space for gallery artists. Clientele: urban professionals and fellow artists. 80% private collectors, 20% corporate collectors. Overall price range: $150-8,000; most work sold at $150-1,000.
Media: Considers oil, acrylic, watercolor, pastel, pen & ink, drawing, ceramics and etchings. Most frequently exhibits watercolor, oil or acrylic and ceramics.
Style: Exhibits painterly abstraction, impressionism and realism.
Terms: Co-op membership fee plus donation of time (35% commission). Retail price set by the artist. Gallery provides promotion; artist pays shipping costs to and from gallery. Prefers artwork framed.
Submissions: Send query letter with résumé, slides, bio, photographs and SASE. Write for appointment to show portfolio of originals, photographs, slides or transparencies. Does not reply; artist should contact. Files résumé. Finds artists through advertisements in art publications, word of mouth, submissions.

KINGSTON GALLERY, 129 Kingston St., Boston MA 02111. (617)423-4113. Co-directors: Kathleen O'Hara and Caroline Taggart. Cooperative gallery. Estab. 1982. Exhibits the work of 12 emerging, mid-career and established artists. Sponsors 11 shows/year. Average display time 1 month. Closed August. Located "in downtown Boston (financial district/Chinatown); 1,300 sq. ft.; large, open room with 12' ceiling and smaller front room—can accomodate large installation." Overall price range: $100-7,000; most work sold at $600-1,000.

Media: Considers all media except craft. 10% of space for special exhibitions.
Style: Exhibits all styles.
Terms: Co-op membership requires dues plus donation of time. 25% commission charged on sales by members. Retail price set by the artist. Sometimes offers payment by installments. Gallery provides insurance, some promotion and contract. Rental of front gallery by arrangement.
Submissions: Accepts only artists from New England for membership. Artist must fulfill monthly co-op responsibilities. Send query letter with résumé, slides, SASE and "any pertinent information. Slides are reviewed once a month. Gallery will contact artist within 1 month." Does not file material but may ask artist to re-apply in future.
Tips: "Please include thorough, specific information on slides: size, price, etc."

LE PETIT MUSÉE, P.O. Box 556, Housatonic MA 01236. (413)274-1200. Owner: Sherry Steiner. Retail gallery. Estab. 1991. "Specializes in vintage and contemporary small works of art of extraordinary merit." Interested in the work of emerging artists. Exhibited artists include Roy Interstate and Felicia Zumakoo. Average display time 1-3 months. Open all year; weekends 12-5; weekdays by appointment or chance, opens at noon or by appointment. Located in village of Housatonic "Soho of the Berkshires"; 144 sq. ft.; storefront in an arts community. Clientele: tourists, upscale local. 70% private, 30% corporate collectors. Overall price range: $100-10,000; most work sold at $100-10,000.
Media: Considers all media except craft. Considers wood engravings, engravings, mezzotints, lithographs and serigraphs. Most frequently exhibits paintings, drawings, photographs, mixed media.
Style: Exhibits all styles. Prefers postmodern works, realism and imagism.
Terms: Artwork is accepted on consignment (50% commission). Retail price set by the gallery. Gallery provides promotion. Artist pays for shipping costs. Framed art only.
Submissions: Send slides, photographs, reviews, bio and SASE. Call for appointment. Replies in 1 week. Finds artists through word of mouth, referrals and submissions.
Tips: Advises artists to "submit adequate information on work and clean photos or slides."

LICHTENSTEIN CENTER FOR THE ARTS/BERKSHIRE ARTISANS GALLERY, 28 Renne Ave., Pittsfield MA 01201. (413)499-9348. Artistic Director: Daniel M. O'Connell. Nonprofit retail and rental gallery, alternative space and art consultancy exhibiting juried shows. Estab. 1976. Represents/exhibits 60 emerging, mid-career and established artists/year. Exhibited artists include Thomas Patti and Rapheal Soyer. Sponsors 8 shows/year. Average display time 6 weeks. Open Tuesday-Friday, 11-5; Saturday, 12-4. Located in downtown Pittsfield, 2,400 sq. ft.; historic brownstone, high oak ceilings, north light, wood floors. 100% of space for special exhibitions of gallery artists. 35% private collectors, 10% corporate collectors. Overall price range: $150-20,000; most work sold at $150-20,000.
Media: Considers all media and all types of prints. Most frequently exhibits painting, drawing/prints, sculpture/glass.
Style: Exhibits all styles. All genres.
Terms: "We exhibit juried works at 20% commission." Retail price set by the artist. Gallery provides insurance, promotion and contract. Artist pays for shipping costs.
Submissions: Send query letter with résumé, slides, photographs, reviews, bio and SASE. Does not reply. Artist should send 20 slides with résumé and SASE only. No entry fee.
Tips: "We are usually booked solid for exhibitions 3-5 years ahead of schedule." Advises artists to "develop professional, leather bound portfolio in duplicate with up to 20 slides, résumé, exhibit listings and SASE. Submit to specialized galleries and museums."

‡MERCURY GALLERY, 8 Newbury St., Boston MA 02116. (617)859-0054. Fax: (617)859-5968. Retail gallery. Represents 12 emerging and mid-career artists/year. Exhibited artists include Karl Zerbe and Joseph Solman. Sponsors 4 shows/year. Average display time 1 month. Open all year; Monday-Saturday, 10-6. Located on Back Bay. 50% of space for special exhibitions; 50% of space for gallery artists. Overall price range: $200-80,000.
Media: Considers oil, acrylic, watercolor, pen & ink, drawing, mixed media, collage, paper; no prints.
Style: Exhibits expressionism, painterly abstraction, surrealism, conceptualism, minimalism, postmodern works, impressionism. All genres.
Terms: Accepts work on consignment (50% commission.) Retail price set by the gallery and the artist. Gallery provides promotion. Shipping costs are shared. Prefers artwork framed.

MARKET CONDITIONS are constantly changing! If you're still using this book and it is 1998 or later, buy the newest edition of *Artist's & Graphic Designer's Market* at your favorite bookstore or order directly from Writer's Digest Books.

Submissions: Send query letter with slides, photographs, reviews, bio and SASE. Write for appointment to show portfolio of photographs, transparencies and slides. Replies in 2 weeks. Files bio. Finds artists through referrals by other artists, submissions.

R. MICHELSON GALLERIES, 132 Main St., Northampton MA 01060. (413)586-3964. Also 25 S. Pleasant St., Amherst MA 01002. (413)253-2500. Owner: R. Michelson. Retail gallery. Estab. 1976. Represents 30 emerging, mid-career and established artists/year. Exhibited artists include Barry Moser and Leonard Baskin. Sponsors 6 shows/year. Average display time 1 month. Open all year; Monday-Saturday, 10-6; Sunday, 12-5. Located downtown; Northampton gallery has 1,500 sq. ft.; Amherst gallery has 1,800 sq. ft. 50% of space for special exhibitions. Clientele: 80% private collectors, 20% corporate collectors. Overall price range: $10-75,000; most artwork sold at $1,000-25,000.
Media: Considers all media and all types of prints. Most frequently exhibits oil, egg tempera, watercolor and lithography.
Style: Exhibits impressionism, realism and photorealism. Genres include florals, portraits, wildlife, landscapes, Americana and figurative work.
Terms: Accepts work on consignment (50% commission). Retail price set by gallery and artist. Customer discounts and payment by installment are available. Gallery provides promotion; shipping costs are shared.
Submissions: Prefer local, Pioneer Valley artists. Send query letter with résumé, slides, bio, brochure and SASE. Write for appointment to show portfolio. Replies in 3 weeks. Files slides.

‡NIELSEN GALLERY, 179 Newbury St., Boston MA 02116. (617)266-4835. Fax: (617)266-0480. Owner/Director: Nina Nielsen. Retail gallery. Estab. 1963. Represents 25 emerging, mid-career and established artists/year. Exhibited artists include Joan Snyder and John Walker. Sponsors 8 shows/year. Average display time 3-5 weeks. Open all year; closed in August. Located downtown; 2,500 sq. ft.; brownstone with 2 floors. 100% of space for gallery artists. 80% private collectors, 20% corporate collectors. Overall price range: $1,000-100,000; most work sold at $5,000-20,000.
Media: Considers all media.
Style: Exhibits all styles.
Terms: Retail price set by the gallery and the artist. Gallery provides insurance and promotion.
Submissions: Send query letter with slides. Replies in 2 months. Finds artists through word of mouth, referrals by other artists, visiting art fairs and exhibitions, submissions.

PEPPER GALLERY, 38 Newbury St., Boston MA 02116. (617)236-4497. Fax: (617)236-4497. Director: Audrey Pepper. Retail gallery. Estab. 1993. Represents 20 emerging, mid-career and established artists/year. Exhibited artists include Damon Lehrer, Michael V. David, Edith Vonnegut, Robert Bauer, Nicholas Kahn and Richard Selesnick. Sponsors 9 shows/year. Average display time 6 weeks. Open all year; Tuesday-Saturday, 10-5. Located downtown, Back Bay; 700 sq. ft. 80% of space for special exhibitions. Clientele: private collectors, museums, corporate. 70% private collectors, 15% corporate collectors, 15% museum collectors. Overall price range: $275-15,000; most work sold at $800-4,000.
Media: Considers oil, watercolor, pastel, drawing, mixed media, glass, woodcuts, engravings, lithographs, mezzotints, etchings and photographs. Most frequently exhibits oil on canvas, lithos/etchings and photographs.
Style: Exhibits contemporary representational paintings, prints, drawings and photographs.
Terms: Accepts work on consignment (50% commission). Retail price set by the gallery and the artist. Gallery provides insurance and contract.
Submissions: Send query letter with résumé, slides, bio, SASE and reviews. Call for appointment to show portfolio of originals, photographs, slides and transparencies. Replies in 2 months. Finds artists through exhibitions, word of mouth, open studios and submissions.

‡SIGNATURE AND THE GROHE GALLERY, 24 North St., Dock Square, Boston MA 02109. (617)227-4885. Fax: (617)723-5898. Director: Nancy Cooney. Retail gallery. Estab. 1978. Represents 600 emerging, mid-career and established artists/year. Exhibited artists include Debbie Fecher, Josh Simpson. Sponsors 6 shows/year. Average display time 1 month. Open all year; Monday-Saturday, 10-8; Sunday, 12-6. Located downtown; 1,900 sq. ft. 30% of space for special exhibitions; 30% of space for gallery artists. Clientele: tourists, upscale. 10% private collectors, 10% corporate collectors. Overall price range: $30-9,000; most work sold at $100 minimum.
Media: Considers paper, fiber, sculpture, glass, watercolor, mixed media, ceramics and craft. Most frequently exhibits glass, clay, mixed media.
Style: Exhibits all styles.
Terms: Accepts work on consignment (50% commission). Buys outright for 50% of retail price (net 30 days). Price set by the artist. Gallery provides insurance, promotion, contract; shipping costs are shared. Prefers artwork framed.
Submissions: Send query letter with résumé, slides, artist's statement, bio and SASE. Write for appointment to show portfolio of photographs or slides. Replies in 3 weeks.
Tips: "Include price sheets."

THRONJA ORIGINAL ART, 260 Worthington St., Springfield MA 01103. (413)732-0260. Director/ Owner: Janice S. Throne. Retail gallery and art consultancy. Estab. 1967. Represents 75 emerging, mid-career and established artists. Exhibited artists include Harold Altman, Philip Hicken, Asa Cheffetz, Teri Malo and Robert Sweeney. Sponsors 4-5 shows/year. Open all year; Monday-Friday, 9:30-4:45; Saturday and evenings, by appointment; special holiday hours. Located in downtown Springfield; 1,000 sq. ft.; 2nd floor location overlooking park. 75% of space for special exhibitions; 75% of space for gallery artists. Clientele: corporate, professional, private. 30% private collectors, 70% corporate collectors. Overall price range: $100-15,000; most work sold at $150-1,500.
Media: Considers oil, acrylic, pastel, pen & ink, drawing, mixed media, collage, paper, sculpture, ceramics. fiber, glass, photography and all types of prints. Most frequently exhibits oils, watercolors and prints.
Style: Exhibits expressionism, painterly abstraction, conceptualism, impressionism, photorealism, realism and imagism, all genres. Prefers impressionism, realism and expressionism.
Terms: Accepts work on consignment (50% commission) or buys outright for 50% of retail price (net 30 days).
Retail price set by the gallery and the artist. Gallery provides promotion and contract, "sometimes." Artist pays shipping to and from gallery.
Submissions: Send query letter with résumé, slides, bio, photographs, SASE and reviews. Call or write for appointment to show portfolio of photographs, slides and transparencies. Replies in 1 month. "Follow up with a postcard if you don't hear from us." Finds artists through visiting exhibitions at colleges, museums; submissions (a great number); recommendations from museum professionals and art traders; reading art publications.
Tips: "Send in your best works; slides, b&w glossies for publicity purposes, a complete bio and a separate list of titles and retail prices. Prices should be reasonable! Market is difficult and new artists with us should price to *sell*."

‡ **J. TODD GALLERIES**, 572 Washington St., Wellesley MA 02181. (617)237-3434. Owner: Jay Todd. Retail gallery. Estab. 1980. Represents 55 emerging, mid-career and established artists. Sponsors 10 shows/ year. Average display time 1 month. Open all year; Tuesday-Saturday, 9:30-5:30; Sunday, 1:00-5:00. Located "in Boston's wealthiest suburb"; 4,000 sq. ft.; vast inventory, professionally displayed. 90% of space for special exhibitions; 90% of space for gallery artists. Clientele: residential and corporate. 70% private collectors, 30% corporate collectors. Overall price range: $100-25,000; most work sold at $500-5,000.
Media: Considers oil, acrylic, watercolor, pen & ink, drawing, mixed media, woodcuts, engravings, lithographs, wood engravings, mezzotints, serigraphs, linocuts and etchings. Most frequently exhibits oils, woodcuts and etchings
Style: Exhibits primitivism, postmodern works, impressionism and realism. Genres include landscapes, florals, figurative work and still life. Prefers landscapes, figures and still life.
Terms: Accepts work on consignment (negotiable commission). Retail price set by the artist. Gallery provides promotion. Prefers artwork unframed.
Submissions: No abstract work. Send query letter with résumé, slides, bio, photographs and price list. Call or write for appointment to show portfolio of photographs or slides. Replies in 6 weeks. Enclose SASE for return of slides/photos. Files "all that is interesting to us." Finds artists through agents, visiting exhibitions, word of mouth, art publications and sourcebooks and submissions.
Tips: "Give us a minimum of six works that are new and considered to be your BEST."

WENNIGER GALLERY, 19 Mount Pleasant St., Rockport MA 01966. (508)546-8116. Directors/Owners: Mary Ann and Mace Wenniger. Retail gallery and art consultancy. Estab. 1971. Represents 250 emerging, mid-career and established artists. Exhibited artists include Yuji Hiratsuka and Helen Frank. Sponsors 10 shows/year. Average display time 3 weeks. Open all year; Monday-Saturday, 11-5. Located on waterfront; 1,000 sq. ft.; downtown, attractive, cheery building. 50% of space for special exhibitions, 50% of space for gallery artists. Clientele: young professionals, young families. 25% private collectors, 25% corporate collectors. Overall price range: $50-1,000.
Media: Considers watercolor, woodcuts, engravings, lithographs, wood engravings, mezzotints, serigraphs, etchings, collagraphs, monoprints. Most frequently exhibits collagraphs, mezzotints and wood engravings.
Style: Exhibits expressionism, color field and realism. Genres include figurative work.
Terms: Accepts work on consignment (50% commission). Retail prices set by the artist. Gallery provides insurance and shipping costs from gallery; artist pays shipping costs to gallery. Prefers artwork unframed, matted and shrinkwrapped.
Submissions: Send query letter with résumé, 6 slides or 6 color photographs. Write for appointment to show portfolio. Replies only if interested within 2 months. Finds artists through visiting exhibitions and through gallery contacts.

Michigan

THE ART CENTER, 125 Macomb Place, Mount Clemens MI 48043. (810)469-8666. Fax: (810)469-4529. Executive Director: Jo-Anne Wilkie. Nonprofit gallery. Estab. 1969. Represents emerging, mid-career and established artists. 500 members. Sponsors 10 shows/year. Average display time 1 month. Open all year except July and August; Tuesday-Friday, 11-5; Saturday, 9-2. Located in downtown Mount Clemens; 1,300 sq. ft. The Art Center is housed in the historic Carnegie Library Building, listed in the State of Michigan Historical Register. 100% of space for special exhibitions. Clientele: private and corporate collectors. Overall price range: $5-1,000; most work sold at $50-500.
Media: Considers oil, acrylic, watercolor, pastel, pen & ink, drawing, mixed media, collage, paper, sculpture, ceramics, photography, jewelry, metals, craft, fiber, glass, all types of printmaking. Most frequently exhibits oils/acrylics, watercolor, ceramics and mixed media.
Style: Exhibits all styles, all genres.
Terms: The Art Center receives a 30% commission on sales of original works; 50% commission on prints.
Submissions: Send query letter with reviews good, professional slides and a professional artist biography. Send photographs or slides and résumé with SASE for return. Finds artists through submissions, queries, exhibit announcements, word of mouth and membership.
Tips: "Join The Art Center as a member, call for placement on our mailing list, enter the Michigan Annual Exhibition."

‡ART CENTER OF BATTLE CREEK, 265 E. Emmett St., Battle Creek MI 49017. (616)962-9511. Director: A.W. Concannon. Estab. 1948. Represents 150 emerging, mid-career and established artists. 90% private collectors, 10% corporate clients. Represents 150 artists. Exhibition program offered in galleries, usually 3-4 solo shows each year, two artists' competitions, and a number of theme shows. Also offers Michigan Artworks Shop featuring work for sale or rent. Average display time 1 month. "Four galleries, converted from church—handsome high-vaulted ceiling, arches lead into galleries on either side. Welcoming, open atmosphere." Overall price range: $5-1,000; most work sold at $5-300.
Media: Considers oil, acrylic, watercolor, pastel, pen & ink, drawings, mixed media, collage, works on paper, sculpture, ceramic, craft, fiber, glass, photography and original handpulled prints.
Style: Exhibits painterly abstraction, minimalism, impressionism, photorealism, expressionism, neo-expressionism and realism. Genres include landscapes, florals, Americana, portraits and figurative work. Prefers Michigan artists.
Terms: Accepts work on consignment (33⅓% commission). Retail price set by artist. Exclusive area representation not required. Gallery provides insurance, promotion and contract; artist pays for shipping.
Submissions: Michigan artists receive preference. Send query letter, résumé, brochure, slides and SASE. Slides returned; all other material is filed.
Tips: "Contact Art Center before mailing materials. We are working on several theme shows with groupings of artists."

‡ART TREE GIFT SHOP/GALLERY II, 461 E. Mitchell, Petoskey MI 49770. (616)347-4337. Manager: Mary Wiklanski. Retail shop and gallery of a nonprofit arts council. Estab. 1982. Represents emerging, mid-career and established artists. Prefers Michigan artists. Clientele: heavy summer tourism. 99% private collectors, 1% corporate clients. Overall price range: $6-2,000; most work sold at $20-1,000.
 ● Gallery II is an exhibit gallery. Monthly thematic exhibits will feature work from the area. Some work exhibited will be for sale.
Media: Considers collage, works on paper, sculpture, ceramic, wood, fiber, glass, original handpulled prints, posters, watercolor, oil, acrylics and mixed media.
Style: Seeks "moderately sized work that expresses creativity and fine art qualities."
Terms: "A handler's fee is charged on all gallery sales." Retail price is set by gallery and artist. All work is accepted by jury. Gallery provides insurance and promotion; artist pays for shipping.
Submissions: Call or write for information.
Tips: "Our audience tends to be conservative, but we enjoy stretching that tendency from time to time. A common mistake artists make in presenting their work is not having it ready for presentation." Great need for new work to attract the potential purchaser. "We work from an artist list which is constantly being updated by request, participation or reference."

ARTS EXTENDED GALLERY, INC., 1553 Woodward, 212, Detroit Michigan 48226. Director: Dr. C.C. Taylor. Retail, nonprofit gallery, educational 501C3 space and art consultancy. Estab. 1959. Represents/exhibits many emerging, mid-career and established artists. Exhibited artists include Michael Kelly Williams and Samuel Hodge. Sponsors 10 shows/year. Average display time 4-6 weeks. Open all year; Wednesday-Saturday, 12-5. Located downtown; 1,000 sq. ft.; three small comfortable spaces inside the historic David Whitney Bldg. 75% of space for special exhibitions. Clientele: tourists, upscale, local community. 80% private collectors, 20% corporate collectors. Overall price range: $150-1,200 up; most work sold at $200-300 (for paintings—craft items are considerably less).

Media: Considers all media, woodcuts, engravings, linocuts, etchings and monoprints. Most frequently exhibits painting, fibers and photographs.
Style: "The work which comes out of the community we serve is varied but rooted in realism, ethnic symbols and traditional designs/patterns with some exceptions."
Terms: Artwork is accepted on consignment and there is a 33⅓% commission or artwork is bought outright for 50% of the retail price. Retail price set by the gallery and the artist. Gallery provides insurance, promotion and contract; shipping costs are shared. Prefers artwork framed or ready to install.
Submissions: Send query letter with résumé, slides, photographs and reviews. Call for appointment to show a portfolio of photographs, slides and bio. Replies in 2-3 weeks. Files biographical materials sent with announcements, catalogs, résumés, visual materials to add to knowledge of local artists, letters, etc.
Tips: "Our work of recruiting local artists is known and consequently artists beginning to exhibit or seeking to expand are sent to us. Many are sent by relatives and friends who believe that ours would be a logical place to inquire. Study sound technique—there is no easy way or scheme to be successful. Work up to a standard of good craftsmanship and honest vision. Come prepared to show a group of artifacts. Have clearly in mind a willingness to part with work and understand that market moves fairly slowly."

‡**BELIAN ART CENTER**, 5980 Rochester Rd., Troy MI 48098. (313)828-7001. Directors: Garabe or Zabel Belian. Retail gallery and art consultancy. Estab. 1985. Represents 20 emerging, mid-career and established artists/year. Exhibited artists include Reuben Nakian and Edward Avesdisian. Sponsors 8-10 shows/year. Average display time 1 month. Open all year; Monday-Saturday, 12-6. Located in a suburb of Detroit; 2,000 sq. ft.; has outdoor area for pool side receptions; different levels of exhibits. 50% of space for special exhibitions; 50% of space for gallery artists. Clientele: 50-60% local, 30% Metropolitan area 10-20% national. 70-80% private collectors, 10-20% corporate collectors. Overall price range: $1,000-20,000.
Media: Considers oil, acrylic, watercolor, pastel, pen & ink, drawing, mixed media, collage, paper, sculpture, ceramics, installation, photography, woodcuts, engravings, lithographs, wood engravings, mezzotints and serigraphs. Most frequently exhibits oils, sculptures (bronze) and engraving.
Style: Exhibits expressionism, neo-expressionism, primitivism, painterly abstraction, surrealism, conceptualism, minimalism, color field, postmodern works, impressionism, photorealism, hard-edge geometric abstraction, realism and imagism. Includes all genres. Prefers abstraction, realism, mixed.
Terms: Accepts work on consignment (commission varies) or buys outright for varying retail price. Retail price set by the gallery and the artist. Gallery provides insurance and promotion; shipping costs are shared. prefers artwork framed.
Submissions: Send query letter with résumé, slides, bio, brochure, photographs and reviews. Call or write for appointment to show portfolio of photographs, slides and transparencies. Replies only if interested within 2-3 weeks. Finds artists through catalogs, sourcebooks, exhibitions and magazines.
Tips: "Produce good art at an affordable price."

DETROIT ARTISTS MARKET, 300 River Place, Suite 1650, Detroit MI 48207. (313)393-1770. Executive Director: MariaLuisa Belmonte. Nonprofit gallery. Estab. 1932. Exhibits the work of 600 emerging, mid-career and established artists/year; 1,100 members. Sponsors 12-14 shows/year. Average display time 1 month. Open Tuesday-Saturday, 11-5; Friday until 8. Closed August. Located in downtown Detroit; 3,500 sq. ft. 95% of space for special exhibitions. Clientele: "extremely diverse client base—varies from individuals to the Detroit Institute of Arts." 95% private collectors; 5% corporate collectors. Overall price range: $200-15,000; most work sold at $100-500.
Media: Considers all media. No posters. Most frequently exhibits painting, sculpture and craft.
Style: All contemporary styles and genres.
Terms: Accepts artwork on consignment (40% commission). Retail price set by the artist. Gallery provides insurance; artist pays for shipping. Prefers artwork framed.
Submissions: Accepts only artists from Michigan. Send query letter with résumé, slides and SASE. "No portfolio reviews." Replies only if interested.
Tips: "The Detroit Artists Market is a nonprofit contemporary art gallery that exhibits the work of Michigan artists and educates the public of southeastern Michigan about contemporary art and artists. It is the oldest continuously operating gallery in Detroit."

‡**FIELD ART STUDIO**, 242½ Woodward Ave., Pleasant Ridge MI 48069. (313)399-1320. Director: Jerome Feig. Retail gallery and art consultancy. Estab. 1950. Represents 6 mid-career and established artists. Average display time 1 month. Overall price range: $25-3,000; most work sold at $100-800.
● Field Art Studio is in a new location with double the space of its former location.
Media: Considers watercolor, pastel, pen & ink, mixed media, collage, paper, fiber and original handpulled prints. Specializes in etchings and lithographs.
Style: Exhibits landscapes, florals and figurative work. Genres include aquatints, watercolor and acrylic paintings.
Terms: Accepts work on consignment (40% commission). Retail price set by gallery and artist. Exclusive area representation not required. Gallery provides insurance, promotion and contract; shipping costs are shared.

Submissions: Send query letter, résumé, slides or photographs. Write for appointment to show portfolio of originals and slides. Bio and résumé are filed.
Tips: "We are looking for creativeness in the artists we consider. Do not want to see commercial art. Approach gallery in a businesslike manner."

‡**GALLERY SHOP: BIRMINGHAM BLOOMFIELD ART ASSOCIATION**, 1516 S. Cranbrook Rd., Birmingham MI 48009. (810)644-0866. Program Chairperson: Elaine Borruso. Nonprofit, rental, gallery shop. Estab. 1962. Represents emerging, mid-career and established artists. Sponsors ongoing exhibition with featured artists monthly. Average display time 1 month. Open all year; Monday-Friday, 9-5; Saturday, 10-5. Suburban location. 50% of space for special exhibitions; 50% of space for gallery artists. Clientele: upscale, local. 100% private collectors. Overall price range: $1,000-15,000.
Media: Considers all media and all types of prints. Most frequently exhibits watercolor, acrylic and jewelry.
Style: Exhibits all styles. Prefers painterly abstraction, florals and still life, portraits.
Terms: Accepts work on consignment (30% commission). Rental fee for space; covers 1 month. Retail price set by the artist. Gallery provides promotion and contract; artist pays for shipping costs to gallery. Prefers artwork framed.
Submissions: "We do not represent individual artists except in gallery shop. We review proposals for group or concept shows twice yearly." Send query letter with résumé, brochure, slides, photographs, reviews, artist's statement, bio, SASE; "as much information as possible." Files résumé, bio, brochure, photos.

‡**THE GALLERY SHOP/ANN ARBOR ART ASSOCIATION ART CENTER**, 117 W. Liberty, Ann Arbor MI 48104. (313)994-8004. E-mail: a2artcen@aol.com. Gallery Shop Director: Elizabeth Nelson. Estab. 1978. Represents over 200 artists, primarily regional. Clientele: private collectors and corporations. Overall price range: $2,000; most 2-dimensional work sold at $400-800; 3-dimensional work from $25-100. "Proceeds help support the Art Association's exhibits and education programs for all ages."
- The Ann Arbor Art Association also has exhibition opportunities for Michigan artists in off-site exhibits; in "Michigan Artists Design for the Home." Showcase, which features fine art and craft for the contemporary home; and a 2-month holiday gifts show, which features 25 new artists every November and December.
Media: Considers original work in virtually all two- and three-dimensional media, including jewelry, original handpulled prints and etchings, ceramics, glass and fiber.
Style: "The gallery specializes in well-crafted and accessible artwork. Many different styles are represented, including innovative contemporary."
Terms: Accepts work on consignment (40% commission on members' work; 50% on nonmembers). Retail price set by artist. Offers customer discounts and payment by installments. Exclusive area representation not required. Gallery provides contract; artist pays for shipping.
Submissions: Send query letter, résumé, brochure, slides and SASE. Materials are considered on a rolling basis. Great Lakes area artists may be called in for one-on-one review. "We look for artists through visiting exhibitions, wholesale and retail craft shows, networking with graduate and undergraduate schools, word of mouth, artist referral and submissions."
Tips: "We are particularly interested in contemporary, glass, ceramics, wood and metal at this time."

‡**ROBERT L. KIDD GALLERY**, 107 Townsend St., Birmingham MI 48009. (810)642-3909. Fax: (810)647-1000. Director: Ray Frost Fleming. Retail gallery. Estab. 1976. Represents approximately 125 emerging, mid-career and established artists. Sponsors 8 solo and 3 group shows/year. Average display time is 1 month. Clientele: 50% private collectors, 50% corporate clients. Overall price range: $500-80,000; most artwork sold at $2,000-6,000.
Media: Considers oil, acrylic, watercolor, pastel, mixed media, works on paper, sculpture, ceramic, fiber and glass. Most frequently exhibits acrylic, oil and sculpture.
Style: Exhibits color field, painterly abstraction, photorealism and realism. "We specialize in original contemporary paintings, sculpture, glass and clay by contemporary American artists."
Terms: Accepts work on consignment. Retail price set by gallery and artist. Exclusive area representation required. Gallery provides insurance and promotion; shipping costs are shared.
Submissions: Send query letter, résumé, slides and SASE.
Tips: Looks for "high-quality technical expertise and a unique and personal conceptual concept. Understand the direction we pursue and contact us with appropriate work."

KOUCKY, 319 Bridge St., Charlevoix MI 49720. (616)547-2228. Fax: (616)547-2455. Owners: Chuck and Nancy. Retail gallery.
- This gallery has two locations (Michigan and Naples, Florida). See its listing in the Florida section for information about the galleries' submissions policies as well as media and style needs.

‡**MUSKEGON MUSEUM OF ART**, 296 W. Webster, Muskegon MI 49440. (616)722-2600. Fax: (616)726-5567. Director and curator: Henry Matthews. Museum. Estab. 1912. Represents emerging, mid-career and established artists. Sponsors 22 shows/year. Average display time 6 weeks. Open all year. Located

downtown; 13,000 sq. ft. "Through the process of selection we offer 6-10 one-artist shows a year, as well as opportunity to show in the regional competition."

Media: Considers oil, acrylic, watercolor, pastel, pen & ink, drawings, mixed media, collage, works on paper, sculpture, ceramic, craft, fiber, glass, installation, photography, original handpulled prints, woodcuts, wood engravings, linocuts, engravings, mezzotints, etchings, lithographs, serigraphs and posters.

Style: Exhibits expressionism, neo-expressionism, primitivism, painterly abstraction, surrealism, imagism, conceptualism, minimalism, color field, postmodern works, impressionism, realism, photorealism, pattern painting, hard-edge geometric abstraction; all styles and genres.

Terms: Accepts work on consignment (25% commission) "in our gift shop." Retail price set by the artist. Gallery provides insurance, promotion and contract. Prefers framed artwork.

Submissions: Most one-artist shows have a Michigan base. Send query letter with résumé, slides, bio, SASE and reviews. Write to schedule an appointment to show a portfolio, which should include originals, photographs, slides, transparencies or any combination thereof. Replies in 1 month. Files "those that we feel might have the possibility of a show."

‡**PERCEPTION**, 7 Ionia, S.W., Grand Rapids MI 49503. (616)451-2393. Owner: Kim L. Smith. Retail gallery. Estab. 1989. Represents 20 emerging, mid-career and established artists/year. Exhibited artists include Mathias J. Alten and Jack Smith. Sponsors 4-6 shows/year. Average display time 6-8 weeks. Open all year; Monday-Friday, 10-5:30. Open Saturday, 10-2 from Labor Day to Memorial Day. Located downtown; 2,200 sq. ft.; "open space, unique design." 100% of space for special exhibitions; 100% of space for gallery artists. Clientele: private collectors, dealers. 75% private collectors, 5% corporate collectors. Overall price range: $500-75,000; most work sold at $1,000-4,000.

Media: Considers oil, acrylic, watercolor, pastel, pen & ink, drawing, mixed media, collage, paper, sculpture, ceramics, craft, stone, bronze, woodcuts, engravings, lithographs, wood engravings, mezzotints, serigraphs, linocuts and etchings. Most frequently exhibits oils, etchings and lithographs.

Style: Exhibits all styles; prefers impressionism and realism. Genres include landscapes and figurative work. Prefers American impressionism, contemporary figurative and still life, fine art prints—1900-present.

Terms: Accepts work on consignment (40% commission) or buys outright for 50% of retail price (net 10 days). Retail prices set by the gallery and the artist. Gallery provides insurance, promotion and shipping costs from gallery; artist pays shipping costs to gallery. Prefers artwork unframed.

Submissions: Send query letter with slides and photographs. Call for appointment to show portfolio of originals and slides. Replies in 1 month. Files bios and résumés. Finds artists through visiting exhibitions, word of mouth, submissions.

Tips: "We are interested in seeing at least 30 to 40 examples and/or pieces that represent work done within a three to four year period."

‡**PEWABIC POTTERY**, 10125 E. Jefferson, Detroit MI 48214. (313)822-0954. Fax: (313)822-6266. Director of Exhibitions: Helen Broughton. Nonprofit gallery, ceramics only. Estab. 1981. Represents 80 emerging, mid-career and established artists/year. Sponsors 10 shows/year. Average display time 7 weeks. Open all year; Monday-Saturday, 10-6; 7 days during holiday. Located 3 miles east of downtown Detroit; historic building (1906). 50% of space for special exhibitions; 50% of space for gallery artists. Clientele: tourists, ceramic collectors. 98% private collectors, 2% corporate collectors. Overall price range: $15-1,500; most work sold at $50-100.

Media: Considers ceramics, mixed media, ceramic jewelry.

Style: Exhibits utilitarian and sculptural clay.

Terms: Accepts work on consignment (50% commission). Retail price set by the artist. Gallery provides insurance and promotion; shipping costs are shared. Prefers artwork framed.

Submissions: Prefers only ceramics. Send query letter with résumé, slides, artist's statement and SASE. Write for appointment to show portfolio of slides. Replies in 1-3 months. Finds artists through word of mouth, referrals by other artists, visiting art fairs and exhibitions, submissions.

Tips: "Avoid sending poor-quality slides."

REFLECTIONS OF COLOR GALLERY, 18951 Livernois Ave., Detroit MI 48221. (313)342-7595. Owners: Carl and Marla Wellborn. Retail gallery. Estab. 1988. Represents 30 emerging, mid-career and established artists. Exhibited artists include Kathleen Wilson and Carl Owens. Average display time 6 weeks. Open all year; Monday-Friday, 10-6; Saturday, 11-5. 30% of space for special exhibitions; 100% of space for gallery artists. Clientele: middle to upper income (professional). 90% private collectors, 10% corporate collectors. Overall price range: $100-3,000; most work sold at $250-400.

Media: Considers oil, acrylic, watercolor, pastel, pen & ink, drawing, mixed media, collage, paper, sculpture, ceramic, fiber, glass, photography, woodcuts, etchings, lithographs, serigraphs and posters. Most frequently exhibits oil, acrylic, pastel, blown glass, pottery.

Style: Exhibits conceptualism, photorealism, hard-edge geometric abstraction, realism and surrealism. All genres. Prefers realism, conceptualism and photorealism.

Terms: Accepts work on consignment (40-50% commission). Offers payment by installments. Gallery provides promotion, contract; shipping costs are shared. Prefers artwork unframed.

Submissions: "Prefers minority artists—African-American, Hispanic, African, Native American, East Indian, etc." Send query letter with slides, brochure and photographs. Call or write for appointment to show portfolio of originals, photographs and slides. Replies only if interested within 1 month. Files photos and brochures.

SAPER GALLERIES, 433 Albert Ave., East Lansing MI 48823. (517)351-0815. Fax: (517)351-0815. E-mail: rsaper812@aol.com. Website: http://home.aol.com/RSaper812. Director: Roy C. Saper. Retail gallery. Estab. in 1978 as 20th Century Fine Arts; in 1986 designed and built new location and name. Displays the work of 60 artists; mostly mid-career. Exhibited artists include H. Altman and J. Isaac. Sponsors 2-3 shows/year. Average display time 6 weeks. Open all year. Located downtown; 3,700 sq. ft.; "We were awarded *Decor* magazine's Award of Excellence for gallery design." 30% of space for special exhibitions. Clientele: students, professionals, experienced and new collectors. 80% private collectors, 20% corporate collectors. Overall price range: $30-140,000; most work sold at $400-4,000.
Media: Considers oil, acrylic, watercolor, pastel, drawings, mixed media, collage, paper, sculpture, ceramic, craft, glass and original handpulled prints. Considers all types of prints except offset reproductions. Most frequently exhibits intaglio, serigraphy and sculpture. "Must be of highest quality."
Style: Exhibits expressionism, painterly abstraction, surrealism, postmodern works, impressionism, realism, photorealism and hard-edge geometric abstraction. Genres include landscapes, florals, Southwestern and figurative work. Prefers abstract, landscapes and figurative. Seeking artists who will continue to produce excellent work.
Terms: Accepts work on consignment (negotiable commission); or buys outright for negotiated percentage of retail price. Retail price set by gallery and artist. Offers payment by installments. Gallery provides insurance, promotion and contract; shipping costs are shared. Prefers artwork unframed (gallery frames).
Submissions: Send query letter with bio or résumé, brochure and slides or photographs and SASE. Call for appointment to show portfolio of originals or photos of any type. Replies in 1 week. Files any material the artist does not need returned. Finds artists mostly through NY Art Expo.
Tips: "Artists must know the nature of works displayed already. Must be outstanding, professional quality. Student quality doesn't cut it. Must be great. Be sure to include prices and SASE."

‡PERRY SHERWOOD FINE ART, 200 Howard St., Petoskey MI 49770. (616)348-5079. Fax: (616)348-5057. Director: Zalmon Sherwood. Retail gallery. Estab. 1993. Represents 25 emerging, mid-career and established artists/year. Sponsors 4 shows/year. Average display time 6 weeks. Open all year; Monday-Saturday, 10-6; Sunday, 12-4. Located in downtown historic district; 3,000 sq. ft. 25% of space for special exhibitions; 75% of space for gallery artists. Clientele: tourists and upscale. 80% private collectors, 20% corporate collectors. Overall price range: $800-25,000; most work sold at $2,000-5,000.
Media: Considers oil, glass, watercolor, ceramics, pastel and photography. Most frequently exhibits oil painting, sculptural glass and ceramics.
Style: Exhibits realism and impressionism. Genres include florals, landscapes and figurative work.
Terms: Accepts work on consignment (50% commission). Retail price set by the artist. Gallery provides insurance, promotion and contract; artist pays for shipping. Prefers artwork framed.
Submissions: Send query letter with résumé, slides, photographs, reviews, artist's statement and SASE. Call for appointment to show portfolio of photographs and slides. Replies in 3 weeks. Finds artists through word of mouth, referrals by other artists, visiting art fairs and exhibitions, submissions.

‡SWORDS INTO PLOWSHARES, Peace Center, 33 E. Adams, Detroit MI 48226. (313)963-7575. Fax: (313)965-4328. Executive Director: James W. Bristah. Nonprofit gallery. "Our theme is 'World Peace.' " Estab. 1985. Represents 250-300 emerging, mid-career and established artists/year. Sponsors 4-6 shows/year. Average display time 2½ months. Open all year; Tuesday, Thursday, Saturday, 11-3; second Saturday, 12-2. Located in downtown Detroit in the Theater District; 2,881 sq. ft.; 1 large gallery, 2 small galleries. 100% of space for special exhibitions. Clientele: walk-in, church, school and community groups. 100% private collectors. Overall price range: $75-6,000; most work sold at $75-700.
Media: Considers all media. Considers all types of prints. "We have a juried show every 2 years for Ontario and Michigan artists about our theme. The juries make the selection of 2- and 3-dimensional work."
Terms: Accepts work on consignment (25% commission). Retail price set by the artist. Gallery provides insurance and promotion; shipping costs from gallery.
Submissions: Accepts artists primarily from Michigan and Ontario. Send query letter with statement on how other work relates to our theme. Replies in 2 months. Finds artists through lists of Michigan Council of the Arts, Windsor Council of the arts.

URBAN PARK–DETROIT ART CENTER, 508 Monroe, Detroit MI 48226. (313)963-5445. Fax: (313)963-2333. Director: Dave Roberts. Retail cooperative gallery. Estab. 1991. Represents 100 emerging and mid-career artists/year. Exhibited artists include Walter Warren and Diana Gamerman. Sponsors 60 shows/year. Average display time 1 month. Open all year; Monday-Thursday, 10-9; Friday-Saturday, 10-11; Sunday 12-7. Located downtown inside Trappers Alley, Greektown; 3,316 sq. ft.; 10 individual exhibit spaces in historic building. 90% of space for special exhibitions; 10% of space for gallery artists. Clientele: mostly

beginning collectors, tourists. 90% private collectors, 10% corporate collectors. Overall price range: $50-2,000; most work sold at $50-600.
Media: Considers all media. Most frequently exhibits paintings, sculpture and photography.
Style: Exhibits all styles.
Terms: Co-op membership fee plus donation of time (40% commission). Rental fee for space; covers 1 month. Retail price set by the artist. Gallery provides promotion; shipping costs are shared. Prefers artwork framed.
Submissions: Send query letter with résumé, slides, bio and SASE. Call for appointment to show portfolio of originals, slides and transparencies. Replies in 3 weeks. Files résumé, bio. Finds artists through submissions.
Tips: "Request gallery brochure for specific information."

‡**THE WETSMAN COLLECTION**, 132 N. Woodward Ave., Birmingham MI 48009. (810)645-6212. Fax: (810)642-5101. Retail gallery. Estab. 1988. Represents 30 emerging, mid-career and established artists/year. Sponsors 5 shows/year. Average display time 1½ months. Open all year; Tuesday-Saturday, 11-5. Located downtown. 66% of space for special exhibitions; 33% of space for gallery artists. Clientele: local collectors. 75% private collectors, 5% corporate collectors. Overall price range: $500-10,000; most work sold at $2,000 minimum.
Media: Considers paper, fiber, ceramics, craft, wood and metal. Considers all types of prints. Most frequently exhibits fiber, ceramic and wood.
Terms: Accepts work on consignment (50% commission). Retail price set by the artist. Gallery provides insurance, promotion and contract; shipping costs are shared.
Submissions: Accepts only decorative arts. Send query letter with résumé and slides. Call for appointment to show portfolio of photographs and slides. Replies in 2-4 weeks. Finds artists through word of mouth, referrals by other artists, visiting art fairs and exhibitions, submissions.

Minnesota

‡**CIRCA GALLERY**, 1637 Hennepin Ave., Minneapolis MN 55403. (612)332-2386. Director: Wanda S. Flechsig. Retail gallery. Estab. 1990. Represents 26 emerging and mid-career artists/year. Sponsors 9 shows/year. Average display time 5 weeks. Open all year; Tuesday-Friday, 10-4; Saturday, 11-4. Located downtown; historic building; tile floors/wrought iron. 75% of space for special exhibitions; 25% of space for gallery artists. Overall price range: $1,500-10,000.
Media: Considers oil, acrylic, watercolor, pastel, drawing, mixed media, collage, paper, sculpture, ceramics, woodcuts, engravings, lithographs, wood engravings, mezzotints, serigraphs, linocuts and etchings. Most frequently exhibits painting, printmaking and mixed media.
Style: Exhibits expressionism, neo-expressionism, painterly abstraction, conceptualism, color field, postmodern works, impressionism. Prefers contemporary abstract, figurative and conceptual.
Terms: Artwork is accepted on consignment. Retail price set by the gallery and the artist. Gallery provides insurance, promotion and contract; shipping costs are shared.
Submissions: Send query letter with résumé, slides, artist's statement, bio and SASE. Write for appointment to show portfolio of slides. Replies in 2 months. Finds artists through word of mouth, submissions, referrals, exhibitions.

‡**FLANDERS CONTEMPORARY ART**, 400 N. 1st Ave., Minneapolis MN 55401. (612)344-1700. Fax: (612)344-1643. Director: Douglas Flanders. Retail gallery. Estab. 1972. Represents emerging, mid-career and established artists. Exhibited artists include Jim Dine and David Hockney. Sponsors 8 shows/year. Average display time 6 weeks. Open all year; Tuesday-Saturday 10-5. Located in downtown warehouse district: 2,600 sq. ft.: 17′ ceilings. Clientele: private, public institutions, corporations, museums. Price range starts as low as $85. Most work sold at $9,500-55,000.
Media: Considers all media and original handpulled prints. Most frequently exhibits sculpture, paintings and various prints; some photography.
Style: Exhibits all styles and genres. Prefers abstract expressionism, impressionism and post-impressionism.
Terms: Accepts work on consignment (50% commission). Gallery provides insurance, promotion and contract; shipping costs are shared. Prefers artwork framed.
Submissions: Send query letter with résumé, slides, bio and SASE. Write for appointment to show portfolio of slides. Replies in 1 week.

JEAN STEPHEN GALLERIES, 924 Nicollet Mall, Minneapolis MN 55402. (612)338-4333. Directors: Steve or Jean Danke. Retail gallery. Estab. 1987. Represents 12 established artists. Interested in seeing the work of emerging artists. Exhibited artists include Jiang, Hart and Max. Sponsors 2 shows/year. Average display time 4 months. Open all year; Monday-Saturday, 10-6. Located downtown; 2,300 sq. ft. 15% of space for special exhibitions; 85% of space for gallery artists. Clientele: upper income. 90% private collectors, 10% corporate collectors. Overall price range: $600-12,000; most work sold at $1,200-2,000.

© Bruce Nygren

When you look at Bruce Nygren's *Elephants and Blocks*, "the first thing you say is that it is beautiful! Then you laugh," says Douglas Flanders of Flanders Contemporary Art. "The message is serious but done so in a very playful way. Letters are the building blocks of words; and words, books; and books, the world." According to Flanders, his patrons love this piece, painted in oils. "It could have been reproduced a hundred times." Flanders Contemporary Art exclusively represents Nygren's work.

Media: Considers oil, acrylic, pastel, pen & ink, drawing, mixed media, collage, paper, sculpture, ceramics, woodcuts, engravings, lithographs, wood engravings, mezzotints, serigraphs, linocuts and etchings. Most frequently exhibits serigraphs, stone lithographs and sculpture.
Style: Exhibits expressionism, neo-expressionism, surrealism, minimalism, color field, postmodern works and impressionism. Genres include landscapes, Southwestern, portraits and figurative work. Prefers Chinese contemporary, abstract and impressionism.
Terms: Accepts work on consignment (50% commission). Retail price set by the gallery. Gallery provides insurance and contract; artist pays shipping costs to and from gallery.
Submissions: Send query letter with résumé, slides and bio. Call for appointment to show portfolio of originals, photographs and slides. Replies in 1-2 months. Finds artists through art shows and visits.

‡**UMEROV GALLERY**, 100 N. 16th St., #214, Minneapolis MN 55403. (612)339-1652. Fax: (612)339-5964. Director: Elena Borochin. Retail gallery. Estab. 1991. Represents emerging, mid-career and established artists. Exhibited artists include Mikhail Chemiakin, Eugene Yelchin and others. Sponsors 8 shows/year. Average display time 6 weeks. Open all year; Tuesday-Friday, 10:30-5:30; Saturday, 11:30-4. Located downtown; features Russian and Eastern-European art, icons. 50% of space for special exhibitions; 50% of space for gallery artists. Clientele: tourist, local community. 90% private collectors, 10% corporate collectors. Overall price range: $400-15,000; most work sold at $1,000-3,000.
Media: Considers oil, acrylic, watercolor, pastel, drawing, mixed media, collage, paper, sculpture, ceramics, craft, glass and lithographs. Most frequently exhibits oil, water color and acrylic.
Style: Exhibits expressionism, neo-expressionism and primitivism. Exhibits all genres, Russian and Eastern European. Prefers landscapes, figurative work and florals.
Terms: Artwork is accepted on consignment and there is a 40% commision. Retail price set by the gallery and the artist. Gallery provides insurance, promotion and contract; shipping costs are shared. Prefers artwork framed.
Submissions: Send query letter with slides. Call for appointment to show portfolio of photographs and slides. Replies in 3 weeks. Finds artists through word of mouth, referrals by other artists, visiting art fairs and exhibitions, submissions.

THE FREDERICK R. WEISMAN ART MUSEUM, 333 East River Rd., Minneapolis MN 55455. (612)625-9494. Fax: (612)625-9630. E-mail: bitza001@maroon.tc.umn.edu. Website: http://hudson.acad.um n.edu/. Public Relations Director: Robert B. Bitzan. Museum. Frederick R. Weisman Art Museum opened in November 1993; University of Minnesota Art Museum established in 1934. Represents 13,000 works in permanent collection. Represents established artists. 1,000 members. Sponsors 6-7 shows/year. Average display time 10 weeks. Open all year; Tuesday, Wednesday, Friday, 10-5; Thursday, 10-8; Saturday-Sunday, 11-5. Located at the University of Minnesota, Minneapolis; 11,000 sq. ft.; designed by Frank O. Gehry. 40% of space for special exhibitions.
Media: Considers all media and all types of prints. Most frequently exhibits oil, acrylic and watercolor.
Style: Exhibits all styles, all genres.
Terms: Gallery provides insurance. Prefers artwork framed.
Submissions: "Generally we do not exhibit one-person shows. We prefer thematic exhibitions with a variety of artists. However, we welcome exhibition proposals. Formulate exhibition proposal with a scholarly base. Exhibitions which are multi-disciplinary are preferred."

Mississippi

‡**BRYANT GALLERIES**, 2845 Lakeland Dr., Jackson MS 39208. (601)932-1993. Fax: (601)932-8031. Vice-President: David Lambert. Retail gallery. Estab. 1965. Represents 20 emerging, mid-career and established artists/year. Exhibited artists include Leonardo Nierman, Ed Dwight. Sponsors 12 shows/year. Average display time 1 month. Open all year; Monday-Friday, 10-5:30; Sataurday, 10-5. 3,500 sq. ft. 20% of space for special exhibitions; 80% of space for gallery artists. Clientele: tourist, upscale, local community, stuents. 95% private collectors, 5% corporate collectors. Overall price range: $200-30,000; most work sold at $3,000-7,000.
Media: Considers oil, acrylic, watercolor, pastel, mixed media, collage, paper, sculpture, ceramics, glass. Considers all types of prints except posters. Most frequently exhibits oil, watercolor and acrylic.
Style: Exhibits expressionism. Genres include landscapes. Prefers impressionism, realism, expressionism.
Terms: Artwork is accepted on consignment and there is a 50% commission. Retail price set by the artist. Gallery provides insurance and promotion; artist pays shipping costs. Prefers artwork framed.
Submissions: Send query letter with résumé, brochure, slides, bio and SASE. Call for appointment to show portfolio. Replies in 3 weeks. Files brochures, sometimes slides. Finds artists through word of mouth, traveling to other cities, submissions, referrals by other artists.

‡**HILLYER HOUSE INC.**, 207 E. Scenic Dr., Pass Christian MS 39571. (601)452-4810. Owners: Katherine and Paige Reed. Retail gallery. Estab. 1970. Represents emerging, mid-career and established artists: 19 artists, 34 potters, 46 jewelers, 10 glass-blowers. Interested in seeing the work of emerging artists. Exhibited artists include Barbara Quigley and Patt Odom. Sponsors 24 shows/year. Average display time 2 months. Open Monday-Saturday 10-5, Sunday 12-5. Open all year. Located beachfront-middle of CBD historic district; 1,700 sq. ft. 50% of space for special exhibitions; 50% of space for gallery artists. Clientele: 80% of clientele are visitors to the Mississippi Gulf Coast, 20% private collectors. Overall price range: $25-700; most work sold at $30-150; paintings $250-700.
 • Hillyer House has special exhibitions in all areas.
Media: Considers oil, watercolor, pastel, mixed media, sculpture (metal fountains), ceramic, craft and jewelry. Most frequently exhibits watercolor, pottery and jewelry.
Style: Exhibits expressionism, imagism, realism and contemporary. Genres include aquatic/nautical. Prefers realism, impressionism and expressionism.
Terms: Accepts work on consignment (35% commission); or artwork is bought outright for 50% of the retail price (net 30 days). Retail price set by gallery or artist. Gallery provides promotion and contract; artist pays for shipping. Prefers artwork framed.
Submissions: Send query letter with résumé, slides, bio, brochure, photographs, SASE and reviews. Call or write for appointment to show portfolio of originals and photographs. Replies only if interested within 3 weeks. Files photograph and bio. (Displays photo and bio with each person's art.)
Tips: "Work must be done in last nine months.Watercolors sell best. Make an appointment. Looking for artists with a professional attitude and approach to work. Be sure the work submitted is in keeping with the nature of our gallery."

Missouri

‡**THE ASHBY-HODGE GALLERY OF AMERICAN ART**, Central Methodist College, Fayette MO 65248. (816)248-3391, ext. 563. Curator: Thomas L. Yancey. Nonprofit gallery, "Not primarily a sales gallery—only with special exhibits." Estab. 1993. Exhibits the work of 27 artists in permanent collection.

Exhibited artists include Robert MacDonald Graham, Jr. and Birger Sandzén. Sponsors 4 shows/year. Average display time 7 weeks. Open Tuesday-Thursday, 1:30-4:30; Sunday, 2:30-5. Located on campus of central Methodist college. 1,400 sq. ft.; on lower level of campus library. 100% of gallery artists for special exhibitions. Clientele: local community and surrounding areas of mid-America. Overall price range: $900-40,000.
Media: Considers all media. Considers lithographs. Most frequently exhibits acrylic, lithographs and oil.
Style: Exhibits Midwestern regionalists. Genres include portraits and landscapes. Prefers realism.
Terms: Accepts work on consignment (30% commission.) Retail price set by the gallery. Gallery provides insurance and promotion; shipping costs are shared. Prefers artwork framed.
Submissions: Accepts primarily Midwestern artists. Send query letter with résumé, slides, photographs and bio. Call for appointment to show portfolio of photographs, transparencies and slides. Finds artists through word of mouth and submissions.

AUSTRAL GALLERY—AUSTRALIAN CONTEMPORARY ART, 2115 Park Ave., St. Louis MO 63104. (314)776-0300. Fax: (314)664-1030. E-mail: australart@aol.com. Website: http://www.australian-art.com. Director: Ms. Mary Reid Brunstrom. Retail gallery. The gallery brings to the United States exhibitions of contemporary art from Australia, including Aboriginal painting and other media. Estab. 1988. Represents/exhibits 12 emerging and mid-career Australian fine artists and several Aboriginal artists. Represents the Victorian Tapestry Workshop, Melbourne. Open September-July; by appointment only during August; Wednesday-Saturday, 1-5 and by appointment. Located in Lafayette Square downtown; 2,500 sq. ft.; in a 3-story historic house built in 1860s. 10% of space for gallery artists. Clientele: local community and out of state. 60% private collectors, 40% corporate collectors. Overall price range: $100-25,000; most work sold at $500-5,000.
Media: Considers all media and all types of prints. Most frequently exhibits acrylic and oil painting, limited edition prints and mixed media.
Style: Exhibits expressionism, conceptualism, minimalism, pattern painting, primitivism, hard-edge geometric abstraction and painterly abstraction. All genres. Prefers figurative and abstract.
Terms: Artwork is accepted on consignment (50% commission). Retail price set by the gallery. Gallery provides insurance, promotion and contract. Shipping costs are shared.
Submissions: Accepts only artists from Australia. Send query letter with résumé, business card, slides, photographs, reviews and bio. Call for appointment to show portfolio of photographs. Replies only if interested within 2 months. Files all material if it is an artist of interest.

‡BOODY FINE ARTS, INC., 10734 Trenton Ave., St. Louis MO 63132. (314)423-2255. Retail gallery and art consultancy. "Gallery territory includes 15 Midwest/South Central states. Staff travels on a continual basis, to develop collections within the region." Estab. 1978. Represents 100 mid-career and established artists. Clientele: 30% private collectors, 70% corporate clients. Overall price range: $500-200,000.
Media: Considers oil, acrylic, watercolor, pastel, drawings, mixed media, collage, sculpture, ceramic, fiber, metalworking, glass, works on handmade paper, neon and original handpulled prints.
Style: Exhibits color field, painterly abstraction, minimalism, impressionism and photorealism. Prefers nonobjective, figurative work and landscapes.
Terms: Accepts work on consignment or buys outright. Retail price is set by gallery and artist. Customer discounts and payment by installments available. Exclusive area representation required. Gallery provides insurance, promotion and contract; shipping costs are shared.
Submissions: Send query letter, résumé and slides. Write to schedule an appointment to show a portfolio, which should include originals, slides and transparencies. All material is filed.
Tips: Finds artists by visiting exhibitions, word of mouth, artists' submissions and art collectors' referrals. "Organize your slides."

‡BYRON COHEN LENNIE BERKOWITZ, 2000 Baltimore, Kansas City MO 64108. (816)421-5665. Fax: (816)421-5775. Owner: Byron Cohen. Retail gallery. Estab. 1994. Represents emerging and established artists. Exhibited artists include Squeak Carnwath. Sponsors 6-7 shows/year. Average display time 7 weeks. Open all year; Thursday-Saturday, 11-5. Located downtown; 1,500 sq. ft.; 100% of space for gallery artists. 90% private collectors, 10% corporate collectors. Overall price range: $300-42,000; most work sold at $2,000-7,000.
Media: Considers all media. Most frequently exhibits painting, works on paper and sculpture.
Style: Exhibits all styles. Prefers contemporary painting and sculpture, contemporary prints, contemporary ceramics.
Terms: Accepts work on consignment (50% commission.) Retail price set by the gallery and the artist. Gallery provides insurance, promotion and contract; shipping costs are shared. Prefers artwork framed.
Submissions: Send query letter with résumé, slides, artist's statement and bio. Write for appointment to show portfolio of photographs, transparencies and slides. Call. Files slides, bio and artist's statement. Finds artists through word of mouth, referrals by other artists, visiting art fairs and exhibitions.

FINE ARTS RESOURCES, 11469 Olive St., #266, St. Louis MO 63141. Phone/fax: (314)432-5824. President: R. Michael Bush. Art consultancy, broker. Estab. 1986. Represents over 50 emerging, mid-career

and established artists. Interested in seeing the work of emerging artists. Open all year; by appointment only. Located in suburb. Clientele: commercial/residential. 25% private collectors, 75% corporate collectors. Overall price range: $150-10,000; most work sold at $1,000-3,000.

Media: Considers oil, pen & ink, paper, acrylic, drawing, sculpture, glass, watercolor, pastel and all types of prints. Most frequently exhibits oil, acrylic and sculpture.

Terms: Artwork is accepted on consignment (40% commission). Retail price set by the gallery and the artist. Shipping costs are shared. Prefers artwork framed.

Submissions: Send query letter with résumé, slides and bio. Write for appointment to show portfolio of slides. Replies only if interested within 2 weeks.

FORUM FOR CONTEMPORARY ART, 3540 Washington Ave., St. Louis MO 63103. (314)535-4660. Fax: (314)535-1226. E-mail: forum@inlink.com. Executive Director/Curator: Elizabeth Wright Millard. Non-profit gallery, museum. Estab. 1980. Represents/exhibits emerging, mid-career and established artists. Interested in seeing the work of emerging artists. Sponsors 5-8 shows/year. Average display time 2 months. Open all year; Tuesday-Saturday 10-5. Located mid-town, Grand Center; 4,000 sq. ft.; urban, spare space. 95% of space for special exhibitions. Clientele: local community, students.

Media: Considers all media. Most frequently exhibits installation, multi-media, performance, time arts and photography.

Style: Exhibits all styles. Genres include cutting edge, contemporary.

Terms: Gallery provides insurance, promotion and shipping costs.

Submissions: Only interested in contemporary work. Send query letter with résumé, slides and SASE. Write for appointment to show portfolio of slides. Replies in 6 months. Finds artists through referrals from other artists and galleries or museums.

Tips: "Do not submit unless your work fits the 'alternative' contemporary criteria of the museum."

GALERIE BONHEUR, 9243 Clayton Rd., St. Louis MO 63124. (314)993-9851. Fax: (314)993-4790. E-mail: varley1@ix.netcom.com. Owner: Laurie Carmody. Private retail and wholesale gallery. Focus is on international folk art. Estab. 1980. Represents 60 emerging, mid-career and established artists/year. Exhibited artists include Woodie Long and Justin McCarthy. Sponsors 6 shows/year. Average display time 1 year. Open all year; by appointment. Located in Ladue (a suburb of St. Louis); 1,500 sq. ft.; art is all displayed all over very large private home. 75% of sales to private collectors. Overall price range: $25-25,000; most work sold at $50-1,000.

Media: Considers oil, acrylic, watercolor, pastel, pen & ink, drawing, mixed media, collage, paper, sculpture, ceramics and craft. Most frequently exhibits oil, acrylic and metal sculpture.

Style: Exhibits expressionism, primitivism, impressionism, folk art, self-taught, outsider art. Genres include landscapes, florals, Americana and figurative work. Prefers genre scenes and figurative.

Terms: Accepts work on consignment (50% commission) or buys outright for 50% of retail price. Retail price set by the gallery and the artist. Gallery provides promotion; artist pays shipping costs to and from gallery. Prefers artwork framed.

Submissions: Prefers only self-taught artists. Send query letter with bio, photographs and business card. Write for appointment to show portfolio of photographs. Replies only if interested within 6 weeks. Finds artists through agents, visiting exhibitions, word of mouth, art publications and sourcebooks and submissions.

Tips: "Be true to your inspirations. Create from the heart and soul."

GOMES GALLERY OF SOUTHWESTERN ART, 7513 Forsyth, Clayton MO 63105. (314)725-1808. E-mail: artgal1@aol.com. Website: http://www.icon-stl.net/gomes/. President: Larry Gomes. Retail gallery. Estab. 1985. Represents 80 emerging, mid-career and established artists. Exhibited artists include R.C. Gorman and Frank Howell. Sponsors 5 shows/year. Average display time 4 months. Open all year; Monday-Thursday, 10-6; Friday and Saturday, 10-8; Sunday, 11-4. Located "downtown, across from the Ritz Carlton; 3,600 sq. ft.; total Southwestern theme, free covered parking." 35% of space for special exhibition during shows. Free standing display wall on wheels. Clientele: tourists, local community. 96% private collectors, 4% corporate collection. Overall price range: $100-15,000; most work sold at $1,200-2,000.

● This gallery reports that business is up 10%.

Media: Considers all media and all types of prints. Most frequently exhibits stone lithos, originals and serigraphs.

Style: Exhibits all styles. Genres include landscapes, Western, wildlife and Southwestern. Prefers Western/Southwestern themes and landscapes.

Terms: Accepts artwork on consignment (50% commission); or buys outright for 40-50% of retail price (net 10-30 days). Retail price set by gallery and artist. Customer payment by installment is available. Gallery provides insurance, promotion and contract; shipping costs are shared.

Submissions: Prefer, but not limited to Native American artists. Send query letter with slides, bio, medium, price list, brochure and photographs. Portfolio review requested if interested in artist's work. Portfolio should include originals, slides, photographs, transparencies and brochure. Replies in 2-3 weeks; or does not reply, in which case the artist should "call and remind." Files bio.

Tips: "Send complete package the first time you submit. Include medium, size and cost or retail. Submit until you get 8-10 galleries, then do serigraphs and stone lithos. Promote co-op advertising with your galleries."

‡**GRAND ARTS**, 1819 Grand, Kansas City MO 64108. (816)421-6887. Fax: (816)421-1561. E-mail: grand. arts@kc.grapevine.com. Director: Sean Kelley. Nonprofit gallery/foundation. Estab. 1995. Represents 6-8 emerging and established artists/year. Exhibited artists include Alice Aycock, Larry Buechel. Sponsors 6-8 shows/year. Average display time 6-8 weeks. Open all year; Thursday-Saturday, 10-5, or by appointment. Located downtown; 3,500 sq. ft.; sculpture studio. Overall price range: $5,000-10,000.
Media: Considers all media. Most frequently exhibits sculpture, painting and mixed media installations.
Style: Exhibits conceptualism and contemporary.
Terms: Retail price set by the gallery and the artist; gallery pays shipping costs.
Submissions: Send query letter with résumé, slides, bio and SASE. Call for appointment to show portfolio. Replies in 1 month.

THE JAYNE GALLERY, 108 W. 47th St., Kansas City MO 64112. (816)561-5333. Fax: (816)561-8402. E-mail: cjnkc.@aol.com. Owners: Ann Marie Jayne and Clint Jayne. Retail gallery. Represents/exhibits 30 emerging, mid-career and established artists/year. Exhibited artists include Jody dePew McLeane and Robert Striffolino. Sponsors 4-6 shows/year. Average display time 3 weeks. Open all year; Monday-Saturday, 10-7; Thursday, 10-6; Sunday, 12-5. 2,000 sq. ft. in outdoor gallery located in The Plaza, a historic shopping district featuring Spanish architecture such as stucco buildings with red tile roofs, ornate towers and beautiful courtyards. 100% of space is devoted to the work of gallery artists. 40% out-of-town clients; 60% Kansas City metro and surrounding communities. Overall price range: $500-5,000; most work sold at $1,500-3,700.
Media: Considers all media and all types of prints by artists whose original work is handled by gallery. Most frequently exhibits paintings—all media, ceramics, glass and other fine crafts.
Style: Exhibits all styles. Genres include landscapes and figurative work. Prefers impressionism, expressionism and abstraction.
Terms: Artwork is accepted on consignment (50% commission). Retail price set by the artist. Gallery provides insurance, promotion and contract; shipping costs are shared. Requires artwork framed.
Submissions: Accepts only artists from US. Send query letter with résumé, brochure, business card, slides, photographs, reviews, bio, SASE and price list. Write for appointment to show portfolio of photographs, transparencies, slides of available work. Replies in 6-8 weeks; if interested within 2 weeks. Files résumé, any visuals that need not be returned. Finds artists through referrals, travel, art fairs and exhibitions.
Tips: "Visit galleries to see if your work 'fits' with gallery's look, vision, philosophy."

‡**MORTON J. MAY FOUNDATION GALLERY**, Maryville University, 13550 Conway, St. Louis MO 63141. (314)576-9300. Director: Nancy N. Rice. Nonprofit gallery. Exhibits the work of 6 emerging, mid-career and established artists/year. Sponsors 10 shows/year. Average display time 1 month. Open all year. Located on college campus. 10% of space for special exhibitions. Clientele: college community. Overall price range: $100-4,000.
● The gallery is long and somewhat narrow, therefore it is inappropriate for very large 2-D work. There is space in the lobby for large 2-D work but it is not as secure.
Media: Considers oil, acrylic, watercolor, pastel, pen & ink, drawings, mixed media, collage, works on paper, sculpture, ceramic, fiber, installation, photography, original handpulled prints, woodcuts, engravings, lithographs, wood engravings, mezzotints, linocuts and etchings. Exhibits all genres.
Terms: Artist receives all proceeds from sales. Retail price set by artist. Gallery provides insurance and promotion; artist pays for shipping. Prefers framed artwork.
Submissions: Prefers St. Louis area artists. Send query letter with résumé, slides, bio, brochure and SASE. Portfolio review requested if interested in artist's work. Portfolio should include slides, photographs and transparencies. Replies only if interested within 3 months. Finds artists through referrals by colleagues, dealers, collectors, etc. "I also visit group exhibits especially if the juror is someone I know and or respect."
Tips: Does not want to see "hobbyists/crafts fair art."

WILLIAM SHEARBURN FINE ART, 4740-A McPherson, St. Louis MO 63108. (314)367-8020. Owner/Director: William Shearburn. Retail gallery. Estab. 1990. Represents/exhibits 40 mid-career and established artists/year. Exhibited artists include James McGarrel and Michael Eastman. Sponsors 5 shows/year. Average display time 6 weeks. Open all year; Tuesday-Saturday, 1-5. Located midtown; 1,200 sq. ft. "Has feel of a 2nd floor New York space." 60% of space for special exhibitions; 40% of space for gallery artists. Clientele: local and corporate collectors. 70% private collectors, 30% corporate collectors. Overall price range: $500-50,000; most work sold at $2,500-3,500.
Media: Considers all media and all types of prints. Most frequently exhibits paintings, prints and photography.
Style: Exhibits expressionism, minimalism, painterly abstraction and realism. Prefers abstraction, figurative and minimalism.
Terms: Artwork is accepted on consignment (50% commission). Retail price set by the gallery. Gallery provides promotion and contract; shipping costs are shared. Prefers artwork framed.

Submissions: Prefers established artists only. Send query letter with résumé, slides, reviews and SASE. Call for appointment to show portfolio of photographs or transparencies. Replies in 2 weeks. Finds artists through art fairs.
Tips: "Please stop by the gallery first to see the kind of work we show and the artists we represent before you send us your slides. You are your best salesperson."

Montana

CUSTER COUNTY ART CENTER, Box 1284, Water Plant Rd., Miles City MT 59301. (406)232-0635. Executive Director: Mark Browning. Nonprofit gallery. Estab. 1977. Interested in emerging and established artists. Clientele: 90% private collectors, 10% corporate clients. Sponsors 8 group shows/year. Average display time is 6 weeks. Overall price range: $200-10,000; most artwork sold at $300-500.
 • The galleries are located in the former water-holding tanks of the Miles City WaterWorks. The underground, poured concrete structure is listed on the National Register of Historic Places. It was constructed in 1910 and 1924 and converted to its current use in 1976-77.
Media: Considers all media and original handpulled prints. Most frequently exhibits painting, sculpture and photography.
Style: Exhibits painterly abstraction, conceptualism, primitivism, impressionism, expressionism, neo-expressionism and realism. Genres include landscapes, Western, portraits and figurative work. "Our gallery is seeking artists working with traditional and non-traditional Western subjects in new, contemporary ways." Specializes in Western, contemporary and traditional painting and sculpture.
Terms: Accepts work on consignment (30% commission). Retail price is set by gallery and artist. Exclusive area representation not required. Gallery provides insurance, promotion and contract; shipping expenses are shared.
Submissions: Send query letter, résumé, brochure, slides, photographs and SASE. Write for appointment to show portfolio of originals, "a statement of why the artist does what he/she does" and slides. Slides and résumé are filed.

HARRIETTE'S GALLERY OF ART, 510 First Ave. N., Great Falls MT 59405. (406)761-0881. Owner: Harriette Stewart. Retail gallery. Estab. 1970. Represents 20 artists. Exhibited artists include Don Begg, Larry Zabel, Frank Miller, Arthur Kober, Richard Luce, Lane Kendrick, Susan Guy and Lee Cable. Sponsors 1 show/year. Average display time 6 months. Open all year. Located downtown; 1,000 sq. ft. 100% of space for special exhibitions. Clientele: 90% private collectors, 10% corporate collectors. Overall price range: $100-10,000; most artwork sold at $200-750.
Media: Considers oil, acrylic, watercolor, pastel, pencils, pen & ink, mixed media, sculpture, original handpulled prints, lithographs and etchings. Most frequently exhibits watercolor, oil and pastel.
Style: Exhibits expressionism. Genres include wildlife, landscape, floral and Western.
Terms: Accepts work on consignment (33⅓% commission); or outright for 50% of retail price. Retail price set by gallery and artist. Sometimes offers customer discounts and payment by installment. Gallery provides promotion; "buyer pays for shipping costs." Prefers artwork framed.
Submissions: Send query letter with résumé, slides, brochure and photographs. Portfolio review requested if interested in artist's work. "Have Montana Room in largest Western Auction in US—The "Charles Russell Auction," in March every year—looking for new artists to display."
Tips: "Proper framing is important."

HOCKADAY CENTER FOR THE ARTS, P.O. Box 83, Kalispell MT 59903. (406)755-5268. Director: Magee Nelson. Museum. Estab. 1968. Exhibits emerging, mid-career and established artists. Interested in seeing the work of emerging artists. 500 members. Exhibited artists include Theodore Waddell and David Shaner. Sponsors approximately 20 shows/year. Average display time 6 weeks. Open year round. Located 2 blocks from downtown retail area; 2,650 sq. ft.; historic 1906 Carnegie Library Building with new (1989) addition; wheelchair access to all of building. 50% of space for special exhibitions. Overall price range $500-35,000.
Media: Considers all media, plus woodcuts, wood engravings, linocuts, engravings, mezzotings, etchings, lithographs and serigraphs. Most frequently exhibits painting (all media), sculpture/installations (all media), photography and original prints.

A BULLET introduces comments by the editor of *Artist's & Graphic Designer's Market* indicating special information about the listing.

Style: Exhibits all styles and genres. Prefers contemporary art (all media and styles), historical art and photographs and traveling exhibits. "We are not interested in wildlife art and photography, mass-produced prints or art from kits."
Terms: Accepts work on consignment (30% commission). Also houses permanent collection: Montana and regional artists acquired through donations. Sometimes offers customer discounts and payment by installment to museum members. Gallery provides insurance, promotion and contract; shipping costs are shared. Prefers artwork framed.
Submissions: Send query letter with résumé, slides, bio, reviews and SASE. Portfolio should include b&w photographs and slides (20 maximum). "We review *all* submitted portfolios once a year, in spring." Finds artists through submissions and self-promotions.

Nebraska

‡ARTISTS' COOPERATIVE GALLERY, 405 S. 11th St., Omaha NE 68102. (402)342-9617. President: Robin Davis. Cooperative and nonprofit gallery. Estab. 1974. Exhibits the work of 30-35 emerging, mid-career and established artists. 35 members. Exhibited artists include Carol Pettit and Jerry Jacoby. Sponsors 14 shows/year. Average display time 1 month. Open all year. Located in historic old market area; 5,000 sq. ft.; "large open area for display with 25' high ceiling." 20% of space for special exhibitions. Clientele: 85% private collectors, 15% corporate collectors. Overall price range: $20-2,000; most work sold at $20-1,000.
Media: Considers oil, acrylic, watercolor, pastel, drawings, mixed media, collage, paper, sculpture, ceramic, fiber, glass, photography, woodcuts, serigraphs. Most frequently exhibits pastel, acrylic, oil and ceramic.
Style: Exhibits all styles and genres.
Terms: Co-op membership fee plus donation of time. Retail price set by artist. Sometimes offers payment by installment. Artist provides insurance; artist pays for shipping. Prefers artwork framed. No commission charged by gallery.
Submissions: Accepts only artists from the immediate area. "We each work one day a month." Send query letter with résumé, slides and bio. Write for appointment to show portfolio of originals and slides. "Applications are reviewed and new members accepted and notified in August if any openings are available." Files applications.
Tips: "Fill out application and touch base with gallery in July."

HAYDON GALLERY, 335 N. Eighth St., Suite A, Lincoln NE 68508. (402)475-5421. Fax: (402)472-9185. Director: Anne Pagel. Nonprofit sales and rental gallery in support of Sheldon Memorial Art Gallery. Estab. 1984. Exhibits 100 mid-career and established artists. Exhibited artists include Karen Kunc, Stephen Dinsmore, Kirk Pedersen, Tom Rierden and Neil Christensen. Sponsors 12 shows/year. Average display time 1 month. Open all year; Monday-Saturday, 10-5. Located in Historic Haymarket District (downtown); 1,100 sq. ft. 85% of space for special exhibitions; 10% of space for gallery artists. Clientele: collectors, corporate, residential, architects, interior designers. 75% private collectors, 25% corporate collectors. Overall price range: $75-20,000; most work sold at $500-3,000.
Media: Considers all media and all types of original prints. Most frequently exhibits paintings, mixed media and prints.
Style: Exhibits all styles. Genres include landscapes, abstracts, still lifes and figurative work. Prefers contemporary realism, nonrepresentational work in all styles.
Terms: Accepts work on consignment (45% commission). Retail price set by gallery and artist. Offers customer discounts and payment by installments. Gallery provides insurance, promotion, contract; artist pays for shipping.
Submission: Accepts primarily Midwest artists. Send query letter with résumé, slides, reviews and SASE. Portfolio review requested if interested in artist's work. Portfolio should include originals, photographs or slides. Replies only if interested within 1 month (will return slides if SASE enclosed). Files slides and other support information. Finds artists through submissions, regional educational programs, visiting openings and exhibitions and news media.

‡ADAM WHITNEY GALLERY, 8725 Shamrock Rd., Omaha NE 68114. (402)393-1051. Manager: Linda Campbell. Retail gallery. Estab. 1986. Represents 350 emerging, mid-career and established artists. Exhibited artists include Valerie Berlin and Christopher Darling. Average display time 3 months. Open all year; Monday-Saturday, 10-5. Located in countryside village; 2,500 sq. ft. 40% of space for special exhibitions. Overall price range: $150-7,000.
Media: Considers oil, paper, fiber, acrylic, sculpture, glass, watercolor, mixed media, ceramic, installation, pastel, collage, craft, jewelry, mezzotints, lithographs and serigraphs. Most frequently exhibits glass, jewelry, 2-dimensional works.
Style: Exhibits all styles and genres.
Terms: Accepts work on consignment (50% commission). Retail price set by gallery and artist. Gallery provides insurance, promotion and contract; shipping costs are shared. Prefers artwork framed.

Submissions: Send query letter with résumé, slides, photographs and reviews. Call or write for appointment to show portfolio of originals, photographs and slides. Files résumé, slides, reviews.

Nevada

RED MOUNTAIN GALLERY (Truckee Meadows Community College), 7000 Dandini Blvd., Reno NV 89512. (702)673-7084. Gallery Director: Erik Lauritzen. Nonprofit and college gallery. Estab. 1991. Represents emerging and mid-career artists. Sponsors 7 shows/year. Average display time 1 month. Located north of downtown Reno; 1,200 sq. ft.; "maximum access to entire college community—centrally located." 100% of space for special exhibitions. Clientele: corporate art community and students/faculty. 95% private collectors, 5% corporate collectors. Overall price range: $150-1,500; most work sold at $300-800.
Media: Considers oil, acrylic, watercolor, pastel, pen & ink, drawings, mixed media, collage, paper, sculpture, ceramic, fiber and photography. "Video is a new addition." Considers original handpulled prints, woodcuts, engravings, lithographs, wood engravings, mezzotints, serigraphs, linocuts and etchings. Most frequently exhibits painting, photography, sculpture and printmaking.
Style: Exhibits all styles and genres. Prefers primitivism and socio-political works. Looks for "more contemporary concerns—less traditional/classical approaches. Subject matter is not the basis of the work—innovation and aesthetic exploration are primary."
Terms: Accepts work on consignment (20% commission). Retail price set by gallery and artist. Gallery provides insurance, full color announcements, promotion, contract and shipping from gallery. Prefers artwork unframed.
Submissions: Accepts only artists from NM, WA, OR, CA, ID, UT, AZ and NV. Send query letter with résumé, 15 slides, SASE, reviews and artist's statement. Deadline for submissions: April 1 of each year. Replies in 1 month. Files résumé. Submission fee: $15.

New Hampshire

PERFECTION FRAMING, 213 Rockingham Rd., Londonderry NH 03053. Phone/fax: (603)434-7939. Owner: Valerie Little. Retail gallery. Estab. 1986. Represents "3 or 4 local/regional," emerging, mid-career and established artists/year. Interested in seeing the work of emerging artists. Exhibited artists include Bateman, Kuck. Sponsors 2-3 shows/year. Average display time 2 months. Open all year; Tuesday-Saturday, 10-6. Located on Route 28; 1,100 sq. ft. 25% of space for special exhibitions; 60% of space for gallery artists. Clientele: residential and corporate. 90% private collectors, 10% corporate collectors. Overall price range: $200-400; most work sold at $300.
Media: Considers all media and all types of prints. Most frequently exhibits limited edition prints, originals and etchings.
Style: Exhibits impressionism and realism. Genres include landscapes, florals, Americana and wildlife. Prefers wildlife, landscapes and Americana.
Terms: Accepts work on consignment (25% commission). Retail price set by the artist. Gallery provides promotion and contract; artist pays shipping costs. Prefers artwork unframed.
Submissions: Accepts only artists from New Hampshire. Send query letter with bio and photographs. Write for appointment to show portfolio of originals and photographs. Finds artists through word of mouth.

New Jersey

ARC-EN-CIEL, 64 Naughright Rd., Long Valley NJ 07853. (908)832-6605. Fax: (908)832-6509. E-mail: arreed@aol.com, areed@escape.cnct.com. Owner: Ruth Reed. Retail gallery and art consultancy. Estab. 1980. Represents 35 mid-career and established artists/year. Exhibited artists include Andre Pierre, Petian Savain. Clientele: 50% private collectors, 50% corporate clients. Average display time is 6 weeks-3 months. Open by appointment only. Represents emerging, mid-career and established artists. Overall price range: $150-158,000; most artwork sold at $250-2,000.
Media: Considers oil, acrylic, wood carvings, sculpture. Most frequently exhibits acrylic, painted iron, oil.
Style: Exhibits minimalism and primitivism. "I exhibit country-style paintings, naif art from around the world. The art can be on wood, iron or canvas."
Terms: Accepts work on consignment (50% commission). Retail price is set by gallery and artist. Customer discounts and payment by installment are available. Exclusive area representation required. Gallery provides promotion; shipping costs are shared.
Submissions: Send query letter, photographs and SASE. Portfolio review requested if interested in artist's work. Photographs are filed. Finds artists through word of mouth and art collectors' referrals.

ART FORMS, 16 Monmouth St., Red Bank NJ 07701. (201)530-4330. Fax: (201)530-9791. Director: Charlotte T. Scherer. Retail gallery. Estab. 1984. Represents 12 emerging, mid-career and established artists. Exhibited artists include Paul Bennett Hirsch and Sica. Sponsors 7 exhibitions/year. Average display time 1 month. Open all year. Located in downtown area; 1,200 sq. ft.; "Art Deco entranceway, tin ceiling, Soho appeal." 50% of space for special exhibitions. Clientele: 60% private collectors, 40% corporate collectors. Overall price range: $250-70,000; most work sold at $1,200-4,500.

Media: Considers all media, including wearable art. Considers original handpulled prints, woodcuts, wood engravings, linocuts, engravings, mezzotints, etchings, lithographs, pochoir and serigraphs. Most frequently exhibits mixed media, oil and lithographs.

Style: Exhibits neo-expressionism, expressionism and painterly abstraction. Interested in seeing contemporary representationalism.

Terms: Accepts work on consignment (50% commission). Retail price set by artist. Gallery provides insurance, promotion, contract and shipping costs from gallery. Prefers artwork unframed.

Submissions: Send query letter with résumé, slides, bio and SASE. Write for appointment to show portfolio of originals and slides. Replies in 1 month. Files résumé and slides.

‡EXTENSION GALLERY, 60 Ward Avenue Extension, Mercerville NJ 08619. (609)890-7777. Fax: (609) 890-1816. Gallery Director: Jim Ulry. Nonprofit gallery/alternative space. Estab. 1984. Represents 60 emerging, mid-career, established artists/year. Sponsors 11 exhibitions/year. Average display time: 1 month. Open all year; Monday-Thursday 10-4 p.m. 1400 sq. ft.; attached to the Johnson Atelier Technical Institute of Sculpture. 90% of space devoted to showing the work of gallery artists.

● Extension Gallery is a service-oriented space for Johnson Atelier members; all work is done inhouse by Atelier members, apprentices and staff.

Media: Considers oils, acrylics, watercolor, pastels, drawings, mixed media, sculpture and all types of prints. Most frequently exhibits sculpture and drawing.

Style: Considers all styles. Prefers contemporary sculpture. Most frequently exhibits realism, expressionism, conceptualism.

DAVID GARY LTD. FINE ART, 391 Millburn Ave., Millburn NJ 07041. (201)467-9240. Fax: (201)467-2435. Director: Steve Suskauer. Retail and wholesale gallery. Estab. 1971. Represents 17-20 mid-career and established artists. Exhibited artists include John Talbot and Marlene Lenker. Sponsors 3 shows/year. Average display time 3 weeks. Open all year. Located in the suburbs; 2,500 sq. ft.; high ceilings with sky lights and balcony. Clientele: "upper income." 70% private collectors, 30% corporate collectors. Overall price range: $250-25,000; most work sold at $1,000-15,000.

Media: Considers oil, acrylic, watercolor, drawings, sculpture, pastel, woodcuts, engravings, lithographs, wood engravings, mezzotints, linocuts, etchings and serigraphs. Most frequently exhibits oil, original graphics and sculpture.

Style: Exhibits primitivism, painterly abstraction, surrealism, impressionism, realism and collage. All genres. Prefers impressionism, painterly abstraction and realism.

Terms: Accepts artwork on consignment (50% commission). Retail price set by gallery and artist. Gallery services vary; artist pays for shipping. Prefers artwork unframed.

Submissions: Send query letter with résumé, photographs and reviews. Call for appointment to show portfolio of originals, photographs and transparencies. Replies in 1-2 weeks. Files "what is interesting to gallery."

Tips: "Have a basic knowledge of how a gallery works, and understand that the gallery is a business."

‡KEARON-HEMPENSTALL GALLERY, 536 Bergen Ave., Jersey City NJ 07304. (201)333-8855. Fax: (201)333-8488. Director: Suzann McKernan. Retail gallery. Estab. 1981. Represents 10 emerging, mid-career and established artists/year. Exhibited artists include: Dong Sik-Lee; Andrea Zampella. Sponsors 3 shows/year. Average display time 2 months. Open all year; Monday-Friday, 10-3; closed July and August. Located on a major commercial street; 150 sq. ft.; Brownstone main floor, ribbon parquet floors, 14 ft. ceilings, ornate moldings, traditional. 60% of space for special exhibitions; 40% of space for gallery artists. Clientele: local community, corporate. 60% private collectors, 40% corporate collectors. Overall price range: $200-8,000; most work sold at $1,500-2,500.

Media: Considers oil, acrylic, watercolor, pastel, drawing, mixed media, collage, paper, sculpture, fiber, glass, installation, photography, engravings, lithographs, serigraphs, etchings and posters. Most frequently exhibits mixed media painting, photography and sculpture.

Style: Exhibits expressionism, painterly abstraction, surrealism, realism. Exhibits all genres. Prefers figurative expressionism and realism.

Terms: Accepts work on consignment (40% commission). Retail price set by the gallery. Gallery provides promotion; artist pays for shipping. Prefers artwork framed.

Submissions: Send query letter with résumé, slides, bio, brochure, SASE, reviews, artist's statement, price list of sold work. Write for appointment to show portfolio of photographs and slides. Replies in 6 weeks. Files slides and résumés. Finds artists through art exhibitions, magazines (trade), submissions.

Tips: "Be sure to include any prior show listings with prices for sold work and have an idea of marketing."

‡**KERYGMA GALLERY**, 38 Oak St., Ridgewood NJ 07450. (201)444-5510. Gallery Directors: Ron and Vi Huse. Retail gallery. Estab. 1988. Represents 50 mid-career artists. Sponsors 11 shows/year. Average display time 3-4 weeks. Open all year. Located in downtown business district; 2,000 sq. ft.; "professionally designed contemporary interior with classical Greek motif accents." Clientele: primarily residential, some corporate. 80-85% private collectors, 15-20% corporate collectors. Most work sold at $2,000-5,000.
Media: Considers oil, acrylic, watercolor, pastel, mixed media, paper, sculpture and glass (sculpture only). Prefers oil or acrylic on canvas.
Style: Exhibits expressionism, painterly abstraction, impressionism and realism. Genres include landscapes, florals, Americana, Southwestern, portraits and figurative work. Prefers impressionism and realism still life.
Terms: Accepts artwork on consignment (50% commission). Retail price set by gallery and artist. Gallery provides insurance, promotion and in some cases, a contract; shipping costs are shared.
Submissions: Send query letter with résumé, slides, bio, photographs, reviews and SASE. Call for appointment to show portfolio originals, photographs and slides "only after interest is expressed by slide/photo review." Replies in 1 month. Files all written information, returns slides/photos.
Tips: "An appointment is essential—as is a slide register."

LANDSMAN'S GALLERY & PICTURE FRAMING, 401 S. Rt. 30, Magnolia NJ 08049. (609) Fine Art. Fax: (609)784-0334. Owner: Howard Landsman. Retail gallery and art consultancy. Estab. 1965. Represents/exhibits 25 emerging, mid-career and established artists/year. Interested in seeing the work of emerging artists. Open all year; Tuesday-Saturday, 9-5. Located in suburban service-oriented area; 2,000 sq. ft. "A refuge in an urban suburban maze." Clientele: upscale, local, established. 50% private collectors, 50% corporate collectors. Overall price range: $100-10,000; most work sold at $300-1,000.
Media: Considers all media and all types of prints. Most frequently exhibits serigraphs, oils and sculpture.
Style: Exhibits all styles. All genres. Gallery provides insurance, promotion and contract. Artist pays for shipping costs. Prefers artwork framed.
Terms: Artwork is accepted on consignment (50% commission). Retail price set by artist. Gallery provides insurance, promotion, contract. Artist pays shipping costs. Prefers artwork framed.
Submissions: Send query letter with slides, photographs and reviews. Write for appointment to show portfolio of photographs and slides. Files slides, bios and résumé. Finds artists through word of mouth, referrals by other artists, visiting art fairs and exhibitions, submissions.

‡**MARKEIM ART CENTER**, Lincoln Ave. and Walnut St., Haddonfield NJ 08033. (609)429-8585. Fax: (609)428-1199. Curator: P.J. Friend. Nonprofit gallery. Estab. 1956. Represents 20 emerging, mid-career and established artists/year. 150 members. Exhibited artists include: Aubre Duncan/Paul Friend. Sponsors 12 shows/year. Average display time 1 month. Open all year; Monday-Friday; 8-4. Located downtown (center of town); 600 sq. ft. 50% of space for special exhibitions; 50% of space for gallery artists. 35% private collectors, 10% corporate collectors. Overall price range: $85-5,000; most work sold at $1,000 minimum.
Media: Considers all media and all types of prints. Most frequently exhibits glass, stained glass, watercolors and sculpture.
Style: Exhibits all styles and genres. Prefers abstract, florals and figurative work.
Terms: Accepts work on consignment (20% commission.) Retail price set by the artist. Gallery provides promotion and contract; shipping costs are shared. Prefers artwork ready to hang.
Submissions: Send query letter with résumé, slides, bio, brochure, photographs, SASE, business card, reviews and artist's statement. Write for appointment to show portfolio of photographs and slides. Replies in 2 weeks. Files slide registry. Finds artists through exhibitions at national shows.

‡**NABISCO GALLERY**, (formerly Nabisco Foods Group), 100 DeForest Ave., E. Hanover NJ 07936. (201)503-3238. Fax: (201)515-0358. Art Advisor: Mary M. Chandor. Nonprofit corporate gallery. Estab. 1975. Limited to artists in N.Y. metropolitan area. Interested in emerging, mid-career and established artists. Sponsors 8 group shows/year. Average display time 6 weeks. Overall price range $200-25,000.
Media: Exhibits original prints, oil, acrylic, watercolor, sculpture, photography and crafts.
Style: Exhibits all styles and genres. "The Nabisco Gallery organizes 8 exhibitions per year in its spacious lobby area. A variety of media, style and subject matter is the goal in arranging each year's schedule. Nabisco accepts slides and résumés from artists which it keeps on file. These files are then utilized in putting together various shows."
Terms: Retail price set by artist. Exclusive area representation not required. Gallery provides insurance and some promotion; shipping costs are shared. Artwork must be framed.
Submissions: Send query letter with résumé and slides. "We do not review portfolios." Replies only if interested. Files all material sent.
Tips: "Send five slides and any relevant published material."

THE NOYES MUSEUM, Lily Lake Rd., Oceanville NJ 08231. (609)652-8848. Fax: (609)652-6166. Curator of Collections and Exhibitions: Stacy Smith. Museum. Estab. 1982. Exhibits emerging, mid-career and established artists. Sponsors 15 shows/year. Average display time 6 weeks to 3 months. Open all year; Wednesday-Sunday, 11-4. 9,000 sq. ft.; "modern, window-filled building successfully integrating art and

nature; terraced interior central space with glass wall at bottom overlooking Lily Lake." 75% of space for special exhibitions. Clientele: rural, suburban, urban mix; high percentage of out-of-state vacationers during summer months. 100% private collectors. "Price is not a factor in selecting works to exhibit."
Media: All types of fine art, craft and folk art.
Style: Exhibits all styles and genres.
Terms: Accepts work on consignment (10% commission). "Artwork not accepted solely for the purpose of selling; we are a nonprofit art museum." Retail price set by artist. Gallery provides insurance. Prefers artwork framed.
Submissions: Send query letter with résumé, slides, photographs and SASE. "Letter of inquiry must be sent; then museum will set up portfolio review if interested." Portfolio should include originals, photographs and slides. Replies in 1 month. "Materials only kept on premises if artist is from New Jersey and wishes to be included in New Jersey Artists Resource File or if artist is selected for inclusion in future exhibitions."

‡SHEILA NUSSBAUM GALLERY, 341 Millburn Ave., Millburn NJ 07041. (201)467-1720. Fax: (201)467-2114. Director: Sheila Nussbaum Drill. Retail gallery. Estab. 1982. Represents 300 emerging and mid-career artists/year. Exhibited artists include Hal Larsen (painter), MaryLou Higgins (ceramics). Sponsors 5 shows/year. Average display time 1 month. Open all year; Monday-Saturday, 9-5; Thursday, 9-8. Located downtown; 3,500 sq. ft. 70% of space for special exhibitions. Clientele: upscale. 90% private collectors, 10% corporate collectors. Overall price range: $30-15,000; most work sold at $250-2,000.
Media: Considers all media except installation. Most frequently exhibits oil/acrylic paintings, ceramics, fine art jewelry.
Style: Exhibits primitivism, painterly abstraction, color field, postmodern works. Prefers contemporary abstract, postmodern and folk art.
Terms: Accepts work on consignment (50% commission). Retail price set by the artist. Gallery provides insurance and promotion; shipping costs are shared. Prefers artwork framed.
Submissions: Send query letter with résumé, slides and artist's statement. Portfolio should include slides. Replies ASAP. Finds artists through submissions, art shows, referrals.

‡POLO GALLERY, 276 River Rd., Edgewater NJ 07020. (201)945-8200. Fax: (201)224-0150. Director: Robert Zimmerman. Retail gallery, art consultancy. Estab. 1993. Represents 30 emerging, mid-career and established artists/year. Exhibited artists include Christian Hal. Sponsors 6 shows/year. Average display time 6-8 weeks. Open all year; Tuesday-Sunday, 1:30-6; Friday, 1:30-7. Located downtown, Shadyside section; 1,100 sq. ft.; Soho atmosphere in burgeoning art center. 70% of space for special exhibitions; 30% of space for gallery artists. Clientele: tourists-passersby, private clientele, all economic strata. 90% private collectors, 10% corporate collectors. Overall price range: $80-18,000; most work sold at $350-4,000.
Media: Considers all media and all types of prints. Most frequently exhibits oil, sculpture, works on paper.
Style: Exhibits all styles and genres. Prefers realism, painterly abstraction, conceptual.
Terms: Accepts work on consignment (50% commission). Retail price set by the gallery and the artist. Gallery provides promotion and contract; artist pays for shipping or costs are shared.
Submissions: Send query letter with résumé slides, bio, artist's statement, assumed price list. Call or write for appointment to show portfolio of slides and b&w prints for newspapers. Replies in 2 months. Artist should call if no contact. Files future show possibilities.
Tips: Common mistakes artists make are not labeling slides, not including price list, and not indicating which slides are available.

QUIETUDE GARDEN GALLERY, 24 Fern Rd., East Brunswick NJ 08816. (908)257-4340. Fax: (908)257-1378. Owner: Sheila Thau. Retail/wholesale gallery and art consultancy. Estab. 1988. Represents 60 emerging, mid-career and established artists/year. Exhibited artists include Tom Doyle, Han Van de Boven Kamp. Sponsors 5 shows/year. Average display time 6 weeks. Open April 24-November 1; by appointment. Located in a suburb; 4 acres; unique work exhibited in natural and landscaped, wooded property—each work in its own environment. 25% of space for special exhibitions; 75% of space for gallery artists. Clientele: upper middle class, private home owners and collectors, small corporations. 75% private collectors, 25% corporate collectors. Overall price range: $2,000-50,000; most work sold at $10,000-20,000.
Media: Considers "only sculpture suitable for outdoor (year round) display and sale." Most frequently exhibits metal (bronze, steel), ceramic and wood.
Style: Exhibits all styles.
Terms: Accepts work on consignment. Retail price set by the artist. Gallery provides insurance, promotion and contract; artist pays shipping costs to and from gallery.
Submissions: Send query letter with résumé, slides, bio, photographs, SASE and reviews. Write for appointment to show portfolio of photographs, slides and bio. Replies in 2 weeks. Files "slides, bios of artists who we would like to represent or who we do represent." Finds artists through word of mouth, publicity on current shows and ads in art magazines.

SCHERER GALLERY, 93 School Rd. W., Marlboro NJ 07746. (908)536-9465. Fax: (908)536-8475. Owners: Tess Scherer and Marty Scherer. Retail gallery. Estab. 1968. Represents over 30 mid-career and estab-

lished artists. May be interested in seeing the work of emerging artists in the future. Exhibited artists include Tamayo, Hundertwasser, Friedlaender, Delaunay, Calder and Barnet. Sponsors 4 solo and 3 group shows/year. Average display time 2 months. Open Wednesday-Sunday, 10-5; closed mid-July to early September. Located in "New York" suburb; 2,000 sq. ft.; 25% of space for special exhibitions; 75% for gallery artists. Clientele: upscale, local community and international collectors. 90% private collectors, 10% corporate clients. Overall price range: $1,000-20,000; most artwork sold at $5,000-10,000.

Media: Considers all media except craft; considers all types of original handpulled prints (no posters or off-sets). Most frequently exhibits paintings, original graphics and sculpture.

Style: Exhibits color field, minimalism, surrealism, expressionism, modern and post modern works. Looking for artists "who employ creative handling of a given medium(s) in a contemporary manner." Specializes in handpulled graphics (lithographs, serigraphs, monotypes, woodcuts, etc.). "Would like to be more involved with original oils and acrylic paintings."

Terms: Accepts work on consignment (50% commission). Retail price set by artist. Exclusive area representation required. Gallery provides insurance, promotion and contract; shipping costs are shared.

Submissions: Send query letter, résumé, bio, photographs and SASE. Follow up with a call for appointment to show portfolio. Replies in 2-4 weeks.

Tips: Considers "originality and quality of handling the medium."

BEN SHAHN GALLERIES, William Paterson College, 300 Pompton Rd, Wayne NJ 07470. (201)595-2654. Director: Nancy Einreinhofer. Nonprofit gallery. Estab. 1968. Interested in emerging and established artists. Sponsors 5 solo and 10 group shows/year. Average display time is 6 weeks. Clientele: college, local and New Jersey metropolitan-area community.

 • The gallery specializes in contemporary art and encourages site-specific installations. They also have a significant public sculpture collection and welcome proposals.

Media: Considers all media.

Style: Specializes in contemporary and historic styles, but will consider all styles.

Terms: Accepts work for exhibition only. Gallery provides insurance, promotion and contract; shipping costs are shared.

Submissions: Send query letter with résumé, brochure, slides, photographs and SASE. Write for appointment to show portfolio. Finds artists through submissions, referrals and exhibits.

‡SHOE-STRING GALLERY, 111 First St., 5th Floor, Jersey City NJ 07302. (201)420-5018. Director: Bill Barrell. Retail gallery. Estab. 1993. Represents 10 artists/year. Sponsors 6 shows/year. Average display time 5-6 weeks. Open winter, spring, fall; Saturdays, 12-4 and by appointment. Located in downtown warehouse district; 500 sq. ft. 100% private collectors. Overall price range: $500-15,000; most work sold at $1,500-2,000.

Media: Considers all media and all types of prints. Most frequently exhibits painting, sculpture, prints/drawing.

Style: Exhibits expressionism, neo-expressionism, primitivism, painterly abstraction, conceptualism. Exhibits all genres. Prefers figurative expressionism, abstraction, social documentary.

Terms: Accepts work on consignment (40% commission.) Retail price set by the artist. Gallery provides promotion; artist pays shipping costs. Prefers artwork unframed.

Submissions: Accepts only artists from New York/New Jersey metro area. Send query letter. Call for appointment to show portfolio. Replies only if interested within 2 weeks. Finds artists through friends, galleries, studio visits.

‡WALKER-KORNBLUTH ART GALLERY, 7-21 Fair Lawn Ave., Fair Lawn NJ 07410. (201)791-3374. Director: Sally Walker. Retail gallery. Estab. 1965. Represents 20 mid-career and established artists/year. Exhibited artists include Wolf Kahn, Richard Segaliran. Sponsors 10 shows/year. Open Tuesday-Saturday, 10-5:30; Sunday, 1-5; closed August. 2,000 sq. ft., 1920's building (brick), 2 very large display windows. 75% of space for special exhibitions; 25% of space for gallery artists. Clientele: mostly professional and business people. 85% private collectors, 15% corporate collectors. Overall price range: $400-45,000; most work sold at $1,000-4,000.

Media: Considers all media except installation. Considers all types of prints. Most frequently exhibits oil, watercolor, pastel and monoprints.

Style: Exhibits painterly abstraction, impressionism, realism. Exhibits florals, Southwestern, landscapes, figurative work. Prefers painterly realism, painterly abstraction, impressionism.

Terms: Accepts work on consignment (40-50% commission). Retail price set by the gallery and the artist. Gallery provides insurance and promotion; shipping costs are shared. Prefers artwork framed.

Submissions: "We don't usually show local artists." Send query letter with résumé, slides, reviews and SASE. Write for appointment to show portfolio of transparencies and slides. Files slides. Finds artists through word of mouth, referrals by other artists, visiting art fairs and exhibitions, submissions.

Tips: "Don't ask to show work before submitting slides."

WYCKOFF GALLERY, 648 Wyckoff Ave., Wyckoff NJ 07481. (201)891-7436. Director: Sherry Cosloy. Retail gallery. Estab. 1980. Interested in emerging, mid-career and established artists. Sponsors 1-2 solo and 4-6 group shows/year. Average display time 1 month. Clientele: collectors, art lovers, interior decorators and businesses. 75% private collectors, 25% corporate clients. Overall price range: $250-10,000; most artwork sold at $500-3,000.
Media: Considers oil, acrylic, watercolor, pastel, pen & ink, pencil, mixed media, sculpture, ceramic, collage and limited edition prints. Most frequently exhibits oil, watercolor and pastel.
Style: Exhibits contemporary, abstract, traditional, impressionistic, figurative, landscape, floral, realistic and neo-expressionistic works.
Terms: Accepts work on consignment. Retail price set by gallery or artist. Gallery provides insurance and promotion.
Submissions: Send query letter with résumé, slides and SASE. Résumé and biography are filed.
Tips: Sees trend toward "renewed interest in traditionalism and realism."

New Mexico

A.O.I. GALLERY (ART OBJECTS INTERNATIONAL), 634 Canyon Rd., Santa Fe NM 87501. (505)982-3456. Fax: (505)982-2040. Director: Frank. Retail gallery. Estab. 1993. Represents 24 emerging and mid-career artists/year. Exhibited artists include Carl Goldhagen, Gary Dodson, Kimiko Fujimura, Masao Yamamoto, Ernst Haas, Maxine Fine. Sponsors 5 shows/year. Average display time 4-6 weeks. Open daily; 10-6 (summer), 11-5 (winter, closed on Tuesdays). 1,000 sq. ft.; beautiful adobe house, over 100 years old. 100% of space for special exhibitions; 100% of space for gallery artists. Clientele: "Highly sophisticated collectors who are interested in contemporary arts." 50% private collectors. Overall price range: $500-15,000; most work sold at $1,000-3,000.
Media: Considers all types. Most frequently exhibits photography and multi-media work, drawing and painting.
Style: Exhibits all styles. Prefers contemporary art.
Terms: Accepts work on consignment (50% commission). Retail price set by both the gallery and the artist. Gallery provides insurance; shipping costs are shared. Prefers artwork unframed.
Submissions: Must call first for appointment to show portfolio.
Tips: Impressed by "professional artists who can accept rejection with grace and who are extremely polite and well mannered."

THE ALBUQUERQUE MUSEUM, 2000 Mountain Rd. NW, Albuquerque NM 87104. (505)243-7255. Curator of Art: Ellen Landis. Nonprofit museum. Estab. 1967. Interested in emerging, mid-career and established artists. Sponsors mostly group shows. Average display time is 3-6 months. Located in Old Town (near downtown).
Media: Considers all media.
Style: Exhibits all styles. Genres include landscapes, florals, Americana, Western, portraits, figurative and nonobjective work. "Our shows are from our permanent collection or are special traveling exhibitions originated by our staff. We also host special traveling exhibitions originated by other museums or exhibition services."
Submissions: Send query letter, résumé, slides, photographs and SASE. Call or write for appointment to show portfolio.
Tips: "Artists should leave slides and biographical information in order to give us a reference point for future work or to allow future consideration."

BENT GALLERY AND MUSEUM, 117 Bent St., Box 153, Taos NM 87571. (505)758-2376. Owner: Otto Noeding. Retail gallery and museum. Estab. 1961. Represents 15 emerging, mid-career and established artists. Exhibited artists include E. Martin Hennings, Joseph Sharp, Herbert Dunton and Leal Mack. Open all year. Located 1 block off of the Plaza; "in the home of Charles Bent, the first territorial governor of New Mexico." Clientele: 95% private collectors, 5% corporate collectors. Overall price range: $100-10,000; most work sold at $500-1,000.
Media: Considers oil, acrylic, watercolor, pastel, pen & ink, drawings, sculpture, original handpulled prints, woodcuts, engravings and lithographs.
Style: Exhibits impressionism and realism. Genres include traditional, landscapes, florals, Southwestern and Western. Prefers impressionism, landscapes and Western works. "We continue to be interested in collectors' art: deceased Taos artists and founders works."
Terms: Accepts work on consignment (33⅓-50% commission). Retail price set by gallery and artist. Artist pays for shipping. Prefers artwork framed.
Submissions: Send query letter with brochure and photographs. Write for appointment to show portfolio of originals and photographs. Replies if applicable.
Tips: "It is best if the artist comes in person with examples of his or her work."

FENIX GALLERY, 228-B N. Pueblo Rd., Taos NM 87571. Phone/Fax: (505)758-9120. E-mail: judith@lapl azataos.nm.us. Website: http://taoswebb.com/nmusa/FENIX. Director/Owner: Judith B. Kendall. Retail gallery. Estab. 1989. Represents 14 emerging, mid-career and established artists/year. Exhibited artists include Alyce Frank, Earl Stroh. Sponsors 4 shows/year. Average display time 4-6 weeks. Open all year; daily, 10-5; Sunday, 12-5; closed Wednesday during winter months. Located on the main road through Taos; 1,000 sq. ft.; minimal hangings; clean, open space. 100% of space for special exhibitions during one-person shows; 100% of space for gallery artists during group exhibitions. Clientele: experienced and new collectors. 90% private collectors, 10% corporate collectors. Overall price range: $400-10,000; most work sold at $1,000-2,500.
Media: Considers all media; primarily non-representational, all types of prints except posters. Most frequently exhibits oil, sculpture and paper work/ceramics.
Style: Exhibits expressionism, painterly abstraction, conceptualism, minimalism and postmodern works. Prefers conceptualism, expressionism and abstraction.
Terms: Accepts work on consignment (50% commission). Retail price set by the artist or a collaboration. Gallery provides insurance, promotion and contract; artist pays shipping costs to and from gallery. Prefers artwork framed.
Submissions: Prefers artists from area; "we do very little shipping of artist works." Send query letter with résumé, slides, bio, brochure, photographs, SASE, business card and reviews. Call for appointment to show portfolio of photographs. Replies in 3 weeks. Files "material I may wish to consider later—otherwise it is returned." Finds artists through personal contacts, exhibitions, studio visits, reputation regionally or nationally.

‡MEGAN FOX, 311 Aztec St., Santa Fe NM 87501. (505)989-9141. Fax: (505)820-6885. Owner: Megan Fox. Retail gallery. Estab. 1995. Represents 20 emerging, mid-career and established artists/year. Exhibited artists include Charles Thomas ONeil, Tom Baril. Sponsors 9 shows/year. Average display time 1 month. Open all year; Tuesday-Saturday, 11-5. Located downtown; 1,200 sq. ft.; 1920s bungalow. 80% of space for special exhibitions; 20% of space for gallery artists. Clientele: tourists, international collectors, local community. 95% private collectors, 5% corporate collectors. Overall price range: $500-50,000; most work sold at $1,000-5,000.
Media: Considers oil, acrylic, watercolor, pastel, drawing, collage, paper, photography. Most frequently exhibits photography, oil painting on steel and canvas, works on paper—various media.
Style: Exhibits painterly abstraction, conceptualism, conceptual photography. Prefers conceptual photography, painterly abstraction, conceptual painting.
Terms: Accepts work on consignment (60% commission). Retail price set by the gallery. Gallery provides insurance, promotion and contract; shipping costs are shared. Prefers artwork framed.
Submissions: Send query letter with slides, bio, photographs, SASE, reviews and artist's statement. Portfolio should include slides. Replies only if interested within 1 week. Files résumés. Finds artists through word of mouth, referrals by other artists, visiting art fairs and exhibitions, submissions.
Tips: "Visit the gallery; know scale of the gallery; send work that has relevance to my programme."

FULLER LODGE ART CENTER, Box 790, 2132 Central Ave., Los Alamos NM 87544. (505)662-9331. Director: Gloria Gilmore-House. Retail gallery/nonprofit gallery and rental shop for members. Estab. 1977. Represents over 50 emerging, mid-career and established artists. 388 members. Sponsors 11 shows/year. Average display time 1 month. Open all year. Located downtown; 1,300 sq. ft. 98% of space for special exhibitions. Clientele: local, regional and international visitors. 99% private collectors, 1% corporate collectors. Overall price range: $50-1,200; most artwork sold at $30-300.
Media: Considers all media, including original handpulled prints, woodcuts, engravings, lithographs, wood engravings, mezzotints, serigraphs, linocuts and etchings.
Style: Exhibits all styles and genres.
Terms: Accepts work on consignment (30% commission). Retail price set by the artist. Gallery provides insurance and promotion; artist pays for shipping. "Work should be in exhibition form (ready to hang)."
Submissions: "Prefer the unique." Send query letter with résumé, slides, bio, brochure, photographs, SASE and reviews. Files "résumés, etc.; slides returned only by SASE."
Tips: "No one-person shows—artists will be used as they fit in to scheduled shows." Should show "impeccable craftsmanship."

‡ELAINE HORWITCH GALLERIES, 129 W. Palace Ave., Santa Fe NM 87501. (505)988-8997. Fax: (505)989-8702. Assistant Director: David Perry. Retail gallery. Represents 75 emerging, mid-career and established artists/year. Exhibited artists include Tom Palmore, John Fincher. Sponsors 7 shows/year. Average display time 3-4 weeks. Open all year; Monday-Saturday, 9:30-5:30; Sunday 12-5:30 (summer); Tuesday-Saturday, 9:30-5; (winter). Located downtown; 10,000 sq. ft.; varied gallery spaces; upstairs barrel-vaulted ceiling with hardwood floors. 25-30% of space for special exhibitions; 75-70% of space for gallery artists. Clientele: "broad range—from established well-known collectors to those who are just starting." 95% private collectors, 5% corporate collectors. Overall price range: $650-350,000; most work sold at $1,500-15,000.

Media: Considers oil, acrylic, mixed media, sculpture and installation, lithograph and serigraphs. Most frequently exhibits oil, mixed media and acrylic/sculpture.

Style: Exhibits surrealism, minimalism, postmodern works, photorealism, hard-edge geometric abstraction and realism. Genres include landscapes, Southwestern and Western. Prefers realism/photorealism, postmodern works and minimalism.

Terms: Accepts work on consignment (50% commission). Retail price set by the gallery and the artist. Gallery provides insurance, promotion, contract and shipping costs from gallery; artist pays shipping costs to gallery. Prefers artwork framed.

Submissions: Prefers only "artists from the western United States but we consider all artists." Send query letter with résumé, slides or photographs, reviews and bio. "Artist must include self-addressed, stamped envelope if they want materials returned." Call for appointment to show portfolio of originals, photographs, slides or transparencies. Replies in 2 months. Finds artists through visiting exhibitions, various art magazines and art books, word of mouth, other artists, submissions.

IAC CONTEMPORARY ART/FISHER GALLERY, P.O. Box 11222, Albuquerque NM 87192-0222. (505)292-3675. E-mail: iac1@unm.edu. Website: www.artcafe.com.artcafe. Broker/Agent: Michael F. Herrmann.Gallery, art consultancy. Estab. 1992. Represents/exhibits emerging, mid-career and established artists. Exhibited artists include Vincent Distasio, Mary Sweet and Francine Tint. Sponsors 12 shows/year. Average display time 6 weeks. Open all year; Tuesday-Saturday, 12:15-5, May-September to 6. Gallery located at 1620 Central SE in upscale area on old Route 66, one block west of University of New Mexico. 100% of space for gallery artists. 80% private collectors, 10% corporate collectors, 10% museums. Overall price range: $250-40,000; most work sold at $800-7,000.

Media: Considers all media. Most frequently exhibits acrylics on canvas.

Style: Exhibits primitivism, painterly abstraction, postmodern works and surrealism. Genres include figurative work.

Terms: Artwork is accepted on consignment (50% commission). "Fees vary depending on event, market, duration." Retail price set by collaborative agreement with artist. Artist pays shipping costs. Prefers artwork framed.

Submissions: Send query letter with résumé, brochure, business card, slides, photographs, reviews, bio and SASE. Call or write for appointment to show portfolio of photographs or slides. Replies in 1 month.

Tips: "I characterize the work we show as Fine Art For the *Non*-McMainstream. We are always interested in seeing new work."

‡THE JAMISON GALLERIES, 560 Montezuma, #103, Santa Fe NM 87501. (505)982-3666. Fax: (505)982-3667. Contact: Z.B. Conley. Retail gallery, art consultancy. Estab. 1964. Represents 50 emerging, mid-career and established artists/year. Sponsors 1-2 shows/year. Average display time 2-3 weeks. Open all year; Monday-Friday, 10-5. Located in Guadalupe/Railroad District; 1,500 sq. ft.; placqued building, Santa Fe's oldest fine arts gallery. 33⅓% of space for special exhibitions. Clientele: tourists, upscale, local community. 85% private collectors. Most work sold at $500-2,000.

Media: Considers oil, acrylic, watercolor, pastel, pen & ink, drawing, mixed media, paper, sculpture, woodcuts, engravings, lithographs, wood engravings, mezzotints, serigraphs, linocuts and etchings. Most frequently exhibits oil/acrylic, watercolor, prints (original graphics).

Style: Exhibits expressionism, neo-expressionism, painterly abstraction, surrealism, impressionism, realism, imagism. Genres include Southwestern, landscapes, Americana. Prefers landscapes, figure work, still life.

Terms: Accepts work on consignment. Retail price set by the gallery and the artist. Gallery provides insurance and promotion; clients pay shipping costs from gallery; artist pays for shipping costs to gallery. Prefers artwork framed.

Submissions: Send query letter with résumé, bio, photographs, SASE, reviews, artist's statement. Call or write for appointment to show portfolio of photographs and transparencies. Replies only if interested within 1 month, call. Files bios, samples. Finds artists through word of mouth, referrals by other artists or clients.

MAYANS GALLERIES, LTD., 601 Canyon Rd., Santa Fe NM 87501; also at Box 1884, Santa Fe NM 87504. (505)983-8068. Fax: (505)982-1999. Contact: Ava Hu. Retail gallery and art consultancy. Estab. 1977. Represents 10 emerging, mid-career and established artists. Sponsors 2 solo and 2 group shows/year. Average display time 1 month. Clientele: 70% private collectors, 30% corporate clients. Overall price range: $1,000 and up; most work sold at $3,000-10,000.

Media: Considers oil, acrylic, watercolor, pastel, pen & ink, drawings, mixed media, sculpture, photography and original handpulled prints. Most frequently exhibits oil, photography, and lithographs.

Style: Exhibits 20th century American and Latin American art. Genres include landscapes and figurative work. Interested in work "that takes risks and is from the soul."

Terms: Accepts work on consignment. Retail price set by gallery and artist. Exclusive area representation required. Shipping costs are shared.

Submissions: Send query letter, résumé, business card and SASE. Discourages the use of slides. Prefers 2 or 3 snapshots or color photocopies which are representative of body of work. Files résumé and business card.

Tips: "Currently seeking contemporary figurative work and still life with strong color and technique. Gallery space cannot accomodate very large work comfortably."

‡THE MUNSON GALLERY, 225 Canyon Rd., Santa Fe NM 87501. (505)983-1657. Fax: (505)988-9867. Retail gallery. Estab. 1860. Represents 30 emerging, mid-career and established artists/year. Exhibited artists include Elmer Schooley. Sponsors 10 shows/year. Average display time 2 weeks. Open all year; everyday, 10-5. Features several rooms that vary in size, wall height; all adobe construction, brick floors, etc. 100% of space for gallery artists. Clientele: upscale locals and tourists. 95% private collectors, 5% corporate collectors. Overall price range: $200-45,000; most work sold at $3,000-5,000.
Media: Considers oil, acrylic, watercolor, pastel, mixed media, sculpture, ceramics. Considers all types of prints. Most frequently exhibits paintings, works on paper, mixed media.
Style: Exhibits expressionism, minimalism, color field, impressionism, photorealism, realism. Genres include florals, wildlife, Southwestern, landscapes, figurative work. Prefers painterly realism, expressionism, realism.
Terms: Accepts work on consignment (50% commission). Retail price set by the gallery and the artist. Gallery provides insurance and promotion; shipping costs are shared.
Submissions: Send query letter with bio, photographs, SASE. Call or write for appointment to show portfolio of photographs. Replies in 2 weeks. Files bios occasionally, announcements.

ROSWELL MUSEUM AND ART CENTER, 100 W. 11th St., Roswell NM 88201. (505)624-6744. Fax: (505)624-6765. Director: William D. Ebie. Museum. Estab. 1937. Represents emerging, mid-career and established artists. Sponsors 12-14 shows/year. Average display time 2 months. Open all year; Monday-Saturday, 9-5; Sunday and holidays, 1-5. Closed Thanksgiving, Christmas and New Years Day. Located downtown; 25,000 sq. ft.; specializes in Southwest. 50% of space for special exhibitions; 50% of space for gallery artists.
Media: Considers all media and all types of prints but posters. Most frequently exhibits painting, prints and sculpture.
Style: Exhibits all styles. Prefers Southwestern but some non-SW for context.
Terms: Accepts work on consignment (20% commission). Retail price set by the artist. Gallery provides insurance, promotion and shipping costs to and from gallery. Prefers artwork framed.
Submissions: Accepts only artists from Southwest or SW genre. Send query letter with résumé, slides, bio, brochure, photographs, SASE and reviews. Write for appointment to show portfolio of photographs, slides and transparencies. Replies in 1 week. Files "all material not required to return."
Tips: Looks for "Southwest artists or artists consistently working in Southwest genre." Advises artists to "make an appointment well in advance. Be on time. Be prepared. Don't bring a truckload of paintings or sculpture. Have copies of résumé and transparencies for filing. Be patient. We're presently scheduling shows 2 years in advance."

‡UNIVERSITY ART GALLERY, NEW MEXICO STATE UNIVERSITY, Williams Hall, Box 30001, Dept. 3572, University Ave. E. of Solano, Las Cruces NM 88003. (505)646-2545. Director: Charles Lovell. Estab. 1972. Represents emerging, mid-career and established artists. Exhibited artists include Liliana Porter, Celia Muñoz, Bill Ravanesi and Eric Avery. Sponsors 8 shows/year. Average display time 6-8 weeks. Open all year. Located at university; 4,000 sq. ft. 100% of space for special exhibitions.
Media: Considers all media and all types of prints.
Style: Exhibits all styles and genres.
Terms: Shipping costs are paid by the gallery. Prefers artwork framed, or ready to hang.
Submissions: Send query letter with résumé, 20 slides, bio, SASE, brochure, photographs, business card and reviews. Write for appointment to show portfolio of originals, photographs, transparencies and slides. Replies in 2 months. Files résumés.
Tips: "Our focus is contemporary art."

New York

ALBANY CENTER GALLERIES, 23 Monroe St., Albany NY 12210. (518)462-4775. Director/Curator: Leslie Urbach. Nonprofit gallery. Estab. 1977. Represents/exhibits emerging, mid-career and established artists. May be interested in seeing work of emerging artists in the future. Presents 12 exhibitions of 6 weeks each year. Exhibited artists include Leigh Li-Jun Wen, Mark McCarty, Martin Benjamin, Ed McCartan, Regis Brodie, David Miller, David Coughtny, Bill Botzow, Irena Altmanova. Selects 12 shows/year. Average display time 6 weeks. Located downtown; 9,000 sq. ft.; "excellent well lit space." 100% of space for gallery artists. Clientele: tourists, upscale, local community, students. 2% private collectors. Overall price range: $250-5,000; most work sold at $800-1,200.
Media: Considers all media and all types of prints except posters. Most frequently exhibits oil, sculpture and photography.

Style: Exhibits all styles. All genres. Prefers painterly abstraction, representational, sculpture and ceramics.
Terms: Artwork is accepted on consignment (30% commission). Retail price set by the artist. Gallery provides insurance, promotion, contract, reception and sales. Artist pays for shipping costs. Prefers artwork framed.
Submissions: Accepts only artists from within a 75 mile radius of Albany (the Mohawk-Hudson area). Send query letter with résumé, slides, reviews, bio and SASE. Call for appointment to show portfolio of photographs, slides and transparencies. Replies only if interested within 1 week. Files slides, résumés, etc. Finds artists through visiting exhibitions, submissions.
Tips: Advice to artists: "Try."

AMERICA HOUSE, 466 Piermont Ave., Piermont NY 10968. (914)359-0106. President: Susanne Casal. Retail craft gallery. Estab. 1974. Represents 200 emerging, mid-career and established artists. Sponsors 2 shows/year. Average display time 2 months. Open all year; Tuesday-Saturday, 10:30-5:30; Sunday, 12:30-5:30. Located downtown; 1,100 sq. ft.; 1st floor of renovated house. 50% of space for special exhibitions; 50% of space for gallery artists.
Media: Considers mixed media, ceramics, jewelry and glass. Most frequently displays jewelry, ceramics and glass.
Terms: Accepts work on consignment (50% commission) or buys outright for 50% of retail price (net 30 days). Retail price set by the artist. Gallery provides insurance, promotion and shipping costs from gallery; artist pays shipping costs to gallery. Prefers artwork framed. Finds artists through visiting exhibitions, word of mouth, art publications and sourcebooks.

‡ART DIALOGUE GALLERY, One Linwood Ave., Buffalo NY 14209-2203. (716)885-2251. Director: Donald James Siuta. Retail gallery, art consultancy. Estab. 1985. Represents 550 emerging, mid-career and established artists/year. Exhibited artists include Catherine Burchfield Parker, Alberto Rey, Raymond A Massey. Sponsors 14 shows/year. Average display time 4-6 weeks. Open all year; Tuesday-Friday, 11-5; Saturday, 11-3. Located in downtown Buffalo/Allentown District; 1,200 sq. ft. 80% of space for special exhibitions; 20% of space for gallery artists. Clientele: young professionals and collectors. 60% private collectors, 20% corporate collectors. Overall price range: $100-25,000; most work sold at $300-500.
Media: Considers oil, acrylic, watercolor, pastel, pen & ink, drawing, mixed media, collage, paper, sculpture, ceramics, glass, photography and all types of prints. Most frequently exhibits oil painting, watercolor and mixed media.
Style: Prefers realism, abstract and cutting edge.
Terms: Accepts work on consignment (40% commission). Retail price set by the gallery. "Art work is insured from time of delivery to set pick-up date. Artists pay for promotion-invitations etc." Artist pays shipping costs. Prefers artwork framed for shows, unframed for stacks.
Submissions: Accepts only artists from western New York, southern Ontario. Send query letter with résumé, slides, bio, or photographs, SASE, reviews, artist's statement. Call or write for appointment to show portfolio of slides. Files slides and résumés. Finds artists through word of mouth, referrals by artists, visiting art fairs and exhibitions, submissions.
Tips: "Don't show work that is not available, price work too high or frame work poorly."

CEPA (CENTER FOR EXPLORATORY AND PERCEPTUAL ART), 700 Main St., 4th Floor, Buffalo NY 14202. Fax: (716)856-2720. E-mail: cepa@aol.com. Director/Curator: Robert Hirsch. Alternative space and nonprofit gallery. Interested in emerging, mid-career and established artists. Sponsors 5 solo and 1 group show/year. Average display time 4-6 weeks. Open fall, winter and spring. Clientele: artists, students, photographers and filmmakers. Prefers photographically related work.
Media: Installation, photography, film, mixed media, computer imaging and digital photography.
Style: Contemporary photography. "CEPA provides a context for understanding the aesthetic, cultural and political intersections of photo-related art as it is produced in our diverse society." Interested in seeing "conceptual, installation, documentary and abstract work."
Terms: Accepts work on consignment (25% commission).
Submissions: Call first regarding suitability for this gallery. Send query letter with résumé, slides, SASE, brochure, photographs, bio and artist's statement. Call or write for appointment to show portfolio of slides and photographs. Replies in 6 weeks.
Tips: "It is a policy to keep slides and information in our file for indefinite periods. Grant writing procedures require us to project one and two years into the future. Provide a concise and clear statement to give staff an overview of your work."

CHAPMAN ART CENTER GALLERY, Cazenovia College, Cazenovia NY 13035. (315)655-9446. Fax: (315)655-2190. Director: John Aistars. Nonprofit gallery. Estab. 1978. Interested in emerging, mid-career and established artists. Sponsors 8-9 shows/year. Average display time is 3 weeks. Clientele: the greater Syracuse community. Overall price range: $50-3,000; most artwork sold at $100-200.
Media: Considers oil, acrylic, watercolor, pastel, pen & ink, drawings, sculpture, ceramic, fiber, photography, craft, mixed media, collage, glass and prints.

Wild about watercolor?

If you work in watercolor, acrylic, gouache or other water-based media, then you'll love WATERCOLOR MAGIC. In every issue you'll explore the unique properties of these media, and learn new techniques that can make a difference in your art.

Like how to capture light in your watercolors. How to impart real emotion in your work. How to make your acrylics behave like watercolor...or oil! You'll learn the keys to great figure painting. Masterful glazing techniques. And get special sections on choosing the right equipment, plus loads of studio tips and shortcuts.

FREE ISSUE OFFER
Mail the card below to get a free issue and try WATERCOLOR MAGIC for yourself. There's no cost or obligation!

CHARTER SUBSCRIPTION OFFER

○ *YES!* Send my **free issue** of WATERCOLOR MAGIC and start my 1-year charter subscription. If the magazine is not for me, I'll return your invoice marked "cancel" and owe nothing. Or, I'll honor it and pay just $14.99 for 3 more issues (4 in all).

NAME _____

ADDRESS _____

SPECIAL! from THE ARTIST'S MAGAZINE

Watercolor Magic

Secrets to
Successful
Watercolor

6 Ways to
Energize
Your Paintings
with **Splatter**

Special Report:
Our Indispensable
Guide to
Color

CITY _____

STATE _____ ZIP _____

Allow 4-6 weeks for first issue delivery. Outside U.S. add $7 (includes GST in Canada) and remit in U.S. funds. Annual newsstand rate $15.96.

Watercolor Magic™

TUAM0

Explore the water-based media or learn specialized techniques...

It's easy with the expert instruction in WATERCOLOR MAGIC. You'll find helpful advice for everything from choosing a palette to framing your work, such as:

- electrifying your paintings with light

- layering with acrylics for watercolor effects

- how to choose and cut mats for your work

- 6 tips for well-placed focal points

- how to achieve dramatic contrasts of light and dark

- creating texture with pen, ink and watercolor

See for yourself how WATERCOLOR MAGIC can enhance your painting skills and make you a better artist. Mail the card below to claim your free issue today!

NO POSTAGE
NECESSARY
IF MAILED
IN THE
UNITED STATES

BUSINESS REPLY MAIL

FIRST CLASS MAIL PERMIT NO. 185 HARLAN, IOWA

POSTAGE WILL BE PAID BY ADDRESSEE

Watercolor Magic™

PO BOX 5439
HARLAN IA 51593-2939

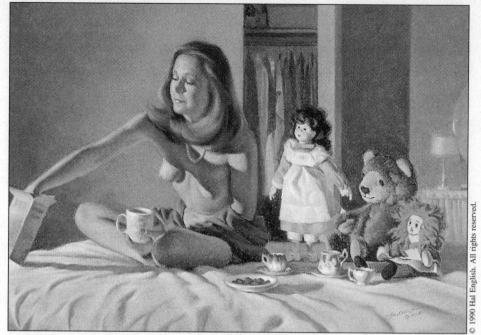

In his pastel drawing, *Closet Friends Revisited*, Hal English sought to convey a wish to return to the innocence of childhood. "The artist's work is always well-received," says a spokesperson for Art Dialogue Gallery. "A Life of Art: A Retrospective Exhibit," including work from throughout English's 62-year career "was one of the most successful selling shows we've had in years." *Closet Friends* sold for $3,500.

Style: Exhibits all styles. "Exhibitions are scheduled for a whole academic year at once. The selection of artists is made by a committee of the art faculty in early spring. The criteria in the selection process is to schedule a variety of exhibitions every year to represent different media and different stylistic approaches; other than that, our primary concern is quality. Artists are to submit to the committee by March 1 a set of slides or photographs and a résumé listing exhibitions and other professional activity."

Terms: Retail price set by artist. Exclusive area representation not required. Gallery provides insurance and promotion; works are usually not shipped.

Submissions: Send query letter, résumé, 10-12 slides or photographs.

Tips: A common mistake artists make in presenting their work is that the "overall quality is diluted by showing too many pieces. Call or write and we will mail you a statement of our gallery profiles."

DARUMA GALLERIES, 554 Central Ave., Cedarhurst NY 11516. (516)569-5221. Owner: Linda Tsuruoka. Retail gallery. Estab. 1980. Represents about 25-30 emerging and mid-career artists. Exhibited artists include Christine Amarger, Eng Tay, Dorothy Rice, Joseph Dawley, Seymour Rosenthal, Kamil Kubick and Nitza Flantz. Sponsors 2-3 shows/year. Average display time 1 month. Open all year. Located on the main street; 1,000 sq. ft. 100% private collectors. Overall price range: $150-5,000; most work sold at $250-1,000.

Media: Considers watercolor, pastel, pen & ink, drawings, mixed media, collage, woodcuts, linocuts, engravings, mezzotints, etchings, lithographs and serigraphs. Most frequently exhibits etchings, lithographs and woodcuts.

Style: Exhibits all styles and genres. Prefers scenic (not necessarily landscapes), figurative and Japanese woodblock prints. "I'm looking for beach, land and sea scapes; sailing; pleasure boats."

Terms: 40% commission for originals; 50% for paper editions. Retail price set by the gallery (with input from the artist). Sometimes offers customer discounts and payment by installments. Artist pays for shipping to and from gallery. Prefers unframed artwork.

Submissions: Send query letter with résumé, bio and photographs. Call for appointment to show portfolio of originals and photographs. Replies "quickly." Files bios and photo examples. Finds artists through agents, visiting exhibitions, word of mouth, various art publications and sourcebooks, submissions/self-promotions and art collectors' referrals.

Tips: "Bring good samples of your work and be prepared to be flexible with the time needed to develop new talent. Have a competent bio, presented in a professional way. Use good materials. Often artists have nice images but they put them on cheap, low-quality paper which creases and soils easily. Also, I'd rather

see work matted in acid-free mats alone, rather than cheaply framed in old and broken frames.''

‡**EAST END ARTS COUNCIL**, 133 E. Main St., Riverhead NY 11901. (516)727-0900. Visual Arts Coordinator: Patricia Berman. Nonprofit gallery. Estab. 1971. Exhibits the work of 30 emerging, mid-career and established artists. Sponsors 30 solo and 7 group shows/year. Average display time 6 weeks. Prefers regional artists. Clientele: 100% private collectors. Overall price range: $10-10,000; most work sold at under $200.
Media: Considers all media and prints.
Style: Exhibits contemporary, abstract, primitivism, non-representational, photorealism, realism and postpop works. Genres include figurative, landscapes, florals, American and Western. "Being an organization relying strongly on community support, we walk a fine line between serving the artistic needs of our constituency and exposing them to current innovative trends within the art world. Therefore, there is not a particular area of specialization. We show photography, fine craft and all art media."
Terms: Accepts work on consignment (30% commission). Retail price set by gallery and artist. Exclusive area representation not required. Gallery provides insurance, promotion and contract; artist pays for shipping to and from gallery.
Submissions: Send query letter, résumé and slides. All materials returned.
Tips: "When making a presentation don't start with 'My slides really are not very good.' Slides should be great or don't use them."

THE GALLERY AT HUNTER MOUNTAIN, Rt. 23A, Ski Bowl Base Lodge, Hunter NY 12442. (518)263-4365. Fax: (518)263-3704. Gallery Director: Peter L. James. Retail gallery and art consultancy. Estab. 1990. Represents/exhibits 275 emerging artists/year. Interested in seeing the work of emerging artists. Exhibited artists include Scott T. Balfe, F.E. Green, Stanley Maltzman and Cecile Johnson. Sponsors 12 shows/year. Average display time 1 month. Open all year; Wednesday-Monday, 9-4:30. Located at Base Lodge of Hunter Mountain Ski Bowl; 800 sq. ft. "We are the only art gallery in the world located at a ski resort and open year round." 40% of space for special exhibitions; 60% of space for gallery artists. Clientele: tourists, second home res. 90% private collectors, 10% corporate collectors. Overall price range: $100-7,000; most work sold at $100-500.
Media: Considers all media and all types of prints. Most frequently exhibits oil on canvas, pastel and acrylic on canvas/board.
Style: Exhibits expressionism, photorealism, realism and impressionism. Genres include landscapes, florals, wildlife, Americana, portraits and figurative work. Prefers landscape, figurative and wildlife.
Terms: Artwork is accepted on consignment (25% commission). Retail price set by the artist. Gallery provides promotion and shipping costs.
Submissions: Accepts only artists from Catskills and Mid-Hudson (Hudson Valley) Region. Send query letter with résumé and SASE. Call for appointment to show portfolio of photographs and slides. Replies in 6 weeks. Files résumé. Finds artists through submissions, referrals by other artists.
Tips: "Please stop into the gallery to see if our space and location meets the artist's needs before sending in a portfolio. Artist should live within a reasonable distance from gallery so that we may change work frequently."

‡**GIL'S BOOK LOFT AND GALLERY**, 82 Court St., 2nd Floor, Binghamton NY 13901. (607)771-6800. Owner: Gil Williams. Retail gallery. Estab. 1991. Represents 50 emerging, mid-career and established artists/year. Exhibited artists include James Skvarch, Mel Fowler. Sponsors 6 shows/year. Average display time 2 months. Open all year; Tuesday-Saturday, 11-5:30; extra hours October-December. 1,800 sq. ft. "We create a living room atmosphere with new and old pottery, art and books." 10% of space for special exhibitions; 10% of space for gallery artists. Clientele: upscale, tourists. 100% private collectors. Overall price range: $25-2,500; most work sold at $50-200.
Media: Considers oil, watercolor, pastel, pen & ink, drawing, ceramics, photography, woodcuts, engravings, lithographs, wood engravings, mezzotints, serigraphs, linocuts, etchings; "Must be artist-made prints—no photo prints, offset or photocopy." Most frequently exhibits etchings, oils, drawings (pencil or pastel).
Style: Exhibits impressionism, photorealism, realism. Genres include florals, portraits, landscapes, Americana, figurative work. Prefers American realism, American impressionists.
Terms: Buys outright for 50% of retail price (net 90 days). Retail price set by the gallery with the artist's help. Gallery provides promotion; artist pays for shipping costs to gallery. Prefers artwork unframed.
Submissions: Accepts only artists from PA, NY and New England. Send query letter with résumé, slides, bio, SASE, business card, reviews. Call or write for appointment to show portfolio of postcards, when available and original art. Replies in 2 weeks. Files almost all material. Finds artists through exhibitions, print clubs, *American Artist* profiles.

GUILD HALL MUSEUM, 158 Main St., East Hampton NY 11937. (516)324-0806. Fax: (516)324-2722. Curator: Christina Mossaides Strassfield. Museum. Estab. 1931. Represents emerging, mid-career and established artists. Sponsors 6-10 shows/year. Average display time 6-8 weeks. Open all year; Wednesday-Sunday,

11-5. 500 running feet; features artists who live and work on eastern Long Island. 85% of space for special exhibitions.
Media: Considers all media and all types of prints. Most frequently exhibits painting, prints and sculpture.
Style: Exhibits all styles, all genres.
Terms: Artwork is donated or purchased. Gallery provides insurance and promotion. Prefers artwork framed.
Submissions: Accepts only artists from eastern Long Island. Send query letter with résumé, slides, bio, brochure, SASE and reviews. Write for appointment to show portfolio of originals and slides. Replies in 2 months.

‡KIRKLAND ART CENTER, East Park Row, P.O. Box 213 Clinton NY 13323-0213. (315)853-8871. Contact: Director. Nonprofit gallery. Estab. 1960. Interested in emerging, mid-career and established artists. Sponsors 4 solo and 6 group shows/year. Average display time is 1 month. Clientele: general public and art lovers; 99% private collectors, 1% corporate clients. Overall price range: $60-4,000; most artwork sold at $200-1,200.
Media: Considers oil, acrylic, watercolor, pastel, pen & ink, drawings, mixed media, collage, works on paper, sculpture, ceramic, craft, fiber, glass, installation, photography, performance art and original handpulled prints. Most frequently exhibits watercolor, oil/acrylic, prints, sculpture, drawings, photography and fine crafts.
Style: Exhibits painterly abstraction, conceptualism, impressionism, photorealism, expressionism, realism and surrealism. Genres include landscapes, florals and figurative work.
Terms: Accepts work on consignment (25% commission). Retail price set by artist. Exclusive area representation not required. Gallery provides insurance, promotion and contract; artist pays for shipping.
Submissions: Send query letter, résumé, slides, slide list and SASE or write for appointment to show portfolio.
Tips: "Shows are getting very competitive—artists should send us slides of their most challenging work, not just what is most saleable. We are looking for artists who take risks in their work and display a high degree of both skill and imagination. It is best to call or write for instructions and more information."

LEATHERSTOCKING GALLERY, Pioneer Alley, P.O. Box 446, Cooperstown NY 13326. (607)547-5942. (Gallery) (607)547-8044 (Publicity). Publicity: Dorothy V. Smith. Retail nonprofit cooperative gallery. Estab. 1968. Represents emerging, mid-career and established artists. 55 members. Sponsors 1 show/year. Average display time 3 months. Open in the summer (mid-June to Labor Day); daily 11-5. Located downtown Cooperstown; 300-400 sq. ft. 100% of space for gallery artists. Clientele: varied locals and tourists. 100% private collectors. Overall price range: $25-500; most work sold at $25-100.
Media: Considers oil, acrylic, watercolor, pastel, pen & ink, drawing, mixed media, collage, paper, sculpture, ceramics, craft, photography, handmade jewelry, woodcuts, engravings, lithographs, wood engravings, mezzotints, serigraphs, linocuts and etchings. Most frequently exhibits watercolor, oil and crafts.
Style: Exhibits impressionism and realism, all genres. Prefers landscapes, florals and American decorative.
Terms: Co-op membership fee plus a donation of time (10% commission). Retail price set by the artist. Gallery provides insurance, promotion and contract; artist pays shipping costs from gallery if sent to buyer. Prefers artwork framed.
Submissions: Accepts only artists from Otsego County; over 18 years of age; member of Leatherstocking Brush & Palette Club. Replies in 2 weeks. Finds artists through word of mouth locally; articles in local newspaper.
Tips: "We are basically non-judgemental (unjuried). You just have to live in the area!"

‡MILLENNIUM GALLERY, 62 Park Place, East Hampton NY 11937. (516)329-2288. Fax: (516)329-2294. Director: Dr. Jon-Henri Bonnard. Retail gallery. Estab. 1994. Represents 15 emerging, mid-career and established artists/year. Exhibited artists include Tor Lundval, Jarvis Wilcox. Sponsors 12 shows/year. Average display time 3-4 weeks. Open all year; 7 days a week. 1,200 sq. ft. 90% for special exhibitions. Clientele: tourists, upscale. Most work sold at $400-20,000.
Media: Considers all media, woodcuts and engravings. Most frequently exhibits oil/canvas, pastel/paper, sculpture.
Style: Exhibits expressionism, painterly abstraction, conceptualism, impressionism, realism. Genres include landscapes and figurative work. Prefers realism, expressionism, conceptualism.
Terms: Accepts work on consignment (50% commission). Retail price set by the gallery. Gallery provides insurance, promotion and contract; artist pays for shipping. Prefers artwork framed.
Submissions: Accepts only artists from east end of Long Island. Send query letter with slides, bio, photographs. Call for appointment to show portfolio of photographs. Replies only if interested within 2 weeks.

OXFORD GALLERY, 267 Oxford St., Rochester NY 14607. (716)271-5885. Fax: (716)271-2570. Director: Virginia Hall. Retail gallery. Estab. 1961. Represents 50 emerging, mid-career and established artists. Sponsors 10 shows/year. Average display time 1 month. Open all year. Located "on the edge of downtown; 1,000 sq. ft.; large gallery in a beautiful 1910 building." 50% of space for special exhibitions. Overall price range: $100-30,000; most work sold at $1,000-2,000.

Media: Considers oil, acrylic, watercolor, pastel, pen & ink, drawings, mixed media, collage, paper, sculpture, ceramic, fiber, installation, original handpulled prints, woodcuts, engravings, lithographs, wood engravings, mezzotints, serigraphs, linocuts and etchings.

Styles: All styles.

Terms: Accepts artwork on consignment (50% commission). Retail price set by gallery and artist. Gallery provides promotion and contract.

Submissions: Send query letter with résumé, slides, bio and SASE. Replies in 2-3 months. Files résumés, bios and brochures.

Tips: "Have professional slides done of your artwork."

‡PORT WASHINGTON PUBLIC LIBRARY, One Library Dr., Port Washington NY 11050. (516)883-4400. Fax: (516)883-7927. Chair, Art Advisory Council: Eric Pick. Nonprofit gallery. Estab. 1970. Represents 10-12 emerging, mid-career and established artists/year. 23 members. Exhibited artists include Frank Stella, Robert Dash. Sponsors 10-12 shows/year. Average display time 1 month. Open all year; Monday-Friday, 9-9; Saturday, 9-5; Sunday, 1-5. Located midtown, 972 sq. ft. Overall price range: up to $100,000; most work sold at $500-1,000.

Media: Considers all media and all types of prints.

Style: Exhibits all styles.

Terms: Accepts work on consignment (0% commission); buys outright for 100% of retail price. Price set by the artist. Gallery provides insurance and promotion; gallery pays for shipping.

Submissions: Send query letter with résumé, slides, bio, SASE. Replies in 1 month. Artist should call library. Finds artists through word of mouth, referrals by other artists, visiting art fairs and exhibitions, submissions.

‡PRAKAPAS GALLERY, 1 Northgate 6B, Bronxville NY 10708. (914)961-5091 or (914)961-5192. Private dealers. Estab. 1976. Represents 50-100 established artists/year. May be interested in seeing the work of emerging artists in the future. Exhibited artists include Leger, El Lissitsky. Located in suburbs. Clientele: institutions and private collectors. Overall price range: $500-500,000.

Media: Considers all media and all types of prints

Style: Exhibits all styles. "Emphasis in on classical modernism."

Submissions: Finds artists through word of mouth, referrals by other artists, visiting art fairs and exhibitions, submissions.

PRINT CLUB OF ALBANY, 140 N. Pearl St., P.O. Box 6578, Albany NY 12206. (518)432-9514. President: Dr. Charles Semowich. Nonprofit gallery and museum. Estab. 1933. Exhibits the work of 70 emerging, mid-career and established artists. Sponsors 1 show/year. Average display time 6 weeks. Located in downtown arts district. "We currently have a small space and hold exhibitions in other locations." Clientele: varies. 90% private collectors, 10% corporate collectors.

Media: Considers original handpulled prints.

Style: Exhibits all styles and genres. "No reproductions."

Terms: Accepts work on consignment from members. Membership is open internationally. "We welcome donations (of artists' works) to the permanent collection." Retail price set by artist. Customer discounts and payment by installment are available. Gallery provides promotion. Artist pays for shipping. Prefers artwork framed.

Submissions: Prefers only prints. Send query letter. Write for appointment to show portfolio of slides. Replies in 1 week.

Tips: "We are a nonprofit organization of artists, collectors and others. Artist members exhibit without jury. We hold member shows and the Triannual National Open Competitive Exhibitions. We commission an artist for an annual print each year. Our shows are held in various locations. We are planning a museum (The Museum of Prints and Printmaking) and building. We also collect artists' papers, etc. for our library."

RCCA: THE ARTS CENTER, 189 Second St., Troy NY 12180. (518)273-0552. Fax: (518)273-4591. Gallery Director: Tara Fracalossi. Nonprofit arts center. Estab. 1969. Represents/exhibits 12-15 emerging artists/year. Interested in seeing the work of emerging artists. Exhibited artists include Robin Tewes, Ken Polinskie and Thomas Lail. Sponsors 6-8 shows/year. Average display time 4-6 weeks. Open all year; Monday-Saturday, 9-5. Located in historic district; 1,200 sq. ft.; moving to 40,000 sq. ft. renovated arts center in spring 1997. 100% of space for special exhibitions. Clientele: upscale, students, artists. 90% private collectors, 10% corporate collectors. Overall price range: $50-5,000; most work sold at $400-500.

Media: Considers all media, woodcuts, wood engravings, linocuts, engravings, mezzotints, etchings and lithographs. Most frequently exhibits painting, sculpture and photography/installation.

Style: Exhibits neo-expressionism, painterly abstraction, all styles. Prefers contemporary images, conceptual work and postmodern.

Terms: Artwork is accepted on consignment (25% commission). Retail price set by the gallery and the artist. Gallery provides insurance and promotion. Artist pays for shipping costs.

Submissions: Send query letter with SASE to receive information about annual call for slides. Submit work to call for slides. Portfolio should include slides. Replies in 1 month. Files slides and résumés in curated slide registry.

SCHWEINFURTH MEMORIAL ART CENTER, 205 Genesee St., Auburn NY 13021. (315)255-1553. Director: David Kwasigroh. Museum. Estab. 1981. Represents emerging, mid-career and established artists. Sponsors 15 shows/year. Average display time 2 months. Open Tuesday-Friday, 12-5; Saturday, 10-5; Sunday, 1-5. Closed in January. Located on the outskirts of downtown; 7,000 sq. ft.; large open space with natural and artificial light.
 • Schweinfurth has an AA Gift Shop featuring handmade arts and crafts, all media, for which they're looking for work.
Media: Considers all media, all types of prints.
Style: Exhibits all styles, all genres.
Terms: Retail price set by the artist. Gallery provides insurance and promotion; artist pays for shipping costs. Artwork must be framed and ready to hang.
Submissions: Accepts artists from central New York and across the nation. Send query letter with résumé, slides and SASE.

‡**CHARLES SEMOWICH FINE ARTS**, 242 Broadway, Rensselaer NY 12144. (518)449-4756. Owner: Charles Semowich. Private art gallery. Estab. 1985. Represents 250 established artists/year. Open all year; by appointment. Located downtown. Clientele: dealers. 20% private collectors. Overall price range: $200-800.
Media: Considers all media and all types of prints.
Style: Exhibits all styles and all genres.
Terms: Buys outright for 50% of retail price. Retail price set by the gallery.
Submissions: Write for appointment.

‡**SHOESTRING GALLERY**, 1855 Monroe Ave., Rochester NY 14618. (716)271-3886. Manager: Julie Rowe. Retail gallery. Estab. 1968. Represents 50 emerging, mid-career and established artists/year. Exhibited artists include Lynn Shaler, Ruth Vaughan. Sponsors 9 shows/year. Average display time 1 month. Open all year; Monday-Friday, 9-5; Saturday, 10-5; Thursday until 8pm. Located in a suburb on edge of city; 1,600 sq. ft. 30% of space for special exhibitions; 80% of space for gallery artists. Clientele: local community. 25% corporate collectors. Overall price range: $15-3,000; most work sold at $300-500.
Media: Considers oil, acrylic, watercolor, pastel, mixed media, collage, paper, ceramics, glass, woodcuts, engravings, lithographs, wood engravings, mezzotints, serigraphs, linocuts and etchings. Most frequently exhibits watercolor, pastel and acrylic.
Style: Exhibits expressionism, impressionism, pattern painting and realism. Genres include florals, land-scapes, figurative work, still life, interiors. Prefers impressionism, realism, abstract expressionism.
Terms: Accepts work on consignment (50% commission). Retail price set by the artist. Gallery provides promotion and contract; shipping costs are shared. Prefers artwork framed.
Submissions: Send query letter with slides, bio, photographs and SASE. Replies in 1 month. Files letter of query. Finds artists through submissions, local exhibitions and art fairs.
Tips: "Be sure to include enough information about the work, particularly pricing."

BJ SPOKE GALLERY, 299 Main St., Huntington NY 11743. (516)549-5106. President: Constance Wain-Schwartz. Cooperative and nonprofit gallery. Estab. 1978. Exhibits the work of 24 emerging, mid-career and established artists. Sponsors 2-3 invitationals and juried shows/year. Average display time 1 month. Open all year. "Located in center of town; 1,400 sq. ft.; flexible use of space—3 separate gallery spaces." Generally, 66% of space for special exhibitions. Overall price range: $300-2,500; most work sold at $900-1,600. Artist is eligible for a 2-person show every 18 months. Entire membership has ability to exhibit work 11 months of the year.
 • Sponsors annual national juried show. Deadline December. Send SASE for prospectives.
Media: Considers all media except crafts, all types of printmaking. Most frequently exhibits paintings, prints and sculpture.
Style: Exhibits all styles and genres. Prefers painterly abstraction, realism and expressionism.
Terms: Co-op membership fee plus donation of time (25% commission). Monthly fee covers rent, other gallery expenses. Retail price set by artist. Payment by installment is available. Gallery provides promotion

HOW TO USE your *Artist's & Graphic Designer's Market* offers suggestions for understanding and using the information in these listings. Read this and other articles in the front of this book for important business tips.

and publicity; artists pay for shipping. Prefers artwork framed; large format artwork can be tacked.
Submissions: For membership, send query letter with résumé, high-quality slides, bio, SASE and reviews. For national juried show send SASE for prospectus and deadline. Call or write for appointment to show portfolio of originals and slides. Files résumés; may retain slides for awhile if needed for upcoming exhibition.
Tips: "Send slides that represent depth and breadth in the exploration of a theme, subject or concept. They should represent a cohesive body of work."

‡**THE TRUE FRESCO STUDIO**, P.O. Box 1865, Bridgehampton NY 11932. (516)537-0004 or (516)729-8668. Fax: (516)725-0918. Art-Founder: Ilia Anossov. Estab. 1994. Represents 5 emerging artists/year. Exhibited artists include Garles Gallager, Ilia Ano. Sponsors 4-8 shows/year. Average display time 1 year. Open all year; Thursday-Monday, 9-6. 1,000 sq. ft. 100% of space for gallery artists. Clientele: upscale, tourists, local. 50% private collectors, 50% corporate collectors. Overall price range: $2,000-4,000.
Media: Considers true fresco, marble, drawings, cartoons; new naive style—all media, lithographs and serigraphs. Most frequently exhibits true fresco, marble, video.
Style: Exhibits new naive.
Terms: Agreement varies. Retail price set by the gallery and the artist. Gallery provides insurance, promotion and contract; shipping costs are shared.
Submissions: Send query letter with résumé, bio, SASE and artist's statement. Call for appointment to show portfolio of photographs, slides and reviews. Replies in 3 weeks. Call in 2 following weeks. Files portfolio.
Tips: "Artist's statement must explain artist's faith (beliefs)."

‡**VERED GALLERY**, 66-68 Park Place Passage, East Hampton NY 11937. (516)324-3303. Fax: (516)324-3303. Estab. 1976. Represents 20 established artists. Interested in seeing work of emerging artists. Exhibited artists include Milton Avery, Wolf Kahn. Sponsors 10 shows/year. Average display time 3 weeks. Open all year; Thursday-Monday, 11-6. Located across from the movie theater in East Hampton; 2,000 sq. ft.

New York City

A.I.R. GALLERY, 40 Wooster St., Floor 2, New York NY 10013-2229. (212)966-0799. Director: Alissa Schoenfeld. Cooperative nonprofit gallery, alternative space. To advance the status of women artists and provide a sense of community. Estab. 1972. Represents/exhibits emerging, mid-career and established women artists. 20 New York City members; 15 National Affiliates. Sponsors 15 shows/year. Average display time 3 weeks. Open all year except late summer; Tuesday-Saturday, 11-6. Located in Soho; 1,600 sq. ft., 11′8″ ceiling; the end of the gallery which faces the street is entirely windows. 20% of space for special exhibitions; 80% of space for gallery artists. Clientele: art world professionals, students, artists, local community, tourists. Overall price: $500-15,000; most work sold at $1,000-5,000.
Media: Considers all media and all types of prints.
Style: Exhibits all styles. All genres.
Terms: There is a co-op membership fee plus a donation of time. There is a 15% commission. Retail price set by the artist. Gallery provides limited promotion (i.e., Gallery Guide listing) and contract. Artist pays for shipping costs. Prefers artwork framed.
Submissions: Membership and exhibitions are open to women artists. Send query letter with résumé, slides and SASE. Replies in 2 months. Files no material unless an artist is put on the waiting list for membership. Finds artists through word of mouth, referrals by other artists, suggestions by past and current members.
Tips: "A.I.R. has both New York City members and members across the United States. We also show emerging artists in our Gallery II program which is open to all artists interested in a one-time exhibition. Please specify whether you are applying for membership, Gallery II or both."

‡**THE ART ALLIANCE**, 98 Greene St., New York NY 10012. (212)274-1704. Fax: (212)274-1682. President: Leah Poller. Artist agent, curator and consultant. Estab. 1989. Represents 15 mid-career and established artists/year. Exhibited artists include Bernardo Torrens, Mario Murua. Sponsors 3-5 in gallery, 10 in outside spaces/year. Average display time 1 month. Open 11-5 by appointment. Closed July and August. Located in Soho loft; 1,200 sq. ft. 70% of space for special exhibitions; 30% of space for gallery artists. Clientele: international, corporate, major collectors. 80% private collectors, 20% corporate collectors. Overall price range: $1,500-75,000; most work sold at $10,000-20,000.
Media: Considers oil, acrylic, watercolor, pastel, pen & ink, drawing, mixed media, collage and sculpture. Most frequently exhibits oil, sculpture and drawing.
Style: Exhibits expressionism, neo-expressionism, surrealism and realism. Prefers realism—figurative, sculpture—figurative, expressionism/neo-expressionism.
Terms: Accepts work on consignment (50% commission). Retail price set by the artist. Gallery provides insurance, promotion, contract and shipping costs from gallery. Requires artwork framed.

Submissions: Prefers non-American artists; does not accept emerging artists. Send query letter with résumé, slides, bio and SASE. Write for appointment to show portfolio of slides and artist statement. Replies in 1 month. Finds artists through art fairs, other artists.
Tips: "Ask for catalogs on my artists to see quality, bios."

ARTISTS SPACE, 38 Greene St., 3rd Floor, New York NY 10013. (212)226-3970. Fax: (212)966-1434. Website: http\\www.avsi.com\artistsspace. Curator: Anastasia Aukeman. Nonprofit gallery, alternative space. Estab. 1973. Represents/exhibits emerging artists. Sponsors 4-5 shows/year. Average display time 6-8 weeks. Open Tuesday-Saturday, 10-6. Located in Soho; 5,000 sq. ft. 100% of space for special exhibitions.
Media: Considers all media.
Terms: "All curated shows selected by invitation." Gallery provides insurance and promotion.
Submissions: Send query letter with slides and SASE and application. Portfolio should include slides.

‡ASIAN AMERICAN ARTS CENTRE, 26 Bowery, New York NY 10013. (212)233-2154. Fax: (212)766-1287. Executive Director: Robert Lee. Nonprofit gallery. Estab. 1974. Exhibits the work of emerging and mid-career artists; 600 artists in archives file. Sponsors 4 shows/year. Average display time 4-6 weeks. Open September through June. Located in Chinatown; 1,800 sq. ft.; "a gallery and a research facility." 100% of space for special exhibitions. Overall price range: $500-10,000; most work sold at $500-3,000.
Media: Considers all media and all types of prints. Prefers paintings, installation and mixed media.
Style: Exhibits all styles and genres.
Terms: Suggests a donation of 20% of the selling price. Retail price set by the artist. Gallery provides insurance and promotion. Shipping costs are shared. Prefers artwork framed.
Submissions: Send query letter with résumé and slides. Will call artists if interested. Portfolio should include slides. Replies only if interested within 6-8 weeks. Files slides.

‡BARNARD—BIDERMAN FINE ART, 22 E. 72nd St., New York NY 10021. (212)772-2352. Fax: (212)921-2058. Director: Isabel Barnard-Biderman. Retail gallery. Estab. 1990. Represents 20 emerging and established artists/year. Exhibited artists include Andres Monreal, Fernando De Szyszlo, Toledo. Sponsors 8 shows/year. Average display time 1 month. Open all year; 12-6. Located uptown; 2,000 sq. ft. 90% of space for special exhibitions; 90% of space for gallery artists. 80% private collectors, 20% corporate collectors. Overall price range: $2,000-18,000; most work sold at $2,000-12,000.
Media: Considers oil, acrylic, engravings, lithographs, mezzotints and etchings. Most frequently exhibits oil and acrylic on canvas and mezzotints.
Style: Exhibits expressionism, neo-expressionism, painterly abstraction, postmodern works and realism. Genres include landscapes. Prefers expressionism, neo-expressionism and realism.
Terms: "We work on commission from 30% to 50%. We also buy." Retail price set by the gallery. Gallery provides insurance, promotion and contract; artist pays shipping to and from gallery. Prefers artwork framed.
Submissions: Accepts only artists from Latin America. Send query letter with résumé, slides and photographs. Call for appointment to show portfolio of photographs and transparencies. Replies only if interested within 3 weeks. Finds artists through word of mouth, submissions.

BROOKLYN BOTANIC GARDEN—STEINHARDT CONSERVATORY GALLERY, 1000 Washington Ave., Brooklyn NY 11225. (718)622-4433, ext. 215. Fax: (718)622-7839. Director of Public Programs: Joanne Woodfin. Nonprofit botanic garden gallery. Estab. 1988. Represents emerging, mid-career and established artists. 20,000 members. Sponsors 8-10 shows/year. Average display time 4-6 weeks. Open all year; Tuesday-Sunday, 10-4. Located near Prospect Park and Brooklyn Museum; 1,200 sq. ft.; part of a botanic garden, gallery adjacent to the tropical, desert and temperate houses. Clientele: BBG members, tourists, collectors. 100% private collectors. Overall price range: $75-7,500; most work sold at $75-500.
Media: Considers all media and all types of prints. Most frequently exhibits watercolor and oil.
Style: Exhibits all styles. Genres include landscapes, florals and wildlife. Prefers florals.
Terms: Accepts work on consignment (20% commission). Retail price set by the artist. Gallery provides insurance, promotion and contract; artist pays shipping costs to and from gallery. Prefers artwork framed.
Submissions: Work must have botanical, horticultural or environmental theme. Send query letter with résumé, slides, bio, brochure, photographs, SASE, business card and reviews. Write for appointment to show portfolio of slides. Replies in 2 weeks. Files résumé.
Tips: "Artists' groups contact me by submitting résumé and slides of artists in their group. BBG has had only group shows in the last 2 years, because of city budget cuts in the exhibit department. Groups such as Flatbush Artists Association, Guild of National Science Illustrators, Women in the Arts, Penumbra, Brooklyn Watercolor Society contact us for group shows."

‡BRUSHSTROKES FINE ART GALLERY, 4612 13th Ave., Brooklyn NY 11219. Phone/fax: (718)972-0682. Director: Sam Pultman. Retail gallery. Estab. 1993. Represents 15 emerging, mid-career and established artists/year. Exhibited artists include Elena Flerova, Itshak Holtz. Sponsors 2 shows/year. Average display time 1 month. Open all year; Sunday and Monday, 11-6:30; Tuesday by appointment; Wednesday-Thursday, 11-6:30; Friday, 11-1:30; Closed Saturday. 1,100 sq. ft. "We're one of the only sources for fine art Judaica."

100% of space for gallery artists. Clientele: upscale. 100% private collectors. Overall price range: $1,000-40,000; most work sold at $8,000-15,000.

Media: Considers oil, acrylic, watercolor, pastel, pen & ink, drawing. Considers all types of prints. Most frequently exhibits oil, acrylic, pastel.

Style: Exhibits surrealism, impressionism, realism. Genres include florals, portraits, landscapes Judaic themes. Prefers realism, impressionism, surrealism.

Terms: Accepts work on consignment. Retail price set by the gallery. Gallery provides promotion; artist pays for shipping costs to gallery. Prefers artwork unframed.

Submissions: "No abstract art please." Send query letter with slides, bio, brochure, photographs. Call for appointment to show portfolio of photographs. Replies only if interested within 1 week. Finds artists through word of mouth, referrals by other artists, submissions.

AMOS ENO GALLERY, 594 Broadway, Suite 404, New York NY 10012. (212)226-5342. Director: Anne Yearsley. Nonprofit and cooperative gallery. Estab. 1973. Exhibits the work of 34 mid-career artists. Sponsors 16 shows/year. Average display time 3 weeks. Open all year. Located in Soho; about 1,000 sq. ft.; "excellent location."

Media: Considers oil, acrylic, watercolor, pastel, pen & ink, drawings, mixed media, collage, works on paper, sculpture, fiber, glass, installation and photography.

Style: Exhibits a range of styles. Not interested in genre art.

Terms: Co-op membership fee (20% commission). Retail price set by the gallery and the artist. Artist pays for shipping.

Submissions: Send query letter with SASE for membership information.

STEPHEN E. FEINMAN FINE ARTS LTD., 448 Broome St., New York NY 10012. (212)925-1313. Contact: S.E. Feinman. Retail/wholesale gallery. Estab. 1972. Represents 20 emerging, mid-career and established artists/year. Exhibited artists include Mikio Watanabe, Johnny Friedlaender, Andre Masson, Felix Sherman, John Axton, Miljenko and Bengez. Sponsors 4 shows/year. Average display time 10 days. Open all year; Monday-Sunday, 12-6. Located in Soho; 1,000 sq. ft. 100% of space for gallery artists. Clientele: prosperous middle-aged professionals. 90% private collectors, 10% corporate collectors. Overall price range, $300-20,000; most work sold at $1,000-2,500.

Media: Considers oil, acrylic, watercolor, pastel, pen & ink, drawing, mixed media, sculpture, woodcuts, engravings, lithographs, mezzotints, serigraphs, linocuts and etchings. Most frequently exhibits mezzotints, aquatints and oils. Looking for artists that tend toward abstract-expressionists, (watercolor/oil or acrylic) in varying sizes.

Style: Exhibits painterly abstraction and surrealism, all genres. Prefers abstract, figurative and surrealist.

Terms: Mostly consignment but also buys outright for % of retail price (net 90-120 days). Retail price set by the gallery. Gallery provides insurance, promotion, contract and shipping costs from gallery; artist pays shipping costs to gallery. Prefers artwork unframed.

Submissions: Send query letter with résumé, slides and photographs. Replies in 2-3 weeks.

Tips: Currently seeking artists of quality who (1) see a humorous bent in their works (sardonic, ironic), (2) are not pretensious. "Artists who show a confusing presentation drive me wild. Artists should remember that dealers and galleries are not critics. They are merchants who try to seduce their clients with aesthetics. Artists who have a chip on their shoulder or an 'attitude' are self-defeating. A sense of humor helps!!"

FOCAL POINT GALLERY, 321 City Island, Bronx NY 10464. (718)885-1403. Artist/Director: Ron Terner. Retail gallery and alternative space. Estab. 1974. Interested in emerging and mid-career artists. Sponsors 2 solo and 6 group shows/year. Average display time 3-4 weeks. Clientele: locals and tourists. Overall price range: $175-750; most work sold at $300-500.

Media: Most frequently exhibits photography. Will exhibit painting and etching and other material by local artists only.

Style: Exhibits all styles and genres. Prefers figurative work, landscapes, portraits and abstracts. Open to any use of photography.

Terms: Accepts work on consignment (30% commission). Exclusive area representation required. Customer discounts and payment by installment are available. Gallery provides promotion. Prefers artwork framed.

Submissions: "Please call for submission information. Do not include résumés. The work should stand by itself. Slides should be of high quality."

GALLERY HENOCH, 80 Wooster, New York NY 10012. (212)966-6360. Director: George Henoch Shechtman. Retail gallery. Estab. 1983. Represents 40 emerging and mid-career artists. Exhibited artists include Daniel Greene and Max Ferguson. Sponsors 10 shows/year. Average display time 3 weeks. Closed August. Located in Soho; 4,000 sq. ft. 50% of space for special exhibitions. Clientele: 95% private collectors, 5% corporate clients. Overall price range: $3,000-40,000; most work sold at $10,000-20,000.

Media: Considers oil, acrylic, watercolor, pastel, pen & ink, drawings, and sculpture. Most frequently exhibits painting, sculpture, drawings and watercolor.

Style: Exhibits photorealism and realism. Genres include still life, cityscapes and figurative work. Prefers landscapes, cityscapes and still lifes.
Terms: Accepts work on consignment (50% commission). Retail price set by gallery. Gallery provides insurance and promotion; shipping costs are shared. Prefers artwork framed.
Submissions: Send query letter with slides, bio and SASE. Portfolio should include slides and transparencies. Replies in 3 weeks.
Tips: "We suggest artists be familiar with the kind of work we show and be sure their work fits in with our styles."

GALLERY JUNO, 568 Broadway, Suite 604B, New York NY 10012. (212)431-1515. Fax: (212)431-1583. Gallery Director: Gary Timmons. Retail gallery, art consultancy. Estab. 1992. Represents 18 emerging artists/year. Exhibited artists include Pierre Jacquemon, Kenneth McIndoe and Otto Mjaanes. Sponsors 8 shows/year. Average display time 6 weeks. Open all year; Monday-Friday, 10-6; Saturday, 11-6. Located in Soho; 1,000 sq. ft.; small, intimate space. 50% of space for special exhibitions; 50% of space for gallery artists. Clientele: corporations, private, design. 20% private collectors, 80% corporate collectors. Overall price range: $600-5,000; most work sold at $2,000-5,000.
Media: Considers oil, acrylic, watercolor, pastel, pen & ink, drawing, mixed media. Most frequently exhibits painting and works on paper.
Style: Exhibits expressionism, neo-expressionism, painterly abstraction, pattern painting and abstraction. Genres include landscapes. Prefers contemporary modernism and abstraction.
Terms: Accepts work on consignment (50% commission). Retail price set by the gallery and the artist. Gallery provides insurance and promotion; artist pays shipping costs. Prefers artwork framed.
Submissions: Send query letter with résumé, slides, bio, photographs, SASE, business card and reviews. Write for appointment to show portfolio of originals, photographs and slides. Replies in 3 weeks. Files slides, bio, photos, résumé. Finds artists through visiting exhibitions, word of mouth and submissions.

GALLERY 10, 7 Greenwich Ave., New York NY 10014. (212)206-1058. Director: Marcia Lee Smith. Retail gallery. Estab. 1972. Open all year. Represents approximately 150 emerging and established artists. Clientele: 100% private collectors. Overall price range: $24-1,000; most work sold at $50-300.
Media: Considers ceramic, craft, glass, wood, metal and jewelry.
Style: "The gallery specializes in contemporary American crafts."
Terms: Accepts work on consignment (50% commission); or buys outright for 50% of retail price (net 30 days). Retail price set by gallery and artist.
Submissions: Call or write for appointment to show portfolio of originals, slides, transparencies or photographs.

O.K. HARRIS WORKS OF ART, 383 W. Broadway, New York NY 10012. Director: Ivan C. Karp. Commercial exhibition gallery. Estab. 1969. Represents 55 emerging, mid-career and established artists. Sponsors 50 solo shows/year. Average display time 3 weeks. Open fall, winter, spring and early summer. "Four separate galleries for 4 separate one-person exhibitions. The back room features selected gallery artists which also change each month." Clientele: 90% private collectors, 10% corporate clients. Overall price range: $50-250,000; most work sold at $12,500-100,000.
Media: Considers all media. Most frequently exhibits painting, sculpture and photography.
Style: Exhibits realism, photorealism, minimalism, abstraction, conceptualism, photography and collectibles. Genres include landscapes, Americana but little figurative work. "The gallery's main concern is to show the most significant artwork of our time. In its choice of works to exhibit, it demonstrates no prejudice as to style or materials employed. Its criteria demands originality of concept and maturity of technique. It believes that its exhibitions over the years have proven the soundness of its judgment in identifying important artists and its pertinent contribution to the visual arts culture."
Terms: Accepts work on consignment (50% commission). Retail price set by gallery. Customer discounts and payment by installment are available. Exclusive area representation required. Gallery provides insurance and limited promotion. Prefers artwork ready to exhibit.
Submissions: Send query letter with slides "labeled with size, medium, top, etc." and SASE. Replies in 1 week.
Tips: "We strongly suggest the artist be familiar with the gallery's exhibitions, and the kind of work we prefer to show. Always include SASE." Common mistakes artists make in presenting their work are "poor, unmarked photos (size, material, etc.), submissions without return envelope, utterly inappropriate work. We affiliate about one out of 10,000 applicants."

HELLER GALLERY, 71 Greene St., New York NY 10012. (212)966-5948. Fax: (212)966-5956. Director: Douglas Heller. Retail gallery. Estab. 1973. Represents/exhibits emerging, mid-career and established artists. Exhibited artists include Bertil Vallien and Robin Grebe. Sponsors 11 shows/year. Average display time 3 weeks. Open all year; Tuesday-Saturday, 11-6; Sunday, 12-5. Located in Soho; 4,000 sq. ft.; classic Soho Cast Iron landmark building. 65% of space for special exhibitions; 35% of space for gallery artists. Clientele: serious private collectors and museums. 80% private collectors, 10% corporate collectors and 10% museum

collectors. Overall price range: $1,000-35,000; most work sold at $3,000-10,000.
Media: Considers glass sculpture. Most frequently exhibits glass, glass and mixed media.
Style: Prefers geometric abstraction and figurative.
Terms: Artwork is accepted on consignment (50% commission). Retail price set by the artist. Gallery provides insurance and limited promotion; shipping costs are shared.
Submission: Send query letter with résumé, slides, photographs, reviews, bio and SASE. Call or write for appointment to show portfolio of photographs, slides and résumé. Replies in 2-4 weeks. Files information on artists represented by the gallery. Finds artists through word of mouth, referrals by other artists, visiting art fairs and exhibitions, submissions.

BILL HODGES GALLERY, 24 W. 57th St., 606, New York NY 10019. (212)333-2640. Fax: (212)333-2644. Owner/Director: Bill Hodges. Retail gallery. Estab. 1979. Represents/exhibits 10 emerging, mid-career and established artists/year. Exhibited artists include Romare Bearden and Norman Lewis. Sponsors 8 shows/year. Average display time 6 weeks. Open all year; Tuesday-Friday, 10-6; Saturday, 12-6. 1,000 sq. ft., 80% of space for gallery artists. Clientele: upscale. 60% private collectors, 20% corporate collectors. Overall price range: $2,000-90,000; most work sold at $5,000-40,000.
Media: Considers all media and all types of prints except posters. Most frequently exhibits works on canvas, sculpture and limited edition graphics.
Style: Exhibits color field, hard-edge geometric abstraction and painterly abstraction. Genres include landscapes, Americana and figurative work. Prefers abstract paintings on canvas, figurative work and landscape.
Terms: Artwork is accepted on consignment (50% commission), or artwork is bought outright for 30% of the retail price; net 30 days. Retail price set by the artist. Gallery provides insurance, promotion and contract; shipping costs are shared.
Submissions: Send query letter with slides and photographs. Write for appointment to show portfolio of photographs and slides. Replies in 3 weeks. Files material under consideration. Finds artists through word of mouth and referrals by other artists.
Tips: "Keep working."

MICHAEL INGBAR GALLERY OF ARCHITECTURAL ART, 568 Broadway, New York NY 10012. (212)334-1100. Curator: Millicent Hathaway. Retail gallery. Estab. 1977. Represents 145 emerging, mid-career and established artists. Exhibited artists include Richard Haas and Judith Turner. Sponsors 6 shows/year. Average display time 2 months. Open all year; Tuesday-Saturday, 12-6. Located in Soho; 1,000 sq. ft. 60% private collectors, 40% corporate clients. Overall price range: $500-10,000; most work sold at $3,000.
Media: Considers all media and all types of prints. Most frequently exhibits paintings, works on paper and sculpture.
Style: Exhibits photorealism, realism and impressionism. Prefers New York City buildings, New York City structures (bridges, etc.) and New York City cityscapes.
Terms: Artwork accepted on consignment (50% commission). Artists pays shipping costs.
Submissions: Accepts artists preferably from New York City Metro area. Send query letter with SASE. Call for appointment to show portfolio of slides. Replies in 1-2 weeks.
Tips: The most common mistakes artists make in presenting their work are "coming in person, constantly calling, poor slide quality (or unmarked slides)."

‡JADITE GALLERIES, 413 and 415 W. 50th St., New York NY 10019. (212)315-2740. Fax: (212)315-2793. Director: Roland Sainz. Retail gallery. Estab. 1985. Represents 25 emerging and established, national and international artists. Sponsors 20 solo and 2 group shows/year. Average display time 3 weeks. Clientele: 80% private collectors, 20% corporate clients. Overall price range: $500-8,000; most artwork sold at $1,000-3,000.
Media: Considers oil, acrylic, watercolor, pastel, pen & ink, drawings, mixed media, collage, sculpture and original handpulled prints. Most frequently exhibits oils, acrylics, pastels and sculpture.
Style: Exhibits minimalism, postmodern works, impressionism, neo-expressionism, realism and surrealism. Genres include landscapes, florals, portraits, Western collages and figurative work. Features mid-career and emerging international artists dealing with contemporary works."
Terms: Accepts work on consignment (40% commission). Retail price set by gallery and artist. Exclusive area representation not required. Gallery provides insurance, promotion and contract; exhibition costs are shared.
Submissions: Send query letter, résumé, brochure, slides, photographs and SASE. Call or write for appointment to show portfolio of originals, slides or photos. Resume, photographs or slides are filed.

‡KOUROS, 23 E. 73rd St., New York NY 10021. (212)288-5888. Fax: (212)794-9397. Contact: Anthony Crisafulli. Retail gallery. Represents 15 emerging, mid-career and established artists/year. Exhibited artists include Paul Russotto, Biala, Bill Barrett, John von Bergen, and Grace Hartigan. Sponsors 12 shows/year. Average display time 1 month. Open all year; 10-6. Located uptown; 3,500 sq. ft. 75% of space for gallery artists. 80% private collectors, 10% corporate collectors.

Media: Consider oil, acrylic, watercolor, pastel, pen & ink, mixed media, collage, paper and sculpture. Most frequently exhibits oil and sculpture.
Style: Exhibits expressionism, neo-expressionism, painterly abstraction, color field, impressionism and post-modern works.
Terms: Accepts work on consignment (50% commission). Retail price set by the gallery and the artist. Gallery provides insurance and contract; artist pays shipping costs to and from gallery. Prefers artwork framed or "the artist's preference."
Submissions: Send query letter with résumé, slides, brochure, photographs and reviews. Portfolio should include photographs, slides and transparencies. Replies only if interested within 1 month.

‡**LA MAMA LA GALLERIA**, 6 E. First St., New York NY 10003. (212)505-2476. Director: Lawry Smith. Nonprofit gallery. Estab. 1981. Exhibits the work of emerging, mid-career and established artists. Sponsors 14 shows/year. Average display time 3 weeks. Open September-June. Located in East Village; 2,500 sq. ft.; "very large and versatile space." 100% of space for special exhibitions. Clientele: 20% private collectors, 20% corporate clients. Overall price range: $1,000-5,000; most work sold at $1,000.
Media: Considers oil, acrylic, watercolor, pastel, pen & ink, drawings, mixed media, collage, sculpture, ceramic, craft, installation, photography, original handpulled prints, woodcuts, engravings and lithographs. Most frequently exhibits oil, installation and collage. "No performance art."
Style: Exhibits expressionism, neo-expressionism, primitivism, painterly abstraction, imagism, conceptualism, minimalism, postmodern works, impressionism, photorealism and hard-edge geometric abstraction.
Terms: Accepts work on consignment (20% commission). Retail price set by gallery. Gallery provides promotion; artist pays for shipping or shipping costs are shared. Prefers artwork framed.
Submissions: Send query letter with résumé, slides and bio. Write for appointment to show portfolio of originals, slides, photographs or transparencies. Replies in 6 weeks. Files slides and résumés.
Tips: Make sure to "include résumé and artist's statement and label slides (size, medium, etc)."

THE MARBELLA GALLERY INC., 28 E. 72nd St., New York NY 10021. (212)288-7809. President: Mildred Thaler Cohen. Retail gallery. Estab. 1971. Represents/Exhibits established artists. Exhibited artists include Pre Ten and The Eight. Sponsors 1 show/year. Average display time 6 weeks. Open all year; Tuesday-Saturday, 11-5:30. Located uptown; 750 sq. ft. 100% of space for special exhibitions. Clientele: tourists, upscale. 50% private collectors, 10% corporate collectors, 40% dealers. Overall price range: $1,000-60,000; most work sold at $2,000-4,000.
Style: Exhibits expressionism, realism and impressionism. Genres include landscapes, florals, Americana and figurative work. Prefers Hudson River, "The Eight" and genre.
Terms: Artwork is bought outright for a percentage of the retail price. Retail price set by the gallery. Gallery provides insurance.

JAIN MARUNOUCHI GALLERY, 979 Third Ave., New York NY 10022. (212)355-8606. Fax: (212)355-8308. President: Ashok Jain. Retail gallery. Estab. 1991. Represents 30 emerging artists. Exhibited artists include Fernando Pamalaza and Pauline Gagnon. Sponsors 10 shows/year. Average display time 3 weeks. Open all year; Monday-Friday 11-6. Located in Design & Decoration Bldg., 800 sq. ft. 80% of space for special exhibitions; 20% of space for gallery artists. Clientele: corporate and designer. 50% private collectors, 50% corporate collectors. Overall price range: $1,000-20,000; most work sold at $5,000-10,000.
Media: Considers oil, acrylic and mixed media. Most frequently exhibits oil, acrylic and collage.
Style: Exhibits painterly abstraction. Prefers abstract only.
Terms: Accepts work on consignment (50% commission). Retail price set by artist. Offers customer discount. Gallery provides contract; artist pays for shipping costs. Prefers artwork framed.
Submissions: Send query letter with résumé, brochure, slides, reviews and SASE. Portfolio review requested if interested in artist's work. Portfolio should include originals, photographs, slides, transparencies and reviews. Replies in 1 week. Finds artists through referrals and promotions.

FRIEDRICH PETZEL GALLERY, 26 Wooster St., New York NY 10013. (212)334-9466. Fax: (212)431-6638. Contact: Petzel. Retail gallery and office for organization of art events. Estab. 1993. Represents 7 emerging artists/year. Exhibited artists include Paul Myoda, Keith Edmier, Jorge Pardo. Sponsors 9-10 shows/year. Average display time 1 month. Open September-July; Tuesday-Saturday, 11-6. Located in Soho; 800 sq. ft. 100% of space for gallery artists. 80% private collectors, 20% corporate collectors. Overall price range: $1,000-8,000; most work sold at $4,000.
Media: Considers all media. Most frequently exhibits mixed media.
Terms: Accepts work on consignment (50% commission). Retail price set by the gallery and the artist. Gallery provides promotion, contract and shipping costs to and from gallery. Prefers artwork framed.
Submissions: Send query letter with résumé, slides, bio and reviews. Call for appointment to show portfolio of photographs, slides and transparencies. Replies in 2-3 weeks. Files "only material we are interested in." Finds artists through various art publications, word of mouth and studio visits.

THE PHOENIX GALLERY, 568 Broadway, Suite 607, New York NY 10012. (212)226-8711. Director: Linda Handler. Nonprofit gallery. Estab. 1958. Exhibits the work of 32 emerging, mid-career and established artists. 32 members. Exhibited artists include Pamela Bennet Ader and Beth Cartland. Sponsors 10-12 shows/year. Average display time 1 month. Open fall, winter and spring. Located in Soho; 180 linear ft.; "We are in a landmark building in Soho, the oldest co-op in New York. We have a movable wall which can divide the gallery into two large spaces." 100% of space for special exhibitions. Clientele: 75% private collectors, 25% corporate clients, also art consultants. Overall price range: $50-20,000; most work sold at $300-10,000.
 • In addition to providing a venue for artists to exhibit their work, the Phoenix Gallery also actively reaches out to the members of the local community: scheduling juried competitions, dance programs, poetry readings, book signings, plays and lectures. A special exhibition space, Gallery III, has been established for guest-artist exhibits.
Media: Considers oil, acrylic, watercolor, pastel, pen & ink, drawings, mixed media, collage, works on paper, sculpture, ceramic, photography, original handpulled prints, woodcuts, engravings, wood engravings, linocuts and etchings. Most frequently exhibits oil, acrylic and watercolor.
Style: Exhibits painterly abstraction, minimalism, realism, photorealism, hard-edge geometric abstraction and all styles. Prefers painterly abstraction, hard-edge geometric abstraction and sculpture.
Terms: Co-op membership fee plus donation of time (25% commission). Retail price set by gallery. Offers customer discounts and payment by installment. Gallery provides promotion and contract; artist pays for shipping. Prefers artwork framed.
Submissions: Send query letter with résumé, slides and SASE. Call for appointment to show portfolio of slides. Replies in 1 month. Only files material of accepted artists. The most common mistakes artists make in presenting their work are "incomplete résumés, unlabeled slides and an application that is not filled out properly."
Tips: "We find new artists by advertising in art magazines and art newspapers, word of mouth, and inviting artists from our juried competition to be reviewed for membership. Come and see the gallery—meet the director.

QUEENS COLLEGE ART CENTER, Benjamin S. Rosenthal Library, Queens College/CUNY, Flushing NY 11367. (718)997-3770. Fax: (718)997-3753. E-mail: sbsqc@cunyvm.cuny.edu. Website: http://www.qc.edu/Library/aexhibit.htm. Director: Suzanna Simor. Curator: Alexandra de Luise. Nonprofit university gallery. Estab. 1955. Exhibits work of emerging, mid-career and established artists. Sponsors 10 shows/year. Average display time 1 month. Open all year; Monday-Thursday, 9-7; Friday, 9-5. Located in borough of Queens; 1,000 sq. ft. The gallery is wrapped "Guggenheim Museum" style under a circular skylight in the library's atrium. 100% of space for special exhibitions. Clientele: "college and community, some commuters." 100% private collectors. Overall price range: up to $10,000; most work sold at $300.
Media: Considers all media and all types of prints. Most frequently exhibits paintings, prints, drawings and photographs.
Style: Exhibits all styles.
Terms: Accepts work on consignment (40% commission). Retail price set by the artist. Gallery provides promotion. Artist pays for shipping costs and announcements. Prefers artwork framed.
Submissions: Cannot exhibit large 3-D objects. Send query letter with résumé, brochure, slides, photographs, reviews, bio and SASE. Replies in 3 weeks. Files all documentation.

ST. LIFER ART EXCHANGE, INC., 3 Hanover Square, #21E, New York NY 10004. (212)825-2059. Fax: (212)825-2582. Director: Jane St. Lifer. Art consultancy and fine art brokers and appraisers. Estab. 1988. Represents established artists. May be interested in seeing the work of emerging artists in the future. Exhibited artists include Miro, Picasso. Open all year by appointment. Located in the Wall Street area. Clientele: national and international contacts. 50% private collectors, 50% corporate collectors. Overall price range: $300-3,000.
Media: Considers oil, acrylic, watercolor, pastel, pen & ink, drawing, woodcuts, engravings, lithographs, wood engravings, mezzotints, serigraphs, linocuts, etchings, posters (original).
Style: Exhibits postmodern works, impressionism and realism. Considers all genres.
Terms: Accepts work on consignment or buys outright. Retail price set by the gallery. Gallery pays shipping costs from gallery; artist pays shipping costs to gallery. Prefers artwork framed.
Submissions: Send query letter with résumé, bio, photographs, SASE and business card. Portfolio should include photographs. Replies in 3-4 weeks. Files résumé, bio.

‡**SCULPTORS GUILD, INC.,** 110 Greene St., Suite 305, New York NY 10012. Phone/fax: (212)431-5669. President: Stephen Keltner. Nonprofit gallery. Estab. 1937—office exhibit space; 1993—53 Mercer exhibit spaces. Represents 110 emerging, mid-career and established artists/year. 110 members. Exhibited artists include Dorothy Dehner, Clement Meadmore. Sponsors 5 shows/year. Average display time 1 month. Open all year; Tuesday-Friday 10-5. Located in Soho; office space—700 sq. ft.; 53 Mercer Galleries—548 sq. ft. each; all kinds of sculpture. 100% of space for gallery artists. Clientele: private and corporate collectors. 50% private collectors, 50% corporate collectors. Overall price range: $1,500-40,000; most work sold at $3,000-6,000.

Media: Considers mixed media, sculpture, ceramics, fiber and glass. Most frequently exhibits metal, stone and wood.

Style: Exhibits all styles, all genres.

Terms: Accepts work on consignment (20% commission). Membership fee plus donation of time (20% commission) "We are not a co-op gallery, but an organization with dues-paying members." Retail price set by the artist. Gallery provides promotion; shipping costs are shared.

Submissions: Sculptors only. Send query letter with résumé, slides and SASE. "Once a year we have a portfolio review." Call for application form. Portfolio should include photographs and slides. Replies in 2-3 weeks. Files "information regarding our members."

‡SLOWINSKI GALLERY, (formerly Limner Gallery) 215 Mulberry St., New York NY 10012. Phone/fax: (212)431-1190. E-mail: slowart@aol.com. Website: http://www.slowart.com/slow. Director: Tim Slowinski. Slowinski Gallery is an artist-owned alternative retail (consignment) gallery. Estab. 1987. Represents emerging and mid-career artists. Exhibited artists include Slowinski. Hosts biannual exhibitions of emerging artists selected by competition, cash awards up to $1,000. Entry available for SASE or from website. Sponsors 6-8 shows/year. Average display time 3 weeks. Open Wednesday-Saturday, 12-6, July 15-August 30, by appointment. Located in Soho, 700 sq. ft. storefront. 60-80% of space for special exhibitions; 20-40% of space for gallery artists. Clientele: lawyers, real estate developers, doctors, architects. 95% private collectors, 5% corporate collectors. Overall price range: $300-10,000.

Media: Considers all media, all types of prints except posters. Most frequently exhibits painting, sculpture and works on paper.

Style: Exhibits primitivism, surrealism, all styles, postmodern works, all genres. "Gallery exhibits all styles but emphasisis is on non-traditional figurative work."

Terms: Accepts work on consignment (50% commission). Retail price set by the gallery and the artist. Gallery provides promotion and contract; artist pays shipping costs to and from gallery. Prefers artwork framed.

Submissions: Send query letter with résumé, slides, bio and SASE. Call for appointment to show portfolio of originals, photographs, slides and transparencies. Replies in 2-3 weeks. Files slides, résumé. Finds artists through word of mouth, art publications and sourcebooks, submissions.

‡HOLLY SOLOMON GALLERY, 172 Mercer St., New York NY 10012.
 ● Holly Solomon represents a strong stable of artists, including William Wegman and Nam June Paik. She is not looking for submissions at this time. However, she shares her insights into the art world in a candid interview on page 472.

‡TENRI GALLERY, 575 Broadway, New York NY 10012. (212)925-8500. Fax: (212)925-8501. Director: Mikio Shinagawa. Nonprofit gallery. Estab. 1991. Represents established artists. Sponsors 7 shows/year. Average display time 6 weeks. Open September-July; Monday-Friday, 12-6, Saturday, 12-5. Located in Soho; 2,200 sq. ft.; interior by Scott Marble. 40% of space for special exhibitions.

Terms: Retail prices set by the gallery and the artist. Gallery provides insurance, promotion and shipping costs. Prefers artwork framed.

TIBOR DE NAGY GALLERY, 41 W. 57th St., New York NY 10019. (212)421-3780. Fax: (212)421-3731. Directors: Andrew H. Arnst and Eric Brown. Retail gallery. Estab. 1950. Represents 18 emerging and mid-career artists. Exhibited artists include Robert Berlind, Gretna Campbell, Rudy Burckhardt and Duncan Hannah. Sponsors 12 shows/year. Average display time 1 month. Closed August. Located midtown; 3,500 sq. ft. 100% of space for work of gallery artists. 60% private collectors, 40% corporate collectors. Overall price range: $1,000-100,000; most work sold at $5,000-20,000.
 ● The gallery focus is on painting within the New York school traditions and photography.

Media: Considers oil, pen & ink, paper, acrylic, drawings, sculpture, watercolor, mixed media, pastel, collage, etchings, and lithographs. Most frequently exhibits oil/acrylic, watercolor and sculpture.

Style: Exhibits representation work as well as abstrct painting and sculpture. Genres include landscapes and figurative work. Prefers abstract, painterly realism and realism.

Terms: Accepts work on consignment (50% commission). Retail price set by gallery and artist. Gallery provides insurance, promotion and contract; artist pays for shipping. Prefers artwork framed.

Submissions: Gallery is not looking for submissions at this time.

VIRIDIAN ARTISTS INC., (formerly Viridian Gallery), 24 W. 57 St., New York NY 10019. (212)245-2882. Director: Joan Krawczyk. Cooperative gallery. Estab. 1970. Exhibits the work of 35 emerging, mid-career and established artists. Sponsors 13 solo and 2 group shows/year. Average display time is 3 weeks. Clientele: consultants, corporations, private collectors. 50% private collectors, 50% corporate clients. Overall price range: $500-20,000; most work sold at $1,000-8,000.

Media: Considers oil, acrylic, watercolor, pastel, pen & ink, drawings, mixed media, collage, works on paper, sculpture, installation, photography and limited edition prints. Most frequently exhibits works on canvas, sculpture, mixed media, works on paper and photography.

INSIDER REPORT

Visibility Sends Powerful Message to Galleries

For Holly Solomon, owner of one of New York's most prestigious galleries, art is a necessity, not a luxury. Not content just to work with art by day, Solomon transformed her apartment into a veritable art installation—filled to the brim with work by William Wegman, Kim McConnel, Izhar Patkin and others. Even her curtains are paintings. "I need art because I find it nourishing," she says.

Holly Solomon

Art has been a passion since the age of 12, when she wrote in her diary her earnest wish to one day be a great actress and own "real oil paintings." While her first loves were the pastel ballerinas of Degas and the idyllic paintings of Fragonard, Solomon's tastes evolved when she discovered the work of Arp and Calder—not in a museum—but in the collection of her college housemother. "Miss Barber was a great lady, not wealthy by any means, but she owned several pieces. For the first time I realized—Ah! An ordinary person can collect art!"

That epiphany inspired Solomon to begin collecting while a young actress struggling to make it in New York. When a group of artists persuaded her to open a gallery, Solomon's experience as a collector gave her a distinct advantage. She understood what drives collectors to buy.

"Collectors are people for whom art is absolutely necessary to get through the day. They will justify any expense to own a particular piece. A collector might even rationalize buying your painting because looking at it makes him feel like getting up in the morning and going to work!" The desired piece need not be beautiful. More often, it makes the collector think, evokes a strong emotion, or just plain intrigues him.

Collectors get a raw deal, says Solomon. "It takes a brave soul to collect. Collecting is often looked on as eccentric. It's risky to have things on your wall other people have opinions about." Try to understand collectors' hearts. When potential buyers express interest in your work, don't be intimidated—make friends with them.

Galleries are misunderstood, too. If you think artists who have "connections" get all the shows, you are partially right. You might think your work should speak for itself, but in the real world, says Solomon, two factors come into play. First, your work must be different from other artists' work. Secondly, you should be visible in the arts community.

Being visible in the arts community merely means you regularly visit galleries, attend openings, enter shows and are familiar with your peers in the art world.

INSIDER REPORT, *Solomon*

Your visibility sends a message to galleries that you are committed to your art. Shyness is no excuse, says Solomon. "When someone says 'I'm shy.' I say 'Aren't we all?' If you care about art and really need to do it, you have to get over your shyness."

Galleries expect you to know what your fellow artists are up to. You have to know what is being done to make sure your work doesn't look like "more of the same" to galleries. It's also advantageous to get to know your peers because galleries are more likely to represent your work if it is respected by other artists.

Art openings are perfect opportunities to meet other artists, says Solomon. It is totally acceptable to walk up to even a well-known artist you've never met and ask about his work. Introduce yourself to gallery people. Don't worry about seeming obsequious. "You're not selling your body, you know! Ask for advice. Talk to people on a human level. It doesn't all have to be about art. Talk about movies, museums, restaurants, or a book you've just read. I don't care what it is you're interested in, but have some interests!"

According to Solomon, great artists have a balance in their lives. They spend a great deal of time living and learning. They are curious about all kinds of things. And they have a sensitivity outside the mainstream. Most importantly, they have standards by which they live. "I'm not talking about religion—just that they are spiritually committed to their work."

Electronic Super Highway is part of an installation by artist Nam June Paik that appeared in a show by the same name at Holly Solomon Gallery in New York.

Style: Exhibits hard-edge geometric abstraction, color field, painterly abstraction, conceptualism, postmodern works, primitivism, photorealism, abstract, expressionism, and realism. "Eclecticism is Viridian's policy. The only unifying factor is quality. Work must be of the highest technical and aesthetic standards."

Terms: Accepts work on consignment (30% commission). Retail price set by gallery and artist. Sometimes offers customer discounts and payment by installment. Exclusive area representation not required. Gallery provides promotion, contract and representation.

Submissions: Send query letter, slides or call ahead for information on procedure. Portfolio review requested if interested in artist's work.

Tips: "Artists often don't realize that they are presenting their work to an artist-owned gallery where they must pay each month to maintain their representation. We feel a need to demand more of artists who submit work. Because of the number of artists who submit work our critieria for approval has increased as we receive stronger work than in past years as commercial galleries are closing."

‡L.J. WENDER FINE CHINESE PAINTINGS, 3 E. 80th St., New York NY 10021. (212)734-3460. Fax: (212)427-4945. Owners: Karen and Leon Wender. Retail gallery. Estab. 1980. Represents established artists. Exhibited artists include Zhu Qizhan, Qi Baishi. Sponsors 4-5 shows/year. Average display time 1 month. Open all year; Monday-Saturday, 10-5. Located on the upper Eastside of New York City; 1,500 sq. ft. 90% of space for special exhibitions. Clientele: private collectors, museums. 95% private collectors, 5% corporate collectors. Overall price range: $400-50,000; most work sold at $2,000-8,000.

Media: Considers watercolor, Chinese ink and color on paper. Most frequently exhibits Chinese ink and color on paper.

Style: Exhibits traditional Chinese painting. Genres include landscapes, florals, wildlife and portraits. Prefers landscapes, flowers, portraits (nonfigurative).

Terms: Retail price set by the gallery. Gallery provides insurance and promotion; artist pays shipping costs to and from gallery. Prefers artwork framed.

Submissions: Accepts only artists from China or overseas Chinese. Prefers only traditional Chinese painting. Send query letter with bio and photographs. Call for appointment to show portfolio of originals and photographs. Replies only if interested within 2 weeks.

YESHIVA UNIVERSITY MUSEUM, 2520 Amsterdam Ave., New York NY 10033. (212)960-5390. Director: Sylvia A. Herskowitz. Nonprofit museum. Estab. 1973. Interested in emerging, mid-career and established artists. Clientele: New Yorkers and tourists. Sponsors 5-7 solo shows/year. Average display time is 3 months. "4 modern galleries; track lighting; some brick walls." Museum works can be sold through museum shop.

Media: Considers all media and original handpulled prints.

Style: Exhibits postmodernism, surrealism, photorealism and realism with Jewish themes or subject matter. Genres include landscapes, florals, Americana, portraits and figurative work. "We mainly exhibit works of Jewish theme or subject matter or that reflect Jewish consciousness but are somewhat willing to consider other styles or mediums."

Terms: Accepts work for exhibition purposes only, no fee. Pieces should be framed. Retail price is set by gallery and artist. Gallery provides insurance, promotion and contract; artist pays for shipping and framing.

Submissions: Send query letter, résumé, brochure, good-quality slides, photographs and statement about your art. Prefers not to receive phone calls/visits. "Once we see the slides, we may request a personal visit." Resumes, slides or photographs are filed if work is of interest.

Tips: Mistakes artists make are sending "slides that are not identified, nor in a slide sheet." Notices "more interest in mixed media and more crafts on display."

North Carolina

ASSOCIATED ARTISTS OF WINSTON-SALEM, 226 N. Marshall St., Winston-Salem NC 27101. (910)722-0340. Executive Director: Sue Kneppelt. Nonprofit gallery. Gallery estab. 1982; organization estab. 1956. Represents 500 emerging, mid-career and established artists/year. 375 members. Sponsors 12 shows/year. Average display time 1 month. Open all year; office hours: Monday-Friday, 9-5; gallery hours: Monday-Friday, 9-9; Saturday, 9-6. Located in the historic Sawtooth Building downtown. "Our gallery is 1,000 sq. ft., but we often have the use of 2 other galleries with a total of 3,500 sq. ft. The gallery is housed in a renovated textile mill (circa 1911) with a unique 'sawtooth' roof. 30% of space for special exhibitions; 70% of space for gallery artists. Clientele: "generally walk-in traffic—this is a multi-purpose public space, used for meetings, receptions, classes, etc." 85% private collectors, 15% corporate collectors. Overall price range: $50-3,000; most work sold at $100-500.
Media: Considers oil, acrylic, watercolor, pastel, pen & ink, drawing, mixed media, collage, paper, sculpture, photography, woodcuts, engravings, lithographs, wood engravings, mezzotints, serigraphs, linocuts and etchings (no photo-reproduction prints). Most frequently exhibits watercolor, oil and photography.
Style: Exhibits all styles, all genres.
Terms: "Artist pays entry fee for each show; if work is sold, we charge 30% commission. If work is unsold at close of show, it is returned to the artist." Retail price set by the artist; artist pays shipping costs to and from gallery. Artwork must be framed.
Submissions: Request membership information and/or prospectus for a particular show. Replies in 1 week to membership/prospectus requests. Files "slides and résumés of our exhibiting members only."
Tips: "We don't seek out artists per se—membership and competitions are generally open to all. We advertise call for entries for our major shows in national art magazines and newsletters. Artists can impress us by following instructions in our show prospecti and by submitting professional-looking slides where appropriate. Because of our non-elitist attitude, we strive to be open to all artists—from novice to professional, so first-time artists can exhibit with us."

‡**CHAPELLIER FINE ART**, 124 Glenwood Ave., Raleigh NC 27603. (919)828-9230. Fax: (919)833-1872. E-mail: chapellier@aol.com. Director: Shirley C. Lally. Retail gallery. Estab. 1916. Represents 5 established artists/year. Exhibited artists include Sarah Blakeslee, Elsie Dinsmore Popkin. Sponsors 3-4 shows/year. Average display time 6-8 weeks. Open all year; Tuesday-Friday, 10:30-5; Saturday, 11-3. Located near downtown; 1,000 sq. ft. 75% of space for special exhibitions; 25% of space for gallery artists. Clientele: upscale. 90% private collectors, 10% corporate collectors. Overall price range: $500-90,000; most work sold at $3,000-10,000.
Media: Considers oil, acrylic, watercolor, pastel, pen & ink, drawing, mixed media, paper, sculpture (limited to small pieces) and all types of prints. Most frequently exhibits oil, watercolor, pastel.
Style: Exhibits impressionism and realism. Exhibits all genres. Prefers realism and impressionism.
Terms: Accepts work on consignment (50% commission). Retail price set by the gallery. Gallery provides insurance, promotion and contract; shipping costs are shared. Prefers artwork framed.
Submissions: Accepts only artists from America. Send query letter with résumé, slides, bio or photographs, price list and description of works offered, exhibition record. Write for appointment to show portfolio of photographs, transparencies or slides. Replies in 1 month. Files material only if interested. Finds artists through word of mouth, visiting art fairs and exhibitions.

‡**COMPTON ART GALLERY**, 409 W. Fisher Ave., Greensboro NC 27401. (919)370-9147. Owner: Anne Compton. Retail gallery and art consultancy. Estab. 1985. Represents 60 emerging, mid-career and established artists. Exhibited artists include Marcos Belhove and Betty Mitchell. Sponsors 6 shows/year. Average display time 1 month. Open all year. Located near downtown. 75% of space for special exhibitions. 50% private collectors; 50% corporate collectors. Overall price range: $100-4,000; most work sold at $1,500.
Media: Considers oil, acrylic, watercolor and pastel.
Style: Considers contemporary expressionism, impressionism and realism. Genres include landscapes, florals and figurative work.
Terms: Accepts artwork on consignment (45% commission). Retail price set by the artist. Gallery provides some insurance, promotion and contract; artist pays for shipping. Prefers artwork framed if oil, or a finished canvas. Prefers matted watercolors.
Submissions: Send query letter with slides, résumé, brochure, photographs and SASE. Write to schedule an appointment to show a portfolio, which should include originals, slides and transparencies. Replies in 1 month. Files brochures, résumé and some slides.
Tips: "We only handle original work."

DURHAM ART GUILD, INC., 120 Morris St., Durham NC 27701. (919)560-2713. Gallery Director: Susan Hickman. Nonprofit gallery. Estab. 1948. Represents/exhibits 400 emerging, mid-career and established artists/year. Sponsors 9 shows/year. Average display time 4½ weeks. Open all year; Monday-Saturday, 9-9; Sunday, 1-6. Located in center of downtown Durham in the Arts Council Building; 3,600 sq. ft.; large, open, movable walls. 100% of space for special exhibitions. Clientele: general public. 80% private collectors, 20% corporate collectors. Overall price range: $100-14,000; most work sold at $200-1,200.
Media: Considers all media. Most frequently exhibits painting, sculpture and photography.
Style: Exhibits all styles, all genres.
Terms: Artwork is accepted on consignment (30-40% commission). Retail price set by the artist. Gallery provides insurance and promotion. Artist installs show. Prefers artwork framed.
Submissions: Artists 18 years or older. Send query letter with résumé, slides and SASE. We accept slides for review by January 31 for consideration of a solo exhibit. Does not reply. Artist should include SASE. Finds artists through word of mouth, referral by other artists, call for slides.

‡WELLINGTON B. GRAY GALLERY, EAST CAROLINA UNIVERSITY, Jenkins Fine Art Center, Greenville NC 27858. (919)757-6336. Fax: (919)757-6441. Website: http://ecuuax.cis.@cu.edu/academics/schdept/art/art.htm. Director: Gilbert W. Leebrick. Nonprofit university gallery. Estab. 1977. Represents emerging, mid-career and established artists. Sponsors 12 shows/year. Average display time 5-6 weeks. Open year round. Located downtown, in the university; 5,500 sq. ft.; "auditorium for lectures, sculpture garden." 100% of space for special exhibitions. Clientele: 25% private collectors, 10% corporate clients, 50% students, 15% general public. Overall price range: $1,000-10,000.
Media: Considers all media plus environmental design, architecture, crafts and commercial art, original prints, relief, intaglio, planography, stencil and offset reproductions. Most frequently exhibits paintings, printmaking and sculpture.
Style: Exhibits all styles and genres. Interested in seeing contemporary art in a variety of media.
Terms: 20% suggested donation on sales. Retail price set by artist. Gallery provides insurance and promotion; shipping costs are shared. Prefers artwork framed.
Submissions: Send query letter with résumé, slides, brochure and SASE. Write for appointment to show portfolio of originals, slides, photographs and transparencies. Replies in 2-6 months. Files "all mailed information for interesting artists. The rest is returned."

‡LEE HANSLEY GALLERY, 16 W. Martin St., Suite 201, Raleigh NC 27601. (919)828-7557. Proprietor: Lee Hansley. Retail gallery, art consultancy. Estab. 1993. Represents 40 mid-career and established artists/year. Exhibited artists include Mary Anne K. Jenkins, Paul Hartley. Sponsors 10 shows/year. Average display time 5-7 weeks. Open all year; Tuesday-Friday, 10:30-6; Saturday, 11-4. Located downtown; 1,200 sq. ft.; 3 small, intimate exhibition galleries, one small hallway interior. 75% of space for special exhibitions; 25% of space for gallery artists. Clientele: local, state collectors. Overall price range: $250-18,000; most work sold at $500-2,500.
Media: Considers all media except large-scale sculpture. Considers all types of prints except poster. Most frequently exhibits painting/canvas, mixed media on paper.
Style: Exhibits expressionism, neo-expressionism, painterly abstraction, minimalism, color field, photorealism, pattern painting, hard-edge geometric abstraction. Genres include landscapes, figurative work. Prefers geometric abstraction, expressionism, minimalism.
Terms: Accepts work on consignment (50% commission). Retail price set by the gallery and the artist. Gallery provides insurance, promotion and verbal contract; shipping costs are shared. Prefers artwork framed.
Submissions: "Work must be strong, not political please." Send query letter with slides, bio and artist's statement. Write for appointment to show portfolio of photographs or slides. Replies in 2 months. Files slides, résumés.

JERALD MELBERG GALLERY INC., 3900 Colony Rd., Suite C, Charlotte NC 28211. (704)365-3000. Fax: (704)365-3016. President: Jerald Melberg. Retail gallery. Estab. 1983. Represents 26 emerging, mid-career and established artists/year. Exhibited artists include Arless Day and Wolf Kahn. Sponsors 15-16 shows/year. Average display time 5 weeks. Open all year; Monday-Saturday, 10-6. Located in suburbs; 2,500 sq. ft. 100% of space for gallery artists. Clientele: national. 70-75% private collectors, 25-30% corporate collectors. Overall price range: $1,000-80,000; most work sold at $2,000-6,000.
Media: Considers all media except photography and crafts. Considers all types of prints. Most frequently exhibits pastel, oil/acrylic and monotypes.
Style: Genres include painterly abstraction, color field, impressionism and realism. Genres include florals and landscapes. Prefers landscapes, abstraction and still life.
Terms: Artwork is accepted on consignment (50% commission). Retail price set by the gallery and the artist. Gallery provides insurance, promotion. Gallery pays for shipping costs from gallery. Artists pays for shipping costs to gallery. Prefers artwork unframed.
Submissions: Send query letter with résumé, slides, reviews, bio, SASE and price structure. Write for appointment to show portfolio of transparencies and slides. Replies in 2-3 weeks. Finds artists through art fairs, other artists, travel.

Tips: "The common mistakes artists make is not finding out what I handle and not sending professional quality materials."

SOMERHILL GALLERY, 3 Eastgate E. Franklin St., Chapel Hill NC 27514. (919)968-8868. Fax: (919)967-1879. Director: Joseph Rowand. Retail gallery. Estab. 1972. Represents emerging, mid-career and established artists. Sponsors 10 major shows/year, plus a varied number of smaller shows. Open all year. 10,000 sq. ft.; gallery features "architecturally significant spaces, pine floor, 18' ceiling, 6 separate gallery areas, stable, photo, glass." 50% of space for special exhibitions.
Media: Considers all media, woodcuts, wood engravings, linocuts, engravings, mezzotints, etchings, lithographs and serigraphs. Does not consider installation. Most frequently exhibits painting, sculpture and glass.
Style: Exhibits all styles and genres.
Submissions: Focus is on Southeastern contemporary of the United States; however artists from all over the world are exhibited. Send query letter with résumé, slides, bio, SASE and any relevant materials. Replies in 6-8 weeks. Files slides and biographical information of artists.

North Dakota

‡**DAKOTA FINE ART**, 307 Main Ave., Fargo ND 58103. (701)241-9897. Owner: Dan Jones. Retail gallery. Estab. 1992. Represents 30 emerging and mid-career artists/year. Exhibited artists include Walter Piehl, Betty Strand. Sponsors 6 shows/year. Average display time 1 month. Open all year; Monday-Friday, 10-5:30; Saturday, 10-4; Sunday, 12-4. Located downtown; 3,000 sq. ft.; features natural light, 12' ceilings, floating walls. 25-40% of space for special exhibitions; 60-75% of space for gallery artists. 80% private collectors, 20% corporate collectors. Overall price range: $100-7,000; most work sold at $300-1,200.
Media: Considers all media and all types of prints. Most frequently exhibits landscape painting, printmaking, sculpture.
Style: Exhibits conceptualism, minimalism, realism. Genres include landscapes and figurative work. Prefers landscape painting, abstract painting, conceptual mixed media.
Terms: Accepts work on consignment (50% commission). Retail price set by the artist. Gallery provides insurance, promotion and contract; shipping costs are shared. Prefers artwork framed.
Submissions: Send query letter with résumé, slides and bio. Call for appointment to show portfolio of photographs and slides. Replies in 2 weeks. Files slides. Finds artists through word of mouth, referrals by other artists.
Tips: "Have good slides and a good attitude."

HUGHES FINE ART CENTER ART GALLERY, Department of Visual Arts, University of North Dakota, Grand Forks ND 58202-7099. (701)777-2257. Director: Brian Paulsen. Nonprofit gallery. Estab. 1979. Exhibits emerging, mid-career and established artists. Sponsors 5 shows/year. Average display time 3 weeks. Open all year. Located on campus; 96 running ft. 100% of space for special exhibitions.
• Director states gallery is interested in "well-crafted, clever, sincere, fresh, inventive, meaningful, unique, well-designed compositions—surprising, a bit shocking, etc."
Media: Considers all media. Most frequently exhibits painting, photographs and jewelry/metal work.
Style: Exhibits all styles and genres.
Terms: Retail price set by artist. Gallery provides "space to exhibit work and some limited contact with the public and the local newspaper." Gallery pays for shipping costs. Prefers artwork framed.
Submissions: Send query letter with slides and résumé. Portfolio review not required. Replies in 1 week. Files "duplicate slides, résumés." Finds artists from submissions through *Artist's & Graphic Designer's Market* listing, *Art in America* listing in their yearly museum compilation; as an art department listed in various sources as a school to inquire about; the gallery's own poster/ads.
Tips: "We have a video we send out by request. Send slides and approximate shipping costs."

MINOT ART GALLERY, Box 325, Minot ND 58702. (701)838-4445. Executive Director: Jeanne M. Rodgers. Nonprofit gallery. Estab. 1970. Represents emerging, mid-career and established artists. Sponsors 9-12 shows/year. Average display time 1-2 months. Open all year. Located at North Dakota state fairgrounds; 1,600 sq. ft.; "2-story turn-of-the-century house." 100% of space for special exhibitions. Clientele: 100% private collectors. Overall price range: $50-2,000; most work sold at $100-400.

Media: Considers oil, acrylic, watercolor, pastel, pen & ink, drawings, mixed media, collage, works on paper, sculpture, ceramic, fiber, glass, photograph, woodcuts, engravings, lithographs, serigraphs, linocuts and etchings. Most frequently exhibits watercolor, acrylic and mixed media.
Style: Exhibits all styles and genres. Prefers figurative, Americana and landscapes. No "commercial-style work (unless a graphic art display)." Interested in all media.
Terms: Accepts work on consignment (30% commission). Retail price set by artist. Offers discounts to gallery members and sometimes payment by installments. Gallery provides insurance, promotion and contract; pays shipping costs from gallery or shipping costs are shared. Requires artwork framed.
Submissions: Send query letter with résumé and slides. Write for appointment to show portfolio of good quality photographs and slides. "Show variety in your work." Files material interested in. Finds artists through visiting exhibitions, word of mouth, submissions of slides and members' referrals.
Tips: "Do not call for appointment. We are seeing many more photographers wanting to exhibit. Will take in a small show to fill in an exhibit."

NORTHWEST ART CENTER, Minot State University, 500 University Ave. W., Minot ND 58707. (701)857-3264 or 3836. Fax: (701)839-6933. E-mail: olsonl@warp6.cs.misu.nodak.edu. Director: Linda Olson. Nonprofit gallery. Estab. 1970. Represents emerging, mid-career and established artists. Sponsors 15-25 shows/year. Average display time 4-6 weeks. Open all year. Two galleries: Hartnett Hall Gallery; Monday-Friday, 8-5; The Library Gallery; Monday-Friday, 8-10. Located on University campus; 1,000 sq. ft. 100% of space for special exhibitions. 100% private collectors. Overall price range: $100-40,000; most work sold at $100-4,000.
Media: Considers all media and all types of prints except posters.
Style: Exhibits all styles, all genres.
Terms: Retail price set by the artist. Gallery provides insurance, promotion and contract; shipping costs are shared. Prefers artwork framed.
Submissions: Send query letter with résumé, slides, bio, SASE and artist's statement. Call for appointment to show portfolio of originals, photographs, slides and transparencies. Replies in 1-2 months. Files all material. Finds artists through submissions, visiting exhibitions, word of mouth.
Tips: "Develop a professional presentation. Use excellent visuals—slides, etc."

Ohio

ALAN GALLERY, 36 Park St., Berea OH 44017. (216)243-7794. Fax: (216)243-7772. President: Alan Boesger. Retail gallery and arts consultancy. Estab. 1983. Represents 25-30 emerging, mid-career and established artists. Sponsors 4 solo shows/year. Average display time 6-8 weeks. Clientele: 20% private collectors, 80% corporate clients. Overall price range: $700-6,000; most work sold at $1,500-2,000.
Media: Considers all media and limited edition prints. Most frequently exhibits watercolor, works on paper and mixed media.
Style: Exhibits color field, painterly abstraction and surrealism. Genres include landscapes, florals, Western and figurative work.
Terms: Accepts work on consignment (40% commission). Retail price set by gallery and artist. Exclusive area representation not required. Gallery provides insurance, promotion and contract; shipping costs are shared.
Submissions: Send résumé, slides and SASE. Call or write for appointment to show portfolio of originals and slides. All material is filed.

‡THE ART EXCHANGE, 539 E. Town St., Columbus OH 43215. (614)464-4611. Fax: (614)464-4619. Art consultancy. Estab. 1978. Represents 40 emerging, mid-career and established artists/year. Exhibited artists include Mary Beam, Carl Krabill. Open all year; Monday-Friday, 9-5. Located near downtown; historic neighborhood; 2,000 sq. ft.; showroom located in Victorian home. 100% of space for gallery artists. Clientele: corporate leaders. 20% private collectors; 80% corporate collectors. Overall price range: $150-6,000; most work sold at $1,000-1,500.
Media: Considers oil, acrylic, watercolor, pastel, mixed media, collage, sculpture, ceramics, fiber, glass, photogrpahy and all types of prints. Most frequently exhibits oil, acrylic, watercolor.
Style: Exhibits painterly abstraction, impressionism, realism. Genres include florals and landscapes. Prefers impressionism, painterly abstraction, realism.
Terms: Accepts work on consignment. Retail price set by the gallery and the artist.
Submissions: Send query letter with résumé and slides or photographs. Write for appointment to show portfolio. Replies in 2 weeks. Files slides or photos and artist information. Finds artists through word of mouth, referrals by other artists, visiting art fairs and exhibitions, submissions.
Tips: "Our focus is to provide high-quality artwork and consulting services to the corporate, design and architectural communities. Our works are represented in corporate offices, health care facilities, hotels, restaurants and private collections throughout the country."

‡ARTSPACE/LIMA, P.O. Box 1948, Lima OH 45802. (419)222-1721. Fax: (419)222-6587. Curator: Douglas Drury. Nonprofit gallery. Exhibits 50-70 emerging and mid-career artists/year. Interested in seeing the work of emerging artists. Sponsors 10-13 shows/year. Average display time 5 weeks. Open all year; Monday-Friday, 10-4; Saturday, 10-2; Sunday, 2-4. Located downtown; 1,104 sq. ft. 100% of space for special exhibitions. Clientele: local community. 80% private collectors, 5% corporate collectors. Overall price range: $300-6,000; most work sold at $500-1,000.

• Most shows are thematic and geared toward education. A ceramic teapot exhibition was featured in *Ceramics Monthly* (March 1996). An April 1996 show featured contemporary abstract sculpture.
Media: Considers all media and all types of prints. Most frequently exhibits painting, sculpture, drawing.
Style: Exhibits all styles of contemporary and traditional work.
Terms: Accepts work on consignment (30% commission). Retail price set by the artist. Gallery provides insurance, promotion and contract; shipping costs are shared. Prefers artwork framed.
Submissions: Send query letter with résumé, slides, artist's statement and SASE. Portfolio should include slides. Replies only if interested within 3-6 weeks. Files résumé. Also represents about 30 regional artists working in fine craft (glass, ceramics, etc.) and painting in gallery shop. Contact Megan Runk, Artspace Gallery Shop if interested.

CHELSEA GALLERIES, 23225 Mercantile Rd., Beachwood OH 44122. (216)591-1066. Fax: (216)591-1068. Director: Jill T. Wieder. Retail gallery. Estab. 1975. Represents/exhibits 400 emerging and mid-career artists/year. Exhibited artists include Leonard Urso and Tom Seghi. Sponsors 5 shows/year. Average display time 6 months. Open all year; Monday-Friday, 9-5; Saturday, 12-4. Located in suburban design and architectural resource area; 3,500 sq. ft.; open, adjustable showroom; easy access, free parking, halogen lighting. 40% of space for special exhibitions; 100% of space for gallery artists. Clientele: upscale. 85% private collectors, 15% corporate collectors. Overall price range: $50-10,000; most work sold at $500-2,000.
Media: Considers all media and all types of prints. Most frequently exhibits painting, glass and ceramics.
Style: Exhibits all styles. All genres. Prefers impressionism, realism and abstraction.
Terms: Artwork is accepted on consignment (50% commission). Retail price set by the gallery and the artist. Gallery provides insurance, promotion and contract; shipping costs are shared. Prefers artwork framed.
Submissions: Send query letter with résumé and slides. Call for appointment to show portfolio of photographs and slides. Replies in 6 weeks. Files résumé and slides.
Tips: "Be realistic in pricing—know your market."

THE A.B. CLOSSON JR. CO., 401 Race St., Cincinnati OH 45202. (513)762-5510. Fax: (513)762-5515. Director: Phyllis Weston. Retail gallery. Estab. 1866. Represents emerging, mid-career and established artists. Average display time 3 weeks. Clientele: general. Overall price range: $600-75,000.
Media: Considers oil, watercolor, pastel, mixed media, sculpture, original handpulled prints and limited offset reproductions.
Style: Exhibits all styles and genres.
Terms: Accepts work on consignment or buys outright. Retail price set by gallery and artist. Customer discounts and payment by installment are available. Exclusive area representation required. Gallery provides insurance and promotion; shipping costs are shared.
Submissions: Send photos, slides and résumé. Call or write for appointment. Portfolio review requested if interested in artist's work. Portfolio should include originals. Finds artists through agents, visiting exhibitions, word of mouth, various art publications, sourcebooks, submissions/self-promotions and art collectors' referrals.

SPANGLER CUMMINGS GALLERY, 641 N. High St., Suite 106, Columbus OH 43215. (614)224-4484. Fax: (614)224-4483. Owner/Director: Spangler Cummings. Retail gallery. Estab. 1984. Represents 12 emerging, mid-career and established artists. Sponsors 4 shows/year. Average display time 6 weeks. Open all year; Tuesday-Saturday, 11-5. Located slightly north of downtown in art district; 900 sq. ft.; features historic architecture, rehabilitated with Frank Geary-inspired office. Clientele: upscale local community. 85% private collectors, 15% corporate collectors. Overall price range: $100-8,000; most work sold at $1,500-3,000.
Media: Considers oil, acrylic, watercolor, handcolored prints only. Most frequently exhibits oil on canvas and acrylic on canvas.
Style: Exhibits expressionism, painterly abstraction, minimalism and color field. Prefers color field, painterly abstraction, expressionism.
Terms: Accepts work on consignment (negotiated commission). Retail price set by the artist. Gallery provides insurance, promotion and contract; artist pays shipping costs. Prefers artwork framed.
Submissions: Accepts artists from all areas except local. Prefers only oil or acrylic on canvas based on landscape. Send résumé, slides, bio, brochure and SASE. Call for appointment to show portfolio of slides. Replies only if interested. Files material from potential artists. Finds artists through visiting art fairs, etc.
Tips: "Send in sleeves of slides (6-20 each) of one trend, subject, exploration, etc. Include retail prices with slides."

‡**HILLEL JEWISH STUDENT CENTER GALLERY**, 2615 Clifton Ave., Cincinnati OH 45220. (513)221-6728. Fax: (513)221-7134. Gallery Curator: Claire Lee. Nonprofit gallery, museum. Estab. 1982. Represents 5 emerging artists/academic year. Exhibited artists include Melissa Harshman, Erich Hartmann. Sponsors 5 shows/year. Average display time 5-6 weeks. Open all year Fall, Winter, Spring; Monday-Thursday, 9-5; Friday, 9-3; other hours in conjunction with scheduled programming. Located uptown (next to University of Cincinnati); 1,056 sq. ft.; features the work of Jewish artists in all media; listed in AAA Tourbook; has permanent collection of architectural and historic Judaica from synagogues. 20% of space for special exhibitions; 80% of space for gallery artists. Clientele: upscale, community, students. 90% private collectors, 10% corporate collectors. Overall price range: $150-3,000; most work sold at $150-800.
Media: Considers all media except installations. Considers all types of prints. Most frequently exhibits prints/mixed media, watercolor, photographs.
Style: Exhibits all styles. Genres include landscapes, figurative work and Jewish themes. Avoids minimalism and hard-edge geometric abstraction.
Terms: Artwork accepted for exhibit and there is a 30% commission. Retail price set by the artist. Gallery provides insurance, promotion, contract, opening reception; shipping costs are shared. Prefers artwork framed.
Submissions: "With rare exceptions, we feature Jewish artists." Send query letter with slides, bio or photographs, SASE. Call or write for appointment to show portfolio. Replies in 1 week. Files bios/résumés, description of work.

‡**KUSSMAUL GALLERY**, 140 E. Broadway, P.O. Box 338, Granville OH 43023. (614)587-4640. Owner: James Young. Retail gallery, custom framing. Estab. 1989. Represents 6-12 emerging and mid-career artists/year. Exhibited artists include James Young, Greg Murr. Sponsors 3-4 shows/year. Average display time 30 days. Open all year; Monday-Saturday, 10-5. Located downtown; 3,200 sq. ft.; restored building erected 1830—emphasis on interior brick walls and restored tin ceilings. 25% of space for art displays. Clientele: upper-middle. 75% private collectors, 25% corporate collectors. Overall price range: $75-2,500; most work sold at $150-350.
Media: Considers oil, acrylic, watercolor, mixed media, sculpture, glass, all types of prints. Most frequently exhibits watercolor.
Style: Exhibits expressionism, neo-expressionism, primitivism, abstraction, impressionism, realism. Prefers impressionism.
Terms: Accepts work on consignment (40% commission) or buys outright. Retail price set by the gallery. Gallery provides insurance and promotion; artist pays shipping costs to and from gallery. Prefers artwork unframed.
Submissions: Send query letter with résumé, slides, bio and SASE. Replies only if interested within 1 month. Files slides, bio or returns them. Finds artists through networking, talking to emerging artists.
Tips: "Don't overprice your work, be original. Have large body of work representing your overall talent and style."

‡**MALTON GALLERY**, 2709 Observatory, Cincinnati OH 45208. (513)321-8614. Director: Donald Malton. Retail gallery. Estab. 1974. Represents about 75 emerging, mid-career and established artists. Exhibits 12 artists/year. Exhibited artists include Kendall Jan Jubb and Barbara Young. Sponsors 6 shows/year. Average display time 1 month. Open all year; Monday-Saturday, 10-5. Located in high-income neighborhood shopping district. 1,700 sq. ft. "Friendly, non-intimidating environment." Two-person shows alternate with display of gallery artists. Clientele: private and corporate. Overall price range: $250-10,000; most work sold at $400-2,500.
Media: Considers oil, acrylic, drawing, sculpture, watercolor, mixed media, pastel, collage and original handpulled prints.
Style: Exhibits all styles. Genres include landscapes, florals and figurative work.
Terms: Accepts work on consignment (50% commission). Retail price set by artist (sometimes in consultation with gallery). Gallery provides insurance, promotion, contract and shipping costs from gallery; artist pays shipping costs to gallery. Prefers framed works for canvas; unframed works for paper.
Submissions: Send query letter with résumé, slides or photographs, reviews, bio and SASE. Replies in 2-4 weeks. Files résumé, review or any printed material. Slides and photographs are returned.
Tips: "Never drop in without an appointment. Be prepared and professional in presentation. This is a business. Artists themselves should be aware of what is going on, not just in the 'art world,' but with everything."

THE MIDDLETOWN FINE ARTS CENTER, 130 N. Verity Pkwy., P.O. Box 441, Middletown OH 45042. (513)424-2416. Contact: Peggy Davish. Nonprofit gallery. Estab. 1957. Represents emerging, mid-career and established artists. Sponsors 5 solo and/or group shows/year. Average display time 3 weeks. Clientele: tourists, students, community. 95% private collectors, 5% corporate clients. Overall price range: $100-1,000; most work sold at $150-500.
Media: Considers all media except prints. Most frequently exhibits watercolor, oil, acrylic and drawings.
Style: Exhibits all styles and genres. Prefers realism, impressionism and photorealism. "Our gallery does not specialize in any one style or genre. We offer an opportunity for artists to exhibit and hopefully sell their

work. This also is an important educational experience for the community. Selections are chosen 2 years in advance by a committee."

Terms: Accepts work on consignment (30% commission). Retail price set by artist. Sometimes offers customer discounts and payment by installment. Exclusive area representation not required. Gallery provides promotion; artist pays for shipping. Artwork must be framed and wired.

Submissions: Send query letter with résumé, brochure, slides, photographs and bio. Write for an appointment to show portfolio, which should include originals, slides or photographs. Replies in 3 weeks-3 months (depends when exhibit committee meets.). Files résumé or other printed material. All material is returned if not accepted or under consideration. Finds artists through word of mouth, submissions and self-promotions.

Tips: "Decisions are made by a committee of volunteers, and time may not permit an on-the-spot interview with the director."

MILLER GALLERY, 2715 Erie Ave., Cincinnati OH 45208. (513)871-4420. Fax: (513)871-4429. Co-Directors: Barbara and Norman Miller. Retail gallery. Estab. 1960. Interested in emerging, mid-career and established artists. Represents about 50 artists. Sponsors 5 solo and 4 group shows/year with display time 1 month. Located in affluent suburb. Clientele: private collectors. Overall price range: $100-35,000; most artwork sold at $300-12,000.

Media: Considers, oil, acrylic, mixed media, collage, works on paper, ceramic, fiber, bronze, stone, glass and original handpulled prints. Most frequently exhibits oil or acrylic, glass and sculpture.

Style: Exhibits impressionism, realism and painterly abstraction. Genres include landscapes, interior scenes and still lifes. "Everything from fine realism (painterly, impressionist, pointilist, etc.) to beautiful and colorful abstractions (no hard-edge) and everything in between. Also handmade paper, collage, fiber and mixed mediums."

Terms: Accepts artwork on consignment (50% commission). Retail price set by artist and gallery. Sometimes offers payment by installment. Exclusive area representation is required. Gallery provides insurance, promotion and contract; shipping and show costs are shared.

Submissions: Send query letter with résumé, brochure, slides or photographs with sizes, wholesale (artist) and selling price and SASE. All submissions receive phone or written reply. Finds artists through agents, visiting exhibitions, word of mouth, various art publications and sourcebooks, submissions/self-promotions, art collectors' referrals, and *Artist's and Graphic Designer's Market.*

Tips: "Artists often either completely omit pricing info or mention a price without identifying as artist's or selling price. Submissions without SASE will receive reply, but no return of materials submitted. Make appointment—don't walk in without one. Quality, beauty, originality are primary. Minimal, conceptual, political works not exhibited."

‡ONLY ARTISTS, 1315 Main St., Cincinnati OH 45210. (513)241-6672. Partners: Patsy Bonafair, Donna Schiff. Retail gallery. Estab. 1994. Represents 40 emerging, mid-career and established artists/year. Exhibited artists include Jimmy Sudduth, Howard Finster. Sponsors 5 shows/year. Average display time 2 months. Open all year; Tuesday-Saturday, 11-5. Located downtown; 900 sq. ft.; great downtown architecture. 30% of space for special exhibitions; 70% of space for gallery artists. 30% private collectors. Overall price range: $15-7,000; most work sold at $200-500.

Media: Considers acrylic, mixed media, ceramics, carving.

Style: Exhibits primitivism, contemporary folk art.

Terms: Retail price set by the gallery and the artist. Gallery provides insurance and promotion; shipping costs are shared. Prefers artwork framed.

Submissions: Prefers untrained, self-taught.

‡REINBERGER GALLERIES, CLEVELAND INSTITUTE OF ART, 11141 E. Blvd., Cleveland OH 44106. (216)421-7407. Fax: (216)421-7438. Director: Bruce Checefsky. Nonprofit gallery, college. Estab. 1882. Represents established artists. 8 gallery committee members. Sponsors 9 shows/year. Average display time 4-6 weeks. Open all year; Sunday 1-4, Monday 9-4, Tuesday-Saturday, 9:30-9. Located University Circle; 5,120 sq. ft.; largest independant exhibit facility in Cleveland (for college or university). 100% of space for special exhibitions. Clientele: students, faculty and community at large. 80% private collectors, 30% corporate collectors. Overall price range: $50-75,000; most work sold under $1,000.

Media: Considers all media. Most frequently exhibits prints, drawings, paintings, sculpture, installation, fiber and experimental.

Style: Exhibits all styles, all genres.

Terms: Accepts work on consignment (15% commission). Retail price set by the artist. Gallery provides insurance, promotion, contract and shipping costs.

Submissions: Send query letter with résumé, slides, bio, photographs, SASE and reviews. No phone inquires. Replies in 6 months. Files bio and slides when applicable.

RUTLEDGE GALLERY, 1964 N. Main St., Dayton OH 45405. (513)278-4900. Director: Jeff Rutledge. Retail gallery, art consultancy. Focus is on artists from the Midwest. Estab. 1991. Represents 80 emerging and mid-career artists/year. Exhibited artists include Pat Antonic, Chris Shatzby and M. Todd Muskopf.

Sponsors 12 shows/year. Average display time 2 months. Open all year; Tuesday-Saturday, 11-6. Located 1 mile north of downtown in Dayton's business district; 2800 sq. ft. "We specialize in sculpture and regional artists. We also offer commissioned work and custom framing." 70% of space for special exhibitions; 70% of space for gallery artists. Clientele: residential, corporate, private collectors, institutions. 65% private collectors, 35% corporate collectors.

Media: Considers oil, acrylic, watercolor, pastel, pen & ink, drawing, mixed media, paper, sculpture, ceramic, craft, glass, jewelry, woodcuts, engravings, lithographs, linocuts, etchings and posters. Most frequently exhibits paintings, drawings, prints and sculpture.

Style: Exhibits expressionism, painterly abstraction, surrealism, color field, impressionism and realism. Considers all genres. Prefers contemporary (modern), geometric and abstract.

Terms: Accepts work on consignment (40% commission). Retail price set by gallery. Gallery provides insurance, promotion and contract; artists pays shipping costs. Prefers artwork framed.

Submissions: Accepts mainly Midwest artists. Send query letter with résumé, brochure, 20 slides and 10 photographs. Call for appointment to show portfolio of originals, photographs, slides and transparencies. Replies only if interested within 1 month. Files "only material on artists we represent; others returned if SASE is sent or thrown away."

Tips: "Be well prepared, be professional, be flexible on price and listen."

‡**SCARABB GALLERY**, 28809 Chagrin Blvd., Cleveland OH 44122. (216)591-1115. Fax: (216)831-1552. Retail gallery. Estab. 1991. Represents dozens of emerging, mid-career and established artists/year. Exhibited artists include Stanley Boxer. Sponsors 6-10 shows/year. Average display time 4-6 weeks. Open all year; Tuesday-Friday, 10-5:30; Saturday, 10-5; closed Mondays. Located in a suburban area. 90% private collectors, 10% corporate collectors. Overall price range: $500-35,000; most work sold at $6,000-12,000.

Media: Considers all media and all types of prints.

Style: Exhibits all genres.

Terms: Accepts work on consignment (40% commission). Retail price set by the gallery and the artist. Gallery provides insurance, promotion and contract; shipping costs are shared. Prefers artwork framed.

Submissions: Send query letter with résumé, slides, SASE, reviews and videos. Write for appointment to show portfolio of photographs, transparencies, slides and small works when applicable. Replies in 1-2 months. Files slides and bios. Finds artists through word of mouth, referrals by other artists, visiting art fairs and exhibitions, artists' submissions, etc.

Tips: "Avoid sending too much material: too many slides, photos."

SPACES, 2220 Superior Viaduct, Cleveland OH 44113. (216)621-2314. Alternative space. Estab. 1978. Represents emerging artists. Has 300 members. Sponsors 10 shows/year. Average display time 1 month. Open all year. Located downtown Cleveland; 6,000 sq. ft.; "loft space with row of columns." 100% private collectors.

Media: Considers all media. Most frequently exhibits installation, painting and sculpture.

Style: Exhibits all styles. Prefers challenging new ideas.

Terms: Accepts work on consignment. 20% commission. Retail price set by the artist. Sometimes offers payment by installment. Gallery provides insurance, promotion and contract.

Submissions: Send query letter with résumé, slides and SASE. Annual deadline in spring for submissions.

THE ZANESVILLE ART CENTER, 620 Military Rd., Zanesville OH 43701. (614)452-0741. Fax: (614)452-0797. Director: Philip Alan LaDouceur. Nonprofit gallery, museum. Estab. 1936. Represents emerging, mid-career and established artists. "We usually hold 3 exhibitions per month." Sponsors 25-30 shows/year. Average display time 6-8 weeks. Open all year; closed Mondays and major holidays. 1,152 sq. ft. 50% of space for special exhibitions; 50% of space for gallery artists. Clientele: artists of distinguished talent. 25% private collectors, 25% corporate collectors. Most work sold at $300-1,500.

Media: Considers all media. Most frequently exhibits watermedia, oil, collage, ceramics, sculpture and children's art, as well as all photography media.

Style: Exhibits all styles. Accepts all genres.

Terms: Accepts work on consignment (33% commission on sales). Retail price set by the artist. Gallery provides insurance and promotion; artist responsible for shipping costs to and from gallery. Prefers artwork framed.

Submissions: Send query letter with résumé, slides, bio, photographs and reviews. Replies in 1 month. Artist should follow up after query letter or appointment. Files bio or résumé. Finds artists through exhibitions, word of mouth, art publications and submissions.

Oklahoma

LACHENMEYER ART CENTER, 700 S. Little, P.O. Box 586, Cushing OK 74023. (918)225-7525. Director: Rob Smith. Nonprofit. Estab. 1984. Represents 35 emerging and mid-career artists/year. Exhibited

artists include Darrell Maynard, Steve Childers and Dale Martin. Sponsors 4 shows/year. Average display time 2 weeks. Open in August, September, December; Monday, Wednesday, Friday, 9-5; Tuesday, Thursday, 5-9. Located inside the Cushing Youth and Community Center; 550 sq. ft. 80% of space for special exhibitions; 80% of space for gallery artists. 100% private collectors.

Media: Considers oil, acrylic, watercolor, pastel, pen & ink, drawing, mixed media, collage, paper, sculpture, ceramics, fiber, photography, woodcuts, engravings, lithographs, wood engravings, mezzotints, serigraphs, linocuts and etchings. Most frequently exhibits oil, acrylic and works on paper.

Style: Exhibits all styles. Prefers landscapes, portraits and Americana.

Terms: Accepts work on consignment (0% commission). Retail price set by the artist. Gallery provides promotion; shipping costs are shared. Prefers artwork framed.

Submissions: Send query letter with résumé, professional quality slides, SASE and reviews. Call or write for appointment to show portfolio of originals. Replies in 1 month. Files résumés. Finds artists through visiting exhibits, word of mouth, other art organizations.

Tips: "We are booked one to two years in advance. I prefer regional artists."

NO MAN'S LAND MUSEUM, P.O. Box 278, Goodwell OK 73939-0278. (405)349-2670. Fax: (405)349-2302. Director: Kenneth R. Turner. Museum. Estab. 1934. Represents emerging, mid-career and established artists. Sponsors 12 shows/year. Average display time 1 month. Open all year; Tuesday-Saturday, 9-12 and 1-5. Located adjacent to university campus. 10% of space for special exhibitions. Clientele: general, tourist. 100% private collectors. Overall price range: $20-1,500; most work sold at $20-500.

Media: Considers all media and all types of prints. Most frequently exhibits oils, watercolors and pastels.

Style: Exhibits primitivism, impressionism, photorealism and realism. Genres include landscapes, florals, Americana, Southwestern, Western and wildlife. Prefers realist, primitive and impressionist.

Terms: "Sales are between artist and buyer; museum does not act as middleman." Retail price set by the artist. Gallery provides promotion and shipping costs to and from gallery. Prefers artwork framed.

Submissions: Send query letter with résumé, brochure, photographs and reviews. Call or write for appointment to show portfolio of photographs. Replies only if interested within 3 weeks. Files all material. Finds artists through art publications, exhibitions, news items, word of mouth.

SHORNEY GALLERY OF FINE ART, 6616 N. Olie, Oklahoma City OK 73116-7318. Owner/director: Margo Shorney. Retail gallery. "Some private lessons and critiques given." Estab. 1976. Represents 40 emerging, mid-career and established artists. Exhibited artists include Rita Busch and Bill Thompson. Sponsors 2 major shows/year, and several Artist of the Month shows. Average display time 1 month. Open all year. Located in NW Oklahoma City; "gallery on one acre of land with landscaping, fish ponds and outdoor and indoor entertaining spaces." 1,800 sq. ft; 66% of space for special exhibitions. Clientele: experienced as well as beginning collectors. 80% private collectors, 20% corporate collectors. Overall price range: $60-6,000; most work sold at $500-3,500.

Media: Considers oil, acrylic, watercolor, pastel, pen & ink, mixed media, sculpture, fiber, raku pottery, stoneware, original handpulled prints, woodcuts, engravings, lithographs, etchings and serigraphs. Most frequently exhibits bronze, oil and watercolor.

Style: Exhibits painterly abstraction, surrealism, imagism, conceptualism, color field, impressionism and realism. Genres include landscapes, florals, Southwestern, Western, wildlife, portraits and figurative work. Prefers painterly realism, impressionism and representational bronze sculpture.

Terms: Accepts artwork on consignment (40% commission); or buys outright for 50% of retail price. Retail price set by gallery and artist. Gallery provides 50% of promotion and contract; artist pays for shipping. Prefers artwork framed.

Submission: Send query letter with résumé, bio, brochure and SASE. Write for appointment to show portfolio of originals, photographs and slides. Replies only if interested within 3 months. Files bio, résumé and brochure.

Tips: "Artist should have exposure through juried shows, other galleries, education or workshops in their expertise. Looking for serious, committed professionals, not 'Sunday' artists. We are adding artists only as a niche develops or when a certain style is in demand. The clientele has become very discerning and requires a greater degree of professionalism in all areas, the work itself and the presentation. We ship to out-of-state buyers more often. They are looking for quality at reasonable prices, which has been good for emerging and lesser-known artists."

Oregon

‡BLACKFISH GALLERY, 420 NW Ninth Ave., Portland OR 97209. (503)224-2634. Director: Cheryl Snow. Retail cooperative gallery. Estab. 1979. Represents 24 emerging and mid-career artists. Exhibited artists include Carolyn Wilhelm and Stephan Soihl. Sponsors 12 shows/year. Open all year. Located downtown, in the "Northwest Pearl District; 2,500 sq. ft.; street-level, 'garage-type' overhead wide door, long, open space (100' deep)." 70% of space for feature exhibits, 15-20% for gallery artists. Clientele: 80% private collectors,

20% corporate clients. Overall price range: $250-12,000; most artwork sold at $900-1,400.

Media: Considers oil, acrylic, watercolor, pastel, pen & ink, drawings, mixed media, collage, sculpture, ceramic, photography, woodcuts, wood engravings, linocuts, engravings, mezzotints, etchings, lithographs, pochoir and serigraphs. Most frequently exhibits paintings, sculpture and prints.

Style: Exhibits expressionism, neo-expressionism, painterly abstraction, surrealism, conceptualism, minimalism, color field, postmodern works, impressionism and realism. Prefers neo-expressionism, conceptualism and painterly abstraction.

Terms: Accepts work on consignment from invited artists (50% commission); co-op membership includes monthly dues plus donation of time (40% commission on sales). Retail price set by artist with assistance from gallery on request. Customer discounts and payment by installment are available. Gallery provides insurance, promotion and contract, and shipping costs from gallery. Prefers artwork framed.

Submissions: Accepts only artists from northwest Oregon and southwest Washington ("unique exceptions possible"); "must be willing to be an active cooperative member—write for details." Send query letter with résumé, slides, SASE, reviews and statement of intent. Write for appointment to show portfolio of photographs and slides. "We review throughout the year." Replies in 1 month. Files material only if exhibit invitation extended. Finds artists through agents, visiting exhibitions, word of mouth, various art publications and sourcebooks, submissions/self-promotions and art collectors' referrals.

Tips: "Understand—via research—what a cooperative gallery is. Call or write for information packet. Do not bring work or slides to us without first having contacted us by phone or mail."

BUCKLEY CENTER GALLERY, UNIVERSITY OF PORTLAND, 5000 N. Willamette Blvd., Portland OR 97203. (503)283-7258. E-mail: soissen@uofport.edu. Gallery Director: Michael Miller. University gallery. Exhibits emerging, mid-career and established artists. Exhibited artists include Don Gray and Melinda Thorsnes. Sponsors 7 shows/year. Average display time 3-4 weeks. Open September-May; Monday-Friday; 8:30-8:00 and Saturday, 8:30-4:00. Located 5 miles from downtown Portland; 525 sq. ft.; 2 walls of floor to ceiling windows (natural light). Clientele: students, faculty staff and locals. 100% private collectors. Overall price range: $300-3,000; most work sold at $400-700.

Media: Considers all media and all types of prints. Prefers oil/acrylic, photography, watercolor and mixed media.

Style: Exhibits all styles and genres. Prefers neo-expressionism, realism and primitivism.

Terms: Accepts work on consignment (10% commission). Retail price set by artist. Gallery provides insurance and promotion; artist pays shipping costs. Prefers artwork framed.

Submissions: Accepts only artists from Portland metropolitan area. No shipping, artist must deliver and pick-up. Send query letter with résumé, professional slides, bio and SASE. Replies in 3 weeks. Files résumés.

‡BUTTERS GALLERY, LTD., 223 NW Ninth Ave., Portland OR 97209. (503)248-9378. Fax: (503)248-9390. E-mail: bgl@teleport.com. Director: Jeffrey Butters. Retail gallery. Estab. 1987. Represents 50 emerging and mid-career artists/year. Exhibited artists include David Geiser, Ming Fay. Sponsors 12 shows/year. Average display time 1 month. Open all year; Tuesday-Friday, 10-5:30; Saturday, 11-5. Located in Northwest Triangle; 5,000 sq. ft.; concrete floors, large roll up garage doors. Clientele: tourists, upscale, local community, students. 70% private collectors, 30% corporate collectors. Overall price range: $500-40,000; most work sold at $500-10,000.

Media: Considers all media and all types of prints. Most frequently exhibits painting, sculpture, graphic works.

Style: Exhibits all styles and genres. Prefers painterly abstraction, expressionism, postmodern.

Terms: Accepts work on consignment (50% commission). Retail price set by the gallery and the artist. Gallery provides insurance, promotion and contract; shipping costs are shared.

Submissions: Send query letter with slides, bio and SASE. Write for appointment to show portfolio of photographs, transparencies and slides. Replies in 2 months. Finds artists through word of mouth, referrals by other artists, visiting art fairs and exhibitions, submissions.

‡GRAVEN IMAGES GALLERY, 270 E. Main St., Ashland OR 97520. (541)488-4201. Fax: (541)488-8077. Owner: Jack Hardesty. Retail gallery. Estab. 1994. Represents 15 emerging, mid-career and established artists/year. Exhibited artists include Yuji Hiratsuka, Steve McMillan. Sponsors 11 shows/year. Average display time 1 month. Open all year; Tuesday-Saturday, 10-5. Located downtown; 525 sq. ft. 100% of space for gallery artists. Clientele: tourists, local community. 10% private collectors. Overall price range: $100-800; most work sold at $100-300.

 THE DOUBLE DAGGER before a listing indicates that the listing is new in this edition. New markets are often more receptive to freelance submissions.

Media: Considers small sculpture, ceramics, glass, fine art prints only (contemporary). Most frequently exhibits prints (contemporary fine arts), ceramics.
Terms: Accepts work on consignment (40% commission). Retail price set by the artist. Gallery provides insurance and promotion; shipping costs are shared. Prefers artwork unframed.
Submissions: Prefers fine art prints and decorative ceramics. Prefers artists who can come for openings. Call for appointment to show portfolio of photographs. Replies in 1 month. Files only information on artists to be exhibited. Finds artists through Northwest Print Council, out-of-town galleries, exhibitions, submissions.

LANE COMMUNITY COLLEGE ART GALLERY, 4000 E. 30th Ave., Eugene OR 97405. (503)747-4501. Gallery Director: Harold Hoy. Nonprofit gallery. Estab. 1970. Exhibits the work of emerging, mid-career and established artists. Sponsors 7 solo and 2 group shows/year. Average display time 3 weeks. Most work sold at $100-2,000.
Media: Considers all media.
Style: Exhibits contemporary works. Interested in seeing "contemporary, explorative work of quality. Open in terms of subject matter."
Terms: Retail price set by artist. Sometimes offers customer discounts. Exclusive area representation not required. Gallery provides insurance, promotion and contract; shipping costs are shared. "We retain 25% of the retail price on works sold."
Submissions: Send query letter, résumé and slides with SASE. Portfolio review required. Résumés are filed.

LAWRENCE GALLERY, Box 187, Sheridan OR 97378. (503)843-3633. Director: Gary Lawrence. Retail gallery and art consultancy. Estab. 1977. Represents 150 mid-career and established artists. Sponsors 10 two-person and 1 group shows/year. "The gallery is surrounded by several acres of landscaping in which we feature sculpture, fountains and other outdoor art." Clientele: tourists, Portland and Salem residents. 80% private collectors, 20% corporate clients. Overall price range: $10-50,000; most work sold at $1,000-5,000.
Media: Considers oil, acrylic, watercolor, pastel, mixed media, collage, sculpture, ceramic, fiber, glass, jewelry and original handpulled prints. Most frequently exhibits oil, watercolor, metal sculpture and ceramic.
Style: Exhibits painterly abstraction, impressionism, photorealism and realism. Genres include landscapes and florals. "Our gallery features beautiful artworks that celebrate life."
Terms: Accepts work on consignment (50% commission). Retail price set by artist. Offers payment by installments. Exclusive area representation required. Gallery provides insurance, promotion and contract; artist pays for shipping.
Submissions: Send query letter, résumé, brochure, slides and photographs. Portfolio review required if interested in artists' work. Files résumés, photos of work, newspaper articles, other informative pieces and artist's statement. Find artists through agents, visiting exhibitions, word of mouth, art publications and sourcebooks, submissions/self-promotions, art collectors' referrals.
Tips: "Do not bring work without an appointment."

RICKERT ART CENTER AND GALLERY, 620 N. Hwy. 101, Lincoln City OR 97367. (503)994-0430. Fax: (503)1-800-732-8842. Manager/Director: Lee Lindberg. Retail gallery. Represents more than 20 emerging, mid-career and established artists/year. Exhibited artists include Sharon Rickert. Sponsors 3 shows/year. Open all year; daily, 9:30-5:30. Located south end of town on main street; 2,300 sq. ft.; 50-year-old building. 20% of space for special exhibitions; 60% of space for gallery artists. Overall price range: $200-6,000; most work sold at $800-3,000.
Media: Considers oil, acrylic, watercolor, pastel, mixed media, sculpture, lithographs, serigraphs and posters. Most frequently exhibits oil, acrylic, watercolor and pastel.
Style: Exhibits all styles. Genres include landscapes, florals, Southwestern, Western, wildlife, portraits, figurative work, seascapes. Prefers seascapes, florals, landscapes.
Terms: Accepts work on consignment (50% commission). Retail price set by the gallery and the artist. Gallery provides promotion; artist pays shipping costs to and from gallery. Prefers artwork framed.
Submissions: Send query letter with résumé and photographs. Call or write for appointment to show portfolio of originals. Artist should follow up with call.
Tips: Looking for landscapes and seascapes in oil.

‡ROGUE GALLERY & ART CENTER, 40 S. Bartlett, Medford OR 97501. (503)772-8118. Executive Director: Nancy Jo Mullen. Nonprofit rental gallery. Estab. 1961. Represents emerging, mid-career and established artists. Sponsors 8 shows/year. Average display time 6 weeks. Open all year; Tuesday-Friday 10-5, Saturday 10-4. Located downtown; main gallery 240 running ft. (2,000 sq. ft.); rental/sales and gallery shop, 1,800 sq. ft.; classroom facility, 1,700 sq. ft. "This is the only gallery/art center/exhibit space of its kind in region, excellent facility, good lighting." 33% of space for special exhibitions; 33% of space for gallery artists. 95% private collectors. Overall price range: $100-5,000; most work sold at $300-600.
Media: Considers all media and all types of prints. Most frequently exhibits mixed media, drawing, painting, sculpture, watercolor.

Style: Exhibits all styles, all genres. Prefers figurative work, collage, landscape, florals, handpulled prints.
Terms: Accepts work on consignment (35% commission). Retail price set by the artist. Gallery provides insurance, promotion and contract; in the case of main gallery exhibit, gallery assumes cost for shipping 1 direction, artist 1 direction.
Submissions: Send query letter with résumé, slides, bio and SASE. Call or write for appointment. Replies in 1 month.

Pennsylvania

ALBER GALLERIES, 3300 Darby Rd., Suite 5111, Haverford PA 19041. (610)896-9297. Owners: Howard and Elaine Alber. Wholesale gallery/art consultancy. Represents emerging, mid-career and established artists. Clientele: 20% private collectors, 80% corporate clients, cooperating with affiliated galleries. Overall price range: $25-10,000; most work sold at $150-800.
Media: Considers oil, acrylic, watercolor, mixed media, collage, works on paper, sculpture, photography, woodcuts, linocuts, lithographs and serigraphs.
Style: Exhibits impressionism, realism, painterly abstraction, conceptualism. Considers all styles. Genres include landscapes and figurative work. "We're a contributor to the sales and rental gallery of the Philadelphia Museum of Art."
Terms: Accepts work on consignment (40% commission). Retail price set by gallery and artist. Exclusive area representation not required.
Submissions: Presently, only accepting work requested by clients (search material).
Tips: Advises artists to "stop being loners. Join Artists Equity Association (local and national chapters) to get better laws for the art world."

THE ART BANK, 3028 N. Whitehall Rd., Norristown PA 19403-4403. Phone/fax: (610)539-2265. Director: Phyllis Sunberg. Retail gallery, art consultancy, corporate art planning. Estab. 1985. Represents 40-50 emerging, mid-career and established artists/year. Exhibited artists include Lisa Fedon, and Bette Ridgeway. Average display time 3-6 months. Open all year; by appointment only. Located in a Philadelphia suburb; 1,000 sq. ft.; Clientele: corporate executives and their corporations. 20% private collectors, 80% corporate collectors. Overall price range: $300-35,000; most work sold at $500-1,000.
Media: Considers oil, acrylic, watercolor, pastel, mixed media, collage, sculpture, glass, installation, holography, exotic material, lithography, serigraphs. Most frequently exhibits acrylics, serigraphs and sculpture.
Style: Exhibits expressionism, painterly abstraction, color field and hard-edge geometric abstraction. Genres include landscapes. Prefers color field, hard edge abstract and impressionism.
Terms: Accepts work on consignment (40% commission). Shipping costs are shared. Prefers artwork unframed.
Submissions: Prefers artists from the region (PA, NJ, NY, DE). Send query letter with résumé, slides, brochure, SASE and prices. Write for appointment to show portfolio of originals (if appropriate), photographs and corporate installation photos. Replies only if interested within 2 weeks. Files "what I think I'll use— after talking to artist and seeing visuals." Finds artists through agents, by visiting exhibitions, word of mouth, art publications and sourcebooks, submissions.

THE ART INSTITUTE OF PHILADELPHIA, 1622 Chestnut St., 1st Floor, Philadelphia PA 19103. (215)567-7080. Fax: (215)246-3339. Gallery Coordinator: Alicia A. Bruno. Estab. 1971. Represents/exhibits emerging, mid-career and established artists. Interested in seeing the work of emerging artists. Sponsors 12 shows/year. Average display time 1 month. Open all year; Monday-Friday, 9-6; Saturday, 9-3. Located in Center City Philadelphia. Clientele: local community and students. Overall price range: $150-2,000; most work sold at $400-500.
Media: Considers oil, pen & ink, paper, acrylic, drawing, watercolor, mixed media, pastel, photography and all types of prints. Most frequently exhibits photography, graphic design, illustration and painting (all media).
Style: Exhibits all styles. All genres.
Terms: No rental fee. Artist retains 100% of sales. Retail price set by the artist. Gallery provides insurance, promotion. "Invitation payment must be worked out with gallery." Artists pays for shipping costs. Prefers artwork framed.
Submissions: Send query letter with résumé, slides, bio and SASE. Write for appointment to show portfolio of slides. Replies in 3 months. Finds artists through word of mouth and referrals.

CAT'S PAW GALLERY, 31 Race St., Jim Thorpe PA 18229. (717)325-4041. Director/Owner: John and Louise Herbster. Retail gallery. Represents 100 emerging, mid-career and established artists/year. Exhibited artists include Shelley Buonaiuto, Nancy Giusti. Sponsors 1 or 2 shows/year. Average display time 1 month. Open all year; April-December, Wednesday-Sunday, 11-5; January-March, by chance or appointment. Located in historic downtown district; 400 sq. ft.; in one of 16 "Stone Row" 1848 houses built into mountainside. 40% of space for special exhibitions; 60% of space for gallery artists. Clientele: collectors, tourists,

corporate. 50% private collectors. 5% corporate. Overall price range: $2-2,000; most work sold at $20-200.
Media: Considers oil, acrylic, watercolor, pastel, pen & ink, drawing, mixed media, collage, paper, sculpture, ceramics, craft, fiber, glass, original hand-pulled prints. Most frequently exhibits ceramics, sculpture and jewelry.
Style: Exhibits all styles. Only domestic feline subjects.
Terms: Accepts work on consignment (40% commission) or buys outright for 50% of retail price (net 30 days). "We usually purchase, except for major exhibits." Retail price set by the artist. Gallery provides insurance, promotion and contract; shipping costs are shared. Prefers artwork framed.
Submissions: Accepts artists from all regions of the US. Send query letter with résumé, slides or photographs, bio, brochure and reviews. Call or write for appointment to show portfolio of photographs. Replies only if interested within 1 week. Files all material of interest. Finds artists through visiting exhibitions and trade shows, word of mouth, submissions, collectors, art publications.
Tips: "Submit only studio work depicting the domestic feline. We strive to treat cat art in a serious manner. Cat art should be accorded the same dignity as equestrian art. We are not interested in cutsey items aimed at the mass market. We will review paintings and graphics, but are not currently seeking them."

CENTER GALLERY OF BUCKNELL UNIVERSITY, Elaine Langone Center, Lewisburg PA 17837. (717)524-3792. Fax: (717)524-3480. E-mail: peltier@bucknell.edu. Director: Johann JK Reusch. Assistant Director: Cynthia Peltier. Nonprofit gallery. Estab. 1983. Represents emerging, mid-career and established artists. Sponsors 6 shows/year. Average display time 6 weeks. Open all year; Monday-Friday, 11-5; Saturday-Sunday, 1-4. Located on campus; 3,000 sq. ft. plus 40 movable walls.
Media: Considers all media, all types of prints. Most frequently exhibits painting, prints and photographs.
Style: Exhibits all styles, all genres.
Terms: Retail price set by the artist. Gallery provides insurance, promotion (local) and contract; artist pays shipping costs to and from gallery. Prefers artwork framed.
Submissions: Send query letter with résumé, slides and bio. Write for appointment to show portfolio of originals. Replies in 2 weeks. Files bio, résumé, slides. Finds artists through occasional artist invitationals/competitions.
Tips: "We usually work with themes and then look for work to fit that theme."

‡THE CLAY PLACE, 5416 Walnut St., Pittsburgh PA 15232. (412)682-3737. Fax: (412)681-1226. Director: Elvira Peake. Retail gallery. Estab. 1973. Represents 50 emerging, mid-career and established artists. Exhibited artists include Warren MacKenzie and Kirk Mangus. Sponsors 12 shows/year. Open all year. Located in small shopping area; "second level modern building with atrium." 2,000 sq. ft. 50% of space for special exhibition. Overall price range: $10-2,000; most work sold at $40-100.
Media: Considers ceramic, sculpture, glass and pottery. Most frequently exhibits clay, glass and enamel.
Terms: Accepts artwork on consignment (50% commission), or buys outright for 50% of retail price (net 30 days). Retail price set by artist. Sometimes offers customer discounts and payment by installments. Gallery provides insurance, promotion and shipping costs from gallery.
Submissions: Prefers only clay, some glass and enamel. Send query letter with résumé, slides, photographs, bio and SASE. Write for appointment to show portfolio. Portfolio should include actual work rather than slides. Replies in 1 month. Does not reply when busy. Files résumé. Does not return slides. Finds artists through visiting exhibitions and art collectors' referrals.
Tips: "Functional pottery sells well. Emphasis on form, surface decoration. Some clay artists have lowered quality in order to lower prices. Clientele look for quality, not price."

‡CONCEPT ART GALLERY, 1031 S. Braddock Ave., Pittsburgh PA 15218. (412)242-9200. Director: Sam Berkovitz. Retail gallery. Estab. 1972. Clientele: 60% private collectors, 40% corporate clients. Represents 40 artists; emerging, mid-career and established.
Media: Considers oil, acrylic, watercolor, pastel, pen & ink, drawings, mixed media, collage, works on paper, sculpture, ceramic, craft, fiber, glass and limited edition original handpulled prints. Most frequently exhibits watercolor, prints and paintings.
Style: Exhibits geometric abstraction, color field, painterly abstraction, impressionistic, photorealistic, expressionistic and neo-expressionistic works. Genres include landscapes and florals, 19th century European and American paintings. Interested in seeing "a wide range of styles and quality work."
Terms: Accepts work on consignment. Retail price is set by gallery. Exclusive area representation required. Gallery provides insurance and promotion; shipping costs are shared.
Submissions: Send query letter with résumé, brochure, good-quality slides, photographs and SASE.
Tips: "Only show work appropriate for the gallery."

GALLERY ENTERPRISES, 310 Bethlehem Plaza Mall, Bethlehem PA 18018. (610)868-1139. Fax: (610)868-9482. Owner: David Michael Donnangelo. Wholesale gallery. Estab. 1981. Represents/exhibits 10 established artists/year. May be interested in seeing the work of emerging artists in the future. Exhibited artists include K. Haring and Andy Warhol. Sponsors 1 show/year. Average display time 3 weeks. Open all year; 12:30-5:30. Located in mall, 700 sq. ft.; good light and space. 100% of space for special exhibitions.

Clientele: upscale. 50% private collectors; 10% corporate collectors. Overall price range: $350-5,000; most work sold at $1,200-2,500.

Media: Considers all media, etchings, lithographs, serigraphs and posters. Most frequently exhibits serigraphs, lithography and posters.

Style: Exhibits neo-expressionism, realism, surrealism and environmental. Genres include landscapes and wildlife. Prefers pop art, kenetic art, environmental and surrealism.

Terms: Artwork is accepted on consignment. Retail price set by the gallery. Prefers artwork unframed.

Submissions: Well-established artists only. Send query letter with slides and photographs. Call for appointment to show portfolio of photographs and slides. "If slides or photos are sent they will be kept on file but not returned. We reply only if we are interested."

‡**GALLERY 500**, Church & Old York Rds., Elkins Park PA 19027. (215)572-1203. Fax: (215)572-7609. Owners: Harriet Friedburg and Rita Greenfield. Retail gallery. Estab. 1969. Represents emerging, mid-career and established artists/year. Sponsors 6-8 shows/year. Average display time 1 month. Open all year; Monday-Saturday, 10-5:30. Located in Yorktown Inn Courtyard of Shops; 3,000 sq. ft.; 40% of space for special exhibitions; 60% of space for gallery artists. 20% private collectors, 30% corporate collectors. Overall price range: $50-6,000; most work sold at $200-3,000.

Media: Considers oil, acrylic, watercolor, pastel, drawing, mixed media, collage, handmade paper, sculpture, ceramics, metal, wood, furniture, jewelry, fiber and glass. Most frequently exhibits jewelry, ceramics, glass, furniture and painting.

Style: Exhibits painterly abstraction, color field, pattern painting and geometric abstraction. Genres include landscape, still life and figurative work.

Terms: Accepts work on consignment (50% commission) or buys outright for 50% of retail price (net 30 days). Retail price set by the gallery and the artist. Gallery provides insurance, promotion, contract and shipping costs from gallery; artist pays shipping costs to gallery. Prefers artwork framed.

Submissions: Accepts only artists from US and Canada. Send query letter with résumé, slides, bio, brochure, price list and SASE. Replies in 1 month. Files all materials pertaining to artists who are represented. Finds artists through craft shows, travel to galleries.

‡**RENA HAVESON GALLERY**, 2820 Smallman St., Pittsburgh PA 15222. (412)471-5444. Fax: (412)471-2919. Owner: Rena Haveson. Retail gallery. Estab. 1986. Represents 40 mid-career artists/year. Interested in seeing the work of emerging artists. Exhibited artists include Burton Morris, Val Dubasky. Sponsors 3 shows/year. Average display time 2 months. Open all year. 1,100 sq. ft.; warehouse decor. 50% of space for special exhibitions; 50% of space for gallery artists. Clientele: upscale. 40% private collectors, 10% corporate collectors. Overall price range: $2,000-5,000; most work sold at $3,000 minimum.

Media: Considers all media and all types of prints. Most frequently exhibits sculpture, mixed media, acrylic paintings.

Style: Exhibits painterly abstraction. Exhibits all genres. Prefers painterly abstraction, impressionist landscape, bronze sculpture.

Terms: Accepts work on consignment (50% commission). Retail price set by the artist. Gallery provides insurance, promotion and contract; shipping costs are shared. Prefers artwork framed.

Submissions: Send query letter with résumé, slides, bio, brochure, reviews and artist's statement. Write for appointment to show portfolio of photographs and slides. Replies in 2 weeks. Files résumés and slides. Finds artists through travel.

Tips: "Don't call without sending slides first."

LANCASTER MUSEUM OF ART, (formerly Community Gallery of Lancaster County), 135 N. Lime St., Lancaster PA 17602. (717)394-3497. Executive Director: Ellen Rosenholtz. Assistant Director: Carol Foley. Nonprofit gallery. Estab. 1965. Represents 12 emerging, mid-career and established artists/year. 500 members. Exhibited artists include Alice Neel, Christo, Tom Lacagnini. Sponsors 12 shows/year. Average display time 1 month. Open all year; Monday-Saturday, 10-4; Sunday, 12-4. Located downtown Lancaster; 4,000 sq. ft.; neoclassical architecture. 100% of space for special exhibitions. 100% of space for gallery artists. Overall price range: $100-25,000; most work sold at $100-10,000.

Media: Considers all media.

Terms: Accepts work on consignment (30% commission). Retail price set by the artist. Gallery provides insurance; shipping costs are shared. Artwork must be ready for presentation.

Submissions: Send query letter with résumé, slides, photographs and SASE. Files slides, résumé, artist's statement. Finds artists through word of mouth, other galleries and "many times the artist will contact me first."

Tips: Advises artists to submit quality slides and well-presented proposal. "No phone calls."

‡**GILBERT LUBER GALLERY**, 1220 Walnut St., Philadelphia PA 19107. (215)732-2996. Fax: (215)546-2210. Co-owner: Shirley Luber. Retail gallery. Estab. 1971. Represents mid-career and established artists. Exhibited artists include Shigeki Kuroda, Kazutoshi Sugiura. Sponsors 6 shows/year. Average display time 6 weeks. Open all year; Monday-Saturday, 11-30-5:30. Located Center City; 1,000 sq. ft.; Asian art. 50% of

space for special exhibitions; 50% of space for gallery artists. Clientele: collectors, decorators. 50% private collectors. Overall price range: $5-15,000; most work sold at $200-500.

Media: Considers watercolor, mixed media, paper, craft, woodblocks, woodcuts, engravings, lithographs, mezzotints, serigraphs and etching. Most frequently exhibits woodblocks, silkscreen and mezzotints.

Style: Exhibits all styles, all genres. Prefers landscapes, floral and actor prints.

Terms: Artwork is bought outright. Retail price set by the gallery. Gallery provides insurance, promotion and shipping costs to and from gallery. Prefers artwork unframed.

Submissions: Accepts only artists from Asia. Prefers only works on paper. Send query letter with résumé and photographs. Call for appointment to show portfolio of originals. Finds artists through agents, exhibitions and word of mouth.

‡**MAIN LINE ART CENTER**, Old Buck Rd. and Lancaster Ave., Haverford PA 19041. (215)525-0272. Director: Judy Herman. Accepts only artists from Mid-Atlantic (Pennsylvania, New Jersey, New York, Delaware). Interested in emerging artists. Average display time 1 month. "Spacious galleries (high ceilings, hardwood floors) in 19th century 'white house'." Clientele: 100% private collectors. Overall price range: $50-3,000; most work sold at $40-300.

Media: Considers oil, acrylic, watercolor, pastel, pen & ink, drawings, mixed media, collage, works on paper, sculpture, ceramic, craft, fiber, glass and original handpulled prints. Most frequently exhibits works on paper, paintings and sculpture.

Style: Exhibits all styles and genres. "Main Line Art Center has a varied exhibition schedule to complement its educational mission to serve Montgomery and Delaware counties with classes and a wide range of arts activities as well as to create an active forum for artists in this community. Our annual schedule includes juried and curated exhibitions (works on paper exhibition, craft, painting and sculpture), an art festival, a faculty exhibition, student and professional members' exhibitions and exhibitions of public school artwork."

Terms: Accepts work on consignment (30% commission). Retail price set by artist. Exclusive area representation not required. Gallery provides promotion and contract; artist pays for shipping.

Submissions: Send query letter with résumé, slides and SASE. Call or write for appointment to show portfolio of originals and slides. Files résumés. All material returned if not accepted or under consideration.

Tips: "Nonprofit spaces are gaining status and filling an important vacuum. We've added a juried art festival targeted at our local community which presents a range of affordable art and fine crafts."

‡**MATTRESS FACTORY**, 500 Sampsonia Way, Pittsburgh PA 15212. (412)231-3169. Fax: (412)322-2231. E-mail: info@mattress.org. Website: http://www.mattress.org. Curator: Michael Olijnyk. Nonprofit contemporary arts museum. Estab. 1977. Represents 8-12 emerging, mid-career and established artists/year. Exhibited artists include James Turrell, Bill Woodrow, Ann Hamilton, Jessica Stockholder, John Cage, Allain Wexter, Winnifred Lutz and Christian Boltanski. Sponsors 8-12 shows/year. Average display time 6 months. Tuesday-Saturday, 10-5; Sunday 1-5; closed August. Located in Pittsburgh's historic Mexican War streets; 14,000 sq. ft.; a six-story warehouse and a turn-of-the century general store present exhibitors of temporary and permanent work.

Media: Considers site-specific installations—completed in residency at the museum.

Submissions: Send query letter with résumé, slides, bio. Write for appointment to show portfolio of slides. Replies in 3 months.

OLIN FINE ARTS GALLERY, Washington and Jefferson College, Washington PA 15301. (412)223-6110. Gallery Chairman: P. Edwards. Nonprofit gallery. Estab. 1982. Exhibits emerging, mid-career and established artists. Exhibited artists include Jim Salem and Michael Gorrie. Sponsors 9 shows/year. Average display time 3 weeks. Open all year. Located near downtown (on campus); 1,925 sq. ft.; modern, air-conditioned, flexible walls, secure. 100% of space for special exhibitions. Clientele: mostly area collectors and students. 95% private collectors, 5% corporate collectors. Most work sold at $300-500.

● This gallery describes its aesthetic and subject matter as "democratic."

Media: Considers all media, except installation, offset reproductions and pochoir. Most frequently exhibits oil, acrylic and watercolor.

Style: Exhibits all styles and genres. Prefers realism/figure, landscapes and abstract.

Terms: Accepts work on consignment (20% commission). Retail price set by artist. Sometimes offers customer discounts. Gallery provides insurance and promotion; artist pays for shipping. Prefers artwork framed.

Submissions: Send query letter with résumé, slides, bio and SASE. Portfolio review not required. "A common mistake artists make is sending unprofessional material." Replies in 2-4 weeks. Finds artists through word of mouth, submissions and self-promotions.

Tips: Values "timely follow-through."

‡**ONLINE GALLERY**, Internet Marketing Corporation, P.O. Box 280, Chalfont, PA 18914-0280. (215)997-1234. Fax: (215)997-1991. Website: http://www.OnLineGallery.com. Marketing manager: Leah Lembo. Virtual gallery located on the Internet. Estab. 1996. Represents over 500 emerging, mid-career and established artists. Open 24 hours/day, 7 days/week. Located on the Internet.

Media: Considers all media.

Style: Considers all styles

Terms: There is a rental fee for space. Retail price set by the artist. Gallery provides promotion.

Submissions: Call or write for information on submitting work. Portfolio should include photographs, slides, transparencies and/or digital files. Replies in 1 week. Files all material. Finds artists through referrals, direct solicitation.

‡PAINTED BRIDE ART CENTER, 230 Vine St., Philadelphia PA 19106. (215)925-9914. Fax: (215)925-7402. Gallery Director: A.M. Weaver. Nonprofit gallery and alternative space. Estab. 1969. Represents emerging, mid-career and established artists. Sponsors 7-9 shows/year. Average display time 6 weeks. Open September-June. Located in Old City Philadelphia; 3,500 sq. ft.; "two levels and a large exhibit room contiguous to a performance space, wheel chair accessible." 100% of space for special exhibitions. Clientele: corporations, students, artists and "grass-roots types." Overall price range: $800-2,000; most work sold at $500-1,000.

Media: Considers performance art and all media except glass. Original handpulled prints, woodcuts, engravings, lithographs, wood engravings, mezzotints, linocuts, etching and serigraphs. Most frequently exhibits paintings, works on paper, sculpture and mixed media.

Style: Exhibits all styles. Primarily promotes experimental works.

Terms: Buys artwork outright for 100% of retail price or "in the nonprofit/alternative space, artist pays 20% of retail price." Retail price set by the artist. Gallery provides insurance, promotion and contract; shipping costs are shared. "Artwork must be ready to present."

Submissions: Prefers Philadelphia artists. Send query letter with résumé, slides, brochure and reviews. Call to schedule an appointment to show a portfolio, which should include originals and slides. Replies in 6 months. Files slides and résumés.

ROSENFELD GALLERY, 113 Arch St., Philadelphia PA 19106. (215)922-1376. Owner: Richard Rosenfeld. Retail gallery. Estab. 1976. Represents 35 emerging and mid-career artists/year. Sponsors 18 shows/year. Average display time 3 weeks. Open all year; Wednesday-Saturday, 10-5; Sunday, noon-5. Located downtown, "Old City"; 2,200 sq. ft.; ground floor loft space. 85% of space for gallery artists. 80% private collectors, 20% corporate collectors. Overall price range: $200-6,000; most work sold at $1,500-2,000.

Media: Considers oil, acrylic, watercolor, pastel, drawing, mixed media, paper, sculpture, ceramics, craft, fiber, glass, woodcuts, engravings, lithographs, monoprints, wood engravings and etchings. Most frequently exhibits works on paper, sculpture and crafts.

Style: Exhibits all styles. Prefers painterly abstraction and realism.

Terms: Accepts work on consignment (50% commission). Retail price set by the gallery. Gallery provides insurance and promotion; shipping costs are shared. Prefers artwork framed.

Submissions: Send query letter with slides and SASE. Call or write for appointment to show portfolio of photographs and slides. Replies in 2 weeks. Finds artists through visiting exhibitions, word of mouth, various art publications and submissions.

THE STATE MUSEUM OF PENNSYLVANIA, Third and North St., Box 1026, Harrisburg PA 17108-1026. (717)787-4980. Contact: Senior Curator, Art Collections. The State Museum of Pennsylvania is the official museum of the Commonwealth, which collects, preserves and exhibits Pennsylvania history, culture and natural heritage. The Museum maintains a collection of fine arts, dating from 1645 to present. Current collecting and exhibitions focus on works of art by contemporary Pennsylvania artists. The Archives of Pennsylvania Art includes records on Pennsylvania artists and continues to document artistic activity in the state by maintaining records for each exhibit space/gallery in the state. Estab. 1905. Sponsors 9 shows/year. Accepts only artists who are Pennsylvania natives or past or current residents. Interested in emerging and mid-career artists.

Media: Considers all media including oil, works on paper, photography, sculpture, installation and crafts.

Style: Exhibits all styles and genres.

Submissions: Send query letter with résumé, slides, SASE and bio. Replies in 1-3 months. Retains résumé and bio for archives of Pennsylvania Art. Photos returned if requested. Finds artists through professional literature, word of mouth, Gallery Guide, exhibits, all media and unsolicited material.

Tips: "Have the best visuals possible. Make appointments. Remember most curators are also overworked, underpaid and on tight schedules."

ZOLLER GALLERY, Penn State University, 102 Visual Arts Building, University Park PA 16802. (814)863-3352. Contact: Exhibition Committee. Nonprofit gallery. Estab. 1971. Exhibits 250 emerging, mid-career and established artists. Interested in seeing the work of emerging artists. Sponsors 8 shows/year. Average display time 4-6 weeks. Closed in May. Located on Penn State University campus; 2,200 sq. ft. 100% of space for special exhibitions. Overall price range: $50-10,000; most work sold at $300-500.

● This campus gallery features artists' lectures, installation art, visual artists' residencies and interdisciplinary events.

INSIDER REPORT

Alternative Space Offers Conceptual Outlet

When the average person hears the word "art," painting and perhaps sculpture come to mind. But to the open-minded, art can take any form, albeit unconventional, odd, outlandish or off-beat; created not in oils, acrylics, pastels, or clay, but from bed sheets, shoe boxes, steel drums or house flies. Art can be built; art can be installed. And alternative spaces exist to accommodate artists with ideas extending beyond canvas or paper to the conceptual realm of installation.

Michael Olijnyk

Pittsburgh is home to one such space, a museum called the Mattress Factory, unique in that it's solely devoted to installation work. And although called "museum," curator Michael Olijnyk says the Mattress Factory doesn't feel like one. "You're not separated from the work by a velvet rope—you're in it. So it's easier to react. The work is not a painting on the wall or a sculpture on a pedestal. You can approach it in a different way."

Olijnyk and company don't accept specific ideas from artists, unlike most galleries showing installation pieces. Instead they choose artists by viewing previous work (either submitted as one would approach a traditional gallery or seen on studio visits) and offer artists a space in which to create. "We want the situation to be as close to working in their studios as possible. They come here and choose where they want to work and decide what they want to do in that space. They're not bringing an idea from somewhere else, they're actually making a site-specific piece for us."

Olijnyk says that a lot of museums do installation and performance work, but the Mattress Factory is different, because they collect installations and have some permanent displays. One floor of the main building (a six-story former warehouse) houses three permanent works by James Turrell. "There are very few permanent installations in the world. You see them up for special exhibitions, and because they take up so much room, you never see them again. We're really the only place in the world where you can see permanent pieces installed."

Although most installation work is not permanent, it can be sold. Individual collectors and museums and galleries can purchase the plans to a work. "They're sold as a sort of a travelling idea, very similar to buying the plans for a house from an architect. The buyer owns the rights to rebuild it."

Once artists are chosen and pick their space among the 14,000 square feet in two buildings, Olijnyk becomes less curator and more general contractor, orchestrating construction and locating materials for the working artists—some

INSIDER REPORT, *continued*

basic, some quite odd. Ideas for installation work really have no limits (think Christo draping islands with pink cellophane). The Mattress Factory has knocked out walls and installed new plumbing to aid artists in fulfilling their visions. Olijnyk has borrowed 6,600 cans of beer from Budweiser and located garbage bags of human hair.

In an exhibit entitled "Bad Environment for White Monochrome Paintings," the Mattress Factory staff bred flies for a year. They were in a completely sealed, pristine-white space that the public entered through a glass and steel corridor. "Behind the windows there were four pure white paintings hanging on the walls with bowls in front of them. In the bowls were the flies. Every week someone would go in and change the food and water, and as it got warmer, there were more and more flies, and the windows got dirtier and the paintings got dirtier. It was almost like a scientific experiment."

What's special about much installation work is that seeing photos or reading descriptions won't give the full effect—the work must be experienced. A good example is a Mattress Factory exhibit called "Cold Fashioned Room," conceived by Buzz Spector. You opened a door to find what appeared to be a Victorian library. There was a dropped ceiling with wallpaper that looked like old tin tiles; wood paneling, oriental rugs, old furniture and books. The only strange thing was that in the fireplace, instead of a fire, there was a freezer unit blowing icy air into the space, and it was like a refrigeration unit, completely insulated and 28 degrees.

"When you opened up the door everything looked normal, but you saw a vase of flowers sitting on the table. They were frozen solid. In the summer when it

© L'ubo Stacho

Message From Saint Veronica, 1994-95 is the title of L'ubo Stacho's installation at the Mattress Factory. The installation was created using fabric, clothes lines, clothes pins and transferred images.

Media: Considers all media, styles and genres.
Terms: "We charge no commission." Retail price set by artist. Gallery provides insurance and promotion; shipping costs are shared. Prefers artwork framed.
Submissions: "We accept proposals once a year. Deadline is February 1." Send query letter with résumé, slides, reviews and SASE. Replies by April 1. Files résumés.

Rhode Island

HERA EDUCATIONAL FOUNDATION, HERA GALLERY, 327 Main St., P.O. Box 336, Wakefield RI 02880. (401)789-1488. Director: Alexandra Broches. Nonprofit gallery. Estab. 1974. Located in downtown Wakefield, a rural resort Northeast area (near Newport beaches). Exhibits the work of emerging and mid-career artists. 15 members. Sponsors 16 shows/year. Average display time 3 weeks. Open all year. Located downtown; 1,200 sq. ft. 40% of space for special exhibitions.
Media: Considers all media and original handpulled prints.
Style: Exhibits expressionism, neo-expressionism, painterly abstraction, surrealism, conceptualism, postmodern works, realism and photorealism. "We are interested in innovative, conceptually strong, contemporary works that employ a wide range of styles, materials and techniques." Prefers "a culturally diverse range of subject matter which explores contemporary social and artistic issues important to us all."
Terms: Co-op membership fee plus donation of time. Retail price set by artist. Sometimes offers customer discount and payment by installments. Gallery provides promotion; artist pays for shipping, or sometimes shipping costs are shared.
Submissions: Send query letter with résumé, slides and SASE. Portfolio required for membership; slides for invitational/juried exhibits. Files résumé. Finds artists through word of mouth, advertising in art publications, and referrals from members.
Tips: "Be sensitive to the cooperative nature of our gallery. Everyone donates time and energy to assist in installing exhibits and running the gallery. Please write for membership guidelines, and send SASE."

South Carolina

CECELIA COKER BELL GALLERY, Coker College, 300 E. College Ave., Hartsville, SC 29550. (803)383-8152. Director: Larry Merriman. "A campus-located teaching gallery which exhibits a great diversity of media and style to expose students and the community to the breadth of possibility for expression in art. Exhibits include regional, national and international artists with an emphasis on quality. Features international shows of emerging artists and sponsors competitions." Estab. 1984. Interested in emerging and mid-career artitsts. Sponsors 5 solo shows/year. Average display time 1 month. "Gallery is 30×40, located in art department; grey carpeted walls, track lighting."
Media: Considers oil, acrylic, drawings, mixed media, collage, works on paper, sculpture, installation, photography, performance art, graphic design and printmaking. Most frequently exhibits painting, sculpture/installation and mixed media.
Style: Considers all styles. Not interested in conservative/commercial art.
Terms: Retail price set by artist (sales are not common). Exclusive area representation not required. Gallery provides insurance, promotion and contract; shipping costs are shared.
Submissions: Send résumé, good-quality slides and SASE by November 1. Write for appointment to show portfolio of slides.

PORTFOLIO ART GALLERY, 2007 Devine St., Columbia SC 29205. (803)256-2434. Owner: Judith Roberts. Retail gallery and art consultancy. Estab. 1980. Represents 40-50 emerging, mid-career and estab-

lished artists. Exhibited artists include Sharon Bliss, Sigmund Abeles and Joan Ward Elliott. Sponsors 4-6 shows/year. Average display time 3 months. Open all year. Located in a 1930s shopping village, 1 mile from downtown; 500 sq. ft. plus 1,100 sq. ft.; features 12 foot ceilings. 100% of space for work of gallery artists. "We have added exhibition space by opening second location (716 Saluda Ave.) around the corner from our 16-year location. The new space has excellent visibility and accomodates large pieces. A unique feature is glass shelves where matted and medium to small pieces can be displayed without hanging on the wall." Clientele: professionals, corporations and collectors. 40% private collectors, 40% corporate collectors. Overall price range: $150-12,500; most work sold at $300-3,000.

● Portfolio Art Gallery was selected by readers of the local "entertainment" weekly paper as the best gallery.

Media: Considers oil, acrylic, watercolor, pastel, mixed media, collage, works on paper, sculpture, ceramic, glass, original handpulled prints, woodcuts, wood engravings, linocuts, engravings, mezzotints, etchings, lithographs and serigraphs. Most frequently exhibits watercolor, oil and original prints.

Style: Exhibits neo-expressionism, painterly abstraction, imagism, minimalism, color field, impressionism, realism, photorealism and pattern painting. Genres include landscapes and figurative work. Prefers landscapes/seascapes, painterly abstraction and figurative work. "I especially like mixed media pieces, original prints and oil paintings. Pastel medium and watercolors are also favorites. Kinetic sculpture and whimsical clay pieces."

Terms: Accepts work on consignment (40% commission). Retail price set by gallery and artist. Offers payment by installments. Gallery provides insurance, promotion and contract; artist pays for shipping. Artwork may be framed or unframed.

Submissions: Send query letter with slides, bio, brochure, photographs, SASE and reviews. Write for appointment to show portfolio of originals, slides, photographs and transparencies. Replies only if interested within 1 month. Files tearsheets, brochures and slides. Finds artists through visiting exhibitions and referrals.

Tips: "The most common mistake beginning artists make is showing all the work they have ever done. I want to see only examples of recent best work—unframed, originals (no copies)—at portfolio reviews."

South Dakota

THE HERITAGE CENTER, INC., Red Cloud Indian School, Pine Ridge SD 57770. (605)867-5491. Fax: (605)867-1291. Director: Brother Simon. Nonprofit gallery. Estab. 1984. Represents emerging, mid-career and established artists. Sponsors 6 group shows/year. Accepts only Native Americans. Average display time 10 weeks. Clientele: 80% private collectors. Overall price range: $50-1,500; most work sold at $100-400.

Media: Considers oil, acrylic, watercolor, pastel, pen & ink, drawings, sculpture and original handpulled prints.

Style: Exhibits contemporary, impressionism, primitivism, Western and realism. Genres include Western. Specializes in contemporary Native American art (works by Native Americans). Interested in seeing pictographic art in contemporary style. Likes clean, uncluttered work.

Terms: Accepts work on consignment (20% commission). Retail price set by artist. Customer discounts and payment by installments are available. Exclusive area representation not required. Gallery provides insurance and promotion; artist pays for shipping.

Submissions: Send query letter, résumé, brochure and photographs Wants to see "fresh work and new concepts, quality work done in a professional manner." Portfolio review requested if interested in artist's work. Finds artists through word of mouth, publicity in Native American newspapers.

Tips: "Show art properly matted or framed. Good work priced right always sells. We still need new Native American artists if their prices are not above $300. Write for information about annual Red Cloud Indian Art Show."

Tennessee

BENNETT GALLERIES, Dept. AGDM, 4515 Kingston Pike, Knoxville TN 37919. (615)584-6791. Director: Marga Hayes. Owner: Rick Bennett. Retail gallery. Represents established artists. Exhibited artists include Richard Jolley, Carl Sublett, Scott Duce, Sarah Frederick, Lanie Oxman, Charles Movalli and James Tormey. Sponsors 10 shows/year. Average display time 1 month. Open all year. Located in West Knoxville. Clientele: 70% private collectors; 30% corporate collectors. Overall price range: $200-20,000; most work sold at $2,000-4,000.

Media: Considers oil, acrylic, watercolor, pastel, drawing, mixed media, works on paper, sculpture, ceramic, craft, glass, original handpulled prints. Most frequently exhibits painting, ceramic/clay, wood, glass and sculpture.

Style: Exhibits primitivism, abstraction, figurative, non-objective, impressionism and realism. Genres include landscapes, still life and interiors. Prefers realism and contemporary styles.

Terms: Accepts artwork on consignment (50% commission). Retail price set by the gallery and the artist. Sometimes offers customer discounts and payment by installments. Gallery provides insurance, promotion, contract from gallery. "We are less willing to pay shipping costs for unproven artists." Prefers artwork framed.

Submissions: Send query letter with résumé, slides, bio, photographs, SASE and reviews. Portfolio review requested if interested in artist's work. Portfolio should include originals, slides, photographs and transparencies. Replies in 6 weeks. Files samples and résumé. Finds artists through agents, visiting exhibitions, word of mouth, various art publications, sourcebooks, submissions/self-promotions and art collectors' referrals.

COOPER ST. GALLERY, 964 S. Cooper St., Memphis TN 38104. (901)272-7053. Owner: Jay S. Etkin. Retail gallery. Estab. 1989. Represents/exhibits 20 emerging, mid-career and established artists/year. Exhibited artists include Rob vander Schoor and Pamela Cobb. Sponsors 10 shows/year. Average display time 1 month. Open all year; Wednesday, Friday and Saturday, 11-5 or by appointment. Located in midtown Memphis; 1,200 sq. ft.; gallery features public viewing of works in progress. 33⅓ of space for special exhibitions; 75% of space for gallery artists. Clientele: young upscale, corporate. 80% private collectors, 20% corporate collectors. Overall price range $200-12,000; most work sold at $500-2,000.

Media: Considers all media except craft, papermaking. Also considers kinetic sculpture and conceptual work. "We do very little with print work." Most frequently exhibits oil on paper canvas, mixed media and sculpture.

Style: Exhibits expressionism, conceptualism, neo-expressionism, painterly abstraction, postmodern works, realism, surrealism. Genres include landscapes and figurative work. Prefers figurative expressionism, abstraction, landscape.

Terms: Artwork is accepted on consignment (40% commission). Retail price set by the gallery and the artist. Gallery provides promotion. Artist pays for shipping or costs are shared at times.

Submissions: Accepts artists generally from mid-south. Prefers only original works. Looking for long-term committed artists. Send query letter with photographs, bio and SASE. Write for appointment to show portfolio of photographs, slides and cibachromes. Replies only if interested within 1 month. Files bio/slides if interesting work. Finds artists through referrals, visiting area art schools and studios, occasional drop-ins.

Tips: "Be patient. The market in Memphis for quality contemporary art is only starting to develop."

CUMBERLAND GALLERY, 4107 Hillsboro Circle, Nashville TN 37215. (615)297-0296. Director: Carol Stein. Retail gallery. Estab. 1980. Represents 35 emerging, mid-career and established artists. Sponsors 6 solo and 2 group shows/year. Average display time 5 weeks. Clientele: 60% private collectors, 40% corporate clients. Overall price range: $450-35,000; most work sold at $1,000-5,000.

Media: Considers oil, acrylic, watercolor, pastel, mixed media, collage, works on paper, sculpture, photography, woodcuts, wood engravings, linocuts, engravings, mezzotints and etchings. Most frequently exhibits painting, drawings and sculpture.

Style: Exhibits realism, photorealism, minimalism, painterly abstraction, postmodernism and hard-edge geometric abstraction. Prefers landscapes, abstraction, realism and minimalism. "We have always focused on contemporary art forms including paintings, works on paper, sculpture and multiples. Approximately half of the artists have national reputations and half are strongly emerging artists. These individuals are geographically dispersed." Interested in seeing "work that is technically accomplished, with a somewhat different approach, not derivative."

Tips: "I would hope that an artist would visit the gallery and participate on the mailing list so that he/she has a sense of what we are doing. It would be helpful for the artist to request information with regard to how we prefer work to be considered for inclusion. I suggest slides, résumé, prices, recent articles and a SASE for return of slides. We are currently not actively looking for new work but always like to review work that may be appropriate for our needs."

‡EATON GALLERY, 2288 Dunn Ave., Memphis TN 38114-4806. (901)744-8024. Fax: (901)744-8725. Owner/Director: Sandra Saunders. Retail gallery. Estab. 1984. Represents 25 emerging, mid-career and established artists. Exhibited artists include Marjorie Liebman, Jiaxian Hao, Taylor Lin, Weimin and Charles Jing. Sponsors 10 shows in Gallery I. Average display time 1 month. 30% of space for special exhibitions. Clientele: 60% private collectors, 40% corporate clients. Overall price range: $350-10,000; most work sold at $700-4,500.

Media: Considers oil, acrylic, watercolor, pastel, drawings, mixed media, works on paper, sculpture, original handpulled prints, woodcuts, engravings, lithographs, mezzotints, serigraphs and etchings. Most frequently exhibits oil, acrylic and watercolor.

Style: Exhibits expressionism, painterly abstraction, color field, impressionism and realism. Genres include landscapes, florals, Americana, Southwestern, portraits and figurative work. Prefers impressionism, expressionism and realism.

Terms: Accepts work on consignment (50% commission). Retail price set by artist or both gallery and artist. Gallery provides insurance, promotion and contract; artist pays for shipping. Prefers artwork framed.

Submissions: Send query letter with résumé, bio, slides, photographs and reviews. Write for appointment to show portfolio of originals "so that we may see how the real work looks" and photographs. Replies in 1 week. Files photos and "anything else the artists will give us."
Tips: "Just contact us—we are here for you."

PAUL EDELSTEIN GALLERY/EDELSTEIN ART INVESTMENTS, 519 N. Highland St., Memphis TN 38122-4521. (901)454-7105. Owner/Director: Paul Edelstein. Assistant: Todd Perkins. Retail gallery and art consultancy. Estab. 1985. Represents 30 emerging, mid-career and established artists. Exhibited artists include Nancy Cheairs, Marjorie Liebman and Carroll Cloar. Sponsors 1-2 shows/year. Average display time 12 weeks. Open all year; by appointment only. Located in East Memphis; 2,500 sq. ft.; 80% of space for special exhibitions. Clientele: upscale. 80% private collectors, 20% corporate collectors. Overall price range: $100-25,000; most work sold at $200-400.
 • The gallery is in a '30s house with many different rooms for exhibiting.
Media: Considers all media and all types of prints. Most frequently exhibits oil, watercolor and prints.
Style: Exhibits hard-edge geometric abstraction, color field, painterly abstraction, minimalism, postmodern works, feminist/political works, primitivism, photorealism, expressionism and neo-expressionism. Genres include florals, landscapes, Americana and figurative. Most frequently exhibits primitivism, painterly abstraction and expressionism. "Especially seeks new folk artists and N.Y. Soho undiscovered artists." Specializes in contemporary and black folk art, Southern regionalism, modern contemporary abstract and WPA 1930's modernism. Interested in seeing modern, contemporary art and contemporary photography.
Terms: Accepts work on consignment (40% commission). Retail price set by gallery. Offers customer discounts and payment by installments. Gallery provides insurance and contract; artist pays for shipping. Prefers artwork framed.
Submissions: Send query letter with résumé, slides, bio, brochure, photographs, SASE and business card. Portfolio review not required. Replies in 2 months. Files all material. Finds artists mostly through word of mouth, *Art in America*, and also through publications like *Artist's & Graphic Designer's Market*.
Tips: "Most artists do not present enough slides or their biographies are incomplete. Professional artists need to be more organized when presenting their work."

‡**HANSON ARTSOURCE INC.**, 5607 Kingston Pike, Knoxville TN 37919. (423)584-6097. Fax: (423)588-3789. President: Diane Hanson. Retail gallery. Estab. 1988. Represents 150 mid-career artists/year. Exhibited artists include Thomas Pradzynsky. Sponsors 3 shows/year. Average display time 1 month. Open all year; Monday-Friday, 10-5:30; Saturday, 10-4. Located in midtown; 3,500 sq. ft. showroom; features clean, contemporary organization of work. 33⅓% of space for special exhibitions; 33⅓% of space for gallery artists. Clientele: upscale, professional. 70% private collectors, 30% corporate collectors. Overall price range: $25-5,000; most work sold at $100-1,000.
Media: Considers oil, acrylic, watercolor, pastel, mixed media, collage, paper, sculpture, ceramics, craft, fiber, glass and all prints. Most frequently exhibits oil, acrylic, glass.
Style: Exhibits expressionism, painterly abstraction, impressionism, realism. Prefers landscape, figurative, abstract.
Terms: Accepts work on consignment (50% commission). Buys outright for 50% of retail price (net 30 days). Retail price set by the gallery. Gallery provides insurance, promotion, selective contract. Prefers artwork framed or unframed.
Submissions: Send query letter with résumé, slides, bio, photographs, SASE, reviews and artist's statement. Call for appointment to show portfolio of photographs or slides. Replies in 1 month. Files only material from artists of interest.

‡**THE PARTHENON**, Centennial Park, Nashville TN 37201. (615)862-8431. Fax: (615)880-2265. Museum Director: Miss Wesley Paine. Nonprofit gallery in a full-size replica of the Greek Parthenon. Estab. 1931. Exhibits the work of emerging and mid-career artists. Clientele: general public, tourists. 50% private collectors, 50% corporate clients. Sponsors 8 solo and 3 group shows/year. Average display time 6 weeks. Overall price range: $300-2,000; most work sold at $750.
Media: Considers "nearly all" media.
Style: Exhibits contemporary works and American impressionism. Currently seeking contemporary works. "Interested in both objective and non-objective work, although our clientele respond more favorably to representational work. Sick of barns and sunsets."
Terms: Accepts work on consignment (20% commission). Retail price set by artist. Gallery provides a contract and limited promotion. The Parthenon does not represent artists on a continuing basis.
Submissions: Send query letter with résumé and good-quality slides that show work to best advantage. Portfolio review required.

‡**RIVER GALLERY**, 400 E. Second St., Chattanooga TN 37403. (423)267-7353. Fax: (423)265-5944. Owner Director: Mary R. Portera. Retail gallery. Estab. 1992. Represents 30 emerging and mid-career artists/ year. Exhibited artists include Sarah A. Hatch and Scott E. Hill. Sponsors 11 shows/year. Average display time 1 month. Open all year; Monday-Saturday, 10-5; Sunday, 1-5. Located in art district in downtown area;

2,500 sq. ft.; restored early New Orleans-style 1900s home; arched openings into rooms. 30% of space for special exhibitions; 70% of space for gallery artists. Clientele: upscale tourists, local community. 95% private collectors, 5% corporate collectors. Overall price range: $500-5,000; most work sold at $600-2,000.
Media: Considers all media. Considers woodcuts, engravings, lithographs, wood engravings, mezzotints, linocuts and etchnigs. Most frequently exhibits oil, photography, fiber.
Style: Exhibits all styles and genres. Prefers painterly abstraction, impressionism, photorealism.
Terms: Accepts work on consignment (50% commission). Retail price set by the gallery. Gallery provides insurance, promotion and contract; shipping costs are shared. Prefers artwork framed.
Submissions: Send query letter with résumé, slides, bio, photographs, SASE, reviews and artist's statement. Write for appointment to show portfolio of photographs and slides. Does not reply. Files all material "unless we are not interested then we return all information to artist." Finds artists through word of mouth, referrals by other artists, visiting art fairs and exhibitions, submissions, ads in *Art Calendar.*

‡**UNIVERSITY GALLERY, The University of the South**, 735 University Ave., Sewanee TN 37383. (615)598-1223. E-mail: suroom@seruphl.sewanee.edu. Director: Steven Michael Uroom. Nonprofit gallery, museum. Estab. 1960. Represents emerging, mid-career and established artists. Exhibited artists include Imogen Cunningham, Pradip Malde. Sponsors 5 shows/year. Average display time 6 weeks. Open during academic year; Tuesday-Sunday, noon-5. Located Georgia Ave., Guerry Hall; 240 sq. ft.; two levels, climate controlled, exceptional security. 100% of space for gallery artists. Clientele: academic community. 95% private collectors, 5% corporate collectors. Overall price range: $50-5,000; most work sold at $3,500-4,000.
Media: Considers oil, acrylic, pen & ink, drawing, mixed media, collage, paper, sculpture, installation, photography, woodcuts, engravings, lithographs, wood engravings, mezzotints, serigraphs, linocuts, etchings and posters. Most frequently exhibits photography, painting and prints.
Style: Exhibits all styles, all genres. Prefers Fluxus—mail art, Dada, contemporary prints.
Terms: Accepts work on consignment (20% commission). Retail price set by the artist. Gallery provides insurance, promotion, contract and shipping costs to and from gallery. Prefers artwork framed.
Submissions: Send query letter with résumé, slides, bio, brochure, photographs, SASE, business card and reviews. Write for appointment to show portfolio of photographs, slides and transparencies. Replies in 7 weeks. Finds artists through the College Art Association.
Tips: "Put your proposal in essay form."

Texas

‡**ARCHWAY GALLERY**, 2013 W. Gray St., #C, Houston TX 77014-3601. (713)522-2409. Director: Gary Kosmas. Cooperative gallery. Estab. 1976. Represents 15 emerging artists. Interested in emerging and established artists. Sponsors 9 solo and 3 group shows/year. Average display time 1 month. Accepts only artists from the Houston area. Clientele: 70% private collectors, 30% corporate clients. Overall price range: $150-4,000; most work sold at $150-1,000.
Media: Considers all 2- and 3- dimensional media.
Style: Considers all styles and genres.
Terms: Co-op membership "buy-in" fee, plus monthly rental fee, donation of time and 10% commission. Retail price set by artist. Exclusive area representation not required. Gallery provides promotion and contract.
Submissions: Send query letter with résumé, brochure and SASE. Write for appointment to show portfolio of originals, slides and photographs. Replies in 1 month. Files résumé, brochure and slides. All material returned if not accepted or under consideration.
Tips: "Please query before sending materials and know that we don't accept out-of-Houston-area artists. Make sure materials include telephone number."

‡**ART LEAGUE OF HOUSTON**, 1953 Montrose Blvd., Houston TX 77006. (713)523-9530. Executive Director: Linda Haag Carter. Nonprofit gallery. Estab. 1948. Represents emerging and mid-career artists. Sponsors 12 individual/group shows/year. Average display time 3-4 weeks. Located in a contemporary metal building; 1,300 sq. ft., specially lighted; smaller inner gallery/video room. Clientele: general, artists and collectors. Overall price range: $100-5,000; most artwork sold at $100-2,500.
Media: Considers all media.
Style: Exhibits contemporary avant-garde, socially aware work. Features "high-quality artwork reflecting serious aesthetic investigation and innovation. Additionally the work should have a sense of personal vision."
Terms: 30% commission. Retail price set by artist. Exclusive area representation not required. Gallery provides insurance, promotion and contract; artist pays for shipping.
Submissions: Must be a Houston-area-resident. Send query letter, résumé and slides that accurately portray the work. Portfolio review not required. Submissions reviewed once a year in mid-June and exhibition agenda determined for upcoming year.

THE ART STUDIO, INC., 720 Franklin St., Beaumont TX 77701. (409)838-5393. Executive Director: Greg Busceme. Assistant Director: Terri Fox. Cooperative, nonprofit gallery "in the process of expanding into multicultural arts organization." Estab. 1983. Exhibits 20 emerging, mid-career and established artists. Sponsors 10 shows/year. Average display time 1 month. No shows July through August. Artist space open and sales gallery open. Located in the downtown industrial district; 14,000 sq. ft.; 1946 brick 2-story warehouse with glass brick accents. Overall price range: $25-500; most work sold at $50-250.
 • Gallery publishes an arts review tabloid called *"Issue,"* which is open for submissions of poetry, essays, opinions from public. The publication welcomes alternative views and controversial subjects.
Media: Considers all media and all types of prints. Most frequently exhibits painting, ceramics and collage.
Style: Exhibits all styles. Prefers contemporary, painterly abstraction and photorealism.
Terms: Co-op membership fee plus donation of time (25% commission). Retail price set by artist. Gallery provides contract; artist pays for shipping. Prefers artwork framed.
Submissions: Send query letter with résumé and slides. Write for appointment to show portfolio of slides. Replies only if interested within 2 months. Files résumé and slides.
Tips: "Send résumé stating style and reason for choosing the Art Studio."

ARTHAUS GALERIE, 4319 Oak Lawn Ave., Suite F, Dallas TX 75219. (214)522-2721. Director: Michael Cross. Retail gallery, art consultancy. Estab. 1991. Represents 10 emerging, mid-career and established artists/year. Exhibited artists include Michael Cross, Joerg Fercher. Sponsors 9 shows/year. Average display time 3 weeks. Open all year; Tuesday-Saturday, 11-5 and by appointment. Located in Highland Park/Oak Lawn area of Dallas; 500 sq. ft. of exhibition space. Clientele: international collectors of contemporary art. 60% private collectors, 40% corporate collectors. Overall price range: $500-8,000; most work sold at $500-3,000.
 • Arthaus Galerie is working more with artists on an individual-exhibit basis rather than signing longer-term representation agreements.
Media: Considers oil, acrylic, mixed media, sculpture, installation, woodcuts and linocuts. Most frequently exhibits mixed media, acrylic and oil.
Style: Exhibits painterly abstraction, minimalism and postmodern works. Genres include landscapes and figurative work. Prefers painterly abstraction and landscape.
Terms: Accepts work on consignment (40% commission). Retail price set by the gallery. Gallery provides promotion and contract; shipping costs are shared.
Submissions: Send query letter with résumé, slides, bio and photographs. Call or write for appointment to show portfolio of photographs, slides and works from the past 2-3 years. Replies in 2 months. Files bio and slides. Finds artists through submissions.

‡BARNARDS MILL ART MUSEUM, 307 SW. Barnard St., Glen Rose TX 76043. (817)897-7494. Directors: Teresa Westmoreland, Steve Igou. Museum. Estab. 1989. Represents 30 mid-career and established artists/year. Interested in seeing the work of emerging artists. Sponsors 2 shows/year. Open all year; Saturday, 10-5; Sunday, 1-5. Located 2 blocks from the square. "Barnards Mill is the oldest structure (rock exterior) in Glen Rose. 20% of space for special exhibitions; 80% of space for gallery artists.
Media: Considers oil, acrylic, watercolor, pastel, pen & ink, drawing, mixed media, collage, paper, sculpture, ceramics, fiber, glass, installation, photography, woodcuts, engravings, lithographs, wood engravings, mezzotints, serigraphs, linocuts and etchings. Most frequently exhibits oil, pastel and watercolor.
Style: Exhibits experssionism, postmodern works, impressionism and realism, all genres. Prefers realism, impressionism and Western.
Terms: Gallery provides promotion. Prefers artwork framed.
Submissions: Send query letter with résumé, slides or photographs, bio and SASE. Write for appointment to show portfolio of photographs or slides. Replies only if interested within 3 months. Files résumés, photos, slides.

‡WILLIAM CAMPBELL CONTEMPORARY ART, 4935 Byers Ave., Ft. Worth TX 76107. (817)737-9566. Fax: (817)737-9571. President: Bill Campbell. Retail gallery. Estab. 1974. Represents 35 emerging, mid-career and established artists/year. Exhibited artists include Richard Thompson, Bob Wade. Sponsors 8 shows/year. Average display time 5-6 weeks. Open all year; Tuesday-Friday, 10-5; Sataurday, 11-4. Located in commercial area near residential; 2,000 sq. ft. 50% of space for special exhibitions; 50% of space for gallery artists. Clientele: upscale and designers. 80% private collectors, 20% corporate collectors. Overall price range: $500-10,000; most work sold at $1,000-5,000.
Media: Considers oil, acrylic, drawing, mixed media, collage, paper, sculpture, ceramics, glass, installation, photography, woodcuts, engravings, lithographs, wood engravings, mezzotints, serigraphs, linocuts, etchings. Most frequently exhibits painting, mixed media on paper.
Style: Exhibits expressionism, neo-expressionism, painterly abstraction, conceptualism, minimalism, color field, postmodern works. Prefers figurative work, abstracts, contemporary.
Terms: Accepts work on consignment (50% commission). Retail price set by the gallery and the artist. Gallery provides insurance and promotion; shipping costs are shared.
Submissions: Send query letter with résumé, slides, bio, SASE, reviews. Write for appointment to show portfolio of photographs and slides. Finds artists through word of mouth.

DALLAS VISUAL ART CENTER, 2917 Swiss Ave., Dallas TX 75204. (214)821-2522. Fax: (214)821-9103. Director: Katherine Wagner. Nonprofit gallery. Estab. 1981. Represents emerging, mid-career and established artists. Sponsors 20 shows/year. Average display time 3-6 weeks. Open all year. Located "downtown; 24,000 sq. ft.; renovated warehouse." Provides information about opportunities for local artists, including resource center.
Media: Considers all media.
Style: Exhibits all styles and genres.
Terms: Invitational and juried exhibitions are determined through review panels. Invitational exhibits, including shipping, insurance and promotion, are offered at no cost to the artist. The annual *Critics Choice* exhibition is juried by well-respected curators and museum directors from other arts institutions. They also offer an annual membership exhibition open to all members.
Submissions: Supports Texas-area artists. Send query letter with résumé, slides, bio and SASE.
Tips: "We offer a lot of information on grants, commissions and exhibitions available to Texas artists. We are gaining members as a result of our inhouse resource center and non-lending library. Our Business of Art seminar series provides information on marketing artwork, presentation, museum collection, tax/legal issues and other related business issues."

‡BARBARA DAVIS GALLERY, 2627 Colquitt, Houston TX 77098. (713)520-9200. Fax: (713)520-8409. Contact: Barbara Davis or Holly Johnson. Retail gallery. Estab. 1984. Represents 15-20 emerging, mid-career and established artists/year. Exhibited artists include Jesús Balltista Moroles and Joe Mancuso. Sponsors 10-12 shows/year. Average display time 4-5 weeks. Open all year; Tuesday-Friday, 10-5:30; Saturday, 11-5. Located within the loop on Gallery Row; 4,000 sq. ft.; "Architectonica redid exterior of building. Howard Barnstone redid our interior." Clientele: local community, private and corporate. 60% private collectors, 40% corporate collectors. Overall price range: $500-75,000; most work sold at $2,000-20,000.
Media: Considers oil, acrylic, watercolor, pastel, pen & ink, drawing, mixed media, collage, paper, sculpture, installation, photography, woodcuts, engravings, lithographs, wood engravings, mezzotints, linocuts and etchings. Most frequently exhibits painting, sculpture, works on paper.
Style: Exhibits expressionism, painterly abstraction, conceptualism, minimalism, postmodern works, hard-edge geometric abstraction. Prefers minimal, expressionistic, conceptual.
Terms: Accepts work on consignment. Retail price set by the gallery and the artist. Gallery provides insurance and promotion; shipping costs are shared. Prefers artwork framed.
Submissions: Send query letter with résumé, slides, bio, brochure, photographs, SASE, reviews and artist's statement. Write for appointment to show portfolio of photographs, transparencies and slides. Replies in 6-8 weeks. Files slides, bio and cover letter. Finds artists through word of mouth, referrals by other artists, visiting art fairs and exhibitions, submissions.

DEBUSK GALLERY, 3813 N. Commerce, Ft. Worth TX 76106. (817)625-8476. Owner: Barrett DeBusk. Retail/wholesale gallery, alternative space. Estab. 1987. Represents 5 emerging artists/year. Exhibited artists include Barrett DeBusk. Sponsors 4 shows/year. Average display time 6 weeks. Open all year; hours vary. Located industrial area; 1,000 sq. ft.; in DeBusk's avant-garde studio. Clientele: mostly wholesale. 90% private collectors, 10% corporate collectors. Overall price range: $60-10,000; most work sold at $500-1,000.
Media: Considers oil, acrylic, sculpture, photography, woodcuts, engravings, lithographs and serigraphs. Most frequently exhibits sculpture, painting and performance.
Style: Exhibits expressionism, primitivism, conceptualism and impressionism. Prefers figurative sculpture, expressionist painting and performance.
Terms: Accepts work on consignment (50% commission). Retail price set by the gallery and the artist. Shipping costs are shared.
Submissions: Send query letter with résumé and slides. Write for appointment to show portfolio of photographs and slides. Finds artists through word of mouth, exhibitions.

‡DIVERSEWORKS ARTSPACE, 1117-1119 E. Freeway, Houston TX 77002. (713)223-8346. Fax: (713)223-4608. E-mail: info@diverseworks.org. Visual Arts Director: Susie Kalil. Nonprofit gallery/performance space. Estab. 1982. Represents 1,400 members; emerging and mid-career artists. Sponsors 10-12 shows/year. Average display time 6 weeks. Open all year. Located just north of downtown (warehouse district). Has 4,000 sq. ft. for exhibition, 3,000 sq. ft. for performance. "We are located in the warehouse district of Houston. The complex houses five artists's studios (20 artists), and a conservator/frame shop." 75% of space for special exhibition.
Style: Exhibits all contemporary styles and all genres.
Terms: "DiverseWorks does not sell artwork. If someone is interested in purchasing artwork in an exhibit we have, the artist contacts them." Gallery provides insurance and promotion; shipping costs. Accepts artwork framed or unframed, depending on the exhibit and artwork.
Submissions: All proposals are put before an advisory board made up of local artists. Send query letter with résumé, slides and reviews. Call or write to schedule an appointment to show a portfolio, which should include originals and slides. Replies in 3 months. "We maintain an artists slide registry."
Tips: "Call first for proposal guidelines."

‡**DOUGHERTY ARTS CENTER GALLERY**, 1110 Barton Springs Rd., Austin TX 78704. (512)397-1472. Acting Curator: Julie Butridge. Nonprofit gallery. Represents emerging, mid-career and established artists. Exhibited artists include John Christensen and T. Paul Hernandez. Sponsors 12 shows/year. Average display time 1 month. Open all year; Monday-Thursday, 9-9:30; Friday 9-5:30; Saturday 10-2. Located central Austin—downtown; 1,800 sq. ft.; open to all artists. 100% of space for special exhibitions. Clientele: citizens of Austin and central Texas. Overall price range: $100-5,000.
Media: Considers all media, all types of prints. Most frequently exhibits flat work.
Style: Exhibits all styles, all genres. Prefers contemporary.
Terms: "Gallery does not handle sales or take commissions. Sales are encouraged but must be conducted by the artist or his/her affiliate." Rental fee for space; covers 1 month. Retail price set by the artist. Gallery provides insurance and promotion; artist pays shipping costs to and from gallery. Artwork must be framed.
Submissions: Accepts only regional artists, central Texas. Send query letter with résumé and slides. Write for appointment to show portfolio of photographs and slides. Replies in 1 month. Files résumé, slides.
Tips: Finds artists through visiting exhibitions, publications, submissions. "The gallery sponsors 3 call-for-entry exhibitions per year and there are 9 exhibitions by group or individuals chosen annually through applications (applications reviewed March every year)."

‡**EL TALLER GALLERY-AUSTIN**, 8015 Shoal Creek Blvd. #109, Austin TX 78757. (512)302-0100. Fax: (512)302-4895. Website: http://www.instar.com. Owner/Director: Olga or Diana. Retail gallery, art consultancy. Estab. 1980. Represents 20 emerging, mid-career and established artists/year. Exhibited artists include R.C. Gorman and Amado Peña. Sponsors 6 shows/year. Average display time 2-4 weeks. Open all year; Tuesday-Saturday, 10-6. 1,850 sq. ft. 50% of space for special exhibitions; 100% of space for gallery artists. Clientele: tourists, upscale. 90% private collectors, 10% corporate collectors. Overall price range: $500-15,000; most work sold at $2,500-4,000.
Media: Considers all media and all types of prints. Most frequently exhibits mixed media, pastels and watercolors.
Style: Exhibits expressionism, primitivism, conceptualism, impressionism. Genres include florals, Western, Southwestern, landscapes. Prefers Southwestern, landscape, florals.
Terms: Accepts work on consignment (50% commission). Retail price set by the artist. Gallery provides insurance, promotion and contract; artist pays shipping costs. Prefers artwork framed.
Submissions: Send query letter with bio, photographs and reviews. Write for appointment to show portfolio of photographs and actual artwork. Replies only if interested within 2 months.

‡**FLATBED PRESS AND GALLERY**, 912 W. Third St., Austin TX 78703. (512)477-9328. Director: Katherine Brimberry. Gallery showcasing Texas and national artists who work in printmaking media. Average display time 6 weeks. "The gallery space is long (about 25 feet uninterrupted on the masonry side and 20 feet of interrupted space on the other) and the space between the walls varies in width (15 to 10 feet.) One of the walls we hang against is corrugated steel roof material. The other wall is masonry. We have a hanging system on the masonry wall that is adjustable aluminum rods from a high carrying support. The steel wall has small chains that support the artwork at any level." Overall price range: $400-1,700; most work sold at $600-800.
Media: Considers all types of prints. Most frequently exhibits intaglio, relief, lithography.
Style: Exhibits all styles—primarily contemporary approaches. Prefers expressionism, imagism, postmodern works.
Terms: Accepts work on consignment (40% commission). Retail price set by the artist. Gallery provides insurance; artist usually pays for shipping. Prefers artwork framed for exhibits, unframed for sales.
Submissions: Send query letter with slides and reviews. Write for appointment to show portfolio of slides and small prints. Replies only if interested within 3 weeks. Files slides if accepted. Finds artists through visiting galleries, word of mouth and referrals, submissions.

‡**GALERIA SIN FRONTERAS**, 1701 Guadalupe, Austin TX 78701-1214. (512)478-9448. Fax: (512)477-4668. Director: Cristabel Bodden. Retail gallery. Estab. 1986. Represents 100 emerging and mid-career artists. Exhibited artists include Carmen Lomas Garza and Cesar Martinez. Sponsors 5 shows/year. Average display time 2 months. Open all year. 1,500 sq. ft.; located in building built in 1930. 60% of space for special exhibitions; 40% of space for gallery artists. Clientele: 90% private collectors, 10% corporate collectors. Overall price range: $100-10,000; most work sold at $200-1,000.
Media: Considers oil, acrylic, drawings, mixed media, paper, photography, original handpulled prints, woodcuts, wood engravings, linocuts, engravings, mezzotints, etchings, lithographs, monotypes and serigraphs. Most frequently exhibits oil/acrylic on canvas, prints (litho, serigraph and monotype) and drawings (charcoal, pen & ink).
Style: Exhibits neo-expressionism, conceptualism, postmodern works and imagism. Genres include figurative work and Chicano and Latin American.
Terms: Accepts work on consignment (50% commission). Retail price set by gallery and artist. Customer discounts and payment by installment are available. Gallery provides insurance, promotion, contract and frame shop; shipping costs are shared.

Submissions: Prefers artists from Latin American background. Send query letter with résumé, slides, bio and SASE. Write for appointment to show portfolio of slides. Replies in 1 month. Files résumé, bio and slides.
Tips: "We specialize in Chicano artwork, which tends to be heavily geared towards socio-political commentary. Most of the work tends to be figurative while deeply rooted in modern and postmodern aesthetics."

THE GALLERY GOLDSMITHS, 5175 Westheimer, #2350 Galleria III, Houston TX 77056. (713)961-3552. Fax: (713)626-9608. Owner: Michael Zibman. Retail gallery. Estab. 1977. Represents/exhibits 100 emerging, mid-career and established artists/year. Exhibited artists include Loren Gideon and Jim Grahl. Open all year; Monday-Friday, 10-9; Saturday, 10-7; Sunday, 12-6. Located in The Galleria (mall with hotels, offices, ice rink, etc.); 450 sq. ft.; simple all white decor. 100% of space for gallery artists. Clientele: 85% local middle income to high income mostly professionals. Overall price range: $20-50,000; most work sold at $200-1,500.
Media: Considers only jewelry: precious metals and gemstones.
Style: Exhibits all styles.
Terms: Artist sets wholesale price and gallery prices at retail based on internal criteria. Most artists start on consignment. Retail price set by the gallery. Gallery provides insurance and promotion. Gallery pays for shipping costs.
Submissions: Accepts only artists work in the US. Prefers only jewelry. Send query letter with résumé, brochure, slides and photographs. Include phone number. Call or write for appointment to show portfolio of photographs and slides. Replies in 1 week. Files all promotional information, slides, photos, etc. Finds artists through referrals by artists, customers, trade magazines and trade shows.
Tips: Be persistent, learn a little about the business end of the business.

GALLERY 1114, 1114 N. Big Spring, Midland TX 79701. (915)685-9944. President: Pat Cowan Harris. Cooperative gallery and alternative space. Estab. 1983. Represents 12-15 emerging, mid-career and established artists. 11 members. Sponsors 8 shows/year. Average display time 6 weeks. Closed during August. Located at edge of downtown; 900-950 sq. ft.; special features include one large space for featured shows, smaller galleries for members and consignment—"simple, elegant exhibit space, wood floors, and white walls." 60% of space for special exhibitions. Clientele: "younger." Almost 100% private collectors. Overall price range: $10-8,000; most work sold at $50-350.
Media: Considers all media. Interested in all original print media. Most frequently exhibits painting, ceramics and drawing.
Style: Exhibits all styles and all genres—"in a contemporary sense, but we are not interested in genre work in the promotion sense."
Terms: Accepts work on consignment (40% commission). Retail price set by gallery. Customer discounts and payment by installment are available. Gallery provides promotion and shipping costs from gallery. Prefers artwork framed.
Submissions: Send query letter, résumé, slides, bio, reviews and SASE. Call or write for appointment to show portfolio of slides. Replies in 3-6 weeks. Files all material of interest. "We schedule up to 2-3 years in advance. It helps us to keep material. We do not file promotional material."
Tips: "Make a neat, sincere, consistent presentation with labeled slides and SASE. We are interested in serious work, not promotion. We are an alternative space primarily for central U.S. We are here to give shows to artists working in a true contemporary or modernist context: artists with a strong concern for formal strength and originality and an awareness of process and statement."

‡GRAY MATTERS, 113 N. Haskell Ave., Dallas TX 75226. (214)824-7108. Director: D. Szafranski. Retail gallery. Estab. 1991. Sponsors 4 shows/year. Average display time 5 weeks. Open September-May; Saturday 11-5. Located in Fairpark—Deep Ellum area; 1,000 sq. ft.; 1920s industrial building with tin ceiling. 100% of space for special exhibitions. Clientele: 100% private collectors.
Media: Considers oil, pen & ink, paper, acrylic, drawings, sculpture, watercolor, mixed media, installation, collage, photography. No prints.
• Shows at Gray Matters have been reviewed in *Art in America*, *New Art Examiner*, *Art Papers* and other local newspapers.
Style: "I prefer experimental research in visual art."
Terms: Accepts work on consignment (40% commission). Retail price set by gallery and artist. Gallery provides promotion; artist pays shipping costs.
Submissions: Accepts only artists from Texas. Send query letter with résumé, slides, reviews, bio and SASE. "No portfolio reviews given." Replies in 1 month.
Tips: "Visit gallery several times to see shows, observe what is exhibited."

‡HUMMINGBIRD ORIGINALS, INC., 4319 Camp Bowie Blvd., Ft. Worth TX 76107. (817)732-1549. President: Carole Alford. Retail gallery. Estab. 1983. Represents 100 mid-career and established artists. Exhibited artists include Gale Johnson and Robert Rohm. Sponsors 2-5 shows/year. Open all year. Located 2 miles west of downtown in the cultural district; 1,600 sq. ft. 20% of space for special exhibitions, 80% for

gallery artists. Clientele: 80% private collectors, 20% corporate collectors. Overall price range: $50-10,000; most work sold at $300-2,500.

• The Hummingbird Gallery is in its 13th year in the same location.

Media: Considers oil, acrylic, watercolor, pastel, drawings, mixed media, collage, works on paper, sculpture, ceramic, craft, fiber, glass and original prints. Most frequently exhibits watercolor, oil and acrylic.

Style: Exhibits painterly abstraction, surrealism, conceptualism, minimalism, impressionism, realism and all styles. Genres include landscapes, florals, Americana, Southwestern, Western and wildlife. Prefers impressionism, abstraction and realism.

Terms: Accepts work on consignment (40-50% commission). Retail price set by gallery and artist. Offers customer discounts and payment by installments, only with artist's approval. Gallery provides insurance, promotion and contract; shipping costs are shared. Prefers artwork unframed.

Submissions: Send query letter with résumé, slides, bio, brochure, photographs, SASE, business card and reviews. Call or write for appointment to show portfolio of originals, slides, photographs and transparencies. Replies only if interested within 2 weeks. Files material useful to clients and future exhibit needs. Finds artists through art publications, offers from artists and exhibitions to see work, occasional referrals and/or agents.

Tips: "Be prepared. Know if your work sells well, what response you are getting. Know what your prices are. Also understand a gallery, its role as an agent and its needs."

‡**IRVING ARTS CENTER—MAIN AND NEW TALENT GALLERIES**, 3333 N. MacArthur Blvd., Irving TX 75062. (214)252-7558. Fax: (214)570-4962. E-mail: iac@airmail.net. Gallery Curator: Marcie J. Inman. Nonprofit municipal arts center. Estab. 1990. Represents emerging, mid-career and established artists. Sponsors 15-20 shows/year. Average display time 3-6 weeks. Open all year; Monday-Friday, 9-5; Saturday, 10-5; Sunday, 1-5. Located in the middle of residential, commercial area; 4,600 sq. ft.; has 2 theaters in addition to the galleries—Main Gallery has 30' ceiling, skylights and 45' high barrel vault. 100% of space for special exhibitions. Clientele: local community. Overall price range: $200-80,000; most work sold at $200-4,000.

Media: Considers all media except craft. Considers all types of prints except posters. Most frequently exhibits painting, sculpture, photography.

Style: Exhibits all styles. "Interested in exhibiting more ceramics."

Terms: Artists may sell their work and are responsible for the sales. Retail price set by the artist. Gallery provides insurance, promotion and contract; shipping costs are shared. Prefers artwork framed.

Submissions: Send query letter with résumé, brochure, business card, slides, photographs, reviews, artist's statement, bio and SASE. Call for appointment to show portfolio of photographs, transparencies or slides. Replies in 6-18 months. Files slides, résumé, artist's statement. Finds artists through word of mouth, referrals by other artists, visiting galleries and exhibitions, submissions, visiting universities' galleries and graduate students' studios.

Tips: "Have high-quality slides or photographs made. It's worth the investment. Be prepared—i.e. know something about the Arts Center. Present yourself professionally—whatever your level of experience."

‡**IVÁNFFY & UHLER GALLERY**, 4623 W. Lovers Lane, Dallas TX 75209. (214)352-8600. Fax: (214)352-1898. Director: Paul Uhler. Retail/wholesale gallery. Estab. 1990. Represents 20 mid-career and established artists/year. May be interested in seeing the work of emerging artists in the future. Exhibited artists include Maria Bozoky, Rudolf Lang. Sponsors 3-4 shows/year. Average display time 3 weeks. Open all year; Tuesday-Sunday, 10-6. Located near Love Field Airport. 2,000 sq. ft. 100% of space for gallery artists. Clientele: upscale, local community. 85% private collectors, 15% corporate collectors. Overall price range: $1,000-20,000; most work sold at $1,500-4,000.

Media: Considers oil, acrylic, watercolor, pastel, pen & ink, drawing, mixed media, collage, paper, sculpture, woodcuts, engravings, lithographs, wood engravings, mezzotints, serigraphs, linocuts and etchings. Most frequently exhibits oils, mixed media, sculpture.

Style: Exhibits neo-expressionism, painterly abstraction, surrealism, postmodern works, impressionism, hard-edge geometric abstraction, postmodern European school. Genres include florals, landscapes, figurative work.

Terms: Gallery provides promotion; shipping costs are shared.

Submissions: Accepts only artists from Europe. Send query letter with résumé, photographs, bio and SASE. Write for appointment to show portfolio of photographs. Replies only if interested within 1 month.

‡**LYONS MATRIX GALLERY**, 1712 Lavaca St., Austin, TX 78701. (512)479-0068. Fax: (512)479-6188. President: Camille Lyons. Retail gallery. Estab. 1981. Represents 25 mid-career and established artists. May consider emerging artists in the future. Exhibited artists include David Everett and Robert Willson. Sponsors 6 shows/year. Average display time 2 months. Open all year. 2,500 sq. ft. 65% of space for special exhibitions; 100% of space for gallery artists. Clientele: 75% private collectors, 25% corporate collectors. Overall price range: $200-12,000; most work sold at $750-2,500.

"*Orbit* is somewhat awe-inspiring due to its large size (12′6″ × 12′6″ × 6′). Also, the piece is kinetic—it rolls or rotates around its central axis when pushed," explains a spokesperson from Irving Arts Center. *Orbit* is a collaboration in steel between two well-known Dallas artists, Art Shirer and Sherry Owens. The work was part of a collaborative exhibition entitled "Shirer + Owens: A Transformation of Space at the Irving Arts Center Gallery." "This piece is a wonderful synthesis of the two artists' styles. The motif of the circle or wheel has a powerful presence and universality as a symbol."

Media: Considers oil, acrylic, mixed media, sculpture, ceramic, glass, photography, woodcuts, wood engravings, linocuts and etchings. Most frequently exhibits glass sculpture, original handpulled prints and oil on canvas.

Style: Exhibits expressionism, painterly abstraction, postmodern works, photorealism, realism and imagism. Genres include figurative work. "We generally have 2 solo exhibits at a time and try to show 1 glass artist, 1 painter."

Terms: Accepts work on consignment (50% commission). Retail price set by artist. Gallery provides insurance, promotion and contract; shipping costs are shared. Prefers prints framed, paintings unframed.

Submissions: Prefers artists from Southwestern region. Send query letter with résumé, photographs and reviews. Do not send slides. Call for appointment to show portfolio of photographs. Replies in 3 months. Files résumés and brochures.

Tips: "Have a good-quality postcard made from an image and use it for all correspondence."

‡**NEW GALLERY/THOM ANDRIOLA**, 2639 Colquitt, Houston TX 77098. Phone/fax: (713)520-7053. Assistant Director: Sondra Schwetman. Retail gallery. Estab. 1976. Represents 65 emerging, mid-career and established artists/year. Exhibited artists include Larry Bell, Michal Rovner. Sponsors 12 shows/year. Average display time 1 month. Open all year; Tuesday-Friday, 10:30-5; Saturday, 11-5. Located in upper Kirby

District; 3,000 sq. ft.; spacious, wide open. "We have special shows for University MFAs once a year." 100% of space for gallery artists. 50% private collectors, 50% corporate collectors. Overall price range: $1,000-50,000; most work sold at $1,800-6,000.

Media: Considers oil, acrylic, mixed media, collage, paper, sculpture, installation, photography. Most frequently exhibits oil/acrylic, sculpture, photography.

Style: Exhibits expressionism, neo-expressionism, primitivism, painterly abstraction, minimalism, color field, postmodern works, new or unusual figurative/representational work. Prefers painterly abstraction, minimalism, postmodern works.

Terms: Accepts work on consignment (50% commission). Retail price set by the gallery. Gallery provides insurance and promotion; artist pays for shipping costs.

Submissions: Send query letter with résumé, slides, bio, SASE and artist's statement. Write for appointment to show portfolio of photographs, transparencies and slides. Replies in 1-2 months. Files "only material of artists we choose to represent—all others returned in SASE or tossed." Finds artists through submission, referrals by other artists and galleries.

Tips: "Don't come in without an appointment—we arrange appointments after we have reviewed submitted materials, etc."

‡THE ROSSI GALLERY, 2821 McKinney Ave., Dallas TX 75204. (214)871-0777. Fax: (214)871-1343. Owner: Hank Rossi. Retail gallery. Estab. 1990. Represents 10 emerging artists. Exhibited artists include Constance Muller, Valeriya Veron and Helon Thomson. Sponsors 6 shows/year. Average display time 1 month. Open all year. Located downtown; 1,200 sq. ft.; historic two-story buildings built in 1910. 80% of space for special exhibitions. Clientele: 80% private collectors; 20% corporate collectors. Overall price range: $750-2,500; most work sold at $500-1,000.

Media: Considers oil, acrylic, watercolor, pen & ink, drawing, mixed media, collage, works on paper, sculpture, craft, photography and jewelry. Most frequently exhibits oil, watercolor and photography.

Style: Exhibits all styles. Prefers conceptualism, primitivism and realism.

Terms: Accepts artwork on consignment (50% commission). Retail price set by the gallery. Gallery provides insurance, promotion, contract and shipping costs from gallery. Prefers artwork framed.

Submissions: Send query letter with résumé, slides, SASE and reviews. Call for appointment to show portfolio of originals and slides. Replies only if interested in 2 weeks. Files slides and résumé.

SELECT ART, 10315 Gooding Dr., Dallas TX 75229. (214)353-0011. Fax: (214)350-0027. Owner: Paul Adelson. Private art gallery. Estab. 1986. Represents 25 emerging, mid-career and established artists. Exhibited artists include Barbara Elam and Larry Oliverson. Open all year; Monday-Saturday, 9-5 by appointment only. Located in North Dallas; 2,500 sq. ft. "Mostly I do corporate art placement." Clientele: 15% private collectors, 85% corporate collectors. Overall price range: $200-7,500; most work sold at $500-1,500.

Media: Considers oil, fiber, acrylic, sculpture, glass, watercolor, mixed media, ceramic, pastel, collage, photography, woodcuts, linocuts, engravings, etchings and lithographs. Prefers monoprints, paintings on paper and photography.

Style: Exhibits photorealism, minimalism, painterly abstraction, realism and impressionism. Genres include landscapes. Prefers abstraction, minimalism and impressionism.

Terms: Accepts work on consignment (50% commission). Retail price set by consultant and artist. Sometimes offers customer discounts. Provides contract (if the artist requests one). Consultant pays shipping costs from gallery; artist pays shipping to gallery. Prefers artwork unframed.

Submissions: "No florals or wildlife." Send query letter with résumé, slides, bio and SASE. Call for appointment to show portfolio of slides. Replies only if interested within 1 month. Files slides, bio, price list. Finds artists through word of mouth and referrals from other artists.

Tips: "Be timely when you say you are going to send slides, artwork, etc., and neatly label slides."

‡WEBB GALLERIES, 2816 W. 6th St., Amarillo TX 79109. (806)342-4044. Director: Kelley Netherton. Retail gallery and art consultancy. Estab. 1969. Represents 25 emerging and established artists. Exhibited artists include Emil Bisttram and Dean Cornwell. Sponsors 4 show/year. Average display time 6 months. Open all year. Clientele: "knowledgeable." 50% private collectors, 50% corporate collectors. Overall price range $125-2,000,000; most work sold at $3,000.

Media: Considers oil, acrylic, watercolor, pastel, mixed media, collage and sculpture. Does not consider prints. Most frequently exhibits impressionism, realism and "deceased masters"; all genres. Accepts artwork on consignment (varying % commission) or buys outright. Retail price set by the gallery and the artist. Gallery provides promotion. Artist pays for shipping costs to gallery. Prefers artwork unframed.

Submissions: Accepts artists from "outside the Texas-Oklahoma Panhandle." Send query letter with résumé, brochure, slides, photographs, reviews, bio and SASE. Write to schedule an appointment to show a portfolio, which should include everything the artist considers appropriate. Replies in 2 weeks. Files all material.

Utah

EVERGREEN FRAMING CO. & GALLERY, 2019 E. 3300 S., Salt Lake City UT 84109. (801)467-8770. Fax: (801)485-7172. Manager: David Schultz. Retail gallery. Estab. 1985. Represents 6 mid-career artists. Interested in seeing the work of emerging artists. Exhibited artists include Karen Christensen and Ann Argyle. Sponsors 2 show/year. Average display time 2 months. Open all year. Located in Holladay, at the mouth of Parleys Canyon; 1,000 sq. ft. 30% of space for special exhibitions. 65% private collectors, 35% corporate collectors. Overall price range: up to $1,000; most work sold at $300-500.
Media: Considers acrylic, watercolor, pastel and photography. Considers lithographs, serigraphs and limited editions. Most frequently exhibits watercolor, acrylic and oil.
Style: Exhibits classic and traditional. Genres include landscapes, florals, Americana, Southwestern, Western and wildlife.
Terms: Accepts work on consignment (40% commission) or buys outright for 50% of retail price. Retail price set by the gallery and the artist. Gallery provides promotion. Prefers artwork unframed.
Submissions: Prefers local area watercolor, oil, acrylic and photography—unframed. Send query letter and make an appointment. Call for appointment to show portfolio of originals, photographs and slides. Replies only if interested within 1 month.
Tips: "We offer unique (original) local art—support local economy. Also want our customer to be able to purchase any medium, style, etc. from our gallery. We have the lazer disc system for viewing. To represent an artist well we need a minimum of six pieces."

KIMBALL ART CENTER, 638 Park Ave., P.O. Box 1478, Park City UT 84060. (801)649-8882. Fax: (801)649-8889. Program Coordinator: Rebecca Samson. Nonprofit gallery. Estab. 1976. Represents/exhibits 24-100 emerging, mid-career and established artists/year. Exhibited artists include Northwest Rendezvous Group. Sponsors 24 shows/year. Average display time 1 month. Open all year; Monday-Saturday, 10-6; Sunday, 12-6. Located in Old Town District; restored historic building. 50% of space for special exhibitions; 30% of space for gallery artists. Clientele: tourists, upscale, local clientele. 90% private collectors, 10% corporate collectors. Overall price range: $100-30,000; most work sold at $200-5,000.
Media: Considers all media except craft. Most frequently exhibits oil paintings, watercolor and sculpture.
Style: Exhibits realism and impressionism. All genres. Prefers landscapes, western and mixed genres.
Terms: Artwork is accepted on consignment (40% commission). Retail price set by the artist. Gallery provides insurance, promotion and contract; shipping costs are shared. Prefers artwork framed.
Submissions: Prefers Southwest—West Coast artists. Send query letter with résumé, slides, bio and SASE. Portfolio should include slides. Replies in 4 months. Finds artists through word of mouth, Park City Art Festival (Kimball Art Center production) and submissions.

‡PHILLIPS GALLERY, 444 E. 200 S., Salt Lake City UT 84111. (801)364-8284. Fax: (801)364-8293. E-mail: phillips@thoughtport.com. Director: Meri Ploetz. Retail gallery, art consultancy, rental gallery. Estab. 1965. Represents 80 emerging, mid-career and established artists/year. Exhibited artists include Tony Smith, Doug Snow, Lee Deffebach. Sponsors 8 shows/year. Average display time 1 month. Open all year; Tuesday-Friday, 10-6; Saturday, 10-4; closed August 1-20 and December 25-January 1. Located downtown; has 3 floors at 2,000 sq. ft. and a 2,400 sq. ft. sculpture deck on the roof. 40% private collectors, 60% corporate collectors. Overall price range: $100-10,000; most work sold at $200-4,000.
Media: Considers all media, woodcuts, engravings, lithographs, wood engravings, linocuts, etchings. Most frequently exhibits oil, acrylic, sculpture/steel.
Style: Exhibits expressionism, conceptualism, neo-expressionism, minimalism, pattern painting, primitivism, color field, hard-edge geometric abstraction, painterly abstraction, postmodern works, realism, surrealism, impressionism. Genres include Western, Southwestern, landscapes, figurative work, contemporary. Prefers abstract, neo-expressionism, conceptualism.
Terms: Accepts work on consignment (50% commission). Gallery provides insurance and promotion; shipping costs are shared. Prefers artwork framed.
Submissions: Accepts only artists from western region/Utah. Send query letter with résumé, slides, reviews, artist's statement, bio and SASE. Call for appointment to show portfolio of transparencies and slides. Replies in 2 weeks. Files slides, bio, statement, press. Finds artists through word of mouth, referrals.

TIVOLI GALLERY, 255 S. State, Salt Lake City UT 84111. (801)521-6288. Fax: (801)363-3528. Gallery Coordinator: Kate Carlson. Retail gallery. Estab. 1966. Represents 30 mid-career and established artists. Interested in seeing the work of emerging artists. Exhibited artists include Elva Malin and Fred Crawford. Open all year. Located "downtown; 25,000 sq. ft. (largest in the country); Utah's first burlesque theater, has 20 ft. ceilings." Clientele: all types. 60% private collectors, 40% corporate collectors. Overall price range: $500-20,000; most work sold at $800-2,500.
Media: Considers oil, acrylic, watercolor, pastel, sculpture and ceramic. Does not consider prints. Most frequently exhibits oil, watercolor and acrylic.
Style: Exhibits expressionism, painterly abstraction, imagism, impressionism, realism and hard-edge geometric abstraction. Genres include landscapes, florals, Southwestern, Western and figurative work. Prefers land-

scapes and expressionism. Work is 50% traditional, 50% modern expressionist.

Terms: Accepts work on consignment (50% commission).

Submissions: Send query letter with slides, photographs and bio. Call or write for appointment to show portfolio of originals or photographs or slides. Replies in 2 weeks. Files slides, photos and bios.

Tips: "We like to talk to all artists!"

Vermont

COTTONBROOK GALLERY, 1056-13 Mt. Rd., Stowe VT 05672. (802)253-8121. Owner: Vera Beckerhoff. Retail gallery and custom frame shop. Estab. 1981. Average display time 3 weeks. Clientele: upscale second homeowners. Overall price range: $50-3,000; most work sold at $100-200.

Media: Considers oil, watercolor, drawings, mixed media and sculpture. Most frequently exhibits watercolor and oil.

Style: Exhibits painterly abstraction, primitivism and impressionism. Shows are thematic.

Terms: Work accepted on consignment. Retail price set by gallery or artist. Exclusive area representation required. Shipping costs are shared.

Submissions: Send query letter with résumé, slides and SASE. Write for appointment to show portfolio of originals.

Tips: "Have good slides. Have a consistent body of work. Be business-like—not flashy, but honest and thorough."

‡PARADE GALLERY, Box 245, Warren VT 05674. (802)496-5445. E-mail: shelbynut@aol.com. Owner: Jeffrey S. Burnett. Retail gallery. Estab. 1982. Represents 15-20 emerging, mid-career and established artists. Clientele: tourist and upper middle class second-home owners. 98% private collectors. Overall price range: $20-2,500; most work sold at $50-300.

Media: Considers oil, acrylic, watercolor, pastel, mixed media, collage, works on paper, sculpture and original handpulled prints. Most frequently exhibits etchings, silkscreen and watercolor. Currently looking for oil/acrylic and watercolor.

Style: Exhibits primitivism, impressionistic and realism. "Parade Gallery deals primarily with representational works with country subject matter. The gallery is interested in unique contemporary pieces to a limited degree." Does not want to see "cutesy or very abstract art."

Terms: Accepts work on consignment (33⅓% commission) or occasionally buys outright (net 30 days). Retail price set by gallery or artist. Sometimes offers customer discounts and payment by installment. Exclusive area representation required. Gallery provides insurance and promotion.

Submissions: Send query letter with résumé, slides and photographs. Portfolio review requested if interested in artist's work. A common mistake artists make in presenting their work is having "unprofessional presentation or poor framing." Biographies and background are filed. Finds artists through customer recommendations, shows, magazines or newspaper stories and photos.

Tips: "We need to broaden offerings in price ranges which seem to offer a good deal for the money."

Virginia

THE ART LEAGUE, INC., 105 N. Union St., Alexandria VA 22314. (703)683-1780. Executive Director: Cora J. Rupp. Gallery Director: Katy Hunt. Cooperative gallery. Estab. 1954. Interested in emerging, mid-career and established artists. 1,000-1,200 members. Sponsors 10 solo and 16 group shows/year. Average display time 1 month. Located in The Torpedo Factory Art Center. Accepts artists from metropolitan Washington area, northern Virginia and Maryland. Clientele: 75% private collectors, 25% corporate clients. Overall price range: $50-4,000; most work sold at $150-500.

Media: Considers oil, acrylic, watercolor, pastel, pen & ink, drawings, mixed media, collage, works on paper, sculpture, ceramic, fiber, glass, photography and original handpulled prints. Most frequently exhibits watercolor, all printmaking media and oil/acrylic.

Style: Exhibits all styles and genres. Prefers impressionism, painted abstraction and realism. "The Art League is a membership organization open to anyone interested."

Terms: Accepts work on consignment (33⅓% commission) and co-op membership fee plus donation of time. Retail price set by artist. Offers customer discounts (designers only) and payment by installments (if requested on long term). Exclusive area representation not required.

Submissions: Portfolio review requested if interested in artist's work.
Tips: "Artists find us and join/exhibit as they wish within framework of our selections jurying process."

CUDAHY'S GALLERY, 1314 E. Cary St., Richmond VA 23219. (804)782-1776. Director: Helen Levinson. Retail gallery. Estab. 1981. Represents 50 emerging and established artists. Exhibited artists include Eldridge Bagley and Nancy Witt. Sponsors 12 shows/year. Average display time 4-5 weeks. Open all year; Monday-Thursday, 10-6; Friday-Saturday, 10-10; Sunday, 12-5. Located downtown in historic district; 3,600 sq. ft.; "1870s restored warehouse." 33% of space for special exhibits. Clientele: diverse. 70% private collectors, 30% corporate collectors. Overall price range: $100-10,000; most work sold at $400-2,500.
Media: Considers all media except fiber; and all types of prints except posters. Most frequently exhibits oil, watercolor and pastel.
Style: Exhibits impressionism, realism and photorealism. Genres include landscapes, portraits and figurative work. Prefers realism, figurative work and abstraction.
Terms: Accepts work on consignment (45% commission). Retail price set by artist. Gallery provides insurance and promotion; shipping costs are shared. Prefers artwork framed.
Submissions: Prefers artists from Southeast or East Coast. Send query letter with résumé, slides, bio, brochure, business card, reviews, photographs and SASE. Replies in 1 month.

FINE ARTS CENTER FOR NEW RIVER VALLEY, P.O. Box 309, Pulaski VA 24301. (703)980-7363. Director: Michael Dowell. Nonprofit gallery. Estab. 1978. Represents 75 emerging, mid-career and established artists and craftspeople. Sponsors 10 solo and 2 group shows/year. Average display time is 1 month (gallery); 3-6 months (Art Mart). Clientele: general public, corporate, schools. 80% private collectors, 20% corporate clients. Overall price range: $20-500; most artwork sold at $20-100.
● Downtown Pulaski has enjoyed a new growth in the arts, music and antiques areas thanks to an active and successful main street revitalization program.
Media: Considers all media. Most frequently exhibits oil, watercolor and ceramic.
Style: Exhibits hard-edge/geometric abstraction, painterly abstraction, minimalism, post-modernism, pattern painting, feminist/political works, primitivism, impressionism, photorealism, expressionism, neo-expressionism, realism and surrealism. Genres include landscapes, florals, Americana, Western, portraits and figurative work. Most frequently exhibits landscapes, abstracts, Americana.
Terms: Accepts work on consignment (30% commission). Retail price is set by gallery or artist. Sometimes offers payment by installments. Exclusive area representation not required. Gallery provides insurance (80% of value), promotion and contract.
Submissions: Send query letter with résumé, brochure, clearly labeled slides, photographs and SASE. Slides and résumés are filed. Portfolio review requested if interested in artist's work. "We do not want to see unmatted or unframed paintings and watercolors." Finds artists through visiting exhibitions and art collectors' referrals.
Tips: "In the selection process, preference is often (but not always) given to regional and Southeastern artists. This is in accordance with our size, mission and budget constraints."

GALLERY WEST, LTD., 205 S. Union St., Alexandria VA 22314. (703)549-7359. Director: Craig Snyder. Cooperative gallery and alternative space. Estab. 1979. Exhibits the work of 30 emerging, mid-career and established artists. Sponsors 17 shows/year. Average display time 3 weeks. Open all year. Located in Old Town; 1,000 sq. ft. 60% of space for special exhibitions. Clientele: individual, corporate and decorators. 90% private collectors, 10% corporate collectors. Overall price range: $100-2,000; most work sold at $150-400.
Media: Considers all media.
Style: All styles and genres.
Terms: Co-op membership fee plus a donation of time. (25% commission.) Retail price set by artist. Sometimes offers customer discounts and payment by installments. Gallery assists promotion; artist pays for shipping. Prefers artwork framed.
Submissions: Send query letter with résumé, slides, bio and SASE. Call for appointment to show portfolio of slides. Replies in 3 weeks. Files résumés.

HAMPTON UNIVERSITY MUSEUM, Marshall Ave. at Shore Rd., Hampton VA 23668. (804)727-5308. Fax: (804)227-5084. Director: Jeanne Zeidler or Curator of Exhibitions: Jeffrey Bruce. Museum. Estab. 1868. Represents/exhibits established artists. Exhibited artists include Elizabeth Catlett and Jacob Lawrence.

HOW TO USE your *Artist's & Graphic Designer's Market* offers suggestions for understanding and using the information in these listings. Read this and other articles in the front of this book for important business tips.

Sponsors 4-5 shows/year. Average display time 4-5 weeks. Open all year; Monday-Friday, 8-5; Saturday-Sunday, 12-4; closed on major and campus holidays. Located on the campus of Hampton University.
Media: Considers all media and all types of prints. Most frequently exhibits oil or acrylic paintings, ceramics and mixed media.
Style: Exhibits African-American, African and/or Native American art.
Submissions: Send query letter with résumé and slides. Portfolio should include photographs and slides.

MARSH ART GALLERY, University of Richmond, Richmond VA 23173. (804)289-8276. Fax: (804)287-6006. E-mail: waller@urvax.urich.edu. Website: http://www.urich.edu/. Director: Richard Waller. Museum. Estab. 1967. Represents emerging, mid-career and established artists. Sponsors 10 shows/year. Average display time 1 month. Open all year; with limited summer hours June-August. Located on University campus; 5,000 sq. ft. 100% of space for special exhibitions.
Media: Considers all media and all types of prints. Most frequently exhibits painting, sculpture, photography and drawing.
Style: Exhibits all styles and genres.
Terms: Work accepted on loan for duration of special exhibition. Retail price set by the artist. Gallery provides insurance, promotion, contract and shipping costs. Prefers artwork framed.
Submissions: Send query letter with résumé, slides, brochure, SASE, reviews and printed material if available. Write for appointment to show portfolio of photographs, slides, transparencies or "whatever is appropriate to understanding the artist's work." Replies in 1 month. Files résumé and other materials the artist does not want returned (printed material, slides, reviews, etc.).

‡RESTON ART GALLERY, 11400 Washington Plaza W., Reston VA 22090. (703)481-8156. Publicity: Pat Macintyre. Estab. 1988. Represents 8 artists. Interested in emerging artists. Sponsors 10 solo and 2 group shows/year. Average display time 2 months. 75% private collectors, 25% corporate clients. Overall price range: $25-1,750; most work sold at $150-350.
 • This gallery offers some working studios and exhibition space.
Media: Considers all media and prints. Most frequently exhibits oil, acrylic, watercolor, photos and graphics.
Style: Exhibits all styles and genres. Prefers realism and painterly abstraction. The gallery's purpose is to "promote local artists and to educate the public. Gallery sitting and attendance at meetings are required."
Terms: Some consignment (33⅓ commission). Retail price set by artist. Customer discounts and payment by installments are available. Exclusive area representation not required. Gallery provides promotion; artist pays for shipping.
Submissions: Send query letter with résumé, slides, photographs, bio and SASE. Portfolio review requested if interested in artist's work. Portfolio should include originals, slides and photographs. Replies in 1 week. All material is returned if not accepted or under consideration. Finds artists through visiting exhibitions and word of mouth.

‡1708 GALLERY, 103 E. Broad St., P.O. Box 12520, Richmond VA 23241. (804)643-7829. Contact: Exhibitions Chair. Alternative space, nonprofit gallery. Estab. 1978. Represents emerging and mid-career artists. 21 members. Sponsors 18 shows/year. Average display time 1 month. Open all year; Tuesday-Friday, 11-5; Saturday-Sunday, 1-5. Located downtown; one gallery space is 2,000 sq. ft., 16 ft. ceilings, art deco staircase; additional gallery space, 600 sq. ft. 100% of space for exhibitions. Clientele: broad cross-section of community. 70% private collectors, 30% corporate collectors. Overall price range: $50-7,000; most work sold at $250-800.
Media: Considers oil, acrylic, watercolor, pastel, pen & ink, drawing, mixed media, collage, sculpture, ceramics, installation, photography, "all contemporary media," woodcuts, engravings, lithographs, wood engravings, mezzotints, serigraphs, linocuts, etchings, "all original print media." Most frequently exhibits painting and works on paper, sculpture and installations.
Style: Exhibits expressionism, neo-expressionism, painterly abstraction, surrealism, conceptualism, minimalism, postmodern works, realism, imagism, "no additional academic."
Terms: Work is for sale during exhibition only. Retail price set by the artist. Gallery provides insurance, promotion and contract; artist pays shipping costs.
Submissions: Send SASE for proposal form then send query letter with résumé, slides, bio and SASE. Reports in 2-3 months.
Tips: Open call for proposals is ongoing.

Washington

THE AMERICAN ART COMPANY, 1126 Broadway Plaza, Tacoma WA 98402. (206)272-4377. Director: Rick Gottas. Retail gallery. Estab. 1978. Represents/exhibits 50 emerging, mid-career and established artists/year. Exhibited artists include Toko Shinoda. Sponsors 10 shows/year. Open all year; Monday-Friday, 10-5; Saturday, 10-5:30. Located downtown; 3,500 sq. ft. 60% of space for special exhibitions; 40% of space

for gallery artists. Clientele: local community. 95% private collectors; 5% corporate collectors. Overall price range: $500-15,000; most work sold at $1,800.

Media: Considers oil, fiber, acrylic, sculpture, glass, watercolor, mixed media, pastel, collage; woodcuts, wood engravings, linocuts, engravings, mezzotints, etchings, lithographs and serigraphs. Most frequently exhibits works on paper, sculpture and oils.

Style: Exhibits all styles. Genres include landscapes, Chinese and Japanese.

Terms: Artwork is accepted on consignment (50% commission) or bought outright for 50% of retail price; net 30 days. Retail price set by the gallery and the artist. Gallery provides insurance and promotion; shipping costs are shared. Prefers artwork unframed.

Submissions: Send query letter with résumé, slides, bio and SASE. Write for appointment to show portfolio of slides. Replies in 2-3 weeks. Finds artists through word of mouth, referrals by other artists, visiting art fairs and exhibitions, submissions.

‡**BRUSKIN GALLERY**, 820 Water, Port Townsend WA 98368. (206)385-6227. Contact: Kathleen Bruskin. Retail gallery. Estab. 1985. Represents 200 established artists/year. Sponsors 12 shows/year. Average display time 1 month. Open all year; daily, 10-4:30. Located downtown. 100% of space for special exhibitions. Clientele: upper middle class. 100% private collectors. Overall price range: $200-900; most work sold at $350-500.

Media: Considers oil, acrylic, watercolor, pastel, mixed media, collage, sculpture and photography. Most frequently exhibits oil, watercolor and mixed media.

Style: Exhibits all styles, all genres. Prefers landscapes, figures, abstractions.

Terms: Retail price set by the gallery and the artist. Gallery provides promotion and contract; artist pays shipping costs to and from gallery. Prefers artwork framed.

Submissions: Send query letter with slides and photographs. Write for appointment to show portfolio of originals, photographs, slides and transparencies. Replies in 2 weeks. Finds artists through visiting exhibitions and submissions.

‡**COMMENCEMENT ART GALLERY**, 902 Commerce, Tacoma WA 98402-4407. (206)593-4331. Fax: (206)591-2002. Website: http://www.cl.tacoma.wa.us. Coordinator: Ben Meeker. Alternative space, art consultancy and nonprofit gallery run by Tacoma Arts Commission. Estab. 1993. Represents 12 emerging artists/year. Exhibited artists include Vivian Kendall. Sponsors 11-12 shows/year. Average display time 1 month. Open all year; Tuesday-Saturday, 11-5. Located downtown theater district; 600 sq. ft. (main gallery), 600 ft. performance/installation space, 2 large window display cases. "We occupy the basement of a 19th century theater." 10% of space for special exhibitions; 90% of space for gallery artists. Clientele: full range of Tacoma's population, poor to rich. 100% private collectors. Overall price range: $100-3,500; most work sold at $300-500.

Media: Considers all media, all types of prints. Most frequently exhibits painting/print/photo (2D), sculpture (3D) and installation/performance (4D).

Style: Exhibits all styles, all genres. Prefers cynicism, altruism and didacticism.

Terms: "We act as noncommissioned agent liason for artists." Retail price set by the artist. Gallery provides promotion; artist pays shipping costs to and from gallery.

Submissions: Accepts only emerging or under-shown artists from Puget Sound area (Tacoma, Seattle, Olympia). Send query letter with résumé, slides, bio. Call for appointment to show portfolio of originals and slides. Replies only if interested within 1-2 weeks. Files slides, résumé, bio. Finds artists through annual juried slide competition open to all.

FOSTER/WHITE GALLERY, 311½ Occidental Ave. S., Seattle WA 98104. (206)622-2833. Fax: (206)622-7606. Owner/Director: Donald Foster. Retail gallery. Estab. 1973. Represents 90 emerging, mid-career and established artists/year. Interested in seeing the work of local emerging artists. Exhibited artists include Chihuly, Tobey, George Tsutakawa. Average display time 1 month. Open all year; Monday-Saturday, 10-5:30; Sunday, 12-5. Located historic Pioneer Square; 5,800 sq. ft. Clientele: private, corporate and public collectors. Overall price range: $300-35,000; most work sold at $2,000-8,000.

• Gallery has additional space at 126 Central Way, Kirkland WA 98033. (206)822-2305. Fax: (206)828-2270.

Media: Considers oil, acrylic, watercolor, pastel, pen & ink, drawing, mixed media, collage, paper, sculpture, ceramics, craft, fiber, glass and installation. Most frequently exhibits glass sculpture, works on paper and canvas and ceramic and metal sculptures.

Style: Contemporary Northwest art. Prefers contemporary Northwest abstract, contemporary glass sculpture.

Terms: Gallery provides insurance, promotion and contract.

Submissions: Accepts only artists from Pacific Northwest. Send query letter with résumé, slides, bio and reviews. Write for appointment to show portfolio of slides. Replies in 3 weeks.

‡**LINDA HODGES GALLERY**, 410 Occidental Ave. S., Seattle WA 98104. (206)624-3034. Fax: (206)624-3034. Owner: Linda Hodges. Retail gallery. Estab. 1983. Represents 27 mid-career and established artists/year. Interested in seeing the work of emerging artists. Exhibited artists include Gaylen Hansen, Tom Fawkes.

Sponsors 12 shows/year. Average display time 1 month. Open all year; Tuesday-Saturday, 11-5, Sunday 1-5. Located Old Town/Pioneer Square; 1,600 sq. ft.; large exhibition space. 100% of space for gallery artists. Clientele: corporate, private. 70% private collectors, 30% corporate collectors. Overall price range: $300-12,000; most work sold at $700-2,500.

Media: Considers oil, acrylic, watercolor, pastel, pen & ink, drawing, mixed media, collage, paper, fiber and photography, all types of prints except posters. Most frequently exhibits oil, acrylic and mixed media, all on canvas/board/paper.

Style: Exhibits all styles. Genres include landscapes.

Terms: Accepts work on consignment (50% commission). Retail price set by the gallery. Gallery provides promotion and contract; artist pays shipping costs to and from gallery. Prefers artwork framed.

Submissions: Prefers Northwest regional artists, but open. Send query letter with résumé, SASE, slides. Call or write for appointment to show portfolio of slides. Replies in 2 weeks. Finds artists through word of mouth, inquiries.

Tips: "We usually only exhibit local, Northwest artists."

MING'S ASIAN GALLERY, 10217 Main St., Old Bellevue WA 98004-6121. (206)462-4008. Fax: (206)453-8067. Director: Nelleen Klein Hendricks. Retail gallery. Estab. 1964. Represents/exhibits 3-8 mid-career and established artists/year. Exhibited artists include Kim Man Hee, Kai Wang and Kaneko Jonkoh. Sponsors 8 shows/year. Average display time 1 month. Open all year; Monday-Saturday, 10-6. Located downtown; 6,000 sq. ft.; exterior is Shanghai architecture circa 1930. 20% of space for special exhibitions. 35% private collectors, 20% corporate collectors. Overall price range: $350-10,000; most work sold at $1,500-3,500.

Media: Considers oil, acrylic, watercolor, sumi paintings, Japanese woodblock. Most frequently exhibits sumi paintings with woodblock and oil.

Style: Exhibits expressionism, primitivism, realism and imagism. Genres include Asian. Prefers antique, sumi, watercolors, temple paintings and folk paintings.

Terms: Artwork is accepted on consignment (50% commission). Retail price set by the gallery and the artist. Gallery provides insurance, promotion and contract; shipping costs are shared. Prefers artwork framed.

Submissions: Send query letter with résumé, brochure, slides, photographs, reviews, bio and SASE. Write for appointment to show portfolio of photographs, slides and transparencies. Replies in 2 weeks. Finds artists by traveling to Asia, visiting art fairs, and through submissions.

PAINTERS ART GALLERY, 30517 S.R. 706E, P.O. Box 106, Ashford WA 98304. Owner: Joan Painter. Retail gallery. Estab. 1972. Represents 60 emerging, mid-career and established artists. Exhibited artists include Cameron Blagg, Roger Kamp and David Bartholet. Open all year. Located 5 miles from the entrance to Mt. Rainier National Park; 1,200 sq. ft. 75% of space for work of gallery artists. Clientele: collectors and tourists. Overall price range $10-5,500; most work sold at $300-2,500.

• The gallery has over 100 people on consignment. It is very informal, outdoors atmosphere.

Media: Considers oil, acrylic, watercolor, pastel, pen & ink, drawings, mixed media, sculpture (bronze), photography, stained glass, original handpulled prints, reliefs, offset reproductions, lithographs, serigraphs and etchings. "I am seriously looking for bronzes, totem poles and outdoor carvings." Most frequently exhibits oil, pastel and acrylic.

Style: Exhibits primitivism, surrealism, imagism, impressionism, realism and photorealism. All genres. Prefers Mt. Rainier themes and wildlife. "Indians are a strong sell."

Terms: Accepts artwork on consignment (30% commission on prints and bronzes; 40% on paintings). Retail price set by gallery and artist. Gallery provides promotion; artist pays for shipping. Prefers artwork framed.

Submissions: Send query letter or call. "I can usually tell over the phone if artwork will fit in here." Portfolio review requested if interested in artist's work. Does not file materials.

Tips: "Sell paintings and retail price items for the same price at mall and outdoor shows that you price them in galleries. I have seen artists under price the same paintings/items, etc. when they sell at shows."

PHINNEY CENTER GALLERY, 6532 Phinney Ave. N., Seattle WA 98103. (206)783-2244. Fax: (206)783-2246. E-mail: pnacenter@aol.com. Website: http://www.poppyware.com/PNA/. Arts Coordinator: Ed Medeiros. Nonprofit gallery. Estab. 1982. Represents 10-12 emerging artists/year. Sponsors 10-12 shows/year. Average display time 1 month. Open all year; Monday-Friday, 10-9; Saturday, 10-1. Located in a residential area; 92 sq. ft.; in 1904 building—hardwood floors, high ceilings. 20% of space for special exhibitions; 80% of space for gallery artists. 50-60% private collectors. Overall price range: $50-4,000; most work sold at $50-200.

Media: Considers oil, acrylic, watercolor, pastel, pen & ink, drawing, mixed media, collage, paper, sculpture, ceramics, installation, photography, all types of prints. Most frequently exhibits painting, sculpture and photography.

Style: Exhibits painterly abstraction, all genres.

Terms: Accepts work on consignment (25% commission). Retail price set by the artist. Gallery provides promotion and contract; artist pays shipping costs to and from gallery. Prefers artwork framed.

Submissions: Send query letter with résumé, bio and SASE. Call or write for appointment to show portfolio of slides. Replies in 2 weeks. Finds artists through calls for work in local and national publications.

West Virginia

THE ART STORE, 1013 Bridge Rd., Charleston WV 25314. (304)345-1038. Director: E. Schaul. Retail gallery. Estab. 1980. Represents 16 mid-career and established artists. Sponsors 4 shows/year. Average display time 1 month. Open all year. Located in a suburban shopping center; 2,000 sq. ft. 50% of space for special exhibitions. Clientele: professionals, executives, decorators. 60% private collectors, 40% corporate collectors. Overall price range: $200-8,000; most work sold at $1,800.
Media: Considers oil, acrylic, watercolor, pastel, mixed media, works on paper, ceramic, woodcuts, engravings, linocuts, etchings, and monoprints. Most frequently exhibits oil, pastel, mixed media and watercolor.
Style: Exhibits expressionism, painterly abstraction, color field and impressionism.
Terms: Accepts artwork on consignment (40% commission). Retail price set by gallery and artist. Gallery provides insurance, promotion and shipping costs from gallery. Prefers artwork unframed.
Submissions: Send query letter with résumé, slides, SASE and announcements from other galleries if available. Gallery makes the contact after review of these items; replies in 4-6 weeks.
Tips: "Do not sent slides of old work."

Wisconsin

ART INDEPENDENT GALLERY, 623 Main St., Lake Geneva WI 53147. (414)248-3612. Fax: (414)248-2227. Owner: Betty C.S. Sterling. Retail gallery. Estab. 1968. Represents 180 emerging, mid-career and established artists/year. Exhibited artists include Peg Sindelar, Martha Hayden, Gail Jones, Eric Jensen, John Yapelli and Lou Taylor. Sponsors 2-3 shows/year. Average display time 6-8 weeks. Open January-March: Thursday/Friday/Saturday, 10-5; Sundays, 12-5. April-May: daily, 10-5; Sundays, 12-5; closed Tuesday. June-August: daily, 10-5; Sundays, 12-5. September-December: daily 10-5; Sundays, 12-5; closed Tuesday. 3,000 sq. ft.; loft-like 1st floor, location in historic building. 25% of space for special exhibitions; 100% of space for gallery artists. Clientele: collectors, tourists, designers. 90% private collectors, 10% corporate collectors. Overall price range: $2-4,000; most work sold at $200-800.
Media: Considers oil, acrylic, watercolor, pastel, pen & ink, mixed media, collage, paper, sculpture, ceramics, fiber, glass, photography, jewelry, woodcuts, engravings, serigraphs, linocuts and etchings. Most frequently exhibits paintings, ceramics and jewelry.
Style: Exhibits expressionism and painterly abstraction. Genres include landscapes, florals, portraits and figurative work. Prefers abstracts, impressionism and imagism.
Terms: Accepts work on consignment (50% commission). Retail prices set by the artist. Gallery provides insurance, promotion, contract and shipping costs from gallery; artist pays shipping costs to gallery. Prefers artwork framed.
Submissions: Send query letter with résumé, slides, bio and SASE. Call or write for application. Portfolio should include slides and transparencies. Replies in 2-4 weeks. Files bios and résumés. Finds artists through visiting exhibitions, word of mouth, shows/art fairs.

DAVID BARNETT GALLERY, 1024 E. State St., Milwaukee WI 53202. (414)271-5058. Fax: (414)271-9132. Office Manager: Milena Marich. Retail and rental gallery and art consultancy. Estab. 1966. Represents 300-400 emerging, mid-career and established artists. Exhibited artists include Claude Weisbuch and Carol Summers. Sponsors 12 shows/year. Average display time 1 month. Open all year. Located downtown at the corner of State and Prospect; 6,500 sq. ft.; "Victorian-Italianate mansion built in 1875, three floors of artwork displayed." 25% of space for special exhibitions. Clientele: retail, corporations, interior decorators, private collectors, consultants, museums and architects. 20% private collectors, 10% corporate collectors. Overall price range: $50-375,000; most work sold at $1,000-50,000.
Media: Considers oil, acrylic, watercolor, pastel, pen & ink, drawings, mixed media, collage, sculpture, ceramic, fiber, glass, photography, bronzes, marble, woodcuts, engravings, lithographs, wood engravings, serigraphs, linocuts, etchings and posters. Most frequently exhibits prints, drawings and oils.
Style: Exhibits expressionism, neo-expressionism, primitivism, painterly abstraction, surrealism, imagism, conceptualism, minimalism, postmodern works, impressionism, realism and photorealism. Genres include landscapes, florals, Southwestern, Western, wildlife, portraits and figurative work. Prefers old master graphics, contemporary and impressionistic.
Terms: Accepts artwork on consignment (50% commission). Retail price set by gallery and artist. Sometimes offers customer discounts and payment by installment. Gallery provides insurance and promotion; artist pays for shipping. Prefers artwork framed.

Submissions: Send query letter with slides, bio, brochure and SASE. "We return everything if we decide not to carry the artwork." Finds artists through agents, word of mouth, various art publications, sourcebooks, submissions and self-promotions.

‡TORY FOLLIARD GALLERY, 233 N. Milwaukee St., Milwaukee WI 53202. (414)273-7311. Fax: (414)273-7313. Contact: Katherine Schwab. Retail gallery. Estab. 1988. Represents mid-career and established artists. Interested in seeing the work of emerging artists. Exhibited artists include Tom Uttech, John Wilde. Sponsors 8-9 shows/year. Average display time 4-5 weeks. Open all year; Tuesday-Friday, 11-5; Saturday, 11-4. Located downtown in historic Third Ward; 3,000 sq. ft. 60% of space for special exhibitions; 40% of space for gallery artists. Clientele: tourists, upscale, local community and artists. 90% private collectors, 10% corporate collectors. Overall price range: $300-25,000; most work sold at $1,000-2,500.
Media: Considers all media except installation and craft. Most frequently exhibits painting, sculpture, monoprints.
Style: Exhibits expressionism, painterly abstraction, realism, surrealism and imagism. Prefers realism, painterly abstraction, expressionism.
Terms: Accepts work on consignment. Retail price set by the gallery and the artist. Gallery provides insurance and promotion; artist pays shipping costs. Prefers artwork framed.
Submissions: Prefers only artists working in Midwest regional art. Send query letter with résumé, slides, photographs, reviews, artist's statement and SASE. Portfolio should include photographs or slides. Replies in 2 weeks. Finds artists through referrals by other artists.

GALLERIA DEL CONTE, 1226 N. Astor St., Milwaukee WI 53202. (414)276-7545. Co-Directors: Cece Murphy and Beth Eisendrath. Retail gallery. Estab. 1991. Represents/exhibits 30 emerging, mid-career and established artists/year. Exhibited artists include Joseph Friebert and Angela Colombo. Sponsors 9 shows/year. Average display time 6 weeks. Open all year; Tuesday-Saturday, 11-4 or by appointment. Located on east side of downtown; 125-year-old historic townhouse. 60% of space for special exhibitions. Overall price range: $130-10,000; most work sold at $200-4,000.
Media: Considers oil, pen & ink, acrylic, drawing, watercolor, mixed media, pastel, collage, wall sculpture, woodcuts, linocuts, mezzotints, lithographs, serigraphs and metal prints. Most frequently exhibits oils, watercolors and prints.
Style: Exhibits painterly abstraction. Genres include landscapes and figurative work. Prefers landscapes and figures.
Terms: Artwork is accepted on consignment (50% commission). Retail price set by the artist. Gallery provides insurance and promotion; shipping costs are shared. Prefers artwork framed.
Submissions: Prefers Wisconsin artists. Must be trained artists (college level). Send query letter with résumé, slides, photographs, bio and SASE. Call for appointment to show portfolio of originals, photographs and slides. Replies in 4-6 weeks. Files some bios for reference. Finds artists through visiting exhibitions, word of mouth and submissions.
Tips: Both directors are active artists quite involved in community on artistic and business level. "Presentation is important. Have professional slides or photos, well ordered résumé. Do not simply show up. Call first for appointment."

‡GALLERY 218, 218 S. Second St., Milwaukee WI 53204. (414)277-7800. President: Judith Hooks. Nonprofit gallery, cooperative gallery, alternative space. "Gallery 218 is committed to providing exhibition opportunities to area artists. 218 sponsors exhibits, poetry readings, performances, recitals and other events. 'The audience is the juror.'" Estab. 1990. Represents 50 emerging, mid-career and established artists/year. Exhibited artists include Richard Waswo, ROAN. Sponsors 14 shows/year. Average display time 1 month. Open all year; Thursday, 1-5; Friday, 4-8; Saturday and Sunday 12-5. Located just south of downtown; 1,500 sq. ft.; warehouse-type space—wooden floor, halogen lights; includes information area with magazines, bulletins. 100% of space for gallery artists. 75% private collectors, 25% corporate collectors. Overall price range: $100-1,000; most work sold at $100-600.
Media: Considers all media except crafts. Considers linocuts, monotypes, woodcuts, mezzotints, etchings, lithographs and serigraphs. Most frequently exhibits paintings/acrylic, photography, mixed media.
Style: Exhibits expressionism, conceptualism, photorealism, neo-expressionism, minimalism, hard-edge geometric abstraction, painterly abstraction, postmodern works, realism, surrealism, imagism, fantasy, comic book art. Exhibits all genres, portraits, figurative work; "anything with an edge." Prefers abstract expressionism, street photography, personal visions.
Terms: There is a Co-op membership fee plus donation of time (20% commission.) Membership good 1 year. There is a rental fee for space; covers 1 month. Group shows at least four times a year (small entry fee). Retail price set by the artist. Gallery provides insurance and promotion; artist pays for shipping. Prefers artwork framed.
Submissions: Prefers only adults (21 years plus), no students (grad students OK), serious artists pursuing their careers. Send query letter with résumé, business card, slides, photographs, bio, SASE or request for application. Write for appointment to show portfolio of photographs, slides, résumé, bio. Replies in 1 month.

Files all. Finds artists through referrals, visiting art fairs, submissions. "We advertise for new members on a regular basis."
Tips: "Don't wait to be 'discovered'. Get your work out there—not just once, but over and over again. Don't get distracted by material things, like houses, cars and real jobs."

THE FANNY GARVER GALLERY, 230 State St., Madison WI 53703. (608)256-6755. Vice President: Jack Garver. Retail Gallery. Estab. 1972. Represents 100 emerging, mid-career and established artists/year. Exhibited artists include Harold Altman and Josh Simpson. Sponsors 11 shows/year. Average display time 1 month. Open all year; Monday-Saturday, 10-5. Located downtown; 3,000 sq. ft.; older refurbished building in unique downtown setting. 33% of space for special exhibitions; 95% of space for gallery artists. Clientele: private collectors, gift-givers, tourists. 40% private collectors, 10% corporate collectors. Overall price range: $10-10,000; most work sold at $30-200.
 • Gallery has second location at 7432 Mineral Point Rd., Madison, WI 53717, (608)833-8000; 7,000 sq. ft., suburban locale with upscale clientele.
Media: Considers oil, pen & ink, paper, fiber, acrylic, drawing, sculpture, glass, watercolor, mixed media, ceramics, pastel, collage, craft, woodcuts, wood engravings, linocuts, engravings, mezzotints, etchings, lithographs and serigraphs. Most frequently exhibits watercolor, oil and glass.
Style: Exhibits all styles. Prefers landscapes, still lifes and abstraction.
Terms: Accepts work on consignment (40% commission) or buys outright for 50% of retail price (net 30 days). Retail price set by gallery. Gallery provides promotion and contract, shipping costs from gallery; artist pays shipping costs. Prefers artwork framed.
Submissions: Send query letter with résumé, slides, bio, brochure, photographs and SASE. Write for appointment to show portfolio, which should include originals, photographs and slides. Replies only if interested within 1 month. Files announcements and brochures.

DEAN JENSEN GALLERY, 165 N. Broadway, Milwaukee WI 53202. Phone/fax: (414)278-7100. Director: Dean Jensen. Retail gallery. Estab. 1987. Represents/exhibits 20 mid-career and established artists/year. Exhibited artists include Alex Katz and Fred Stonehouse. Sponsors 8 shows/year. Average display time 5-6 weeks. Open all year. Tuesday-Friday, 10-6; Saturday, 10-4. Located downtown; 1,800 sq. ft.; located directly across from New Broadway Theater center in a high-ceiling, former warehouse building. 60% of space for special exhibitions; 30% of space for gallery exhibitions. Clientele: local community, museums, visiting business people. 90% private collectors, 10% corporate collectors. Overall price range: $350-35,000; most work sold at $1,500-6,000.
Media: Considers all media except crafts, fiber, glass; all types of prints except posters. Most frequently exhibits painting, prints and photography.
Style: Exhibits conceptualism, neo-expressionism, minimalism, postmodern works, imagism and outsider art.
Terms: Artwork is accepted on consignment (50% commission). Retail price set by the gallery. Gallery provides insurance and promotion; shipping costs are shared. Prefers artwork framed.
Submissions: Send query letter with résumé, slides, bio and SASE. "We review portfolios only after reviewing slides, catalogs, etc." Replies in 4-6 weeks.
Tips: "Most of the artists we handle are nationally or internationally prominent. Occasionally we will select an artist on the basis of his/her submission, but this is rare. Do not waste your time—and ours—by submitting your slides to us unless your work has great clarity and originality of ideas, is 'smart,' and is very professionally executed."

LATINO ARTS, 1028 S. Ninth, Milwaukee WI 53204. (414)384-3100 ext. 61. Fax: (414)649-4411. Visual Artist Specialist: Robert Cisneros. Nonprofit gallery. Represents emerging, mid-career and established artists. Sponsors 4 individual to group exhibitions/year. Average display time 2 months. Open all year; Monday-Friday, 10-4. Located in the near southeast side of Milwaukee; 1,200 sq. ft.; one-time church. 50% of space for special exhibitions; 40% of space for gallery artists. Clientele: the general Hispanic community. Overall price range: $100-2,000.
Media: Considers all media, all types of prints. Most frequently exhibits original 2- and 3-dimensional works and photo exhibitions.
Style: Exhibits all styles, all genres. Prefers artifacts of Hispanic cultural and educational interests.
Terms: "Our function is to promote cultural awareness (not to be a sales gallery)." Retail price set by the artist. Artist is encouraged to donate 15% of sales to help with operating costs. Gallery provides insurance, promotion, contract, shipping costs to gallery; artist pays shipping costs from gallery. Prefers artwork framed.
Submissions: Send query letter with résumé, slides, bio, business card and reviews. Call or write for appointment to show portfolio of photographs and slides. Replies in 2 weeks. Finds artists through recruiting, networking, advertising and word of mouth.

NEW VISIONS GALLERY, INC., at Marshfield Clinic, 1000 N. Oak Ave., Marshfield WI 54449. Executive Director: Ann Waisbrot. Nonprofit educational gallery. Runs museum and art center program for community. Represents emerging, mid-career and established artists. Organizes a variety of group and thematic

shows (10 per year), very few one-person shows, sponsors Marshfield Art Fair. "Culture and Agriculture": annual springtime invitational exhibit of art with agricultural themes. Does not represent artists on a continuing basis. Average display time 6 weeks. Open all year. 1,500 sq. ft. Price range varies with exhibit. Small gift shop with original jewelry, notecards and crafts at $10-50. "We do not show 'country crafts.' "

Media: Considers all media.

Style: Exhibits all styles and genres.

Terms: Accepts work on consignment (35% commission). Retail price set by artist. Gallery provides insurance and promotion. Prefers artwork framed.

Submissions: Send query letter with résumé, high-quality slides and SASE. Label slides with size, title, media. Replies in 1 month. Files résumé. Will retain some slides if interested, otherwise they are returned.

Tips: "Meet deadlines, read directions, make appointments—in other words respect yourself and your work by behaving as a professional."

Wyoming

CROSS GALLERY, 180 N. Center, Box 4181, Jackson Hole WY 83001. (307)733-2200. Fax: (307)733-1414. Director: Mary Schmidt. Retail gallery. Estab. 1982. Exhibited artists include Penni Anne Cross, Kennard Real Bird, Val Lewis and Kevin Smith. Sponsors 2 shows/year. Average display time 1 month. Open all year. Located at the corner of Center and Gill; 1,000 sq. ft. 50% of space for special exhibitions. Clientele: retail customers and corporate businesses. Overall price range: $20-35,000.

Media: Considers oil, acrylic, watercolor, pastel, pen & ink, drawings, mixed media, sculpture, original handpulled prints, engravings, lithographs, pochoir, serigraphs and etchings. Most frequently exhibits oil, original graphics, alabaster, bronze, metal and clay.

Style: Exhibits realism and contemporary styles. Genres include Southwestern, Western and portraits. Prefers contemporary Western and realist work.

Terms: Accepts artwork on consignment (33⅓% commission) or buys outright for 50% of retail price. Retail price set by gallery and artist. Offers payment by installments. Gallery provides insurance, promotion and contract; shipping costs are shared. Prefers artwork unframed.

Submissions: Send query letter with résumé, slides and photographs. Portfolio review requested if interested in artist's work. Portfolio should include originals, slides and photographs. Samples not filed are returned by SASE. Reports back within "a reasonable amount of time."

Tips: "We are seeking artwork with creative artistic expression for the serious collector. We look for originality. Presentation is very important."

HALSETH GALLERY—COMMUNITY FINE ARTS CENTER, 400 C, Rock Springs WY 82901. (307)362-6212. Fax: (307)382-6657. Director: Gregory Gaylor. Nonprofit gallery. Estab. 1966. Represents 12 emerging, mid-career and established artists/year. Sponsors 8-10 shows/year. Average display time 1 month. Open all year; Monday, 12-9; Tuesday and Wednesday, 10-9; Thursday, 12-9; Friday, 10-5; Saturday, 12-5. Located downtown—on the Rock Springs Historic Walking Tour route; 2,000 ground sq. ft. and 120 running sq. ft. of rotating exhibition space remodeled to accommodate painting and sculpture. 50% of space for special exhibitions; 50% of space for gallery artists. Clientele: community at large. 100% private collectors. Overall price range: $100-1,000; most work sold at $200-600.

Media: Considers all media, all types of prints. Most frequently exhibits oil/watercolor/acrylics, sculpture/ceramics, and installation.

Style: Exhibits all styles, all genres. Prefers neo-expressionism, realism and primitivism.

Terms: "We require a donation of a work." Retail price set by the artist. Gallery provides promotion; artist pays shipping costs to and from gallery. Prefers artwork framed.

Submissions: Send query letter with résumé, slides, bio, brochure, photographs, SASE, business card, reviews, "whatever available." Call or write for appointment to show portfolio of slides. Replies only if interested within 1 month. Files all material sent. Finds artists through submissions.

‡NICOLAYSEN ART MUSEUM, 400 E. Collins Dr., Casper WY 82601. (307)235-5247. Director: Karen Mobley. Community museum. Estab. 1967. Average display time 2 months. Interested in emerging, mid-career and established artists. Sponsors 10 solo and 10 group shows/year. Open all year. Clientele: 90% private collectors, 10% corporate clients.

Media: Considers all media.

Style: Exhibits all subjects.

Terms: Accepts work on consignment (40% commission). Retail price set by artist. Exclusive area representation not required. Gallery provides insurance, promotion and shipping costs from gallery.

Submissions: Send query letter with slides. Write to schedule an appointment to show a portfolio, which should include originals or slides. Replies in 2 months.

‡**WYOMING ARTS COUNCIL GALLERY**, 2320 Capitol Ave., Cheyenne WY 82002. (307)777-7742. Fax: (307)777-5499. Visual Arts Program Manager: Liliane Francuz. Nonprofit gallery. Estab. 1990. Represents 15 emerging, mid-career and established artists/year. Sponsors 6 exhibitions/year. Average display time 6 ½ weeks. Open all year, Monday-Friday 8-5. Located downtown in capitol complex; 660 sq. ft.; in historical carriage house. 100% of space devoted to special exhibitions. Clientele: tourists, upscale, local community. 98% private collectors. Overall price range $50-$1,500; most work sold at $100-250.
Media: Considers all media and all types of prints except posters. Most frequently exhibits photography, paintings/drawings and mixed media.
Style: Exhibits all styles and all genres. Most frequently exhibits contemporaty styles and craft.
Terms: Retail price set by the artist. Gallery provides insurance, promotion and contract. Shipping costs are shared. Prefers artwork framed.
Submissions: Accepts only artists from Wyoming. Send query letter with résumé, slides and bio. Call for portfolio review of photographs and slides. Replies in 2 weeks. Files résumé and slides. Finds artists through artist registry slide bank, word of mouth and studio visits.
Tips: Common mistakes artists make: "lack of professional presentation, poor slides, incomplete information."

Canada

‡✹**OPEN SPACE**, 510 Fort St., Victoria British Columbia V8W 1E6 Canada. (604)383-8833. Director: Sue Donaldson. Alternative space and nonprofit gallery. Estab. 1971. Represents emerging, mid-career and established artists. 311 members. Sponsors 8-10 shows/year. Average display time 3½ weeks. Open all year. Located downtown; 2,200 sq. ft.; "multi-disciplinary exhibition venue." 100% of space for gallery artists. Overall price range: $300-8,000.
Media: Considers oil, acrylic, watercolor, pastel, pen & ink, drawing, mixed media, collage, works on paper, sculpture, ceramic, installation, photography, video, performance art, original handpulled prints, woodcuts, wood engravings, linocuts, engravings, mezzotints and etchings.
Style: Exhibits all styles and all contemporary genres.
Terms: "No acquisition. Artists selected are paid exhibition fees for the right to exhibit their work." Retail price set by artist. Gallery provides insurance, promotion, contract and fees; shipping costs shared. Only artwork "ready for exhibition." Artists should be aware of the trend of "de-funding by governments at all levels."
Submissions: "Non-Canadian artists must submit by September 30 in order to be considered for visiting foreign artists' fees." Send query letter with résumé, 10-20 slides, bio, SASE (with IRC, if not Canadian), reviews and proposal outline. "No original work in submission." Replies in 1 month.

International

*****ABEL JOSEPH GALLERY**, Avenue Maréchal Foch, 89 Bruxelles Belgique 1030. 32-2-2456773. Directors: Kevin and Christine Freitas. Retail gallery and alternative space. Estab. 1989. Represents young and established national and international artists. Exhibited artists include Bill Boyce, Diane Cole, Régent Pellerin and Ron DeLegge. Sponsors 6-8 shows/year. Average display time 5 weeks. Open all year. Located in Brussels. 100% of space for work of gallery artists. Clientele: varies from first time buyers to established collectors. 80% private collectors; 20% corporate collectors. Overall price range: $500-15,000; most work sold at $1,000-8,000.
Media: Considers most media except craft. Most frequently exhibits sculpture, painting/drawing and installation (including active-interactive work with audience—poetry, music, etc.).
Style: Exhibits painterly abstraction, conceptualism, minimalism, post-modern works and imagism. "Interested in seeing all styles and genres." Prefers abstract, figurative and mixed-media.
Terms: Accepts artwork on consignment (50% commission). Retail price set by the gallery with input from the artist. Customer discounts and payment by installments are available. Gallery provides insurance, promotion and contract; shipping costs are shared.
Submissions: Send query letter with résumé, slides, bio, SASE and reviews. Portfolio review requested if interested in artist's work. Portfolio should include slides, photographs and transparencies. Replies in 1 month. Files résumé, bio and reviews.
Tips: "Gallery districts are starting to spread out. Artists are opening galleries in their own studios. Galleries have long outlived their status as the center of the art world. Submitting work to a gallery is exactly the same as applying for a job in another field. The first impression counts. If you're prepared, interested, and have any initiative at all, you've got the job."

Syndicates/Cartoon Features & Clip Art Firms

If you dream of seeing your characters in the funny papers, you must first sell the idea to a syndicate. Syndicates basically act as agents for cartoonists, selling comic strips, panels and editorial cartoons to newspapers and magazines. The syndicate edits, promotes and distributes the cartoonist's work, and keeps careful records of sales in exchange for a cut of the profits. Some syndicates also handle merchandising of licensed products, such as mugs, T-shirts and calendars.

The syndicate business is one of the hardest to break into. There are an overwhelming number of aspiring cartoonists competing for a very limited amount of space in the comics sections of newspapers. If you know your competition (as you should) you'll realize that spaces don't open up often. Editors are always reluctant to drop a long-established strip for a new one, as such action often results in a deluge of reader complaints.

Selling to syndicates is not easy, but it is achievable. Most syndicates say they're looking for a "sure thing," a feature in which they'll feel comfortable investing the more than $25,000 needed for promotion and marketing. Work worthy of syndication must be original, saleable and timely, and characters must have universal appeal in order to attract a diversity of readers.

To succeed in the syndicate market, you have to be more than a fabulous cartoonist. You must also be a good writer and stay in touch with current events and public concerns. Cartooning is an idea business just as much as it is an art business—and the art won't sell if the idea isn't there in the first place.

HOW TO APPROACH A SYNDICATE

How you approach a syndicate, and what you should send, depends on the type of feature you create. If you're an editorial cartoonist, you'll need to start out selling your cartoons to a base newspaper (probably in your hometown) and build up some clips before approaching a syndicate. Submitting published clips will prove to the syndicate that you have established a loyal following and are able to produce cartoons on a regular basis. Once you've built up a good collection of clips, submit at least 12 photocopied samples of your published work along with a brief cover letter.

Strips are handled a bit differently. Since they usually originate with the syndicate, it's not always necessary for them to have been previously published. Some syndicates even prefer to "discover" new strip artists and introduce them fresh to newspapers.

Each syndicate has a preferred method for submissions. Some of the larger syndicates have printed guidelines you can send for. If guidelines are available we have indicated that in the listing. Guidelines are also printed in several helpful books, such as *Your Career in the Comics* by Lee Nordling (Andrews and McMeel) and *The Practical Guide for Marketing to Syndicates* by Pasqual Battaglia (Syndicate Publications) (see Publications of Interest on page 681). To submit a strip idea, send a brief cover letter (50 words or less is ideal) that summarizes your idea, along with a character sheet (this shows your major characters along with their names and a description of each), and photocopies of 24 of your best strip samples on 8½ × 11 paper, six daily strips per

page. Don't send originals. Be tough on yourself—only the best stay afloat. By sending at least one month of samples, you'll show the syndicate that you're capable of producing high-quality humor, consistent artwork and a long lasting idea. Never submit originals; always make photocopies of your work and send those. It's OK to make simultaneous submissions to various syndicates. Since response time can take several months, syndicates understand that it would be impractical for cartoonists to wait for replies before submitting their ideas to other syndicates.

PAYMENT AND CONTRACTS

Should you be one of the lucky few to be picked up by a syndicate, the amount you earn will depend on the number of publications in which your work appears and the size of those publications. Whereas a top strip such as Garfield may be in as many as 2,000 papers worldwide, it takes a minimum of about 60 interested newspapers to make it worthwhile and profitable for a syndicate to distribute a strip.

Newspapers pay in the area of $10-15 a week for a daily feature. Your payment will be a percentage of gross or net receipts. Contracts usually involve a 50/50 split between the syndicate and the cartoonist. Check the listings in this section for more specific information about terms of payment.

Before signing a contract with a syndicate, be sure you understand the terms and are comfortable with them. The most favorable contracts will offer the following:
- Creator ownership of the strip and its characters.
- Periodic evaluation of the syndicate's performance.
- A five-year contract without automatic renewal.
- A percentage of gross, instead of net, receipts.

SELF-SYNDICATION

An alternative to consider is self-syndication. Self-syndicated cartoonists retain all rights to their work and keep all profits, but they also have to act as their own salespeople, sending packets to newspapers and other likely outlets. This requires developing a mailing list, promoting the strip (or panel) periodically, and developing a pricing, billing and collections structure. If you're a good businessperson and have the required time and energy, this might be the route for you. Weekly newspapers are the best bet here (not many—if any—daily newspapers buy from self-syndicated cartoonists).

EXPLORE THE CLIP ART MARKET

Clip art firms provide their clients—individuals, associations and businesses—with camera-ready illustrations, cartoons, spot drawings, borders and dingbat symbols. Some clip art books can be purchased in bookstores, but clients who are frequent users normally subscribe to a service and receive collections by mail once a month on disk, CD-ROM or in booklet format. Clip art is used in a variety of capacities, from newsletters to brochures to advertisements and more. In subscribing to a clip art service, clients buy the right to use the artwork as frequently as they wish.

Most clip art is b&w representational line art, rendered in a realistic or stylized manner. However, many firms are now offering a few special color reproductions with each monthly package. Collections usually fall into certain subject areas, such as animals, food, clothing or medicine. Most clip art firms keep track of consumer demands and try to offer images that cover current topics and issues. For example, many have begun to market more images with multicultural and environmental themes. Keith Coleman struck gold with his idea for a clip art service that offers multicultural images.

Read about Afrocentrex and learn more about the clip art market on page 519.

Artists cannot retain rights to work sold as clip art, since clip art is, by nature, virtually copyright free. Consequently, name credits are rarely given, although some firms will allow inclusion of a small monogram or logo alongside the artwork. Payment rates aren't astronomical, but there are advantages to working with clip art firms. For example, most give long lead times, which allow freelancers to work projects into their schedules at their convenience. Moreover, clip art businesses tend to pay in a very timely manner (some within 10 days of invoice).

‡AFROCENTREX, 2770 N. Lincoln Ave., Suite A, Chicago IL 60614. (312)463-6269. Fax: (312)404-5599. E-mail: Afrocentre@aol.com. Chief Executive Officer: Keith Coleman. Estab. 1993. Clip art firm. Distributes to over 20 outlets, including newspapers, schools and corporate accounts.
Needs: Approached by 2 cartoonists and 4-10 illustrators/year. Buys from 2-4 illustrators/year. Considers caricatures and illustrations. Prefers b&w line drawings.
First Contact & Terms: Send cover letter with résumé and photocopies or tearsheets and SASE. Include 3-5 samples. Samples are filed. Reports back within 2 weeks. Write for appointment to show portfolio of final art. Pays flat fee; $25-50. **Pays on acceptance.** Negotiates rights purchased. Offers automatic renewal. Clip art firm owns original art and characters.

ALLIED FEATURE SYNDICATE, P.O. Drawer 48, Joplin MO 64802-0048. (417)673-2860. Fax: (417)673-4743. Editor: Robert Blanset. Estab. 1940. Syndicate serving 50 outlets: newspapers, magazines, etc.
● Allied Features is the only agency syndicating cartoons solely geared toward electronics. Also owns separate syndicates for environmental, telecommunications, space and medical instruments fields. The same company also owns *ENN*, *The Lead Trader* and *Circuit News Digest*, a monthly electronics news magazine.
Needs: Approached by 100 freelancers/year. Buys from 1-10 freelancers/year. Introduces 25 new strips/year. Introductions include Outer Space by Ken Muse and Shuttlebutt by James Wright. Considers comic strips, gag cartoons, editorial/political cartoons. Considers single or multiple panel, b&w line drawings, with gagline. Prefers creative works geared toward business, the Space Program, electronics, engineering and environmental topics.
First Contact & Terms: Sample package should include cover letter, roughs, photocopies and 3 finished cartoon samples. One sample of each should be included. Samples are filed or are returned by SASE if requested by artist. Reports back within 90 days. Portfolio review requested if interested in artist's work. **Pays on acceptance**; flat fee of $10-50; or 50% of net proceeds. Negotiates rights purchased. Interested in buying second rights (reprint rights) to previously published artwork. Minimum length of contract is 5 years. Freelancer owns original art and the characters. "This is negotiable with artist. We always negotiate."

ART PLUS REPRO RESOURCE, P.O. Box 4710, Sarasota FL 34230-4710. (941)955-2950. Fax: (941)955-5723. E-mail: 70244.331@compuserve.com. Publisher: Wayne Hepburn. Estab. 1983. Clip art firm serving about 6,000 outlets, primarily churches, schools, associations and ministries. Guidelines, catalog and sample available for 9×12 SAE with 4 first-class stamps.
● This clip art firm works one year ahead of publication, pays within 90 days of acceptance, accepts any seasonal material at any time, and has been using more digitized and computer images. They will furnish a list of topics needed for illustration.
Needs: Buys 40-60 cartoons and 500-1,000 freelance illustrations/year. Prefers illustrations and single panel cartoons and b&w line art with gagline. Maximum size is 7×10 and must be reducible to 20% of size without losing detail. "We need very graphic material." Prefers religious, educational and seasonal themes. Accepts camera ready line art or digital files: CDR, CGM, EPS, PCX, TIFF and WMF formats for Windows or Mac if digitized, perfers WMF. Freelance work demands knowledge of CorelDraw 5.0.
First Contact & Terms: Send photocopies. Samples not filed are returned by SASE. Reports back within 2-3 months. Portfolio review not required. Pays $15 for cartoons; $15-40 for spot or clip art. Buys all rights. Finds artists through *Artist's & Graphic Designer's Market*.
Tips: "All our images are published as clip art to be reproduced by readers in their bulletins and newsletters for churches, schools, associations, etc. We need art for holidays, seasons and activities; new material every three months. We want single panel cartoons, not continuity strips. We're always looking for people images, ethnic and mixed races. No cartoon strips."

BENNETT PUBLISHING, 3400 Monroe Ave., Rochester NY 14618. (716)381-5450. President: Lois B. Bennett. Estab. 1978. Clip art firm serving schools.
Needs: Approached by 20 freelancers/year. Buys from 1 freelancer/year. Considers illustrations, spot drawings. Prefers educational themes. 90% of freelance work demands knowledge of Adobe Illustrator and Adobe Photoshop on the Mac.

INSIDER REPORT

Clip Art Sales Add Up for Prolific Artists

Keith Coleman had never heard of "clip art" until he hired freelance artist Tim Jackson to create artwork for his marketing firm. The two began talking about the need for more available and affordable images of African-Americans. When Jackson mentioned clip art, Coleman was intrigued, and the seeds of a partnership were born. "It was a clear case of being aware of a need and trying to fill it."

Keith Coleman

Coleman and Jackson launched their Chicago-based clip art firm, Afrocentrex, in 1993 with only Jackson's cartoons. To meet the demand for multicultural images, they quickly added images by Derrell Spicy, whose style is more realistic, and Hispanic artwork by Angel Silva. Their client base quickly grew to include Howard University, the Sara Lee Foundation, Quaker Oats and Disney.

Coleman defines "clip art" as "ready-made graphics" sold to corporations, small businesses, schools, churches and organizations who use the artwork for advertisements, fliers, in-house newsletters and other projects. Because there are over half a million desktop publishers in the United States, Coleman says there is a growing need for clip art available on disk and CD-ROM.

Not every artist can succeed in this market, says Coleman. Artists who take hours rendering drawings won't find the $25-75 per image fees attractive. But those fees add up for artists who can sit down and quickly create ten drawings out of their imagination. "Personally, I have to have the object in front of me to draw it. I can't create works out of my head. It seems you either have that ability or you don't. Certain artists just seem to be born with it." For such artists, the market can be lucrative. If a clip art firm likes your style, "the number of images you can sell is limited only by your imagination."

Whether a clip art firm fills a specific niche, such as Afrocentrex, or its needs are wide open, all have characteristics in common, says Coleman. Here are his suggestions for submitting the kind of art they need.

● **Create images around themes.** Clip art firms package art by themes, so create series of images dealing with themes such as family life, health care issues, church activities or life at the office. Study clip art booklets in bookstores or electronic clip art packages in computer stores to get an understanding of the themes used.

● **Use one style per theme.** Styles range from cartoons to realistic sketches. It is OK to work in more than one style, but stick to one style per series of drawings. Painting is not used.

INSIDER REPORT, *continued*

- **Work in black & white.** As technology advances, some clip art is offered in color, but black & white images are still preferred because they reproduce better.
- **Draw active characters.** Don't send portraits of faces, says Coleman. Show entire figures or torsos and place characters within a scene. "Make characters interact in specific (but not too specific) ways. Instead of showing a child with a dog, show a child holding a hula hoop with the dog jumping through it. Instead of showing father and child, show father and daughter sitting together reading a book."
- **Be politically correct.** Portray women executives, physically challenged employees, single-parents, youthful seniors and non-traditional families and lifestyles. Show people of all colors, religions and nationalities.
- **Images should be up-to-date, yet conservative.** Clip art firms tend to be conservative. "We like to see mainstream images. You don't see avant-garde clip art." Show today's hairstyles and fashions, but only to a point. Consider the audience. "For example, we sell hip-hop oriented clips, but mostly to church groups who want to attract teens to their services," says Coleman.
- **Create objects, logos and special fonts.** Images of objects, such as coffee mugs, and food, such as pizza, are needed, as are words that can be used in layouts, such as "Happy Holidays!" or, "TGIF." Clip art dealing with serious topics, such as AIDS, features phrases like "AIDS Awareness" in dramatic lettering.
- **Research firms before you submit.** Every clip art firm has different needs and submission policies, so read the listings in *Artist's & Graphic Designer's Market* to find out what to send. Afrocentrex asks for at least 20 images, either photocopies, printed samples or on disk. They pay from $25-75 per image and offer 7% royalties, though not all firms pay royalties. While some firms purchase all rights, Afrocentrex enters into a licensing agreement to sell artists' work on diskettes for up to two years.

Finally, Coleman encourages artists to network. He and Jackson find most of their artists by scouting art fairs and shows, or by meeting them informally in cafes and coffee houses. "Be sure to follow up when someone shows interest in

© 1995 Afrocentrex

This image created by Afrocentrex artist, Tim Jackson, is available to schools, corporations and other clients on CD-ROM.

INSIDER REPORT, *Coleman*

your work. When I first started I gave my card to six artists. But only one, Derrell Spicy, gave me a call. You never know where you might meet someone who can be important to your career."
—Robin Gee

First Contact & Terms: Sample package should include cover letter, résumé. Accepts submissions on disk compatible with Adobe Illustrator. "We contact artist when needed." **Pays on acceptance**. Buys all rights. Syndicate owns original art and characters.

BLACK CONSCIENCE SYNDICATION, INC., Dept. AGDM, 21 Bedford St., Wyandanch NY 11798. (516)491-7774. President: Clyde R. Davis. Estab. 1987. Syndicate serving 10,000 daily and weekly newspapers, regional magazines, schools and television.
Needs: Considers comic strips, gag cartoons, caricatures, editorial or political cartoons, illustrations and spot drawings. Prefers single, double or multipanel cartoons. "All material must be of importance to the Black community in America and the world." Especially needs material on gospel music and its history. "Our new format is a TV video magazine project. This half hour TV program highlights our clients' material. We are accepting ½" tapes, 2 minutes maximum. Tape must describe the artist's work and provide brief bio of the artist. Mailed to 25 different Afrocentric publications every other month."
First Contact & Terms: Send query letter with résumé, tearsheets and photocopies. Samples are filed or are returned by SASE only if requested by artist. Reports back within 2 months. Portfolio review not required. Pays on publication; 50% of net proceeds. Considers client's preferences when establishing payment. Buys first rights.
Tips: "We need positive Afro-centric information. All material must be inspiring as well as informative. Our main search is for the truth."

‡BONAT'S DIVERSIFIED, 255 N. El Cielo #688, Palm Springs CA 92262. (619)324-1503. Fax: (619)327-1505. President: Natalie Carlton. Estab. 1974. Syndicate serving 45 magazines, newspapers and tabloids. Guidelines available for #10 SASE.
Needs: Approached by 10 cartoonists and 5 illustrators/year. Buys from 2 cartoonists/year. Prefers single panel with gagline. Prefers cartoon with balloon or gagline at bottom. Maximum size of artwork 5×7.
First Contact & Terms: Sample package should include cover letter and tearsheets. 10 samples should be included. Samples are filed. Reports back if SASE enclosed. Pays 70% of gross income. Pays cartoonist when payment is received from newspapers. Buys reprint rights. Minimum length of contract is until terminated by either party. Artist owns original art and characters.

CAROL BRYAN IMAGINES, THE LIBRARY IMAGINATION PAPER, 1000 Byus Dr., Charleston WV 25311. Editor: Carol Bryan. Estab. 1978. Syndicates clip art for 3,000 public and school libraries. Sample issue $1.
Needs: Buys 6-15 freelance illustrations/issue. Considers gag cartoons, illustrations and spot drawings. Prefers single panel; b&w line drawings. Prefers library themes—"not negative towards library or stereotyped (example: showing a spinster librarian with glasses and bun)." Prefers subjects dealing with "today's libraries—fax mediums, computers, equipment—good-looking librarians—upbeat ideas. It's a more-than-books-world now—it's the complete information place. Need more focus on school library items."
First Contact & Terms: Send query letter with tearsheets, photocopies and finished cartoons. Send no more than 6 samples. Samples are filed or are returned by SASE. Reports back within 3 weeks. Pays on publication; flat fee of $25. Buys one-time or reprint rights.
Tips: "Seeing a sample issue is mandatory—we have a specific, very successful style. Your style may blend with our philosophy. Need great cartoons that libraries can publish in their newsletters. We are interested in seeing more cartoons about the school library, fun and upbeat; and cartoons which show the latest, trendiest library activities and more of a multicultural consideration when drawing figures."

‡CARTOON COMEDY CLUB, 560 Lake Forest Dr., Cleveland OH 44140. (216)871-5449. Cartoon Editor: John Shepherd. Estab. 1988. Publisher (syndicated). Guidelines available for #10 SASE.
Needs: Approached by 12-20 cartoonists/year. Considers gag cartoons. Prefers single panel with gagline. Maximum size of artwork 8½×11 or less.
First Contact & Terms: Sample package should include finished cartoons. 6-12 samples should be included. Reports back to the artist only if interested. Pays $5-7 for previously published cartoons.

Tips: "We seek cartoons of a general nature, family oriented plus other humor cartoons—no blue material."

CATHOLIC NEWS SERVICE, 3211 Fourth St. NE, Washington DC 20017. (202)541-3250. Fax: (202)541-3255. Photos/Graphics Editor: Nancy Wiechec. Estab. 1920. Syndicate serving 160 Catholic newspapers.
Needs: Buys from 3 cartoonists and 3-5 illustrators/year. Considers single panel, editorial political cartoons and illustrations. Prefers religious, church or family themes.
First Contact & Terms: Sample package should include cover letter and roughs. Pays on publication. Rights purchased vary according to project.

‡CELEBRATION: AN ECUMENICAL RESOURCE, (formerly Celebration: A Creative Worship Service), Box 419493, Kansas City MO 64141-6493. (301)681-4927. Editor: Bill Freburger. Clients: Churches, clergy and worship committees.
Needs: Buys 75 religious theme cartoons/year. Does not run an ongoing strip. Buys cartoons on church themes (worship, clergy, scripture, etc.) with a bit of the offbeat.
First Contact & Terms: Query; out-of-town artists only. Reports within 1-2 weeks. No originals returned to artist at job's completion. Pays $40/illustration. Pays $30/cartoon.

CHRONICLE FEATURES, 870 Market St., Suite 1011, San Francisco CA 94102. (415)777-7212. Comics Editor: Susan Peters. Syndicate serving 1,600 daily, weekly and monthly newspapers, occasionally magazines. Guidelines available for #10 SASE.
Needs: Approached by 2,000 illustrators/year. Introduces 1 or 2 new strips/year. Considers comic strips and panels. A recent feature is GameZone by Vox Day. "We have no preferred format, as long as the work is stellar and has a style all its own. We do not need spot drawings or caricatures. We already have artists covering these areas." Maximum size of artwork 8½×11; must be reducible to standard newspaper strip/panel size.
First Contact & Terms: Sample package should include cover letter, photocopies and SASE large enough to return response and/or work. 24 samples should be included. Do not send originals. Samples are not filed and are returned by SASE only if requested by artist, otherwise not returned. Reports back within 6 weeks. To show portfolio, mail appropriate materials. Pays 50% of gross income. Buys all rights. Minimum length of contract is 5 years. Artist owns the original art and characters.
Tips: "Please send all inquiries by mail. We prefer to minimize telephone contact, as it interrupts the flow of our work. Be original."

‡CITY NEWS SERVICE, Box 39, Willow Springs MO 65793. (417)469-2423. President: Richard Weatherington. Estab. 1969. Editorial service providing editorial and graphic packages for magazines.
Needs: Buys from 12 or more freelance artists/year. Considers caricature, editorial cartoons and tax and business subjects as themes; considers b&w line drawings and shading film.
First Contact & Terms: Send query letter with résumé, tearsheets or photocopies. Samples should contain business subjects. "Send 5 or more b&w line drawings, color drawings, shading film or good line drawing editorial cartoons." Does not want to see comic strips. Samples not filed are returned by SASE. Reports within 4-6 weeks. To show a portfolio, mail tearsheets or photostats. Pays 50% of net proceeds; pays flat fee of $25 minimum. "We may buy art outright or split percentage of sales."
Tips: "We have the markets for multiple sales of editorial support art. We need talented artists to supply specific projects. We will work with beginning artists. Be honest about talent and artistic ability. If it isn't there then don't beat your head against the wall."

COMMUNITY PRESS SERVICE, P.O. Box 639, Frankfort KY 40602. (502)223-1736. Fax: (502)223-2679. Editor: Gail Combs. Estab. 1990. Syndicate serving 200 weekly and monthly periodicals.
Needs: Approached by 15-20 cartoonists and 30-40 illustrators/year. Buys from 8-10 cartoonists and 4-5 illustrators/year. Introduces 1-2 new strips/year. Considers comic strips. Prefers single panel b&w line drawings with or without gagline. Maximum size of artwork 8½×11; must be reducible to 50% of original size.
First Contact & Terms: Sample package should include cover letter, finished cartoons, photocopies. 5-10 samples should be included. Samples are filed. Reports back within 2 months. Call for appointment to show portfolio of b&w final art. **Pays on acceptance**. Buys all rights. Offers automatic renewal. Syndicate owns original art; artist owns characters.

CONTINENTAL FEATURES/CONTINENTAL NEWS SERVICE, 341 W. Broadway, Suite 265, San Diego CA 92101. (619)492-8696. Director: Gary P. Salamone. Parent firm established August, 1981. Syndicate serving 3 outlets: house publication, publishing business and the general public through the *Continental Newstime* magazine.
● This syndicate is putting less emphasis on children's material in their mix of cartoon/comic features.
Needs: Approached by 200 cartoonists/year. Number of new strips introduced each year varies. Considers comic strips and gag cartoons. Does not consider highly abstract, computer-produced or stick-figure art.

GET YOUR WORK INTO THE RIGHT BUYERS' HANDS!

You work hard... and your hard work deserves to be seen by the right buyers. But with the constant changes in the industry, it's not always easy to know who those buyers are. That's why you'll want to keep up-to-date and on top with the most current edition of this indispensable market guide.

Totally Updated Each Year

1998 ARTIST'S & GRAPHIC DESIGNER'S MARKET

WHERE & HOW TO SELL YOUR ILLUSTRATION, FINE ART, GRAPHIC DESIGN & CARTOONS

2,500 markets, including magazine, book and greeting card publishers; galleries; art publishers and ad agencies!

Totally Updated! Plus 800 New Markets!

Keep ahead of the changes by ordering *1998 Artist's & Graphic Designer's Market* today. You'll save the frustration of getting your work returned in the mail, stamped MOVED: ADDRESS UNKNOWN. And of NOT submitting your work to new listings because you don't know they exist. All you have to do to order the upcoming 1998 edition is complete the attached order card and return it with your payment or credit card information. Order now and you'll get the 1998 edition at the 1997 price—just $24.99—no matter how much the regular price may increase! *1998 Artist's & Graphic Designer's Market* will be published and ready for shipment in September 1997.

Keep on top of the fast-changing industry and get a jump on selling your work with help from the *1998 Artist's & Graphic Designer's Market*. Order today! You deserve it!

Turn over for more books to help you sell your work

More Great Books to Help You Get Ahead!

The Complete Guide to Greeting Card Design & Illustration

Let experts guide you to success in this lucrative market. You'll discover step-by-step demonstrations, loads of examples, do's and don'ts in the industry, plus nine all-new personal perspectives. #30573/$29.95/144 pages/200 illus.

Totally Updated!
1997 Children's Writer's and Illustrator's Market

Break into this lucrative field! You'll get the names and address of over 700 buyers of freelance materials, plus information-packed articles written by the experts! #10494/$22.99/384 pages/avail. 2-97

How to be a Successful Cartoonist

Get the scoop from the funniest—and most successful—cartoonists in the business. Tom Wilson, Bill Schorr, Tom Cheney, Lynn Johnston, and dozens of others give you priceless advice on making your work look professional, where and how to sell work, impressing editors, and pricing your work. #30757/$19.99/128 pages/90 illus.

NEW!
How to Get Started Selling Your Art

Turn your spare-time hobby into a satisfying and profitable career. Carol Katchen offers proven advice on exhibiting, creating a professional image, assembling a portfolio, pricing your work—plus worksheets, success stories, and loads of inspiration. #30814/$17.99/128 pages/paperback

GRAPHIC DESIGN BASICS!

Gain essential design and business savvy you need to succeed in your career with these practical reference tools.

Pricing, Estimating & Budgeting
#30744/$27.99/128 pages

Creating Logos & Letterheads
#30616/$27.99/128 pages

Marketing and Promoting Your Work
#30706/$27.99/128 pages

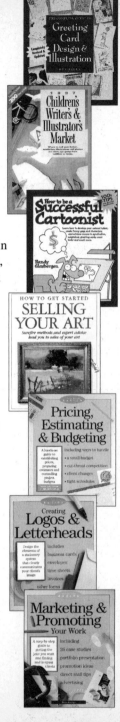

Order these helpful references today from your local bookstore, or use the handy order card on the reverse.

Prefers single panel with gagline. Recent features include All Micks D'UP by Mick Williams and Xanthan Gumm by Robin Reed. Guidelines available for #10 business envelope. Maximum size of artwork 8×10, must be reducible to 65% of original size.

First Contact & Terms: Sample package should include cover letter, photocopies (10-15 samples). Samples are filed or are returned by SASE if requested by artist. Reports back within 1 month with SASE only if interested. To show portfolio, mail photocopies and cover letter. Pays 70% of gross income on publication. Rights purchased vary according to project. Minimum length of contract is 1 year. The artist owns the original art and the characters.

Tips: "We need single-panel cartoon and comic strips appropriate for adult readers of *Continental Newstime*. Do not send samples reflecting the highs and lows and different stages of your artistic development. CF/CNS wants to see consistency and quality, so you'll need to send your best samples."

‡✿COREL CORPORATION, 1600 Carling Ave., Ottawa, Ontario K1Z 8R7 Canada. (613)728-3733. Fax: (613)728-9790. Product Manager, Digital Libraries: Katie Gray. Estab. 1985. Clip art firm, software developer, marketer, manufacturer.

Needs: Considers illustrations, spot drawings, animations, photos, fonts, clip art, templates, macros and forms.

First Contact & Terms: Sample package should include cover letter, tearsheets, photostats, résumé, slides and/or roughs. Samples are filed. Reports back only if interested. Portfolio should include final reproduction product, slides and photographs.

CREATIVE SYNDICATION SUS, Box 40, Eureka MO 63025. (314)587-7126. Editor: Debbie Holly. Syndicate serving 400 daily and weekly newspapers.

Needs: Approached by 2-3 illustrators/year. Buys from 2-3 illustrators/year. Considers illustrations. Prefers double panel b&w line drawings. Maximum size of artwork 8½×11.

First Contact & Terms: Sample package should include roughs. 1-2 samples should be included. Samples are not filed. Reports back within 1 month. Mail appropriate materials. Portfolio should include roughs. Pays on publication; net proceeds. Rights purchased vary according to project. Offers automatic renewal. Syndicate owns original art; artist owns characters.

CREATORS SYNDICATE, INC., 5777 W. Century Blvd., Los Angeles CA 90045. (310)337-7003. Address work to Editorial Review Board—Comics. President: Richard S. Newcombe. Editor: Laura Ramm. Estab. 1987. Serves 2,400 daily newspapers, weekly and monthly magazines worldwide. Guidelines available.

Needs: Syndicates 100 writers and artists/year. Considers comic strips, caricatures, editorial or political cartoons and "all types of newspaper columns."

First Contact & Terms: Send query letter with brochure showing art style or résumé and "anything but originals." Samples are not filed and are returned by SASE. Reports back in a minimum of ten weeks. Pays 50% of net proceeds. Considers saleability of artwork and client's preferences when establishing payment. Negotiates rights purchased.

Tips: "If you have a cartoon or comic strip you would like us to consider, we will need to see at least four weeks of samples, but not more than six weeks of dailies and two Sundays. If you are submitting a comic strip, you should include a note about the characters in it and how they relate to each other. As a general rule, drawings are most easily reproduced if clearly drawn in black ink on white paper, with shading executed in ink wash or Benday® or other dot-transfer. However, we welcome any creative approach to a new comic strip or cartoon idea. Your name(s) and the title of the comic or cartoon should appear on every piece of artwork. If you are already syndicated elsewhere, or if someone else owns the copyright to the work, please indicate this."

DEAR NEWSPAPERS, (publisher of *Arlington Courier*), 3440 N. Fairfax Dr., Arlington VA 22101. (703)522-9898. Managing Editor: Joe Farruggia. Estab. 1986. Publishes weekly newspapers covering Arlington, Virginia. Syndicates to weekly newspapers and local guide books.

Needs: Buys from 2 freelancers/year. Prefers local or Virginia artists. Considers comic strips, gag cartoons, caricatures, editorial or political cartoons, illustrations and spot drawings. Prefers pen & ink with washes.

First Contact & Terms: Send query letter with brochure or résumé and tearsheets. Samples are filed or are returned by SASE. Reports back only if interested. To show portfolio, mail tearsheets. Pays on publication; flat fee, $5-90. Considers clients' preferences when establishing payment. Negotiates rights purchased.

Tips: "We prefer local Northern Virginia freelancers who have local themes in their work."

FOR A LIST of markets interested in humorous illustration, cartooning and caricatures, refer to the Humor Index at the back of this book.

DREAM MAKER SOFTWARE, 925 W. Kenyon Ave., #16, Englewood CO 80110. (303)762-1001. Fax: (303)762-0762. E-mail: dreammaker@eworld.com. Art Director: David Sutphin. Estab. 1986. Clip art firm, computer software publisher serving homes, schools, businesses, publishers, designers, ad agencies.
Needs: Approached by 10-20 freelancers/year. Considers cartoon type illustrations/characters, illustrations, spot drawings, "all work suitable for publication as clip art."
First Contact & Terms: Sample package should include cover letter. 8-12 samples should be included. Accepts submissions on disk compatible with Adobe Illustrator 5.0. Send EPS files. Samples are not filed and are returned by SASE. Reports back to the artist in 1-2 months only if interested. Considers both traditional and computer based (Illustrator) artwork. Pays $10-75% flat fee on completion of contract. Typical contract includes 50-150 illustrations. Rights purchased include assignment of copyright from artist.

DYNAMIC GRAPHICS INC., 6000 N. Forest Park Dr., Peoria IL 61614-3592. (309)688-8800. Art Director: Frank Antal. Distributes to thousands of magazines, newspapers, agencies, industries and educational institutions.
• Dynamic Graphics is a clip art firm and publisher of *Step-by-Step Graphics* magazine. Uses illustrators from all over the world; 99% of all artwork sold as clip art is done by freelancers.
Needs: Works with 30-40 freelancers/year. Prefers illustration, graphic design and elements; primarily b&w, but will consider some 2- and full-color. "We are currently seeking to contact established illustrators capable of handling b&w and highly realistic illustrations of contemporary people and situations."
First Contact & Terms: Submit portfolio with SASE. Reports within 1 month. Buys all rights. Negotiates payment. **Pays on acceptance.**
Tips: "Concentrate on mastering the basics in anatomy and figure illustration before settling into a 'personal' or 'interpretive' style!"

EDITORS PRESS SERVICE, INC., 330 W. 42nd St., 15th Floor, New York NY 10036. (212)563-2252. Fax: (212)563-2517. President: Mr. Kerry Slagle. Estab. 1933. Syndicate representative servicing 1,700 publications: daily and weekly newspapers and magazines. International, US and Canadian sales.
Needs: Buys from 1-2 freelancers/year. Introduces 1-2 new strips/year. Considers comic strips, gag cartoons, caricatures, editorial/political cartoons and illustrations. Considers single, double and multiple panel, pen & ink. Prefers non-American themes. Maximum size of artwork: 11×17. Does not accept unsolicited submissions.
First Contact & Terms: Send cover letter, finished cartoons, tearsheets and photocopies. Include 24-48 strips/panels. Does not want to see original artwork. Include SASE for return of materials. Pays 50% of gross income. Buys all rights. Minimum length of contract: 2 years. Artist owns original art and characters.
Tips: "Look for niches. Study, but do not copy the existing competition. Read the newspaper!" Looking for "well written gags and strong character development."

FILLERS FOR PUBLICATIONS, 7015 Prospect Place NE, Albuquerque NM 87110. (505)884-7636. President: Lucie Dubovik. Distributes to magazines and newspapers. Guidelines available.
Needs: Buys 72 pieces/year from freelancers. Considers single panel, 4×6 or 5×7 cartoons on current events, education, family life, retirement, factory and office themes; clip art and crossword puzzles. Inquire for subject matter and format.
First Contact & Terms: Send query letter with samples of style and SASE. Samples are returned. Reports in 3 weeks. Previously published and simultaneous submissions OK. Buys first rights. **Pays on acceptance**; $7 for cartoons and line drawings; $25/page of clip art.
Tips: Does not want to see comic strips.

✦FOTO EXPRESSION INTERNATIONAL, Box 1268, Station "Q," Toronto, Ontario M4T 2P4 Canada. (416)445-3594. Fax: (416)445-4953. E-mail: fotopres@enterprise.ca or kubikjmn@freenet.npiec.on.ca. Director: M.J. Kubik. Serving 35 outlets.
Needs: Buys from 80 freelancers/year. Considers b&w and color single, double and multiple panel cartoons, illustrations and spot drawings.
First Contact & Terms: Send query letter with brochure showing art style or résumé, tearsheets, slides and photographs. Samples not filed are returned by SASE with Canadian International Reply Coupon, $4 US money order or $4.50 Canadian money order. Reports within 1 month only if postage is included. To show portfolio, mail final reproduction/product and color and b&w photographs. Pays on publication; artist receives percentage. Considers skill and experience of artist and rights purchased when establishing payment. Negotiates rights purchased.

FUTURE FEATURES SYNDICATE, 1923 Wickham Rd., Suite 117, Melbourne FL 32935. (407)259-3822. Fax: (407)259-1471. E-mail: futrfeat@iu.net and penninc@aol.com. Creative Director: Jerry Forney. Estab. 1989. Syndicate markets to 1,500 daily/weekly newspapers. Guidelines available for SASE with first-class postage.
• Future Features has a home page on World Wide Web (http://www.spindata.com/futrfeat/.) that gives them global exposure with links to various other sites on a first come, first serve basis. They

hope to market cartoon services this way, in addition to building a subscriber base for their features.
Needs: Approached by 400-500 freelancers/year. Introduces 10-15 new strips/year. Considers comic strips, gag cartoons, editorial/political cartoons and humorous strips with contemporary drawing styles. Recent introductions include Grinzday by Dave Sanders and Cream City by Linda Godfrey. Prefers single, double and multiple panel strips with or without gagline; b&w line drawings. Prefers "unpublished, well designed art, themed for general newspaper audiences." Maximum size of artwork 8½×11 panel, 3½×14 strip: must be reducible to 25% of original size, suitable for scanning purposes.
First Contact & Terms: Sample package should include cover letter, photocopies and a short paragraph stating why you want to be a syndicated cartoonist. 12-36 samples should be included. "We are interested in cartoons produced on the Macintosh in Illustrator, FreeHand, Photoshop, or Ray Dream Designer. We can review files saved as PICT, TIFF, GIF, JPEG or Adobe Acrobat (PDF) files." Samples are filed or are returned only if SASE is included. Reports back within 4-6 weeks. Portfolio review not required, but portfolio should not include original/final art. Pays on publication; 50% of gross income. Buys first rights. Minimum length of contract is 2 years. Artist owns original art; syndicate owns characters.
Tips: "Avoid elaborate résumés; short bio with important career highlights/achievements is preferable. Include clean, clear copies of your best work. Don't send binders or bound collections of features; loose samples on 8½×11 bond paper are preferable."

GRAHAM NEWS SERVICE, 2770 W. Fifth St., Suite G20, Brooklyn NY 11224. (718)372-1920. Contact: Paula Royce Graham. Syndicates to newspapers and magazines.
Needs: Considers b&w illustrations. Uses freelancers for advertising and graphics.
First Contact & Terms: Send business card and samples to be kept on file. Samples returned by SASE only if requested. Reports within days. Write for appointment to show portfolio. Pays on publication; negotiable. Considers skill of artist, client's preferences and rights purchased when establishing payment. Buys all rights.
Tips: "Keep it simple—one or two samples."

‡GRAPHIC ARTS COMMUNICATIONS, Box 421, Farrell PA 16121. (412)342-5300. President: Bill Murray. Estab. 1980. Syndicates to 200 newspapers and magazines.
Needs: Buys 400 pieces/year from artists. Humor through youth and family themes preferred for single panel and multipanel cartoons and strips. Needs ideas for anagrams, editorial cartoons and puzzles, and for comic panel "Sugar & Spike." Introductions include "No Whining" by John Fragle and "Attach Cat" by Dale Thompson; both similar to past work—general humor, family oriented.
First Contact & Terms: Query for guidelines. Sample package should contain 5 copies of work, résumé, SASE and cover letter. Reports within 4-6 weeks. No originals returned. Buys all rights. Pays flat fee, $8-50.
Tips: "Inter-racial material is being accepted more."

‡HEALTH CARE PR GRAPHICS, Division of Solution Resources, Inc., Suite 1, 1121 Oswego St., Liverpool NY 13088. (315)451-9339. E-mail: erobe73423@aol.com. Editor: Eric Roberts. Estab. 1981. Clip art firm. Distributes monthly to hospitals and other health care organizations.
Needs: Uses illustration, drawings and graphic symbols for use in brochures, folders, newsletters, etc. Prefers sensitive line illustrations, spot drawings and graphics related to health care, hospitals, nurses, doctors, patients, technicians and medical apparatus. Also buys cartoons.
First Contact & Terms: Experienced illustrators only, preferably having hospital exposure or access to resource material. Works on assignment only. Send query letter, résumé, photostats or photocopies to be kept on file. "Send 10 to 20 different drawings which are interesting and show sensitive, caring people." Would like to see color illustration. Samples returned by SASE if not kept on file. Reports within 1 month. Original art not returned at job's completion. Buys all rights. **Pays on acceptance**; pays flat rate of $30-100 for illustrations or negotiates payment according to project. Finds artists through submissions, word of mouth.
Tips: "We are looking to establish a continuing relationship with freelance graphic designers and illustrators. Looking for different, 'breakthrough' '90s styles! Send enough samples to show the variety (if any) of styles you're capable of handling. Indicate the length of time it took to complete each illustration or graphic, and/or remuneration required. Practice drawing people's faces. Many illustrators fall short when drawing people."

HISPANIC LINK NEWS SERVICE, 1420 N St. NW, Washington DC 20005. (202)234-0737. Fax: (202)234-4090. Editor: Patricia Guadalupe. Syndicated column service to 100 newspapers and a newsletter serving 1,300 subscribers: "movers and shakers in the Hispanic community in U.S., plus others interested in Hispanics." Guidelines available.
Needs: Buys from 20 freelancers/year. Considers single panel cartoons; b&w, pen & ink line drawings. Introductions include In the Dark by Clyde James Aragón and Editorial by Alex González. Work should have a Hispanic angle; "most are editorial cartoons, some straight humor."
First Contact & Terms: Send query letter with résumé and photocopies to be kept on file. Samples not filed are returned by SASE. Reports within 3 weeks. Portfolio review not required. **Pays on acceptance**; $25 flat fee (average). Considers clients' preferences when establishing payment. Buys reprint rights and negotiates rights purchased. "While we ask for reprint rights, we also allow the artist to sell later."

Tips: Interested in seeing more cultural humor. "While we accept work from all artists, we are particularly interested in helping Hispanic artists showcase their work. Cartoons should offer a Hispanic perspective on current events or a Hispanic view of life."

‡IA USERS CLUB D/B/A GRAPHIC CORP., 3348 Overland Ave., Suite 100, Los Angeles CA 40034. (310)287-2001. Fax: (310)287-2347. E-mail: 74354.1204@compuserve.com. Business Affairs: Michael K. Walker, Esq. Estab. 1986. Clip art firm specializing in audio and animation clips, clip art, photos and fonts for use by computer hardware and software companies. Approached by 50 cartoonists and 50 illustrators/year. Buys from 20 cartoonists and 20 illustrators/year. Considers gag cartoons, caricature and illustrations. Prefers single panel. Also uses freelancers for computer illustration.
First Contact & Terms: Sample package should include cover letter, finished cartoons, electronic samples. Maximum possible should be included. Samples are not filed and are returned by SASE if requested by artist. Reports back only if interested. Mail appropriate materials. Portfolio should include final art and photographs. Pays 12% of gross income. Pays on publication. Negotiates rights purchased. Minimum length of contract is 5 years. Offers automatic renewal. Artist owns original art and characters.
Tips: "We prefer prolific artists or artists with large existing collections. Images must be in electronic format.

‡♥IMAGE CLUB GRAPHICS, 729 24th St., SE, Calgary, Alberta T2G 5K8 Canada. (403)262-8008. Fax: (403)261-7013. E-mail: clarsen@adobe.com. Designer: Cathy Larsen. Estab. 1985. Clip art firm with a monthly catalog distribution of 500,000. Guidelines available.
Needs: Approached by 200 cartoonists and illustrators/year. Buys from 12 freelancers/year. Considers illustrations and spot drawings. Prefers b&w line drawings. Maximum size of artwork 11 × 17 must be reducible to 10% of original size.
First Contact & Terms: Sample package should include cover letter, tearsheets, slides, photocopies or digital files. 10 samples should be included. Samples are filed or returned by SASE if requested by artist. Reports back within 1 month. Mail appropriate materials. Portfolio should include final reproduction product, tearsheets and slides. Pays $50-200. **Pays on acceptance.** Buys all rights. Minimum length of contract is indefinite. Offers automatic renewal. Clip art firm owns original art and characters.

INTERPRESS OF LONDON AND NEW YORK, 400 Madison Ave., New York NY 10017. (212)832-2839. Editor/Publisher: Jeffrey Blyth. Syndicates to several dozen European magazines and newspapers.
Needs: Buys from 4-5 freelancers/year. Prefers material universal in appeal; no "American only."
First Contact & Terms: Send query letter and photographs; write for artists' guidelines. Samples not kept on file are returned by SASE. Reports within 3 weeks. Purchases European rights. Pays 60% of net proceeds on publication.

JODI JILL FEATURES, 1705 14th St., Suite 321, Boulder CO 80302. Art Editor/President: Jodi Jill. Estab. 1983. Syndicate serving "hundreds" of newspapers, magazines, publications.
Needs: Approached by 250 freelancers/year. "We try to average ten new strips per year." Considers comic strips, editorial/political cartoons and gag cartoons. "Looking for silly, funny material, not sick humor on lifestyles or ethnic groups." Introductions include From My Eyes by Arnold Peters and Why Now? by Ralph Stevens. Prefers single, double and multiple panel b&w line drawings. Needs art, photos and columns that are visual puzzles. Maximum size of artwork 8½ × 11.
First Contact & Terms: Sample package should include cover letter, résumé, tearsheets, finished cartoons and photocopies. 6 samples should be included. Samples are not filed and are returned by SASE if requested by artist. Portfolio review requested if interested in artist's work. Reports back within 1 month. Portfolio should include b&w roughs and tearsheets. **Pays on acceptance**; 40-50% of net proceeds. Negotiates rights purchased. Minimum length of contract is 1 year. The artist owns original art and characters. Finds artists "by keeping our eyes open and looking at every source possible."
Tips: "Would like to see more puzzles with puns in their wording and visual effects that say one thing and look like another. We like to deal in columns. If you have a visual puzzle column we would like to look it over. Some of the best work is unsolicited."

A.D. KAHN, INC., 35336 Spring Hill, Farmington Hills MI 48331. (810)355-4100. Fax: (810)356-4344. President/Editor: David Kahn. Estab. 1960. Syndicate serving daily and weekly newspapers, monthly magazines. Introductions include Zoolies (captionless cartoon).
• They are creating a whole new area with Internet Website developers.
Needs: Approached by 24-30 freelancers/month.Considers comic strips, editorial/political cartoons, gag cartoons, puzzles/games.
First Contact & Terms: Sample package should include material that best represents artist's work. Files samples of interest; others returned by SASE if requested by artist. Pays 50% of net proceeds. Negotiates

rights purchased according to project. The artist owns original art and characters.

KING FEATURES SYNDICATE, 235 E. 45th St., New York NY 10017. (212)455-4000. Comics Editor: Jay Kennedy. Estab. 1915. Syndicate servicing 3,000 newspapers. Guidelines available for #10 SASE.
• This is one of the oldest, most established syndicates in the business. It runs such classics as Blondie, Hagar, Dennis the Menace and Beetle Bailey and such contemporary strips as Zippy the Pinhead and Ernie. If you are interested in selling your cartoons on an occasional rather than fulltime basis, refer to the listings for The New Breed and Laff-A-Day (also run by King Features).
Needs: Approached by 6,000 freelancers/year. Introduces 3 new strips/year. Considers comic strips and single panel cartoons. Prefers humorous single or multiple panel, and b&w line drawings. Maximum size of artwork 8½×11. Comic strips must be reducible to 6½″ wide; single panel cartoons must be reducible to 3½″ wide.
First Contact & Terms: Sample package should include cover letter, character sheet that names and describes major characters and photocopies of finished cartoons. "Résumé optional but appreciated." 24 samples should be included. Returned by SASE. Reports back within 8 weeks. Pays 50% of net proceeds. Rights purchased vary according to project. Artist owns original art and characters. Length of contract and other terms negotiated.
Tips: "We look for a uniqueness that reflects the cartoonist's own individual slant on the world and humor. If we see that slant, we look to see if the cartoonist is turning his or her attention to events that other people can relate to. We also very carefully study a cartoonist's writing ability. Good writing helps weak art, better than good art helps weak writing."

LAFF-A-DAY, % King Features Syndicate, 235 E. 45th St., New York NY 10017. (212)455-4000. Contact: Laff-A-Day Editors. Estab. 1936. Syndicated feature. "Showcases single panel gag cartoons with a more traditional approach."
Needs: Reviews 3,000 cartoons/year. Buys 312 cartoons/year. Maximum size of artwork 8½×11. Must be reducible to 3½″ wide.
First Contact & Terms: "Submissions should include 10-25 single panel cartoons per batch. Cartoons should be photocopied 1 per page and each page should have cartoonist's name and address on back. All submissions must include SASE large enough and with enough postage to return work. No original art." Reports back within 6 weeks. **Pays on acceptance**; flat fee of $50.

LEW LITTLE ENTERPRISES, INC., P.O. Box 47, Bisbee AZ 85603-0047. (520)432-8003. Editor: Lew Little. Estab. 1986. Syndicate serving all daily and weekly newspapers. Guidelines available for legal SAE with 1 first-class stamp.
Needs: Approached by 300-400 artists/year. Buys from 1-2 artists/year. Introduces 1-2 new strips/year. Considers comic strips, text features, editorial/political cartoons and gag cartoons. Recent introductions include weekly column by Dr. Judi Craig and humorous religion feature by Mike Riley. Prefers single or multiple panel with gagline.

Cartoonist Russ Montoya sold several cartoons to King Features Syndicate to be used in their strip The New Breed, including this poke at Albert Einstein.

First Contact & Terms: Sample package should include cover letter ("would like to see an intelligent cover letter"), résumé, roughs and photocopies of finished cartoons or text feature samples. Minimum of 12 samples should be included. Samples are not filed and are returned by SASE. Reports back within 6 weeks. Schedule appointment to show portfolio or mail final reproduction/product, b&w roughs, tearsheets and SASE. Pays on publication; negotiable percentage of net proceeds. Negotiates rights purchased. Minimum length of contract 5 years. Offers automatic renewal. Artist owns original art and syndicate owns characters during the contract term, after which rights revert to artist.

Tips: Does not want to see "bulky portfolios or elaborate presentations."

LOS ANGELES TIMES SYNDICATE, 218 S. Spring St., Los Angeles CA 90012. (213)237-7987. Promotion Manager: Cathryn Irvine.

Needs: Considers comic strips, panel cartoons and editorial cartoons. "We prefer humor to dramatic continuity and general illustrations for political commentary. We consider only cartoons that run six or seven days/week. Cartoons may be of any size, as long as they're to scale with cartoons running in newspapers." (Strips usually run approximately $6\frac{7}{16} \times 2$; panel cartoons $3\frac{1}{8} \times 4$; editorial cartoons vary.)

First Contact & Terms: Submit photocopies or photostats of 24 dailies. Submitting Sunday cartoons is optional; if you choose to submit them, send at least four. Reports within 2 months. Include SASE. Finds artists through word of mouth, submissions, newspapers.

Tips: "Don't imitate cartoons that are already in the paper. Avoid linework or details that might bleed together, fade out or reproduce too small to be seen clearly. We hardly ever match artists with writers or vice versa. We prefer people or teams who can do the entire job of creating a feature."

MASTERS AGENCY, 703 Ridgemark Dr., Hollister CA 95023. (408)637-9795. Publisher: George Crenshaw. Estab. 1961. Magazine gag-cartoon publisher.

Cartoons: Buys 100 cartoons/year. Prefers single panel with gagline. Wants finished roughs, accepts previously published clips. Samples are not filed and are returned by SASE. Reports back within 1 month. Buys reprint rights. Pays $20/cartoon.

Tips: "We carefully review all submissions." Seeks cartoons on the following topics: computers, environment, farm, motor homes and rec vehicles, physical fitness, industrial safety, senior citizens, trucks, ecology, medical, hospitals, women executives, women winning, sales and insurance. Write for additional categories needed.

METRO CREATIVE GRAPHICS, INC., 33 W. 34th St., New York NY 10001. (212)947-5100. Fax: (212)714-9139. Contact: Ann Habe Weiss. Estab. 1910. Creative graphics/art firm. Distributes to 7,000 daily and weekly paid and free circulation newspapers, schools, graphics and ad agencies and retail chains. Guidelines available.

Needs: Buys from 100 freelancers/year. Considers all styles of illustrations and spot drawings; b&w and color. Editorial style art or cartoons for syndication not considered. Special emphasis on computer-generated art for Macintosh. Send floppy disk samples using Adobe Illustrator 5.0. Prefers all categories of themes associated with retail, classified, promotion and advertising. Also needs covers for special-interest tabloid sections. 90% of design and 70% of illustration demand knowledge of Adobe Illustrator, QuarkXPress and Adobe Photoshop.

First Contact & Terms: Send query letter with brochure, photostats, photocopies, slides, photographs or tearsheets to be kept on file. Accepts submissions on disk compatible with Adobe Illustrator 5.0. Send EPS files. Samples not filed are returned by SASE. Reports only if interested. Works on assignment only. **Pays on acceptance**; flat fee of $25-1,500. Considers skill and experience of artist, saleability of artwork and clients' preferences when establishing payment.

Tips: This company is "very impressed with illustrators who can show a variety of styles." They prefer that electronic art is drawn so all parts of the illustration are drawn completely, and then put together. "It makes the art more versatile to our customers."

MIDWEST FEATURES INC., P.O. Box 9907, Madison WI 53725-0907. (608)274-8925. Editor/Founder: Mary Bergin. Estab. 1991. Syndicate serving daily/weekly newspapers and other Wisconsin publications.

Needs: Approached by dozens of freelancers/year. Buys from 2-3 freelancers/year. Freelaners most likely to get 1-shot assignments. Considers comic strips, editorial/political cartoons and illustrations. Prefers single panel and b&w line drawings without gagline. Emphasis on Wisconsin material is mandatory.

First Contact & Terms: Sample package should include cover letter, résumé, tearsheets and $8\frac{1}{2} \times 11$ photocopies. "No originals!" 6 samples should be included. Samples are filed. Reports back to the artist only if interested or if artist sends SASE. Pays on publication; 50% of gross income. Rights purchased vary according to project. Minimum length of contract one year for syndication work. Offers automatic renewal. Artist owns original art and characters.

Tips: "Do not send originals. Phone calls are not appreciated. Make it Wisconsin specific and find another home for it for a minimum of one year before peddling it our way."

MILESTONE GRAPHICS, 1093 A1A Beach Blvd., #388, St. Augustine FL 32084. (904)823-9962. E-mail: 72142.1471@compuserve.com. Owner: Jill O. Miles. Estab. 1993. Clip art firm providing targeted markets with electronic graphic images.
Needs: Buys from 20 illustrators/year. 50% of illustration demands knowledge of Adobe Illustrator.
First Contact & Terms: Sample package should include non-returnable photocopies or samples on computer disk. Accepts submissions on disk compatible with Adobe Illustrator on the Mac. Send EPS files. Interested in b&w and some color illustrations. All styles and media are considered. Macintosh computer drawings accepted (Adobe Illustrator preferred). "Ability to draw people a plus, but many other subject matters needed as well." Reports back to the artist only if interested. Pays flat fee of $25 minimum/illustration, based on skill and experience. A series of illustrations is often needed.

MINORITY FEATURES SYNDICATE, INC., P.O. Box 421, Farrell PA 16121. (412)342-5300. Fax: (412)342-6244. Editor: Bill Murray. Estab. 1980. Syndicate serving 150 daily newspapers, school papers and regional and national publications. Art guidelines available for #10 SASE.
Needs: Approached by 800 freelance artists/year. Buys from 650 freelancers/year. Introduces 100 new strips/year. Considers comic strips, gag cartoons and editorial/political cartoons. Prefers multiple panel b&w line drawing with gagline. Prefers family-oriented, general humor featuring multicultural, especially Black characters. Maximum size of artwork 8½×11; must be reducible to 65%.
First Contact & Terms: Sample package should include cover letter, tearsheets and photocopies. 5 samples should be included. Samples are filed or returned by SASE. Reports back in 3 months. To show portfolio, mail b&w tearsheets. Pays flat fee of $50-150. Rights purchased vary according to project. No automatic renewal. Syndicate owns original art. Character ownership negotiable.

NATIONAL NEWS BUREAU, Box 43039, Philadelphia PA 19129. (215)546-8088. Editor: Harry Jay Katz. Syndicates to 300 outlets and publishes entertainment newspapers on a contract basis.
Needs: Buys from 500 freelancers/year. Prefers entertainment themes. Uses single, double and multiple panel cartoons, illustrations; line and spot drawings.
First Contact & Terms: To show portfolio, send samples and résumé. Samples returned by SASE. Reports within 2 weeks. Returns original art after reproduction. Send résumé and samples to be kept on file for future assignments. Negotiates rights purchased. Pays on publication; flat fee of $5-100 for each piece.

THE NEW BREED, %King Features Syndicate, 235 E. 45th St., New York NY 10017. (212)455-4000. Contact: *The New Breed* Editors. Estab. 1989. Syndicated feature.
• *The New Breed* showcases single panel gag cartoons done by cartoonists with a contemporary or wild sense of humor. *The New Breed* is a place where people can break into newspaper syndication without making a commitment to producing a comic on a daily basis. The feature is intended as a means for King Features to encourage and stay in touch with promising cartoonists who might one day develop a successful strip for regular syndication.
Needs: Reviews 30,000 cartoons/year. Buys 500 cartoons/year. Maximum size of artwork 8½×11; must be reducible to 3½ wide.
First Contact & Terms: "Submissions should include 10-25 single panel cartoons per batch. The cartoons should be photocopied one per page and each page should have cartoonist's name and address on back. All submissions must include SASE large enough and with enough postage to return work. Do not send originals." Reports back within 6 weeks. **Pays on acceptance**; flat fee of $50. Buys first worldwide serial rights.

NEW ENGLAND MOTORSPORTS/INTERNATIONAL MOTORSPORTS SYNDICATES, 84 Smith Ave., Stoughton MA 02072. (617)344-3827. Estab. 1988. Syndicate serving 15 daily newspapers, motorsports trade weeklies.
Needs: Considers sports pages material. Prefers single panel, motorsports motif. Maximum size 1 column.
First Contact & Terms: Sample package should include cover letter and 1 sample. Samples are filed. Reports back within 1 week. To show a portfolio, mail original/final art. **Pays on acceptance**; flat fee of $5. Syndicate owns original art and characters.

‡ONE MILE UP, INC., 7011 Evergreen Court, Annandale VA 22003. (703)642-1177. Fax: (703)642-9088. Website: http://www.onemileup.com. President: Gene Velazquez. Estab. 1988.
Needs: Approached by 5 cartoonists and 10 illustrators/year. Buys from 5 illustrators/year. Prefers illustration and animation.
First Contact & Terms: Send photostats, résumé and/or diskettes. Include 3-5 samples. Call or mail appropriate materials for portfolio review of final art. Pays flat fee; $30-120. **Pays on acceptance.** Negotiates rights purchased.

REPORTER, YOUR EDITORIAL ASSISTANT, 7015 Prospect Place NE, Albuquerque NM 87110. (505)884-7636. Editor: George Dubow. Syndicates to newspapers and magazines for secondary level schools and colleges. Guidelines available.

Needs: Considers single panel cartoons on teenage themes.
First Contact & Terms: Mail art and SASE. Reports in 3 weeks. Buys first rights. Originals returned to artist only upon request. Pays $5-10.
Tips: Does not want to see comic strips.

SALMON SYNDICATION, P.O. Box 4272, Vallejo CA 94590-9991. (707)552-1699. Syndicated comics serving 42 newspapers.
Needs: Approached by 25-50 freelancers/year. Prefers subtle, mature material.
First Contact & Terms: Sample package should include cover letter and photocopies. 6-18 samples should be included. Samples are filed or are returned by SASE if requested. Reports back to the artist only if interested. To show portfolio, mail appropriate materials, including photostats. Artist owns original art and characters.
Tips: "We're not looking for material at this time, but will consult with SASE."

SAM MANTICS ENTERPRISES, P.O. Box 77727, Menlo Park CA 94026. (415)854-9698. E-mail: corrco ok@syndicate.com. Website: http://www.syndicate.com. President: Carey Cook. Estab. 1988. Syndicate serving schools, weekly newspapers.
Needs: Approached by 25-40 artists/year. Considers comic strips, word puzzles, word games and educational text. Prefers multiple panel comic strips and b&w line drawings. Prefers themes relating to educational stimulating, training and vocabulary. Maximum size of artwork 11 × 17; must be reducible to 65% of original size.
First Contact & Terms: Sample package should include cover letter, photocopies of finished cartoons. 20 samples should be included. Samples not filed and are returned by SASE if requested by artist. Reports back within 1 month. To show portfolio, mail tearsheets. Pays on publication. Rights purchased vary according to project. The artist owns original art and characters. Finds artists through submissions.
Tips: "The World Wide Web and the Internet have become the preferred way to communicate educational ideas. Stimulating products can now be shown on the Internet with instantaneous distribution."

‡❤SEMPLE COMIC FEATURES, 725 Coronation Blvd., Cambridge, Ontario N1R 7S9 Canada. (519)622-1520. Fax: (519)622-9954. E-mail: rcomely@i-site.on.ca. President: Richard Comely. Estab. 1993. Syndicate serving 15 newspapers.
Needs: Approached by 40 cartoonists and 50 illustrators/year. Buys from 1-2 cartoonists and 1-2 illustrators/year. Strips introduced include Captain Canuck, Wabbits, Trumpet the Elephant. Considers comic strips and illustrations. Prefers single panel, multiple panel, b&w line drawings. Also uses freelancers for occasional illustration work. Maximum size of artwork 8½ × 11.
First Contact & Terms: Sample package should include cover letter and photocopies. 6-10 samples should be included. Samples are filed or returned by SASE if requested by artist. Reports back only if interested. Call for appointment to show portfolio of tearsheets and photostats. Pays 50% of gross income. Pays on publication. Rights purchased vary according to project. Minimum length of contract varies.

SINGER MEDIA CORP., Seaview Business Park, 1030 Calle Cordillera, Unit #106, San Clemente CA 92673. (714)498-7227. Fax: (714)498-2162. Acquisitions Director: Kristy Lee. Syndicates to 300 worldwide magazines, newspapers, book publishers and poster firms. Geared toward the family, business management. Artists' guidelines $2.
 ● Oceanic Press Service is also run by this company. This syndicate provides a list of subjects they're interested in covering through cartoons. Ask for this list when you write for guidelines.
Needs: Syndicates several hundred pieces/year. Considers single panel cartoons targeted at an international reader, mute humor or easily translatable text. No ballooned text, please. Recent features include Sherlock Holmes' Crime Scene Chronicles by Jack Harris and Howard Bender. Current marketable subjects are computer-related topics, as well as business, golf, travel or sex.
First Contact & Terms: Send query letter with synopsis and or samples, promotional material, photocopies, SASE and tearsheets. Do not send any original work. Show 10-12 samples. Reports within 2-3 weeks. Returns cartoons to artist at job's completion if requested at time of submission with SASE. Syndication rights with 50/50 split on all sales. Exceptions can be negotiated.

STATON GRAPHICS, P.O. Box 618, Winterville GA 30683-0618. President: Bill Staton. Syndicates almost exclusively to weekly newspapers. Art guidelines available for #10 SASE.
Needs: Approached by 200 cartoonists/year. Buys from 1-2/year. Introduces 1-2 new strips/year. Considers comic strips and gag cartoons.
First Contact & Terms: Sample package should include minimum of 12 photocopied samples. Samples not filed are returned by SASE. Pays 50% of gross income at time of sale. Rights purchased vary according to project. Artist owns original art and characters. Finds artists through word of mouth, sourcebooks.
Tips: Also offers critique service for $15 fee. "Sloppy lettering is an automatic rejection. We are not looking for the next Far Side, so don't send us your version. We are impressed with funny, well-drawn cartoons."

® and © 1996 Richard Comely

Richard Comely, president of Semple Comics and creator of Captain Canuck, uses trading cards such as these to promote his comic book character. "People love the cards—especially when given out free as we do at malls, parades, schools, etc.," says Comely. "The cards are sold in comic shops in Canada for $2 each. They're listed as being worth $2.50 in the U.S." Captain Canuck is Canada's most popular comic book superhero. He also appears in comic strips in Canadian newspapers, and has been on Canadian postage stamps.

‡STUDIO ADVERTISING ART, P.O. Box 43912, Las Vegas NV 89116. (702)641-7041. Fax: (702)641-7001. Director: Rick Barker. Clip art firm. Guidelines available for #10 SASE.
Needs: Approached by 40 freelance artists/year. Buys from 1-3 artists/year. Considers illustrations and spot drawings. Prefers b&w line drawings. Computer (Macintosh/Adobe Illustrator files only).
First Contact & Terms: Sample package should include photocopies *only*. 10-15 samples should be included. Samples are returned by SASE if requested by artist. Reports back to the artist only if interested. To show a portfolio, send photostats. Pays a flat fee of $10. **Pays on acceptance.** Buys all rights.
Tips: "Submit good quality art that can be reused by a large section of the desktop publishing industry."

‡T/MAKER COMPANY, 1390 Villa St., Mountain View CA 94041. (415)962-0195. Fax: (415)962-0201. E-mail: clickart-info@tmaker.com. Website: http://www.clickart.com. Contact: ClickArt. Estab. 1984. Clip art firm serving thousands of retail outlets, catalog sales.
Needs: Approached by hundreds of cartoonists and artists/year. Considers illustrations, caricatures, spot drawings. Prefers Macintosh Adobe Illustrator files, b&w or 4-color.
First Contact & Terms: Sample package should include cover letter, résumé, tearsheets, photostats. Samples are filed. Reports back to the artist only if interested. To show portfolio, mail appropriate b&w and color materials. Rights purchased vary according to project. Minimum length of contract is "forever."

TRIBUNE MEDIA SERVICES, INC., 435 N. Michigan Ave., Suite 1500, Chicago IL 60611. (312)222-5998. E-mail: tms@tribune.com. Website: http://www.comicspage.com. Managing Editor: Mark Mathes. Syndicate serving daily and Sunday newspapers. Introductions include Bound & Gagged (strip) by Dana Summers, Pluggers (comic panel) by Jeff MacNelly, Bottom Liners (comic panel) by Eric and Bill Teitelbaum. "All are original comic strips, visually appealing with excellent gags." Art guidelines available for SASE with first-class postage.
 ● Tribune Media Services is a leading provider of Internet and electronic publishing content, including the WebPoint Internet Service.
Needs: Seeks comic strips and newspaper panels, puzzles and word games. Prefers original comic ideas, with excellent art and timely, funny gags; original art styles; inventive concepts; crisp, funny humor and dialogue.

First Contact & Terms: Send query letter with résumé and photocopies. Sample package should include 2-3 weeks of daily strips or panels. "Interactive submissions invited." Samples not filed are returned only if SASE is enclosed. Reports within 4-6 weeks. Pays 50% of net proceeds.
Tips: "Be sure to describe recurring characters, acknowledge other comics or features similar to the submission and tell why yours is unique. Creators may examine the current TMS product line of 130 features in the Editor & Publisher Syndicate Directory or the TMS Website which includes the directory, submission guidelines and selected TMS features."

‡UNITED FEATURE SYNDICATE/NEWSPAPER ENTERPRISE ASSOCIATION, 200 Madison Ave., New York NY 10016. (212)293-8500. Contact: Comics Editor. Syndicate serving 2500 daily/weekly newspapers. Guidelines available for #10 SASE.
Needs: Approached by 5,000 cartoonists/year. Buys from 2-3 cartoonists/year. Introduces 2-3 new strips/year. Strips introduced include Dilbert, Over the Hedge. Considers comic strips, editorial political cartoons and panel cartoons.
First Contact & Terms: Sample package should include cover letter, photocopies of finished cartoons, 18-36 dailies. Samples are returned by SASE if requested by artist. Reports back within 10 weeks.

‡UNITED MEDIA, 200 Madison Ave., New York NY 10016. Website: http://www.unitedmedia.com. Editorial Director: Diana Loevy. Estab. 1978. Syndicate servicing US and international newspapers. Guidelines for SASE. "United Media consists of United Feature Syndicate and Newspaper Enterprise Association. Submissions are considered for both syndicates. Duplicate submissions not needed." Guidelines available.
Needs: Introduces 2-4 new strips/year. Considers comic strips and single, double and multiple panels. Recent introductions include Over the Hedge by Mike Fry and T. Lewis. Prefers pen & ink..
First Contact & Terms: Send cover letter, résumé, finished cartoons and photocopies. Include 36 dailies; "Sundays not needed in first submissions." Do not send "oversize submissions or concepts without strips." Samples are not filed and are returned by SASE. Reports back within 3 months. "Does not view portfolios." UFS pays 50% of net proceeds. NEA pays flat fee, $500 and up a week. Buys all rights. Minimum length of contract 5 years and 5 year renewal. Automatic renewal.
Tips: "Send copies, but not originals. Do not send mocked-up licensing concepts." Looks for "originality, art and humor writing. Be aware of long odds; don't quit your day job. Work on developing your own style and humor writing. Worry less about 'marketability'—that's our job."

UNITED NEWS SERVICE, 48 Scribner Ave., Staten Island NY 10301. (718)981-2365. Fax: (718)981-6292. Assignment Desk: Jane Marie Johnson. Estab. 1979. Syndicate servicing 600 regional newspapers. Considers caricatures, editorial political cartoons, illustrations and spot drawings. Prefers b&w line drawings.
First Contact & Terms: Sample package should include cover letter and résumé. Samples are filed or returned by SASE if requested. Reports back within weeks. Mail appropriate materials. Pays on publication; $50-100. Buys reprint rights. Syndicate owns original art; artist owns characters.

‡UNIVERSAL PRESS SYNDICATE, Dept. AM, 4520 Main St., Suite 700, Kansas City MO 64111. (816)932-6600. Editorial Director: Lee Salem. Syndicate serving 2,750 daily and weekly newspapers.
Needs: Considers single, double or multiple panel cartoons and strips; b&w and color. Prefers photocopies of b&w, pen & ink, line drawings.
First Contact & Terms: Reports within 1 month. To show a portfolio, mail photostats. Buys syndication rights. Send query letter with résumé and photocopies.
Tips: "Be original. Don't be afraid to try some new idea or technique. Don't be discouraged by rejection letters. Universal Press receives 100-150 comic submissions a week, and only takes on two or three a year, so keep plugging away. Talent has a way of rising to the top."

WHITEGATE FEATURES SYNDICATE, 71 Faunce Dr., Providence RI 02906. (401)274-2149. Talent Manager: Eve Green. Estab. 1988. Syndicate serving daily newspapers internationally, book publishers and magazines. Introduced Dave Berg's Roger Kaputnik.
Needs: Considers comic strips, gag cartoons, editorial/political cartoons, illustrations and spot drawings; single, double and multiple panel. Work must be reducible to strip size. Also needs artists for advertising and publicity. Whitegate is looking for fine artists and illustrators for book publishing projects.
First Contact & Terms: Send cover letter, résumé, tearsheets, photostats and photocopies. Include about 12 strips. To show portfolio, mail tearsheets, photostats, photographs and slides; include b&w. Pays 50% of net proceeds upon syndication. Negotiates rights purchased. Minimum length of contract 5 years (flexible). Artists owns original art; syndicate owns characters (negotiable).
Tips: Include in a sample package "info about yourself, tearsheets, notes about the strip and enough samples to tell what it is. Don't write asking if we want to see; just send samples." Looks for "good writing, strong characters, good taste in humor. No hostile comics. We like people who have cartooned for a while and are printed. Get published in local papers first."

Design Firms

You'll enjoy freelancing for this market because you'll have a lot in common with the people you work for. You won't encounter many "suits" in this market. You're more likely to meet people who view the world as you do—through artists' eyes. In fact, this section could have been entitled "Artists who hire other artists."

Design firms create print ads, annual reports, logos, corporate identity programs, brochures, packaging, signage and other projects. Firms vary in size, ranging from two-person operations to large concerns complete with administrative staff and sales force. All rely on freelancers. If you have the required talent and skills, this market offers a steady stream of assignments.

There are thousands of design firms across the country and around the world. Though we alert you to a number of them, our page-count is limited. So be aware the listings on the following pages are the tip of the proverbial iceberg. Look for additional firms in industry directories, such as *Workbook* (Scott & Daughters Publishing) and *The Design Firm Directory* (Wefler & Associates), available in the business section of most large public libraries. Find local firms in the yellow pages and your city's business-to-business directory. You can also pick up leads by reading *HOW*, *Print*, *Step-by-Step Graphics*, *Communications Arts* and other design publications (see addresses in Publications of Interest on page 681).

HOW DESIGN FIRMS WORK WITH FREELANCERS

Design Firms are similar to advertising agencies when it comes to freelance needs. (See the Advertising, Audiovisual and PR section, page 578.) They hire the following creative talent on a project-by-project basis:

- **Illustrators.** Design firms hire illustrators to provide fresh images and a variety of styles.
- **Design and production freelancers.** Design firms need freelancers who have polished computer skills on Mac graphic programs, who know how to spec type, create layouts and produce charts and graphs. They might hire you to work on a project at home on your Mac, or ask you to work on their premises. It is not uncommon for design firms to reserve one of their computer stations for freelancers.
- **Fine artists, artisans and sculptors.** When working on upscale annual reports and other projects that might require an artistic ambiance, design firms often look to fine artists to help them accomplish their goals. Design firms specializing in exhibit design for museums or trade shows, often rely on freelancers with knowledge of sculpture and model-making techniques.
- **Calligraphers, lettering artists and font designers.** Most design projects require appropriate text for insertion in a layout. Though design firms mainly spec existing fonts, they often turn to freelancers who specialize in portraying text in attractive or unusual ways. One calligrapher markets her work to design firms specializing in book publishing. Another artist found a lucrative niche designing specialized fonts that fit smoothly within circular designs.
- **Multimedia designers.** There is a growing need for designers who can create websites and work on CD-ROM projects.
- **Storyboard artists.** Artists who have experience drawing storyboards pick up

assignments from design firms as well as advertising agencies. (See Mark Simon's Insider Report, page 539, for the low-down on this fascinating skill.)

- **Animation and special effects artists.** When a project calls for it, design firms turn to freelancers for special services such as animation, morphing or special effects.

First, Consider Your Talents and Location

Several factors should be weighed when choosing which design firms are right for you. The first consideration is what talents and services you offer. The second is where you live, and how easily you can communicate with the design firm. These days, illustrators who have access to fax machines or modems, can work with firms in any city. For the time being, however, most firms still prefer to work with local design and production freelancers. (We list this section by state for that reason.)

Fill a Need

Choose firms whose clients and specialties are in line with the type of work you create. (You'll find clients and specialties in the first paragraph of each listing.) If you create charts and graphs, contact firms whose clients include financial institutions. Fashion illustrators should approach firms whose clients include department stores and catalog publishers. Sculptors and modelmakers might find opportunities with firms specializing in exhibition design.

Within the listings are clues to help you create the submission most likely to impress each firm. If a firm specializes in package design, for example, and its clients include wineries and coffee companies, a sample showing vineyard or coffee images would be right on target and might prompt them to give you a call. But if you would rather market yourself as a medical illustrator, skip the firm specializing in packaging and look for firms specializing in pharmaceutical companies.

Your best strategy is this: *Don't create work based on the kind of images you think markets want to see. Rather, target design firms (and other markets) who need the type of the type of work you want to specialize in.*

It may take some initial digging to find markets in need of your specialty, but it's worth the effort. When you submit work you enjoy creating, it shows! In the long run your samples will win the kind of assignments you'll enjoy working on and you'll have a more rewarding freelance career.

Bowl Them Over With Your Sample!

Once you choose which firms to approach, create samples that will knock their socks off! Design firms are perhaps the most picky clients you'll approach. Being artists themselves, they have high standards. Follow these tips for better mailings:

- Submit samples appropriate to each design firm's specialties. Doing so demonstrates you did your homework and gives the impression you'll be just as thorough when tackling assignments.
- Postcards or color photocopies work well as samples for illustrators. To save on printing costs, first narrow your market, then design and print several hundred postcard samples of an image that both represents your style and is appropriate to the listings you have selected for your mailings. Another economical strategy is to design several samples and submit color photocopies or laser prints instead of printed cards. (See What Should I Submit?, page 4.)
- Be sure the style you choose for your sample is one you can easily duplicate, because firms will expect you to create assignments in the style of your sample.
- Illustrators should make sure the *design* elements in their samples—the layout,

typography, etc.—are well thought out and clearly show name, address, phone number, fax.

- If you are a designer, remember the stationery you choose for your cover letter is as important as your samples. The layouts (as well as the content) of your cover letter and resume will be scrutinized, along with the fonts and paper grades you choose. If you submit beautiful samples with a poorly designed résumé, you'll be quickly ruled out.
- Consider showcasing your capabilities by designing a brochure or booklet. You can find dozens of examples of creative self-promotional pieces in North Light's *Fresh Ideas* series. (See More Great Books for Artists!, page 714.)
- Mailings have a cumulative effect, so don't give up after one or two mailings. Send a new sample every few months to the same mailing list, adding additional names to the list as you come across them in *HOW* and other design publications.

REACH FOR YOUR DREAM TEAMS!

As you browse through *HOW, Communication Arts* and award directories, you undoubtedly come across firms whose work you admire more than others. You may even dream of working with them. Strive to create work of similar caliber. When your work is up to snuff, write to the principals of your dream teams and tell them why you admire their work. Enclose your best samples. You might even follow up with an e-mail message asking if they got your samples. The trick is to show enthusiasm without being a pest. If your dream firms don't respond, add them to your regular mailing list and keep trying. What have you got to lose?

PROFESSIONAL ORGANIZATIONS: THE BEST-KEPT SECRET

Ever wonder why some freelancers find so many opportunities? Maybe they share a secret weapon—membership in a professional organization. The Graphic Artists Guild (GAG), The American Institute of Graphic Art (AIGA), The Society of Illustrators, The Society of Publication Designers (SPD) and the Art Directors Club are just a handful of national organizations that can give your career a boost. Chances are there is a branch of one or more of these organizations in your city. In addition to benefits like newsletters, group insurance, credit unions and competitions, organizations hold regular meetings, happy hours and lectures where you can gain business smarts and share information with fellow designers and illustrators.

As you read the listings that follow, note which acronyms the firms list as their professional affiliations. Most successful firms hold memberships in several organizations. That's another reason savvy freelancers join. Becoming a "groupie" is a great way to network with potential clients. *For more about the AIGA and other groups, see Ric Grefé's Insider Report in the Organizations section on page 679.*

Arizona

GODAT/JONCZYK DESIGN CONSULTANTS, 807 S. Fourth Ave., Tucson AZ 85701-2701. (520)620-6337. Partners: Ken Godat and Jeff Jonczyk. Estab. 1983. Number of employees: 6. Specializes in annual reports, marketing communications, publication design and signage. Clients: corporate, retail, institutional, public service. Current clients include Weiser Lock, Rain Bird, IBM and University of Arizona. Professional affiliations: AIGA, ACD.

Needs: Approached by 75 freelancers/year. Works with 6-10 freelance illustrators and 2-3 designers/year. Freelancers should be familiar with Aldus PageMaker, Aldus FreeHand, Adobe Photoshop or Adobe Illustrator. Needs editorial and technical illustration.

First Contact & Terms: Send query letter with samples. Samples are filed. Request portfolio review in original query. Art Director will contact artist for portfolio review if interested. Pays for design by the hour, $15-40 or by the project. Pays for illustration by the project. Finds artists through sourcebooks.

THE M. GROUP GRAPHIC DESIGN, 2512 E. Thomas Rd., Suite #7, Phoenix AZ 85016. (602)957-7557. Fax: (602)957-7876. President: Gary Miller. Estab. 1987. Number of employees: 7. Approximate annual billing: 1.5 million. Specializes in annual reports; corporate identity; direct mail and package design; and advertising. Clients: corporations and small business. Current clients include Arizona Public Service, Comtrade, Sager, Dole Foods, Giant Industries, Microchip, Coleman Spas, ProStar, Teksoft and CYMA.

Needs: Approached by 50 freelancers/year. Works with 3-5 freelance illustrators/year. Uses freelancers for ad, brochure, poster and P-O-P illustration. 95% of freelance work demands knowledge of Adobe Illustrator, Adobe Photoshop and QuarkXPress.

First Contact & Terms: Send postcard sample or query letter with samples. Samples are filed or returned by SASE if requested by artist. Reports back to the artist only if interested. Request portfolio review in original query. Artist should follow-up. Portfolio should include b&w and color final art, photographs and transparencies. Rights purchased vary according to project. Finds artists through publications (trade) and reps.

Tips: Impressed by "good work, persistence, professionalism."

RAINWATER COMMUNICATIONS, INC., P.O. Box 14507, Scottsdale AZ 85267-4507. (602)948-0770. Fax: (602)948-0683. President/Creative Director: Bob Rainwater. Estab. 1980. Number of employees: 5. Approximate annual billing: $980,000. Specializes in magazine ads, corporate brochures and annual reports. Current clients include AT&T, Axxess Technologies, W.L. Gore. Client list available upon request. Professional affiliations: AIGA, GAG and IAGD.

Needs: Approached by 10 freelancers/year. Works with 6 freelance illustrators and 4 designers/year. Prefers artists with experience in consumer and corporate communications—must be Macintosh literate. Uses illustrators mainly for concept executions. Also for annual reports, billboards, brochure and catalog design and illustration, lettering, logos, mechanicals, posters, retouching, signage and TV/film graphics. Also for multimedia projects. 100% of design and 50% of illustration demand knowledge of Adobe Photoshop, QuarkXPress and Adobe Illustrator.

First Contact & Terms: Send query letter with photocopies, résumé, brochure, photographs, SASE, slides, tearsheets and transparencies. Accepts submissions on disk compatible with Adobe Illustrator 5.0, Adobe Photoshop 2.0.1 and QuarkXPress 3.3.1. Send EPS files. Samples are sometimes filed or returned by SASE if requested by artist. Art Director will contact artist for portfolio review if interested. Portfolio should include samples of work used in printed pieces. Pays for design and illustration by the project. Rights purchased vary according to project. Finds artists through agents, sourcebooks, magazines, word of mouth and submissions.

Tips: This company is looking for a professional approach with presentation samples. "Prefers experienced people. No students please."

California

BERSON, DEAN, STEVENS, 65 Twining Lane, Wood Ranch CA 93065. (818)713-0134. Fax: (818)713-0417. Owner: Lori Berson. Estab. 1981. Specializes in annual reports, brand and corporate identity and display, direct mail, package and publication design. Clients: manufacturers, ad agencies, corporations and movie studios. Professional affiliation: LA Ad Club.

HOW TO USE your *Artist's & Graphic Designer's Market* offers suggestions for understanding and using the information in these listings. Read this and other articles in the front of this book for important business tips.

Needs: Approached by 50 freelancers/year. Works with 10-20 illustrators and 5 designers/year. Works on assignment only. Uses illustrators mainly for brochures, packaging and comps. Also for catalog, P-O-P, ad and poster illustration; mechanicals retouching; airbrushing; lettering; logos; and model making. 90% of freelance work demands knowledge of Aldus PageMaker, Adobe Illustrator, QuarkXPress, Adobe Photoshop and Aldus FreeHand.

First Contact & Terms: Send query letter with tearsheets and photocopies. Samples are filed. Art Director will contact artist for portfolio review if interested. Pays for design and illustration by the project. Rights purchased vary according to project. Considers buying second rights (reprint rights) to previously published work. Finds artists through word of mouth, submissions/self-promotions, sourcebooks and agents.

BRAINWORKS DESIGN GROUP, INC., 2 Harris Court, #A7, Monterey CA 93940. (408)657-0650. Fax: (408)657-0750. Art Director: Al Kahn. Vice President Marketing: Michele Strub. Estab. 1970. Number of employees: 4. Specializes in ERC (Emotional Response Communications), graphic design, corporate identity, direct mail and publication. Clients: colleges, universities, nonprofit organizations, majority are colleges and universities. Current clients include Marymount College, Iowa Wesleyan, Union University, Notre Dame College and Xavier University. Client list available upon request.

Needs: Approached by 100 freelancers/year. Works with 2 freelance illustrators and 10 designers/year. Prefers freelancers with experience in type, layout, grids, mechanicals, comps and creative visual thinking. Works on assignment only. Uses freelancers mainly for mechanicals and calligraphy. Also for brochure, direct mail and poster design; mechanicals; lettering; and logos. 100% of design work demands knowledge of Aldus PageMaker, QuarkXPress, Aldus FreeHand and Adobe Photoshop.

First Contact & Terms: Send brochure or résumé, photocopies, photographs, tearsheets and transparencies. Samples are filed. Artist should follow up with call and/or letter after initial query. Art Director will contact artist for portfolio review if interested. Portfolio should include thumbnails, roughs, final reproduction/product and b&w and color tearsheets, photostats, photographs and transparencies. Pays for design by the project, $200-2,000. Considers complexity of project and client's budget when establishing payment. Rights purchased vary according to project. Finds artists through sourcebooks and self-promotions.

Tips: "Creative thinking and a positive attitude are a plus." The most common mistake freelancers make in presenting samples or portfolios is that the "work does not match up to the samples they show." Would like to see more roughs and thumbnails.

CAREW DESIGN, 49 Sunset Dr., San Rafael CA 94901-1641. (415)454-1989. Fax: (415)457-7916. E-mail: carewdsgn@aol.com. President: Jim Carew. Estab. 1975. Number of employees: 3. Approximate annual billing: $250,000. Specializes in corporate identity, direct mail and package design.

Needs: Approached by 60 freelancers/year. Works with 10 freelance illustrators and 30 designers/year. Prefers local artists only. Works on assignment only. Uses freelancers for brochure and catalog design and illustration, mechanicals, retouching, airbrushing, direct mail design, lettering, logos and ad illustration. 100% of design and 50% of illustration demand knowledge of QuarkXPress, Aldus FreeHand, Adobe Illustrator or Adobe Photoshop. Needs editorial and technical illustration.

First Contact & Terms: Send query letter with photocopies. Accepts submissions on disk. Send EPS or TIFF files. Samples are filed or are returned only if requested by artist. Reports back only if interested. Call for appointment to show portfolio of roughs and original/final art. Pays for production by the hour, $18-30. Pays for design by the hour, $20-25 or by the project. Pays for illustration by the project, $100-1,500. Buys all rights.

‡DENTON DESIGN ASSOCIATES, 491 Arbor St., Pasadena CA 91105. (818)792-7141. President: Margi Denton. Estab. 1975. Specializes in annual reports, corporate identity and publication design. Clients: nonprofit organizations and corporations. Current clients include California Institute of Technology, Huntington Memorial Hospital.

Needs: Approached by 12 freelance graphic artists/year. Works with 4 freelance illustrators and 3 freelance designers/year. Prefers local designers only. "We work with illustrators from anywhere." Works on assignment only. Uses designers and illustrators for brochure design and illustration, lettering, logos and charts/graphs. 100% of design work demands knowledge of QuarkXPress, Adobe Photoshop and Adobe Illustrator.

First Contact & Terms: Send résumé, tearsheets and samples (illustrators just send samples). Samples are filed and are not returned. Reports back to the artist only if interested. Art director will contact artist for portfolio review if interested. Portfolio should include color samples "doesn't matter what form." Pays for design by the hour, $20-25. Pays for illustration by the project, $250-6,500. Rights purchased vary according to project. Finds artists through sourcebooks, AIGA, *Print* and *CA*.

DESIGN AXIOM, 50 B, Peninsula Center Dr., 156, Rolling Hills Estates CA 90274. (310)377-0207. President: Thomas Schorer. Estab. 1973. Specializes in graphic, environmental and architectural design; product development; and signage.

Needs: Approached by 100 freelancers/year. Works with 5 freelance illustrators and 10 designers/year. Works on assignment only. Uses designers for all types of design. Uses illustrators for editorial and technical illustration. 50% of freelance work demands knowledge of Aldus PageMaker or QuarkXPress.

First Contact & Terms: Send query letter with all appropriate samples. Art Director will contact artist for portfolio review if interested. Portfolio should include all appropriate samples. Pays for design and illustration by the project. Finds artists through word of mouth, self-promotions, sourcebooks and colleges.

‡EVENSON DESIGN GROUP, 4445 Overland Ave., Culver City CA 90230. (310)204-1995. Fax: (310)204-4879. E-mail: evensoninc@aol.com. Production Manager: Elisabeth Sanderson. Estab. 1976. Specializes in annual reports, brand and corporate identity, display design, direct mail, package design and signage. Clients: ad agencies, hospitals, corporations, law firms, entertainment companies, record companies, publications, PR firms. Current clients include Warner Bros., The Disney Channel, Mattel Toys, Twentieth Century Fox, MCA/Universal, Price Waterhouse and DayRunner.
Needs: Approached by 75-100 freelance artists/year. Works with 20-25 illustrators and 10 designers/year. Prefers artists with production experience as well as strong design capabilities. Works on assignment only. Uses illustrators mainly for covers for corporate brochures. Uses designers mainly for logo design, page layouts, all overflow work. Also for brochure, catalog, direct mail, ad, P-O-P and poster design and illustration; mechanicals; lettering; logos; and charts/graphs. 100% of design work demands knowledge of QuarkXPress, Aldus FreeHand, Adobe Photoshop or Adobe Illustrator.
First Contact & Terms: Send query letter with résumé. Also has drop-off policy. Samples are filed. Returned by SASE if requested. Reports back to the artist only if interested. Portfolio should include b&w and color photostats and tearsheets and 4×5 or larger transparencies. All work must be printed or fabricated in form of tearsheets, transparencies or actual piece. Pays for design by the hour, $20-35. Rights purchased vary according to project.

‡FREEASSOCIATES, 3728 Hayvenhurst Ave., Encino CA 91436-3844. (818)784-2380. Fax: (818)784-0452. E-mail: freeassocs@aol.com. President: Josh Freeman. Estab. 1974. Number of employees: 1. Design firm. Specializes in marketing materials for corporate clients. Client list available upon request. Professional affiliations: AIGA.
Needs: Approached by 50 illustrators and 20 designers/year. Works with 15 illustrators and 5 designers/year. Prefers freelancers with experience in top level design and advertising. Uses freelancers mainly for design, production, illustration. Also for airbrushing, brochure design and illustration, catalog design and illustration, humorous illustration, lettering, logos, mechanicals, multimedia projects, posters, retouching, signage, storyboards, technical illustration and web page design. 10% of work is with print ads. 90% of design and 50% of illustration demand skills in Aldus PageMaker, Adobe Photoshop, QuarkXPress, Adobe Illustrator.
First Contact & Terms: Designers send query letter with photocopies, photographs, résumé, tearsheets and transparencies. Illustrators send postcard sample of work and/or photographs and tearsheets. Accepts Mac compatible disk submissions to view in current version of major software or self-running presentations. CD-ROM OK. Samples are filed or returned by SASE. Will contact for portfolio review if interested. Pays for design and illustration by the project; negotiable. Rights purchased vary according to project. Finds artists through *LA Workbook, CA, Print. Graphis*, submissions and samples.
Tips: Designers should have their own computer modem. Must have sensitivity to marketing requirements of projects they work on. Deadline commitments are critical.

GRAPHIC DESIGN CONCEPTS, 4123 Wade St., Suite #2, Los Angeles CA 90066. (310)306-8143. President: C. Weinstein. Estab. 1980. Specializes in package, publication and industrial design; annual reports; corporate identity; displays; and direct mail. "Our clients include public and private corporations, government agencies, international trading companies, ad agencies and PR firms." Current projects include new product development for electronic, hardware, cosmetic, toy and novelty companies.
Needs: Works with 15 illustrators and 25 designers/year. "Looking for highly creative idea people, all levels of experience." All styles considered. Uses illustrators mainly for commercial illustration. Uses designers mainly for product and graphic design. Also uses freelancers for brochure, P-O-P, poster and catalog design and illustration; book, magazine, direct mail and newspaper design; mechanicals; retouching; airbrushing; model making; charts/graphs; lettering; logos. Also for multimedia design, program and content development. 50% of freelance work demands knowledge of Aldus PageMaker, Adobe Illustrator, QuarkXPress, Adobe Photoshop or Aldus FreeHand.
First Contact & Terms: Send query letter with brochure, résumé, tearsheets, photostats, photocopies, slides, photographs and/or transparencies. Accepts disk submissions compatible with Windows on the IBM. Samples are filed or are returned if accompanied by SASE. Reports back within 10 days with SASE. Portfolio should include thumbnails, roughs, original/final art, final reproduction/product, tearsheets, transparencies and references from employers. Pays for design by the hour, $15 minimum. Pays for illustration by the hour, $50 minimum. Considers complexity of project, client's budget, skill and experience of artist, how work will be used, turnaround time and rights purchased when establishing payment.
Tips: "Send a résumé if available. Send samples of recent work or *high quality* copies. Everything sent to us should have a professional look. After all, it is the first impression we will have of you. Selling artwork is a business. Conduct yourself in a business-like manner."

INSIDER REPORT

Quick on the Draw? Storyboarders Get Plenty of Action

Before the cameras recorded the action, Mark Simon's pencil brought the characters and action of *seaQuest DSV* to life. Simon was the storyboarder for Spielberg's science fiction series during its run on NBC. Though most artists have only a vague idea of what storyboarding is, Simon says it's fun and lucrative. But you have to be quick on the draw to succeed.

Mark Simon

"If it takes you two hours to finish a sketch, you're never going to make any money and you're never going to be hired because you're never going to finish." You'll need skills at drawing the human body, proficiency at perspective, and a good understanding of spacial relationships, but detailed renderings won't get you jobs, says Simon. Getting an idea across is more important than how realistic or pretty your art looks. As many as 200 crew members might be reading the same storyboards and every single person on that crew must derive the same meaning from them to work together effectively. A storyboard takes the producer's or director's initial vision and enhances it, says Simon. "I look at a storyboard as a kind of visual blueprint of the finished product." Before a script is shot, the artist reads the script and often sits down with the director to discuss each shot. The artist then "translates" the script into a simple comic strip of the action, detailing camera angles, how shots flow into one another and how details like special effects change shots.

Storyboarders save producers lots of money and time. Because changes during production are so expensive, producers and directors use storyboards during preproduction to iron out details, and to make sure each scene is shot for maximum effect.

Television commercial producers rely on boards even more heavily than film or series producers. After boards are shown to an agency's clients, they may be revised several times to make sure every second of expensive air time counts. It's less expensive for the commercial producer to have the artist redraw the boards than shoot and revise a commercial four or five times.

Simon became intrigued with storyboards while working as an art director for film and television in Los Angeles. In his job, Simon hired other artists to create storyboards, but often wished he could try his hand at the process. So he made an appointment with an agent who repped storyboard artists to find out how to get started. The rep suggested Simon take scenes from feature films and TV

INSIDER REPORT, *continued*

commercials and draw sample storyboards to add to his portfolio. After spending several months creating samples, Simon showed his new portfolio to Home Box Office Executive Producer Jonathan Debin. Three weeks later, Debin called. Simon was handed a script and told to "make it scary."

Simon landed more storyboarding work on two made-for-TV movies, which led to the *seaQuest* job. Since then, so many doors have opened up he no longer has to art direct fulltime.

The first step to getting assignments is creating a portfolio of sample storyboards. Fill your samples with plenty of action sequences because, as Simon says, "If you have the choice between looking at two guys talking, or two guys hitting each other, which one are you going to look at first?" Once you think you have a good portfolio, send samples to production designers, managers, producers, directors, special effects houses and even stuntmen, who use storyboards to map out complicated stunts.

Not all production companies are in New York City and LA. Check the yellow pages for local advertising agencies, film and video production firms. Send a cover letter, résumé and samples of your work to prospective clients and plan direct mailings at least twice a year.

Contact state film agencies and get your name in local production guides to let people in the industry know you're there. Once you're into the grapevine, it's easier to get your foot in the door, says Simon. A good strategy for beginners is offering to work for free for film students and low-budget filmmakers. You'll gain experience plus samples to show future clients.

Simon uses 4×3 panels for his portfolio, three drawings to a page. He uses color copies because they show line work better. Show both rough and detailed storyboards because both types are marketable, says Simon.

For Simon, storyboarding has turned into a well-paying vocation, earning him up to $2,000 a week on ongoing productions. For smaller jobs, like commercials, he charges by the panel. Simon suggests consulting the Graphic Artist's Guild's *Handbook of Pricing and Ethical Guidelines* for pricing. Fees can range from $15 to $45 per panel. One commercial can have between eight and 30 panels.

© 1994 Mark Simon

Mark Simon created this storyboard to help the actors and camera crew understand the director's vision for an episode of *seaQuest DSV*. The storyboard is one of many featured in Simon's helpful book, *Storyboards: Motion in Art*.

INSIDER REPORT, *Simon*

Though Simon has moved from LA to Orlando, he still gets plenty of storyboarding assignments. He works on commercials, creates storyboards for Disney and Universal Studios in Orlando, art directs, lectures on opportunities for artists within the entertainment industry, and is the author of *Storyboards: Motion in Art* (1994, Nomis Creations). "Storyboarding is a tremendous creative outlet," he says, "You get to sit in a movie theater and see your art come to life."
—*Douglas S. Wood*

‡**IMPACT MEDIA GROUP**, 1920 Franklin St., #7, San Francisco CA 94109. (415)563-9083. Fax: (415)563-7637. E-mail: impactmg@aol.com. Website: http://www.impactmg.com. Senior Partner: Garner Moss. Estab. 1993. Number of employees: 6. Approximate annual billing: 1 million. Digital design firm. Specializes in web design and programming, packaging, direct mail, marketing, desktop video and animation, 3D modeling, logos. Product specialty is design. Current clients include: Los Angeles Kings, Sun Microsystems, Kodak, Lucas Film, NHL, NBA, NFL, the AMA. Professional affiliations: AIGS, Art Directors Club, America Advertising Federation, SF Ad Club, Ad2 Club.
Needs: Approached by 10 illustrators and 30 designers/year. Works with 3 illustrators and 5 designers/year. Prefers local designers with experience in QuarkXPress and Adobe Photoshop. Uses freelancers mainly for direct mail, web design. Also for animation, annual reports, billboards, brochure design and illustration, catalog design and illustration, logos, medical illustration, model making, multimedia projects, posters, signage, storyboards, technical illustration, TV/film graphics, web page design, web programers. 50% of work is with print ads. 100% of design and 50% of illustration demand skills in Aldus FreeHand, Adobe Photoshop 4.0, QuarkXPress 3.32, Adobe Illustrator.
First Contact & Terms: Designers send query letter with photocopies, résumé, SASE, tearsheets, samples to keep on file. Illustrators send postcard sample and/or query letter with photocopies, résumé, SASE, tearsheets, samples of brochure or 4-color work. Send follow-up postcard every 2 months. Accepts Mac compatible disk submissions. Send QuarkXPress files—version 3.2 and above and EPS files. Samples are filed. Will contact artist for portfolio review of b&w, color final art, photographs, photostats, roughs, slides, tearsheets, thumbnails and transparencies if interested. Pays by the hour, $10-20, flat rates may be applied. Rights purchased vary according to project. Finds artists through ads, word of mouth and referrals.
Tips: "Really know your Quark. Be willing to go overtime on project. Work on a project like it's a matter of winning an award."

‡**LEKASMILLER**, 3210 Old Tunnel Rd., Lafayette CA 94549. (510)934-3971. Fax: (510)934-3978. Production Manager: Marilyn Tiernan. Estab. 1979. Specializes in annual reports, corporate identity, direct mail and brochure design. Clients: corporate and retail. Current clients include CivicBank of Commerce, Tosco Refining Co., Voicepro and Chevron USA.
Needs: Approached by 80 freelance artists/year. Works with 1-3 illustrators and 5-7 designers/year. Prefers local artists only with experience in design and production. Works on assignment only. Uses artists for brochure design and illustration, mechanicals, direct mail design, logos, ad design and illustration. 100% of freelance work demands knowledge of Aldus PageMaker, QuarkXPress, Adobe Photoshop or Adobe Illustrator.
First Contact & Terms: Designers send résumé. Illustrators send postcard samples. Samples are filed or are returned if accompanied by SASE. Reports back only if interested. To show a portfolio, mail thumbnails, roughs, final reproduction/product, tearsheets and transparencies. Considers skill and experience of artist when establishing payment. Negotiates rights purchased.

JACK LUCEY/ART & DESIGN, 84 Crestwood Dr., San Rafael CA 94901. (415)453-3172. Contact: Jack Lucey. Estab. 1960. Art agency. Specializes in annual reports, brand and corporate identity, publications, signage, technical illustration and illustrations/cover designs. Clients: businesses, ad agencies and book publishers. Current clients include U.S. Air Force, TWA Airlines, California Museum of Art & Industry, Lee Books, High Noon Books. Client list available upon request. Professional affiliations: Art Directors Club, Academy of Art Alumni.
Needs: Approached by 20 freelancers/year. Works with 1-2 freelance illustrators/year. Uses mostly local freelancers. Uses freelancers mainly for type and airbrush. Also for lettering for newspaper work.
First Contact & Terms: Query. Prefers photostats and published work as samples. Provide brochures, business card and résumé to be kept on file. Portfolio review not required. Originals are not returned to artist

at job's completion. Requests work on spec before assigning a job. Pays for design by the project.

Tips: "Show variety in your work. Many samples I see are too specialized in one subject, one technique, one style (such as air brush only, pen & ink only, etc.). Subjects are often all similar too."

‡PACE DESIGN GROUP, 665 Third St., #250, San Francisco CA 94107. (415)495-3600. Fax: (415)495-3155. Creative Director: Joel Blum. Estab. 1988. Number of employees: 5. Approximate annual billing: $600,000. Specializes in collateral. Product specialties are financial and computer industries. Current clients include: Bank of America, Wells Farto, E*Trade, Aldon Computer. Client list available upon request. Professional affiliations: AIP (Artists in Print).

Needs: Approached by 100 illustrators and 75 designers/year. Works with 3-5 illustrators and 3-5 designers/year. Prefers local designers with experience in QuarkXPress and Adobe Photoshop. Uses freelancers mainly for illustration and graphics. Also for brochure design and illustration, logos, technical illustration and web page design. 2% of work is with print ads. 100% of design and 85% of illustration demand skills in the latest versions of Adobe Photoshop, Adobe Illustrator and QuarkXPress.

First Contact & Terms: Designers send query letter with photocopies and résumé. Illustrators send query letter with photocopies, tearsheets, follow-up postcard samples every 6 months. Accepts disk submissions. Submit latest version software, System 7.5, EPS files. Samples are filed and are not returned. Will contact for portfolio review of color final art and printed pieces if interested. Pays for design by the hour, $25-35. Pays for illustration, by the project. Rights purchased vary according to project. Finds artists through sourcebooks, word of mouth, submissions.

Tips: "Attention to detail!"

DEBORAH RODNEY CREATIVE SERVICES, 1635 16th St., Santa Monica CA 90404. (310)450-9650. Fax: (310)450-9793. Owner: Deborah Rodney. Estab. 1975. Number of employees: 1. Specializes in advertising design and collateral. Clients: ad agencies and direct clients. Current clients include PritiKin Longevity Center, Monterey Carpets Inc. and UC Irvine Medical Center.

Needs: Approached by 3 freelancers/year. Works with 3-4 freelance illustrators and 1-2 designers/year. Prefers local freelancers. Uses illustrators mainly for finished art and lettering. Uses designers mainly for logo design. Also uses freelancers for mechanicals, charts/graphs, ad design and illustration. Especially needs "people who work on Macintosh." 100% of design demands knowledge of QuarkXPress, Adobe Illustrator 5.0 or Adobe Photoshop. Needs advertising illustration.

First Contact & Terms: Designers send postcard sample or query letter with brochure, tearsheets and photocopies. Illustrators send postcard samples and tearsheets. Request portfolio review in original query. Portfolio should include final reproduction/product and tearsheets or "whatever best shows work." Accepts disk submissions compatible with Adobe Illustrator 5.0. Send EPS files. Pays for design by the hour, $30-50; by the project; by the day, $100 minimum. Pays for illustration by the project, $100 minimum. Negotiates rights purchased. Considers buying second rights (reprint rights) to previously published work. Finds artists through sourcebooks and referrals.

Tips: "I do more concept and design work inhouse and hire out production and comps because it is faster, cheaper that way. It's all timing! Be in sourcebooks such as *Workbook*, *Black Book*, *Showcase*, etc."

CLIFFORD SELBERT DESIGN COLLABORATIVE, 2016 Broadway, Santa Monica CA 90404. (310)453-1093. Fax: (310)453-9491.

• See the Clifford Selbert listing in Massachusetts for information on the firm's freelance needs.

SPLANE DESIGN ASSOCIATES, 10850 White Oak Ave., Granada Hills CA 91344. (818)366-2069. Fax: (818)831-0114. President: Robson Splane. Specializes in display and package design renderings, model making and phototyping. Clients: small, medium and large companies. Current clients include Teledyne Laars, Baton Labs, MGB Clareblend, Ediflex, Superspine, Likay International, Telaire Systems, Teleflora, 3D Systems and Hanson Research. Client list available upon request.

Needs: Approached by 25-30 freelancers/year. Works with 1-2 freelance illustrators and 0-4 designers/year. Works on assignment only. Uses illustrators mainly for logos, mailings to clients, renderings. Uses designers mainly for sourcing, drawings, prototyping, modeling. Also uses freelancers for brochure design and illustration, ad design, mechanicals, retouching, airbrushing, model making, lettering and logos. 20-50% of freelance work demands knowledge of Aldus FreeHand, Ashlar Vellum and Excel.

First Contact & Terms: Send query letter with résumé and photocopies. Samples are filed or are returned. Reports back to the artist only if interested. Art Director will contact artist for portfolio review if interested. Portfolio should include color roughs, final art, photostats, slides and photographs. Pays for design and illustration by the hour, $7-25. Rights purchased vary according to project. Finds artists through submissions and contacts.

STUDIO WILKS, 2148-A Federal Ave., Los Angeles CA 90025. (310)478-4442. Fax: (310)478-0013. Estab. 1990. Specializes in print, collateral, packaging, editorial and environmental work. Clients: ad agencies, architects, corporations and small business owners. Current clients include Walt Disney Co., Smartek Software, Malibu Bread & Bagel and Microgames of America.

Needs: Works with 6-10 freelance illustrators and 10-20 designers/year. Uses illustrators mainly for packaging illustration. Also for brochures, print ads, collateral, direct mail and promotions.

First Contact & Terms: Designers send query letter with brochure, résumé, photocopies and tearsheets. Illustrators send postcard sample or query letter with tearsheets. Samples are returned by SASE if requested by artist. Art Director will contact artist for portfolio review if interested. Pays for design by the project. Buys all rights. Considers buying second rights (reprint rights) to previously published work. Finds artists through *The Workbook* and word of mouth.

JULIA TAM DESIGN, 2216 Via La Brea, Palos Verdes CA 90274. (310)378-7583. Fax: (310)378-4589. Contact: Julia Tam. Estab. 1986. Specializes in annual reports, corporate identity, brochures, promotional material, packaging and design. Clients: corporations. Current clients include Southern California Gas Co., *Los Angeles Times*, UCLA. Client list available upon request. Professional affiliations: AIGA.

Needs: Approached by 20 freelancers/year. Works with 6-12 freelance illustrators 2 designers/year. "We look for special styles." Works on assignment only. Uses illustrators mainly for brochures. Also uses freelancers for brochure design and illustration; catalog and ad illustration; retouching; and lettering. 50-100% of freelance work demands knowledge of QuarkXPress, Adobe Illustrator or Adobe Photoshop.

First Contact & Terms: Designers send query letter with brochure and résumé. Illustrators send query letter with résumé and tearsheets. Samples are filed. Reports back to the artist only if interested. Artist should follow up. Portfolio should include b&w and color final art, tearsheets and transparencies. Pays for design by the hour, $10-20. Pays for illustration by the project. Negotiates rights purchased. Finds artists through *LA Workbook*.

THARP DID IT, 50 University Ave., Suite 21, Los Gatos CA 95030. (Also an office in Portland OR—Tharp and Drummondz Did It). Art Director/Designer: Rick Tharp. Estab. 1975. Specializes in brand identity; corporate, non-corporate, and retail visual identity; packaging; and signage. Clients: direct and through agencies. Current clients include BRIO Scanditoy (Sweden), Sebastiani Vineyards, Harmony Foods, Mirassou Vineyards, LeBoulanger Bakeries, Simpson Paper Company and Hewlett-Packard. Professional affiliations: Society for Environmental Graphic Design (SEGD), Western Art Directors Club (WADC), American Institute of Graphic Arts (AIGA).

Needs: Approached by 250-350 freelancers/year. Works with 5-10 freelance illustrators and 2 designers/year. Needs advertising/product, food and people illustration. Prefers local designers with experience. Works on assignment only. 50% of freelance work demands computer skills.

First Contact & Terms: Send query letter with brochure or printed promotional material. Samples are filed or are returned by SASE. Art Director will contact artist for portfolio review if interested. "No phone calls please. We'll call you." Pays for design by the project. Pays for illustration by the project, $100-10,000. Considers client's budget and how work will be used when establishing payment. Rights purchased vary according to project. Finds artists through awards annuals and submissions/self-promotions.

Tips: Rick Tharp predicts "corporate globalization will turn all flavors of design into vanilla, but globalization is inevitable. Today, whether you go to Mall of America in Minnesota or to the Gamla Stan (Old Town) in Stockholm, you find the same stores with the same interiors and the same products in the same packages. The cultural differences are fading quickly. Environmental and communication graphics are losing their individuality. Eventually we'll have to go to Mars to find anything unique or stimulating. But, as long as the dictum of business is 'grow, grow, grow' there will always be a place for the designer."

TRIBOTTI DESIGNS, 22907 Bluebird Dr., Calabasas CA 91302-1832. (818)591-7720. Fax: (818)591-7910. E-mail: bob4149@aol.com. Contact: Robert Tribotti. Estab. 1970. Number of employees: 2. Approximate annual billing: $150,000. Specializes in graphic design, annual reports, corporate identity, packaging, publications and signage. Clients: PR firms, ad agencies, educational institutions and corporations. Current clients include Southwestern University, Northrup Grumman and city of Calabasas.

Needs: Approached by 8-10 freelancers/year. Works with 2-3 freelance illustrators and 1-2 designers/year. Prefers local freelancers only. Works on assignment only. Uses freelancers mainly for brochure illustration. Also for catalogs, mechanicals, retouching, airbrushing, charts/graphs, lettering and ads. Prefers marker, pen & ink, airbrush, pencil, colored pencil and computer illustration. 75% of freelance design and 50% of illustration demand knowledge of Aldus PageMaker, Adobe Illustrator 5.5, QuarkXPress, Adobe Photoshop 3.0, Aldus FreeHand or Delta Graph. Needs editorial and technical illustration and illustration for annual reports/brochures.

First Contact & Terms: Send postcard sample or query letter with brochure, photocopies and résumé. Accepts submissions on disk compatible with Aldus PageMaker 6.0, Adobe Illustrator 5.5 or Adobe Photoshop 3.0. Send EPS files. Art Director will contact artist for portfolio review if interested. Portfolio should include thumbnails, roughs, original/final art, final reproduction/product and b&w and color tearsheets, photostats and photographs. Pays for design by the hour, $35-85. Pays for illustration by the project, $100-1,000. Rights purchased vary according to project. Finds artists through word of mouth and self-promotion mailings.

Tips: "We will consider experienced artists only. Must be able to meet deadline. Send printed samples and follow up with a phone call."

YAMAGUMA & ASSOCIATES, 255 N. Market St., #120, San Jose CA 95110-2409. (408)279-0500. Fax: (408)293-7819. E-mail: sayd2m@aol.com. Estab. 1980. Specializes in corporate identity, displays, direct mail, publication design, signage and marketing. Clients: high technology, government and business-to-business. Current clients include Hewlett-Packard, Metra Corp and 50/50 Micro Electronics. Client list available upon request.

Needs: Approached by 6 freelancers/year. Works with 3 freelance illustrators and 2 designers/year. Works on assignment only. Uses illustrators mainly for 4-color, airbrush and technical work. Uses designers mainly for logos, layout and production. Also uses freelancers for brochure, catalog, ad, P-O-P and poster design and illustration; mechanicals; retouching; lettering; book, magazine, model making; direct mail design; charts/graphs; and AV materials. Also for multimedia projects (Director SuperCard). Needs editorial and technical illustration. 100% of design and 75% of illustration demand knowledge of Aldus PageMaker, QuarkXPress, Aldus FreeHand, Adobe Illustrator, Model Shop, Strata, MMDir. or Adobe Photoshop.

First Contact & Terms: Send postcard sample or query letter with brochure and tearsheets. Accepts disk submissions compatible with Adobe Illustrator, QuarkXPress, Adobe Photoshop and Strata. Samples are filed. Art Director will contact artist for portfolio review if interested. Portfolio should include thumbnails, roughs, b&w and color photostats, tearsheets, photographs, slides and transparencies. Sometimes requests work on spec before assigning a job. Pays for design by the hour, $15-50. Pays for illustration by the project, $300-3,000. Rights purchased vary according to project. Finds artists through self-promotions.

Tips: Would like to see more Macintosh-created illustrations.

Colorado

TARA BAZATA DESIGN, 9947 Monroe Dr., Thornton CO 80229. Phone/fax: (303)252-7712. E-mail: tarabazata@aol.com. Owner/Designer: Tara L. Bazata. Estab. 1991. Number of employees: 1. Approximate annual billing: $20,000. Specializes in publication design. Clients: publishers (primarily textbook), service bureaus. Current clients include Brown & Benchmark, Lachina Publishing and York Production Services. Client list available upon request.

Needs: Approached by 5 freelancers/year. Works with 5 freelance illustrators and 1 designer/year. Prefers artists with experience in textbook illustration. Uses illustrators and designers mainly for college textbook covers. Also for book design, lettering and logos. 100% of freelance design and 90% of illustration demand knowledge of Adobe Photoshop, Aldus FreeHand and QuarkXPress.

First Contact & Terms: Send postcard sample of work or send tearsheets with SASE (if you want them returned). Art Director will contact artist for portfolio review if interested. Portfolio should include b&w and color photographs. Pays for design and illustration by the project, or artist is paid by publisher directly. Rights purchased vary according to project. Finds artists through sourcebooks and sample postcards.

JO CULBERTSON DESIGN, INC., 1034 Logan St., Denver CO 80203. (303)861-9046. President: Jo Culbertson. Estab. 1976. Number of employees: 2. Approximate annual billing: $200,000. Specializes in direct mail, packaging, publication and marketing design; annual reports; corporate identity; design; and signage. Clients: corporations, not-for-profit organizations. Current clients include Love Publishing Company, Newman & Associates, American Cancer Society, Great-West Life. Client list available upon request.

Needs: Approached by 15 freelancers/year. Works with 3 freelance illustrators and 2 designers/year. Prefers local freelancers only. Works on assignment only. Uses illustrators mainly for corporate collateral pieces. Also uses freelancers for brochure design and illustration, book and direct mail design, lettering and ad illustration. 50% of freelance work demands knowledge of QuarkXPress, Adobe Photoshop, CorelDraw.

First Contact & Terms: Send query letter with résumé, tearsheets and photocopies. Samples are filed. Reports back to the artist only if interested. Artist should follow up with call. Portfolio should include b&w and color thumbnails, roughs and final art. Pays for design by the hour, $15-25; by the project, $250 minimum. Pays for illustration by the hour, $15-25; by the project, $100 minimum. Finds artists through file of résumés, samples, interviews.

UNIT ONE, INC., 950 S. Cherry St., Suite G-16, Denver CO 80222. (303)757-5690. Fax: (303)757-6801. President: Chuck Danford. Estab. 1968. Specializes in annual reports, corporate identity, direct mail, publication design, corporate collateral and signage. Clients: industrial, financial, nonprofit and construction/architecture. Examples of recent projects include Bonfils Blood Center corporate identity, Western Mobile plant signage.

Needs: Approached by 15-30 freelancers/year. Works with 1 or 2 illustrators and 3-5 designers/year. Uses freelancers mainly for computer design and production, brochures, ad design, direct mail, posters, logos, charts/graphs and signage. 100% of freelance work demands knowledge of Aldus PageMaker, Adobe Photoshop, MS Word/Works, QuarkXPress or Aldus FreeHand. Needs editorial and general print illustration.

First Contact & Terms: Send query letter with brochure, tearsheets, photographs, photocopies and résumé. Samples are filed and are returned by SASE if requested. Reports back only if interested. Art Director will contact artist for portfolio review if interested. Portfolio should include thumbnails, photographs, slides and

transparencies. Pays for design by the hour, $6-25; by the project, $50 minimum; by the day, $48-200. Pays for illustration by the project, $100 minimum. Considers skill and experience of artist when establishing payment. Rights purchased vary according to project.

Tips: "Show printed pieces whenever possible; don't include fine art. Explain samples, outlining problem and solution. If you are new to the business develop printed pieces as quickly as possible to illustrate practical experience."

Connecticut

DeCESARE DESIGN ASSOCIATES, P.O. Box 3447, Noroton CT 06820. (203)655-6057. Fax: (203)656-1983. President: John de Cesare. Estab. 1978. Number of employees 2. Specializes in annual reports and publication design. Clients: corportions and publishers. Current clients include American Medical Association and Mead Corp. Professional affiliations: Connecticut ADC.

Needs: Approached by 3 dozen freelancers/year. Works with 6-12 freelance illustrators and 2-3 designers/year. Uses illustrators and designers mainly for magazines, corporate literature. Also uses freelancers for book and magazine design, brochure and poster design and illustration, charts/graphs, logos and mechanicals. 90% of design and 10% of illustration demand knowledge of Adobe Illustrator, Adobe Photoshop and QuarkXPress 3.3.

First Contact & Terms: Send photocopies and résumé. Samples are filed and not returned. Art Director will contact artist for portfolio review if interested. Pays for design by the hour, $10-30; by the project, $500-5,000. Pays for illustration by the project; $300-5,000. Rights purchased vary according to project. Finds artists through sourcebooks and referrals.

Tips: "Be creative; be business-like. Do outstanding work, win awards. I'll find you!"

FREELANCE EXCHANGE, INC., P.O. Box 1165, Glastonbury CT 06033-6165. (860)633-8116. Fax: (860)633-8106. President: Stella Neves. Estab. 1983. Number of employees: 3. Approximate annual billing: $600,000. Specializes in annual reports; brand and corporate identity; animation; display, direct mail, package and publication design; web page design; illustration (cartoon, realistic, technical, editorial, product and computer). Clients: corporations, nonprofit organizations, state and federal government agencies and ad agencies. Current clients include Lego Systems, Milton Bradley Co., Hartford Courant, Abrams Publishing Co., Otis Elevator, Phoenix Home Life Insurance Co., Heublein, Black & Decker, Aetna Health Plans, The Allied Group. Client list available upon request. Professional affiliations: GAIG, Connecticut Art Directors Club.

Needs: Approached by 350 freelancers. Works with 25-40 freelance illustrators and 30-50 designers/year. Prefers freelancers with experience in publications, direct mail, consumer products and desktop publishing. "Computer graphics and illustration are becoming more important and requested by clients." Works on assignment only. Uses illustrators mainly for editorial and computer illustration and cartooning. Design projects vary. Also uses freelancers for brochure, catalog, poster and P-O-P design and illustration; newspaper design; mechanicals; audiovisual materials; lettering; logos; and charts/graphs. 95% of design and 50% of illustration demand knowledge of Aldus PageMaker, QuarkXPress, Aldus FreeHand, Adobe Illustrator, Adobe Photoshop, Persuasion, Powerpoint and Macromind Director.

First Contact & Terms: Designers send postcard sample or query letter with résumé, SASE, brochure, tearsheets and photocopies. Illustrators send postcard sample or query letter with résumé, photocopies, photographs, SASE, slides and tearsheets. Samples are filed and are returned by SASE. Reports back within 2 weeks. Call or write for appointment to show portfolio of thumbnails, roughs, final art (if appropriate) and b&w and color photostats, slides, tearsheets, photographs. "We prefer slides." Pays for design by the project, $500 minimum. Pays for illustration by the project, $300 minimum. Rights purchased vary according to project.

Tips: "Send us one sample of your best work that is unique and special. All styles and media are OK, but we're really interested in computer-generated illustration. We want to find new talent with a new fresh look. Don't repeat the same themes that everyone else has—we're looking for different and unique styles. Send me a sample that will make me *notice* you. There's lots of talent you're competing with; set your work apart."

‡MCKENZIE AND COMPANY, 5 Iris Lane, Westport CT 06880. (203)454-2443. Fax: (203)454-0416. E-mail: mchub@aol.com. Specializes in annual reports, corporate identity, direct mail and publication design.

Needs: Approached by 100 freelance artists/year. Works with 5 freelance designers/year. Uses freelance designers mainly for computer design. Also uses freelance artists for brochure and catalog design. 100% of design and 50% of illustration demand knowledge of QuarkXPress 3.3, Adobe Illustrator 6.0 and Adobe Photoshop 3.0.

First Contact & Terms: Send query letter with brochure, résumé, photographs and photocopies. Samples are filed or are returned by SASE if requested by artist. Write to schedule an appointment to show a portfolio.

Portfolio should include slides. Pays for design by the hour, $15-30. Pays for illustration by the project, $150-3,000. Rights purchased vary according to project.

Delaware

‡R & M DAUB STUDIO, (formerly It Figures Studio), 410 E. Ayre St., Wilmington DE 19804-2513. (302)994-1124. Fax: (302)994-9473. Partners: Ray Daub and Mary Berg. Estab. 1979. Manufacturer/service-related firm. "IFS designs and creates animated (mechanical) figures, animated exhibits and attractions, museum figures (lifecast) and sets, stage sets and props for industrial videos and meetings, and puppet characters for film and video." Clients: department stores, museums, businesses, corporations and film/video producers. Current clients include DuPont Co., The Smithsonian, and Dayton Hudson Corp.
Needs: Approached by 20 freelance artists/year. Works with 1-3 freelance illustrators and 1-3 freelance designers/year. Assigns 1-10 jobs to freelance artists/year. Prefers local artists only. Uses freelance artists mainly for sculpture, mold making, set building and conceptual art. Also uses artists for advertising design, illustration and layout; brochure and catalog design and layout; product design and rendering; model making and makeup. Needs proposal art.
First Contact & Terms: Send query letter with résumé, slides and photographs. Samples are filed or are returned only if requested. Reports back only if interested. Call or write to schedule an appointment to show a portfolio. Pays for design and illustration by the project, $100 minimum. Considers complexity of project, client's budget and skill and experience of artist when establishing payment. Buys all rights.
Tips: "After submitting a résumé, artists should attempt to arrange for a meeting providing examples of their strengths and interests. Show overt enthusiasm with the follow-up after submission of your résumé/portfolio."

District of Columbia

LOMANGINO STUDIO INC., 3209 M St. NW, Washington DC 20007. (202)338-4110. Fax: (202)625-0848. E-mail: lomangino@aol.com. President: Donna Lomangino. Estab. 1987. Number of employees: 6. Specializes in annual reports, corporate identity and publication design. Clients: corporations, nonprofit organizations. Client list available upon request. Professional affiliations: President, AIGA Washington DC.
Needs: Approached by 25-50 freelancers/year. Works with 1 freelance illustrator and 1-2 designers/year. Uses illustrators and production designers for publication. Also for multimedia projects. Accepts disk submissions, but not preferable. 99% of design work demands knowledge of Adobe Illustrator, Adobe Photoshop, Aldus FreeHand and QuarkXPress.
First Contact & Terms: Send postcard sample of work. Samples are filed. Art Director will contact artist for portfolio review if interested. Pays for design and illustration by the project. Finds artists through sourcebooks, word of mouth and studio files.
Tip: "Please don't call. Send samples for consideration."

Florida

AURELIO & FRIENDS, INC., 14971 SW 43 Terrace, Miami FL 33185. (305)225-2434. Fax: (305)225-2121. President: Aurelio Sica. Vice President: Nancy Sica. Estab. 1973. Number of employees: 3. Specializes in corporate advertising and graphic design. Clients: corporations, retailers, large companies.
Needs: Approached by 4-5 freelancers/year. Works with 1-2 freelance illustrators and 3-5 designers/year. Also uses freelancers for ad design and illustration; brochure, catalog and direct mail design; and mechanicals. 50% of freelance work demands knowledge of Adobe Ilustrator, Adobe Photoshop and QuarkXPress.
First Contact & Terms: Send brochure and tearsheets. Samples are filed. Art Director will contact artist for portfolio review if interested. Portfolio should include b&w and color final art, photographs, roughs and transparencies. Pays for design and illustration by the project. Buys all rights.

THE MULTIMEDIA INDEX preceding the General Index in the back of this book lists markets seeking freelancers with multimedia, CD-ROM skills.

D.A. DESIGN, INC., 8206 NW 105th Ave., Tamarac FL 33321. (305)726-4453. Fax: (305)726-1229. Contact: Albert Barry. Estab. 1984. Specializes in package design and graphic design for toy industry. Clients: toy and novelty manufacturers.
• Albert Barry has a special need for cartoons and humorous illustrations for toy package design. He will work with out-of-town artists.
Needs: Approached by 150 freelancers/year. Works with 8 freelance illustrators and 3 designers/year. Prefers freelancers with experience in packaging, cartoon and basic illustration. Works on assignment only. Uses freelance illustrators mainly for packaging and headers. Also uses freelancers for brochure and P-O-P design, mechanicals and airbrushing. 50% of design and 20% of illustration demand knowledge of QuarkXPress.
First Contact & Terms: Call for appointment to show portfolio. Send photocopies and résumé. Samples are filed. Art Director will contact artist for portfolio review if interested. Portfolio should include original/final art, tearsheets and comps. Pays for design and illustration by the hour, $10-15. Buys all rights. Finds artists through art schools and submissions.
Tips: Will have more need for computer-generated art in the future.

‡EXHIBIT BUILDERS INC., Dept. AM, 150 Wildwood Rd., Deland FL 32720. (904)734-3196. Fax: (904)734-9391. President: Penny D. Morford. Produces themed custom trade show exhibits and distributes modular and portable displays, and sales centers. Clients: museums, primarily manufacturers, government agencies, ad agencies, tourist attractions and trade show participants.
• Looking for freelance trade show designers.
Needs: Works on assignment only. Uses artists for exhibit/display design murals.
First Contact & Terms: Provide résumé, business card and brochure to be kept on file. Samples returned by SASE. Reports back for portfolio review. Considers complexity of project, skill and experience of artist, how work will be used, turnaround time and rights purchased when establishing payment.
Tips: "Wants to see examples of previous design work for other clients; not interested in seeing school-developed portfolios."

‡TOM GRABOSKI ASSOCIATES, INC., 3315 Rice St., Suite 11, Coconut Grove FL 33133. (305)445-2522. Fax: (305)445-5885. President: Tom Graboski. Estab. 1980. Specializes in exterior/interior signage, environmental graphics, corporate identity, publication design and print graphics. Clients: corporations, museums, a few ad agencies. Current clients include Universal Studios, Florida, Royal Caribbean Cruise Line and The Equity Group.
Needs: Approached by 50-80 freelance artists/year. Works with approximately 4-8 designers/mechanical artists/draftspersons/year. Prefers artists with a background in signage and knowledge of architecture. Freelance artists used in conjunction with signage projects, occasionally miscellaneous print graphics. 100% of design and 10% of illustration demand knowledge of Aldus PageMaker, Adobe Illustrator, QuarkXPress or Aldus FreeHand.
First Contact & Terms: Send query letter with brochure and résumé. "We will contact designer/artist to arrange appointment for portfolio review. Portfolio should be representative of artist's work and skills; presentation should be in a standard portfolio format." Pays for design, by the hour $15 minimum, or by the project. Pays for illustration by the project, $200 minimum. Rights purchased vary per project.
Tip: "Knowledge of environmental graphics, detailing, a plus."

‡KELLY & CO., GRAPHIC DESIGN, INC., Dept. AM, 7490 30 Ave. N., St. Petersburg FL 33710. (813)341-1009. Art Director: Ken Kelly. Estab. 1971. Specializes in print media design, logo design, corporate identity, ad campaigns, direct mail, brochures, publications, signage, architectural and technical illustrations. Clients: industrial, banking, auto, boating, real estate, accounting, furniture, travel and ad agencies. Majority of clients are real estate.
Needs: Works with 2 illustrators and 1 designer/year. Prefers artists with a minimum of 5 years of experience. "Local artists preferred. Must have a good working attitude." Uses artists for design, technical illustration, brochures, catalogs, magazines, newspapers, P-O-P displays, mechanicals, retouching, airbrushing, posters, model making, direct mail packages, charts/graphs, lettering and logos. 90% of design and 75% of illustration demand knowledge of Aldus PageMaker, QuarkXPress, Aldus FreeHand, Adobe Illustrator or "other programs."
First Contact & Terms: Send query letter with résumé, brochure and photocopies, or "copies of work showing versatility." Accepts submissions on Mac floppy or CD. Samples are filed. Reports back only if interested. Pays for design by the hour, $35-55. Pays for illustration by the hour, $65-95; by the day, $90-110. Buys all rights.
Tips: "Be highly talented in all areas with reasonable rates. Don't oversell yourself. Must be honest with a high degree of integrity and appreciation. Send clean, quality samples and résumé. I prefer to make the contact. Our need for freelancers has been reduced."

PRODUCTION INK, 2826 NE 19th Dr., Gainesville FL 32609. (352)377-8973. Fax: (352)373-1175. President: Terry Van Nortwick. Estab. 1979. Number of employees: 5. Specializes in publications, marketing, healthcare, engineering, development and ads. Professional affiliations: Public Relations Society of America,

Society of Professional Journalists, International Society of Professional Journalists, Gainesville Advertising Federation.

Needs: Works with 6-10 freelancers/year. Works on assignment only. Uses freelancers for brochure illustration, airbrushing and lettering. 80% of freelance work demands knowledge of Aldus PageMaker, Adobe Illustrator, QuarkXPress, Adobe Photoshop or Aldus FreeHand. Needs editorial, medical and technical illustration.

First Contact & Terms: Send résumé, samples, tearsheets, photostats, photocopies, slides and photography. Samples are filed or are returned if accompanied by SASE. Reports back only if interested. Call or write for appointment to show portfolio of original/final art. Pays for design and illustration by the project, $50-500. Rights purchased vary according to project.

Tips: "Check back with us regularly."

URBAN TAYLOR & ASSOCIATES, 12250 SW 131 Ave., Miami FL 33186. (305)255-7888. Fax: (305)256-7080. E-mail: urbantay@aol.com. Estab. 1976. Specializes in annual reports, corporate identity and communications and publication design. Current clients include University of Miami, Polaroid and Hughes Supply, Inc. Professional affiliation: AIGA.

Needs: Approached by 10 freelancers/year. Works with 1-2 freelance illustrators and 1-2 designers/year. Works with artist reps and local freelancers. Looking for a variety of editorial, technical and corporate communications illustration styles and freelancers with Mac experience. Works on assignment only. Uses illustrators mainly for brochures and publications. Also uses freelancers for lettering and charts/graphs. 100% of freelance work demands knowledge of QuarkXPress, Aldus FreeHand, Adobe Illustrator, Adobe Photoshop or Microsoft Word.

First Contact & Terms: Send query letter with SASE and appropriate samples. Samples are filed. Art Director will contact artist for portfolio review if interested. Pays for design by the project. "Payment depends on project and quantity printed." Rights purchased vary according to project. Finds artists through sourcebooks, direct mail pieces, referral from collegues, clients and reps.

Tips: "The field is completely technical—provide all illustrations on Mac compatible disk or CD-ROM.'"

Georgia

‡CRITT GRAHAM & ASSOCIATES, 2970 Clairmont Rd., Suite 850, Atlanta GA 30329. (404)320-1737. Fax: (404)320-1920. E-mail: cgaoffice@aol.com. Creative Director: Hal Smith. Estab. 1979. Specializes in design and production of annual reports, corporate magazines, capabilities brochures, identification systems and packaging, product literature, multi-media/interactive presentations and web pages. Clients: primarily major corporations; "9 are members of the Fortune 1000." Current clients include Coca-Cola, Eastman Chemical, Harris, Royal Caribbean Cruises, SunTrust Banks.

Needs: Works with 5-10 freelance illustrators/year. Also needs photographers, illustrators, typesetters and computer production designers. Also for multimedia projects. 100% of design and 75% of illustration requires computer skills. All design work is done internally.

First Contact & Terms: Designers send query letter with résumé and photocopies. Illustrators send postcard samples and tearsheets. Accepts submissions on disk compatible with Aldus FreeHand 5.5. Send EPS files. Samples are filed. Art Director will contact artist for portfolio review if interested. Pays for illustration by the project, depending on style. Considers buying second rights (reprint rights) to previously published work. Finds artists through word of mouth, magazines, artists' submissions/self-promotions, sourcebooks and agents.

Tips: "Price is always a consideration, also usage and sometimes buy-out. Try not to price yourself out of a job."

DAUER ASSOCIATES, 1134 Warren Hall Lane, Atlanta GA 30319. (404)252-0248. Fax: (404)252-1018. President/CEO: Thomas G. Dauer. Estab. 1978. Number of employees: 1. Specializes in annual reports, brand and corporate identity; display, direct mail, fashion, package and publication design; technical illustration and signage.

Needs: Approached by hundreds of freelancers/year. Uses freelancers for ad, brochure, catalog, poster and P-O-P design and illustration; airbrushing; audiovisual materials; charts/graphs; direct mail and magazine design; lettering; logos; mechanicals; and model making. Freelancers should be familiar with Adobe Illustrator, Adobe Photoshop, Aldus FreeHand, Aldus PageMaker and QuarkXPress.

First Contact & Terms: Send postcard sample of work or send brochure, photocopies, résumé, slides, tearsheets and transparencies. Samples are filed and are not returned. Request portfolio review in original query. Artist should follow-up with call. Art Director will contact artist for portfolio review if interested. Portfolio should include "work produced on a professional basis." Pays for design and illustration by the project. Rights purchased vary according to project.

Tips: "Be professional; be dedicated; be flexible. Learn how to make every art buyer who uses you once want to work with you again and again."

LEVY DESIGN INC., 1801 Piedmont Ave., #200, Atlanta GA 30324. (404)355-3292. Fax: (404)355-3621. E-mail: levydesah@aol.com. Contact: Art Director. Estab. 1989. Number of employees: 3. Specializes in annual reports; corporate identity; direct mail, package, publication and interactive design. Clients: Fortune 100-500 corporations. Professional affiliations: AIGA, IABC.
Needs: Approached by 100 freelancers/year. Works with 5 freelance illustrators and 5 designers/year. Prefers artists with experience in Macintosh programs. Uses illustrators mainly for corporate illustrations. Uses designers mainly for design and production. Also uses freelancers for ad, brochure and poster illustration; charts/graphs. 75% of freelance work demands knowledge of Adobe Illustrator, Adobe Photoshop and Quark-XPress.
First Contact & Terms: Send query letter with résumé and samples. Accepts disk submissions. Samples are filed. Art Director will contact artist for portfolio review if interested. Portfolio should include b&w and color photographs, photostats, roughs, slides, thumbnails or transparencies. Pays for design by the hour, $20-35. Pays for illustration by the project. Rights purchased vary according to project. Finds artists through samples sent by mail.
Tips: "Send interesting samples in a unique package—do not call—we call if interested."

LORENC DESIGN, INC., 724 Longleaf Dr. NE, Atlanta GA 30342-4307. (404)266-2711. President: Mr. Jan Lorenc. Specializes in architectural signage design; environmental, exhibit, furniture and industrial design. Clients: corporate, developers, product manufacturers, architects, real estate and institutions. Current clients include Gerald D. Hines Interests, MCI, Georgia-Pacific, IBM, Homart Development, HOH Associates. Client list available upon request.
Needs: Approached by 25 freelancers/year. Works with 5 illustrators and 10 designers/year. Local senior designers only. Uses freelancers for design, illustration, brochures, catalogs, books, P-O-P displays, mechanicals, retouching, airbrushing, posters, direct mail packages, model making, charts/graphs, AV materials, lettering and logos. Needs editorial and technical illustration. Especially needs architectural signage and exhibit designers. 95% of freelance work demands knowledge of QuarkXPress, Adobe Illustrator or Aldus FreeHand.
First Contact & Terms: Send brochure, résumé and samples to be kept on file. Prefers slides as samples. Samples are filed or are returned. Call or write for appointment to show portfolio of thumbnails, roughs, original/final art, final reproduction/product and color photostats and photographs. Pays for design by the hour, $10-50; by the project, $250-20,000; by the day, $80-400. Pays for illustration by the hour, $10-50; by the project, $100-2,000; by the day, $80-400. Considers complexity of project, client's budget, and skill and experience of artist when establishing payment.
Tips: "Sometimes it's more cost-effective to use freelancers in this economy, so we have scaled down permanent staff."

MURRELL DESIGN GROUP, 1280 W. Peachtree #120, Atlanta GA 30309. (404)892-5494. Fax: (404)874-6894. President: James Murrell. Estab. 1992. Number of employees: 12. Approximate annual billing: $500,000. Specializes in annual reports, brand and corporate identity, package and publication design and signage. Clients: ad agencies and corporations. Current clients include: ACOG, Coca-Cola, Delta. Professional affiliations: AIGA.
Needs: Approached by 100 freelancers/year. Works with 10 freelance illustrators and 25 designers/year. Uses illustrators mainly for high tech work. Uses designers mainly for package design. 75% of freelance work demands knowledge of Adobe Illustrator, Adobe Photoshop and QuarkXPress.
First Contact & Terms: Send postcard sample of work or send photographs, slides or transparencies and résumé. Send follow-up postcard every 6 months. Accepts disk submissions compatible with Adobe Illustrator 6.0. Samples are filed. Request portfolio review in original query. Art Director will contact artist for portfolio review if interested. Portfolio should include b&w and color photocopies and photographs. Pays by the project, $25 minimum. Pays for illustration by the hour, $15-40. Rights purchased vary according to project. Finds artists through sourcebooks, agents and submissions.
Tips: Looks for team players with flexible attitudes who are able to meet tight deadlines.

T-D DESIGN INC., 7007 Eagle Watch Court, Stone Mountain GA 30087. (770)413-8276. Fax: (770)413-9856. Creative Director: Charlie Palmer. Estab. 1991. Number of employees: 3. Approximate annual billing: $350,000. Specializes in brand identity, display, package and publication design. Clients: corporations. Current clients include Coca-Cola, Hanes, MLB.
Needs: Approached by 4 freelancers/year. Works with 2 freelance illustrators and 2 designers/year. Prefers local artists with Mac systems traditional background. Uses illustrators and designers mainly for comps and illustration on Mac. Also uses freelancers for ad, brochure, poster and P-O-P design and illustration; book design; charts/graphs; lettering; logos; mechanicals (important); and page layout. Also for multimedia projects. 75% of freelance work demands knowledge of Adobe Illustrator, Adobe Photoshop, Aldus FreeHand and QuarkXPress. "Knowledge of multimedia programs such as Director and Premier would also be desirable."
First Contact & Terms: Send query letter or photocopies, résumé and tearsheets. Accepts disk submissions compatible with Adobe Illustrator 5.5 or Aldus FreeHand. Samples are filed. Art Director will contact artist for portfolio review if interested. Portfolio should include b&w and color final art, roughs (important) and

thumbnails (important). Pays for design and illustration by the project. Rights purchased vary according to project. Finds artists through submissions and word of mouth.

Tips: "Be original, be creative and have a positive attitude. Need to show strength in illustration with a good design sense. A flair for typography would be desirable."

Hawaii

‡**ERIC WOO DESIGN, INC.**, 733 Bishop St., Suite 1280, Honolulu HI 96813. (808)545-7442. Fax: (808)545-7445. E-mail: woostuff@pixi.com. Principal: Eric. Estab. 1985. Number of employees: 1.5. Approximate annual billing: 300,000. Design firm. Specializes in image development, packaging, print. Specializes in state/corporate. Current clients include BHP Hawaii, State of Hawaii. Client list available upon request. Professional affiliations: AIGA Honolulu (Chapter President).

Needs: Approached by 5-10 illustrators and 10 designers/year. Works with 1-2 illustrators/year. Prefers freelancers with experience in multimedia. Uses freelancers mainly for multimedia projects and lettering. 5% of work is with print ads. 90% of design demands skills in Aldus PageMaker 6.0, Adobe Photoshop, Adobe Illustrator.

First Contact & Terms: Designers send query letter with brochure, photocopies, photographs, résumé, slides and tearsheets. Illustrators send postcard sample of work or query letter with brochure, photocopies, photographs, photostats, résumé, slides, tearsheets, transparencies. Send follow-up postcard samples every 1-2 months. Accepts submissions on disk in above software. Samples are filed. Does not report back. Artist should call. Will contact for portfolio review of final art, photographs, photostats, roughs, slides, tearsheets, thumbnails and transparencies. Pays for design by the hour, $10-50. Pays for illustration by the hour, $25-50. Rights purchased vary according to project.

Tips: "Flexibility is important."

Idaho

HENRY SCHMIDT DESIGN, 3141 Hillway Dr., Boise ID 83702. (208)385-0262. President: Henry Schmidt. Estab. 1976. Specializes in brand and corporate identity; package, brochure and catalog design. Clients: corporations. Current clients include Marinco-AFI, Colorado Leisure Sports, Global Theraputics and Swallowtail Corp. Client list available upon request.

Needs: Approached by 25 freelancers/year. Works with 1-5 freelance illustrators and 1-3 designers/year. Uses illustrators mainly for product illustration, board games. Uses designers mainly for overload. Also uses freelancers for brochure and catalog illustration. 100% of design and 50% of illustration demand knowledge of Aldus PageMaker, QuarkXPress, Adobe Illustrator and/or Adobe Photoshop.

First Contact & Terms: Send postcard sample or query letter with résumé, tearsheets and photocopies. Accepts disk submissions compatible with Adobe Illustrator 5.0. Send EPS files. Samples are filed. Reports back to the artist only if interested. Request portfolio review in original query. Artist should follow up. Portfolio should include b&w and color final art, tearsheets, photographs and transparencies. Pays for design by the hour, $20-40; by the project, $100-1,000. Pays for illustration by the project, $100-1,500. Rights purchased vary according to project.

Illinois

‡**BACKART DESIGN**, 239 Forest Ave., River Forest IL 60305-2005. Contact: Rudi Backart. Estab. 1980. Corporate identity and package design. Clients: corporations and agencies. Client list available upon request.

Needs: Approached by 50 freelance artists/year. Works with 4 illustrators and 2 designers/year. Works on assignment only. Uses illustrators mainly for brochure and packaging. Uses freelance designers mainly for mechanicals and lettering. Also for brochure illustration, mechanicals, lettering and ad illustration. 80% of design and 20% of illustration demand computer skills in Abode Illustrator 5.5, QuarkXPress or Adobe Photoshop. Needs editorial illustration.

First Contact & Terms: Send query letter with tearsheets and photocopies. Accepts disk submissions. Samples are filed. Does not report back, in which case the artist should call occasionally. Call to schedule an appointment to show a portfolio which should include roughs, original/final art, tearsheets and photographs. Pays by the project, $500-10,000 for design; $200-3,000 for illustration. Rights purchased vary according to project.

‡**BEDA DESIGN**, 26179 Tarvin Lane, Ingleside IL 60041. Phone/fax: (847)973-1719. President: Lynn Beda. Estab. 1971. Number of employees: 2-3. Approximate annual billing: $250,000. Design firm. Special-

izes in collateral, P.O.P., publishing. Product specialties are food and auto industries. Current clients include business to business accounts. Client list available upon request.

Needs: Approached by 6-12 illustrators and 6-12 designers/year. Works with 6 illustrators and 6 designers/year. Prefers local freelancers. Also for retouching, technical illustration and production. 50% of work is with print ads. 75% of design demands skills in Adobe Photoshop, QuarkXPress 3.3, Adobe Illustrator.

First Contact & Terms: Designers send query letter with brochure, photocopies and résumé. Illustrators send postcard samples and/or photocopies. Samples are filed and are not returned. Will contact for portfolio review if interested. Pays $250-1,000. Buys all rights. Finds artists through word of mouth.

BENTKOVER'S DESIGN & MORE, 1222 Cavell, Suite 3C, Highland Park IL 60035. (847)831-4437. Fax: (847)831-4462. Creative Director: Burt Bentkover. Estab. 1989. Number of employees: 2. Approximate annual billing: $100,000. Specializes in annual reports; corporate, package and publication design. Clients: advertising, business-to-business, food, retail promo.

Needs: Works with 3 freelance illustrators/year. Works with artist reps. Prefers local artists only. Uses freelancers for ad and brochure illustration, airbrushing, lettering, mechanicals, retouching and desk top mechanicals. 80% of freelance work demands computer skills.

First Contact & Terms: Send brochure, photocopies and tearsheets. No original art—only disposable copies. Samples are filed. Reports back in 1 week if interested. Request portfolio review in original query. Art Director will contact artist for portfolio review if interested. Portfolio should include b&w and color photocopies. "No final art or photographs." Pays for design and illustration by the project. Rights purchased vary according to project. Finds artists through sourcebooks and agents.

CHICAGO COMPUTER AND LIGHT, INC., 5001 N. Lowell Ave., Chicago IL 60630-2610. (312)283-2749. Fax: (312)283-9972. E-mail: ccl@wwa.com. President: Larry Feit. Estab. 1987. Number of employees: 3. Approximate annual billing: $200,000. Multi-faceted advertising, marketing, design and manufacturing corporation. Product specialty is consumer.

Needs: Approached by 12 illustrators and 12 designers/year. Works with 4 illustrators and 5 designers/year. Uses freelancers mainly for billboards, brochure design and illustration, catalog design and illustration, logos, mechanicals, posters, retouching, signage, web page design. 70% of freelance work demands computer skills.

First Contact & Terms: Send query letter with tearsheets and/or samples. Accepts 3.5″ disk submissions in any viewable IBM format. Samples are filed and are not returned. Will contact for portfolio review of color tearsheets, thumbnails, transparencies if interested. Pays by the project, $30-3,500. Rights purchased vary according to project.

Tips: Looking for simple design that leaves a lasting impression. Likes Rockwell-type illustrations.

‡**CONDON NORMAN DESIGN**, 11 W. Main St., #300, Carpentersville IL 60110. (312)226-3646. Creative Director: Phylane Norman. Estab. 1984. Specializes in display design, direct mail design, package design and publication design. Clients: corporations and manufacturers.

Needs: Approached by 75-100 freelance artists/year. Works with college interns and 10 freelance designers/year. Prefers local artists only. Prefers artists with experience with Macintosh computers. Works on assignment only. Uses freelance illustrators mainly for collateral material, comps and marker rendering. Uses freelance designers mainly for package and publication design. Also uses freelance artists for brochure design and illustration, catalog design, mechanicals, airbrushing, lettering, logos, ad design, P-O-P design and illustration, and direct mail design.

First Contact & Terms: Send query letter with brochure, tearsheets and résumé. Samples are filed. Reports back to the artist only if interested. Call to schedule an appointment to show a portfolio. Portfolio should include thumbnails, roughs and original/final art. Pays for design by the hour, project or day. Pays for illustration by the project. Negotiates rights purchased.

DESIGN ASSOCIATES, 6117 N. Winthrop Ave., Chicago IL 60660. (312)338-4196. Fax: (312)338-4197. Contact: Paul Uhl. Estab. 1986. Number of employees: 2. Specializes in annual reports, corporate identity, packaging, website development and publication design. Clients: corporations, publishers and museums. Client list available upon request.

Needs: Approached by 5-10 freelancers/year. Works with 100 freelance illustrators and 5 designers/year. Uses freelancers for book design; brochure, catalog and poster design and illustration; charts/graphs; lettering; logos; and retouching. 100% of freelance work demands knowledge of Adobe Illustrator 5.5, Adobe Photoshop 3.0 and QuarkXPress 3.31.

First Contact & Terms: Send query letter with samples that best represent work. Accepts disk submissions. Samples are filed. Art Director will contact artist for portfolio review if interested. Portfolio should include b&w and color samples. Pays for design by the hour and by the project. Pays for illustration by the project. Buys all rights. Finds artists through sourcebooks, reps and word of mouth.

DESIGN MOVES, LTD., 1073 Gage St., #3, Chicago IL 60093. (708)441-6996. Fax: (708)441-6998. Principal: Laurie Medeiros Freed. Estab. 1988. Number of employees: 2. Specializes in publication, brochure and logo design; annual reports; and direct mail. Clients: corporations, financial institutions, marketing

agencies, hospitals and associations. Current clients include Allstate Insurance, Humana Healthcare, Microsoft Corp. and the American Fund for Dental Health. Professional affiliations: AIGA, GAG, WID, ACD, NAWBO.

Needs: Approached by 5-10 freelancers/year. Works with 3-5 freelance illustrators and 1-3 designers/year. Works on assignment only. Uses freelance designers mainly for brochures and comping existing designs. Also uses freelancers for lettering, poster illustration and design, direct mail design and charts/graphs. 100% of freelance work demands knowledge of Adobe Illustrator, QuarkXPress and Adobe Photoshop. Needs editorial and medical illustration.

First Contact & Terms: Send query letter with brochure, résumé and tearsheets. Samples are filed or are returned by SASE if requested. Request portfolio review in original query. Reports back to the artist only if interested. Portfolio should include thumbnails, tearsheets, photographs and transparencies. Pays for design by the hour, $15-25. Pays for illustration by the project, $50-500. Rights purchased vary according to project.

HIRSCH O'CONNOR DESIGN INC., 205 W. Wacker Dr., Suite 622, Chicago IL 60606. (312)329-1500. President: David Hirsch. Number of employees: 11. Specializes in annual reports, corporate identity, publications and promotional literature. Clients: manufacturing, PR, real estate, financial and industrial firms. Professional affiliations: American Center for Design, AIGA and IABC.

Needs: Approached by more than 100 freelancers/year. Works with 6-10 freelance illustrators and 4-8 designers/year. Uses freelancers for design, illustration, brochures, retouching, airbrushing, AV materials, lettering, logos and photography. Freelancers should be familiar with Adobe Photoshop and Adobe Illustrator.

First Contact & Terms: Send query letter with promotional materials showing art style or samples. Samples not filed are returned by SASE. Reports back only if interested. Call for appointment to show portfolio of roughs, final reproduction/product, tearsheets and photographs. Pays for design and illustration by the project. Considers complexity of project, client's budget and how work will be used when establishing payment. Interested in buying second rights (reprint rights) to previously published work. Finds artists primarly through source books and self-promotions.

Tips: "We're always looking for talent at fair prices."

HUTCHINSON ASSOCIATES, INC., 1147 W. Ohio, Suite 305, Chicago IL 60622. (312)455-9191. Fax: (312)455-9190. E-mail: hutch@hutchinson.com. Website: http://www.hutchinson.com. Contact: Jerry Hutchinson. Estab. 1988. Number of employees: 3. Specializes in annual reports, corporate identity, multimedia, direct mail, publication design and web page design. Clients: corporations, associations and PR firms. Professional affiliations: AIGA, ACD.

Needs: Approached by 5-10 freelancers/year. Works with 3-10 freelance illustrators and 5-15 designers/year. Uses freelancers mainly for brochure design and illustration and annual reports. Also uses freelancers for ad and direct mail design, catalog illustration, charts/graphs, logos and mechanicals. Also for multimedia projects. 80% of design and 50% of illustration demand knowledge of Adobe Illustrator 5.5, Adobe Photoshop 3.0, Aldus PageMaker and QuarkXPress 3.3.

First Contact & Terms: Send postcard sample of work or send query letter with résumé, brochure, photocopies and photographs. Accepts disk submissions compatible with Adobe Illustrator and Director. Samples are filed. Request portfolio review in original query. Artist should folow-up with call. Art Director will contact artist for portfolio review if interested. Portfolio should include transparencies and printed pieces. Pays by the project, $100-10,000. Rights purchased vary according to project. Finds artists through *Creative Illustration, Workbook*, Chicago sourcebooks, Illinois reps, submissions.

Tips: "Persistence pays off."

IDENTITY CENTER, 1340 Remington Rd, Suite S, Schaumburg IL 60173. President: Wayne Kosterman. Number of employees: 3. Approximate annual billing: $250,000. Specializes in brand and corporate identity, print communications and signage. Clients: corporations, hospitals, manufacturers and banks. Professional affiliations: AIGA, American Center for Design, SEGD.

Needs: Approached by 40-50 freelancers/year. Works with 4 freelance illustrators and 4 designers/year. Prefers 3-5 years of experience minimum. Uses freelancers for editorial and technical illustration, mechanicals, retouching and lettering. 50% of freelance work demands knowledge of QuarkXPress and Adobe Illustrator.

First Contact & Terms: Send résumé and photocopies. Samples are filed or are returned. Reports back within 1 week. To show a portfolio, mail photostats and photographs. Pays for design by the hour, $12-35. Pays for illustration by the project, $200-5,000. Considers client's budget, skill and experience of artist and how work will be used when establishing payment. Rights purchased vary according to project.

Tips: "Not interested in amateurs or 'part-timers.' "

‡INNOVATIVE DESIGN & GRAPHICS, 1234 Sherman Ave., Suite 214, Evanston IL 60202-1375. (708)475-7772. Contact: Tim Sonder. Clients: magazine publishers, corporate communication departments, associations.

Needs: Works with 3-15 freelance artists/year. Prefers local artists only. Uses artists for editorial and technical illustration and desktop (CorelDraw, Aldus FreeHand, Adobe Illustrator).

First Contact & Terms: Send query letter with résumé or brochure showing art style, tearsheets, photostats, slides and photographs. Art Director will contact artist for portfolio review if interested. Pays for illustration by the project, $100-700 average. Considers complexity of project, client's budget and turnaround time when establishing payment. Interested in buying second rights (reprint rights) to previously published work.

Tips: "Interested in meeting new illustrators, but have a tight schedule. Looking for people who can grasp complex ideas and turn them into high-quality illustrations. Ability to draw people well is a must. Do not call for an appointment to show your portfolio. Send non-returnable tearsheets or self-promos, and we will call you when we have an appropriate project for you."

‡LESIAK/CRAMPTON DESIGN INC., 1030 Busse Way, Park Ridge IL 60068. (847)692-6688. Fax: (847)692-6693. President: Lucy. Specializes in book design. Clients: educational publishers. Current clients include Harper Collins Publishers, Scott Foresman, Richard D. Irwin, National Text Book, South-Western Publishing, Wm. C. Brown, Mosby-Year Book. Client list available upon request.

Needs: Approached by 20 freelance artists/year. Works with 5-10 illustrators and 2-3 designers/year. Works on assignment only. Uses illustrators mainly for story or cover illustration, also editorial, technical and medical illustration. Uses designers mainly for text design. Also for book design, mechanicals and logos. 100% of design work demands knowledge of QuarkXPress, Adobe Illustrator or Adobe Photoshop.

First Contact & Terms: Send postcard sample or query letter with photocopies, brochure and résumé. Accepts disk submissions compatible with Mac Adobe Illustrator 5.0 and QuarkXPress 3.3. Samples are filed. Art Director will contact artist for portfolio review if interested. Portfolio should include final art, color tearsheets and transparencies. Pays for design by the hour, $30-50. Pays for illustration by the project, $30-3,000. Rights purchased vary according to project. Finds artists through agents, sourcebooks and self-promotions.

QUALLY & COMPANY INC., 2238 Central St., Suite 3, Evanston IL 60201-1457. (708)864-6316. Creative Director: Robert Qually. Specializes in integrated marketing/communication and new product development. Clients: major corporations.

Needs: Works with 20-25 freelancers/year. "Freelancers must have talent and the right attitude." Works on assignment only. Uses freelancers for design, illustration, mechanicals, retouching, lettering and computer graphics.

First Contact & Terms: Send query letter with brochure, résumé, business card and samples. Samples not filed are returned by SASE. Reports back within several days. Call or write for appointment to show portfolio.

Tips: Looking for "talent, point of view, style, craftsmanship, depth and innovation" in portfolio or samples. Sees "too many look-alikes, very little innovation."

TESSING DESIGN, INC., 3822 N. Seeley Ave., Chicago IL 60618. (312)525-7704. Fax: (312)525-7756. Principals: Arvid V. Tessing and Louise S. Tessing. Estab. 1975. Number of employees: 2. Specializes in corporate identity, marketing promotions and publications. Clients: publishers, educational institutions and nonprofit groups. Majority of clients are publishers. Professional affiliation: Women in Design.

Needs: Approached by 30-80 freelancers/year. Works with 5 freelance illustrators and 2 designers/year. Works on assignment only. Uses freelancers mainly for publications. Also for book and magazine design and illustration, mechanicals, retouching, airbrushing, charts/graphs and lettering. 90% of design and 75% of illustration demand knowledge of QuarkXPress, Adobe Photoshop or Adobe Illustrator. Needs textbook, editorial and technical illustration.

First Contact & Terms: Designers send query letter with photocopies. Illustrators send postcard samples. Samples are filed or are not returned. Request portfolio review in original query. Artist should follow up with letter after initial query. Art Director will contact artist for portfolio review if interested. Portfolio should include original/final art, final reproduction/product and photographs. Pays for design by the hour, $40-60. Pays for illustration by the project, $100 minimum. Rights purchased vary according to project. Finds artists through word of mouth, submissions/self-promotions and sourcebooks.

Tips: "We prefer to see original work or slides as samples. Work sent should always relate to the need expressed. Our advice for artists to break into the field is as always—call prospective clients, show work and follow up."

‡ **THE DOUBLE DAGGER** before a listing indicates that the listing is new in this edition. New markets are often more receptive to freelance submissions.

Indiana

HEIDEMAN DESIGN, 9301 Brunson Run, Indianapolis IN 46256. (317)845-4064. E-mail: heideman@ surf-ici.com. Contact: Mark Heideman. Estab. 1985. Specializes in display, direct mail, package and publication design, annual reports, brand and corporate identity, signage, technical illustration, vehicle graphics and web page design. Clients: technical and industrial.
Needs: Works with 2-3 freelance illustrators and 2-3 designers/year. Works on assignment only. Uses freelancers for marker comps, brochure, catalog, P-O-P, and poster illustration. 100% of design demands knowledge of Adobe Illustrator, Adobe Dimensions, QuarkXPress or Adobe Photoshop. Needs editorial and illustration.
First Contact & Terms: Send postcard sample or query letter with brochure, résumé, photocopies and tearsheets. Accepts disk submissions. Send EPS files. Samples are filed. Art Director will contact artist for portfolio review if interested. Portfolio should include thumbnails, roughs and tearsheets. Pays for design by the project, $100 minimum. Pays for illustration by the project, $100-2,000. Considers client's budget, skill and experience of artist and turnaround time when establishing payment. rights purchased vary according to project.

JMH CORPORATION, 921 E. 66th St., Indianapolis IN 46220. (317)255-3400. President: J. Michael Hayes. Number of employees: 3. Specializes in annual reports, corporate identity, advertising, collateral, packaging and publications. Clients: publishers, consumer product manufacturers, corporations and institutions. Professional affiliations: AIGA.
Needs: Approached by 30-40 freelancers/year. Works with 5 freelance illustrators and 2 designers/year. Prefers experienced, talented and responsible artists only. Works on assignment only. Uses artists for advertising, brochure and catalog design and illustration; P-O-P displays; mechanicals; retouching; charts/graphs and lettering. Needs editorial and medical illustration. 100% of design and 30% of illustration demand knowledge of QuarkXPress, Adobe Illustrator or Adobe Photoshop (latest versions).
First Contact & Terms: Send query letter with brochure/flyer, résumé, photocopies, photographs, tearsheets and slides. Accepts disk submissions compatible with QuarkXPress 3.11 and Adobe Illustrator 5.0. Send EPS files. Samples returned by SASE, "but we prefer to keep them." Reporting time "depends entirely on our needs." Write for appointment to show portfolio. Pays for design by the hour, $15-40. Pays for illustration by the project, $300-2,000.
Tips: "Prepare an outstanding mailing piece and 'leave-behind' that allows work to remain on file. Our need for freelance artists has diminished. Keep doing great work and stay in touch."

Kansas

‡GRETEMAN GROUP, 142 N. Mosley, 3rd Floor, Wichita KS 67202-4617. (316)263-1004. Fax: (316)263-1060. E-mail: greteman@frl.net. Owner: Sonia Greteman. Estab. 1989. Number of employees: 7. Approximate annual billing: $1.3 million. Design firm. Specializes in corporate identity, annual reports, brochures, collateral. Professional affiliations: AIGA.
Needs: Approached by 2 illustrators and 10-20 designers/year. Works with 2 illustrators and 2 designers/ year. Also for brochure illustration. 10% of work is with print ads. 100% of design demands skills in Aldus PageMaker, Aldus FreeHand, Adobe Photoshop, QuarkXPress, Adobe Illustrator. 30% of illustration demands computer skills.
First Contact & Terms: Send query letter with brochure and résumé. Accepts disk submissions. Send EPS files. Samples are filed. Will contact for portfolio review of b&w and color final art and photostats if interested. Pays for design by the hour. Pays for illustration by the project. Rights purchased vary according to project.

Kentucky

DESIGN ELEMENTS, INC., 201 W. Short, Suite 702, Lexington KY 40508. (606)252-4468. President: C. Conde. Estab. 1979. Specializes in corporate identity, package and publication design. "Work directly with end user (commercial accounts)."
Needs: Approached by 6-8 freelancers/year. Works with 2-3 freelance illustrators and designers/year. Works on assignment only. Uses freelancers for brochure and P-O-P design and illustration, mechanicals, airbrushing, poster design, lettering and logos. 100% of freelance work demands knowledge of QuarkXPress or Adobe Illustrator 5.0.
First Contact & Terms: Send query letter with brochure, résumé, tearsheets and slides. Accepts disk submissions. "Disk must come with their own 'projector' or use programs such as Adobe Illustrator 5.0,

Hire a good business manager for your studio.

Just $34.99
Plus a signing bonus!

yes ORDER FORM

Start my 1-year subscription to HOW and send me the next 6 issues for just $34.99...a savings of more than $23 off the newsstand price. Upon payment, send my free copy of **What They Don't Teach You in Design School 2.**

❑ Payment enclosed ❑ Bill me Charge my ❑ Visa ❑ Mastercard

Signature _____

Acct. # _____ Exp. _____ / _____

NAME _____

COMPANY _____

JOB TITLE _____

ADDRESS _____

CITY _____ STATE _____ ZIP_____

IMPORTANT! Please take a moment to complete the following information.

My company is best described as: (choose one)
1 ❑ Advertising agency 3 ❑ Design studio
4 ❑ Graphic arts vendor 2 ❑ Company
7 ❑ Educational institution
63 ❑ Other (specify) _____

My job title/occupation is: (choose one)
16 ❑ Owner/management 22 ❑ Creative director 12 ❑ Art director /designer
13 ❑ Advertising/marketing staff
25 ❑ Instructor 19 ❑ Student
63 ❑ Other (specify) _____

* In Canada add $15 (includes GST); overseas, add $22; airmail, add $65. Remit in U.S. funds. Allow 4-6 weeks for first issue delivery. Annual newsstand rate $58.75.

TTAM2-HOW

QuarkXPress, etc." Samples are filed or are returned if requested by artist. Reports back only if interested. Call or write for appointment to show portfolio. Pays by the hour, $25 minimum. Considers complexity of project, client's budget and skill and experience of artist when establishing payment. Buys all rights.
Tips: "Freelancers need to be more selective about portfolio samples—show items actually done by person presenting, or explain why not. Send résumé and samples of work first."

HAMMOND DESIGN ASSOCIATES, INC., 206 W. Main, Lexington KY 40507. (606)259-3639. Fax: (606)259-3697. Vice-President: Mrs. Kelly Johns. Estab. 1986. Specializes in direct mail, package and publication design and annual reports, brand and corporate identity, display and signage. Clients: corporations, universities and medical facilities.
Needs: Approached by 35-50 freelance/year. Works with 5-7 illustrators and 5-7 designers/year. Works on assignment only. Uses freelancers mainly for brochures and ads. Also for editorial, technical and medical illustration; airbrushing; lettering; P-O-P and poster illustration; and charts/graphs. 100% of design and 50% of illustration require computer skills.
First Contact & Terms: Send postcard sample or query letter with brochure or résumé. "Sample in query letter a must." Samples are filed or returned by SASE if requested by artist. Reports back only if interested. Art Director will contact artist for portfolio review if interested. Sometimes requests work on spec before assigning job. Pays by the project, $100-10,000. Rights negotiable.

Louisiana

ANTHONY DI MARCO, 2948½ Grand Route St. John, New Orleans LA 70119. (504)948-3128. Creative Director: Anthony Di Marco. Estab. 1972. Number of employees: 1. Specializes in illustration, sculpture, costume design and art photo restoration and retouching. Current clients include Audubon Institute, Louisiana Nature and Science Center, City of New Orleans, churches, agencies. Client list available upon request. Professional affiliations: Art Directors, Designers Association; Energy Arts Council; Louisiana Crafts Council; Louisiana Alliance for Conservation of Arts.
Needs: Approached by 50 or more freelancers/year. Works with 5-10 freelance illustrators and 5-10 designers/year. Seeks "local freelancers with ambition. Freelancers should have substantial portfolios and an understanding of business requirements." Uses freelancers mainly for fill-in and finish: design, illustration, mechanicals, retouching, airbrushing, posters, model making, charts/graphs. Prefers highly polished, finished art in pen & ink, airbrush, charcoal/pencil, colored pencil, watercolor, acrylic, oil, pastel, collage and marker. 25% of freelance work demands computer skills.
First Contact & Terms: Send query letter with résumé, business card, slides, brochure, photocopies, photographs, transparencies and tearsheets to be kept on file. Samples not filed are returned by SASE. Reports back within 1 week if interested. Call or write for appointment to show portfolio. Pays for illustration by the hour; by the project, $100 minimum.
Tips: "Keep professionalism in mind at all times. Put forth your best effort. Apologizing for imperfect work is a common mistake freelancers make when presenting a portfolio. Include prices for completed works (avoid overpricing). 3-dimensional works comprise more of our total commissions than before."

Maryland

ANDERSON DESIGN, INC., 18952 Bonanza Way, Gaithersburg MD 20879. (301)948-0007. Fax: (301)670-6728. Principal: Christopher Anderson. Estab. 1987. Number of employees: 2. Specializes in corporate identity; display, publication, lighting design and signage. Clients: corporations, medical institutions, research firms and architectural firms.
Needs: Works with 6 freelance illustrators and 12 designers/year. Uses illustrators mainly for architectural renderings, medical illustrations. Uses designers mainly for computer-aided design for publications. Also uses freelancers for ad and brochure design and illustration; book, magazine and newspaper design; lettering; and mechanicals. 90% of design and 75% of illustration demand knowledge of Adobe Illustrator 6.0, Adobe Photoshop 3.0, Aldus FreeHand 5.5 and QuarkXPress 3.2.
First Contact & Terms: Send postcard sample of work or send query letter with résumé and tearsheets. Accepts non-returnable disk submissions compatible with Adobe Photoshop or Adobe Illustrator. Send EPS files. Samples are filed and are not returned. Reports back within 2 months. Art Director will contact artist for portfolio review if interested. Portfolio should include "media presentation that best represents the artist's style." Payment for design and illustration "depends on the situation and the artist expensive." Rights purchased vary according to project. Finds artists through interviewing, samples send by mail and referrals.
Tips: Impressed by "a clear, easy-to-interpret résumé, and a portfolio which reflects the creative idealogy of the artist or designer."

DEVER DESIGNS, INC., 9101 Cherry Lane, Suite 102, Laurel MD 20708. (301)776-2812. Fax: (301)953-1196. President: Jeffrey Dever. Estab. 1985. Number of employees: 5. Approximate annual billing: $300,000. Specializes in annual reports, brand and corporate identity, package and publication design. Clients: corporations, museums, government agencies, associations, nonprofit organizations. Current clients include Population Reference Bureau, University of Maryland, McGraw-Hill, National Gallery of Art, The National Museum of Women in the Arts, Washington Post. Client list available upon request.
Needs: Approached by 5-10 freelancers/year. Works with 10-20 freelance illustrators and 1-2 designers/year. Prefers artists with experience in editorial illustration. Uses illustrators mainly for publications. Uses designers mainly for on-site help when there is a heavy workload. Also uses freelancers for brochure illustration, charts/graphs and in-house production. 100% of design and 50% of illustration demand knowledge of QuarkXPress 3.2.
First Contact & Terms: Send postcard sample or query letter with photocopies, résumé and tearsheets. Accepts disk submissions compatible with Adobe Illustrator or QuarkXPress. Samples are filed. Art Director will contact artist for portfolio review if interested. Portfolio should include b&w and color photocopies for files. Pays for design and illustration by the project. Rights purchased vary according to project. Finds artists through referrals.
Tips: Impressed by "uniqueness and tenacity."

‡PICCIRILLI GROUP, 502 Rock Spring Rd., Bel Air MD 21014. (410)879-6780. Fax: (410)879-6602. E-mail: info@picgroup.com. Website: www.picgroup.com. President: Charles Piccirilli. Art Director: Micah Piccirilli. Estab. 1974. Specializes in design and advertising; also annual reports, advertising campaigns, direct mail, brand and corporate identity, displays, packaging, publications and signage. Clients: recreational sport industries, fleet leasing companies, technical product manufacturers, commercial packaging corporations, direct mail advertising firms, realty companies, banks, publishers and software companies.
Needs: Works with 4 freelance designers/year. Works on assignment only. Mainly uses freelancers for layout or production. Prefers local freelancers. 75% of design demands knowledge of Adobe Illustrator 5.5 and QuarkXPress 3.3.
First Contact & Terms: Send query letter with brochure, résumé and tearsheets; prefers originals as samples. Samples returned by SASE. Reports on whether to expect possible future assignments. To show a portfolio, mail roughs and finished art samples or call for an appointment. Pays for design and illustration by the hour, $20-45. Considers complexity of project, client's budget, and skill and experience of artist when establishing payment. Buys one-time or reprint rights; rights purchased vary according to project.
Tips: "Portfolios should include work from previous assignments. The most common mistake freelancers make is not being professional with their presentations. Send a cover letter with photocopies of work."

SPIRIT CREATIVE SERVICES INC., 412 Halsey Rd., Annapolis MD 21401. (410)974-9377. Fax: (410)974-8290. President: Alice Yeager. Estab. 1992. Number of employees: 1. Approximate annual billing: $90,000. Specializes in annual reports; brand and corporate identity; display, direct mail, package and publication design; web page design; technical and general illustration; signage. Clients: government associations, corporations. Client list available upon request.
Needs: Approached by 5-10 freelancers/year. Works with 3-4 freelance illustrators and 4-5 designers/year. Prefers local designers. Uses freelancers for ad, brochure, catalog, poster and P-O-P design and illustration; book direct mail and magazine design; audiovisual materials; crafts/graphs; lettering; logos; mechanicals. Also for multimedia projects. 100% of design and 10% of illustration demand knowledge of Adobe Illustrator, Adobe Photoshop, Aldus FreeHand, Adobe PageMaker and QuarkXPress.
First Contact & Terms: Send postcard sample of work or send query letter with brochure, photocopies, résumé, SASE and tearsheets. Accepts disk submissions compatible with Adobe Illustrator 5.0 or 5.5. Send EPS files. Samples are filed. Reports back within 1-2 weeks if interested. Request portfolio review in original query. Artist should follow-up with call and/or letter after initial query. Portfolio should include b&w and color final art, tearsheets, sample of comping ability. Pays for design and illustration by the project. Rights purchased vary according to project.
Tips: "Paying attention to synchronicity and intuition is vital."

Massachusetts

RICHARD BERTUCCI/GRAPHIC COMMUNICATIONS, 3 Juniper Lane, Dover MA 02030-2146. (508)785-1301. Fax: (506)785-2072. Owner: Richard Bertucci. Estab. 1970. Number of employees: 2. Approximate annual billing: $1 million. Specializes in annual reports; corporate identity; display, direct mail, package design, print advertising, collateral material. Clients: companies and corporations. Professional affiliations: AIGA.
Needs: Approached by 12-24 freelancers/year. Works with 6 freelance illustrators and 3 designers/year. Prefers local artists with experience in business-to-business advertising. Uses illustrators mainly for feature products. Uses designers mainly for fill-in projects, new promotions. Also uses freelancers for ad, brochure

and catalog design and illustration; airbrushing; direct mail, magazine and newpaper design; logos; and mechanicals. 50% of design and 25% of illustration demand knowledge of Aldus FreeHand, Adobe Illustrator, CorelDraw and QuarkXPress.

First Contact & Terms: Send postcard sample of work or send query letter with brochure and résumé. Samples are filed. Art Director will contact artist for portfolio review if interested. Portfolio should include b&w and color roughs. Pays for design by the project, $500-5,000. Pays for illustration by the project, $250-2,500. Rights purchased vary according to project.

Tips: "Send more information, not just postcard with no written information."

‡**SIDNEY A. BOGUSS & ASSOC., INC.**, (The Creative Center), 44 Garden St., Danvers MA 01923. (508)777-3500. Fax: (508)777-2154. President: Sidney A. Boguss. Vice President: Carrie A. Lavoie. Design Director: Phil Parisi. Estab. 1957. Specializes in brand and corporate identity, display and package design and collateral materials. Clients: manufacturers, corporations. Client list available upon request.

Needs: Approached by 10 freelance artists/year. Works with 3 freelance illustrators and 6 freelance designers/year. Prefers artists with experience in packaging design and art production. Prefers designers who can work on premises. Works on assignment only. Uses freelance illustrators mainly for instructional drawings and product-in-use drawings. Uses freelance designers mainly for comprehensive mock-ups, mechanical art, refinement and development layouts, line extension layouts. Also uses freelance artists for brochure design and illustration, catalog design and illustration, retouching, airbrushing, lettering, logos, and P-O-P design and illustration. Needs editorial and instructional illustration. 75% of freelance work demands knowledge of Adobe Illustrator, QuarkXPress and Adobe Photoshop.

First Contact & Terms: Send query letter with brochure, tearsheets, photostats, résumé and photocopies. Accepts disk submissions. Samples are filed. Portfolio should include thumbnails, roughs, original/final art, tearsheets and slides. Pays for production by the hour, $15-18. Pay for design determined by complexity of project and skill and experience of the individual. Rights purchased vary according to project.

Tips: "Although there is less need for freelancers overall, there is more need per project. Strong typographic skills are positive."

FLAGLER ADVERTISING/GRAPHIC DESIGN, Box 280, Brookline MA 02146. (617)566-6971. Fax: (617)566-0073. President/Creative Director: Sheri Flagler. Specializes in corporate identity, brochure design, ad campaigns and technical illustration. Clients: cable television, finance, real estate, high-tech and direct mail agencies, infant/toddler manufacturers.

Needs: Works with 10-20 freelancers/year. Works on assignment only. Uses freelancers for illustration, mechanicals, retouching, airbrushing, charts/graphs and lettering.

First Contact & Terms: Send résumé, business card, brochures, photocopies or tearsheets to be kept on file. Call or write for appointment to show portfolio. Samples not filed are not returned. Reports back only if interested. Pays for design and illustration by the project, $150-2,500. Considers complexity of project, client's budget and turnaround time when establishing payment.

Tips: "Send a range and variety of styles showing clean, crisp and professional work."

‡**HAYWOOD & SULLIVAN**, 1354 Hancock St., Suite 306, Quincy MA 02169. (617)471-1144. Fax: (617)471-0202. E-mail: liz@hsdesign.com. Website: http://hsdesign.com. President: Liz Haywood. Creative Director: Michael Sullivan. Estab. 1986. Number of employees: 4. Design firm. Specializes in interactive multimedia, collateral and packaging. Product specialty high technology. Client list available upon request. Professional affiliations: AIGA, GAG.

Needs: Approached by 70 designers/year. Works with 12 designers/year. Prefers local designers. Uses freelancers mainly for design and production. Also for collateral design and corporate identity, CD-ROM, multimedia projects, webpage design. 2% of work is with print ads. 100% of design demands skills in Aldus PageMaker 6.0, Aldus FreeHand 5.5, Adobe Photoshop 3.0, QuarkXPress 3.3.1, Adobe Illustrator 6.0.

First Contact & Terms: Send query letter with photocopies, résumé, tearsheets, URL. Send postcard sample and follow-up postcards every 6 months. Accepts disk submissions. Call first. Samples are filed or returned by SASE. Follow up with call or letter. Will contact for portfolio review of b&w and color final art, photographs, tearsheets if interested. Pays for design by the hour or by the project depending on project and skill level. Pays for illustration by the project. Negotiates rights purchased. Finds artists through word of mouth or "designers contacting us—a lot of e-mail with URLs."

Tips: "Know your software! Understanding of typography, balance, color, imperative. We are willing to work with dedicated junior designers—willing to learn and take direction. We are also interested in interns (we will pay at least minimum wage)."

ICONS, 76 Elm St., Suite 313, Boston MA 02130. Phone/fax: (617)522-0165. E-mail: 75573.3077@compuserve.com. Principal: Glenn Johnson. Estab. 1985. Number of employees: 1. Approximate annual billing: $100,000. Specializes in annual reports, brand and corporate identity, direct mail and package design. Clients: high tech and retail restaurants. Current clients include Lotus Corp., Vicki Boyajain. Client list available upon request.

Needs: Approached by 20 freelancers/year. Works with 6 freelance illustrators and 6 designers/year. Uses illustrators mainly for brochures. Uses designers mainly for concept and mechanical. Also uses freelancers for ad design and illustration, brochure design, lettering and logos. 100% of design work demands knowledge of Adobe Illustrator, Adobe Photoshop, Aldus FreeHand and QuarkXPress.

First Contact & Terms: Designers send query letter with brochure, photocopies, photographs and tearsheets. Illustrators send photocopies and tearsheets. Accepts disk submissions. Samples are filed or returned by SASE if requested by artist. Art Director will contact artist for portfolio review if interested. Pays for design and illustration by the project, $150 minimum. Negotiates rights purchased. Finds artists through sourcebooks and direct mail samples.

Tips: "Don't skimp on your mail presentations. Send quality reproductions of work, preferably color."

McGRATHICS, 24 Abbot St., Marblehead MA 01945. (617)631-7510. Art Director: Vaughn McGrath. Estab. 1978. Number of employees: 4-6. Specializes in corporate identity, annual reports, package and publication design. Clients: corporations and universities. Professional affiliations: AIGA, VUGB.

Needs: Approached by 30 freelancers/year. Works with 8-10 freelance illustrators/year. Uses illustrators mainly for advertising, corporate identity (both conventional and computer). Also for ad, brochure, catalog, poster and P-O-P illustration; charts/graphs. Computer and conventional art purchased.

First Contact & Terms: Send postcard sample of work or send brochure, photocopies, photographs, résumé, slides and transparencies. Samples are filed. Reports back to the artist only if interested. Portfolio review not required. Pays for illustration by the hour or by the project. Rights purchased vary according to project. Finds artists through sourcebooks and mailings.

Tips: "Annually mail us updates for our review."

CLIFFORD SELBERT DESIGN COLLABORATIVE, 2067 Massachusetts Ave., Cambridge MA 02140. (617)497-6605. Fax: (617)661-5772. E-mail: eastcsel@aol.com. Estab. 1980. Number of employees: 45. Specializes in annual reports, corporate identity design, displays, landscape, architecture and urban design, direct mail, product and package design, exhibits, interactive media and CD-ROM design and print and environmental graphics design. Clients: colleges, radio stations, corporations, hospitals, computer companies and retailers. Professional affiliations: AIGA, SEGD.

● This company has an office in the Los Angeles area.

Needs: Approached by "hundreds" of freelancers/year. Works with 10 freelance illustrators and 20 designers/year. Prefers artists with "experience in all types of design and computer experience." Uses freelance artists for brochures, mechanicals, logos, P-O-P, poster and direct mail. Also for multimedia projects. 100% of freelance work demands knowledge of QuarkXPress, Aldus FreeHand, Adobe Photoshop, Aldus PageMaker, Canvas and Persuasion.

First Contact & Terms: Send query letter with brochure, résumé, tearsheets, photographs, photocopies, slides and transparencies. Samples are filed. Reports back only if interested. Portfolios may be dropped off every Monday-Friday. Artist should follow up with call and/or letter after initial query. Art Director will contact artist for portfolio review if interested. Pays for design by the hour, $15-35; by the project. Pays for illustration by the project. Rights purchased vary according to project. Finds artists through word of mouth, magazines, submissions/self-promotions, sourcebooks and agents.

‡SPECTRUM BOSTON CONSULTING, INC., 85 Chestnut St., Boston MA 02108. (617)367-1008. Fax: (617)367-5824. E-mail: spectrum@aol.com. President: George Boesel. Estab. 1985. Specializes in brand and corporate identity, display and package design and signage. Clients: consumer, durable manufacturers.

Needs: Approached by 50 freelance artists/year. Works with 15 illustrators and 3 designers/year. All artists employed on work-for-hire basis. Works on assignment only. Uses illustrators mainly for package and brochure work. Also for brochure design and illustration, mechanicals, logos, P-O-P design and illustration and modelmaking. 100% of design and 85% of illustration demand knowledge of Adobe Illustrator, QuarkXPress, Adobe Photoshop or Aldus FreeHand. Needs technical and instructional illustration.

First Contact & Terms: Designers send query letter with résumé and photocopies. Illustrators send query letter with tearsheets, photographs and photocopies. Accepts any Mac formatted disk submissions except for Aldus PageMaker. Samples are filed. Reports back to the artist only if interested. Call or write for appointment to show portfolio of roughs, original/final art and color slides. Pays for design by the hour, $20-40, depending on assignment and skill level. Pays for illustration by the project, $50-1,500. Buys all rights.

TRIAD DESIGNS, INC., 18 Water St., Holliston MA 01746. (508)429-2498. Fax: (508)429-3042. Design Director: Alan King. Estab. 1981. Number of employees: 3. Approximate annual billing: $350,000. Special-

● **A BULLET** introduces comments by the editor of *Artist's & Graphic Designer's Market* indicating special information about the listing.

izes in brand and corporte identity, display and package design, technical illustration and signage. Clients: ad agencies, corporations. Current clients include Sony, Pennzoil, Lotus and GTE.

Needs: Approached by 2-3 freelancers/year. Works with 2-3 freelance designers/year. Prefers local artists with experience in silkscreen printing prep. Uses designers mainly for exhibit and T-shirt graphics. Also uses freelancers for lettering, mechanicals and retouching. Also for multimedia projects. 100% of design and 50% of illustration demand knowledge of Adobe Illustrator, Adobe Photoshop and Aldus FreeHand.

First Contact & Terms: Designers send postcard sample of work or résumé, brochure and tearsheets. Illustrators send postcard sample and tearsheets. Samples are filed. Reports back to the artist only if interested. Art Director will contact artist for portfolio review if interested. Portfolio should include color final art, roughs and thumbnails. Pays for design by the project. "I ask designers to price out their end of the job first. I need a quotation before I can present a bid to my client." Rights purchased vary according to project. Finds artists through sourcebooks and word of mouth recommendations.

Tips: "Be exceptionally good."

‡WAVE DESIGN WORKS, 560 Harrison Ave., Boston MA 02118. (617)482-4470. Fax: (617)482-2356. Principal: John Buchholz. Estab. 1986. Specializes in corporate identity and display, package and publication design. Clients: corporations—primarily biotech and software. Current clients include Genzyme, Integrated Genetics, New England Biolabs.

Needs: Approached by 24 freelance graphic artists/year. Works with 1-5 freelance illustrators and 1-5 freelance designers/year. Works on assignment only. Uses illustrators mainly for ad illustration. Also uses freelance artists for brochure, catalog, poster and ad illustration; lettering; and charts/graphs. 100% of design and 50% of illustration demand knowledge of Aldus PageMaker, QuarkXPress, Aldus FreeHand, Adobe Illustrator or Adobe Photoshop.

First Contact & Terms: Send query letter with brochure, résumé, photocopies, photographs, SASE, slides, transparencies and tearsheets. Accepts disk submissions compatible with above programs. Samples are filed. Reports back to the aritst only if interested. Artist should follow up with call and/or letter after initial query. Portfolio should include b&w and color thumbnails and final art. Pays for design by the hour, $12.50-25. Pays for illustration by the project. Rights purchased vary according to project. Finds artists through submissions and sourcebooks.

WEYMOUTH DESIGN, INC., 332 Congress St., Boston MA 02210-1217. (617)542-2647. Fax: (617)451-6233. E-mail: dwey@aol.com. Website: http://www.weymouth@USA1.com. Office Manager: Judith Hildebrandt. Estab. 1973. Number of employees: 10. Specializes in annual reports, corporate collateral, designing home pages, CD-ROMs and miscellaneous multimedia. Clients: corporations and small businesses. Client list not available. Professional affiliation: AIGA.

Needs: Approached by "tons" of freelancers/year. Works with 3-5 freelance illustrators and 0-1 designer/year. 100% of design demands knowledge of QuarkXPress. Computer knowledge not required for illustration. Prefers freelancers with experience in corporate annual report illustration. Works on assignment only. Needs editorial, medical and technical illustration mainly for annual reports. Also uses freelancers for brochure and poster illustration and multimedia projects.

First Contact & Terms: Send query letter with résumé or illustration samples and/or tearsheets. Samples are filed or are returned by SASE if requested by artist. Art Director will contact artist for portfolio review if interested. Pays for design by the hour, $20. Pays for illustration by the project; "artists usually set their own fee to which we do or don't agree." Rights purchased vary according to project. Finds artists through magazines and agents.

Michigan

HEART GRAPHIC DESIGN, 501 George St., Midland MI 48640. (517)832-9710. Fax: (517)832-9420. Owner: Clark Most. Estab. 1982. Number of employees: 3. Approximate annual billing: $200,000. Specializes in corporate identity and publication design. Clients: corporations. Current clients include Tannoy North America (Canadian Company), Snow Makers, Lyle Industries, Mullinex Packaging.

Needs: Approached by 6 freelancers/year. Works with 3-6 freelance illustrators and 5-8 designers/year. Uses illustrators mainly for computer illustration. Uses designers mainly for brochure design. Also uses freelancers for ad design, brochure illustration, charts/graphs, logos and mechanicals. 100% of design and 50% of illustration demand knowledge of Adobe Illustrator, Adobe Photoshop, Aldus FreeHand, Painter, Aldus PageMaker and QuarkXPress.

First Contact & Terms: Send postcard sample or query letter with brochure and résumé. Accepts disk submissions. Send EPS or TIFF files. Samples are filed (if interested) or returned if requested. Reports back only if interested. Artist should follow-up with call and/or letter after initial query. Portfolio should include b&w and color final art, photographs, roughs and transparencies. Pays for design and illustration by the project. Negotiates rights purchased. Finds artists through word of mouth, sourcebooks and design books.

Tips: "Present yourself as diligent, punctual and pliable. Let your portfolio speak for itself (it should)."

Minnesota

LUIS FITCH DESIGN, INC., 401 S. First St., Suite 910, Minneapolis MN 55401. (612)376-0661. E-mail: fitch@tcaccess. Creative Director: Luis Fitch. Estab. 1990. Number of employees: 6. Approximate annual billing: $890,000. Specializes in brand and corporate identity; display, package and retail design; and signage. Clients: Latin American corporations, retail. Current clients include MTV Latino, FEDCO, CIFRA Mexico. Client list available upon request. Professional affiliations: AIGA, GAG.

Needs: Approached by 33 freelancers/year. Works with 40 freelance illustrators and 20 designers/year. Works only with artists reps. Prefers local artists with experience in retail design, graphics. Uses illustrators mainly for packging. Uses designers mainly for retail graphics. Also uses freelancers for ad and book design; brochure, catalog and P-O-P design and illustration; audiovisual materials; logos and model making. Also for multimedia projects (Interactive Kiosk, CD-Educational for Hispanic Market). 60% of design demands computer skills in Adobe Illustrator, Adobe Photoshop, Aldus FreeHand and QuarkXPress.

First Contact & Terms: Designers send postcard sample, brochure, résumé, photographs, slides, tearsheets and transparencies. Illustrators send postcard sample, brochure, photographs, slides and tearsheets. Accepts disk submissions compatible with Adobe Illustrator, Adobe Photoshop, Aldus FreeHand. Send EPS files. Samples are filed. Art Director will contact artist for portfolio review if interested. Portfolio should include color final art, photographs and slides. Pays for design by the project, $500-6,000. Pays for illustration by the project, $200-20,000. Rights purchased vary according to project. Finds artists through artist reps, *Creative Black Book* and *Workbook*.

Tip: It helps to be bilingual and to have an understanding of Hispanic cultures.

PATRICK REDMOND DESIGN, P.O. Box 75430-AGDM, St. Paul MN 55175-0430. (612)646-4254. Designer/Owner/President: Patrick M. Redmond, M.A. Estab. 1966, "Celebrating 30 Years of Commitment to Creativity in Graphic Design." Number of employees: 1. Specializes in book and/or book cover design; logo and trademark design; package, publication and direct mail design; brand and corporate identity; design consulting and education; and posters. Has provided design services for more than 100 clients in the following categories: publishing, advertising, marketing, retail, financial, food, arts, education, computer, manufacturing, small business, health care, government and professions. Recent clients include: Mid-List Press, *Catholic Digest*, Hauser Artists and others.

Needs: Approached by 150 freelancers/year. Works with 2-4 freelance illustrators and 2-4 designers/year (some years more of both, depending on client needs). Uses freelancers mainly for editorial and technical illustration, publications, books, brochures and newsletters. Also for multimedia projects. 70% of freelance work demands knowledge of Macintosh, QuarkXPress, Adobe Photoshop, Adobe Illustrator, Aldus FreeHand (latest versions).

First Contact & Terms: Send postcard sample, brochure, and/or photocopies. Also "send us quarterly mailings/updates; a list of three to four references; a rate sheet/fee schedule." Samples not filed are thrown away. No samples returned. Reports back only if interested. "Artist will be contacted for portfolio review if work seems appropriate for client needs. Patrick Redmond Design will not be responsible for acceptance of delivery or return of portfolios not specifically requested from artist or rep. Samples must be presented in person unless other arrangements are made. Unless specifically agreed to in writing in advance, portfolios should not be sent unsolicited." Pays for design and illustration by the project. Rights purchased vary according to project. Considers buying second rights (reprint rights) to previously published work. Finds artists through word of mouth, magazines, submissions/self-promotions, exhibitions, competitions, CD-ROM, sourcebooks and agents.

Tips: "I see trends toward a broader spectrum of approaches to images, subject matter and techniques. Clients also seem to have increasing interest in digitized, copyright-free stock images of all kinds."

Missouri

SIGNATURE DESIGN, 2101 Locust, St. Louis MO 63103. (314)621-6333. Fax: (314)621-0179. Owners: Therese McKee and Sally Nikolajevich. Estab. 1988. Specializes in corporate identity and display and exhibit design. Clients: museums, nonprofit institutions, corporations, government agencies, botanical gardens. Current clients include Missouri Botanical Garden, Huntsville Botanical Garden, U.S. Army Corps of Engineers, American Classic Voyages. Client list available upon request.

Needs: Approached by 15 freelancers/year. Works with 1-2 illustrators and 1-2 designers/year. Prefers local freelancers only. Works on assignment only. 50% of freelance work demands knowledge of Aldus PageMaker, QuarkXPress, Adobe Illustrator or Adobe Photoshop.

First Contact & Terms: Send query letter with résumé, tearsheets and photocopies. Samples are filed. Reports back to the artist only if interested. Artist should follow up with letter after initial query. Portfolio should include "whatever best represents your work." Pays for design by the hour. Pays for illustration by the project.

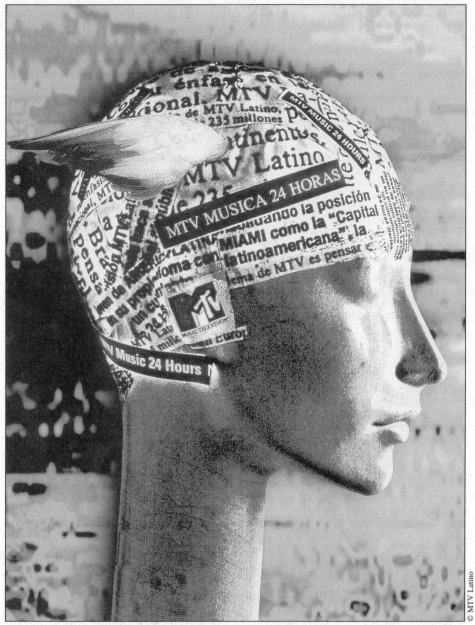

© MTV Latino

Luis Fitch Design created a young, flashy, loud, very "TV," glossy, spiral bound marketing brochure for MTV Latino. "Going into 28 South American Countries, MTV has to serve not only different countries, but different cultures. This piece ties the ideas, feelings and social status of the Hispanic generation, age 15-30, in the entire Latin America," says Luis Fitch. This particular page from the brochure was designed by Kirk Smith of Firehouse 101 using Adobe Photoshop and Adobe Illustrator starting from a b&w photo from Will Shively Photography.

Montana

AYERS/JOHANEK PUBLICATION DESIGN, INC., 4750 Rolling Hills Dr., Bozeman MT 59715. (406)585-8826. Fax: (406)585-8837. Partner: John Johanek. Estab. 1987. Number of employees: 5. Special-

izes in publication design. Clients: magazines. Current clients include: US News & World Report, Rodale Press, CMP Publications, Hearst.
Needs: Approached by 100 freelancers/year. Works with dozens of freelance illustrators/year. Uses illustrators mainly for editorial illustration. Also uses freelancers for magazine illustration. 10-15% of freelance work demands knowledge of Adobe Illustrator, Adobe Photoshop, Aldus FreeHand and QuarkXPress.
First Contact & Terms: Send postcard sample of work or send brochure, photocopies, résumé and any non-returnable samples. Samples are filed. Does not report back. "Extensive files are kept and updated annually. Every project sends us to the files to match artist with project." Art Director will contact artist for portfolio review if interested. Portfolio should include color samples and originals. Pays for illustration by the project, $250-2,500. Rights purchased vary according to project. Finds artists through sourcebooks, word of mouth, references from clients, peers, examples seen in print.

GOTTLEIB COMMUNICATIONS, 25 S. Ewing St., Suite 505, Helena MT 59601. Phone/fax: (406)449-4127. President: Michael Gottleib. Estab. 1979. Specializes in annual reports; corporate identity and collateral; corporate communication programs; strategic planning, marketing, graphics and posters for the sport of Lacrosse. Clients: corporations. Current clients include Helena Chamber of Commerce, Valley Bank, Boyd Andrew Center, The Summit Project. Client list available upon request. Relocated to Montana after 12 years in San Francisco.
Needs: Approached by 12 freelancers/year. Works with 2 illustrators and 3 designers/year. Prefers local freelancers only. Works on assignment only. Uses freelancers mainly for spot illustrations. Also for brochure design and illustration, mechanicals, airbrushing, logos and computer design. 75% of freelance work demands knowledge of Aldus PageMaker or Adobe Illustrator. Needs editorial illustration.
First Contact & Terms: Send query letter with brochure and résumé. Samples are filed. Reports back to the artist only if interested. Call for appointment to show portfolio of thumbnails, roughs, color original/final art. Pays for design by the hour, $15-35. Pays for illustration by the hour, $15-35; by the project, $200-1,000. Buys one-time rights. Negotiates rights purchased.

Nebraska

MICHAEL EDHOLM DESIGN, 4201 Teri Lane, Lincoln NE 68502. (402)489-4314. Fax: (402)489-4300. E-mail: edholmdes@aol.com. President: Michael Edholm. Estab. 1989. Number of employees: 1. Approximate annual billing: $100,000. Specializes in annual reports; corporate identity; direct mail, package and publication design. Clients: ad agencies, insurance companies, universities and colleges, publishers, broadcasting. Professional affiliations: AIGA.
Needs: Approached by 6 freelancers/year. Also uses freelancers for ad, catalog and poster illustration; brochure design and illustration; direct mail design; logos; and model making. 20% of freelance work demands knowledge of Adobe Illustrator, Adobe Photoshop, Aldus FreeHand, Aldus PageMaker and QuarkXPress.
First Contact & Terms: Contact through e-mail. Send postcard sample of work or send brochure, photocopies, SASE and tearsheets. Samples are filed. Art Director will contact artist for portfolio review if interested. Portfolio should include b&w and color final art, photographs and slides. Pays for design and illustration by the project. Rights purchased vary according to project. Finds artists through *Workbook*, direct mail pieces.

STUDIO GRAPHICS, 7337 Douglas St., Omaha NE 68114. (402)397-0390. Fax: (402)558-3717. Owner: Leslie Hanson. Number of employees: 1. Approximate annual billing: $85,000. Specializes in corporate identity, displays, direct mail, packaging, publications and signage. Clients: agencies, corporations, direct with print advertisers, marketing organizations and restaurant chains.
Needs: Approached by 20 freelancers/year. Works with 2 freelance illustrators and 2 designers/year. Works on assignment only. Uses freelancers for illustration, retouching, airbrushing and AV materials. 25% of freelance work demands knowledge of QuarkXPress, Adobe Photoshop and Adobe Illustrator.
First Contact & Terms: Send postcard sample or query letter with brochure. Samples are filed or are returned by SASE if requested. Reports back only if interested. Write for an appointment to show portfolio. Pays for design and illustration by the project, $100 minimum. Considers complexity of project and client's budget when establishing payment. Negotiates rights purchased.

New Hampshire

PATTERN PEOPLE, INC., 10 Floyd Rd., Derry NH 03038. (603)432-7180. President: Janice M. Copeland. Estab. 1988. Design studio servicing various manufacturers of consumer products. Designs wallcoverings and textiles with "classical elegance and exciting new color themes for all ages."

Needs: Approached by 5 freelancers/year. Works with 5 freelance designers/year. Prefers freelancers with professional experience in various media. Uses freelancers mainly for original finished artwork. Also for textile and wallcovering design. "We use all styles but they must be professional." Special needs are "floral (both traditional and contemporary), textural (faux finishes, new woven looks, etc.) and geometric (mainly new wave contemporary)."

First Contact & Terms: Send query letter with photocopies and transparencies. Samples are filed. Art Director will contact artist for portfolio review if interested. Portfolio should include original/final art and color samples. Sometimes requests work on spec before assigning a job. Pays for design by the project, $100-1,000. Buys all rights. Finds artists through sourcebooks and other artists.

New Jersey

THE FORMAN GROUP, P.O. Box 3174, Princeton NJ 08543. Phone/fax: (609)275-6077. Creative Director: Thomas Forman. Estab. 1990. Number of employees: 8. Specializes in brand identity and fashion design. Clients: corporations, clothing manufacturing. Client list available upon request. Professional affiliations: GAG.

Needs: Approached by 10-20 freelancers/year. Works with 3 freelance illustrators and 2 designers/year. Prefers artists with experience in graphics for fashion industry. Uses illustrators mainly for art for screen printing. Also uses freelancers for ad illustration and mechanicals. 40% of freelance work demands knowledge Adobe Illustrator and QuarkXPress.

First Contact & Terms: Send brochure and tearsheets. Samples are filed and are not returned. Art Director will contact artist for portfolio review if interested. Negotiates rights purchased. Finds artists through *Workbook*, *Black Book*, *American Showcase*, *Creative Illustration* and submissions.

HOWARD LEVY DESIGN, 40 Cindy Lane, Ocean NJ 07712. (908)493-4888. Art Director: Howard Levy. Estab. 1991. Number of employees: 2. Specializes in corporate marketing and communication design: identities, brochures, annual reports, direct mail, advertising and promotion. Professional affiliations: AIGA and JSPRAA.

Needs: Approached by 10 freelancers/year. Works with 20 freelance illustrators and 20 designers/year. Prefers artists with experience in QuarkXPress, Adobe Illustrator and Adobe Photoshop. Uses designers and illustrators mainly for annual reports, brochure and catalog design and illustration, lettering, logos, mechanicals, posters, retouching, signage and TV/film graphics. 80% of freelance work demands knowledge of Adobe Photoshop, QuarkXPress and Adobe Illustrator.

First Contact & Terms: Call or send query letter with brochure, photocopies, photographs, photostats, résumé, SASE, slides, tearsheets and transparencies. Samples are filed. Reports back to the artist only if interested. Artist should follow-up with call. Pays for design and illustration by the project. Finds artists through creative sourcebooks and submissions.

Tips: "Demonstrate an understanding of the client's marketing objectives and present ideas that meet those objectives and can be produced. We like to see printed samples as well as comps."

‡MURRAY MULTI MEDIA, P.O. Box M, Blairstown NJ 07825. (908)362-8174. Fax: (908)362-5446. Services Manager: Alice Frable. Estab. 1972. Number of emplloyees: 11. Design/multimedia firm. Specializes in collateral and presentation. Product specialty is corporate. Current clients include J&J, Schering, Roche, WL, ADT, ATT. Client list available upon request. Professional affiliations: IABC.

Needs: Approached by 10 illustrators and 15 designers/year. Works with 5 illustrators and 2 designers/year. Prefers local designers. Also for animation; brochure, catalog and web page design; brochure, humorous, medical and technical illustration; multimedia projects; and TV/film graphics. 1% of work is with print ads. 100% of design demands skills in Aldus FreeHand, Adobe Photoshop, QuarkXPress, Adobe Illustrator. 50% of illustration demands skills in Aldus FreeHand, Adobe Photoshop, Adobe Illustrator, Painter.

First Contact & Terms: Send query letter with photocopies and résumé. Accepts disk submissions compatible with Mac or PC. Samples are filed. Will contact for portfolio review of b&w and color final art, photographs, photostats, roughs, slides, tearsheets, thumbnails or transparencies. Pays for design by the hour, $12-50. Pays for illustration by the project, $75-10,000. Finds artists through yearly portfolio review, word of mouth.

Tips: Looks for advanced technology and good design.

FOR A LIST of markets interested in humorous illustration, cartooning and caricatures, refer to the Humor Index at the back of this book.

RICHARD PUDER DESIGN, 2 W. Blackwell St., P.O. Box 1520, Dover NJ 07802-1520. (201)361-1310. Fax: (201)361-1663. E-mail: strongtype@aol.com. Project Manager: Lee Grabarczyk. Estab. 1985. Number of employees: 2. Approximate annual billing: $200,000. Specializes in annual reports, direct mail and publication design, technical illustration. Current clients include AT&T, Warner Lambert, Scholastic, Simon & Schuster. Professional affiliation: Type Directors Club.
Needs: Approached by 60 freelancers/year. Works with 10 freelance illustrators and 5 designers/year. Prefers artists with experience in anatomy, color, perspective—many illustrative styles; prefers artists without reps. Uses illustrators mainly for publishing clients. Uses designers mainly for corporate, publishing clients. Also uses freelancers or ad and brochure design and illustration; book, direct mail, magazine and poster design; charts/graphs; lettering; logos; mechanicals; and retouching. 80% of freelance work demands knowledge of Adobe Illustrator 6.0, Adobe Photoshop 3.0, Adobe PageMill 1.0, Aldus FreeHand 4.0, QuarkXPress 3.3 and Macromedia Director 4.0.
First Contact & Terms: Send postcard sample of work or send résumé and tearsheets. Samples are filed. Art Director will contact artist for portfolio review if interested. Portfolio should include b&w and color photocopies, photographs, roughs and thumbnails. Pays for design by the hour, $15-35. Pays for illustration by the hour, $20-40. Buys first rights or rights purchased vary according to project. Finds artists through sourcebooks (e.g., *American Showcase* and *Workbook*) and by client referral.
Tips: Impressed by "listening, speed, technical competency and creativity."

RITTA & ASSOCIATES, 568 Grand Ave., Englewood NJ 07631. (201)567-4400. Fax: (201)567-7330. Art Director: Steven Scheiner. Estab. 1976. Specializes in annual reports, corporate identity and communications, and publication design. Clients: corporations. Current clients include Accudart, AT&T, Bellcore, Hoffman LaRoche, Kulite Tungsten Corp., Warner Lambert, Valley National Bancorp. Client list available upon request.
Needs: Approached by 50-100 freelancers/year. Works with 20 freelance illustrators/year. Uses illustrators mainly for corporate publications. 100% of design and 50% of illustration demand knowledge of QuarkXPress, Adobe Illustrator or Adobe Photoshop.
First Contact & Terms: Send query letter with résumé and tearsheets. Accepts disk submissions compatible with Adobe Illustrator and QuarkXPress. Send EPS and TIFF files. Samples are filed or are returned by SASE if requested by artist. Reports back to the artist only if interested. Art Director will contact artist for portfolio review if interested. Pays for illustration by the project. Rights purchased vary according to project.
Tips: Finds artists through sourcebooks, publications, agents and artists' submissions.

SMITH DESIGN ASSSOCIATES, 205 Thomas St., Box 190, Glen Ridge NJ 07028. (201)429-2177. Fax: (201)429-7119. Vice President: Larraine Blauvelt. Clients: cosmetics firms, toy manufacturers, life insurance companies, office consultants. Current clients: Popsicle, Good Humor, Breyer's and Schering Plough. Client list available upon request.
Needs: Approached by more than 100 freelancers/year. Works with 10-20 freelance illustrators and 2-3 designers/year. Requires quality and dependability. Uses freelancers for advertising and brochure design, illustration and layout; interior design; P-O-P; and design consulting. 90% of freelance work demands knowledge of Adobe Illustrator, QuarkXPress, Adobe Photoshop and Painter. Needs children's, packaging and product illustration.
First Contact & Terms: Send query letter with brochure showing art style or résumé, tearsheets and photostats. Samples are filed or are returned only if requested by artist. Reports back within 1 week. Call for appointment to show portfolio of color roughs, original/final art and final reproduction. Pays for design by the hour, $25-100; by the project, $175-5,000. Pays for illustration by the project, $175-5,000. Considers complexity of project and client's budget when establishing payment. Buys all rights. Also buys rights for use of existing non-commissioned art. Finds artists through word of mouth, self-promotions/sourcebooks and agents.
Tips: "Know who you're presenting to, the type of work we do and the quality we expect. We use more freelance artists not so much because of the economy but more for diverse styles."

New Mexico

BEAR CANYON CREATIVE, 6753 Academy Rd. NE, Albuquerque NM 87109. (505)823-9150. Fax: (505)823-9291. Senior Designer: Melanie Wegner. Design Director: Raymond Peña. Estab. 1985. Specializes in graphic and package design. Clients: audio publishers and corporations.
Needs: Approached by 25 freelancers/year. Works with 20 illustrators/year. Prefers freelancers with extensive experience in full color illustration; some children's illustration. Works on assignment only. Uses freelancers mainly for illustration for audio packaging covers. 20% of illustration demands computer skills.
First Contact & Terms: Send postcard samples. Samples are filed or are returned by SASE if requested by artist. Reports back only if interested. Call or write for appointment to show portfolio, or mail appropriate materials. Portfolio should include finished art samples, slides, color tearsheets, transparencies and photo-

graphs. Pays by the project, $500-900. Buys original plus all rights. Finds artists mainly through sourcebooks, occasionally through word of mouth and submissions.

Tips: "Work within our budget. Be highly professional. The illustration field is more competitive—with a lot of very stylized work. We're looking for more realistic styles within our budget."

BOOKMAKERS LTD., P.O. Box 1086, Taos NM 87571. (505)776-5435. Fax: (505)776-2762. President: Gayle Crump McNeil. "We provide service in illustration and design to educational and trade publishers, as well as to the advertising market."

Needs: Approached by 100 freelancers/year. Works with 20-30 freelance illustrators/year. "We are agents and designers. We represent artists for juvenile through adult markets."

First Contact & Terms: Send query letter with samples showing style (tearsheets, photostats, printed pieces or slides). Samples not filed are returned. Reports within 2 weeks. Considers skill and experience of artist when establishing payment.

Tips: The most common mistake freelancers make in presenting samples or portfolios is "too much variety—not enough focus. Be clear about what you are looking for and what you can do in relation to the real markets available."

New York

‡ALBEE SIGN CO., 561 E. Third St., Mt. Vernon NY 10553. (914)668-0201. President: William Lieberman. Produces interior and exterior signs and graphics. Clients are banks and real estate companies.

Needs: Works with 6 freelance artists per year for sign design, 6 for display fixture design, 6 for P-O-P design and 6 for custom sign illustration. Prefers local artists only. Works on assignment only.

First Contact & Terms: Send query letter with samples, SASE, résumé and business card to be kept on file. Pays by job. Previous experience with other firms preferred. Reports within 2-3 weeks. Samples are not returned. Reports back as assignment occurs.

CSOKA/BENATO/FLEURANT, INC., 134 W. 26th St., New York NY 10001. (212)242-6777. (212)675-2078. President: Robert Fleurant. Estab. 1969. Specializes in brand and corporate identity; display, direct mail, package and publication design. Clients: corporations and foundations. Current clients include Metropolitan Life Insurance and RCA/BMG Special Products.

Needs: Approached by approximately 120 freelancers/year by mail. Works with 3-4 freelance illustrators/year. Prefers local freelancers with experience in print, full color, mixed media. Seeks freelancers "with professionalism and portfolio who can meet deadlines, work from layouts and follow instructions." Works on assignment only. Uses illustrators mainly for album covers, publications and promotions. Also for brochure, catalog and P-O-P illustration; mechanicals; retouching; airbrushing; and lettering. 90% of freelance work demands knowledge of Aldus PageMaker, QuarkXPress, Aldus FreeHand, Adobe Illustrator, Adobe Photoshop, Adobe Streamline, OmniPage and Microsoft Word 5.1.

First Contact & Terms: Send query letter with tearsheets and résumé. Samples are filed. Reports back only if interested. Write for appointment to show portfolio of thumbnails, roughs, final art and b&w and color tearsheets. Pays for design by the hour, $20-35. Pays for illustration by the project (estimated as per requirements). Buys all rights.

‡DE FIGLIO DESIGN, 11 W. 30 St., Suite 6, New York NY 10001-4405. (212)695-6109. Fax: (212)695-4809. Creative Director: R. De Figlio. Estab. 1981. Number of employees: 2. Design firm. Specializes in magazine ads, annual reports, collateral, postage stamps and CD albums. Specializes in postage stamps.

Needs: Approached by 10 illustrators and 10 designers/year. Works with 4 illustrators and 10 designers/year. Prefers local designers with experience in Mac-based programs. Illustrators can be "from anywhere." Uses freelancers mainly for design. Also for airbrushing, annual reports, brochure design and illustration, logos, mechanicals on Mac, posters, retouching and web page design. 80% of design and 25% of illustration demand knowledge of latest versions of Aldus FreeHand, Adobe Photoshop, QuarkXPress and Adobe Illustrator. Illustrators can use any version that works for project.

First Contact & Terms: Designers send photocopies and résumé. Illustrators send postcard sample or photocopies and résumé. Samples are filed. Does not report back. Payment negotiable. Finds artists through submissions and networking.

‡JOSEPH B. DEL VALLE, HCR 84, Claverack NY 12513. Fax: (518)851-3857. Director: Joseph B. Del Valle. Specializes in annual reports, publications, book design. Clients: major publishers and museums. Current clients include Metropolitan Museum of Art and Cambridge University Press.

Needs: Works with approximately 6 freelance artists/year. Artists must have experience and be able to work on a job-to-job basis. Uses freelancers for design and mechanicals. Needs computer-literate freelancers for design and production.

First Contact & Terms: Send query letter with résumé. Reports only if interested. Call or write for appointment to show portfolio of final reproduction/product. Pays for design by the hour, $15-25. Considers client's budget and turnaround time when establishing payment.

‡**DESIGN CONCEPTS**, 104 Main St., Box 5A1, RR 1, Unadilla NY 13849. (607)369-4709. Owner: Carla Schroeder Burchett. Estab. 1972. Specializes in annual reports, brand identity, design and package design. Clients: corporations, individuals. Current clients include American White Cross and Private & Natural.
Needs: Approached by 6 freelance graphic artists/year. Works with 2 freelance illustrators and designers/year. Prefers artists with experience in packaging, photography, interiors. Uses freelance artists for mechanicals, poster illustration, P-O-P design, lettering and logos.
First Contact & Terms: Send query letter with tearsheets, brochure, photographs, résumé and slides. Samples are filed or are returned by SASE if requested by artist. Reports back. Artists should follow up with letter after initial query. Portfolio should include thumbnails and b&w and color slides. Pays for design by the hour, $10 minimum. Negotiates rights purchased.
Tips: "Artists and designers are used according to talent; team cooperation is very important. If a person is interested and has the professional qualification, he or she should never be afraid to approach us—small or large jobs."

‡**THE GRAPHIC CENTER, INC.**, 60 Madison Ave., New York NY 10010. (212)686-6585. Fax: (212)779-0647. President: Harvey Schlackman. Estab. 1978. Specializes in direct mail and package design. Clients: corporations; mostly pharamaceutical companies. Current clients include Parke-Davis, Ciba Giegy, Key Scherring. Client list available upon request.
Needs: Approached by 12 freelance artists/year. Works with 6-7 freelance illustrators and 2-3 freelance designers/year. Prefers artists with experience in packaging design and construction, pharmaceutical and direct mail concepts. Works on assignment only. Uses freelance artists for brochure and direct mail design, mechanicals, retouching, lettering, logos, ad design and illustration and model making. Needs medical illustration.
First Contact & Terms: Send query letter with brochure, slides and photocopies. Samples are filed or are returned by SASE if requested by artist. Reports back to the artist only if interested. Call to schedule an appointment to show a portfolio or mail roughs and slides. Pays for design by the project, $200-600. Pays for illustration by the project, $200-2,000. Buys all rights.

JEWELITE SIGNS, LETTERS & DISPLAYS, INC., 106 Reade St., New York NY 10013. (212)233-1900. Fax: (212)233-1998. Vice President: Bobby Bank. Produces signs, letters, silk screening, murals, handlettering, displays and graphics. Current clients include Transamerica, Duggal Labs, Steve Horn and MCI.
Needs: Approached by 15 freelancers/year. Works with 12 freelancers/year. Works on assignment only. Uses freelancers for handlettering, walls, murals, signs, interior design, architectural renderings, design consulting and model making. 80% of freelance work demands computer skills. Prefers airbrush, lettering and painting.
First Contact & Terms: Call or send query letter. Call for appointment to show portfolio of photographs. Pays for design and illustration by the project, $75 and up. Considers complexity of project and skill and experience of artist when establishing payment.

LESLEY-HILLE, INC., 136 E. 57th St., New York NY 10022. (212)759-9755. President: Valrie Lesley. Specializes in annual reports, corporate identity, publications, advertising and sales promotion. Clients: nonprofit organizations, hotels, restaurants, investment, oil and real estate, financial and fashion firms.
Needs: Seeks "experienced and competent" freelancers. Uses freelancers for photography, illustration, computer production, mechanicals, charts/graphs, AV materials and lettering.
First Contact & Terms: Send query letter with résumé, business card and samples to be kept on file. Accepts "whatever best shows work capability" as samples. Samples not filed are returned by SASE. Reports only if interested. Call or write for an appointment to show portfolio. Payment varies according to project.
Tips: "Designers and artists must be *able to do* what they say they can and agree to do . . . professionally and on time!"

LUBELL BRODSKY INC., 21 E. 40th St., Suite 1806, New York NY 10016. (212)684-2600. Art Directors: Ed Brodsky and Ruth Lubell. Number of employees: 5. Specializes in corporate identity, direct mail, promotion and packaging. Clients: ad agencies and corporations. Professional affiliations: ADC, TDC.
Needs: Approached by 100 freelancers/year. Works with 10 freelance illustrators and 1-2 designers/year. Works on assignment only. Uses freelancers for illustration, mechanicals, retouching, airbrushing, charts/graphs, AV materials and lettering. 100% of design and 30% of illustration demand knowledge of Adobe Photoshop.
First Contact & Terms: Send postcard sample, brochure or tearsheets to be kept on file. Reports back only if interested.

‡JODI LUBY & COMPANY, INC., 808 Broadway, New York NY 10003. (212)473-1922. Fax: (212)473-2858. President: Jodi Luby. Estab. 1983. Specializes in corporate identity, promotion and direct mail design. Clients: magazines, corporations.
Needs: Approached by 10-20 freelance artists/year. Works with 5-10 illustrators/year. Prefers local artists only. Uses freelancers for brochure and catalog illustration, mechanicals, retouching and lettering. 5% of freelance work demands computer skills.
First Contact & Terms: Send postcard sample or query letter with résumé and photocopies. Samples are not filed and are not returned. Art Director will contact artist for portfolio review if interested. Portfolio should include thumbnails, roughs, b&w and color printed pieces. Pays for design by the hour, $25 minimum; by the project, $100 minimum. Pays for illustration by the project, $100 minimum. Rights purchased vary according to project. Finds artists through word of mouth.

MIRANDA DESIGNS INC., 745 President St., Brooklyn NY 11215. (718)857-9839. President: Mike Miranda. Estab. 1970. Number of employees: 3. Approximate annual billing: $350,000. Solves marketing problems, specializes in "giving new life to old products, creating new markets for existing products, and creating new products to fit existing manufacturing/distribution facilities." Clients: agencies, manufacturers, PR firms, corporate and retail companies. Professional affiliation: Art Directors Club.
Needs: Approached by 80 freelancers/year. Works with 6 freelance illustrators and 10 designers/year; at all levels, from juniors to seniors, in all areas of specialization. Works on assignment only. Uses freelancers for editorial, food, fashion, product illustration, design; and mechanicals. Also for catalog design and illustration; brochure, ad, magazine and newspaper design; mechanicals; model making; direct mail packages and multi-media projects. 60% of freelance work demands knowledge of Aldus PageMaker, QuarkXPress, Adobe Photoshop or Adobe Illustrator.
First Contact & Terms: Send postcard sample. Samples are filed or are not returned. Art Director will contact artist for portfolio review if interested. Portfolio should include thumbnails, roughs, original/final art and final reproduction/product. Pays for design and illustration by the project, "whatever the budget permits." Considers complexity of project, client's budget and skill and experience of artist when establishing payment. Rights purchased vary according to project. Considers buying second rights (reprint rights) to previously published work; depends on clients' needs. Finds artists through submissions/self-promotions, sourcebooks and agents.
Tips: "Don't call, persevere with mailings. Be professional. Show a variety of subject material and media."

MITCHELL STUDIOS DESIGN CONSULTANTS, 1111 Fordham Lane, Woodmere NY 11598. (516)374-5620. Fax: (516)374-6915. E-mail: mspakdes@aol.com. Principals: Steven E. Mitchell and E.M. Mitchell. Estab. 1922. Specializes in brand and corporate identity, displays, direct mail and packaging. Clients: major corporations.
Needs: Works with 5-10 freelance designers and 20 illustrators/year. "Most work is started in our studio." Uses freelancers for design, illustration, mechanicals, retouching, airbrushing, model making, lettering and logos. 100% of design and 50% of illustration demand knowledge of Adobe Illustrator 5.5, Adobe Photoshop 3.5 and QuarkXPress 3.3. Needs technical illustration and illustration of food, people.
First Contact & Terms: Send query letter with brochure, résumé, business card, photographs and photocopies to be kept on file. Accepts non-returnable disk submissions compatible with Adobe Illustrator, QuarkXPress, Aldus FreeHand and Adobe Photoshop. Reports only if interested. Call or write for appointment to show portfolio of roughs, original/final art, final reproduction/product and color photostats and photographs. Pays for design by the hour, $25 minimum; by the project, $250 minimum. Pays for illustration by the project, $250 minimum.
Tips: "Call first. Show actual samples, not only printed samples. Don't show student work. Our need has increased—we are very busy."

MIZEREK DESIGN INC., 318 Lexington Ave., New York NY 10016. (212)689-4885. President: Leonard Mizerek. Estab. 1975. Specializes in catalogs, direct mail, jewelry, fashion and technical illustration. Clients: corporations—various product and service-oriented clientele. Current clients include: Rolex, Leslies Jewelry, World Wildlife, The Baby Catalog and Time Life.
Needs: Approached by 20-30 freelancers/year. Works with 10 freelance designers/year. Works on assignment only. Uses freelancers for design, technical illustration, brochures, retouching and logos. 85% of freelance work demands knowledge of Adobe Illustrator, Adobe Photoshop and QuarkXPress.
First Contact & Terms: Send postcard sample or query letter with résumé, tearsheets and transparencies. Accepts disk submissions compatible with Adobe Illustrator and Adobe Photoshop 3.0. Art Director will contact artist for portfolio review if interested. Portfolio should include original/final art and tearsheets. Pays for design by the project, $500-5,000. Pays for illustration by the project, $500-3,500. Considers client's budget and turnaround time when establishing payment. Finds artists through sourcebooks and self-promotions.
Tips: "Let the work speak for itself. Be creative. Show commercial product work, not only magazine editorial. Keep me on your mailing list!"

LOUIS NELSON ASSOCIATES INC., 80 University Place, New York NY 10003. (212)620-9191. Fax: (212)620-9194. E-mail: lnanyc@aol.com. President: Louis Nelson. Estab. 1980. Number of employees: 6. Approximate annual billing: $750,000. Specializes in environmental, interior and product design and brand and corporate identity, displays, packaging, publications, signage, exhibitions and marketing. Clients: non-profit organizations, corporations, associations and governments. Current clients include Korean War Veterans Memorial, Port Authority of New York & New Jersey, Richter+Ratner Contracting Corporation, Central Park Conservancy, Steuben, MTA and NYC Transit. Professional affiliations: IDSA, AIGA, SEGD, APDF.
Needs: Approached by 30-40 freelancers/year. Works with 30-40 designers/year. Works on assignment only. Uses freelancers mainly for specialty graphics and three-dimensional design. Also for design, mechanicals, model making and charts/graphs. 100% of design demands knowledge of Aldus PageMaker, QuarkXPress, Adobe Photoshop, Velum or Adobe Illustrator. Needs editorial illustration.
First Contact & Terms: Send postcard sample or query letter with résumé. Accepts disk submissions compatible with Adobe Illustrator 5.0 or Adobe Photoshop 2.5.1. Send EPS files. Samples are returned only if requested. Reports within 2 weeks. Write for appointment to show portfolio of roughs, color final reproduction/product and photographs. Pays for design by the hour, $10-40; by the project, negotiable.
Tips: "I want to see how the artist responded to the specific design problem and to see documentation of the process—the stages of development. The artist must be versatile and able to communicate a wide range of ideas. Mostly, I want to see the artist's integrity reflected in his/her work."

‡NICOSIA CREATIVE EXPRESSO LTD., 16 W. 56th St., New York NY 10019. (212)489-6423. Fax: (212)265-5422. Website: http://soho.ios.com/~niceltd/. President/Creative Director: Davide Nicosia. Estab. 1993. Number of employees: 6. Specializes in annual reports, corporate identity, brochures, promotional material, packaging, signage and design. Clients: corporations and small companies. Client list available upon request.
Needs: Approached by 25 freelancers/year. Works with 3 freelance illustrators and 3 designers/year. Works by assignment only. Uses illustrators, designers, 3-dimensional comp artists and computer artists familiar with Adobe Illustrator, Adobe Photoshop and QuarkXPress.
First Contact & Terms: Send query letter and résumé. Reports back to artist for portfolio review only if interested. Pays for design by the hour. Pays for illustration by the project. Rights purchased vary according to project.

Science fell asleep without results and without inventions is the title of this piece by Albanian-born illustrator Agim Sulaj. The work is one of 20 diverse pieces of art and photos appearing in a capabilities brochure for Nicosia Creative Expresso (NiCE). Sulaj, who now lives in Italy, is one of a pool of artists used by NiCE. He created *Science fell asleep* as "a portrayal of the absolute vacuum experienced by the younger generations and by the entire country under the dominant culture of the regime" in his native Albania.

© Agim Sulaj

NOVUS VISUAL COMMUNICATIONS, INC., 18 W. 27th St., New York NY 10001. (212)689-2424. Fax: (212)696-9676. President: Robert Antonik. Estab. 1984. Specializes in annual reports, brand and corpo-

rate identity; display, direct mail, fashion, package and publication design; technical illustration; and signage. Clients: ad agencies and corporations. Client list available upon request.

Needs: Approached by 12 freelancers/year. Works with 2-4 freelance illustrators and 2-6 designers/year. Works with artist reps. Prefers local artists only. Uses freelancers for ad, brochure, catalog, poster and P-O-P design and illustration; airbrushing; audiovisual materials; book, direct mail, magazine and newpaper design; charts/graphs; lettering; logos; mechanicals; and retouching. 75% of freelance work demands knowledge of Adobe Illustrator, Adobe Photoshop, Aldus FreeHand, Aldus PageMaker and QuarkXPress.

First Contact & Terms: Contact only through artist rep. Send postcard sample of work. Samples are filed. Reports back ASAP. Follow-up with call. Pays for design and illustration by the project. Rights purchased vary according to project. Finds artists through *Creative Illustration, Workbook,* agents and submissions.

Tips: "First impressions are important, a portfolio should represent the best, whether it's 4 samples or 12."

MIKE QUON DESIGN OFFICE, INC., 568 Broadway, New York NY 10012. (212)226-6024. Fax: (212)219-0331. President: Mike Quon. Contact: Katherine Lumb. E-mail: mikequon@aol.com. Estab. 1982. Number of employees: 7. Approximate annual billing: $700,000. Specializes in corporate identity, displays, direct mail, packaging, publications and technical illustrations. Clients: corporations (fashion, beauty, financial) and ad agencies. Current clients include American Express, HBO, Amtrak, Revlon, Nynex and AT&T. Client list available upon request. Professional affiliations: AIGA, Society of Illustrators.

Needs: Approached by 100 illustrators and 200 designers/year. Works with 15 freelance illustrators and 25 designers/year. Prefers local freelancers. Works by assignment only. Prefers graphic style. Uses artists for brochures, design and catalog illustration, P-O-P displays, logos, mechanicals, model making, charts/graphs and lettering. Especially needs computer artists with knowledge of QuarkXPress, Adobe Illustrator, Adobe Photoshop and Dimensions 3.0.

First Contact & Terms: Send query letter with résumé and photocopies. Samples are filed or are returned if accompanied by SASE. Reports back only if interested. Portfolio may be dropped off Monday-Friday. Pays for design by the hour, $20-45. Pays for illustration by the hour, $20-50; or by the project, $150-500 and up. Buys first rights.

Tips: "The introduction of the computer has given us much more control and flexibility in our design and production. It has also allowed us to work much quicker; but on the downside, the clients also want work quicker. The economy has made available a larger pool of talent to make our choice from, and has enabled us to recruit more experienced designers and illustrators on a more competitive price scale. This is not only beneficial to us but to our clients."

DAVID SCHIFFER DESIGN, INC., 156 Fifth Ave., New York NY 10010. (212)255-3464. E-mail: dsdesign@interport.net. Website: http://www.interport.net/~design. President: David Schiffer. Estab. 1986. Number of employees: 2. Approximate annual billing: $150,000. Design firm. Specializes in print and website design: logos, annual reports, catalogs, ads and home pages. Product specialties are publishing, non-profit and industrial. Current clients include Foundation Center, New Castle Fabrics, McGraw Hill. Client list available on request. Professional affiliations: AIGA.

Needs: Approached by 3 freelancers/month. Works with 5 illustrators and 2 designers/year. Works on assignment only. Uses freelancers mainly for illustration. Also for art for websites: home pages, icons, buttons, etc.; retouching and desktop publishing. 20% of work is with print ads. 100% of design and 75% of illustration demand knowledge of QuarkXPress, Adobe Photoshop and Adobe Illustrator.

First Contact & Terms: Send query letter with résumé, photographs and tearsheets. Also contact by e-mail. Accepts disk submissions compatible with Adobe Illustrator 5.0 and Adobe Photoshop. Send EPS files. Samples are filed. Reports back to the artist only if interested. Write for appointment to show portfolio of roughs or final art. Pays for illustration by the project, $250-2,500. Rights purchased vary according to project.

‡SMALLKAPS ASSOCIATES, INC., 21 Beacon Dr., Port Washington NY 11050. (516)944-5530. Fax: (516)944-5618. E-mail: smallkaps@aol.com. President: Marla Kaplan. Estab. 1976. Specializes in brand and corporate identity, direct mail and publication design, signage and illustration. Clients: ad agencies, publishers, small and large corporations. Current clients include Integra Tooling & Accessories, Reco International, IEEE and Oxbridge Communications, Inc.

Needs: Approached by 20 freelance artists/year. Works with 2 illustrators and 2 designers/year. Prefers local artists with experience in mechanicals and comps. Works on assignment only. Also uses artists for brochure design and illustration; catalog, ad, P-O-P and direct mail design; retouching; airbrushing; lettering; logos; charts/graphs and AV materials. Also for multimedia projects. 90% of design and 100% of illustration demand knowledge of Aldus PageMaker, QuarkXPress, Adobe Illustrator or Aldus FreeHand 5.0. Needs editorial, medical and technical illustrations.

First Contact & Terms: Designers send query letter with résumé and photocopies. Illustrators send postcard samples. Accepts disk submissions. Send EPS files. Samples are filed or are returned by SASE if requested by artist. Reports back only if interested. Call for appointment to show portfolio which should include thumbnails, roughs, original/final art and photostats. Pays for design by the hour, $15. Pays for illustration by the project, $50 minimum. Negotiates rights purchased.

‡**JAMES WEAVER GRAPHIC DESIGN**, P.O. Box 114 SVS, Binghamton NY 13903-0114. (607)722-3007. Fax: (607)722-3007 (Call first). Owner: James Weaver. Estab. 1984. Specializes in annual reports; corporate identity; display, direct mail, package and publication design; and signage. Clients: corporations (mostly industrial), health care, ad agencies.

Needs: Approached by 5-10 freelance artists/year. Works with 2-3 illustrators/year. Prefers local artists who are flexible in style and medium. Works on assignment only. Uses illustrators mainly for industry portrayal and spots. Also for brochure, catalog and ad illustration and charts/graphs. 40% of design requires knowledge of CorelDraw and QuarkXPress.

First Contact & Terms: Send query letter with brochure, résumé and photocopies. Samples are filed or returned if requested. Reports back only if interested. Call for appointment to show portfolio. Portfolio should include color samples. Pays for illustration by the project. Buys all rights.

North Carolina

BOB BOEBERITZ DESIGN, 247 Charlotte St., Asheville NC 28801. (704)258-0316. Owner: Bob Boeberitz. Estab. 1984. Number of employees: 1. Approximate annual billing: $80,000. Specializes in graphic design, corporate identity and package design. Clients: retail outlets, hotels and restaurants, textile manufacturers, record companies, professional services, realtor/developers. Majority of clients are manufacturers—business-to-business. Current clients include GrooVee Appalachian Hardwoods, Blue Duck Music, Transylvania Partnership Inc., Owen Manufacturing Co., Cross Canvas Co. and High Windy Audio. Professional affiliations: AAF, ACAD.

 • Owner Bob Boeberitz predicts "everything in art design will be done on computer; more electronic; photo image editing and conversions will be used; there will be less commissioned artwork."

Needs: Approached by 50 freelancers/year. Works with 5 freelance illustrators/year. Works on assignment only. Uses freelancers primarily for technical illustration and comps. Prefers pen & ink, airbrush and acrylic. 50% of freelance work demands knowledge of Aldus PageMaker, Adobe Illustrator, Adobe Photoshop or CorelDraw.

First Contact & Terms: Send query letter with résumé, brochure, SASE, photographs, slides and tearsheets. "Anything too large to fit in file" is discarded. Accepts disk submissions compatible with IBM PCs. Send AI-EPS and TIFF files. Samples are returned by SASE if requested. Reports only if interested. Art Director will contact artist for portfolio review if interested. Portfolio should include thumbnails, roughs, final art, b&w and color slides and photographs. Sometimes requests work on spec before assigning a job. Pays for design and illustration, by the project, $50 minimum. Rights purchased vary according to project. Will consider buying second rights to previously published artwork. Finds artists through word of mouth, submissions/self-promotions, sourcebooks, agents.

Tips: "Show sketches—sketches help indicate how an artist thinks. The most common mistake freelancers make in presenting samples or portfolios is not showing how the concept was developed, what their role was in it. I always see the final solution, but never what went into it. In illustration, show both the art and how it was used. Portfolios should be neat, clean and flattering to your work. Show only the most memorable work, what you do best. Always have other stuff, but don't show everything. Be brief. Don't just toss a portfolio on my desk; guide me through it. A 'leave-behind' is helpful, along with a distinctive-looking résumé."

Ohio

‡**FIREHOUSE 101 ART & DESIGN**, 492 Armstrong St., Columbus OH 43215. (614)464-0928. Fax: (614)464-0944. E-mail: fh101@aol.com. Creative Director: Kirk Richard Smith. Estab. 1990. Number of employees: 2. Approximate annual billing: $200,000. Design studio. Specializes in CD packaging, book cover, brochure, poster, logo identity, illustration. Product specialties are entertainment, software, retail fashion. Current clients include CompuServe, Structure, Sony Music, Nickelodeon, Levi Strauss & Co., MCA Records, Arista Records, Ray Gun Magazine. Client list available upon request. Professional affiliations: CSCA (Columbus Society of Communicating Arts).

 • Firehouse 101 has won many awards. Look for work in *Graphis Poster*, *Print Regional*, *Mead Top 60* and *Graphic Design America: 2*. Also, note the firm's work on the marketing brochure created by Luis Fitch Design for MTV Latino on page 561.

Needs: Approached by 40 illustrators and 50 designers/year. Works with 5 illustrators and 12 designers/year. Uses freelancers mainly for design production. Also for lettering, mechanicals and marketing/proposals. 5% of work is with print ads. 80% of design demands skills in Aldus PageMaker 5, Adobe Photoshop 3, QuarkXPress 3.3. 30% of illustration demands skills in Adobe Photoshop.

First Contact & Terms: Designers send query letter with brochure, photocopies, résumé and tearsheets. Illustrators send postcard sample of work. Accepts submissions on disk compatible with QuarkXPress 3.3.

Send EPS files. Samples are filed and are not returned. Reports back only if interested. Request portfolio review in original query. Portfolio should include tearsheets and transparencies. Pays for design by the hour, $20-30. Pays for illustration by the project, $200-2,000. Buys one-time or all rights. Finds artists through postcard mailings, *Print, Graphis, How* and *Eye.*
Tips: "Be open to working hard and learning new methodologies. Stay informed of the industry and art world."

‡**PETRO GRAPHIC DESIGN ASSOCIATES**, 315 Falmouth Dr., Rocky River OH 44116. (216)356-0429. Principal/Graphic Designer: Nancy Petro. Estab. 1976. Specializes in corporate identity, direct mail and collateral design, design for print communications and ads.
Needs: Approached by 20-25 freelance artists/year. Works with 5-8 illustrators/year. Works on assignment only. Uses illustrators mainly for ads and brochures.
First Contact & Terms: Illustrators send postcard sample and/or query letter with brochure, résumé, tearsheets or photocopies. Samples are filed. Reports back only if interested. Considers complexity of project, client's budget, skill and experience of artist, how work will be used, turnaround time and rights purchased when establishing payment. Negotiates rights purchased; rights purchased vary according to project.
Tips: "Show work that is of high quality that can be matched (in quality) if you are hired for a job. Please send samples or copies of your work."

WATT, ROOP & CO., 1100 Superior, Cleveland OH 44114. (216)566-7019. (216)566-0857. VP, Design Operations: Tom Federico. Estab. 1981. Specializes in annual reports, corporate identity, direct mail and publication design and capability pieces. Clients: corporate and business-to-business. Current clients include TRW, NCR and AT&T.
Needs: Approached by 60 freelancers/year. Works with 12 freelance illustrators and 10 designers/year. Prefers local freelancers. Works on assignment only. Uses illustrators mainly for editorial and newsletter spot illustrations. "Uses designers mainly for completing our designs (follow through)." Also uses freelancers for brochure design and illustration, magazine and direct mail design, mechanicals, retouching and airbrushing. 50% of freelance work demands knowledge of Aldus PageMaker, QuarkXPress or Adobe Illustrator.
First Contact & Terms: Send query letter with brochure and résumé. Samples are filed. Does not report back. Artist should follow up with call. Sometimes requests work on spec before assigning a job. Pays for design by the project, $500 minimum. Pays for illustration by the project, $50 minimum. Rights purchased vary according to project. Interested in buying second rights (reprint rights) to previously published artwork.
Tips: "Send samples of work. Usually we are looking for a specific style. Freelancers should know that budgets are generally lower now, due to computers (clients have become somewhat spoiled)."

WILDER-FEARN & ASSOC., INC., 2035 Dunlap St., Cincinnati OH 45214. (513)621-5237. Fax: (513)621-4880. President: Gary Fearn. Estab. 1946. Number of employees: 7. Specializes in annual reports; brand and corporate identity; and display, package and publication design. Clients: ad agencies, corporations, packaging. Current clients include Jergens Co., Kenner Toys, Kroger and Kraft. Client list available upon request. Professional affiliation: Art Directors Club of Cincinnati.
Needs: Approached by 20-25 freelancers/year. Works with 5-10 freelance illustrators and 2-5 designers/year. Prefers freelancers with experience in packaging and illustration comps. Uses freelance illustrators mainly for comps and finished art on various projects. Needs editorial illustration. Uses freelance designers mainly for packaging and brochures. Freelancers should be familiar with QuarkXPress, Adobe Illustrator, Aldus FreeHand, Adobe Photoshop, Adobe Streamline and O-Photo-Scan.
First Contact & Terms: Send query letter with photocopies, résumé and slides. Accepts disk submissions compatible with Adobe Illustrator 5.0. Send EPS files. Samples are filed or are returned by SASE if requested by artist. Reports back to the artist only if interested. Call for appointment to show portfolio of roughs, original/final art and color tearsheets and slides. Payment for design and illustration is based upon talent, client and project. Rights purchased vary according to project.

Oregon

‡**DESIGN PARTNERSHIP/PORTLAND**, 500 NW Ninth Ave., Portland OR 97209-3403. (503)223-9682. Fax: (503)223-9685. Director of Design: Ken Ambrosini. Estab. 1989. Number of employees: 5.

Design firm. Specializes in architectural graphics, signage, wayfinding exhibits, retail, marketing imagery. Product specialties are corporate, retail, transportation. Current clients include NIKE, Inc., Leupold & Stevens, Intel, Kaiser Permanente. Client list available upon request. Professional affiliations: SEGD, Portland Chapter AIA.

• This firm has a long and impressive list of awards from *How* magazine, SEGD, *Print*, AIA and numerous competitions. Look for their work in *Print Casebook 10.*

Needs: Approached by 10 illustrators and 6 designers/year. Works with 2 illustrators and 3 designers/year. Prefers local designers with experience in 3D design/signage and industrial design. Uses freelancers mainly for graphic design. Also for brochure design and illustration, logos, signage. 1% of work is with print ads. 95% of design and 85% of illustration demand skills in Aldus PageMaker, Aldus FreeHand, Adobe Photoshop, QuarkXPress, Adobe Illustrator.

First Contact & Terms: Send query letter with brochure, résumé and slides. Accepts submissions on disk if compatible with QuarkXPress 7.5. Send EPS files. Samples are filed or returned by SASE. Reports back only if interested within 3 days. Artist should follow-up with call after initial query to show portfolio of final art and thumbnails. Payment negotiable. Rights purchased vary according to project. Finds artists through professional networking, trade publications, submissions.

OAKLEY DESIGN STUDIOS. 6663 SW Bvrtn-Hillsdale, Suite 318, Portland OR 97225. (503)241-3705. Fax: (503)241-3812. E-mail: oakleyds@teleport.com or oakleyds@aol.com. Creative Director: Tim Oakley. Estab. 1992. Number of employees: 3. Specializes in brand and corporate identity; display, package and publication design; and advertising. Clients: ad agencies, record companies, surf apparel manufacturers, mid-size businesses. Current clients include Safari Motorcoaches, Dutch Hill Corp., C2F, Bratwear, Judan Records, Amigo Records, Triad Pools, First Interstate Bank, Paragon Cable, Mira Mobile Television, Mira Creative Group. Professional affiliations, OMPA, AIGA and PDXAD.

• Second location is at 519 SW Park Ave., Suite 521, Portland OR 97205.

Needs: Approached by 5-10 freelancers/year. Works with 3 freelance illustrators and 2 designers/year. Prefers local artists with experience in technical illustration, airbrush. Also for multimedia projects. Uses illustrators mainly for advertising. Uses designers mainly for logos. Also uses freelancers for ad and P-O-P illustration, airbrushing, catalog illustration, lettering and retouching. 60% of design and 30% of illustration demand knowledge of Adobe Illustrator 5.5 or 6.0, Adobe Photoshop 3.0 and QuarkXPress 3.31.

First Contact & Terms: Contact through artist rep or send query letter with brochure, photocopies, photographs, résumé and tearsheets. Accepts disk submissions compatible with Adobe Illustrator 5.0. Send EPS files. Samples are filed or returned by SASE if requested by artist. Reports back within 4-6 weeks. Request portfolio review in original query. Art Director will contact artist for portfolio review if interested. Portfolio should include b&w and color final art, photocopies, photostats, roughs and slides. Pays for design and illustration by the project. Rights purchased vary according to project. Finds artists through design workbooks.

Tips: "Be yourself. No phonies."

WISNER ASSOCIATES, Advertising, Marketing & Design, 2237 NE Wasco, Portland OR 97232. (503)228-6234. Creative Director: Linda Wisner. Estab. 1979. Number of employees: 1. Specializes in brand and corporate identity, book design, direct mail, packaging and publications. Clients: small businesses, manufacturers, restaurants, service businesses and book publishers.

Needs: Approached by 2-3 freelancers/year. Works with 3-5 freelance illustrators/year. Prefers experienced freelancers and "fast, clean work." Works on assignment only. Uses freelancers for technical and fashion illustration, books, mechanicals, airbrushing and lettering. 100% of design and 50% of illustration demand knowledge of QuarkXPress, CorelDraw, Adobe Photoshop, Adobe Illustrator and other Windows-compatible software.

First Contact & Terms: Send query letter with résumé, photocopies and tearsheets. Prefers "examples of completed pieces which show the fullest abilities of the artist." Samples not kept on file are returned by SASE only if requested. Art Director will contact artist for portfolio review if interested. Portfolio should include thumbnails, roughs and final reproduction/product. Pays for illustration by the hour, $20-45 average; by the project by bid. Pays for paste-up/production by the hour, $15-25.

Tips: "Bring a complete portfolio with up-to-date pieces."

Pennsylvania

‡DAVE LOOSE DESIGN, INC., 620 E. Oregon Rd., Lititz PA 17543. (717)569-6568. Fax: (717)569-7410. Art Director: Lynn Ritts. Estab. 1986. Number of employees: 9. Design firm. Specializes in capabilities brochures, corporate ID. Client list available upon request.

Needs: Approached by 2 illustrators and 4 designers/year. Works with 2 illustrators/year. Uses freelancers mainly for illustration. Also for animation; catalog, humorous and technical illustration; TV/film graphics.

10% of work is with print ads. 50% of design demands skills in Adobe Photoshop, QuarkXPress, Adobe Illustrator.

First Contact & Terms: Designers send query letter with photocopies, résumé and tearsheets. Illustrators send postcard sample of work. Accepts disk submissions compatible with QuarkXPress 7.5/version 3.3. Send EPS files. Samples are filed. Reports back only if interested. Artist should follow-up with call. Portfolio should include color final art, roughs and tearsheets. Pays for design and illustration by the project. Buys all rights. Finds artists through *American Showcase*, postcard mailings, word of mouth.

Tips: "Be conscientious of deadlines, willing to work with hectic schedules."

WILLIAM SKLAROFF DESIGN ASSOCIATES, 124 Sibley Ave., Ardmore PA 19003. (610)649-6035. Fax: (610)649-6063. Design Director: William Sklaroff. Estab. 1956. Specializes in display, interior, package and publication design and corporate identity and signage. Clients: contract furniture, manufacturers, health care corporations. Current clients include: Kaufman, Halcon Corporation, L.U.I. Corporation, McDonald Products, Smith Metal Arts, Baker Furniture, Novikoff and Metrologic Instruments. Client list available upon request.

Needs: Approached by 2-3 freelancers/year. Works with 2-3 freelance illustrators and 2-3 designers/year. Works on assignment only. Uses freelancers mainly for assistance on graphic projects. Also for brochure design and illustration, catalog and ad design, mechanicals and logos.

First Contact & Terms: Send query letter with brochure, résumé and slides to Lori L. Minassian, PR Coordinator. Samples are returned. Reports back within 3 weeks. To show portfolio, mail thumbnails, roughs, finished art samples and color slides and transparencies. Pays for design by the hour. Rights purchased vary according to project. Finds artists through word of mouth and submissions.

Rhode Island

SILVER FOX ADVERTISING, 11 George St., Pawtucket RI 02860. (401)725-2161. Fax: (401)726-8270. E-mail: silfoxadv@aol.com. President: Fred Marzocchi, Jr. Estab. 1979. Number of employees: 6. Approximate annual billing: $1 million. Specializes in annual reports; brand and corporate identity; display; package and publication design; and technical illustration. Clients: corporations, retail. Client list available upon request.

Needs: Approached by 16 freelancers/year. Works with 6 freelance illustrators and 12 designers/year. Works only with artist reps. Prefers local artists only. Uses illustrators mainly for cover designs. Also for multimedia projects. 50% of freelance work demands knowledge of Adobe Illustrator, Adobe Photoshop, Aldus PageMaker and QuarkXPress.

First Contact & Terms: Send query letter with résumé and photocopies. Accepts disk submissions compatible with Adobe Photoshop 3.0 or Adobe Illustrator 5.5. Samples are filed. Does not report back. Artist should follow-up with call and/or letter after initial query. Portfolio should include final art, photographs, photostats, roughs and slides.

Tennessee

AB STUDIOS INC., 807 Third Ave. S., Nashville TN 37210. (615)256-3393. Fax: (615)256-3464. President: Rick Arnemann. Estab. 1988. Number of employees: 20. Approximate annual billing: $2.5 million. Specializes in brand identity, display and direct mail design and signage. Clients: ad agencies, corporations, mid-size businesses. Current clients include Best Products, Service Merchandise, WalMart, Hartmann Luggage. Client list available upon request. Professional affiliations: Creative Forum.

Needs: Approached by 20 freelancers/year. Works with 4-5 freelance illustrators and 2-3 designers/year. Uses illustrators mainly for P-O-P. Uses designers mainly for fliers and catalogs. Also uses freelancers for ad, brochure, catalog, poster and P-O-P design and illustration; logos; magazine design; mechanicals; and retouching. 85% of freelance work demands knowledge of Adobe Illustrator 5.5, Adobe Photoshop 3.0 and QuarkXPress 3.31.

First Contact & Terms: Send photographs, résumé, slides and transparencies. Samples are filed. Art Director will contact artist for portfolio review if interested. Portfolio should include color final art, roughs, slides and thumbnails. Pays for design and illustration by the project. Rights purchased vary according to project. Finds artists through sourcebooks and portfolio reviews.

ANDERSON STUDIO, INC., 2609 Grissom Dr., Nashville TN 37204. (615)255-4807. Fax: (615)255-4812. Contact: Andy Anderson. Estab. 1976. Number of employees: 13. Approximate annual billing: $1.6 million. Specializes in T-shirts (designing and printing of art on T-shirts for retail/wholesale market). Clients: business and retail.

Needs: Approached by 20 freelancers/year. Works with 1-2 freelance illustrators and 1-2 designers/year. "We use freelancers with realistic (photorealistic) style or approach to various subjects, animals and humor. Also contemporary design and loose film styles accepted." Works on assignment only. Needs freelancers for retail niche markets, resorts, theme ideas, animals, zoos, educational, science, American motorcycle v-twin art, hip kid art (skateboarder/BMX bike type art for T's) and humor-related themes.

First Contact & Terms: Send postcard sample or query letter with color copies, brochure, photocopies, photographs, SASE, slides, tearsheets and transparencies. Samples are filed and are returned by SASE if requested by artist. Portfolio should include slides, color tearsheets, transparencies and color copies. Sometimes requests work on spec before assigning a job. Pays for design and illustration by the project, $300-1,000 or in royalties per piece of printed art. Negotiates rights purchased. Considers buying second rights (reprint rights) to previously published work.

Tips: "We're looking for fresh ideas and solutions for art featuring animals, zoos, science, humor and education. We need work that is marketable for specific tourist areas—state parks, beaches, islands; also for women's markets. Be flexible in financial/working arrangements. Most work is on a commission or flat buy out. We work on a tight budget until product is sold. Art-wise, the more professional the better."

‡IMAGINE THAT CREATIVE SERVICES, 704 Brookhaven Circle W., Memphis TN 38117-4504. (901)684-1714. Fax: (901)684-1714. E-mail: imagenethat@aol.com. Partner: Scott Stallup. Estab. 1994. Number of employees: 2. Approximate annual billing: 30,000. Design firm. Specializes in print advertising, web presence, presentations, photography, strategic marketing. Current clients include University of Tennessee-Memphis, University of Memphis, VNA, Inc., Yalorusha General Hospital, MPG, Inc., Formus, Inc. Client list available upon request. Professional affiliations: NFIB.

Needs: Approached by 5 illustrators and 5 designers/year. Works with 2 illustrators and 2 designers/year. Prefers freelancers with experience in Macintosh FreeHand. Uses freelancers mainly for print media, marketing, video. Also for airbrushing, animation, model making, multimedia projects, TV/film graphics. 30% of work is with print ads. 100% of design demands skills in Aldus PageMaker 5, MacroMedia FreeHand 5.5, Adobe Photoshop 3.01, QuarkXPress 3.3, any authoring package. 100% of illustration demands skills in Aldus PageMaker 5, Aldus FreeHand 5.5, Adobe Photoshop 3.01, QuarkXPress 3.3.

First Contact & Terms: Send query letter with photographs, résumé, SASE and tearsheets. Send follow-up postcard every year. Accepts disk submissions. Send EPS files. Samples are filed. Will contact for portfolio review of final art, photographs, slides, tearsheets if interested. Pays by the hour, $20-30 for design; $20-45 for illustration. Buys reprint rights. Finds artists through word of mouth.

Tips: "Be willing to take and adapt to criticism; have a devoted attitude to the project and be able to produce quickly."

Texas

STEVEN SESSIONS INC., 5177 Richmond, Suite 500, Houston TX 77056. (713)850-8450. Fax: (713)850-9324. Contact: Steven Sessions. Estab. 1981. Number of employees: 8. Approximate annual billing: $2.5 million. Specializes in annual reports; brand and corporate identity; fashion, package and publication design. Clients: corporations and ad agencies. Current clients include Compaq Computer, Kellogg Foods, Stroh Foods, Texas Instruments, Schlumberger, Johnson & Higgins. Client list available upon request. Professional affiliations: AIGA, Art Directors Club, American Ad Federation.

Needs: Approached by 75 freelancers/year. Works with 10 illustrators and 2 designers/year. Uses freelancers for brochure, catalog and ad design and illustration; poster illustration; lettering; and logos. 50% of freelance work demands knowledge of Adobe Illustrator, QuarkXPress, Adobe Photoshop or Aldus FreeHand. Needs editorial, technical and medical illustration.

First Contact & Terms: Send query letter with brochure, tearsheets, slides and SASE. Samples are filed. Reports back within 10 days. To show portfolio, mail slides. Payment depends on project, ranging from $1,000-20,000/illustration. Rights purchased vary according to project.

Virginia

JOHNSON DESIGN GROUP, INC., 200 Little Falls St., Suite 410, Falls Church VA 22046-4302. (703)533-0550. Art Director: Leonard A. Johnson. Specializes in publications. Clients: corporations, associations and PR firms.

Needs: Approached by 15 freelancers/year. Works with 15 freelance illustrators and 5 designers/year. Works on assignment only. Uses freelancers for brochure and book illustration, mechanicals, retouching and lettering. Especially needs editorial line illustration and a realistic handling of human figure in real-life situations. 90% of freelance work demands knowledge of QuarkXPress, Aldus FreeHand or Adobe Illustrator.

First Contact & Terms: Send query letter with brochure/flyer and nonreturnable samples (photocopies OK) to be kept on file. Pays for design by the hour, $10-15. Pays for illustration by the project.
Tips: The most common mistakes freelancers make in presenting samples or portfolios are "poor quality or non-relevant subject matter." Artists should "have a printed 'leave behind' sheet or photocopied samples that can be left in the art director's files."

Washington

AUGUSTUS BARNETT ADVERTISING/DESIGN, 632 St. Helens Ave., Tacoma WA 98402. (206)627-8508. Fax: (206)593-2116. E-mail: abarnett1@aol.com. President: Charlie Barnett. Estab. 1981. Number of employees: 4. Approximate annual billing: $1.2 million. Specializes in food, beverages, mass merchandise, retail products, corporate identity, package design, business-to-business advertising and marketing. Clients: corporations, manufacturers. Current clients include Tree Top, Inc., I.P. Callison & Sons, Columbia Crest Winery, Alaska Seafood Marketing Institute, Martinac Shipbuilding, Pope & Talbot, QFC Stores. Client list available upon request. Professional affiliations: AAF and AIGA.
Needs: Approached by 20 freelancers/year. Works with 4-6 freelance illustrators and 6-8 designers/year. Prefers freelancers with experience in food/retail and Mac usage. Works on assignment only. Uses illustrators for product, theme and food illustration. Uses designers mainly for concept refinement. Also uses freelancers for illustration, multimedia projects and lettering. 90% of freelance work demands knowledge of Aldus FreeHand 5.5 and Adobe Photoshop. Send query letter with samples, résumé and photocopies. Samples are filed. Reports back within 2 weeks. Portfolios may be dropped off if pre-arranged and should include b&w and color printer samples. Pays for design by the hour, $20-55. Pays for illustration by the hour, $20-75. Rights purchased vary according to project.
Tips: "Freelancers must understand design is a business, deadlines and budgets. Freelancers need to go above and beyond the norm to get noticed."

BELYEA DESIGN ALLIANCE, 1809 Seventh Ave., Suite 1007, Seattle WA 98101. (206)682-4895. Fax: (206)623-8912. Estab. 1980. Specializes in annual reports; brand and corporate identity; marketing materials; in-store P-O-P; direct mail, package and publication design. Clients: corporate, manufacturers, retail. Current clients include Weyerhaeuser and Princess Tours. Client list available upon request.
Needs: Approached by 20-30 freelancers/year. Works with 10 freelance illustrators and 3-5 designers/year. Prefers local design freelancers only. Works on assignment only. Uses illustrators for "any type of project." Uses designers mainly for overflow. Also uses freelancers for brochure, catalog, poster and ad illustration; and lettering. 100% of design and 70% of illustration demand knowledge of QuarkXPress, Aldus FreeHand or Adobe Photoshop.
First Contact & Terms: Send postcard sample and résumé. Accepts disk submissions. Samples are filed. Reports back to the artist only if interested. Pays for design by the hour, $25-40. Pays for illustration by the project, $125-1,000. Rights purchased vary according to project. Finds artists through submissions by mail and referral by other professionals.
Tips: "Designers must be computer-skilled. Illustrators must develop some styles that make them unique in the marketplace."

‡HORNALL ANDERSON DESIGN WORKS, INC., 1008 Western Ave., Suite 600, Seattle WA 98104. (206)467-5800. Fax: (206)467-6411. Receptionist: Dacon Lister. Estab. 1982. Number of employees: 31. Design firm. Specializes in full range—from identity systems, packaging, collateral, signage, exhibits, environmental graphics annual reports. Product specialties are large corporations to smaller businesses. Current clients include Starbucks Coffee Company, Frank Russell Company, Smith Sport Optics, Novell, Inc. Professional affiliations: AIGA, Society for Typographic Arts, Seattle Design Association.
 • This firm has received numerous awards and honors, including the International Mobius Awards, London International Advertising Awards, Northwest and National ADDY Awards, Industrial Designers Society of America IDEA Awards, and two merit awards in *HOW*'s 1996 International Design competition.
Needs: Approached by 50 illustrators and 100 designers/year. Works with 25 illustrators and 10 designers/year. Uses freelancers mainly for computer production. Also for annual reports, lettering, mechanicals, retouching, technical illustration, web page design. 90% of design and 20% of illustration demand skills in Aldus FreeHand 5.0, Adobe Photoshop, QuarkXPress 3.3.
First Contact & Terms: Designers send query letter with photocopies and résumé. Illustrators send query letter with brochure and follow-up postcard. Accepts disk submissions compatible with QuarkXPress, Aldus FreeHand or Adobe Photoshop, "but the best is something that is platform/software independent (i.e., Director)." Samples are filed. Reports back only if interested. Portfolios may be dropped off. Pays for design by the hour. Pays for illustration by the project. Rights purchased vary according to project. Finds designers through word of mouth and submissions; illustrators through sourcebooks, reps and submissions.

‡**SAM PAYNE & ASSOCIATES**, 1471 Elliott Ave. W., Suite A, Seattle WA 98119. (206)285-2009. Fax: (206)285-2948. Owner: Sam Payne. Estab. 1979. Specializes in brand and corporate identity; direct mail, package and publication design; and signage. Clients: food companies, corporations, small to medium-sized businesses and packaging companies. Current clients include Shurgard Inc., Speciality Seafoods and Liberty Orchards. Client list available upon request.
Needs: Approached by 10-12 freelance artists/year. Works with 2-3 freelance illustrators/year. Prefers local artists with experience in food. Works on assignment only. Uses freelance illustrators mainly for packaging and miscellaneous publications. Also uses freelance artists for ad, brochure, editorial, food, catalog and P-O-P illustration and retouching, airbrushing and lettering. Also for multimedia projects. 100% of design demands knowledge of QuarkXPress, Adobe Photoshop, Aldus FreeHand and Adobe Illustrator.
First Contact & Terms: Send query letter with résumé, color photocopies and SASE. Samples are filed or are returned by SASE if requested by artist. Art Director will contact artist for portfolio review if interested. Portfolio should include color slides, photographs and finished printed pieces. Pays for design and illustration by the project, $50-5,000. Rights purchased vary according to project. Considers buying second rights (reprint rights) to previously published work.

TMA, (Ted Mader Associates), 2562 Dexter Ave. N., Seattle WA 98109. (206)270-9360. E-mail: tmaseattle@ aol.com. Website: http://www.tmseattle.com/~tma/. Creative Head: Ted Mader. Number of employees: 10. Specializes in corporate and brand identity, displays, direct mail, fashion, packaging, publications, signage, book covers, interactive media and CD-ROM. Client list available upon request.
Needs: Approached by 150 freelancers/year. Works with 25 freelancer illustrators and 10-20 designers/year. Uses freelancers for illustration, retouching, electronic media, production and lettering. 100% of freelance work demands knowledge of QuarkXPress, Aldus FreeHand, Adobe Illustrator or Director.
First Contact & Terms: Send postcard sample or query letter with résumé and samples. Accepts disk submissions compatible with Mac. Samples are filed. Write or call for an appointment to show portfolio. Pays by the project. Considers skill and experience of freelancer and project budget when establishing payment. Rights purchased vary according to project.

Wisconsin

HARE STRIGENZ, INC., 306 N. Milwaukee St., Milwaukee WI 53202. (414)272-0072. Fax: (414)291-7990. Owner/Creative Director: Paula Hare. Estab. 1986. Number of employees: 9. Specializes in packaging, annual reports, collateral, corporate communications. Clients: manufacturers, retail, agricultural, electronics industries. Client list available upon request.
Needs: Approached by 12-18 freelancers/year. Works with 10-12 freelance illustrators and 12-15 designers/ year. Prefers local illustrators but uses national designers. 100% of freelance work demands knowledge of Adobe Photoshop, QuarkXPress and Adobe Illustrator.
First Contact & Terms: Send query letter with brochure and tearsheets. Samples are filed. Reports back to the artist only if interested. Portfolios may be dropped off every Monday. Artist should follow-up with letter after initial query. Portfolio should include thumbnails. Buys all rights.

‡**IMAGINASIUM DESIGN STUDIO**, 1967 Allouez Ave., Green Bay WI 54311-6233. (414)468-5262. Fax: (414)468-1888. E-mail: imagine@netnet.net. Creative Director: Joe Bergner. Estab. 1991. Number of employees: 3. Approximate annual billing: $400,000. Design firm. Specializes in corporate identity, collateral. Product specialties are industrial, business to business. Current clients include Georgia Pacific, Schneider National. Client list available upon request. Professional affiliation: Green Bay Advertising Federation.
Needs: Approached by 10 illustrators and 15 designers/year. Works with 10 illustrators and 2 designers/ year. Prefers local designers. Uses freelancers mainly for overflow. Also for airbrushing, brochure illustration and lettering. 5-10% of work is with print ads. 100% of design and 10-20% of illustration demand skills in Adobe Photoshop 3.0, QuarkXPress 3.3 and Adobe Illustrator 6.0.
First Contact & Terms: Designers send query letter with brochure, photographs and tearsheets. Illustrators send postcard sample of work with follow-up postcard every 6 months. Accepts Macintosh disk submissions of above programs. Samples are filed and are not returned. Will contact for portfolio review of color tearsheets, thumbnails and transparencies if interested. Pays for design by the hour, $20-40. Pays for illustration by the project. Rights purchased vary according to project. Finds artists through submissions, word of mouth.

Canada

✸2 **DIMENSIONS INC.**, 88 Advance Rd., Etobicoke, Ontario M8Z 2T7 Canada. (416)234-0088. Fax: (416)234-8599. Estab. 1989. Number of employees: 14. Specializes in annual reports; brand and corporate identity; direct mail, package and publication design. Clients: Fortune 500 corporations (IBM, etc.), major

distributors and manufacturers (Letraset), most government ministries (Canadian), television (Fox TV, CBC). Partial client list available (does not include confidential clients). Professional affiliations: GAG, GDAC
Needs: Approached by 200 freelancers/year. Works with 35 freelance illustrators and 3 designers/year. Looks for unique and diverse signature styles. Designers must be local, but not illustrators. Works on assignment only (illustrators mostly). Uses illustrators mainly for advertising, collateral. Uses designers mainly for special projects and overflow work. Designers must work under creative director. Also uses freelancers for brochure design and illustration; magazine design; catalog, P-O-P, poster and ad illustration; and charts/graphs. 100% of freelance design demands knowledge of QuarkXPress, Aldus FreeHand, Adobe Photoshop, Microsoft Word or Suitcase.
First Contact & Terms: Send query letter with brochure or tearsheets, résumé, SASE. Samples are filed or are returned by SASE if requested by artist. Reports back within 2 weeks. Write for appointment to show portfolio."Don't send portfolio unless we phone. Send tearsheets that we can file." Pays for design by the project, $300-10,000. Pays for illustration by the project, $300-8,000. Negotiates rights purchased.
Tips: "We look for diverse styles of illustration for specific projects. Send tearsheets for our files. Our creative director refers to these files and calls with assignment offer. We don't normally have time to view portfolios except relative to a specific job. Strong defined styles are what we notice. The economy has reduced some client budgets and increased demand for speculative work. Since we are emphatically opposed to spec work, we do not work this way. Generalist artists who adapt to different styles are not in demand. Unique illustrative styles are easier to sell."

Foreign

‡*ELTON WARD DESIGN, 4 Grand Ave., Parramatta NSW 2124 Australia. 61-2-6356500. Fax: 61-2-6353436. Design Director: Steve Coleman. Estab. 1941. Number of employees: 37. Approximate annual billing: $5 million. Design firm. Specializes in packaging design. Product specialty is consumer products. Current clients include Procter & Gamble, Lever Rexona, Mars, Kellogg's. Client list available upon request. Professional affiliations: AGDA and AIGA
Needs: Approached by 6 illustrators and 24 designers/year. Works with 1-2 illustrators and 1-2 designers/year. Prefers freelancers with experience in packaging. Uses freelancers mainly for design and artwork. Also for model making. 5% of work is with print ads. 50% of design demands skills in Adobe Photoshop, QuarkXPress, Adobe Illustrator.
First Contact & Terms: Designers send brochure. Illustrators send postcard sample and/or query letter with brochure. Samples are filed. Reports back within 2 weeks. Portfolio review required for designers. Request portfolio review in original query. Portfolios should include photographs, roughs, tearsheets, transparencies. Pays by the hour, $30-80. Negotiates rights purchased.
Tips: Understand strategic branding.

Advertising, Audiovisual & Public Relations Firms

If you are an illustrator who can work in a consistent style or a designer with excellent computer skills, here's a great market. Advertising is the most lucrative market for freelancers. You can make more money in advertising than in magazines, book publishing or greeting cards. We also list public relations and audiovisual firms in this section because they have similar freelance needs.

The agencies listed in this section hire freelancers for all kinds of projects, from lettering to airbrushing, model making, illustration, charts, production, storyboards and a myriad of other services. Their needs are similar to design firms, so see the bulleted list on page 532 to determine how you fit in. You will most likely be paid by the hour for work done on the firm's premises (inhouse), and by the project if you take the assignment back to your studio. Most checks are issued 40-60 days after completion of assignments. Fees depend on the client's budget, but most agencies are willing to negotiate, taking into consideration the experience of the freelancer, the lead time given, and the complexity of the project. Be prepared to offer an estimate for your services before you take an assignment.

Some ad agencies will ask you to provide a preliminary sketch, which, if approved by the client, can land you a plum assignment. If you are asked to create something "on spec," you may not receive payment beyond an hourly fee for your time if the project falls through. So be sure to ask upfront about each agency's payment policy before you start an assignment.

If you're hoping to retain usage rights to your work, you'll want to discuss this up front, too. You can generally charge more if the client is requesting a buyout. If research and travel are required, make sure you find out ahead of time who will cover these expenses.

WHERE TO START

Your initial contact at ad agencies is the art director, creative director or art buyer. The latter title is a recent development in the industry. (See Andrea Kaye's Insider Report on page 610 for more insight into this trend.) Some audiovisual and public relations firms may not be large enough to have an art director on staff so you could be dealing with anyone from an account executive to a company's president. Look for the contact name in the listings to find out who to approach. The companies listed in this section are accustomed to receiving samples from freelancers, but before you send that first mailing, follow these tips to increase your odds of winning an assignment.

Contact local agencies first. Although fax and modem have made it easier for agencies to work with out-of-town illustrators, most prefer to work with local freelancers for design projects.

Design an attractive self-promotional mailer. Consider your mailer as an assignment. Create a memorable piece that is a "keeper." Art directors and buyers say postcard-size mailers are easy to file or tack onto a bulletin board. Don't depend on one mailing to place your name firmly in art directors' minds. Send out follow-up mailings at least twice a year. Be sure to spell the contact person's name correctly. Keep a record

of all your mailings. (For more tips on self-promotional mailings see What Should I Submit? on page 4.)

Research each agency before you submit. Look at the listings in this section and see what type of clients they have. Do they specialize in retail? Perhaps their client base consists of financial institutions, restaurants or health care providers. Find agencies whose focus is compatible with your interests and background.

Some freelancers prefer to approach larger agencies while others have better luck with smaller firms. To help you find a good fit, there is information to the listings that will help determine their size. Within the first paragraph we show the number of employees on staff and the firm's annual billing. Whenever possible, we also list professional affiliations of each agency. Readers tell us it is useful to know if an agency is a member of the Graphic Artists Guild (GAG), the American Institute of Graphic Arts (AIGA), or is a member of a local chapter of the Art Directors Club or the Ad Club.

Read industry trade publications. If you are at all serious about freelancing for ad agencies, it is absolutely imperative that you read at least a few issues of *Advertising Age* and *Adweek*. These magazines will give you a feel for the industry. Current issues can be found in most public libraries.

Become familiar with design annuals. Sometimes called creative service books or sourcebooks, these thick reference books are used by art directors looking for fresh styles. Exploring the sourcebooks will give you a realistic picture of the competition. Though graphic artists and artists' reps pay thousands of dollars to place ads in the commercial sourcebooks like *Showcase*, many of the annuals, like those published yearly by the Society of Illustrators and the American Institute of Graphic Artists, showcase the winners of annual competitions. A small entry fee and some innovative designs or illustrations could put your work in front of thousands of art directors. A list of competitions and their deadlines is published in *HOW* magazine's business annual each fall. If you cannot find these books in your public library, a university library should carry them.

If you are an illustrator, aim for consistency in style. "A freelancer should never have more than two styles in one portfolio," advises Patti Harris, art buying manager at Grey Advertising's New York office. "Otherwise it gets too confusing and the person won't be remembered."

Freelance designers must be versatile. Agencies seek jacks-of-all-trades, experienced in design, typesetting and production work, who are adept at Mac-based programs. You also should be able to meet tight deadlines.

Learn the lingo. An illustrator or designer is a "creative"; non-creative agency staffers such as "AEs" (account executives) are known as "suits"; a brochure is just one of many "collateral" pieces; your portfolio is your "book." If you don't already know the meaning of "comp," "rough" and "on spec," check the glossary of this book or pick up a copy of the magazines *HOW*, *Communication Arts* or *Print* and take a crash course.

Get editorial assignments first. It is easier to break into advertising if you can show some tearsheets of previous editorial (magazine or newspaper) work.

Portfolios must be clean, logical and easy to read. Each piece should be accompanied by a brief description of the project: the time it took to produce, the budget constraints and what your instructions were. If you schedule an appointment to show your book, try to find out ahead of time what the art director likes to see. Some may be interested in reviewing different steps of a project (from roughs, to comps, to final product) while others are interested only in the finished piece. Some like to see a wide variety of work, while others look for a portfolio that's been tailored to their specialties.

Network with your peers. In most cities there are local chapters of the Art Directors

Club, the American Insitute of Graphic Arts and the Graphic Artists Guild. Join one of these groups and become an *active* member. (See Ric Grefé's Insider Report page on 679 for more information on AIGA and other professional organizations.)

Consider hiring a rep. The ad agency market is highly competitive. Freelancers with inside contacts often get first crack at juicy assignments. An artists' rep with extensive knowledge of the industry and working relationships with art directors, could help you break in.

Don't put all your eggs in one basket. Send mailings to design firms, book publishers, magazines, or greeting cards as well as to advertising and public relations agencies. In the advertising field, the work depends more on the state of the economy and may not always be steady, so have some back up work in other areas.

PUBLIC RELATIONS FIRMS

It's sometimes difficult to distinguish between ad agencies and PR firms. Some ad agencies offer public relations as one item on their menu of services, while other houses specialize only in PR.

The main difference between advertising and public relations work is the mission: it's a matter of hard sell versus soft sell. Advertising urges the public to buy a company's product or service by influencing them through paid advertisements and direct marketing. PR firms simply encourage the public to feel positively about their clients through the media and promotional campaigns. Thus, PR firms handle a wide variety of tasks, ranging from development of corporate identity systems, to production of public service announcements, and planning community events and fundraisers. This can mean just about anything under the sun for a freelance designer or illustrator.

AUDIOVISUAL FIRMS

Many ad agencies offer multimedia production services, but there is also a definite niche in the marketplace for firms that specialize in this type of work. A house working exclusively in audiovisuals may produce instructional motion pictures, filmstrips, special effects, test commercials and corporate slide presentations for employee training and advertising.

Computer graphics and electronic design are gaining importance as audiovisual vehicles, and there are a growing number of video houses being established as animation specialists. Closely associated with this trend is television art. Many networks and local television stations need out-of-house help in designing slide shows, news maps, promotional materials and "bumpers" that are squeezed between commercials.

Arizona

ARIZONA CINE EQUIPMENT, INC., 2125 E. 20th St., Tucson AZ 85719. (602)623-8268. Vice President: Linda A. Bierk. Estab. 1967. Number of employees: 11. Approximate annual billing: $850,000. AV firm. Full-service, multimedia firm. Specializes in video. Product specialty is industrial.
Needs: Approached by 5 freelancers/year. Works with 5 illustrators and 5 freelance designers/year. Prefers local artists. Uses freelancers mainly for graphic design. Also for brochure and slide illustration, catalog design and illustration, print ad design, storyboards, animation and retouching. 20% of work is with print ads. Also for multimedia projects. 70% of design and 80% of illustration demand knowledge of Aldus PageMaker, QuarkXPress, Aldus FreeHand, Adobe Illustrator or Adobe Photoshop.
First Contact & Terms: Send query letter with brochure, résumé, photocopies, tearsheets, transparencies, photographs, slides and SASE. Samples are filed. Reports back to the artist only if interested. Art Director will contact artist for portfolio review if interested. Portfolio should include color thumbnails, final art, tearsheets, slides, photostats, photographs and transparencies. Pays for design by the project, $100-5,000. Pays for illustration by the project, $25-5,000. Buys first rights or negotiates rights purchased.

CBI GRAPHICS & ADVERTISING, (formerly CBI Advertising), 8160 E. Batherus, Suite 6, Scottsdale AZ 85260. (602)948-0440. Fax: (602)443-1263. Contact: Gail Cross, Graphic Dept. Estab. 1987. Number of employees: 5. Approximate annual billing: $600,000. Ad agency. Full-service, multimedia firm. Specializes in graphic design, computer graphics. Product specialty is high technology. Client list available upon request. Professional affiliations: AIN.

Needs: Approached by 100 freelance artists/year. Works with 10 freelance illustrators and 10 designers/year. Prefers local artists with experience in Macintosh computer graphics. Uses freelancers mainly for special projects and overflow. Also uses freelancers for brochure and catalog design and illustration, lettering, logos, model making, posters, retouching, signage and TV/film graphics. 50% of work is with print ads. 85% of freelance work demands knowledge of Aldus PageMaker, Adobe Photoshop, QuarkXPress, Adobe Illustrator and Painter.

First Contact & Terms: Send query letter with photocopies, résumé and tearsheets. Samples are filed or returned. Reports back to the artist only if interested. Portfolio should include b&w and color final art, roughs and thumbnails. Pays for design and illustration by the project. Rights purchased vary according to project.

PAUL S. KARR PRODUCTIONS, 2925 W. Indian School Rd., Box 11711, Phoenix AZ 85017. Phone/fax: (602)266-4198. Contact: Paul or Kelly Karr. Utah Division: 1024 N. 300 East, Box 1254, Orem UT 84057. Phone/fax: (801)226-3001. Contact: Michael Karr. Film and video producer. Clients: industry, business, education, TV, cable and feature films.

Needs: Occasionally works with freelance filmmakers in motion picture and video projects. Works on assignment only.

First Contact & Terms: Advise of experience, abilities, and funding for project.

Tips: "If you know about motion pictures and video or are serious about breaking into the field, there are three avenues: 1) have relatives in the business; 2) be at the right place at the right time; or 3) take upon yourself the marketing of your idea, or develop a film or video idea for a sponsor who will finance the project. Go to a film or video production company, such as ours, and tell them you have a client and the money. They will be delighted to work with you on making the production. Work, and approve the various phases as it is being made. Have your name listed as the producer on the credits. With the knowledge and track record you have gained you will be able to present yourself and your abilities to others in the film and video business and to sponsors."

MILES & ASSOCIATES ADVERTISING, 380 E. Fort Lowell Rd., Suite 239, Tucson AZ 85705. (602)623-4944. Contact: Bill Miles. Estab. 1973. Number of employees: 2. Approximate annual billing: $750,000. Ad agency. Full-service, multimedia firm. Specializes in local TV advertising, outdoor. Product specialty is automotive. Client list available upon request.

Needs: Approached by 30 freelancers/year. Works with 1 freelance illustrator and 3 designers/year. Prefers local freelancers only. Uses freelancers mainly for newspaper and outdoor design and layout, plus television graphics. Also for signage. 20% of work is with print ads. Needs computer-literate freelancers for design and production.

First Contact & Terms: Send query letter with photocopies. Samples are filed and are not returned. Art Director will contact artist for portfolio review if interested. Portfolio should include b&w and color final art and roughs. Pays for design by the project, $40-2,500. Pays for illustration by the project. Buys all rights.

California

‡ADAMS AND ASSOCIATES, 80 Gilman Ave. #2-D, Campbell CA 95008-3024. (408)370-5390. Fax: (408)370-5392. E-mail: jaadams@ix.netcom.com. Principal: Jim Adams. Estab. 1992. Number of employees: 5. Integrated marketing communications agency. Specializes in ads, collateral, multimedia, World Wide Web. Product specialty is high tech. Client list available upon request.

Needs: Approached by 25 designers/year. Works with 3 freelance designers/year. Uses freelancers mainly for design. Also for animation, logos, multimedia projects, web page design. 25% of work is with print ads. 100% of freelance design demands skills in Aldus PageMaker 6.0, Adobe Photoshop 3.0, Adobe Illustrator 3.0.

First Contact & Terms: Send query letter with résumé. Accepts disk submission compatible with PC based graphic files. Samples are not filed and not returned. Will contact for portfolio review if interested. Pays by project; negotiable. Rights purchased vary according to project. Finds artists through personal network.

‡THE ADVERTISING CONSORTIUM, 10536 Culver Blvd., Suite D, Culver City CA 90232. (310)287-2222. Fax: (310)287-2227. Contact: Kim Miyade. Estab. 1985. Ad agency. Full-service, multimedia firm. Specializes in print, collateral, direct mail, outdoor, broadcast. Current clients include Bernini, Meridian Communications, Royal-Pedic Mattress.

Needs: Approached by 5 freelance artists/month. Works with 1 illustrator and 3 art directors/month. Prefers local artists only. Works on assignment only. Uses freelance artists and art directors for everything (none on staff), including brochure, catalog and print ad design and illustration and mechanicals and logos. 80% of work is with print ads. Also for multimedia projects. 100% of freelance work demands knowledge of Aldus PageMaker, QuarkXPress, Aldus FreeHand, Adobe Illustrator and Adobe Photoshop.

First Contact & Terms: Send postcard sample or query letter with brochure, tearsheets, photocopies, photographs and anything that does not have to be returned. Samples are filed. Write for appointment to show portfolio. "No phone calls, please." Portfolio should include original/final art, b&w and color photostats, tearsheets, photographs, slides and transparencies. Pays for design by the hour, $60-75. Pays for illustration by the project, based on budget and scope.

‡CREATIVE CONNECTIONS, 423 S. Pacific Coast Hwy., Suite 205, Redondo Beach CA 90277. (310)543-4480 or (800)600-1167. Fax: (310)540-5281. President: Cathleen Cunningham. Estab. 1996. Number of employees: 4. Approximate annual billing: New company. Temporary service specializing in creative personnel. Specializes in collateral and advertising. Product specialty is consumer. Client list available upon request. Professional affiliations AMA, Ad Club-L.A.

Needs: Approached by 50 illustrators/year and 200 designers/year. Works with 50 freelance illustrators and 100 designers/year. Prefers local freelancers. Also for airbrushing; animation; annual reports; billboards; brochure, catalog and web page design; brochure, catalog, humorous, medical, technical illustration; lettering; logos; mechanical; model making; multimedia projects; posters; retouching; storyboards; TV/film graphics. 50% of work is with print ads. 95% of freelance design demands skills in Aldus PageMaker, Aldus FreeHand, Adobe Photoshop, QuarkXpress, Adobe Illustrator, CorelDraw. 10% of freelance illustration demands skills in Adobe Illustrator.

First Contact & Terms: Send query letter with photocopies and résumé. Accepts disk submissions compatible with Adobe Photoshop, QuarkXPress 3.3. Send EPS files. Samples are filed. Portfolio review required. To arrange portfolio review of final art, roughs, tearsheets and thumbnails, follow up with letter. Pays for design by the hour, $15-50. Pays for illustration by the hour, $30-60. Rights purchased vary according to project. Finds artists through classified ads, word of mouth.

‡DESIGN COLLABORATIVE, One Simms, 1st Floor, San Rafael CA 94901-5400. (415)456-0252. Art Director: Joyce Moeller. Estab. 1987. Number of employees: 8. Approximate annual billing: $400,000. Ad agency/design firm. Specializes in publication design, package design, environmental graphics. Product specialty is consumer. Current clients include B of A, Lucus Film Ltd., Broderbund Software. Client list available upon request. Professional affiliations: AAGD, PINC, AAD.

Needs: Approached by 20 freelance illustrators and 60 designers/year. Works with 15 freelance illustrators and 20 designers/year. Prefers local designers with experience in package design. Uses freelancers mainly for art direction production. Also for brochure design and illustration, mechanicals, multimedia projects, signage, web page design. 25% of work is with print ads. 80% of design and 85% of illustration demand skills in Aldus PageMaker, Aldus FreeHand, Adobe Photoshop, QuarkXPress, Adobe Illustrator, PageMill.

First Contact & Terms: Designers send query letter with photocopies, résumé, color copies. Illustrators send postcard sample and/or query letter with photocopies and color copies. After introductory mailing send follow-up postcard samples. Accepts disk submissions. Send EPS files. Samples are filed or returned. Reports back in 1 week. Artist should call. Portfolio review required if interested in artist's work. Portfolios of final art and transparencies may be dropped off every Monday. Pays for design by the hour, $30-60. Pays for illustration by the hour, $40-80. Buys first rights. Rights purchased vary according to project. Finds artists through creative sourcebooks.

Tips: "Listen carefully and execute well."

DIMON CREATIVE COMMUNICATION SERVICES, 3515 W. Pacific Ave., Burbank CA 91505. (818)845-3748. Fax: (818)954-8916. E-mail: dimon@earthlink.net. Creative Director: Sonia Batalian. Number of employees: 12. Approximate annual billing: $2 million. Ad agency/printing firm. Serves clients in industry, finance, computers, electronics, health care and pharmaceutical.

Needs: Works with 3 freelance illustrators and 2 designers/year. 95% of freelance work demands knowledge of Aldus PageMaker, QuarkXPress, Aldus FreeHand, Adobe Illustrator and Adobe Photoshop. Needs freelancers experienced in multimedia; editorial and technical illustration.

First Contact & Terms: Send query letter with tearsheets, finished art samples, photocopies and SASE. Provide brochure, flier, business card, résumé and tearsheets to be kept on file for future assignments. Accepts

HOW TO USE your *Artist's & Graphic Designer's Market* offers suggestions for understanding and using the information in these listings. Read this and other articles in the front of this book for important business tips.

disk submissions. Send EPS, TIFF or PICT files. Portfolio should include comps. Pays for design by the hour, $20-50. Pays for illustration by the project, $75 minimum.

Tips: "We have cut staff so we rely more on freelancers to fill in the gaps when work load requires it."

‡**ESSANEE UNLIMITED, INC.**, 710 Pier Ave., Santa Monica CA 90405. (310)396-0192. Fax: (310)392-4673. Art Director: Sharon Rubin. Estab. 1982. Integrated marketing communications agency/design firm. Specializes in magazine and trade ads, packaging and promotion. Product specialties are media, film, TV, CD-ROM, consumer product. Current clients include NewLine Pictures, M&M Mars.

Needs: Works with 3-5 freelance illustrators and 3-5 designers/year. Prefers local freelancers with experience in graphic design. Also for brochure and web page design, mechanicals, multimedia projects. 20% of work is with print ads. 100% of design and some illustration demand skills in Adobe Photoshop, QuarkXPress.

First Contact & Terms: Send query letter with photocopies, photographs, résumé, SASE and slides. Accepts disk submissions compatible with QuarkXPress 7.5/version 3.3. Samples are filed or returned by SASE. Reports back within 2 weeks. Portfolio review only if interested in artist's work. Artist should follow-up with call. Finds artists through word of mouth, submissions.

EVANS & PARTNERS INC., 55 E. G St., Encinitas CA 92024-3615. (619)944-9400. Fax: (619)944-9422. President/Creative Director: David Evans. Estab. 1988. Number of employees: 7. Approximate annual billing: $1.5 million. Ad agency. Full-service, multimedia firm. Specializes in marketing communications from strategies and planning through implementation in any media. Product specialties are marketing and graphics design for high-tech, high-tech medical, manufacturing. Current clients include Procare, Novus Technologies, Orincon, Verticle Market Software, various credit unions.

• Very interested in CD-ROM combination photography illustration—typographic work.

Needs: Approached by 24-36 freelancers/year. Works with 5-7 freelance illustrators and 4-6 designers/year. Works only with artist reps/illustrators. Prefers local freelancers with experience in listening, concepts, print and collateral. Uses freelancers mainly for comps, design and production (brochure and print ad design and illustration, storyboards, mechanicals, retouching, billboards, posters, TV/film graphics, lettering and logos). Needs editorial, technical and medical illustration. 40% of work is with print ads. 90% of freelance work demands knowledge of Adobe Illustrator, Adobe Photoshop, QuarkXPress or CorelDraw.

First Contact & Terms: Send query letter with brochure, photocopies, résumé and photographs. "Send samples that have an appreciation for dynamic design but are still reader friendly." Samples are filed. Reports back to the artist only if interested. Art Director will contact artist for portfolio review if interested. Portfolio should include roughs, photostats, tearsheets, transparencies and actual produced pieces. Very rarely may request work on spec. Pays for design by the project, $100-24,000. Pays for illustration by the project, $100-18,000. Rights purchased vary according to project. Finds artists through word of mouth, magazines, submissions, sourcebooks and agents.

‡**THE HITCHINS COMPANY**, 22756 Hartland St., Canoga Park CA 91307. (818)715-0150. E-mail: whitchins@aol.com. President: W.E. Hitchins. Estab. 1985. Advertising agency. Full-service, multimedia firm.

Needs: Works with 1-2 illustrators and 3-4 designers/year. Works on assignment only. Uses freelance artists for brochure and print ad design and illustration, storyboards, mechanicals, retouching, TV/film graphics, lettering and logo. Needs editorial and technical illustration and animation. 60% of work is with print ads. 90% of design and 50% of illustration demand knowledge of Aldus PageMaker, Adobe Illustrator, QuarkXPress or Aldus FreeHand.

First Contact & Terms: Send postcard sample. Samples are filed if interested and are not returned. Reports back to the artist only if interested. Call for appointment to show portfolio. Portfolio should include tearsheets. Pays for design and illustration by the project, according to project and client. Rights purchased vary according to project.

LINEAR CYCLE PRODUCTIONS, P.O. Box 2608, San Fernando CA 91393-0608. Producer: Rich Brown. Production Manager: R. Borowy. Estab. 1980. Number of employees: 30. Approximate annual billing: $200,000. AV firm. Specializes in audiovisual sales and marketing programs and also in teleproduction for CATV. Current clients include Katz, Inc. and McDave and Associates.

Needs: Works with 7-10 freelance illustrators and 7-10 designers/year. Prefers freelancers with experience in teleproductions (broadcast/CATV/non-broadcast). Works on assignment only. Uses freelancers for storyboards, animation, TV/film graphics, editorial illustration, lettering and logos. 10% of work is with print ads. 25% of freelance work demands knowledge of Aldus FreeHand, Adobe Photoshop or Tobis IV.

First Contact & Terms: Send query letter with résumé, photocopies, photographs, slides, transparencies, video demo reel and SASE. Samples are filed or are returned by SASE if requested by artist. Reports back to the artist only if interested. To show portfolio, mail audio/videotapes, photographs and slides; include color and b&w samples. Pays for design and illustration by the project, $100 minimum. Considers skill and experience of artist, how work will be used and rights purchased when establishing payment. Negotiates rights purchased. Finds artists through reviewing portfolios and published material.

Tips: "We see a lot of sloppy work and samples, portfolios in fields not requested or wanted, poor photos, photocopies, graphics, etc. Make sure your materials are presentable."

‡MEDIA ENTERPRISES, 1644 S. Clementine St., Anaheim CA 92802. (714)778-5336. Fax: (714)778-6367. E-mail: mei@imagine-net.com. Website: http://www.communicom.com. Creative Director: John Lemieux Rose. Estab. 1982. Number of employees: 5. Approximate annual billing: $1.5 million. Integrated marketing communications agency. Specializes in interactive multimedia, CD-ROMs, Internet, magazine publishing. Product specialty high tech. Client list available upon request. Professional affiliations: Orange County Multimedia Users Group (OCMUG), Software Council of Southern California.
Needs: Approached by 30 freelance illustrators and 10 designers/year. Works with 8-10 freelance illustrators and 3 designers/year. Also for animation, humorous illustration, lettering, logos, mechanicals, multimedia projects. 30% of work is with print ads. 100% of freelance work demands skills in Aldus PageMaker, Adobe Photoshop, QuarkXPress, Adobe Illustrator, Director.
First Contact & Terms: Send postcard sample and/or query letter with photocopies, photographs or URL. Accepts disk submissions compatible with Mac or PC. Samples are filed. Will contact for portfolio review of color photographs, slides, tearsheets, transparencies and/or disk. Pays by project; negotiated. Buys all rights.

NEW & UNIQUE VIDEOS, 2336 Sumac Dr., San Diego CA 92105. (619)282-6126. Fax: (619)283-8264. Estab. 1982. Number of employees: 3. AV firm. Full-service, multimedia firm. Specializes in special interest video titles—documentaries, how-to's etc. Current clients include Coleman Company, Caribou, DuPont, Canari Cyclewear, Giant Bicycles, Motiv Bicycles. Client list available upon request.
Needs: Approached by 5-10 freelancers/year. Works with 2-3 freelance illustrators/year. Prefers freelancers with experience in computer animation. Works on assignment only. Uses freelancers mainly for video box covers, video animation. Also for catalog and print ad design, animation, posters and TV/film graphics. 10% of work is with print ads. 50% of freelance work demands compatability with Macintosh.
First Contact & Terms: Send query letter with brochure, résumé and SASE. Samples are filed or returned by SASE. Reports back in 1 month only if interested. Artist should follow up. Art Director will contact artist for portfolio review if interested. Portfolio should include thumbnails, photographs and tearsheets. Pays for design and illustration by the project (negotiated). Buys one-time rights.

ON-Q PRODUCTIONS, INC., 618 E. Gutierrez St., Santa Barbara CA 93103. President: Vincent Quaranta. AV firm. "We are producers of multi-projector slide presentations. We produce computer-generated slides for business presentations and interactive presentations on CD-ROM." Clients: banks, ad agencies, R&D firms and hospitals.
Needs: Works with 10 freelancers/year. Uses freelancers mainly for slide presentations. Also for editorial and medical illustration, retouching, animation and lettering. 75% of freelance work demands knowledge of QuarkXPress, Aldus FreeHand or Aldus Persuasion.
First Contact & Terms: Send query letter with brochure or résumé. Reports back only if interested. Write for appointment to show portfolio of original/final art and slides. Pays for design and illustration by the hour, $25 minimum; or by the project, $100 minimum.
Tips: "Artist must be *experienced* in computer graphics and on the board. The most common mistakes freelancers make are poor presentation of a portfolio (small pieces fall out, scratches on cover acetate) and they do not know how to price out a job. Know the rates you're going to charge and how quickly you can deliver a job. Client budgets are tight."

PALKO ADVERTISING, INC., 2075 Palos Verdes Dr. N., Suite 207, Lomita CA 90717. (310)530-6800. E-mail: palkoadv@beachnet.com. Art Director: Chuck Waldman. Number of employees: 6. Ad agency. Specializes in business-to-business, retail and high-tech. Professional affiliation: ADLA, AMA.
 • Palko's illustration needs vary widely from fashion to high tech to architectural.
Needs: Approached by 20-30 freelancers/year. Works with 0-1 freelance illustrator and 1-2 designers/year. Prefers local freelancers. Uses freelancers mainly for illustration, computer art production, copywriting and photography. 100% of design and 75% of illustration demand knowledge of QuarkXPress, Adobe Illustrator and Adobe Photoshop. Produces ads, brochures and collateral material.
First Contact & Terms: Send postcard sample or query letter with brochure, résumé, "where you saw our address" and samples or photocopies to be kept on file. Accepts tearsheets, photographs, photocopies, printed material or slides as samples. Samples not filed returned only if requested. President will contact artists for portfolio review if interested. Artist should follow-up with letter after initial query. Sometimes requests work on spec before assigning a job. Pays for design by the project. Pays for illustration by the project, $50-1,500. Pays for production $15-20/hour or by the project. Negotiates rights purchased. Finds artists through sourcebooks.
Tips: "Send us something memorable that is indicative of your capabilities. Include one or two business cards and a word about what you do. The advertising field continues to be tough, but positive—no end in sight for higher level of service for least amount of money."

‡**EDGAR S. SPIZEL ADVERTISING INC.**, 2610 Torrey Pines Rd. C-31, La Jolla CA 92037. (415)474-5735. President: Edgar S. Spizel. AV producer. Clients: "Consumer-oriented from department stores to symphony orchestras, supermarkets, financial institutions, radio, TV stations, political organizations, hotels, real estate firms, developers and mass transit, such as BART." Works a great deal with major sports stars and TV personalities. Specializes in marketing to "over-50" age group.
Needs: Uses artists for posters, ad illustrations, brochures and mechanicals.
First Contact & Terms: Send query letter with tearsheets. Provide material to be kept on file for future assignments. No originals returned at job's completion.

‡**21ST CENTURY VIDEO PRODUCTIONS**, 1292 N. Sacramento St., Orange CA 92667. Phone/fax: (714)538-8427. Estab. 1986. AV firm. Full-service, multimedia firm. Specializes in video productions. Current clients include IBM, Ronald Reagan, CHSOC, Electro-Plasma, Norms Restaurants, Cal Spas and Cryogenic Systems.
Needs: Approached by 2 freelance artists/month. Works with 1 illustrator and 1 designer/year. Prefers local artists with experience in video productions. Uses freelance artists mainly for animation, TV/film graphics and logos. 10% of work is with print ads.
First Contact & Terms: Send query letter with video. Samples are filed. Reports back to the artist only if interested. To show a portfolio, mail video. Pays for design by the project. Buys all rights.

‡**VIRTUAL VINEYARDS**, 3803 E. Bayshore, Palo Alto CA 94303. (800)289-1275. CEO: Harry Max. Estab. 1994. Number of employees: 14. Direct market. Specializes in websites. Product specialties are wine and food.
Needs: Approached by 2-5 freelance illustrators and 10-20 designers/year. Works with 2 freelance illustrators and 2 designers/year. Prefers local, web savvy freelancers. Also for brochure, catalog and webpage design; brochure and catalog illustration, logos, mechanicals. 2% of work is with print ads. 100% of freelance design and 60-100% of illustration demand skills in Aldus FreeHand, Adobe Photoshop, Adobe Illustrator.
First Contact & Terms: Send query letter with brohcure, photocopies, photographs and résumé. Accepts disk submissions compatible with Adobe Photoshop 3.0 Mac PPC. Samples are not filed. Samples are returned if requested. Follow-up with call and/or letter. Will contact for portfolio review if interested. Pays by the project. Rights purchsed vary according to project.
Tips: Establish your own website.

VISUAL AID/VISAID MARKETING, Box 4502, Inglewood CA 90309. (310)399-0696. Manager: Lee Clapp. Estab. 1961. Number of employees: 3. Distributor of promotion aids, marketing consultant service, "involved in all phases." Specializes in manufacturers, distributors, publishers and graphics firms (printing and promotion) in 23 SIC code areas.
Needs: Approached by 25-50 freelancers/year. Works with 1-2 freelance illustrators and 6-12 designers/year. Uses freelancers for advertising, brochure and catalog design, illustration and layout; product design; illustration on product; P-O-P display; display fixture design; and posters. Buys some cartoons and humorous cartoon-style illustrations. Additional media: fiber optics, display/signage, design/fabrication.
First Contact & Terms: Works on assignment only. Send postcard sample or query letter with brochure, photostats, duplicate photographs, photocopies and tearsheets to be kept on file. Reports back if interested and has assignment. Write for appointment to show portfolio. Pays for design by the hour, $5-75. Pays for illustration by the project, $100-500. Considers skill and experience of artist and turnaround time when establishing payment.
Tips: "Do not say 'I can do anything.' We want to know the best media you work in (pen & ink, line drawing, illustration, layout, etc.)."

DANA WHITE PRODUCTIONS, INC., 2623 29th St., Santa Monica CA 90405. (310)450-9101. Owner/Producer: Dana C. White. AV firm. "We are a full-service audiovisual production company, providing multi-image and slide-tape, video and audio presentations for training, marketing, awards, historical and public relations uses. We have complete inhouse production resources, including slidemaking, soundtrack production, photography, and AV multi-image programming. We serve major industries, such as GTE, Occidental Petroleum; medical, such as Whittier Hospital, Florida Hospital; schools, such as University of Southern California, Pepperdine University, Clairbourne School; publishers, such as McGraw-Hill, West Publishing; and public service efforts, including fundraising."
Needs: Works with 4-6 freelancers/year. Prefers freelancers local to greater Los Angeles, "with timely turnaround, ability to keep elements in accurate registration, neatness, design quality, imagination and price." Uses freelancers for design, illustration, retouching, characterization/animation, lettering and charts. 50% of freelance work demands knowledge of Adobe Illustrator or Aldus FreeHand.
First Contact & Terms: Send query letter with brochure or tearsheets, photostats, photocopies, slides and photographs. Samples are filed or are returned only if requested. Reports back within 2 weeks only if interested. Call or write for appointment to show portfolio. Pays by the project. Payment negotiable by job.
Tips: "These are tough times. Be flexible. Negotiate. Deliver quality work on time!"

Los Angeles

ANCHOR DIRECT MARKETING, 7926 Cowan Ave., Suite 100, Los Angeles CA 90045. (310)216-7855. Fax: (310)337-0542. President: Robert Singer. Estab. 1986. Ad agency. Specializes in direct marketing.
Needs: Prefers local freelancers with experience in direct response and illustration. Works on assignment only. Uses freelancers mainly for layout. 80% of freelance work demands knowledge of Aldus PageMaker, Adobe Illustrator, Aldus FreeHand or QuarkXPress.
First Contact & Terms: Call for appointment to show portfolio of direct response work. Sometimes requests work on spec before assigning job. Pays for design and illustration by the project.

BRAMSON (+ ASSOC.), 7400 Beverly Blvd., Los Angeles CA 90036. (213)938-3595. Fax: (213)938-0852. Art Directors: Alex or Gene. Estab. 1970. Number of employees: 12. Approximate annual billing: more than $2 million. Advertising agency. Specializes in magazine ads, collateral, ID, signage, graphic design, imaging, campaigns. Product specialties are healthcare, consumer, business to business. Current clients include Johnson & Johnson, Chiron Vision, Lawry's, IOLAB Corp. and Surgin, Inc.
Needs: Approached by 150 freelancers/year. Works with 10 freelance illustrators and 5 designers/year. Prefers local freelancers. Works on assignment only. Uses freelancers for brochure and print ad design; brochure, technical, medical and print ad illustration; storyboards; mechanicals; retouching; lettering; logos. 30% of work is with print ads. 50% of freelance work "prefers" knowledge of Aldus Pagemaker, Adobe Illustrator, QuarkXPress, Adobe Photoshop or Aldus Freehand.
First Contact & Terms: Send query letter with brochure, photocopies, résumé, photographs, tearsheets, SASE. Samples are filed. Art Director will contact artist for portfolio review if interested. Portfolio should include roughs, color tearsheets. Sometimes requests work on spec before assigning job. Pays for design by the hour, $15-25. Pays for illustration by the project, $250-2,000. Buys all rights or negotiates rights purchased. Finds artists through sourcebooks.

‡GORDON GELFOND ASSOCIATES, INC., 11500 Olympic Blvd., Los Angeles CA 90064. (310)478-3600. Fax: (310)477-4825. Art Director: Barry Brenner. Estab. 1967. Ad agency. Full-service, multimedia firm. Specializes in print campaigns. Product specialties are financial, general, consumer. Current clients include Long Beach Bank, Century Bank and Deluxe Color Labs.
Needs: Works only with artists reps. Uses freelancers for print ad illustration, mechanicals, retouching and lettering. 95% of work is with print ads.
First Contact & Terms: Send query letter with photostats. Art Director will contact artist for portfolio review if interested. Pays for illustration by the project, $200 minimum. Rights purchased vary according to project.

RHYTHMS PRODUCTIONS, P.O. Box 34485, Los Angeles CA 90034. President: Ruth White. Estab. 1955. AV firm. Specializes in CD-ROM and music production/publication. Product specialty is educational materials for children.
Needs: Works with 2 freelance illustrators and 2 designers/year. Prefers local artists with experience in cartoon animation and graphic design. Works on assignment only. Uses freelancers artists mainly for cassette covers, books, character design. Also for catalog design, multimedia, animation and album covers. 2% of work is with print ads. 75% of design and 50% of illustration demand knowledge of Adobe Illustrator, Adobe Photoshop or Macromind Director.
First Contact & Terms: Send query letter with photocopies and SASE (if you want material returned). Samples are returned by SASE if requested. Reports back within 2 months only if interested. Art Director will contact artist for portfolio review if interested. Pays for design and illustration by the project. Buys all rights. Finds artists through word of mouth and submissions.

San Francisco

THE AD AGENCY, P.O. Box 470572, San Francisco CA 94147. (415)928-2264. Creative Director: Michael Carden. Estab. 1972. Ad agency. Full-service, multimedia firm. Specializes in print, collateral, magazine ads. Client list available upon request.
Needs: Approached by 120 freelancers/year. Works with 120 freelance illustrators and designers/year. Uses freelancers mainly for collateral, magazine ads, print ads. Also for brochure, catalog and print ad design and illustration; mechanicals; billboards; posters; TV/film graphics; multimedia; lettering; and logos. 60% of freelance work is with print ads. 50% of freelance design and 25% of illustration demand computer skills.
First Contact & Terms: Send query letter with brochure, photocopies and SASE. Samples are filed or returned by SASE. Reports back in 1 month. Portfolio should include color final art, photostats and photographs. Buys first rights or negotiates rights purchased. Finds artists through word of mouth, referrals and submissions.

Tips: "We are an eclectic agency with a variety of artistic needs."

COMMUNICATIONS WEST, 1426 18th St, San Francisco CA 94107. (415)863-7220. Fax: (415)621-2907. Contact: Creative Director. Estab. 1983. Number of employees: 9. Approximate annual billing: $4 million. Ad agency/PR firm. Product specialties are transportation and consumer. Specializes in magazine ads and collateral. Current clients include Blue Star Line, Sector Watches, Dionex, Attachmate, Finnigan MAT.
Needs: Approached by 48 freelancers/year. Works with 2-4 freelance illustrators and 6-8 designers/year. Prefers local freelancers with experience. Works on assignment only. Uses freelancers mainly for brochure and print ad design and illustration, slide illustration, mechanicals, retouching, posters, lettering and logos. 50% of work is with print ads. 50% of freelance work demands knowledge of Adobe Illustrator, QuarkXPress and Adobe Photoshop.
First Contact & Terms: Send query letter with brochure, résumé, photocopies and tearsheets. Samples are filed. Reports back to the artist only if interested. Call for appointment to show portfolio of color tearsheets and finished art samples. Pays for design by the project, $250-5,000. Pays for illustration by the project, $500-2,500. Buys all rights.

‡MEDIA SERVICES CORP., 10 Aladdin Terrace, San Francisco CA 94133. (415)928-3033. Fax: (415)441-1859. President: Gloria Peterson. Estab. 1974. Ad agency. Specializes in publishing and package design. Product specialties are publishing and consumer. Current clients include San Francisco Earthquake Map and Guide, First Aid for the Urban Cat, First Aid for the Urban Dog.
Needs: Approached by 3 freelance artists/month. Works with 1-2 illustrators and 2 designers/month. Prefers artists with experience in package design with CAD. Works on assignment only. Uses freelancers mainly for support with mechanicals, retouching and lettering. 5% of work is with print ads.
First Contact & Terms: Designers send query letter with résumé. Illustrators send postcard sample. Samples are filed or are returned by SASE only if requested by artist. Reports back to the artist only if interested. To show portfolio, mail tearsheets or 5×7 transparencies. Payment for design and illustration varies. Rights purchased vary according to project.
Tips: Wants to see "computer literacy and ownership."

PURDOM PUBLIC RELATIONS, 395 Oyster Point, S. San Francisco, CA 94080. (415)588-5700. Fax: (415)588-1643. E-mail: purdompr@netcom.com. President: Paul Purdom. Estab. 1962. Number of employees: 18. Approximate annual billing: $2 million. PR firm. Full-service, multimedia firm. Specializes in high-tech and business-to-business. Current clients include Sun Microsystems and Varian Associates. Professional affiliation: PRSA.
Needs: Approached by 20 freelancers/year. Works with 10 freelance designers/year. Works on assignment only. Prefers local freelancers for work on brochure and catalog design; slide, editorial and technical illustration; mechanicals; and TV/film graphics. 75% of freelance work demands knowledge of Aldus PageMaker, Aldus FreeHand or Adobe Illustrator.
First Contact & Terms: Samples are not filed and are returned. Call for appointment to show portfolio, of completed projects. Pays for design by the project. Buys all rights.

Colorado

CINE DESIGN FILMS, Box 6495, Denver CO 80206. (303)777-4222. Producer/Director: Jon Husband. AV firm. Clients: automotive companies, banks, restaurants, etc.
Needs: Works with 3-7 freelancers/year. Works on assignment only. Uses freelancers for layout, titles, animation and still photography. Clear concept ideas that relate to the client in question are important.
First Contact & Terms: Send query letter to be kept on file. Reports only if interested. Write for appointment to show portfolio. Pays by the project. Considers complexity of project, client's budget and rights purchased when establishing payment. Rights purchased vary according to project.

Connecticut

‡COPLEY MEDIAWORKS, 3006 Fairfield, Bridgeport CT 06605. (203)333-6633. Fax: (203)333-8844. Office Manager: Pam Brown. Estab. 1987. Number of employees: 3. Approximate annual billing: $2,600,000. Integrated marketing communications agency. Specializes in television, business-to-business print. Product specialties are sports, publishing.
Needs: Approached by 12 freelance illustrators and 20 designers/year. Works with 2 freelance illustrators and 2 designers/year. Uses freelancers mainly for brochures and ads. Also for brochure illustration, catalog design, lettering, logos, mechanicals, storyboards, TV/film graphics. 25% of work is with print ads. 100%

of freelance design demands skills in Aldus PageMaker, Adobe Photoshop, QuarkXPress, Adobe Illustrator. 50% of freelance illustration demands skills in Adobe Photoshop and Adobe Illustrator.

First Contact & Terms: Send query letter with brochure and résumé. Accepts disk submissions compatible with QuarkXPress. Samples are filed. Will contact for portfolio review if interested. Pays by project. Buys all rights. Finds artists through word of mouth, magazines, submissions.

Tips: "Bring overall business sense plus sense of humor. Must be punctual, trustworthy."

EFFECTIVE COMMUNICATION ARTS, INC., 149 Dudley Rd., P.O. Box 250, Wilton CT 06897-0250. (203)761-8787. E-mail: info@e-talenet.com. President: David Jacobson. Estab. 1965. Number of employees: 4. AV firm. Produces films, videotapes and interactive videodiscs on science, medicine and technology. Specialize in pharmaceuticals, medical devices and electronics. Current clients include ICI Pharma, AT&T, Burroughs Wellcome and SmithKline Beecham.

● This president predicts the audiovisual field will continue to see growth of CD-ROM projects and the need for more art. Currently, CD-ROM projects are the bulk of this company's work.

Needs: Approached by 8 freelancers/year. Works with 6 freelance illustrators and 4 designers/year. Prefers freelancers with experience in science and medicine. Works on assignment only. Uses freelancers mainly for animation and computer graphics. Also for editorial, technical and medical illustration, brochure design, storyboards, slide illustration, mechanicals and TV/film graphics. 90% of freelance work demands knowledge of computer graphics packages.

First Contact & Terms: Send postcard samples. Accepts disk submissions. Samples are filed or are returned by SASE only if requested by artist. Reports back to the artist only if interested. Portfolio review not required. Pays for design by the project or by the day, $200 minimum. Pays for illustration by the project, $150 minimum. Considers complexity of project, client's budget and skill and experience of artist when establishing payment. Buys all rights.

Tips: "Show good work and have good references."

INFOVIEW CORPORATION, INC., 124 Farmingdale Rd., Wethersfield CT 06109. Phone/fax: (203)721-0270. General Manager: Larry Bell. Estab. 1985. Number of employees: 3. Advertising specialties firm. Specializes in personalized products for organization identity—logos on jackets, sweatshirts, leather goods and canvas bags.

Needs: Works with 4-5 freelance illustrators/year. Uses freelancers in developing coporate, club and organizational logos. 100% of freelance work demands knowledge of Adobe, any version.

First Contact & Terms: Send fax with sample logos for evaluation. Will contact artist for additional photocopies of work. Accepts submissions on disk compatible with Adobe Illustrator (EPS) or PageMaker Windows/PM5). Pays for design by the project. Finds artists through word of mouth, agents submissions.

Tips: "Show us creative range of work from 'Mustang' car clubs to service organizations logo designs."

‡LISTENING LIBRARY, INC., 1 Park Ave., Old Greenwich CT 06870-1727. (203)637-3616. Fax: (203)698-1998. Art Director: Deanna Thomas. Produces books on tape for children and adults. Product specialties include catalogs and cassette covers.

Needs: Periodically requires illustrators for covers of 3 catalogs/year. Uses artists for catalog and advertising design and layout, advertising and editorial illustration and direct mail packages. 100% of freelance work demands knowledge of QuarkXPress, Adobe Photoshop and Adobe Illustrator.

First Contact & Terms: Prefers local Fairfield County, New York City and Westchester County artists only. Works on assignment only. Send résumé and nonreturnable samples to be kept on file for possible assignments. Art Director will contact artist for portfolio review if interested. "Payment is determined by the size of the job and skill and experience of artist." Buys all rights.

REALLY GOOD COPY CO., 92 Moseley Terrace, Glastonbury CT 06033. (203)659-9487. Fax: (203)633-3238. E-mail: copyqueen@aol.com. President: Donna Donovan. Estab. 1982. Number of employees: 2. Ad agency. Full-service, multimedia firm. Specializes in direct mail and catalogs. Product specialties are medical/health care, consumer products and services. Current clients include Tobacco Shed Antiques, The Globe-Pequot Press, Fanfare Enterprises/The Music Stand, Motherwear, Adapt Ability, WorldWide Games and SA-SO Company. Professional affiliations: Connecticut Art Directors Association, Direct Marketing Association of Connecticut.

Needs: Approached by 40-50 freelancers/year. Works with 1-2 freelance illustrators and 6-8 designers/year. Prefers local freelancers whenever possible. Works on assignment only. Uses freelancers for all projects. "There are no on-staff artists." 50% of work is with print ads. 100% of design and 50% of illustration demand knowledge of QuarkXPress, Adobe Illustrator or Adobe Photoshop.

First Contact & Terms: Designers send query letter with résumé. Illustrators send postcard samples. Accepts disk submissions. Send EPS files only. Samples are filed or are returned by SASE only if requested. Reports back to the artist only if interested. Portfolio review not required, but portfolio should include roughs and original/final art. Pays for design by the hour, $25-80. Pays for illustration by the project, $100-750.

Tips: "I continue to depend upon word of mouth from other satisfied agencies and local talent. I'm fortunate to be in an area that's overflowing with good people. Send two or three good samples—not a bundle."

‡ULTITECH, INC., Foot of Broad St., Stratford CT 06497. (203)375-7300. Fax: (203)375-6699. E-mail: comcowic@meds.com. Website: http://www.meds.com. President: W.J. Comcowich. Estab. 1993. Number of employees: 3. Approximate annual billing: $1 million. Integrated marketing communications agency. Specializes in interactive multimedia, software, online services. Product specialties are medicine, science, technology. Current clients include Glaxo, Smithkline, Pharmacia. Professional affiliation: IMA.
Needs: Approached by 10-20 freelance illustrators and 10-20 designers/year. Works with 2-3 freelance illustrators and 6-10 designers/year. Prefers freelancers with experience in interactive media design and online design. Uses freelancers mainly for interactive media—online design (WWW). Also for animation, brochure and webpage design, medical illustration, multimedia projects, TV/film graphics. 10% of work is with print ads. 100% of freelance design demands skills in Adobe Photoshop, QuarkXPress, Adobe Illustrator, 3D packages.
First Contact & Terms: Send query letter with résumé. Illustrators send postcard sample and/or query letter with photocopies, résumé, tearsheets. Accepts disk submissions in PC formats. Samples are filed. Reports back only if interested. Request portfolio review in original query. Pays for design by the project, by the day. Pays for illustration by the project. Buys all rights. Finds artists through sourcebooks, word of mouth.
Tips: "Learn design principles for interactive media."

Delaware

‡ALOYSIUS BUTLER & CLARK (AB&C), (formerly AB&C Marketing Communications), One Riverwalk Center, Wilmington DE 19801. (302)655-1552. Contact: Tom McGivney. Ad agency. Clients: health care, banks, industry, restaurants, hotels, businesses, government offices.
Needs: Works with 12 or more illustrators and 3-4 designers/year. Uses artists for trade magazines, billboards, direct mail packages, brochures, newspapers, stationery, signage and posters. 95% of design and 15% of illustration demand knowledge of QuarkXPress, Adobe Illustrator or Adobe Photoshop.
First Contact & Terms: Designers send query letter with résumé and photocopies. Illustrators send postcard samples. Samples are filed; except work that is returned only if requested. Reports only if interested. Works on assignment only. Pays for design by the hour, $20-50. Pays for illustration by the hour; or by the project, $250-1,000.

CUSTOM CRAFT STUDIO, 310 Edgewood St., Bridgeville DE 19933. (302)337-3347. Fax: (302)337-3444. AV producer. Vice President: Eleanor H. Bennett.
Needs: Works with 12 freelance illustrators and 12 designers/year. Works on assignment only. Uses freelancers mainly for work on filmstrips, slide sets, trade magazines and newspapers. Also for print finishing, color negative retouching and airbrush work. Prefers pen & ink, airbrush, watercolor and calligraphy. 10% of freelance work demands knowledge of Adobe Illustrator. Needs editorial and technical illustration.
First Contact & Terms: Send query letter with résumé, slides or photographs, brochure/flyer and tearsheets to be kept on file. Samples returned by SASE. Reports back in 2 weeks. Originals not returned. Pays by the project, $25 minimum.

GLYPHIX ADVERTISING, 105 Second St., Lewes DE 19958. (302)645-0706. Fax: (302)645-2726. Creative Director: Richard Jundt. Estab. 1981. Number of employees: 2. Approximate annual billing: $200,000. Ad agency. Specializes in collateral and advertising. Current clients include Cytec Industries, CasChem, Lansco Colors. Client list available upon request.
Needs: Approached by 10-20 freelancers/year. Works with 2-3 freelance illustrators and 2-3 designers/year. Prefers local artists only. Uses freelancers mainly for "work I can't do." Also for brochure and catalog design and illustration and logos. 20% of work is with print ads. 100% of freelance work demands knowledge of Adobe Photoshop, QuarkXPress, Adobe Illustrator and Delta Graph.
First Contact & Terms: Send query letter with samples. Reports back within 10 days if interested. Artist should follow-up with call. Portfolio should include b&w and color final art, photographs and roughs. Buys all rights. Finds artists through word of mouth and submissions.

Florida

‡CREATIVE EYE MARKETING RESOURCES, P.O. Box 610543, North Miami FL 33261. (305)948-6174. Fax: (305)940-9663. E-mail: icreate@creativeeye.com. Website: http://www.creativeeye.com/icreate/. Owner: Giselle Aguiar. Estab. 1995. Number of employees: 2. Internet marketing. Specializes in websites. Product specialties are any. Current clients include South Florida OnLine, Academy Travel, Be Our Guest Vacation Homes. Client list available upon request (or see Website). Professionsl affiliations: North Dade Chamber of Commerce, N. Miami Chamber.

Needs: Approached by 30-40 freelance designers/year. Works with 3-4 freelance designers/year. Prefers local designers with experience in web pages, HTML, Java, VRML. Uses freelancers mainly for creating web pages. Also for animation, logos. 100% of design demands skills in Aldus PageMaker, Adobe Photoshop, CorelDraw, HTML Editor.

First Contact & Terms: Send query letter on e-mail with URLS. Accepts electronic submissions by e-mail only. Send HTM files. Samples are filed. Reports back only if interested. Portfolio review not required. Pays for design by the project, $25 minimum. Buys all rights. Finds artists through "posting on our website."

Tips: "To work with us, freelancers need to know HTML. VRML and Java extra."

GOLD & ASSOCIATES INC., 100 Executive Way, Ponte Vedra Beach FL 32082. (904)285-5669. Fax: (904)285-1579. Creative Director/President: Keith Gold. Estab. 1988. Ad agency. Full-service, multimedia firm. Specializes in graphic design. Product specialties are publishing, health care, entertainment and fashion.

● The president of Gold & Associates believes agencies will offer more services than ever before, as commissions are reduced by clients.

Needs: Approached by 120-140 freelancers/year. Works with 24-36 freelance illustrators and 24-36 designers/year. Works only with artist reps. Works on assignment only. Uses freelancers for brochure, catalog, medical, editorial, technical, slide and print ad illustration; storyboards; animatics; animation; mechanicals; retouching. 50% of work is with print ads. 50% of freelance work demands knowledge of Aldus PageMaker, Adobe Illustrator, QuarkXPress and Adobe Photoshop.

First Contact & Terms: Contact through artist rep or send query letter with photocopies, tearsheets and capabilities brochure. Samples are filed. Reports back to the artist only if interested. Request portfolio review in original query. Art Director will contact artists for portfolio review if interested. Follow-up with letter after initial query. Portfolio should include tearsheets. Pays for design by the hour, $35-125. "Maximum number of hours is negotiated up front." Pays for illustration by the project, $200-7,500. Buys all rights. Finds artists primarily through sourcebooks and reps.

STEVE POSTAL PRODUCTIONS, P.O. Box 428, Carraway St., Bostwick FL 32007-0428. (904)325-5254. Director: Steve Postal. Estab. 1958. Number of employees: 8. Approximate annual billing: $1 million. AV firm. Full-service, multimedia firm. Specializes in documentaries, feature films. Product specialty is films and videos. Professional affiliations: Directors Guild of Canada, FMPTA.

Needs: Approached by 150 freelancers/year. Works with 10 freelance illustrators and 5 designers/year. Prefers artists with experience in advertising, animation, design for posters. Works on assignment only. Uses freelancers mainly for films and film ads/VHS boxes. Also for brochure, catalog and print ad design and illustration; animation; TV/film graphics; and lettering. 10% of work is with print ads. 10% of design and 15% of illustration demand knowledge of Aldus FreeHand.

First Contact & Terms: Send query letter with résumé, brochure, photocopies and SASE. Samples are filed. Reports back to the artist only if interested. "Artist should follow-up their mailing with at least two telephone calls within two weeks of mailing." Portfolio should include b&w and color final art, tearsheets and photographs. Pays for design and illustration by the project. Buys all rights. Finds artists through submissions.

ROBERTS & CLINE, 5405 Cypress Center Dr., Suite 250, Tampa FL 33609-1025. (813)281-0088. Fax: (813)281-0271. Creative Director: Amy Phillips. Estab. 1986. Number of employees: 9. Ad agency, PR firm. Full-service, multimedia firm. Specializes in integrated communications compaigns using multiple media and promotion. Professional affiliations: AIGA, PRSA, AAF.

Needs: Approached by 50 freelancers/year. Works with 10 freelance illustrators and designers/year. Prefers local artists with experience in conceptualization and production knowledge. Uses freelancers for billboards, brochure design and illustration, lettering, logos, mechanicals, posters, retouching and signage. 60% of work is with print ads. 95% of freelance work demands knowledge of Adobe Photoshop 2.5, QuarkXPress 3.3 and Adobe Illustrator 5.0.

First Contact & Terms: Send postcard sample or query letter with photocopies, résumé and SASE. Samples are filed or are returned by SASE if requested by artist. Portfolios may be dropped off every Monday. Art Director will contact artist for portfolio review if interested. Portfolio should include b&w and color final art, roughs and thumbnails. Pays for design by the hour, $20-85; by the project, $100 minimum; by the day, $150-500. Pays for illustration by the project, "as appropriate." Rights purchased vary according to project. Finds artists through agents, sourcebooks, seeing actual work done for others, annuals (*Communication Arts*, *Print*, *One Show*, etc.).

Tips: Impressed by "work that demonstrates knowledge of product, willingness to work within budget, contributing to creative process, delivering on-time. Continuing development of digital technology hand-in-hand with new breed of traditional illustrators sensitive to needs of computer production is good news."

‡SANCHEZ & LEVITAN, INC., 3191 Coral Way, Suite 510, Miami FL 33145. Phone/fax: (305)442-1586. Full-service, multimedia ad agency and PR firm. Specializes in TV, radio and magazine ads, etc. Specializes in consumer service firms and Hispanic markets. Current clients include Florida Lottery, Bell-South Telecommunications, Metro-Dade, Marlboro Grand Prix, Coca-Cola, USA, The House of Seagram and Benihana.

Needs: Approached by 1 artist/month. Prefers local artists only. Works on assignment only. Uses freelancers for storyboards, slide illustration, new business presentations and TV/film graphics and logos. 35% of work is with print ads. 25% of freelance work demands knowledge of Aldus PageMaker, QuarkXPress and Adobe Illustrator.
First Contact & Terms: Send query letter with brochure and résumé. Samples are not filed and are returned by SASE only if requested by artist. Reports back to the artist only if interested. Write for appointment to show portfolio.

Georgia

‡GRANT/GARRETT COMMUNICATIONS, INC., Box 53, Atlanta GA 30301. (404)755-2513. President: Ruby Grant Garrett. Estab. 1979. Production and placement firm for print media. Specializes in recruitment advertising and graphics. Clients: banks, organizations, products-service consumer. Client list available for SASE.
 ● Grant/Garrett Communications predicts there will be more small jobs in the future.
Needs: Assigns 24 jobs/year. Works with 2-3 illustrators and 2 designers/year. "Experienced, talented artists only." Works on assignment only. Uses freelancers for billboards, brochures, signage and posters. 100% of work is with print ads. Needs editorial, technical and medical illustration. Especially needs "help-wanted illustrations that don't look like clip art." 30% of freelance work demands knowledge of Aldus PageMaker.
First Contact & Terms: Designers send query letter with résumé to be kept on file. Illustrators send postcard samples and résumé. Reports within 10 days. Art Director will contact artist for portfolio review if interested. Portfolio should include roughs and tearsheets. "Do not send samples or copies of fine art or paintings." Requests work on spec before assigning a job. Pays for design by the hour, $25-35; or by the project, $75-3,500. Pays for illustration by the project, $35-2,500. Considers client's budget, skill and experience of artist and turnaround time when establishing payment. Negotiates rights purchased. Finds artists through submissions and sourcebooks.

Hawaii

‡MILICI VALENTI NG PAC, (formerly Milici Valenti Gabriel DDB Needham Worldwide), Amfac Bldg., 700 Bishop St., Honolulu HI 96813. (808)536-0881. Creative Director: Walter Wanger. Ad agency. Serves clients in food, finance, utilities, entertainment, chemicals and personal care products. Clients include First Hawaiian Bank, Aloha Airlines, Sheritan Hotels.
Needs: Works with 3-4 freelance illustrators/month. Artists must be familiar with advertising demands; used to working long distance through the mail; and be familiar with Hawaii. Uses freelance artists mainly for illustration, retouching and lettering for newspapers, multimedia kits, magazines, radio, TV and direct mail.
First Contact & Terms: Send brochure, flier and tearsheets to be kept on file for future assignments. Pays $200-2,000.

Illinois

BRAGAW PUBLIC RELATIONS SERVICES, 800 E. Northwest Hwy., Palatine IL 60067. (708)934-5580. Fax: (708)934-5596. Principal: Richard S. Bragaw. Number of employees: 3. PR firm. Specializes in newsletters and brochures. Clients: professional service firms, associations and industry. Current clients include Arthur Andersen, KPT Kaiser Precision Tooling, Inc. and Nykiel-Carlin and Co. Ltd.
Needs: Approached by 12 freelancers/year. Works with 2 freelance illustrators and 2 designers/year. Prefers local freelancers only. Works on assignment only. Uses freelancers for direct mail packages, brochures, signage, AV presentations and press releases. 90% of freelance work demands knowledge of Aldus PageMaker. Needs editorial and medical illustration.
First Contact & Terms: Send query letter with brochure to be kept on file. Reports back only if interested. Pays by the hour, $25-75 average. Considers complexity of project, skill and experience of artist and turnaround time when establishing payment. Buys all rights.
Tips: "We do not spend much time with portfolios."

JOHN CROWE ADVERTISING AGENCY, INC., 2319½ N. 15th St., Springfield IL 62702-1226. Phone/fax: (217)528-1076. President: Bryan J. Crowe. Ad/art agency. Number of employees: 3. Approximate annual billing: $250. Specializes in industries, manufacturers, retailers, banks, publishers, insurance firms,

packaging firms, state agencies, aviation and law enforcement agencies. Product specialty is creative advertising. Current clients include US West Direct, Fitness America.

Needs: Approached by 250-300 freelancers/year. Works with 10-15 freelance illustrators and 2-5 designers/year. Works on assignment only. Uses freelancers for color separation, animation, lettering, paste-up and type specing for work with consumer magazines, stationery design, direct mail, slide sets, brochures/flyers, trade magazines and newspapers. Especially needs layout, camera-ready art and photo retouching. Needs technical illustration. Prefers pen & ink, airbrush, watercolor and marker. 75% of freelance design and 25% of illustration demand computer skills.

First Contact & Terms: "Send a letter to us with photocopies of your work regarding available work at agency. Tell us about yourself. We will reply if work is needed and request additional samples of work." Reports back in 2 weeks. Pays for design and illustration by the hour, $15-25. Originals not returned. No payment for unused assigned illustrations.

Tips: "Current works are best. Show your strengths and do away with poor pieces that aren't your stonghold. A portfolio should not be messy and cluttered. There has been a notable slowdown across the board in our use of freelance artists."

‡ESROCK PARTNERS, 14550 S. 94th Ave. Orland Park IL 60462. (708)349-8400. Fax: (708)349-8471. Advertising Group VP: Ciela Quitsch. Estab. 1978. Ad Agency. Full-service, multimedia firm. Specializes in magazine ads, direct mail, catalogs, sales support materials. Product specialties are food, food service, food processing. Current clients include Van Den Bergh Foods, Custom Foods, Sargento Foods Co.

Needs: Approached by 10 freelance artists/month. Works with 3-5 illustrators and 3-5 designers/month. Prefers local artists only. Works on assignment only. Uses freelancers mainly for illustration. Also for posters, lettering and logos. 40% of work is with print ads.

First Contact & Terms: Send query letter with brochure, photocopies and résumé. Samples are filed and are not returned. Reports back only if interested. Write for appointment to show portfolio. Portfolio should include thumbnails, roughs, b&w. Pays for design by the project. Pays for illustration by the project. Buys all rights.

DAN GLAUBKE, INC., 189 Lowell, Glen Ellyn IL 60137. (708)953-2300. Fax: (708)953-2714. Estab. 1995. Number of employees: 2. Approximate annual billing: $500,000. Ad agency. Specializes in trade, consumer, retail ads, sales brochures, newsletters, catalogs and AV presentations. Product specialties are trade, consumer and retail. Client list available upon request.

Needs: Approached by 25-50 freelance artists/year. Works with 5 freelance illustrators and 5 designers/year. Prefers local artists only. Uses freelancers mainly for ads/collateral pieces. Also for brochure and catalog design and illustration, lettering, mechanicals, model making and retouching. 70% of work is with print ads. Needs computer-literate freelancers. Freelancers should be familiar with PageMaker 5.0, Aldus FreeHand 4.0, Photoshop 3.8 and Adobe Illustrator 4.0.

First Contact & Terms: Send query letter with brochure, photocopies and photographs. Samples are filed. Reports back within 1 week. Art Director will contact artist for portfolio review if interested. Portfolio should include "representative samples of capabilities." Pays for design by the hour, $55-125. Illustration rates negotiable. Buys all rights. Finds artists through soucebook library.

WALTER P. LUEDKE & ASSOCIATES, INC., 3105 Lardstrom Rd., Rockford IL 61107. (815)637-4266. Fax: (815)637-4200. President: W. P. Luedke. Estab. 1959. Ad agency. Full-service multimedia firm. Specializes in magazine ads, brochures, catalogs and consultation. Product specialty is industry.

Needs: Prefers freelancers with experience in technical computer layout and production skills. Works on assignment only.

First Contact & Terms: Send query letter with résumé, photographs, tearsheets, photostats and slides. Samples are filed and are not returned. Reports back to the artist only if interested. Call for appointment to show portfolio of thumbnails, roughs, original/final art, b&w and color photostats, tearsheets, photographs or slides. Pays for design and illustration by the hour, by the project or by the day (negotiable). Buys all rights.

‡MADISON & SUMMERDALE, INC., 155 Pfingste, #215, Deerfield IL 60015. (847)317-0077. Fax: (847)317-0082. President: Mark Bryzinski. Estab. 1989. Number of employees: 16. Approximate annual billing: 3mm. Ad agency. Specializes in direct mail. Specializes in direct mail. Product specialties are financial, high-tech. Current clients include Ameritech, Metamor Technologies, Windsor Digital Design, Anixter, Diners Club, LaSalle National Bank, Sears, Incredible Universe. Professional affiliations: DMA, CADM.

Needs: Approached by 10 freelance illustrators and 5 designers/year. Works with 8 freelance illustrators and 6 designers/year. Uses freelancers mainly for overflow, illustration. Also for airbrushing; brochure design; brochure, humorous and technical illustration; lettering, multimedia projects, posters, retouching, signage. 15% of work is with print ads. 80% of freelance design and 50% of illustration demand skills in Adobe Photoshop, QuarkXPress, Adobe Illustrator.

First Contact & Terms: Designers send query letter with brochure. Illustrators send postcard sample or query letter with brochure, photocopies, photographs and tearsheets. Accepts disk submissions. Samples are

filed. Samples are not returned. Will contact for portfolio review if interested. Pays for design by the hour, by the project, or by the day. Pays for illustration by the project. Negotiates rights purchased.

‡**CHUCK THOMAS CREATIVE, INC.**, 6N303 Ferson Wood Dr., St. Charles IL 60175. (708)377-6006. Estab. 1989. Approximate annual billing: 1 mm. Integrated marketing communications agency. Specializes in magazine ads, collateral. Product specialties health care, family. Current clients include Kidspeace, Cook Communications, Family Research Council.
Needs: Works with 1-2 freelance illustrators and 2-3 designers/year. Needs freelancers for brochure design and illustration, logos, multimedia projects, posters, signage, storyboards, TV/film graphics. 20% of work is with print ads. 100% of freelance design demands skills in Aldus PageMaker, Aldus FreeHand.
First Contact & Terms: Designers send query letter with brochure and photocopies. Illustrators send postcard sample of work. Samples are filed. Reports back only if interested. Portfolio review not required. Pays by the project. Buys all rights.

Chicago

‡**ACCESS INC.**, 1301 W. Chicago Ave., Suite 200, Chicago IL 60622-5706. (312)226-1390. E-mail: spollac k@iia.org. Art Director: Bob Goldberg. Estab. 1991. Number of employees: 5. Approximate annual billing: $2 million. Ad agency. Specializes in film and print ads, image strategy, children's development, animation. Product specialties are children's, consumer/food, beverage, cosmetic. Current clients include Kraft Foods, American Crew, Creative Balloons, Nickelodeon.
Needs: Approached by 15 freelance illustrators and 5 designers/year. Works with 6 freelance illustrators and 20 designers/year. Prefers local designers with experience in children and food related design. Uses freelancers mainly for concept, work in process. Also for animation, brochure design, mechanicals, multimedia projects, retouching, technical illustration, TV/film graphics. 70% of work is with print ads. 100% of design and 30% of illustration demand skills in Adobe Photoshop, QuarkXPress, Adobe Illustrator 5.1, SoftImage.
First Contact & Terms: Designers send query letter with samples. Illustrators send postcard sample and/ or query letter with photocopies. Accepts disk submissions. Samples are filed or returned by SASE. Will contact for portfolio review if interested. Pays for design by the hour, $15-50. Pays for illustration by the project, $100-1,000. Rights purchased vary according to project. Finds artists through agents, sourcebooks, AIGA.
Tips: "Be innovative, push the creativity, understand the business rationale."

DeFRANCESCO/GOODFRIEND, 444 N. Michigan Ave., Suite 1000, Chicago IL 60611. (312)644-4409. Fax: (312)644-7651. Partner: John DeFrancesco. Estab. 1985. Number of employees: 8. Approximate annual billing: $700,000. PR firm. Full-service, multimedia firm. Specializes in marketing, communication, publicity, direct mail, brochures, newsletters, trade magazine ads, AV presentations. Product specialty is consumer home products. Current clients include S-B Power Tool Co., Northern Trust Co., Wells Lamont, NYLCARE Midwest, Promotional Products Association International. Professional affiliations: Chicago Direct Marketing Association, Sales & Marketing Executives of Chicago, Public Relations Society of America, Publicity Club of Chicago.
Needs: Approached by 15-20 freelancers/year. Works with 2-5 freelance illustrators and 2-5 designers/year. Works on assignment only. Uses freelancers mainly for brochures, ads, newsletters. Also for print ad design and illustration, editorial and technical illustration, mechanicals, retouching and logos. 90% of freelance work demands computer skills.
First Contact & Terms: Send query letter with brochure and résumé. Samples are filed. Does not report back. Request portfolio review in original query. Artist should call within 1 week. Portfolio should include printed pieces. Pays for design and illustration by the project, $50 minimum. Rights purchased vary according to project. Finds artists through word of mouth and queries.
Tips: "I think there is a slow but steady upward trend in the field. Computerization is adding to fragmentation: many new people opening shop."

DOWLING & POPE ADVERTISING, 311 W. Superior, Suite 308, Chicago IL 60610. (312)573-0600. Fax: (312)573-0071. E-mail: dpadvestarnetinc.com. Estab. 1988. Number of employees: 16. Approximate annual billing: $15 million. Ad agency. Full-service multimedia firm. Specializes in magazine ads and collateral. Product specialty is recruitment.
Needs Approached by 6-12 freelance artists/year. Works with 6 freelance illustrators and 72 designers/year. Uses freelancers mainly for collateral. Also for annual reports, multimedia, brochure design and illustration, catalog illustration, lettering and posters. 80% of work is with print ads. 80% of design and 50% of illustration demand knowledge of Aldus FreeHand, Adobe Photoshop and Adobe Illustrator.
First Contact & Terms: Designers send postcard sample with brochure, résumé, photocopies and photographs. Illustrators send postcard sample with brochure and résumé. Accepts submissions on disk. Samples

are filed. Reports back with 2 weeks. Portfolios may be dropped off every Monday. Art Director will contact artist for portfolio review if interested. Portfolio should include b&w and color final art. Pays for design and illustration by the project. Negotiates rights purchased. Finds artists through *Black Book*, *Workbook* and *Chicago Source Book*.

‡HUTCHINSON ASSOCIATES, INC., 1147 W. Ohio, Suite 305, Chicago IL 60622. (312)455-9191. Fax: (312)455-9190. E-mail: hutch@hutchinson. Contact: Jerry Hutchinson. Estab. 1988. Design firm. Specializes in annual reports, collateral, multimedia, interactive internet applications. Professional affiliations: AIGA, ACD (American Center for Design).
Needs Approached by 20 freelance illustrators and 5 designers/year. Works with 5 freelance illustrators and 5 designers/year. Also for annual reports, brochure and web page design, brochure illustration, lettering, logos, mechanicals, multimedia projects, posters, signage, TV/film graphics. 1% of work is with print ads. 100% of design demands skills in Aldus FreeHand, Adobe Photoshop, QuarkXPress, Adobe Illustrator.
First Contact & Terms: Designers send query letter with résumé. Illustrators send postcard sample. Accepts disk submissions compatible with QuarkXPress 7.5/version 3.3. Samples are filed or returned if requested. Requests portfolio if interested. Follow-up with call and/or letter. Pays for design by the hour. Pays for illustration by the project. Rights purchased vary according to project. Finds artists through *Black Book* and word of mouth.
Tips: Looks for persistance and good typography.

KAUFMAN RYAN STRAL INC., 650 N. Dearborn St., Suite 700, Chicago IL 60610. (312)467-9494. Fax: (312)467-0298. President/Creative Director: Robert Ryan. Estab. 1993. Number of employees: 7. Ad agency. Specializes in all materials in print. Product specialty is business-to-business. Client list available upon request. Professional affiliations: BMA, American Israel Chamber of Commerce.
Needs: Approached by 30 freelancers/year. Works with 6 freelance illustrators and 5 designers/year. Prefers local freelancers only. Uses freelancers for design, production, illustration and computer work. Also for brochure, catalog and print ad design and illustration; animation; mechanicals; retouching; model making; posters; lettering; and logos. 30% of work is with print ads. 75% of freelance work demands knowledge of QuarkXPress, Adobe Photoshop or Adobe Illustrator.
First Contact & Terms: Send query letter with résumé and photostats. Samples are filed or returned by SASE. Reports back to the artist only if interested. Artist should follow-up with call and/or letter after initial query. Art Director will contact artist for portfolio review if interested. Portfolio should include b&w and color roughs and final art. Pays for design by the hour, $35-75; or by the project. Pays for illustration by the project, $75-8,000. Buys all rights. Finds artists through sourcebooks, word of mouth, submissions.

MEYER/FREDERICKS & ASSOCIATES, 333 N. Michigan Ave., #1300, Chicago IL 60601. (312)782-9722. Fax: (312)782-1802. Estab. 1972. Number of employees: 15. Ad agency, PR firm. Full-service, multimedia firm.
Needs: Prefers local freelancers only. Freelancers should be familiar with Adobe Photoshop 3.0, QuarkXPress 3.31 and Adobe Illustrator 5.
First Contact & Terms: Send query letter with samples. Art Director will contact artist for portfolio review if interested.

MSR ADVERTISING, INC., P.O. Box 10214, Chicago IL 60610-0214. (312)573-0001. Fax: (312)573-1907. E-mail: msradv.com. President: Marc S. Rosenbaum. Art Director: Margaret Wilkins. Estab. 1983. Number of employees: 6. Approximate annual billing: $2.5 million. Ad agency. Full-service, multimedia firm. Specializes in collateral. Product specialties are medical, food, industrial and aerospace. Current clients include Baxter Healthcare, Mama Tish's, Pizza Hut, hospitals, healthcare, Helene Curtis, Colgate-Palmolive.
Needs: Approached by 6-10 freelancers/year. Works with 5-10 freelance illustrators and 5-10 designers/year. Prefers local artists who are "innovative, resourceful and hungry." Works on assignment only. Uses freelancers mainly for creative through boards. Also for brochure, catalog and print ad design and illustration; multimedia; storyboards; mechanicals; billboards; posters; lettering; and logos. 30% of work is with print ads. 75% of design and 25% of illustration demand computer skills.
First Contact & Terms: Send query letter with brochure, photographs, photocopies, slides, SASE and résumé. Accepts submissions on disk. Samples are filed and returned. Reports back within 1-2 weeks. Write for appointment to show portfolio or mail appropriate materials: thumbnails, roughs, finished samples. Artist should follow up with call. Buys all rights. Finds artists through submissions and agents.

✝ **THE DOUBLE DAGGER** before a listing indicates that the listing is new in this edition. New markets are often more receptive to freelance submissions.

Tips: "We maintain a relaxed environment designed to encourage creativity, however, work must be produced timely and accurately. Normally the best way for a freelancer to meet with us is through an introductory letter and a follow-up phone call a week later. Repeat contact every 4-7 weeks."

Indiana

C.R.E. INC., 400 Victoria Centre, 22 E. Washington St., Indianapolis IN 46204. (317)631-0260. Website: http://www.cremarcom.com. VP/Creative Director: Mark Gause. Senior Art Director: Rich Lunseth. Number of employees: 40. Approximate annual billing: $16 million. Ad agency. Specializes in business-to-business, transportation products and services, computer equipment, biochemicals and electronics. Clients: primarily business-to-business.
Needs: Approached by 50 freelancers/year. Works with 15 freelance illustrators and 2 designers/year. Works on assignment only. Uses freelancers for technical line art, color illustrations and airbrushing; also for multimedia, primarily CD-ROM and Internet applications. 100% of freelance design and 25% of illustration demand computer skills.
First Contact & Terms: Send query letter with résumé and photocopies. Accepts disk submissions. Samples not filed are returned. Reports back only if interested. Call or write for appointment to show portfolio, or mail final reproduction/product and tearsheets. Pays by the project, $100 minimum. Buys all rights.
Tips: "Show samples of good creative talent."

Iowa

F.A.C. MARKETING, 719 Columbia St., Burlington IA 52601. (319)752-9422. Fax: (319)752-7091. President: Roger Sheagren. Estab. 1952. Number of employees: 5. Approximate annual billing: $500,000. Ad agency. Full-service, multimedia firm. Specializes in newspaper, television, direct mail. Product specialty is funeral home to consumer.
Needs: Approached by 30 freelancers/year. Works with 1-2 freelance illustrators and 4-6 designers/year. Prefers freelancers with experience in newspaper and direct mail. Uses freelancers mainly for newspaper design. Also for brochure design and illustration, logos, signage and TV/film graphics. Freelance work demands knowledge of Aldus PageMaker, Adobe Photoshop, CorelDraw and QuarkXPress.
First Contact & Terms: Send query letter with brochure, photostats, SASE, tearsheets and photocopies. Samples are filed or returned by SASE if requested by artist. Request portfolio review in original query. Portfolio should include b&w photostats, tearsheets and thumbnails. Pays by the project, $100-500. Rights purchased vary according to project.

Kentucky

MENDERSON & MAIER, INC., 1001 Second Ave., Dayton KY 41074-1205. (606)491-2880. Fax: (606)491-7980. Art Director: Barb Phillips. Estab. 1954. Number of employees: 5. Full-service ad agency in all aspects of media. Professional affiliations: Cincinnati Ad Club.
 • This art director predicts there will be more catalog and brochure work.
Needs: Approached by 15-30 freelancers/year. Works with 5-10 freelance illustrators and 5-10 designers/year. Prefers local artists only. Uses freelancers mainly for editorial, technical, fashion and general line illustrations and production. Also for brochure, catalog and print ad design and illustration; slide illustration; mechanicals; retouching; and logos. Prefers mostly b&w art, line or wash. 85% of freelance work demands knowledge of Aldus PageMaker 5.0 or 6.0, Aldus FreeHand 5.0 and Word 5.0. 50% of work is with print ads.
First Contact & Terms: Contact only through artist rep. Send résumé and photocopies. Samples are filed and are not returned. Reports back within 6 days. Art Director will contact artist for portfolio review if interested. Artist should follow up with call. Portfolio should include b&w and color photostats, tearsheets, final reproduction/product and photographs. Sometimes requests work on spec before assigning a job. Pays for design by the hour, $12 minimum, or by the project. Pays for illustration by the project. Considers complexity of project and client's budget when establishing payment. Buys all rights. Finds artists through résumés and word of mouth.
Tips: The most effective way for a freelancer to get started in advertising is "by any means that build a sample portfolio. Have a well-designed résumé and nice samples of work whether they be illustrations, graphic design or logo design."

Louisiana

PETER O'CARROLL ADVERTISING, 710 W. Drien Lake Rd., Suite 209, Lake Charles LA 70601. (318)478-7396. Fax: (318)478-0503. Art Director: Kathlene Deaville. Estab. 1977. Ad agency. Specializes in newspaper, magazine, outdoor, radio and TV ads. Product specialty is consumer. Current clients include Players Riverboat Casino, First Federal Savings & Loan, Charter Hospital. Client list available upon request.
Needs: Approached by 2 freelancers/month. Works with 1 illustrator/month. Prefers freelancers with experience in computer graphics. Works on assignment only. Uses freelancers mainly for time consuming computer graphics. Also for brochure and print ad illustration and storyboards. 65% of work is with print ads. 50% of freelance work demands knowledge of Adobe Illustrator, Adobe Photoshop or Aldus FreeHand.
First Contact & Terms: Send query letter wtih résumé, transparencies, photographs, slides and tearsheets. Samples are filed or returned by SASE if requested. Reports back to the artist only if interested. Art Director will contact artist for portfolio review if interested. Portfolio should include color roughs, final art, tearsheets, slides, photostats and transparencies. Pays for design by the project, $30-300. Pays for illustration by the project, $50-275. Rights purchased vary according to project. Find artists through viewing portfolios, submissions, word of mouth, district advertising conferences and conventions.

Maryland

SAM BLATE ASSOCIATES, 10331 Watkins Mill Dr., Gaithersburg MD 20879-2935. (301)840-2248. Fax: (301)990-0707. E-mail: samblate@aol.com. President: Sam Blate. Number of employees: 2. Approximate annual billing: $70,000. AV and editorial services firm. Clients: business/professional, US government, some private.
Needs: Approached by 6-10 freelancers/year. Works with 1-5 freelance illustrators and 1-2 designers/year. Only works with freelancers in the Washington DC metropolitan area. Works on assignment only. Uses freelancers for cartoons (especially for certain types of audiovisual presentations), editorial and technical illustrations (graphs, etc.) for 35mm slides, pamphlet and book design. Especially important are "technical and aesthetic excellence and ability to meet deadlines." 80% of freelance work demands knowledge of CorelDraw, Aldus PageMaker or Harvard Graphics for Windows.
First Contact & Terms: Send query letter with résumé and tearsheets, brochure, photocopies, slides, transparencies or photographs to be kept on file. Accepts disk submissions compatible with CorelDraw and Aldus PageMaker. IBM format only. "No original art." Samples are returned only by SASE. Reports back only if interested. Pays by the hour, $20-40. Rights purchased vary according to project, "but we prefer to purchase first rights only. This is sometimes not possible due to client demand, in which case we attempt to negotiate a financial adjustment for the artist."
Tips: "The demand for technically oriented artwork has increased."

‡**FSP COMMUNICATIONS**, 3103 Harview Ave., Baltimore MD 21234. (410)426-0202. President: F.L. Sibley. Estab. 1981. Number of employees: 2. Approximate annual billing: $80,000. AV firm. Specializes in multimedia graphics, animation, video and still photography. Product specialties are music, education, PR, sales training. Client list available upon request.
Needs: Approached by 10 freelance illustrators and 10 designers/year. Works with 2 freelance illustrators and 2 designers/year. Prefers freelancers with experience in video and multimedia. Also for animation, brochure design and illustration, humorous illustration, lettering, logos, mechanicals, multimedia projects, posters, signage, storyboards, TV/film graphics, web page design. 10% of work is with print ads. 50% of freelance work demands skills in Aldus PageMaker, Aldus FreeHand, Adobe Photoshop, Adobe Illustrator.
First Contact & Terms: Send query letter with brochure, photographs, résumé, slides. Accepts disk submissions compatible with Windows or Mac. Samples are filed or returned by SASE. Portfolio review not required. Pays by the project; negotiable. Finds artists through sourcebooks and recommendations.
Tips: Looks for freelancers who are "willing to have passion for the project and do their best and act with integrity."

‡**media 21**, 3421 Pierce Dr., Ellicott City MD 21042-3549. Phone/fax: (410)715-1701. E-mail: david@media21.com. Website: http://www.media21.com. President: David W. South. Estab. 1993. Number of employees: 15. Approximate annual billing: $1 million. Digital media. Specializes in linear and interactive media. Current clients include Rouse Co., Bell Atlantic, Damar Group. Client list available upon request. Professional affiliation: Intermedia Professionals Association.
Needs: Approached by 100 freelance illustrators and 200 designers/year. Works with 5-10 freelance illustrators and 10-20 designers/year. Prefers freelancers with experience in new media. Uses freelancers mainly for production. Also for airbrushing; animation; annual reports; billboards; brochure and web page design; brochure, catalog, medical, technical illustration; logos; mechanicals; model making; multimedia projects; posters; retouching; signage; storyboards; TV/film graphics. 40% of work is with print ads. 100% of freelance

work demands skills in Aldus PageMaker, Aldus FreeHand, Adobe Photoshop, QuarkXPress, Adobe Illustrator, Director, APM, Premiere, After Effects.
First Contact & Terms: Prefers digital portfolio or send query letter with brochure, photocopies, photographs, photostats, résumé, SASE, slides, tearsheets, transparencies. Accepts disk submissions. Samples are filed, or returned by SASE or not returned. Will contact for portfolio review of b&w, color, final art, photographs, photostats, roughs, slides, tearsheets, thumbnails, transparencies or digital images. Pays for design and illustration by the hour, by the project. Rights purchased vary according to project. Finds artists through referral.

NORTH LIGHT COMMUNICATIONS, 7100 Baltimore Ave., #307, College Park MD 20740. (301)864-2626. Fax: (301)864-2629. Vice President: Hal Kowenski. Estab. 1989. Number of employees: 6. Approximate annual billing: $6.9 million. Ad agency. Product specialties are business-to-business and consumer durables. Current clients include Sundance Spas, Olin Corporation, INSL-X and Egg Harbor Yachts.
Needs: Approached by 6 freelancers/year. Works with 4 freelance illustrators and 6 designers/year. Prefers artists with experience in collateral and agency background. Also uses freelancers for annual reports, brochure design and illustration, mechanicals, posters and signage. 20% of work is with print ads. 100% of design and 50% of illustration demand knowledge of Aldus PageMaker 4.2, Aldus FreeHand 3, Adobe Photoshop, QuarkXPress and Adobe Illustrator.
First Contact & Terms: Designers send query letter with brochure, photocopies, résumé and SASE. Illustrators send query letter with photocopies and SASE. Samples are filed are returned by SASE if requested by artist. Art Director will contact artist for portfolio review if interested. Portfolio should include: b&w and color final art, tearsheets and thumbnails. Pays for design by the hour, $20-60; by the day, $150-500. Pays for illustration by the project. Buys all rights.
Tips: Finds artists through *Black Book, Sourcebook,* classified ads.

Massachusetts

‡FOREMOST COMMUNICATIONS, 59 Fountain St., Framingham MA 01701. (508)820-1130. Fax: (508)820-0558. E-mail: frmstphoto@aol.com. President: David Fox. Estab. 1983. AV firm. Full-service photography and video firm. Specializes in training, marketing, sales, education and industrial. Product specialties are corporate and consumer. Current clients include Granada, American Cancer Society and Harlem Rockers.
Needs: Approached by 0-1 freelancer/month. Works with 1-2 freelance illustrators and 1-2 designers/month. Works on assignment only. Uses freelancers mainly for logo designs and image presentation. Also for brochure, catalog and print ad design and illustration; storyboards; multimedia; animation; retouching. 10-20% of work is with print ads. 90% of freelance work demands knowledge of Adobe Illustrator.
First Contact & Terms: Send postcard sample or query letter with brochure, tearsheets, photographs, slides, transparencies and SASE. Accepts disk submissions compatible with Mac. Samples are filed. Does not report back. Artist should follow up. Call or write for appointment to show portfolio or mail b&w and color photographs and slides. Pays for design and illustration by the project. Buys all rights.
Tips: "Do not send original promos, slides, etc. We would prefer copies or dupes only."

HELIOTROPE STUDIOS LTD., 21 Erie St., Cambridge MA 02139. (617)868-0171. Production Coordinator: Susan Mabbett. Estab. 1984. Number of employees: 3. AV firm. "We are a full-service, sophisticated facility for film and video production and post-production." Current projects include NBC-TV "Unsolved Mysteries" series; "Nova"-WGBH-TV, BBC-TV and corporate video projects.
Needs: Approached by 50 freelancers/year. Works with 0-10 freelance illustrators and 0-10 designers/year. Works on assignment only. Uses freelancers mainly for set design and animation. Also for brochure design and storyboards. Needs technical and medical illustration. 50% of freelance work demands computer skills.
First Contact & Terms: Send query letter with brochure. Samples are filed. Reports back to the artist only if interested. To show portfolio, mail appropriate materials. Pays for design and illustration by the hour, $20 minimum; by the day, $200 minimum. Considers client's budget and turnaround time when establishing payment. Rights purchased vary according to project.
Tips: "Have excellent referrals and a solid demo tape of work."

ERIC HOLCH/ADVERTISING, 11 Wauwinet Rd., Nantucket MA 02554. President: Eric Holch. Number of employees: 3. Approximate annual billing: $300,000. Full-service ad agency. Product specialties are packaging, food, candy, machinery and real estate. Current clients include International Insurance Brokers and McDonald Long & Associates. Professional affiliation: AAN.
Needs: Approached by 35 freelancers/year. Works with 3 freelance illustrators and 3 designers/year. Works on assignment only. Uses freelancers mainly for technical and commercial ads and brochure illustration. Prefers food, candy, packages and seascapes as themes. "No cartoons." 50% of freelance work demands knowledge of Aldus PageMaker, QuarkXPress, Adobe Photoshop and Adobe Illustrator.

First Contact & Terms: Send query letter with brochure showing art style or 8½×11 samples to be kept on file. Art director will contact artist for portfolio review if interested. Portfolio should include roughs, photocopies and original/final art. Sometimes requests work on spec before assigning job. Pays for design and illustration by the project, $100-3,000. Negotiates rights purchased depending on project. Finds artists through submissions.

‡**MATZELL RICHARD & WATTS**, 142 Berkeley St., Boston MA 02116-5100. (617)236-4700. Fax: (617)236-8604. E-mail: kcmrw@wing.net. Website: http://www.mrwinc.com. Contact: Jim Richard. Estab. 1983. Approximate annual billing: $8,400,000. Ad agency. Specializes in ads, collateral, DM. Product specialties are high tech, health care. Client list available upon request.
Needs: Approached by 40-50 freelance illustrators and 40-50 designers/year. Works with 5-10 freelance illustrators and 2-5 designers/year. Prefers freelancers with experience in a variety of techniques: brochure, medical and technical illustration; multimedia projects; retouching; storyboards; TV/film graphics; web page design. 75% of work is with print ads. 90% of design and 90% of illustration demand skills in Aldus FreeHand, Adobe Photoshop, QuarkXPress, Adobe Illustrator.
First Contact & Terms: Designers send query letter with photocopies, photographs, résumé. Illustrators send postcard sample and résumé, follow-up postcard every 6 months. Accepts disk submissions compatible with QuarkXPress 7.5/version 3.3. Send EPS files. Samples are filed. Will contact for portfolio review of b&w, color final art if interested. Pays by the hour, by the project or by the day depending on experience and ability. Rights purchased vary according to project. Finds artist through sourcebooks and word of mouth.

‡**DONYA MELANSON ASSOCIATES**, 437 Main St., Boston MA 02129. Fax: (617)241-5199. E-mail: dma7300@aol.com. Contact: Donya Melanson. Advertising agency. Number of employees: 5. Clients: industries, institutions, education, associations, publishers, financial services and government. Current clients include: US Geological Survey, Mannesmann, Massachusetts Turnpike Authority, Security Dynamics, Writings of Mary Baker Eddy, Cambridge College, American Psychological Association and US Dept. of Agriculture. Client list available upon request.
Needs: Approached by 30 artists/year. Works with 3-4 illustrators/year. Most work is handled by staff, but may occasionally use illustrators and designers. Uses artists for stationery design, direct mail, brochures/flyers, annual reports, charts/graphs and book illustration. Needs editorial and promotional illustration. 50% of freelance work demands knowledge of Adobe Illustrator, QuarkXPress, Adobe Photoshop or Aldus FreeHand.
First Contact & Terms: Query with brochure, résumé, photostats and photocopies. Provide materials (no originals) to be kept on file for future assignments. Originals returned to artist after use only when specified in advance. Call or write for appointment to show portfolio or mail thumbnails, roughs, final art, final reproduction/product and color and b&w tearsheets, photostats and photographs. Pays for design and illustration by the project, $100 minimum. Considers complexity of project, client's budget, skill and experience of artist and how work will be used when establishing payment.
Tips: "Be sure your work reflects concept development. We would like to see more electronic design and illustration capabilities."

RUTH MORRISON ASSOCIATES, INC., 22 Wendell St., Cambridge MA 02138. (617)354-4536. Fax: (617)354-6943. Account Executive: Rebecca Field. Estab. 1972. PR firm. Specializes in food, travel, design, education, non-profit. Assignments include logo/letterhead design, invitations and brochures.
Needs: Prefers local freelancers with experience in advertising and/or publishing. Uses freelancers mainly for brochure design, P-O-P materials and direct mail. Also for catalog and print ad design, mechanicals, editorial illustration, posters, lettering and logos. 5% of work is with print ads. 10% of freelance work demands computer skills.
First Contact & Terms: Send query letter with photocopies. Samples are filed or returned by SASE only if requested by artist. Does not report back. Pays for design and illustration by the project. Rights purchased vary according to project. Finds artists through word of mouth, magazines and advertising.

THE PHILIPSON AGENCY, 241 Perkins St., Suite B201, Boston MA 02130. (617)566-3334. Fax: (617)566-3363. President and Creative Director: Joe Philipson. Marketing design firm. Specializes in packaging, collateral, P-O-P, corporate image, sales presentations, direct mail, business-to-business and high-tech.
Needs: Approached by 3-4 freelancers/month. Works with 4 illustrators and 3 designers/month. Prefers freelancers with experience in design, illustration, comps and production. Works on assignment only. Uses freelancers mainly for overflow and special jobs. Also for brochure, catalog and print ad design and illustration; packaging, multimedia, mechanicals, retouching, posters, lettering and logos. Needs editorial illustration. 65% of work is with print ads. 100% of design and 50% of illustration demand knowledge of QuarkXPress, Aldus FreeHand or Adobe Photoshop.
First Contact & Terms: Send postcard sample, query letter with brochure, tearsheets, photocopies, SASE, résumé. Samples are filed or are returned by SASE. Reports back to the artist only if interested. To show a portfolio, mail roughs, photostats, tearsheets, photographs and slides. Pays by the project. Buys all rights.

‡**PRECISION ARTS ADVERTISING INC.**, 2 Narrows Rd., Suite 201, Westminster MA 01473-0740. (508)874-9944. Fax: (508)874-9943. E-mail: designs@paadv.com. Website: http://www.tlac.net/users/paadv.

President: Terri Adams. Estab. 1985. Number of employees: 3. Ad agency. Specializes in trade ads, media marketing, web page design. Product specialty is industrial. Client list available upon request.
Needs: Approached by 5 freelance illustrators and 5 designers/year. Works with 1 freelance illustrator and 1 designer/year. Prefers local freelancers. 40% of work is with print ads. 50% of freelance work demands knowledge of Adobe Photoshop 3.31, QuarkXPress, 3.31, Adobe Illustrator 5.5.
First Contract & Terms: Send query letter with photocopies and résumé. Accepts disk submissions. Samples are not filed and are returned by SASE. Reports back only if interested.

RSVP MARKETING, INC., 450 Plain St., Suite 5, Marshfield MA 02050. (617)837-2804. Fax: (617)837-5389. E-mail: rsvpmktg@aol.com. President: Edward C. Hicks. Direct marketing consultant services—catalogs, direct mail, brochures and telemarketing. Clients: insurance, wholesale, manufacturers and equipment distributors.
Needs: Works with 1-2 illustrators and 7-8 designers/year. Prefers local freelancers with direct marketing skills. Uses freelancers for advertising, copy and catalog design, illustration and layout; and technical illustration. Needs line art for direct mail. 80% of design and 50% of illustration demand knowledge of Aldus PageMaker, QuarkXPress and Adobe Illustrator.
First Contact & Terms: Designers send query letter with résumé and finished, printed work. Illustrators send postcard sample. Samples are kept on file. Accepts disk submissions. Art Director will contact artist for portfolio review if interested. Sometimes requests work on spec before assigning a job. Pays for design and illustration by the hour, $25-70; or by the project $300-5,000. Considers skill and experience of artist when establishing payment.
Tips: "We are an agency and therefore mark up pricing. Artists should allow for agency mark up."

Michigan

‡LEO J. BRENNAN, INC. Marketing Communications, Suite 300, 2359 Livernois, Troy MI 48083-1692. (810)362-3131. Fax: (810)362-3131. Vice President: Virginia Janusis. Estab. 1969. Ad agency, PR and marketing firm. Clients: industrial, electronics, robotics, automotive, banks and CPAs.
Needs: Works with 2 illustrators and 2 designers/year. Prefers experienced artists. Uses freelancers for design, technical illustration, brochures, catalogs, retouching, lettering, keylining and typesetting. Also for multimedia projects. 50% of work is with print ads. 100% of freelance work demands knowledge of IBM software graphics programs.
First Contact & Terms: Send query letter with résumé and samples. Samples not filed are returned only if requested. Reports back to artist only if interested. Call for appointment to show portfolio of thumbnails, roughs, original/final art, final reproduction/product, color and b&w tearsheets, photostats and photographs. Payment for design and illustration varies. Buys all rights.

CLASSIC ANIMATION, 1800 S. 35th St., Galesburg MI 49053-9688. (616)665-4800. Creative Director: David Baker. Estab. 1986. AV firm. Specializes in animation—computer (Topas, Lumena, Wavefront SGI, Rio) and traditional. Current clients include Amway, Upjohn, Armstrong, NBC.
Needs: Approached by 60 freelancers/year. Works with 36 illustrators and 12 designers/year. Prefers artists with experience in animation. Uses freelancers for animation and technical, medical and legal illustration. Also for storyboards, slide illustration, animatics, animation, TV/film graphics and logos. 10% of work is with print ads. 50% of freelance work demands computer skills.
First Contact & Terms: Send query letter with résumé, photocopies and ½" VHS. Samples are filed or are returned by SASE. Reports back within 1 week only if interested. Write for appointment to show portfolio or mail appropriate materials. Portfolio should include slides and ½" VHS. Pays for design and illustration by the hour, $25 minimum; or by the project, $250 minimum. Rights purchased vary according to project.

‡DON COLEMAN & ASSOCIATES, INC., 30150 Telegraph Rd., Suite 323, Bingham Farms MI 48025. (810)645-6161. Fax: (810)645-2237. Art Director: Lynn Berry. Estab. 1988. Number of employees: 32. Approximate annual billing: $30 million. Ad agency. Specializes in magazine ads, P.O.S., outdoor, broadcast (radio and TV). Product specialties are automotive, recreational food, breakfast food, hair care. Current clients include Chrysler Corporation, Domino's Pizza, Western Union, Carson Products, General Mills, Detroit Receiving Hospital. Client list available upon request. Professional affiliations: B.A.R.T.-Blacks in Advertising Radio and Television.

THE MULTIMEDIA INDEX preceding the General Index in the back of this book lists markets seeking freelancers with multimedia, CD-ROM skills.

Needs: Approached by 20 freelance illustrators/year. Works with 4 freelance illustrators and 2 designers/year. Uses freelancers mainly for illustration. Also for mechanicals, retouching, storyboards. 35% of work is with print ads. 75% of design demands skills in Adobe Photoshop, QuarkXPress, Adobe Illustrator. Illustration demands skills in Adobe Photoshop, Adobe Illustrator.

First Contact & Terms: Designers send query letter with résumé. Illustrators send query letter with résumé, tearsheets. Accepts disk submission compatible with Aldus PageMaker 5.0, QuarkXPress 3.31, Adobe Illustrator 5.0 and Adobe Photoshop 3.0. Samples are filed. Will contact for portfolio review of b&w, color, final art, roughs, tearsheets if interested. Pay negotiable according to project budget. Rights purchased vary according to project. Finds artists through agents, word of mouth, submissions.

Tips: "Must be willing to take direction, provide quick turnarounds and rework design/illustration as many times as needed."

COMMUNICATIONS ELECTRONICS, INC., Dept AM, Box 2797, Ann Arbor MI 48106-2797. (313)996-8888. E-mail: ken@cyberspace.org. Editor: Ken Ascher. Estab. 1969. Number of employees: 38. Approximate annual billing: $2 million. Manufacturer, distributor and ad agency (12 company divisions). Specializes in marketing. Clients: electronics, computers.

Needs: Approached by 150 freelancers/year. Works with 20 freelance illustrators and 20 designers/year. Uses freelancers for brochure and catalog design, illustration and layout; advertising; product design; illustration on product; P-O-P displays; posters; and renderings. Needs editorial and technical illustration. Prefers pen & ink, airbrush, charcoal/pencil, watercolor, acrylic, marker and computer illustration. 30% of freelance work demands knowledge of Aldus PageMaker or QuarkXPress.

First Contact & Terms: Send query letter with brochure, résumé, business card, samples and tearsheets to be kept on file. Samples not filed are returned by SASE. Reports within 1 month. Art Director will contact artist for portfolio review if interested. Pays for design and illustration by the hour, $15-100; by the project, $10-15,000; by the day, $40-800.

JMK & ASSOCIATES, INC., 146 Monroe Center St., 418, Grand Rapids MI 49503. (616)774-0923. Fax: (616)774-2802. President: Joel Jetzer. Estab. 1974. Number of employees: 4. Approximate annual billing: $1 million. Ad agency. Specializes in magazine ads, book covers and collateral. Product specialty is publishing. Current clients include World Publishing, Kirkbride Publishers. Client list available upon request.

Needs: Approached by 10-25 freelancers/year. Works with 5 freelance illustrators and 7 designers/year. Uses freelancers for brochure and catalog design and illustration, lettering, logos, mechanicals, retouching and signage. 100% of freelance work demands knowledge of Aldus PageMaker, Aldus FreeHand, Adobe Photoshop, QuarkXPress, Adobe Illustrator and CorelDraw.

First Contact & Terms: Samples are filed. Does not report back. Artist should call. Portfolio review not required. Pays for design and illustration by the project. Buys all rights.

PHOTO COMMUNICATION SERVICES, INC., 6055 Robert Dr., Traverse City MI 49864. (616)943-8800. Contact: M'Lynn Hartwell. Estab. 1970. Full-service, multimedia AV firm. Specializes in corporate and industrial products.

Needs: Approached by 24-36 freelancers/year. Works with 12 illustrators/year. Works on assignment only. Uses freelancers mainly for animated illustration. Also for brochure, catalog and print ad design and illustration storyboards; slide illustration; animation; retouching; lettering; and logos. 30% of work is with print ads.

First Contact & Term: Send query with brochure, SASE and tearsheets. Samples are filed or returned by SASE if requested by artist. Reports back only if interested. To show portfolio, mail tearsheets and transparencies. Pays for design and illustration by the project, $25 minimum. Rights purchased vary according to project.

J. WALTER THOMPSON USA, One Detroit Center, 500 Woodward Ave., Detroit MI 48226-3428. (313)964-3800. Art Administrator: Maryann Inson. Number of employees: 450. Approximate annual billing: $50 million. Ad agency. Clients: automotive, consumer, industry, media and retail-related accounts.

Needs: Approached by 50 freelancers/year. Works with 15 freelance illustrators and 5 designers/year. "Prefer using local talent. Will use out-of-town talent based on unique style." 75% of design and 50% of illustration demand knowledge of Adobe Photoshop. Deals primarily with established artists' representatives and art/design studios. Uses in-house computer/graphic studio.

First Contact & Terms: Send postcard sample. Assignments awarded on lowest bid. Call for appointment to show portfolio of thumbnails, roughs, original/final art, final reproduction/product, color tearsheets, photostats and photographs. Pays for design and illustration by the project.

Tips: "Portfolio should be comprehensive but not too large. Organization of the portfolio is as important as the sample. Mainly, consult professional rep."

Minnesota

TAKE I PRODUCTIONS, 5325 W. 74th St., Minneapolis MN 55439. (612)831-7757. Fax: (612)831-2193. Producer: Rob Hewitt. Estab. 1985. Number of employees: 5. Approximate annual billing: $500,000. AV firm. Full-service, multimedia firm. Specializes in video and multimedia production. Specialty is industrial. Current clients include 3M, NordicTrack and Kraft. Client list available upon request. Professional affiliations: ITVA, SME.
Needs: Approached by 100 freelancers/year. Works with 10 freelance illustrators/year. Prefers freelancers with experience in video production. Uses freelancers for graphics, sets. Also for animation, brochure design, logos, model making, signage and TV/film graphics. 2% of work is with print ads. 90% of freelance work demands knowledge of Adobe Photoshop and Lightwave.
First Contact & Terms: Send query letter with video. Samples are filed. Art Director will contact artist for portfolio review if interested. Pays for design and illustration by the hour or by the project. Rights purchased vary according to project. Finds artists through sourcebooks, word of mouth.
Tips: "Tell me about work you have done with videos."

Mississippi

VON SUTHÖFF & CO. ADVERTISING INC., 811 Tucker Ave., Pascagoula MS 39567. (601)762-9674. Fax: (601)762-7363. Creative Director: Eric Suthöff. Estab. 1987. Number of employees: 4. Ad agency. Full-service, multimedia firm. Specializes in broadcast and corporate film/video, magazine, billboard, logos. Specialties are financial, auto, event, electronics, defense, industrial. Professional affiliations: American Ad Federation (AAF).
Needs: Approached by 20 freelancers/year. Works with 6-12 freelance illustrators and 3-6 designers/year. Uses freelancers mainly for magazine ads, billboard, logo, brochures. Also for animation, brochure illustration, posters, signage and TV/film graphics. 50% of work is with print ads. 50% of freelance design and 25% of illustration demand knowledge of latest versions of Aldus PageMaker, Adobe Photoshop, QuarkXPress and Adobe Illustrator.
First Contact & Terms: Send postcard-size sample of work. Accepts disk submissions compatible with all mainstream graphics programs on PC format. Samples are filed. Art Director will contact artist for portfolio review if interested. Pays for design by the hour, $15-80; by the project, $100 minimum. Pays for illustration by the hour, $15 minimum; by the hour, $100 minimum. Rights purchased vary according to project. Finds artists through sourcebooks like *Workbook* and word of mouth.
Tips: "Send us a package, postcard or other sample and follow up with a phone call within the week of anticipated arrival."

Missouri

ANGEL FILMS COMPANY, 967 Hwy. 40, New Franklin MO 65274-9778. Phone/fax: (573)698-3900. Vice President of Marketing/Advertising: Linda G. Grotzinger. Estab. 1980. Number of employees: 9. Approximate annual billing: more than $10 million. Ad agency, AV firm, PR firm. Full-service, multimedia firm. Specializes in "all forms of television and film work plus animation (both computer and art work)." Product specialties are feature films, TV productions, cosmetics. Current clients include Azian, Mesn, Angel One Records.
Needs: Approached by 100 freelancers/year. Works with 10 freelance illustrators and 10 designers/year. Prefers freelancers with experience in graphic arts and computers. Works on assignment only. Uses freelancers mainly for primary work ("then we computerize the work"). Also for brochure and print ad design and illustration, storyboards, animation, model making, posters and TV/film graphics. 45% of work is with print ads. 50% of freelance work demands knowledge of Adobe Illustrator, Adobe Photoshop or CorelDraw.
First Contact & Terms: Send query letter with résumé and SASE. Samples are filed. Reports back within 1 month. Art Director will contact artist for portfolio review if interested. Portfolio should include b&w and color slides and computer disks (IBM). Pays for design and llustration by the hour, $8.19 minimum. Buys all rights.
Tips: "You can best impress us with what you can do now not what you did ten years ago. Times change; the way people want work done changes also with the times. Disney of today is not the same as Disney of ten or even five years ago."

BRYAN/DONALD, INC. ADVERTISING, 2345 Grand, Suite 1625, Kansas City MO 64108. (816)471-4866. E-mail: 76443.3156@compserve.com. President: Don Funk. Number of employees: 9. Approximate

annual billing: $3.5 million. Multimedia, full-service ad agency. Clients: food, pharmaceutical chemicals, insurance, hotels, franchises.
Needs: Works with 6 freelance illuatrators and 2 designers/year. Works on assignment only. Uses freelancers for design, illustration, brochures, catalogs, books, newspapers, consumer and trade magazines, P-O-P display, mechanicals, retouching, animation, billboards, posters, direct mail packages, lettering, logos, charts/graphs and ads.
First Contact & Terms: Send samples showing your style. Samples are not filed and are not returned. Reports back only if interested. Call for appointment to show portfolio. Considers complexity of project and skill and experience of artist when establishing payment. Buys all rights.

PHOENIX FILMS, 2349 Chaffee Dr., St. Louis MO 63146. (314)569-0211. E-mail: wjburns@aol.com. President: Heinz Gelles. Vice President: Barbara Bryant. Number of employees: 50. Clients: libraries, museums, religious institutions, US government, schools, universities, film societies and businesses. Produces and distributes educational films.
Needs: Works with 1-2 freelance illustrators and 2-3 designers/year. Prefers local freelancers only. Uses artists for motion picture catalog sheets, direct mail brochures, posters and study guides. Also for multimedia projects. 85% of freelance work demands knowledge of Aldus PageMaker and QuarkXPress.
First Contact & Terms: Send postcard sample and query letter with brochure (if applicable). Send recent samples of artwork and rates to director of promotions. "No telephone calls please." Reports if need arises. Buys all rights. Keeps all original art "but will loan to artist for use as a sample." Pays for design and illustration by the hour or by the project. Rates negotiable. Free catalog upon written request.

STOBIE BRACE, 240 Sovereign Court, St. Louis MO 63011. (314)256-9400. Fax: (314)256-0943. Creative Director: Mary Tuttle. Estab. 1935. Number of employees: 10. Approximate annual billing: $3.5 million. Ad agency. Full-service, multimedia firm. Product specialties are business-to-business, industrial and consumer services. Current clients include Dine-Mor Foods, Star Manufacturing. Professional affiliation: AAAA.
Needs: Approached by 100-150 freelancers/year. Works with 12 freelance illustrators and 6 designers/year. Uses freelancers for illustration, production and retouching. Also for brochure, catalog, print ad and slide illustration; storyboards; mechanicals; and lettering. 40% of work is with print ads. 75% of freelance work demands knowledge of QuarkXPress or Adobe Illustrator. Needs technical, medical and creative illustration.
First Contact & Terms: Send query letter with résumé, photostats, photocopies, and slides. Samples are filed or are returned by SASE if requested by artist. Art Director will contact artist for portfolio review if interested. Portfolios may be dropped off Monday-Friday. Portfolio should include thumbnails, roughs, original/final art and tearsheets. Sometimes requests work on spec before assigning a job. Pays for design by the project, $150-5,000. Pays for illustration by the project. Negotiates rights purchased. Finds artists through word of mouth, reps and work samples.
Tips: Freelancers "must be well organized; meet deadlines; listen well; have concise portfolio of abilities."

New Hampshire

CORPORATE COMMUNICATIONS, INC., Main St. Box 854, N. Conway NH 03860. (603)356-7011. President: Kim Beals. Estab. 1983. Ad agency and PR firm. Specializes in advertising, marketing and public relations. Product specialties are hospitality, sports events, insurance, real estate.
Needs: Approached by 400 freelancers/year. Works with 12 freelance illustrators and 24 designers/year. Works on assignment only. Uses freelancers for brochure, catalog and print ad design and storyboards; mechanicals; billboards; posters; TV/film graphics; lettering; and logos. 15% of work is with print ads. 50% of work demands knowledge of Aldus PageMaker, QuarkXPress, Aldus FreeHand, Adobe Illustrator or Adobe Photoshop. "Freehand skills also required."
First Contact & Terms: Send query letter with brochure, résumé, photocopies, photographs and tearsheets. Samples are filed. Reports back to the artist only if interested. Artist should follow-up with a letter after initial query. Art Director will contact artist for portfolio review if interested. Portfolio should include b&w and color thumbnails, roughs, final art, tearsheets, slides, photostats, photographs and transparencies. Pays for design and illustration by the hour or by the project. "Rates vary." Buys all rights.

New Jersey

‡AMERICA'S INTERACTIVE PRODUCTION NETWORK, 7250 Westfield Ave., Pensauken NJ 08109. (609)665-5600. E-mail: aipn@netaxs.com. Website: http://www.tvjobne. Director of Production: Andrew Jenkins. Estab. 1992. Number of employees: 11. Approximate annual billing: $2 million. AV firm. Specializes in multimedia, production—interactive content. Product specialties are employment, advertising. Current clients include Recruitment Advertisers. Professional affiliations: NAB, Chamber of Commerce.

Needs: Approached by 20 freelance illustrators and 10 designers/year. Works with 3 freelance illustrators and 3 designers/year. Prefers freelancers with experience in GUI, AV products. Uses freelancers mainly for logo, icon, interface creation. Also for animation, brochure illustration, logos, multimedia projects, storyboards, TV/film graphics, web page design. 75% of freelance work demands skills in Adobe Photoshop, Adobe Illustrator, Adobe After Effects, QuarkXPress, Director.
First Contact & Terms: Send query letter with photocopies. Accepts disk submissions compatible with Quick Time, Adobe Photoshop 2.5. Send EPS or PICT files. Samples are filed. Will contact for portfolio review of photostats if interested. Pays for design by the project, $500-7,500. Pays by the project, $500-7,500. Buys all rights or negotiates rights purchased. Finds artists through word of mouth, submissions, demo spools.
Tips: Looking for absolute flexibility with creative design and apptitude to give creative direction, tone, ideas to project.

AM/PM ADVERTISING INC., 196 Clinton Ave., Newark NJ 07108. (201)824-8600. Fax: (201)824-6631. President: Bob Saks. Estab. 1962. Number of employees: 130. Approximate annual billing: $18 million. Ad agency. Full-service, multimedia firm. Specializes in national TV commercials and print ads. Product specialties are health and beauty aids. Current clients include J&J, Bristol Myers, Colgate Palmolive. Client list available upon request. Professional affiliations: AIGA, Art Directors Club, Illustration Club.
Needs: Approached by 35 freelancers/year. Works with 3 freelance illustrators and designers/month. Works only with artist reps. Works on assignment only. Uses freelancers mainly for illustration and design. Also for brochure and print ad design and illustration, storyboards, slide illustration, animation, mechanicals, retouching, model making, billboards, posters, TV/film graphics, lettering and logos and multimedia projects. 30% of work is with print ads. 50% of work demands knowledge of Aldus PageMaker, QuarkXPress, Aldus FreeHand, Adobe Illustrator or Adobe Photoshop.
First Contact & Terms: Send postcard sample and/or query letter with brochure, résumé and photocopies. Samples are filed or returned. Reports back within 10 days. Portfolios may be dropped off every Friday. Artist should follow up after initial query. Portfolio should include b&w and color thumbnails, roughs, final art, tearsheets, photographs and transparencies. Pays for design by the hour, $40-200; by the project, $500-5,000; or by the day, $200-1,000. Pays for illustration by the project, $200-5,000. Rights purchased vary according to project.
Tips: "When showing work, give time it took to do job and costs."

‡CATHOLIC FOCUS PRODUCTIONS, 177 Ballantine Rd., Middletown NJ 07748. (908)957-0005. Fax: (908)671-4959. E-mail: catholic@ghh.com. Website: http://members.gnn.com/catholic/focus.htm. President: Robert Pladek. Estab. 1987. Number of employees: 9. Approximate annual billing: open. AV firm. Specializes in video production documentaries/training. Product specialty is religious videos. Current clients include direct mail.
Needs: Works with 3 freelance illustrators/year. Prefers freelancers with experience in religious drawings. Uses freelancers mainly for video cover designs. Also for brochure design and illustration, TV/film graphics, web page design. 75% of work is with print ads.
First Contact & Terms: Send résumé or contact by e-mail. Accepts disk submissions compatible with BMP, CDR or Adobe Photoshop 3.0. Samples are filed or returned. Reports back within 1 month. Portfolio review not required. Follow-up with call. Pays by the project. Buys all rights. Finds artists through word of mouth.
Tips: Prefers freelancers with strong Christian values.

NORMAN DIEGNAN & ASSOCIATES, 3 Martens Rd., Lebanon NJ 08833. (908)832-7951. President: N. Diegnan. Estab. 1977. Number of employees: 5. Approximate annual billing: $1 million. PR firm. Specializes in magazine ads. Product specialty is industrial.
Needs: Approached by 10 freelancers/year. Works with 20 freelancers illustrators/year. Works on assignment only. Uses freelancers for brochure, catalog and print ad design and illustration; storyboards; slide illustration; animatics; animation; mechanicals; retouching; and posters. 50% of work is with print ads. Needs editorial and technical illustration.
First Contact & Terms: Send query letter with brochure and tearsheets. Samples are filed and are not returned. Reports back within 1 week. To show portfolio, mail roughs. Pays for design and illustration by the project. Rights purchased vary according to project.

IMPACT COMMUNICATIONS, INC., 1300 Mt. Kemble Ave., Morristown NJ 07960. (201)425-0700. Fax: (201)425-0505. E-mail: impact@planet.net. Creative Director: Scott R. Albini. Estab. 1983. Number of employees: 15. Marketing communications firm. Full-service, multimedia firm. Specializes in electronic media, business-to-business and print design. Current clients include AT&T, BASF, Schering-Plough, Warner-Lambert and Ricoh. Professional affiliations: IICS, NCCC and ITVA.
Needs: Approached by 12 freelancers/year. Works with 12 freelance illustrators and 12 designers/year. Uses freelancers mainly for illustration, design and computer production. Also for brochure and catalog design and illustration, multimedia, logos. 10% of work is with print ads. 90% of design and 50% of illustration

demand knowledge of Adobe Photoshop, QuarkXPress, Adobe Illustrator and Macro Mind Director.

First Contact & Terms: Designers send query letter with photocopies, photographs, résumé and tearsheets. Illustrators send postcard sample. Samples are filed and are not returned. Art Director will contact artist for portfolio review if interested. Portfolio should include b&w and color final art, photographs, photostats, roughs, slides, tearsheets and thumbnails. Pays for design and illustration by the project, depending on budget. Rights purchased vary according to project. Finds artists through sourcebooks and self-promotion pieces received in mail.

Tips: "Be flexible."

INSIGHT ASSOCIATES, 14 Rita Lane, Oak Ridge NJ 07438. (201)697-0880. Fax: (201)697-6904. President: Raymond Valente. Estab. 1979. Business communications firm. Full-service, multimedia firm. Specializes in video programs, manuals, interactive media. Product specialties are training, meetings. Client list available upon request.

Needs: Approached by 6 freelancers/year. Prefers freelancers with experience in design for video and ancillary materials. Uses freelancers for catalog design and illustration and TV/film graphics. 60% of freelance work demands knowledge of Aldus PageMaker and QuarkXPress.

First Contact & Terms: Send query letter with résumé. Samples are filed or returned by SASE if requested by artist. Art Director will contact artist for portfolio review if interested. Pays for design and illustration by the project. Finds artists through associated vendors, i.e., print shops, etc.

JANUARY PRODUCTIONS, INC., 210 Sixth Ave., Hawthorne NJ 07507. (201)423-4666. Fax: (201)423-5569. Art Director: Karen Sigler. Estab. 1973. Number of employees: 12. AV producer. Serves clients in education. Produces children's educational materials—videos, sound filmstrips and read-along books and cassettes and CD-ROM.

Needs: Works with 1-2 freelance illustrators/year. "While not a requirement, a freelancer living in the same geographic area is a plus." Works on assignment only, "although if someone had a project already put together, we would consider it." Uses freelancers mainly for illustrating children's books. Also for artwork for filmstrips, sketches for books and layout work. 50% of freelance work demands knowledge of QuarkXPress, Aldus FreeHand and Adobe Photoshop.

First Contact & Terms: Send query letter with résumé, tearsheets, SASE, photocopies and photographs. Art Director will contact artist for portfolio review if interested. "Include child-oriented drawings in your portfolio." Requests work on spec before assigning a job. Pays for design and illustration by the project, $20 minimum. Originals not returned. Buys all rights. Finds artists through submissions.

KJD TELEPRODUCTIONS, 30 Whyte Dr., Voorhees NJ 08043. (609)751-3500. Fax: (609)751-7729. E-mail: mactoday@10.com. President: Larry Scott. Estab. 1989. Ad agency/AV firm. Full-service, multimedia firm. Specializes in magazine, radio and television. Current clients include ICI America's and Taylors Nightclub.

Needs: Works with 20 freelance illustrators and 12 designers/year. Prefers freelancers with experience in TV. Works on assignment only. Uses freelancers for brochure and print ad design and illustration, storyboards, animatics, animation, TV/film graphics. 70% of work is with print ads. Also for multimedia projects. 90% of freelance work demands knowledge of QuarkXPress, Adobe Illustrator 6.0, Aldus PageMaker and Aldus FreeHand.

First Contact & Terms: Send query letter with brochure, photographs, slides, tearsheets or transparencies and SASE. Samples are filed or are returned by SASE. Accepts submissions on disk from all applications. Send EPS files. Reports back to the artist only if interested. To show portfolio, mail roughs, photographs and slides. Pays for design and illustration by the project; rate varies. Buys first rights or all rights.

‡PRINCETON DIRECT, INC., 5 Vaughn Dr., Princeton NJ 08540. (609)520-8575. Fax: (609)520-0695. E-mail: renee@picdirect.com. Website: http://www.btb.com/picdirect. Creative Director: Reneé Hobbs. Estab. 1987. Number of employees: 10. Approximate annual billing: $8 million. Ad agency. Specializes in direct mail, multimedia, web sites. Product specialties are financial, computer. Current clients include Vanguard, HIP of New Jersey, United Jersey Bank. Client list available upon request. Professional affiliation: NJ Cama (communication, advertising, marketing association).

Needs: Approached by 12 freelance illustrators and 25 designers/year. Works with 6 freelance illustrators and 10 designers/year. Prefers local designers with experience in Macintosh. Also for airbrushing, animation, brochure design and illustration, multimedia projects, retouching, technical illustration, TV/film graphics. 10% of work is with print ads. 90% of design demands skills in Adobe Photoshop, QuarkXPress, Adobe Illustrator, Macromedia Director. 50% of illustration demands skills in Adobe Photoshop, Adobe Illustrator.

First Contact & Terms: Send query letter with résumé, tearsheets, video or sample disk. Send follow-up postcard every 6 months. Accepts disk submissions compatible with QuarkXPress, Adobe Photoshop. Send

EPS, PICT files. Samples are filed. Reports back only if interested. Pay negotiable. Rights purchased vary according to project.

‡SORIN PRODUCTIONS INC., 919 Hwy. 33, Suite 46, Freehold NJ 07728. (908)462-1785. President: David Sorin. Estab. 1982. AV firm. Full-service, multimedia firm. Specializes in corporate video, slides, audio. Current clients include AT&T, First Fidelity Bank, J&J. Client list available upon request.
Needs: Approached by 2-3 freelance artists/month. Works with 1 freelance illustrator and designer/month. Prefers local artists only with experience in graphics for video/slides. Works on assignment only. Uses artists for storyboards, slide illustration, animation, model making and TV/film graphics. 5% of work is with print ads. 75% of freelance work demands knowledge of Aldus PageMaker, Aldus FreeHand or Lotus Freelance.
First Contact & Terms: Send query letter with brochure. Samples are not filed and are not returned or are returned by SASE if requested. Reports back to the artist only if interested. Art Director will contact artist for portfolio review if interested. Pays for design and illustration by the project. Buys all rights.

‡TAA INC., 65 Horse Hill Rd., Cedar Knolls NJ 07927. (201)267-2670. Production Manager: Barbara Perkalis. In-house ad agency. Clients: pharmaceutical marketing.
Needs: Assigns 3 freelance jobs/year. Works with 1 illustrator/month. Works on assignment only. Uses artists for work on direct mail packages, brochures and posters.
First Contact & Terms: Send query letter with brochure to be kept on file. Samples not filed are returned by SASE only if requested. Reports only if interested. Write for appointment to show portfolio. Pays for design by the hour, $25 minimum or by the project, $400 minimum. Pays for illustration by the project, (payment negotiated). Considers "my own judgment on what job is worth before the work is done" when establishing payment. "If unforeseen complications arise, artist must tell me."
Tips: "Artists should know something about the company before they come in."

‡VIDEO PIPELINE INC., 16 Haddon Ave., Haddonfield NJ 08083. (609)427-9799. President: Jed Horovitz. Estab. 1985. Number of employees: 9. Approximate annual billing: $1 million. Point of purchse firm. Specializes in video and interactive display. Product specialties are movies, music, CD-ROM, video games. Current clients include Blockbuster.
Needs: Approached by 2 freelance illustrators and 1 designer/year. Works with 1 freelance illustrator and 1 designer/year. Prefers experienced freelancers. Uses freelancers mainly for fliers, ads, logos. Also for brochure illustration, catalog and web page design, TV/film graphics. 25% of work is with print ads. 100% of freelance work demands skills in Aldus PageMaker, Aldus FreeHand, Adobe Photoshop, QuarkXPress, Adobe Illustrator, CorelDraw.
First Contact & Terms: Send query letter with résumé. Accepts disk submissions. Send EPS files. Samples are filed. Will contact for portfolio review if interested. Pays by the project. Buys all rights.

New Mexico

R H POWER AND ASSOCIATES, INC., 6616 Gulton Court, NE, Albuquerque NM 87109. (505)761-3150. Fax: (503)761-3153. Art Director: Mark Hellyer. Estab. 1989. Number of employees: 12. Ad agency. Full-service, multimedia firm. Specializes in TV, magazine, billboard, direct mail, newspaper, radio. Product specialties are recreational vehicles and automotive. Current clients include Holiday RV Super Stores, Venture Out RV, Valley Forge RV Show. Client list available upon request.
Needs: Approached by 10-50 freelancers/year. Works with 5-10 freelance illustrators and 5-10 designers/ year. Prefers freelancers with experience in retail automotive layout and design. Uses freelancers mainly for work overload, special projects and illustrations. Also for annual reports, billboards, brochure and catalog design and illustration, logos, mechanicals, posters and TV/film graphics. 50% of work is with print ads. 100% of design demands knowledge of Adobe Photoshop, CorelDraw 5.0, Ventura Publisher and QuarkXPress.
First Contact & Terms: Send query letter with photocopies or photographs and résumé. Accepts disk submissions compatible with CorelDraw or QuarkXPress. Send PC EPS files. Samples are filed and are not returned. Art Director will contact artist for portfolio review if interested. Portfolio should include b&w and color final art, roughs and thumbnails. Pays for design and illustration by the hour, $8 minimum; by the project, $50 minimum. Buys all rights.

Tips: Impressed by work ethic and quality of finished product. "Deliver on time and within budget. Do it until it's right without charging for your own corrections."

New York

‡AUTOMATIC MAIL SERVICES, INC., 30-02 48th Ave., Long Island City NY 11101. (212)361-3091. Contact: Michael Waskover. Manufacturer and service firm. Provides printing Internet sites and direct mail advertising. Clients: publishers, banks, stores, clubs, businesses.
Needs: Works with 5-10 artists/year. Uses freelancers for advertising, brochure and catalog design, illustration and layout.
First Contact & Terms: Send business card and photostats to be kept on file. Call for appointment to show portfolio. Samples not kept on file are returned if requested. Works on assignment only. Pays by the project, $10-1,000 average. Considers skill and experience of artist and turnaround time when establishing payment.

CHANNEL ONE PRODUCTIONS, INC., 82-03 Utopia Pkwy., Jamaica Estates NY 11432. (718)380-2525. E-mail: bmp.emht@lx.netcom.com. President: Burton M. Putterman. AV firm. "We are a multimedia, film and video production company for broadcast, image enhancement and P-O-P displays." Clients: multinational corporations, recreational industry and PBS.
Needs: Works with 25 freelancers/year. Assigns 100 jobs/year. Prefers local freelancers. Works on assignment only. Uses freelancers mainly for work on brochures, catalogs, P-O-P displays, animation, direct mail packages, motion pictures, logos and advertisements. Needs technical illustration. 100% of freelance work demands knowledge of Aldus PageMaker, Aldus FreeHand or Adobe Illustrator.
First Contact & Terms: Send query letter with résumé, slides and photographs. Samples are not filed and are returned by SASE. Reports back within 2 weeks only if interested. Call to schedule an appointment to show a portfolio of original/final art, final reproduction/product, slides, video disks and videotape. Pays for design by the project, $400 minimum. Considers complexity of project and client's budget when establishing payment. Rights purchased vary according to project.
Tips: "Our freelance needs have increased."

‡DESIGN O'SAURS, 6771 Yellowstone Blvd., Forest Hills NY 11375. (212)459-4438. E-mail: harry_widoff@msn.com. Contact: H. Widoff. Estab. 1986. AV firm, integrated marketing communications agency. Specializes in interactive marketing. Client list available upon request. Professional affiliation: SIGGRAPH.
Needs: Approached by 15 freelance illustrators and 15 designers/year. Works with 3 freelance illustrators and 6 designers/year. Prefers local freelancers with experience in computers, PC/Mac. Uses freelancers mainly for interactive screens. Also for animation, logos, multimedia projects, retouching, storyboards, technical illustration, TV/film graphics, web page design. 15% of work is with print ads. 90% of freelance work demands skills in Aldus PageMaker, Aldus FreeHand, Adobe Photoshop, QuarkXPress, Adobe Illustrator, Director, 3DStudio.
First Contact & Terms: Designers send query letter with brochure, résumé, SASE, tearsheets. Illustrators send postcard sample and/or query letter with brochure, SASE, tearsheets. Accepts disk submissions compatible with QuarkXPress, Adobe Photoshop (PC or Mac). Samples are filed, returned by SASE or not returned. Will contact for portfolio review of b&w, color final art, photographs, photostats, roughs, slides, tearsheets, thumbnails, transparencies, floppy with interactive work if interested. Pays by the project. Rights purchased vary according to project. Finds artists through word of mouth.
Tips: "Maintain/obtain computer skills. 'Look-under-the-hood' (learn hardware as well)."

FINE ART PRODUCTIONS, RICHIE SURACI PICTURES, MULTIMEDIA, INTERACTIVE, (formerly Fine Art Productions), 67 Maple St., Newburgh NY 12550-4034. Phone/fax: (914)561-5866. E-mail: richie.suraci@bbs.mhv.net. Website: http://www.qeopages.com/Hollywood/1077 or http://www.lookup.com/Homepages/61239/home.html. Contact: Richie Suraci. Estab. 1990. Ad agency, AV and PR firm. Full-service, multimedia firm. Specializes in film, video, print, magazine, documentaries and collateral. "Product specialties cover a broad range of categories."
• Fine Art Productions is looking for artists who specialize in science fiction and erotic art for upcoming projects.
Needs: Approached by 288 freelancers/year. Works with 12-48 freelance illustrators and 12-48 designers/year. "Everyone is welcome to submit work for consideration in all media." Works on assignment only. Uses freelancers for brochure, catalog and print ad design and illustration; storyboards; slide illustration; animatics; animation; mechanicals; retouching; billboards; posters; TV/film graphics; lettering; and logos. Also for multimedia projects. Needs editorial, technical, science fiction, jungle, adventure, children's, fantasy and erotic illustration. 20% of work is with print ads. 50% of freelance work demands knowledge of "all state of the art software."

First Contact & Terms: Send query letter with brochure, photocopies, résumé, photographs, tearsheets, photostats, slides, transparencies and SASE. Accepts submissions on disk compatible with Macintosh format. Samples are filed or returned by SASE if requested by artist. Reports back in 4-6 months if interested. Art Director will contact artist for portfolio review if interested. Portfolio should include thumbnails, roughs, b&w and color photostats, tearsheets, photographs, slides and transparencies. Requests work on spec before assigning a job. Pays for design and illustration by the project; negotiable. Rights purchased vary according to project.
Tips: "We need more freelance artists. Submit your work for consideration in field of interest specified."

‡**GARRITY COMMUNICATIONS, INC.**, 213 N. Aurora St., Ithaca NY 14850. (607)272-1323. Creative Director: Michael Mayhew. Estab. 1978. Ad agency, AV firm. Specializes in trade ads, newspaper ads, annual reports, video, etc. Product specialties are financial services, industrial.
Needs: Approached by 8 freelance artists/month. Works with 2 freelance illustrators and 1 freelance designer/month. Works on assignment only. Uses freelance artists mainly for work overflow situations; some logo specialization. Also uses freelance artists for brochure design and illustration, print ad illustration, TV/film graphics and logos. 40% of work is with print ads. 90% of freelance work demands knowledge of Aldus PageMaker (IBM) or Corel.
First Contact & Terms: Send query letter with brochure and photocopies. Samples are filed and are not returned. Reports back to the artist only if interested. Art Director will contact artist for portfolio review if interested. Pays for design by the hour, $15-50. Pays for illustration by the project, $150-500. Rights purchased vary according to project. Finds artists through sourcebooks, submissions.

IMAC, Inter-Media Art Center, 370 New York Ave., Huntington NY 11743. (516)549-9666. Fax: (516)549-9423. Executive Director: Michael Rothbard. Estab. 1974. AV firm. Full-service, multimedia firm. Specializes in TV and multimedia productions.
Needs: Approached by 12 freelancers/month. Works with 3 illustrators and 2 designers/month. Prefers freelancers with experience in computer graphics. Uses freelancers mainly for animation, TV/film graphics and computer graphics. 50% of work is with print ads.
First Contact & Terms: Send query letter with photographs. Samples are not filed and are not returned. Reports back within 10 days. Rights purchased vary according to project.

‡**MEDIA LOGIC, INC.**, 1520 Central Ave., Albany NY 12205. (518)456-3015. Fax: (518)456-4279. E-mail: postmaster@mlinc.com. Website: http://www.mlinc.com. Production Manager: Jen Hoehn. Estab. 1984. Number of employees: 25. Approximate annual billing: $20 million. Integrated marketing communications agency. Specializes in advertising, marketing communications, design. Product specialties are retail, entertainment. Current clients include education, business-to-business, industrial. Professional affiliations: American Marketing Associates, Ad Club of Northeast NY.
Needs: Approached by 20-30 freelance illustrators and 20-30 designers/year. Works with 2 freelance illustrators and 2 designers/year. Prefers freelancers with experience in Mac/Photoshop. Also for annual reports, brochure design, mechanicals, multimedia projects, retouching, web page design. 30% of work is with print ads. 100% of design and 60% of illustration demand skills in Adobe Photoshop, QuarkXPress, Adobe Illustrator, Director.
First Contact & Terms: Designers send query letter with photocopies, résumé. Illustrators send postcard and/or query letter with résumé. Accepts disk submissions compatible with QuarkXPress 7.5/version 3.3. Send EPS files. Samples are not filed and are returned. Reports back only if interested. Portfolios may be dropped off Monday-Friday. Pays by the project; negotiable. Buys all rights.
Tips: "Be fast, flexible, talented and able to work with demanding creative director."

‡**MESMERIZED HOLOGRAPHIC MARKETING**, P.O. Box 984, White Plains NY 10602-0984. (914)948-6138. Fax: (914)948-9509. Creative Director: Jeff Levine. Estab. 1986. Number of employees: 5. Holographic promotional marketing firm. Specializes in holographic promotional marketing from print promotions to P-O-P displays. Product specialties are computer, multimedia, pharmaceutical.
Needs: Approached by 3 freelance illustrators and 3 designers/year. Works with 12 freelance illustrators and 8 designers/year. Prefers freelancers with experience in 3-D animation and virtual environments. Uses freelancers mainly for 3-D graphic animation, medical modeling, general model making. Also for medical illustration, multimedia projects, storyboards. 20% of design and 80% of illustration demand computer skills in Aldus FreeHand, Adobe Photoshop, SGI.
First Contact & Terms: Designers send brochure, photocopies, photographs, résumé, tearsheets. Illustrators send postcard sample and/or query letter with brochure, photocopies, photographs, CD-ROM. Accepts disk submissions compatible with Mac and QuarkXPress. Samples are filed and are not returned. Does not report back. Artist should follow-up. Will contact for portfolio review if intereted. Pays by the project. Buys all rights. Finds artists through word of mouth.
Tips: "Always make suggestions, then take direction."

‡**PARAGON ADVERTISING**, 43 Court St., Suite 1111, Buffalo NY 14202-3101. (716)854-7161. Fax: (716)854-7163. Art Director: Leo Abbott. Estab. 1988. Ad agency. Full-service, multimedia firm. Product specialty is food industry.
Needs: Approached by 2-3 freelance artists/month. Works on assignment only. Uses freelancers mainly for illustrations. Also for lettering. 40% of work is with print ads. 80% of freelance work demands knowledge of Adobe Illustrator, QuarkXPress or Adobe Photoshop.
First Contact & Terms: Send query letter with résumé, photocopies, photographs, slides, tearsheets and transparencies. Samples are returned by SASE only if requested by artist. Reports back only if interested. Call for appointment to show portfolio of roughs, final art, b&w photostats, transparencies, color tearsheets, photographs, slides. Pays for illustration by the project, $50-2,500. Buys all rights or rights purchased vary according to project.

JACK SCHECTERSON ASSOCIATES, 5316 251 Place, Little Neck NY 11362. (718)225-3536. Fax: (718)423-3478. Principal: Jack Schecterson. Estab. 1967. Ad agency. Specializes in packaging, product marketing, graphic design and new product introduction.
Needs: Works only with artist reps. Prefers local freelancers only. Works on assignment only. Uses freelancers for package and product design and illustration, brochures, catalogs, retouching, lettering, logos. 100% of design and 40% of illustration demand skills in Adobe Illustrator, Adobe Photoshop and QuarkXPress.
First Contact & Terms: Send query letter with brochure, photocopies, tearsheets, résumé, photographs, slides, transparencies and SASE; "whatever best illustrates work." Samples not filed are returned by SASE only if requested by artist. Request portfolio review in original query. Art Director will contact artist for portfolio review if interested. Portfolio should include roughs, b&w and color—"whatever best illustrates abilities/work." Pays for design and illustration by the project; depends on budget. Buys all rights.

‡**TOBOL GROUP, INC.**, 14 Vanderventer Ave., #L-2, Port Washington NY 11080. (516)767-8182. Fax: (516)767-8185. Estab. 1981. Ad agency. Product specialties are "50/50, business and consumer." Current clients include: Weight Watchers, Eutectict Castolin, Mainco, Lightalarms and Briarcliffe College.
Needs: Approached by 2 freelance artists/month. Works with 1 freelance illustrator and 1 designer/month. Works on assignment only. Uses freelancers for brochure, catalog and print ad design and technical illustration, mechanicals, retouching, billboards, posters, TV/film graphics, lettering and logos. 45% of work is with print ads. 75% of freelance work demands knowledge of QuarkXPress or Adobe Illustrator.
First Contact & Terms: Send query letter with SASE and tearsheets. Samples are filed or are returned by SASE. Reports back within 1 month. Call for appointment to show portfolio or mail thumbnails, roughs, b&w and color tearsheets and transparencies. Pays for design by the hour, $25 minimum; by the project, $100-800; by the day, $200 minimum. Pays for illustration by the project, $300-1,500 ($50 for spot illustrations). Negotiates rights purchased.

VISUAL HORIZONS, 180 Metro Park, Rochester NY 14623. (716)424-5300. Fax: (716)424-5313. E-mail: 73730.2512@compuserve.com or slides1@aol.com. Estab. 1971. AV firm. Full-service, multimedia firm. Specializes in presentation products. Current clients include US government agencies, corporations and universities.
Needs: Works on assignment only. Uses freelancers mainly for slide illustration. 10% of work is with print ads. 100% of freelance work demands knowledge of Aldus PageMaker, Aldus FreeHand, Adobe Illustrator or Arts and Letters.
First Contact & Terms: Send query letter with tearsheets. Samples are not filed and are not returned. Reports back to the artist only if interested. Portfolio review not required. Pays for design and illustration by the hour or project, negotiated. Buys all rights.

New York City

‡**BARON VIDEO PRODUCTIONS**, 301 E. 47th St., Suite 10M, New York NY 10017. (212)223-1826. Fax: (212)223-3737. President: Jed Canaan. Estab. 1992. AV firm. Full-service, multimedia firm. Specializes in VNRs and satellite media tours. Current clients include Sudafed, Clairol, Women's Sports Foundation.
Needs: Approached by very few freelance artists/month. Works with 0 freelance artists/month. Prefers local artists only. Works on assignment only.
First Contact & Terms: Samples are filed.

‡**BBDO NEW YORK**, 1285 Avenue of the Americas, New York NY 10019-6095. (212)459-5000. Fax: (212)459-6645. Estab. 1891. Ad agency. Full-service multimedia firm. Senior Art Buyer: Marita R. Marone.
 ● BBDO New York is part of BBDO Worldwide, with offices in most major cities. BBDO art buyers have hundreds of contacts with illustrators and agents and are not actively seeking submissions.

ANITA HELEN BROOKS ASSOCIATES, PUBLIC RELATIONS, 155 E. 55th St., New York NY 10022. (212)755-4498. President: Anita Helen Brooks. PR firm. Specializes in fashion, "society," travel, restaurant, political and diplomatic and publishing. Product specialties are events, health and health campaigns.
Needs: Works on assignment only. Uses freelancers for consumer magazines, newspapers and press releases. "We're currently using more abstract designs."
First Contact & Terms: Send query letter with résumé. Call for appointment to show portfolio. Reports back only if interested. Considers client's budget and skill and experience of artist when establishing payment.
Tips: "Artists interested in working with us must provide rate schedule, partial list of clients and media outlets. We look for graphic appeal when reviewing samples."

CANON & SHEA ASSOCIATES, INC., 224 W. 35th St., Suite 1500, New York NY 10001. (212)564-8822. E-mail: canonshea@aol.com. Art Buyer: Sal Graci. Estab. 1978. Technical advertising/PR/marketing firm. Specializes in business-to-business and financial services.
Needs: Works with 20-30 freelance illustrators and 2-3 designers/year. Mostly local freelancers. Uses freelancers mainly for mechanicals and technical illustrations. 85% of work is with print ads. 100% of freelance work demands knowledge of QuarkXPress, Adobe Illustrator, Adobe Photoshop, Director.
First Contact & Terms: Send postcard sample and/or query letter with résumé, photocopies and tearsheets. Accepts submissions on disk. Art Director will contact artist for portfolio review if interested. Pays by the hour: $25-35 for animation, annual reports, catalogs, trade and consumer magazines; $25-50 for packaging; $50-250 for corporate identification/graphics; $10-45 for layout, lettering and paste-up.
Tips: Finds artists through art schools, design schools and colleges. "Artists should have business-to-business materials as samples and should understand the marketplace. Do not include fashion or liquor ads. Common mistakes include showing wrong materials, not following up and lacking understanding of the audience."

GREY ADVERTISING INC., 777 Third Ave., New York NY 10017. Fax: (212)546-2255. Vice President/Art Buying Manager: Patti Harris. Number of employees: 1,800. Specializes in cosmetics, food and toys. Professional affiliations: Arts Buyers Club, 4A's Art Services Committee, NAFE.
Needs: Approached by hundreds of freelancers/year. Works with some freelance illustrators and few designers/year.
First Contact & Terms: Works on assignment only. Call at beginning of the month for appointment to show portfolio of original/final art. Pays by the project. Considers client's budget and rights purchased when establishing fees.
Tips: Show your work in a neat and organized manner. Have sample leave-behinds and do not expect to leave with a job. It takes time to plant your ideas and have them accepted."

McANDREW ADVERTISING, 2125 St. Raymond Ave., P.O. Box 254, Bronx NY 10462. Phone/fax: (718)892-8660. Art/Creative Director: Robert McAndrew. Estab. 1961. Number of employees: 3. Approximate annual billing: $130,000. Ad agency. Clients: industrial and technical firms. Current clients include Yula Corp. and Electronic Devices.
Needs: Approached by 20 freelancers/year. Works with 3 freelance illustrators and 5 designers/year. Uses mostly local freelancers. Uses freelancers mainly for design, direct mail, brochures/flyers and trade magazine ads. Needs technical illustration. Prefers realistic, precise style. Prefers pen & ink, airbrush and occasionally markers. 50% of work is with print ads. 5% of freelance work demands computer skills.
First Contact & Terms: Query with photocopies, business card and brochure/flier to be kept on file. Samples not returned. Reports in 1 month. Originals not returned. Art Director will contact artist for portfolio review if interested. Portfolio should include roughs and final reproduction. Pays for illustration by the project, $35-300. Pays for design by the project. Considers complexity of project, client's budget and skill and experience of artist when establishing payment. Finds artists through sourcebooks, word of mouth and business cards in local commercial art supply stores.
Tips: Artist needs "an understanding of the product and the importance of selling it."

‡**MARTIN/ARNOLD COLOR SYSTEMS**, 150 Fifth Ave., New York NY 10011. (212)675-7270. President: Martin Block. Vice President Marketing: A.D. Gewirtz. AV producer. Produces slides, filmstrips and Vu Graphs, large blow-ups in color and b&w. Clients: industry, education, government and advertising.
Needs: Assigns 20 jobs/year. Works with 2 illustrators and 2 designers/month. Works on assignment only. Uses freelancers mainly for presentations and display.

INSIDER REPORT

Targeted Promo Pieces Open Agency Doors

At many agencies, art directors, the people who develop the "look" for ad campaigns, hire freelancers directly. But increasingly, art buyers will be your contacts for agencies hiring talent. Art buyers are a relatively new phenomenon, says Andrea Kaye, executive art buyer for BBDO, one of New York City's oldest and largest ad agencies.

"An art buyer is to print what a producer is to TV. We are liasons between the ad agency and the client and all outside creative suppliers." The position was created by large agencies so art directors could spend more time art directing and less time minding to the details of hiring freelancers. Financial accountability and a changing economy have swelled the ranks of art buyers in smaller agencies as well.

Andrea Kaye

To make sure your submission gets into the right hands, research agencies you're interested in to determine if your first contact should be the art director or art buyer. Don't just submit to every agency, warns Kaye. Make the effort to get your promo piece to agencies most likely to need what you have to offer. If you excel at fashion sketches, target agencies whose clients include department stores and clothing manufacturers. If medical illustration is your strong suit, approach agencies specializing in pharmaceutical companies or hospitals. To determine who an agency's clients are, look in *Artist's & Graphic Designer's Market* or consult the *Standard Directory of Advertising Agencies* in the public library.

Look through magazines, trade publications and award annuals to see how your work measures up to the competition. Consider the published work a benchmark from which to measure your own work. If your talents aren't up to the work used by larger agencies, approach a boutique (small) agency or design firm first.

Kaye advises artists to run ads in sourcebooks as soon as they can afford it. Art directors and buyers rely on them as valuable shortcuts in the quest for variety. While many sourcebooks have high advertising rates, competition annuals do not charge expensive fees and are just as widely used by art directors and buyers. (See Talent Directories subhead on page 9 for more on sourcebooks.)

Once you've targeted agencies, mail promo pieces. "A promo card is meant to introduce your work. It can be 3×6 to 8×10. Some are accordian (folded) or fold-outs. It should be designed for visual appeal—not cluttered, busy or confusing, but clean and direct." Send your promo piece in an envelope with a cover letter detailing your experience before you call for an interview, Kaye suggests. Wait a few days after they receive it and then call to introduce yourself. Tell what you do, and how it relates to the agency's work.

INSIDER REPORT, *Kaye*

When you get an appointment with an art buyer, make it easy for her to see your work. Kaye recommends buying a manageable lap-size portfolio case rather than one that requires a whole desktop to display. Your book may be circulated to an art director and others who may be short on viewing space. Include 20 to 30 pieces or fewer. Show your portfolio to people whose opinions you respect and listen for their reactions. "Lead with your strongest work—if you don't grab them on the first few pages, you're in trouble!"

Don't expect a contract at your first meeting. The get-together of five to ten minutes to half an hour is just an introduction to see whether the art buyer feels your work is up to agency standards. The agency may not have an immediate need, but if they like your work, they will file your "leave behind" and may hire you in the future.

When you're offered a job, make sure you have a contract or purchase order before beginning work. "It should give the details of the assignment, the rights being purchased, how they'll use the work and the fee." Make sure you understand the assignment. What's understood verbally may be different from the wording on your contract. Avoid complications by asking questions until the assignment is clear. To get help in negotiating fees, rights and other details, Kaye suggests joining an artist's organization or consulting an experienced associate.

Even if you don't get hired at first, maintain contact by sending a new promo card every six months or so. Look at it as a continuous process where you get to know the agency and they get to know you and your work. "Our business is a people business and we tend to give work to people we know," Kaye says. "You're in sales now. Once you get your foot in the door, you're in. The hardest thing is getting your foot in the door."

—*Mari Messer*

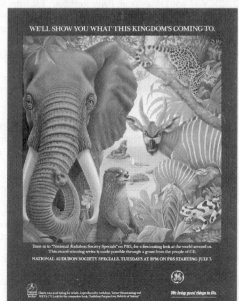

This illustration of a fanciful animal kingdom, by Bob Giusti, was used in a BBDO ad campaign to call attention to a series of National Audubon Society specials on PBS sponsored by General Electric.

Reprinted with permission of BBDO NY

First Contact & Terms: Send query letter with résumé to be kept on file. Call or write for appointment to show portfolio, which should include original/final art and photographs. Pays for design by the project. Pays for illustration by the hour, $50 minimum. Original artwork returned to artist after publication. Negotiates rights purchased.

Tips: Artist should have "knowledge of computer graphics."

‡**OUTSIDE THE BOX INTERACTIVE**, 133 W. 19th, Suite 10B, New York NY 10011-4117. (212)463-7160. Fax: (212)463-9179. E-mail: theoffice@outboxin.com. Website: http://www.outboxin.com. Design Manager: Lauren Schwartz. Estab. 1995. Number of employees: 5. Integrated marketing communications agency. Specializes in multimedia and integrated digital marketings, online and web content development. Product specialty is business-to-business. Professional affiliations: NY New Media Assoc., Assoc. of Internet Users, Harvestworks/Digital Media.

Needs: Approached by 30-40 freelance illustrators and 30-40 designers/year. Works with 8-10 freelance illustrators and 8-10 designers/year. Prefers freelancers with experience in computer arts. Also for airbrushing, animation, brochure and humorous illustration, logos, model making, multimedia projects, posters, retouching, storyboards, TV/film graphics, web page design. 30% of work is with print ads. 90% of design demands skills in Adobe Photoshop 3, QuarkXPress 3.2, Adobe Illustrator 5, Director HTML, Java Script and any 3D program. 60% of illustration demands skills in Adobe Photoshop 3, QuarkXPress 3.2, Adobe Illustrator 5, any animation and 3D program.

First Contact & Terms: Send query letter with brochure, photocopies, photographs, photostats, résumé, SASE, slides, tearsheets, transparencies. Send follow-up postcard every 3 months. Accepts disk submissions compatible with Power PC. Samples are filed and are returned by SASE. Will contact for portfolio review of b&w, color, final art, photographs, roughs, tearsheets, thumbnails, transparencies if interested. Pays by project. Rights purchased vary according to project.

Tips: "Be able to think on your feet, and to test your limits."

PRO/CREATIVES COMPANY, 25 W. Burda Place, New York NY 10956-7116. President: D. Rapp. Estab. 1986. Ad agency and marketing/promotion PR firm. Specializes in direct mail, ads, collateral. Product specialties are consumer/trade, goods/services.

Needs: Works on assignment only. Uses freelancers for brochure and print ad design and illustration. 30% of work is with print ads.

First Contact & Terms: Samples are filed and are returned by SASE. Portfolio review not required. Pays for design and illustration by the project.

PETER ROTHHOLZ ASSOCIATES INC., 360 Lexington Ave., 3rd Floor, New York NY 10017-6502. (212)687-6565. President: Peter Rothholz. PR firm. Specializes in government (tourism and industrial development), publishing, pharmaceuticals (health and beauty products) and business services.

Needs: Works with 24 freelance illustrators and 24 designers/year. Works on assignment only. Needs editorial illustration.

First Contact & Terms: Call for appointment to show portfolio of résumé or brochure/flyer to be kept on file. Samples are returned by SASE. Reports back in 2 weeks. Assignments made based on freelancer's experience, cost, style and whether he/she is local. Originals are not returned. Sometimes requests work on spec before assigning a job. Negotiates payment based on client's budget. Finds artists through word of mouth and submissions.

TALCO PRODUCTIONS, 279 E. 44th St., New York NY 10017. (212)697-4015. Fax: (212)697-4827. President: Alan Lawrence. Number of employees: 5. TV/film producer. Specializes in nonprofit organizations, industry, associations and PR firms. Produces videotapes, motion pictures and some filmstrips and sound-slide sets. Professional affiliation: DGA.

Needs: Works with 1-2 freelance illustrators and 1-2 designers/year. Prefers local freelancers with professional experience. 15% of freelance work demands knowledge of Aldus FreeHand or Adobe Illustrator.

First Contact & Terms: Send query letter with résumé, brochure and SASE. Reports back only if interested. Portfolio should include roughs, final reproduction/product, and color photostats and photographs. Payment varies according to assignment. Pays on production. Originals sometimes returned at job's completion. Buys all rights. Considers complexity of project, client's budget and rights purchased when establishing payment.

FOR A LIST of markets interested in humorous illustration, cartooning and caricatures, refer to the Humor Index at the back of this book.

TRITON AND COMPANY, (formerly Triton Advertising Inc.), 15 W. 44th St., New York NY 10036. (212)840-3040. E-mail: triton@aol. PR firm. Estab. 1950. Clients: fashion industry, entertainment and Broadway shows.

Needs: Works with 6 illustrators and 6 designers/year. Uses freelancers for consumer magazines, brochures/flyers and newspapers; occasionally buys cartoon-style illustrations. Prefers pen & ink and collage. 90% of work is with print ads. 100% of design and 70% of illustration demand knowledge of QuarkXPress, Aldus FreeHand and Adobe Photoshop.

First Contact & Terms: Send postcard sample with brochure and résumé to B. Epstein. Accepts submissions on disk compatible with Mac. Originals not returned. Pays for illustration and design by the project, $100-3,500.

Tips: "Don't get too complex—make it really simple. Don't send originals."

VAN VECHTEN & ASSOCIATES PUBLIC RELATIONS, The Carriage House, 142 E. 30th St., New York NY 10016. (212)684-4646. President: Jay Van Vechten. Number of employees: 8. Approximate annual billing: $1.1 million. PR firm. Clients: medical, consumer products, industry. Client list available for SASE.

Needs: Approached by 20 freelancers/year. Works with 8 freelance illustrators and 8 designers/year. Works on assignment only. Uses artists for editorial and medical illustration, consumer and trade magazines, brochures, newspapers, stationery, signage, AV presentations and press releases. 20% of freelance work demands computer skills.

First Contact & Terms: Send query letter with brochure, résumé, business card, photographs or photostats. Samples not returned. Reports back only if interested. Pays for design and illustration by the project. Considers client's budget when establishing payment. Buys all rights.

‡WILCOX AND ASSOCIATES, 50 W. 23rd, 11th Floor, New York NY 10010. (212)675-4300. Fax: (212)924-0821. Creative Director: Melody Kaplan. Estab. 1910. Number of employees: 30. Financial marketing agency. Specializes in financial communications. Product specialty is banks. Current clients include United Jersey, Citibank, Citicorp, Chase Manhattan Bank. Client list available upon request.

Needs: Approached by 7 freelance illustrators and 20 designers/year. Works with 1 freelance illustrator and 4 designers/year. Prefers local designers with experience in financials. Uses freelancers mainly for design. Also for brochure and web page design, logos, posters, storyboards. 10% of work is with print ads. 100% of design demands skills in Adobe Photoshop, QuarkXPress, Adobe Illustrator.

First Contact & Terms: Designers send query letter with résumé, slides. Illustrators send postcard sample of work with brochure, résumé. Accepts disk submissions compatible with QuarkXPress. Send EPS files. Samples are filed. Will contact for portfolio review of final art and slides if interested. Pays for design by the hour, $35-40. Pays for illustration by the project. Buys first rights.

North Carolina

IMAGE ASSOCIATES INC., 4909 Windy Hill Dr., Raleigh NC 27609. (919)876-6400. Fax: (919)876-7064. President: David Churchill. Estab. 1984. Number of employees: 35. AV firm. "Visual communications firm specializing in computer graphics and AV, multi-image, interactive multimedia, print and photographic applications."

Needs: Approached by 10 freelancers/year. Works with 4 freelance illustrators and 4 designers/year. Prefers freelancers with experience in high-tech orientations and computer-graphics. Works on assignment only. Uses freelancers mainly for brochure design and illustration. Also for print ad design and illustration, slide illustration, animation and retouching. 25% of work is with print ads. 90% of freelance work demands knowledge of Aldus FreeHand, Adobe Photoshop and Macromind Director.

First Contact & Terms: Send query letter with brochure, résumé and tearsheets. Samples are filed or are returned by SASE if requested by artist. Reports back to the artist only if interested. To show portfolio, mail roughs, finished art samples, tearsheets, final reproduction/product and slides. Pays for design and illustration by the project, $100 minimum. Considers complexity of project, client's budget and how work will be used when establishing payment. Rights purchased vary according to project.

North Dakota

FLINT COMMUNICATIONS, 101 Tenth St. N., Fargo ND 58102. (701)237-4850. Fax: (701)234-9080. Art Director: Gerri Lien. Estab. 1947. Number of employees: 25. Approximate annual billing: $9 million. Ad agency. Full-service, multimedia firm. Product specialties are agriculture, manufacturing, healthcare, insurance and banking. Client list available upon request. Professional affiliations: AIGA.

Needs: Approached by 50 freelancers/year. Works with 6-10 freelance illustrators and 3-4 designers/year. Uses freelancers for annual reports, brochure design and illustration, lettering, logos and TV/film graphics.

40% of work is with print ads. 20% of freelance work demands knowledge of Aldus PageMaker, Adobe Photoshop, QuarkXPress and Adobe Illustrator.

First Contact & Terms: Send postcard-size sample of work and query letter. Samples are filed. Art Director will contact artist for portfolio review if interested. Pays for illustration by the project, $100-2,000. Rights purchased vary according to project.

Ohio

‡BARON ADVERTISING, INC., Hanna Bldg., Suite 645, 1422 Euclid Ave., Cleveland OH 44115-1901. (216)621-6800. Fax: (216)621-6806. President: Selma Baron. Estab. 1956. Ad agency. Specializes in magazine ads and collateral. Product specialties are business-to-business, food, building products, technical products, industrial food service.

Needs: Approached by 30-40 freelance artists/month. Prefers artists with experience in food and technical equipment. Works on assignment only. Uses freelance artists mainly for specialized projects. Also uses freelance artists for brochure, catalog and print ad illustration and retouching. 90% of work is with print ads. Freelancers should be familiar with Aldus PageMaker, QuarkXPress, Aldus FreeHand, Adobe Illustrator or Adobe Photoshop.

First Contact & Terms: Send query letter with résumé and photocopies. Samples are filed and are not returned. Does not report back. "Artist should send only samples or copies that do not need returning." Art Director will contact artist for portfolio review if interested. Portfolio should include final art and tearsheets. Pay for design depends on style. Pay for ilustration depends on technique. Buys all rights. Finds artists through agents, sourcebooks, word of mouth and submissions.

HOLLAND ADVERTISING, 252 Ludlow Ave., Cincinnati OH 45220. (513)221-1252. Fax: (513)221-0758. E-mail: holland@eos.net. Estab. 1937. Number of employees: 12. Approximate annual billing: $7 million. Ad agency. Full-service, multimedia firm. Specializes in magazine trade, print, newspaper and direct mail. Product specialty is consumer. Professional affiliation: TAAN.

Needs: Approached by 6-12 freelancers/year. Works with 5-10 freelance illustrators and 2-3 designers/year. Prefers artists with experience in Macintosh. Uses freelancers for brochure illustration, logos, retouching and TV/film graphics. 100% of freelance work demands knowledge of Aldus PageMaker, Aldus FreeHand, Adobe Photoshop, QuarkXPress and Adobe Illustrator.

First Contact & Terms: Send query letter with photocopies and résumé. Accepts submissions on disk. Samples are filed and are not returned. Art Director will contact artist for portfolio review if interested. Portfolio should include b&w and color final art, photographs, roughs, tearsheets and thumbnails. Pays for design by the hour, by the project and by the day. Pays for illustration by the project. Rights purchased vary according to project.

‡INSTANT REPLAY, Dept. AM, 1349 E. McMillan, Cincinnati OH 45206. (513)861-7065. President: Terry Hamad. Estab. 1977. AV/Post Production/Graphic Design firm. "We are a full-service film/video production and video post production house with our own sound stage. We also do traditional animation, paintbox animation with Harry, and 3-D computer animation for broadcast groups, corporate entities and ad agencies. We do many corporate identity pieces as well as network affiliate packages, car dealership spots and general regional and national advertising for TV market." Current clients include Procter and Gamble, General Electric, NBC, CBS, ABC and FOX affiliates.

Needs: Works with 1 designer/month. Prefers freelancers with experience in video production. Works on assignment only. Uses freelancers mainly for production. Also use freelancers for storyboards, animatics, animation and TV/film graphics.

First Contact & Terms: Send query letter with résumé, photocopies, slides and videotape. "Interesting samples are filed." Samples not filed are returned by SASE only if requested. Reports back only if interested. Call for appointment to show slide portfolio. Pays by the hour, $25-50 or by the project and by the day (negotiated by number of days.) Pays for production by the day, $75-300. Considers complexity of project, client's budget and turnaround time when establishing payment. Buys all rights.

LOHRE & ASSOCIATES, 2330 Victory Parkway, Suite 701, Cincinnati OH 45206. (513)961-1174. E-mail: lohre@12c.net. Website: http://www.12c.net/~lohre. President: Chuck Lohre. Number of employees: 8. Approximate annual billing: $1 million. Ad agency. Specializes in industrial firms. Professional affiliation: BMA.

Needs: Approached by 24 freelancers/year. Works with 10 freelance illustrators and 10 designers/year. Works on assignment only. Uses freelance artists for trade magazines, direct mail, P-O-P displays, multimedia, brochures and catalogs. 100% of freelance work demands knowledge of Aldus PageMaker, Aldus FreeHand and Adobe Photoshop.

First Contact & Terms: Send postcard sample. Accepts submissions on disk, any Mac application. Pays for design and illustration by the hour, $10 minimum.

Tips: Looks for artists who "have experience in chemical and mining industry, can read blueprints and have worked with metal fabrication. Needs Macintosh-literate artists who are willing to work at office, during day or evenings."

ART MERIMS COMMUNICATIONS, Bank One Center, Suite 1300, 600 Superior Ave., Cleveland OH 44114-2650. (216)522-1909. Fax: (216)479-6801. President: Arthur M. Merims. Number of employees: 4. Approximate annual billing: $800,000. Ad agency/PR firm. Current clients include Ohio Pest Control Association, HQ Business Centers, Osborn Engineering, Patrick Douglas, Inc., Woodruff Foundation.
Needs: Approached by 10 freelancers/year. Works with 1-2 freelance illustrators and 3 designers/year. Prefers local freelancers. Works on assignment only. Uses freelancers mainly for work on trade magazines, brochures, catalogs, signage, editorial illustrations and AV presentations. 20% of freelance work demands computer skills.
First Contact & Terms: Send query letter with samples to be kept on file. Call for appointment to show portfolio of "copies of any kind" as samples. Sometimes requests work on spec before assigning a job. Pays for design and illustration by the hour, $20-60, or by the design project, $300-1,200. Considers complexity of project, client's budget and skill and experience of artist when establishing payment. Finds artists through contact by phone or mail.
Tips: When reviewing samples, looks for "creativity and reasonableness of cost."

PIHERA ADVERTISING ASSOCIATES, INC, 1605 Ambridge Rd., Dayton OH 45459. (513)433-9814. President: Larry Pihera. Estab. 1970. Ad agency, PR firm. Full-service multimedia firm. Specializes in magazine ads, collateral, corporate video production. Product specialties are industrial and retail. Client list not available.
Needs: Approached by 10 freelancers/year. Works with 5 freelance illustrators/year. Uses freelancers for animation, annual reports, billboards, brochure design and illustration, catalog illustration, lettering, mechanicals, retouching and signage. 50% of work is with print ads. 10% of freelance work demands computer skills.
First Contact & Terms: Send query letter with brochure and photostats. Samples are filed and are not returned. Does not report back. Artist should follow up. Art Director will contact artist for portfolio review if interested. Portfolio should include b&w and color photographs. Pays for design and illustration by the project. Buys all rights. Finds artists through submissions.

‡TRIAD, (Terry Robie Industrial Advertising, Inc.), 7654 W. Bancroft St., Toledo OH 43617-1656. (419)241-5110. President/Creative Director: Janice Robie. Ad agency specializing in graphics and promotions. Product specialties are industrial, consumer.
Needs: Assigns 30 freelance jobs/year. Works with 5 illustrators/year and 20 designers/year. Works on assignment only. Uses freelancers for consumer and trade magazines, brochures, catalogs, newspapers, filmstrips, stationery, signage, P-O-P displays, AV presentations, posters and illustrations (technical and/or creative). 100% of design and 50% of illustration require computer skills. Also needs freelancers experienced in CD-ROM for authoring, animation and design.
First Contact & Terms: Send query letter with résumé and slides, photographs, photostats or printed samples. Accepts disk submissions compatible with Mac or Windows. Samples returned by SASE if not filed. Reports only if interested. Write for appointment to show portfolio, which should include roughs, finished art, final reproduction/product and tearsheets. Pays by the hour, $10-60 or by the project, $25-2,500. Considers client's budget and skill and experience of artist when establishing payment. Negotiates rights purchased.
Tips: "We are interested in knowing your specialty."

‡WATT, ROOP & CO., 1100 Superior Ave., Suite 1350, Cleveland OH 44114. (216)566-7019. Fax: (216)566-0857. Vice President: Tom Federico. Estab. 1981. Number of employees: 30. Approximate annual billing: $3 million. Integrated marketing communications agency. Specializes in annuals, sales literature, ads. Product specialties are manufacturing, high tech, healthcare. Current clients include NCR, RPM, TRW, AT&T. Professional affiliations: AIGA, Cleveland Ad Club.
Needs: Approached by 30 freelance illustrators and 20 designers/year. Works with 3 freelance illustrators and 6 designers/year. Prefers local freelancers. Uses freelancers mainly for overflow. Also for airbrushing; animation; humorous, medical and technical illustration; lettering, mechanicals, model making, multimedia projects, storyboards, TV/film graphics. 10% of work is with print ads. 100% of design demands skills in Aldus PageMaker, Aldus FreeHand, Adobe Photoshop, QuarkXPress, Adobe Illustrator. 50% of illustration demands skills in Aldus FreeHand, Adobe Photoshop, Adobe Illustrator.
First Contact & Terms: Designers send query letter with photocopies. Illustrators send postcard sample of work. Accepts disk submissions compatible with QuarkXPress 7.5/version 3.3. Send EPS files. Samples are filed. Reports back only if interested. Portfolio of color, final art, photographs may be dropped off. Pays for design by the hour, $20-30. Pays for illustration by the project. Buys all rights. Finds artists through word of mouth, creative outlet books.
Tips: "Be flexible and fast."

Oregon

ADFILIATION ADVERTISING & DESIGN, 323 W. 13th Ave., Eugene OR 97401. (503)687-8262. Fax: (503)687-8576. President/Creative Director: Gary Schubert. Media Director/VP: Gwen Schubert. Estab. 1976. Ad agency. "We provide full-service advertising to a wide variety of regional and national accounts. Our specialty is print media, serving predominantly industrial and business-to-business advertisers." Product specialties are forest products, heavy equipment, software, sporting equipment, food and medical.

Needs: Works with approximately 4 freelance illustrators and 2 designers/year. Works on assignment only. Uses freelancers mainly for specialty styles. Also for brochure and magazine ad illustration (editorial, technical and medical), retouching, animation, films and lettering. 80% of work is with print ads. 80% of freelance work demands knowledge of Adobe Illustrator, QuarkXPress, Aldus FreeHand, MultiMedia, Director, 3D Renderman or Adobe Photoshop.

First Contact & Terms: Send query letter, brochure, résumé, slides and photographs. Samples are filed or are returned by SASE only if requested. Reports back only if interested. Write for appointment to show portfolio. Pays for design illustration and by the hour, $25-100. Rights purchased vary according to project.

Tips: "We're busy. So follow up with reminders of your specialty, current samples of your work and the convenience of dealing with you. We are looking at more electronic illustration. Find out what the agency does most often and produce a relative example for indication that you are up for doing the real thing! Follow-up after initial interview of samples. Do not send fine art, abstract subjects."

‡CREATIVE COMPANY, INC., Dept. AM, 3276 Commercial St. SE, Salem OR 97302. (503)363-4433. E-mail: cr8ivity@open.org. President/Owner: Jennifer Larsen Morrow. Specializes in marketing-driven corporate identity, collateral, direct mail, packaging and P-O-P displays. Product specialties are food, garden products, financial services, colleges, pharmaceutical, medical, technical instruments, franchises, transportation programs.

Needs: Works with 3-7 freelance designers and 3-7 illustrators/year. Prefers local artists. Works on assignment only. Uses freelancers for design, illustration, computer production (Mac), retouching and lettering. "Looking for clean, fresh designs!" 80% of design and 30% of illustration demand skills in QuarkXPress, Aldus Pagemaker, Aldus FreeHand, Adobe Illustrator and Adobe Photoshop.

First Contact & Terms: Send query letter with brochure, résumé, business card, photocopies and tearsheets to be kept on file. Samples returned by SASE only if requested. Art Director will contact for portfolio review if interested. "We require a portfolio review. Years of experience not important if portfolio is good. We prefer one-on-one review to discuss individual projects/time/approach." Pays for design by the hour or project, $25-75. Pays for illustration by the project. Considers complexity of project and skill and experience of artist when establishing payment.

Tips: Common mistakes freelancers make in presenting samples or portfolios are: "1) poor presentation, samples not mounted or organized; 2) not knowing how long it took them to do a job to provide a budget figure; 3) not demonstrating an understanding of the audience, the problem or printing process and how their work will translate into a printed copy; 4) just dropping in without an appointment; 5) not following up periodically to update information or a résumé that might be on file."

SULLIVAN PATTISON CLEVENGER, (formerly Prideaux Sullivan Pattison), 219 SW Stark St., #200, Portland OR 97204-2602. (503)226-4553. Fax: (503)273-8052. E-mail: hpattison@aol.com. Art Director: Kirsten Finstad. Partner: Harry Pattison. Estab. 1988. Number of employees: 12. Approximate annual billing: $8-10 million. Ad agency, PR firm. Full-service, multimedia firm. Specializes in print, broadcast and PR. Product specialties are healthcare, resort, restaurant, real estate, high tech industries and lumber. Client list available upon request. Professional affiliations: PAF, PAAA.

Needs: Approached by over 100 freelancers/year. Works with 10-20 freelance illustrators/year. Also Uses freelancers for billboards, brochure and catalog illustration, retouching and TV/film graphics. 80% of work is with print ads. 50% of freelance work demands knowledge of Adobe Photoshop, QuarkXPress and Adobe Illustrator.

First Contact & Terms: Send postcard-size sample of work, photocopies and tearsheets. Art Director will contact artist for portfolio review if interested. Portfolio should include "anything in a good creative presentation." Payment for illustration depends on the project. Rights purchased vary according to project. Finds artists through *Creative Black Book*, *Workbook*, magazines, word of mouth, submissions.

Tips: Impress art director "with intelligence, open-minded attitude, creative, break-through work only; and flexibility with budget."

Pennsylvania

‡BALL ADVERTISING AND MARKETING, 1689 Crown Ave., Lancaster PA 17601. (717)299-1598. Fax: (717)299-9690. Art Director: Marlin Miller. Estab. 1985. Number of employees: 7. Approximate annual

billing: $5 million. Integrated marketing communications agency. Specializes in new market development. Professional affiliation: Central Pennsylvania Ad Club.

• Ball Advertising received nine Addy awards in the 1995 Central Pennsylvania Ad Club competition.

Needs: Approached by 5 freelance illustrators and 5 designers/year. Works with 5 freelance illustrators and 1 designer/year. Uses freelancers mainly for illustration. Also for airbrushing; animation; brochure, catalog, humorous and technical illustration; logos; multimedia projects; retouching; signage; storyboards; TV/film graphics; web page design. 20% of work is with print ads. 80% of design demands skills in Aldus PageMaker, Aldus FreeHand, Adobe Photoshop.

First Contact & Terms: Designers send query letter with photocopies, résumé. Illustrators send query letter with photocopies, photographs. Accepts disk submissions compatible with Aldus PageMaker 5.0, Aldus FreeHand 5.0 or Adobe Photoshop 3.0. Samples are filed. Will contact for portfolio review of final art, photographs if interested. Pays for design by the hour, $15-35. Pays for illustration by the project. Rights purchased vary according to project. Finds artists through agents, direct mail, sourcebooks.

‡BELLMEDIA CORP., (formerly Gra-Mark Advertising), P.O. Box 18053, Pittsburgh PA 15236. (412)469-0301. Fax: (412)469-8244. Full-service, multimedia firm. Product specialty is business-to-business telephonic production.

Needs: Prefers local artists only. Uses freelance artists mainly for print ad, brochure and logo design. Also uses freelance artists for catalog and print ad design. 90% of freelance work demands knowledge of Aldus PageMaker.

First Contact & Terms: Send query letter with brochure and résumé. Accepts submissions on disk. Samples are filed. Reports back to the artist only if interested. Artist should follow up with call. Portfolio should include thumbnails, roughs, final art and mechanicals. Pays for design and illustration by the hour or by the project. Buys reprint rights or all rights. Finds artists through word of mouth, submissions.

‡THE CONCEPTS CORP., Dept. AM, 120 Kedron Ave., Holmes PA 19043. (610)461-1600. Fax: (610)461-1650. President: James Higgins. Estab. 1962. AV firm. Full-service, multimedia firm. Specializes in design, collateral, location and studio photography, computer graphics and special effects photography. Product specialties are computer, medical and industrial. Current clients include Unisys, GE, Westinghouse, Wyeth-Ayerst, Franklin Mint, Hercules and DuPont.

Needs: Approached by 8-10 artists/month. Works with 6 illustrators and 6 designers/month. Prefers local artists with experience in collateral and AV design, type-spec, layout, comps and client contact. Uses freelancers mainly for fill-in for overflow and special design illustrator talent. Also for brochure, catalog and print ad design and illustration; storyboards; multimedia; mechanicals; and TV/film graphics. 25% of work is with print ads. 75% of design and 50% of illustration demand computer skills.

First Contact & Terms: Send query letter with résumé. Samples are filed or are returned. Reports back to the artist only if interested. Write for appointment to show portfolio of thumbnails, roughs, tearsheets and slides. Pays for design by the hour, $10-60; or estimated by the project. Pays for illustration by the project. Buys first rights.

CROSS KEYS ADVERTISING & MARKETING, INC., 329 S. Main St., Doylestown PA 18901. (215)345-5435. Fax: (215)345-4570. President: Laura T. Barnes. Estab. 1981. Number of employees: 10. Approximate annual billing: $2 million. Ad agency.

Needs: Approached by 30 freelancers/year. Works with 4 freelance illustrators and 5 designers/year. Prefers local freelancers. Uses freelancers for design and illustration, logos, mechanicals and retouching. 80% of work is with print ads. 50% of freelance work demands knowledge of Adobe Photoshop, QuarkXPress and Adobe Illustrator on Mac.

First Contact & Terms: Send query letter with photocopies and résumé. "We will accept work in Adobe Illustrator 5.0 or as EPS files and in QuarkXPress 3.31." Samples are filed. Art Director will contact artist for portfolio review if interested. Portfolio should include b&w and color final art, roughs. Pays for design and illustration by the project. Rights purchased vary according to project.

‡THE NEIMAN GROUP, Harrisburg Transportation Center, Fourth and Chesnut St., Harrisburgh PA 19101. (717)232-5554. Fax: (717)232-7998. E-mail: neimangrp@aol.com. Art Director: Paul Murray. Estab. 1978. Full-service ad agency specializing in print collateral and ad campaigns. Product specialties are healthcare, banks, retail and industry.

Needs: Works with 5 illustrators and 4 designers/month. Prefers local artists with experience in comps and roughs. Works on assignment only. Uses freelancers mainly for advertising illustration and comps. Also uses freelancers for brochure design, mechanicals, retouching, lettering and logos. 50% of work is with print ads. 3% of design and 1% of illustration demand knowledge of Adobe Illustrator and Adobe Photoshop.

First Contact & Terms: Designers send query letter with résumé. Illustrators send postcard sample, query letter and tearsheets. Samples are filed. Art Director will contact artist for portfolio review if interested. Portfolio should include color and b&w samples, thumbnails, roughs, original/final art, photographs. Pays for design and illustration by the project, $300 minimum. Buys all rights. Finds artists through sourcebooks and workbooks.

Tips: "Everybody looks great on paper. Try to get a potential client's attention with a novel concept. Never, ever, miss a deadline. Enjoy what you do. There will be a need for more multimedia and electronic design. We are moving in that direction gradually."

PERCEPTIVE MARKETERS AGENCY LTD., 1100 E. Hector St., Suite 301, Conshohocken PA 19428-2394. (610)825-8710. Fax: (610)825-9186. E-mail: perceptmkt@aol.com. Creative Director: Jason Solovitz. Estab. 1972. Number of employees: 8. Approximate annual billing: $4 million. Ad agency. Product specialties are communications, sports, hospitals, health care consulting, computers (software and hardware), environmental products, automotive, insurance, financial, food products and publishing. Professional Affiliation: Philadelphia Ad Club, Philadelphia Direct Marketing Association, AANI, Second Wind Network.
Needs: Approached by 20 freelancers/year. Works with 10 freelance illustrators and 5 designers/year. Uses 80% local talent. In order of priority, uses freelancers for computer production, photography, illustration, comps/layout and design/art direction. Also for multimedia. "Concepts, ability to follow instructions/layouts and precision/accuracy are important." 100% of design and 50% of illustration demand knowledge of Quark-XPress, Adobe Illustrator or Adobe Photoshop. 50% of work is with print ads.
First Contact & Terms: Send résumé and photostats, photographs and tearsheets to be kept on file. Accepts as samples "whatever best represents artist's work—but preferably not slides." Accepts submissions on disk. Samples not filed are returned by SASE only. Reports back only if interested. Call for appointment to show portfolio. Pays for design by the hour or by the project. Pays for illustration by the project, up to $3,500. Considers complexity of the project, client's budget and turnaround time when establishing payment. Buys all rights.
Tips: "Freelance artists should approach us with unique, creative and professional work. And it's especially helpful to follow-up interviews with new samples of work (i.e., to send a month later a 'reminder' card or sample of current work to keep on file)."

Rhode Island

MARTIN THOMAS, INC., 26 Bosworth St., Barrington RI 02806-4108. (401)245-8500. Fax: (401)245-1242. E-mail: 75017.2370@compuserve.com. Production Manager: Richard E. Rounds. Estab. 1987. Number of employees: 12. Approximate annual billing: $7 million. Ad agency, PR firm. Specializes in industrial, business-to-business. Product specialties are plastics, medical and automotive. Professional affiliations: Four AAAA Boston Ad Club.
Needs: Approached by 10-15 freelancers/year. Works with 1 freelance illustrator and 10-15 designers/year. Prefers freelancers with experience in business-to-business/industrial. Uses freelancers mainly for design of ads, literature and direct mail. Also for brochure and catalog design and illustration. 85% of work is print ads. 70% of design and 40% of illustration demand knowledge of QuarkXPress.
First Contact & Terms: Send query letter with brochure and résumé. Samples are filed and are returned. Reports back within 3 weeks. Art Director will contact artist for portfolio review if interested. Portfolio should include b&w and color final art. Pays for design and illustration by the hour and by the project. Buys all rights. Finds artists through *Creative Black Book*.
Tips: Impress agency by "knowning industries we serve."

South Carolina

‡JIT INTERACTIVE MEDIA TM, 8 Park Dr., York SC 29745-2029. (803)628-0015. Fax: (803)684-4242. E-mail: jit@jit.com. Website: http://www.jit.com. Contact: Peggy Sigmon. Estab. 1995. Number of employees: 2. Ad agency. Specializes in Internet, web services, design. Current clients include ABIN, Com, D&D Herbs. Professional affiliation: US Chamber of Commerce.
Needs: Approached by 3 freelance illustrators and 6 designers/year. Works with 2 freelance illustrators and 2 designers/year. Prefers freelancers with experience in HTML, JAVA. Also for brochure design and illustration, multimedia projects, web page design, JAVA. 5% of work is with print ads. 100% of freelance work demands skills in Adobe Photoshop, QuarkXPress 3.3, Adobe Illustrator.
First Contact & Terms: Send query letter with résumé, SASE, tearsheets and/or web page printout. Accepts disk submissions compatible with QuarkXPress 7.5/version 3.3. Send EPS files. Samples are filed. Reports back within 2 weeks. Will contact for portfolio review of color, final art, tearsheets if interested. Pays by the project; negotiable. Rights purchased vary according to project. Finds artists through *Creative Black Book*, online services (CompuServe), word of mouth, submissions.
Tips: "Be yourself and have passion!"

Tennessee

‡MEDIAGRAPHICS, 717 Spring St., P.O. Box 12525, Memphis TN 38182-0525. (901)324-1658. Fax: (901)323-7214. CEO: J.D. Kinney. Estab. 1973. Integrated marketing communications agency. Specializes in all visual communications. Product specialties are financial, fundraising, retail, business-to-business. Client list available upon request. Professional affiliations: Memphis Area chamber, B.B.B.
 • This firm reports they are looking for top illustrators only. When they find illustrators they like, they generally consider them associates and work with them on a continual basis.
First Contact & Terms: Send query letter with résumé and tearsheets. Accepts disk submissions compatible with Mac or PC. Send EPS file. Also CD-ROM. Samples are filed and are not returned. Will contact for portfolio review if interested. Rights purchased vary according to project.

Texas

DYKEMAN ASSOCIATES INC., 4115 Rawlins, Dallas TX 75219. (214)528-2991. Fax: (214)528-0241. Contact: Alice Dykeman. PR/marketing firm. Specializes in business, industry, sports, environmental, energy, health.
Needs: Works with 30 illustrators and designers/year. "We prefer artists who can both design and illustrate." Local freelancers only. Uses freelancers for editorial and technical illustration, brochure design, exhibits, corporate identification, signs, posters, ads and all design and finished artwork for graphics and printed materials.
First Contact & Terms: Request portfolio review in original query. Pays by the project, $250-3,000. "Artist makes an estimate; we approve or negotiate."
Tips: "Be enthusiastic. Present an organized portfolio with a variety of work. Portfolio should reflect all that an artist can do. Don't include examples of projects for which you only did a small part of the creative work. Have a price structure but be willing to negotiate per project. We prefer to use artists/designers/ illustrators who will work with barter (trade) dollars and join one of our associations. We see steady growth ahead."

FUTURETALK TELECOMMUNICATIONS COMPANY, INC., P.O. Box 270942, Dallas TX 75227- 0942. Contact: Marketing Department Manager. Estab. 1993. Ad agency and PR firm. Full-service, multimedia firm and telecommunications company. Specializes in MCI videophone sales (authorized MCI dealer). Current clients include small to medium businesses and individuals.
Needs: Approached by 20-30 freelancers/year. Works with 10-15 illustrators and 2-3 designers/year. Prefers freelancers with experience in computer graphics. Works on assignment only. Uses freelancers mainly for promotional projects. Also for brochure and catalog illustration, storyboards, animation, model making, billboards and TV/film graphics. 20% of work is with print ads. 60% of freelance work demands computer skills.
First Contact & Terms: Send query letter with résumé, photocopies, photographs and SASE. Samples are filed or are returned by SASE if requested by artist. Reports back within 3 weeks. Art Director will contact artist for portfolio review if interested. Portfolio should include b&w and color final art, tearsheets and photostats. Pays for design by the hour, $10-25; by the project, $250-2,500; by the day, $250-2,500. Pays for illustration by the hour, $20-40; by the project, $250-2,500; by the day, $250-2,500. Rights purchased vary according to project. Finds artists through sourcebooks, word of mouth and artists' submissions.
Tips: "Please either write for Job Package (include $3) or dial from fax machine line and press start to (800)934-1618."

HEPWORTH ADVERTISING COMPANY, 3403 McKinney Ave., Dallas TX 75204. (214)526-7785. Manager: S.W. Hepworth. Full-service ad agency. Clients: finance, consumer and industrial firms.
Needs: Works with 3-4 freelancers/year. Uses freelancers for brochure and newspaper ad design, direct mail packages, magazine ad illustration, mechanicals, billboards and logos.
First Contact & Terms: Send a query letter with tearsheets. Samples are not filed and are returned by SASE only if requested by artist. Does not report back. Portfolio should include roughs. Pays for design and illustration by the project. Considers client's budget when establishing payment. Buys all rights.
Tips: Looks for variety in samples or portfolio.

‡McCANN-ERICKSON WORLDWIDE, Suite 1900, 1360 Post Oak Blvd., Houston TX 77056. (713)965-0303. Creative Director: Jesse Caesar. Ad agency. Clients: all types including consumer, industrial, gasoline, transportation/air, entertainment, computers and high-tech.
Needs: Works with about 20 illustrators/month. Uses freelancers in all media.
First Contact & Terms: Art Director will contact artist for portfolio review if interested. Selection based on portfolio review. Pays for design by the hour, $40 minimum. Pays for illustration by the project, $100

minimum. Negotiates payment based on client's budget and where work will appear. Finds artists through word of mouth.

Tips: Wants to see full range of work including past work used by other ad agencies and tearsheets of published art in portfolio.

‡**THE TENAGRA CORPORATION**, 1100 Hercules, #120, Houston TX 77058. (713)480-6300. Fax: (713)480-7715. E-mail: info@tenagra.com. Website: http://www.tenagra.com/. Director UFB Services: Melanie Mitchell. Estab. 1993. Number of employees: 7. Internet marketing and PR firm. Specializes in PR and promotion via the Internet. Client list available upon request.
Needs: Prefers local freelancers with experience in HTML, design, Internet experience. Uses freelancers mainly for design, HTML coding. Also for web page design. 100% of freelance design demands skills in Aldus PageMaker 6.0, Adobe Photoshop 3.0, QuarkXPress 3.0. 100% of freelance illustration demands skills in Adobe Photoshop, Adobe Illustrator.
First Contact & Terms: Designers send query letter with brochure, résumé, slides. Illustrators send query letter with photographs, slides. Accepts disk submissions compatible with Aldus PageMaker 5.0 or Adobe Photoshop 3.0 (Mac versions). Samples are filed. Reports back only if interested. Follow-up with call and/ or letter. Portfolio should include final art, photographs, roughs. Pays $45 maximum. Buys all rights.
Tips: "Know the design constraints of the Internet."

‡**EVANS WYATT ADVERTISING**, P.O. Box 18958, Corpus Christi TX 78480-8958. (512)854-1661. Creative Director: E. Wyatt. Estab. 1975. Ad agency. Full-service, multimedia firm. Specializes in general and industrial advertising.
Needs: Approached by 2-4 freelance artists/month. Works with 2-3 illustrators and 5-6 designers/month. Works on assignment only. Uses freelancers for ad design and illustration, brochure and catalog design and illustration, storyboards, retouching, billboards, posters, TV/film graphics, lettering, logos and industrial/ technical art. 80% of work is with print ads.
First Contact & Terms: Send a query letter with brochure, photocopies, SASE, résumé and photographs. Samples are filed or are returned by SASE if requested by artist. Reports back within 1 month. Call for appointment to show portfolio or mail thumbnails, roughs and b&w and color photostats, tearsheets and photographs. Pays by the hour, by the project, or by arrangement. Buys all rights.

Utah

BROWNING ADVERTISING, 1 Browning Place, Morgan UT 84050. (801)876-2711, ext. 336. Fax: (801)876-3331. Senior Art Director: Brent Evans. Estab. 1878. Distributor and marketer of outdoor sports products, particularly firearms. Inhouse agency for 3 main clients. Inhouse divisions include non-gun hunting products, firearms and accessories.
Needs: Approached by 50 freelancers/year. Works with 20 freelance illustrators and 20 designers/year. Prefers freelancers with experience in outdoor sports—hunting, shooting, fishing. Works on assignment only. Uses freelancers mainly for design, illustration and production. Also for advertising and brochure layout, catalogs, product rendering and design, signage, P-O-P displays, and posters.
First Contact & Terms: Send query letter with résumé and tearsheets, slides, photographs and transparencies. Samples are not filed and are not returned. Reports back to the artist only if interested. To show portfolio, mail photostats, slides, tearsheets, transparencies and photographs. Pays for design by the hour, $50-75. Pays for illustration by the project. Buys all rights or reprint rights.

‡**ALAN FRANK & ASSOCIATES INC.**, Dept. AM, 1524 S. 1100 E., Salt Lake City UT 84105. (801)486-7455. Art Director: Kazuo Shiotani. Serves clients in travel, fast food chains and retailing.
Needs: Uses freelancers for illustrations, animation and retouching for annual reports, billboards, ads, letterheads, TV and packaging.
First Contract & Terms: Mail art with SASE. Reports within 2 weeks. Minimum payment: $500, animation; $100, illustrations; $200, brochure layout.

Virginia

‡**DEADY ADVERTISING**, Dept. AM, 17 E. Cary St., Richmond VA 23219. (804)643-4011. President: Jim Deady. Specializes in industrial, financial, manufacturing equipment, medical supplies, real estate and displays and publications. Clients: industrial (nautical), food service, health care.
Needs: Works with 10-12 freelance illustrators and 8-10 designers/year. Seeks only local or regional artists with minimum of 2 years experience with an agency. Works on assignment only. Uses freelancers for design and illustration, for brochures, magazine ads, websites and interactive presentation. Needs technical illustra-

tion. 100% of design and 50% of illustration demand knowledge of Adobe Illustrator.

First Contact & Terms: Designers send query letter with résumé to be kept on file; also send photocopies with SASE to be returned. Illustrators send postcard sample. Reports back only if interested. Call or write for appointment to show portfolio, which should include photostats. Pays for design by the project, $250-2,500. Pays for illustration by the project, $275-1,500 average.

Tips: "Agency is active; freelancers who are accessible are our most frequently-used resource."

LONGLEY/BABB & ASSOCIATES, Box 32107, Hillsboro VA 22312. (540)668-6039. Fax: (540)668-9018. Partner: Drew Babb. Estab. 1993. Number of employees: 3. Ad agency, PR firm. Full-service, multimedia firm. Specializes in advertising and PR in all media. Also marketing counsel, advocacy, public service advertising, the arts and education. Current clients include National Business Education Association, National Association of Children's Hospitals, Union of Concerned Scientists, Music Educators National Conference, Thelonious Monk Institute of Jazz, Very Special Arts. Client list available upon request.

Needs: Approached by 12-25 freelancers/year. Works with 10-20 freelance illustrators and 5-10 designers/year. Uses freelancers mainly for design and production. Also uses freelancers for annual reports, brochure design and illustration, logos, mechanicals, posters and retouching. 75% of work is with print ads. 75% of freelance work demands knowledge of QuarkXPress 3.31.

First Contact & Terms: Send postcard-size sample of work or brochure. Samples are filed and are not returned. Does not report back. Artist should "send updated sample(s) about once a year." Pays for design and illustration by the project. Negotiates rights purchased. Finds artists through *Communication Arts*, *Ad Week* and *Creative Source Book*.

Tips: "Send great samples! Computer design is often the crippler of the written word."

‡VIVID IMAGES PRESS, INC., 8907 Necessary Rd., #100, Wise VA 24293. (540)328-2223. Fax: (540)328-6915. E-mail: jallio@cre.com. President: Jacqueline C. Allio. Estab. 1975. Specializes in webpages. Product specialties motorsports. Professional affiliations: AARWBA, AICPA, ABBSA.

Needs: Approached by 5 freelance illustrators and 5 designers/year. Works with 10 freelance illustrators and 10 designers/year. Prefers freelancers with experience in HTML. Uses freelancers mainly for contract jobs. Also for brochure and technical illustration, logos, multimedia projects, posters, TV/film graphics, webpage design. 80% of work is with print ads. 80% of freelance work demands skills in Aldus PageMaker, Adobe Photoshop.

First Contact & Terms: Send query letter with photocopies, résumé, SASE. Send follow-up postcard every 4 months. Accepts disk submissions compatible with DOS and Windows on 3.5 or 5.25 disks. Samples are filed or returned by SASE. Reports back within 15 days. Portfolios may be dropped off every Tuesday. Will contact for portfolio review of photostats, diskettes if interested. Pays by the project, $35 minimum. Negotiates rights purchased. Rights purchased vary according to project. Finds artists through word of mouth, submissions, agents.

Tips: "We welcome new talent."

Wisconsin

AGA COMMUNICATIONS, (formerly Greinke, Eiers & Associates), 2557 C. N. Terrace Ave., Milwaukee WI 53211-3822. (414)962-9810. Fax: (414)352-3233. CEO: Arthur Greinke. Estab. 1984. Number of employees: 7. Ad agency, PR firm. Full-service multimedia firm. Specializes in special events (large display and photo work), print ads, TV ads, radio, all types of printed material (T-shirts, newsletters, etc.). Current clients include Great Circus Parade, Eastside Compact Disc and Landmark Theatre Chain. Professional affiliations: PRSA, IABC, NARAS.

Needs: Approached by 125 freelancers/year. Works with 25 freelance illustrators and 25 designers/year. Uses freelancers for "everything and anything"—brochure and print ad design and illustration, storyboards, slide illustration, retouching, model making, billboards, posters, TV/film graphics, lettering and logos. Also for multimedia projects. 40% of work is with print ads. 75% of freelance work demands knowledge of Aldus PageMaker, Adobe Illustrator, QuarkXPress, Adobe Photoshop, Aldus FreeHand or Powerpoint.

First Contact & Terms: Send postcard sample and/or query letter with brochure, résumé, photocopies, photographs, SASE, slides, tearsheets, transparencies. Accepts disk submissions compatible with BMP files, Aldus PageMaker, QuarkXPress and Adobe Illustrator. Samples are filed and are not returned. Reports back only if interested. Art Director will contact artists for portfolio review if interested. Portfolio should include b&w and color thumbnails, roughs, final art, tearsheets, photographs, transparencies, etc. Pays by personal contract. Rights purchased vary according to project. Finds artists through submissions and word of mouth.

Tips: "We look for stunning, eye-catching work—surprise us!"

‡MARATHON COMMUNICATIONS, 2001 Second St., Wausau WI 54403. (715)845-4231. Fax: (715)845-9276. E-mail: rwunsch@marcomm.com. Website: http://www.emarkets.com. Creative Director: Rick Wunsch. Estab. 1926. Number of employees: 140. Approximate annual billing: $16 million. Marketing

communications agency/design firm and commercial printer. Specializes in paper mill samples, swatch books, museum literature. Product specialties are paper, insurance, windows. Professional affiliation: AAF.

Needs: Approached by 25 freelance illustrators and 5 designers/year. Works with 20 freelance illustrators/year. Uses freelancers mainly for illustration. Also for airbrushing; brochure, catalog and humorous illustration; multimedia projects. 100% of freelance design and 50% of illustration demand skills in Aldus FreeHand, Adobe Photoshop, QuarkXPress, Adobe Illustrator.

First Contact & Terms: Designers send query letter with brochure. Illustrators send postcard sample of work. Samples are not filed and are not returned. Reports back only if interested. Portfolio review not required. Pays for design by the hour, $20-40. Pays for illustration by the project, $250-1,500. Negotiages rights purchased.

Canada

♦**NORTHWEST IMAGING & F.X.**, 2339 Columbia St., Suite 100, Vancouver, British Columbia V5Y 3Y3 Canada. (604)873-9330. Fax: (604)873-9339. General Manager: Alex Tkach. Estab. 1956. AV firm. Specializes in graphics and visual special effects for TV and motion pictures, including storyboards and animation. Product specialties are TV commercials and shows. Current clients include: NBC, CBC, CBS, CTV, FOX, MGM, Paramount, Cannell and MTV.

Needs: Approached by 5 freelancers/month. Works with 2 illustrators and 2 designers/month. Prefers freelancers with experience in computer design. Works on assignment only. Uses freelancers mainly for backup and computer design. Also for brochure design and illustration, print ad design, storyboards, animatics, animation, TV/film graphics, lettering and logos. 10% of work is with print ads.

First Contact & Terms: Send query letter with résumé. Samples are filed. Reports back within 3 days. Art Director will contact artist for portfolio review if interested. Pays for design by the hour, $10-45; by the project, $100-2,500; also short term contract work by the week and by the day, $100-750. Pays for illustration by the project, $250 minimum. Buys all rights.

Tips: "I look for young, affordable artists we can train on our systems. Attitude plays an important role in their development."

♦**WARNE MARKETING & COMMUNICATIONS**, 111 Avenue Rd., Suite 810, Toronto, Ontario M5R 3J8 Canada. (416)927-0881. Graphics Studio Manager: John Coljee. Number of employees: 11. Approximate annual billing: $4 million. Specializes in business-to-business promotion. Current clients: The Raymond Corporation (and dealers), Gould Shawmut, Wellesley Hospital and Johnston Equipment. Professional affiliations: INBA, IMM, BMA, CCAB.

Needs: Approached by 5-6 freelancers/year. Works with 4-5 freelance illustrators and 1-2 designers/year. Works on assignment only. Uses freelancers for design and technical illustrations, brochures, catalogs, P-O-P displays, retouching, billboards, posters, direct mail packages, logos. Artists should have "creative concept thinking." Prefers charcoal/pencil, colored pencil and markers. 10% of freelance work demands knowledge of Adobe Illustrator.

First Contact & Terms: Send query letter with résumé and photocopies. Samples are not returned. Reports back only if interested. Pays for design by the hour, $100-150 or by the project, $500-1,000. Pays for illustration by the hour, $100-150. Considers complexity of project, client's budget and skill and experience of artist when establishing payment. Buys all rights.

Record Companies

If you walk into a record store and examine the CDs and cassettes, you'll notice that many of them feature exciting artwork and design. Record companies are keenly aware that visuals can lure customers. A great illustration can often capture the mood of the music better than a photograph of the recording artist. So don't overlook this market. Art directors for recording labels tell us they depend on freelancers for the various elements of CD and album packages.

According to the Recording Industry Association of America, the industry exceeded $12.3 billion in sales in 1995. This multi-billion dollar market is waiting for you. All it takes is a lot of talent, determination, and some research into the market and its popular recording formats.

The recording industry is dominated by a handful of major labels. Major labels are defined as those record companies distributed by one of the "Big 6" distribution companies: BMG, CEMA, Polygram, Sony Music, UNI and WEA. But there are thousands of independent labels. Some are thriving, others struggling, but they are a big part of the industry. In 1995, these "indie" distributors commanded 19.2 percent of the total market share, up from 15.5 percent the year before. And you'll find indies are great places to start when looking for freelance assignments.

CHANGING FORMATS, CHANGING NEEDS

CDs continue to dominate the other full-length formats with a healthy 65 percent of the market. CD sales have doubled in the last six years and registered an 11.1 percent increase in dollar value to $9.4 billion in 1995. Full-length cassettes remain a viable alternative for today's consumer, with 25 percent of the market. Vinyl, once believed to be dead since the advent of the CD, made an impressive comeback, with 1995 sales increasing by 41 percent. So art directors look for freelancers who can create dynamic work with those formats.

The enhanced CD was probably the biggest news in the past year. These CDs provide visual as well as audio information. When played in a standard CD player, they play audio only. But when played in a CD-ROM drive, they offer videos, graphics, lyrics, games and links to websites on the Internet. When the predominant format was 12×12 LPs, designers had plenty of space to work with, both on the front and back of the album. But since the CD was introduced in 1983, designers have faced the challenge of creating compelling covers within a much smaller format. Nearly all CDs are designed in either 6×12 or 5×5 formats. In the past several years, the 6×12 packaging was abandoned by most record companies as ecologically unsound. The majority are now packaged in 5×5 jewel boxes. Included in an average CD package is an inlay card and a 4- to 5-page fold-out booklet. But some booklets run as long as 128 pages. Booklets include material such as lyrics, written or photographic essays, biographies and artwork.

In addition to the CD destined for retail outlets, record companies produce promotional and limited-edition versions of the same release, which feature lavish design, bold use of material and expensive touches, such as leather-bound packaging, slipcases, wood boxes and other extraordinary touches. Several examples of elaborate promotional CDs are featured in *CD Packaging & Graphics*, by Ken Pfeifer, a Rockport Book.

Often an art director works with several freelancers on one project. For example, one person might handle typography, another illustration; a photographer is sometimes used and a designer can be hired for layout. Labels also turn to outside creatives for display design, promotional materials, collateral pieces or video production.

It will benefit you to keep up with new technology within the music industry. The digital compact cassette (DCC) and the mini-disk, for instance, have entered the arena to compete with CD and cassette sales. Ultimately, the consumer will determine the winning format.

LANDING THE ASSIGNMENT

Submit your work to record companies the same way you would approach any market. Check the listings in the following section to see how the art director prefers to be approached and what type of samples to send. Check also to see what type of music they produce. If the company produces classical recordings, don't send images more appropriate to a heavy metal band. Assemble a portfolio of your best work in case an art director wants to see more of your work.

Be sure your portfolio includes quality samples. It doesn't matter if the work is of a different genre—quality is key. However, consider following the advice of Virgin Records art director, Steve Gerdes, featured in the Insider Report on page 651. Gerdes advises artists without experience in the industry to create their own CD packages.

Get the name of the art director or creative director from the listings in this section and send a cover letter that asks for a portfolio review. If you are not contacted within a couple of weeks, make a polite follow-up call to the office manager. (Most art directors prefer not to be called directly. If they are interested, they will call.)

Another route of entry is through management companies who work for recording artists. They represent musicians in the many facets of their business, one being control over the artwork used in releases. Follow the steps already listed to get a portfolio review. Lists of management companies can be found in *Songwriter's Market* published by Writer's Digest Books and the *Recording Industry Sourcebook* published by Ascona Group, Inc.

Once you nail down an assignment, get an advance and a contract. Independent labels usually provide an advance and payment in full when a project is done. When negotiating a contract, ask for a credit line on the finished piece and samples for your portfolio.

You don't have to live in one of the recording capitals to land an assignment, but it does help to familiarize yourself with the business. Visit record stores and study the releases of various labels. Ask to see any catalogs or promotional materials the store may have received from the companies you're interested in. Read music industry trade magazines, like *Spin*, *Rolling Stone*, *Vibe*, *Ray Gun* and *Billboard*. For further information about CD design read *Rock Art*, by Spencer Drate (PBC International).

A & M RECORDS, 1416 N. LaBrea Ave., Hollywood CA 90028. (213)469-2411. Art Director: Chuck Beesom, Sr. Produces CDs and tapes: all types
First Contact & Terms: Send query letter with brochure, tearsheets, photostats, résumé, photographs, slides, photocopies, transparencies and SASE. Write for appointment to show portfolio. Portfolios may be dropped off every Tuesday at 10 a.m. (It is also possible to make arrangements to FedEx your portfolio.) Pays by the hour. Rights purchased vary according to project.

A&R RECORDS/RDS PROMOTIONS, 900 19th Ave. S., Suite 207, Nashville TN 37212. (615)329-9127. President: Ruth Steele. Estab. 1986. Produces CDs, tapes and videos: rock, R&B, folk, gospel, country/western, alternative by solo artists and groups. Recent releases: "It's Not Over Till The Fat Lady Sings," by Kitty Kelley; "Fighting Another Man's War," by David Steele.

Needs: Works with 2 freelancers/year. Prefers local artists only. Uses freelancers for CD cover, tape cover, advertising and brochure design and illustration; direct mail packages; posters; multimedia projects. 90% of freelance work demands computer skills.

First Contact & Terms: Send query letter with brochure, photocopies, résumé, photographs and SASE. Accepts disk submissions. Samples are filed or returned by SASE if requested by artist. May not report back. Artist should re-submit in 6 months. Art Director will contact artist for portfolio review if interested. Portfolio should include b&w and color final art, photocopies and photographs. Pays by the project. Rights purchased vary according to project.

Tips: "Contact everyone—study industry directories/lists and do a blanket mailing. Be flexible with charges."

AFTERSCHOOL PUBLISHING COMPANY, P.O. Box 14157, Detroit MI 48214. (313)571-0363. President: Herman Kelly. Estab. 1978. Produces CDs and tapes: rock, jazz, rap, R&B, soul, pop, classical, folk, educational, country/western, dance and new wave. Recent releases: *Funny People* soundtrack from the film *Musiranma*.

Needs: Produces 1 solo artist/year. Works with 10 freelance designers and 10 illustrators/year. Prefers professional artists with experience in all forms of the arts. Uses artists for CD cover design, tape cover and advertising design and illustration, brochure design, multimedia projects and posters. 10% of freelance work demands computer skills.

First Contact & Terms: Send query letter with brochure, résumé, SASE, bio, proposal and appropriate samples. Samples are filed or are returned by SASE. Reports back within 2-4 weeks. Requests work on spec before assigning a job. To show portfolio, mail roughs, printed samples, b&w/color tearsheets, photographs, slides and transparencies. Pays by the project. Negotiates rights purchased. Interested in buying second rights (reprint rights) to previously published work. Finds artists through Michigan Council for the Arts' Artist Directory and Detroit Arts Council.

Tips: "Be on a local or national artist roster to work outside your hometown."

‡AIRWAX RECORDS, Box 288291, Chicago IL 60628. (312)779-2384. Fax: (312)779-7898. President: Casey Jones. Estab. 1983. Produces CDs, tapes and albums; rhythm and blues, soul, and blues. Recent releases: *On My Way to Chicago*, by Casey Jones and *100% Chicago Style Blues*, by various artists.

Needs: Produces 2 soloists and 2 groups/year. Works with 5 visual artists/year. Prefers artists with experience in the performing circuit. Works on assignment only. Uses artists for posters.

First Contact & Terms: Send query letter with brochure. Samples are not filed and are returned. Reports back only if interested. To show a portfolio, mail b&w material. Pays by the project. Rights purchased vary according to project.

‡AMERICATONE INTERNATIONAL—U.S.A., 1817 Loch Lomond Way, Las Vegas NV 89102-4437. (702)384-0030. Fax: (702)382-1926. President: Joe Jan Jaros. Estab. 1983. Produces CDs and tapes: rock & roll, jazz, pop, progressive, classical, country/western and rap by solo artists and groups. Recent releases: *This is New York, Music for Lovers Only*, compilation; *Jazz in the Rain*, by Rain Band; *Coming Home*, by Jim Evans.

Needs: Produces 10 solo artists and 3 groups/year. Uses artists for direct mail packages and posters.

First Contact & Terms: Samples are returned by SASE. Reports back to artist within 2 months only if interested. To show a portfolio, mail appropriate materials.

THE AMETHYST GROUP LTD., 273 Chippewa Dr., Columbia SC 29210-6508. Contact: Management. Produces rock, dance, soul, R&B; solo artists. Releases: "Silhouette," "New Fire Ceremony," "Slither" and "Bodyshop."

Needs: Produces 3 solo artists and 5 groups/year. Uses freelancers for album cover and brochure design, direct mail packages and promotional materials. Prefers b&w or color, abstract designs.

First Contact & Terms: Send query letter with résumé and samples. Samples are returned by SASE. Reports back within 2 months. Write for appointment to show portfolio of b&w photographs. Pays by the project, $25 minimum. Considers available budget and rights purchased when establishing payment. Negotiates rights purchased. Must sign release forms.

Tips: "Be realistic and practical. Remember that b&w is the industry standard; color is used a great deal with major companies. Express talent, not hype; be persistent. Always include proper postage for any reply and/or return of materials. Give us an idea of how you expect to be paid and/or credited."

ANGEL/EMI RECORDS, 810 Seventh Ave., 4th Floor, New York NY 10019. (212)603-8631. Fax: (212)603-8648. Vice President, Creative Services: J. Barbieri. Produces CDs and tapes: pop, classical, adult, by solo artists and groups. Recent releases: *Chant*, by Benedictine Monks; and *Vision, The Music of Hilderg-ard von Bingen*.

Needs: Produces 40 releases/year. Works with 5 freelancers/year. Uses freelancers for CD cover design and illustration. 70% of freelance work demands knowledge of Adobe Illustrator, QuarkXPress, Adobe Photoshop, Aldus FreeHand.

First Contact & Terms: Send postcard sample of work. Samples are filed and not returned. Reports back to the artist only if interested. Call for appointment to show portfolio of b&w and color final. Finds artists through word of mouth, sourcebooks.
Tips: "Learn the industry standards—lingo, standard specs, etc."

ANTELOPE PUBLISHING, 23 Lover's Lane, Wilton CT 06897. (203)834-9884. President: Tony LaVorgna. Estab. 1982. Produces CDs and tapes: "1940s' swing and 1950s' jazz styles only." Recent releases: *I Wish You Love*, by The Tony LaVorgna Trio.
Needs: Produces 1 solo artist and 1 group/year. Works with 2 freelancers/year. Works on assignment only. Uses artists for CD/tape cover design and illustration, brochure illustration, direct mail packages, multimedia projects and poster. 50% of freelance work demands computer skills.
First Contact & Terms: Send query letter with brochure, résumé, photocopies, photographs, SASE, slides and tearsheets. Accepts disk sumbissions (include necessary fonts). Samples are filed. Reports back to the artist only if interested. To show portfolio, mail b&w final art. Pays for design by the project. Negotiates rights purchased.
Tips: "Start with a small company where more attention will be received. You have to be damned good and willing to work cheap."

‡❧AQUARIUS RECORDS/TACCA MUSIQUE, 1445 Lambert-Closse, Suite 200, Montreal, Quebec H3H 1Z5 Canada. (514)939-3775. Fax: (514)939-2778. Production Manager: Rene LeBlanc. Estab. 1970. Produces CDs, cassettes and CD-ROMs; pop, progressive and rock by solo artists and groups. Recent releases "Rats," by Sass Jordan; "Pigeon D'Argile," by Kevin Parent.
Needs: Produces 6 releases/year. Works with 4 freelancers/year. Prefers designers who own IBM PCs. Uses freelancers for album, cassette and CD cover design and illustration; CD booklet design and illustration; CD-ROM design and packaging; poster design; advertising and brochure. 100% of freelance work demands knowledge of Adobe Illustrator and QuarkXPress.
First Contact & Terms: Send postcard sample of work. Samples are filed and are not returned. Will contact for portfolio review of b&w and color photocopies and photogrpahs if interested. Pays for design and illustration by the project. Rights purchased vary according to project. Finds artists through word of mouth.
Tips: "Be creative. Understand that each project is different and unique. Stay away from generics!"

‡ARISTA RECORDS, 6 W. 57th St., New York, NY 10019. (212)489-7400. Senior Art Director: Angela Skouras. Produces CDs, tapes and LPs: all types.
Needs: Uses artists for CD, tape cover and brochure design and illustration; catalog design, illustration and layout; advertising design and illustration; direct mail packages and posters.
First Contact & Terms: Call or write for appointment to show portfolio. Payment varies. Rights purchased vary according to project.

ART ATTACK RECORDINGS/MIGHTY FINE RECORDS, 3305 North Dodge Blvd., Tucson AZ 85716. (602)881-1212. President: William Cashman. Produces rock, country/western, jazz, pop, R&B; solo artists.
Needs: Produces 4 albums/year. Works with 1-2 freelance designers and 1-2 illustrators/year. Uses freelancers for CD/album/tape cover design and illustration; catalog design and layout; advertising design, illustration and layout; posters; multimedia projects.
First Contact & Terms: Works on assignment only. Send postcard sample or brochure to be kept on file. Samples not filed are returned by SASE only if requested. Reports back only if interested. Write for appointment to show portfolio. Original artwork is not returned. Pays for design by the hour, $15-25; by the project, $100-500. Pays for illustration by the project, $100-500. Considers complexity of project and available budget when establishing payment. Buys all rights. Sometimes interested in buying second rights (reprint rights) to previously published artwork.

BABY FAZE RECORDS & TAPES, 45 Pearl St., San Francisco CA 94103. (415)495-5312. Owner: G. Miller Marlin. Estab. 1989. Produces tapes and vinyl: rock, jazz, pop, R&B, soul, progressive, classical, folk, country/western, rap, industrial. Recent releases: "King Size Size Queen," by Cat Howdy; "Choice Cuts," by Pandora's Lunch Box, "Sweet, Light Crude," by LMNOP.
Needs: Produces 24 releases/year.
First Contact & Terms: Send query letter with brochure, tearsheets, SASE, photocopies and photographs. Accepts disk submissions compatible with Adobe Photoshop and Adobe Illustrator, in Mac format. Send

 THE MAPLE LEAF before a listing indicates that the market is Canadian.

PICT files. Samples are filed and are not returned. Reports back to the artist only if interested. Portfolio should include b&w and color final art, photographs. No payment—credit line given. Negotiates rights purchased. Finds artists through submissions.
Tips: Impressed by "talent and a willingness to work easily for exposure. Don't expect too much, too soon in the record business."

babysue, P.O. Box 8989, Atlanta GA 30306-8989. (404)875-8951. Website: http://www.babysue.com. President: Don W. Seven. Estab. 1983. Produces CDs, tapes and albums: rock, jazz, classical, country/western, folk and pop. Releases: *Mnemonic*, by LMNOP; *Homo Trip*, by The Stereotypes; and *Bad is Good*, by Lisa Shame.
Needs: Produces 6 solo artists and 10 groups/year. Uses 5 freelancers/year for CD/album/tape cover design and illustration, catalog design, advertising design and illustration and posters. 20% of design and 50% of illustration demand computer skills.
First Contact & Terms: Send postcard sample or query letter with SASE, photographs, photostats and slides. Samples are not filed and are not returned. Reports back to the artist only if interested. To show portfolio, mail roughs, b&w and color photostats and photographs. Pays by the day, $250-500. Rights purchased vary according to project.
Tips: "Be persistent. We are open minded."

B-ATLAS & JODY RECORDS, 1353 E. 59th St., Brooklyn NY 11234. (718)968-8362. Vice President/A&R Director: Vincent Vallis. Vice President/Sales: Ron Alexander. Estab. 1979. Produces CDs, tapes and albums: rock, jazz, rap, R&B, soul, pop, country/western and dance. Releases: "Where Did Our Love Go," by Demetrius Dollar Bill; "Master Plan," by Keylo; and "Our Lives," and "Alone," both by Alan Whitfield.
Needs: Produces 20 solo artists and 10 groups/year. Works with 5 freelancers/year on assignment only. Uses artists for CD cover design and illustration; brochure illustration.
First Contact & Terms: Send query letter with SASE and photocopies. Samples are filed. Reports back to the artist only if interested. To show portfolio, mail photographs. Pays by the project, $50-100. Rights purchased vary according to project.

BEACON RECORDS, P.O. Box 3129, Peabody MA 01961. (508)762-8400. Fax: (508)762-8467. Principal: Tony Ritchie. Estab. 1992. Produces CDs and tapes: folk, Celtic, alternative by solo artists and groups. Releases: "Of Age," by Aztec Two-Step; "Were You At The Rock," by A¡ne Minogue.
Needs: Produces 10-15 solo artists and groups/year. Work with 2-3 visual artists/year. Prefers artists with experience in music industry graphics. Uses artists for CD cover design and illustration; tape cover design and illustration; brochure design and illustration; catalog design, illustration and layout; direct mail packages; advertising design and illustration; and posters. 95% of freelance work demands computer skills.
First Contact & Terms: Send query letter with brochure and samples. Samples are filed. Reports back to the artist only if interested. Write for appointment to show portfolio of b&w and color final art and photographs. Pays for design, by the project. Buys all rights.

***BIG BEAR RECORDS**, P.O. Box, Birmingham B16 8UT England. (021)454-7020. Fax: (21)454-9996. Managing Director: Jim Simpson. Produces CDs and tapes: jazz, R&B. Recent releases: *Let's Face the Music*, by Bruce Adams/Alan Barnes Quintet and *Blues & Rhythm, Volume One*, by King Pleasure & The Biscuit Boys; and *The Boss Is Home*, by Kenny Bakers Dozen.
 ● A Mary Jo Mazzella design, bought by this company through *Artist's and Graphic Designer's Market*, won the 1995 bronze 3 Dimensional Art Directors and Illustrators award in New York. See Mazella's award-winning design on the next page.
Needs: Produces 8-10 records/year. Works with 4-6 illustrators/year. Uses freelancers for album cover design and illustration. Needs computer-literate freelancers for illustration.
First Contact & Terms: Works on assignment only. Send query letter with photographs or photocopies to be kept on file. Samples not filed are returned only by SAE (nonresidents include IRC). Negotiates payment. Considers complexity of project and how work will be used when establishing payment. Buys all rights. Interested in buying second rights (reprint rights) to previously published work.

‡BIZZ-E PRODUCTIONS, 156 Fifth Ave., Suite 434, New York NY 10010. (212)691-5630. Fax: (212)645-5038. President: E. Ramos. Estab. 1979. Produces CDs, tapes and albums: rap and group artists.
Needs: Produces 30 soloists and 40 groups/year. Uses 3 local artists/year for CD and album/tape cover design and illustration, brochure design and illustration, catalog design and layout and advertising illustration.
First Contact & Terms: Send query letter with SASE. Samples are not filed and are returned by SASE if requested by artist. Reports back within 6-8 weeks. To show portfolio, mail thumbnails, roughs, b&w and color photostats and tearsheets. Pays by the project, $50-1,000. Buys all rights.

BLACK & BLUE RECORDS, 400D Putnam Pike, Suite, 152, Smithfield RI 02917. (401)949-4887. Art Dept: Boris Ofterhaul. Estab. 1988. Produces CDs, tapes and albums: rock, punk rock, underground and

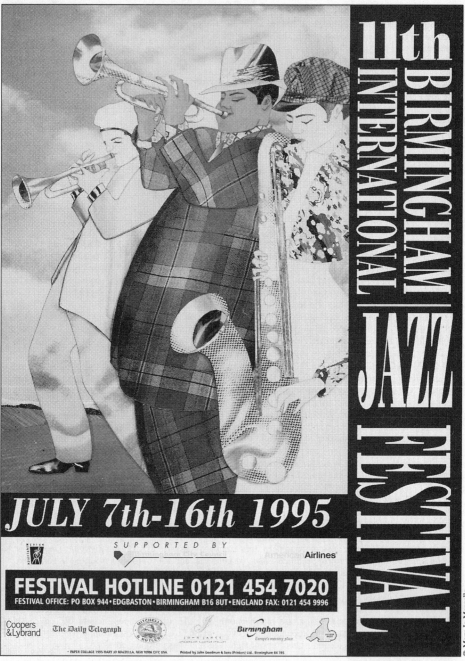

© Mary Jo Mazzella

New Yorker Mary Jo Mazzella has been illustrating the posters for the Birmingham International Jazz Festival since 1988 when she first sent samples to Big Bear Records (which she found in *Artist's & Graphic Designer's Market*). The poster for the 11th annual festival is a paper collage incorporating hand-made papers and xerography. "I wanted to express a certain light-heartedness and feeling of merriment," says Mazzella. "Yet I also tried to capture the intensity and humanity of the musicians, while they work their jazzy magic together."

country/western. Releases: *Darkness In Me*, by Blue Nouveaux; *Sleep With Evil*, by Northwinds; and *Hunger and Stoned*, by Bloody Mess and The Skabs.

Needs: Produces 1 solo artist and 4-8 groups/year. Works with 1-3 freelancers/year on assignment only. Uses freelancers for CD/album/tape cover and advertising design and illustration; and catalog design, illustration and layout. 10% of freelance work demands computer skills.

First Contact & Terms: Send query letter with "any type of sample work and description of limitations." Samples are not filed and are not returned. Reports back only if interested. To show portfolio, mail appropriate materials. Pays by the project, $25-500. Rights purchased vary according to project.

BLASTER BOXX HITS, 519 N. Halifax Ave., Daytona Beach FL 32118. (904)252-0381. Fax: (904)252-0381. C.E.O.: Bobby Lee Cude. Estab. 1978. Produces CDs, tapes and albums: rock, R&B, folk, educational, country/western and marching band music. Releases: *In and Out Urge* and *Don't Stop*, by Zonky-Honky Man.

Needs: Produces 6 CDs and tapes/year. Works on assignment only. Uses freelancers for CD cover design and illustration.

First Contact & Terms: Send query letter with appropriate samples. Samples are filed. Reports back within 1 week. To show portfolio, mail thumbnails. Sometimes requests work on spec before assigning a job. Pays by the project. Buys all rights.

BOUQUET-ORCHID ENTERPRISES, P.O. Box 1335, Norcross GA 30091. (770)798-7999. President: Bill Bohannon. Estab. 1972. Produces CDs and tapes: rock, country, pop and contemporary Christian by solo artists and groups. Releases: *Blue As Your Eyes*, by Adam Day; and *Take Care Of My World*, by Bandoleers.

Needs: Produces 6 solo artists and 4 groups/year. Works with 8-10 freelancers/year. Works on assignment only. Uses freelancers for CD/tape cover and brochure design; direct mail packages; advertising illustration. 25% of freelance work demands knowledge of Aldus PageMaker, Adobe Illustrator and QuarkXPress.

First Contact & Terms: Send query letter with brochure, SASE, résumé and samples. "I prefer a brief but concise overview of an artist's background and works showing the range of his talents." Include SASE. Samples are not filed and returned by SASE if requested by artist. Reports within 1 month. To show a portfolio, mail b&w and color tearsheets and photographs. Pays for design by the project, $100-500. Rights purchased vary according to project.

Tips: "Keep being persistent in sending out samples of your work and inquiry letters as to needs. Always strive to be creative and willing to work within guidelines, as well as budgets."

‡**BLUE ROCK'IT RECORDS**, P.O. Box 383, Redwood Valley CA 95470. (707)485-8308. Fax: (707)485-8308. Owner: Patrick Ford. Estab. 1983. Produces CDs and tapes: blues. Recent releases: *Mark Ford with the Robben Ford Band*; and *Hot Shots*, by The Ford Blues Band.

Needs: Produces 1 soloist and 3-5 groups/year. Works on assignment only. Uses artists for CD cover design and illustration, tape cover illustration, advertising design and posters. 50% of work demands computer skills.

First Contact & Terms: Send query letter with examples of work in whatever format is available. Samples are filed. Reports back only if interested. Pays by the project. Negotiates rights purchased.

BRIARHILL RECORDS, 3484 Nicolette Dr., Crete IL 60417. (708)672-6457. President/A&R Director: Danny Mack. Estab. 1984. Produces tapes, CDs and records: pop, gospel, country/western, polka, Christmas by solo artists and groups. Recent releases: "Old Rockers Never Die," and "There's No Place Like Home for Christmas," by Danny Mack.

Needs: Produces 2-5 solo artists/year. Work with 2 freelancers/year. Prefers artists with experience in album covers. Works on assignment only. Uses freelancers for CD/tape cover design and illustration; brochure design and advertising illustration.

First Contact & Terms: Send postcard sample with brochure, photographs and SASE. Samples are filed and are not returned. Reports back within 3 weeks. To show portfolio, mail photostats. Pays for design by the project, $100 minimum. Buys all rights.

Tips: "Especially for the new freelance artist, get acquainted with as many recording studio operators as you can and show your work. Ask for referrals. They can be a big help in getting you established locally. When sending samples for submission, always include illustrations that relate in some way to the types of music we produce as listed. This is the best way to recieve consideration for upcoming projects. We keep on file only those who have done similar work."

‡**BROKEN RECORDS INTERNATIONAL**, 305 S. Westmore Ave., Lombard IL 60148. (708)916-6874. Fax: (708)916-6928. President: Roy Bocchieri. Estab. 1985. Produces 2 CDs and tapes/year: rock & roll and dance. Recent releases: *Hallowed Ground* and *Immortal*, by Day One.

Needs: Works with 1 freelance designer, 1 freelance illustrator/year. Requests work on spec before assigning a job. Uses artists for CD and album/tape cover design and illustration; brochure, catalog and advertising design and illustration; catalog layout; direct mail packages; multimedia prjects; and posters.

First Contact & Terms: Send postcard samples. Samples are filed or are not returned. Reports back only if interested. To show a portfolio, mail appropriate materials. Requests work on spec before assigning a job. Pay is determined by the work needed. Rights purchased vary according to project.

BSW RECORDS, Box 2297, Universal City TX 78148. (210)659-2338. Fax: (210)659-2557. President: Frank Willson. Estab. 1987. Produces tapes and albums: rock, country/western by solo artists. Releases 8 CDs/tapes each year. Recent releases: *Takin The Reins*, by Harold Dean; *Dream Catcher*, by Shawn DeLoeme *Trails Less Traveled*, by Wes Winginton.
Needs: Produces 25 solo artists and 5 groups/year. Works with 4-5 freelance designers, 4-5 illustrators/year. Uses 3-4 freelancers/year for CD cover design; album/tape cover, advertising and brochure design and illustration; direct mail packages; and posters. 25% of freelance work demands knowledge of Aldus FreeHand.
First Contact & Terms: Send postcard sample and brochure. Samples are filed. Reports back within 1 month. To show portfolio, mail photographs. Requests work on spec before assigning a job. Pays by the project. Buys all rights. Sometimes interested in buying second rights (reprint rights) to previously published work. Finds new artists through submissions and self-promotions.

BUSINESS DEVELOPMENT CONSULTANTS, Box 16540, Plantation FL 33318. (305)741-7766. President: Phyllis Finney Loconto. Estab. 1980. Produces CDs, tapes and albums: rock, jazz, rap, R&B, soul, pop, classical, folk, educational, country/western, disco by groups and solo artists. Releases: "Come Follow Me," by Frank X. Loconto (inspirational); "Back in Bimini," by The Calypsonians; and "Out of the Darkness," by June and Jr. Battiest.
Needs: Produces 50 solo artists and 20 groups/year. Works with 10 local freelancers/year. Works on assignment only. Uses artists for CD/album/tape cover, brochure and advertising design and illustration; catalog design, illustration and layout; direct mail packages; and posters.
First Contact & Terms: Send query letter with samples. Samples are filed and returned by SASE if requested. Reports back only if interested. To show portfolio, mail thumbnails and other samples. Pays by the project. Rights purchased vary according to project.
Tips: "Freelance artists need to be able to communicate/negotiate."

C.L.R. INC., 1400 Aliceanna St., Baltimore MD 21231. (410)522-1001. President of A&R: Stephen Janis. Estab. 1992. Produces CDs, cassstettes, albums: dance and rap. Recent releases: *D.J. Kool*; *Blood Sky*; *San Francisco House Culture*; *Space II*; *Sam "The Beast!"*
Needs: Produces 4-5 groups/year. Works with 2-5 freelancers/year on assignment only. Uses freelancers for CD cover design and illustration, album/tape cover and advertising design and posters.
First Contact & Terms: Send query letter with brochure, tearsheets, photostats, résumé, slides and transparencies. Samples are filed and are not returned. Call for appointment to show portfolio of roughs, original/ final art, b&w tearsheets. Pays by the project, $750-3,000. Buys all rights.

C&S PRODUCTIONS, P.O Box 91492, Anchorage AK 99509-1492. (907)522-3228. Fax: (907)265-4822. Partner: Tim Crawford. Estab. 1992. Produces CDs and tapes: Native American flute. Recent releases: *Mystic Visions*; *Hear My Heart* and *Guardian Spirits*, by Time Crawford and Paul Stavenjord.
Needs: Produces 1 release/year. Works with 1 freelancer/year. Uses freelancers for tape/CD cover illustration.
First Contact & Terms: Send query letter with photostats, photocopies, photographs. Samples are not filed and are returned by SASE if requested by artist. Reports back to the artist only if interested. Pays for illustration by the project, $100-250. Rights purchsed vary according to project. Finds artists typically through Southwest publications.
Tips: "Keep making contacts and do not get discouraged."

‡CAPITOL MANAGEMENT, Dept. AM, 1300 Division St., Suite 200, Nashville TN 37203-4023. (615)242-4722. Fax: (615)242-1177. Owner: Robert Metzgar. Estab. 1979. Produces CDs, tapes and albums: rock and roll, jazz, group artists, R&B, pop, country/western and solo artists. Recent releases: Cary Cooley (Platinum Plus), Jennifer LeClere (Platinum Plus), Mickey Jones (Capitol Records).
Needs: Produces 25 soloists and 5 groups/year. Works with 15 artists/year with experience in music field. Works on assignment only. Uses artists for CD and album/tape cover design and illustration; brochure design and illustration; catalog design, illustration and layout; direct mail packages; advertising design; and illustration and posters.
First Contact & Terms: Send query letter with samples of work. Samples are filed. Reports back within 1 month. Call or write for appointment to show portfolio, which should include thumbnails, b&w and color tearsheets and photographs. Pays by the project, $300-5,000. Buys all rights. Negotiates rights purchased. Rights purchased vary according to project.

‡CAPRICE INTERNATIONAL RECORDS, Postal Suite 808, Lititz PA 17543. President: Joey Welz. Produces CDs, tapes and albums. Releases include: "Living in a Black & White World," by Joey Welz and "Bankin' on Losin' the Blues," by Amy Beth.

Needs: Produces 6 soloists and 3 groups/year. Works with 2 visual artists/year. Prefers artists with experience in album, cassette and disc covers. Works on assignment only. Uses artists for CD cover design and illustration, album/tape cover design and illustration.
First Contact & Terms: Send query letter with tearsheets, photostats, photographs and photocopies. Samples are filed and not returned. Reports back only if interested. To show a portfolio, mail b&w and color photostats, tearsheets, photographs and slides. Offers 1-5% royalty. Rights purchased vary according to project.

CASH PRODUCTIONS, INC. (Recording Artist Development Corporation), 744 Joppa Farm Rd., Joppatowne MD 21085. Phone/Fax: (410)679-2262. President/CEO: Ernest W. Cash. Estab. 1987. Produces CDs and tapes: country/western by solo artists and groups. Releases: "Family Ties," by The Short Brothers.
Needs: Produces 8-10 solo artists and 8-10 groups/year. Works with 10-12 freelancers/year. Works only with artist reps. Works on assignment only. Uses artists for CD cover design and illustration; brochure design; catalog design and layout; direct mail packages; advertising design; posters. 20% of freelance work demands computer skills.
First Contact & Terms: Send query letter with résumé. Samples are filed. Reports back to the artist only if interested. To show portfolio, mail final art. Pays for design by the project. "Price will be worked out with rep or artist." Buys all rights.

CASTLE RECORDS, P.O. Box 1130, Tallevast FL 34270-1130. Phone/fax: (813)351-3253. Vice President: Bob Francis. Estab. 1964. Produces CDs, tapes and albums: rock, R&B, jazz, soul, dance and pop. Recent releases: *Rat Pack Rules*, by Big Cheese; *Thunderfoot*, by David Isley.
Needs: Produces 3-4 solo artists and 6-10 groups/year. Works with 3-4 freelance designers, 3-4 freelance illustrators/year. Uses artists for CD and album/tape cover and catalog illustration; posters; artist and label logos.
First Contact & Terms: Send query letter with tearsheets, résumé, photographs and SASE. Samples are filed or are returned by SASE. Reports back within 2 weeks. To show a portfolio, mail b&w and color photographs. Sometimes requests work on spec before assigning a job. Pays by the hour, $7.50-15; by the project, $100-2,500. Interested in buying second rights (reprint rights) to previously published work. Rights purchased vary according to project. Finds new artists through *Artist's & Graphic Designer's Market* and referrals.

CAT'S VOICE PRODUCTIONS, P.O. Box 1361, Sanford ME 04073-7361. (207)490-3676. Owner: Tom Reeves. Estab. 1982. Produces tapes, CDs and multimedia: rock, R&B, progressive, folk, country/western, New Age. Recent releases: *Loaded Soul*, by Loaded Soul; *Hot Moist Wet and Stinky*, by the Mangled Ducklings; *The Last Charade*, by Paul Wilcox.
Needs: Produces 4 solo artists and 4 groups/year. Works with 4 freelancers/year. Prefers freelancers with experience in album and rock media. Works on assignment only. Uses artists for CD/tape cover and brochure design and illustration; catalog design, illustration and layout; direct mail packages; advertising illustration; multimedia and CD-ROM projects; posters. 100% of freelance work demands knowledge of Aldus Page-Maker, QuarkXPress, Aldus FreeHand, Adobe Illustrator, Adobe Photoshop and Claris Works.
First Contact & Terms: Send postcard sample or query letter with brochure, photocopies, photographs and SASE. Samples are filed and are returned by SASE if requested by artist. Reports back within 1 month. Write for apointment to show portfolio or mail appropriate materials including b&w and color final art and photographs. Pays for design by the hour, $15-75; by the project, $125-500; by the day, $200-400. Buys all rights. But also refers to clients for hire fee.
Tips: Ability to produce camera-ready art and video or CD-ROM experience helpful. "Be cost effective and cooperate with printing companies."

‡CHAPMAN RECORDING STUDIOS, 228 W. Fifth St., Kansas City MO 64105. (816)842-6854. Fax: (816)842-3086. Office Manager: Gary Sutton. Estab. 1973. Produces CDs, tapes and albums; rock and roll, soul, country/western, jazz, folk, pop, R&B, rap, educational, and solo artists. Recent releases: *Statement of Direction,* by Joy Unlimited; *Poet & A Wealthy Man,* by Land-Hildebrand.
Needs: Produces 12 soloists and 12 groups/year. Works with 2 designers and 2 illustrators/year. Prefers artists with experience in CD, cassette and albums art/layout. Works on assignment only. Uses artists for CD and album/tape cover design and illustration, brochure design, direct mail packages, advertising design and illustration. 100% of freelance work demands computer skills in Aldus PageMaker, QuarkXPress, Aldus FreeHand, Adobe Illustrator or Adobe Photoshop.
First Contact & Terms: Send query letter with brochure and tearsheets. Samples are filed. Reports back only if interested. To show a portfolio, mail appropriate materials. Portfolio should include b&w photostats, tearsheets and photographs. Pays by the project, $250-1,000. Buys first, one-time and all rights.
Tips: "Keep current."

‡**CHATTAHOOCHEE RECORDS**, 15230 Weddington St., Sherman Oaks CA 91411. (818)788-6863. Fax: (818)788-4229. A&R: André Duval. Estab. 1958. Produces CDs and tapes: rock & roll, pop by groups. Recent releases: "Thanks for Nothing," by DNA.

Needs: Produces 1-2 groups/year. Works with 1 visual artist/year. Prefers local artists only. Works on assignment only. Uses artists for CD cover design and illustration; tape cover design and illustration; advertising design and illustration; posters. 50% of freelance work demands knowledge of Adobe Illustrator.

First Contact & Terms: Send query letter with brochure, résumé and photographs. Samples are filed and are not returned. Reports back to the artist only if interested. To show portfolio, mail final art and photographs. Pays for design by the project. Rights purchased vary according to project.

CHERRY STREET RECORDS, INC., P.O. Box 52681, Tulsa OK 74152. (918)742-8087. President: Rodney Young. Estab. 1991. Produces CDs and tapes: rock, R&B, country/western, soul, folk by solo and group artists. Releases: "Land of the Living," by Richard Elkerton, "Loose Change," by Brad Absher, "Moments of Love," by George Carroll and "2 Hip 4 Droom," by Chuck Shipman.

Needs: Produces 2 solo artists/year. Works with 2 designers and 2 illustrators/year. Prefers freelancers with experience in CD and cassette design. Works on assignment only. Uses freelancers for CD/album/tape cover design and illustration; catalog design; multimedia projects; and advertising illustration. 100% of design and 50% of illustration demand knowledge of Adobe Illustrator and CorelDraw for Windows.

First Contact & Terms: Send postcard sample or query letter with photocopies and SASE. Accepts disk submissions compatible with Windows '95 in above programs. Samples are filed or are returned by SASE. Reports back only if interested. Write for appointment to show portfolio of printed samples, b&w and color photographs. Pays by the project, $50-1,000. Buys all rights.

Tips: "Compact disc covers and cassettes are small—your art must get consumer attention. Be familiar with CD and cassette music layout on computer in either Adobe or Corel. Be familiar with UPC bar code portion of each program. Be under $500.00 for layout to include buyout of original artwork and photographs. Copyright to remain with Cherry Street—no reprint rights or negatives retained by illustrator, photographs or artist."

‡**CIMIRRON/RAINBIRD RECORDS, INC.**, 607 Piney Point Rd., Yorktown PA 23692. (804)898-8155 or 6757. E-mail: lpuck42285@aol.com. President: Lana Puebitt. Estab. 1985. Produces CDs and tapes: country/western, acoustic and new age. Recent releases: *Guitar Town* and *Solos and Duets*, by Stephen Bennett and *Windows of Life* and *Cowgirls* by Lana Puckett and Kim Person.

Needs: Produces 2-5 soloists/year. Works with 2-3 freelance artists/year. Preferes artists with experience in the recording industry. Uses freelancers for CD and tape cover design and illustration and advertising illustration. 50% of design and 25% of illustration demand knowledge of Adobe Photoshop, Aldus FreeHand, Aldus PageMaker and QuarkXPress.

First Contact & Terms: Send postcard sample with brochure. Accepts disk submissions compatible with above programs. Samples are filed or returned by SASE if requested. Reports back only if interested. Pays by the project. Rights purchased vary according to project.

Tips: "Learn through freelance and design projects for local artists and move up the ladder—learn pitfalls of production and reproduction. Don't miss any opportunity to get your name out there and build your portfolio of projects."

‡**CMH RECORDS**, P.O. Box 39439, Los Angeles CA 90039. (213)663-8073. Fax: (213)669-1470. Art Director: Diana Collette. Estab. 1975. Produces CDs and cassettes: country, folk and bluegrass by groups. Recent releases: *Plectrasonics*, by Nashville Mandolin Ensemble; *The Mac Wiseman Story*, by Mac Wiseman.

Needs: Produces 20 releases/year. Works with 2-3 freelancers/year. Prefers local illustrators. Uses freelancers for cassette, CD booklet and cover illustration and cassette cover design.

First Contact & Terms: Send postcard sample and/or query letter with brochure, photocopies, photographs, SASE and tearsheets. Samples are filed. Will contact for portfolio review if interested. Pays by the project, $200-400. Rights purchased vary according to project.

Tips: "We are always looking for creative, clever cover artwork. We have a graphics designer who puts all of our projects together."

*__COMMA RECORDS & TAPES__, Box 2148, D-63243, Neu Isenburg, Germany. 06102-51065. Fax: 06102-52696. Contact: Marketing Department. Estab. 1972. Produces CDs, tapes and albums: rock, R&B, classical, country/western, soul, folk, dance, pop by group and solo artists.

Needs: Produces 70 solo artists and 40 groups/year. Uses 10 freelancers/year for CD/album/tape cover and brochure design and illustration; posters.

First Contact & Terms: Send query letter with brochure, résumé, tearsheets, slides, photographs, SASE, photocopies and transparencies. Samples are not filed and are returned by SASE if requested by artist. Reports back to the artist only if interested and SASE enclosed. To show portfolio, mail copies of final art and b&w photostats, tearsheets, photographs and transparencies. Payment negotiated. Buys first rights and all rights.

COWBOY JUNCTION FLEA MARKET & PUBLISHING CO., Highway 44 and Junction 490, Lecanto FL 34461. (904)746-4754. Secretary: Elizabeth Thompson. Estab. 1957. Produces tapes, albums and CDs: country/western and bluegrass. Recent releases: "And I Hung up My Cowboy Hat" and "Pretty Girls on TV," by Buddy Max.
Needs: Produces 3 albums/year by soloists and groups. Uses 12 freelancers/year for album/tape cover illustration and design; and direct mail packages.
First Contact & Terms: Send query letter with SASE. Samples are not filed and are returned by SASE. Portfolio review not required. Requests work on spec before assigning a job.
Tips: "Come to Cowboy Junction Flea Market on Tuesday or Friday and display your work and try to sell or find a buyer or someone interested in your work." Closed July and August.

CREATIVE NETWORK INC., Box 2818, Newport Beach CA 92663. (714)494-0181. Fax: (714)494-0982. President: J. Nicoletti. Estab. 1976. Produces CDs, tapes and albums: rock, jazz, rap, group artists, rhythm and blues, soul, pop, folk, country/western, dance and solo artists. Recent releases include: *My Bible Tells Me So*, by Don Simmons (CD and video); and *Amelia's Themes*, by Amelia Homer.
Needs: Produces 3 soloists/year. Works with 10 freelancers/year. Uses freelancers for all design, illustration and layout work.
First Contact & Terms: Send query letter with tearsheets, photostats, résumé, SASE, photographs, slides, photocopies and transparencies—present "a clean package of your best work." Samples are filed. Reports back within 3 weeks. Call for appointment to show portfolio, or mail appropriate materials. Negotiates payment and rights purchased. Finds new artists through submissions/self-promotional material.

‡CRITIQUE RECORDS, (formerly Avex-Critique Records), 50 Cross St., Winchester MA 01890. (617)729-8137. Fax: (617)729-2320. Creative Services Director: Caryn Hirsch. Estab. 1983. Produces albums, CDs and cassettes: country, pop, R&B, rap, rock. Recent releases: *Hits Unlimited*, by 2 Unlimited; *Secrets*, by Nicki French.
Needs: Varied number of releases/year. Works with 3-4 freelancers/year. Uses freelancers for album, cassette and CD booklet and cover illustration. 100% of design and 50% of illustration demand knowledge of Aldus PageMaker, Adobe Illustrator, QuarkXPress, Adobe Photoshop, Aldus FreeHand.
First Contact & Terms: Send postcard sample of work. Samples are filed. Will contact for portfolio review if interested. Pays for illustration by the project, $250-500. Buys all rights. Finds artists through magazines.

‡CRS ARTISTS, 724 Winchester Rd., Broomall PA 19008. (215)544-5920. Fax: (215)544-5921. Administrative Assistant: Caroline Hunt. Estab. 1981. Produces CDs, tapes and albums: jazz and classical by solo artists and compilations. Recent releases: *Excursions* and *Albumleaf*.
Needs: Produces 20 CDs/year. Works with 4 designers and 5 illustrators/year on assignment only. Also uses freelancers for multimedia projects. 50% of freelance work demands knowledge of Word Perfect and Wordstar.
First Contact & Terms: Send query letter with brochure, résumé, SASE and photocopies. Samples are filed or are returned by SASE if requested by artist. Reports back within 1 month only if interested. Call for appointment to show portfolio or mail roughs, b&w tearsheets and photographs. Requests work on spec before assigning a job. Pays by the project. Buys all rights; negotiable. Finds new artists through *Artist's and Graphic Designer's Market*.

‡DIRECT FORCE PRODUCTIONS, Box 255, Roosevelt NY 11575. (516)867-3585. President: Ronald Amedee. Estab. 1989. Produces CDs and tapes: rock and roll, jazz, rap, rhythm and blues, soul, pop, country/western by group and solo artists. Recent releases: *Barbaric*, by Paco Amedee; *Scandelous* by Helen Perry and *Tanjania*, by Tanjania.
Needs: Produces 25 albums/year; soloists and groups. Works with 15 freelance designers and 10 freelance illustrators/year. Prefers artists with experience in the music field. Uses artists for CD cover design; album/tape cover design and illustration; advertising design; posters. 25% of design and 50% of illustration demand computer literacy in QuarkXPress or Adobe Illustrator.
First Contact & Terms: Send query letter with brochure, SASE, photocopies and photographs. Samples are filed or are returned. Reports back within 15 days. Call to schedule an appointment to show a portfolio or mail appropriate materials: original/final art and b&w and color samples. Sometimes requests work on spec before assigning a job. Pays for design and illustration by the project, $200-1,500. Rights purchased vary according to project.

DISC-TINCT MUSIC, INC., 95 Cedar Land, Englewood NJ 07631. (201)568-0040. Fax: (201)568-8699. President: Jeffrey Collins. Estab. 1985. Produces CDs tapes and posters: rock, jazz, pop, R&B, soul, rap. Recent releases: *Live in '62*, by The Beatles; and *Music for the '90s*, by G. Simone & KRS 1.
Needs: Produces 20 releases/year. Works with 2-3 freelancers/year. Prefers local freelancers with experience in record album covers. Uses freelancers for CD design and illustration; tape cover illustration; catalog design

and layout; posters; and advertising design. 75% of freelance work demands knowledge of Aldus PageMaker, QuarkXPress, Aldus FreeHand.

First Contact & Terms: Send query letter with résumé, photocopies. Samples are filed or returned by SASE if requested by artist. Reports back within 3 weeks if interested. Portfolio may be dropped every Wednesday or Thursday. Artist should follow up with call. Portfolio should include b&w and color final art, photocopies. Pays for design by the project, $300-1,000. Rights purchased vary according to project.

Tips: "Listen carefully to what the record company's production manager is requesting."

♥**DMT RECORDS**, 11714-113th Ave., Edmonton, Alberta T5G 0J8 Canada. (403)454-6848. Fax: (403)454-9291. E-mail: dmt@ccinet.ab.ca Producer: Gerry Dere. Estab. 1986. Produces CDs and tapes: rock, jazz, pop, R&B, soul, country/western by solo artists and groups. Recent releases: *She Ain't Use to Tellin' Lies*, by Kidd Country; and *Seattle Rain*, by High Park.

Needs: Produces 4 releases/year. Works with 1-2 freelancers/year. Prefers freelancers with experience in computers. Uses freelancers for CD/tape cover design and illustration; and posters. 90% of freelance work demands knowledge of CorelDraw 3.0, 4.0, 5.0.

First Contact & Terms: Send postcard sample of work. Samples are filed. Reports back only if interested. Art Director will contact artist for portfolio review if interested. Portfolio should include color photocopies, photographs. Payment negotiated. Negotiates rights purchased. Finds artists through submissions.

‡**DUTCH EAST INDIA TRADING**, P.O. Box 738, Syosset NY 11791. (516)677-6000. Fax: (516)677-6007. Production Manager: Frank Disponzio. Estab. 1983. Produces CDs, tapes and albums: rock and roll and progressive jazz. Recent releases: *Tao*, by David S. Ware; *Tattoo of Blood*, by Captain Howdy.

● Record labels include Homestead Records, Shimmy-Disc, Too-Damn Hype, Excursion Records, Bus Stop, Ozone, Sunday Records.

Needs: Produces 2 soloists and 8 groups/year. Works with 5 visual artists/year. Prefers local artists only. Works on assignment only. Uses artists for CD and album/tape cover design, catalog design and layout, advertising design and posters.

First Contact & Terms: Send query letter with résumé and photocopies. Samples are filed. Reports back only if interested. Call to schedule an appointment to show a portfolio. Pays by the hour, $10-15; by the project; $100-200. Rights purchased vary according to project.

THE ETERNAL SONG AGENCY, 6326 E. Livingston Ave., #153, Reynoldsburg OH 43068. (614)834-1272. Art Director: Anastacia Crawford. Estab. 1986. Produces CDs, tapes and videos: rock, jazz, pop, R&B, soul, progressive, classical, gospel, country/western. Recent releases: *Escape*, by Robin Curenton; and *You Make Me New*, by Greg Whigtscel.

Needs: Produces 6 releases/year. Works with 5-7 freelancers/year. Prefers freelancers with experience in illustration and layout. "Designers need to be computer-literate and aware of latest illustration technology." Uses freelancers for CD/tape cover, and advertising design and illustration, direct mail packages, posters, catalog design and layout. 65% of freelance work demands knowledge of Aldus PageMaker, Adobe Illustrator, Adobe Photoshop, Aldus FreeHand. "Other programs may be acceptable."

First Contact & Terms: Send postcard sample of work or send query letter with brochure, photocopies, résumé, photographs. Samples are filed. Reports back within 4-5 weeks. Art Director will contact artist for portfolio review if interested. Portfolio should include b&w and color final art and photocopies. Pays for design by the project, $300-5,000. Pays for illustration by the hour, $15-35; by the project, $300-5,000. Finds artists through word of mouth, seeing previously released albums and illustration, art colleges and universities. "Be persistent. Know your trade. Become familiar with technical advances as related to your chosen profession."

‡**50,000,000,000,000,000,000,000 WATTS RECORDS**, 5721 SE Laguna Ave., Stuart FL 34997-7828. Phone and Fax: (407)283-6195. President: M.C. Estab. 1985. Produces CDs, tapes and albums: rock and roll. Recent releases: *The Velvet Underground Handbook* and *What Goes on Magazine No. 5*, by M.C.

● The name of this company is pronounced "50 Skidillion Watts Records."

Needs: Produces 3-5 groups/year. Works with 3-5 visual artists/year. Works only with artist reps. Prefers artists with experience in music packaging. Works on assignment only. Uses artists for CD cover design and illustration, album/tape cover design and illustration, brochure and catalog design, illustration and layout, direct mail packages, advertising design and illustration, posters and a magazine "What Goes On."

First Contact & Terms: Send query letter with brochure, tearsheets, résumé, photographs, SASE and photocopies. Samples are filed or are returned by SASE if requested by artist. Reports back within 3-8 weeks. "Follow up anyway." To show a portfolio, mail thumbnails, roughs and b&w tearsheets and photographs. Pays by the project, $500 maximum. Negotiates rights purchased according to project.

Tips: "Pursue bands and labels you really enjoy, whom you think might enjoy your work."

‡**FUTURIST LABEL GROUP**, 6 Greene St., 2nd Floor, New York NY 10013. (212)226-7272. Fax: (212)941-9409. E-mail: sings@aol.com. Art Director: Peter Tsakiris. Estab. 1990. Produces albums, CDs and cassettes: pop, progressive, rock, hard rock/metal. Recent releases: *The Space Age Playboys*, by Warrior

Soul; *Open Mouth Kiss*, by Leeway; *The Angel and The Dark River*, by My Dying Bride.
Needs: Produces 12 releases/year. Prefers local designers and illustrators who own Mac computers. Uses freelancers for album cover design; album, cassette and CD cover and CD booklet illustration. 90% of design and 50% of illustration demand knowledge of Adobe Illutrator 5.5, QuarkXPress 3.3, Adobe Photoshop 3.0 and Aldus FreeHand 5.0.
First Contact & Terms: Send postcard sample and/or query letter with brochure, photocopies, tearsheets, résumé, photographs and slides. Accepts disk submissions compatible with Mac. Samples are filed or returned by SASE if requested by artist. Follow-up with call. Will contact for portfolio review of b&w, color final art of photocopies, photographs, photostats, slides, tearsheets and transparencies. Pays by the project. Rights vary according to project. Finds artists through submissions, *Black Book*, magazines, World Wide Web.

‡**GM RECORDINGS**, 167 Dudley Rd., Newton Centre MA 02159. (617)332-6398. Manager: Bruce Millard. Estab. 1980. Produces CDs, tapes and LPs: classical, jazz, thirdstream, world; solo and group artists. Recent releases: *Vintage Dolphy*, by Eric Dolphy; *Man of the Forest*, by Ivo Perelman, *Phantasmata*, by Marimolin and *Scatter*, by Human Feel.
Needs: Produces 4 soloists and 8 groups/year. Works with 3-4 visual artists/year. Prefers artists with CD and tape cover design. Works on assignment only. Uses artists for CD and tape cover design and illustration and catalog design, illustration and layout. 90% of design and 50% of illustration demand knowledge of Aldus PageMaker, QuarkXPress, Aldus FreeHand, Adobe Illustrator and Adobe Photoshop.
First Contact & Terms: Send query letter with brochure, tearsheets, résumé, photographs, photocopies and SASE. Samples are filed or returned by SASE if requested. Reports back only if interested. Negotiates payment. Rights purchased vary according to project.
Tips: "Start by working cheap if necessary. If you're good, you'll gradually get your price. Knowing the company and their product before you contact them helps considerably."

‡**GRASS ROOTS PRODUCTIONS**, Box 532, Malibu CA 90265. (213)858-7282. President: Lee Magid. Produces jazz, rock, country, blues, instrumental, gospel, classical, folk, educational, pop and reggae; group and solo artists. Assigns 15 jobs/year.
Needs: Produces 15-20 records/year; works with 6 soloists and 6 groups/year. Local artists only. Works on assignment only. Uses artists for album cover design and illustration; brochure design, illustration and layout; catalog design, direct mail packages, posters and advertising illustration. Sometimes uses cartoons and humorous and cartoon-style illustrations depending on project.
First Contact & Terms: Send brochure to be kept on file. Include SASE. Samples not filed are returned by SASE. Reports only if interested. Write for appointment to show portfolio. Pays by the project. Considers available budget when establishing payment. Buys all rights.
Tips: "It's important for the artist to work closely with the producer, to coincide with the feeling of the album, rather than throwing a piece of art against the wrong sound." Artists shouldn't "get overly progressive. 'Commercial' is the name of the game."

HAMMERHEAD RECORDS, 41 E. University Ave., Champaign IL 61820. (217)355-9052. Fax: (217)355-9057. E-mail: hammerhd@prairienet.org. Website: http://www.shout.net/~hammerhead. President: Todd Thorstenson. Estab. 1993. Produces CDs and tapes: rock, by groups. Recent releases: "Better Off at Home," by the Bludgers; and "Chateau," by Free Range Chicken.
Needs: Produces 4 releases/year. Works with 3-4 freelancers/year. Uses freelancers for CD/tape cover design and illustration; posters. 80% of freelance work demands knowledge of Aldus PageMaker 5.0, Adobe Illustrator (version 4 for Windows).
First Contact & Terms: Send query letter with résumé, photographs, tearsheets. Samples are filed or returned by SASE if requested by artist. Reports back to the artist only if interested. Artist should follow-up with call and/or letter after initial query. Portfolio should include b&w and color roughs, photostats. Pays for design and illustration by the project. Rights purchased vary according to project.

HARD HAT RECORDS AND CASSETTE TAPES, 519 N. Halifax Ave., Daytona Beach FL 32118-4017. (904)252-0381. Fax: (904)252-0381. E-mail: hardhat@kspace.com. Website: http://www.kspace.com/hardhat. CEO: Bobby Lee Cude. Produces rock, country/western, folk and educational by group and solo artists. Publishes high school/college marching band arrangements. Recent releases include: *Broadway USA* CD series (a six volume CD program of new and original music); and *Times-Square Fantasy Theatre* (CD release with 18 tracks of new and original Broadway style music).
 ● Also owns Blaster Boxx Hits.
Needs: Produces 6-12 records/year. Works with 2 designers and 1 illustrator/year. Works on assignment only. Uses freelancers for album cover design and illustration; advertising design; and sheet music covers. Prefers "modern, up-to-date, on the cutting edge" promotional material and cover designs that fit the music style. 60% of freelance work demands knowledge of Adobe Photoshop.

First Contact & Terms: Send query letter with brochure to be kept on file one year. Samples not filed are returned by SASE. Reports within 2 weeks. Write for appointment to show portfolio. Sometimes requests work on spec before assigning a job. Pays by the project. Buys all rights.

❦**HICKORY LANE RECORDS**, Box 2275, Vancouver, British Columbia V6B 3W5 Canada. (604)987-3756. Fax: (604)987-0616. President: Chris Michaels. A&R Manager: David Rogers. Estab. 1985. Produces CDs and tapes: country/western. Recent releases: "So In Love," by Chris Michaels; and "Tear & Tease," by Steve Mitchell/Chris Michaels.
Needs: Produces 5 solo artists and 2 groups/year. Works with 13 freelancers/year. Works on assignment only. Uses freelancers for CD/tape cover, brochure and advertising design and illustration; and posters. 25% of freelance work demands knowledge of Aldus PageMaker, Adobe Illustrator, QuarkXPress, Adobe Photoshop, Aldus FreeHand.
First Contact & Terms: Send query letter with brochure, résumé, photostats, transparencies, photocopies, photographs, SASE and tearsheets. Samples are filed and are returned by SASE if requested by artist. Reports back within 6 weeks. Call or write for appointment to show portfolio of b&w and color roughs, final art, tearsheets, photostats, photographs, transparencies and computer disks. Pays for design by the project, $250-650. Negotiates rights purchased.
Tips: "Keep ideas simple and original. If there is potential in the submission we will contact you. Be patient and accept criticism."

‡**HIGHWAY ONE MEDIA ENTERTAINMENT**, 964 Pacific Coast Hwy. Santa Monica CA 90403. (310)260-4777. Fax: (310)319-2421. E-mail: hwyone@aol.com or highwayone@earthlink.net. President: Ken Caillat. Estab. 1994. Produces CD-ROMs and enhanced music CDs: pop and rock by solo artists and groups. Recent releases: *Looking East*, by Jackson Browne; *Little Things*, by Bush; *Burning Down the House*, by Bonnie Raitt; *Supermodels in the Rainforest* and *Virtual Graceland* (ECDs).
Needs: Produces 6-10 releases/year. Works with 10-20 freelancers/year. Prefers local designers who own computers. Uses freelancers for CD booklet and cover design and illustration; CD-ROM design and packaging. 100% of freelance work demands knowledge of Adobe illustrator, QuarkXPress, Adobe Photoshop.
First Contact & Terms: Send query letter with brochure, photocopies, tearsheets, résumé. Accepts disk submissions. Samples are filed. Reports back within 2 weeks. Will contact for portfolio review of color photocopies if interested. Pays by the project, $200-6,000.

HOTTRAX RECORDS, 1957 Kilburn Dr., Atlanta GA 30324. (770)662-6661. Publicity and Promotion: Teri Blackman. Estab. 1975. Produces CDs and tapes: rock, R&B, country/western, jazz, pop and blues/novelties by solo and group artists. Recent releases: *Volume 1, The Rhythm & Blues Period 1959-1964*, by The Night Shadows.
Needs: Produces 2 soloists and 4 groups/year. Works with 2-4 freelancers/year. Prefers freelancers with experience in multimedia—mixing art with photographs—and caricatures. Uses freelancers for CD/tape cover, catalog and advertising design and illustration; and posters. 25% of freelance work demands knowledge of Aldus PageMaker, Adobe Illustrator and Photoshop.
First Contact & Terms: Send postcard samples. Accepts disk submissions compatible with Adobe Illustrator and CorelDraw. Some samples are filed. If not filed, samples are not returned. Reports back only if interested. Pays by the project, $100-1,000. Buys all rights.

‡**HULA RECORDS**, Box 2135, Honolulu HI 96805. (808)847-4608. President: Donald P. McDiarmid III. Produces pop, educational and Hawaiian records; group and solo artists.
Needs: Produces 1-2 soloists and 3-4 groups/year. Works on assignment only. Uses artists for album cover design and illustration, brochure and catalog design, catalog layout, advertising design and posters.
First Contact & Terms: Send query letter with tearsheets and photocopies. Samples are filed or are returned only if requested. Reports back within 2 weeks. Write for appointment to show portfolio. Pays by the project, $50-350. Considers available budget and rights purchased when establishing payment. Negotiates rights purchased.

‡**I.R.S. RECORDS**, 3520 Hayden Ave., Culver City CA 90232. (310)841-4100. Fax: (310)838-4070. Estab. 1981. Produces albums, CDs and cassettes: pop, progressive and rock by solo artists and groups. Recent releases: "El Subliminoso," by Dada; "Camp Grenada," by Gren.
Needs: Produces 20-30 releases/year. Works with 5-10 freelancers/year. Prefers local designers and illustrators who own Macs. Uses freelancers for album and CD cover and CD booklet design and illustration; poster

● **A BULLET** introduces comments by the editor of *Artist's & Graphic Designer's Market* indicating special information about the listing.

design; point of purchase and production work. 100% of design demands knowledge of Adobe Illustrator, QuarkXPress, Adobe Photoshop.

First Contact & Terms: Send postcard sample of work. Accepts disk submissions compatible with Mac. Samples are filed or returned by SASE if requested. Does not report back. Artist should send a different promo in a few months. Portfolios may be dropped off every Monday. Will contact for portfolio review of b&w and color final art, photocopies, photographs, photostats, roughs, slides, tearsheets, thumbnails or transparencies. Pays by the project. Buys all rights. Finds artists through interesting promos, *"The Alternative Pick."*

Tips: "Even though I get CD-ROMs with work on it, I much prefer hand-held stuff. If you do send CD-ROMs, don't use it as an excuse to put tons on it. Keep it manageable to the eyes. Send out a limited edition of a 'cool' object/art-thing that you only send to 20 or so and then a few months later send a corresponding follow-up. I find food to work the best (candy especially)."

ICHIBAN RECORDS, INC., P.O. Box 724677, Atlanta GA 31139-1677. (770)419-1414. Fax: (770)419-1230. Art Director: Frank Dreyer. Estab. 1985. Produces CDs, tapes, LPs, singles: rock, jazz, pop, R&B, soul, progressive, folk, rap, by solo artists and groups. Recent releases: *To da Beat Ch'all*, by MC Breed; and *Tia*, by Tia; and *Brain Washed*, by MC Brainz.

Needs: Produces 75 releases/year. Works with 5-10 freelancers/year. Uses freelancers for CD/tape cover design and illustration; catalog design; direct mail packages; and posters. 30% of freelance work demands knowledge of Aldus PageMaker 6.0, Adobe Illustrator 5.0, QuarkXPress 3.3, Adobe Photoshop 3.0, Aldus FreeHand 5.0.

First Contact & Terms: Send query letter with photocopies. Samples are filed. Art Director will contact artist for portfolio review if interested. Portfolio should include b&w and color photocopies, photographs, tearsheets. Pays for design by the project, $150 minimum. Pays for illustration by the project, $50 minimum. Buys all rights. Finds artists through self-promotion mailings, word of mouth.

IKON RECORDS, (formerly Rage-N-Records), 212 N. 12th St., #3, Philadelphia PA 19107. (215)977-7779. Fax: (215)496-9321. E-mail: rage@netaxs.com. Website: http://www.IKONMAN.com. Creative Director: Vincent Kershner. Estab. 1984. Produces CDs and tapes: rock, pop, R&B, blues by solo artists and groups. Recent releases: "Ah Ho, Ah Ho & Nittany Joe," by The Anzalone Brothers; and "Reindeer Games," by Pat Godwin.

Needs: Produces 10 solo artists and 10 groups/year. Works with 5-10 freelancers/year. Prefers artists with experience in rock designs. Works on assignment only. Uses artists for CD/tape cover design and illustration; multimedia projects and posters. 90% of freelance work demands computer skills.

First Contact & Terms: Samples are not filed and are returned by SASE if requested by artist. Does not report back. Artist should follow up. Call for appointment to show portfolio. Pays for design by the project.

IMAGINARY ENTERTAINMENT CORP., P.O. Box 66, Whites Creek TN 37189. (615)299-9237. Proprietor: Lloyd Townsend. Estab. 1982. Produces CDs, tapes and albums: rock, jazz, classical, folk and spoken word. Releases include: *Bone Dali*, by Bone Dali and *One of a Kind*, by Stevens, Siegel and Ferguson.

Needs: Produces 1-2 solo artists and 1-2 groups/year. Works with 1-2 freelancers/year. Works on assignment only. Uses artists for CD/album/tape cover design and illustration and catalog design.

First Contact & Terms: Send query letter with brochure, tearsheets, photographs and SASE. Samples are filed or returned by SASE if requested by artist. Reports back within 2-3 months. To show portfolio, mail thumbnails, roughs and photographs. Pays by the project, $25-500. Negotiates rights purchased.

Tips: "I always need one or two dependable artists who can deliver appropriate artwork within a reasonable time frame."

‡IMI RECORDS, 541 N. Fairbanks, Suite 2040, Chicago IL 60611. (312)245-9334. Fax: (312)245-9327. E-mail: imirecords@interaccess.com. Head of Management Services: Jennifer Woyan. Estab. 1993. Produces albums, CDs, CD-ROMs, cassettes: jazz, pop, R&B, rock by solo artists and groups. Recent releases: "Mind-blowing," by David Josias; *The Falling Wallendas*.

Needs: Produces 10-15 releases/year. Works with 5-7 freelancers/year. Prefers local illustrators. Prefers designers who own Macs with experience in all types of computer and noncomputer usages, photo manipulation and art direction in package design. Uses freelancers for album, cassette, CD cover design and illustration; CD booklet design and illustration; CD-ROM design and packaging; animation and poster design; advertising art direction; design illustration; direct mail packages. 95% of freelance work demands knowledge of Aldus PageMaker, Adobe Illustrator, QuarkXPress, Adobe Photoshop, Aldus FreeHand.

First Contact & Terms: Send query letter with tearsheets, résumé, photostats, photographs, SASE, tearsheets and high quality final work. Samles are filed or returned by SASE if requested by artist. Will contact for portfolio review of b&w or color final art, photographs, photostats and tearsheets. Pays for design by the project, $250-1,500. Pays for illustration by the hour, $20-45; by the project, $150-1,000. Rights purchased vary according to proeject. Finds artists through industry recommendations.

Tips: "Use technology as a tool to facilitate your work. Cyber art is cool—but we are tending to favor traditional, straight forward, interesting designs that do not overshadow the product itself." Looks for "a

concept that somehow reflects, or invokes an emotion from designers. Clean lines or mass confusion—as long as it's utmost quality—from illustrators."

‡**INSTINCT RECORDS**, 26 West 17th St., #502, New York NY 10011. (212)727-1360. Label Manager: Gerald Helm. Estab. 1989. Produces CDs and tapes: acid jazz, triphop, electronic and ambient. Recent releases: *This is Acid Juce*, compilation; *Abstract Workshop*, compilation.
Needs: Works with 10 visual artists/year. Releases 30 CDs, tapes each year. Prefers local artists and Macintosh-based designers only. Artists work on assignment only. Uses artists for CD cover, tape cover and advertising design and illustration. 90% of freelance work demands knowledge of QuarkXPress, Adobe Illustrator and Adobe Photoshop.
First Contact & Terms: Send query letter with SASE. Reports back only if interested. Call for appointment to show portfolio of thumbnails, roughs, final art and color slides. Requests work on spec before assigning a job. Pays by the project, $400 minimum. Rights purchased vary according to project.

‡**ISLAND RECORDS**, 825 Eighth Ave., New York NY 10019. (212)603-7898. Fax: (212)333-1059. Creative Director: Tony Wright. Estab. 1962. Produces albums, CDs, CD-ROMs, cassettes, LPs: folk, gospel, pop, progressive, R&B, rap and rock by solo artists and groups. Recent releases: "Your Little Secret," by Melissa Etheridge; "To Bring You My Love," PJ Harvey.
Needs: Works with 15 freelancers/year. Prefers designers who own Mac with experience in music industry. Uses freelancers for album, cassette and CD cover design and illustration; CD booklet design and illustration; and poster design; advertising; merchandising. 100% of design and 50% of illustration demand knowledge of Adobe Illustrator, QuarkXPress and Adobe Photoshop.
First Contact & Terms: Send postcard sample and or query letter with tearsheets. Accepts disk submissions. Samples are filed. Portfolios of b&w and color final art and tearsheets may be dropped off every Tuesday. Pays by the project. Rights purchased vary according to project. Finds artists through submissions and word of mouth.

JAZZAND, 12 Micieli Place, Brooklyn NY 11218. (718)972-1220. E-mail: jazzand@pan.com. Proprietor: Rick Stone. Estab. 1984. Produces CDs and tapes: jazz. Releases: *Far East*, by Rick Stone Quartet; and *Blues for Nobody*, by Rick Stone.
Needs: Produces 1 solo artist and 1 group/year. Works with 2 designers/year. Prefers local freelancers with experience in cover and poster design. Works on assignment only. Uses freelancers for CD/album/tape cover design and illustration; brochure and catalog design and layout; direct mail packages; advertising design; and posters. 100% of freelance work demands knowledge of QuarkXPress, Adobe Illustrator and Adobe Photoshop.
First Contact & Terms: Send postcard sample or query letter with résumé, tearsheets and photocopies. Samples are filed. Reports back within 1 month. Call for appointment to show portfolio or mail appropriate materials, including tearsheets and photographs. Pays by the project, $150-750.
Tips: "Get to know people at labels, producers, etc. Establish *personal* contacts; even if someone can't use your services right now, six months from now he may be in need of someone. People in the music business tend to move around frequently to other record companies, agencies, etc. If you've developed a good rapport with someone and he leaves, find out where he's gone; the next company he works for might hire you. Send us a small sample of what you consider your best work. We *do* keep this stuff on file. We will contact you if we feel we can use your services."

KEPT IN THE DARK RECORDS, 332 Bleeker St., K-138, New York NY 10014. (602)298-8627. Fax: (602)290-5795. E-mail: sakin@rtd.com. President: Larry A. Sakin. Estab. 1988. Produces CDs, tapes and 7-inch singles: rock, jazz, pop, R&B, folk. Recent releases: *Recliner-TBA: Way Past Cool*, by TBA.
Needs: Produces 4-6 releases/year. Works with 5 freelancers/year. Uses freelancers for CD cover, catalog and advertising design and illustration; tape cover illustration; and multimedia projects. 60% of design and 50% of illustration demand knowledge of Adobe Illustrator/Printshop and QuarkXPress.
First Contact & Terms: Send query letter with photocopies, SASE, tearsheets. Samples are filed or returned by SASE if requested by artist. Reports back within 2 weeks. Portfolio review not required. Pays for design and illustration by the project. Rights purchased vary according to project.
Tips: "Many artists send their work to me, without copyright which is a dangerous habit. I do not consider material without copyright. If interested, I help with copyright procedure. Original designs are very important; I like very creative and off-the-beaten-path. Patience is very impressive."

KIMBO EDUCATIONAL, 10 N. Third Ave., Long Branch NJ 07740. Production Manager: Amy Laufer. Educational record/cassette company. Produces 8 records, cassettes and compact discs/year for schools, teacher supply stores and parents. Primarily early childhood physical fitness, although other materials are produced for all ages.
Needs: Works with 3 freelancers/year. Prefers local artists on assignment only. Uses artists for CD/cassette/album covers; catalog and flier design; and ads. Helpful if artist has experience in the preparation of album jackets or cassette inserts.

First Contact & Terms: "It is very hard to do this type of material via mail." Write or call for appointment to show portfolio. Prefers photographs or actual samples of past work. Reports only if interested. Pays for design and illustration by the project, $200-500. Considers complexity of project and budget when establishing payment. Buys all rights.
Tips: "The jobs at Kimbo vary tremendously. We produce material for various levels—infant to senior citizen. Sometimes we need cute 'kid-like' illustrations and sometimes graphic design will suffice. We are an educational firm so we cannot pay commercial record/cassette/CD art prices."

K-TEL INTERNATIONAL (USA) INC., 2605 Fernbrook Lane N., Plymouth MN 55447. (612)559-6800. Director of Creative Services: Barbara Elfenbein. Creative Managers: Karen Hacking and Ann Cleary. Estab. 1969. Produces CDs and tapes: rock, jazz, rap, R&B, soul, pop, classical, country/western and dance. Also produces books on cassette and CD-ROM. Releases: *Club Mix*; *Players and Huslters*; and *Hit Country '96*, by various artists.
Needs: "Frequently uses freelancers for illustration and design. Works on assignment only. Uses freelancers for CD/cassette/tape package design and illustration for books and CD-ROM. Needs illustration in all media. Freelance designers should be familiar with Adobe Illustrator and Adobe Photoshop.
First Contact & Terms: Send query letter with résumé and tearsheets. Samples are filed. Reports back only if interested. Pays by project, $500-1,500.

LaFACE RECORDS, 3350 Peachtree Rd., Suite 1500, Atlanta GA 30326. (404)848-8050. Fax: (404)848-8051. Creative Director: D.L. Warfield. Senior National Director of Marketing & Artist Development: Davett Singletary. Estab. 1989. Produces CD and tapes: pop, R&B, rap. Recent releases: Goodie Mob, Donell Jones, Outcast and Society of Soul.
Needs: Produces 10 releases/year. Works with 10-15 freelancers/year. Uses freelancers for CD cover design; advertising design and illustration; and posters. Needs computer-literate freelancers for design.
First Contact & Terms: Send postcard sample of work or query letter with résumé and tearsheets. Samples are filed or returned. Reports back within 3 weeks. Portfolios may be dropped off anytime. Art Director will contact artist for portfolio review if interested. Portfolio should include b&w and color samples. Rights purchased vary according to project. Finds artists through *Black Book*, magazines, *The Alternative Pick*, *Workbook*.

LAMBSBREAD INTERNATIONAL RECORD COMPANY/LBI, Box 328, Jericho VT 05465. (802)899-3787. Creative Director: Robert Dean. Estab. 1983. Produces CDs, tapes and albums: R&B, reggae. Recent releases: *Reggae Mood*, by Lambsbread; and *African Princess*, by Mikey Dread; *The Hotter, The Better*, by Lambsbread.
Needs: Produces 2 soloists and 2 groups/year. Works with 3 designers and 2 illustrators/year. Works on assignment only. Uses freelancers for CD cover, catalog and advertising design; album/tape cover design and illustration; direct mail packages; and posters. 70% of freelance work demands computer skills.
First Contact & Terms: Send query letter with brochure, tearsheets, résumé, photographs, SASE and photocopies. Samples are filed. Reports back only if interested. To show a portfolio, mail thumbnails, roughs, photostats and tearsheets. Sometimes requests work on spec before assigning a job. Payment negotiated by the project. Buys all rights or negotiates rights purchased according to project.
Tips: "Become more familiar with the way music companies deal with artists. Also check for the small labels which may be active in your area. The technology is unreal regarding computer images and graphics. So don't over price yourself right out of work."

LAMON RECORDS INC., P.O. Box 25371, Charlotte NC 28229. (704)882-8845. Fax: (704)545-1940. Chairman of Board: Dwight L. Moody Jr. Produces CDs and tapes: rock, country/western, folk, R&B and religious music; groups. Releases: *Going Home*, by Moody Brothers; and *The Woman Can Love*, by Billy Marshall.
Needs: Works on assignment only. Works with 3 designers and 4 illustrators/year. Uses freelancers for album cover design and illustration, brochure and advertising design, and direct mail packages. 50% of freelance work demands knowledge of Adobe Photoshop.
First Contact & Terms: Send brochure and tearsheets. Samples are filed and are not returned. Reports back only if interested. Call for appointment to show portfolio or mail appropriate materials. Considers skill and experience of artist and how work will be used when establishing payment. Buys all rights.
Tips: "Include work that has been used on album, CD or cassette covers."

‡LANDMARK COMMUNICATIONS GROUP, Box 1444, Hendersonville TN 37077. President: Bill Anderson Jr. Estab. 1980. Produces CDs, albums and tapes: country/western and gospel. Releases include: *You Were Made for Me*, by Skeeter Davis and *Talkin' Bout Love*, by Gail Score.
Needs: Produces 6 soloists and 2 groups/year. Works with 2-3 freelance designers and illustrators/year. Works on assignment only. Uses artists for CD cover design and album/tape cover illustration.
First Contact & Terms: Send query letter with brochure. Samples are filed. Reports back within 1 month. Portfolio should include tearsheets and photographs. Rights purchased vary according to project.

LBJ PRODUCTIONS, 8608 W. College St., French Lick IN 47432. (812)936-7318. E-mail: lbjprod@inters ource.com. Website: http://www.intersource.com/~lbjprod. Executive Producer: Larry B. Jones. Estab. 1989. Produces tapes, CDs, records, posters: rock, gospel, country/western by solo artists and groups. Recent releases: *Respectable Voodoo*, by Heart & Soul.
Needs: Produces 5-6 solo artists and 2-3 groups/year. Works with 1-2 freelancers/year. Prefers local artists with experience in music industry. Works on assignment only. Uses freelancers for CD/tape cover and advertising design and illustration; brochure design; and posters. 50% of freelance work demands knowledge of Aldus PageMaker, Adobe Illustrator, Adobe Photoshop and Autocad.
First Contact & Terms: Send query letter with résumé, photocopies, SASE and tearsheets. Accepts disk submissions. Send PCX, TIFF and GIF files. Samples are filed and are returned by SASE if requested by artist. Reports back within 6 weeks. Call for appointment to show portfolio of b&w thumbnails, final art and tearsheets. Pays for design by the project, $75-500. Rights purchased vary according to project.

✤**LCDM ENTERTAINMENT**, Box 79564, 1995 Weston Rd., Weston, Ontario M9N 3W9 Canada. (416)242-7391. Fax: (416)743-6682. Publisher: Lee. Estab. 1991. Produces CDs, tapes, publications (quarterly): pop, folk, country/western and original. Recent releases: "Glitters & Tumbles," by Liana; and *Indie Tips & the Arts* (publication).
Needs: Prefers local artists but open to others. Uses freelancers for CD cover design, brochure illustration, posters and publication artwork. Needs computer-literate freelancers for production, presentation and multimedia projects.
First Contact & Terms: Send query letter with brochure, résumé, photocopies, photographs, SASE, tearsheets, terms of renumeration (i.e., pay/non-pay/alternative). Samples are filed. Art Director will contact artist for portfolio review if interested. Pays for design and illustration by the project. Rights purchased vary according to project.

PATTY LEE RECORDS, 6034 Graciosa Dr., Hollywood CA 90068. (213)469-5431. Contact: Susan Neidhart. Estab. 1986. Produces CDs and tapes: New Orleans rock, jazz, folk, country/western, cowboy poetry and eclectic by solo artists. Recent releases: *Return to Be Bop*, by Jim Sharpe; *Alligator Ball*, by Armand St. Martin; and *Horseshoe Basin Ranch*, by Timm Daughtry.
Needs: Produces 4-5 soloists/year. Works with 1 designer and 2 illustrators/year. Works on assignment only. Uses freelancers for CD/tape cover, sign and brochure design; and posters.
First Contact & Terms: Send postcard sample. Samples are filed or are returned by SASE. Reports back only if interested. Write for appointment to show portfolio. "Do not send anything other than an introductory letter." Payment varies. Rights purchased vary according to project. Finds new artists through word of mouth, magazines, submissions/self-promotional material, sourcebooks, agents and reps and design studios.
Tips: "Our label is small but growing. The economy has not affected our need for artists. Sending a postcard representing your 'style' is very smart. It's inexpensive and we can keep the card on file. We are very small and have limited funds so if you don't hear back from us, it is not a reflection on your talent. Keep up the good work."

LIVING MUSIC RECORDS, P.O. Box 72, Litchfield CT 06759. (860)567-8796. Fax: (860)567-4276. Director of Communications: Chantal Harris. Estab. 1980. Produces CDs and tapes: classical, jazz, folk, progressive, world, New Age. Recent releases: *Pete*, by Pete Seeger; *Celtic Soul*, by Noirin Ni Riain.
Needs: Produces 1-3 releases/year. Works with 1-5 freelancers/year. Uses freelancers for CD/tape cover and brochure design and illustration; direct mail packages; advertising design; catalog design, illustration and layout; and posters. 70% of freelance work demands knowledge of Aldus PageMaker, Adobe Illustrator, QuarkXPress, Adobe Photoshop, Aldus FreeHand.
First Contact & Terms: Send postcard sample of work or query letter with brochure, transparencies, photographs, slides, SASE, tearsheets. Samples are filed or returned by SASE if requested by artist. Reports back to the artist only if interested. Art Director will contact artist for portfolio review of b&w and color roughs, photographs, slides, transparencies and tearsheets. Pays for design by the project. Rights purchased vary according to project.
Tips: "We look for distinct 'earthy' style; sometimes look for likenesses."

LUCIFER RECORDS, INC., Box 263, Brigantine NJ 08203. (609)266-2623. President: Ron Luciano. Produces pop, dance and rock.
Needs: Produces 2-12 records/year. Prefers experienced freelancers. Works on assignment only. Uses freelancers for album cover and catalog design; brochure and advertising design, illustration and layout; direct mail packages; and posters.
First Contact & Terms: Send query letter with résumé, business card, tearsheets, photostats or photocopies. Reports only if interested. Original art sometimes returned to artist. Write for appointment to show portfolio, or mail tearsheets and photostats. Pays by the project. Negotiates pay and rights purchased.

MAGGIE'S MUSIC, INC., Box 4144, Annapolis MD 21403. (410)268-3394. Fax: (410)267-7061. President: Maggie Sansone. Estab. 1984. Produces CDs and tapes: traditional, Celtic and new acoustic music.

Recent releases *Midsummer Moon*, by Al Petteway; *Dance Upon the Shore*, by Maggie Sansone; *Hills of Erin*, by Karen Ashbrook; and *Celtic Circles*, by Bonnie Rideout and *Midnight Howl*, by Robin Bullock.
Needs: Produces 3-4 albums/year. Works with 2 freelance designers and 2 illustrators/year. Prefers freelancers with experience in album covers, Celtic and folk art. Works on assignment only. Uses artists for CD/album/tape cover and brochure design and illustration; and catalog design, illustration and layout. Needs computer-literate freelancers for design and production.
First Contact & Terms: Send query letter with color and b&w samples, brochure. Samples are filed. Reports back only if interested. Company will contact artist for portfolio review if interested. Requests work on spec before assigning a job. Pays for design by the hour, $30-60. Pays for illustration by the project, $500-1,000. Sometimes interested in buying second rights (reprint rights) to previously published work, or as edited. Buys all rights.
Tips: This company asks that the artist requests a catalog first "to see if their product is appropriate for our company, then send samples (non-returnable for our files)."

MECHANIC RECORDS, INC., Dept. AGDM, 6 Greene St., 2nd Floor, New York NY 10013. (212)226-7272. Fax: (212)941-9401. Production Manager: Gina Rainville. Estab. 1988. Produces CDs, tapes and albums: pop and rock. Recent releases: *Live Alien Broadcast*, by Tad; *Progress of Decadence*, by Overdose and *Puppet's Night Out*, by Supple.
Needs: Produces 10 albums/year. Works with 3-4 freelance designers and 5-6 illustrators/year. Uses freelancers for CD/album/tape cover; brochure and advertising design and illustration; direct mail packages, multimedia projects; and posters. 100% of design and 75% of illustration demand knowledge of Adobe Photoshop 2.5 and Adobe Illustrator.
First Contact & Terms: Send postcard sample or query letter with brochure, résumé and tearsheets. Accepts disk submissions compatible with Adobe Illustrator, Adobe Photoshop, Aldus FreeHand and Painter. Samples are filed and not returned. Reports back only if interested. To show portfolio, mail appropriate materials. Payment varies. Rights purchased vary according to project.

MIA MIND MUSIC, 500½ E. 84th St., Suite 4B, New York NY 10028. (212)861-8745. Fax: (212)439-9109. Producer: Steven Bentzel. Director Art Department: Ashley Wilkes. Produces tapes, CDs, DATs, demos, records: rock, pop, R&B, soul, progressive, folk, gospel, rap, alternative; by solo artists and groups. Recent releases: *Flowers Dice*, *Chemical Wedding* and *Piper Stone*.
Needs: Produces 15 solo artists and 5 groups/year. Works with 12 freelancers/year. Prefers freelancers with experience in rock/pop art. Works on assignment only. Uses artists for CD/tape cover design and illustration; brochure design and illustration; direct mail packages; advertising design; posters. 100% of freelance work demands knowledge of Adobe Illustrator, Adobe Photoshop and QuarkXPress.
First Contact & Terms: Send query letter with résumé, photocopies, tearsheets. Samples are filed. Reports back within 2 weeks. Call for appointment to show portfolio of b&w and color final art and photographs or mail appropriate materials. Pays for design by the project, $50-500. Rights purchased vary according to project.
Tips: "Be willing to do mock-ups for samples to be added to company portfolio."

MIRAMAR PRODUCTIONS, 200 Second Ave., Seattle WA 98119. (206)284-4700. Fax:(206)286-4433. Website: http://useattle.uspan.com/miramar/. Vice President of Special Projects: Kipp Kilpatrick. Estab. 1984. Produces CDs, tapes and videos: rock, R&B, jazz, progressive and adult contemporary by solo artists and groups. Recent releases: *The Gate to the Mind's Eye*, by Thomas Dolby; *Turn of the Tides*, by Tangerine Dream; and *Opera Imaginaire*, by various artists.
Needs: Produces 10 soloists and 10 groups/year. Works with 10 freelancers/year. Works on assignment only. Uses freelancers for CD/tape cover; brochure and advertising design and illustration; posters; and videotape packaging. 90% of freelance work demands knowledge of QuarkXPress, Aldus FreeHand, Adobe Illustrator and Adobe Photoshop.
First Contact & Terms: Send query letter with brochure, tearsheets, résumé and photocopies. Samples are filed. Reports back only if interested. Write for appointment to show portfolio of b&w and color photostats, tearsheets, photographs, slides and printed pieces. Pays by the project. Rights purchased vary according to project.

‡MIRROR RECORDS INC; HOUSE OF GUITARS BLVD., 645 Titus Ave., Rochester NY 14617. (716)544-3500. Art Director: Armand Schaubroeck. Produces CDs tapes and albums: rock and roll, heavy metal, middle of the road and new wave music. Recent releases: "Drunk On Muddy Waters" and "Berlin Wall of Sound," by Chesterfield Kings.
Needs: Produces 6 records/year; all of which have cover/jackets designed and illustrated by freelance artists. Works with 3 freelance designers and 6-8 freelance illustrators/year. Uses artists for catalogs, album covers, inner sleeves and advertising design. "Always looking for new talent."
First Contact & Terms: Send query letter with brochure showing art style, samples and SASE. Reports within 1 month. Negotiates pay.

‡**MOTOWN RECORD CO., L.P.**, 5750 Wilshire Blvd., Suite 300, Los Angeles CA 90036. (213)634-3500. Fax: (213)954-0209. Art Director: Jackie Salway. Estab. 1959. Produces CDs, tapes and video. Produces R&B, jazz, soul and rap. Recent releases: "End of the Road," by Boyz II Men; *All 4 One One 4 All*, by East Coast Family and *Cooly High Harmony*, by Boyz II Men.

Needs: Produces 11 soloists and 9 groups/year. Works with 8 artists/year. Prefers artists with experience in computer graphics (QuarkXPress and Adobe Photoshop). Uses artists for CD cover, tape cover and advertising design and illustration; catalog design, illustration and layout; posters and video box set special packaging. 100% of freelance work demands computer skills.

First Contact & Terms: Send query letter with tearsheets, résumé, slides and photocopies. Samples are filed or are returned by SASE if requested. Reports back only if interested. Call for appointment to show portfolio of final art and b&w and color tearsheets, photographs and slides. Pays by the project, $2,500-15,000. Buys all rights.

MUSIC FOR LITTLE PEOPLE/EARTHBEAT! RECORD COMPANY, P.O. Box 1460, Redway CA 95560. (707)923-3991. Fax: (707)923-3241. Creative Director: Sandy Bassett. Estab. 1984. Produces music, interactive CD-ROM and collateral materials. "The Music For Little People label specializes in culturally diverse, nurturing music for families and children. EarthBeat! promotes an eclectic, global vision that allows cultural barriers to disappear and reveals music to be a truly unifying force." Recent releases: *Sacred Ground*, by Sweet Honey In The Rock; *A Child's Celebration of Rock & Roll*, by various artists; *Tribal Winds*, by various Native American artists; *Adventures at Catfish Pond*, by Catfish Hodge; *Ancient Tower*, with Meryl Streep, Robert Lepley and New York voices.

Needs: Produces about 20 releases/year. All work done on a freelance, contractual basis. Uses freelancers also for interactive CD-ROM projects. Prefers illustrators specializing in portraying diverse cultures: kids and adults in imaginative, lively scenes for CD/cassette cover and booklet art. Works on assignment only. 80% of design and 20% of illustration demand knowledge of QuarkXPress, Adobe Photoshop, Adobe Illustrator and Live Picture.

First Contact & Terms: Send query letter with résumé, tearsheets, photocopies and/or Macintosh compatible floppy disk. Accepts disk submissions. Samples are filed or are returned by SASE if requested by artist. Reports back only if interested. Frequently reviews portfolios. To show portfolio, mail or fax roughs.

Tips: This company looks for a "vibrant, lively, non-derivative style."

NERVOUS RECORDS*, 7-11 Minerva Rd., London NW10 6HJ England. (01)963-0352. Fax: (01)963-1170. E-mail: 100613.3456@compuserve.com. Website: http://www.184.72.60.86.www/nervousrecords. Contact: R. Williams. Produces CDs, tapes and albums: rock and rockabilly. Recent releases: *Shock Rock*, by The Elektraws.

Needs: Produces 9 albums/year. Works with 5 freelance designers and 2 illustrators/year. Uses freelancers for album cover, brochure, catalog and advertising design and multimedia projects. 50% of design and 75% of illustration demand knowledge of Page Plus II and Microsoft Word 6.0.

First Contact & Terms: Send query letter with postcard samples; material may be kept on file. Write for appointment to show portfolio. Accepts disk submissions compatible with PagePlus and Microsoft Word. Samples not filed are returned by SAE (nonresidents include IRC). Reports only if interested. Original art returned at job's completion. Pays for design by the project, $10-500. Pays for illustration by the project, $10-100. Considers available budget and how work will be used when establishing payment. Buys first rights.

Tips: "We have noticed more use of imagery and caricatures in our field so fewer actual photographs are used." Wants to see "examples of previous album sleeves, in keeping with the style of our music. Remember, we're a rockabilly label."

NEW EXPERIENCE RECORDS/GRAND SLAM RECORDS, P.O. Box 683, Lima OH 45802. President: James Milligan. Estab. 1989. Produces tapes, CDs and records: rock, jazz, pop, R&B, soul, folk, gospel, country/western, rap by solo artists and groups. Recent releases: "You Promise Me Love," by The Impressions; and "He'll Steal Your Heart," by Barbara Lomus/BT Express.

Needs: Produces 5-10 solo artists and 4-6 groups/year. Works with 2-3 freelancers/year. Works with artist reps. Prefers freelancers with experience in album cover design. "Will consider other ideas." Works on assignment only. Uses freelancers for CD/tape cover design and illustration; brochure and advertising design; catalog layout; posters. 50% of freelance work demands knowledge of Aldus PageMaker.

First Contact & Terms: Send query letter with brochure, résumé, photocopies and photographs. Samples are filed. Reports back within 6 weeks. Artist should follow up with letter or phone call. Call or write for appointment to show portfolio of b&w roughs, final art and photographs. Pays for design by the project, $250-500. Buys one-time rights or reprint rights.

NORTH STAR MUSIC INC., 22 London St., East Greenwich RI 02818. (401)886-8888. Fax: (401)886-8886. Vice President: Paul Mason. Estab. 1985. Produces CDs and tapes: jazz, classical, folk, traditional, contemporary, world beat, New Age by solo artists and groups. Recent releases: *The Very Thought of You*,

by The North Star Jazz Ensemble; *Songs of the Spirit*, by Robin Spielberg; and *Primal Colors*, by Emilio Kauderer.

Needs: Produces 8 solo artists and 8 groups/year. Works with 4 freelancers/year. Prefers freelancers with experience in CD and cassette cover design. Works on assignment only. Uses artists for CD/tape cover and brochure design and illustration; catalog design, illustration and layout; direct mail packages. 80% of design and 20% of illustration demand knowledge of QuarkXPress 3.3.

First Contact & Terms: Send postcard sample or query letter with brochure, photocopies and SASE. Accepts disk submissions compatible with QuarkXPress 3.3. Send EPS or TIFF files. Samples are filed. Reports back to the artist only if interested. To show portfolio, mail color roughs and final art. Pays for design by the project, $500-1,000. Buys first rights, one-time rights or all rights.

Tips: "Learn about our label style of music/art. Send appropriate samples."

NUCLEUS RECORDS, Box 282, 885 Broadway, Bayonne NJ 07002. President: Robert Bowden. Produces albums and tapes: country/western, folk and pop. Recent releases: "4 O'clock Rock" and "Always," by Marco Sission.

Needs: Produces 2 records/year. Artists with 3 years' experience only. Works with 1 freelance designer and 2 illustrators/year on assignment only. Uses freelancers for album cover design. 25% of design and 20% of illustration demand knowledge of Adobe Illustrator and Adobe Photoshop.

First Contact & Terms: Send query letter with résumés, SASE, printed samples and photographs. Write for appointment to show portfolio of photographs. Accepts disk submissions. Samples are returned. Sometimes requests work on spec before assigning a job. Pays for design by the project, $150-200. Pays for illustration by the project, $125-150. Reports within 1 month. Originals returned at job's completion. Considers skill and experience of artist when establishing payment. Buys all rights. Finds new artists through submissions and design studios.

‡OH BOY RECORDS, 33 Music Square W., Suite 102A, Nashville TN 37066. (615)742-1250. Fax: (615)742-1360. Produces CDs: folk, gospel, jazz, pop. "Lost Dogs and Mixed Blessings," by John Prine; "Mascara Falls," by Heather Eatman.

Needs: Produces 6-10 releases/year. Works with 4 freelancers/year. Prefers local designers who own Mac with experience in film output. Uses freelancers for CD booklet design and illustration, poster and advertising design. 100% of freelance work demands knowledge of QuarkXPress, Adobe Photoshop and Aldus FreeHand.

First Contact & Terms: Send query letter with brochure, transparencies, photographs, slides and SASE. Accepts disk submissions compatible with Mac. Samples are not filed and are returned by SASE. Will contact for portfolio review if interested. Pays for design by the project, $100-2,000. Buys all rights.

‡OMNI CAST CORPORATION, (formerly T.O.G. Music Enterprises), 2107 S. Oakland St., Arlington VA 22204. (703)685-0199. President: Teo Graca. Estab. 1988. Produces CDs, tapes, CD-ROM and movies: rock & roll, jazz, pop, R&B, soul, progressive, classical, folk, gospel, country/western, rap, fusion, independent and novelty by solo artists and groups.

● Omni Cast Corporation also airs a TV program called "Couch Potatoes." They need 3D animation.

Needs: Uses artists for CD cover design and illustration; tape cover design and illustration.

First Contact & Terms: Send postcard sample and SASE. Samples are filed and are returned by SASE if requested by artist. Reports back within 2-6 weeks. Pays for design by the project, $25-1,000. Rights purchased vary according to project.

Tips: "Be willing to work on spec or to share in the success of a project rather than expecting upfront monies."

ONE STEP TO HAPPINESS MUSIC, % Jacobson & Colfin, P.C., 156 Fifth Ave., New York NY 10010. (212)691-5630. Fax: (212)645-5038. Attorney: Bruce E. Colfin. Produces CDs, tapes and albums: reggae group and solo artists. Release: "Make Place for the Youth," by Andrew Tosh.

Needs: Produces 1-2 soloists and 1-2 groups/year. Works with 1-2 freelancers/year on assignment only. Uses artists for CD/album/tape cover design and illustration.

First Contact & Terms: Send query letter with brochure, résumé and SASE. Samples are filed or returned by SASE if requested by artist. Reports back within 6-8 weeks. Call or write for appointment to show portfolio of tearsheets. Pays by the project. Rights purchased vary according to project.

OPUS ONE, Box 604, Greenville ME 04441. (207)997-3581. President: Max Schubel. Estab. 1966. Produces CDs, LPs, 78s, contemporary American concert and electronic music.

Needs: Produces 6 releases/year. Works with 1-2 freelancers/year. Prefers freelancers with experience in commercial graphics. Uses freelancers for CD cover design.

First Contact & Terms: Send postcard sample or query letter with rates and example of previous artwork. Samples are filed. Reports back within 3-5 days. Pays for design by the project. Buys all rights. Finds artists through meeting them in arts colonies, galleries or by chance.

Tips: "Contact record producer directly. Send samples of work that relate in size and subject matter to what Opus One produces."

‡**ORINDA RECORDS**, P.O. Box 838, Orinda CA 94563. (510)833-7000. A&R Director: H. Balk. Produces CDs and tapes: jazz, pop, classical by solo artists and groups.
Needs: Works with 6 visual artists/year. Works on assignment only. Uses artists for CD cover design and illustration; tape cover design and illustration.
First Contact & Terms: Send postcard sample or query letter with photocopies. Samples are filed and are not returned. Reports back to the artist only if interested. Write for appointment to show portfolio of b&w and color photographs. Pays for design by the project. Rights purchased vary according to project.
Tips: "Keep current."

PAVEMENT MUSIC, INC., 17W703A Butterfield Rd., Oakbrook Terrace IL 60181. (708)916-1155. Fax: (708)916-1159. E-mail: pvmnt@aol.com. Vice President: Lorraine Margala. Estab. 1993. Produces CDs, tapes and video: rock, pop, alternative, metal. Recent releases: *Better Class of Losers*, by L.U.N.G.S; *Voracious Contempt*, by Internal Bleeding; and *Time Heals Nothing*, by Crowbar.
Needs: Produces 24 releases/year. Works with 20 freelancers/year. 50% of design and 5% of illustration demand knowledge of QuarkXPress and Adobe Photoshop.
First Contact & Terms: Send query letter with brochure, SASE. Samples are filed or returned by SASE if requested by artist. Art Director will contact artist for portfolio review if interested. Portfolio should include photocopies. Pays by the project, $100-1,000. Rights purchased vary according to project.
Tips: "We're mostly looking for cover art. Many of the artists we hire were suggested to us by the group in question—befriend a band."

‡**PPI ENTERTAINMENT GROUP**, 88 St. Francis St., Newark NJ 07105. (201)344-4214. Creative Director: Dave Hummer. Estab. 1923. Produces CDs and tapes: rock and roll, dance, soul, pop, educational, rhythm and blues; aerobics and self-help videos; group and solo artists. Also produces children's books, cassettes and CD-ROMs. Recent releases: "Rock & Soul," by Sugar Minott and "Manhattan Blues," by Manhattan Jazz Quintet Reunion.
Needs: Produces 200 records and videos/year. Works with 10-15 freelance designers/year and 10-15 freelance illustrators/year. Uses artists for album cover design and illustration; brochure, catalog and advertising design, illustration and layout; direct mail packages; posters; and packaging. 80% of freelance work demands computer literacy in "All Mac and any of the following: Aldus PageMaker, Quark XPress, Aldus FreeHand or Adobe Illustrator."
First Contact & Terms: Works on assignment only. Send query letter with samples to be kept on file; call or write for appointment to show portfolio. Prefers photocopies or tearsheets as samples. Samples not filed are returned only if requested. Reports only if interested. Original artwork returned to artist. Pays by the project. Considers complexity of project and turnaround time when establishing payment. Purchases all rights.

‡**PUTUMAYO WORLD MUSIC**, 627 Broadway, 8th Floor, New York NY 10012. (212)995-9400. Fax: (212)420-9174. E-mail: putumayo@aol.com. Vice President: Lynn Grossman. Estab. 1974. Produces CDs, cassettes: folk, world. Recent releases: *Women of the World: Celtic*; *Women of the World: International*.
Needs: Produces 10 releases/year. Works with 1-4 freelancers/year. Prefers local designers who own computers with experience in digi pak CDs. Uses freelancers for album and cassette cover illustration and World Wide Web page design. 90% of design demands knowledge of QuarkXPress, Adobe Photoshop.
First Contact & Terms: Send postcard sample. Samples are not filed and are returned by SASE if requested. Will contact for portfolio review of final art if interested. Pays by the project.
Tips: "We use a CD-digi pak rather than the standard jewel box."

‡**QUALITY RECORDS**, 15260 Ventura Blvd., Suite 980, Sherman Oaks CA 91403. (818)905-9250. Fax: (818)905-7533. Art Director: SaraJane Smith. Estab. 1990. Produces CDs and tapes: rock & roll, pop and rap; solo and group artists. Recent releases: *Jointz From Back in da Day, Dance Mix USA*, compilations; *Brewed in South Central*, Juvenile Style.
Needs: Produces 5 soloists and 3 groups/year. Works with 3-5 visual artists/year. Uses artists for CD cover, tape cover and advertising design and illustration and posters. 90% of freelance work demands knowledge of Adobe Illustrator and Adobe Photoshop.
First Contact & Terms: Send query letter with brochure, tearsheets and photographs. Samples are filed or returned by SASE if requested. Does not report back, in which case the artist should call. Call for appointment to show portfolio, which should include final art and b&w and color tearsheets and photographs. Pays by the project. Buys all rights.

✝ **THE DOUBLE DAGGER** before a listing indicates that the listing is new in this edition. New markets are often more receptive to freelance submissions.

❦**RAMMIT RECORDS**, 414 Ontario St., Toronto, Ontario M5A 2W1 Canada. (416)923-7611. Fax: (416)923-3352. President: Trevor G. Shelton. Estab. 1988. Produces CDs, tapes and 12-inch vinyl promos for CDs: rock, pop, R&B and soul by solo artists and groups. Recent releases: *2 Versatile*, by 2 Versatile, hip hop/R&B, A&M distribution; *Hopping Penguins*, by Trombone Chromosome, ska/reggae, MCA distribution; *Line Up In Paris*, by Line Up in Paris, rock, A&M distribution.
Needs: Produces 4 releases/year. Works with 3-5 freelancers/year. Uses freelancers for CD cover design and illustration, tape cover illustration, advertising design and posters. 75% of freelance work demands computer skills.
First Contact & Terms: Send query letter with "whatever represents you the best." Reports back to the artist only if interested. Artist should follow-up with call and/or letter after initial query. Portfolio should include b&w and color photostats. Pays for design by the project, $1,000-3,000. Negotiates rights purchased. Finds artists through word of mouth, referrals and directories.

RCA RECORDS/BMG, 1133 Avenue of the Americas, New York NY 10036. Does not need freelance artists at this time.

‡**RED ROCKET RECORDS, USA**, 213 12th Ave. E., Seattle WA 98102. (206)322-2154. E-mail: info-rama@redrocket.com. Director of A&R: Curtis Crawford. Estab. 1991. Produces albums, CDs, CD-ROMs, cassettes and video. Recent releases: "L.O.V.Evil," by Second Coming; "Silver Mirror," by China Rose.
Needs: Produces 5-10 releases/year. Works with 2-4 freelancers/year. Prefers designers who own IBM computers. Uses freelancers for album, cassette and CD cover design and illustration; brochure, catalog and CD booklet design and illustration; animation; CD-ROM design and packaging; poster and World Wide Web design; direct mail packages and multimedia projects. 70% of design and 50% of illustration demand knowledge of Aldus PageMaker, Adobe Illustrator, Adobe Photoshop, CorelDraw.
First Contact & Terms: Send query letter with color copies. Samples are filed or returned by SASE if requested. Does not report back. Artist should follow-up by letter or e-mail. Will contact for portfolio review of samples of work if interested. Pays by the projdect, $25-500. Buys all rights. Finds artists through referrals.

‡**RELATIVITY RECORDINGS**, 79 Fifth Ave., New York NY 10003. (212)337-5300. Fax: (212)337-5374. Art Director: David Bett. Estab. 1979. Produces albums, CDs and cassettes: R&B, rap and urban. Recent releases: "Jealous One's Envy," by Fat Joe; "Smile Now Die Later," by Frost.
Needs: Produces 20-40 releases/year. Works with 10 freelancers/year. Prefers designers who own Macs. Uses freelancers for album, cassette and CD cover, CD booklet illustration and logos. 10-20% of illustration demands knowledge of Adobe Illustrator, QuarkXPress, Adobe Photoshop, Aldus FreeHand.
First Contact & Terms: Send postcard sample. Samples are filed. Will contact for portfolio review of b&w and color photocopies and photographs if interested. Pays for illustration by the project, $500-2,500. Buys one-time rights. Finds artists through submissions and word of mouth.

‡**REPTILE RECORDS**, P.O. Box 121213, Nashville TN 37212. (615)331-7400. Fax: (615)331-5412. Contact: Scott Tutt. Estab. 1987. Produces CDs, tapes and albums: rock and roll and country/western. Recent releases: *My Own Time*, by Susan Marshall; *Rock-a-billy in 3-D*, by Justin Curtis.
Needs: Produces 1 soloist and 1 group/year. Works with 2-3 visual artists/year. Prefers local artists only. Works on assignment only. Uses artists for CD and album/tape cover design and illustration.
First Contact & Terms: Send query letter with brochure, tearsheets, résumé, photographs and photocopies. Samples are filed or are returned by SASE if requested by artist. Reports back only if interested. To show a portfolio, mail thumbnails, roughs, b&w and color tearsheets, photographs and photocopies. Pays by the project, $50 minimum. Buys all rights.
Tips: "Past credits usually help when selecting the artist but good work speaks for itself!"

‡**RESTLESS RECORDS**, 1616 Vista Del Mar Ave., Hollywood CA 90028. (213)957-4357. Fax: (213)957-4355. E-mail: restless.com. Website: http://www.restless.com. Marketing Manager: Lyndsey Parker. Estab. 1991. Produces CDs, cassettes, occasional vinyl 12", 10 " and 7": pop, alternative, rock by solo artists and groups. Recent releases: *Mood Elevator*, by Jack Logan; *The Blue Moods of Spain*, by Spain.
Needs: Produces 10 releases/year. Prefers local designers who own Mac. Uses freelancers for cassette and CD cover and CD booklet design and illustration. 100% of design demands knowledge of QuarkXPress 3.31 and Adobe Photoshop 2.5.
First Contact & Terms: Send query letter with brochure, résumé, transparencies, photocopies and/or tearsheets. Samples are filed or returned by SASE if requested by artist. Will contact for portfolio review of color and final art if interested. Pays by the project. Rights purchased vary according to project.

‡**RHINO RECORDS**, 10635 Santa Monica Blvd., Los Angeles CA 90025. (310)474-4778. Fax: (310)441-6579. Manager, Art Department Services: John Sperling. Estab. 1977. Produces albums, CDs, CD-ROMs, cassettes: country, folk, gospel, jazz, pop, progressive, R&B, rap, rock, soul. Recent releases: *Cocktail Mix Vol. 1-3*, by various; *People Get Ready: The Curtis Mayfield Story*, by Curtis Mayfield.

Needs: Produces 200 releases/year. Works with 10 freelancers/year. Prefers local designers and illustrators who own Mac computers. Uses freelancers for album, cassette and CD cover design and illustration; CD booklet design and illustration; and CD-ROM design and packaging. 100% of design demands knowledge of Adobe Illustrator, QuarkXPress, Adobe Photoshop, Aldus FreeHand.
First Contact & Terms: Send postcard sample. Accepts disk submissions compatible with Mac. Samples are filed. Does not report back. Artist should "keep us updated." Portfolios of tearsheets may be dropped off every Tuesday. Buys one-time rights. Rights purchased vary according to project. Finds artists through word of mouth, sourcebooks.

RHYTHMS PRODUCTIONS, Box 34485, Los Angeles CA 90034. President: R.S. White. Estab. 1955. Produces albums, tapes, multimedia items and books: educational children's. Release: *First Reader's Kit.*
Needs: Works on assignment only. Prefers Los Angeles artists. All cassettes have covers/jackets designed and illustrated by freelance artists. Works with 1-2 artists/year with experience in cartooning and graphic design. Uses freelance artists for album/tape cover design and illustration and children's books. Needs computer-literate freelancers for design animation, illustration and production.
First Contact & Terms: Send query letter photocopies and SASE. Samples are filed or are returned by SASE if requested. Reports within 1 month. "We do not review portfolios unless we have seen photocopies we like." Pays by the project. Buys all rights.
Tips: "We like illustration that is suitable for children. We find that cartoonists have the look we prefer. However, we also like art that is finer and that reflects a 'quality look' for some of our more classical publications."

ROCK DOG RECORDS, P.O. Box 3687, Hollywood CA 90028-9998. (213)661-0259. E-mail: patt2@netc om.com. President, A&R and Promotion: Gerry North. Estab. 1987. Produces CDs and tapes: rock, R&B, dance, New Age, contemporary instrumental, ambient and music for film, TV and video productions. Recent releases: *Variations on a Dream*, by Brainstorm; *Circadian Breath*, by Elijah; and *Uninvited Visitor*, by Empath.
- This company has a second location at P.O. Box 884, Syosset, NY 11791-0899. Fax: (516)364-1998. A&R, Promotion and distribution: Maria Cuccia.
Needs: Produces 2-3 solo artists and 2-3 groups/year. Works with 5-6 freelance illustrators/year. Prefers freelancers with experience in album art. Uses artists for CD album/tape cover design and illustration, direct mail packages, multimedia projects, ad design and posters. 95% of design and 75% of illustration demand knowledge of Print Shop or Adobe Photoshop.
First Contact & Terms: Send postcard sample or query letter with photographs, SASE and photocopies. Accepts disk submissions compatible with DOS. Send Bitmap, TIFF, GIF or JPG files. Samples are filed or are returned by SASE. Reports back within 2 weeks. To show portfolio, mail photocopies. Sometimes requests work on spec before assigning a job. Pays for design by the project, $50-500. Pays for illustration by the project, $50-500. Interested in buying second rights (reprint rights) to previously published work. Finds new artists through submissions from artists who use *Artist's & Graphic Designer's Market.*
Tips: "Be open to suggestions; follow directions. Don't send us pictures, drawings (etc.) of people playing an instrument. Usually we are looking for something abstract or conceptual."

ROTTEN RECORDS, P.O. Box 2157, Montclair CA 91763. (909)624-2332. Fax: (909)624-2392. E-mail: rotten@primenet.com. Website: http://www.PrimeNet.com/~Rotten. President: Ron Peterson. Estab. 1988. Produces CDs and tapes: rock by groups. Recent releases: *Pomona Queen*, by Street Cleaners; and *Full Speed Ahead*, by D.R.I.
Needs: Produces 4-5 releases/year. Works with 3-4 freelancers/year. Uses freelancers for CD/tape cover design; and posters. Needs computer-literate freelancers for desigin, illustration, production.
First Contact & Terms: Send postcard sample of work or query letter with photocopies, tearsheets (any color copies samples). Samples are filed and not returned. Reports back to the artist only if interested. Artist should follow-up with call. Portfolio should include color photocopies. Pays for design and illustration by the project.

‡*SCOTDISC B.G.S. PRODUCTIONS LTD., Newtown St., Kilsyth, Glasgow G65 0JX Scotland. 01236-821081. Director: Dougie Stevenson. Produces rock and roll, country, jazz and folk; solo artists. Recent releases: *Scottish Love Songs*, by Ronnie Browne (of the Corries); *Highland Holiday* by Tommy Scott; and *Ceilidh* by Jim Macleod.
Needs: Produces 15-20 records/videos per year. Uses 2 visual artists/year for album cover design and illustration; brochure design, illustration and layout; catalog design, illustration and layout; advertising design, illustration and layout; posters.
First Contact & Terms: Send postcard sample or brochure, résumé, photocopies and photographs to be kept on file. Call or write for appointment to show portfolio. Accepts disk submissions compatible with Adobe Illustrator 3.2 or Aldus FreeHand 3.0. Send Mac formatted EPS files. Samples not filed are returned only if requested. Reports only if interested. Pays by the hour, $20 average. Considers available budget when establishing payment. Buys all rights.

SELECT RECORDS, 16 W. 22nd St., 10th Floor, New York NY 10010. (212)691-1200. Fax: (212)691-3375. Art Director: Ian Thornell. Produces CDs, tapes, 12-inch singles and marketing products: rock, R&B, rap and comedy solo artists and groups. Recent releases: *Jerky Boys II*, by Jerky Boys; and *To the Death*, by M.O.P.

Needs: Produces 6-10 releases/year. Works with 6-8 freelancers/year. Prefers local freelancers with experience in computer (Mac). Uses freelancers for CD/tape cover design and illustration, brochure design, posters. 70-80% of freelance work demands knowledge of Adobe Illustrator, QuarkXPress, Adobe Photoshop and Aldus FreeHand.

First Contact & Terms: Send postcard sample of work or query letter with photostats, transparencies, slides and tearsheets. Samples are not filed or returned. Portfolios may be dropped off Monday-Friday. Art Director will contact artist for portfolio review if interested. Portfolio should include slides, transparencies, final art and photostats. Payment depends on project and need. Rights purchased vary according to project. Finds artists through submissions, *Black Book*, agents.

Tips: Impressed by "good creative work that shows you took chances; clean presentation."

JERRY SIMS RECORDS, Box 648, Woodacre CA 94973. (415)789-8322. Owner: Jerry Sims. Estab. 1984. Produces CDs and tapes: rock, R&B, classical. Recent releases: *Viaggio* and *December Days*, by Coral; and *King of California*, by Chuck Vincent.

Needs: Produces 4-5 releases/year. Works with 4-5 freelancers/year. Prefers local artists with experience in album cover art. Uses freelancers for CD cover design and illustration; tape cover and advertising illustration; catalog design; posters. 50% of freelance work demands computer skills.

First Contact & Terms: Send query letter with brochure and résumé. Samples are filed. Art Director will contact artist for portfolio review if interested. Portfolio should include photographs. Pays for design and illustration by the project. Buys one-time rights.

SIRR RODD RECORD & PUBLISHING COMPANY, 2453 77th Ave., Philadelphia PA 19150-1820. President: Rodney J. Keitt. Estab. 1985. Produces disco, soul, jazz, pop, R&B by group and solo artists. Releases: *Fashion & West Oak Lane Jam*, by Klassy K; and *The Essence of Love/Ghetto Jazz*, by Rodney Jerome Keitt.

Needs: Produces 2 solo artists and 3 groups/year. Works with 1 freelancer/year on assignment only. Uses freelancers for album cover and advertising design and illustration, direct mail packages and posters.

First Contact & Terms: Send query letter with résumé, photostats, photocopies and slides. Samples are filed and are not returned. Reports back within 2 months. Write for appointment to show portfolio of color thumbnails, roughs, final reproduction/product, photostats and photographs. Pays by the project, $100-3,500. Buys reprint rights or negotiates rights purchased.

Tips: "Treat every project as though it were a major project. Always request comments and criticism of your work."

‡SOLAR RECORDS/J. HINES CO., 1635 N. Cahuenga Blvd., Hollywood CA 90028. (213)461-0390. Fax: (213)461-9032. Art Director: Orietta Murdock. Estab. 1972. Produces albums, CDs, cassettes and videos: gospel, jazz, R&B, rap, soul and Latin. Recent releases: *One Million Strong*, (soundtrack from *Million Man March*) featuring 2 Pac, Notorious B.I.G., B.O.N.E., Thugs n Harmony, Dr. Dre, Ice T., Snoop Dogg; and *Rated G*, by Top Authority.

Needs: Produces 20 releases/year. Prefers designers who own Mac with experience in rap music. Uses freelancers for album cover illustration. 30% of design demands knowledge of Adobe Illustrator, QuarkXPress and Adobe Photoshop.

First Contact & Terms: Send postcard sample. Samples are filed. Will contact for portfolio review if interested. Pays by the project. Buys all rights.

‡SOLID ENTERTAINMENT INC., (formerly AVC Entertainment), 11300 Magnolia Blvd., Suite 1000, North Hollywood CA 91601. (818)763-3535. President: James Warsinske. Estab. 1989. Produces CDs and tapes: rock & roll, R&B, soul, dance, rap and pop by solo artists and groups. Recent releases: *Let It Be Right*, by Duncan Faure; *Knowledge to Noise*, Madrok; *Push Harder*, 7th Stranger; *Psycho Love Child*, by Psycho Love Child.

Needs: Produces 2-6 soloists and 2-6 groups/year. Uses 4-10 visual artists for CD and album/tape cover design and illustration; brochure design and illustration; catalog design, layout and illustration; direct mail packages; advertising design and illustration. 50% of freelancers work demands knowledge of Aldus Page-Maker, Adobe Illustrator, QuarkXPress, Adobe Photoshop.

First Contact & Terms: Send query letter with SASE, tearsheets, photographs, photocopies, photostats, slides and transparencies. Samples are filed. Reports back within 1 month. To show portfolio, mail roughs, printed samples, b&w and color photostats, tearsheets, photographs, slides and transparencies. Pays by the project, $100-1,000. Buys all rights.

Tips: "Get your art used commercially, regardless of compensation. It shows what applications your work has."

SONIC IMAGES RECORDS, P.O. Box 691626, W. Hollywood CA 90069. (213)650-1000. Fax: (213)650-1016. E-mail: sonicimages@sonicimages.com. Art Director: Darwin Foye. Estab. 1990. Produces CDs and tapes: acid jazz, ambient and sound tracks by solo artists and groups. Recent releases: *Babylon 5*, by Christopher Franke; and *Live*, by ShadowFax.
Needs: Produces 10 releases/year. Works with 10 freelancers/year. Prefers artists with experience in Macintosh. Uses freelancers for CD cover design; tape cover illustration. 50% of freelance work demands computer skills.
First Contact & Terms: Send query letter with brochure. Samples are filed. Reports back within 5 weeks. Portfolios of color final art may be dropped off every Friday. Pays $1,200 minimum for design. Buys all rights. Finds artists through word of mouth.

‡SOUND ACHIEVEMENT GROUP, INC., P.O. Box 24625, Nashville TN 37202. (615)883-2600. Fax: (615)885-7353. A&R Director: Royce Gray. Estab. 1985. Produces CDs, tapes and videos: gospel by solo artists and groups. Recent releases: "Another Alternative," by Jeff Deyd; "Tapestry of Praise," by Darla McFabben.
Needs: Produces 6 solo artists and 8 groups/year. Works with 3 visual artists/year. Prefers local artists only. Works on assignment only. Uses artists for CD cover design and illustration; tape cover design and illustration; advertising design. 40% of freelance work demands knowledge of CorelDraw.
First Contact & Terms: Send query letter with brochure and SASE. Samples are not filed and are returned by SASE. Reports back to the artist only if interested Call for appointment to show portfolio of b&w and color samples. Pays for design by the project, $50-400. Buys all rights.

SOUND SOUND SAVAGE FRUITARIAN PRODUCTIONS, P.O. Box 22999, Seattle WA 98122-0999. (206)322-6866. Fax: (206)720-0075. Owner: Tom Fallat. Estab. 1991. Produces CDs and tapes: rock, jazz, pop, R&B, soul, progressive, classical, folk, gospel, country/western, rap. Recent releases: *Victim of the Gat*, by Lethal Crew; and *The Ocean Shows The Sky*, by Joe Panzetta.
Needs: Produces 5 releases/year. Works with 6 freelancers/year. Freelancers should be familiar with Aldus PageMaker, Adobe Illustrator and Adobe Photoshop.
First Contact & Terms: Send postcard sample of work or send query letter with brochure, photocopies, photographs and SASE. Samples are filed or are returned by SASE if requested by artist. Reports back within 2 months. Art Director will contact artist for portfolio review if interested. Portfolio should include b&w and color final art, photocopies, photographs. Pays for design and illustration by the project. Negotiates rights purchased. Finds artists through word of mouth or by seeing their existing work.
Tips: "Volunteer to do first project for a reduced fee to have work to submit to different companies."

STARDUST RECORDS/WIZARD RECORDS, 341 Billy Goat Hill Rd., Winchester TN 37398. Fax: (615)649-2732. Contact: Col. Buster Doss, Box 13, Estill Springs TN 37330. (615)649-2577. Produces CDs, tapes and albums: rock, folk, country/western. Recent releases: *Movin' Out, Movin' Up, Movin' On*, by "Danny Boy" Squire; *Rainbow of Roses*, by Larry Johnson; and *Keeping Country, Country*, by Dwane Hall.
Needs: Produces 12-20 CDs and tapes/year. Works with 2-3 freelance designers and 1-2 illustrators/year on assignment only. Uses freelancers for CD/album/tape cover design and illustration; brochure design; and posters.
First Contact & Terms: Send query letter with brochure, tearsheets, résumé and SASE. Samples are filed. Reports back within 1 week. Call for appointment to show portfolio of thumbnails, b&w photostats. Pays by the project, $300. Buys all rights. Finds new artists through *Artist's & Graphic Designer's Market*.

‡TELARC INTERNATIONAL, 23307 Commerce Park Rd., Cleveland OH 44122. (216)464-2313. Fax: (216)360-9663. Art Director: Anilda Ward. Estab. 1915. Produces albums, CDs, cassettes: classical, jazz, R&B by solo artists and groups. Recent releases: *Young Lions & Old Tigers*, by Dave Brubeck; *Oscar Peterson Christmas*, by Oscar Peterson.
Needs: Produces 59 releases/year. Works with 12 freelancers/year. Prefers designers who own Macs. Uses freelancers for album, cassette and CD cover illustration. 60% of illustration demands knowledge of QuarkXPress, Adobe Photoshop 3.0, Aldus FreeHand 5.1.
First Contact & Terms: Send postcard sample and/or query letter with brochure, photocopies, tearsheets. Accepts disk submissions compatible with Mac. Samples are filed and are not returned. Will contact for portfolio review of b&w and color final art, photographs, slides and transparencies. Pays for illustration by the project, $1,500-7,000. Negotiates rights purchased. Finds artists through word of mouth, submissions, sourcebooks.

TOM THUMB MUSIC, (division of Rhythms Productions), Box 34485, Los Angeles CA 90034. President: Ruth White. Record and book publisher for children's market.
Needs: Works on assignment only. Prefers local freelancers with cartooning talents and animation background. Uses freelancers for catalog cover and book illustration, direct mail brochures, layout, magazine ads, multimedia kits, paste-up and album design. Needs computer-literate freelancers for animation. Artists must have a style that appeals to children.

First Contact & Terms: Buys 3-4 designs/year. Send query letter with brochure showing art style or résumé, tearsheets and photocopies. Samples are filed or are returned by SASE. Reports back within 3 weeks. Pays by the project. Considers complexity of project, available budget and rights purchased when establishing payment. Buys all rights on a work-for-hire basis.

***TOP RECORDS**, 4, Galleria del Corso, Milano Italy. (02)76021141. Fax: 0039/2/76021141. Estab. 1975. Produces CDs, tapes, albums: rock, rap, R&B, soul, pop, folk, country/western, disco; solo and group artists. Recent releases: "Raga-ragazzina," by Alex Nardi; "Cocktail d'amore," by Alessandra; "Inside Myself," by Claudia Delon; and "Al mercato dell'usato," by Paolo Luciani.
Needs: Produces 5 solo artists and 5 groups/year. Works with 2 freelancer/year on assignment only.
First Contact & Terms: Send query letter with brochure. Samples are filed but not returned, unless requested and paid for by the artist. Reports back within 1 month. Call for appointment to show portfolio or mail appropriate materials. Portfolio should include original/final art and photographs. Buys all rights.
Tips: "Have a new and original idea."

‡TOURMALINE, 894 Mayville, Bethel ME 04217. Phone/fax: (207)824-3246. Contact: Conni. Estab. 1987. Produces albums, CDs and cassettes: jazz, progressive, spokenword, avant-garde. Recent releases: *The Holy Babble*, by Willie "Loco" Alexander; and *Scrawls from the Unconscious*, by Forest Floor.
Needs: Produces 5 releases/year. Works with 3-4 freelancers/year. Prefers local freelancers. Uses freelancers for album, cassette and CD cover design and illustration; animation; CD booklet design and illustration; poster design; World Wide Web page design; and catalog design. 50% of freelance work demands knowledge of Aldus Pagemaker 5.0 and Adobe Photoshop.
First Contact & Terms: Send postcard sample and/or query letter with photocopies. Accepts disk submissions compatible with Mac. Send EPS, Adobe Photoshop or Aldus PageMaker files. Samples are not filed and are returned by SASE. Will contact for portfolio review if interested. Pays by the project. Buys all rights.
Tips: "Indie labels and bands work with artists they know. If you like a band, offer your services. But you may have to get your foot in the door working on spec."

‡♥TRUE NORTH RECORDS/FINKELSTEIN MANAGEMENT CO. LTD., Suite 501, 151 John St., Toronto, Ontario M5V 2T2 Canada. (416)596-8696. Fax: (416)596-6861. Contact: Karin Doherty. Estab. 1969. Produces CDs, tapes and albums: rock and roll, folk and pop; solo and group artists. Recent releases: *Dart to the Heart*, by Bruce Cockburn; *Assassin's Apprentice*, by Stephen Fearing; and *Gin Palace*, by Barney Bentall.
Needs: Produces 2 soloist and 2 groups/year. Works with 4 designers and 1 illustrator/year. Prefers artists with experience in album cover design. Uses artists for CD cover design and illustration, album/tape cover design and illustration, posters and photography. 50% of freelance work demands computer skills.
First Contact & Terms: Send postcard sample, brochure, résumé, photocopies, photographs, slides, transparencies with SASE. Samples are filed or are returned by SASE if requested by artist. Reports only if interested. Pays by the project. Buys all rights.

‡TVT RECORDS, 23 E. Fourth St., New York NY 10003. (212)979-6418. Fax: (212)979-6489. E-mail: gknoll@tvtrecords.com. Website: http://www.tvtrecords.com. Art Director: Greg Knoll. Estab. 1982. Produces albums, CDs, CD-ROMs, cassettes: pop, progressive, R&B, rap, rock, industrial, alternative. Recent releases: *Gravity Kills*, by Gravity Kills; *Mortal Kombat Soundtrack*.
Needs: Produces 60-80 releases/year. Works with 10-20 freelancers/year. Prefers local freelancers and designers who own Macs. Uses freelancers for album cover design and illustration, CD booklet and catalog design and illustration and poster design. 100% of design and 2% of illustration demand knowledge of Adobe Illustrator, QuarkXPress, Adobe Photoshop, Aldus FreeHand.
First Contact & Terms: Send postcard sample and/or query letter with brochure and tearsheets. Accepts disk submissions only for multimedia—CD-ROM or diskette. Samples are filed and are not returned. Does not report back. Artist should not call. Portfolios of color final art may be dropped off every Monday. Pays for design by the project, $500 minimum. Pays for illustration by the project, $250 minimum. Rights purchased vary according to project. Finds artists through submissions.
Tips: "Send lots of mail but no e-mail. Do lots of work for smaller record companies before going for the big ones. Illustrators: don't send corporate art. Designers: send something that is uniquely your work. I don't hire generalists."

‡VIRGIN RECORDS, 338 N. Foothill Rd., Beverly Hills CA 90210. (310)278-1181. Fax: (310)288-1490. Art Director: Steve Gerdes. Designer: Tom Dolan. Uses freelancers for CD and album cover design and illustration. Send query letter with samples. Samples are filed. Reports back only if interested.

‡WAGON WHEEL RECORDS, P.O. Box 1115, New York NY 10276. Phone/fax: (212)477-2930. Co-Owner: Rick Wagner. Estab. 1993. Produces CDs: rock by solo artists and groups. Recent releases: *Pop Matters*, by various artists; *The Beat*, by The Beat.

Needs: Produces 3-5 releases/year. Works with 3-5 freelancers/year. Prefers designers who own Mac PCs. Uses freelancers for CD booklet and cover design and illustration, poster design, advertising, catalog design, newsletter. 85% of freelance work demands knowledge of Adobe Illustrator and QuarkXPress.
First Contact & Terms: Send postcard sample and/or query letter with tearsheets. Samples are filed. Will contact for portfolio review of final art, slides and tearsheets if interested. Pays by the project, $25-300. Rights purchased vary according to project. Finds artists through referrals and word of mouth.
Tips: "Do as many projects as possible and don't burn any bridges." Looks for "quality work, well organized with attention to detail."

‡**WARLOCK RECORDS, INC.**, 122 E. 25th St., Sixth and Seventh Floors, New York NY 10010. (212)673-2700. Fax: (212)677-4443. Art Director: Isabelle Wong. Estab. 1986. Produces CDs, tapes and albums: rhythm and blues, jazz, rap and dance. Recent releases: *You're Not Alone*, by Kim Waters; *Real Love*, by Little Johanna; and *Zooism*, by Poison Clan.
Needs: Produces 5 soloists and 12-15 groups/year. Works with 5 visual artists/year. Prefers artists with experience in record industry graphic art and design. Works on assignment only. Uses artists for CD and album/tape cover design; posters; and advertising design. Seeking artists who both design and produce graphic art, to "take care of everything, including typesetting, stats, etc."
First Contact & Terms: Send query letter with brochure, résumé, photocopies and photostats. Samples are filed and are not returned. "I keep information on file for months." Reports back only if interested; as jobs come up. Call to schedule an appointment to show a portfolio, or drop off for a day or half-day. Portfolio should include photostats, slides and photographs. Pays by the project, $50-1,000. Rights purchased vary according to project.
Tips: "Work for a low fee with one or two companies to gain experience in the recording industry and then remain loyal to them—you'll get experience and great recommendations."

WARNER BROS. RECORDS, 3300 Warner Blvd., Burbank CA 91505. (818)953-3361. Fax: (818)953-3232. Art Dept. Assistant: Michelle Barish. Produces the artwork for CDs, tapes and sometimes albums: rock, jazz, rap, R&B, soul, pop, folk, country/western by solo and group artists. Releases include: *Automatic for the People*, by R.E.M. Releases approximately 300 total packages/year.
Needs: Works with freelance art directors, designers, photographers and illustrators on assignment only. Uses freelancers for CD and album tape cover design and illustration; brochure design and illustration; catalog design, illustration and layout; advertising design and illustration; and posters. 100% of freelance work demands knowledge of Aldus PageMaker, QuarkXPress, Aldus FreeHand, Adobe Illustrator or Adobe Photoshop.
First Contact & Terms: Send query letter with brochure, tearsheets, résumé, slides and photographs. Samples are filed or are returned by SASE if requested by artist. Reports back to the artist only if interested. Submissions should include roughs, printed samples and b&w and color tearsheets, photographs, slides and transparencies. "Any of these are acceptable." Do not submit original artwork. Pays by the project.
Tips: "Send a portfolio—we tend to use artists or illustrators with distinct/stylized work—rarely do we call on the illustrators to render likenesses; more often we are looking for someone with a conceptual or humorous approach."

WATCHESGRO MUSIC, BMI—INTERSTATE 40 RECORDS, 9208 Spruce Mountain Way, Las Vegas NV 89134. (702)363-8506. President: Eddie Lee Carr. Estab. 1975. Produces CDs, tapes and albums: rock, country/western and country rock. Releases include: *The Old Cowboy*, by Don Williams; *What About Us*, by Scott Ellison; and *Eldorado*, by Del Reeves.
Needs: Produces 8 solo artists/year. Works with 3 freelancers/year for CD/album/tape cover design and illustration; and videos.
First Contact & Terms: Send query letter with photographs. Samples are filed or are returned by SASE. Reports back within 1 week only if interested. To show portfolio, mail b&w samples. Pays by the project. Negotiates rights purchased.

‡**WELK MUSIC GROUP**, 1299 Ocean Ave., #800, Santa Monica CA 90401. (310)451-5727. Fax: (310)394-4148. E-mail: vangardrec@aol.com or gcartwright@e-znet.com. Preproduction Coordinator: Georgette Cartwright. Estab. 1987. Produces CDs, tapes and albums; R&B, jazz, soul, folk, country/western, solo artists. Recent release: *Acoustic Traveler*, by John McEuen.
Needs: Produces 2 soloists and 6 groups/year. Works with 4 designers/year. Prefers artists with experience in the music industry. Uses artists for CD cover design and illustration, album/tape cover design and illustration; catalog design, illustration and layout; direct mail packages; advertising design. 100% of freelance work demands knowledge of QuarkXPress, Adobe Illustrator or Adobe Photoshop.
First Contact & Terms: Send postcard sample with brochure, photocopies, photographs and tearsheets. Samples are filed. Reports back only if interested. To show a portfolio, mail tearsheets and printed samples. Pays for design by the hour, $25-45; by the project, $800-2,000. Pays for illustration by the project, $200-500. Buys all rights.
Tips: "We need to have artwork for cover combined with CD booklet format."

INSIDER REPORT

Add Passion to Your Portfolio

When Steve Gerdes, art director for Virgin Records, stands in line at the bank waiting to cash his check, he sometimes sees a familiar face. One of the bank tellers was a former classmate from art school—the most talented in the class. It saddens him to see her waiting on customers instead of using her extraordinary gifts. "There is no greater gift than the gift of creativity," says Gerdes. "Yet from the time we're very young, society discourages artists. I don't know how many times people told me, 'Learn something else so you'll have something to fall back on.' I guess I'm lucky I never took their advice!"

Steve Gerdes

By age ten, Gerdes had already zeroed in on his life's ambition. "I knew I wanted to be an artist, but I didn't want to do stuff that hangs in galleries where only an elite group can see it." The artwork that impressed him most was on album covers. Even at that early age, Gerdes knew that since albums are mass produced, his work could reach more people. Over the years, he picked up knowledge about the industry by hanging out in record stores, going to concerts and playing in a band.

Gerdes received more formal training while attending the Art Center in Pasadena, California. Since there was no such major as "album cover design," he studied advertising illustration, keeping his goal of working in the music industry in mind. Shortly before graduating, he made an appointment to show his book to a Warner Bros. art director. A combination of luck, talent, and a great hairdo (he sported a 2-inch blonde Mohawk at the time) led to his first job as staff designer for Warner Bros. Records. He has worked in the recording industry, either on staff or as a freelancer ever since.

Gerdes came to Virgin Records in 1990, and has worked on dozens of projects with such diverse talents as Isaac Hayes, Lennie Kravitz and Shonen Knife. "Once you work in the recording industry you will always work in the recording industry if you want to," says Gerdes. "After you have printed pieces and know a few people—you're in. You can call people and say 'Hi, Remember me? I'm looking for work.'"

Granted, it's hard to get that first break. Art directors rarely hire people they don't know, but there's a good reason for their hesitancy, says Gerdes. "Let's say I get this great promo piece and I look at it and think 'Wow, this is just the coolest,' and I am on deadline. If the choice is between really-cool-guy 'A' or guy-that-I-worked-with-before-again-and-again 'B,' I'll go with the guy 'B' because ultimately, I'm responsible for this cover coming in on time."

INSIDER REPORT, *continued*

One way around this situation is persistence. Projects with flexible deadlines do come up. If an experienced freelancer suddenly becomes unavailable, an art director will take a chance on a newcomer. It's also possible to enter the field through connections with musicians or their managers, since they have a big say in cover decisions. (Such was the case when Billy Corgan of The Smashing Pumpkins chose designer Frank Olinsky and illustrator John Craig to create the art for *Mellon Collie and the Infinite Sadness*.) You can also send your samples to tour merchandisers ("merch companies") who create T-shirts and programs sold during a band's tour. Merch companies are listed in *Billboard's International Talent & Touring Directory* available in most public libraries.

The best case scenario is to get an appointment to personally show your book to an art director. But since most labels have drop off policies these days, put together a portfolio so strong that a drop off will sell it. Remember, in the recording industry your portfolio doesn't have to be an expensive black leather binder with plastic sleeves. "We get portfolios that look as though they cost thousands of dollars. They're really nice, but there's just no point." The purpose of a portfolio is to get great work in front of the art director as quickly as possible.

At Virgin, the art department works with recording artists to develop the look of each project. Billy Corgan of The Smashing Pumpkins chose designer Frank Olinsky and illustrator John Craig to create artwork for his group's CD, *Mellon Collie and The Infinite Sadness*. On the Shonen Knife CD, *the birds and the b-sides*, the group asked Mark Gerdes to design a cover reminiscent of those on the legendary Blue Note label. Gerdes created three paintings using the Painter program. Buyers could choose their choice of covers based on how the CD booklet folded inside the case. The Japanese girl group liked the package so much they sent Gerdes a thank you note.

INSIDER REPORT, *Gerdes*

Gerdes's own book is an unpretentious blue-gray, three-ring, cloth-covered binder. He fills it with color photocopies of his best work.

If you don't have experience in the industry, Gerdes advises creating some CD packages of your own design for your portfolio. Since you'll be designing your own assignments, you can get as wild as you want. Art directors in the recording industry expect imaginative work. (Gerdes once received a portfolio in an astro-turf covered box.) But regretfully, most work submitted is "so middle-of-the-road you wouldn't believe it. In a lot of cases the presentation is WAZOO—very slick—but the work inside is conceptually average. I could care less about presentation. But if somebody would send me a book of color photocopies of work that showed an original thought—I'd be all over it."

Besides creativity, another quality Gerdes finds lacking is enthusiasm. "I've been working for this industry for half my life now and I love it. I truly love it. When I see people who look bored by their work it really bums me out. I love to see absolute enthusiasm and at least the willingness to try new things."

Gerdes also notices that some talented artists give up too soon. "I know people who can't design their way out of a brown paper bag and they're making better money than I am. And I know other people, more talented than I am who are working at the bank." Don't give up on your dreams. "Be as selfish as possible about finding what you really want to do. That's where the passion lies. That's where your work is going to be really good. Starve a little? Who hasn't! We all have. Talent just doesn't go unnoticed. Sooner or later it comes to the surface."

—Mary Cox

YOUNG COUNTRY RECORDS/PLAIN COUNTRY RECORDS/NAPOLEON COUNTRY RE-CORDS, P.O. Box 5412, Buena Park CA 90620. (619)245-2920. Owner: Leo J. Eiffert, Jr. Estab. 1968. Produces tapes and records: gospel and country/western by solo artists and groups. Releases: "The Singing Housewife," by Pam Bellows; "Little Miss Candy Jones," by Johnny Horton; and "My Friend," by Leo J. Eiffert, Jr.
Needs: Produces 7 solo artists and 3 groups/year. Works with 40-60 freelancers/year. 10% of freelance work demands computer skills.
First Contact & Terms: Send query letter with tearsheets. Samples are filed. Reports back within 3-4 weeks. To show portfolio, mail b&w and color samples. Pays for design by the project, $150-500. Buys all rights.

Resources

Artists' Reps

Many artists find leaving promotion to a rep allows them more time for the creative process. In exchange for actively promoting an artist's career, the representative receives a percentage of sales (usually 25-30%).

Reps concentrate on either the commercial or fine art markets, rarely both. Very few reps handle designers. Fine art reps promote the work of fine artists, sculptors, craftspeople and fine art photographers to galleries, museums, corporate art collectors, interior designers and art publishers. Commercial reps help illustrators obtain assignments from advertising agencies, publishers, magazines and other art buyers. Reps negotiate contracts, handle billing and collect payments.

Your rep will work with you to help bring your portfolio up-to-speed. She might recommend advertising in one of the many creative directories such as *American Showcase* or *Creative Illustration* so that your work will be seen by hundreds of art directors. Expect to make an initial investment in costs for duplicate portfolios and mailings.

Getting representation isn't as easy as you might think. Reps are choosy about who they represent, not just in terms of talent, but in terms of marketability and professionalism. A rep will only take on talent she knows will sell.

Start by approaching a rep with a brief query letter and direct mail piece. If you do not have a flier or brochure, send photocopies or (duplicate) slides along with a self-addressed, stamped envelope. Check the listings for specific information. Don't just choose the first rep who shows interest. As artists' rep Scott Hull points out in the Insider Report on page 666, you must take an active role in choosing your rep.

The Society of Photographers and Artists Representatives (SPAR) is an organization for professional representatives. SPAR members are required to maintain certain standards and follow a code of ethics. For more information, write to SPAR, 60 E. 42nd St., Suite 1166, New York NY 10165, phone (212)779-7464.

One final note: artists' reps work on commission. Artists' advisors, on the other hand, are consultants who advise artists on marketing strategies. Advisors usually work short term and are paid hourly rates. They advertise in art magazines, or find clients through word of mouth. Some offer marketing seminars. So if you feel you aren't ready to contract with a rep, you might want to seek the help of an advisor.

ANNE ALBRECHT AND ASSOCIATES, 68 E. Wacker Place, Suite 800, Chicago IL 60601. Agent: Anne Albrecht. Commercial illustration, photography representative. Estab. 1991. Member of SPAR, Graphic Artists Guild. Represents 7 illustrators, 3 photographers. Markets include advertising agencies, corporations/client direct, design firms, editorial/magazines.
Handles: Illustration, photography.
Terms: Rep receives 25% commission. Exclusive area representation is required. For promotional purposes, talent must provide a presentation portfolio and advertise in a national sourcebook. Advertises in *American Showcase*, *The Workbook*.
How to Contact: For first contact, send direct mail flier/brochure, tearsheets. Reports back within 2 days. After initial contact, drop off or mail in appropriate materials. Portfolio should include tearsheets, slides, photographs.
Tips: Looks for artists who are "motivated, easy to work with, and have great portfolios."

FRANCE ALINE ASSOCIATES, 1076 S. Ogden Dr., Los Angeles CA 90019. (213)933-2500. Fax: (213)933-2081. Owner: France Aline. Commercial illustration, photography and graphic design representative. Represents illustrators, photographers, designers. Specializes in advertising. Markets include: advertising, corporations, design firms, movie studios, record companies.
Handles: Illustration, photography.
Terms: Rep receives 25% commission. Exclusive area representation is required. Advertises in *American Showcase*, *The Workbook*.
How to Contact: For first contact, send tearsheets. Reports back within a few days. Mail in appropriate materials. Portfolio should include tearsheets, photographs.
Tips: "Send promotions. No fashion."

AMERICAN ARTISTS, REP. INC., 353 W. 53rd St., #1W, New York NY 10019. (212)582-0023. Fax: (212)582-0090. E-mail: amerart@aol.com. Commercial illustration representative. Estab. 1930. Member of SPAR. Represents 30 illustrators. Markets include: advertising agencies; corporations/client direct; design firms; editorial/magazines; paper products/greeting cards; publishing/books; sales/promotion firms.
Handles: Illustration, design.
Terms: Rep receives 30% commission. "All portfolio expenses billed to artist." Advertising costs are split: 70% paid by talent; 30% paid by representative. "Promotion is encouraged; portfolio must be presented in a professional manner—8×10, 4×5, tearsheets, etc." Advertises in *American Showcase*, *Black Book*, *RSVP*, *The Workbook*, medical and Graphic Artist Guild publications.
How to Contact: For first contact, send query letter, direct mail flier/brochure, tearsheets. Reports in 1 week if interested. After initial contact, drop off or mail appropriate materials for review. Portfolio should include tearsheets, slides.
Tips: Obtains new talent through recommendations from others, solicitation, conferences.

JACK ARNOLD FINE ART, 5 E. 67th St., New York NY 10021. (212)249-7218. Fax: (212)249-7232. Contact: Jack Arnold. Fine art representative. Estab. 1979. Represents 15 fine artists. Specializes in contemporary graphics and paintings. Markets include: galleries; museums; private collections; corporate collections.
Handles: Looking for contemporary impressionists and realists.
Terms: Agent receives 50% commission. Exclusive area representation preferred. No geographic restrictions. To be considered, talent must provide color prints or slides.
How to Contact: For first contact, send bio, photographs, retail prices and SASE. Reports in days. After initial contact, drop off or mail in portfolios of slides, photographs.
Tips: Obtains new talent through referrals.

ART EMOTION CORP., 729 Pine Crest, Prospect Heights IL 60070. (847)397-9300. E-mail: gperez@artemo.com. Contact: Gerard V. Perez. Estab. 1977. Represents 45 fine artists. Specializes in "selling to art galleries." Markets include: corporate collections; galleries; interior decorators.
Handles: Fine art.
Terms: "We buy for resale." Exclusive area representation is required. For promotional purposes talent must provide slides, color prints, "any visuals." Advertises in *Art News*, *Decor*, *Art Business News*.
How to Contact: For first contact, send tearsheets, slides, photographs and SASE. Reports in 1 month, only if interested. "Don't call us—if interested, we will call you." Portfolio should include slides, photographs.

‡ART SOURCE L.A., INC., 11901 Santa Monica Blvd., Suite 555, Los Angeles CA 90025. (310)479-6649. Fax: (310)479-3400. E-mail: fran37@aol.com. Contact: Francine Ellman. Fine art representative. Estab. 1980. Member of Architectural Design Council. Represents artists in all media in fine art and accessories. Specializes in fine art consulting and curating worldwide; creative management, exhibition and design. Markets include: architects; corporate collections; developers; hospitality public space; interior designers; and private collections.
Handles: Fine art in all media, including a broad array of accessories handmade by American artists.
Terms: Agent receives commission, amount varies. Exclusive area representation required in some cases. No geographic restrictions. "We request artists submit a minimum of 10 slides/visuals, résumé and SASE. Advertises in *Art News*, *Artscene*, *Art in America*, *Blue Book*, *Gallery Guide*, *Visions*, *Art Diary*, *Art & Auction*, *Guild*, and *Internet*.
How to Contact: For first contact, send résumé, bio, slides or photographs and SASE. Reports in 1-2 months. After initial contact, "we will call to schedule an appointment" to show portfolio of original art,

HOW TO USE your *Artist's & Graphic Designer's Market* offers suggestions for understanding and using the information in these listings. Read this and other articles in the front of this book for important business tips.

slides, photographs. Obtains new talent through recommendations, artists' submissions and exhibitions.
Tips: "Be professional when submitting visuals. Remember—first impressions can be critical! Have a body of work that is consistent and of the highest quality. Work should be in excellent condition and already photographed for your records. Framing does not enhance the presentation to a dealer."

‡ARTCO INCORPORATED, 3148 RFD Cuba Rd., Long Grove IL 60047-9606. (847)438-8420. Fax: (847)438-6464. Contact: Sybil Tillman. Fine art representative. Estab. 1970. Member of International Society of Appraisers. Represents 60 fine artists. Specializes in contemporary artists' originals and limited edition graphics. Markets include: architects; art publishers; corporate collections; galleries; private collections.
Handles: Fine art.
Terms: "Each commission is determined mutually. For promotional purposes, I would like to see original work or transparencies." No geographic restrictions. Advertises in newspapers, magazine, etc.
How to Contact: For first contact, send query letter, résumé, bio, slides, SASE, photographs or transparencies. After initial contact, call for appointment to show portfolio of original art, slides, photographs.
Tips: Obtains new talent through recommendations from others, solicitation, conferences, advertising.

ARTISAN PROFESSIONAL FREELANCE REPS, INC., 1950 S. Sawtelle, Suite 333, Los Angeles CA 90025. (310)312-2062. Fax: (310)312-0670. Website: http://www.artisan-inc.com. Creative Recruiter: Tracy Forsythe. Commercial illustration, graphic design representative. Estab. 1988. Represents 100 illustrators, 15 photographers, 200 designers. Markets include: advertising agencies, corporations/client direct, design firms.
Handles: Illustration, photography, design, multimedia. Looking for multimedia and 3-D artists for CD-ROM and interactive projects.
Terms: Rep receives 20-30% commission. 100% of advertising costs paid by the representative. For promotional purposes, talent must provide 8½ × 11 color photocopies in a mini-portfolio. Advertises in *Black Book*, *The Workbook*, magazines for the trade.
How to Contact: For first contact, send résumé, photocopies. Reports in 1 week. After initial contact, call to schedule an appointment for portfolio review. Portfolio should include roughs, tearsheets, slides, photographs, photocopies.
Tips: "Have a thorough understanding of Q, IL, PS; also key into Macromind Director whenever possible."

ARTIST DEVELOPMENT GROUP, 21 Emmett St., Suite 2, Providence RI 02903-4503. (401)521-5774. Fax: (401)521-5176. Contact: Rita Campbell. Represents photography, fine art, graphic design, as well as performing talent to advertising agencies, corporate clients/direct. Staff includes Rita Campbell. Estab. 1982. Member of Rhode Island Women's Advertising Club, NE Collaborative of Artist's Representatives. Markets include: advertising agencies; corporations/client direct. Clients include Hasbro, Etonic, Puma, Tretorn, Federal Computer Week. Client list available upon request.
Handles: Illustration, photography.
Terms: Rep receives 20-25% commission. Advertising costs are split: 50% paid by talent; 50% paid by representative. For promotional purposes, talent must provide direct mail promotional piece; samples in book for sales meetings.
How to Contact: For first contact, send résumé, bio, direct mail flier/brochure. Reports in 3 weeks. After initial contact, drop off or mail in appropriate materials for review. Portfolios should include tearsheets, photographs.
Tips: Obtains new talent through "referrals as well as inquiries from talent exposed to agency promo."

ARTISTS ASSOCIATES, 4416 La Jolla Dr., Bradenton FL 34210-3927. (941)756-8445. Fax: (941)727-8840. Contact: Bill Erlacher. Commercial illustration representative. Estab. 1964. Member of Society of Illustrators, Graphic Artists Guild, AIGA. Represents 11 illustrators. Markets include: advertising agencies; corporations/client direct; design firms; editorial/magazines; paper products/greeting cards; publishing/books; sales/promotion firms.
Handles: Illustration, fine art, design.
Terms: Rep receives 25% commission. Advertises in *American Showcase*, *RSVP*, *The Workbook*, *Society of Illustrators Annual*.
How to Contact: For first contact, send direct mail flier/brochure.

ARTISTS INTERNATIONAL, 320 Bee Brook Rd., Washington CT 06777-1911. (203)868-1011. Fax: (203)868-1272. Contact: Michael Brodie. Commercial illustration representative. Estab. 1970. Represents 20 illustrators. Specializes in children's books. Markets include: advertising agencies; design firms; editorial/magazines; licensing.
Handles: Illustration and book packaging.
Terms: Rep receives 30% commission. No geographic restrictions. Advertising costs are split: 70% paid by talent; 30% paid by representative. For promotional purposes, talent must provide 2 portfolios. "We have our own full-color brochure, 24 pages, and do our own promotions."

How to Contact: For first contact, send slides, photocopies and SASE. Reports in 1 week.
Tips: Obtains new talent through recommendations from others, solicitation, conferences, *Literary Market Place*, etc. "SAE with example of your work; no résumés required."

‡**ASCIUTTO ART REPS., INC.**, 1712 E. Butler Circle, Chandler AZ 85225. (602)899-0600. Fax: (602)899-3636. Contact: Mary Anne Asciutto. Children's illustration representative. Estab. 1980. Member of SPAR, Society of Illustrators. Represents 20 illustrators. Specializes in children's illustration for books, magazines, posters, packaging, etc. Markets include: publishing/packaging/advertising.
Handles: Illustration only.
Terms: Rep receives 25% commission. No geographic restrictions. Advertising costs are split: 75% paid by talent; 25% paid by representative. For promotional purposes, talent should provide "prints (color) or originals within an 11 × 14 size format."
How to Contact: Send a direct mail flier/brochure, tearsheets, photocopies and SASE. Reports in 2 weeks. After initial contact, send appropriate materials if requested. Portfolio should include original art on paper, tearsheets, photocopies or color prints of most recent work. If accepted, materials will remain for assembly.
Tips: In obtaining representation "be sure to connect with an agent who handles the kind of accounts you (the artist) *want*."

CAROL BANCROFT & FRIENDS, 121 Dodgingtown Rd., P.O. Box 266, Bethel CT 06801. (203)748-4823. Fax: (203)748-4581. Owner: Carol Bancroft. Promotion Manager: Wendy Rickard. Illustration representative for children's publishing. Estab. 1972. Member of SPAR, Society of Illustrators, Graphic Artists Guild. Represents 40 illustrators. Specializes in illustration for children's publishing—text and trade; any children's-related material. Clients include Scholastic, Houghton Mifflin, Franklin Mint. Client list available upon request.
Handles: Illustration for children of all ages. Looking for multicultural and fine artists.
Terms: Rep receives 25-30% commission. Advertising costs are split: 75% paid by talent; 25% paid by representative. For promotional purposes, talent must provide "flat copy (not slides), tearsheets, promo pieces, good color photocopies, etc.; 6 pieces or more is best; narrative scenes and children interacting." Advertises in *RSVP*.
How to Contact: For contact, "call Wendy for information or send samples and SASE." Reports in 1 month.
Tips: "We're looking for artists who can draw animals and people well. They need to show characters in an engaging way with action in situational settings. Must be able to take a character through a story."

‡**SAL BARRACCA ASSOC. INC.**, 381 Park Ave. S., New York NY 10016. (212)889-2400. Fax: (212)889-2698. Contact: Sal Barracca. Commercial illustration representative. Estab. 1988. Represents 23 illustrators. "90% of our assignments are book jackets." Markets include: advertising agencies; publishing/ books.
Handles: Illustration.
Terms: Rep receives 25% commission. Exclusive area representation is required. Advertising costs are split: 75% paid by talent; 25% paid by representative. For promotional purposes "portfolios must be 8 × 10 chromes that are matted. We can shoot original art to that format at a cost to the artist. We produce our own promotion and mail out once a year to over 16,000 art directors."
How to Contact: For first contact, send direct mail flier/brochure, tearsheets and SASE. Reports in 1 week; 1 day if interested. After initial contact, drop off or mail in appropriate materials for review. Portfolio should include tearsheets, slides.
Tips: "Make sure you have at least three years of working on your own so that you don't have any false expectations from an agent."

BEATE WORKS, 7916 Melrose Ave., Suite 2, Los Angeles CA 90046. (213)653-5088. Fax: (213)653-5089. E-mail: beateworks@aol.com. President: Beate Chelette. Commercial illustration, photography, graphic design representative. Estab. 1992. Represents 2 illustrators, 5 photographers, 1 designer, 1 fine artist. Markets include: advertising agencies; corporations/client direct; design firms; editorial/magazines; paper products/ greeting cards.
Handles: Illustration, photography. Looking for well-established, versatile artists with existing clientele.
Terms: Rep receives 25-30% commission. Charges special mailing fees. Exclusive area representation is required. Advertising costs are split: 75% paid by talent; 25% paid by representative. For promotional purposes, talent must provide direct mailers, portfolio 11 × 14 (2 minimum) with logo and type.
How to Contact: For first contact, send query letter, direct mail flier/brochure. Reports back within 1 week. After initial contact, call to schedule an appointment for portfolio review. Portfolio should include tearsheets, slides, photographs, photocopies.
Tips: Likes artists who possess "business sense, ability to keep clients and strong flexible personalities. It's a business and you have to be professional. Just talent is not enough anymore."

‡NOEL BECKER ASSOCIATES, 150 W. 55th St., New York NY 10019. (212)764-1988. Contact: Noel Becker. Commercial illustration and photography representative. Estab. 1975. Member of Graphic Artists Guild. Represents 2 photographers. Specializes in fashion. Markets include corporations/client direct.
Handles: Illustration, photography.
Terms: Agent receives 25-30% commission. Advertising costs are paid by talent. For promotional purposes, talent must provide direct mail piece.
How to Contact: For first contact, send direct mail flier/brochure, photocopies. After initial contact, call for appointment to show portfolio of tearsheets, photographs.
Tips: Suggests that work be saleable in the NYC Garment Center.

BERENDSEN & ASSOCIATES, INC., 2233 Kemper Lane, Cincinnati OH 45206. (513)861-1400. Fax: (513)861-6420. President: Bob Berendsen. Commercial illustration, photography, graphic design representative. Incorporated 1986. Represents 24 illustrators, 2 photographers, 2 designers/illustrators. Specializes in "high-visibility consumer accounts." Markets include: advertising agencies; corporations/client direct; design firms; editorial/magazines; paper products/greeting cards; publishing/books; sales/promotion firms. Clients include Disney, CNN, Pentagram, F&W Publications. Client list available upon request.
Handles: Illustration, photography. "We are always looking for illustrators who can draw people, product and action well. Also, we look for styles that are unique."
Terms: Rep receives 25% commission. Charges "mostly for postage but figures not available." No geographic restrictions. Advertising costs are split: 75% paid by talent; 25% paid by representative. For promotional purposes, "artist must co-op in our direct mail promotions, and sourcebooks are recommended. Portfolios are updated regularly." Advertises in *RSVP, Creative Illustration Book* and *American Showcase*.
How to Contact: For first contact, send query letter, résumé, and any nonreturnable tearsheets, slides, photographs or photocopies. Follow up with a phone call.

‡BERNSTEIN & ANDRIULLI INC., 60 E. 42nd St., New York NY 10165. (212)682-1490. Fax: (212)286-1890. Contact: Sam Bernstein. Commercial illustration and photography representative. Estab. 1975. Member of SPAR. Represents 54 illustrators, 16 photographers. Staff includes Anthony Andriulli; Howard Bernstein; Samuel Bernstein; Molly Birenbaum; Martha Dunning; Randi Fiat; Ivy Glick; Liz McCann; Christine Priola; Fran Rosenfeld; Susan Wells. Markets include: advertising agencies; corporations/client direct; design firms; editorial/magazines; paper products/greeting cards; publishing/books; sales/promotion firms.
Handles: Illustration and photography.
Terms: Rep receives a commission. Exclusive career representation is required. No geographic restrictions. Advertises in *American Showcase, Black Book, The Workbook, New York Gold, Creative Illustration Book; Bernstein & Andriulli International Illustration*.
How to Contact: For first contact, send query letter, direct mail flier/brochure, tearsheets, slides, photographs, photocopies. Reports in 1 week. After initial contact, drop off or mail appropriate materials for review. Portfolio should include tearsheets, slides, photographs.

SAM BRODY, ARTISTS & PHOTOGRAPHERS REPRESENTATIVE & CONSULTANT, 77 Winfield St., Apt. 4, E. Norwalk CT 06855-2138. Phone/fax: (203)854-0805 (for fax, add 999). Contact: Sam Brody. Commercial illustration and photography representative and broker. Estab. 1948. Member of SPAR. Represents 4 illustrators, 3 photographers, 2 designers. Markets include: advertising agencies; corporations/client direct; design firms; editorial/magazines; publishing/books; sales/promotion firms.
Handles: Illustration, photography, design, "great film directors."
Terms: Agent receives 30% commission. Exclusive area representation is required. Advertising costs are split: 75% paid by talent; 25% paid by representative. For promotional purposes, talent must provide 8×10 transparencies (dupes only) with case, plus back-up advertising material, i.e., cards (reprints—*Workbook*, etc.) and self-promos.
How to Contact: For first contact, send bio, direct mail flier/brochure, tearsheets. Reports in 3 days or within 1 day if interested. After initial contact, call for appointment or drop off or mail in appropriate materials for review. Portfolio should include tearsheets, slides, photographs.
Tips: Obtains new talent through recommendations from others, solicitation. In obtaining representation, artist/photographer should "talk to parties he has worked with in the past year."

PEMA BROWNE LTD., HCR Box 104B, Pine Rd., Neversink NY 12765. (914)985-2936. Fax: (914)985-7635. Contact: Pema Browne or Perry Browne. Commercial illustration representative. Estab. 1966. Represents 12 illustrators. Specializes in general commercial. Markets include: all publishing areas; children's picture books; collector plates and dolls; advertising agencies; editorial/magazines. Clients include Harper-Collins, Thomas Nelson, Bradford Exchange. Client list available upon request.
Handles: Illustration. Looking for "professional and unique" talent.
Terms: Rep receives 30% commission. Exclusive area representation is required. For promotional purposes, talent must provide color mailers to distribute. Representative pays mailing costs on promotion mailings.

How to Contact: For first contact, send query letter, direct mail flier/brochure and SASE. If interested will ask to mail appropriate materials for review. Portfolios should include tearsheets and transparencies or good color photocopies.
Tips: Obtains new talent through recommendations. Freelancers "should be on their own for experience and knowledge of the marketplace."

SID BUCK AND BARNEY KANE, 135 W. 41st St., #408, New York NY 10036. (212)221-8090. Fax: (212)221-8092. E-mail: andi9@aol.com. President: Sid Buck. Commercial illustration representative. Estab. 1964. Markets include: advertising agencies; corporations/client direct; design firms; editorial/magazines; paper products/greeting cards; publishing/books; fashion.
Handles: Illustration, fashion.
Terms: Rep receives 25% commission. Exclusive area represention is required. Advertising costs are split: 75% paid by talent; 25% paid by representative. Advertises in *American Showcase*, *Black Book*, *The Workbook*.
How to Contact: For first contact, send photocopies, photostats. Reports in 1 week. After initial contact, call to schedule an appointment for portfolio review. Portfolio should include photostats, photocopies.

‡CAROL CHISLOVSKY DESIGN INC., 853 Broadway, New York NY 10003. (212)677-9100. Fax: (212)353-0954. Contact: Carol Chislovsky. Commercial illustration representative. Estab. 1975. Member of SPAR. Represents 20 illustrators. Markets include: advertising agencies; design firms; editorial/magazines; publishing/books.
Handles: Illustration.
Terms: Rep receives 30% commission. Advertising costs are split: 70% paid by talent; 30% paid by representative. For promotional purposes, talent must provide direct mail piece. Advertises in *American Showcase*, *The Workbook*, *Black Book* and sends out a direct mail piece.
How to Contact: For first contact, send direct mail flier/brochure. Portfolio should include tearsheets, slides, photostats.

WOODY COLEMAN PRESENTS INC., 490 Rockside Rd., Cleveland OH 44131. (216)661-4222. Fax: (216)661-2879. Contact: Woody. Creative services representative. Estab. 1978. Member of Graphic Artists Guild. Specializes in illustration. Markets include: advertising agencies; corporations/client direct; design firms; editorial/magazines; paper products/greeting cards; publishing/books; sales/promotion firms; public relations firms.
Handles: Illustration.
Terms: Rep receives 25% commission. Advertising costs are split: 75% paid by talent; 25% paid by representative. For promotional purposes, talent must provide "all portfolios in 4×5 transparencies." Advertises in *American Showcase*, *Black Book*, *The Workbook*, other publications.
How to Contact: For first contact, send query letter, tearsheets, slides, SASE. Reports in 7 days, only if interested. Portfolio should include tearsheets, 4×5 transparencies.
Tips: "Solicitations are made directly to our agency. Concentrate on developing 8-10 specific examples of a single style exhibiting work aimed at a particular specialty, such as fantasy, realism, Americana or a particular industry such as food, medical, architecture, transportation, film, etc."

‡JAN COLLIER REPRESENTS, P.O. Box 470818, San Francisco CA 94147. (415)383-9026. Contact: Jan. Commercial illustration representative. Estab. 1978. Represents 12 illustrators. Markets include: advertising agencies; design firms and editorial.
Handles: Illustration.
Terms: Rep receives 25% commission. Exclusive area representation is required. Advertising costs are split: 75% paid by talent; 25% paid by representative. Advertises in *American Showcase*, *Black Book*, *The Workbook*.
How to Contact: For first contact, send tearsheets, slides and SASE. Reports in 5 days, only if interested. After initial contact, call for appointment to show portfolio of slides.

DANIELE COLLIGNON, 200 W. 15th St., New York NY 10011. (212)243-4209. Contact: Daniele Collignon. Commercial illustration representative. Estab. 1981. Member of SPAR, Graphic Artists Guild, Art Director's Club. Represents 12 illustrators. Markets include: advertising agencies; corporations/client direct; design firms; editorial/magazines; publishing/books.
Handles: Illustration.
Terms: Rep receives 30% commission. Exclusive area representation is required. No geographic restrictions. Advertising costs are split: 75% paid by talent; 25% paid by representative. For promotional purposes, talent must provide 8×10 transparencies (for portfolio) to be mounted, printed samples, professional pieces. Advertises in *American Showcase*, *Black Book*, *The Workbook*.
How to Contact: For first contact, send direct mail flier/brochure, tearsheets. Reports in 3-5 days, only if interested. After initial contact, drop off or mail in appropriate materials for review. Portfolio should include tearsheets, transparencies.

‡CORNELL & MCCARTHY, 2-D Cross Hwy., Westport CT 06880. (203)454-4210. Fax: (203)454-4258. Contact: Merial Cornell. Children's book illustration representative. Estab. 1989. Member of SCBWI. Represents 30 illustrators. Specializes in children's books: trade, mass market, educational.
Handles: Illustration.
Terms: Agent receives 25% commission. Advertising costs are split: 75% paid by talent; 25% paid by representative. For promotional purposes, talent must provide 10-12 strong portfolio pieces relating to children's publishing.
How to Contact: For first contact, send query letter, direct mail flier/brochure, tearsheets, photocopies and SASE. Reports in 1 month. After initial contact, call for appointment or drop off or mail appropriate materials for review. Portfolio should include original art, tearsheets, photocopies.
Tips: Obtains new talent through recommendations, solicitation, conferences. "Work hard on your portfolio."

CREATIVE FREELANCERS MANAGEMENT, INC., 25 W. 45th St., New York NY 10036. (800)398-9544. Fax: (203)532-2927. Contact: Marilyn Howard. Commercial illustration representative. Estab. 1988. Represents 30 illustrators. "Our staff members have art direction, art buying or illustration backgrounds." Specializes in children's books, advertising, architectural, conceptual. Markets include: advertising agencies; corporations/client direct; design firms; editorial/magazines; paper products/greeting cards; publishing/books; sales/promotion firms.
 • Agency anticipated moving in fall of '96 so call to check address before sending promotional mailers.
Handles: Illustration. Artists must have published work.
Terms: Rep receives 30% commission. Exclusive area representation is preferred. Advertising costs are split: 75% paid by talent; 25% paid by representative. For promotional purposes, talent must provide "printed pages to leave with clients. Co-op advertising with our firm could also provide this. Transparency portfolio preferred if we take you on but we are flexible." Advertises in *American Showcase*, *Workbook*.
How to Contact: For first contact, send tearsheets or "whatever best shows work. We also have a portfolio drop off policy on Wednesdays." Reports within 1 month only if interested. After initial contact, drop off or mail in appropriate materials for review. Portfolios should include tearsheets, photocopies.
Tips: Looks for experience, professionalism and consistency of style. Obtains new talent through "word of mouth and advertising."

‡CVB CREATIVE RESOURCE, 1856 Elba Circle, Costa Mesa CA 92626. (714)641-9700. Fax: (714)641-9700. E-mail: cbrenneman@aol.com. Website: http://www.charlottes-web.com/cindyb. Contact: Cindy Brenneman. Commercial illustration, photography and graphic design representative; portfolio consultation. Estab. 1984. Member of SPAR, ADDOC. Specializes in "high-quality innovative images." Markets include: advertising agencies; corporations/client direct; design firms.
Handles: Illustration. Looking for "a particular style or specialized medium."
Terms: Rep receives 30% commission. Exclusive area representation is required. Advertising costs are split: 70% paid by talent; 30% paid by representative, "if rep's name and number appear on piece." For promotional purposes, talent must provide promotional pieces on a fairly consistent basis. Portfolio should be laminated. Include transparencies or cibachromes. Images to be shown are mutually agreed upon by talent and rep.
How to Contact: For first contact, send slides or photographs. Reports in 2 weeks, only if interested. After initial contact, call for appointment to show portfolio of tearsheets, slides, photographs, photostats.
Tips: Obtains new talent through referrals. "You usually know if you have a need as soon as you see the work. Be professional. Treat looking for a rep as you would looking for a freelance job. Get as much exposure as you can. Join peer clubs and network. Always ask for referrals. Interview several before settling on one. Personality and how you interact will have a big impact on the final decision."

LINDA DE MORETA REPRESENTS, 1839 Ninth St., Alameda CA 94501. (510)769-1421. Fax: (510)521-1674. Contact: Linda de Moreta. Commercial illustration and photography representative; also portfolio and career consultant. Estab. 1988. Represents 9 illustrators, 4 photographers. Markets include: advertising agencies; corporations/client direct; design firms; editorial/magazines; paper products/greeting cards; publishing/books; sales/promotion firms.
Handles: Illustration, lettering/title design, photography.
Terms: Rep receives 25% commission. Exclusive representation requirements vary. Advertising costs are according to individual agreements. Materials for promotional purposes vary with each artist. Advertises in *The Workbook*, *Black Book*, *The Creative Illustration Book*, *American Showcase*.
How to Contact: For first contact, send direct mail flier/brochure, tearsheets, slides, photocopies, photostats and SASE. "Please do *not* send original art. SASE for any items you wish returned." Responds to any inquiry in which there is an interest. Portfolios are individually developed for each artist and may include tearsheets, prints, transparencies.
Tips: Obtains new talent through client and artist referrals primarily, some solicitation. "I look for great creativity, a personal vision and style of illustration or photography combined with professionalism, maturity and a willingness to work hard."

DWYER & O'GRADY, INC., Mountain Rd., P.O. Box 239, East Lempster NH 03605. (603)863-9347. Fax: (603)863-9346. Contact: Elizabeth O'Grady. Agents for children's picture book artists and writers. Estab. 1990. Member of Society of Illustrators, Graphic Artists Guild, SCBWI, ABA. Represents 26 illustrators and 12 writers. Staff includes Elizabeth O'Grady, Jeffrey Dwyer. Specializes in children's picture books. Markets include: publishing/books.
Handles: Illustrators and writers of children's books. "Favor realistic and representational work for the older age picture book. Artist must have full command of the figure and facial expressions."
Terms: Rep receives 15% commission. Additional fees are negotiable. Exclusive area representation is required (world rights). Advertising costs are paid by representative. For promotional purposes, talent must provide both color slides and prints of at least 20 sample illustrations depicting the figure with facial expression.
How to Contact: When making first contact, send query letter, slides, photographs and SASE. Reports in 1½ months. After initial contact, call for appointment and drop off or mail in appropriate materials for review. Portfolio should include slides, photographs.

ELLIOTT/OREMAN ARTISTS' REPRESENTATIVES, 25 Drury Lane, Rochester NY 14625-2013. Contact: Shannon Elliott. Commercial illustration representative. Estab. 1983. Represents 10 illustrators. Markets include: advertising agencies; corporations/client direct; design firms; editorial/magazines; paper products/greeting cards; publishing/books; architectural firms.
Handles: Illustration.
Terms: For promotional purposes, talent must have a tearsheet, which will be combined with others in a sample folder.
How to Contact: For first contact, send query letter, tearsheets, slides. "I will call to schedule an appointment, if interested."

FORTUNI, 2508 E. Belleview Place, Milwaukee WI 53211. (414)964-8088. Fax: (414)332-9629. Contact: Marian F. Deegan. Commercial illustration, photography representative. Estab. 1990. Member of Graphic Artists Guild. Represents 5 illustrators, 2 photographers. Markets include: advertising agencies; corporations/client direct; design firms; editorial/magazines; publishing/books.
Handles: Illustration, photography. "I am interested in artists who have developed a consistent, distinctive style of illustration."
Terms: Rep receives 30% commission. Advertising costs are split: 70% paid by talent; 30% paid by representative. For promotional purposes, talent must provide direct mail support, advertising, and a minimum of 4 duplicate transparency portfolios. "All promotional materials are developed and produced within my advertising specifications." Advertises in *Directory of Illustration*, *The Workbook*.
How to Contact: For first contact, send direct mail flier/brochure, slides, photographs, photocopies, SASE. Reports in 2 weeks if SASE is enclosed. After initial contact, call to schedule an appointment for portfolio review. Portfolio should include roughs, original art, tearsheets, slides, photographs, photocopies, transparencies (if available).

FREELANCE ADVANCERS, INC., 441 Lexington Ave., Suite 408, New York NY 10017. (212)661-0900. Fax: (212)661-1883. President: Gary Glauber. Commercial illustration, graphic design, freelance artist representative. Estab. 1987. Member of Society of Illustrators. Represents 150 illustrators, 250 designers. Specializes in freelance project work. Markets include: advertising agencies; corporations/client direct; design firms; editorial/magazines; publishing/books.
Handles: Illustration, design. Looks for artists with Macintosh software and multimedia expertise.
Terms: Rep receives 20% commission. 100% paid by the representative. Advertises in *Art Direction*, *Adweek*.
How to Contact: For first contact, send query letter, résumé, tearsheets. Reports back within 1 week. After initial contact, call to schedule an appointment.
Tips: Looking for "talent, flexibility and reliability" in an artist. "Always learn, but realize you are good enough now."

‡G.A.I. INCORPORATED, Box 30309, Indianapolis IN 46230. (317)257-7100. President: William S. Gardner. Licensing agents. Represents artists to the collectible and gift industries (high quality prints, collector's plates, figurines, bells, etc.)
● See G.A.I.'s listing in the Greeting Cards, Games and Products section for more information.

ROBERT GALITZ FINE ART/ACCENT ART, 166 Hilltop Court, Sleepy Hollow IL 60118. (847)426-8842. Fax: (847)426-8846. Contact: Robert Galitz. Fine art representative. Estab. 1985. Represents 100 fine artists (includes 2 sculptors). Specializes in contemporary/abstract corporate art. Markets include: architects; corporate collections; galleries; interior decorators; private collections. Clients include Graphique Du Jour, Editions Limited Inc.

Handles: Fine art.

Terms: Agent receives 25-40% commission. No geographic restrictions; sells mainly in Chicago, Illinois, Wisconsin, Indiana and Kentucky. For promotional purposes talent must provide "good photos and slides." Advertises in monthly art publications and guides.

How to Contact: For first contact, send query letter, slides, photographs. Reports in 2 weeks. After initial contact, call for appointment to show portfolio of original art.

Tips: Obtains new talent through recommendations from others, solicitation, conferences. "Be confident, persistent. Never give up or quit."

RITA GATLIN REPRESENTS, 83 Walnut Ave., Corte Madera CA 94925. (415)924-7881. Fax: (415)924-7891. Agent: Rita Gatlin. Commercial illustration. Estab. 1991. Member of Society of Illustrators. Represents 12 illustrators. Markets include: advertising agencies; corporations/client direct; design firms; editorial/magazines; paper products/greeting cards; publishing/books.

Handles: Commercial illustrators only.

Terms: Rep receives 25% commission. Charges fees for portfolio materials (mounting and matting); postage for yearly direct mail divided among artists. Advertising costs are split: 75% paid by talent; 25% paid by representative. For promotional purposes, talent must provide at least one 8½ × 11 printed page. Prefers portfolios in transparency form. Advertises in *American Showcase*, *The Workbook*, *Creative Illustration*.

How to Contact: For first contact, send query letter and tearsheets. Reports back within 5 days. After initial contact, call to schedule an appointment for portfolio review. Portfolio should include tearsheets, slides.

Tips: "Artists must have a minimum of five years experience as commercial illustrators." When asked what their illustration style is, artists should never say they can do all styles—it's "a sign of a beginner."

DENNIS GODFREY REPRESENTING ARTISTS, 231 W. 25th St., Suite 2G, New York NY 10001. Phone/fax: (212)807-0840. Contact: Dennis Godfrey. Commercial illustration representative. Estab. 1985. Represents 6 illustrators. Specializes in publishing and packaging. Markets include: advertising agencies; corporations/client direct; design firms; publishing/books. Clients include Putnam Berkley, Dell, Avon, Ogilvy & Mather, Oceanspray, Tropicana, Celestial Seasonings.

Handles: Illustration.

Terms: Rep receives 25% commission. Prefers exclusive area representation in NYC/Eastern US. Advertising costs are split: 75% paid by talent; 25% paid by representative. For promotional purposes, talent must provide mounted portfolio (at least 20 pieces), as well as promotional pieces. Advertises in *The Workbook*.

How to Contact: For first contact, send tearsheets. Reports in 2 weeks, only if interested. After initial contact, write for appointment to show portfolio of tearsheets, slides, photographs, photostats.

BARBARA GORDON ASSOCIATES LTD., 165 E. 32nd St., New York NY 10016. (212)686-3514. Fax: (212)532-4302. Contact: Barbara Gordon. Commercial illustration and photography representative. Estab. 1969. Member of SPAR, Society of Illustrators, Graphic Artists Guild. Represents 9 illustrators, 1 photographer. "I represent only a small, select group of people and therefore give a great deal of personal time and attention to the people I represent."

Terms: No information provided. No geographic restrictions in continental US.

How to Contact: For first contact, send direct mail flier/brochure. Reports in 2 weeks. After initial contact, drop off or mail appropriate materials for review. Portfolio should include tearsheets, slides, photographs; "if the talent wants materials or promotion piece returned, include SASE."

Tips: Obtains new talent through recommendations from others, solicitation, conferences, etc. "I do not care if an artist or photographer has been published or is experienced. I am essentially interested in people with a good, commercial style. Don't send résumés and don't call to give me a verbal description of your work. Send promotion pieces. *Never* send original art. If you want something back, include a SASE. Always label your slides in case they get separated from your cover letter. And always include a phone number where you can be reached."

T.J. GORDON/ARTIST REPRESENTATIVE, P.O. Box 4112, Montebello CA 90640. (213)887-8958. Contact: Tami Gordon. Commercial illustration, photography and graphic design representative; also illustration or photography broker. Estab. 1990. Represents 8 illustrators, 3 photographers. Markets include: advertising agencies; corporations/client direct; design firms; editorial/magazines.

Handles: Illustration, photography, design.

Terms: Rep receives 30% commission. Advertising costs are paid by talent (direct mail costs, billable at end of each month). Represents "illustrators from anywhere in US; designers and photographers normally LA only, unless photographer can deliver a product so unique that it is unavailable in LA." For promotional purposes, talent must provide "a minimum of 3 pieces to begin a 6-month trial period. These pieces will be used as mailers and leave behinds. Portfolio is to be professional and consistent (pieces of the same size, etc.). At the end of the trial period agreement will be made on production of future promotional pieces."

How to Contact: For first contact, send bio, direct mail flier/brochure. Reports in 2 weeks, if interested. After initial contact, call for appointment to show portfolio of tearsheets.

"Mary Ross's whimsical, colorful, spontaneous style has been delighting clients, art directors and designers for 15 years," says Ross's agent Rita Gatlin of Rita Gatlin Represents. Ross has worked on logos, menu covers and cookbooks, brochures and annuals reports, album and CD covers, and editorial assignments. This sample of the artist's work appeared in the 1996 *Black Book*. Gatlin also promotes her clients through direct mail and personal visits.

Tips: Obtains new talent "primarily through recommendations and as the result of artists' solicitations. Have an understanding of what it is you do, do not be afraid to specialize. If you do everything, then you will always conflict with the interests of the representatives' other artists. Find your strongest selling point, vocalize it and make sure that your promos and portfolio show that point."

CAROL GUENZI AGENTS, INC., 865 Delaware St., Denver CO 80210. (303)820-2599. Contact: Carol Guenzi. Commercial illustration, film and animation representative. Estab. 1984. Member of Denver Adver-

tising Federation and Art Directors Club of Denver. Represents 26 illustrators, 5 photographers, 4 computer illustrators, 3 multimedia developers and 1 animator. Specializes in a "wide selection of talent in all areas of visual communications." Markets include: advertising agencies; corporations/client direct; design firms; editorial/magazine, paper products/greeting cards, sales/promotions firms. Clients include The Integer Group, Karsh & Hagan, Barnhart. Partial client list available upon request.

Handles: Illustration, photography. Looking for "unique style application."

Terms: Rep receives 25% commission. Exclusive area representative is required. Advertising costs are split: 75% paid by talent; 25% paid by the representation. For promotional purposes, talent must provide "promotional material after six months, some restrictions on portfolios." Advertises in *American Showcase*, *Black Book*, *Rocky Mountain Sourcebook*, *The Workbook*, "periodically."

How to Contact: For first contact, send direct mail flier/brochure. Reports in 2-3 weeks, only if interested. Call or write for appointment to drop off or mail in appropriate materials for review, depending on artist's location. Portfolio should include tearsheets, slides, photographs.

Tips: Obtains new talent through solicitation, art directors' referrals, an active pursuit by individual artist. "Show your strongest style and have at least 12 samples of that style, before introducing all your capabilities. Be prepared to add additional work to your portfolio to help round out your style." Have a digital background.

GUIDED IMAGERY PRODUCTIONS, 2995 Woodside Rd., #400, Woodside CA 94062. (415)324-0323. Fax: (415)324-9962. Owner/Director: Linda Hoffman. Fine art representative. Estab. 1978. Member of Hospitality Industry Association. Represents 2 illustrators, 12 fine artists. Guidelines available for #10 SASE. Specializes in large art production—perspective murals (tromp l'oiel); unusual painted furniture/screens. Markets include: design firms; interior decorators; hospitality industry.

Handles: Looking for "mural artists (realistic or trompe l'oiel) with good understanding of perspectives—humor helps too."

Terms: Rep receives 25-33% commission. 100% of advertising costs paid by representative. For promotional purposes, talent must provide a direct mail piece to preview work along with color copies of work (SASE too). Advertises in *The Workbook*.

How to Contact: For first contact, send query letter, résumé, photographs, photocopies and SASE. Reports in 2-3 weeks. After initical contact drop off or mail in appropriate materials. Portfolio should include photographs.

Tips: Wants artists with talent, references and follow through. "Send samples of original work that show your artistic style. Never send one-of-a-kind snapshots. My focus is 3-D murals. References from previous clients very helpful."

PAT HACKETT/ARTIST REPRESENTATIVE, 101 Yesler Way, Suite 502, Seattle WA 98104-2552. (206)447-1600. Fax: (206)447-0739. E-mail: pathackett@aol.com. Contact: Pat Hackett. Commercial illustration and photography representative. Estab. 1979. Represents 27 illustrators, 2 photographers. Markets include: advertising agencies; corporations/client direct; design firms; editorial/magazines. Clients include Microsoft Inc., Rodale Press.

Handles: Illustration.

Terms: Rep receives 25-33% commission. Exclusive area representation is required. No geographic restrictions, but sells mostly in Washington, Oregon, Idaho, Montana, Alaska and Hawaii. Advertising costs are split: 75% paid by talent; 25% paid by representative. For promotional purposes, talent must provide "standardized portfolio, i.e., all pieces within the book are the same format. Reprints are nice, but not absolutely required." Advertises in *American Showcase*, *Black Book*, *The Workbook*, *Creative Illustration*, *Medical Illustration Source Book*.

How to Contact: For first contact, send direct mail flier/brochure. Reports in 1 week, only if interested. After initial contact, drop off or mail in appropriate materials: tearsheets, slides, photographs, photostats, photocopies.

Tips: Obtains new talent through "recommendations and calls/letters from artists moving to the area. We prefer to handle artists who live in the area unless they do something that is not available locally."

‡BARB HAUSER, ANOTHER GIRL REP, P.O. Box 421443, San Francisco CA 94142-1443. (415)647-5660. Fax: (415)285-1102. Estab. 1980. Represents 13 illustrators and 1 photographer. Markets include: primarily advertising agencies and design firms; corporations/client direct.

Handles: Illustration and photography.

Terms: Rep receives 25-30% commission. Exclusive representation in the San Francisco area is required. No geographic restrictions.

ALWAYS ENCLOSE a self-addressed, stamped envelope (SASE) with queries and sample packages.

How to Contact: For first contact, send direct mail flier/brochure, tearsheets, slides, photographs, photocopies and SASE. Reports in 3-4 weeks. Call for appointment to show portfolio of tearsheets, slides, photographs, photostats, photocopies.

‡JOANNE HEDGE/ARTIST REPRESENTATIVE, 1838 El Cerrito Place, Suite 3, Hollywood CA 90068. (213)874-1661. Fax: (213)874-0136. Contact: J. Hedge. Commercial illustration representative. Estab. 1975. Member of Graphic Artists Guild, Art Directors Club of LA. Represents 14 illustrators. Specializes in "high-quality, painterly and realistic illustration and lettering." Markets include advertising agencies, design firms, movie studios, package design firms.
Handles: Illustration. Seeks established realists in airbrush, painting. Also quality computer-generated art suppliers.
Terms: Rep receives 30% commission. Charges quarterly portfolio maintenance expenses and freight fees usually when no job netted. Advertising costs are split: 75% paid by talent; 25% paid by representative. For promotional purposes, talent should provide "ad reprint flyer, 4×5 or 8×10 copy transparencies, matted on 11×14 laminate mattes." Advertises in *The Workbook*.
How to Contact: For first contact, send query letter with direct mail flier/brochure, 35mm slides OK with SASE. Reports in 1 week, if interested. After initial contact, call or write for appointment to show portfolio of tearsheets (laminated), photocopies, 4×5 or 8×10 transparencies.
Tips: Obtains new talent after talent sees workbook directory ad, or through referrals from art directors or other talent. "Have as much experience as possible and as few other reps as possible! That, and a good looking $8\frac{1}{2} \times 11$ flier!"

HK PORTFOLIO, 666 Greenwich St., New York NY 10014. (212)675-5719. Contact: Harriet Kasak. Commercial illustration representative. Estab. 1986. Member of SPAR. Represents 30 illustrators. Specializes in illustration for juvenile markets. Markets include: advertising agencies; editorial/magazines; publishing/books.
Handles: Illustration.
Terms: Rep receives 25% commission. No geographic restrictions. Advertising costs are split: 75% paid by talent; 25% paid by representative. Advertises in *American Showcase*, *RSVP*, *The Workbook*.
How to Contact: No geographic restrictions. For first contact, send query letter, direct mail flier/brochure, tearsheets, slides, photographs, photostats and SASE. Reports in 1 week. After initial contact, drop off or mail in appropriate materials for review. Portfolio should include tearsheets, slides, photographs, photostats, photocopies.
Tips: Leans toward highly individual personal styles.

SCOTT HULL ASSOCIATES, 68 E. Franklin S., Dayton OH 45459. (513)433-8383. Fax: (513)433-0434. Contact: Scott Hull or Frank Sturges. Commercial illustration representative. Estab. 1981. Represents 20 illustrators.
Terms: No information provided.
How to Contact: Contact by sending slides, tearsheets or appropriate materials for review. Follow up with phone call. Reports within 2 weeks.

‡INTERNATIONAL ART CONNECTION AND ART CONNECTION PLUS, 444 Brickell Ave., #51, Miami FL 33131. (305)361-9997. Fax: (305)365-9330. President: Jane Chambeaux (between June 15 and November 15, contact Ms. Chambeaux at Museum of the Commanderiè of Unet, 47400, Tonneins, Bordeaux France). "Nonprofit organization dedicated to helping artists." Estab. 1966 in Europe, 1987 in USA. Represents photographers, fine artists and sculptors. "We organize exhibits and promote artists." Markets include: galleries; museums; private collectors.
Terms: Not-for-profit service. $25 fee.
How to Contact: For first contact, send résumé, slides, photographs, SASE. Reports back within 4 days. After initial contact, drop off or mail in appropriate materials for review. Portfolios should include original art (or framed), photocopies.
Tips: Obtains new talent through "an ad in *Photo* or *Art Review* and contacts in the museums." If interested in obtaining representation, "make international exhibits in museums. Take risks. Be open to all kinds of communication. Be honest and professional."

‡INTERPRESS WORLDWIDE, P.O. Box 8374, Los Angeles CA 91608-0374. (213)876-7675. Rep Coordinator: Ellen Bow. Commercial illustration, photography, fine art, graphic design, actor, make-up artist, musician representative. Estab. 1989. Represents 2 illustrators, 10 photographers, 2 designers, 5 fine artists. Specializes in subsidiaries worldwide. Markets include advertising agencies; corporations/client direct; editorial/magazines; movie industry; art publishers; galleries; private collections; publishing/books.
Handles: Illustration, photography, fine art, graphic arts.
Terms: Rep receives 30% commission. Charges for postage and initial rep fee. Exclusive area representation is required. Advertising costs are split: 80% paid by talent; 20% paid by the representative. For promotional

INSIDER REPORT

Take Charge of Interviews When Choosing a Rep

It may come as a surprise to learn that one of the nation's most sought-after artists' representative firms is located, not in a big city hub, but in the heart of the Midwest. But it's no surprise to the multitude of art directors around the country who rely on Scott Hull Associates in Dayton, Ohio, to match them with problem-solving illustrators.

Scott Hull

As a former designer, Scott Hull has seen the view from both sides of an art director's desk, and, with former photographers' representative Frank Sturges, has built his firm's reputation on understanding his clients' needs. Representing just 20 artists, Hull believes in the importance of continuing relationships—between rep and artist, between artist and client, and between client and rep. "My hope is with the talent we rep, there is stability," says Hull. "When an art director or buyer contacts us, we hope to establish a long-term relationship between the art director and the artist.

"Good relationships take time and planning," says Hull. He warns that "rushing through the selection process when looking for a rep is always a big mistake." Artists should hire a rep "using the same painstaking techniques parents use in hiring a nanny to care for their children." From his 15 years in the business, Hull gives these recommendations to artists looking to find the perfect rep:

• The time to give serious thought to that initial interview is before you send out your portfolio. Prepare a detailed description of what you're looking for in an agent, then use it to write a job description to present to all your candidates. If a rep seems surprised or disappointed by your job description, you're safe in assuming they may not be right for you.

• List qualifications of the ideal candidate, including years in the business, background, character and personality traits.

• Research possible candidates, and, during the interview, let them know you did. That basic input sets the tone for any interview. It tells the agent you invested time in research and are serious. If you know nothing about the agent, she will quickly conclude you're primarily concerned with a paycheck, rather than building a career.

• Interviews are too important to be rushed so don't sandwich them into your schedule. Set aside an uninterrupted time for both parties to meet and assess facts and information.

INSIDER REPORT, *Hull*

- Structure the interview. A brief ten-minute, get-acquainted first "act" sets the tone. (This preliminary "small talk" gives you insight into how well the person reacts when faced with new people and situations.) Follow up with a question-and-answer second act. The final act is the wrap-up, in which the rep is encouraged to ask questions.
- Ask the right questions. Make a list of general and specific questions. General questions provide an overall picture; specific ones tell whether the rep has the skills you need. What do you enjoy about your work? What turns you off? Why did you pick representing artists as a career? Why should I join your group? What are your responsibilities as an agent? What are your expectations? What are your greatest strengths?
- Take notes during the interview. Jot down your observations on how the rep responded, and special traits that impress or disturb you.
- Let the agent do the talking. Don't make the mistake of dominating the interview. Ask good questions, then sit back and listen carefully.
- Call top candidates back for additional information. You should consider the first interview an information-gathering session. A second meeting gives you a chance to ask more important, specific questions.
- Check references. Interview artists the firm represents. Even more important, when possible, find artists who have left the rep, and ask them why they left.

Your rep will expect you to produce quality work in a consistent style and always meet deadlines. What do you expect in return? The best reps, like Hull, stay on top of the market, produce aggressive promotional campigns and take care of billing so you can concentrate on what you do best. They don't just "get

Scott Hull regularly promotes the artists he reps through promotional brochures designed around common themes. For a brochure featuring classic idioms, Hull asked each of his artists to illustrate a different phrase. Greg Dearth's scratchboard illustration of dozing dalmatians, portraying the idiom "Let sleeping dogs lie," was one of the most popular images in the brochure and generated a number of calls for assignments.

© 1994 Greg Dearth

INSIDER REPORT, *continued*

you work." They go after the kind of assignments that interest *you*. The interview is the time to make sure you share the same vision, says Hull. When expectations on both sides coincide, you're well on your way to a beautiful relationship.
—*Lynn Haller*

purposes, talent must provide 2 show portfolios, 6 traveling portfolios. Advertises in *Red Book*, *Production-Creation*.
How to Contact: For first contact, send query letter, résumé, bio, direct mail flier/brochure, tearsheets, slides, photographs and photostats. Reports in 45-60 days. After initial contact, write to schedule an appointment, mail in appropriate materials. Portfolio should include thumbnails, roughs, original art, tearsheets, slides, photographs, photostats, E-folio (Mac).

JOHNSON REPRESENTS, 1643 W. Swallow Rd., Fort Collins CO 80526. (303)223-3027. Contact: Sally Johnson. Commercial illustration representative. Estab. 1992. Represents 5 illustrators. Markets include: advertising agencies; corporations/client direct; design firms; editorial/magazines.
Handles: Illustration.
Terms: Rep receives 25% commission. Exclusive area representation is required. For promotional purposes, talent must provide promo piece with current images.
How to Contact: For first contact, send query letter, direct mail flier/brochure and tearsheets. Reports in 1 month only if interested. After initial contact, call to schedule an appointment. Portfolio should include tearsheets, transparencies.

VINCENT KAMIN & ASSOCIATES, 260 E. Chestnut, Suite 3005, Chicago IL 60611. (312)787-8834. Commercial photography, graphic design representative. Estab. 1971. Member of CAR (Chicago Artists Representatives). Represents 6 illustrators, 6 photographers, 1 designer, 1 fine artist (includes 1 sculptor). Markets include: advertising agencies.
Handles: Illustration, photography.
Terms: Rep receives 30% commission. Advertising costs are split: 90% paid by talent; 10% paid by representative. Advertises in *The Workbook* and *Chicago Directory*.
How to Contact: For first contact, send tearsheets. Reports back within 10 days. After initial contact, call to schedule an appointment. Portfolio should include tearsheets.

‡KASTARIS & ASSOCIATES, 3301a S. Jefferson, St. Louis MO 63118. (314)773-2600. Fax: (314)773-6406. E-mail: harriet@kastaris.com. Commercial illustration representative. Estab. 1987. Represents 21 illustrators. Markets include: advertising agencies; design firms; editorial/magazines; publishing/books; sales/promotion firms.
Handles: Illustration.
Terms: Rep receives 30% commission. Exclusive area representation is negotiable. Advertising costs are split: 75% paid by talent; 25% paid by representative. Talent must advertise with my firm; must provide 4×5 transparencies for portfolio." Produces own promotional book every year with a distribution of 6,000.
How to Contact: For first contact, send direct mail flier/brochure, tearsheets and SASE if you want sampler back. Reports in 1 month if interested. After initial contact, call for appointment.
Tips: "Show me your style. I enjoy reviewing samples. Have a strong portfolio that includes images of people, products, animals, food and typography."

KIRCHOFF/WOHLBERG, ARTISTS REPRESENTATION DIVISION, 866 United Nations Plaza, #525, New York NY 10017. (212)644-2020. Fax: (212)223-4387. Director of Operations: John R. Whitman. Estab. 1930s. Member of SPAR, Society of Illustrators, AIGA, Associaton of American Publishers, Bookbuilders of Boston, New York Bookbinders' Guild. Represents over 50 illustrators. Artist's Represenative: Elizabeth Ford (juvenile and young adult trade book and textbook illustrators). Specializes in juvenile and young adult trade books and textbooks. Markets include: publishing/books.
Handles: Illustration and photography (juvenile and young adult).
Terms: Rep receives 25% commission. Exclusive representation to book publishers is usually required. Advertising costs paid by representative ("for all Kirchoff/Wohlberg advertisements only"). "We will make transparencies from portfolio samples; keep some original work on file." Advertises in *American Showcase*, *Art Directors' Index*, *Society of Illustrators Annual*, children's book issue of *Publishers Weekly*.

How to Contact: Please send all correspondence to the attention of Elizabeth Ford. For first contact, send query letter, "any materials artists feel are appropriate." Reports in 4-6 weeks. "We will contact you for additional materials." Portfolios should include "whatever artists feel best represents their work. We like to see children's illustration in any style."

KLIMT REPRESENTS, 15 W. 72nd St., 7-U, New York NY 10023. (212)799-2231. Contact: Bill or Maurine. Commercial illustration representative. Estab. 1978. Member of Society of Illustrators, Graphic Artists Guild. Represents 14 illustrators. Specializes in paperback covers, young adult, romance, science fiction, mystery, etc. Markets include: advertising agencies; corporations/client direct; design firms; editorial/ magazines; paper products/greeting cards; publishing/books; sales/promotion firms.
Handles: Illustration.
Terms: Rep receives 25% commission, 30% commission for "out of town if we do shoots. The artist is responsible for only his own portfolio. Exclusive area representation is required. Advertising costs are split: 75% paid by talent; 25% paid by representative. For promotional purposes, talent must provide 4×5 or 8×10 mounted transparencies. Advertises through direct mail.
How to Contact: For first contact, send direct mail flier/brochure, and "any image that doesn't have to be returned unless supplied with SASE." Reports in 5 days. After initial contact, call for appointment to show portfolio of professional, mounted transparencies.

ELLEN KNABLE & ASSOCIATES, INC., 1233 S. LaCienega Blvd., Los Angeles CA 90035. (310)855-8855. (310)657-0265. Contact: Ellen Knable, Kathee Toyama. Commercial illustration, photography and commercial production representative. Estab. 1978. Member of SPAR, Graphic Artists Guild. Represents 4 illustrators, 6 photographers. Markets include: advertising agencies; corporations/client direct; design firms. Clients include Chiat/Day, BBDO, J.W. Thompson/SF, Ketchum/SF. Client list available upon request.
Terms: Rep receives 25-30% commission. Exclusive West Coast/Southern California representation is required. Advertising costs split varies. Advertises in *The Workbook*.
How to Contact: For first contact, send query letter, direct mail flier/brochure and tearsheets. Reports within 2 weeks. Call for appointment to show portfolio.
Tips: Obtains new talent from creatives/artists. "Have patience and persistence!"

LANGLEY ARTIST REPRESENTATIVE, (formerly Sharon Langley Represents!), 4300 N. Narragansett Ave., Chicago IL 60634-1591. (847)670-0912. Fax: (847)670-0926. Contact: Sharon Langley. Commercial illustration and photography representative. Estab. 1988. Member of CAR (Chicago Artists Representatives). Represents 8 illustrators. Markets include: advertising agencies; corporations/client direct; design firms; editorial/magazines; publishing/books; sales/promotion firms. Clients include Leo Burnett Advertising, *The Chicago Tribune*, Chicago Mercantile Exchange. Client list available upon request.
Handles: Illustration and photography. Although representative prefers to work with established talent, "I am always receptive to reviewing illustrators' work."
Terms: Rep receives 25% commission. Exclusive area representation is preferred. Advertising costs are split: 75% paid by talent; 25% paid by representative. For promotional purposes, talent must provide printed promotional piece, well organized portfolio. Advertises in *American Showcase, The Workbook*.
How to Contact: For first contact, send printed promotional piece. Reports in 2 weeks if interested. After initial contact, call for appointment to show portfolio of tearsheets, transparencies.
Tips: Obtains new talent through art directors, clients, referrals. "When an artist starts freelancing it's a good idea to represent yourself for a while. Only then are you able to appreciate a professional agent. Don't be discouraged when one rep turns you down. Contact the next one on your list!"

NELDA LEE INC., 2610 21st St., Odessa TX 79761. (915)366-8426. Fax: (915)550-2830. President: Nelda Lee. Vice President: Cory Ricot. Fine art representative. Estab. 1967. Senior member of American Society of Appraisers, Past President of Texas Association of Art Dealers. Represents 50-60 artists (includes 4 sculptors). Markets include: corporate collections; developers; galleries; interior decorators; museums; private collections.
Handles: Fine art, illustration.
Terms: Agent receives 40-50% commission. Exclusive area representation is required. No geographic restrictions. Advertising costs are paid by representative. Advertises in *Texas Monthly, Southwest Art*, local TV and newspapers.
How to Contact: For first contact, send query letter and non-returnable photographs ("include phone number"). Reports back only if interested. Materials not returned.

LEHMEN DABNEY INC., 1431 35th Ave. S., Seattle WA 98144. (206)325-8595. Fax: (206)325-8594. Principals: Nathan Dabney, Connie Lehmen. Commercial illustration, photography representative. Estab. 1989. Represents 20 illustrators, 1 photographer. Specializes in commercial art. Markets include: advertising agencies; corporations/client direct; design firms; editorial/magazines; paper products/greeting cards; publishing/books.

Handles: Illustration, photography.

Terms: Rep receives 25% commission. "Artists are responsible for providing portfolio pieces and cases." Exclusive area representation is required. Advertising costs are split: 75% paid by talent; 25% paid by representative. For promotional purposes, talent must provide transparencies or printed art on 11×14 art boards with museum box case; backlog of printed samples 1,000-1,500 minimum. Advertises in *American Showcase, The Workbook, Alternative Pic.*

How to Contact: For first contact, send direct mail flier/brochure and tearsheets. Reports in 10 days. After initial contact, call to schedule an appointment. Portfolio should include tearsheets, photographs, photocopies, transparencies (4×5), proofs.

Tips: Artists "must have published work, experience working with art directors and designers; computer skills a plus."

LESLI ART, INC., Box 6693, Woodland Hills CA 91364. (818)999-9228. Fax: (818)999-0833. Contact: Stan Shevrin. Fine art agent, publisher and advisor. Estab. 1965. Represents emerging, mid-career and established artists. Specializes in artists painting in oil or acrylic, in traditional subject matter in realistic or impressionist style. Also represents illustrators who want to establish themselves in the fine art market.

Terms: Receives 50% commission. Pays all expenses including advertising and promotion. Artist pays one-way shipping. All artwork accepted unframed. Exclusives preferred. Contract provided.

How to Contact: For first contact, send either color prints or slides with short bio and SASE. Material will be filed if SASE is not included. Reports in 2 weeks.

Tips: Obtains new talent through "reviewing portfolios. Artists should show their most current works and state a preference for subject matter and medium."

LINDGREN & SMITH, 250 W. 57th St., #916, New York NY 10107. (212)397-7330. Assistant: Miel Roman. Commercial illustration representative. Estab. 1984. Member of SPAR. Represents 32 illustrators. Markets include advertising agencies; corporations/client direct; design firms; editorial/magazines; paper products/greeting cards; publishing/books.

Handles: Illustration.

Terms: Exclusive representation is required. Advertises in *American Showcase, The Workbook.*

How to Contact: For first contact, send direct mail flier/brochure, tearsheets, photocopies. We will respond by mail or phone."

Tips: "Have experience. We only represent experienced artists who have been professionals for some time."

LULU CREATIVES, 4645 Colfax Ave. S., Minneapolis MN 55409. Phone/fax: (612)825-7564. Creative Representative: Lulu Zabowski. Commercial illustration representative. Estab. 1983. Represents 12 illustrators. Markets include: advertising agencies; corporations/client direct; design firms; editorial/magazines; paper products/greeting cards; publishing/books.

Handles: Illustration.

Terms: Rep receives 25% commission. Exclusive area representation is required. Advertising costs are split: 75% paid by talent; 25% paid by representative. For promotional purposes, talent must provide yearly national advertising, direct mailers (2 to 3 times yearly). Advertises in *American Showcase, Black Book, The Workbook.*

How to Contact: For first contact, send tearsheets. Reports immediately if interested. After initial contact, call to schedule an appointment.

Tips: Artists must have "good telephone communication skills."

MARTHA PRODUCTIONS, INC., 11936 W. Jefferson, Suite C, Culver City CA 90230. (310)390-8663. Fax: (310)390-3161. E-mail: marthaprod@earthlink.net.com. Contact: Martha Spelman. Commercial illustration and graphic design representative. Estab. 1978. Member of Graphic Artists Guild. Represents 25 illustrators. Staff includes Laura Fogarty (artist representative), Martha Spelman (artist representative), Kristie Powell (artist representative). Specializes in b&w and 4-color illustration. Markets include: advertising agencies; corporations/client direct; design firms; editorial/magazines; paper products/greeting cards.

Handles: Illustration.

Terms: Rep receives 30% commission. Exclusive area representation is required. No geographic restrictions. Advertising costs are split: 70% paid by talent; 30% paid by representative. For promotional purposes, talent must provide "a minimum of 12 images, 4×5 transparencies of each. (We put the transparencies into our own format.) In addition to the transparencies, we require 4-color promo/tearsheets and participation in the biannual Martha Productions brochure." Advertises in *The Workbook, Single Image.*

How to Contact: For first contact, send query letter, direct mail flier/brochure, tearsheets, slides and SASE (if materials are to be returned). Reports only if interested. After initial contact, drop off or mail in appropriate materials for review. Portfolio should include tearsheets, slides, photographs, photostats.

Tips: Obtains new talent through recommendations and solicitation. "We look for work we can sell to our clients—your work and the samples you send should relate to the market. Do research on what clients in the advertising, design and corporate markets are buying."

MATTELSON ASSOCIATES LTD., 37 Cary Rd., Great Neck NY 11021. (212)684-2974. Fax: (516)466-5835. Contact: Judy Mattelson. Commercial illustration representative. Estab. 1980. Member of SPAR, Graphic Artists Guild. Represents 3 illustrators. Markets include: advertising agencies; corporations/client direct; design firms; editorial/magazines; paper products/greeting cards; publishing/books; sales/promotion firms.
Handles: Illustration.
Terms: Rep receives 25-30% commission. Exclusive area representation is required. No geographic restrictions. Advertising costs are split: 75% paid by talent; 25% paid by representative. For promotional purposes, talent must provide c-prints and tearsheets, custom-made portfolio. Advertises in *American Showcase, RSVP*.
How to Contact: For first contact, send direct mail flier/brochure, tearsheets and SASE. Reports in 2 weeks, if interested. After initial contact, call for appointment to show portfolio of tearsheets, c-prints.
Tips: Obtains new talent through "recommendations from others, solicitation. Illustrator should have ability to do consistent, professional-quality work that shows a singular direction and a variety of subject matter. You should have a portfolio that shows the full range of your current abilities. Work should show strong draftsmanship and technical facility. Person should love her work and be willing to put forth great effort in each assignment."

‡MEDIA GALLERY/ENTERPRISES, 145 W. Fourth Ave., Garnett KS 66032-1313. (913)448-5813. Contact: Robert Cugno. Fine art representative. Estab. 1963. Number of artists and sculptors represented varies. Specializes in clay—contemporary and modern. Markets include: galleries; museums; private collections.
Handles: Fine art, clay.
Terms: Agent receives 40-60% commission. For promotional purposes, talent must provide photos and slides.
How to Contact: For first contact, send bio, slides, SASE. Reports in 1-2 weeks. After initial contact, drop off or mail in appropriate materials for review.
Tips: Obtains new talent through recommendations from other artists, collectors, art consultants and gallery directors.

MONTAGANO & ASSOCIATES, 401 W. Superior, Chicago IL 60611. (312)527-3283. Fax: (312)642-7543. Contact: David Montagano. Commercial illustration, photography and television production representative and broker. Estab. 1983. Represents 7 illustrators, 1 photographer. Markets include: advertising agencies; corporations/client direct; design firms; editorial/magazines; paper products/greeting cards.
Handles: Illustration, photography, design.
Terms: Rep receives 30% commission. No geographic restrictions. Advertises in *American Showcase, The Workbook, CIB*.
How to Contact: For first contact, send direct mail flier/brochure, tearsheets, photographs. Portfolio should include original art, tearsheets, photographs.

VICKI MORGAN ASSOCIATES, 194 Third Ave., New York NY 10003. (212)475-0440. Contact: Vicki Morgan. Commercial illustration representative. Estab. 1974. Member of SPAR, Graphic Artists Guild, Society of Illustrators. Represents 14 illustrators. Markets include: advertising agencies; corporations/client direct; design firms; editorial/magazines; paper products; publishing/books; sales/promotion firms.
Handles: Illustration. "Fulltime illustrators only."
Terms: Rep receives 30% commission. Exclusive area representation is required. No geographic restrictions. Advertising costs are split: 70% paid by talent; 30% paid by representative. "We require samples for three duplicate portfolios; the presentation form is flexible." Advertises in *American Showcase*, other directories and individual promotions.
How to Contact: For first contact, send any of the following: direct mail flier/brochure, tearsheets, slides with SASE. "If interested, we keep on file and consult these samples first when considering additional artists. No drop-off policy."
Tips: Obtains new talent through "recommendations from artists I represent and mail solicitation. Reuse of existing work and stock illustration are being requested more often than before!"

‡MICHELE MORGAN/ARTIST REPRESENTATIVE, 2646 DuPont St., #20-425, Irvine CA 92715. (714)770-9255. Owner: Michele Morgan. Commercial illustration representative. Estab. 1978. Represents 6 illustrators. Markets include: advertising agencies; corporations/client direct; design firms; editorial/magazines; paper products/greeting cards; publishing/books; art publishers; publishing/books.
Handles: Illustration.
Terms: Rep receives 30% commission. Advertising costs are split: 70% paid by talent; 30% paid by the representative. Advertises in *American Showcase, The Workbook*.
How to Contact: For first contact, send query letter, tearsheets and photocopies. Does not report back. Follow up with call. Agent will contact for portfolio review of photocopies if interested.
Tips: "Looking for artists with five years commercial experience."

MUNRO GOODMAN, 405 N. Wabash, Suite 2405, Chicago IL 60611. (312)321-1336. Fax: (312)321-1350. President: Steve Munro. Commercial illustration, photography representative. Estab. 1987. Member of SPAR, CAR (Chicago Artists Representatives). Represents 22 illustrators, 2 photographers. Markets include advertising agencies; corporations/client direct; design firms; publishing/books.
Handles: Illustration.
Terms: Rep receives 25-30% commission. Exclusive area representation is required. Advertising costs are split: 75% paid by talent; 25% paid by representative. For promotional purposes, talent must provide 2 portfolios. Advertises in *American Showcase*, *Black Book*, *The Workbook*.
How to Contact: For first contact, send query letter, bio, tearsheets and SASE. Reports back within 2 weeks. After initial contact, write to schedule an appointment. Portfolio should include 4×5 or 8×10 transparencies.

THE NEWBORN GROUP, 270 Park Ave. S., Apt. 8E, New York NY 10010-6105. (212)260-6700. Fax: (212)260-9600. Owner: Joan Sigman. Commercial illustration representative. Estab. 1964. Member of SPAR, Society of Illustrators, Graphic Artists Guild. Represents 12 illustrators. Markets include: advertising agencies; design firms; editorial/magazines; publishing/books. Clients include Leo Burnett, Berkley Publishing, Weschler Inc.
Handles: Illustration.
Terms: Rep receives 25% commission. Exclusive area representation is required. Advertising costs are split: 75% paid by talent; 25% paid by representative. Advertises in *American Showcase*, *The Workbook*.
How to Contact: "Not reviewing new talent."
Tips: Obtains new talent through recommendations from other talent or art directors.

LORI NOWICKI AND ASSOCIATES, 33 Cogswell Ave., Suite #7, Cambridge MA 02140. (617)497-5336. Fax: (617)441-0674. E-mail: lanow@aol.com. Artist Representative: Lori Nowicki. Commercial illustration representative. Estab. 1993. Represents 8 illustrators. Markets include: advertising agencies; design firms; editorial/magazines; publishing/books.
Handles: Illustration.
Terms: Rep receives 25-30% commission. Cost for direct mail promotional pieces is paid by illustrator. Exclusive area representation is required. Advertising costs are split: 75% paid by talent; 25% paid by representative. Advertises in *American Showcase*, *The Workbook*, *Black Book*.
How to Contact: For first contact, send query letter, résumé, tearsheets. Samples are not returned. After initial contact, call to schedule an appointment. Portfolio should include tearsheets, transparencies.
Tips: Wants artists with consistent style.

PENNAMENITIES, Box 1080, R.D. #2, Schuylkill Haven PA 17972. (717)754-7744. Fax: (717)754-7744. Director: Deborah A. Miller. Fine art representative. Estab. 1988. Certificated, NYU School of Appraisal; Schuylkill County Council for the Arts, Board of Directors; New Arts Program, member, Who's Who in American Business. Represents 40 fine artists. Markets include: commercial and academic galleries; private collectors. "Currently working with 14 galleries located in Pennsylvania and New York City."
Handles: Two dimensional fine art in all media (originals and prints).
Terms: Agent receives 25-50% commission. Charges $350 annual fee which covers correspondence, copies, phone and fax or services involved in setting up exhibits. New York City expenses, if applicable, are additional
How to Contact: Send bio with slides, transparencies, SASE, photos or laser prints labeled with size, medium, title and artist's name; include corresponding price list that reflects price to artist.
Tips: Currently seeking great art at marketable prices.

CAROLYN POTTS & ASSOC. INC., 1872 N. Clybourn, Suite #404, Chicago IL 60614. (312)935-1707. President: Carolyn Potts. Commercial illustration, photography representative. Estab. 1976. Member of SPAR, CAR (Chicago Artists Reps). Represents 12 illustrators, 7 photographers. Specializes in contemporary advertising and design. Markets include: advertising agencies; corporations/client direct; design firms; publishing/books.
Handles: Illustration, photography. Looking for "artists able to work with new technologies (interactive, computer, etc.)."
Terms: Rep receives 30-35% commission. Artists share cost of their direct mail postage and preparation. Exclusive area representation is required. Advertising costs are split: 70% paid by the talent; 30% paid by the representative after initial trial period wherein artist pays 100%. For promotional purposes, talent must provide direct mail piece and multiple portfolios. Advertises in *American Showcase*, *Black Book*, *The Workbook*, *Single Image*.
How to Contact: For first contact, send direct mail flier/brochure and SASE. Reports back within 3 days. After initial contact, write to schedule an appointment. Portfolio should include tearsheets, slides, photographs.
Tips: Looking for artists with high level of professionalism, awareness of current advertising market, professional presentation materials and positive attitude.

‡**PUBLISHERS' GRAPHICS**, 251 Greenwood Ave., Bethel CT 06801. (203)797-8188. Fax: (203)798-8848. Commercial illustration representative for juvenile markets. Estab. 1970. Member of Graphic Artists Guild, Author's Guild Inc. Staff includes Paige C. Gillies (President, selects illustrators, develops talent). Specializes in children's book illustration. Markets include: design firms; editorial/magazines; paper products/greeting cards; publishing/books; sales/promotion firms.
Handles: Illustration.
Terms: Rep receives 25% commission. Exclusive area representation is required. For promotional purposes, talent must provide original art, proofs, photocopies "to start. The assignments generate most sample/promotional material thereafter unless there is a stylistic change in the work." Advertises in *Literary Market Place*.
How to Contact: For first contact, send résumé, photocopies and SASE. Reports in 6 weeks. After initial contact, "We will contact them. We don't respond to phone inquiries." Portfolios should include original art, tearsheets, photocopies.
Tips: Obtains new talent through "clients recommending our agency to artists. We ask for referrals from our illustrators. We receive submissions by mail."

GERALD & CULLEN RAPP, INC., 108 E. 35th St., New York NY 10016. (212)889-3337. Fax: (212)889-3341. Contact: John Knepper. Commercial illustration representative. Estab. 1944. Member of SPAR, Society of Illustrators, Graphic Artists Guild. Represents 34 illustrators. Markets include: advertising agencies; corporations/client direct; design firms; editorial/magazines; paper products/greeting cards; publishing/books; sales/promotion firms.
Handles: Illustration.
Terms: Rep receives 25-30% commission. Exclusive area representation is required. No geographic restrictions. Split of advertising costs is negotiated. Advertises in *American Showcase*, *The Workbook*, *Graphic Artists Guild Directory* and *CA*, *Print*, *Art Direction* magazines. "Conducts active direct mail program."
How to Contact: For first contact, send query letter, direct mail flier/brochure. Reports in 1 week. After initial contact, call for appointment to show portfolio of tearsheets, slides.
Tips: Obtains new talent through recommendations from others, solicitations.

‡**REDMOND REPRESENTS**, 4 Cormer Ct., #304, Timonium MD 21093. (410)560-0833. Contact: Sharon Redmond. Commercial illustration and photography representative. Estab. 1987. Markets include: advertising agencies; corporations/client direct; design firms.
Handles: Illustration, photography.
Terms: Rep receives 30% commission. Exclusive area representation is required. No geographic restrictions. Advertising costs and expenses are split: 50% paid by talent; 50% paid by representative. For promotional purposes, talent must provide a small portfolio (easy to Federal Express) and at least 6 direct mail pieces (with fax number included). Advertises in *American Showcase, Black Book*.
How to Contact: For first contact, send photocopies. Reports in 2 weeks. After initial contact, representative will call talent to set an appointment.
Tips: Obtains new talent through recommendations from others, advertisting in "black book," etc. "Even if I'm not taking in new talent, I do want *photocopies* sent of new work. You never know when an ad agency will require a different style of illustration/photography and it's always nice to refer to my files."

KERRY REILLY: REPS, 1826 Asheville Place, Charlotte NC 28203. Phone/fax: (704)372-6007. Contact: Kerry Reilly. Commercial illustration and photography representative. Estab. 1990. Represents 16 illustrators, 3 photographers. Markets include: advertising agencies; corporations/client direct; design firms; editorial/magazines. Clients include Paramount Parks, Price/McNabb Advertising, Indigo Design.
Handles: Illustration, photography. Looking for computer graphics: Adobe Photoshop, Adobe Illustrator, Aldus FreeHand, etc.
Terms: Rep receives 25% commission. Exclusive area representation is required. No geographic restrictions. Advertising costs are split: 75% paid by talent; 25% paid by representative. For promotional purposes, talent must provide at least 2 pages printed leave-behind samples. Preferred format is 9×12 pages, portfolio work on 4×5 transparencies. Advertises in *American Showcase*, *The Workbook*.
How to Contact: For first contact, send direct mail flier/brochure or samples of work. Reports in 2 weeks. After initial contact, call for appointment to show portfolio or drop off or mail tearsheets, slides, 4×5 transparencies.
Tips: "Have a lot of printed samples."

‡**REPERTOIRE**, Suite 104-338, 5521 Greenville, Dallas TX 75206. (214)369-6990. Fax: (214)369-6938. Contact: Larry Lynch (photography) or Andrea Lynch (illustration). Commercial illustration and photography representative and broker. Estab. 1974. Member of SPAR. Represents 12 illustrators and 6 photographers. Specializes in "importing specialized talent into the Southwest." Markets include advertising agencies, corporations/client direct, design firms, editorial/magazines.
Handles: Illustration, photography.
Terms: Rep receives 25% commission. Exclusive area representation is required. Advertising costs are split: printing costs are paid by talent; distribution costs are paid by representative. Talent must provide

promotion, both direct mail and a national directory. Advertises in *The Workbook*.

How to Contact: For first contact, send direct mail flier/brochure, tearsheets. Reports in 1 month. After initial contact, write for appointment or drop off or mail portfolio of tearsheets, slides, photographs.

Tips: Obtains new talent through referrals, solicitations. "Have something worthwhile to show."

THE ROLAND GROUP, 4948 St. Elmo Ave., Suite #201, Bethesda MD 20814. (301)718-7955. Fax: (301)718-7958. Commercial illustration, photography, film and graphic design representative. Estab. 1988. Member of SPAR, Society of Illustrators, Ad Club, Production Club. Represents 20 illustrators, 40 photographers, 7 designers. Markets include: advertising agencies; corporations/client direct; design firms; editorial/magazines; paper products/greeting cards; publishing books.

Handles: Illustration, photography, film and design.

Terms: Rep receives 25-30% commission. Charges $150 marketing fee. Exclusive area representation is required. 100% of costs paid by talent. For promotional purposes, talent must provide $8\frac{1}{2} \times 11$ promo sheet. Advertises in *American Showcase*, *The Workbook*, *Sourcebook*.

How to Contact: For first contact, send query letter, résumé, tearsheets and photocopies. Reports back within 2 weeks. Portfolio should include nonreturnable tearsheets, photocopies.

ROSENTHAL REPRESENTS, 3850 Eddington Ave., Calabasas CA 91302. (818)222-5445. Fax: (818)222-5650. Commercial illustration representative and licensing agent for artists who do advertising, entertainment, action/sports, children's books, giftware, collectibles, figurines, children's humorous, storyboard, animal, graphic, floral, realistic, impressionistic and game packaging art. Estab. 1979. Member of SPAR, Society of Illustrators, Graphic Artists Guild, Women in Design and Art Directors Club. Represents 100 illustrators, 2 designers and 5 fine artists. Specializes in game packaging, personalities, licensing, merchandising art and storyboard artists. Markets include: advertising agencies; corporations/client direct; paper products/greeting cards; sales/promotion firms; licensees and manufacturers.

Handles: Illustration.

Terms: Rep receives 25-30% as a rep; 40% as a licensing agent. Exclusive area representation is required. No geographic restrictions. Advertising costs are paid by talent. For promotion purposes, talent must provide 1-2 sets of transparencies (mounted and labeled), 10 sets of slides of your best work (labeled with name on each slide), 1-3 promos. Advertises in *American Showcase* and *The Workbook*.

How to Contact: For first contact, send direct mail flier/brochure, tearsheets, slides, photocopies, photostats and SASE. Reports in 1 week. After initial contact, call for appointment to show portfolio of tearsheets, slides, photographs, photocopies.

Tips: Obtains new talent through seeing their work in an advertising book or at an award show.

FRAN SEIGEL, ARTIST REPRESENTATIVE, 515 Madison Ave., Suite #2200, New York NY 10022. (212)486-9644. Fax: (212)486-9646. Commercial illustration. Estab. 1982. Member of SPAR, Graphic Artists Guild. Represents 7 illustrators. Specializes in "stylized realism leaning toward the conceptual." Markets include advertising agencies; corporations/client direct; design firms; editorial/magazines; paper products/greeting cards; publishing/books.

Handles: Illustration, fine art. "Artists in my group must have work applicable to wide commercial market; a unique marketable style for book jackets and/or corporate and packaging is a plus."

Terms: Rep receives 30% commission. Artists pay mass mailing and folio charge (approximately $500/year). Exclusive national representation is required. Advertising costs are split: 70% paid paid by talent; 30% paid by representative. "First promotion is designed by both of us paid for by talent; subsequent promotion costs are split." Advertises in *American Showcase*, *Graphic Artists Guild Directory of Illustration*.

How to Contact: For first contact, send 12-20 images, direct mail flier/brochure, tearsheets, slides and SASE. Reports in 2 weeks only if SASE is included.

Tips: Looking for artists with " 'uniquely wonderful' artwork, vision and energy toward developing market-oriented portfolio, and absolute reliability and professionalism."

SIMPATICO ART & STONE, 1221 Demaret Lane, Houston TX 77055-6115. (713)467-7123. Contact: Billie Blake Fant. Fine art broker/consultant/exhibitor. Estab. 1973. Specializes in unique fine art, sculpture and Texas domestic stone furniture, carvings, architectural elements. Market includes: corporate; institutional and residential clients.

Handles: Looking for unique fine art and sculpture not presently represented in Houston, Texas.

Terms: Standard commission. Exclusive area representation required.

How to Contact: For first contact, send query letter, résumé, slides.

Tips: Obtains new talent through travel, publications, exhibits and referrals.

DANE SONNEVILLE ASSOC. INC., 67 Upper Mountain Ave., Montclair NJ 07042. (201)744-4465. Fax: (201)744-4467. Contact: Dane. Commercial illustration, photography and graphic design representative, illustration or photography broker, paste up, printing, hair and make up, all type stylists, computer image artists, writers. Estab. 1971. Represents 20 illustrators, 10 photographers and 10 designers. Specializes in "resourcefulness and expeditious service." Markets include: advertising agencies; corporations/client direct;

design firms; editorial/magazines; publishing/books; sales/promotion firms. Clients include Merrill Lynch Inc., Q.L.M. Advertising, GWP Advertising.

Handles: Illustration, photography, design, writing, all creative support personnel.

Terms: Rep receives 25% commission. Advertising costs are paid by talent. For promotional purposes, talent must provide unlimited promo pieces (to leave behind). Advertises in *American Showcase, Black Book, RSVP, The Workbook*.

How to Contact: For first contact, send résumé, direct mail flier/brochure, tearsheets. Reports in 1 week if interested. After initial contact, call for appointment to show portfolio of original art, tearsheets, slides, photographs.

Tips: Obtains new talent through recommendations from others. "Knock on every door. Be as diversified as possible and include a style that is unique."

TORREY SPENCER-ARTIST REPRESENTATIVE, 11201 Valley Spring Lane, Studio City CA 91602. (818)505-1124. Fax: (818)753-5921. Contact: Torrey Spencer. Commercial illustration, photography representative. Estab. 1980. Represents 3 illustrators, 5 photographers. Specializes in advertising/design markets. Markets include advertising agencies; corporations/client direct; design firm.

Handles: All styles.

Terms: Rep receives 25% commission (in Los Angeles), 30% commission (out of Los Angeles). Advertising costs are negotiable. "I need artist to be prepared to regularly produce direct mail pieces and to advertise in *The Workbook*."

How to Contact: For first contact, send query letter, résumé, direct mail flier/brochure, tearsheets, slides, photographs, photocopies, photostats and SASE. After initial contact, drop off or mail in appropriate materials. Portfolio should include tearsheets, prints (4×5 or 8×10).

Tips: Artists must be "easy to work with, honest and willing to produce new images regularly for the portfolio."

SULLIVAN & ASSOCIATES, 3805 Maple Court, Marietta GA 30066. (404)971-6782. Fax: (404)973-3331. E-mail: sullivan@atlcom.net. Contact: Tom Sullivan. Commercial illustration, commercial photography and graphic design representative. Estab. 1988. Member of Creative Club of Atlanta, Atlanta Ad Club. Represents 14 illustrators, 7 photographers and 7 designers, including those with computer graphic skills in illustration/design/production and photography. Staff includes Tom Sullivan (sales, talent evaluation, management); Debbie Sullivan (accounting, administration). Specializes in "providing whatever creative or production resource the client needs." Markets include: advertising agencies, corporations/client direct; design firms; editorial/magazines; publishing/books; sales/promotion firms.

Handles: Illustration, photography. "Open to what is marketable; computer graphics skills."

Terms: Rep receives 25% commission. Exclusive area representation in Southeastern US is required. Advertising costs are split: 75-100% paid by talent; 0-25% paid by representative. "Negotiated on individual basis depending on: (1) length of time worked with; (2) area of representation; (3) scope of exclusive representation." For promotional purposes, talent must provide "direct mail piece, portfolio in form of $8\frac{1}{2} \times 11$ (8×10 prints) pages in 22-ring presentation book." Advertises in *American Showcase, The Workbook*.

How to Contact: For first contact, send bio, direct mail flier/brochure; "follow up with phone call." Reports in 2 weeks if interested. After initial contact, call for appointment to show portfolio of tearsheets, photographs, photostats, photocopies, "anything appropriate in nothing larger than $8\frac{1}{2} \times 11$ print format."

Tips: Obtains new talent through referrals and direct contact from creative person. "Have direct mail piece or be ready to produce it immediately upon reaching an agreement with a rep. Be prepared to immediately put together a portfolio based on what the rep needs for that specific market area."

SUSAN AND CO., 2717 Western Ave., Seattle WA 98121. (206)728-1300. Fax: (206)728-7522. Owner: Susan Trimpe. Commercial illustration, photography representative. Estab. 1979. Member of SPGA. Represents 19 illustrators, 2 photographers. Specializes in commercial illustrators and photographers. Markets include advertising agencies; corporations/client direct; design firms; publishing/books.

Handles: Illustration, photography. Looks for "computer illustration, realism, corporate, conceptual."

Terms: Rep receives 30% commission. Charges postage if portfolios are shipped out of town. Exclusive area representation is required. Advertising costs are split: 70% paid by talent; 30% paid by representative. "Artists must take out a page in a publication, i.e., *American Showcase, CIB, The Workbook* with rep."

How to Contact: For first contact, send query letter and direct mail flier/brochure. Reports back within 2 weeks only if interested. After initial contact, call to schedule an appointment. Portfolio should include tearsheets, slides, photographs, photostats, photocopies.

Tips: Wants artists with "unique well-defined style and experience."

JOSEPH TRIBELLI DESIGNS, LTD., 254-33 Iowa Rd., Great Neck NY 11020. (516)482-2699. Contact: Joseph Tribelli. Representative of textile designers only. Estab. 1988. Member of Graphic Artists Guild. Represents 9 designers. Specializes in textile surface design for apparel (women and men). "All designs are on paper."

Handles: Textile design for apparel and home furnishings.

Terms: Rep receives 40% commission. Exclusive area representation is required.

How to Contact: "Telephone first." Reports back in 2 weeks. After initial contact, drop off or mail appropriate materials. Portfolio should include original art.

Tips: Obtains new talent through "placing ads, recommendations. I am interested in only textile designers who can paint on paper. Do not apply unless you have a flair for fashion."

T-SQUARE, ETC., 1990 S. Bundy Dr., Suite #190, Los Angeles CA 90025. (310)826-7033. Fax: (310)826-7133. E-mail: tsquare@pacificnet.net. Managing Director: Diane Pirritino. Graphic design representative. Estab. 1990. Member of Advertising Production Association of California, Ad Club of LA. Represents 50 illustrators, 100 designers. Specializes in computer graphics. Markets include advertising agencies; corporations/client direct; design firms; editorial/magazines.

Handles: Design.

Terms: Rep receives 25% commission. Advertising costs are split: 25% paid by talent; 75% paid by representative. For promotional purposes, talent must provide samples from their portfolio (their choice).

How to Contact: For first contact, send résumé. Reports back within 5 days. After initial contact, call to schedule an appointment. Portfolio should include thumbnails, roughs, original art, tearsheets, slides.

Tips: Artists must possess "good design, computer skills, flexibility, professionalism."

‡CHRISTINA A. TUGEAU: ARTIST AGENT, 110 Rising Ridge Rd., Ridgefield CT 06877. Phone/fax: (203)438-7307. Owner: Chris Tugeau. Commercial illustration representative. Estab. 1994. Member of Graphic Artists Guild, SCBWI. Represents 20 illustrators. Specializes in children's book publishing and educational market and related areas.

Handles: Illustration. Must be proficient at illustrating children and animals in a variety of interactive situations, in real space, full color/b&w, and with a strong narrative sense.

Terms: Rep receives 20% commission. Exclusive area representation is required (self-promotion is OK). Advertising costs are split: 80% paid by the talent; 20% paid by the representative. For promotional purposes, talent must provide a direct mail promo piece, 8-10 good "back up" samples (multiples), 3 strong portfolio (8 × 10 or printed pieces). Advertises in *RSVP* and *Gag Directory of Illustration*.

How to Contact: For first contact, send direct mail flier/brochure, tearsheets, photographs, photocopies, SASE, "prefer no slides!" Reports in 1-2 weeks. Call to schedule an appointment. Portfolio should include tearsheets, photocopies, "no originals."

Tips: "You should have a style uniquely and comfortably your own and be great with deadlines."

‡SUSAN P. URSTADT INC. WRITERS AND ARTISTS AGENCY, P.O. Box 1676, New Canaan CT 06849. (203)972-8226. Contact: Susan Urstadt. Illustration and photography representative. Estab. 1975. Member of AAR. Specializes in illustrated books.

Handles: Adult books on lifestyle, gardening, food, health, popular reference, botanical and zoological illustration. Photography and illustration for children's books.

Terms: Agent receives 25% commission. Advertising costs are negotiable. Charges for out of pocket expenses. Exclusive area representation is required. For promotional purposes, talent is required to provide oversize color postcard with 4 different images and artist bio on back.

How to Contact: For first contact, send query letter, resume, bio, direct mail/flier and SASE. "No original art, no oversize submissions." Reports in 1 month. After initial contact, "we'll call you if we fall in love with it." Portfolio should include appropriate materials as advised.

VARGO BOCKOS, 500 N. Michigan Ave., Suite 2000, Chicago IL 60611. (312)661-1717. Fax: (312)661-0043. Partners: Julie Vargo, Patrice Bockos. Commercial illustration, photography, film production representative. Estab. 1994. Member of CAR (Chicago Artists Reps). Represents 3 photographers. Markets include: advertising agencies; design firms.

Handles: Illustration, photography and film.

Terms: Rep receives 30% commission. Advertising costs are split: 70% paid by talent; 30% paid by representative. "Direct mail pieces are great bonuses. The portfolio must be professionally presented." Advertises in *The Workbook*.

How to Contact: For first contact, send query letter and direct mail flier/brochure. Reports back within 2 days if interested. After initial contact, call to schedule an appointment. Portfolio should include original art, tearsheets, photographs.

PHILIP M. VELORIC, ARTIST REPRESENTATIVE, 128 Beechtree Dr., Broomall PA 19008. (610)356-0362. Fax: (610)353-7531. Contact: Philip M. Veloric. Commercial illustration representative. Estab. 1963. Member of Art Directors Club of Philadelphia. Represents 22 illustrators. "Most of my business is from textbook publishing, but not all of it." Markets include: advertising agencies; design firms; publishing/books; collectibles.

Handles: Illustration. "Artists should be able to do (and have samples to show) all ethnic children (getting ages right; tell a story; develop a character); earth science, life and physical science; some trade books also."

Terms: Rep receives 25% commission. Exclusive area representation is required. Advertising costs are split: 75% paid by talent; 25% paid by representative. Advertises in *RSVP*.
How to Contact: For first contact call. After initial contact, send samples of original art, tearsheets, photocopies, laser copies.

GWEN WALTERS, 50 Fuller Brook Rd., Wellesley MA 02181. (617)235-8658. Commercial illustration representative. Estab. 1976. Member of Graphic Artists Guild. Represents 17 illustrators. "I lean more toward book publishing." Markets include: advertising agencies; corporations/client direct; editorial/magazines; paper products/greeting cards; publishing/books; sales/promotion firms.
Handles: Illustration.
Terms: Rep receives 30% commission. Charges for color photocopies. Advertising costs are split; 70% paid by talent; 25% paid by representative. For promotional purposes, talent must provide direct mail pieces. Advertises in *American Showcase* (sometimes), *Black Book, RSVP*.
How to Contact: For first contact, send résumé bio, direct mail flier/brochure. After initial contact, representative will call. Portfolio should include "as much as possible."

W/C STUDIO INC., 208 Providence Rd., Annapolis MD 21401. (410)349-8669. Fax: (410)349-8632. E-mail: acomport@aol.com. Artist's Representative: Allan Comport. Commercial illustration, photography representative. Estab. 1983. Member of SPAR, Society of Illustrators. Represents 4 illustrators, 1 photographer. Markets include: advertising agencies; design firms; editorial/magazines.
Handles: Illustration, photography.
Terms: Rep receives 25% commission. Advertising costs are split: 75% paid by talent; 25% paid by representative. For promotional purposes, talent must provide 4×5 transparencies; "We put them into our own 11×12 format." Advertises in *American Showcase, Black Book, The Workbook*.
How to Contact: Send query letter, direct mail flier/brochure, tearsheets, photocopies and SASE. Reports in 1 month. Portfolio should include tearsheets.
Tips: Artists must have "strong conceptual talent, highest professional/work ethic, good attitude."

DAVID WILEY REPRESENTS, 282 Second St., 2nd Floor, San Francisco CA 94105. (415)442-1822. Fax: (415)442-1823. E-mail: dwr@slip.net. Website: http://www.dwrepresents.com/dwr. Contact: David Wiley. Commercial illustration and photography representative. Estab. 1984. Member of AIP (Artists in Print). Represents 9 illustrators. Specializes in "reliability and quality!" Clients include Coke, Pepsi, '96 Summer Olympics, Disney Co., Bank of America. Client list available upon request; "depends who and why."
Terms: Advertises in *American Showcase* and *Creative Illustration Book*.
How to Contact: For first contact, send direct mail flier/brochure, tearsheets, slides, photographs, and SASE ("very important"). Will call back, if requested, within 48 hours. After initial contact, call for appointment or drop off appropriate materials. Portfolio should include, roughs, original art, tearsheets.

DEBORAH WOLFE LTD., 731 N. 24th St., Philadelphia PA 19130. (215)232-6666. Fax: (215)232-6585. Contact: Deborah Wolfe. Commercial illustration representative. Estab. 1978. Represents 25 illustrators. Markets include: advertising agencies; corporations/client direct; design firms; editorial/magazines; publishing/books.
Handles: Illustration.
Terms: Rep receives 25% commission. Advertises in *American Showcase* and *Black Book*.
How to Contact: For first contact, send direct mail flier/brochure, tearsheets, slides. Reports in 3 weeks.
Tips: "Artists usually contact us through mail or drop off at our office. If interested, we ask to see more work (including originals)."

Organizations

Organizations provide services and opportunities to assist artists. They provide support services, hotlines, seminars, workshops, conferences, advocacy programs, legal advice, publications, referral services, and even group insurance plans. Many offer funding opportunities as well.

Call or write for information and additional benefits. Refer to the Gale *Encyclopedia of Associations* in your local library for additional organizations.

‡**AMERICAN CENTER FOR DESIGN**, 233 E. Ontario, Suite 500, Chicago IL 60611. (312)787-2018. Fax: (312)649-9518. E-mail: acdchicago@aol.com. Website: http://www.design.chi.il.us/ac4d/.

‡**AMERICAN INSTITUTE OF GRAPHIC ARTS (AIGA)**, 164 Fifth Ave., New York NY 10010. (212)807-1990. Website: http://www.aiga.org. Executive Director: Richard Grefé.

AMERICAN SOCIETY OF ARCHITECTURAL PERSPECTIVISTS, 52 Broad St., Boston MA 02109. (617)951-1433, ext. 225. E-mail: robert@asap.org. Website: http://www.asap.org. Executive Director: Alexander Lee.

AMERICAN SOCIETY OF ARTISTS, INC., P.O. Box 1326, Palatine IL 60078. (312)751-2500 or (847)991-4748. Membership Chairman: Helen Del Valle.

AMERICAN SOCIETY OF AVIATION ARTISTS, 1805 Meadowbrook Heights Rd., Charlottesville VA 22901. (804)296-9771. Fax: (804)293-5185. E-mail: lyg@virginia.edu. Executive Secretary: Luther Y. Gore.

ARTISTS IN PRINT, 665 Third St., Suite 530, San Francisco CA 94107. (415)243-8244. Fax: (415)495-3155. E-mail: pattimangan@designlink.com. Website: http://www.designlink.com/aip. President: Patti Mangan.

‡**ASSOCIATION FOR VISUAL ARTISTS (AVA)**, 744 McCallie Ave., Suite 321, Chattanooga TN 37403. (423)265-4282. Fax: (423)265-5233. Director: Christy Mitchell.

COALITION OF WOMEN'S ART ORGANIZATIONS, 123 E. Beutel Rd., Port Washington WI 53074-1103. (414)284-4458. Fax: (414)284-8875. E-mail: dprovis@omnifest.uwm.edu. President: Dorothy Provis.

‡**GRAPHIC ARTISTS GUILD**, 11 W. 20th St., New York NY 10011-3704. (212)463-7730. Fax: (212)463-8779. E-mail: paulatgag@aol.com. Website: http://www.gag.org. Executive Director: Paul Basista.

INTERNATIONAL SCULPTURE CENTER (ISC), 1050 17th St. NW, Suite 250, Washington DC 20036. (202)785-1144. Fax: (202)785-0810. Executive Director: Jeanne C. Pond.

‡*NATIONAL ASSOCIATION FOR THE VISUAL ARTS**, P.O. Box 60, Potts Point, New South Wales, 2011 Australia. (02)368-1900. Fax: (02)358-6909. Contact: Artists Unit.

‡**NATIONAL ASSOCIATION OF ARTISTS' ORGANIZATIONS**, 918 F St. NW, Suite 611, Washington DC 20004. (202)347-6350. Fax: (202)347-7376. E-mail: nuaoz@tmn.com.

‡**NOVA (New Organization for the Visual Arts)**, 4614 Prospect Ave., Suite 410, Cleveland OH 44103. (216)431-7500. Executive Director: Janus Small.

ORGANIZATION OF INDEPENDENT ARTISTS, 19 Hudson St., Suite 402, New York NY 10013. (212)219-9213. Fax: (212)219-9216. Website: http://www.arts-online.com/oia.htm.

‡**PASTEL SOCIETY OF AMERICA**, 15 Gramercy Park S., New York NY 10003. (212)533-6931. Chairman of the Board: Flora B.Giffuni.

INSIDER REPORT

Organizations Guide Artists Through Sea of Change

As Richard Grefé, director of the American Institute of Graphic Arts (AIGA) observes, artists have traditionally worked in relative isolation. Because of this isolation, perhaps artists need organizations more urgently than other professions.

Richard Grefé

Since many artists are in business for themselves, insurance coverage and credit unions are not as available to them as they are for employees who work in large companies. Many beginning artists enter their careers with a "sink or swim" attitude. Without benefits like insurance, knowledge of marketing opportunities and solid business advice, many artists often sink because they are unaware of the lifeline organizations can provide—and that it is possible for artists to get insurance benefits, to join a credit union and to gain business savvy.

One of the best favors you can do for yourself and your profession is to join an artists' organization. There are organizations for practically every type of artist—cartoonists, illustrators, designers, fine artists and even calligraphers. There are organizations for artists who draw with colored pencils, for realists, and for artists who work in pastels, or watercolors. There are organizations to help artists find funding, exhibition opportunities, studio space and jobs. For artists just starting out, organizations can offer opportunities to gain practical information. More seasoned artists might link up with organizations strictly for networking and social reasons.

One of the oldest and largest of all these organizations is AIGA, founded in 1914. Because of its age and size (over 7,400 members) there is a depth of experience in the membership and a range of disciplines represented that is not true of other organizations.

Prior to Grefé's appointment to executive director, he worked as the CEO of an association for public television stations, managed a think tank and consulted on urban planning. He's been a journalist, a naval lieutenant, an intelligence analyst, and an attaché in Manila. Such a varied career involving economics, communications, management and, of course, design, makes Grefé an ideal candidate to navigate the largest and oldest of graphic design's membership organizations through the technological and economic changes facing the design profession in the '90s.

Grefé believes AIGA's most important role in such tumultuous times is to provide fellowship, inspiration and education. Members join AIGA for four rea-

INSIDER REPORT, *continued*

sons, he says—to develop a sense of community, to share information, and to promote understanding of, and respect for the profession.

Though it is a national organization with headquarters in New York City, AIGA offers local activities through 35 chapters across the country. Local functions are excellent places for graphic artists to network and share information. AIGA's local chapters become involved in civic projects (such as projects which advance literacy in the community).

On a national level, AIGA provides a united voice whenever graphic artists need to speak out on issues pertaining to their profession. One of the organization's major goals is to increase the public's understanding of the value of design and encourage respect for the profession. Some of its other goals are to encourage communication between beginning and established designers, and to increase racial diversity within the profession. In addition to these intangibles, AIGA offers benefits such as annual competitions, traveling shows, a membership directory, discounts, and national conferences on both business and design. "Freelancers have found the sheer scale of the national conferences reinforcing. . . . They remind the freelancer that he or she is part of a larger whole which is quite extraordinary, diverse, and marvelously creative," says Grefé.

Under Grefé's leadership, much of AIGA's agenda has focused on change, which he sees as a fundamental part of design and its relationship to business and popular culture. While designers are challenged by change, he points out "What is daunting is the opportunity, not the obstacles." AIGA seeks to work cooperatively, not competitively with other artists' organizations and works on joint projects that benefit artists. For example, AIGA is working with the Graphic Artists Guild to advocate simpler registration practices for copyrights, and supports greater protection for digital design. AIGA has extended an invitation to other graphic arts organizations to share its New York headquarters at advantageous rates.

One of the most exciting ways AIGA and other organizations communicate with their members and the public is through the World Wide Web. Through AIGA's website, graphic artists can instantly find activities of interest and share information, job resources and discuss news and trends that affect their profession. You can visit AIGA's website at http://www.aiga.org. Look for other organizations' websites in the listings within this section.

—Lynn Haller

THE SOCIETY FOR CALLIGRAPHY & HANDWRITING, P.O. Box 3761, Bellevue WA 98009. Contact: Secretary.

‡SOCIETY OF PUBLICATION DESIGNERS, 60 E. 42nd St., Suite 721, New York NY 10165. (212)983-8585. Fax: (212)983-6043. E-mail: spdnyc@aol.com. Director: Bride Whelan.

VOLUNTEER LAWYERS FOR THE ARTS, One E. 53rd St., Sixth Floor, New York NY 10022. (212)319-2910. Executive Director: Daniel Y. Mayer, Esq.

Publications of Interest

The following publications will help you keep up with market trends and provide additional leads. A few offer advertising opportunities for artists. Most are available in libraries or bookstores or from the publisher.

DIRECTORIES

AMERICAN SHOWCASE, 915 Broadway, 14th Floor, New York NY 10010. (212)673-6600. Annual hardcover directory of illustrators. Most often used by art directors and artist representatives to find new talent.

ART BUSINESS NEWS, 19 Old Kings Hwy. S., Darien CT 06820-4526. (203)656-3402. Monthly magazine covering business issues in the art industry.

ART NOW GALLERY GUIDE, 97 Grayrock Rd., P.O. Box 5541, Clinton NJ 08809. (908)638-5255. Monthly guide listing galleries by region. Also publishes international guide.

AUDIO VIDEO MARKETPLACE, R.R. Bowker, A Reed Reference Publishing Co., 121 Chanlon Rd., New Providence NJ 07974. (908)464-6800. Annual directory listing audiovisual companies and related services.

BLACK BOOK, (formerly Creative Black Book), Black Book Marketing, Inc., 10 Astor Place, 6th Floor, New York NY 10003. (800)841-1246. Annual directory listing illustrators, photographers, printers and service houses. Also publishes regional directories.

CREATIVE ILLUSTRATION BOOK, Black Book Marketing, Inc., 10 Astor Place, 6th Floor, New York NY 10003. (800)841-1246. Annual directory of illustration.

GRAPHIC ARTISTS GUILD'S DIRECTORY OF ILLUSTRATION, Serbin Communications, 511 Olive St., Santa Barbara CA 93101. (805)963-0439. Annual directory of illustration.

LITERARY MARKET PLACE, R.R. Bowker, A Reed Reference Publishing Co., 121 Chanlon Rd., New Providence NJ 07974. (908)464-6800. Annual directory listing book publishers and related services.

O'DWYER'S DIRECTORY OF PUBLIC RELATIONS FIRMS, J.R. O'Dwyer Company, Inc., 271 Madison Ave., New York NY 10016. (212)679-2471. Annual directory listing PR firms, indexed by specialties.

RSVP, The Directory of Illustration and Design, P.O. Box 050314, Brooklyn NY 11205. (718)857-9267. Annual directory in which designers and illustrators can advertise their services. Most often used by art directors seeking new talent.

STANDARD DIRECTORY OF ADVERTISING AGENCIES (The Redbook), National Register Publishing, A Reed Reference Publishing Co., 121 Chanlon Rd., New Providence NJ 07974. (908)464-6800. Annual directory listing advertising agencies.

STANDARD RATE AND DATA SERVICE (SRDS), 1700 E. Higgins Rd., Des Plains IL 60018. (847)375-5000. Monthly directory listing magazines, plus their advertising rates and related information.

MAGAZINES

ADVERTISING AGE, Crain Communications, 740 N. Rush St., Chicago IL 60611-2590. (312)649-5200. Weekly trade tabloid covering the ad industry.

ADWEEK, Adweek Magazines, 1515 Broadway, New York NY 10036-8986. (212)536-5336. Weekly advertising and marketing magazine. Also publishes annual directory of ad agencies.

AMERICAN ARTIST BPI Communications, 1515 Broadway, New York NY 10036. (800)745-8922.

ART CALENDAR, *P.O. Box 199, Upper Fairmount MD 21867-0199. (410)651-9150. Monthly magazine listing galleries, juried shows, percent-for-art programs, scholarships and art colonies, plus other art-related articles.*

ART IN AMERICA, *Brant Publications, Inc., 575 Broadway, New York NY 10012. (212)941-2800. Monthly magazine covering national and international news and issues relating to the fine art world. Also publishes annual guide to museums, galleries and artists (August issue).*

THE ARTIST'S MAGAZINE, *F&W Publications, Inc., 1507 Dana Ave., Cincinnati OH 45207. (513)531-2222. Monthly magazine for fine artists, illustrators and cartoonists. Features how-to articles on techniques and business issues. Subscription services: P.O. Box 2120, Harlan IA 51593. (800)333-0444.*

ARTNEWS, *ARTnews Associates, 48 W. 38th St., New York NY 10018. (212)398-1690. Magazine published 10 times/year covering the latest issues in national and international fine art, plus reviews and other feature articles.*

ARTWEEK, *2149 Paragon Dr., Suite 100, San Jose CA 95131-1312. (408)441-7065. Biweekly magazine covering fine art issues, galleries and other events on the West Coast.*

BILLBOARD, *1515 Broadway, 15th Floor, New York NY 10036. (212)764-7300. Weekly magazine covering the music industry.*

COMMUNICATION ARTS, *410 Sherman Ave., Box 10300, Palo Alto CA 94303. (415)326-6040. Magazine published 8 times/year covering design, illustration and photography.*

DECOR, *Commerce Publishing Co., 330 N. Fourth St., St. Louis MO 63102. (314)421-5445. Monthly trade magazine for gallery owners and gallery directors. Also publishes an annual buyers' guide directory.*

EDITOR & PUBLISHER, *The Editor & Publisher Co. Inc., 11 W. 19th St., New York NY 10011. (212)675-4380. Weekly magazine covering latest developments in journalism and newspaper production. Publishes annual directory issue listing syndicates and another directory listing newspapers.*

FOLIO, *Cowles Business Media, 911 Hope St., Box 4949, Stamford CT 06907-0949. (203)358-9900. Biweekly magazine featuring trends in magazine circulation, production and editorial.*

GIFTWARE NEWS, *Talcott Communications Corp., 3405 Empire State Bldg., New York NY 10118. (212)629-0800. Monthly trade magazine covering the giftware and paper products industry.*

GREETINGS MAGAZINE, *Mackay Publishing Corp., 307 Fifth Ave., 16th Floor, New York NY 10016. (212)679-6677. Monthly trade magazine covering the greeting card and stationery industry.*

HOW, *F&W Publications, Inc., 1507 Dana Ave., Cincinnati OH 45207. (513)531-2222. Monthly magazine for graphic design professionals.*

PARTY & PAPER RETAILER, *4Ward Corp., 70 New Canaan Ave., Norwalk CT 06850. (203)845-8020. Monthly magazine covering the giftware and paper products industry.*

PRINT, *RC Publications, 104 Fifth Ave., 19th Floor, New York NY 10011. (212)463-0600. Bimonthly magazine focusing on creative trends and technological advances in illustration, design, photography and printing. Also publishes* Regional Design Annual *featuring the year's best in design and illustration.*

PUBLISHERS WEEKLY, *Cahners Publishing Co., 249 W. 17th St., New York NY 10011. (212)645-9700. Weekly trade magazine covering industry trends and news in book publishing, book reviews and interviews.*

SOUTHWEST ART, *Cowles Magazines, 5444 Westheimer, Suite 1440, Houston TX 77056. (713)850-0990. Monthly magazine covering fine arts in the Southwest.*

STEP-BY-STEP GRAPHICS, *Dynamic Graphics Inc., 6000 N. Forest Park Dr., Peoria IL 61614. (800)255-8800. Bimonthly magazine featuring step-by-step demonstrations for designers and illustrators.*

UPPER & LOWER CASE (U & lc), *International Typeface Corp., 866 Second Ave., New York NY 10017. (212)371-0699. Quarterly publication covering the latest in typography and issues relating to type designers.*

ENCOURAGING REJECTION, *Box 750 Intervale NH 03845 (603)356-9910. Bimonthly newsletter for professional cartoonists.*

Glossary

Acceptance (payment on). An artist is paid for his work as soon as a buyer decides to use it.
Adobe Illustrator®. Drawing and painting computer software.
Adobe Photoshop®. Photo manipulation computer program.
Advance. Amount paid to an artist before beginning work on an assigned project. Often paid to cover preliminary expenses.
Airbrush. Small pencil-shaped pressure gun used to spray ink, paint or dye to obtain gradated tonal effects.
Aldus FreeHand. Illustration computer software.
Aldus PageMaker. Page layout computer software.
Art director. In commercial markets, the person responsible for choosing and purchasing artwork and supervising the design process.
Biannually. Occurring twice a year.
Biennially. Occurring once every two years.
Bimonthly. Occurring once every two months.
Biweekly. Occurring once every two weeks.
Book. Another term for a portfolio.
Buy-out. The sale of all reproduction rights (and sometimes the original work) by the artist; also subcontracted portions of a job resold at a cost or profit to the end client by the artist.
Calligraphy. The art of fine handwriting.
Camera-ready. Art that is completely prepared for copy camera platemaking.
Capabilities brochure. A brochure, similar to an annual report, outlining for prospective clients the nature of a company's business and the range of products or services it provides.
Caption. See gagline.
CD-ROM. Compact disc read-only memory; non-erasable electronic medium used for digitized image and document storage and retrieval on computers.
Collateral. Accompanying or auxiliary pieces, such as brochures, especially used in advertising.
Color separation. Photographic process of separating any multi-color image into its primary component parts (cyan, magenta, yellow and black) for printing.
Commission. 1) Percentage of retail price taken by a sponsor/salesman on artwork sold. 2) Assignment given to an artist.
Comprehensive. Complete sketch of layout showing how a finished illustration will look when printed; also called a comp.
Copyright. The exclusive legal right to reproduce, publish and sell the matter and form of a literary or artistic work.
Consignment. Arrangement by which items are sent by an artist to a sales agent (gallery, shop, sales rep, etc.) for sale with the understanding the artist will not receive payment until work is sold. A commission is almost always charged for this service.
Direct-mail package. Sales or promotional material that is distributed by mail. Usually consists of an outer envelope, a cover letter, brochure or flier, SASE, and postpaid reply card, or order form with business reply envelope.
Dummy. A rough model of a book or multi-page piece, created as a preliminary step in determining page layout and length. Also, a rough model of a card with an unusual fold or die cut.
Edition. The total number of prints published of one piece of art.
Elhi. Abbreviation for elementary/high school used by publishers to describe young audiences.
Environmental graphic design (EGD). The planning, designing and specifying of graphic elements in the built and natural environment; signage.
Estimate. A ballpark figure given to a client by a designer anticipating the final cost of a project.
Etching. A print made by the intaglio process, creating a design in the surface of a metal or other plate with a needle and using a mordant to bite out the design.
Exclusive area representation. Requirement that an artist's work appear in only one outlet within a defined geographical area.
Finished art. A completed illustration, mechanical, photo, or combination of the three that is ready to go to the printer. Also called camera-ready art.
Gagline. The words printed with a cartoon (usually directly beneath); also called a caption.
Gouache. Opaque watercolor with definite, appreciable film thickness and an actual paint layer.
Halftone. Reproduction of a continuous tone illustration with the image formed by dots produced by a camera lens screen.
IRC. International Reply Coupon; purchased at the post office to enclose with artwork sent to a foreign buyer to cover his postage cost when replying.
Keyline. Identification of the positions of illustrations and copy for the printer.

Kill fee. Portion of an agreed-upon payment an artist receives for a job that was assigned, started, but then canceled.

Layout. Arrangement of photographs, illustrations, text and headlines for printed material.

Lithography. Printing process based on a design made with a greasy substance on a limestone slab or metal plate and chemically treated so image areas take ink and non-image areas repel ink.

Logo. Name or design of a company or product used as a trademark on letterhead, direct mail packages, in advertising, etc., to establish visual identity.

Mechanicals. Paste-up or preparation of work for printing.

Multimedia. A generic term used by advertising, public relations and audiovisual firms to describe productions involving more than one medium to create a variety of visual effects. Also, a term used to reflect the varied inhouse capabilities of an agency.

Naif. Native art of such cultures as African, Eskimo, Native American, etc., usually associated with daily life.

Offset. Printing process in which a flat printing plate is treated to be ink-receptive in image areas and ink-repellent in non-image areas. Ink is transferred from the printing plate to a rubber plate, and then to the paper.

Overlay. Transparent cover over copy, on which instruction, corrections or color location directions are given.

Panel. In cartooning, the boxed-in illustration; can be single panel, double panel or multiple panel.

Paste-up. Procedure involving coating the backside of art, type, photostats, etc., with rubber cement or wax and adhering them in their proper positions to the mechanical board. The boards are then used as finished art by the printer.

Photostat. Black & white copies produced by an inexpensive photographic process using paper negatives; only line values are held with accuracy. Also called stat.

PMT. Photomechanical transfer; photostat produced without a negative.

P-O-P. Point-of-purchase; in-store marketing display that promotes a product.

Print. An impression pulled from an original plate, stone, block screen or negative; also a positive made from a photographic negative.

Production artist. In the final phases of the design process, the artist responsible for mechanicals, paste up, and sometimes the overseeing of printing.

QuarkXPress. Page layout computer program.

Query. Letter to an art director or buyer eliciting interest in a work an artist wants to illustrate or sell.

Quotation. Set fee proposed to a client prior to commencing work on a project.

Rendering. A drawn representation of a building, interior, etc., in perspective.

Retail. The sale of goods in small quantities directly to the consumer.

Roughs. Preliminary sketches or drawings.

Royalty. An agreed percentage paid by a publisher to an artist for each copy of a work sold.

SASE. Self-addressed, stamped envelope.

Self-publishing. In this arrangement, an artist coordinates and pays for printing, distribution and marketing of his/her own artwork and in turn keeps all ensuing profits.

Semiannual. Occuring twice a year.

Semimonthly. Occurring twice a month.

Semiweekly. Occurring twice a week.

Serigraph. Silkscreen; method of printing in which a stencil is adhered to a fine mesh cloth stretched over a wooden frame. Paint is forced through the area not blocked by the stencil.

Simultaneous submissions. Submission of the same artwork to more than one potential buyer at the same time.

Speculation. Creating artwork with no assurance that a potential buyer will purchase it or reimburse expenses in any way; referred to as work on spec.

Spot drawing. Small illustration used to decorate a page of type, or to serve as a column ending.

Storyboard. Series of panels that illustrate a progressive sequence or graphics and story copy of a TV commercial, film or filmstrip. Serves as a guide for the eventual finished product.

Tabloid. Publication whose format is an ordinary newspaper page turned sideways.

Tearsheet. Published page containing an artist's illustration, cartoon, design or photograph.

Thumbnail. A rough layout in miniature.

Transparency. A photographic positive film such as a color slide.

Type spec. Type specification; determination of the size and style of type to be used in a layout.

Velox. Photoprint of a continuous tone subject that has been transformed into line art by means of a halftone screen.

VHS. Video Home System; a standard videotape format for recording consumer-quality videotape, most commonly used in home videocassette recording and portable camcorders.

Video. General category comprised of videocassettes and videotapes.

Wash. Thin application of transparent color or watercolor black for a pastel or gray tonal effect.

Wholesale. The sale of commodities in large quantities usually for resale (as by a retail merchant).

Internet Resources

If you have access to an online computer service, such as Prodigy, American Online or CompuServe, there is a wealth of information waiting for you online. Many of the galleries, publishers and organizations in our market sections also provide websites within their listings. The following sites were available at press time. If you have trouble accessing a site, or can suggest others, drop us a line to the attention of AGDM, via e-mail to wdigest@aol.com.

art.on.the.web: http://www.artproducts.com
Artists can request information directly from manufacturers and link to a list of art supply stores.

Arts Wire: http://www.tmn.com/oh/artswire/www/about.html
A national computer network devoted to the arts. Subscribers are offered art-related news, grant information, commissioned texts by artists and connection to several data-bases.

ASKTODDART: Keyword: asktoddart and/or Image Exchange
A forum board and consulting area for artists, dealers and collectors focusing on the business side of art.

DesignOnline: http://www.dol.com/
Designers can post work opportunities, e-mail one another, read news and access fonts.

E-Talent.Net Inc.: http://www.e-talentnet.com
Offers copyright information, evaluation, development and networking services to creatives.

GenArt: http://www.genart.org
Provides information on current events organized by GenArt, a group serving artists in their twenties.

Macromedia Positions Wanted: http://www.marcomedia.com/Industry/Job/index.html
Any artist can post their name and qualifications here.

MMWIRE: http://www.mmwire.com
A news and reference source for new media and interactive entertainment profession-als, including job opportunities and conference information.

ONLINE PORTFOLIOS

These websites contain online portfolios that art buyers can access when seeking new talent. They also include helpful general information. Some showcase work for other creatives, such as photographers. Perhaps these sites will give you ideas for publicizing your own work.

Artisan's Corner:http://www.esinet.net/ac.html

Artliaison Virtual Art World: http://artliaison.org

ArtNet: http://www.artnet.com

ArtQuest: Call (800)737-8055 or (314)567-5226, or fax (314)567-1209 for information.

ARTscope: http://www.artscope.com

OnLineGallery: http://www.OnLineGallery.com

Designlink: http://www.designlink.com

Kaleidospace: http://www.kspace.com

Pure Art Mkt.: http://www.PureArtMkt.com

The Free-lance Image Exchange: Call David Dobbs at (404)297-0623 for information.

Multimedia Index

There is a growing need for freelancers who can create webpages and CD-ROM projects. The companies listed below expressed interest in freelancers with multimedia skills. Check individual listings for submission requirements. A double-dagger (‡) indicates it is new to this edition. Refer to the General Index for page number.

Humor & Cartoon Index

If you are a cartoonist, caricaturist or humorous illustrator, this index will lead you to appropriate markets. The companies listed here have indicated an interest in humorous material. Check individual listings for specific information submission requirements. See the General Index for page number.

First For Women
‡First Hand Magazine
Florida Keys Magazine
Food & Service
For Seniors Only, For Gradu-
 ates Only
Foto Expression International
‡Foundation News & Commen-
 tary
Fravessi Greetings, Inc.
‡FreeAssociates
Freelance Exchange, Inc.
‡FSP Communications
Fulcrum Publishing
Future Features Syndicate

‡Gallant Greetings Corp.
Gallery Magazine
Game & Fish Publications
‡Gent
‡Gentry Magazine
Gibbs Smith, Publisher
Gibson Co., C.R.
Glamour
Glass Factory Directory
‡Golf Illustrated
Golf Journal
Graham News Service
‡Graphic Arts Communications
‡Grass Roots Productions
Gray Areas
Great Quotations Publishing
Group Publishing—Book &
 Curriculum Division
Group Publishing—Magazine
 Division
Guided Imagery Productions

Habitat Magazine
Hadassah Magazine
Hallmark Cards, Inc.
H&L Enterprises
‡HarperCollins Publishers Ltd.
 (Canada)
‡Health Care PR Graphics
‡Healthcare Financial Manage-
 ment
Heartland Boating Magazine
HerbalGram
High Range Graphics
Highlights for Children
Hill and Wang
Hispanic Link News Service
Hobson's Choice
‡Home Education Magazine
‡Home Office Computing
 Magazine
‡Home Times
Hopscotch, The Magazine for
 Girls
Horse Illustrated
Humorside of It . . . , The
Humpty Dumpty's Magazine

‡i.e. magazine

‡IA Users Club d/b/a Graphic
 Corp.
Illinois Medicine
In Touch for Men
Intermarketing Group, The
Interrace
Iowa Woman
‡Ivory Tower Books

Jack and Jill
‡Japanophile
‡Jewish News of Western Mas-
 sachusetts
Jill Features, Jodi
‡Jillson & Roberts, Inc.
Journal of Light Construction/
 Tools of the Trade, The
Judicature
Juggler's World

Kahn, Inc., A.D.
‡Kalliope
‡Kashrus
King Features Syndicate
Kipling Creative Dare Devils
Kitchen Sink Press, Inc.
Kiwanis

L.A. Parent Magazine
‡L.A. Weekly
Lacrosse Magazine
Ladybug
Laff-A-Day
‡Laugh Lines Press
Law Practice Management
Listen Magazine
Little Enterprises, Inc., Lew
Log Home Living
Long Island Update
‡Loose Design, Inc., Dave
Los Angeles Times Syndicate
‡Lugus Publications
Lutheran, The

‡Made to Measure
‡Mademoiselle
Management Accounting
Management Review
‡Marathon Communications
Marriage Partnership
Masters Agency
Meadowbrook Press
‡Medical Economics Company
‡Mediphors
Michigan Natural Resources
Midwest Features Inc.
‡Minority Features Syndicate,
 Inc.
‡Model Railroader
‡Modern Drummer
Modern Maturity
‡Montana Magazine
Mother Jones
‡Murray Multi Media
Mushing

‡Mutual Funds Magazine

National Business Employment
 Weekly
National Dragster
National Enquirer
National News Bureau
‡National Notary, The
National Review
‡Nelson Publishers, Thomas
New Breed, The
New Mystery Magazine
New Physician, The
New Republic, The
New Writers Magazine
New Yorker, The
‡Noble Works
‡Northwoods Press
Now and Then
Nugget

Oatmeal Studios
Octameron Press
‡Off Our Backs
Ohio Magazine
Oklahoma Today Magazine
‡Old Bike Journal
Options
Oregon River Watch
‡OutPosts, WingTips, Coast-
 ines
‡Outside The Box Interactive

‡P.S. Greetings, Inc.
Papel Freelance, Inc.
‡Paper Moon Graphics, Inc.
Paperpotamus Paper Products
 Inc.
Paramount Cards Inc.
Phi Delta Kappan
‡PhunPhit Designs, Ltd.
Physician's Management
Planning
Playboy Magazine
PN/Paraplegia News
Pockets
Polish Associates, Marc
‡Popcorn Factory, The
Power and Light
Presbyterian Record, The
Presbyterians Today
‡Prevention
Private Pilot
Proceedings
‡Protooner
Psychology Today
Pyx Press

Queen's Mystery Magazine, El-
 lery

Racquetball Magazine
R-A-D-A-R
Radiance

Random House Value Publishing
Really Good Copy Co.
‡Red Deer College Press
Redbook Magazine
Reform Judaism
Relix Magazine
Renaissance Greeting Cards
Reporter, Your Editorial Assistant
Resident and Staff Physician
Rhythms Productions
Rio Grande Press
Rock Products
‡Room of One's Own
Rosenthal Represents
Rotarian, The
Rough Notes
Running Times
Rutgers Magazine

Salmon Syndication
Sam Mantics Enterprises
‡Saturday Evening Post, The
‡School Administrator, The
Science News
Scott Cards Inc.
Screen Actor
Scuba Times Magazine
Seek
‡Semple Comic Features
$ensible Sound, The
Sheep! Magazine
‡Show Biz News and Model News
Singer Media Corp.
‡Sinister Wisdom

Skydiving Magazine
Smart Art
Soap Opera Digest
Soap Opera Weekly
Solidarity Magazine
Songwriter's Monthly
Spinsters Ink
Spitball
‡Sports Afield
Sports 'n Spokes
Spy Magazine
Staton Graphics
Straight
Technical Analysis of Stocks & Commodities
Texas Connection Magazine
‡Thedamu Arts Magazine
Thema
Thompson Works Inc.
‡T/Maker Company
‡Today's Fireman
Tom Thumb Music
Training Magazine
Tribune Media Services, Inc.
Triton and Company
True West/Old West
Turtle Magazine
Twins Magazine
‡U. The National College Magazine
‡United Feature Syndicate/ Newspaper Enterprise Association
‡United Media
United News Service
‡Universal Press Syndicate
‡USA Softball Magazine

Vagabond Creations Inc.
Vegetarian Journal
Venture
Vibe
Videomaker Magazine
Vintage Images
Visual Aid/visaid Marketing

Warner Bros. Records
Washington Pharmacist
‡Water Skier, The
‡Watt, Roop & Co.
Weekly Reader/Secondary
‡Weiss Associates Inc., Daniel
West Graphics
Western Tales Magazine
Whitegate Features Syndicate
‡Wildlife Art
Wildlife Conservation/Bronx Zoo
‡Willowisp Press
Wilshire Book Co.
‡Wilson Fine Arts, Inc., Carol
Win
Wonder Time
Workbench
Working Mother Magazine
Writer's Digest
Writer's Yearbook
‡Wy'East Historical Journal

‡YM
Your Health
Your Health & Fitness

‡Zymurgy

General Index

A double-dagger (‡) precedes listings that are new to this edition. Companies or galleries that appeared in the 1996 edition but do not appear in this edition are identified by a two-letter code explaining why the market was omitted: **(ED)**—Editorial Decision, **(NS)**—Not Accepting Submissions, **(NR)**—No (or late) Response to Listing Request, **(OB)**—Out of Business, **(RR)**—Removed by Market's Requeset, **(UC)**—Unable to Contact.

1997 Insider Reports

Portrait Artist: Ervin Henderson

Jan Mayer
Artist
Page 262

Michael Olijnyk
Curator, The Mattress Factory
Page 491

Scott Hull
Artists' Representative
Page 666